W9-BXN-333

Masters of Seventeenth-Century Dutch Genre Painting

An exhibition organized by the Philadelphia Museum of Art in cooperation with the Gemäldegalerie, Staatliche Museen Preussischer Kulturbesitz, Berlin (West), and the Royal Academy of Arts, London

Philadelphia Museum of Art

This exhibition and catalogue are made possible by a grant from Mobil Corporation

Also generously supported by the National Endowment for the Arts, a Federal agency; The Pew Memorial Trust; and an indemnity from the Federal Council on the Arts and the Humanities. The international transport of the exhibition is made possible in part through the generosity of Lufthansa German Airlines, Pan American World Airways, and Schenker ARTtrans.

Masters of Seventeenth-Century Dutch Genre Painting

Philadelphia Museum of Art *March 18 to May 13, 1984*

Gemäldegalerie, Staatliche Museen
Preussischer Kulturbesitz, Berlin (West) *June 8 to August 12, 1984*

Royal Academy of Arts, London *September 7 to November 18, 1984*

Philadelphia Museum of Art 1984

Cover: Detail of *Girl with Wineglass*, by
Johannes Vermeer (catalogue 116)

Edited by Jane Iandola Watkins
Composition by Folio Typographers Inc.,
Pennsauken, N. J.
Printed in Great Britain by Balding + Mansell,
Wisbech, Cambs.

©Copyright 1984 Philadelphia Museum of Art
All rights reserved. No part of this publication
may be reproduced, stored in a retrieval system,
or transmitted in any form or by any means,
electronic, mechanical, photocopying, recording,
or otherwise, without prior permission, in
writing of the Philadelphia Museum of Art.

Library of Congress Catalog Card no. 84-5798
ISBN 0-87633-057-X Philadelphia Museum of Art

Masters of Seventeenth-Century Dutch Genre Painting

Organized by
Peter C. Sutton

*Exhibition Committee and
Contributing Authors*
Christopher Brown
Jan Kelch
Otto Naumann
William Robinson
Peter C. Sutton

Contributing Author
Cynthia von Bogendorf-Rupprath

Contents

Lenders to the Exhibition

Amsterdam, Amsterdams Historisch Museum

Amsterdam, City of Amsterdam

Amsterdam, Rijksmuseum

Berlin (West), Gemäldegalerie, Staatliche Museen Preussischer Kulturbesitz

Boston, Museum of Fine Arts

Braunschweig, Herzog Anton Ulrich-Museum

Brussels, Musées royaux des Beaux-Arts de Belgique

Budapest, Szépművészeti Múzeum

Chicago, The Art Institute of Chicago

Cologne, Wallraf-Richartz-Museum

Detroit, The Detroit Institute of Arts

Dublin, National Gallery of Ireland

Eindhoven, Stedelijk Van Abbemuseum

Haarlem, Frans Halsmuseum

The Hague, Dienst Verspreide Rijkskollekties, on loan to Dordrechts Museum,
 Dordrecht, and to Museum Boymans–van Beuningen, Rotterdam

The Hague, Mauritshuis, Royal Cabinet of Paintings

Hannover, Niedersächsisches Landesmuseum

Hanover, New Hampshire, Hood Museum of Art, Dartmouth College

Hartford, Wadsworth Atheneum

Houston, Sarah Campbell Blaffer Foundation

Leiden, Stedelijk Museum "De Lakenhal"

Lille, Musée des Beaux-Arts

London, The Trustees of the National Gallery

London, Victoria and Albert Museum—Wellington Museum

Mainz, Mittelrheinisches Landesmuseum

Manchester, City of Manchester Art Galleries

Munich, Bayerische Staatsgemäldesammlungen, Alte Pinakothek

New Haven, Connecticut, Yale University Art Gallery

New York, The Metropolitan Museum of Art

Nottingham, Castle Museum

Paris, Musée du Louvre

Philadelphia, John G. Johnson Collection at the Philadelphia Museum of Art

Philadelphia, Philadelphia Museum of Art

Rome, Galleria Borghese

Rome, Galleria Nazionale d'Arte Antica, Palazzo Corsini

Rotterdam, Museum Boymans–van Beuningen

Saint Louis, The Saint Louis Art Museum

San Francisco, The Fine Arts Museums of San Francisco

Seattle, Seattle Art Museum

Stockholm, Nationalmuseum

Toledo, The Toledo Museum of Art

Vienna, Gemäldegalerie der Akademie der bildenden Künste

Vienna, Kunsthistorisches Museum, Gemäldegalerie

Washington, D.C., National Gallery of Art

Worcester, Massachusetts, Worcester Art Museum

Her Majesty Queen Elizabeth II

Maida and George Abrams, Boston

Peter Eliot

Mr. and Mrs. P. L. Galjart, The Netherlands

Richard Green Galleries, London

Trustees of the Late Julius Lowenstein

The Walter Morrison Collection, Sudeley Castle, Gloucestershire

H. Shickman Gallery, New York

Thyssen-Bornemisza Collection, Lugano

Thirteen Private Collections in Europe and North America

Preface

There can be few greater pleasures or privileges for institutions devoted to the visual arts than that of presenting to the public an exhibition of Dutch seventeenth-century painting. Recent exhibitions examining the oeuvre of a single artist (such as Jacob van Ruisdael at the Mauritshuis and the Fogg Art Museum in 1980), or specific subject matter (as in the case of "Gods, Saints, and Heroes" organized by the National Gallery of Art, Washington, D.C., the Detroit Institute of Arts, and the Rijksmuseum in 1980) have reminded late twentieth-century audiences of the astonishing virtuosity and range of the Dutch painters, whose expressed goal, as the poet Bredero observed, was to imitate life. In a decade in our own time when narrative and allegory, as well as various forms of descriptive realism, are again exerting strong attraction for contemporary artists around the world, it seems particularly appropriate to offer the opportunity to reassess and delight in the rise and triumph of Dutch genre painting.

All three of the institutions associated with the present exhibition have historical associations with the art of the Netherlands. The Gemäldegalerie in Berlin rejoices in one of the richest collections in that field, launched with paintings commissioned or assembled by the House of Orange and the kings of Prussia, and carefully built by a succession of directors including Wilhelm von Bode, himself a pioneer in the delineation of genre painting as a distinct art form. The Royal Academy of Arts has mounted several distinguished exhibitions, notably the "Exhibition of Dutch Art 1450–1900" of 1929 and "Dutch Pictures 1450–1750" of 1952–53, in response to the long-standing devotion of British painters and public to the Dutch masters, and drawing upon the splendid resources of British royal and private collections. The holdings of the Philadelphia Museum of Art and the John G. Johnson Collection together constitute one of the largest groups of seventeenth-century Dutch painting outside of Holland, complemented by significant examples of decorative arts of the period.

This project was conceived by Peter C. Sutton, Associate Curator of European Painting before 1900 at the Philadelphia Museum of Art, and developed and carried out in collaboration with a group of colleagues, each involved with new scholarship in this intensely studied field. Christopher Brown, Deputy Keeper at the National Gallery, London, Jan Kelch, Curator at the Gemäldegalerie in Berlin, Otto Naumann of the firm Hoogsteder-Naumann, Ltd., in New York, and William Robinson, Acting Curator of Drawings at the Fogg Art Museum, Harvard University, have brought their concerted energies and viewpoints to bear upon establishing the parameters of the exhibition, and proposing the paintings included. In their efforts to locate specific works or gather information, the contributing authors of this catalogue were assisted by scholars in many countries; their own dedication to this project during periods of intense activity in their separate professional lives deserves our gratitude.

Robert Montgomery Scott, President of the Philadelphia Museum of Art, Dr. Wolf-Dieter Dube, General Director, Staatliche Museen Preussischer Kulturbesitz, and Sir Hugh Casson, President of the Royal Academy of Arts, have given their enthusiastic and essential support to this exhibition. The staffs of the three collaborating institutions have been deeply involved at varying stages of this project, which has depended greatly upon their hard work and capability. In particular, the Departments of Conservation, Publications, and Special Exhibitions at the Philadelphia Museum of Art, together with the office of the Registrar, have been untiring in the coordination of a very complex undertaking.

A major international exhibition inevitably owes its realization to a remarkable number of cooperative efforts and to the generosity of many. Without a substantial grant from the National Endowment for the Arts, and very generous support from The Pew Memorial Trust, the Philadelphia Museum of Art could not have undertaken this project. Indemnities received from the Federal Council on the Arts and Humanities in the United States and from the British government have made it possible to reduce the costs of borrowing many important works. Welcome support from Lufthansa German Airlines, Pan American World Airways, and Schenker ARTtrans has assisted the international tour. We are deeply grateful to Mobil Corporation and the American Express Foundation for making the exhibition possible in Philadelphia and London respectively. Without their crucial help, and the thoughtful collaboration of their staffs involved with this project, our dream of presenting the history and achievement of Dutch genre painting would have remained unfulfilled.

To the lenders of this exhibition, many of whom provided scholarly information and enthusiastic support as well as parting with treasured objects, go our most heartfelt thanks. It is clear that museums and private collectors fortunate enough to possess masterpieces of Dutch genre painting also possess the generous and public-spirited desire to see that absorbing subject addressed with distinguished examples. While it is impossible here to thank each lender by name as they so richly deserve, we must record special gratitude to our colleagues at the Rijksmuseum, Amsterdam, the Szépművészeti Múzeum, Budapest, the National Gallery of Art, Washington, D.C., and the Metropolitan Museum of Art, New York, who consented to lend impressive numbers of works or permitted the rare masterpieces of Vermeer to be included. Her Majesty Queen Elizabeth II has most graciously allowed a splendid group of pictures from the Royal Collection to be shown at the Royal Academy.

Present-day scholars may debate whether or not the paintings of the Dutch masters can be said to constitute, as the French critic Thoré-Bürger so strikingly observed in 1860, "a sort of photograph of their great seventeenth century, men and things, feelings and customs—the actions and gestures of an entire nation." Thoré's metaphor retains, in any case, a poetic truth: the peerless paintings of Vermeer, ter Borch, de Hooch, and their contemporaries present images both "luminous and precise" to be enjoyed, contemplated, and interpreted anew by our generation.

Anne d'Harnoncourt
The George D. Widener Director
Philadelphia Museum of Art

Henning Bock
Director
Gemäldegalerie, Staatliche
Museen Preussischer Kulturbesitz
Berlin (West)

Norman Rosenthal
Exhibition Secretary
Royal Academy of Arts, London

Masters of Dutch Genre Painting

The Dutch in the seventeenth century placed a premium on naturalistic accounts of their surroundings, be they in the form of portraits, landscapes, still lifes, or scenes of everyday life—what we have come to call "genre" painting. With this art, the painter recorded the look, the manners, the character of those quotidian events, which comprise day-to-day existence. Through them we enter the immaculate middle-class homes that were the pride and preserve of every Dutch *huisvrouw,* or venture into the fetid recesses of cafés patronized by boors and peasants. Dutch genre painters depicted everything from the leisured refinements of the upper classes and the licit entertainments of simple burghers and tradesmen—a wedding feast, a game of cards or trictrac, or one of the rhetoricians' uproarious performances—to that romping free-for-all, the village kermis, as well as the more iniquitous pleasures of Amsterdam's brothels and dancehalls. Here we meet the tailor and tattered ratcatcher, the soldier on bivouac and the itinerant gypsy, the neglectful maidservant and the nurturing mother, as well as all manner of mendicant and dandy. The Dutchman's social miscellany was unified by a highly representational style of painting; whether a serene interior by Johannes Vermeer or a strident tavern by Jan Steen, Dutch genre had an unprecedented truth to life.

Of all categories of Western painting, genre remains the least understood, largely because its meanings are so deeply rooted in the everyday concerns of the culture. Retrieving associations that lent art meaning in another time is always an imperfect business but rarely more so than when the art appears to be self-explanatory. The naturalism of Dutch art is compelling but potentially misleading. More minutely than any people who came before, the Dutch left a record in paint of their land, people, property, and activities. To what extent, however, this charming and seemingly accessible portrait of a society flatters or edits its subject is a question related to one of art history's great philosophical quandaries: the nature of Dutch realism. The Dutchman's powers of observation were unsurpassed but his fidelity to nature rarely was an end in itself; his was a naturalism at the service of more profound realities. As no other people, the Dutch in the seventeenth century embraced genre painting as an essential component of their cultural lives. The present exhibition traces the

rise and first great flowering of this art form. It further seeks to intimate some of the richness of genre's meanings. Neither mere surface realism nor all disguised symbolism, this was an art that represented unexceptional events in an uncommonly imaginative way, subtly balancing the observed fact and the creative idea.

Genre: Word and Concept
By genre painting we refer, in accordance with modern usage, to scenes of everyday life.[1] The etymology of *genre* leads to the French word meaning "kind" or "type." While broader applications of the term remained in currency, even as they do today, the word *genre* became synonymous with scenes of everyday life only in the late eighteenth century. In earlier literary criticism the word had designated types of subject matter and their appropriate literary forms. French art critics, in turn, took to dividing painting into two major categories: *peinture de genre* and *peinture d'histoire*. History painting encompassed subjects drawn from historical or religious texts, while genre painting comprised the minor categories *(les genres)*, such as landscape, still life, and animal painting. Diderot wrote in 1766, "One calls genre painters, without distinction, those who busy themselves with flowers, fruits, animals, woods, forests, mountains, as well as those who borrow their scenes from common and domestic life."[2] The need for a more specific term referring to genre scenes alone was already manifest in J. B. Descamp's writings (1754 and 1760) on seventeenth-century Dutch art. Though he spoke eloquently of Adriaen van Ostade's "low subjects," Gerard Dou's "occupations," and Gerard ter Borch's "subjects from private life," when he noted that Eglon van der Neer was a genre artist as well as a landscapist, the inadequacy of the language emerges: "One also encounters in his work another *genre*, namely that of depicting Gatherings [of figures] wearing the costumes of the fashion of their country."[3] The term *genre* gained wider recognition when Jean Baptiste Greuze was admitted to the French Academy in 1769 as *peintre de genre;* however, disagreement continued over the word's definition.

In 1791 Quatremère de Quincy proposed a new classification system for painting to facilitate the hiring of the appropriate number of teachers for the Académie Royale de Peinture et Sculpture in Paris. In so doing he wrote, "Le genre proprement dit, on celui des scènes bourgeoises," which, since no class distinction was intended, probably is best translated as "genre, properly speaking, [is] scenes of everyday life."[4] Quatremère de Quincy thus became the first writer to use the word *genre* for images of common or domestic experience. This usage, however, became widespread only toward the middle of the nineteenth century. The connoisseur and dealer John Smith, for example, in compiling his catalogue raisonné of painters, still spoke in 1833 of Dutch genre painters as "painters of familiar life" or "fancy subjects."[5] The more specific definition of genre was codified in Franz Kugler's influential *Handbuch der Geschichte der Malerei* (Berlin, 1837): "Genre painting (in the sense that one generally applies to this word) is the depiction of everyday life."[6] Three years earlier Karl Schnaase had proposed the subdivision of this type of art into "coarse, comical motives" and works in which the "master . . . placed himself among the well-to-do"— the nascent distinction of "low" and "high genre" later adopted by Kugler, G. F. Waagen, and most modern writers.[7]

Genre and Art Theory
Though the Dutch in the seventeenth century referred to landscapes *(landschappen)* and still lifes *(stilleven)*, they had no generic equivalent for the term *genre*. In writings on art as in estate inventories and sales, everyday themes were designated by neutral, descriptive terms: *geselschap* (usually translated as merry company), *conversatie* (conversation; not to be confused with the English "conversation piece"), *cortegarde* ("corps de garde" or guardroom piece), *boerenkermis* (peasant kermis), or *bordeeltje* (brothel scene).[8] The artist-writers Karel van Mander (1604) and Samuel van Hoogstraten (1678) both referred to figure compositions, regardless of subject, as *historien* (histories), but usually used the term to designate religious and mythological themes.[9] Following Italian Renais-

FIG. 1. SAMUEL VAN
HOOGSTRATEN, *The First
Born*, 1670, oil on canvas,
Museum of Fine Arts,
Springfield, Massachusetts,
no. 52.02.

sance art theory (Alberti and Lomazzo), which in turn was founded upon antique ideas (Pliny), van Mander, van Hoogstraten, Gerard de Lairesse, and other seventeenth-century Dutch art theorists accepted as an article of faith the notion that history painting was the highest form of art. With the founding of the French Academy in 1648, the practice of ranking paintings by subject was firmly established. Though scarcely so well defined as the thematic hierarchies developed by André Félibien, Diderot, and Quatremere de Quincy, Dutch writers accepted the idea that some subjects were more estimable than others.[10] In his *Inleyding tot de hooge schoole der schilderkonst* (Introduction to the elevated school of painting) of 1678, van Hoogstraten included a chapter "on the three grades of art," in which a subject's rank was loosely determined by the demands it made on a painter's imagination.[11] Reserved for "the common footsoldiers of art," the first and lowest category was still life and allied subjects.[12] In traditional fashion "poetic histories," or what we call simply history subjects, occupied the third and highest level.[13] Bracketed by these two was van Hoogstraten's second grade, a potpourri of secular themes for "cabinet paintings of every type": "Some with Satyrs, fauns and Thessalian shepherds in cheerful Temples. . . . Others with nightscenes, fires, evening banquets, and mummers: or with *bambootserytjes* [street or peasant scenes as depicted by Pieter van Laer, known as Il Bamboccio], or Jan Hagel [a low-life character] comedies, or barber and shoemaker shops." Though van Hoogstraten clearly had no discrete concept of genre, he

FIG. 2. KAREL VAN MANDER,
Village Feast, 1600, oil on
panel, Hermitage,
Leningrad, no. 3055.

judged such works "deserving of the name of *Rhyparographi*," which he translated as "kleyne beuzelingen" (little trifles). Never without a classical reference, the author here employed the term which, according to Pliny, was applied to the lost paintings of the antique artist Piraeicus.[14] Dubbed *Rhyparographos* for his lowlife subjects—shops, cobblers' stalls, asses, viands—Piraeicus is usually awarded the honor of being the first genre painter.

With the rise of classical art theory in the later seventeenth century, Dutch genre painting thus took its place, albeit ill-defined, in the thematic hierarchy. During the early decades of the century, however, genre flourished in a theoretical vacuum. Gerard ter Borch, Jan Steen, and Pieter de Hooch had painted their greatest works, and the pioneers of genre, as well as Gabriel Metsu and Vermeer, were dead when van Hoogstraten's treatise appeared in 1678. Van Hoogstraten's own career illustrates the free relationship that existed in this period between theory and practice, since many of his finest paintings are "little trifles" or lesser themes—genre scenes (see fig. 1), perspectives, or illusionistic still lifes. As so often in his philosophical positions, van Hoogstraten was anticipated in this regard by van Mander, who, though never doubting the moral supremacy of history subjects (the only way "to obtain the highest perfection in art"[15]), also painted the occasional peasant genre piece (see fig. 2) and praised many genre painters, above all Pieter Bruegel the Elder, in his famous *Het Schilder-boeck* (1604).

The Art Market and Specialization
In a lecture delivered on St. Luke's Day, October 18, 1641, and published the following year as *Lof der Schilderconst* (Praise of the art of painting), the Leiden artist Philips Angel devoted most of his remarks to the importance of painting in antiquity and to history painting in his own time. Perhaps unaware of the disdain his contemporary Franciscus Junius and other theorists held for the meaner genre, he went on to mention other painting types, including landscapes, marines, battles, and *cortegarden* (guardrooms).[16] The cursory treatment was typical. By and large, little was written in the seventeenth century about genre. If we then are uncertain about the Dutchman's conception of

FIG. 3. FRANS VAN MIERIS,
Family Concert, 1675, oil
on panel, Galleria degli
Uffizi, Florence, no. 1306.

this art, we are somewhat better informed about how he valued it. The nickname "Geestige Willem" (Inventive, or Witty, William) applied to the pioneering genre painter Willem Buytewech certainly betokened admiration and regard for his invention and skill.[17] Moreover, the praise biographers like van Mander had for genre painters is indicative of the enjoyment viewers took in these paintings. We also have quantitative evidence of how genre was valued. Systematic studies of the Dutch art market have recently begun to appear and some data on genre prices are available.[18] To a degree, the market supported the theorists; a history painting, especially one executed by an established master, often commanded a higher price than a less "elevated" subject.[19] For example, in the inventory compiled in 1657 of the stock of more than four hundred pictures owned by the late Amsterdam art dealer Johannes de Renialme, the highest valued painting at 1,500 guilders was Rembrandt's *Christ and the Adulteress* (National Gallery, London, no. 45); sharing second place, at 600 guilders, with another history painting by Rembrandt, was a *Kitchenmaid* by the genre painter Gerard Dou (compare pl. 54).[20] Dou's prices, however, were scarcely representative of what the average genre painter could expect for his labors: paintings by Molenaer in Renialme's stock brought between 12 and 60 guilders; *Soldiers* by Gerrit Pietersz. van Zijl, 24 guilders; a *Peasant Company* by Jan Steen, 12 guilders; and *Fighters* and a *Singer* by Adriaen Brouwer, 12 and 6 guilders.

There is some evidence to suggest that high life, pastoral scenes, and works by the Dutch-Italianate genre painters were more highly valued than guardroom and low-life subjects; however, the data vary according to the artist and, presumably, to the quality of the mostly unidentified works.[21] Floerke correctly observed that the genre scenes depicting "better society and the high demimonde" by Gerard ter Borch, Gabriel Metsu, and Caspar Netscher brought good prices.[22] In part a result of foreign patronage, Dou and his gifted pupil Frans van Mieris—the greatest practitioners of the painstaking, highly polished *fijnschilder* (fine painter) manner—commanded enormous sums. According to Angel, Dou was paid 500 guilders per annum by the Swedish minister in The

Hague simply for the right of first refusal of all that he produced.[23] The extraordinary amount of 2,500 guilders that the Grand Duke Cosimo III de Medici paid van Mieris for his *Family Concert* of 1675 (fig. 3) cannot be entirely explained by the custom of overcharging the aristocracy (the local nobleman Cornelis Paedts paid 1,500 guilders for another painting by the artist), since estimates suggest that the average price for a van Mieris in the late 1670s was 800 guilders, which easily distinguishes him as the highest paid seventeenth-century Dutch genre painter.[24] The later artists Godfried Schalcken, Adriaen van der Werff, and Eglon van der Neer were employed as court painters by the Elector Palatine in Düsseldorf and, accordingly, were well paid.

Few Dutch painters producing for the open market knew such financial rewards. Surveying fifty-two inventories in the Delft archives dating from 1617 to 1672, Montias calculated that the average painting carrying an attribution to an artist was valued at 16.6 guilders while an unattributed work brought only 7.2 guilders.[25] Some idea of the value of money at this time can be obtained from wages: around the middle of the century a weaver in Leiden earned 7 guilders per week, a fisherman on a herring boat about 5 to 6 guilders, and a skilled worker in Amsterdam about 6 to 8 guilders.[26] Dutch paintings obviously were relatively cheap. John Evelyn probably exaggerated when, after seeing vendors hawking "landscips and drolleries" (genre) at the Rotterdam kermis in 1641, he claimed that "common farmers" often invested heavily in pictures "to very great gains," but a broad section of the middle classes surely could afford art.[27] Peter Mundy, for example, marveled at the Dutch tradesman's appetite for paintings.[28] We may still be surprised to learn that Leendert Henricksz. bought thirteen paintings from Isaack van Ostade in 1641 for only 27 guilders (barely two guilders per painting!), but the prices of 6 to 20 guilders placed on eleven early works by de Hooch in 1655 and the estimate of 15 guilders each received for a *Tobacco Smoker* and *Trictrac Players* by Jan Steen in 1676 simply constituted average market values.[29] Perhaps reflecting his conversion from guardroom to domestic and high-life scenes, de Hooch's prices seem to have risen slightly in his later career, but

it was not until 1707 that one of his pictures commanded more than 100 guilders.[30] De Monconys complained in 1663 that the 600 guilders asked by a baker for a painting by Vermeer with "only" one figure was overpriced and, given the market, he was probably right.[31] More than thirty years later Vermeer's *Woman Holding a Balance* (pl. 108) brought 155 guilders, a relatively good price but scarcely that of a masterpiece.[32] As late as 1736, Berlin's splendid *Girl with Wineglass* (pl. 106) sold for only 52 guilders.

If the Dutchman's love of genre was not always reflected in the prices he paid, it was confirmed by the sheer volume of paintings produced. Even three centuries later, salesrooms still offer Dutch genre paintings in quantity, proof not only of the care that the artists took in their craft but also of their fecundity. In one sense the Dutch painted too many pictures since the overproduction depressed prices and kept the artists' profit margins low. Many artists, including Jan Steen, Jan van Goyen, Hendrick Sorgh, Pieter de Bloot, and others, held supplemental jobs or entered into other extra-artistic business ventures. It has often been observed that the pressures of this competitive marketplace encouraged artistic specialization because an artist was unlikely to abandon a particular painting type once it proved salable. Thus, Michiel van Mierevelt painted portraits, Jacob van Ruisdael landscapes, Peter Saenredam architecture, Willem van de Velde marines, and Adriaen van

Ostade peasant genre. There were, of course, exceptions: Rembrandt, Jan Baptist Weenix, Cornelis Saftleven, Aelbert Cuyp, and van Hoogstraten painted a variety of subjects. Some artists specializing in other themes, like the church-interior painter Emanuel de Witte or the history painter Joachim Wttewael, painted only a handful of genre scenes. Perhaps reflecting the higher esteem in which such subjects were held, several painters, including Gabriel Metsu, Johannes Vermeer, Jacob Ochtervelt, and Pieter de Hooch, produced history paintings in their youth before later concentrating on genre. Many more genre specialists painted the occasional portrait, for which there was perennial demand; among their number we count Pieter Codde, Willem Duyster, Simon Kick, Anthonie Palamedesz., Jan Miense Molenaer, Gerard Dou, Frans van Mieris, Metsu, Pieter de Hooch, Sorgh, Ochtervelt, Michael Sweerts, Eglon van der Neer, and Cornelis de Man. Gerrit van Honthorst and Gerard ter Borch were renowned and much-sought-after portraitists; Nicolaes Maes and Caspar Netscher devoted themselves almost exclusively to flattering face painting in later years. The promise of better fees was undoubtedly an incentive.

Dutch artists tended, furthermore, to specialize within areas of specialization: Adriaen Brouwer, the Ostades, Cornelis Dusart, and Abraham Diepraam painted peasants almost exclusively; Duyster, Palamedesz., and Jacob Duck depicted soldiers; Quirijn van Brekelenkam, Maes, and de Hooch domestic scenes; and Buytewech, ter Borch, and Eglon van der Neer mostly high life. This penchant of Dutch artists to specialize must not be misconstrued as theoretical orthodoxy. On the contrary, the parameters of seventeenth-century genre were remarkably flexible. Only in the last two centuries have theorists and academicians vainly sought a narrow and binding definition of genre.[33] Dutch painters freely mixed their painting types: a consistent style, though hardly a prerequisite, often provided sufficient cohesion. Thus Emanuel de Witte might paint the *Portrait of Adriana van Heusden and Her Daughter* (fig. 4) in a genre-like situation at the fishmarket in Amsterdam. The *Sleeping Hunter* by Cornelis and Herman Saftleven (pl. 91) devotes at least as much atten-

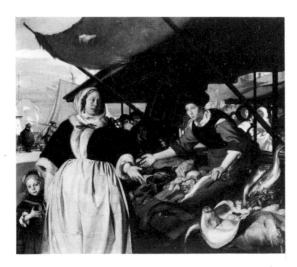

FIG. 4. EMANUEL DE WITTE, *Portrait of Adriana van Heusden and Her Daughter at the Fishmarket in Amsterdam,* oil on canvas, National Gallery, London, no. 3682.

FIG. 5. HERMAN SAFT-
LEVEN, *Boys at Marbles*,
1634, oil on panel, Musées
Royaux des Beaux-Arts,
Brussels, no. 407.

FIG. 6. JOACHIM WTTE-
WAEL, *Kitchen Scene with
the Parable of the Great
Supper*, oil on canvas,
Staatliche Museen
(Bodemuseum), Berlin,
no. 2002.

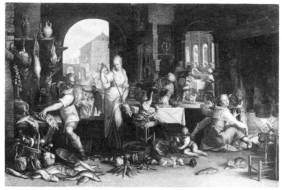

tion to the landscape as to the figure, and
Herman's *Boys at Marbles*, signed and dated
1634 (fig. 5), shows an equally strong interest in
still life. Both works, nevertheless, can be en-
compassed by the elastic boundaries of genre,
which require only that the secular figures play a
major role. Within a single work, genre might be
only one of several genera of painting. A work's
generic classification, moreover, need not be de-
termined by the most conspicuous motifs; in
Joachim Wttewael's *Kitchen Scene with the Par-
able of the Great Supper* of 1605 (fig. 6), for
example, the painting certainly represents the
biblical parable (Luke 14:12–24) even though
the scene is dominated by domestic genre.[34] No
less deceptive for the modern viewer is the genre-
like appearance of Rembrandt's *Parable of the
Rich Man*, dated 1627 (Staatliche Museen
Preussischer Kulturbesitz, Berlin [West], no.
828D), or Jan Steen's *Bathsheba* (fig. 7). At first
glance the latter painting is a depiction of a
woman in fashionable attire of c. 1660 receiving
a letter; its biblical theme (2 Samuel 11:2–4) is

indicated by a tiny inscription on the letter,
which begins "Most beautiful Bathsheba be-
cause. . . ." Devoted both to the imitation of
nature and the Protestant injunction (no less ap-
plicable to Catholic artists, like Steen) that the
word of the Scriptures be made real, the Dutch
artist was less prone to archaize than his Italian
counterpart and often depicted religious and
mythological subjects in contemporary guise.

Training and Local Styles

For the most part Dutch painters received their
artistic training as apprentices to other artists.
Although Karel van Mander, Hendrik Goltzius,
and Cornelis Cornelisz. van Haarlem are re-
ported to have set up an academy in Haarlem
before 1600, and, with the rise of classicism,
drawing schools were established at the end of
the seventeenth century, instruction in large
groups, at least outside Rembrandt's studio, was
rare. More typical was the artist with one or two
adolescent or teenage apprentices, who were
taught for a fee the craft of painting (the prepa-
ration of the canvas, the grinding of pigments,
glazing techniques, and so on), frequently while
living in the master's home. Often an important
supplement to a painter's income, apprentice-
ships were regulated by the guilds and occasion-
ally resulted in quarrels, like the one that
erupted between Frans Hals and Judith Leyster.
Over and above learning the mechanics of their
trade, many Dutch genre painters naturally were
impressed by their teachers' styles: for example,
Frans van Mieris, Godfried Schalcken, and
Matthijs Naiveu owed much to Dou; Jan Steen,
Isaack van Ostade, and Cornelis Bega were in-
fluenced by Adriaen van Ostade; Caspar
Netscher by ter Borch; Adriaen van der Werff
by Eglon van der Neer and so on. However, in
other cases, such as ter Borch's study under
Pieter Molijn or the training of de Hooch
and Ochtervelt with Nicolaes Berchem, the
stylistic influence was limited, even at times
undetectable.

In addition to interaction through the guilds
and student-teacher relationships, Dutch paint-
ers naturally had many professional and social
contacts. Archival documents and marriage regi-
sters offer laconic but evocative testament to
everyday dealings among artists: for example, on
a summer outing in 1625 to a country house at
Meerhuysen owned by the painter, dealer, and

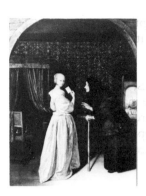

FIG. 7. JAN STEEN,
Bathsheba, oil on panel,
private collection.

innkeeper Barent van Someren, the genre painters Pieter Codde and Willem Duyster became involved in a heated argument that resulted in bloodshed; in 1631 Duyster and Simon Kick married each other's sisters in a double wedding ceremony; in 1635 Cornelis Bega was living in a house owned by Cornelis Cornelisz. van Haarlem; in 1636 the painters Molenaer and Leyster were wed; Jan Steen married Jan van Goyen's daughter in 1649; Vermeer and ter Borch signed together as witnesses to a document in 1653; and de Hooch and the genre painter Hendrick van der Burch repeatedly served as joint witnesses to documents. Though not above embroidering his accounts of artists' lives, Arnold Houbraken attests to the close relationships that often existed between Dutch painters; he informs us, for example, that Steen and van Mieris, as well as Rembrandt and van den Eeckhout, were close friends. De Schildersbent—the organization of Netherlandish painters in Rome—was not only a closely knit group, as one might expect of foreigners living abroad, but also notoriously sociable.

The small size of the Netherlands (apparent to anyone who has ever traveled by train from Amsterdam to Rotterdam, passing through Haarlem, Leiden, The Hague, and Delft at intervals of approximately twenty minutes or less) insured the rapid transmission of artistic ideas; some of the most important genre painters, such as ter Borch and Steen, traveled or moved frequently among the major towns and cities. Nonetheless, there was considerable diversity in Dutch art. The various artistic centers often developed distinctive local styles of painting and favored subjects. The university town of Leiden, for example, was the home of Gerard Dou, who inaugurated a school of genre painting that is readily distinguished by its refined technique from those of other towns. Similarly, an interest in light and the expressive use of space are characteristic of Delft genre painting, whose greatest practitioners were de Hooch and Vermeer. Haarlem peasant painting is readily distinguishable from its Rotterdam counterpart, and Dutch Caravaggism was restricted almost exclusively to Utrecht, a city with long-standing ties to Rome. Nevertheless, the identification of local schools of painting, a practice taken over

from writings on Italian art, has limited application for Dutch art. Attempts, for example, to distinguish an indigenous Haarlem genre painting style from that of Amsterdam—a city barely twelve miles away—seem misleading.

Selective Naturalism
Scarce as seventeenth-century commentaries on genre are, Dutch authors repeatedly stressed that a painting should be an accurate record of the visual world. Angel's panegyric on painting was addressed to his fellow "imitators of life" *(nabootsers van't leven).*[35] A great admirer of art, Frederik Hendrik's versatile secretary Constantijn Huygens claimed that Dutch landscapes "lacked nothing for verisimilitude save the warmth of the sun and the movement of the wind."[36] In an age when Dutch cartographers mapped the globe and Dutch scientists led inquiry into so many fields, the painter shared the respect and enjoyment of the well-observed fact. Whether the sheen of pewter in a breakfast still life by Pieter Claesz., the receding patchwork of bleaching fields in one of Ruisdael's views of Haarlem, or the diffusion of sunlight in an interior by Vermeer, the faithful representation of the visible world was the mandate of every Dutch artist. One of the clearest expressions of the Dutchman's goal of naturalism and its relationship to the practical spirit of seventeenth-century scientific inquiry was the artist's willingness to consult optical aids and instruments— mirrors, lenses, and the camera obscura. Seventeenth-century authors described and recommended the artistic use of such devices, and van Hoogstraten left no uncertainty that the aim was to enhance the natural appearance of paintings. Of the camera obscura and its unrivaled visual fidelity, he wrote, "I am sure that the sight of these reflections in the dark can give no small light to the vision of young Artists; since besides gaining knowledge of nature, one sees here what main or general [characteristics] should belong to a truly natural painting [*een recht natuerlijke Schildery*] . . . the same is also to be seen in diminishing glasses and mirrors, which, although they distort the drawing somewhat, show clearly the main coloring and

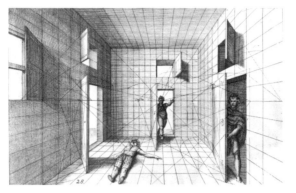

FIG. 8. Engraving from JAN VREDEMAN DE VRIES, *Perspective* (Antwerp, 1605), pl. 28.

harmony."[37] Artists also consulted perspective manuals by such authors as Jan Vredeman de Vries (see fig. 8), his pupil Hendrick Hondius, and Samuel Marolois as well as painters' handbooks on techniques and materials—all in the interest of improving and refining a craft at the service of naturalistic representation.

The Dutchman's delight in naturalism greatly appealed to art lovers and critics in the last century. Nineteenth-century writers perceived Dutch genre as a literal transcription of reality. Reviewing the Exposition Universelle of 1867, Thoré-Bürger found occasion, as he so often did, to mention seventeenth-century Dutch genre: "Usually the subject scarcely matters as long as the artist has well executed the image that he selected."[38] These sentiments found their clearest expression in Eugène Fromentin's *Les Maîtres d'autrefois* (Masters of earlier times) of 1876, which devotes an entire chapter to the premise that "the moral basis of Dutch art [is] the total absence of what we today call *a subject*."[39] "The goal is to imitate what is, to make what is imitated charming, to clearly express simple, lively and true sensations."[40] Reflecting the Hegelian notion that the best art reflects most accurately the spirit of its age, for Fromentin and his century this was the great "probity" and "sincerity" of Dutch painting.[41] Viewed in purely formal terms, the naturalism of Dutch art also seemed to lend support to the "art for art's sake" defenses of Impressionism. Pisarro wrote to his son following a trip to Holland that the works of Frans Hals and Vermeer had persuaded him more than ever to love Monet, Degas, Renoir, Sisley and their fellow Impressionists.

Arguments concerning the nature of realism and its problematic relationship to reality have always been central to Western thought. This is not the place for a historical discussion of theories of perception or phenomenology, but the Dutchman's concept of naturalism is apposite. Although the seventeenth century was the age of inquiry, Dutch paintings' truth to life was as much a matter of art as observation. In a much-quoted passage, van Hoogstraten wrote: "A perfect painting is like a mirror of Nature in which non-existing things [in the painting] appear to exist and deceive in acceptable, pleasing, and commendable fashion."[42] To deceive *(bedriegen)* was the goal not only of the painters of illusionistic still lifes and perspective boxes (these and other trompe l'oeils were called *bedriegertjes* or "little deceivers") and those Dutch history painters who gave form to an unseen world of history and literature, but also of genre painters. The "deceit" of the last mentioned was the look of artless familiarity, since theirs was neither a literal nor an uncritical mirror of reality.

Paintings of artists' studios confirm what common sense suggests, that genre scenes were composed rather than recorded automatically like so many snapshots. Molenaer's *Artist's Studio* (fig. 9) depicts the painter with a group of models, including a hurdy-gurdy player and a dwarf dancing with a dog, relaxing between posing sessions for a half-finished musical genre scene on an easel at the right. The Flemish genre painter Joos van Craesbeeck depicted an artist in the act

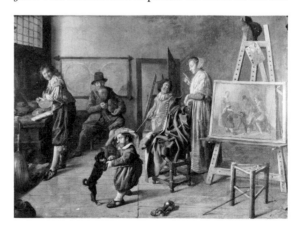

FIG. 9. JAN MIENSE MOLENAER, *Artist's Studio,* oil on canvas, Staatliche Museen (Bodemuseum), Berlin, no. 873.

of painting a merry company group (personifying the Five Senses) around a table (Frits Lugt Collection, Institut Néerlandais, Paris, inv. no. 7087).[43] The paradox, of course, is that these paintings of artists' studios are also composed images. Many painters used their family, friends, and colleagues as models: ter Borch depicted his student Caspar Netscher (pl. 69), and his sisters Jenneken (pl. 71) and Gesina (pl. 70); van Mieris portrayed himself and his wife (pl. 58); Godfried Schalcken depicted himself and his sister Maria (pl. 121); and Steen, as was his practice, painted himself repeatedly (pls. 79, 81, 82, 85). Gudlaugsson first demonstrated that Steen's use of stock characters from the theater, like the comical doctor (pl. 81), attests to their origins in the artist's imagination, not in reality.[44] Though further proof is scarcely necessary, the existence of many preparatory drawings for individual figures in genre paintings (see, as examples, cat. nos. 13, 14) confirms their studied artistry.[45] For all its seeming variety and completeness, then, genre was not an encyclopedic inventory of society's day-to-day activities. Patterns emerge in the selection of subjects that reflect genre's functions for Dutch culture. The naturalism of Dutch art was highly subjective. Though he used the phrase to describe seascape paintings of Porcellis, van Hoogstraten could as readily have spoken of *keurlijke natuerlijkheit* (selective naturalism) in discussing genre.[46] Just like Dutch landscapes and marines, genre scenes were composed in the studio from assemblages of carefully selected, naturalistic motifs.

Methods and Meanings
For the modern viewer, conditioned by a surfeit of photography and video, the naturalism of Dutch genre may veil its sophistication. Genre could operate on many different levels. The Dutch unfortunately provided no manuals explaining genre's meanings; nor could they necessarily have composed such an ideal handbook. As depictions of everyday life, genre scenes naturally had shared associations for the artist and his public as members of the same culture. To begin to recapture these most basic and ephemeral of associations—assumptions about common experience that were often thought so obvious and conventional that they escaped literary record or formulation as symbol—we must study Dutch society and culture in the broadest possible terms. Over and above these common associations the painter could allude to concepts or ideas by introducing to his interpretation of the subject, more or less overtly, a metaphoric dimension; in such cases we may speak of an allegorical aspect which in turn could function as a lesson. The concept or lesson, with or without moral overtones, could be the central meaning of the work of art, one of several meanings, or only a footnote to an otherwise unchanged image. Further, the message might be intended for all or only part of the artist's public. The artist's viewpoint was also variable; rarely a dispassionate observer, he could be comical, righteously earnest, or even ambivalent in his attitude to his subject. Finally, some genre subjects owed their existence primarily to artistic tradition and only secondarily to contemporary reality.[47] It is no surprise that these paintings are difficult to interpret and, perhaps still more challenging, to explain in a fashion that does justice to the balance and emphasis of the artist's original intent.

In the last half-century, Fromentin's notion of Dutch art as *genre pur* has been discredited by various iconographic studies.[48] Allegorical or emblematic meanings have been identified in paintings previously considered only descriptive or picturesque accounts of Dutch life. In the excitement of these discoveries, some students of iconography have become over zealous in seeking the recondite in the everyday.[49] Perhaps inevitably, the rigorous methods of the leading researchers have been vulgarized as writers have become increasingly careless about the crucial question of the congruence of image and symbol. Moreover, Panofsky's phrase "disguised symbolism" has been misleading in two respects:[50] first, for the informed seventeenth-century viewer there was nothing "disguised" or "hidden" about these allegorical allusions; and second, the implication that the work's outward realism was only at the service of symbolic elements there encoded is inconsistent with the Dutchman's celebration of naturalism—his delight in mimicry and the accurate recording of the particular. However, for our new alertness to genre's complexity and our corresponding appreciation of the sophisticated nature of Dutch realism we are much in the researcher's debt.

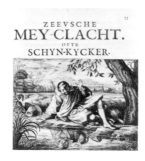

FIG. 10. WILLEM VAN DE
PASSE after Adriaen van de
Venne, *The Melancholy
Poet Regarding His Reflec-
tion*, engraving for Adriaen
van de Venne's poem
"Zeeusche Mey-Clacht. ofte
Schyn-Kycker" in *Zeeusche
Nachtegael ende des selfs
dryderley gesang* (Mid-
delburg, 1623).

Mute Poetry

In developing methods for interpreting Dutch
genre, modern writers have pointed to the close
relationship that often existed between art and
literature in the seventeenth century. Though
much Dutch literature was stilted by classical
conventions, authors like G. A. Bredero (who
was trained as a painter) and Jacob Cats ex-
pressed the national spirit no less clearly than
Holland's painters. In an effort to raise the pres-
tige of painters to that of poets, sixteenth-
century art theorists spoke of the "sister arts" of
painting and poetry, a notion justified by invert-
ing the translation of the phrase "Ut pictura
poesis," coined by the classical poet Horace, so
that it was rendered as "a painting is like a
poem."[51] Many artists were members of the
popular rhetoricians' societies and several, in-
cluding Pieter Codde and Gerbrand van den
Eeckhout, tried their hand at poetry. Adriaen
van de Venne, like van Mander, was a well-
regarded poet; his "Zeeusche Mey-Clacht"
(Zeeland May-plaint) of 1623 is largely devoted
to a discussion of the relationship between paint-
ing and poetry.[52] Van de Venne illustrated his
poem with an engraving (fig. 10) of a poet-
painter gazing Narcissus-like into a still pool—
an allusion (anticipating van Hoogstraten's
"mirror of nature" phrase) to painting's ability
to reflect the visual world. This readiness on the
part of seventeenth-century authors, especially
one who was an artist, to liken painting to po-
etry encourages us to seek in literature the
methods and techniques painting's *stomme
poëzie* (mute poetry) so reluctantly discloses.

More than many other national literatures,
Dutch poetry is filled with allegory, metaphor,
and forms of double entendre. Simple riddle
books and rebuses captured the popular imag-
ination. Masters of the extended homiletic
metaphor as well as the humble pun and
proverb, Dutch Reformed preachers championed
biblical exegesis and hermeneutics. Perhaps the
clearest expression of the Dutchman's love of
interpretive and associative thinking was the
popularity in the Netherlands of emblem books,
an illustrated form of literature in which an im-
age—often an everyday object—was appended
with a motto and poetic commentary prompting

thoughts of larger issues, frequently moral in na-
ture.[53] Emblem books were enormously
popular in sixteenth- and seventeenth-century
Europe. Estimates suggest that in this period as
many as six hundred authors produced in excess
of two thousand titles, representing, in turn, tens
of thousands of individual emblems.[54] The most
influential of the emblem books was probably
Andrea Alciati's *Emblematum libellus* (Paris,
1542), which went through over one hundred
and seventy editions. Roemer Visscher, one of
the most widely read Dutch authors of emblem
books, reflected the medieval foundations of this
literature and its metaphorical view of the world
when he stated in his *Sinnepoppen* of 1614,
"Daer is niets ledighs of ydels in de dingen"
(There is nothing empty or meaningless in
things).[55]

The revelation of an unseen as well as an un-
foreseen idea obviously was one of the emblem's
attractions. By the same token, the outward
form that veiled these meanings was also prized,
since it made the idea appealing and memorably
concrete. Christ's practice of speaking in para-
bles offered sacred precedents. Jacob Cats wrote
in his emblem book *Spiegel van den ouden en
nieuwen tijdt* (Mirror of old and new times):
"Experience teaches us that things appear to best
advantage when not seen completely, but slightly
hooded and shadowed."[56] In 1624 Johan de
Brune characterized the "happy deception" of
his emblems as a "childish mask [*mom-aenzicht*]
which hides an adult discipline," while his son
observed that "we take more pleasure in puzzles,
witticisms and jests in which something secretive
and hidden has been inserted than in things that
are understood at first glance."[57] Like the em-
blematists, Dutch art theorists commended
paintings with richly layered meanings: van
Mander valued paintings with "pleasant adorn-
ment and depictions pregnant with meaning,"
while van Hoogstraten prescribed "accessories
which covertly explain something."[58] For the lat-
ter, these "covert" explanations were part of the
pleasurable "deception" that he so admired in
painting.

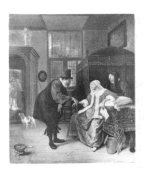

FIG. 11. JAN STEEN, *The Doctor's Visit*, oil on canvas, Bayerische Staatsgemäldesammlungen, Alte Pinakothek, Munich, no. 158.

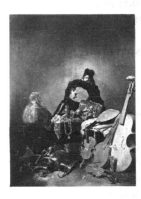

FIG. 12. LEONAERT BRAMER, *Allegory of Vanity*, oil on panel, Kunsthistorisches Museum, Vienna, no. 413.

Allegories and Accessories

Various techniques employed by Dutch genre painters fulfilled van Hoogstraten's prescriptions. One of the commonest was the use of a painting or sculpture within a painting to elucidate or comment on a subject. Metsu painted a small plaster Cupid in his *Hunter's Gift* (pl. 65) no doubt to underscore the amorous meaning of the hunter's gesture; Steen often included a similar statue in his scenes of doctors with lovesick maidens (see fig. 11). The complacent-looking woman holding a letter in Dirck Hals's *Seated Woman with a Letter* (pl. 12) sits before a seascape of a placid stretch of water. In his scenes of parties of men and women drinking and making music (see, for example, pls. 101, 102) de Hooch added to the interior furnishings paintings with religious subjects—respectively, Christ and the Adulteress and the Education of the Virgin—which stand in moral opposition to the merrymaking in the foreground. Similarly, the painting of the Last Judgment, which hangs behind the pregnant woman in Vermeer's *Woman Holding a Balance* (pl. 108)—an image of singular mystery and poignance—only redoubles the painting's rich store of meaning. Paradoxically, the painting or sculpture within a genre painting was a "covert" technique precisely because it was not hidden at all, but part and parcel of the natural appearance of the scene.

While one might reasonably argue that each of these details is simply a feature of the decoration of the room, the skull on which the woman rests her foot in Molenaer's *Woman at Her Toilet* (pl. 20) is, at the very least, an unusual household object. Close inspection of the type undertaken in this case by E. de Jongh reveals a full and carefully coordinated symbolic program; the vanity and the transience of life are expressed not only by the skull but also by the boy at the left blowing bubbles—a secularized version of bubble-blowing putti in prints of the Homo Bulla (Man is a bubble) theme. Moreover, the young woman seated on the right whose head just touches the contour of the map on the back wall is undoubtedly Vrouw Wereld (Lady World)—a personification of worldliness usually depicted in allegorical prints as a woman with a globe on her head but here represented in everyday guise.[59] The vanity of things of this world is also the subject of Leonaert Bramer's scene of a man playing a lute and a woman looking in a mirror with a large still life of musical instruments, songbooks (one inscribed "vanitas"), armor, and precious metalware (fig. 12, *Allegory of Vanity*, which is the pendant to the *Allegory of Transitoriness*, Kunsthistorisches Museum, Vienna, no. 417). Though a popular theme, *vanitas* was only one concept treated allegorically in genre. As J. A. Emmens demonstrated, Dou's lost triptych (see cat. no. 34, fig. 1) representing a mother nursing a child in the central scene with flanking wings depicting a night school and a man sharpening a quill refers in the respective parts to Nature, Education, and Practice.[60] The triptych thus embodies the Aristotelian ideal of pedagogy, which in turn formed the philosophical basis of training in art. Yet another example is provided by Nicolaes Berchem's splendidly exotic painting *A Moor Presenting a Parrot to a Lady* (pl. 51), which may represent the Christian East meeting the pagan West.

Just as the works by Molenaer and Bramer warn in all details against worldliness, Steen's *Easy Come, Easy Go* (pl. 79) presents a thoroughgoing admonition against waste and the vicissitudes of fortune. In a richly appointed interior, a young man with Steen's own features enjoys a meal of oysters in the company of an attractive and particularly attentive young woman who offers him a glass of wine. Through the open door men are seen playing trictrac. The main decoration over the mantle is a figure of Fortuna standing on a gaming die and holding a billowing sail of drapery—attributes of her personification of chance and whimsy. Behind the figure is a seascape with one vessel safely under sail and a second dashed on the rocks, additional symbols, like the fireplace's sculptured putti and other motifs, juxtaposing good and ill fortune. Leaving nothing to chance himself, Steen actually inscribed the title of his work on the mantle's plaque: "Soo gewonne/ Soo verteert" (Easy come, easy go).

FIG. 13. PIETER BRUEGEL
THE ELDER, *The World Up-
side Down,* 1559, tempera
on panel, Staatliche Museen
Preussischer Kulturbesitz,
Berlin (West), no. 1720.

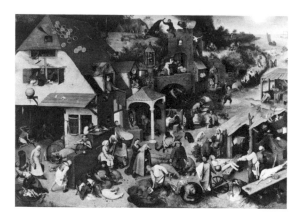

Steen favored carefully elaborated symbolic programs and often inscribed his titles into his works, as in *The Dissolute Household* (pl. 85) and *Beware of Luxury* (pl. 80). In the latter, a key—literally the *clavis interpretandi*—appears on the back wall beside a looted strongbox and empty moneybags. The artist's earnest *Prayer before the Meal* (pl. 78) includes a plaque on the back wall with a stanza versified from Proverbs referring to a balanced, God-fearing, and devout life. In his practice of inscribing titles or legends on his works, Steen followed earlier painters and printmakers, such as Adriaen van de Venne (see, for example, pl. 26). This art ultimately descends from sixteenth-century allegorical genre scenes, the best of which are found in the art of Pieter Bruegel the Elder, who frequently illustrated sayings and proverbs (see fig. 13). Like Bruegel, Steen's approach often was comical but almost always barbed with a warning or moral admonition.

It is sometimes argued that scenes of everyday life that embody allegories or illustrate proverbs are not genre at all but history paintings.[61] In the absence, however, of a clear historical precedent for the division of the two painting types, the boundaries remain vague and permit some arbitrariness in definition. We group these works under the heading of genre because, on a pre-iconographical level, they give the appearance of secular, everyday life. Of the paintings cited above it also must be said that they are unusual among seventeenth-century genre—and here it cannot be a matter solely of

our ignorance and the passage of time—in lending themselves to such systematic allegorical explication. For the few works of this type, there are many more in which the allegorical or emblematic aspect is only one factor in the picture's meaning—in this sense, truly *bijwerken* (accessories), to use van Hoogstraten's term.

In Buytewech's *Merry Company* (pl. 6), for example, the artist seems to be gently mocking the country's new *jeunesse dorée* and their idle recreation. The figures' elegant costumes and manners point to their elevated social standing. Literature from the period also informs us about how such wealthy young people and their sensual pastimes were perceived. To these sociological insights we add those provided by artistic ancestry (the subject's origins in depictions of the Prodigal Son squandering his inheritance and other allegories of Intemperance) and the potentially emblematic motifs of the painting itself—the monkey as a symbol of sensuality, the map as an allusion to earthly desires, the lute connoting lust and luxury, and so on. Similarly, in ter Borch's *Officer Writing a Letter, with a Trumpeter* (pl. 69), it is relevant to know how soldiers, specifically officers, were perceived by society and how they were depicted in earlier art. It is also important to appreciate the popularity at this time of letter writing. To these cultural associations the ace of hearts on the floor adds a possible symbol. That the letter penned may be a billet-doux instead of some dry dispatch or marching orders piques the viewer's interest and makes the letter writer's absorption all the more expressive. Ter Borch was the master of refinement, not only in terms of his socially elevated subjects and peerless technique—renderings of satin and tulle to defeat an army of imitators and copyists—but also in terms of psychology. One can inventory the associations and potential symbolism of objects on a dressing table or discuss the implications of details of costume and furnishings, but the abstracted gaze of the woman fingering her ring (see pl. 72) speaks volumes. Similarly, the anecdotal, anachronistic title *Curiosity* (pl. 71) is surely unhistorical, but the state of mind has rarely been depicted so compellingly. Ter Borch's *Soldier Offering a Young Woman Coins* (pl. 74)

treats a time-honored genre subject, namely that of venal love (compare pls. 10, 39). While the luscious still life of fruit could symbolically reiterate the central themes of love and desire, it still functions only as a subsidiary note to the artist's unprecedentedly subtle interpretation of the narrative.

Seventeenth-century Dutch genre painting thus employed symbolism in various ways and degrees, and some artists were more prone to its use than others. Nicolaes Maes, for example, frequently employed symbols at the service of a moral message. In *The Account Keeper* (pl. 98) the old woman's worldly activity is underscored not only by the prominent map but by the bust of Juno, patroness of commerce. Looking down from above, the bust reminds us of the dozing woman's dereliction of duty. Similarly, Adriaen van der Werff's *Boy with a Mousetrap* (pl. 125) probably warns symbolically of the dangers of love and desire. As we have noted, Dou and Molenaer were both disposed to the use of emblematic allusions. In many cases, however, the meanings are only imperfectly understood today. Molenaer's painting of children teasing a dwarf (pl. 21), for example, may allude to a forgotten expression or proverb or perhaps to emblematic ideas concerning the unalterableness of nature, but its meaning is unclear. There also were symbolic allusions of a less-lofty conceptual order that required no special knowledge of classical sources, emblematic literature, or the handbooks on symbolism by Alciati and Ripa. The ironic gesture of Steen's sot with a herring in *The Doctor's Visit* (pl. 81) would surely have been familiar to anyone who had ever encountered the ubiquitous rhetoricians' performances or come upon fools performing at Shrovetide. Similarly, the erotic implication of the man's gesture in offering the lady a dead bird in Metsu's *Hunter's Gift* (pl. 65) had certainly entered the vernacular imagination together with the slang meaning of the word *vogelen* (to copulate).

At the same time, this picture serves to remind us of the importance of context in the interpretation of symbol. Obviously birds were not always erotic symbols (see, for example, Jan Steen's so-called *Poultry Yard*, or *Portrait of Bernardina van Raesfelt*, dated 1660, Mauritshuis, The Hague, no. 166), nor was a hunter gesturing with a dead bird always making a sexual proposition. In Anthonie Palamedesz.'s respectable

Family Portrait (1635?, Musée Royal des Beaux-Arts, Antwerp, no. 810) depicting the adolescent son returning home proudly from the hunt with a dead duck, hunting's associations with aristocratic pastimes are surely more relevant than the bird's erotic connotations. Likewise, mirrors are not always symbols of vanity, Superbia, or the illusory nature of the world; and maps need not connote worldliness or earthly desire. Some maps and mirrors, obviously, are only furnishings. This is not to suggest, one hastens to add, that the Dutch ever produced anything like the nineteenth century's *genre pur* or "art for art's sake." Over and above what Panofsky would call the "primary or natural subject matter," images that seem outwardly to carry little "disguised" meaning—musical companies by van den Eeckhout and van Loo, de Hooch's scenes of women working by the hearth or in courtyards, Brekelenkam's images of professions, and the Ostades' and Dusart's contented peasants at the inn—undoubtedly conveyed social and cultural ideals that belie mere reportage or illustration. To begin, however, to grasp the relative weight given to social, pictorial, and symbolic elements of a genre image, it is essential to understand the work's place in the history of the painting type.

FIG. 14. HIERONYMUS BOSCH, *Seven Deadly Sins*, tabletop, Prado, Madrid, no. 2822.

FIG. 15. QUENTIN MASSYS, *Unequal Lovers*, oil on panel, National Gallery of Art, Washington, D.C., no. 2561.

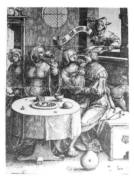

FIG. 16. LUCAS VAN LEYDEN, *Tavern Scene with a Young Woman Passing a Man's Purse to an Accomplice*, woodcut.

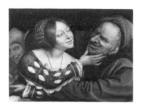

FIG. 17. MARINUS VAN REYMERSWAELE, *Lawyer's Office*, 1542, oil on panel, Bayerische Staatsgemälde-sammlungen, Alte Pinakothek, Munich, no. 718.

Origins of Genre and the Sixteenth Century

So broad is the current definition of genre that the term may refer indiscriminately to scenes of herdsmen on Egyptian tomb reliefs, athletes practicing on Greek vases, musicians or travelers on Chinese scrolls, prayerful peasants by Millet, or poolside gatherings by David Hockney. With such broad usage the term might seem virtually meaningless. The sources, however, for Dutch seventeenth-century genre are charted more narrowly. Secular subject matter had appeared in medieval marginalia and manuscript illumination, and the domestic intimacy of early Netherlandish religious paintings (The Master of Flémalle and Jan van Eyck) was a special attraction of their naturalism. But the direct line of descent to the Dutch genre painters began with the moralistic allegories of Hieronymus Bosch, Quentin Massys, and Lucas van Leyden. Bosch's painted tabletop in the Prado depicts the *Seven Deadly Sins* (fig. 14) with scenes of everyday life—*Gula* (Gluttony) shows peasants gorging themselves at table, *Ira* (Anger) depicts furious combatants with drawn knives, *Superbia* (Luxury) is a woman in a headdress primping before a mirror, *Avaricia* (Avarice) a corrupt judge accepting bribes, and so on—all encircling an image of Christ with the inscription "Beware, beware, God is watching." Bosch's genre paintings also included scenes of quacks or conjurers with gawking onlookers whose purses invariably are snipped by pickpockets. The popular moral

"The fool and his money are soon parted" was later repeated by Quentin Massys in his *Unequal Lovers* of c. 1522–23 (fig. 15), one of the sixteenth century's most popular genre subjects and one with literary parallels in such works as Sebastian Brant's *Ship of Fools* of 1494 and Erasmus's *Praise of Folly* of 1515.[62] As the young girl caresses her elderly and lecherous companion, she passes his purse to a fool accomplice. In the lower left we glimpse cards and money. Lucas van Leyden, whose woodcut *Tavern Scene with a Young Woman Passing a Man's Purse to an Accomplice* (fig. 16) served as a source for Massys's painting,[63] also painted scenes of card and chess games, which undoubtedly expressed the popular notion that love is a game played between the sexes for high moral stakes. Lucas's prints of genre themes also had a lasting influence on later genre artists.

Among Massys's principal followers in Antwerp were his son Jan Massys, Marinus van Reymerswaele, and Jan Sanders van Hemessen. These artists specialized in nearly life-size, half-length compositions of genre figures, often with strongly caricatured features. Van Reymerswaele took from Massys subjects from the world of finance and law (see Quentin Massys's *Money Lender and His Wife*, dated 1514, Musée du Louvre, Paris, no. 1444), offering a grimly satirical view of covetous usurers, tax collectors, and lawyers specializing in client abuse and extortion (see fig. 17). For his part, van Hemessen painted genre subjects with exceptionally monumental figures, often situated very close to the picture plane, with a correspondingly minute technique. His painting of 1536 (fig. 18) is a depiction of the Prodigal Son in the tavern with whores, outwardly a genre theme but in fact a religious subject. The episode is never actually mentioned in the Bible (Luke 15:11–32), which states only that the Prodigal "wasted his substance in riotous living," but through its inclusion in pictoral cycles depicting the parable, it became an important milestone in the history of genre, specifically of high life and the tradition of the merry company.[64] Van Hemessen's *Merry Company* in Karlsruhe (fig. 19) is similar in conception. It depicts the three ages of man with scenes in the background of a young man in a house of ill repute and a middle-aged gentleman at the entryway of a similar establishment; in the

FIG. 18. JAN SANDERS VAN HEMESSEN, *The Prodigal Son*, 1536, oil on panel, Musées Royaux des Beaux-Arts, Brussels, no. 2838.

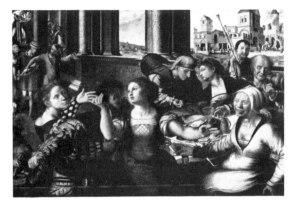

FIG. 19. JAN SANDERS VAN HEMESSEN, *Merry Company*, oil on panel, Staatliche Kunsthalle, Karlsruhe, no. 152.

FIG. 20. JOACHIM BUECKELAER, *Christ in the House of Mary and Martha*, 1565, oil on panel, Musées Royaux des Beaux-Arts, Brussels, no. 782.

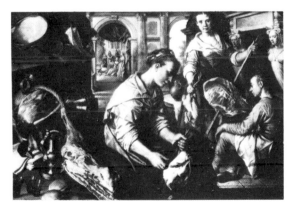

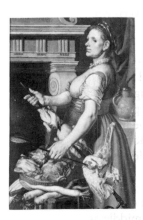

FIG. 21. PIETER AERTSEN, *The Kitchenmaid*, 1559, oil on panel, Musées Royaux des Beaux-Arts, Brussels, no. 705.

foreground a young prostitute embraces a re-morseful-looking old man as a cronish procuress laughs—a mercenary love scene reminiscent of depictions of the unequal lovers theme. Though the subject is no longer religious, the painting bears unmistakable resemblance to scenes of the Prodigal Son as well as allegorical representations of the effects of intemperance.[65] Like these themes it carries a general moral condemnation of drunkenness, whoring, and debauched living.

Van Hemessen's two paintings might seem to support the traditional view that genre, still life, and landscape—the "lesser" genre—evolved out of religious painting. Some of the prime examples used to support this theory were the paintings by Pieter Aertsen and his nephew Joachim Bueckelaer of kitchens and markets with subsidiary religious scenes in the background, such as *Christ in the House of Mary and Martha* (see fig. 20), *Christ and the Adulter-ess*, and *Ecce Homo*. As Emmens has shown, however, the theory that genre was somehow "emancipated" for naturalism is a latter-day notion inspired by the nineteenth century's concept of realism.[66] The religious elements were not a pretext for the painting of still life and

genre but actually reiterated and explained the moral ideals embodied in the sacred themes; the genre scenes were the concrete demonstration, the actual human and material expression, of biblical and moral truths. Thus, even in the absence of a background scene of Martha and Mary (representatives, respectively, of the *vita activa* and *vita meditativa*), a serving-woman with meat or fowl (see fig. 21) probably alludes to *voluptas carnis*—the third and lowest form of existence, a life of sensuousness and carnality. Similarly, the kitchen activities in the foreground of Wttewael's *Kitchen Scene with the Parable of the Great Supper* (see fig. 6) allude to the need for preparations in this life for salvation hereafter.

Surely the greatest sixteenth-century Flemish genre painter was Pieter Bruegel the Elder, who founded an artistic dynasty while creating a vast glossary of witty types and everyday situations.[67] In paintings teeming with incisively observed low-life characters, Bruegel offered an en-cyclopedic view of the peasants' world, whether inventorying Flemish proverbs (fig. 13), chil-dren's games, or the labors of the seasons. In addition to his contemporaries in Antwerp, an important influence on Bruegel was Bosch, whose tabletop in Madrid certainly had an im-pact on works like Bruegel's engravings of the *Seven Deadly Vices*. Additional inspiration came from the popular theater, holy day processions that included didactic tableaux and morality plays featuring Elck (Everyman), local folklore, and proverb books. Among the last mentioned, Erasmus's *Adages* (a compilation of Greek and Latin proverbs with commentaries first pub-lished in 1500) is the most famous. Collections of Netherlandish proverbs had appeared by mid-century and were followed in 1568 by François Goedthals's well-known *Old French and Flemish Proverbs*. The practice of illustrating proverbs was already long-standing when Bruegel gave the tradition a new and memorable vitality (see cat. no. 79, fig. 1). The artist's low-life subjects offer an image of the peasant that is comical and brutally caricatured, but also heroically monumental (see fig. 22). Van Man-der saw the humor and naturalism in these scenes.[68] Little is known of the artist's life, but his works were collected by some of the wealthiest and most-learned members of Flemish society; notwithstanding van Mander's account

FIG. 22. PIETER BRUEGEL THE ELDER, *The Peasant Dance,* oil on panel, Kunsthistorisches Museum, Vienna, no. 1054.

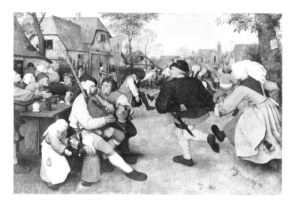

of Bruegel disguising himself to attend and observe a kermis, the artist could scarcely have moved in the circles that enabled him to befriend such men as the renowned cartographer Abraham Ortelius, had he been a peasant himself. Though not portrayed without sympathy, Bruegel's peasants reflect the critical viewpoint of his patrons—namely, socially elevated bankers, merchants, and humanists. His paintings ridicule the sin and folly of the boorish classes to the goal of moral improvement.

Upper-class genre subjects also reflected the moralizing scrutiny of the age. In addition to the Prodigal Son tradition, there were other religious and mythological subjects that laid the groundwork for seventeenth century's "high" genre and merry company scenes.[69] These included the Rich Man and Poor Lazarus, the Parable of the Great Supper, the Banquet of Tarquinius, the Feasts of the Gods (the Marriage of Amor and Psyche or Peleus and Thetis), the earthly life of Mary Magdalen, the parties of the Foolish Virgins, Mankind before the Flood, and Mankind Awaiting the Last Judgment. In the print representing the last mentioned (fig. 23), Dirck Barendsz. no longer depicts the revelers in classical undress as he had in *Mankind before the Flood* (fig. 24), but in the elegant fashion of their day. Only the calamitous destruction visible beyond the colonnade indicates that the scene is anything other than a merry company.[70] The survival through the end of the sixteenth century, of vestiges of the love garden tradition—a central theme in the profane iconography of the Middle Ages—is also apparent in Cornelis Cornelisz. van Haarlem's *Garden of Love* of 1596 (fig. 25). Other aspects of this venerable tradition of depictions of courtly love were the many ball scenes depicted by Flemish artists such as Hieronymus Francken (see fig. 26) and later Mannerist artists such as Joos van Winghe (see cat. no. 28, fig. 2) and Jan Muller.[71] Some later sixteenth-century secular interiors with merry companies or domestic subjects embodied allegories of the Five Senses, the Four Elements, or the Times of the Day, as in Jacob Matham's print after Karel van Mander of *Vesper* (fig. 27). By and large, therefore, the sixteenth-century predecessors of Dutch genre were religious or mythological subjects, visualizations of sayings or proverbs, or allegories, very often with a moral point of view.

FIG. 23. JAN SADELER after Dirck Barendsz., *Mankind Awaiting the Last Judgment,* engraving.

FIG. 24. JAN SADELER after Dirck Barendsz., *Mankind before the Flood,* engraving.

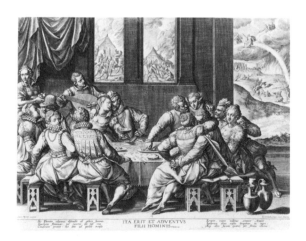

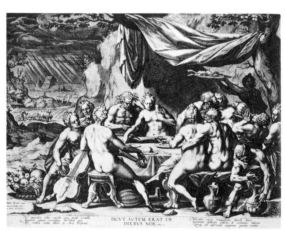

FIG. 25. CORNELIS
CORNELISZ. VAN
HAARLEM, *Garden of
Love*, 1596, oil on panel,
Jagdschloss Grünewald,
Berlin (West), no. 404.

FIG. 26. HIERONYMUS
FRANCKEN THE ELDER, *Ve-
netian Carnival*, 1565, oil
on panel, Suermondt Mu-
seum, Aachen, no. 159.

FIG. 27. JACOB MATHAM
after Karel van Mander,
Vesper, engraving.

Pioneers of Dutch Genre

The first generation of Dutch seventeenth-century artists inherited the preceding century's traditions but substantially transformed them. Born in Mechelen, David Vinckboons was schooled in the Flemish painting tradition, drawing inspiration, on the one hand, from Bruegel for his peasant subjects and, on the other, from contemporary representations of the Prodigal Son and courtly love scenes for his outdoor high-life parties (*buitenpartijen*). Vinckboons's early kermis scenes depict the village from an elevated viewing point, with numerous tiny figures reveling at an inn in the foreground corner or running between the many entertainments in the streets beyond. The subject and conception of these works, with their high horizons and many brightly colored, additively arranged figures, clearly descend from Bruegel. Unlike other Bruegel followers, however, Vinckboons developed a personal manner of combining the figures and landscape setting, which increased the relative scale and importance of the former. His larger figure types are seen in *Peasant Kermis* (pl. 2) and in the Rijksmuseum's boisterous *Garden Party* (fig. 28), which is a further development of the *Outdoor Merry Company* (pl.

1). In that work the landscape, poetically conceived in the style of the wooded views of the Mannerist painter Gillis van Coninxloo, still plays as important a role as the genteel fête in the foreground. Vinckboons's *buitenpartijen* were probably the type of pictures to which van Mander referred when he spoke of "landscapes with little figures in modern dress."[72]

The significance of Vinckboons's works was quickly recognized by the circle of artists working in Haarlem. By 1614 Esaias van de Velde had begun a series of outdoor banquets that convert Vinckboons's wooded views to a more highly ordered garden setting, focusing, in most cases, on only a corner of a park (see pls. 3, 4). Complementing their orderly environments, the figures are arranged horizontally and related to the picture plane. They are at once less animated and more individualized than Vinckboons's figures. Gone are the idealized courtiers on an outing in an idyllic wood; they are replaced by actual Dutch burghers (upper-class to be sure) on a picnic in the park. The new naturalism that Esaias van de Velde brought to his innovative landscapes in these years was applied no less exactingly to his genre paintings, where every idiosyncratic gesture of conversation over a meal and every detail of costume vitalize the scene.

Unfortunately our understanding of the development of genre in the early Haarlem School is hampered by the loss of a potentially important document—the *Banquet in the Open Air* (possibly representing the Prodigal Son) formerly in Berlin but destroyed in 1945 (fig. 29). Judging only from photographs, the unsigned work depicted figures in costumes of c. 1610 and was painted with exceptional verve and freedom. Its old assignment to Frans Hals has found tacit acceptance among many specialists.[73] In the absence, however, of any other work of this type in the artist's oeuvre, crediting Hals with the central role in the innovation of outdoor banquet scenes on such uncertain evidence seems unjustified. The rise of this painting type, moreover, is hardly contingent upon a single work. Though surely not the author of the lost painting as some have believed,[74] Willem Buytewech executed genre scenes similar in subject, scale, and breadth of execution (see pl. 5). While exchanging the diagonally arranged landscape for a centrally organized architectural setting complete with pergola and massive draped columns,

FIG. 28. DAVID VINCK-
BOONS, *The Garden Party*,
oil on panel, Rijksmuseum,
Amsterdam, no. A2109.

FIG. 29. Attributed to
FRANS HALS, *Banquet in the
Open Air*, oil on panel, for-
merly Staatliche Museen,
Berlin, no. 1691 (destroyed
in 1945).

Buytewech depicts elegant, posturing figures of comparable panache. Typical for Buytewech is the orderly architectural environment that counterbalances the figures' nervous animation.

In all of these scenes of meals in the out-of-doors, the subjects' recent ancestry in scenes of the Prodigal Son and other religious themes increases the probability of a moral. Banquets and *buitenpartijen* were, of course, idle, temporary pleasures that could prompt moralizing even without direct reference to the parable. A print by Simon Poelenborch after a drawing of 1614 by Esaias van de Velde of three figures enjoying a meal and wine bears the inscription in French: "Let us pass the time dear friends. Have no fear of the Doctors who sound an infamous discourse wounding the honor of Courtisans."[75] Obviously not a serious exhortation, the sardonic inscription exemplifies the blameful mentality of the company. Similarly, the inscription on Gillis van Scheyndel's print after a drawing of an outdoor party by Esaias van de Velde offers a modern, which is to say seventeenth-century, allusion to the parable. It is delivered in the form of a toast by one of the

youthful members of the party, who no doubt represent Holland's parvenus, that extravagant and free-spending new generation. Loosely translated, the Dutch reads: "May Love live long and bear fruit, our marriage has begun. Our parents were boorish, they earned their living in a miserly fashion. [We, on the other hand, have] a well-greased pot, beautiful weather. Everything must be consumed, we have more than enough, but how will we swallow it all."[76] Again the ironic point of view is both slightly amused and, by implication, morally critical.

This bemused but censorious attitude is also clear in Buytewech's interior genre scenes (see, for example, pl. 6). Though very few in number, these intimately scaled canvases executed between about 1616 and 1622 played a pioneering role in the development of the merry company. Unlike the earlier scenes of balls or the Prodigal Son, the company is reduced to only four or five figures who occupy a shallower and more highly ordered space. Though carefully observed in all naturalistic details, the modish young men and women in these scenes strike self-conscious poses, scarcely interacting with one another. Their air of exaggerated elegance and artifice, like the lack of spatial relief, points to their emblematic character.[77] They are exemplars of carefree and careless youth. These scenes may also include, as secondary symbols, allegorical references to the Five Senses. Among the artists most influenced by these works were Dirck Hals, Hendrick Gerritsz. Pot (c. 1585–1657), and Isaack Elyas (active c. 1620), all three of whom quoted Buytewech's genre figures directly. Elyas's only known genre scene (fig. 30), dated 1620, not only alludes to all Five Senses but also includes a scene of the Flood on the back wall, a naturalistic secularization, as it were, of the background scene in Barendsz.'s engraving *Mankind before the Flood*.[78]

FIG. 30. ISAACK ELYAS, *Merry Company*, 1620, oil on panel, Rijksmuseum, Amsterdam, no. A1754.

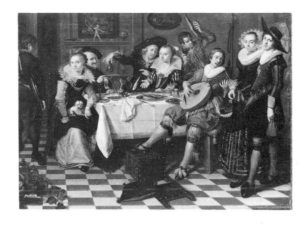

FIG. 31. HENDRICK TER BRUGGHEN, *The Flute Player*, 1621, oil on panel, Staatliche Kunstsammlungen, Kassel, no. GK179.

FIG. 32. CORNELIS DANCKERTS after Abraham Bloemaert, *The Bagpipe Player*, engraving.

Utrecht Caravaggism

As the peasant kermis and the high-life merry company in Dutch art look to Flanders for their roots, the tradition of depicting life-size, half-length genre figures has Italian as well as Northern sources. Würtenberger excluded the half-lengths from his discussions of the history of genre, arguing that they constitute a separate tradition with different origins.[79] However, Frans Hals, Vermeer, and the many other Dutch genre painters inspired by this tradition surely made no such fine distinctions. Furthermore, it would be pedantic to exclude these works simply because the figures often wear semi-theatrical or arcadian dress of a sort rarely, if ever, encountered in everyday life. Such reasoning, by extension, would force the exclusion of Steen's pictures of doctors (see pl. 81), Sorgh's musicians (see pl. 94), and many other genre paintings with anachronistic or imaginary details of costume. Once again, such a narrow concept of genre is historically unjustified.

Centered in the old Catholic city of Utrecht, the Dutch artists who specialized in this painting type included Abraham Bloemaert and his two pupils Gerrit van Honthorst and Hendrick ter Brugghen, Dirck van Baburen, and such lesser figures of the next generation as Jan van Bijlert (1597–1671). Following the prescription for young artists offered by van Mander and all later classical Dutch art theorists, each of these artists, except the older Bloemaert, made a pilgrimage to Italy, where in addition to the splendors of Antiquity and the Renaissance they encountered the recent achievements of Caravaggio and the Carracci. Honthorst arrived in Rome around 1610–12 and soon enjoyed important Italian patronage. His mastery of Caravaggio's nocturnal effects and chiaroscuro won him the sobriquet "Gherardo della Notte."[80] A *Supper Party* executed by 1620 (Uffizi, Florence, no. P1803) is similar in design to *The Concert* (pl. 8) but is treated as a night scene. It too groups the merrymakers around a table but animates their faces and gestures with the light of two candles. With some figures silhouetted and others emerging from the blackness, Honthorst's night scenes make a dramatic effect related to his illusionistic ceiling decorations and trompe l'oeil painting. One of the most compelling of the last mentioned is *The Merry Fiddler* of 1623 (pl. 7), where Honthorst uses the traditional device of a windowframe and a tapestry curtain to create the illusion of the fiddler bursting into the viewer's space.

More poetic in conception is *The Flute Player* of 1621 by Hendrick ter Brugghen in Kassel (fig. 31), companion to *The Flute Player*, Staatliche Kunstsammlungen, Kassel, no. GK180. Ter Brugghen was the only one of the Utrecht artists to arrive in Rome before Caravaggio fled in 1660, but he was then still very young and no works are known from his Italian period (c. 1604–1614). Back in Utrecht he developed a style that was softer and more lyrical than Honthorst's. In the early 1620s ter Brugghen, Honthorst, and Bloemaert painted numerous half-length, single-figure compositions of musicians and drinkers. Some recall the androgenous youths and *bravi* depicted by Caravaggio and his followers (above all Bartolommeo Manfredi), while others with their pseudo-Burgundian dress call to mind actors or street musicians. To judge from Fynes Moryson's comments, some of these dashing itinerant musicians had the appeal of modern rock stars, while others, like the bagpipe player could be perceived as idle fools (see pl. 9 and fig. 32).[81] Still other characters wear a flowing, off-the-shoulder chemise reminiscent of the garb of shepherds or other arcadian types; here again the details of costume are more evocative than historically consistent. The genre characters of the Utrecht Caravaggisti are deliberately exotic, not archeological. This is not to say that the Caravaggisti's works are without roots in earlier genre. The tradition of representing half-length, secular figures against a neutral background descended by way of Caravaggio from the studio of Cavalieri d'Arpino; Annibale Carracci's *Bean Eater* of c. 1583/4 (Colonna Gallery, Rome) is

FIG. 33. DIRCK VAN
BABUREN, *Loose Company*,
1623, oil on canvas, Mit-
telrheinisches Landes-
museum, Mainz, no. 108.

another early example of half-length genre.
However, works like Baburen's *Procuress* of
1622 (pl. 10) and his lighthearted *Loose Com-
pany* of the following year (fig. 33), are not
solely dependent upon Italian sources; they also
recall earlier mercenary love and merry company
scenes by fifteenth- and sixteenth-century North-
ern painters like Jan Massys (see *Merry
Company*, Nationalmuseum, Stockholm, no.
NM2661) and van Hemessen, and share in their
moralizing possibilities.

The Rise of the High-Life Interior

The more intimate type of interior with merry
company figures that first appeared in the
Netherlands in the second decade of the seven-
teenth century was largely the invention of
Willem Buytewech. Although prints by Esaias
and Jan van de Velde probably also played a
role, Buytewech's paintings (for example, pl. 6)
were the most innovative in the transition from
the palatial banquet halls of sixteenth-century
Flemish genre to a simpler, more naturalistic in-
terior setting with what one might be forgiven
for calling bourgeois high-life subjects. Even be-
fore his return to Rotterdam in 1617, Buyte-
wech had left his mark on the circle of artists in
Haarlem. One of the most deeply impressed was
Dirck Hals, younger brother and pupil of Frans.
Throughout his career, Dirck repeatedly quoted
genre figure motifs invented by Buytewech,
Frans Hals, and others (see, for example, pl. 11).
No mere plagiarist, Dirck was a productive artist
who helped to popularize both the new indoor

FIG. 34. DIRCK HALS, *Party
at a Table*, 1626, oil on
panel, National Gallery,
London, no. 1074.

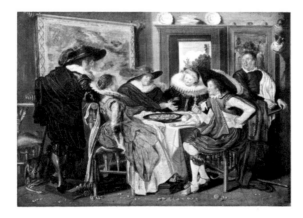

and outdoor genre types. Some earlier dates
have been recorded, but the artist's earliest cer-
tain dated genre scenes are from 1621.[82] Typical
of his painting from the mid-1620s is the *Party
at a Table* of 1626 (fig. 34). In his free technique
and bright palette of unmixed colors the artist is
probably indebted to his more famous brother,
but the latter's genre figures are never full-length
or as small in scale as Dirck's. Dirck often fa-
vored long, horizontal, almost predella-like
formats. His interiors are not unimaginative—
see the glimpse out of doors at the back of the
Party at a Table and the evocative vacancy of
the later picture in Mainz of 1631 (cat. no. 46,
fig. 1)—but his understanding of perspective was
limited. The order, more *retardataire* in its for-
mulation than new, of the *Banquet Scene in a
Renaissance Hall* (pl. 11) is the product of
Dirck's collaboration in 1628 with the archi-
tectural painter Dirck van Delen. Another large
and ambitious work with numerous figures
from this period is the *Fête Champêtre* of 1627
(Rijksmuseum, Amsterdam, no. A1796), a work
entirely by Dirck's hand—indeed, arguably his
masterpiece—that attests to the continuing pop-
ularity of the *buitenpartij* subject. Single-figure
compositions (see pl. 12) appeared in Dirck's art
by 1630[83] and accompanied a new intimacy in
his subjects. About this time he became one of
the first Dutch artists to paint domestic genre
subjects.[84]

The Amsterdam painters Pieter Codde and
Willem Duyster also followed in the footsteps of
Buytewech. Codde had joined the painters' guild
by 1623 and was dating portraits by 1625, but
his earliest dated genre scene, according to Play-
ter, is the *Dancing Lesson* of 1627 (fig. 35).[85]
Typical for his interior genre scenes of this
period is the focus on a small group of figures in
a sparcely furnished and somewhat ill-defined in-
terior. Usually his figures are silhouetted against
a light-colored back wall. About 1630 Codde
began a series of larger merry company gather-
ings in more elegant, paneled rooms (see pls. 14,
15). While the early pictures had been everyday
parties, now they are special *feestdag* (feast day)
celebrations, but the favored amusements of the
figures—drinking, making music, and dancing—
remain the same. Codde differs from Dirck Hals
not only in his more assured technique and
drawing but also in his palette. In the late 1620s
he began to restrict the range of hue in his pic-
tures, concentrating on subtle tonal adjustments

FIG. 35. PIETER CODDE, *The Dancing Lesson*, 1627, oil on panel, Musée du Louvre, Paris, no. MNR452.

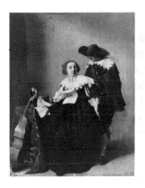

FIG. 36. WILLEM DUYSTER, *The Officer's Visit*, oil on panel, Statens Museum for Kunst, Copenhagen, no. 194.

FIG. 37. CORNELIS VAN KITTENSTEYN after Dirck Hals, *Merry Company*, engraving.

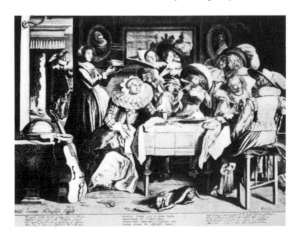

of the grays, browns, and blacks with accents of pink, yellow, and salmon. The new color scheme helped to give his interior scenes an unprecedented unity as well as to enhance the elegance of his parties, where the figures usually wear the formal black then in fashion. This so-called tonal or monochrome painting style parallels concurrent developments in Dutch landscape (see, for example, the works of Pieter Molijn and Jan van Goyen) and still life (Pieter Claesz. and W. C. Heda). In Codde's masterful *Young Man with a Pipe* (pl. 13)—like Dirck Hals's single-figure compositions probably a work from about 1630 or somewhat earlier—the simpler palette complements the understated motif.

Willem Duyster, whose early death in 1635 spoiled the promise of one of Holland's most gifted genre painters, also painted interior merry companies in the tonal manner, but with greater intimacy and subtlety. The sources of his art are readily identified: *The Wedding Feast* (Rijksmuseum, Amsterdam, no. C514) recalls the scenes of balls by Flemish artists of the preceding century, and the *Musical Party* (The Wellington Museum, Apsley House, London, no. WM1524-1948) quotes freely from Buytewech.[86] The animation of the latter work is unusual for Duyster; most of his gatherings barely qualify as merry companies, so quiet and contemplative is their mood. Duyster quickly distilled the musical company to its most intimate form, the duet, in an exceptionally beautiful work in Schloss Grünewald in Berlin.[87] The artist performed a similar function for the merry company in the

so-called *Officer's Visit* (fig. 36). Here not only the upright format but also the letter theme and the subtle interchange between the two figures anticipate ter Borch's works of twenty years later.

Although many of the high-life interiors produced in this period were by artists working in Haarlem and Amsterdam (the lesser figures in Amsterdam included Pieter Potter [1597/1600–1652] and Pieter Quast [1606–1647]), other cities also had their practitioners. In Delft, Jacob van Velsen (active by 1625; died 1656) painted a musical party dated 1631 (National Gallery, London, no. 2575), which precedes by a year the earliest of the works of this type executed by his fellow townsman Anthonie Palamedesz. (see, for example, pl. 16). The latter's best high-life scenes all date from c. 1632–34. Like Jan Olis in Dordrecht (c. 1610–1676), Jacob Duck working in Utrecht and The Hague also produced a few high-life merry companies (see pl. 39); the bulk of his production, however, depicts soldier and guardroom subjects.

Some of these high-life interiors from the 1620s and 30s include symbolic allusions admonishing against intemperance or stressing the fleeting nature of pleasure. A print by Cornelis van Kittensteyn (fig. 37) after a merry company by Dirck Hals, very like the *Party at a Table*, includes a warning against the transience of life.[88] However, a reproductive printmaker's inscription need not reflect the painter's original intent or emphasis.[89] As these popular merry company scenes proliferated, their allegorical and moral aspects became increasingly less distinct, and in many cases entirely secondary.[90] Even in high-life scenes from the early seventeenth century, the clear emblematic and didactic thrust of sixteenth-century genre scenes was often subsumed by new content. The symbolism and moral lessons were supplemented by other, more varied concerns—some social, some aesthetic, some private in nature—which often resist clear explication.

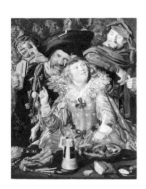

FIG. 38. FRANS HALS, *Merrymakers at Shrovetide*, oil on canvas, Metropolitan Museum of Art, New York, no. 14.40.605.

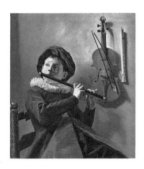

FIG. 39. JUDITH LEYSTER, *Boy with a Flute*, oil on canvas, Nationalmuseum, Stockholm, no. NM1120.

Frans Hals and His Circle

As we have seen, Frans Hals may have played a role in the development of the *buitenpartij* subject, but his contribution to the tradition of life-size, half-length genre scenes is certain and readily demonstrated. The *Merrymakers at Shrovetide* of c. 1615 (fig. 38) and another early painting, *The Rommel Pot Player*, known only through copies (see, for example, Kimbell Art Museum, Fort Worth, acc. no. ACF51.1), are the prime examples of this painting type. As in sixteenth-century Flemish works by such artists as Hemessen, Aertsen, and Bueckelaer, *Merrymakers at Shrovetide* depicts the figures at close quarters but achieves a greater immediacy through an unrivaled freedom and breadth of execution. As Slive has written, "no artist before Hals depicted people with such a love of the joy of life."[91] The Shrovetide (*vastenavond*) revelers include among their company familiar comic characters from contemporary farces, for example the portly Peeckelhaering (Pickle Herring), recognized by his garland of fish, and Hans Worst. *The Rommel Pot Player* employs a similar dense composition of antic types—indeed both works express a sort of *horror vacui*—while demonstrating Hals's early interest in low-life genre. Hals's later scenes from the 1620s of one or two figures drinking or making music (see, for example, pl. 17) relieve the crowding and reflect the influence of the half-length compositions by the Utrecht Caravaggisti.

As we have suggested, Dirck Hals depended heavily on his brother's figure compositions; indeed in 1637 he executed a copy (Frits Lugt Collection, Fondation Custodia, Institut Néerlandais, Paris, no. 34) in miniature of the Shrovetide painting.[92] Closer to Frans in both style and conception, however, was Judith Leyster. Her interest, shared with Hals, in single-figure, half-length compositions is apparent in her early nocturnal *Boy with a Wineglass* (Staatliche Kunsthalle, Karlsruhe, no. 223), once attributed to Honthorst. Leyster undoubtedly learned her bravura technique from Hals.[93] Though long eclipsed by the master, Leyster rises above his other followers and imitators with her masterpiece *Boy with a Flute* (fig. 39). Leyster began her career in the late 1620s as a painter of half-length designs, but about 1630 she began a

series of full-length compositions. Some are nearly half life size (see pl. 18), while others are small, intimately scaled cabinet pictures. The latter are often very freely painted, but they possess a more assured touch than, for example, the works of the prolific Dirck Hals. Of special interest are Leyster's night scenes (see cat. no. 15, fig. 3) and domestic subjects; the latter, together with Dirck's, are among the earliest treatments of these themes in paint.[94]

In 1636 Leyster married Jan Miense Molenaer, another very able painter of lively genre scenes from Frans Hals's circle, and the couple moved to Amsterdam. Though nothing is known of his artistic training, Molenaer first dated half- and full-length genre scenes in 1629 (see fig. 40 and *At Breakfast*, dated 1629, Stiftung Kunsthaus Heylshof, Worms, no. KH469) and from about 1630 to c. 1645 painted relatively large-scale, brightly colored genre paintings of children, peasants, and high-life scenes (see pls. 19, 21). Molenaer's figure types are more substantial and his paint application thicker and more consistently descriptive than Leyster's. His debt to Hals, correspondingly, was absorbed more fully. A collector of sixteenth-century paintings, Molenaer shared with artists of that century a taste for and highly inventive use of symbolism and allegory (see pl. 20). Although his iconography was often traditional, it was applied in creative new ways. In this and in his colorful, large, and vividly characterized figures, Molenaer is an important but often neglected forerunner of the great Jan Steen. After Molenaer and Leyster returned to the Haarlem area in 1648, Molenaer specialized in low-life subjects in the manner of the Ostades but often with more crowded designs. Unfortunately his later works are often uneven in quality.

Adriaen Brouwer and Low Life: The Peasant Painting Tradition

Houbraken's claim that Adriaen Brouwer was apprenticed to Frans Hals in Haarlem is unsubstantiated, indeed, in the light of the biographer's other incorrect statements about the artist, even questionable; Brouwer was not born in Haarlem, as Houbraken states, but in Oudenaerde in Flanders near the Dutch border. There can be no question, however, that he was

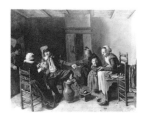

FIG. 40. JAN MIENSE MOLE-
NAER, *Family in an Interior*,
1629, oil on canvas,
Mittelrheinisches Landes-
museum, Mainz, no. 831.

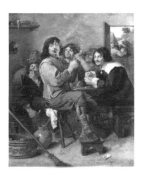

FIG. 41. ADRIAEN BROUWER,
The Smokers, oil on panel,
Metropolitan Museum of
Art, New York, no.
32.100.21.

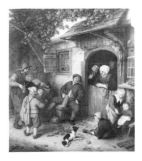

FIG. 42. ADRIAEN VAN
OSTADE, *The Violinist*,
1673, oil on panel,
Mauritshuis, The Hague,
no. 129.

among the most innovative genre painters of this
or any other period. During his brief career—he
was active only about fifteen years—and even
briefer stay in Holland (c. 1625/26–31/32),
Brouwer permanently altered the character of
peasant genre. Like his fellow Fleming Vinck-
boons, he was schooled in the low-life tradition
of Bruegel. His earliest works (see, for example,
Peasant Brawl, Rijksmuseum, Amsterdam, no.
A65) all postdate his arrival in Haarlem and
Amsterdam but reflect the vitality, the anima-
tion, and the comical element of slight caricature
(see pl. 22) that were his Flemish legacy. What is
new is the brutal power of Brouwer's peasants.
Any gloss of rustic charm or cute bumptiousness
is eliminated, leaving only the unapologetic fact
of the underclass and its appetites and passions.
Even the brusque technique—a rapid, spikey sys-
tem of hatched strokes—and the shrill palette
(pink, red, green, and yellow) of these early
works complement their crude subject matter—
peasants drinking, brawling, or gobbling pan-
cakes in a pot house. Brouwer was the prime
innovator in moving the traditional kermis
scene's most gluttonous and violent pastimes in-
doors into the dank shadows of the peasant
tavern and *tabagie*. Here peasants gorge or
smoke themselves into a stupor, swill cheap
beer, roar for a fiddler or, when things heat up,
overturn the crockery and turn on one another
with mortal savagery (see pl. 24). In addition to
tavern scenes, Brouwer took up the low-life
tradition of depicting quacks and unskilled
"professionals," above all the barber-surgeons
specializing in painful foot and shoulder opera-
tions that invariably elicit a horrifying grimace
from their patients.[95]

Toward the end of the 1620s Brouwer de-
veloped a more atmospheric style, tempering his
most strident hues with a more monochrome
palette (see pl. 23). In the later Antwerp period
(c. 1631–38), his tonality became more lumi-
nous and his touch broader (see fig. 41). For all
their coarse, explosive energy, Brouwer's tap-
room scenes like the *Fight Over Cards* (pl. 24)
are highly composed. Works such as this one
descend from pictorial illustrations of Vices, in
this instance Ira (Anger) (compare cat. no. 110),
while other paintings relate to series of the Five
Senses. Moreover, prints by J. de Visscher and

Cornelis Visscher after Brouwer's works warn of
the consuming nature of human desire.[96] By and
large, however, Brouwer had little need of alle-
gory or moralizing symbolism to express his
ethical point of view—an unblinking and darkly
humorous perception of man's baseness.

Of all the artists active in Haarlem during
Brouwer's stay, Adriaen van Ostade was the one
most impressed by his works. Houbraken's
claim that the two artists worked together in
Hals's studio is, once again, unproved, but Os-
tade's works, especially the earliest ones (see pl.
27), closely approximate Brouwer's raucous
peasant types, dramatic chiaroscuro, and the
surprisingly delicate pastel color scheme he de-
veloped in the late 1620s and early 1630s.
Ostade's peasants never achieve the compelling
truth to life of Brouwer's, but before mid-
century they claim an expressive, animal vitality.
In the 1640s Ostade's tavern scenes became
more spatious (see, for example, *Peasant Merry-
makers with Dancers*, Museum of Fine Arts,
Boston, no. 45.735) and, by the time he ex-
ecuted the *Villagers Merrymaking at an Inn* in
1652 (pl. 28), his peasants had become plump
and relatively civilized. Although born the son of
a weaver, Ostade portrayed himself about this
time in a painting with the influential de Goyer
family from Heemstede (Bredius Museum, The
Hague, no. 86-1946), a testament to his rising
social standing. In 1657 he married a wealthy
Catholic woman from Amsterdam, insuring
what probably had already become a comfort-
able existence. Although he painted low-life
subjects throughout his life, by the 1660s his
boors had become middle-class farmers and *bur-
gerlijke* townsmen, as in *Travelers at Rest*, dated
1671 (Rijksmuseum, Amsterdam, no. A299).
The lot of those who worked the land in the
Netherlands improved during the seventeenth
century, but Ostade's fat, rather stupidly self-
satisfied peasants have more to say about upper-
class ideals than social realities (see fig. 42).

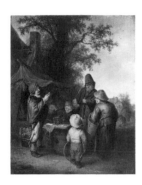

FIG. 43. ADRIAEN VAN
OSTADE, *Quacksalver and
Spectators,* 1648, oil on
panel, Rijksmuseum,
Amsterdam, no. A300.

FIG. 44. ADRIAEN VAN
OSTADE, *Artist's Studio,*
1663, oil on panel,
Gemäldegalerie Alte Meis-
ter, Dresden, no. 1397.

FIG. 45. DAVID VINCK-
BOONS, *Peasant Sorrow,* oil
on panel, Rijksmuseum,
Amsterdam, no. A1351.

Among Ostade's favorite themes were out-
door tavern scenes (see cat. no. 93, fig. 1),
domestic subjects (see pls. 29, 31), and profes-
sions, including everyone from the quacksalver
(fig. 43) to schoolmasters (for example, Musée
du Louvre, Paris, nos. MI 948, 1680), painters
(fig. 44), fishmongers (pl. 30), and even lawyers
(see *Jurist in His Study* [1680?], Museum Boy-
mans–van Beuningen, Rotterdam, inv. no.
1637). With these works and his tavern inte-
riors, Ostade—a long-lived and exceptionally
prolific artist—won a wide following. His most
gifted pupil was his own brother, Isaack who, if
he had not died in 1649 at age twenty-eight,
would probably have surpassed Adriaen's
achievement. Like Adriaen, Isaack painted tav-
ern and stable scenes as well as peasants or
travelers before a cottage door (see pl. 32). The
last mentioned have precedents in the works of
Vinckboons and Rembrandt and exhibit a tran-
quility and poetic calm foreign to Adriaen's
paintings. Isaack's greatest gifts, however, were
in the field of landscape, especially winter scenes.

Like his teacher Adriaen van Ostade, Bega
painted rustic inns, peasant households, and mu-
sical subjects. With their numerous small figures
drinking and dancing, Bega's early works are
especially close in design to his teacher's popu-
lous taverns. The works for which he is most ad-
mired, however, date from the last four years of
his life (1661–64) and focus more on the figures
(see pls. 33–35). In place of the loose, liquid
brushwork of his early paintings, these carefully
delineated works employ a more refined tech-
nique and palette (browns, steely grays and blues

overall, with intense local accents of color),
which owe more to the Leiden School than to
that of Haarlem. If Bega, as Houbraken claimed,
was Ostade's "first and best" pupil, Dusart
surely was his most loyal. Not only did Dusart
complete works left unfinished by his teacher
after the latter's death in 1685, but he also con-
tinued to work in the master's style, repeating
designs and figure motifs, into the eighteenth
century. In his best works (see, for example, pl.
36) emphatic figures and intense colors make a
gay, satirical impression, but his more routine
paintings often descend into coarse and garish
caricature. Like Bega, however, Dusart excelled
as a draftsman; his figure studies are among the
most memorable of all Dutch genre drawings.

The Guardroom Painters

During much of the seventeenth century the
Netherlands was at war. Although the Twelve-
Year Truce (1609–21) provided a brief respite,
at its end the fighting was vigorously renewed.
Much of the combat occurred along the south-
ern borders and in the eastern provinces, but all
of Holland's major cities housed garrisons of
troops. The military was a constant feature of
daily life. Yet, whereas Flemish painters like
Pieter Snayers (1592–after 1667) and Sebastian
Vranx (1573–1647) depicted pitched battles and
cavalry skirmishes, more typical of the Dutch
was the quiet guardroom scene. For the majority
of Dutch painters growing up in the artistic cen-
ters in the maritime provinces, however, actual
warfare was a rare or unknown experience. To
be sure, David Vinckboons depicted soldiers
brutalizing the peasantry (see fig. 45), a subject
that enjoyed much popularity in the later
sixteenth and early seventeenth century
undoubtedly because of its topicality.[97] More-
over, Esaias van de Velde, Adriaen van de
Venne, and Pieter Molijn painted soldiers plun-
dering villages or attacking travelers in the open
landscape. More typical, however, was the im-
age of soldiers relaxing in the *wachtkamer*
(guardroom) as depicted in Duyster's *Soldiers
beside a Fireplace* (pl. 37).

The Caravaggisti and artists like Leonaert

FIG. 46. PIETER CODDE, *Guardroom,* oil on panel, Staatliche Kunsthalle, Karlsruhe, no. 243.

FIG. 47. WILLEM DUYSTER, *Officers with Booty,* oil on panel, Kunstmuseum, Basel, no. 1340.

Bramer had depicted soldiers earlier, but the so-called guardroom painters made a specialty of intimate scenes of the day-to-day lives of soldiers. While Duyster's dramatically illuminated night scene is not without a hint of intrigue and adventure, Pieter Codde's scene of the crumpled figures of soldiers sleeping on the ground or on benches (fig. 46) is surely more typical of the barren and tedious life of the average military man. Although none of Duyster's works are dated, the artist's earliest guardroom paintings, works of c. 1625–30 like the *Soldiers Fighting over Booty* (National Gallery, London, no. 1386) and *Soldiers with Plunder* (Wernher Collection, Luton Hoo, Great Britain), display some of the animation of earlier soldier scenes by Vinckboons and Esaias van de Velde. Gradually, however, Duyster's works became more silent and subdued. The *Officers with Booty* in Basel (fig. 47) is a surprisingly understated image. The officer looks down contemplatively at an object in his hand, very likely a watch, perhaps reflecting on the brevity and danger of the military life. In the seventeenth century, booty and the ransoming of hostages were considered legitimate supplements to the soldier's meager pay. A Dutch soldier named Anthonie Duyck wrote freely in his journal of ransoming women, especially "girls of good quality, provided that they are at least twelve years of age."[98] Duyster's *Maurauders* (Musée du Louvre, Paris, inv. no. 1220) depicts a woman hostage kneeling pathetically before her captors. In the Basel painting, on the other hand, the woman seems to be a member of the company, no doubt one of the lavishly attired camp followers or prostitutes, who so often attended soldiers on campaigns (see fig. 45). Codde's paintings of soldiers plundering or threatening hostages are far more theatrical than Duyster's and come closer to the spirit of the strutting, comically over-dressed officers encountered in Dutch literature of the period (see *Plundering*, Herzog Anton Ulrich-Museum, Braunschweig, no. 671). A number of theater pieces from this time, including Bredero's *Moortje* (1615), Samuel Coster's *Tijsken van der schilden* (1613), and A. van den Bergh's *Ieronimo* (1621), deal with soldier themes, but none of the guardroom paintings, despite strong narrative elements, seem to illustrate an actual episode from a play or literature.[99]

One of Codde's favorite guardroom themes was the scene of soldiers mustering out, a subject taken up in Jacob Duck's *Soldiers Arming Themselves* (pl. 38). Although Duck worked in Utrecht and The Hague, he was certainly acquainted with the paintings of the Amsterdam and Haarlem guardroom painters. Some have speculated that he may even have studied with Codde in the late 1620s. Duck continued to paint soldiers even after the mid-century (see pl. 40), but he also treated merry company subjects (see pl. 39), street scenes (see *The Street Peddler*, c. 1655, Los Angeles County Museum of Art, Los Angeles, no. 58.50.1), and domestic themes (see *Woman Ironing*, c. 1650, Centraal Museum, Utrecht, cat. 1952, no. 88). The Amsterdam painter Simon Kick, who evidently began his career executing Rembrandtesque head studies, also painted domestic genre (see *Woman at Her Toilet*, dated 1648, Museum der bildenden Künste, Leipzig, no. 1036), but specialized in large, colorful scenes of assemblies of soldiers or hunters (see, for example, pl. 41 and *Homecoming of a Fowling Party*, Statens Museum for Kunst, Copenhagen, no. 363), most of which appear to date from the mid to late 1640s. Unlike the guardroom scenes by his brother-in-law, Willem Duyster, Kick's soldier pictures are more deliberately composed; the figures often strike poses and seem to address the viewer. Often conceived on a relatively large scale, Kick's indoor gatherings reflect the influence of contemporary militia company portraits, while his outdoor works (Staatliche Museen, [Bodemuseum] Berlin, no. 858B), continue the tradition of depicting plunderers and marauders.

Among the many lesser guardroom painters, Pieter Potter, Jan Olis, Pieter Quast, and Anthonie Palamedesz. stand out. Judging from the costumes and the few dated works, the soldier scenes by the last mentioned seem mostly to date from the decade c. 1645–55.[100] Most are loosely painted, spotlit scenes in cavernous ruins, barns, or stables, where squat officers order reveille and exhort their soldiers to muster out. Surely, the most gifted artist producing guardroom scenes in the 1640s, however, was the young Gerard ter Borch. His earliest works (such as *Trictrac Players in a Tavern,* dated 1636? Museum, Rouen), are in the tradition of Codde and Duyster, while his somewhat later

FIG. 48. PIETER DE HOOCH, *Officer and Two Card Players*, oil on canvas, Wallraf-Richartz Museum, Cologne, no. 2841.

FIG. 49. PAULUS MOREELSE, *The Blonde Shepherdess*, 1624, oil on canvas, Bayerische Staatsgemäldesammlungen, Alte Pinakothek, Munich, no. 13183.

FIG. 50. JAN MIEL, *Cart with Comedians*, 1653, oil on canvas, Prado, Madrid, no. 1577.

Guardroom in the Victoria and Albert Museum (fig. 69) and *Trictrac Players*, in Bremen (Gudlaugsson 1959–60, cat. no. 12) exhibit figures of a new order of naturalism and atmospheric effects of unprecedented subtlety. These works have a calm and dignity only partially explained by the heritage of Duyster and his colleagues. Yet another outstanding artist active primarily in the third quarter of the century who began his career as a painter in the guardroom tradition was Pieter de Hooch (see fig. 48). These two great painters and others, like Gerbrand van den Eeckhout, helped transform the guardroom tradition around 1650.

The Bamboccianti and the Pastoral
In addition to those Dutch genre painters who depicted the local scene, there were some who turned to the representation of "foreign" life, both in the sense of society abroad—mostly in Italy but also further afield (Koedijck, Boursse, Sweerts, and Victors traveled to the East)—and in the sense of an exotic, imagined realm of the everyday. Scenes of the latter encompass not only the more fanciful musicians and merrymakers of the Caravaggisti but also works in the pastoral mode, such as Abraham Bloemaert's fetching little *Shepherd and Shepherdess* of 1627 (pl. 42). In Dutch art as in literature, the pastoral was a venerable and long-standing tradition. In the early seventeenth century it was popularized by such works as Pieter Cornelisz. Hooft's play *Granida*.[101] Arcadia was, of course, a favored preserve of history painters, but in the 1620s, shortly before Bloemaert's painting was executed, half-length depictions of nameless shepherdesses became popular with the Utrecht painters Hendrick ter Brugghen, Paulus Moreelse, and Gerrit van Honthorst (see, for example, fig. 49). In turn, multifigured, full-length pastoral genre scenes appeared, of which Bloemaert's *Shepherd and Shepherdess* is one of the earliest. The suggestion of an idyllic, nonspecific setting, the shepherd's timeless dress, and the aura of classical repose distinguish these works from the paintings of actual shepherds in the Dutch countryside by artists like Aelbert Cuyp. The goal was the evocation of the everyday life of antiquity.

Though never venturing from the chilly North himself, Bloemaert made the sunny realm of pastoral genre a plausible fiction. For those Dutch genre artists who did make the journey south, the actual Italian countryside and the majestic architecture of Rome provided the settings for paintings of real shepherds and street life—peddlers, beggars, and musicians. Born in Haarlem, Pieter van Laer arrived in Rome around 1625 or 1626. There he joined the association of Netherlandish painters known as De Schildersbent, whose members dubbed him "Bamboccio" (malformed doll or puppet), probably because he was a hunchback. It was shortly after 1630 that he created the new genre-painting type depicting Roman street scenes of low-life characters, mostly peasants, vendors, and small craftsmen, in multifigured compositions (see pl. 43). Often these works employ strong contrasts of light and dark, leave large areas in shadow, and punctuate the darkness with accents of local color. The chiaroscuro effects of van Laer and his followers, known as the Bamboccianti, probably descend from Caravaggio.

In addition to Italians like Michelangelo Cerquozzi (1620–1660), the Bamboccianti included the Netherlandish artists Jan Miel and Jan Lingelbach. Miel, who knew important Italian patronage, executed the extraordinarily large painting *Carnival in the Piazza Colonna, Rome* (pl. 46) as part of a series of five paintings depicting Roman street life commissioned by Marchese Tommaso Raggi for his palazzo. Its great crowd of lively carnival revelers include various figures from the commedia dell'arte. Masked and theatrical characters often featured in Miel's works, as in *Dance at the Trattoria* (Akademie der bildenden Künste, Vienna, inv. no. 1372) and the *Cart with Comedians* dated 1653 (fig. 50), which is a variant of the central group in the *Carnival in the Piazza Colonna, Rome*. Lingelbach also painted large crowds in street scenes and at rustic taverns (see pl. 45). Although the dark, dramatically spotlit works that he executed in Rome (see, for example, pl. 44) have sometimes been mistaken for those of van Laer, his lighter-toned scenes of celebrants or crowds in the street or along the quay painted following his return to Amsterdam are readily distinguished from those of Miel and Il Bamboccio. Lingelbach frequently distributed his figures in a friezelike band in the foreground with a

FIG. 51. MICHAEL SWEERTS, *Street Scene with a Stone Grinder and an Artist Drawing Bernini's "Neptune and Triton,"* oil on canvas, Museum Boymans–van Beuningen, Rotterdam, no. 2358.

FIG. 52. JAN BAPTIST WEENIX, *Italian Landscape with an Inn and Ruins,* 1658, oil on panel, Mauritshuis, The Hague, no. 901.

FIG. 53. NICOLAES KNUPFER, *Brothel Scene,* oil on panel, Rijksmuseum, Amsterdam, no. A4779.

FIG. 54. KAREL DUJARDIN, *Traveling Musicians,* oil on canvas, French & Co., New York.

cityscape or harbor view behind and monuments or sculpture rising dramatically overhead.

Michael Sweerts, like Miel a Flemish-born artist, also painted street scenes of the *vita popolare* in the tradition of van Laer but in a highly personal style. These works portray strangely silent figures that barely interact with one another (see fig. 51). Sweerts also executed religious series in the guise of genre, like the Seven Arts of Mercy, and artists' studios (see pl. 47 and *Artist's Studio,* Rijksmuseum, Amsterdam, no. A1957). The last mentioned probably depict Italian academies or the studio Sweerts himself set up in Brussels rather than Dutch studios (compare fig. 44), where group instruction, as we have noted, was unusual. Sweerts often painted on a dark ground leaving large areas of his composition in half-light, his brilliant highlights alone defining form. The artist's quiet, amply proportioned figures have a classical monumentality and a restrained lyricism that have often been likened to the style of Vermeer. Documented in Amsterdam only in 1661, Sweerts nonetheless left his mark on Dutch painting.

The twenty-one-year-old Amsterdamer Jan Baptist Weenix set out for Italy in 1642 or 1643. He would remain there for four years, enjoying the patronage of no less than Cardinal Pamphili, named Pope Innocent X in 1644. Weenix's earliest known dated works are from 1647 and show a supple figure style descended from van Laer as well as a taste for bright, clear colors (see, for example, pl. 48 and *Landscape with Ford and Riders,* Hermitage, Leningrad, no. 3140). Through the first half of the 1650s Weenix strove for increasingly monumental compositions with a few, relatively large-scale

figures amidst ruins (see cat. no. 124, fig. 1, and *The Vegetable Grocer* dated 1656, Girardet Collection, Kettwig-Ruhr).[102] Toward the end of the decade he developed a tighter, more exacting style (see fig. 52), which formed the basis for that of his son, Jan Weenix (1640–1719). The latter was only one of many painters drawn to Weenix's art. Occasionally Jan Baptist Weenix's figures resemble those of Nicolaes Knüpfer (c. 1603–1655), the exceptionally talented Leipzig-born artist who studied with Bloemaert after 1630 and evidently remained in Utrecht until his death.[103] Though primarily a history painter, Knüpfer executed a few genre scenes notable for their animation, free technique, and colorful palette (see fig. 53). Among the many painters influenced by Knüpfer were his pupil Jan Steen, Gabriel Metsu, and Martin Stoop (c. 1620–1647), whose *Guardroom Scene* (with dealer Hoogsteder/Naumann, The Hague and New York) is dated 1644.

Probably the best-known of all Dutch Italianate painters is the Haarlem-born artist Nicolaes Berchem. In the seventeenth century more prints were made after his works than those of any other Dutch painter. Never mentioned in the early sources, Berchem's trip to Italy remains hypothetical but may have taken place in the early 1650s. Berchem's early work reflects the influence of Jan Baptist Weenix as well as that of the great Italianate landscapists Jan Both (c. 1615–1652) and Jan Asselijn (before 1615–1652). His landscapes with lively bucolic staffage are more familiar than his history paintings and genre subjects. In the late 1650s he began a series of scenes of elegant young ladies amidst the bustle of a Mediterranean harbor; *A Moor Presenting a Parrot to a Lady* (pl. 51) is surely among the finest. In contrast to the Bamboccianti's realistic street scenes, these works express the allure of the South and a longing for the exotic. Among the many Berchem pupils mentioned by Houbraken are Pieter de Hooch, Jacob Ochtervelt, and Karel Dujardin. The first two quickly turned to domestic genre and high life, but Dujardin who, alone among these three, traveled to Italy, arriving in the late 1640s, continued to work in the Dutch Italianate tradition throughout his career. In addition to landscapes with shepherds and herdsmen, he produced street scenes in the manner of the Bamboccianti (see fig. 54), portraits, and history paintings.

FIG. 55. GERARD DOU, *The Young Mother,* 1658, oil on panel, Mauritshuis, The Hague, no. 32.

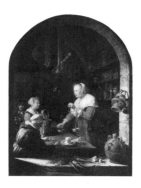

FIG. 56. GERARD DOU, *Village Grocer,* 1647, oil on panel, Musée du Louvre, Paris, no. 1215.

Back in Amsterdam by 1650, Dujardin turned from landscapes in the manner of Berchem by the end of the decade to paintings with more monumentally scaled genre motifs, producing among other works the *Tale of the Soldier* (pl. 49) and the *Young Woman Milking a Red Cow* (pl. 50). Their large, clear forms have inspired writers to refer to this as Dujardin's classical phase. The latter painting again recalls the pastoral, despite realistic details like the woman's dirty feet.

Lesser Bamboccianti deserving note include Andries Both (1612/13–1641), brother of Jan and a painter and craftsman of lively, sometimes slightly caricatured low-life figures, and Thomas Wyck (1616–1677) who, in addition to depicting inns and alchemists in the native Dutch tradition, painted Dutch Italianate street, harbor, and courtyard scenes reminiscent of Asselijn and Weenix (see, for example, *Almsgiving,* John G. Johnson Collection at the Philadelphia Museum of Art, no. 611). Yet another painter who was influenced by van Laer after the latter's return to Haarlem was Philips Wouwerman (1619–1668), but since the figure motifs in the latter's hunting parties, battles, and horse paintings are usually much smaller than the landscape elements, Wouwerman's art probably ought to be excluded from a discussion of genre, although one could argue this borderline case.

The Leiden School and Fijnschilder Painting
When J. J. Orlers composed his *Beschrijvinge der Stadt Leyden* (Description of the city of Leiden) in 1641, he felt obliged to include a short biography of Gerard Dou, a twenty-eight-year-old painter who had already brought honor to the city as one of the most successful artists in the Netherlands and who, at his death in 1675, would claim international renown. When the States General cast about in 1660 for paintings sufficiently distinguished to present to Charles II on the occasion of the Restoration, one which they selected was Dou's *Young Mother* (fig. 55), which John Evelyn characterized as painted "so finely as hardly to be at all distinguished from *Enamail.*"[104] Houbraken claimed that the English King took "great pleasure in Dou's art of the Brush" and invited the artist to come to England, but Dou was evidently unprepared to exchange his native Leiden for the uncertainties of a foreign court.[105] As we have seen, he already enjoyed the benefits of royal patronage

and, despite their high prices, his works found a domestic market; in 1665 Johan de Bye, a Leiden patron, rented a room where he put on view no less than twenty-seven works by the master.

Surely what most appealed to these eager collectors was Dou's technique, a painstakingly refined manner known as *fijnschilderen* (fine painting). Dou had a keen, almost obsessive eye for surface detail. His diligence and care were legendary. According to reports of his working method, a cloth hung from the ceiling over his easel to insure that no dust fell on the minutely finished works. This seems to be confirmed by Dou's paintings of his own studio (see the background of the *Self-Portrait,* Rijksmuseum, Amsterdam, no. A86). Dou first developed this style during a three-year apprenticeship with Rembrandt between 1628 and 1631/32 in Leiden. The student was only fifteen and the teacher twenty-two when this apprenticeship began, but what surely became a collaborative effort was both precocious and fruitful. The closeness of the two artists in these years is reflected not only in Dou's use of Rembrandt and his family as models (Rembrandt's mother is probably to be seen in the *Woman Eating Porridge* [pl. 53] and the *Old Woman Peeling Apples,* Staatliche Museen Preussischer Kulturbesitz, Berlin [West], no. 2031),[106] but also in the artists' shared subjects and styles. Like Rembrandt, Dou painted portraits, including many self-portraits, head studies, religious themes, including praying hermits and Magdalens, artists' studios, and genre scenes. Although none of his works are dated before 1637 (see cat. no. 31, fig. 2), his earliest genre scenes usually depict horizontal or, alternatively, tall interiors in which old men and women work or read, often seated beside a spiral staircase (see, for example, pls. 52, 53). These works are characterized by smooth modeling, soft lighting effects, and a bright but dry, pastel-colored palette (lilac, green, blue, and yellow)—all features comparable to Rembrandt's style of the Leiden and first Amsterdam years. While Rembrandt exchanged the fine

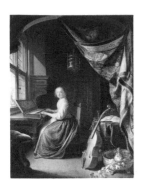

FIG. 57. GERARD DOU,
Lady Playing a Clavichord,
oil on panel, Dulwich College Picture Gallery,
Dulwich, no. 56.

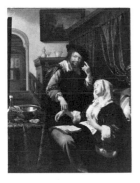

FIG. 58. FRANS VAN MIERIS,
The Doctor's Visit, 1657,
oil on panel, Kunsthistorisches Museum,
Vienna, no. 590.

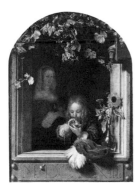

FIG. 59. FRANS VAN MIERIS,
Boy Blowing Bubbles,
1663, oil on panel,
Mauritshuis, The Hague,
no. 106.

manner for a broader, more painterly technique in the next decade, Dou worked in the *fijn-schilder* style for the rest of his life, exploring the very limits of his medium. In his mature works his figures are often larger and better-drawn, the still-life details even more exacting, and the colors increasingly saturated, with deep reds and blues appearing by c. 1650.

Dou's favorite genre subjects were domestic and marketing scenes and depictions of scholars, doctors, quacks, and barber-surgeons. These themes had first appeared in his work of the early 1630s but only reached fruition in the late 1640s and early 1650s with works like the *Girl Chopping Onions* of 1646 (pl. 54), *The Doctor's Visit* of 1653 (cat. no. 98, fig. 2), and the unquestionable masterpiece among his few outdoor scenes, *The Quack* of 1652 (cat. no. 120, fig. 2). One of the artist's preferred compositions was the so-called *nisstuk* (niche piece), which placed an arched windowframe, functioning as a diaphragm, in the immediate foreground of the picture. Though a time-honored illusionistic device (compare pl. 7), the window design was popularized by Dou and became through his army of followers a standard feature of genre painting until well into the nineteenth century. His first dated niche piece is the *Village Grocer* of 1647 (fig. 56), but he probably executed earlier examples. Dou's night scenes (see, for example, pl. 56) which began by 1650 also had many imitators. During the height of his popularity in the nineteenth century, the *Night School* (Rijksmuseum, Amsterdam, no. A87) was among the most famous of all Dutch paintings. An original artist, Dou usually was the innovator in cases of shared motifs and subjects, but his debt to ter Borch becomes clear in works from the 1660s like the *Woman at Her Toilet* (Museum Boymans–van Beuningen, Rotterdam, inv. no. 1186). Similarly, Dou's charming *Lady Playing a Clavichord* (fig. 57), dated by Martin about 1665, would seem to be indebted to earlier works by Jan Steen and Frans van Mieris.[107]

The latter was one of Dou's students. No ordinary apprentice, he was characterized by the master as "the prince of his pupils." Van Mieris's early works clearly attest to Dou's example; *The Charlatan* of c. 1652–55, in the Uffizi, Florence,[108] is openly based on Dou's *Quack* of 1652. Reminiscences of Dou's art as well as of Adriaen van Ostade's tavern scenes

are also apparent in *The Peasant Inn* of c. 1655–57 (pl. 57), but the more amply proportioned figures and exceptionally fine technique—showing not a trace of the hard, dry aspect of Dou's finish—already attest to a personal manner. The subject in van Mieris's earliest dated work and first independent statement, *The Doctor's Visit* of 1657 (fig. 58), once again has precedents in the works of his teacher (compare cat. no. 98, fig. 2) and possibly in those of Steen. Steen became a personal friend in the late 1650s, but none of his lovesick maidens are certain to predate van Mieris's *Doctor's Visit.* The extraordinary depth of color and invisible brushwork of this painting undoubtedly owe something to the fact that it is painted on a gold ground; the painter's father, we recall, was a goldsmith. Moreover, this painting could literally have been van Mieris's *meesterstuk* (masterpiece), submitted for his entrance to the guild in 1658. Whatever its purpose, it was the first of a series of influential masterpieces van Mieris painted between 1657 and 1660. These include his *Duet* of 1658 in Schwerin (cat. no. 118, fig. 2), which had a strong impact on the Delft School of painting, the *Inn Scene* also of 1658 (cat. no. 86, fig. 1) which inspired Metsu, Ochtervelt, and others, and *The Cloth Shop* of 1660 (cat. no. 81, fig. 1). These works established a standard of technical refinement never surpassed in paint. Only with the advent of photography were genre images of greater detail realized.

Though scarcely a demure narrator (note the dogs in the *Inn Scene*), van Mieris evidently came to admire refinement of subject as well as execution. In the late 1650s he turned to elegant themes inspired by ter Borch, as in the *Oyster Meal* of 1659 (Leningrad, Hermitage).[109] Ter Borch's influence is also evident in the *Young Woman Standing before a Mirror* (pl. 59), a work executed ten years later. Dou's themes as well as his compositions, including the niche design, continued to influence van Mieris throughout the 1660s (see *The Doctor's Visit*, private collection,[110] and fig. 59). Van Mieris's later works have an increasingly acrid palette

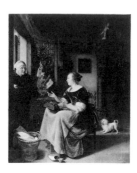

FIG. 60. PIETER CORNELISZ. VAN SLINGELANDT, *Young Woman Making Lace and an Old Woman with a Hen*, 1672, oil on panel, Gemäldegalerie Alte Meister, Dresden, no. 1762.

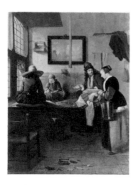

FIG. 61. QUIRIJN VAN BREKELENKAM, *The Tailor Shop*, 1661, oil on canvas, Rijksmuseum, Amsterdam, no. C112.

FIG. 62. QUIRIJN VAN BREKELENKAM, *The Cobbler's Shop*, oil on panel, Norton Simon Museum, Pasadena, no. M.77.28.P.

and, especially after c. 1670, often harden into a stiff and now truly enameled look as in the *Family Concert* of 1675 (fig. 3). This late manner formed the basis of the style of his son, Willem (1662–1747), and grandson, Frans the Younger (1685–1763), who continued to produce works in his manner long into the eighteenth century.

The list of Dou's followers is extensive. Some, like his nephew Dominicus van Tol (c. 1635–1676), are straightforward imitators (see *Woman with a Fowl at a Window*, Museum of Fine Arts, Boston, no. 30.503),[111] while others, such as the enigmatic and exceedingly rare Isaack Koedijck (see pl. 63), rise above the crowd. Pieter van Slingelandt (1640–1691) fashioned his own style from elements of the art of both Dou and Metsu (see fig. 60). With different results, Jacob van Toorenvliet (c. 1635–1719) also took up Dou's subjects (see, for example, *The Quack*, Alte Pinakothek, Munich, no. 2875) but with Metsu's more fluid manner.[112] Dou's more original, later followers include Godfried Schalcken and Matthijs Naiveu.

Two independent Leiden School painters only peripherally connected with Dou are Brekelenkam and Metsu. Very little is known about Quirijn van Brekelenkam's life or training, but he undoubtedly played an important role in the development of domestic genre and the depiction of professions. By the time he joined the Leiden guild in 1648 he had dated scenes of women working quietly in the home (see, for example, pl. 60) which anticipate, in both theme and design, the later domestic genre scenes by Maes and representatives of the Delft School. Around 1652 he began a series of paintings illustrating various professions, including tailors (see pl. 61 and fig. 61), cobblers (see fig. 62), coopers, spinners, smithies, fishmongers, apothecaries, barber-surgeons, even bloodletters (see Mauritshuis, The Hague, no. 562). Very often these artisans, particularly the tailors and cobblers, sit beside or on top of a table placed before a window. Through this window they conduct business and receive the light necessary for their precise work. Although not the first to depict occupations (J. G. van Vliet, for example, executed a series of etchings depicting professions in 1635), Brekelenkam was more active than any other artist in establishing these subjects in the repertoire of Dutch genre.

Brekelenkam's tonalities are consistently lighter and his touch broader and creamier than in works by Dou and his followers. As with many Dutch genre painters, after c. 1660 his subjects became more elegant and his figures slightly attenuated, as in *Three Women and a Young Girl in an Interior* of 1663 (Ruzicka Stiftung, Kunsthaus, Zurich).[113]

An artist of exceptional range, Gabriel Metsu is surely one of the greatest of Dutch genre painters. Active only twenty-two years (Metsu's earliest dated work is from 1645[114]), this productive painter executed domestic subjects reminiscent of Dou and his circle, history and bordello themes in the style of Nicolaes Knüpfer and Jan Steen, and outstanding high-life scenes that support comparison even with ter Borch and Vermeer. His style ranged from the tightly controlled technique of the *fijnschilders* to an extraordinarily broad manner. The quality of his works is also at times uneven. An example of the artist's painting from the Leiden period is *The Usurer* of 1654 (fig. 63), which takes up the moneylender theme familiar to us from sixteenth-century painting (see fig. 17), but depicts it in a style reminiscent of more recent works by the Utrecht painters Knüpfer and Jan Baptist Weenix. Dou, as we have seen, painted professionals abusing clients and customers but on a much smaller scale and more tightly. Ironically, Metsu's refined style only fully emerged after he left Leiden for Amsterdam in 1657. His *Music Party* of 1659 (pl. 66) is the first dated genre painting from his Amsterdam years. While the work still recalls Knüpfer's figure types (see fig. 53), the technique has become finer and the artist's superbly rich color scheme is now in full bloom.

Metsu's stylistic development in these years has been correctly characterized as "a dialectic between the countervailing influences of Dou and Terborch."[115] Metsu's debt to the latter is clear not only in actual quotations but also in the artist's choice of subjects and his new narrative subtlety. While his early works, like *The*

FIG. 63. GABRIEL METSU,
The Usurer, 1654, oil on
canvas, Museum of Fine
Arts, Boston, no. 89.501.

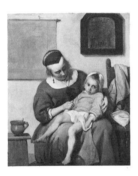

FIG. 66. GABRIEL METSU,
The Sick Child, oil on
canvas, Rijksmuseum,
Amsterdam, no. A3059.

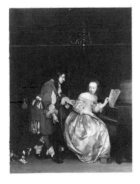

FIG. 67. GABRIEL METSU,
*Lady and Gentleman at a
Harpsichord*, oil on panel,
Wernher Collection, Luton
Hoo, no. A75.

Usurer, were often anecdotal, even melodramatic, his later Amsterdam paintings are more discreet and understated in the manner of ter Borch. The best examples of these achievements are Metsu's unrivaled masterpieces, the *Man Writing a Letter* and the *Woman Reading a Letter* in the Beit Collection (figs. 64, 65). Metsu often seems to have thought in terms of pendants, a mentality sympathetic to contrasting but complementary ideas. In *The Hunter's Gift* (pl. 65), the man's offer and the woman's response are conflated into a single image, which once again treats a dilemma with great subtlety. Citing the precedents of Maes's maternal subjects for a work such as *The Sick Child* (fig. 66) scarcely explains the painting's evocative treatment of the theme; nor does it clarify the meaning of the painting of the Crucifixion on the back wall and the recollection of Deposition scenes in the child's pose. These too are part of Metsu's richly suggestive approach to narration.

Metsu remained receptive to the influences of others throughout his career, but his sources were always reformed in creative ways. The greater spatial clarity of his interiors of the early 1660s, for example, shows his debt to de Hooch and the Delft School, but the spatiously elegant new interior type of a work like the *Visit to the Nursery* of 1661 (Metropolitan Museum, New York, no. 17.190.20) is an original invention. Similarly, Metsu's *Vegetable Market at Amsterdam* (Musée du Louvre, Paris, inv. no. 1460) may recall earlier market scenes by Victors, Sorgh, and Maes, but the painting's spatious upright format and subtle narrative are new. In his later works Metsu turned increasingly from canvas to panel supports to enhance the ever-greater polish of his brushwork (see fig. 67), but, perhaps because of his early death in 1667, he never attained the rock-hard finish of late van Mieris or Eglon van der Neer.

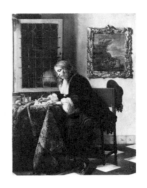

FIG. 64. GABRIEL METSU,
Man Writing a Letter, oil
on panel, Sir Alfred Beit,
Bt., Blessington, Ireland.

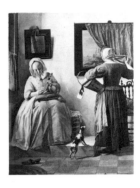

FIG. 65. GABRIEL METSU,
Woman Reading a Letter,
oil on panel, Sir Alfred Beit,
Bt., Blessington, Ireland.

FIG. 68. GERARD TER
BORCH, *Horseman in the
Saddle*, oil on panel, Museum of Fine Arts, Boston,
no. 61.660.16.

Gerard ter Borch: The Height of High Life

It has been appropriate to discuss Metsu with
the Leiden School, but we have outrun history in
speaking of his work in advance of ter Borch's
art. Gerard ter Borch was the leader of the third
generation of Dutch genre painters. Following
the startling and innovative beginnings made by
painters of the generation of Buytewech and
Frans Hals, genre had passed into a phase of
more prudent, considered development, epito-
mized by the progressive refinement of the
Leiden School. By the 1640s there were very few
innovative painters, apart from Dou and
Adriaen van Ostade, who were working in the
area of genre. The genre paintings that were
being produced were mostly variations on sub-
jects and schema invented earlier. Around 1650
ter Borch revitalized the tradition with the
creation of what has come to be known as
"classical" Dutch genre painting. No later high-
life painter could ignore or remain unaffected by
the artist's dazzling achievements.

Ter Borch was born to a distinguished family
in Zwolle. In many regards, the elegant art he
would produce as an adult is an embodiment of
the patrician ideals to which he was early ex-
posed. Ter Borch's father, a public official who
had himself been active as a painter, took a
special interest in his children's upbringing,
encouraging them to draw at an early age.
Remarkably, the family sketchbook has survived
(Rijksprentenkabinet, Amsterdam), enabling us
to trace ter Borch's artistic development from as
early as age eight. His youthful works are figure
studies from life and sketches of the environs of
Zwolle. One, a mounted rider seen from behind,

is undoubtedly the initial conception for one of
ter Borch's earliest paintings (fig. 68), a work
probably executed during his apprenticeship in
Haarlem with the landscapist Pieter Molijn
(1595–1661). In 1635 ter Borch dated his first
painting[116] and entered the Haarlem guild.
Shortly thereafter he began a series of trips
which took him to London, Germany, Italy,
France, and Spain. Despite his travels, ter Borch
never disavowed his Dutch schooling. As we
have seen, his guardroom scenes from the 1640s
are descended from those of Codde and Duyster.
They differ from their predecessors, however, in
their emphasis on the figures; often the shad-
owed background is only a foil for the spotlit
soldiers (see, for example, fig. 69). Ter Borch's
techniques also differ from those of the era's
leading interior genre painters, namely Dou and
Adriaen van Ostade. From the outset of his ca-
reer, he eschewed the action and inner tension
that we associate with the Baroque. Even in his
early works, dramatic gestures rarely disturb the
stillness.

Ter Borch first developed his own independent
manner not in genre but in portraiture. Working
in Amsterdam in 1644–45, he filled important
commissions for his small-scale, three-quarter
and full-length portraits. These works place the
mostly black-clad subjects before a virtually un-
defined gray background in a manner that,
except for the miniaturist's scale, has been lik-
ened to Velásquez's art. In 1648 ter Borch
painted, again on a tiny scale, the signing of the
Treaty of Münster (National Gallery, London,
no. 896). Returning to the Netherlands from this
great event, ter Borch rededicated himself to
genre and quickly realized his mature style. De-
spite his peripatetic life in the late 1640s and
early 1650s (he appeared in Amsterdam,
Haarlem, The Hague, Zwolle, Kampen, and
Delft), he fashioned a new genre type, concen-
trating in works mostly with an upright format
on a few brightly lit half- or full-length figures
whose placement and gestures, rather than the
painted environment, define the pictoral
space.[117] The artist may have been stimulated in

FIG. 69. GERARD TER
BORCH, *Soldiers in a
Guardroom*, oil on panel,
Victoria and Albert Mu-
seum, London, no. CAI.84.

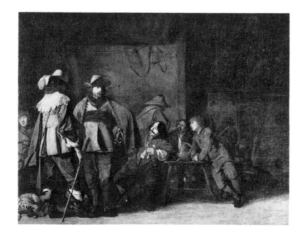

FIG. 70. GERARD TER BORCH, *Letter Writer,* oil on panel, Mauritshuis, The Hague, no. 797.

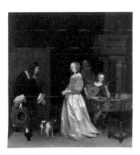

FIG. 71. GERARD TER BORCH, *The Suitor's Visit,* oil on canvas, National Gallery of Art, Washington, D.C., no. 58.

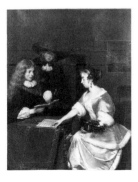

FIG. 72. GERARD TER BORCH, *The Music Party,* oil on panel, Cincinnati Art Museum, Cincinnati, no. 1927.421.

this effort by several Amsterdam painters, including Jacob van Loo, Gerrit van Zyl (c. 1607–1665), and Gerbrand van den Eeckhout, who developed similar compositions around 1650. Moreover, some of these works by ter Borch, like *The Unwelcome Message,* dated 1653 (Mauritshuis, The Hague, no. 176), still owe elements of theme and design to earlier art; in this case to the guardroom painter Palamedesz. A work, on the other hand, like the so-called *Parental Admonition* of c. 1654–55 (pl. 68) is wholly unprecedented. Not only are the design and splendidly refined treatment of materials new, but the elegant atmosphere as well. Here suddenly is a painting of unexampled substance and subtlety, of unforseen reserve and nuance.

The subject of this painting has baffled and intrigued viewers. The eighteenth-century title *Parental Admonition* was known to Goethe and survives today; however, Gudlaugsson, the author of the current monograph on the painter thought it could be a brothel scene. Ter Borch treated other mercenary love subjects (see, for example, pl. 74) with comparable finish and subtlety. Most recently, however, the theory has been proposed that the work is a marriage proposal, a notion supported by, among other details, the similarity of the man's gesture in Netscher's *Presentation of a Medallion Portrait* (pl. 77). It is possible that we will never know the certain meaning of the work; indeed ter Borch did not necessarily wish us to. Although it has precedents in the art of other earlier genre painters (Codde and Duyster) as well as in ter Borch's own first works (see fig. 68), the figure seen from behind or in lost profile is a deliberately ambiguous motif, functioning both to exclude and entice the viewer. As Gudlaugsson observed, ter Borch brought to the refinement of his naturalism the knowledge that events in reality are of interest only as long as they are imperfectly understood; with the revelation of their full meaning, they forfeit their interest.[118] Thus, ter Borch's paintings are filled with figures lost in a moment of revery or self-forgetfulness, staring off obliquely into space, their unspoken thoughts an intriguing mystery.

Ter Borch frequently selected themes that promoted these contemplative states—the writing and reading of letters (see fig. 70), the practicing of music, or concentration on a domestic task, such as sewing, spinning, peeling apples (see pl. 73) or the cleaning of lice from a child's head or ticks from a dog. No doubt for the same reasons, ter Borch favored the quiet, more contemplative life of women to the male world of action. The artist ushers the viewer into a secreted realm of boudoirs and sitting rooms. Here beautiful, highborn women busy themselves with their toilet (see pl. 72 and cat. no. 76, fig. 1) or talk in confidences of love and the intriguing contents of a letter (see *The Letter,* Her Majesty Queen Elizabeth II). Their splendid satin dresses and rich furnishings are the height of fashion, evoking the courtly life. When men venture into this rarefied world, they do so with a great show of deference and *politesse,* as in *The Suitor's Visit* (fig. 71). Yet, while epitomizing what has come to be known as "polite genre," ter Borch's paintings are no mere studies in manners; in *The Suitor's Visit,* for example, a close examination of the hands of the two main figures reveals that they exchange obscene gestures, suggesting an episode from the demimonde. While these gestures are still readily understood, knowledge of the history of costume is required to recognize that ter Borch's women often appear without the wide collars that invariably covered the shoulders and breasts in this period—a deliberately titillating feature.

Ter Borch's elegant new genre scenes made a great impact on later artists, including Metsu, de Hooch, and Vermeer. Not only did his ideal of high life and virtuoso technique influence these artists, but also his practice of fully exploring the possibilities of an artistic concept in a series of paintings. Still, by placing the figure centermost in his art, ter Borch stood apart from further developments of the high-life interior. He set the stage for his scenes with great economy—a table and chair, the suggestion of a fireplace and a chandelier—while later painters would make defined space a more expressive element of their art. Even in his later works, ter Borch focused on the players, expressing with little more than a glance that wanders to a lutist's luminous face an enchanting world of elegance and romance (see, for example, fig. 72).

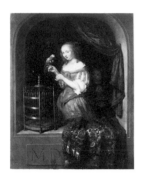

FIG. 73. CASPAR NETSCHER, *Woman with a Parrot,* 1666, oil on panel, Bayerische Staatsgemäldesammlungen, no. 417.

The magnitude of ter Borch's achievement is set in perspective by the derivative efforts of his followers and imitators. Caspar Netscher, the ablest of ter Borch's students, served as a model for his master (see pl. 69) and executed copies of his works. Netscher's independent compositions reflect his debt to his teacher. The earliest (see, for example, pl. 75) recall ter Borch's stable scenes from the late 1640s and early 1650s, while Netscher's mature high-life subjects, which begin c. 1664 (see, for example, the *Letter Writer* dated 1665, Gemäldegalerie Alte Meister, Dresden, no. 1346), are clearly inspired by ter Borch's music and letter paintings from the previous decade; the satins and the sidelong glances in the *Musical Company* of 1665 (pl. 76) are almost caricatures of their prototypes. On the other hand, Netscher's *Woman with a Parrot* of 1666 (fig. 73) shows its debt in both theme and style to Dou and van Mieris of the Leiden School. Netscher was more, however, than a mere imitator, as a masterpiece like *The Lacemaker* of 1664 (cat. no. 84, fig. 1) attests. After c. 1670 he turned from genre to concentrate almost exclusively on fashionable portraiture, executing only an occasional history or pastoral subject.

Jan Steen: Comedy and Admonition
Just as ter Borch was the preeminent high-life painter after mid-century, Jan Steen was the foremost painter of low life and comedy. Though best remembered as the great humorist of Dutch art, Steen was a consummate storyteller, whether depicting the raucous celebrants

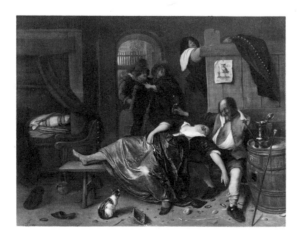

FIG. 74. JAN STEEN, *Drunken Couple,* oil on panel, Rijksmuseum, Amsterdam, no. C232.

of Shrovetide and Twelfth Night or a solemn episode from the Bible. His narratives are often enriched by anecdotal detail; few painters have so accurately characterized in turn human frivolity, petulance, pomposity, and devotion. An artist with a keen interest in the theater (see pl. 82), Steen employed a stock of human types whose actions by their very predictability make us laugh. Many of Steen's characters—the radiant lover, the debauched roué, the nurturing mother—are universally recognizable, while others, above all his doctors (see pl. 81), require historical vision. Though boundlessly generous, Steen's art was also succinct and purposeful. As the great French art critic Thoré-Bürger recognized more than a century ago, Steen's joking had a function; never mere drollery or farce, his art is satire with a moral: "Jan Steen's comical inventions, far from being a glorification of misconduct . . . always have at base a moral significance. The punishment of intemperance, debauchery, idleness, disorder is always intimated by a revealing passage of the painting."[119] Thoré may well have had in mind a painting like Steen's *Drunken Couple* (fig. 74). Surely one of the most vivid images of dissipation and indulgence ever painted, this work includes a print tacked to the partition on the right depicting an owl between a candle and a pair of spectacles. Its inscription admonishes the couple's willful blindness to their own excess: "Wat baet er kaers of brill, als den uyl niet sien en will" (what need of candle or glasses if the owl cannot and does not want to see).

In the tradition of the sixteenth century, Steen actually inscribed proverbs and prayers into his pictures (see cat. nos. 102–104, 109). The details of these works variously illustrate the inscribed messages. Other paintings without inscriptions also employ symbols to encode moral lessons (see, for example, cat. nos. 105, 110). Nonetheless, because of his comedy, Steen's moralizing has usually been misunderstood. The inscriptions have been considered a sop to convention, a mere pretext for the painting of debauched hilarity. But only a cynic could regard the piety of *Prayer before the Meal* (pl. 78) as feigned. In dwelling on human folly, Steen betrays an obvious amusement with his subject, but his images of licentious havoc are never hap-

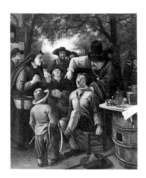

FIG. 75. JAN STEEN, *The Tooth Puller,* 1651, oil on canvas, Mauritshuis, The Hague, no. 165.

hazard; rather, their programmatic nature reflects an ethical point of view. However paradoxical, the artist's images of chaos imply a moral order; as many a moralist before him, Steen marshaled the profane in defense of the sacred. Secure in the assumption that the artist had no serious intent, writers until recently have centered their discussions on Steen's personality. With no basis in fact, Steen has been portrayed as a rebellious bohemian at odds with the bourgeois ideals of his age. The artist's habit of depicting himself in his paintings only encouraged such speculation; Steen cast himself successively as an ironic jester (pl. 81), a sot (pl. 82), a foolish wastrel (pl. 79), a neglectful father (pl. 85) and, on more than one occasion, as an aging libertine tussling with the hostess or being swindled by whores. The possibility that Steen, like the rhetoricians in their various roles, adopted personae in his paintings has usually been ignored, despite the fact that Steen's only known formal self-portrait (Rijksmuseum, Amsterdam, no. A383) depicts a respectable-looking Dutch burgher.

Notwithstanding the artist's brief operation of a brewery and request for permission in the difficult year of 1672 to open a tavern, nothing in the certain facts of Steen's life justifies his reputation as a drunken profligate. Indeed as J. B. Descamps remarked in 1760, it is unlikely that Steen could have produced "so many beautiful things" had he had a weakness for the drink.[120] Although Steen's accepted oeuvre has been pruned back in recent years, it remains large (probably more than 350 works), indeed probably larger than that of any other genre painter of the first rank, with the possible exception of Adriaen van Ostade. Not only was his production prodigious but also varied, both in theme and style. Yet Steen's development is only surveyed with difficulty because of the scarcity of dates. Few works are dated prior to 1660 and none earlier than 1651. Each of the artists reported to have been his teacher seems to have left his mark, although Nicolaes Knüpfer's example was probably more important for his history paintings. Steen's *Tooth Puller* of 1651 (fig. 75), for example, illustrates his debt to Adriaen van Ostade, who was probably the greatest single early influence on his art (compare fig. 43). Steen's choice and treatment of low-life subjects recall Ostade; the gathering of animated villagers outside a cottage in Steen's early *May Queen* (John G. Johnson Collection at the Philadelphia Museum of Art, no. 513) as well as its paint handling and palette invite comparison with Ostade's *Outdoor Tavern Scene* of several years earlier (Staatliche Kunstsammlungen, Kassel, no. GK275). Landscape plays a larger role in Steen's early works than in his mature art. The landscapist Jan van Goyen, who is said to have been another teacher and whose daughter Steen married in 1649, briefly influenced Steen; the tree and landscape in *The Fortune Teller* of c. 1648–52 (W. P. Wilstach Collection, Philadelphia Museum of Art, no. w' 02-1-21), for example, have been wrongly attributed to van Goyen in the past. An early masterpiece by Steen is *The Wedding Procession* of 1653 (fig. 76), which well illustrates his increasing skill in the organization of a large crowd scene. Note how the shaft of sunlight serves to pick out the foppish groom and the bride with her solemn ladies-in-waiting. The figures still recall Ostade's types but now are far more varied and comical. The sniggering onlookers at the left and the mischievous boys driven back bodily at the right suggest that this is no ordinary wedding procession but a depiction of the time-honored theme of the dirty, or pregnant, bride, part of the low-life painter's repertoire since the time of Bruegel.

FIG. 76. JAN STEEN, *The Wedding Procession,* 1653, oil on canvas, Museum Boymans–van Beuningen, Rotterdam, no. 2314.

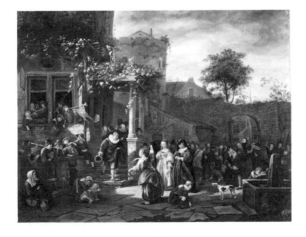

FIG. 77. JAN STEEN, *The Burgher of Delft and His Daughter,* 1655, oil on canvas, private collection.

FIG. 78. JAN STEEN, *Feast of Saint Nicholas,* oil on canvas, Rijksmuseum, Amsterdam, no. A385.

FIG. 79. JAN STEEN, *Bridal Meal in a Tavern,* 1667, oil on canvas, Wellington Museum, Apsley House, London, no. WM1510-1948.

From 1654 to 1657 Steen's father, a grain-handler and brewer, leased a brewery in Delft for his son. Although it is not known whether Steen ever actually lived in the city, his years of contact with Delft brought a lightening of his palette and increased spatial clarity to his art. A major monument from this period is the so-called *Burgher of Delft and His Daughter* of 1655 (fig. 77). It attests to Steen's newly independent style as well as to his gifts as a portraitist and raises the possibility of his having played an innovative role in the rise of outdoor genre in Delft; the painting precedes by three years the earliest dated courtyard scenes by de Hooch. After moving to Warmond in or before 1656, Steen came under the influence of the *fijnschilder* style of nearby Leiden. His *Couple at Music* of 16[5]9 (National Gallery, London, no. 856) is conceived on the intimate scale and painted with the minute touch that we associate with Dou and van Mieris. By 1661 the artist had moved again, this time to Haarlem where he entered the guild and remained until 1670. The 1660s was a period of great productivity for Steen; during these years he executed both large-scale and small, cabinet-sized paintings such as *Easy Come, Easy Go* of 1661 (pl. 79) and *Prayer before the Meal* of 1660 (pl. 78). Returning to Leiden in 1670, Steen seems at first to have faltered in the quality of his art, perhaps reflecting the hardships caused by the French invasion in 1672. At the very end of his life, however, he once again took a creative turn in developing a style anticipating the Rococo (see *Two Men and a Young Woman Making Music on a Terrace* of the early to mid-1670s, National Gallery, London, no. 1421).

Steen's robust and animated art brought the holidays of the religious calendar and civil festivities vividly to life, be it with the depiction of a charming Whitsuntide procession as in the *May Queen,* the delight of the good children and the dismay of the naughty ones at the *Feast of Saint Nicholas* (fig. 78), or costumed singers performing as in *Nocturnal Serenade* (Narodni Gallery, Prague, no. 0-253). Here too are the traditional kermis and the drunken country outing, the noisy rhetoricians' performance (pl. 82) and, of course, the outrageous village wedding feast (fig. 79). In addition to the traditional wedding guests—wilder and funnier than their counterparts in Bruegel's art—Steen invites newcomers, such as the innkeeper at the left based on the theatrical character Pulcinella (Punch) who, like Steen's comical doctor, is borrowed from the commedia dell'arte. The mix of the old and the new was typical for Steen. His *Choice between Youth and Wealth* (fig. 80), for example, takes up the age-old genre theme of the unequal lovers and mercenary love. Steen's interpretation of the subject, however, is new. No longer simply paired images of an old man making advances on a young girl with the roles reversed by an old woman and young man, Steen's work is a richer narrative fashioned from the traditional iconography and incorporating supplemental symbols. Scarcely tempted by the offer of a ring and treasures, the young woman has already made her choice in favor of youth, whose vitality (note the sprig in the young man's cap) and masculinity (the flute) prevail. On the back wall there is a print of a standard type depicting the nine stages of a man's life, and through the door an old hag approaches carrying a bulging money bag. Her designs on the young man's affections are clarified by the saying inscribed on the *belkroon* overhead: "Dat ghy soeckt, soek ick mee" (what you desire, so too do I). In a similar fashion, Steen's *Card Players Quarreling* (pl. 86) updates a theme, the allegory of Ira (Anger), that we encountered on Bosch's tabletop at the very outset of this history. Steen's great contribution was to revitalize these traditions with new and vividly observed characters. For history painting he performed a similar service by enriching his biblical and mythological subjects with numerous genrelike details (see *Moses Striking the Rock,* John G. Johnson Collection at the Philadelphia Museum of Art, no. 509). Never cluttered or cloying,

FIG. 80. JAN STEEN, *Choice between Youth and Wealth*, oil on panel, Muzeum Narodowe, Warsaw, no. 1243.

FIG. 81. JAN STEEN, *The Thirsty Traveler*, oil on panel, Musée Fabre, Montpellier.

FIG. 82. REMBRANDT VAN RIJN, *The Pancake Baker*, pen and ink on paper, Rijksprentenkabinet, Amsterdam, no. A2424.

these anecdotal elements succeed in spite of a theatrical element of caricature because of their profound humanity. Though Steen took a darkly humorous view of mankind, his sympathy for his fellowman is clear in the so-called *Thirsty Traveler* (fig. 81) or even for a silly lovesick girl, in *The Sick Lady* (Rijksmuseum, Amsterdam, no. C230).

Though many paintings have recently been removed from Steen's oeuvre, few have been successfully reassigned, largely because so little is known about the artist's followers and imitators. The ablest seems to have been Richard Brakenburgh (1650–1702), a Haarlem-born artist who studied under the landscapist Hendrick Mommers but painted tavern subjects, weddings, and outdoor scenes of quacks and processions in the manner of Steen (see, for example, *Playing Children* ["Whitsuntide Procession"], 1700, Szépművészeti Múzeum, Budapest, no. 307). His figures, however, are more crudely drawn, heavier set, and have little of the incisive characterization of the master's. The little known Hendrick de Valk (active late seventeenth century) also imitated Steen's art.

Amsterdam and Rotterdam around Mid-Century Of the various centers in Holland where genre was produced around 1650, Leiden and Delft are perhaps the best known, but other cities also claimed artists of talent. In Amsterdam many of the most promising genre painters were members of the Rembrandt School, but Jacob van Loo was one of the innovative independent masters. Little is known of his training, but a sizable number of his history paintings, portraits, and genre scenes have survived. A gifted painter of the nude, van Loo made a speciality of mythological subjects. It was probably his strength in this area that prompted Constantijn Huygens in 1649 to place his name in consideration for the decoration of the Huis ten Bosch. In the same year, van Loo executed the *Concert with Four Figures* (cat. no. 64, fig. 1), a genre scene with animated, full-length figures viewed against a dark background. As has been suggested, this type of upright composition with a few clearly conceived figures may have influenced ter Borch. Other works by van Loo that depict dark interiors with spotlit figures include *Wooing*

(Mauritshuis, The Hague, no. 885) and the *Mother with Two Children* (Staatliche Museen Preussischer Kulturbesitz, Berlin [West], no. 1888). A greater concern for spatial order appears in the *Old Woman Sewing with Merrymakers* (Hermitage, Leningrad, no. 1253). Toward the end of the 1650s van Loo's manner tightened (see the *Musical Company* of 1659, Museum, Bonn, inv. no. 36.186); however, following his forced departure for Paris in 1660, he painted the *Glass Factory* (Statens Museum for Kunst, Copenhagen, inv. no. SP291), a large Caravaggesque genre scene, probably inspired by the Le Nains.

Although he rarely treated genre subjects in paint, Rembrandt often drew and etched domestic and low-life scenes, especially in the 1630s and 40s. Jan van de Capelle, a marine painter and an independently wealthy collector, owned at his death in 1679 a large portfolio of 135 drawings by Rembrandt depicting the "life of women with children." Many such drawings as well as studies of street life—vendors and peddlers (see, for example, fig. 82)—have come down to us. Several of Rembrandt's pupils painted genre scenes around mid-century. One of the most accomplished was Jan Victors, who had probably studied with the master before c. 1640 and who first dated genre scenes in 1646. His *Swine Butcher* of 1648 (Rijksmuseum, Amsterdam, no. C259) takes up a theme treated by Rembrandt and Adriaen van Ostade, and one to which Victors would return in a painting dated three years later (cat. no. 120, fig. 1). Another Rembrandt pupil to treat the slaughtered-pig subject in these years was Barent Fabritius (1624–1673).[121] Victors's rural subjects include the *Scene outside a Dutch Farm* of 1650 (Statens Museum for Kunst, Copenhagen, inv. no. 1727) and a charming *Wedding* of 1652 (Kunstmuseum, Basel, no. 910), both of which serve to illustrate his rather squat figure types, thick touch, and colorful palette. In the early 1650s he also depicted street scenes with vendors of fish, poultry, and vegetables or quacks and artisans (see pl. 89 and the *Greengrocer*, dated 1654, Rijksmuseum, Amsterdam, no. A2345). These works seem to predate the appearance of street peddler subjects in the art of another important Rembrandt pupil, Nicolaes Maes.

FIG. 83. CORNELIS SAFT-
LEVEN, *Shoulder Operation*,
1634, oil on panel, Staat-
liche Kunsthalle, Karlsruhe,
no. 250.

FIG. 84. CORNELIS SAFT-
LEVEN, *Drinkers before a
Rural Tavern*, oil on panel,
Nationalmuseum, Stock-
holm, no. NM693.

FIG. 85. PIETER DE BLOOT,
Peasant Dance, 1634, oil on
panel, Szépművészeti
Múzeum, Budapest, no.
401.

Although the tutelage is undocumented, Gerbrand van den Eeckhout is believed to have studied with Rembrandt in the late 1630s. Houbraken's report that the two painters became great friends is supported by van den Eeckhout's clear admiration for Rembrandt's painterly history and portrait style. The artist's genre scenes also employ a relatively broad and shadowed manner reminiscent of Rembrandt's. The date of 1651 on his *Soldiers Playing Trictrac* (private collection, Detroit, c. 1960) proves that van den Eeckhout, together with van Loo and other Amsterdamers,[122] was an early innovator in the development of the more simplified genre scenes on an upright format. No less innovative were his paintings of parties on terraces (see, for example, pl. 88) which, once again with van Loo's art (see pl. 87), serve to update the *buitenparti-jen* of Buytewech and Esaias van de Velde, while anticipating later works by de Hooch.

By mid-century, Rotterdam had a well-established peasant painting tradition that is to be distinguished from that of the Haarlem low-life painters led by the Ostades and that of the Antwerp School under David Teniers (1610–1690). Drawings and paintings dated by Herman and Cornelis Saftleven in the early 1630s indicate that they were among the first painters to depict barn and stable interiors, subsequently a standard feature of both the peasant painting and still-life traditions. Arranged mostly in a horizontal format, these dark cavernous spaces house piles of barnyard or kitchen implements or groups of peasants and animals, usually placed to one side of the composition or, in the case of both types of motifs, opposite one an-

other. Though an exceptionally versatile artist, Cornelis painted genre more consistently than Herman, who in his maturity devoted himself mostly to landscape, occasionally collaborating with his brother (see, for example, pl. 91). Cornelis's early stable scenes reveal his debt to Brouwer in subjects like a quack performing a shoulder operation (fig. 83) but, even at this youthful juncture, the artist's personal style is apparent in his acutely observed human and animal types. Unusually inventive and daring in his subjects (among other themes he painted monster and fantasy subjects and political satires), Saftleven was not above an anti-clerical barb; at the center of the rowdy party in the *Drinkers before a Rural Tavern* (fig. 84), a tipsy monk with a fiddle makes advances on his female companion. Cornelis continued to paint stable interiors and outdoor tavern scenes throughout his long career (see, for example, pl. 90).

Other painters who contributed to the rise of this Rotterdam stable interior include Pieter de Bloot (see fig. 85), Pieter Jacobsz. Duifhuysen (1608–1677), and the Middelburg artist François Ryckhals (after 1600–1647). Another South Holland artist who adopted this tradition is Egbert van der Poel (1621–1664) who, though better known for his scenes of the explosion in Delft of 1654, executed peasant paintings of this type by 1648.

FIG. 86. HENDRICK SORGH, *Kitchen Scene*, 1643, oil on panel, Muzeum Narodowe, Warsaw, no. 136227.

FIG. 87. HENDRICK SORGH, *Fishmarket*, 1654, oil on panel, Staatliche Kunst-sammlungen, Kassel, no. GK286.

FIG. 88. LUDOLF DE JONGH, *Paying the Hostess*, oil on panel, private collection.

FIG. 89. LUDOLF DE JONGH, *Lady Receiving a Letter*, oil on canvas, British National Trust, Ascott House.

Of those Rotterdam painters of low life who became active in or shortly before the early 1640s, by far the most accomplished was Hendrick Sorgh. Sorgh's earliest dated peasant interior, the *Tavern Scene with Drinkers* of 1642 (sale, London, April 20, 1939, no. 105), attests to the influence of Saftleven as well as lingering regard for Brouwer. In the following year, however, Sorgh turned to more respectable middle-class subjects, depicting a *Kitchen Scene* (fig. 86) with a kneeling man offering a woman a basket of fish. The subject of the peddler in the kitchen became one of Sorgh's favorites. The *Kitchen Scene* may owe something to Dou's kitchenmaids, but with its orderly upright composition it looks ahead to later paintings of this theme by Brekelenkam and de Hooch. By 1653 Sorgh had begun a series of market scenes (see cat. no. 101), which together with his kitchens constitute his most original contributions to genre. The artist's depictions of stands of vegetables, fruit, poultry, and fish along the streets and quays of Rotterdam (see fig. 87) undoubtedly owe their authentic appearance to personal experience: Sorgh's father was a market barge operator, and in his early years the artist himself held a similar position. In later years Sorgh prospered, held public offices, and painted the portraits of well-to-do Rotterdam citizens. The greater elegance and refinement of his later art (see pl. 94) may reflect his rising star, however, these qualities also constituted current fashion by c. 1660. Sorgh continued to paint peasant scenes as well as history subjects involving peasants and kitchens (for example, the Laborers in the Vineyard, the Adoration of the Shepherds, the Satyr and the Peasant, the Supper at Emmaus, and Christ in the House of Mary and Martha) throughout his career. His most talented pupil was Abraham Diepraam, who, though he never executed market subjects, painted peasants in taverns in a highly personal, painterly manner. Diepraam's best works have a sort of manic flair (see, for example, pl. 96).

Like Saftleven, Ludolf de Jongh was an artist of exceptional versatility and range. Though not especially productive, he painted portraits, history paintings, cityscapes, landscapes, hunting and riding scenes and, of course, genre subjects. His earliest dated interior genre piece is the *Messenger Reading* of 1657 (pl. 92); however, de Jongh almost certainly executed earlier guardroom scenes, some of which have wrongly been attributed to Pieter de Hooch. One of these, in which the signature was even altered to that of de Hooch, is *Paying the Hostess* (fig. 88), which combines a stable interior setting (a variation on the Rotterdam peasant painters' barns) with a guardroom theme executed in the simple, clear style familiar to us from contemporary works by Jacob van Loo and others. The work confirms that de Jongh was an accomplished figure painter; indeed in this work of the early 1650s the artist is far more assured than his younger Rotterdam colleagues de Hooch and Jacob Ochtervelt. De Hooch, nonetheless, developed to become an influence on de Jongh's later courtyard scenes (see pl. 93) and few high-life interiors from the 1660s (see fig. 89). Another talented but little-known Rotterdam high-life painter was Joost van Geel (1631–1698), who was a merchant as well as an artist; his works (see, for example, *Visit to the Nursery*, Museum Boymans–van Beuningen, Rotterdam, inv. no. 1227) have often been wrongly assigned to Metsu or Netscher.

FIG. 90. CAREL FABRITIUS, *The Sentry*, 1654, oil on canvas, Staatliches Museum, Schwerin, no. G2477.

FIG. 91. NICOLAES MAES, *Woman Sewing*, 1655, oil on panel, private collection.

FIG. 92. NICOLAES MAES, *The Eavesdropper*, oil on panel, sale, Christie's, London, June 23, 1967, no. 64.

Johannes Vermeer and the Delft School: Forerunners and Followers

Carel Fabritius and Nicolaes Maes both studied with Rembrandt in Amsterdam and subsequently moved south, where they each influenced painting after c. 1650 in Delft, the most creative center of Dutch genre painting at the end of the decade. The reasons for Delft's artistic importance are obscure. A conservative town with a stagnating economy, it nonetheless supported a remarkably innovative community of painters around mid-century. With fewer than one dozen works to his name, Fabritius remains a shadowy figure. Nonetheless he is often celebrated as the greatest of Rembrandt's pupils and the founder of the Delft School. Fabritius evidently studied with Rembrandt in the early 1640s. His earliest known painting is probably *The Raising of Lazarus* of c. 1643–45 (Muzeum Narodowe, Warsaw, no. 366), which attests to his teacher's influence in its painterly manner, dramatic action, and chiaroscuro. By 1650 Fabritius had moved to Delft, where he produced portraits, head studies, and genre scenes. These differ from his earliest works in their light tonality, bold execution, and spatial effects. Samuel van Hoogstraten, who studied with Fabritius under Rembrandt, claimed that he was renowned for his knowledge of perspective. The tiny *Man with Musical Instruments in Delft* (National Gallery, London, no. 3714) dated 1652—one of only two genre scenes by Fabritius to survive—seems to have been curved in format and mounted at the back of a perspective box, lending support to van Hoogstraten's claim. Dated two years later, in the year of Fabritius's death in the calamitous explosion of the powder magazine in Delft, *The Sentry* (fig. 90) takes up a familiar guardroom theme but moves it out of the dim *wachtkamer* into bright daylight. The curious architectural assembly of the column, open archway, and stairs also lends some credence to Fabritius's reputation for expressive spatial effects. However the scarcity of his works, a result surely in part of the explosion, leaves his contribution to Delft painting tantalizingly uncertain.

The role Nicolaes Maes played is clearer. Like Fabritius, he began his career painting large-scale religious subjects in the style of Rembrandt and seems to have taken up genre only after leaving the master's studio in 1653/54. Maes's earliest dated painting, *The Dismissal of Hagar* (Metropolitan Museum of Art, New York, no. 1971.73), is of 1653. The following year when he dated his first domestic subject, *Woman Making Lace beside a Cradle* (Kunsthaus Heylshof, Worms, no. 470), the artist was back in his native Dordrecht. Maes's domestic themes are treated in an understated but respectful manner that lends dignity and beauty to everyday chores (see, for example, pl. 97 and fig. 91). They undoubtedly owe a debt to Rembrandt's *vrouwenleven* drawings and perhaps also to paintings by Adriaen van Ostade, but the monumentality and stillness of Maes's scenes of life in the home were new. The artist's domestic subjects and his expressive use of light and space appealed to the Delft painters de Hooch and Vermeer. An early example (see fig. 92) of his favored eavesdropper theme (compare pl. 99) depicts a complex interior with spiral staircase and an illusionistically painted picture frame and curtain, the latter of the type seen in Metsu's *Woman Reading a Letter* (fig. 65). These trompe l'oeil devices were not new (Rembrandt, Dou, and others painted earlier examples) but, like the orderly pattern of the floor tiles and the view to an adjoining room in *The Idle Servant* (see cat. no. 67, fig. 1) they are significant as expressions of Maes's influential interest in the illusion of space. He shared this interest with Samuel van Hoogstraten, who was also active in Dordrecht in these years and who is today better remembered for his *Perspective Box* of c. 1660 (National Gallery, London, no. 3832) than for his art treatise.

FIG. 93. NICOLAES MAES, *Woman Stealing a Man's Purse,* oil on panel, private collection.

FIG. 94. PIETER DE HOOCH, *Mother with Two Children,* 1658, oil on panel, private collection.

FIG. 95. PIETER DE HOOCH, *Card Players,* 1658, oil on canvas, Her Majesty Queen Elizabeth II.

The tendency of Maes's figures to address the viewer, smiling conspiratorially and putting finger to lips, is a feature of his strongly didactic and moral approach to genre. Whether discovering a maid's dalliance (pl. 99) or lifting a drinker's purse (see fig. 93), these figures issue a warning against idleness and neglect—an ongoing theme in Maes's work (see, for example, pl. 98). Other favored subjects include outdoor scenes of pretty milkmaids as well as peddlers and beggars or urchins seeking a handout at the doorstep of a wealthy townhouse. As we have observed, these vendors may have been inspired by Jan Victors's slightly earlier works. After c. 1659 Maes evidently abandoned genre entirely but continued to produce fashionable portraits for another thirty years.

In many respects Pieter de Hooch brought to fruition Nicolaes Maes's promise. De Hooch began his career, as we have seen, as a painter of guardroom scenes, but by 1658 he had broken with that tradition. The *Mother with Two Children* of 1658 (fig. 94), like many of Maes's works of c. 1654–57, addresses a maternal theme but fills the scene with light to reveal a carefully ordered geometry. The foreshortening gridwork of the tiled floor has been worked out with great care to insure a logical recession and convincing illusion of space. As in Maes's *Idle Servant* of three years earlier, a view to an adjoining room offers a pleasing sense of release; now, however, the threshold of secondary space no longer disrupts the spatial continuum. De Hooch's command of perspective was unprecedented. No earlier genre painter depicted interior or courtyard spaces with such a compelling degree of naturalism. The artist's genius was to recognize that the illusion of space was not simply a matter of orthogonals converging in a vanishing point, but also a product of light, color, and atmosphere (see, for example, pl. 101). Unlike Leiden School interiors, where the figures often seem to move in a vacuum (see pl. 63), de Hooch's spaces envelop forms in air, sending a silvery light shimmering over every surface. One of his favorite lighting systems was *contre-jour* illumination, in which the backlighting streams toward the viewer, silhouetting forms and creating a halo on contours (see, for example, fig. 95). Under the clear light, de Hooch's saturated colors achieve a splendid in-

tensity—the red of the woman's skirt in *Woman Drinking with Soldiers* (pl. 102) or the triad of primary hues in the *Woman Nursing an Infant* (pl. 104). Whether tracing highlights on a mullioned window or feathering diffusions on a white plaster wall, de Hooch's obsession with light was complete.

Constructed with virtually the same spatial formulae as his interiors, de Hooch's courtyards are highly ordered enclosures always relieved by vistas down a pathway or through a garden gate (see pls. 100, 103, and fig. 96). These yards and gardens resemble actual sites in Delft but are in fact imaginary compositions. De Hooch's courtyard scenes are related to the rise of Dutch cityscape painting after c. 1650 but constitute an independent invention. Similarly, his interiors may owe a debt not only to Maes but also to the Delft architectural painters Gerard Houckgeest (c. 1600–1661) and Emanuel de Witte as well as the enigmatic Fabritius; nonetheless, their realization was a personal accomplishment. No earlier painter had achieved such truth to life in the relationship of figures to their manmade environments.

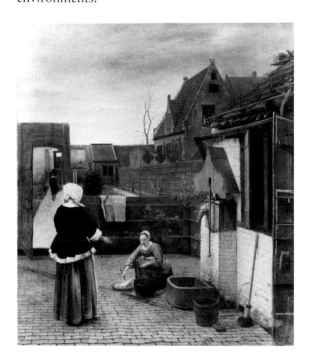

FIG. 96. PIETER DE HOOCH, *Woman with a Maidservant in a Courtyard,* oil on canvas, National Gallery, London, no. 794.

FIG. 97. PIETER DE HOOCH, *The Linen Closet*, 1663, oil on canvas, Rijksmuseum, Amsterdam, no. C1191.

FIG. 98. PIETER DE HOOCH, *Skittles Players in a Garden*, oil on canvas, James A. Rothschild Collection, Waddesdon Manor.

FIG. 99. JOHANNES VERMEER, *The Procuress*, 1656, oil on canvas, Gemäldegalerie Alte Meister, Dresden, no. 1335.

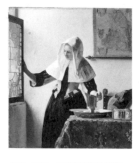

FIG. 100. JOHANNES VERMEER, *Young Woman with a Water Jug*, oil on canvas,

The subjects of de Hooch's new paintings were more conventional than their treatment. The merry company (see, for example, pls. 101, 102) was by this time, of course, a standard theme, and *Paying the Hostess*, dated 1658 (Marquis of Bute, Rothesay), returns to a subject favored by de Jongh (see fig. 88). De Hooch's most original thematic contributions were in the depiction of middle-class home life and domestic virtue subjects (see, for example, pls. 104, 105). His orderly spaces perfectly complement the celebration of domesticity, the walls and light-filled windows and doorways creating a comforting framework for daily chores. After de Hooch moved from Delft to Amsterdam around 1660, his paintings became more elegant but he never abandoned domestic subjects. After c. 1663 his interiors (for example, fig. 97) following the earlier examples of Metsu and Steen, grew richer, his figures, in the manner of ter Borch, more refined, and his touch, like that of the Leiden painters, more minute. In the search for ever more elegant settings, de Hooch's simple Delft courtyards were replaced by the manicured grounds of country villas (see fig. 98) and the early tavern and cottage interiors by palatial halls, some of which are even based on the galleries of the new Town Hall in Amsterdam (see, for example, *Musical Company*, c. 1664–66, Museum der bildenden Künste, Leipzig, inv. no. 1037). At the very end of his life the quality of de Hooch's works often deteriorated, perhaps reflecting his final illness; the artist died in the Dolhuis (bedlam) in 1684. However, the *Musical Party in a Courtyard*, dated 1677 (National Gallery, London, no. 3047), proves that the artist was capable of outstanding work even in his last years. The *Woman Weighing Coins* (cat. no. 118, fig. 3) is de Hooch's personal homage to his younger Delft colleague, the incomparable Johannes Vermeer (see pl. 108). This openly derivative work was probably painted after his move to Amsterdam; while de Hooch was still a resident of Delft, he was the primary innovator in his relationship with Vermeer. The fact that the paintings of 1658 were the first that he dated may reflect his recognition of their significance. With them de Hooch set an utterly unprecedented standard of spatial illusionism in scenes of everyday life.

One of the greatest of the old masters of the first rank, Johannes Vermeer is known today through just thirty-four works. To judge from seventeenth- and early eighteenth-century inventories and sales, his original oeuvre is unlikely to have been significantly larger. Vermeer had little of Steen's productivity, but the results were more consistently breathtaking. Like Metsu, Maes, and other genre painters, Vermeer painted history themes in his youth, perhaps inspired by the higher esteem in which these subjects were held. With full-length figures painted on a relatively large scale, Vermeer's history paintings resemble earlier works by van Loo and the Utrecht Caravaggisti. In his first dated genre subject, *The Procuress* of 1656 (fig. 99), he again turned to the Utrecht painters for his theme, half-length format, and aspects of his bright palette (compare pl. 10). Unfortunately, his next dated picture, *The Astronomer* of 1668 (Musée du Louvre, Paris, inv. no. RF1938-28), appeared only after a dozen years—the period that spanned the most crucial phase of Vermeer's own development and, indeed, that of Delft genre. Many have speculated on the artist's works from these years and the order in which they were created, but only the broadest outlines of a chronology are admissible conjecture. Although the figures and still-life details of *The Procuress* are painted skillfully enough, the space is unintelligible: what the carpet and coat in the foreground cover—a table or is it a balustrade?—is scarcely to be understood. Vermeer's other relatively large-scale genre scene, *The Sleeping Girl* (Metropolitan Museum of Art, New York, no. 14.40.611) shows advances in the representation of space but still resorts to a strategically placed chairback to disguise a tricky spatial transition. It was only with a work like *Girl with Wineglass* (pl. 106) that Vermeer achieved maturity, his conception of the consistent and logical interior space undoubtedly inspired by de Hooch's interiors of 1658 (compare pl. 101). A later and still more expressive use of perspective appears in the *Lady at the Virginals with a Gentleman* (pl. 109).

Metropolitan Museum of Art, New York, no. 89.15.21.

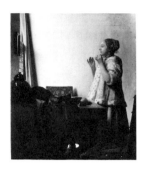

FIG. 101. JOHANNES VER-MEER, *Woman with a Neck-lace*, oil on canvas, Staatliche Museen Preuss-ischer Kulturbesitz, Berlin (West), no. 912B.

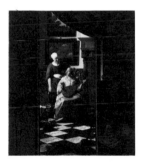

FIG. 102. JOHANNES VER-MEER, *The Letter*, oil on canvas, Rijksmuseum, Amsterdam, no. A1595.

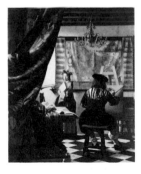

FIG. 103. JOHANNES VER-MEER, *The Art of Painting*, oil on canvas, Kunst-historisches Museum, Vienna, no. 9128.

The mastery of the illusion of space, however, was but a single, dare one say, passing achievement of Vermeer's art. No sooner had he perfected this skill than he reduced the elements of his art to a single three-quarter-length figure in the corner of a room. In a series of four paintings Vermeer depicted a woman standing or sitting before a window holding a silver ewer and chalice (fig. 100), tying a string of pearls before a mirror (fig. 101), tuning a lute (pl. 107), and holding a balance (pl. 108). The elegance and refinement of these works recall the recent achievements of ter Borch and van Mieris; their balance and restraint however, are scarcely the result of influence. So thoroughly composed are these designs that the addition or removal of a single object, the adjustment of chair or map to the right or left, would disrupt the equilibrium. Each of the women is suspended in a moment between rest and action, timeless and permanent. No less judicious than the formal artistry is the selection of subjects, simple themes but ones rich in associations: images of cleansing, adornment, harmony, and equilization. The perfect accord of Vermeer's form and content is the apogee of Dutch genre.

The artist's mature, multifigure compositions, such as *Lady at the Virginals*, minimize action, eschewing the anecdotal, often sentimental approach of Maes and internalizing emotion even more than ter Borch. One never feels, however, as occasionally with de Hooch, that the figures are there only to insure that the room is occupied. *The Letter* (fig. 102) depicts two figures through a darkened doorway, the illusionistic diaphragm familiar to us from Dou and de Hooch. Having delivered the letter, the maid smiles and her mistress seems to turn to her with surprise, even apprehension—a creative variation, complete to the seascape behind, on earlier letter themes by ter Borch and Dirck Hals (see, for example, pl. 12). Vermeer's innovative treatment of genre's traditional themes and techniques also extended to the use of allegory. For example, long called simply "Artist in His Studio," Vermeer's painting in Vienna (fig. 103) represents in

fact an allegory of *The Art of Painting*; it bore the title *Schilderkunst* in the estate of the artist's widow. The woman posing with a laurel wreath, book, and trumpet is Clio, the muse of History. Some knowledge of costume is necessary once again to recognize that the artist's dress (the same worn by the young man in the Caravaggesque *Procuress*, fig. 99) is also imaginary or, at the very least, anachronistically medieval, hence "historical." In this context the artist probably represents History inspired by Clio. Vermeer's painting thus reiterates the notion that history painting is the noblest calling. As supervisor in these years of the new decorations for Delft's Guildhall for artists, Vermeer probably had these ideas much on his mind. In any event, he kept this painting all of his life and his widow went to great lengths to avoid selling it. Toward the end of his career, after c. 1670, Vermeer's style, in accordance with prevailing tastes, became harder and more polished. Unlike the enameled finish of the later Leiden School paintings, however, his highlights became more pronounced, even disembodied in a uniquely abstract manner.[123] While some of his colleagues faltered in these years, there is no evidence of a slackening of Vermeer's powers at the end.

The de Hooch School is a misnomer of convenience; none of these artists is known to have studied with the master and only a few worked in Delft. Nevertheless, all responded to the new genre paintings produced there. Easily the most accomplished was the Rotterdam painter Jacob Ochtervelt. According to Houbraken, he studied under Berchem at the same time as his fellow-townsman and colleague de Hooch. Like de Hooch, Ochtervelt was influenced in the early 1650s by local Rotterdam art, above all by the history paintings and hunting scenes of Ludolf de Jongh (see Ochtervelt's *Hunters and Shepherds in a Landscape* dated 1652, Städtische Museen, Karl-Marx-Stadt, no. 576). Later in the decade he executed soldier scenes which, in their relatively large scale and treatment, owe less to the originators of this tradition, Codde and Duyster, than to its later practitioners, de Jongh, van den Eeckhout, and especially the Dutch Italianate artist Karel Dujardin; compare *The Feast* of c. 1658–60 (Narodni Gallery, Prague, no. o-8789) and the *Tale of the Soldier* (pl. 49). No

FIG. 104. JACOB OCHTER-VELT, *The Embracing Cavalier,* oil on panel, City Art Galleries, Manchester, no. 3024.

FIG. 105. JACOB OCHTER-VELT, *The Sleeping Soldier,* oil on panel, City Art Galleries, Manchester, no. 3025.

genre scenes by Ochtervelt are dated between 1651, the date reported to appear on the *Tavern Scene* (cat. no. 74, fig. 2), and the *Street Musicians in the Doorway of a House* of 1665 (pl. 115), however, dated group portraits survive from the intervening periods. Paintings like the *Violinist and Two Serving Women* (pl. 114) probably predate the *Street Musicians.* Together with the pendants *The Embracing Cavalier* and *The Sleeping Soldier* (figs. 104, 105), this painting illustrates the more refined manner and brighter palette that Ochtervelt developed in response to van Mieris's tavern scenes from the late 1650s. Each of these works paraphrase van Mieris's figure motifs but treat the subjects in a less frank and ribald fashion. From the first, Ochtervelt was a narrator of greater delicacy than his Leiden counterpart.

The backlighted doorway in the *Street Musicians in the Doorway* is a motif readily associated with de Hooch, who may have provided some initial inspiration for Ochtervelt's use of this design. The entrance-hall themes, however, were first perfected and popularized by Ochtervelt, constituting his most original contribution to the history of genre. Focusing the subject on the threshold of a house enabled the painter to juxtapose not only indoor and outdoor space but also the public and private spheres and different social classes. At least nine variations of this theme have survived, ranging from the early 1660s to c. 1680. In the latter half of the 1660s, Ochtervelt's figures became more elongated, their thin, attenuated proportions embodying a new ideal of aristocratic slimness (see *Violin Practice,* dated 1668, Statens Museum for Kunst, Copenhagen, no. 518, and fig. 106), which he, more than any other later Dutch genre painter, served to define. When a work like *The Music Lesson* of 1671 (pl. 116) is compared with its source, Vermeer's *Soldier and Laughing Girl* (cat. no. 88, fig. 2) of some dozen years earlier, the elegant new canon of proportion is clear. Representative of the height of genre's refinement, Ochtervelt's painting was executed only one year before the French invasion of the Netherlands. In later years, Ochtervelt continued to paint high-life themes reminiscent of ter Borch and the Leiden painters as well as some handsome domestic subjects recalling Brekelenkam and de Hooch. Like de Hooch's

late works, Ochtervelt's paintings after the early 1670s claim fewer admirers because of their dark tonality, more summary definition of form, and artificial coloration.

Little is known of the life of Pieter Janssens Elinga, and his small oeuvre, consisting mostly of still lifes (some recalling Willem Kalf) and rather rigidly conceived interior genre scenes, may indicate that he was only a part-time painter; he seems also to have been an actor and a musician. Janssens Elinga may have been in contact with de Hooch in Rotterdam in 1653, or more likely in Amsterdam, where both lived after c. 1660/61; he executed one work (*Woman with a Pearl Necklace,* Bredius Museum, The Hague, inv. no. 42-1946) that is clearly based on de Hooch's *Woman Weighing Coins* (cat. no. 118, fig. 3). Janssens Elinga had little of de Hooch's subtle understanding of space or light. Occasionally, however, he achieved a poetic effect by dint of his rather hermetic approach to interior perspective and figures seen in lost profile (see, for example, pl. 113). Of greater interest is the Amsterdam painter Esaias Boursse, whose *Interior with a Woman at a Spinning Wheel* of 1661 (pl. 112) and undated *Woman Sewing* (Staatliche Museen Preussischer Kulturbesitz, Berlin [West], no. 2036) seem to attest to the influence of de Hooch's domestic interiors of the late 1650s and perhaps Brekelenkam's paintings. Boursse's independent spirit is manifested, however, in his strangely moving *Woman Cooking beside an Unmade Bed* of 1656 (cat. no. 16, fig. 2). The artist's few courtyard scenes seem to acknowledge de Hooch's.

Literally nothing is known about Jacobus Vrel's life or the whereabouts of his activity. His charming, rather naïve manner suggests that he may have been only a Sunday painter. His indoor scenes, the best of which are in museums in Vienna (pl. 111), Brussels (Musées Royaux des Beaux-Arts, no. 252), Lille (Musée des Beaux-Arts), and Antwerp (Koninklijk Museum voor Schone Kunsten, no. 790), all depict high-ceilinged rooms with curiously stunted furnishings but, unlike de Hooch's works, never a door offering a view to a neighboring room or the out-of-doors. No less disarming for their lack of pretense are Vrel's little street scenes.

FIG. 106. JACOB OCHTER-VELT, *The Toast*, 166[8], oil on canvas, private collection.

FIG. 107. HENDRICK VAN DER BURCH, *Officer and a Standing Woman*, oil on canvas, Philadelphia Museum of Art, Philadelphia, no. E24-3-51.

Until recently the Delft painter Hendrick van der Burch (1627–after 1666) was confused with his various namesakes. Thought to be an older painter, he was credited with helping to found the new school of painting in Delft and even was believed to have been Vermeer's teacher. Now, however, he is recognized as only a follower.[124] A contemporary and, in all likelihood, the brother-in-law of de Hooch, van der Burch, like de Hooch, painted guardroom scenes in his youth and interiors and courtyards in his mature career. Few of his works are signed and many have been misattributed to de Hooch, but these can be distinguished from those of the master by their more exaggerated perspective, weaker drawing, and flecked highlights (see fig. 107). An artist of greater talent was Cornelis de Man. His early genre works are probably from the 1650s and resemble tavern and barn scenes by the Rotterdam and Haarlem peasant painters, above all Molenaer. De Man's only dated painting, *The Sweeper* of 1666 (cat. no. 69, fig. 1), reveals an interest in interior perspective that he undoubtedly gained from his younger Delft colleagues Vermeer and de Hooch. It also offers a glimpse of the wood paneling that so often figured in the decorations of his interiors. The artist's two finest works, *The Chess Players* and *The Gold Weigher* (pls. 117, 118) probably postdate *The Sweeper*.

Genre at the End of the Century
The last quarter of the seventeenth century is often characterized as the period of the decadence and decline of Dutch art.[125] Many of the major figures were dead: Rembrandt died in 1669, three years after Frans Hals, Vermeer was dead in 1675, and Jan Steen was deceased four years later. The names of the new generation—Schalcken, van der Neer, and Verkolje—hardly resonate with greatness. To be sure, these were difficult times for the Dutch; the two wars with England in the 1660s and the French invasion in 1672 pushed the United Netherlands permanently from center stage in the European theater. The population ceased to grow and the economy showed signs of stagnation. But money and a sluggish market were not the problem; the Dutch held their claim on the title of the richest folk in Europe until at least 1730 and lost little of their appetite for art. If there was a "decline," it involved one of those peculiar attitudinal

changes—sometimes characterized by historians and politicians with a taste for the dramatic as a failure of the national spirit—that emerges with a sense of tradition and the desire to maintain the status quo. As enterprise withered, a rentier economy grew up. The merchants became magistrates, the entrepreneurs investors, and burghers indistinguishable from the *bourgeois satisfait*.

With the Dutchman's increasing smugness and traditionalism came a new value system in art: where once the Dutch had celebrated craft and creativity, they now stressed style and refinement. There was no shortage of talent in the last quarter of the century—one need but think of Aert de Gelder or Jan van Huysum—only a value system that promoted stylish convention at the expense of invention. Related to these developments is the rise of the academy in the Netherlands and the decline of the guilds. It is often assumed that the growing stylization of late seventeenth-century Dutch art was a result of foreign, especially French, influences. As we have seen, however, the Dutch people and their artists had always been receptive to foreign ideas; the Netherlands had prospered as the *pays sans frontières*. The French invasion in the field of fashion, social manners, and literature is clear, but in art it has been greatly exaggerated. The stylization of late Dutch art was rather a logical extension of indigenous traditions, which only then came to the fore. Indeed, the tide of influence in late Baroque art ran as readily from the Netherlands to France as vice versa.[126]

The refinement and conservatism of late seventeenth-century Dutch art are especially characteristic of the genre painters. The leading artists, frequently virtuoso technicians who quickly mastered the established repertoire of themes, seemed content to repeat their teachers' and forerunners' subjects. Dusart, Diepraam, and Brakenburgh turned out endless variations on the earlier low-life scenes of Brouwer, Adriaen van Ostade, Steen, and the Rotterdam peasant painters (see pl. 96). These later works were not without appeal, as Job Berckheyde's lively *Baker* of c. 1681 (pl. 119) attests, but here again the subject had been treated earlier by both Ostade and Steen. Among the high-life

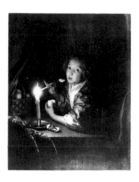

FIG. 108. GODFRIED SCHALCKEN, *Young Girl Eating Oranges by Candlelight*, oil on panel, Staatliches Museum, Schwerin, no. 2337.

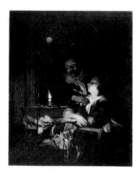

FIG. 109. ADRIAEN VAN DER WERFF, *Nocturnal Scene with Sleeping Woman*, oil on panel, Historisch Museum, Rotterdam.

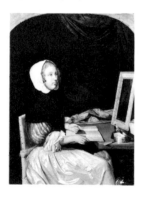

FIG. 110. EGLON VAN DER NEER, *Woman Seated at a Table with a Book and a Mirror*, 1665, oil on canvas, formerly Richard Green Galleries, London.

painters, Godfried Schalcken and Michiel van Musscher repeated the doctor subjects popularized by Steen and Dou (see pls. 120, 124), while the latter's "niche" paintings and night scenes provided constant inspiration for Schalcken (see fig. 108), Eglon van der Neer, his pupil Adriaen van der Werff (see pl. 125 and *Night Scene with an Old Woman and Children in Costume,* Alte Pinakothek, Munich, no. 264), and many other late-seventeenth-century painters. Demonstrations of virtuosity were common. In, for example, the curious night scene by van der Werff with a man leaning in at a window to fondle a sleeping woman (fig. 109), the painter depicts both the intense yellow glow of a candle flame and the cooler light of the moon beyond. Although more than half his subjects are daylight scenes, Schalcken was famous and much sought after for his nocturnal subjects; indeed they helped to buoy his reputation well into the nineteenth century. Still, the subjects of even his best works, like the *Game of Lady Come into the Garden* (pl. 121), were ones that had usually been treated earlier (compare Jacob Duck's *Merry Company with Women Undressing a Man,* Musée d'Art et d'Histoire, Nîmes). When a new theme appeared, such as chess playing (see, for example, pls. 117, 126) or a tea party (treated by both van Musscher and Naiveu), it usually represented newly fashionable recreations rather than a previously unheralded aspect of society or an original point of view.

The foremost genre painters of this period frequently enjoyed the patronage of royalty. Schalcken was favored with commissions by both the stadholder, King William III, and the Elector Palatine. As a teenager, Eglon van der Neer, who studied with Jacob van Loo as well as with his father, the twilight landscape specialist, Aert van der Neer, entered the service of the Dutch governor of the principality of Orange in the South of France. Although he returned to the Netherlands after several years, he later became court painter in Brussels to Charles II of Spain and ended his life, like Schalcken, as painter to the Elector Palatine, Johann Wilhelm, in

Düsseldorf. Van der Neer's subjects and compositions descend from ter Borch's (see fig. 110),[127] but his touch—almost opalescent in the treatment of satins—more closely resembles that of late Metsu. After the mid-1670s the figures in his genre scenes became more aristocratic in bearing and mannered in pose, while the execution, especially of fabrics and metalware, remained a tour de force (see, for example, pl. 123).[128]

The Amsterdam painter Jan Verkolje also specialized in images of upper-class leisure, subjects to which he was probably first introduced in the studio of Gerrit Pietersz. van Zijl. His *Musical Company* of 1673 (cat. no. 115, fig. 2) illustrates how closely he approximated, even as a very young man, the contemporary works of de Hooch and Ochtervelt. Indeed, he would surpass their late efforts with his *Messenger* of 1674 (cat. no. 115, fig. 1)—a work clearly inspired by ter Borch—and the *Elegant Company in an Interior* (pl. 122) of the same period. Verkolje's own late works, however, are dismayingly weak (see *Party in a Garden* dated 1693, sale, A. Lurati, Milan, April 18, 1928, no. 65, ill.).

Adriaen van der Werff's earliest dated painting, *Boy with a Mousetrap* (pl. 125), clearly attests to his tutelage with Eglon van der Neer and his early training in the Leiden School tradition. The *Hunter's Return* of two years later (fig. 111) also employs the arch motif as well as a theme familiar to us from Metsu's work (see cat. no. 71). The more elaborate vegetable still life in the foreground and the greater prominence of the "niche" itself anticipate the later embellishments of this traditional design by Willem van Mieris and Naiveu (see fig. 112). In van der Werff's mature genre scenes the technique sometimes recalls that of late Vermeer, only with darker overall tonalities (see, for example, pl. 126). The mannered elegance of the subject is now matched by an almost manneristic treatment of form. The concept of mannerism has recently been applied to late Dutch paintings.[129] Unburdened of its negative and unhistorical associations of decadence and vacant decoration, it can assist in our appreciation of this art, in which stylishness and artifice were celebrated as positive virtues in their own right.

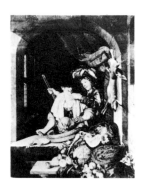

FIG. 111. ADRIAEN VAN DER WERFF, *Hunter's Return,* 1678, oil on panel, private collection, New York.

FIG. 112. WILLEM VAN MIERIS, *The Game Vendor,* oil on panel, Staatliches Museum, Dresden, no. 1767.

FIG. 113. ADRIAEN VAN DER WERFF, *Children Playing before a Statue of Hercules,* 1687, oil on panel, Bayerische Staatsgemälde-sammlungen, Alte Pinakothek, Munich, no. 250.

Van der Werff's patrons included the Kings of Poland and France and the Duke of Braunschweig as well as the Elector Palatine. Through such favor, he achieved greater fame and wealth than virtually any other Dutch painter of his generation. His reputation was built principally on his mature history paintings executed in the cool new international mode of classicism but finished with a feeling for sensuous surface. Perhaps his noble patrons also enjoyed the humanistic ideals embodied in his allegorical genre scenes. The painting of *Children Playing before a Statue of Hercules,* of 1687 (fig. 113), not only reflects van der Werff's regard for the earlier Dutch Italianate artists (Weenix and Asselijn) but also includes a dense symbolic program of a type already encountered in the works of Dou. As identified in an inventory of 1780, the work is an emblematic depiction of the notion of the importance of education for the young and the need for constant industry to attain knowledge.[130] All details of the work, including the sculpture of Hercules defeating Invidia (personification of envy and hatred and an enemy of virtue), symbolically reiterate this central idea.

Like van der Werff, born in Rotterdam, Michiel van Musscher worked in Amsterdam where, according to Houbraken, he took seven lessons from Metsu. This instruction evidently stood him in good stead when he composed the *Doctor Taking a Young Woman's Pulse* (pl. 124). Van Musscher's other works are mostly portraits and high-life genre scenes. The latter are comparable to those of van der Neer and Verkolje in their combination of themes descended from ter Borch with the new spatial order of the Delft School. Indeed this proved to be the formula favored by most of the leading genre figures of the late period. Alternatively, they turned to the Leiden School. Matthijs Naiveu, for example, painted "niche" scenes in the tradition of Dou and themes, like the *Cloth Shop* of 1709 (pl. 127) and the *Visit to the Nursery* (Stedelijk Museum "De Lakenhal," Leiden), that address subjects popularized by Leiden artists (here, respectively, van Mieris and Metsu). The latest painting in the exhibition, *The Cloth Shop* ushers us into the eighteenth century, offering an excellent example of the painting of the new *pruikentijd* (Periwig Period). Once titled

"The Gold-Brocade Shop," it draws to a close the Golden Century (*Gouden Eeuw*). Its style reflects the eighteenth-century's instinct to ornament and delicacy, while its subject—a mercantile theme with a detail of almsgiving—evokes the spirit of the new era: a curious mix of prosperity, smug condescension, and the traditional Dutch values of charity and tolerance.

We have seen that genre painting first arose in the early sixteenth century as an allegorical art form, often but not exclusively encoding a moral clothed in the guise of everyday scenes in which secular figures played a major if not dominant role. It thus was distinct from figure paintings of religious and mythological subjects. The naturalism which early Netherlandish painting had employed to enhance didactic content was applied no less compellingly to the new art. The appearance of reality, therefore, was not an end in itself but a style at the service of a message. Over the course of the sixteenth century, genre changed, broadening its range of subjects and opening new areas of specialization. Many of the most innovative figures, such as Bruegel, worked for an elite circle of wealthy, humanist patrons, who no doubt took pleasure in deciphering illustrations of proverbs and moralistic allegories. By the early seventeenth century, however, the market for genre, and for painting in general, had greatly expanded, a reflection of growing economic prosperity and the burgeoning middle class. As the original forms and subjects were constantly repeated to satisfy this new audience, genre acquired a new freedom. Even in the late sixteenth century, features of a scene of the Prodigal Son might be fused with a representation of Life before the Flood, disregarding their discrete iconography.[131] These hybrid images, like their immediate descendants, the seventeenth-century's merry company and *buitenpartij,* share their antecedents' potential for a moral; but the ambiguity of their subjects

FIG. 114. C. GALLE after
Gerrit Pietersz. Sweelinck,
Outdoor Party, engraving.

blunts the warning. While some inscriptions on prints of early merry companies, like van Kittensteyn's after Dirck Hals (fig. 37), are severely censorious, others offer a frank invitation to join in the *dolce vita* (see fig. 114).[132] Still others, like those we have encountered on prints after early *buitenpartijen* by Esaias van de Velde, suggest an ironical attitude, at once critical and slightly amused.

By the early decades of the seventeenth century, genre had become one of the most vitally innovative of Dutch art forms. Although its original allegorical and moral aspects often persisted, the art became increasingly naturalistic in response to new social and aesthetic concerns. The works of Buytewech and Esaias van de Velde on the one hand and of Brouwer on the other offered a vivid new look at society's extremes, inaugurating, respectively, the seventeenth century's high-life and low-life traditions. The Dutch painters in this period depicted a broader social spectrum and inventoried more of the peculiarities of their existence than any other people before them. Ultimately, though, they were selective; the "realism" of Dutch art was no more radically egalitarian than the country's institutions. Like the painters of landscapes and still lifes, genre painters became highly specialized, some concentrating exclusively on the entertainments of the well-to-do, some on domestic subjects, and some on the gross pleasures of the peasantry. Large sections of society, however, went unrepresented; while there is no shortage of Dutch seascapes, there are surprisingly few genre paintings, for example, of

Holland's many sailors, dockworkers, and merchant marines—a group that comprised perhaps as much as one-tenth of the country's population. By the same token, the countless images of musical companies and banquets obviously in no way reflect their actual incidence. Rather these trends reflect the artistic conventions of the painting type.

Many of the subjects that first appeared in the sixteenth century, like the kermis, tavern and bordello scenes, and the high-life merry company, continued into the seventeenth. To acknowledge the persistence of pictorial tradition, however, is not to deny the fact that the naturalistic depiction of society increasingly displaced genre's original allegorical and moral concerns. Perhaps the clearest expression of this trend was the rise in popularity toward the middle of the century of representations of professions. Such scenes had precedents in series depicting the Labors of the Month and comical low life (quacks and street peddlers), but in Brekelenkam's art, for example, the concern for the accurate record of the trade, its equipment, and the workplace takes precedence over any allegorical meaning, such as the concept of Industria. As in de Hooch's paintings of domestic virtue subjects, the morality of the scene—the virtue of work (labor, which Luther had decreed no less godly than monastic withdrawal)—is self-evident and has little recourse to symbolism. The virtuous associations of domestic scenes and depictions of chores and professional employment arise directly from the imagery and rarely resort to metaphor. Throughout the seventeenth century there were genre painters like van de Venne, Molenaer, Dou, Steen, Vermeer, and van der Werff who carried on the sixteenth century's allegorical practices. However, the innovations of the seventeenth century's developing concept of genre were the many painters who were more concerned with the evocation of the world of actual experience than with the revelation of philosophical or moral concepts. For the generation of Dirck Hals, Codde, and Duyster, scenes of banquets and feasts had been repeated so often that the recollection of their biblical and mythological origins had faded, to be replaced by a delight in the pageantry and splendor of high-life revelry itself. The low-life tradition shows similar trends. The compositions as well

as the comic-moralizing approach of Bruegel can still be detected in Vinckboons's art, while the peasant scenes of Brouwer and Ostade primarily represent new visions of social reality; the former an unblinking image of man's bestial nature, and the latter an increasingly comforting, bourgeois view of the lot of the lower classes. The naturalism of these scenes serves not only as the conduit of the message but assumes its own importance and meaning within genre's new goals. The traditional iconography adapted accordingly.[133] Of course in certain contexts, such as reproductive prints, the naturalistic new genre paintings could still function allegorically, as, for example, a representation of the Five Senses or a moral admonition. But Buytewech and his followers surely intended nothing so grave as the warnings of van Hemessen's Prodigal Son scenes or related genre paintings (see figs. 18, 19). As Gudlaugsson observed, ter Borch, the most influential high-life painter after mid-century, was more concerned with the depiction of the stylish ideal of well-heeled society than with the revelation of moral truths.[134] Ter Borch's wealthy patrons, no less men of their time than Bruegel's, shared the increasingly aristocratic aspirations of the Dutch upper classes. In all likelihood, they were at least as devoted to the maintenance of decorum as to the demonstration of a strict moral code.

This emphasis on decorum was closely allied to the rise of classicism, whose doctrines won increasing acceptance toward the end of the century through the influence of societies such as Nil Volentibus Arduum. The effect on Dutch literature is clear. The early naturalism and pungent language of Bredero, not to mention the downright dirty stories of Constantijn Huygens, were exchanged for a cool, often stilted formalism. Occasionally the earlier texts were even suppressed or bowdlerized. A decorous restraint prevailed which was no less perceptible in painting and social manners than in literature. The elegant terrace scenes of van Loo and van den Eeckhout (see pls. 87, 88) as well as the interiors of Verkolje and van der Neer (see pls. 122, 123) already take a step toward the type of genre painting concentrating on the illustration of manners and customs, which the eighteenth and nineteenth centuries would develop into what

they called *Sittenmalerei, Gattungsbilder,* or *genre pur.* This is not to suggest that Dutch genre's rich legacy of symbolism was ignored; Jean Baptiste Chardin's art reflects the influence of Dou as well as that of ter Borch.[135] Among the many admirers of Steen's genius for comic admonition we include William Hogarth and Honoré Daumier. Moreover, Steen's late works and the garden and terrace scenes of van den Eeckhout, de Hooch, Coques, and others seem to have left their mark on Watteau.[136] Indeed, one could claim with little exaggeration that the Dutch established the forms and techniques that dominated the depiction of daily life until the advent of Impressionism.[137] Even after the mid-nineteenth century, the Dutch influence persisted. Manet's admiration for Frans Hals is now fully appreciated, but the interest of Millet, Bonvin, and the Hague School in Maes and de Hooch or Degas in ter Borch deserves further study.

Ironically, it was the Impressionists' emphasis on contemporaneity, best captured in Daumier's famous remark "Il faut être de son temps," that finally revolutionized genre. This emphasis on the here and now, after all, had been an important innovation and attraction of genre for seventeenth-century Dutch viewers. It was genre's treatment of topical subjects with topical means that formed the basis of the paintings' unprecedented truth to life. What distinguished seventeenth- from nineteenth-century genre painting, however, was a change not only in the character of daily life but also in the nature of truth itself.

P.C.S.

See Bibliography for full citations of references abbreviated here.

1. For definitions and the history of the term *genre*, see G. B. Washburn, "Definition of the Concept of Genre Art," in *Encyclopedia of World Art*, vol. 4, cols. 81–83; "Genre" in H. Osborne, ed., *The Oxford Companion to Art* (Oxford, 1970), pp. 465–67; and, above all, Stechow, Comer 1975–76.

2. Quoted and translated in Stechow, Comer 1975–76, p. 89; see "Essais sur la peinture" (first published 1795), in Diderot's *Oeuvres esthétiques*, ed. Paul Verniere (Paris, 1959), p. 725.

3. See Descamps 1753–64, vol. 2, pp. 22, 128, 176, and vol. 3, p. 136 (author's translation).

4. Quatremère de Quincy, *Considération sur les arts du dessin en France* (Paris, 1791), pt. 2, pp. 28–29.

5. Smith 1829–42, vol. 4, pp. xix, 144.

6. F. Kugler, *Handbuch der Geschichte der Malerei* (Berlin, 1837), vol. 2, p. 187; see Stechow, Comer 1975–76.

7. K. Schnaase, *Niederländische Briefe* (Stuttgart and Tübingen, 1834), p. 81. Kugler differentiates "Bambocciade" (scenes of common people as depicted by the Dutch Italianate Bamboccianti) from "fine genre" as painted by ter Borch (Kugler 1847, vol. 2, pp. 190–91). G. F. Waagen in *Kunstwerke und Künstler in Paris* (Berlin, 1839), pp. 591, 601, speaks of "conversation pieces" (*Conversationstücke*) for subjects taken from the "family life of the upper and rich classes," and "peasant pieces" (*Bauernstücke*) for depictions of the "life of country people . . . in its coarse, comic expression." See also Stechow, Comer 1975–76.

8. In, for example, the inventory of the estate of the genre painter Jan Miense Molenaer, the subjects of genre paintings are simply described: "Een Luytslager" (a lute player), "Een vroutge op de clauw cimbael spelende" (a woman playing a clavier), "Een harderinnetje" (a shepherdess), "Een groote boerekermis" (a large peasant kermis), "Een melckmeisje (a milkmaid), "Een toeback drinckertje" (a drinker), and so forth; see Bredius 1915–22, vol. 1, pp. 2ff., and the citations in the many other inventories listed there. On the *conversatie*, see Goodman 1982, p. 249. For additional terms referring to genre scenes, see Lydia de Pauw-de Veen, *De begrippen "schilder," "schilderij," en "schilderen" in de zeventiende eeuw* (Brussels, 1974), pp. 167–89.

9. See van Mander 1604, chap. 5, fol. 15–22; van Hoogstraten 1678, pp. 108–9. For discussion, see Miedema 1975, pp. 3–5; and Albert Blankert in Washington/Detroit/Amsterdam 1980–81, pp. 15–19.

10. Prior to the appearance of André Félibien's preface to the *Conférences de l'académie royale de peinture et de sculpture. Pendant l'année 1667* (Paris, 1669, pp. 14–15; reprinted in Félibien 1666–88, vol. 5, pp. 310–11), history painting was the only subject given theoretical sanction. Félibien wrote, "dans cet Art il y a différens Ouvriers qui s'appliquent à différens sujets . . . celui qui fait parfaitement des paisages est au-dessus d'un autre qui ne fait que des fruits, des fleurs ou des coquilles. Celui qui peint des animaux vivans est plus estimable que ceux qui ne représent que des choses mortes et sans mouvement; et comme la figure de l'homme est le plus parfait ouvrage de Dieu sur la terre, il est certain aussi que celui qui se rend l'imitateur de Dieu en peignant des figures humaines est beaucoup plus excellent que tous les autre." Though never mentioning genre painters, Félibien goes on to say that a portraitist has not achieved "the highest perfection of the art" because his figures do not move. Further, it is preferable to represent, instead of one figure, several together, and ultimately, "it is necessary to treat history and fable . . . to represent grand actions like those of the Historians or agreeable subjects like those of the Poets." ("C'est en quoi consiste la force, la noblesse et la grandeur de cet Art.") Félibien's first statements on the hierarchy of the genre appear in *De l'Origine de la peinture* (Paris, 1660) (author's translation); see also Félibien 1666–88, where, for example,

he speaks of the genre scenes of the Le Nain brothers as "simple subjects without beauty" painted in an "ignoble manner" (vol. 4, p. 215). Quatremère de Quincy (1791 [see note 4], pp. 30–32) outlines the traditional philosophical hierarchy: "thinking and animate nature" (history themes, bourgeois scenes, portraits, battles, engraved figure compositions), "vegetable and changeable nature" (landscapes, marines, fires, tempests, perspectives, ruins, theater decorations, and engravings of like subjects), and "dead and inanimate nature" (still life).

11. Van Hoogstraten 1678, vol. 3, pp. 75–85.

12. Van Hoogstraten 1678, p. 75: "festoons, braided flower gardens, variegated nosegays in pots and vases, bunches of grapes and beautiful pears and apricots . . . a roman lizard . . . or a music book and *vanitas* . . . kitchens with all sorts of food . . . and everything encompassed by the name *stil leven*" (author's translation).

13. "Poetic histories" were exemplified in van Hoogstraten's view by Apuleius's description of the Judgment of Paris.

14. Pliny, *Natural History*, 35.37. J. A. Emmens (*Rembrandt en de regels van de kunst* [Amsterdam, 1979], p. 144) notes that van Hoogstraten's categories as well as his allusion to *rhyparographi* are indebted to Franciscus Junius's *De Schilder-Konst der Oude* (Middelburg, 1641).

15. Van Mander 1604, fol. 196r (author's translation).

16. See Angel 1642, p. 41. See also H. Miedema, *De Terminologie van Philips Angels "Lof der Schilder Konst" (1642)* (Amsterdam, 1975).

17. See Haverkamp Begemann 1959, p. 53. The word *geestig* meant, above all, "ingenious," but also "learned" or "witty."

18. H. Floerke's classic study of the Dutch art market, *Studien zur niederländischen Kunst und Kulturgeschichte: Die Formen des Kunsthandels, das Atelier und die Sammler in den Niederlanden vom 15.–18 Jahrhundert* (Munich and Leipzig, 1905) has been supplemented by J. M. Montias's extensive *Artists and Artisans in Delft: A Socio-Economic Study of the Seventeenth Century* (Princeton, 1982).

19. In his general remarks, Floerke observed that landscapes and animal paintings were usually valued less than marines and that history paintings and portraits received the best prices (Floerke 1905 [see note 18], pp. 180–81).

20. See Bredius 1915–22, vol. 1, p. 228; Floerke 1905 (see note 18), pp. 109–12. Rembrandt's *Raising of Lazarus* (possibly the work now owned by the Los Angeles County Museum) was valued at 600 guilders, surpassing an unidentified *Nude Children* by Peter Paul Rubens and a landscape by Claude Lorrain, both valued at 500 guilders.

21. For example, "A Room by Emanuel de With [sic]" (possibly pl. 110) was valued at 42 guilders in Laurens Mauritsz. Douci's inventory of 1669 (see Bredius 1915–22, vol. 2, p. 422), where a *Barber, Fleacatcher,* and *Singer* by Brouwer brought respectively 4, 3, and 6 guilders. In the Renialme inventory ter Borch's works, as usual, brought good prices but his *Shepherdess* (see Gudlaugsson 1959–60, cat. no. 85) received twice the value (120 guilders) of his *Soldiers* (60 guilders). A *Robbery Scene* by the Bamboccio-follower Anton Goubau brought 100 guilders in the same inventory, and in Gerard Kuysten's inventory of 1715 (see Bredius 1915–22, vol. 3, p. 857) a *Quacksalver* by Karel du Jardin was estimated at 40 guilders while a *Mother and Child* (see pl. 48) by G. B. Weenix shared the highest valuation with Jan Asselijn's *Ruins with Figures* at 125 guilders. On the other hand, a work by the guardroom painter Jacob Duck was sold for 76 guilders in 1660 (sale, Jakob van Rosendaal, The Hague; see Bredius 1915–22, vol. 5, p. 1586) and a *Peasant Company* by Brouwer was appraised at 50 guilders in the inventory of Fried Roth in 1670 (see Bredius 1915–22, vol. 5, p. 1499), far and away the highest value among the approximately sixty works listed. Regarding a *Barber Shop* by Brouwer, which in 1663 seems to have been very highly valued, see Montias 1982 (note 18), p. 212.

22. Floerke 1905 (see note 18), p. 181. A sampling of late seventeenth- and early eighteenth-century prices suggests that the average genre scene by ter Borch sold for approximately 75 guilders (see Hofstede de Groot 1908–27, vol. 5, nos. 38, 73a, 77, 96, 158, 176a, 188a, 188h, 188c).

23. Angel 1642, p. 23.

24. See Naumann 1981b, esp. p. 655.

25. Montias 1982 (see note 18), p. 259.

26. See van Dillen 1970, pp. 182, 244, 205; and Price 1974, p. 122. The total and fully itemized annual expenses for a preacher's family in Delft in 1658 amounted to 547 guilders; see H. E. van Gelder, "Een gezinsbudget uit 1658," De Florijn. Nederlands Tidschrift voor muntenverzamelaars, vol. 5, no. 22 (1976), pp. 561–62.

27. The Diary of John Evelyn, ed. W. Bray (London, 1901), vol. 1, p. 19. Montias (1982 [see note 18], p. 269) demonstrating that "the buyers of master painters' works were mainly in the top third of the wealth distribution," correctly dispels the legend that the poor and the lower middle classes in Holland owned large quantities of art. His figures suggest that some working-class folk bought paintings but that the bulk of the clientele were in higher-status occupations. The Hendrick van Buyten who owned Vermeers, for example, was by profession a baker, but also the head of his guild and a rich man with inherited money; see Montias 1980, p. 57.

28. Mundy, who traveled to Amsterdam in 1640, reported: "As for the art off Painting and the affection off the people to Pictures, I thincke none other goe beeyond them, . . . All in generall striving to adorne their houses, especially the outer or street roome, with costly peeces, Butchers and bakers not much inferiour in their shoppes, which are Fairely sett Forth, yea many tymes blacksmithes, Coblers, etts., will have some picture or other by their Forge and in their stalle" (R. C. Temple, ed., The Travels of Peter Mundy in Europe and Asia: 1608–1667 [London, 1925], vol. 4, p. 70).

29. Floerke 1905 (see note 18) p. 22; Sutton 1980, p. 54, doc. no. 23; and Braun 1980, p. 14. Also probably typical of the average market value for genre paintings was the case in 1621 of the Utrecht peasant painter Joost Cornelisz. Droochsloot offering twelve of his paintings, valued in total at 150 guilders, in partial payment for a house; see Obreen 1877–90, vol. 5, p. 329.

30. Sutton 1980, p. 54.

31. De Monconys 1665–66, vol. 2, p. 149. The baker probably was Hendrick van Buyten; see note 27.

32. This famous sale in Amsterdam in 1696 included no less than twenty Vermeers (almost two-thirds of the artist's oeuvre) and probably was the collection of the publisher Jacob Abraham Dissius. As the 1699 sale of Vermeer's Allegory of the New Testament (Metropolitan Museum of Art, New York, acc. no. 32.100.18) for 400 guilders attests, the higher regard for history and allegory continued through the end of the century.

33. Too limiting, for example, is M. J. Friedländer's suggestion, first published in 1949, in discussing Brouwer, that the proper genre painter depicts only types, not individualized figures (Landscape, Portrait, Still-life: Their Origin and Development [New York, 1963], pp. 174–75). Washburn correctly stresses that genre is not the depiction of generic beings, nor is it defined by style (for example, realism) or the artist's attitude (satirical, didactic, romantic). "The word 'genre' in accordance with its history refers entirely to a choice of subject, nothing more" (Washburn 1962, p. 82).

34. A. W. Lowenthal, Joachim Wtewael and Dutch Mannerism (forthcoming), cat. no. A33.

35. See Angel 1642, pp. 39, 40, 43, on the importance of imitating nature.

36. Constantijn Huygens, De Jeugd van Constantijn Huygens door hemzelf beschreven (a fragmentary biography written in 1629–31 but only published in 1897; trans. from Latin by A. H. Kan [Rotterdam 1971]), p. 73.

37. Van Hoogstraten 1678, p. 263 (author's translation).

38. Thoré-Bürger, Salons de W. Bürger (Paris, 1870), vol. 2, p. 380 (author's translation).

39. "Le fond moral de l'art hollandais [est] l'absence totale de ce qui nous appelons aujourd'hui un sujet" (E. Fromentin, Les Maîtres d'autrefois, 3rd ed. [Paris, 1904], pp. 193, 204–5): "Why does a Dutch painter paint a picture? For no good reason what-so-ever; and note that no one asked him to. A peasant with wine-red nose looks at you with his large red eyes and, showing his teeth, raises his glass: if the piece is well painted it has its price."

40. Fromentin 1904 (see note 39), p. 178.

41. On nineteenth-century perceptions and theories of Dutch realism, see Demetz 1963, pp. 97–115.

42. "Een volmaekte schildery is als een spiegel van de Natuer, die de dingen, die niet en zijn, doet schijnen te zijn, en op een geoorlofde vermakelijke en prijslijke wijze bedriegt" (van Hoogstraten 1678, p. 25). For discussion of this passage, see E. de Jongh's introduction to Amsterdam 1976, pp. 14–20; and O. Naumann, "Quiet Beauty: Dutch Paintings from the Carter Collection," Tableau, vol. 4, no. 5 (April 1982), pp. 471–75.

43. See also David Ryckaert III's depictions of artists' paint ing models dressed as peasants: for example, Musée du Louvre, Paris, no. MI1146.

44. Gudlaugsson 1975.

45. See Amsterdam/Washington 1981–82.

46. Van Hoogstraten 1678, p. 238.

47. For a recent discussion of these problems see Bruyn et al. 1978.

48. For a brief historiographic study of the iconographic investigation of Dutch art, see K. Renger in Braunschweig 1978, pp. 34–38. See also the following pioneering studies: H. Kauffman, review of Pieter de Hooch, by W. R. Valentiner, Deutsche Literaturzeitung, vol. 17 (April 26, 1930), cols. 801–5; Kauffman 1943; H. W. Janson, "The Putto with the Death's Head," The Art Bulletin, vol. 19 (1937), pp. 423–49; W. Stechow, "Homo Bulla," The Art Bulletin, vol. 20 (1938), pp. 227–28; H. Rudolph 1938; Gudlaugsson 1938; Gudlaugsson 1975; Keyszelitz 1956; and de Jongh 1967.

49. S. Alpers, with good reason, has recently warned that "many students of Dutch art today view the notion of Dutch realism itself as the invention of the nineteenth century" (Alpers 1983, p. xxiv). Her basic thesis, that Dutch seventeenth-century art has been misinterpreted by art historians conditioned by the values of Italian art—to whit, the narrative goals of art are more important than their representational ends—is a view shared by others; see Gaskell 1983. However, as E. H. Gombrich has pointed out ("Mysteries of Dutch Painting," New York Review of Books [November 10, 1983], pp. 13–17), Alpers's effort to demonstrate that the "art of description" acquired an importance and social function equal to narration's religious and moral message in the academic (Italian) art tradition gives a one-sided view of Dutch art. Though a useful counterbalance to the weight of recent iconographic research, it is not clear, despite her efforts to coin a new vocabulary ("mapping," "picturing," etc.), that her concept of Dutch realism is fundamentally different from Fromentin's. In stressing, for example, Dutch art's relationship to cartography, she would have profited from J. Welu's observation that the Dutch often reissued geographically outdated maps because they were beautiful even if inaccurate (Welu 1975a, pp. 531–34). The creative element is at least as important as the record of fact in the Dutchman's subjective form of naturalism.

50. See E. Panofsky, Meaning in the Visual Arts (Garden City, 1955), pp. 26–54, first published as "Zum Problem der Beschreibung und Inhaltsdeutuing von Werken der bildenden Kunst," Logos, vol. 21 (1932), pp. 103–19.

51. Horace, *De arte poetica*, 361. See also R. W. Lee, *Ut Pictura Poesis: The Humanistic Theory of Painting* (New York, 1967). E. de Jongh has been the most active figure in the recent application of these theories to Dutch genre. See especially de Jongh 1967, p. 8; de Jongh 1971, pp. 143–46 n. 5; de Jongh et al. in Amsterdam 1976, p. 22; and de Jongh 1982.

52. "Zeeusche Mey-Clacht. ofte Schyn-Kycker" in *Zeeusche Nachtegael ende des selfs dryderley gesang* (Middelburg, 1623).

53. On emblems, see W. S. Heckscher and K. A. Wirth, "Emblem, Emblembuch," in *Reallexikon zur deutschen Kunstgeschichte* (Stuttgart, 1959), vol. 5, pp. 85–228; Henkel, Schöne 1967; de Jongh 1967; Landwehr 1970; Porterman 1977; Daly 1979.

54. Daly 1979, p. 11.

55. Visscher 1614, p. 1; for discussion, see de Jongh 1967, p. 10. Citing J. Bruyn's work *Over het voortleven der middeleeuwen* (Amsterdam, 1961) and the forthcoming *'Doctrina exemplaris' als historisch perspectief voor het 17de—eeuwse 'genre'-stuk*, E. de Jongh has suggested that the type of thinking that created these visual metaphors constituted "the end rather than the beginning of a tradition" (de Jongh 1982, p. 27). Its origins were in the Middle Ages when all of nature and life were significant as God's reflections.

56. *Alle de Werken* (Amsterdam, 1712), vol. 2, p. 480. Quoted and translated in de Jongh 1982, p. 27 n. 4.

57. Quoted, respectively, in Amsterdam 1976, p. 18 n. 15, and de Jongh 1982, p. 36 n. 4. See de Brune 1624, p. ii ("onder een/kinderlick mom-aenzicht, een mannelicke tucht verborghen houdt"); and J. de Brune the Younger, *Alle Volgeestig werken* (Amsterdam, 1681), p. 305.

58. See de Jongh in Amsterdam 1976, p. 20; the passages in Dutch are, respectively, "aerdige versieringen en sin-rycke uytbeeldinghen" (see Karel van Mander, *Uytbeeldinghe der Figuren* [Amsterdam, 1616] referring to Cornelis Ketel) and "bywerk dat bedecktlijk iets verklaert" (see van Hoogstraten 1678, p. 90).

59. De Jongh 1973.

60. Emmens 1963a, pp. 125–26.

61. See, for example, Gaskell 1983, p. 237, whose ideas are related to Miedema's (see note 9).

62. See P. Wescher, "Ein 'ungleiches Liebespaar' von Hans von Kulmbach," *Pantheon*, vol. 22 (1938), pp. 376–79; L. A. Silver, "The *Ill-Matched Pair* by Quinten Massys," in National Gallery of Art, *Studies in the History of Art* (Washington, D.C., 1974), vol. 4, pp. 104–33; and, especially, A. G. Stewart, *Unequal Lovers: A Study of Unequal Couples in Northern Art* (New York, 1979).

63. Silver 1974 (see note 62); Stewart 1979 (see note 62), p. 68. The print which was originally inscribed "Pay attention to which way the wind blows" (a reference to the vagaries of fortune; see Washington, D.C., National Gallery of Art, *The Prints of Lucas van Leyden and His Contemporaries* [June 5–August 14, 1983], p. 195, no. 72) is thought by some (see Renger 1970, pp. 23–26) to be the first representation of the Prodigal Son in a tavern.

64. See Renger 1970, p. 27, fig. 3. Important descendants of this work are cited by Renger, including paintings from the circle of the Braunschweig Monogrammist (Walker Art Gallery, Liverpool; Renger 1970, fig. 5), the Master of the Prodigal Son (Kunsthistorisches Museums, Vienna; Renger 1970, fig. 6), and Frans Pourbus the Elder (Museum Mayer van den Bergh, Antwerp; Renger 1970, fig. 43).

65. See Renger 1970, pp. 120–28.

66. Emmens 1973.

67. On Bruegel, see C. de Tolnay, *Pierre Bruegel l'Ancien* (Brussels, 1935); Brussels, Musée Royaux des Beaux-Arts, *Le siècle de Bruegel* (September 27–November 24, 1963); F. Grossman, *Pieter Bruegel: Complete Edition* (London and New York, 1973); W. Stechow, *Pieter Bruegel the Elder* (New York, n.d.); W. S. Gibson, *Bruegel* (New York and Toronto, 1977).

68. See van Mander 1604, fols. 233–34. Van Mander states that there are "very few works by his hand that the beholder can look at without laughing" and goes on to commend Bruegel's careful observation of the peasantry, "whose faces and limbs are yellow and brown as if sunburned, they have ugly skin, different from that of citydwellers" (fol. 233v).

69. On the origins of the merry company, see especially Würtenberger 1937, pp. 12–37.

70. On Barendsz.'s contribution to the history of genre, see J. R. Judson, "Dirck Barentsen 'Die . . . des grooten Titiaens boesem heeft ghenoten,'" *Bulletin Musées Royaux des Beaux-Arts Brussels*, vol. 11, nos. 1–2 (1962) pp. 100–110; J. R. Judson, *Dirck Barendsz 1534–1592* (Amsterdam, 1970), pp. 94–98.

71. Concerning balls and high-life scenes by the Flemish Franckens and such artists as Louis de Caulery, see F. C. Legrand, *Les Peintres flamends de genre au XVIIe siècle* (Brussels, 1963), pp. 69–84.

72. Van Mander 1604, fol. 299v: "lantschappen met moderne beeldekens."

73. Plietzsch 1940, p. 7; Haverkamp Begemann 1959, cat. no. 17; Slive 1970–74, vol. 2, pp. 31–33, and vol. 3, cat. no. 51.

74. Poensgen 1926a, pp. 90–94; Martin 1935, vol. 1, pp. 356, 358.

75. "Passons le temps mes chères âmes, Ne craignons point les Médisans qui sonnent de discours Infâmes, Blessent l'honneur des Courtizans" (Haverkamp Begemann 1959, p. 23).

76. Haverkamp Begemann 1959, p. 23. Beneath the Latin "Consumunt nati quesita labore parentum, Indulgent genio, luxurieque vacant," is the Dutch inscription: "Vive lamour met vrucht, ons houwlick is begonnen, On Ouders waeren boersch, sy hebbent vreck ghewonnen, Pannegen vet, moy weer, het moet al doer den krop, Wy hebben goets ghenoech, hoe Cryghen wyt maer op." Text is Haverkamp Begemann's translation.

77. See Würtenberger 1937, pp. 53–54; Kunstreich 1959, p. 79; Haverkamp Begemann 1959, pp. 26–29.

78. See de Jongh 1971, pp. 146–47.

79. Würtenberger 1937, p. 2.

80. See, for example, *Flea Hunt by Candlelight*, Kunstmuseum, Basel, inv. no. 362; another version, with the addition of two peeping toms, is in the Dayton Art Institute, Dayton, Ohio, acc. no. 80.2. For other examples of Honthorst's nocturnal genre scenes, see *Cavalier and Woman Singing by Candlelight*, 1624, Museum of Fine Arts, Montreal, no. 969.1639, and *Merry Company by Candlelight*, Alte Pinakothek, Munich, no. 1312.

81. Cornelis Danckerts's print after Bloemaert's *Bagpipe Player* is inscribed in Latin, "Hot sweat will never smell good to these nostrils/ As long as he pleases farmers by playing a tune on the bagpipe," and in Dutch, "I have use for neither plow nor spade,/ As long as I can earn in this way a few farthings." On the various associations of bagpipes, see E. Winternitz, *Musical Instruments and Their Symbolism in Western Art* (London, 1967), pp. 66–85.

82. Plietzsch speaks of (unspecified) works dated as early as 1614 (Plietzsch 1960, p. 27). Although the painting is certainly by Hals, the date 1617 on the *Couple with Gypsies in a Landscape* with the dealers Hoogsteder/Naumann, New York, is unclear and probably too early. Dated 1621 were the *Merry Company in an Interior*, formerly with the dealer Katz, Dieren, Holland (Spring 1962), cat. no. 26, ill.; and *Merry Company on a Terrace*, formerly in Stadtische Gallery, Frankfurt, inv. no. 825 (lost 1946).

83. See also, for example, *The Flute Player*, dated 1630, Frans Halsmuseum, Haarlem, no. 122.

84. See the two paintings of the *Mother Cleaning a Child's Hair*, dated 1631 (private collection, London [Plietzsch 1960, fig. 9], and Curt Bohnewand, Rottach-Egern [Plietzsch 1960, fig. 11]); *Woman Reading by Candlelight* (Accademia Carrara, Bergamo, cat. 1950, no. 478); and the pendants dated 1631? of *Children Playing Cards* and *Children with a Cat* (Sterling and Francine Clark Art Institute, Williamstown, Massachusetts, inv. nos. 756 and 757).

85. Playter 1972, p. 54.

86. See Playter 1972, p. 68; compare Buytewech's *Musical Company* drawing in the Frits Lugt Collection, Institut Néerlandais, Paris; Haverkamp Begemann 1959, cat. no. 45.

87. See Amsterdam 1976, cat. no. 21.

88. See de Jongh 1967, pp. 6–8, fig. 2. The inscription reads: "De gayle dartle jeucht lichtvaerdich en bedurven/ Verslyten haeren tijt met ydelheyt onkuys/ uijt enckel weelde sat een vuyle smook inslurven/ Waer deur de beurs en 't hooft wert ydel en konfuys./ Het lichaem wert geplaecht de ziel hier nae moet ly[den]/ Niets minder wert geacht als 't alder beste pandt/ En dit licht-sinnich tuych haer nergens in verblyden/ Als in haer onheyl, en haer alder meeste schandt." (The hurtful wanton youth, rash and corrupt,/ Waste their time with unchaste vanity/ From pure sated luxoriousness they are inhaling foul smoke/ Because of which both the purse and the head become empty and confused./ The body is being tormented and the soul must suffer as a result/ Nothing was held in less regard than these, the very best pledges,/ And these frivolous fools don't rejoice in anything/ But in their own destruction, and their greatest disgrace); translated in Brown 1978, p. 12.

89. In discussing the question of inscriptions on prints, Haverkamp Begemann notes that many of the elements of the van Kittensteyn print appear earlier in Buytewech's art, thus permitting a similar interpretation. However, he goes on to ask what was the strength of such a message for the artist and his public, concluding that in the larger context of his art, Buytewech was not given to preaching: "He certainly painted the 'bad conduct' of these young people but with as much pleasure as the viewers took in looking at these pictures" (Rotterdam, Museum Boymans–van Beuningen, *Willem Buytewech* [1591–1624] [November 30, 1974–January 12, 1975], pp. xviii–xix). For a revealing discussion of the various levels of meaning of Buytewech's genre images, see Haverkamp Begemann 1959, pp. 13–14, 27, 61–71.

90. For example, Playter writes, "Although emblematic overtones will continue in the interior Merry Company Subjects throughout the seventeenth century, they become less and less obvious and even cease to exist in many paintings by artists of the generation of Codde and Duyster" (Playter 1972, p. 46; also see p. 84). The author's use of the French phrase *genre pur* to describe the artists' new concerns, however, is misleading in its association with the nineteenth century's concept of realism.

91. Slive 1970–74, vol. 1, p. 34.

92. Slive 1970–74, vol. 3, no. 5–1.

93. See the so-called *Serenade*, dated 1629, Rijksmuseum, Amsterdam, no. 2326.

94. See *Woman Sewing by Candlelight*, National Gallery of Ireland, Dublin, no. 468; other examples, formerly with A. Schloss, Paris, and formerly with G. Stein, Paris.

95. See Brouwer's *Shoulder Operation* (*Touch* from a series on Five Senses), Alte Pinakothek, Munich, no. 581; and the *Foot Operation*, Städelsches Kunstinstitut, Frankfurt, inv. no. 1039.

96. See New York/Maastricht 1982, pp. 12–15, figs. 3, 7; the latter print of a violinist with singing drinkers (*Hearing*, Alte Pinakothek, Munich) is inscribed "trahit sua quemque voluptas" (sensual desire consumes everyone).

97. See Fishman 1979.

98. L. L. Mulder, ed., *Journaal van Anthonis Duyck* (The Hague, 1862), vol. 3, pp. 62, 359, 611.

99. See Playter 1972, p. 114.

100. Also see, as examples, the guardroom scenes in the Rijksmuseum, Amsterdam, no. A3204 (dated 1647); the Princes of Leichtenstein Collection, Vaduz, cat. no. 108 (dated 1648); and the Museum Narodowe, Warsaw, nos. 930 (dated 1650) and 931 (dated 1654).

101. S. J. Gudlaugsson, "Representations of Granida in Dutch Seventeenth Century Painting," *The Burlington Magazine*, vol. 90 (1948), pp. 226ff., 348ff., and (1949), pp. 39ff.; Kettering 1983a.

102. Utrecht 1965, cat. no. 107.

103. J. I. Kuznetsov, "Nikolaus Knüpfer 1603?–1655," *Oud Holland*, vol. 88 (1974), pp. 169–219.

104. *The Diary of John Evelyn* (see note 27), vol. 1, p. 338.

105. On the invitation and Charles II's taste for Titian, Dou, and Elsheimer, see White 1982, p. xli. White quotes a contemporary Dutch epigram "How now, Oh Dou? Shall Stuart drag thee, beacon-light of brushes, to Whitehall? Do not proceed to Charles' Court. Do not sell out thy freedom for smoke, or wind, or dust. He who seeks Royal favours, must play the serf and flatterer."

106. See also Dou's *Rembrandt in His Studio*, David Carrit Ltd., London (Martin 1913, no. 57).

107. Martin 1913, no. 99. Compare Steen's *Young Woman Playing a Harpsichord to a Young Man*, dated 16[5]9, National Gallery, London, no. 856, which was probably also inspired by the van Mieris painting in Schwerin of 1658 (cat. no. 118, fig. 2).

108. Naumann 1981a, cat. no. 9.

109. Naumann 1981a, cat. no. 27.

110. Naumann 1981a, cat. no. 71.

111. Among Dou's most derivative followers we count Abraham de Pape (c. 1621–1666), Pieter van den Bosch (1613–after 1662), Pieter Leemans (c. 1655–1706), Jan van Staveren (c. 1625–after 1668), Bartholomäus Maton (1643/46–1684), Jacob van Spreeuwen (1611–after 1650), and Adriaen van Gaesbeeck (1621–1650).

112. Other independent Dou followers include Arie de Vois (c. 1632–1680) and Carel de Moor (1656–1738).

113. See Zurich, Kunsthaus, *Gemäldegalerie der Ruzicka Stiftung* (December 1949–March 1950), no. 3.

114. *Woman Spooling Thread*, Hermitage, Leningrad; Robinson 1974, fig. 1.

115. Wheelock 1976, p. 458.

116. *The Consultation* (formerly Staatliches Museum, Berlin, cat. 1931, no. 791C; Gudlaugsson 1959–60, cat. no. 4), a work probably based on a lost Brouwer.

117. Gudlaugsson 1959–60, cat. nos. 68–70, 75–76, 78–80, 82–83, 94–99.

118. The Hague/Münster 1974, p. 21.

119. W. Bürger [Theophile Thoré], *Musées de la Hollande: Amsterdam et la Haye* (Paris, 1858), vol. 1, p. 110.

120. Descamps 1753–64, vol. 3, p. 28.

121. See Museum Boymans–van Beuningen, Rotterdam, no. 1214, dated 165[2]; and Staatliche Museen Preussischer Kulturbesitz, Berlin [West], no. 819B, dated 1656.

122. See especially Barent Graat (1628–1709) and Gerrit Pietersz. van Zijl (1619–1665); for examples of their work, see, respectively, *Merry Company* (The Prodigal Son), 1652, Rijksmuseum, Amsterdam, no. A1943, and *The Letter,* formerly F. C. Butôt Collection (Bernt 1970, vol. 3, no. 1457).

123. See, for example, *Woman Writing a Letter,* Sir Alfred Beit, Bt., Blessington, Ireland; and *Lady Standing at a Virginal* and *Lady Seated at a Virginal,* National Gallery, London, nos. 1383 and 2568.

124. See P. C. Sutton, "Hendrick van der Burch," *The Burlington Magazine,* vol. 122 (May 1980), pp. 315–26.

125. In Martin 1935–36, vol. 2, for example, the chapter on the late painters is subtitled "Nabloei en Verval" (late blooming and decay). On the decline of the Dutch, see J. H. Huizinga, *Dutch Civilization in the Seventeenth Century* (New York, 1968), pp. 97–104; C. Wilson, "The Decline of the Netherlands," in *Essays in Economic History,* ed. E. Carus-Wilson (New York, 1954); C. Wilson, *The Dutch Republic and the Civilisation of the Seventeenth Century* (New York and Toronto, 1968), pp. 230–44; D. Ormrod, "Dutch Commercial Decline and British Growth in the Late Seventeenth and Early Eighteenth Centuries," and K. W. Swart, "Holland's Bourgeoisie and the Retarded Industrialization of the Netherlands," in *Failed Transitions to Modern Industrial Society,* ed. F. Krantz and P. M. Hohenberg (Montreal, 1975), pp. 36–43.

126. See O. T. Banks, *Watteau and the North: Studies in the Dutch and Flemish Baroque Influences on French Rococo Painting* (New York, 1977).

127. See also *Young Lady at Breakfast,* Princes of Leichtenstein Collection, Vaduz, cat. 1980, no. 112, which employs the same composition and is also dated 1665; and the comparable but undated *Young Girl with a Dog,* Staatliche Kunsthalle, Karlsruhe, no. 278, and *Lady in Red Drawing,* Wallace Collection, London, no. P243.

128. See also the *House of Pleasure,* dated 1675, Mauritshuis, The Hague, no. 862; and the *Woman Playing a Lute,* dated 1677, Staatliche Kunsthalle, Karlsruhe, no. 279.

129. See A. Blankert, *Johannes Vermeer van Delft 1632–1675,* rev. English ed. (Oxford, 1978), pp. 74, 87; also see Sutton 1980, p. 36 n. 10.

130. For full discussion, see Knüttel 1966; Becker 1976; and Amsterdam 1976, cat. no. 74.

131. See, for example, the painting of *Man before the Flood* (Fort Worth Art Center Museum, Texas) discussed by W. Stechow in his article examining the increasing ambiguity of the subjects of late sixteenth- and early seventeenth-century paintings titled variously "Prodigal Son," "Merry Party," "The Golden Age," "Feast of the Gods," "Bacchanal," and so on—namely those subjects usually regarded as seventeenth-century merry company's immediate predecessors ("Lusus Laetitiaeque Modus," *Art Quarterly,* vol. 35 [1972], pp. 165–73). Stechow concludes that there is an "increasing . . . haziness about the particular subject of such a moralizing picture and a concomitant occurrence of identical features in pictures which are open to different iconographic interpretation" (p. 173).

132. As Stechow observed (see note 131, p. 173) this engraving (Hollstein 1949–, vol. 7, p. 61, no. 376, ill.) after the mannerist artist Gerrit Pietersz. Sweelinck of one of his "ambiguous" outdoor scenes (possibly the Prodigal Son or Mankind before the Last Judgment) bears the Latin inscription: "You who wish to lead a quiet life without worries,/ Join our company here; we have plenty of fun./ Sadness, sorrow and grief, far be they from our circle;/ Truely, mirth and play are our only desire" (Stechow's translation). Stechow observed of such interpretations, "We are on our way from the warnings inherent in the parable of the Prodigal Son and references to the Deluge and Last Judgement to the uninhibited representations of brothel scenes by the young Utrecht Caravaggists and to Frans Hals' *Gipsy Girl.*"

133. The tendency of the iconographic traditions in Dutch genre to be altered, displaced, or even eliminated was first observed by Rudolph (1938) who, like Keyszelitz (1956, pp. 66–68), discussed examples in de Hooch's art. As we have noted, Haverkamp Begemann (1959, pp. 23–34) examined the various levels of meaning in Buytewech's genre scenes in historical context, and Stechow (see note 131) discussed the increasing vagueness of the iconography of Dutch genre's immediate predecessors. L. Grisebach (*Willem Kalf* [Berlin, 1974], pp. 169–76, 180–86) noted that naturalistic description gradually overshadowed traditional symbolism in still life, and de Jongh (1971) spoke of a *verdamping* (evaporation) of iconography in landscape and a "sublimation" of the meaning of Five Senses series in genre (see Amsterdam 1976, p. 123; also see, however, his comments below). In his dissertation on Jan Steen (1977, pp. 84, 94–96), de Vries characterized these developments in the history of genre as *iconographische slijtage* (iconographic erosion) and a growing *aesthetisering* (aestheticization). See also Sutton 1980, pp. 41–51, especially the discussion (p. 44) of the implications of the repetition of the same potentially symbolic motif in different iconographic contexts. Several reviews of Sutton 1980 also offer insights for and opposing views on these problems: see E. de Jongh, in *Simiolus,* vol. 11, no. 3/4 (1980), pp. 181–86; L. de Vries, in *Akt,* vol. 5, no. 3 (1981), pp. 71–80; and H. J. Raupp, in *Oud Holland,* vol. 96, no. 4 (1982), pp. 258–61. As this catalogue went to press, Linda A. Stone-Ferrier's catalogue appeared of the exhibition *Dutch Prints of Daily Life: Mirrors of Life or Masks of Morals?* (shown at Spencer Museum of Art, The University of Kansas, Lawrence, October 8–December 31, 1983; The Yale University Art Gallery, New Haven, January 15–February 26, 1984; and The Huntington Gallery, University of Texas at Austin, March 18–April 29, 1984). She relates these developments to the decline over the course of the century in the production of original emblem books (see esp. pp. 22–23).

134. See Gudlaugsson 1959–60, vol. 1, pp. 117–18.

135. See Snoep-Reitsma 1973b.

136. See O. Banks (see note 126).

137. On the continuing influence of Dutch genre painters, see Gerson 1942.

Life and Culture in the Golden Age

Though an art rich in meaning, Dutch genre was first and foremost an account of everyday life in the Netherlands. Any discussion of genre, therefore, ought to characterize the society and culture that gave it birth and that, in turn, it portrayed. Conventional wisdom holds that Dutch art was an expression of the practical, egalitarian spirit of Dutch burghers celebrating their material culture and a new religious and economic freedom.[1] There is much truth in this view, but it is a limiting one without a sense of the color and complex texture of Dutch life. The following sketch of the Dutch nation, its institutions and people, is offered in the spirit of Fernand Braudel's conviction that "Everyday life [which] consists of the little things one hardly notices in time and space, . . . must be introduced into the domain of history."[2]

The Dutch Revolt and Patrician Government

Founded as a sovereign Protestant republic in 1579, the United Netherlands won its independence from Spain and the Catholic Southern Netherlands through a complex series of revolts.[3] Philip II's efforts to centralize and modernize the Netherlands were resisted from the outset by an alliance of local nobles, ecclesiastics, and rich merchants, all committed to preserving their respective liberties. The diverse motives of these groups were to be reflected in the young nation's atomized politics and administration. Although Calvinism was the banner under which the revolution was waged, the pluralism of the Dutch State manifested itself even before the Truce of 1609 brought de facto peace and independence. The ruling "regent" class, originally a Catholic aristocracy but increasingly a Protestant mercantile elite, dominated the local city councils (vroedschappen), which, in turn, commanded the provincial assemblies and the national States General.[4] Usually a few families ran the city governments, appointing their own members to important posts and even reducing the city council when seats remained unfilled. Thus they sought to restrict the patriciate. However, its ranks were renewed at intervals by political and military upheaval—Maurits's coup and Oldenbarneveldt's ouster in 1618, the political crisis of 1650 following the death of William II, and the fall of the de Witt regime in 1672. Only in the later decades of the century did the regent class begin to harden into an urban

aristocracy. Crises never changed the political system, only the membership in the ruling group by introducing new families of nearly the same economic and social standing. The regent class thus exerted its control through a matrix of municipal oligarchies creating a decentralized, inflexible, and distinctly undemocratic form of government.

The House of Orange, through its command of the office of the stadholder and its alliance with the more militant exponents of Calvinism, constantly sought to extend its authority. It was opposed by the regents, who were instinctively hostile to any form of dynasticism, be it autocratic or theocratic. The regents were ultimately committed to preserving order, not religious conformity. The local rivalries and jealousies that made the States General such a rigid instrument of federalism could, of course, be disastrous during times of crisis or war. In such instances the country traditionally turned for military and executive leadership to the House of Orange—William the Silent, Prince Maurits, Frederik Hendrik, William II, and William III. Yet even when the States party was out of office the true source of power remained the regent class, whose coffers financed the nation's fleets and armies. As the greatest contributor to the nation's revenues, the province of Holland dominated her sisters in the States General. The United Netherlands thus was the exception in absolutist Europe: a country run not by a central monarch or an autocrat, but by a dispersed mercantile class committed above all to economic freedom and nonalignment. Unlike kings, the regents preferred profits to glory.

FIG. 1. GERARD TER BORCH, *The Swearing of the Oath of Ratification of the Treaty of Münster, May 15, 1648*, oil on copper, National Gallery, London, no. 896.

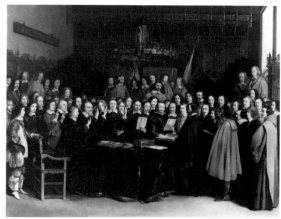

Neither history, language, nor religion inspired the Union of Utrecht, which united the seven northern provinces in 1579. To be sure, the Reformed Church became the state religion and the Calvinist divines constantly fulminated against papists and followers of the antichrist, but sectarianism proved to be the rule. Foreign observers remarked on this heterodoxy; writing to his father from Amsterdam in 1619, James Howell reported that "in this street where I lodge there be well near as many religions as there be houses, for one neighbour knows not, nor cares not much what religion the other is of."[5] Though officially outlawed, Catholicism was tolerated, as was virtually every other religion. On the streets of Amsterdam one met Calvinists, Remonstrants, Counter Remonstrants, Lutherans, Anabaptists, Mennonites, Arminians, Quakers, Pietists, Jews, and devotees to half a dozen other faiths. In Rembrandt's famous *Syndics of the Drapers Guild* (Rijksmuseum, Amsterdam, no. C6), two of the sitters are Calvinists, two are Catholics, and one is a Mennonite. In the venerable tradition of Erasmus, Amsterdam's city fathers believed in the freedom of private conscience. By the 1620s, moreover, it was clear that religious tolerance was a political necessity; forced religious conformity could only cause serious civil unrest. Though the majority of people spoke Dutch, language, like religion, proved to be less than a common bond. Friesland had its own tongue, and the other eastern provinces spoke "Oosters" or Low German; the court and upper classes often spoke French, as did many of the refugees from the South. History, too, provided few precedents for the alliance of the northern provinces; Friesland and Gelderland had spent the fifteenth century fighting Holland and Zeeland. Thus, when the Treaty of Münster was finally ratified in 1648 the event bore little semblance to the image of concord painted by ter Borch (fig. 1); Utrecht's ambassador refused to sign, and Zeeland's delegate was ordered to stay away from the proceedings. Provincial separatism and medieval particularism characterized the government of the United Netherlands throughout the seventeenth century.

FIG. 2. Title page from JAN LUYKEN, *De Nederlandsche Scheeps-Bouw-Konst Open Gestelt* (Amsterdam, 1697).

FIG. 3. JOSEPHUS DE BRAY, *Still Life with a Book with J. Westerbaen's Poem in Praise of Pickled Herring,* 1657, oil on panel, Suermondt-Museum, Aachen, no. 63.

FIG. 4. EMANUEL DE WITTE, *The Stock Exchange in Amsterdam,* oil on panel, Museum Boymans–van Beuningen, Rotterdam, no. 91.

Seafarers, Merchants, and Mother Commerce

The true cement of the union was the practical realization of a common political and economic advantage. This sense of shared purpose— a remarkable corporate spirit—undoubtedly contributed to the success of the United Netherlands in becoming one of the most powerful nations in the seventeenth-century world. With fewer than two million inhabitants, it was less than one-third the size of England (six million) and one-tenth that of France (twenty million). Yet the Netherlands vied with Great Britain as the foremost seapower on earth and became the hub of a far-flung colonial empire. From Brooklyn to New Zealand, Spitsbergen to Cape Horn, the modern map still attests to the seafaring Dutchman's global exploits. Amidst much larger neighbors, the Netherlands was uniquely profitable and efficient but also vulnerable and extended. Naturally its success caused resentment. Sir William Temple observed that "the United Provinces are the envy of some, the fear of others and the wonder of all their neighbors."[6] Sir Thomas Overbury complained in 1609 that the Dutch "give us the law at sea, and eate us out of all trade."[7] Foreign analysts scrutinized the Dutch model; Thomas Mann's *England's Treasure by Foreign Trade* of 1622, for example, is a call for competition with the Dutch. Their governments then took action: the English Navigation Acts of 1651 were designed to break the Dutch hold on foreign trade and led to two ugly Anglo-Dutch wars in 1652–54 and 1665–67. With the same goal in mind, Louis XIV's finance minister, Jean-Baptiste Colbert, instituted a national commercial policy in France with steep tariffs targeted at the Dutch. The foreign nations' extreme countermeasures only served to confirm the Dutch hegemony in trade.

Though Colbert wanted nothing better than to crush Dutch trade, he saw the practical advantage of commissioning ships at Zaandam near Amsterdam, where the Dutch ran one of the largest shipyards in Europe (see fig. 2). The timber used to make these vessels was imported from Norway and the Baltic. The small, flat, watery country that is the Netherlands has virtually no natural resources. The Dutch traditionally have had to live by their commercial wits. If the sale to Louis XIV of the Italian marble used to build Versailles was perhaps the Dutch middleman's neatest trick, maritime commerce was by far the most profitable enterprise. The sea was perceived by the Dutch as an ally; the nation's poets wrote odes to her bounty. Joost van den Vondel catalogued the country's imports and exports and, like Jacob Westerbaen, even versified on the "kindly herring" (see fig. 3).[8] Their praise was justified; herring fishing not only insured Holland against starvation during times of siege and famine but proved in peacetime to be a more valuable source of export than the entire British clothing industry.[9] Howell observed in 1622, "having no land to manure, [the Dutch] furrow the sea for their living."[10] The numbers involved in Dutch trade are revealing. In 1601 Dutch ships in the port of London outnumbered English by 360 to 207; the Dutch merchant fleet by the 1670s probably numerically exceeded the combined fleets of England, France, Spain, Portugal, and Germany.[11] The famous chartered trading companies—the Dutch East India Company and its lesser counterpart, the Dutch West India Company—were the largest private economic enterprises hitherto created. By the end of the century the former employed twelve thousand people with the financing of hundreds of merchants.[12] The success of these distant ventures depended in a large measure on the Dutchman's famed efficiency. Through the diversification of trade, Dutch vessels rarely carried ballast in their holds; calicoes were purchased in India, elephants in Ceylon, copper in Japan, all to sell again in the Moluccas and Java to increase the volume of spices to be carried back to Amsterdam.

Less exotic but even more profitable were trade routes closer to home. The foundation of the international Dutch trading empire was the Baltic grain trade.[13] Known in Holland as mother commerce (*moeder commercie*), it not only was a primary source of wealth but also of food. Three hundred Dutch ships left Danzig each year carrying up to 80 percent of the region's export grain; as late as 1666 three-fourths of all capital on the Amsterdam stock exchange (*beurs*) was committed to Baltic trade (see fig. 4). Amsterdam became Europe's grain entrepôt, but by far the largest market was Holland itself. A great interdependence grew up between Poland and the Low Countries with important effects for both regions. The peasants of the East Elbian states remained virtually enserfed while the Dutch farmers were freed of the burden of growing bread grains for Holland's burgeoning

FIG. 5. IZAAK NICOLAI VAN
SWANENBURGH, *Spinning,
Winding, and Weaving,* oil
on panel, Stedelijk Museum
"De Lakenhal," Leiden, no.
5.421.

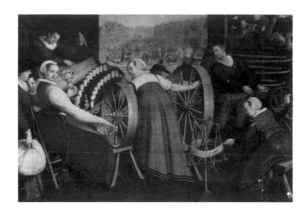

urban populations. Dutch agriculture rapidly became the most commercial and specialized in Europe. In the countryside, dairy and livestock production proved most profitable; nearer the cities, smaller, more labor-intensive farms provided crops for horticulture (bulbs, tobacco) and industry (hemp, hops, madder). Market pressures coupled with Holland's famous land reclamation projects tended to create larger farms owned by urban financiers and operated by fewer hands. The old peasant proprietors typically became tenant farmers or turned to new employment in crafts, shipping, or fuel gathering. As the peasant economy in Holland came undone, many were also forced off the land into the cities. While urban populations, particularly in the first half of the century, grew dramatically, rural populations remained fairly constant.

Textiles, Tow Barges, and Shipping Companies

Rural folk were drawn to the city by the lure of jobs in commerce and industry. In the 1650s the Leiden woolens industry employed nearly forty thousand workers (see fig. 5).[14] Many of the jobs carding, spinning, and weaving were filled by refugees from the old textile centers in the southern Netherlands or by unmarried women from the countryside who would accept the low wages and long hours. Characteristically, however, it was not cheap labor that made Dutch industry competitive in the world market but more advanced technology and a pattern of focusing on the refining of raw materials or semimanufactured goods. English woolens and coarse German linens were sent to Holland for

dyeing and finishing, processes that could account for nearly half the final cost of these products and the greater profit for the Dutchman.[15] New windmill-powered saws, oil presses, and milling machines greatly increased production in the shipyards in Zaandam, where Dutch carpenters produced the famous *fluit,* easily the most efficient bulk cargo vessel traveling the world's sea lanes until well into the eighteenth century. It was no accident that Peter the Great traveled to Holland to learn shipbuilding. Other major Dutch industries included brick and ceramic manufacturing, sugar refining, distilling, brewing, and salt boiling. After wind power, the cheapest source of energy was the peat found in abundance in the moors and marshes of Holland.[16] Although cheap, peat is bulky. The Dutch were able to exploit this fuel because of the unrivaled low costs of their transportation network, namely the huge system of inland waterways and canals. Holland's canals were built at enormous public cost but by the end of the century offered inexpensive and, by most accounts, very agreeable transportation to a large portion of the general populace. A *trekschuit*—Holland's ultimate democratic bark—departed hourly from many major cities. Some of these public barges were even provided with songbooks for their passengers. So cheap did transportation become that Amsterdamers could send their dirty wash to Haarlem or Gouda to have it laundered in the purer waters there.[17]

Many foreign observers equated the seventeenth-century Dutchmen's commercial avidity with avarice; the Dutch appeared obsessed with business, in love with profit even above honor

FIG. 6. CORNELIS
DANCKERTS, *Flora's
Foolscap,* 1637, engraving.

FIG. 7. ABRAHAM VAN DEN TEMPEL, *Pieter de la Court*, 1667, oil on canvas, Rijksmuseum, Amsterdam, no. A2243.

FIG. 8. FRANS HALS, *René Descartes*, oil on panel, Statens Museum for Kunst, Copenhagen, no. 290.

and love itself.[18] Inconvenienced as a traveler in the Lowlands, Voltaire complained that, if they could, the Dutch would "sell voyagers air and water"; Montesquieu, who was charged for simply receiving directions from a passerby, spoke of the Hollander's "utterly corrupt commercial heart."[19] To be sure, there were instances of excess, such as the speculative madness that resulted in tulipomania in 1636/37, the subject of mocking, satirical prints (fig. 6). The seamier side to the gentle Dutch cult of flowers, gambling on the bulb market ruined many investors, including the landscapist Jan van Goyen.[20] But the fact that investment and profit were perceived as the option of every Dutchman gave the Dutch economy great buoyancy and confidence. The stock exchange was officially open to all—burghers, shopkeepers, artisans, farmers, financiers, and even foreigners. Capital thus was drawn from a broad public, distributing the risk; small shipping companies *(rederijen)*, for example, sold shares to individuals to finance a single shipping or fishing journey. The low interest rates that resulted were the envy of all Europe. With international confidence in Dutch fiscal institutions, Amsterdam became the capital of world banking. Dutch bankers could be as tough and practical as the country's merchants. Not only did the traders continue to import wine and salt from the Iberian Peninsula during Holland's long war of independence, but toward the end of the conflict, the Dutch agreed to serve as the agent making disbursements of silver to the Spanish troops![21] Ideology rarely became an obstacle to profit.

The greatest advocate of the Dutch credo of mercantile rationalism, economic freedom, tolerance, and nonalignment was Pieter de la Court (fig. 7), author of *Interest van Holland ofte gronden van Hollands welvaren* (The interest of Holland or the foundation of Holland's welfare) (1662) and Johan de Witt's closest financial adviser. Another Dutchman, Hugo Grotius, known as the founder of modern international law, was the most eloquent spokesman for the doctrine of freedom of the seas. The Dutch leaders' faith in economic freedom and equally strong distrust of war as a weapon of policy were born not of idealism or cynicism but of political and economic realities. Pacifism seemed the wisest course when everyone, or at least the upper classes and average burgher, seemed to be get-

ting rich. While inflation remained low (deflation even seems to have set in at the end of the century), the Dutch East India Company paid an average annual dividend of 18 percent; profits from investments in the large drainage project in north Holland ran nearly as high.[22] By the end of the seventeenth century the Dutch were undoubtedly the wealthiest people in Christendom. Estimates made in 1688 and 1695 by English accountant Gregory King rank per capita income in Holland as the highest in northern Europe, surely the richest region in the West and probably anywhere on earth.[23]

Rest and Refuge
Holland's wealth and tolerance drew the disenfranchised and oppressed—refugees from the Thirty Years' War in Germany, Huguenots from France, Jews from Spain, Portugal, and eastern Europe, as well as waves of skilled and not-so-skilled workers from the Spanish Netherlands, Scandinavia, England, Scotland, even Armenia and Turkey. Immigration was the principal factor in the rise in population. Most western European nations experienced a rapid growth in population in the sixteenth century, but only the Netherlands and England continued this rise through the first half of the seventeenth century—an age of conspicuous hardship for most of the Continent.[24] Polyglot Amsterdam, like other great cosmopolitan port cities that went before—Athens, Marseilles, Venice, Antwerp—was full of strangers.[25] There was, of course, discrimination: Catholics could hold services only in clandestine churches *(schuilkerken)*, Socinians were persecuted as atheists, Jews lived under an apartheid system that forbade mixing with the "daughters and wives of this land," and foreigners were the target of guild restrictions.[26] Yet, by and large, the city fathers rightly looked upon the new arrivals as a source of strength. One of the most distinguished immigrants in Amsterdam was the great philosopher René Descartes (fig. 8), who in 1631 wrote: "What other place in the world could one choose, where all the commodities of life and all the curiosities to be desired are so easy to come by as here? What other land, where one could enjoy such complete freedom?"[27] The great Descartes disciple, Baruch Spinoza, was the son of Sephardic Jews who had immigrated to Amsterdam. Other famous thinkers who were drawn to the rest and

FIG. 9. JAN BOTH after Andries Both, *Singers with Broadsheets*, etching.

refuge of Holland included John Locke, whose *Essay Concerning Human Understanding* was first published in 1688 in Amsterdam. With their relative freedom of the press, Leiden and Amsterdam became major publishing centers, producing many foreign titles that could not be printed in their homelands. A lively pamphlet literature emerged, serving as an important mouthpiece of public opinion (see fig. 9 and cat. no. 56). Though often seditious and crudely polemical, these pamphlets and the printed newsletters, known as *corantos,* helped to make the citizenry of Holland's towns among the best informed in all Europe.[28] Freedom of thought also drew scholars to Dutch universities, which then counted about three thousand foreign students, including many French, English, and Scots; James Boswell, for example, studied briefly at Utrecht.[29]

The most important single group of immigrants, however, came from the southern Netherlands.[30] Flemings made contributions in all fields. De la Court's family emigrated from the South, as did those of Louis de Geer and Elias Trip, two Dutch merchants who became fabulously rich through their dealings, mostly in metals and armaments, in Sweden. The publisher Lodewijk Elzevier started with Plantin in Antwerp but moved to Leiden in 1580; similarly, the publisher of Mercator's cartography, Jodocus Hondius, moved his presses from Antwerp to Amsterdam. Among Holland's poets, the great Vondel was born in Cologne to parents displaced from Antwerp, Daniel Heinsius was

born in Ghent, Constantijn Huygens in Brabant, and Jeremias de Decker in Ostend. Among her artists are many Flemings such as Karel van Mander and David Vinckboons (cat. nos. 121 and 122), the great Frans Hals (cat. no. 47), and Adriaen Brouwer (cat. nos. 20–23). Thus, while Bredero's *Spanish Brabander* (1618) might ridicule the swaggering, seignorial manner of the impoverished Flemish immigrant, the debt that the North owed the South in human terms was very great indeed.

Observation and Inquiry

Many were drawn to Holland because it was a leading center for science and technology.[31] Although there was no official patronage, research could be conducted with little interference. Nowhere else in the seventeenth century was scientific observation pursued so energetically as in the Netherlands, where the close relationship between pure and applied science was closely interconnected. Technological improvements were essential to a competitive economy based on seaborne trade and massive engineering projects, notably land reclamation. Thus, navigation profited from advances in mathematics (Simon Stevin's decimal system of navigation, Willebrord Snellius's new methods of triangulation, and Christian Huygens's highly accurate nautical clocks), as did commerce with the advent of double-entry bookkeeping. The practical spirit of the Dutch scientific community is best demonstrated by the fact that so many of the leading figures were schooled in the craft of lens grinding. Through his own improved telescope, Huygens saw the moons of Saturn; Antonie van Leeuwenhoek—inveterate lens grinder and the executor of Johannes Vermeer's estate—perfected the microscope, through which he discovered a miniature world of protozoa and spermatozoa. Petrus Borellus and Jan Swammerdam were other scientists who made advances with lenses. Of course the seventeenth century was still a mystical and superstitious age; Cornelis Drebbel was as great a devotee of alchemy as of science and engineering. But the rage, for example, for anatomizing (see fig. 10) bespeaks a spirit of investigation and deep curiosity about empirical research. Hermann Boerhaave, perhaps more than anyone in his time, helped to make medicine respectable; when he lectured in

FIG. 10. WILLEM SWANENBURGH after Jan Cornelisz. Woudanus, *Anatomy Theater in Leiden*, 1610, engraving.

FIG. 11. GABRIEL METSU, *Patrician Family*, c. 1657, oil on canvas, Gemälde-galerie, Staatliche Museen Preussischer Kulturbesitz, Berlin (West), no. 792.

Leiden the hall was packed. Respect for education was pervasive in Dutch society and reflected the conviction that knowledge had a practical application beneficial to all.

Class and Opportunity

In the tumultuous and exciting early decades of the seventeenth century, there were fortunes and reputations to be made in the new Republic. Within the broad and emerging middle class, sandwiched as it was between the regents and a permanent underclass of peasants and beggars, there was a relatively high degree of social mobility. Many "rags to riches" stories, such as those often told about Frans Banning Cocq, the central figure in Rembrandt's famous *Night Watch* of 1642 (Rijksmuseum, Amsterdam, no. C5), overlook the advantages of a strategic marriage or influence in high places, but personal advancement on the basis of merit was possible, indeed common. Holland's bourgeois society was diverse in the extreme. Any attempt to identify its strata invariably diminishes its richness. Though insightful, Sir William Temple surely was guilty of oversimplification when he wrote: "The people of Holland may be divided into their several Classes: The Clowns or Boors (as they call them), who cultivate the Land, The Mariners or Schippers, who supply their ships and Inland-Boats, The Merchants or Traders, who fill their towns, the Renteneers, or men that live in all their chief cities upon the Rents and Interest of Estates formerly acquired in their Families; And the Gentlemen and Officers of

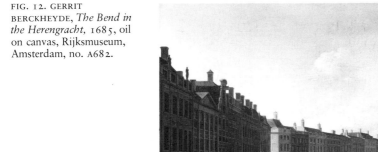

FIG. 12. GERRIT BERCKHEYDE, *The Bend in the Herengracht*, 1685, oil on canvas, Rijksmuseum, Amsterdam, no. A682.

their Armies."[32] If, however, we are mindful of the society's fluid boundaries, we can profitably characterize representative life-styles in seventeenth-century Holland.

The Regents and the Privileged Few

Although some nobility owned small estates in Gelderland and the eastern provinces, the Netherlands had virtually no aristocracy. James Howell observed in 1622: "Gentry among them are very thin and, as in all democracies, little respected, and coming to dwell in towns, they soon mingle and so degenerate."[33] The upper class was comprised of the regents, their immediate circle, and the richest of the merchants, who, at least in the early decades of the century, lived in a restrained, surprisingly abstemious manner. Temple noted that the regents were "differently bred than the Trader, though like them in modesty of Garb and Habit, and the Parsimony of living."[34] On the legendary frugality of Holland's upper classes, Voltaire and others recounted the story of a Spanish envoy to The Hague in 1608 who was so astonished to find members of the Dutch States General seated on a bench eating a simple lunch of cheese and bread that he resolved that such unpretentious folk could never be vanquished.[35] According to the Comte de Guiche, following a famous naval battle in April 1666 the great Admiral de Ruyter retired to his cabin to sweep the floor and feed his chickens.[36] Anecdotes such as these invariably exaggerate the Dutchman's simplicity. With prosperity came refinements of taste (see fig. 11). Amsterdam's broad canals were lined with huge homes (literally *paleisjes*, or little palaces) built in a classical manner from the same Italian stone that was sold to Louis XIV. Owned by magistrates, rich merchants, directors of big trading companies, and, increasingly, investors and rentiers, the great houses along the bend in the Herengracht (see fig. 12) were furnished with splendid appointments. No mere clearinghouse for staples, Amsterdam became Europe's great emporium of luxuries, a "Boutique of Rareties."[37] Not only could one buy the finest imported goods—Chinese porcelain, Venetian glass, Virginia tobacco, Brazilian sugar, and Oriental spices—but also manifold domestic luxuries (see fig. 13)—fine cloth, furniture inlaid with ebony and tortoise shell, skillfully wrought silver, paintings, ceramics, special meats, cheeses, sweets, and, of course, rare tulips.

FIG. 13. ABRAHAM VAN
BEYEREN, *Still Life with
Precious Metal- and Glass-
ware*, 1654, oil on canvas,
Museum Boymans–van
Beuningen, Rotterdam,
no. 90.

Class differences in the Dutch Republic, as elsewhere in the seventeenth century, were usually accepted as an aspect of the eternal scheme of things, but over the century and especially after the midpoint, a greater class consciousness arose. An early attempt to define class appeared in a pamphlet of 1662, which objected to the extravagant new life-styles of the merchants and even lesser traders and artisans: "Mr. Everyman thinks he is entitled to wear what he likes so long as he can pay for it."[38] The upper classes in the Netherlands strove increasingly for an international, which usually meant French, standard of elegance. Aristocratic tastes and pretentions spread among the elite. The rich purchased titles and built noble manors *(heerlijkheden)* on the banks of the Amstel, Vecht, and Oude Rijn. French influence had always been strong at the Dutch court (Prince Maurits set up a French theater) and among the privileged few. The rich educated their children in France; French scholars taught at Leiden University; and French was the diplomatic language. However, the French mode in fashion and a gallicized taste in literature and drama also spread to the petite bourgeoisie and below. Dutch satirists ridiculed the extravagance of dandies with snuffboxes and ladies who so adorned themselves with cosmetic beauty marks that their faces resembled "raisin buns."[39] After serving as ambassador to The Hague in 1668–70, Temple wrote that gentlemen there "strive to imitate the French in their Meen, their Clothes, their way of Talk, of Eating, of Gallentry, or Debauchery; and are, in my mind, something worse than they would be, by affecting to be better than they need; making sometimes but ill Copies, whereas they might be good Originals, by refining and improving the

FIG. 14. CORNELIS J.
VISSCHER, *Prayer before the
Meal*, 1609, engraving.

Customs and Virtues proper to their own Country and Climate."[40] In his comedy *The Preposterous Snob* of 1684, Bernagie satirizes a young Dutchman who, tired of his own "banal" language, takes to interlarding his speech with French phrases to make it "doucer and more pleasant."[41] The aristocratic pretensions of the Periwig period *(pruikentijd)* were not simply a matter of style. Though hard evidence is scarce, the gap between the rich and the poor seems to have widened. In Gouda, for example, the eight richest people in town in 1625 owned about 8 percent of the total private wealth, while one century later this figure had risen to almost 25 percent. This money, moreover, was now invested entirely in land, houses, and provincial and admiralty bonds; not a cent was spent on industry or commerce.[42] Clearly such figures have important implications for the famous "decline" of the Dutch in the eighteenth century.

Burghers, "Little Citizens," and the Home
In the seventeenth century, systems like the shipping stock companies *(rederijen)* helped to disperse the wealth, creating an unprecedentedly large middle class. This undoubtedly explains Overbury's exaggerated claim that in the Netherlands "no one private man there is exceedingly rich, and few very poor."[43] Tax appraisals and other indicators suggested that perhaps as much as a third of the people lived well above the subsistence level.[44] The middle class and the lower middle class *(kleine gemeente*, literally "little citizens"—common tradesmen, artisans, and workers), as judged from spectatorial writings, lived lives of hard work, assiduousness, and discipline, compensated by outbursts of exuberant indulgence. Both French and English observers commented that industriousness and perennial love of gain made the average Dutchman a sober and dispassionate fellow.[45] His refuge was the home; his first concern was the family (see fig. 14). The rise of the entrepreneurial bourgeoisie brought an end to the extended family systems that had prevailed in the northern Netherlands well into the sixteenth century. The typical Dutch family became smaller and more private in its orientation; its members enjoyed greater personal autonomy and closer affective relations at home (see fig. 15).[46] The abolition of monasticism and clerical celibacy also contributed to the new Protestant exaltation of marriage and the family; the home

FIG. 15. MAGDALENA VAN DE PASSE, *Allegory of Winter*, engraving.

FIG. 16. ADRIAEN VAN DE VENNE, *Wife*, engraving from Jacob Cats, *Houwelick*, 2nd ed. (The Hague, 1632).

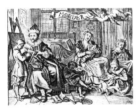

FIG. 17. ADRIAEN VAN DE VENNE, *Mother*, engraving from Jacob Cats, *Houwelick*, 2nd ed. (The Hague, 1632).

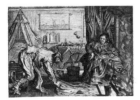

FIG. 18. ADRIAEN VAN DE VENNE, *Henpecked Husband*, engraving from *Tafereel van de belachende werelt* (The Hague, 1635), p. 109.

replaced the church as the primary forum of ethical instruction and character development. The family became the congregational core of the community. The Dutch burgher's orderly house became a sort of secular temple; the beauty of its clean, light-filled spaces was best captured by Vermeer and de Hooch (see cat. nos. 54, 55, 118, 119). A whole literature emerged, celebrating the family and specifying the duties of its members, especially female. By far the most popular of these books was Jacob Cats's *Houwelick* (Marriage), first published in 1625 (see figs. 16 and 17); fifty thousand copies were in circulation by 1655, a time when scarcely any book, aside from the Bible, was printed in editions larger than three thousand.[47] Clearly a broad section of the middle class read the volume. In presenting his image of the model family, Cats traced the course of a woman's life and inventoried her chores and responsibilities while constantly admonishing against straying from the course of domestic virtue.

Foreigners also noted the premium that the Dutch placed on marriage and domesticity. Saint-Evremond attributed the exceptional fidelity of Dutch marriages to the notorious *froideur* of their women, but most French observers related this marital strength and unity to Protestantism and what they perceived to be a genuine fondness between husband and wife.[48] Temple suspected that the dispassionate Dutch only feigned love, but allowed that "a certain sort of chastity [is] hereditary and habitual" among the married women.[49] All observers of Dutch conjugal relations from Erasmus onward agreed on the woman's dominance in the home (see fig. 18).[50] Priestess of the secular temple, the housewife (*huisvrouw*), aided by her minion and confidante, the maidservant, ruled unchallenged. The home was the citadel of middle-class Dutch culture, the primary unit of society, the source of all harmony and grace. Here wayward children, animals, errant or idle domestics, and foot-loose, unmarried women were bridled with restraint and taught industry and piety. The maintenance of order in the home thus became a crucial duty. Parival, noting that Dutch housewives scrubbed and cleaned constantly, complained that one had to remove one's shoes before entering their homes and dared not spit while visiting.[51] The Englishman Brickman caustically observed that the Dutch kept "their houses cleaner than their

persons, and their persons [cleaner than] their souls."[52] The value the Dutch placed on cleanliness is reflected in the fact that Wendela Bicker, wife of the Grand Pensionary Johan de Witt, was celebrated for her tidiness.[53]

The Status of Women
The French naturally were contemptuous of the Dutch husband's abdication of his rightful authority in the home, but Cats never questioned that the administration and maintenance of the house were a woman's sacred trust. Given the importance of the home in Dutch culture, the woman's domestic role was proof of her power in society. Women also made contributions in the professional world: Anna Maria van Schuurman was a writer and a scholar of Oriental studies, Anna Roemer Visscher was a poet and glass-engraver, Adriana Nozeman was an important figure in the theater, and, of course, Judith Leyster (cat. no. 61) was one of the country's many gifted woman painters. Like Guicciardini and Moryson, Howell commented on Dutch women's acumen for business: "In Holland the wives are so well versed in bargaining, ciphering and writing, that in the absence of their husbands in long sea voyages they beat the trade at home, and their word will pass in equal credit."[54] Predictably, the womenfolk's assertive role in the home and in society at large made Dutch men uneasy. The writings of van Beverwijck, which include *Wtnementheit des Vrouwelijke Geslachten* (On the excellence of the female sex), are exceptional in Dutch literature in claiming for women qualities equal or superior to those of men. More typical was a species of misogynist literature with titles like *Spiegel der quade vrouwen*, 1664 (Mirror of wicked women), *Huwelijks Doolhof*, 1634 (Marriage maze), *Biegt der getrouwde*, 1679 (The confession of the betrothed), *De boosardige en bedrigelijke huisvrou*, 1682 (The shrewish and deceitful housewife), and perhaps the most bitterly mocking, Hippolytus de Vrye's *De tien vermakelijkheden des houwelyks*, 1678 (Ten amusements of marriage), which purports to be a widower's lament over his marriage to an extravagant young woman who drives him to

FIG. 19. A. MATHAM after
Adriaen van de Venne,
Bridal Banquet, engraving
from Gilles Jacobs Quintin,
*De Hollandsche Lys met de
Brabandsche-Bely* (The
Hague, 1629), p. 213.

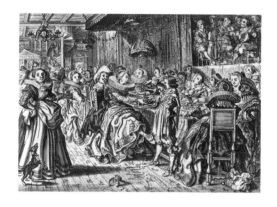

FIG. 20. *Dancing Party,*
engraving from GILLES
JACOBS QUINTIN, *De Hol-
landsche Lys met de
Brabandsche-Bely* (The
Hague, 1629), p. 119.

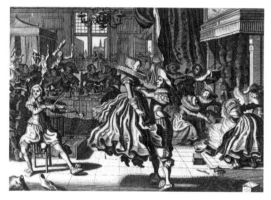

no less scandalized to discover "mothers of good fame" permitting their daughters to sit up at night and even venture abroad with their beaus after their parents had gone to sleep.[57]

Weddings, Banquets, and the Kermis
When a couple finally married, the celebrations might be extravagant and prolonged.[58] The festivities surrounding even a middle-class wedding could last many days and become exceedingly expensive. Though a very rich man, Johan de Witt's father-in-law was alarmed at the mounting costs (many thousands of guilders at a time when a thousand guilders would purchase a modest house) of the presents and parties that attended his daughter's wedding.[59] Cats and authors of seventeenth-century cookbooks listed the seemingly endless courses that set the sideboards and, no doubt, many guests groaning at Dutch wedding feasts (fig. 19). So large and unwieldy did these banquets become that a law was passed in Amsterdam on January 29, 1655, forbidding "anyone to invite more people to a wedding feast than were necessary to its effectiveness or had a role in the proceedings."[60] At such parties there often was music, dancing (fig. 20), and the reading of poems written specially for the occasion, many of which have survived. Most are unmemorable pastiches of the rather ponderous style of verse favored by the leading classical poets, such as Hooft and Vondel, but some speak with easy candor or double entendre of the joys, scarcely less physical than spiritual, of marriage; for all their preachers' policing, most Dutchmen seem to have had a comfortably frank attitude toward sex. Other family events that called for celebrations were baptisms and birthdays. To these were added Saint Nicholas's

bankruptcy and the drink.[55] Despite their comic tone, such writings clearly were designed to reinforce, through the time-honored technique of inversion, the prevailing cultural and sexual authority.

By the harsh standards of the seventeenth century, Dutch women nonetheless enjoyed many rights: wife beating was outlawed; a widow could inherit her husband's property and even his position in the guild; a husband caught or even suspected of consorting with prostitutes could be summoned by his wife before the church authorities for public admonishment; the church could also grant the unfortunate wife of a sailor who returned from a voyage with venereal disease separate beds or even annulment of the marriage.[56] In the Reformed Church women shared pews, the singing of psalms, and communion with men. Despite the hectoring of Cats and Calvinist preachers *(predikants),* a young woman also knew considerable freedom in courtship. If *kweesten,* the practice of allowing the couple to sleep together before marriage, was restricted mostly to villages in the northern provinces, foreigners like Fynes Moryson were

FIG. 21. ADRIAEN VAN DE VENNE, *Kermis*, engraving from *Tafereel van de belachende werelt* (The Hague, 1635), p. 69.

FIG. 22. ADRIAEN VAN DE VENNE, *Quack Doctor*, engraving from *Tafereel van de belachende werelt* (The Hague, 1635), p. 99.

Eve (December 5) and the festivities of the religious calendar, notably Saint Martin's Eve (November 11), Twelfth Night, Shrovetide, and Whitsuntide (late May or June). The gay celebrations for Twelfth Night and Shrovetide included nocturnal banquets, processions, special foods, and, in some cases, masked entertainers.

Though originally formed to defend the cities and still called upon on rare occasions to quell an occasional civic disturbance (the threat of the mob remained ever present), local militia companies had become in their functions more social than military. Frans Hals offered convivial images of their banquets, barely hinting at their capacity for epicurean indulgence; the magistrates of Haarlem in 1621 were forced to limit the duration of these feasts to three or, at most, four days.[61] The militia banquets, however, must have seemed staid by comparison with the annual kermis.[62] Begun as a religious ritual celebrating the anniversary of the founding of a church, the kermis grew into a huge free-for-all of folk culture, a collective excuse for all of society to drink, dance, and be blissfully silly.

Visiting Frenchmen like Pierre le Jolle, who versified on the unruly Amsterdam kermis, thought all the drinking, gluttony, and brawling execrable;[63] predictably, the clergy, ever mindful of the kermis's "papist" roots, roundly condemned this pagan playground: "The public houses and taverns, streets and roads, attest to the licentiousness and the acts of punishable, excessive wickedness, of whoring and adultery."[64] Nonetheless, the kermis attracted all types; city slickers mixed with country bumpkins, and the more stylish Hof-Kermis at The Hague was a favorite of William III. The poetic descriptions of Adriaen van de Venne's *Tafereel van de belachende werelt* (The Hague, 1635) and Lucas Rotgans's *Boerenkermis* (Amsterdam, 1709) mention a myriad of entertainments (fig. 21). In addition to the market stalls where hawkers sold their goods and trinkets, there were conjurers, quacksalvers (fig. 22), roving musicians, acrobats, tightrope walkers, sword dancers, rare animals (including elephants, camels, and trained apes), mummers, harlequins, palm readers, gypsy fortunetellers, and astrologers. The spectacle included puppeteers featuring Jan Klaasen (the Dutch equivalent of Punch and Judy) and freak shows with dwarfs and the "Krabbendammer giant." Toward the end of the century an Englishman named Richardson kept audiences gawking as he chewed hot coals, dripped burning sulphur on his tongue, and drank molten glass. Diversions for the more serious-minded included technical wonders—a diving bell demonstrated by no less than the famous engineer Jan Adriaensz. Leeghwater and what was purported to be a perpetual motion machine.[65] Among the crowds at kermisses and fairs like the Valckenburg horse market, pickpockets and prostitutes also did a brisk business.

FIG. 23. CONSTANTIJN
ADRIAEN RENESSE, *Village
Fair with a Theatrical Per-
formance*, etching.

Rhetoricians, Theater, and Literature

Theatrical entertainment at kermisses and vir-
tually all other large public festivities included
performances by the *rederijkerskamers* (see fig.
23). Rhetoricians' chambers (see fig. 24) were
amateur literary societies, first established in the
sixteenth century, which offered to the public
dramatic readings, performances, and literary
competitions.[66] For the most part their ranks
were filled from the trade guilds. Thus, like
Bottom and the "rude mechanicals" in Shake-
speare's *Midsummer Night's Dream,* the
rhetoricians were not the literati but local car-
penters, joiners, tailors, and other tradesmen.
Their members also included artists. In 1588 the
printer Harmen Jansz. Muller observed that in
the Amsterdam guild called De Egelantier there
were "many painters and many worthy and
witty Souls as able in matters of Rhetoric as in
painting."[67] Frans Hals (1616–25), Dirck Hals
(1618–24), Esaias van de Velde (1617–18),
Adriaen Brouwer (1626), and Job Berckheyde
(1665–72) were active or associate members of
the Haarlem guild, whose motto was "Liefde
boven al" (Love above all).[68] Artists served to
paint scenery and properties and also may have
made literary contributions; Pieter Codde,
Gerbrand van den Eeckhout, and Adriaen van
de Venne are all known to have at least tried
their hand at poetry. Jan Steen, although not
recorded as a member of a rhetoricians' cham-
ber, depicted their comic antics repeatedly (cat.
no. 106). His humorous view of the *rederijkers*
is not without ridicule and accords well with
later seventeenth-century Dutch comedies and
farces in which rhetoricians are portrayed as
coarse uncivilized characters from rural villages
and the lower classes. There probably was some
truth in this view. Rhetoricians' chambers played
an important role, particularly in the southern

Netherlands, in fostering Dutch literature in the
sixteenth and early seventeenth centuries; mem-
bers included poets of the first rank, such as Jan
van Hout, Hendrik Laurens Spiegel, Roemer
Visscher, Jacob Duym, and in the following
generation, Cornelis Pietersz. Hooft, Gerbrand
Adriaensz. Bredero, Samuel Coster, and Joost
van den Vondel. However, no truly distin-
guished later seventeenth-century authors were
rhetoricians, and no important literature was
produced for these societies, which survived into
the eighteenth century, but mostly in the
hinterland.

The plays of the rhetoricians doubtlessly had
appeal, especially to a semiliterate public.
Though accurate literacy statistics are not avail-
able, in Amsterdam in 1630 only about two out
of three men and one out of three women (girls
customarily left school earlier) could sign their
names in the marriage register.[69] In all likelihood
illiteracy ran higher in rural areas.[70] The rarity
of estate inventories that included books other
than the States General Bible, a psalmbook, and
the odd volume of Cats support the conclusion
that few people read a great deal.[71] Dismaying
as such indicators might seem, the Dutch proba-
bly were as literate as any other people in
seventeenth-century Europe. Dutch literature
nonetheless, tended to be the province of the
educated few.[72] Unlike his counterpart in the
field of art, no Dutchman made his living writ-
ing poetry or plays, not even Jan Vos, the author
of hugely popular, sensationalized plays put on
at the Schouwburg, the theater in Amsterdam.
Though Vos was always called an unlettered
glazier and the poet Joachim Oudaen was a tile-
maker, many of Holland's most outstanding
literary figures were high born; P. C. Hooft,
Jacob Cats, and Constantijn Huygens were all
from the regent class, and Vondel—probably
Holland's single greatest poet—rose socially
through his work. The elitist quality of Dutch
literary circles was reinforced by a new cenacle
or salon spirit among writers. The Muiderkring
typifies this trend; Hooft, who was Drost of
Muiden, held meetings of the most brilliant au-

thors and thinkers of the day at Muiderslot, his
castle outside Amsterdam. Spiegel, likewise, wel-
comed writers to Meerhuizen, his estate on the
Amstel.

The absence of a long-standing indigenous lit-
erary tradition coupled with the emphasis placed
by upper-class theorists, the Latin schools, and,
in turn, the chambers of rhetoric on classical
conventions and subject matter made much
Dutch literature hidebound and stilted. For
many promising writers the burden of the
example of the Renaissance was simply over-
whelming. Nevertheless, the achievements of
several of the country's poets deserve note.
Hooft not only wrote some of the purest classi-
cal verse in Dutch but also raised the art of the
chronicle to history in his *Nederlandsche Histo-
riën,* a project to which he devoted his last
twenty years. Despite the fact that Vondel's *Lu-
cifer* may have inspired Milton's *Paradise Lost,*
foreigners have paid little attention to his work.
In our highly secularized age, the preponderance
of religious subject matter and the moral tone of
his poetry is as great an obstacle as the language
barrier. Few still appreciate Vondel's devotional
lyricism. Religious verse *(zededichten)* and
the poetic version of the popular pamphlet
(hekeldicht) comprise more of the national liter-
ature of the Netherlands than of other countries.
The didactic spirit was pervasive in Dutch poetry
and perhaps nowhere stronger than in the writ-
ings and emblem books of "Vader" Cats.
Though of questionable poetic merit, his thump-
ing epigrammatic verse expresses a practical
common-sense wisdom that resides very near the
heart of the national folklore.

The Voice of the People

Johan van Heemskerk's *Batavische Arcadia* of
1637 was the first Dutch novel and a product of
the courtly fashion for the pastoral. Closer to the
true literature of the people were the ephemeral
broadsheets, chapbooks, and *volksboeken* (see
cat. nos. 44 and 56).[73] These popular books in-
cluded romances of chivalry *(ridderromans)* such
as "De Historie van de vier Heemskindern" and
"Floris ende Blancefleur" and such popular clas-
sics as the tales of Mariken van Nimwegen and
Tijl Uilenspiegel. These cheaply produced works
were riddled with misprints and even omissions
(dutifully repeated in successive editions) that
made the texts virtually unintelligible. If *volks-
boeken* were what the common man read,
Bredero's poetry informs us how he sounded.[74]
Son of a cobbler and trained as a painter,
Bredero had a keen ear for the vivid speech of
the streets as well as the broader tongue of the
polders. Even jaded modern audiences often find
the scabrous language in his plays shocking. The
low-life characters in these works come closer
than those of any other Dutch poet to the spirit
of peasant genre painting by Adriaen Brouwer
and his followers. Farces poking fun at the peas-
ant were written by others like Samuel Coster,
P. C. Hooft, J. Z. Baron, and Joos Klaerbout;
however, they neither showed the special interest
for peasant life and lore of Bredero's *Klucht
vande koe,* 1612 (Farce of the cow), and *Klucht
vande molenaer,* 1613 (Farce of the miller), nor
matched his gift for naturalistic *mise en scène* as
witnessed in the full-scale comedies *Moortje,*
1615, and *Spaanschen Brabander,* 1617. Bre-
dero's so-called *boertige* comedies had an
unapologetically coarse rural humor and earthy
wisdom. In his *Groot lied-boeck* (large song-
book) of 1622, the first of three parts (the others
included amorous and devotional poems) is the
Boertigh liedt-boeck, eighty-two songs offering
comic but compellingly realistic glimpses of
peasant life (see fig. 25).[75] As explained in his
introduction, his poems have a moral purpose,
but their style reflects the motto of the painters'
guild: "The best painters are those who come
closest to life."[76]

G. A. BREDEROOS

FIG. 25. JAN VAN DE VELDE, *Peasant Feast*, engraving from G. A. Bredero's *Groot Lied-boeck* (Amsterdam, 1622).

FIG. 26. PIETER DE HOOCH, *Portrait of a Family at Music*, 1663, oil on canvas, The Cleveland Museum of Art, no. 51.355.

FIG. 27. JACOBUS MATHAM, *Filthy Drunkenness*, engraving from a series of four on the *Effects of Intemperance*, pl. 1.

Songs and Songsters

Aside from the compositions of the organist Jan Pietersz. Sweelinck and the carillons that were the pride of every city, Dutch music was undistinguished in the seventeenth century. Music, nonetheless, was a major feature of everyday life.[77] In addition to the players (*speelluiden*) who hired themselves out for weddings and feasts, talented amateur instrumentalists formed collegia musica and practiced earnestly at one another's houses. In the home, music was a charming and particularly important part of family life; indeed music became a standard symbol of familial harmony in portraiture (see fig. 26). Young girls owned little volumes (*juffer-boekjes*) sometimes bound in leather and held with a silver clasp, which were filled with handwritten love songs and often decorated with drawings. In north Holland women were rarely without their *mopsjes*, small books filled with

popular tunes. A hostess would leave songbooks out on tables or keep them close at hand, sometimes tucked under the chair cushions (see cat. nos. 51, 72, and 100). Songbooks were published for nearly every occasion and singer. There were famous political ballads, such as the sea beggars' songs and the odes to Admiral Tromp, as well as crude anti-Spanish ditties in which enemies are referred to as *spekken* (bits of bacon, the origin of the English slur "spik").[78] The song celebrating Piet Heyn's triumphant capture in 1629 of the Spanish silver fleet is still sung by Dutch soccer fans. There were songbooks for sailors and boating parties, collections of songs sung by peasants and shepherds, devotional songbooks—even songs of woe, hunger, and pestilence. The most popular, however, were love songbooks, which were composed by many of the best poets of the day.[79] Tools of courtship, amatory songbooks were often presented by a lover to his lady.[80] The Dutch were so enamored with music and song that, according to Fynes Moryson, they could be captivated even when uncomprehending. Although "not understanding what they sayd," the Dutch followed itinerant English songsters "with wonderful concourse, yea many young Virgines fell in love with some of the players, and followed them from Citty to Citty, till the Magistrates were forced to forbid them to play any more."[81]

Taverns, "Tabagies," and Musicos

Naturally, where there was music and song there was also drink. Taverns, like the alcohol they served, came in many forms and grades.[82] There were upper-class establishments frequented by ambassadors and professors, winehouses featuring Spanish vintages for the middle classes, and the fetid and often violent pubs (*herbergen*) of the peasantry and urban proletariat. Already in the sixteenth century the rich had imported beer from Leipzig while the common folk argued over the merits of the many domestic brews.

FIG. 28. *Loose Company,* engraving from GILLES JACOBS QUINTIN, *De Hollandsche Lys met de Brabandsche-Bely* (The Hague, 1629), p. 233.

FIG. 29. CRISPIJN VAN DE PASSE, frontispiece from *Spiegel der alderschoonste Courtisanen deses tyts* (1631).

FIG. 30. Title page from *'t Amsterdamse Hoerdam* (Amsterdam, 1681).

Beer was an important part of the peasant's diet; van Beverwijck, the Dr. Spock of his day, even recommended that children be weaned on beer.[83] As for spirits, Dutch gin *(genever)* and its ruinous effects only spread in the eighteenth century; brandy *(brandewijn)* was popular earlier. Guicciardini, Sir Thomas Overbury, and many other foreigners commented on the Dutchman's love of drink.[84] Fynes Moryson thought the Dutch drank less than the Saxons but told a story of coming upon a man of "honorable condition," wearing velvet and "many rings," who was sprawled in the "carte rutt of the highway." Thinking him "killed or sore wounded," they alighted from their wagon but were beckoned away by two servants, holding their master's cloak over him to shield him from the sun; "his servants made signs unto us, that we not trouble him who was only drunken and would be well assoone as he had slept a little. At this we much wondered, and went on our journey."[85] Theophile de Viau's complaint at having been forced, while a student at Leiden University in the early seventeenth century, to drink more than he could hold is scarcely surprising; one of the attractions of academic life was the forty gallons of wine per annum that all students and professors were permitted free of excise tax.[86] Evangelists like Simon Simonides railed, with little effect, against "those who would rather sit in the taphouse than the Church, [and] who prefer the tavern's fiddle to David's harp."[87] In addition to taverns serving alcohol, dank *tabagies* catered to the new mania for smoking tobacco and, toward the end of the century, there was a proliferation of the more respectable coffeehouses. At many of these establishments the clientele played cards, trictrac, knuckle bones, and other games of chance.

In addition to these licit distractions, there were less respectable diversions (see fig. 27), including brothels *(bordellen)* (see figs. 28 and 29) and Amsterdam's famed dance halls *(musicos)* where ladies of easy virtue might, for a commission or flat fee paid to the owner, secure a profitable assignation with anyone from a sailor to a foreign diplomat. The house rule at *musicos* required that women take clients elsewhere. Guides to the city's brothels were published; *'t Amsterdamse Hoerdom* of 1681 (fig. 30) took the disingenuous form of a titillating report supposedly delivered by the sheriff of Amsterdam to the narrator, his counterpart from Rotterdam. Less enticing were the reports of most visiting Frenchmen, one of whom in the following century found the women "almost all terribly ugly, very sad, and given to averting their gaze when looked upon."[88] The typical prostitute was an immigrant from the countryside or from Germany or the Spanish Netherlands whose domestic job failed with the cooling of her master's affections or one whose husband was interminably at sea. The magistrates tolerated prostitution, reasoning that it was a necessary vice in a city with such a large maritime population; estimates suggest that as much as 10 percent of the country's menfolk were sailors.

Nonetheless, the city fathers, to avoid the appearance of condoning such activities, staged periodic crackdowns in which such women were banished, pilloried, flogged, and on rare occasions, branded or sentenced to corrective labor in the Spinhuis. Even in tolerant Holland justice was harsh and brutal in the seventeenth century.

The "Grauw" or Rabble

Not all people shared equally in the lucre of Holland's "Golden Age." Although the country's urban centers, by the standards of the rest of Europe, were relatively free from famine, war, and civil disturbance, they remained centers of horrifying poverty and disease, gobbling up rural folk with staggeringly high death rates. Epidemic was the great scourge of the lower classes, who were more vulnerable than the rich because of malnutrition, poor hygiene, and bad housing (see cat. nos. 20 and 89). The plague, though not as devastating as the 1665 epidemic in London, struck Amsterdam repeatedly in 1623–25, 1635–36, 1655, and 1664—each time killing more than one-tenth of the population.[89] The traffic of vast numbers of people made Dutch cities especially vulnerable to disease. New contact between Europe and America caused the deadly reappearance of syphilis after a period of remission.[90]

Assessing the numbers of the poor is a grim and imprecise business. Scattered indicators suggest that amidst prosperity poverty was extensive. In 1622 ten thousand people in Leiden were excused from the poll tax because of poverty; in 1638 twice that number were receiving relief.[91] Though there was no universal assessment of personal income in the seventeenth century, the *Personeele Quotisatie* compiled in Amsterdam in 1742 suggests that only one-third of the heads of households earned more than 600 guilders (probably a minimally comfortable income) and an additional 11 percent between 300 and 600 guilders. The former group included not only the rich merchants but also shopkeepers, independent tradesmen (carpenters, tailors, and so forth), and professionals (lawyers, doctors, professors); the latter group consisted of skilled workers, artisans, and simple tradesmen. More than half of Amsterdam earned less than 300 guilders per year—the pitiable wage of unskilled laborers, traders in irregular goods,

servants, washerwomen, and journeymen who lived on the very edge of subsistence.[92] Baudartius reported in 1624, "where a stuiver is to be earned, ten hands grasp for it."[93] Around 1640 some of the best-paid workers were ship carpenters, who in the summer months could make nearly four times the salary of unskilled laborers, who earned 10 stuivers a day plus beer.[94] Working-class families with two children might spend more than 40 percent of the family income on bread.[95] For the most part lower-class women had no option but to work. In Amsterdam the lesser *gemeente* lived in tiny dwellings (*achterhuizen*) built behind the big houses on the canals or rented a single room, often in the cellar. In the newly expanded quarter known as the Jordaan, the lower classes lived cheek by jowl in cramped wooden houses rarely depicted by the famous Dutch cityscapists. The neighborhood industries—soap boiling, brewing, and sugar refining—added to the stench and constant danger of fire. Sewage, poured directly into canals, contributed to health problems and, by all accounts, the city's ripe aroma in summer months. At the bottom of the social ladder were the unemployed or the underemployed seasonal workers (often seafolk and agricultural laborers) who filled the ranks of the vagabonds, beggars, thieves, and prostitutes. Here too were street urchins, orphans, and the pathetic *ambachtskinderen*, children or adolescents sent by their parents to the city to learn a trade only to be turned out onto the streets by their new masters. In unembellished prose, the arrest ledgers (*confessieboeken*) in Amsterdam attest to these unhappy lives.[96] If they had a permanent domicile, these folk, the poorest of the poor, lived in back alleys, shanties along paths outside the city's walls, or even in the arches of the city wall itself.

The Peasant and the Soldier

The peasantry suffered not only from poor harvests, displacement by absentee rentiers, and the abuses of land tenancy, but also, more than any other sector of the population, from the war

FIG. 31. After DAVID VINCKBOONS, *Soldiers Abusing Peasants*, engraving from a series on *Peasant Sorrow*.

with Spain.[97] It is well known that in the early years of the conflict the countryside around Haarlem, Leiden, and Alkmaar was ravaged; that inland disruption continued much later is often forgotten. Outside the maritime provinces, in border areas and outlying regions, the fighting resumed with new ferocity after the Twelve-Year Truce expired in 1621. The big loser, of course, was the peasant, again victimized when Habsburg troops overran Gelderland and Utrecht in 1629 and when the French army, a hundred thousand strong, invaded the Netherlands in 1672, the year of calamity *(rampjaar)*. The generals of the States Army and Army of Flanders officially discouraged their soldiers from mistreating the peasantry, but without a formal system for provisioning troops in the field, soldiers were billeted with civilians and the peasant became the involuntary host (see fig. 31). The French phrase "le pays doit nourrir le soldat" captures more delicately the same idea expressed in a phrase from Dutch soldiers' popular songs of the period: "Teeren op den boer" (living off the peasant).[98] The peasant was expected to house and feed the soldier and often had to pay extortion fees to protect his life and property (the so-called *brandschat* and *sauvegarde*). The new mass armies, which revolutionized sixteenth-century warfare and its costs, caused unprecedented disruption of rural life. When the army was composed almost exclusively of mercenaries loyal only to the best paymaster, its soldiers need not be the enemy to act like an invader. Especially in the early years of the century, mutineers and *vrijbuiters* (marauding troops seemingly under no government's control) wreaked havoc in the countryside, sometimes kidnapping peasants for ransom or

pressing them into forced labor. It is not surprising that many peasants escaped to the city.

The soldier's life was hardly less brutish. Though Temple claimed that the "Officers of their Armes live after the Customs and Fashions of the Gentlemen" and Dutch poets ridiculed the foppery of their overdressed lieutenants, the common footsoldier knew no such glamour.[99] Germans, French, English, Scots, Danes, and Swiss made up the legions of the House of Orange. According to the recruiters in Leiden who sought to fill the ranks in 1621, Dutch youths would not volunteer for the army simply because the wages were too low.[100] The soldier nonetheless had, in Huygens's words, to support "the ballast of his retinue . . . his napsack, wife and child."[101] Camp followers, sutlers, and the families of soldiers formed the limping entourage of any military campaign. Plunder and booty were simply legitimate supplements to the soldier's meager pay. Indeed, the Dutch army was probably better disciplined than most; in 1609 Sir Thomas Overbury commented that Dutch soldiers committed relatively few robberies and attacks on citizens, a claim reiterated by Howell in 1622.[102] The many images painted before the Treaty of Münster of soldiers resting in guardrooms (see cat. no. 42) simply attest to the fact that there was virtually no fighting in the maritime provinces where these soldiers were bivouacked and the artists lived. Their idleness in the absence of land-based conflict was the cost of preparedness. Yet there was little personal security in this service. Van Deursen cites the case of a soldier with twenty-five years of service; although he had a wife, child, and a useless right arm, his severance pay consisted of a single award of 18 guilders.[103]

FIG. 32. ADRIAEN VAN DE VENNE, *They Are Miserable Legs That Must Carry Poverty*, oil on panel, Museum Boymans–van Beuningen, Rotterdam, no. 2194.

Charity and Justice

The hireling soldier dismissed after a campaign often rejoined the peasantry from whence he came or added his number to the burgeoning urban poor (see fig. 32). Poverty was perceived by the Dutch magistrates as an act of God, a permanent feature of life that might, however, be eased by works of charity. Amsterdam's charitable institutions were among the city's proudest achievements and the wonder of foreign visitors.[104] In 1641 John Evelyn praised the care in the Amsterdam hospital (Gasthuis) "for their lame and decrepit soldiers and seamen, where the accommodations are very great, the building answerable."[105] Other estimable institutions looked after widows (Weduwen hof), the elderly (Oudemannenhuis), orphans, foundlings, and abused children (Weeshuis), and the poor (Aalmoezeniershuis). People with infectious diseases received care in the lepers' house (Leprozenhuis), and the mentally ill were hospitalized in the insane asylum (Dolhuis). In addition to these public institutions, charitable religious organizations ran almshouses *(hofjes)* and other shelters for their own communities. The spread of institutions for the public welfare was related to changes in the criminal justice system that grew partly out of the humane writings such as *Boerentucht* (Amsterdam, 1587) of Dirck Volkertsz. Coornhert and his followers. Coornhert's belief in penal systems that valued discipline and rehabilitation over mere punishment helped create the Tuchthuis (founded 1589), later called the Rasphuis, where criminals were put to work rasping Brazilian wood to make dye. In its counterpart for women, the Amsterdam Spinhuis (founded 1596), inmates convicted of minor crimes like theft or prostitution were put to work sewing. The German Philips von Zesen even likened the Spinhuis to an "inn for princesses."[106] Both institutions became tourist attractions; entrance to the Rasphuis cost one stuiver and was gratis during kermis.

Though an improvement over what went before, there was nothing sentimental about Dutch charity. Both the Englishman Howell and the Venetian Suriano noted that Dutch cities had few beggars, which probably relates more to the fact that beggars were required to obtain permits in Amsterdam after 1596 and were outlawed as of 1613.[107] One of the primary functions of the *aalmoezeniers* was the pursuit of outlawed mendicants, who upon capture were put to work cutting hemp. The impoverished traveler or homeless vagrant might rest three days in De Bayert Gasthuis but was then sent back out onto the street. There was temporary relief but no guardianship for the poor. Speaking not callously but as a man of his time, John Evelyn noted with admiration "in this country . . . as no idle vagabonds are suffered (as in England they are), there is hardly a child of four or five years old, but they find some employment for it."[108] The English poor laws, we recall, were designed not for, but against, the poor. Though child labor had been denounced in the sixteenth century, at the height of the textile boom in Leiden, about 1638–40, as many as four thousand child workers were imported from Liège; beggar boys were said to have been brought to Leiden from as far away as Norwich, Douai, and Cleves.[109]

One of the great paradoxes of Dutch society, then, was that large sections of the population lived on the brink of penury amidst national prosperity and economic expansion. The cynic might assume that his charitable institutions and efforts on behalf of the commonweal were merely a form of atonement for material avidity, but the Dutchman took his own salvation seriously. Rarely was his piety feigned. The church, in turn, recognized that the Republic's survival depended upon its economic strength, hence commercial practices were not necessarily limited to those compatible with Christian ethics. The material world maintained the church and the church spiritually laundered material gains. Such reciprocity—an expression of the national spirit of practicality and tolerance—helped to reconcile the society's most striking contrasts: rapacity and restraint, austerity and largesse, piety and perdition. The rhythms of everyday existence swung between the reserved and the spontaneous, fiercely waste-conscious discipline and unbuttoned indulgence. The tavern, kermis,

and *musico* were simply compensations for the society's strict orthodoxies, be they devotional or domestic. The Dutch thus were eminently adaptable creatures whose rich and variegated pictorial record of their own daily life is one of the great cultural legacies of Western art. Dutch genre painting was, after all, one of the society's foremost achievements, speaking more eloquently of the people's concerns and character than any document or anecdote, statistical or literary.

P.C.S.

1. L. Barzini recently characterized Dutch painting as "the visible expression of [the Dutchman's] concentration on simple material things, the enjoyment of their private opulence, the contempt for glory and fame, the praise of the democratic associations and groups that ran their placid lives, the pleasing contemplation of the ruddy, well fed, happy faces of women, children and men at rest or busy at simple chores and of the pleasure of their flat watery land," in *The Europeans* (New York, 1983), p. 209.

2. Braudel 1981, p. 29.

3. On the Dutch revolt, see D. P. Block, W. Prevenier, and D. J. Roorda, eds., *Algemene Geschiedenis der Nederlanden*, vol. 4 (Amsterdam, 1980); P. Geyl, *The Revolt of the Netherlands 1555–1609* (London, 1962); Parker 1977; and Wilson 1977. Most discussions of daily life in the Netherlands in the seventeenth century have been based until recently on the invaluable studies of G.D.J. Schotel (1903 and 1905). See also G. Kalff, "Huiselijk en maatschappelijk leven onzer vaderen in de zeventiende eeuw," in *Amsterdam in de zeventiende eeuw*, 3 vols. (Amsterdam 1901–4), vol. 2, p. 2; Brugmans 1931; A.L.J. de Vrankrijker, *Het maatschappelijk leven in Nederland in de Gouden Eeuw* (Amsterdam, 1937); A. W. Franken, *Het leven onzer voorouders* (The Hague, 1942); Timmers 1959; P. Zumthor, *Het dagelijks leven in de Gouden Eeuw* (Utrecht and Antwerp, 1962); Haley 1972; Price 1974; E. Locher-Scholten, *Over rendierjagers, burgers en kabouters* (Amsterdam, n.d.); Regin 1976; A. Bailey, *Rembrandt's House* (Boston, 1978); T. Levie and H. Zantkuyl, *Wonen in Amsterdam in de 17de en 18de eeuw* (Purmerend, 1980); Thomas 1981; and A. T. van Deursen's very useful new series *Het Kopergeld van de Gouden Eeuw*, 4 vols. (Amsterdam, 1978; 2nd ed. Assen, 1980).

4. On the regents, see J. E. Elias, *Geschiedenis van het Amsterdamsche Regentpatriciaat* (The Hague, 1923).

5. Howell 1907, p. 19. In *A Brief Character of the Low Countries* (London, 1670), p. 53, O. Feltman also noted the many sects: "If you be unsettled in your Religion, you may here try all, and take at last what you like best. If you fancy none, you have a pattern to follow of two that would be a Church by themselves."

6. Temple 1972 (published in 1673). Typical of the anti-Dutch sentiments is Andrew Marvell's poem "Character of Holland," written in 1653.

7. Overbury 1856, p. 227.

8. At the inauguration of the Amsterdam Town Hall in 1655, Vondel wrote, "The cow's udder cannot enrich the city's life/ But sea trade builds it up and makes it thrive" (quoted by Regin 1976, p. 14).

9. Wilson 1977, pp. 64–66. Straining his metaphors, Prince Maurits called the unassuming herring the stone that the Dutch David placed in his sling to fell the Spanish Goliath; see van Deursen 1978a, p. 34 n. 178. On the Dutch fishing industry, see H.A.A. Kranenburg, *De zeevisscherij van Holland in den tijd der Republiek* (Amsterdam, 1946).

10. Howell 1907, vol. 1, p. 160.

11. Regin 1976, pp. 120–21; on Dutch trade, see Boxer 1977.

12. J. de Vries 1976, p. 132; on the trading companies, see D. Hanney, *The Great Chartered Companies* (London, 1926); and Boxer 1977, pp. 23–24, 44–48.

13. On the important Dutch grain trade, see J. G. van Dillen, in *Algemene Geschiedenis der Nederlanden* (Amsterdam, 1954), vol. 4, pp. 316–17; J. A. Faber, "The Decline of the Baltic Grain-Trade in the Second Half of the 17th Century," *Acta Historiae Neerlandica* (Leiden, 1966), vol. 1, pp. 108–31; J. de Vries 1974, pp. 171, 237; and J. de Vries 1976, pp. 72, 120, 161.

14. J. de Vries 1974, p. 240; on the Leiden textile industry, see N. W. Posthumus, *Bronnen tot de geschiedenis van de Leidsche textielnijverheid, 1611–50* (The Hague, 1914), vol. 4.

15. J. de Vries 1976, p. 92.

16. J. de Vries 1976, p. 165.

17. On the *trekschuit* and Dutch canals, see J. de Vries 1976, pp. 94, 173, 191; and J. de Vries, *Barges and Capitalism* (Utrecht, 1981).

18. The first to make this oft-repeated observation seems to have been von Zesen (1664, p. 216); see also Temple 1972, p. 97; and R. le Pays, *Amitie, amours et amourettes*, 2nd ed. (Paris, 1689), p. 199, which is quoted by Murris (1925, p. 63).

19. See Murris 1925, pp. 65–67; *Oeuvres complètes de Voltaire*, 22 vols. (Paris, 1823–25), vol. 14, p. 374; and *Voyages de Montesquieu* (Paris, 1896), vol. 2, p. 322.

20. See E. H. Krelage, *Bloemenspeculatie in Nederland, de tulipomanie van 1636–'37 en de hyacintenhandel 1720–'36* (Amsterdam, 1946).

21. J. de Vries 1976, pp. 204, 271 n. 15.

22. J. de Vries 1976, p. 213.

23. J. de Vries 1974, p. 242.

24. See E. Hobsbawm, "The Crisis in the Seventeenth Century," in *Crisis in Europe: 1560–1660* (New York, 1967); and J. de Vries 1974, pp. 114–17.

25. Howell observed: "There is no part of Europe so haunted with . . . foreigners. . . . This confluence of strangers makes them very populous" (Howell 1907, vol. 1, p. 163).

26. Van Deursen 1978a, pp. 54–71.

27. *Oeuvres complètes*, 12 vols. (Paris, 1897–1913), vol. 1, p. 203.

28. The newspaper is discussed by Schotel (1905, pp. 66–80); see also C. G. Gibbs, "The Role of the Dutch Republic as the Intellectual Entrepôt of Europe in the 17th and 18th Century," in *Bijdragen en mededelingen betreffende de geschiedenis der Nederlanden*, vol. 86 (1971), p. 340.

29. Wilson 1977, p. 170. A typical account of a Scottish nobleman's education at Leiden University in the 1650s is provided by the *Correspondence of Sir Robert Kerr* (Edinburgh, 1875); see also D. Thomson, *A Virtuous & Noble Education* (Edinburgh, 1971).

30. See J.G.C.A. Briels, *Zuidnederlandse immigratie in Amsterdam en Haarlem omstreeks 1572–1630* (1976).

31. See N. G. van Huffel, "De ontwikkeling der experimenteele wetenschap," ch. 5, in Brugmans 1931, vol. 1, pp. 332–89; see also Wilson 1977, pp. 93–117.

32. Temple 1972, p. 82.

33. Howell 1907, vol. 1, p. 160.

34. Temple 1972, p. 84.

35. See Murris 1925, pp. 91–92; F. A. Voltaire (see note 19), vol. 4, "Essai sur les moeurs et l'esprit des Nations," p. 336; and L'Honoré 1779, p. 37.

36. See Murris 1925, p. 93; le Comte de Guiche, *Memoires concernant les Provinces-Unies des Pays-Bas* (Utrecht, 1744), vol. 2, pp. 109–10.

37. An expression used repeatedly by French observers: le Labourer (1645/46), Boussingault (c. 1660), and the anonymous author (c. 1650) of *Memoires de Hollande* (Paris, 1678); see Murris 1925, p. 42.

38. J. van B.I.C. Tus, *Een onderscheyt boekje ofte tractaetje van de fouten en dwalingen der politie in ons Vaderlant* (Amsterdam, 1662); for discussion, see Boxer 1977, pp. 39–40.

39. See Regin 1976, p. 193; and Naumann 1981a (vol. 2, pp. 31–32) for additional discussion of this fashion.

40. Temple 1972, pp. 85–86; for Frenchmen's comments on the French affectations of the Dutch upper classes, see Murris 1925, pp. 11, 95.

41. Quoted by Regin 1976, p. 193.

42. See P. W. Klein, "Gouden eeuw en pruikentijd—een beeld van contrasten?" in *Spiegel historiael*, vol. 1 (1967), p. 550.

43. Overbury 1856, p. 226; see also Howell 1907, vol. 1, p. 160.

44. Price (1974, p. 48) discusses the income structure in Rotterdam using figures provided by the abortive income tax (*Familiegeld*) of 1674 (see W. F. Oldewelt, "De beroepsstructuur van de bevolking der Hollandse stemhebbende steden volgens de kohieren van familiegelden van 1674, 1715 en 1742," *Economic-historisch jaarboek*, vol. 24, pp. 90–91), concluding that the range of incomes "represented at least a modest level of prosperity."

45. On the Dutchman's sobriety and hard work, see Murris 1925, pp. 80, 93. Temple (1972, pp. 88, 96–97) wrote: "In general, all Appetites and Passions run lower and cooler here . . . [The Dutch] seek their happiness in the common Eases and commodities of Life, or the encrease of Riches; Not amusing themselves with the more speculative contrivance of Passion, or refinements of Pleasure."

46. For a review of the Dutch family, see D. Haks, "Het gezin tijdens het ancien regime: een historiografisch overzicht," in *Tijdschrift voor sociale geschiedenis*, vol. 6 (1980), pp. 236–70; and D. Haks, *Huwelijk en gezin in Holland in de 17de en 18de eeuw* (Assen, 1982).

47. Estimated by the Amsterdam publisher I. I. Schipper in the foreword to the first edition of Jacob Cats, *Alle de Wercken* (Amsterdam, 1655). The collected works were published four times between 1655 and 1665.

48. See Murris 1925, pp. 82, 104, 118–19; Saint-Evremond, *Oeuvres melées* (Amsterdam, 1706), vol. 2, pp. 252–54 (the author lived in Holland in 1661 and 1665–70). See also A. de la Barre de Beaumarchais, *Le Hollandais, ou lettres sur la Hollande ancienne et moderne* (Frankfurt, 1733), pt. 2, p. 255; L'Honoré 1779, p. 285; and P. J. Grosley, *Voyage en Hollande* [in 1772] (Paris, 1813), p. 209.

49. Temple 1972, p. 89: "I have known some among them that personated Lovers well enough but none that ever I thought were at heart in love."

50. The illustration (fig. 18) by Adriaen van de Venne appeared with the motto "De vrou is van been gemaekt uyt de man, waerom sy lichter blijft genegen 't kakebeen meer te rammelen" (Woman, created of man's rib, is prone to rattle her jawbone). See also Moryson 1971, pt. 3, p. 288.

51. Parival 1651, p. 19. Howell wrote, "for cleanliness [the Dutch] may serve for a pattern to all people. . . . After dinner they fall a-scouring of the pots, so that the outside will be as bright as the inside, and the kitchen suddenly so clean as if no meat had been dressed there a month before" (Howell 1907, vol. 1, p. 21).

52. J. Brickman, *Oprechte beschryving waer alle de Neder-landers, voornamenlijck de Hollanders haer aert, mannier en leven, als mede haer policy naecktelijck wert ontledet* (Delft, 1658), p. 6.

53. Rowen 1972, p. 102.

54. See Howell 1907, vol. 1, p. 163; L. Guicciardini, *Descrip-tion de tout le Pais-Bas* (Antwerp, 1567), p. 286; and Moryson 1971, pt. 3, bk. 4, p. 288.

55. For discussion of Dutch views and literature on women, see Schama 1980, p. 9.

56. See Murris 1925, p. 104; Haley 1972, p. 165; and Schama 1980, p. 6.

57. Moryson 1971, pt. 3, p. 34; on *kweesten*, see Schotel 1903, p. 215; Murris 1925, p. 97; Regin 1976, p. 97; and Schama 1980, p. 6.

58. On weddings, see Schotel 1903, pp. 236–84.

59. Rowen 1972, p. 102. Schotel (1903, p. 236) quotes the expression "Huwelyks pret en huyzen stichten, Kan een mensch de goudbeurs lichten" (Marriage's fun and setting up a house can lighten a man's purse).

60. Schotel 1903, p. 236: "Dat niemand op het huwelijk sluiten meer personen mocht ter maaltijd noodigen, als die daar over effective of met der daad gestaan hadden."

61. Slive 1970–74, vol. 1, p. 43.

62. On the kermis, see Schotel 1903, pp. 266–99.

63. Pierre le Jolle, *Description de la ville d'Amsterdam en vers burlesques selon la visite de six jours d'une semaine* (Amsterdam, 1666), p. 315. Diderot also was disgusted by the kermis; see Murris 1925, p. 126.

64. See Schotel 1903, p. 274.

65. See Regin 1976, pp. 122–24.

66. The pioneering study of the rhetoricians is G.D.J. Schotel's *Geschiedenis der rederijkers in Nederland,* 2nd ed., 2 vols. (Amsterdam, 1871). See also P. van Duyse, *De rederijkerskamers in Nederland,* 2 vols. (Ghent, 1900–1902); J. A. Worp, *Geschiedenis van den Amsterdamschen Schouwburg* (Amsterdam, 1920); Ellerbroeck-Fortuin 1937; J. J. Mak, *De Rederijkers* (Amsterdam, 1944); G. J. Steen-bergen, *Het landjuweel van de rederijkers* (Leuven, 1950); W.M.H. Hummelen, *De sinnekens in het rederijkersdrama* (Groningen, 1958); H. Pleij, "De sociale funktie van humor en trivialiteit op het rederijkersspelen," *Spektator,* vol. 5 (1975–76), pp. 108–27; F. C. Boheemen, *De Delfse rederij-kers "Wy rapen gheneucht"* (Amsterdam, 1982); H. Pleij, *Het gilde van de Blauwe Schuit* (Amsterdam, 1983).

67. Quoted by Ellerbroek-Fortuin 1937, p. 31: "veel schilders ende veel cloecke ende constige Gheesten so wel in Rhetorica als in schilderijen."

68. Heppner 1939–40, p. 23.

69. See van Dillen 1970, p. 464; and van Deursen 1978a, pp. 68–69.

70. See J. de Vries 1974, p. 212; and Price 1974, p. 118.

71. See the discussion of inventories in Woerden in J. de Vries 1974, p. 219; see also van Deursen 1978b, p. 84.

72. On Dutch literature see G. Kalff, *Geschiedenis der Nederlandsche letterkunde,* 7 vols. (Groningen, 1906–12); *Geschiedenis van de letterkunde der Nederlanden* (Antwerp, 1939 ff.), 8 vols. to date; G. Knuvelder, *Handboek tot de geschiedenis der Nederlandse letterkunde,* 4 vols. ('s-Her-togenbosch, 1957–61); for an introduction in English, see Price 1974, pp. 85ff.; Regin 1976, pp. 49–69; and R. P. Meijer, *Literature of the Low Countries* (London, 1978).

73. See G.D.H. Schotel, *Vaderlandsche volksboeken en volkssprookjes* 2 vols. (Haarlem, 1873–74); and van Deur-sen 1978b, ch. 4, pp. 84–110.

74. See G. A. Bredero, *De werken,* 3 vols. (Amsterdam 1921–29); see also J. ten Brink, *Gerbrand Adriaensen Bre-deroo* (Utrecht, 1859); and Amsterdam, Amsterdams Historisch Museum, *Gerbrandt Adriaensz. Bredero (1585–1618),* September 26, 1968–November 25, 1968.

75. *Boertigh, amoreus, en aendachtigh groot lied-boeck van G. A. Brederode, Amsteldammer* (Amsterdam, 1622).

76. A. A. van Rijnbach, ed., *Groot lied-boek van G. A. Brederode naar de oorspronkelijke uitgave van 1622* (Rotter-dam, 1968), p. 8. Bredero's full text indicates that he had in mind an approach much like that of the new realists—Esaias van de Velde, Willem Buytewech, and their contemporaries—who sought an alternative to mannerism's artificiality. "Het zijn de beste schilders die 't leven naast komen, en niet de-gene die voor een geestig dingen houden het stellen der standen buiten de nature et het wringen en buigen der geleden en gebeenderen, die zij vaak te onredelijk en buiten de loop des behoorlijksheids opschorten en ommekrommen." (The best painters are those who come closest to life and not those who think it witty to hold an unnatural pose, wringing and bending limbs and bones that are often flexed and dis-torted indecently and without reason.)

77. See Schotel 1903, pp. 176–92; Murris 1925, pp. 132–33; Price 1974, pp. 62–63; Regin 1976, pp. 144–45; and Parker 1977, p. 264.

78. See Parker 1977, p. 270.

79. As examples, see D. Heinsius's *Flora of Boomgaerd van liefelijke bloemen,* P. C. Hoofts's *Minne-zinnebeelden en gezangen,* J. Cats's *Maagdepligten en Maagdeklagten,* and, perhaps the most popular of all, Heemskerk's *Minnekunst.* Other poets who wrote love songbooks included Starter, Bre-dero, and Krul.

80. For a discussion, see Snoep 1968–69.

81. Moryson 1971, pt. 3, bk. 1, p. 34; quoted by Wilson 1977, p. 156.

82. See Schotel 1905, pp. 10–15.

83. van Beverwijck 1651, p. 617.

84. L. Guicciardini (see note 54), p. 37; Overbury wrote: "Concerning the people; they are neither much devout, nor much wicked; given all to drink, and eminently to no other vice; hard in bargaining, but just, surly and respectlesse, as in all democracies, thirstie, industrious and cleanly" (1856, p. 230).

85. Moryson 1971, pt. 3, p. 99.

86. T. de Viau, *Oeuvres complètes,* 2 vols. (Paris, 1855–56), vol. 2, p. 275; see Murris 1925, p. 122; on the tax exemp-tion, see Moryson 1971, pt. 3, p. 287; and Haley 1972, p. 118.

87. Quoted by Schotel 1905, p. 20. On taverns, "tabagies," coffeehouses, and the entertainment they provided see Schotel 1905, pp. 1–65; and van Deursen 1978b, pp. 44–46.

88. See Murris 1925, p. 99.

89. See J. de Vries 1976, p. 8.

90. See Braudel 1981, pp. 87–88.

91. See Haley 1972, p. 72.

92. See W. F. Oldewelt, *Kohier van de personeele quotisatie te Amsterdam over het jaar 1742*, 2 vols. (Amsterdam, 1945); for a brief discussion see T. Levie and H. Zantkuyl (see note 3), pp. 28–34.

93. G. Baudartius, *Memoryen*, 2nd ed., 2 vols. (Amsterdam, 1624) vol. 2, bk. 16, p. 63; quoted by van Deursen 1978a, p. 12.

94. Van Deursen 1978a, p. 13.

95. Van Deursen 1978a, p. 15.

96. See W. F. Oldewelt, "De zelfkant van de Amsterdamse samenleving en de groei der bevolking (1578–1795)," in *Tijdschrift voor geschiedenis*, vol. 77 (1964), pp. 39–56; and Amsterdam, Amsterdams Historisch Museum, *Arm in de Gouden Eeuw*, October 23, 1965–January 31, 1966.

97. On the war and rural populations, see G. Parker, *The Army of Flanders and the Spanish Road* (Cambridge, 1972), pp. 10–19; Fishman 1979, pp. 2–33; M. P. Gutmann, *War and Rural Life in the Early Modern Low Countries* (Princeton, N.J., 1980).

98. See M. P. Gutmann (see note 97), p. 32; and Fishman 1979, p. 6.

99. Temple 1972, p. 86; Adriaen van de Venne's *Tafereel van de belachende werelt* (The Hague, 1635) pokes fun at "brave Captains, like nobles, ranged side by side, beautiful and cruel, most clad in soft silk in the latest fashion."

100. Van Deursen 1978a, p. 45.

101. Constantijn Huygens, *Gedichten*, 4 vols. (Groningen, 1892–94), vol. 2, p. 7; quoted by van Deursen 1978a, p. 46.

102. Overbury 1856, p. 229; Howell wrote: "Martial discipline is nowhere so regular as amongst the States; nowhere are there lesser insolences committed upon the burgher, nor robberies upon the country boors, nor are the officers permitted to insult over the common soldier"; but he added: "I believe they would be insolent enough . . . were not the pay so certain" (1907, vol. 2, p. 159).

103. Van Deursen 1978a, p. 49.

104. See J. de B. Kemper, *Geschiedkundig onderzoek naar de armoede in ons vaderland* (Haarlem, 1851); C. A. van Manen, *Armenpflege in Amsterdam in ihrer historischen Entwicklung* (Leiden, 1913); Murris 1925, pp. 113–16; W. F. Oldewelt, "Het aantal bedelaars, vondelingen en gevangenen te Amsterdam in tijden van welvaart en crisis," *Jaarboek Amstelodamum*, vol. 39 (1942), pp. 21–34; W. F. Oldewelt, "Bestrijding van armoede en misdaad," in *Zeven eeuwen Amsterdam*, vol. 5 (Amsterdam, n.d.); *Arm in de Gouden Eeuw* (see note 96), pp. 34–40; and S. M. D'Moch Muller, "'Charitas' and 'Naastenliefde' in the Seventeenth Century: Pictures of Charity and the Poor for Dutch Charitable Institutions" (Ph.D. diss., University of California, Berkeley, 1982).

105. William Bray, ed., *The Diary of John Evelyn* (London, 1901), vol. 1, p. 22.

106. *Beschreibung der Stadt Amsterdam* (Amsterdam, 1664), pp. 316–17.

107. Van Deursen 1978a, p. 73; Howell, pp. 29–30; see also William Brereton, *Travels in Holland, The United Provinces, England, Scotland and Ireland 1634–1635* (Manchester, 1844), pp. 14, 31.

108. *The Diary of John Evelyn* (see note 105).

109. See Boxer 1977, p. 54.

Plates

PLATE I

David Vinckboons

Catalogue 121

Outdoor Merry Company, 1610
Oil and tempera on panel, 16⅛ x 26⅞" (41 x 68.3 cm.)
Gemäldegalerie der Akademie der bildenden Künste, Vienna, inv. no. 592

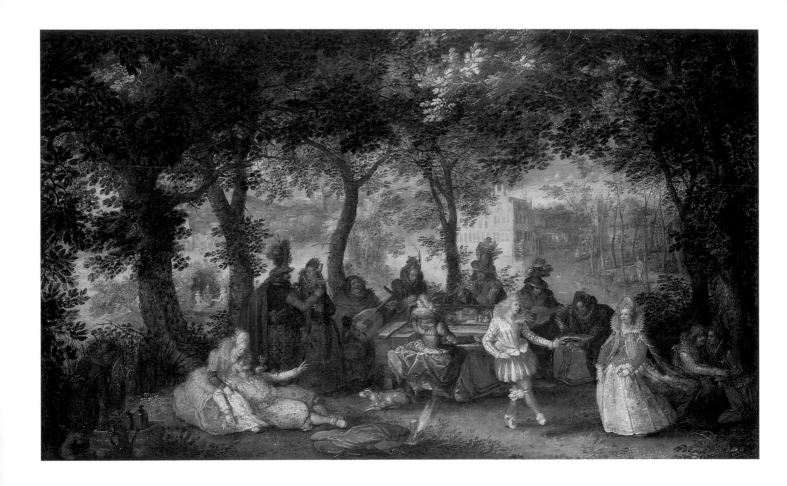

PLATE 2 David Vinckboons

Catalogue 122 *Peasant Kermis*, 1629
Oil on panel, 16 x 26⅝″ (40.5 x 67.5 cm.)
The Royal Cabinet of Paintings, Mauritshuis, The Hague, no. 542

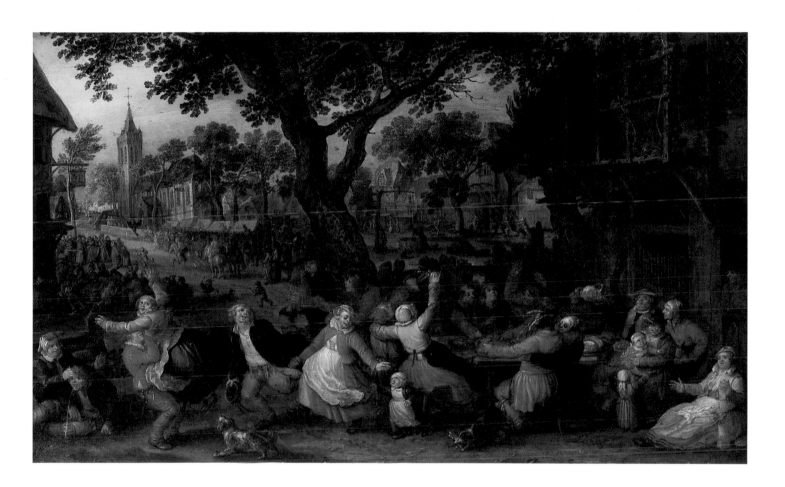

PLATE 3 Esaias van de Velde

Catalogue 112 *Party on a Garden Terrace*, before 1620
 Oil on canvas, 17 x 30¼″ (43 x 77 cm.)
 Gemäldegalerie, Staatliche Museen Preussischer Kulturbesitz, Berlin (West), no. 1838

PLATE 4 Esaias van de Velde

Catalogue 113 *Party in a Garden*, 1619
Oil on panel, 13⅜ x 20¼″ (34 x 51.5 cm.)
Frans Halsmuseum, Haarlem, no. 76-415

PLATE 5 Willem Buytewech

Catalogue 25 *Merry Company in the Open Air*, c. 1616–17
Oil on canvas, 28 x 37″ (71 x 94 cm.)
Gemäldegalerie, Staatliche Museen Preussischer Kulturbesitz, Berlin (West), on permanent loan

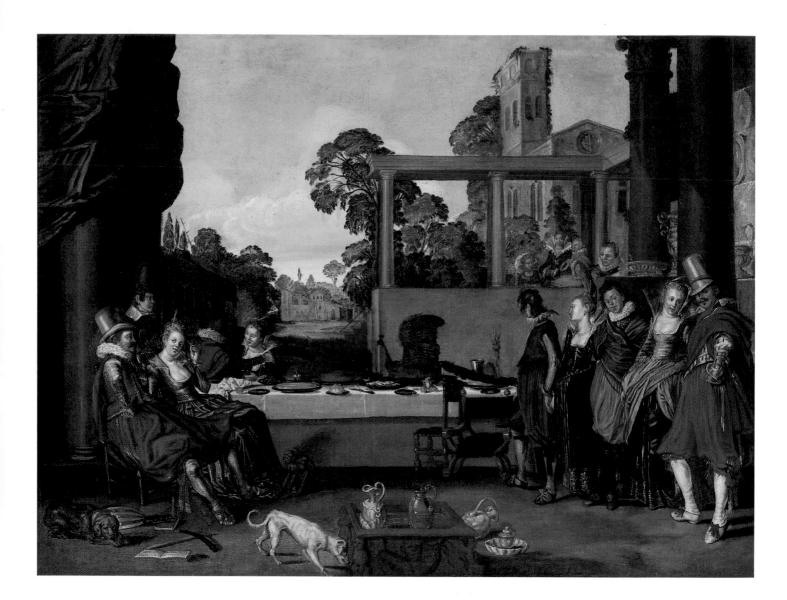

PLATE 6 Willem Buytewech

Catalogue 26 *Merry Company*, c. 1620–22
Oil on canvas, 28½ x 25¾″ (72.4 x 65.4 cm.)
Szépművészeti Múzeum, Budapest, no. 3831

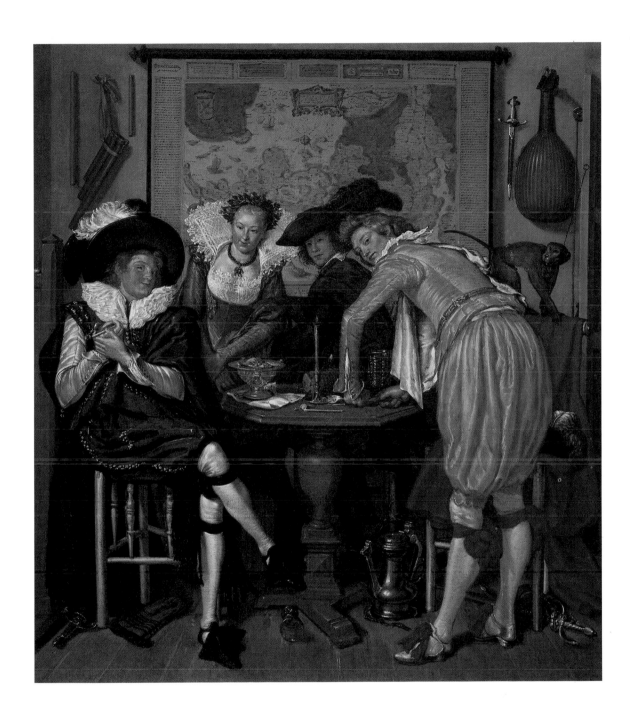

PLATE 7 Gerrit van Honthorst

Catalogue 48 *The Merry Fiddler*, 1623
 Oil on canvas, 42½ x 35" (108 x 89 cm.)
 Rijksmuseum, Amsterdam, no. A180

PLATE 8 Gerrit van Honthorst

Catalogue 49 *The Concert*, c. 1625
Oil on canvas, 66⅛ x 79½″ (168 x 202 cm.)
Galleria Borghese, Rome, no. 31

PLATE 9 Hendrick ter Brugghen

The Bagpipe Player, 1624
Oil on canvas, 39¾ x 32⅝″ (101 x 83 cm.)
Wallraf-Richartz-Museum, Cologne, no. 2613

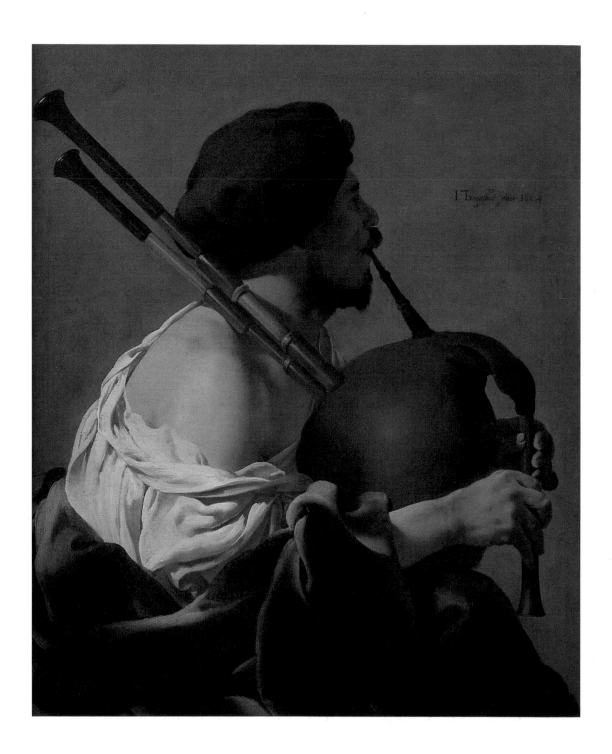

PLATE 10 Dirck van Baburen

Catalogue 1

The Procuress, 1622
Oil on canvas, 39¾ x 42¼" (101 x 107.3 cm.)
Museum of Fine Arts, Boston, Purchased, Maria T. B. Hopkins Fund, 50.2721

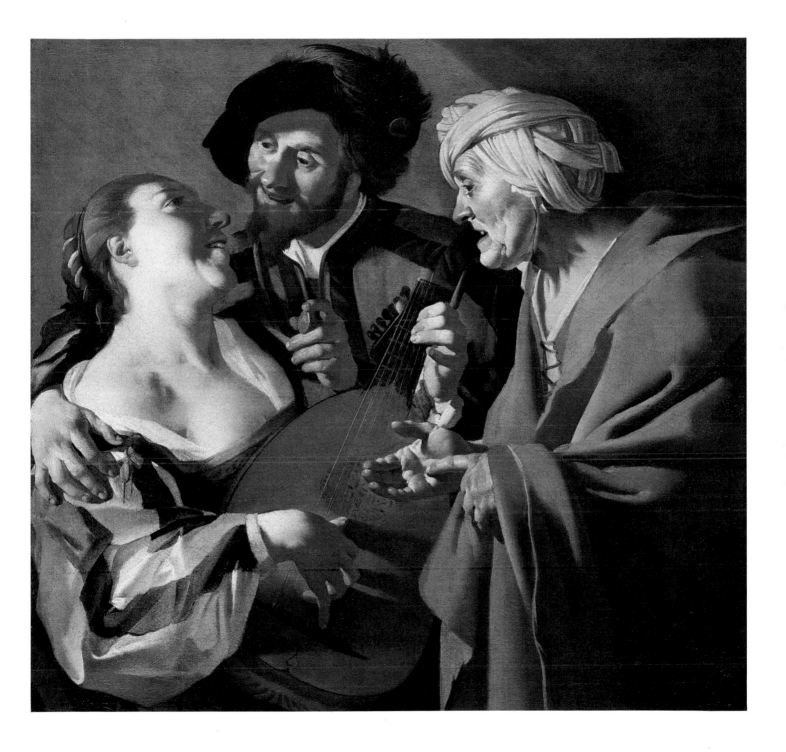

PLATE II Dirck Hals & Dirck van Delen

Catalogue 45 *Banquet Scene in a Renaissance Hall,* 1628
Oil on panel, 30½ x 53¼″ (77.5 x 135 cm.)
Gemäldegalerie der Akademie der bildenden Künste, Vienna, inv. no. 684

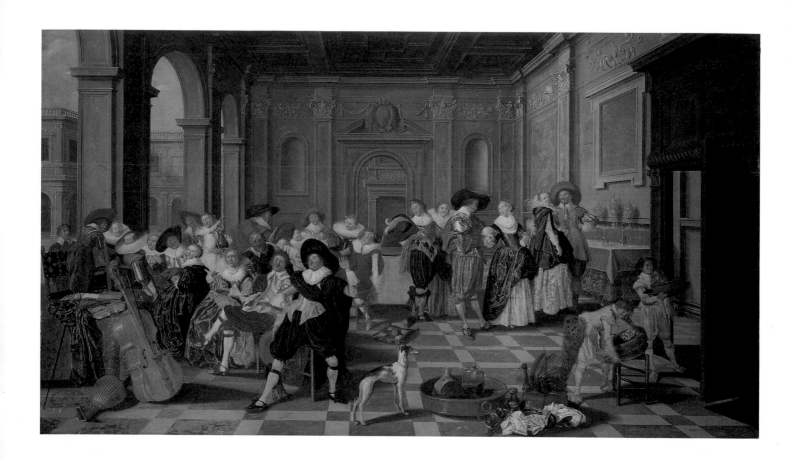

PLATE 12 Dirck Hals

Catalogue 46 *Seated Woman with a Letter,* 1633
Oil on panel, 13½ x 11⅛″ (34.3 x 28.3 cm.)
John G. Johnson Collection at the Philadelphia Museum of Art, no. 434

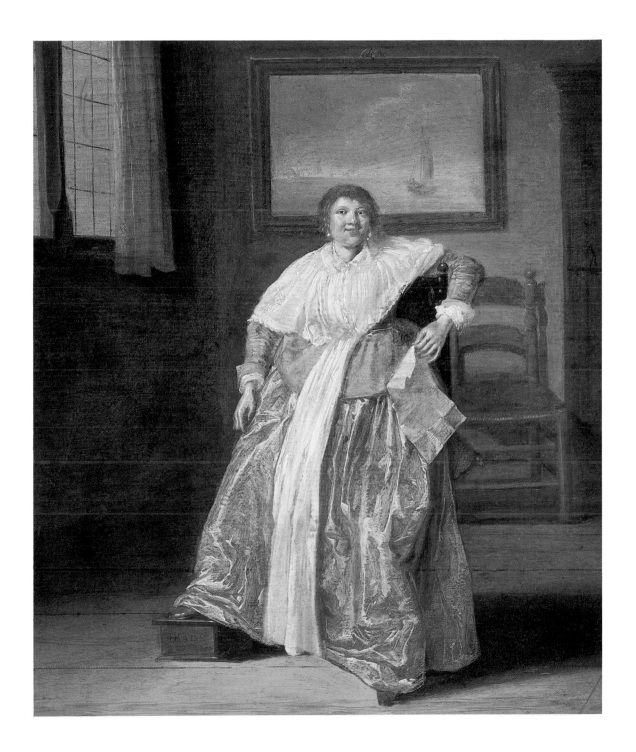

PLATE 13 Pieter Codde

Catalogue 27

Young Man with a Pipe, c. 1628–30
Oil on panel, 18⅛ x 13⅜″ (46 x 34 cm.)
Musée des Beaux-Arts, Lille, inv. no. 240

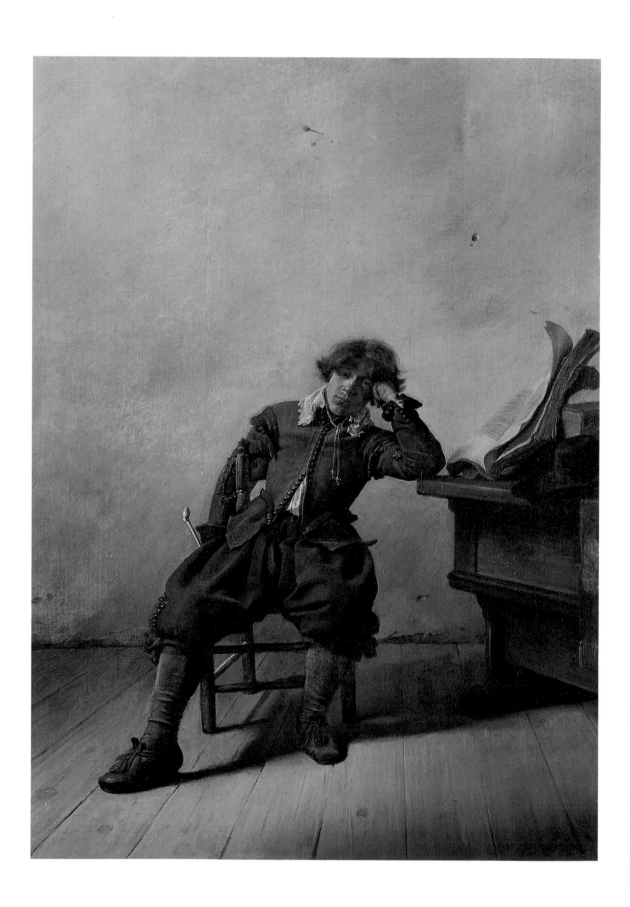

PLATE 14 Pieter Codde

Catalogue 28 *Dancing Party*, 163[0 or 6]
Oil on panel, 19⅝ x 34¼″ (50 x 87 cm.)
Private Collection, Wassenaar

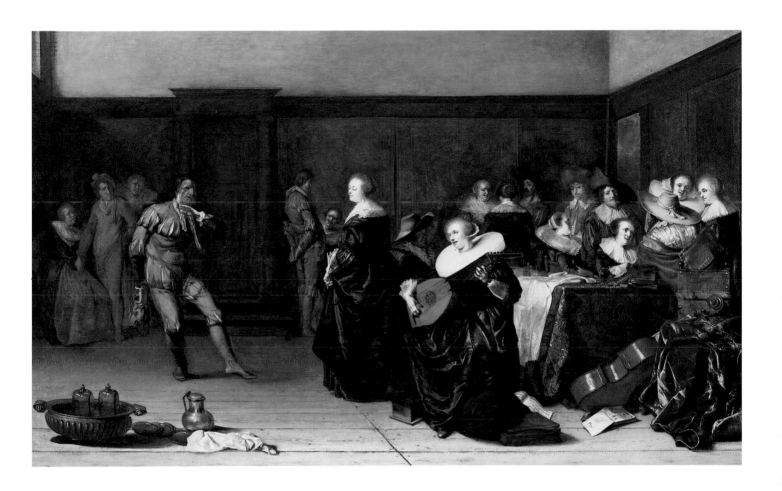

PLATE 15 Pieter Codde

Catalogue 29 *Merry Company,* 1631
Oil on panel, 20½ x 33½″ (52 x 85 cm.)
Private Collection, Montreal

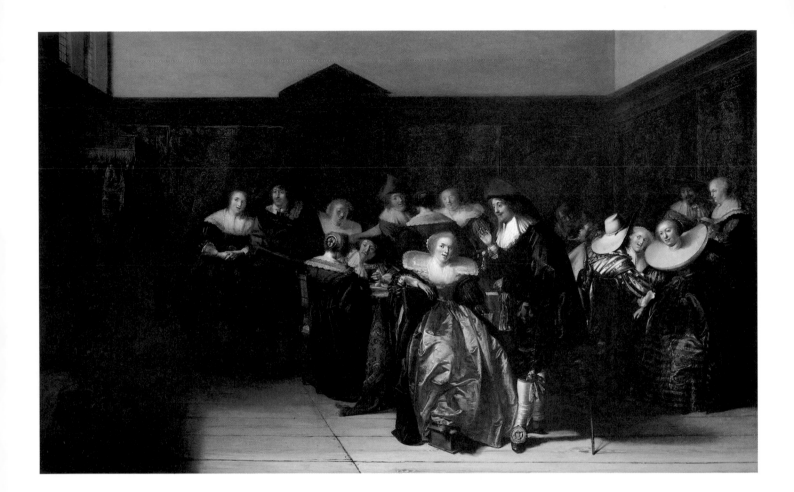

PLATE 16

Anthonie Palamedesz.

Elegant Company Gaming and Drinking, c. 1632–34
Oil on panel, 20¼ x 31½" (51.4 x 80 cm.)
Richard Green Galleries, London

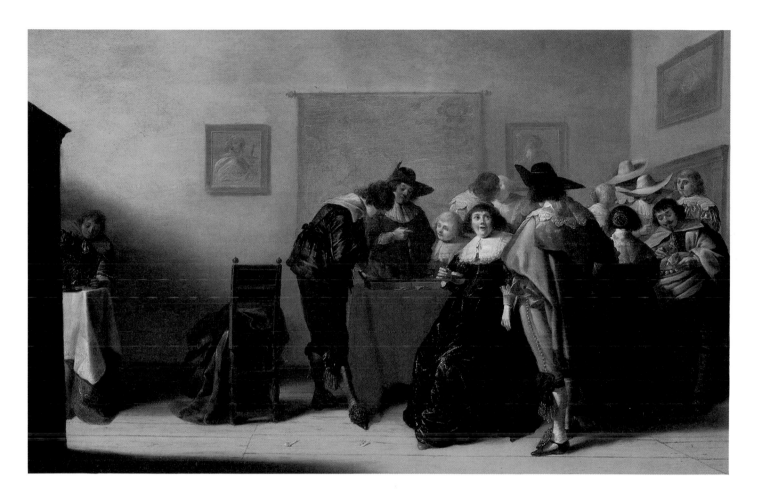

PLATE 17 Frans Hals

Singing Boy with a Flute, c. 1627
Oil on canvas, 24⅜ x 21½″ (62 x 54.6 cm.)
Gemäldegalerie, Staatliche Museen Preussischer Kulturbesitz, Berlin (West), no. 801A

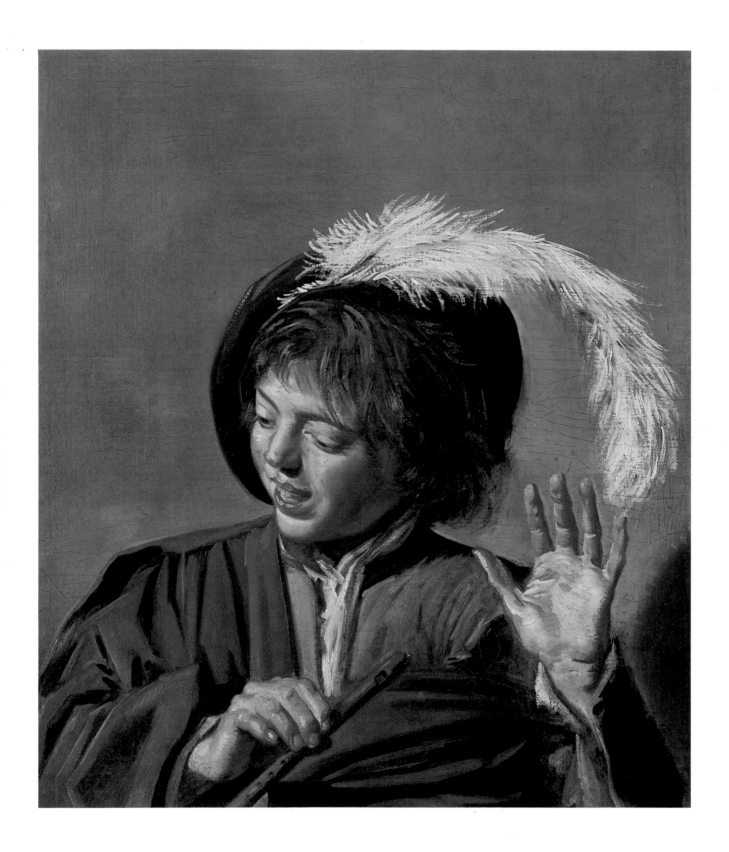

PLATE 18 Judith Leyster

Catalogue 61 *Merry Trio*, c. 1629–31
 Oil on canvas, 34⅝ x 28¾″ (88 x 73 cm.)
 Collection of Mr. and Mrs. P. L. Galjart, The Netherlands

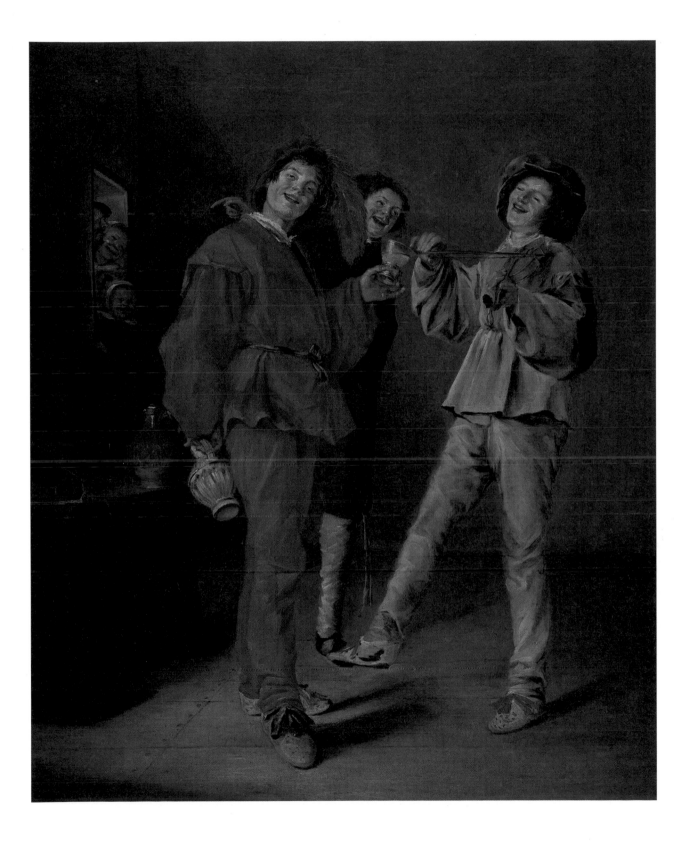

PLATE 19 Jan Miense Molenaer

Catalogue 77

The Duet, c. 1629–31
Oil on canvas, 26⅛ x 20½" (66.4 x 52.1 cm.)
Seattle Art Museum, Gift of the Samuel H. Kress Foundation, inv. no. 61.162

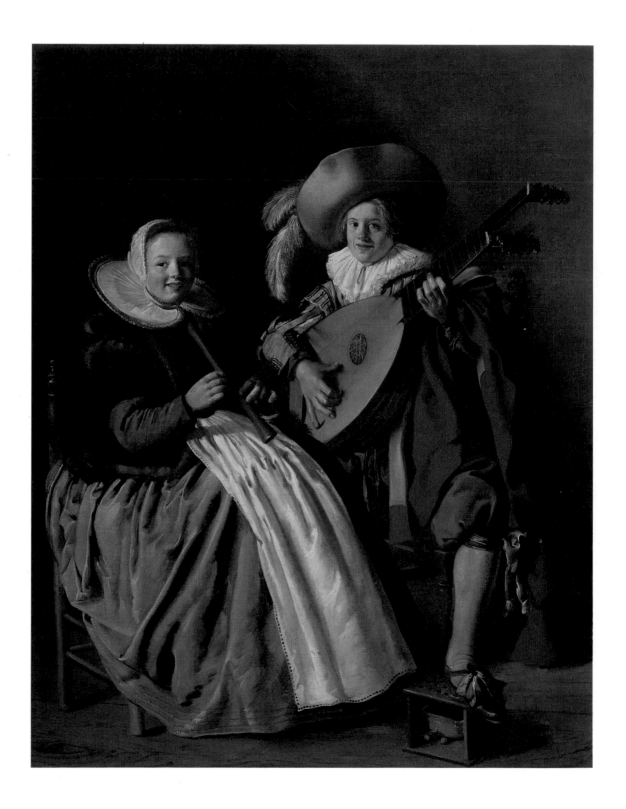

PLATE 20 Jan Miense Molenaer

Catalogue 78 *Woman at Her Toilet (Lady World)*, 1633
Oil on canvas, 40⅛ x 50″ (102 x 127 cm.)
The Toledo Museum of Art, Gift of Edward Drummond Libbey, no. 75.21

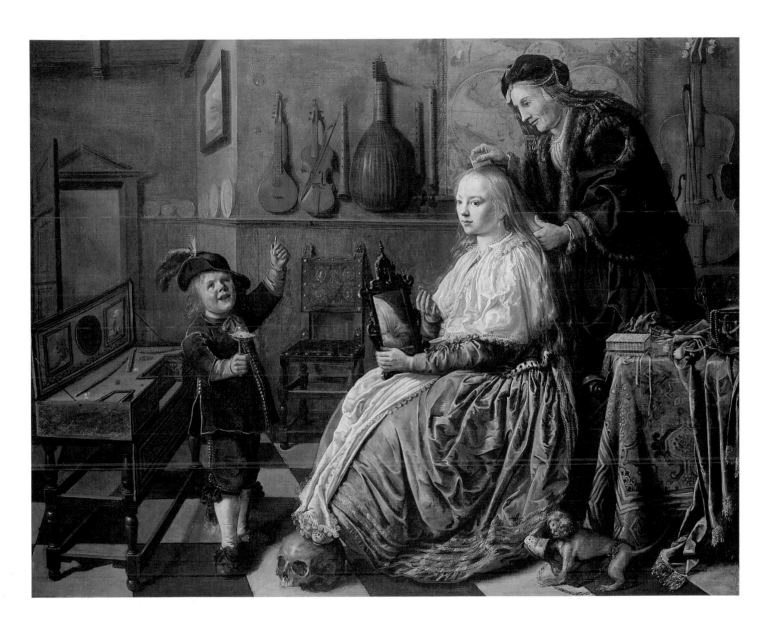

PLATE 21 Jan Miense Molenaer

Catalogue 79 *Boys with Dwarfs,* 1646
 Oil on canvas, 42½ x 50¾″ (108 x 129 cm.)
 Stedelijk Van Abbemuseum, Eindhoven

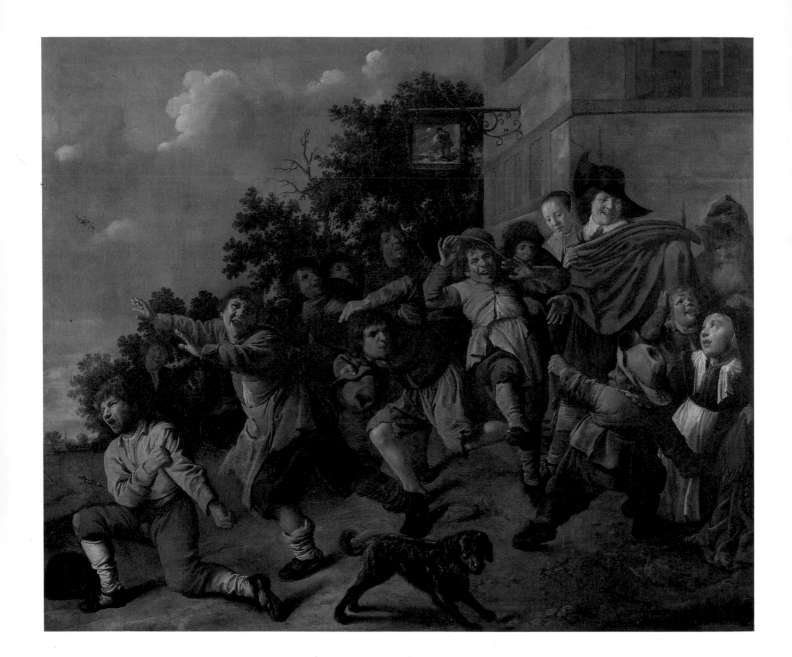

PLATE 22 Adriaen Brouwer

Catalogue 20 *The Pancake Baker,* mid-1620s
Oil on panel, 13¼ x 11⅛″ (33.7 x 28.3 cm.)
John G. Johnson Collection at the Philadelphia Museum of Art, no. 681

PLATE 23 Adriaen Brouwer

Catalogue 21 *The Smokers (The Peasants of Moerdijk)*, c. 1627–30
Oil on panel, 12¼ x 9½″ (31 x 24 cm.)
Private Collection

PLATE 24 Adriaen Brouwer

Catalogue 22 *Fight over Cards*, c. 1631–35
Oil on panel, 13 x 19¼″ (33 x 49 cm.)
Bayerische Staatsgemäldesammlungen, Alte Pinakothek, Munich, no. 562

PLATE 25 Adriaen Brouwer

Singing Drinkers, c. 1635–36
Oil on panel, 8⅛ x 6⅛″ (20.7 x 15.5 cm.)
Private Collection

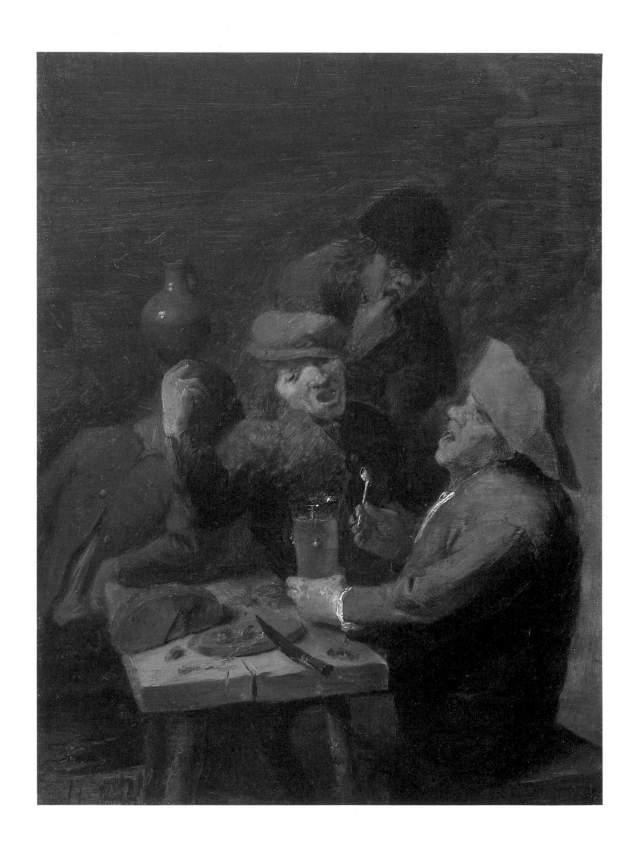

PLATE 26 Adriaen van de Venne

Catalogue 114 *Poor Luxury*, 1635
Oil on panel, 13 x 23⅝″ (33 x 60 cm.)
Museum Boymans–van Beuningen, Rotterdam, no. 1896

PLATE 27 Adriaen van Ostade

Catalogue 89 *Drinking Figures and Crying Children*, 1634
Oil on panel, 12¼ x 16⅞″ (31.1 x 42.8 cm.)
Sarah Campbell Blaffer Foundation, Houston

PLATE 28 Adriaen van Ostade

Catalogue 90 *Villagers Merrymaking at an Inn,* 1652
Oil on panel, 16¾ x 21⅞″ (42.5 x 55.5 cm.)
The Toledo Museum of Art, Gift of Edward Drummond Libbey, no. 69.339

PLATE 29 Adriaen van Ostade

Catalogue 91 *Interior of a Peasant's Cottage*, 1668
Oil on panel, 18⅜ x 16⅜″ (46.7 x 41.6 cm.)
Her Majesty Queen Elizabeth II

PLATE 30

Adriaen van Ostade

Catalogue 92

The Fishwife, 1672
Oil on canvas, 14⅜ x 15½" (36.5 x 39.4 cm.)
Rijksmuseum, Amsterdam, no. A3246

PLATE 31 Adriaen van Ostade

Catalogue 93 *The Cottage Dooryard*, 1673
Oil on canvas, 17⅜ x 15½" (44 x 39.5 cm.)
National Gallery of Art, Washington, D.C., Widener Collection, inv. no. 644

PLATE 32 Isaack van Ostade

Catalogue 94 *Rest by a Cottage,* 1648
 Oil on panel, 14¾ x 18⅞" (37.5 x 48 cm.)
 Frans Halsmuseum, Haarlem, no. 537a

PLATE 33 Cornelis Bega

Catalogue 2 *Merry Company in a Tavern*, 1661?
Oil on canvas, 15¾ x 21¼″ (40 x 54 cm.)
Musées Royaux des Beaux-Arts de Belgique, Brussels, inv. no. 3369

PLATE 34 Cornelis Bega

Catalogue 3 *The Alchemist,* 1663
 Oil on panel, 14 x 12½″ (35.5 x 31.7 cm.)
 H. Shickman Gallery, New York

PLATE 35 Cornelis Bega

Catalogue 4 *The Duet,* 1663
Oil on canvas, 17¾ x 16⅛″ (45 x 41 cm.)
Nationalmuseum, Stockholm, no. NM310

PLATE 36 Cornelis Dusart

Catalogue 41 *Pipe Smoker*, 1684
Oil on canvas, 18¾ x 15¾″ (47.6 x 40 cm.)
Private Collection, U.S.A.

PLATE 37 Willem Duyster

Catalogue 42 *Soldiers beside a Fireplace*, c. 1628–32
Oil on panel, 16¾ x 18¼″ (42.6 x 46.4 cm.)
John G. Johnson Collection at the Philadelphia Museum of Art, no. 445

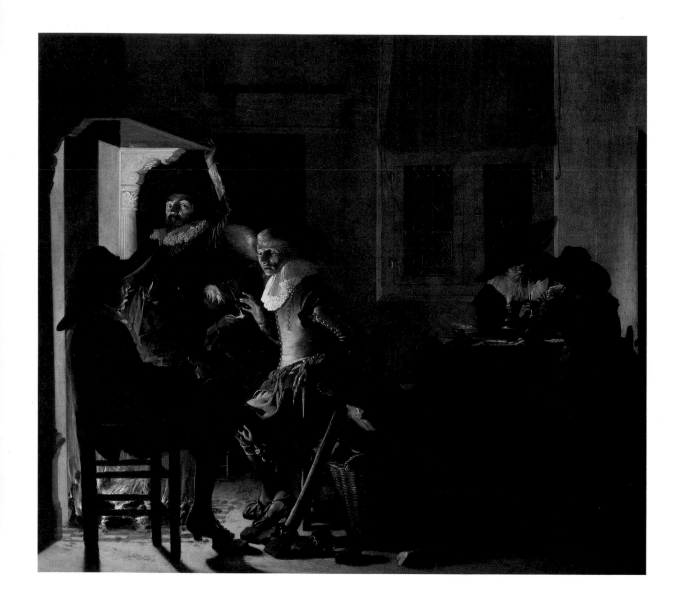

PLATE 38 Jacob Duck

Catalogue 36 *Soldiers Arming Themselves*, mid-1630s
 Oil on panel, 16⅞ x 22⅜″ (43 x 57 cm.)
 H. Shickman Gallery, New York

PLATE 39 Jacob Duck

Catalogue 37 *Card Players and Merrymakers*, c. 1640
Oil on panel, 18⅜ x 29″ (46.7 x 73.7 cm.)
Worcester Art Museum, Worcester, Massachusetts, no. 1974.337

PLATE 40 Jacob Duck

Catalogue 38

Sleeping Woman, 1650s
Oil on panel, 9½ x 7¾″ (24.1 x 19.7 cm.)
Collection of Peter Eliot

PLATE 41 Simon Kick

Catalogue 58

Company of Soldiers, mid to late 1640s
Oil on panel, 48 x 48″ (122 x 122 cm.)
Private Collection

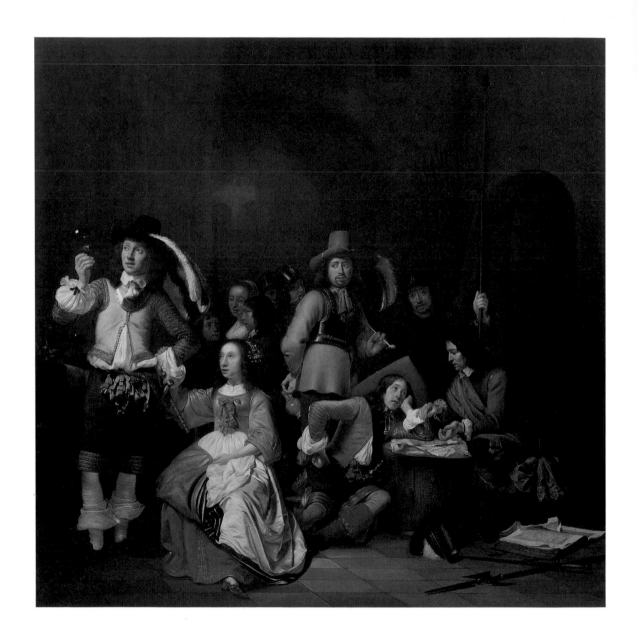

PLATE 42 Abraham Bloemaert

Catalogue 7 *Shepherd and Shepherdess,* 1627
Oil on canvas, 23½ x 29¼″ (59.7 x 74.3 cm.)
Niedersächsisches Landesmuseum, Hannover, PAM917

PLATE 43 Pieter van Laer

Catalogue 60 *Landscape with Mora Players (The Small Limekiln)*, c. 1636–37
Oil on panel, 13⅛ x 18½" (33.3 x 47 cm.)
Szépművészeti Múzeum, Budapest, no. 296

PLATE 44 Jan Lingelbach

Catalogue 62 *The Cake Seller,* late 1640s
Oil on canvas, 13 x 16½″ (33 x 42 cm.)
Galleria Nazionale d'Arte Antica, Palazzo Corsini, Rome, no. 1009

PLATE 45 Jan Lingelbach

Village Festival, early 1650s
Oil on canvas, 34½ x 47½" (87.6 x 120.7 cm.)
Castle Museum, Nottingham, inv. no. 04-92

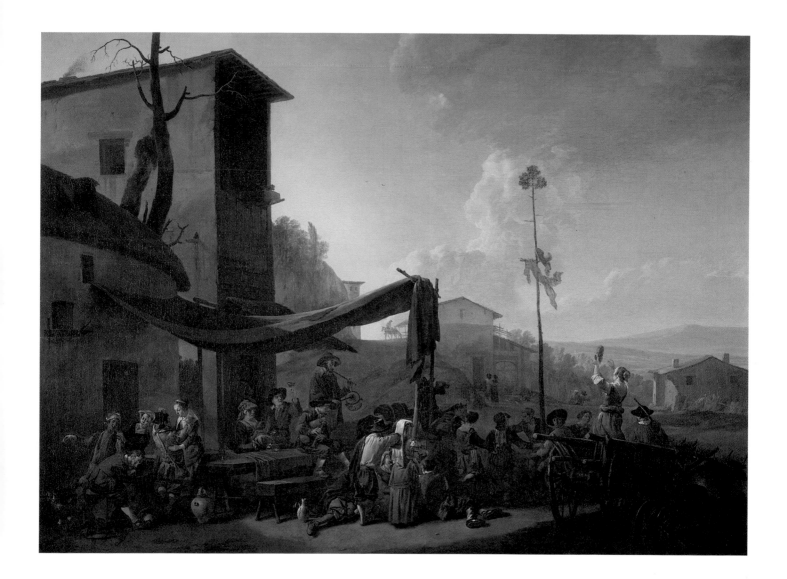

PLATE 46 Jan Miel

Catalogue 73 *Carnival in the Piazza Colonna, Rome*, c. 1645
Oil on canvas, 35 x 69¼″ (89 x 176 cm.)
Wadsworth Atheneum, Hartford, The Ella Gallup Sumner and Mary Catlin Sumner Collection,
1938.603

PLATE 47 Michael Sweerts

Catalogue 111 · *The Academy*, c. 1656–58
Oil on canvas, 30⅛ x 43¼″ (76.5 x 110 cm.)
Frans Halsmuseum, Haarlem, no. 270

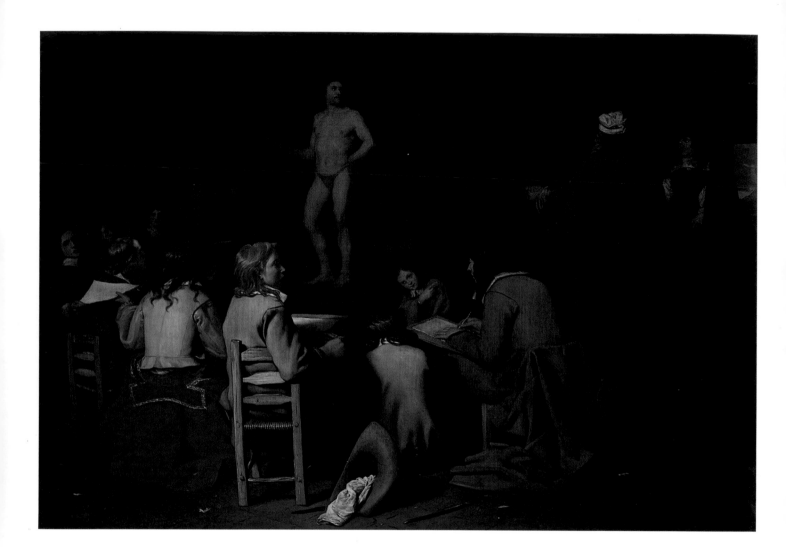

PLATE 48 Jan Baptist Weenix

Catalogue 124 *Mother and Child with Cat*, 1647
Oil on canvas, 18½ x 17″ (47 x 43 cm.)
Private Collection, New York

PLATE 49 Karel Dujardin

Catalogue 39

Tale of the Soldier, 1650s
Oil on canvas, 35 x 31½″ (89 x 80 cm.)
Yale University Art Gallery, New Haven, Leonard C. Hanna, Jr., BA 1913, Fund, 1966.84

PLATE 50 Karel Dujardin

Catalogue 40 *Young Woman Milking a Red Cow,* 1650s
Oil on canvas, 26 x 23¼" (66 x 59 cm.)
Nationalmuseum, Stockholm, NM485

PLATE 50

PLATE 51 Nicolaes Berchem

Catalogue 5

A Moor Presenting a Parrot to a Lady, mid-1660s
Oil on canvas, 37 x 35″ (94 x 89 cm.)
Wadsworth Atheneum, Hartford, The Ella Gallup Sumner and Mary Catlin Sumner Collection,
1961.29

PLATE 52 Gerard Dou

Catalogue 31 *Man Writing in an Artist's Studio*, c. 1628–31
 Oil on panel, 12⅜ x 9⅞″ (31.5 x 25 cm.)
 Private Collection, Montreal

PLATE 53 — Gerard Dou

Catalogue 32 *Woman Eating Porridge*, c. 1632–37
Oil on panel, 20¼ x 16⅛″ (51.5 x 41 cm.)
Private Collection

PLATE 54 Gerard Dou

Catalogue 33

Girl Chopping Onions, 1646
Oil on panel, 7¼ x 5⅞″ (18.4 x 14.9 cm.)
Her Majesty Queen Elizabeth II

PLATE 55 Gerard Dou

The Young Mother, c. 1660
Oil on panel, 19⅜ x 14⅜" (49.1 x 36.5 cm.)
Gemäldegalerie, Staatliche Museen Preussischer Kulturbesitz, Berlin (West), no. KFMV 269

PLATE 55 Gerard Dou

The Young Mother, c. 1660
Oil on panel, 19⅜ x 14⅜" (49.1 x 36.5 cm.)
Gemäldegalerie, Staatliche Museen Preussischer Kulturbesitz, Berlin (West), no. KFMV 269

PLATE 56 Gerard Dou

Catalogue 35 *Astronomer by Candlelight*, late 1650s
Oil on panel, 12⅝ x 8⅜" (32 x 21.3 cm.)
Private Collection

PLATE 57 Frans van Mieris

Catalogue 74

The Peasant Inn, 1655–57
Oil on panel, 14⅞ x 11⅞" (37.9 x 30.1 cm.)
Stedelijk Museum "De Lakenhal," Leiden

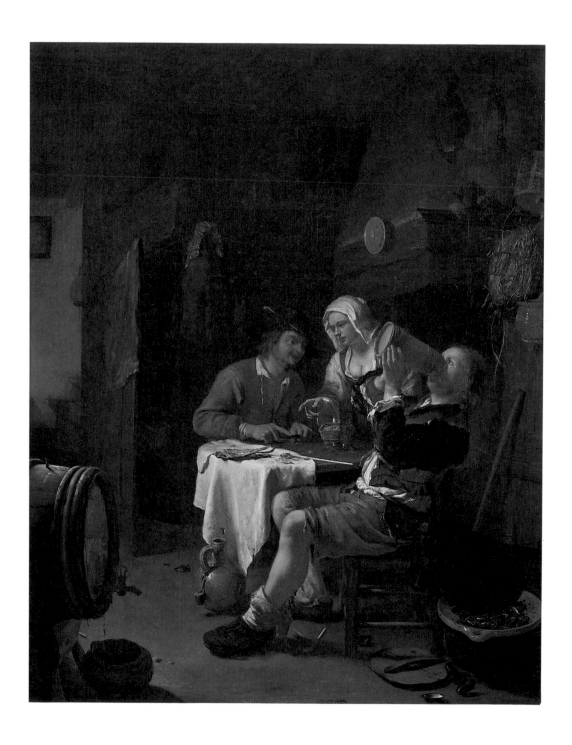

PLATE 58 Frans van Mieris

Catalogue 75 *Teasing the Pet*, 1660
Oil on panel, 10⅞ x 7⅞″ (27.5 x 20 cm.)
The Royal Cabinet of Paintings, Mauritshuis, The Hague, no. 108

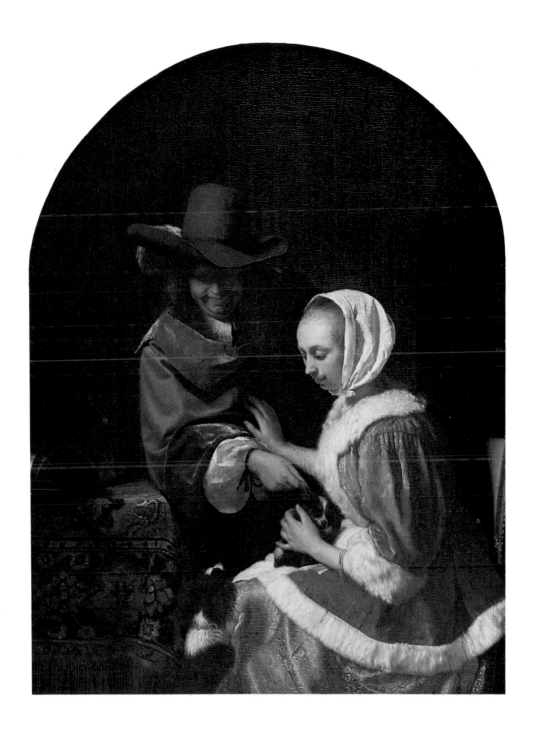

PLATE 59 Frans van Mieris

Catalogue 76 *Young Woman Standing before a Mirror*, 1670?
Oil on panel, 16⅞ x 12⅜" (43 x 31.5 cm.)
Bayerische Staatsgemäldesammlungen, Alte Pinakothek, Munich, no. 219

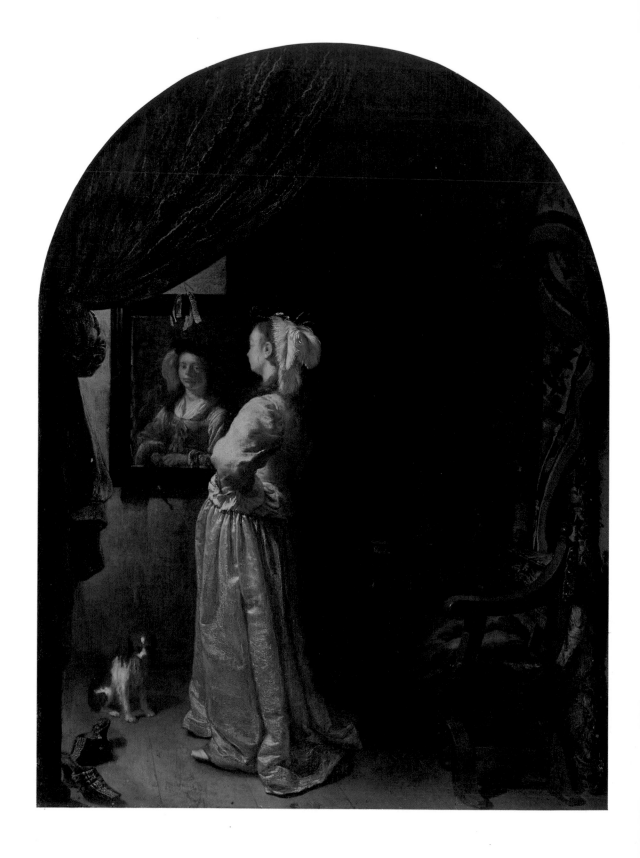

PLATE 60 Quirijn van Brekelenkam

Catalogue 17 *Woman Combing a Child's Hair,* 1648
Oil on panel, 22½ x 21″ (57 x 53.5 cm.)
Stedelijk Museum "De Lakenhal," Leiden, no. 47

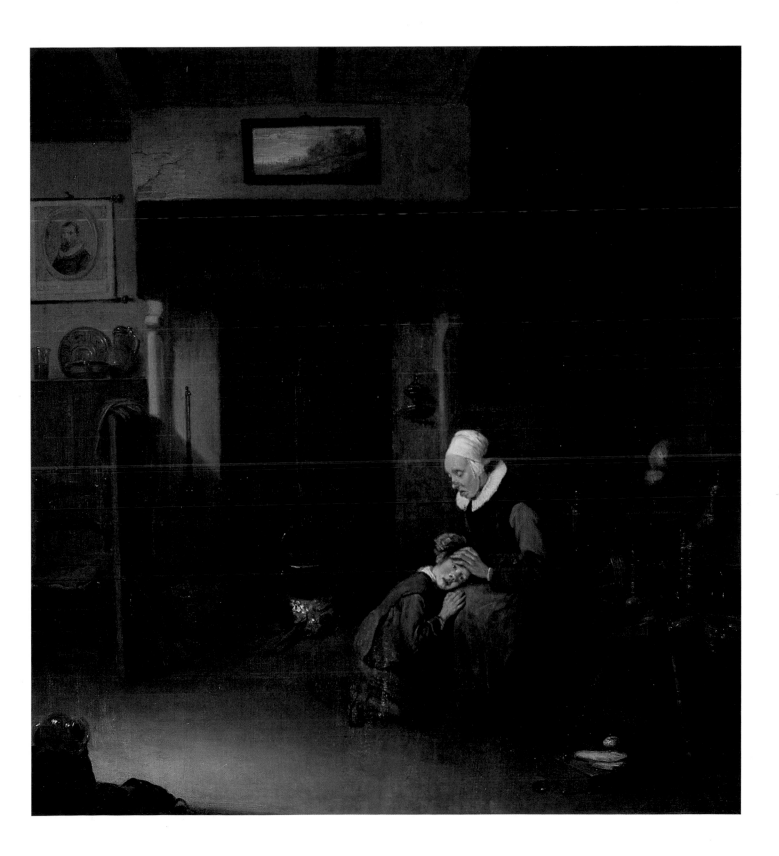

PLATE 60 Quirijn van Brekelenkam

Catalogue 17 *Woman Combing a Child's Hair,* 1648
Oil on panel, 22½ x 21″ (57 x 53.5 cm.)
Stedelijk Museum "De Lakenhal," Leiden, no. 47

PLATE 61 Quirijn van Brekelenkam

Catalogue 18 *Interior of a Tailor's Shop,* 1653
Oil on panel, 23⅝ x 33½" (60 x 85 cm.)
Worcester Art Museum, Worcester, Massachusetts, no. 1910.7

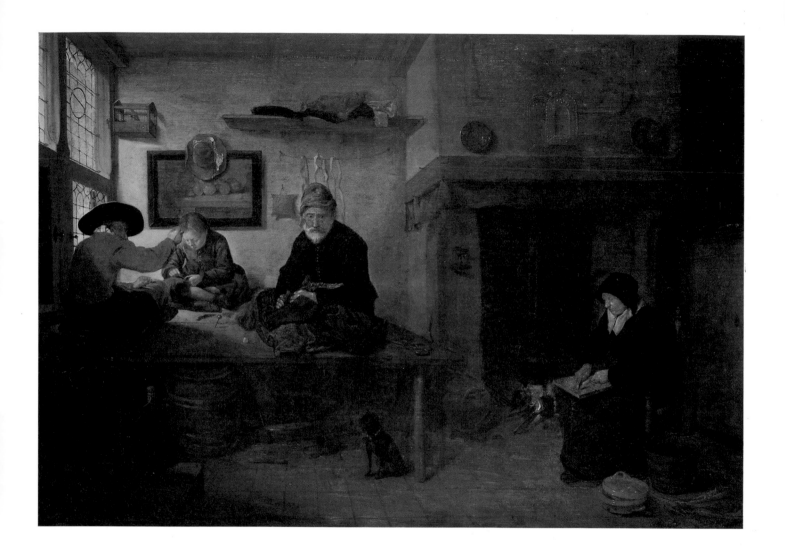

PLATE 62 Quirijn van Brekelenkam

Catalogue 19 *Man Spinning and Woman Scraping Carrots*, c. 1653–54
Oil on panel, 23¼ x 30½" (59 x 77.5 cm.)
John G. Johnson Collection at the Philadelphia Museum of Art, no. 535

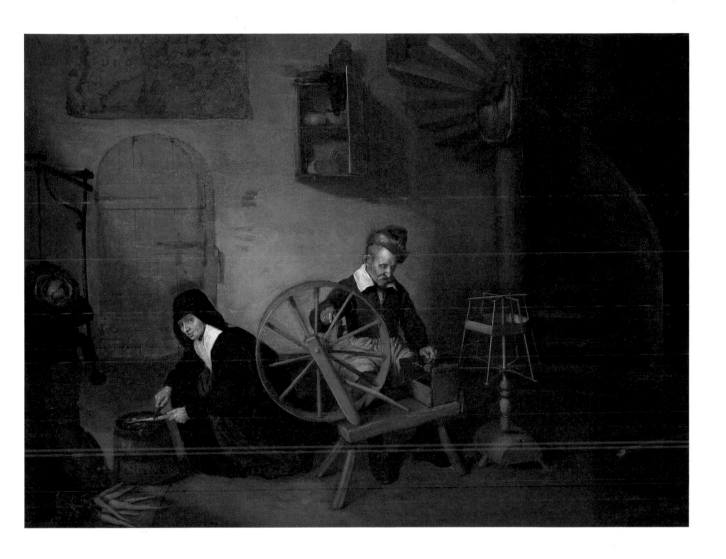

PLATE 63 Isaack Koedijck

Catalogue 59

The Foot Operation, late 1640s or c. 1650
Oil on panel, 35⅝ x 28½″ (90.5 x 72.5 cm.)
Private Collection, Great Britain

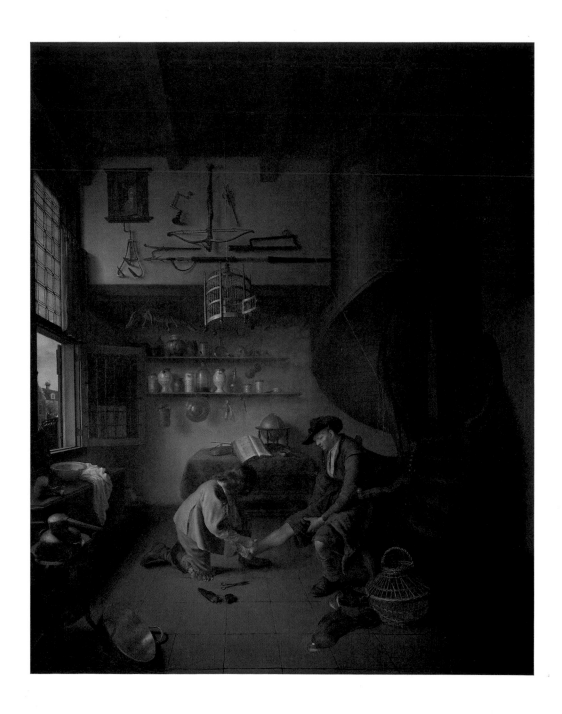

PLATE 64 Gabriel Metsu

Catalogue 70 *Interior of a Smithy,* mid to late 1650s
Oil on canvas, 25¾ x 28⅞″ (65.4 x 73.3 cm.)
The Trustees of the National Gallery, London, no. 2591

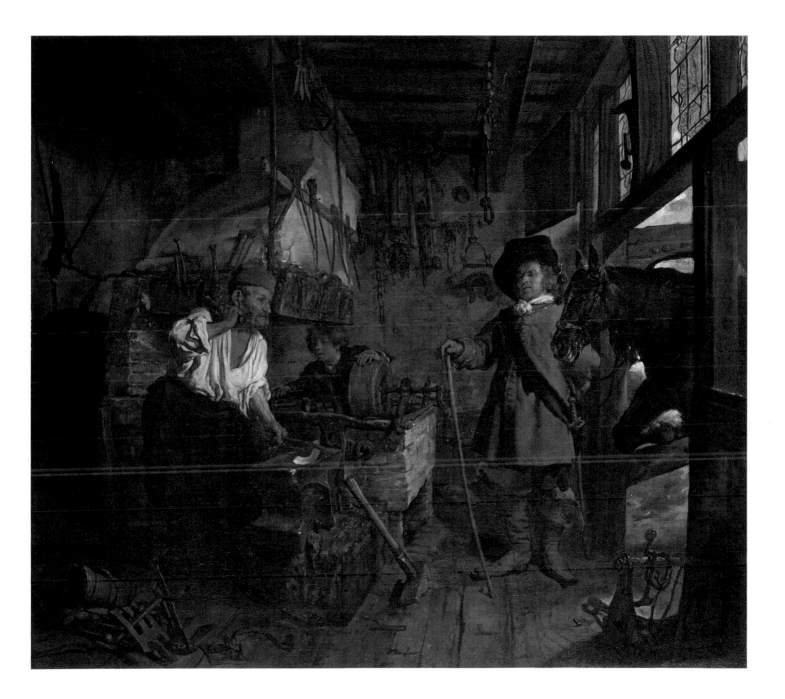

PLATE 65 Gabriel Metsu

Catalogue 71 *The Hunter's Gift,* c. 1658–60
Oil on canvas, 20 x 18⅞″ (51 x 48 cm.)
Rijksmuseum, Amsterdam, no. C177

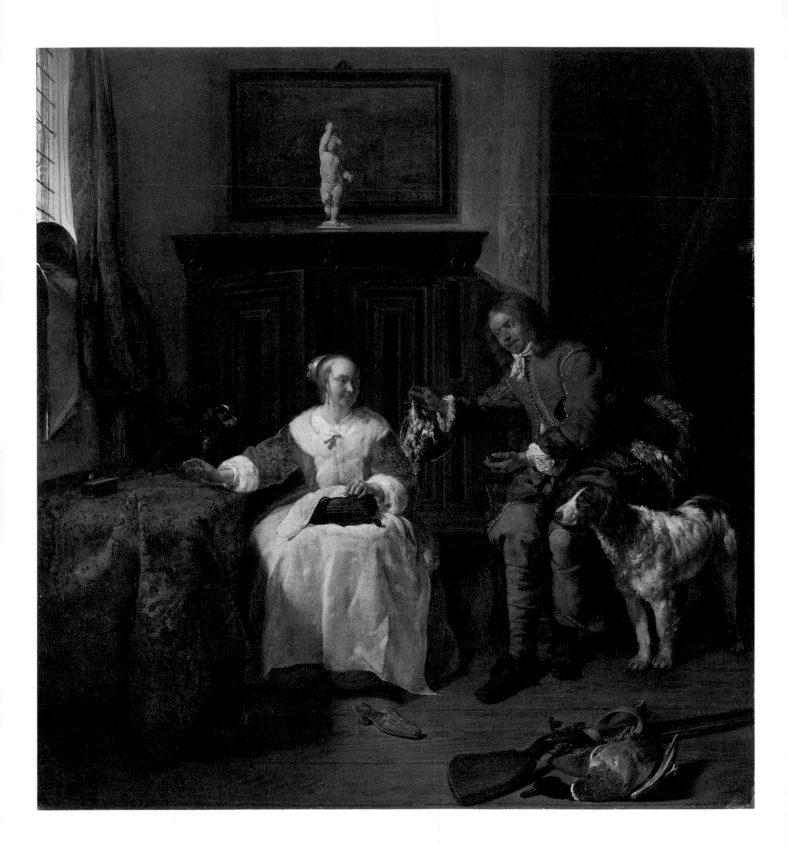

PLATE 66 Gabriel Metsu

Catalogue 72 *Music Party,* 1659
 Oil on canvas, 24½ x 21⅜″ (61.6 x 54.3 cm.)
 The Metropolitan Museum of Art, New York, Gift of Henry G. Marquand, 1890, 91.26.11

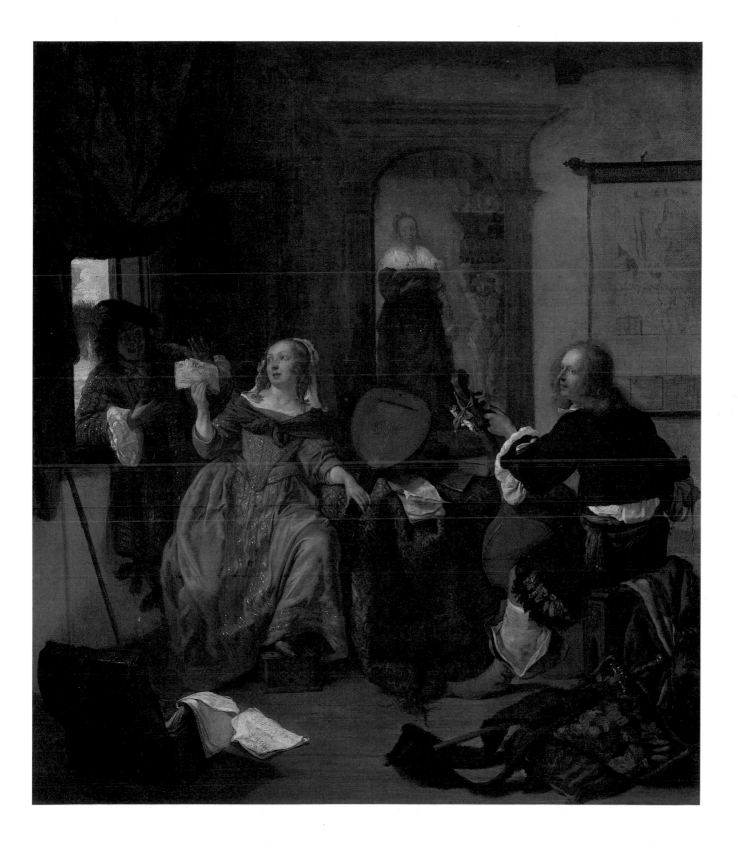

PLATE 66 Gabriel Metsu

PLATE 67 Gerard ter Borch

Catalogue 8 *The Family of the Stone Grinder*, c. 1653–55
Oil on canvas, 28⅜ x 23¼″ (72 x 59 cm.)
Gemäldegalerie, Staatliche Museen Preussischer Kulturbesitz, Berlin (West), no. 793

PLATE 68 Gerard ter Borch

Catalogue 9 *Parental Admonition*, c. 1654–55
Oil on canvas, 27½ x 23⅝″ (70 x 60 cm.)
Gemäldegalerie, Staatliche Museen Preussischer Kulturbesitz, Berlin (West), no. 791

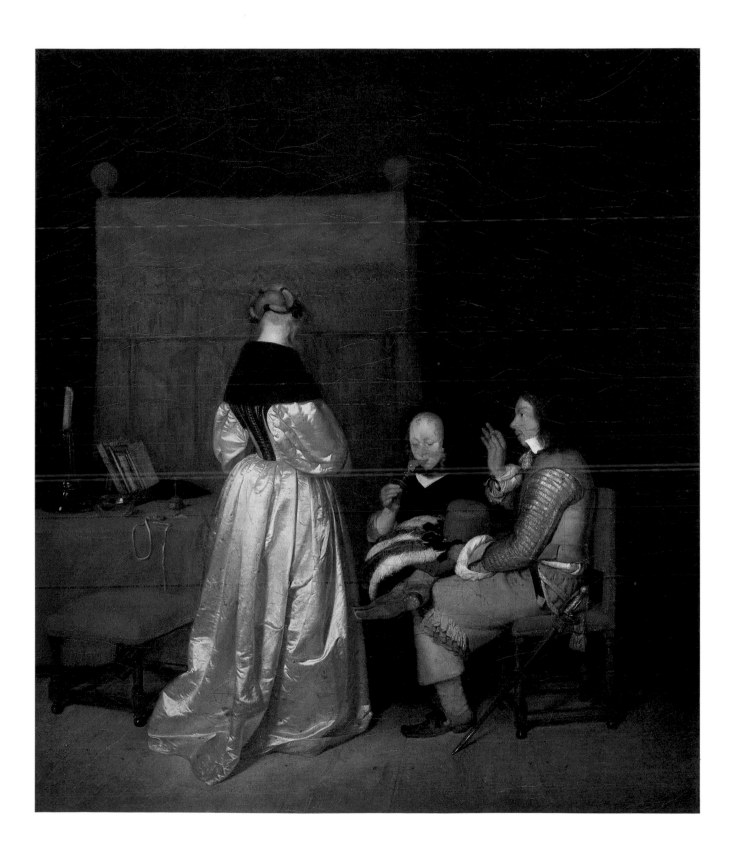

PLATE 69 Gerard ter Borch

Catalogue 10 *Officer Writing a Letter, with a Trumpeter (The Dispatch)*, c. 1658–59
Oil on canvas, 22⅜ x 17¼″ (56.8 x 43.8 cm.)
Philadelphia Museum of Art, William L. Elkins Collection, E24-3-21

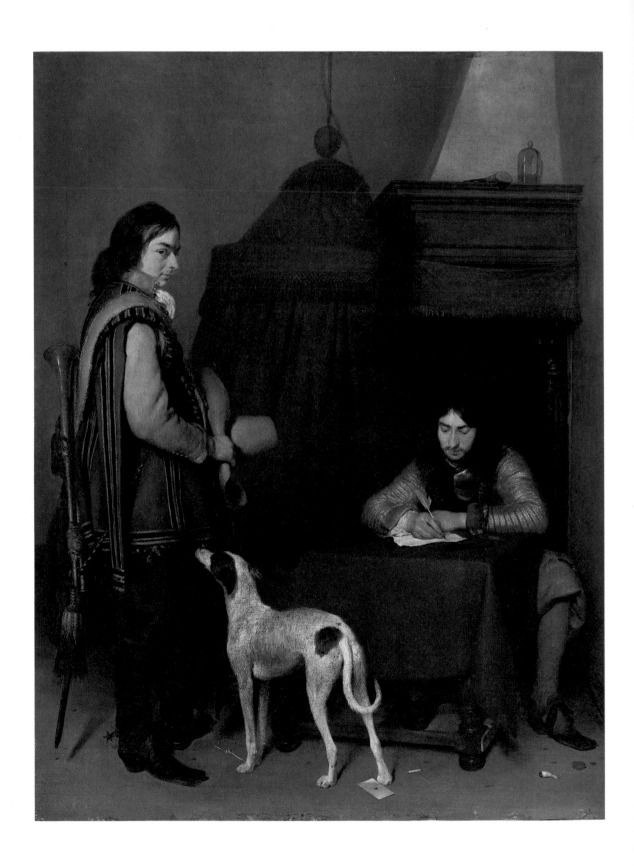

PLATE 70

Gerard ter Borch

Catalogue 11

Woman Drinking Wine with a Sleeping Soldier, early 1660s
Oil on canvas, transferred from panel, 15⅜ x 13⅝" (39 x 34.5 cm.)
Private Collection

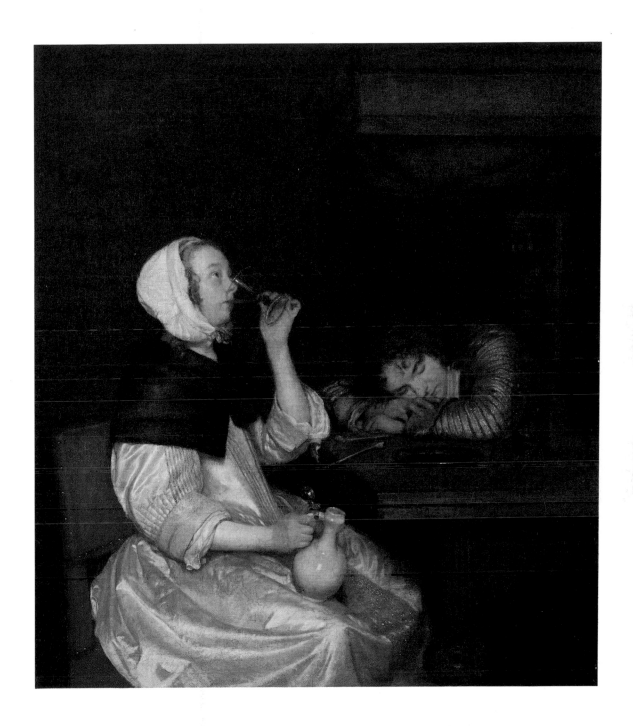

PLATE 71 Gerard ter Borch

Catalogue 12 *Curiosity*, c. 1660
 Oil on canvas, 30 x 24½" (76.2 x 62.2 cm.)
 The Metropolitan Museum of Art, New York, The Jules S. Bache Collection, 1949, 49.7.38

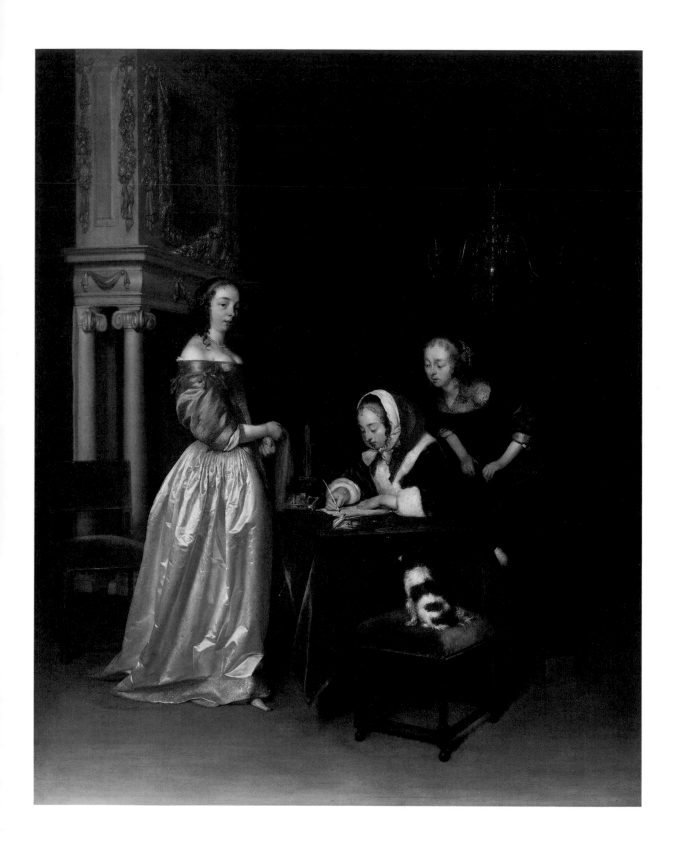

PLATE 72

Gerard ter Borch

Lady at Her Toilet, c. 1660
Oil on canvas, 30 x 23½″ (76.2 x 59.7 cm.)
The Detroit Institute of Arts, Founders Society Purchase, Eleanor Clay Ford Fund, General
Membership Fund, Endowment Income Fund, and Special Activities Fund, no. 65.10

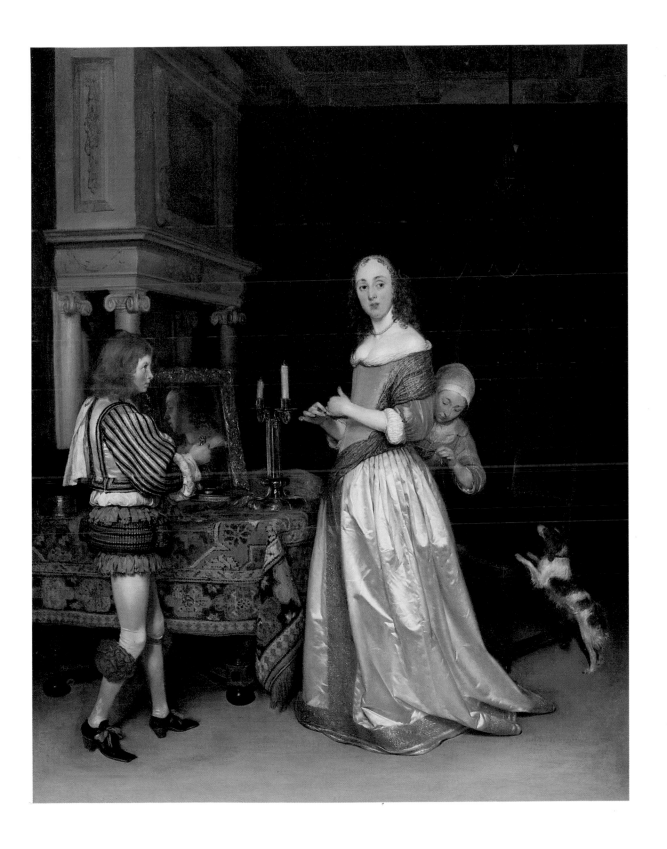

PLATE 73 Gerard ter Borch

Catalogue 14 *Woman Peeling Apples,* c. 1660
Oil on canvas, 14⅛ x 12" (36 x 30.5 cm.)
Kunsthistorisches Museum, Gemäldegalerie, Vienna, inv. no. GG588

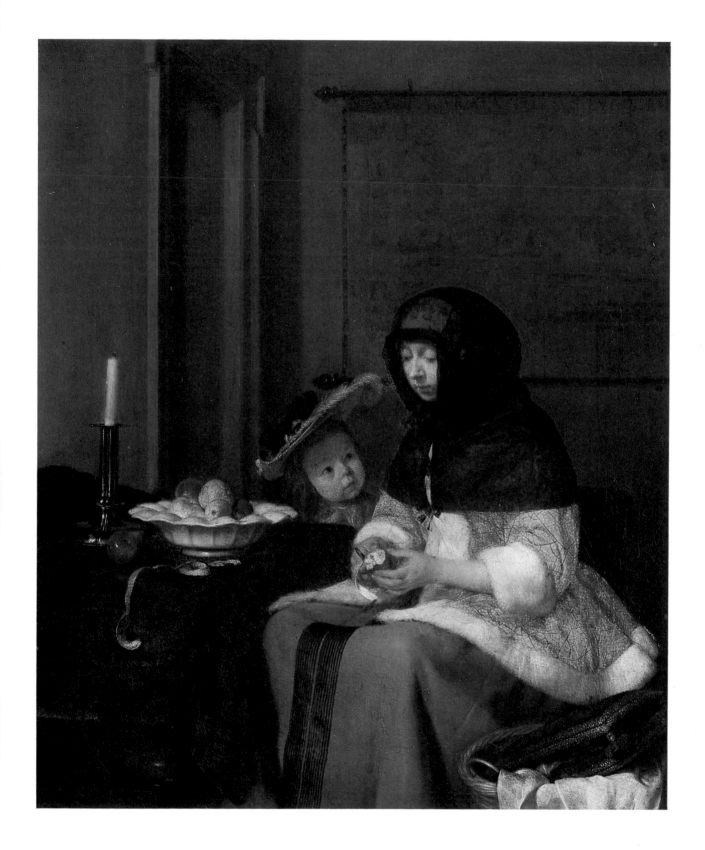

PLATE 73 Gerard ter Borch

Catalogue 15 *Soldier Offering a Young Woman Coins*, c. 1662–63
Oil on canvas, 26¾ x 21¾″ (68 x 55.2 cm.)
Musée du Louvre, Paris, inv. no. 1899

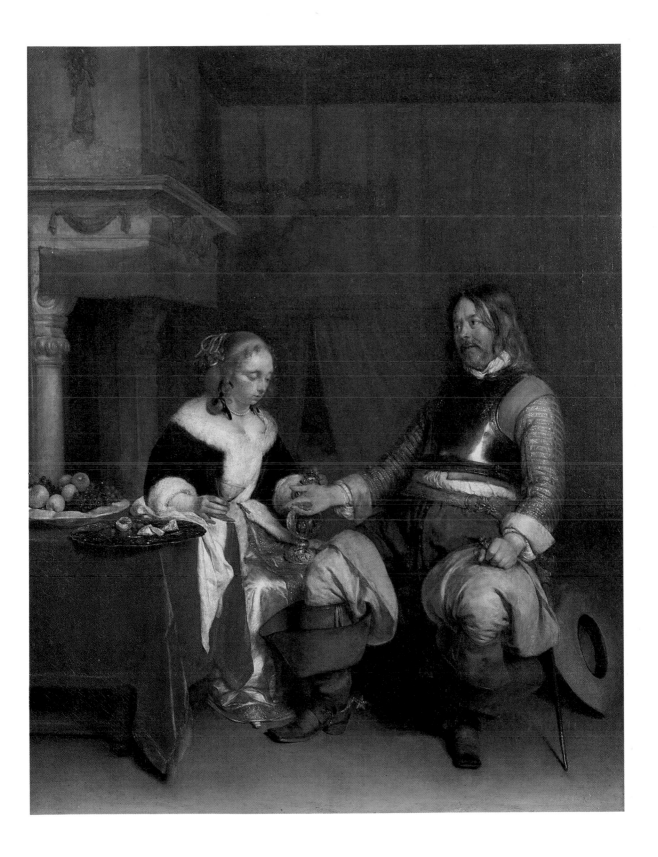

PLATE 75 Caspar Netscher

Catalogue 83

Chaff Cutter with a Woman Spinning and a Young Boy, c. 1662–64
Oil on canvas, 26 x 31" (66 x 79 cm.)
John G. Johnson Collection at the Philadelphia Museum of Art, no. 544

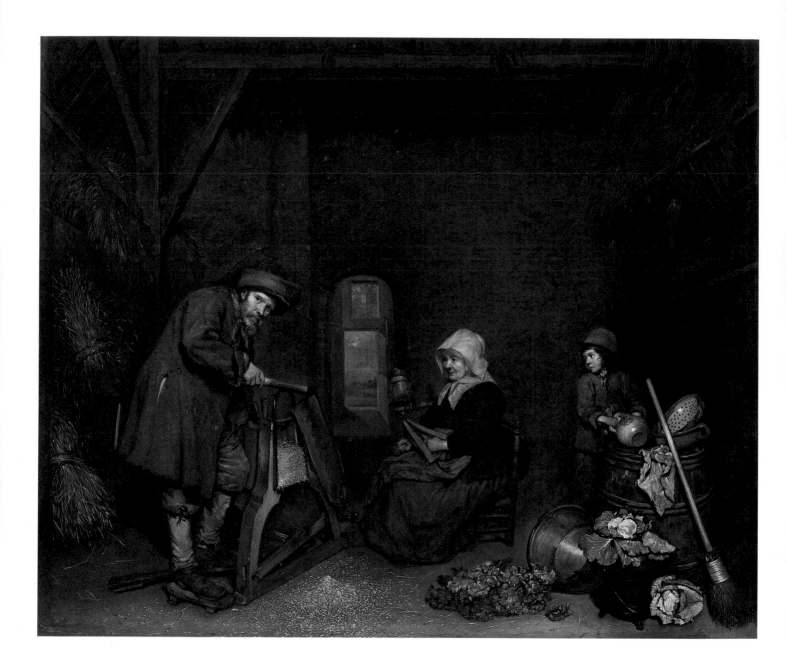

PLATE 76 Caspar Netscher

Catalogue 84

Musical Company, 1665
Oil on canvas, 19⅞ x 18″ (50.4 x 45.7 cm.)
Bayerische Staatsgemäldesammlungen, Alte Pinakothek, Munich, no. 618

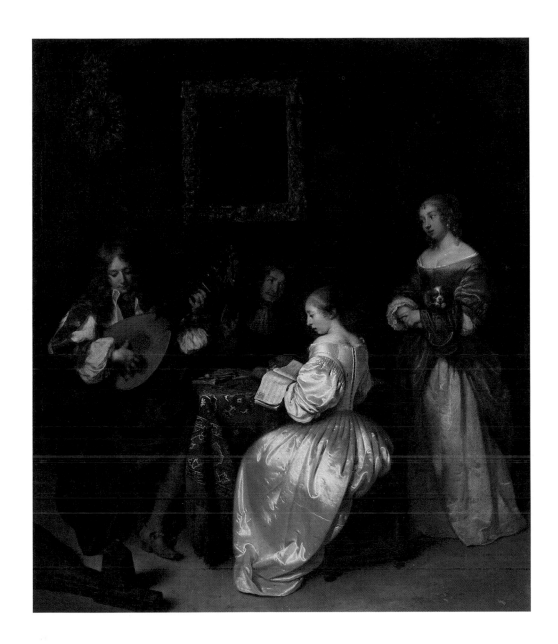

PLATE 77 Caspar Netscher

Catalogue 85 *Presentation of a Medallion Portrait*, c. 1665–68
Oil on canvas, 24⅜ x 26⅝" (62 x 67.5 cm.)
Szépművészeti Múzeum, Budapest, no. 250

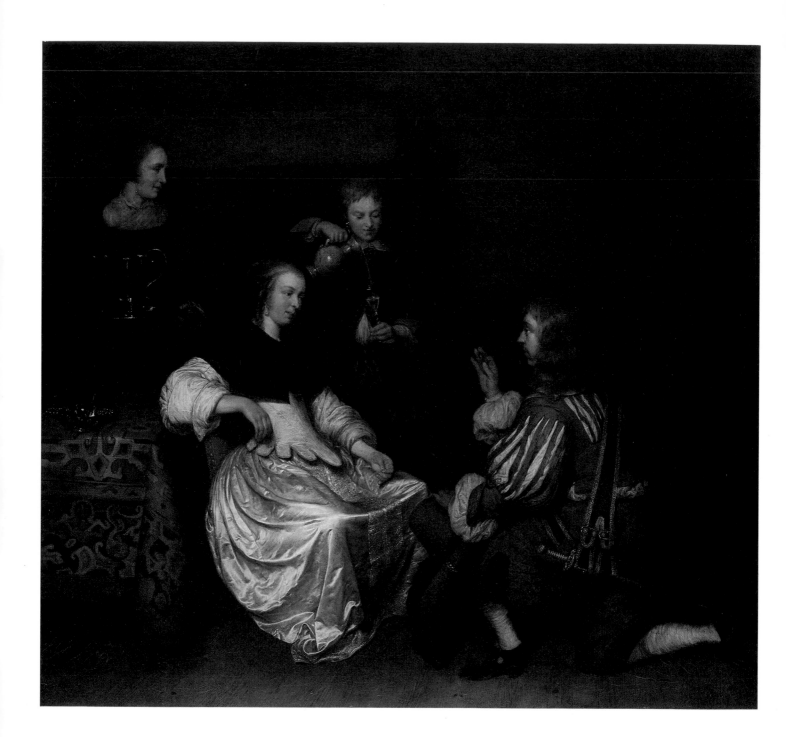

PLATE 78 Jan Steen

Catalogue 102 *Prayer before the Meal*, 1660
 Oil on panel, 20¾ x 17½" (52.7 x 44.5 cm.)
 The Walter Morrison Collection, Sudeley Castle, Gloucestershire

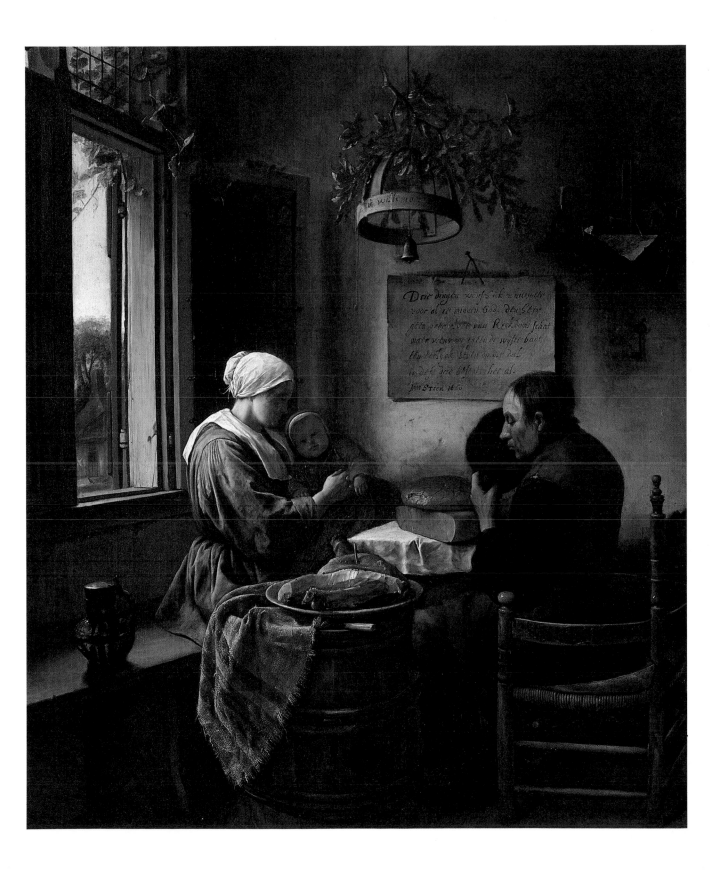

PLATE 79 Jan Steen

Catalogue 103 *Easy Come, Easy Go,* 1661
 Oil on canvas, 31 x 41″ (79 x 104 cm.)
 Museum Boymans–van Beuningen, Rotterdam, no. 2527

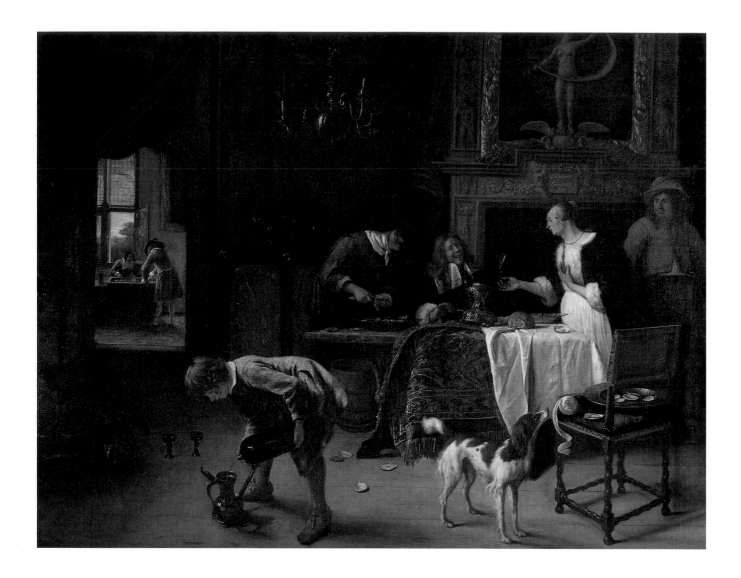

PLATE 80 Jan Steen

Catalogue 104 *Beware of Luxury*, 1663
Oil on canvas, 41⅜ x 57" (105 x 145 cm.)
Kunsthistorisches Museum, Gemäldegalerie, Vienna, inv. no. 791

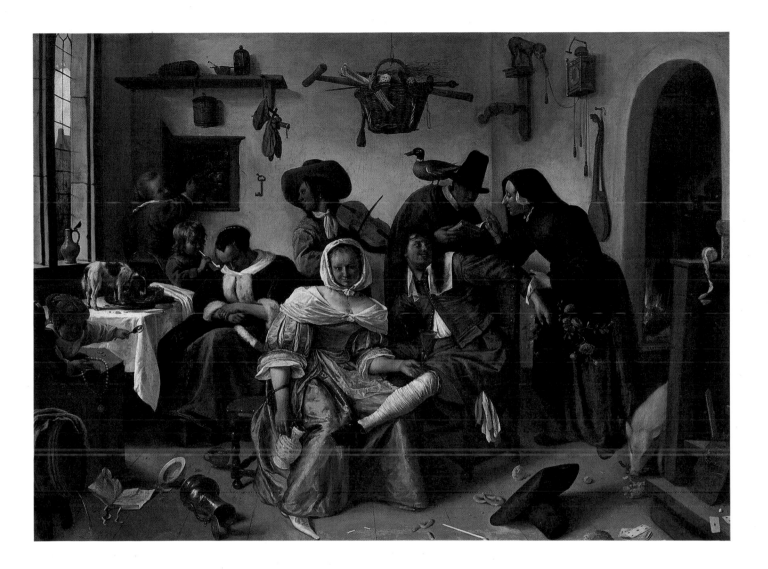

PLATE 81 Jan Steen

Catalogue 105 *The Doctor's Visit,* 1663–65
Oil on panel, 18⅛ x 14½″ (46 x 36.8 cm.)
John G. Johnson Collection at the Philadelphia Museum of Art, no. 510

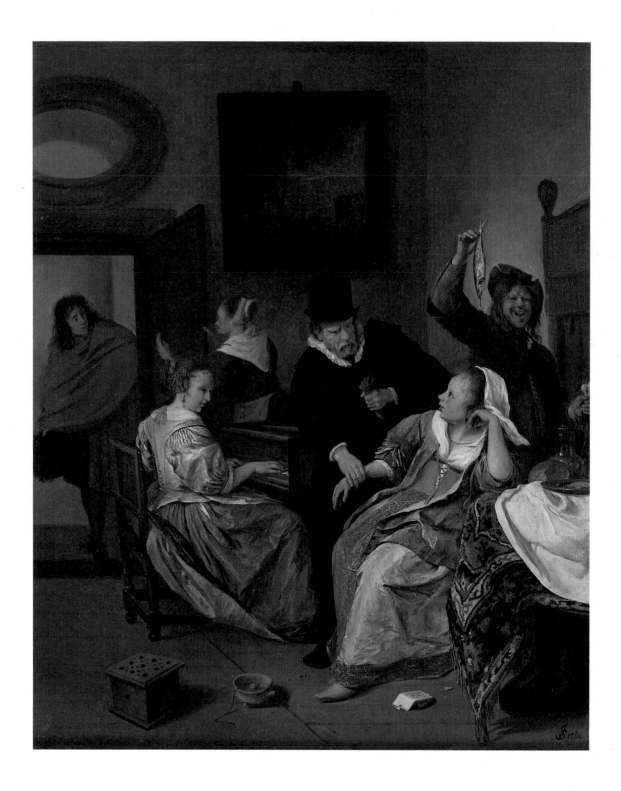

PLATE 82 Jan Steen

Catalogue 106 *Rhetoricians at a Window*, 1662–66
Oil on canvas, 29⅛ x 23¼" (74 x 59 cm.)
John G. Johnson Collection at the Philadelphia Museum of Art, no. 512

PLATE 83 Jan Steen

Catalogue 107 *The Schoolmaster*, c. 1663–65
Oil on canvas, 42⅞ x 31⅞" (109 x 81 cm.)
National Gallery of Ireland, Dublin

PLATE 84 Jan Steen

Catalogue 108 *Inn with Violinist and Card Players*, c. 1665–68
Oil on canvas, 32¼ x 27¼" (81.9 x 69.2 cm.)
Her Majesty Queen Elizabeth II

PLATE 84 Jan Steen

Catalogue 108 *Inn with Violinist and Card Players*, c. 1665–68
Oil on canvas, 32¼ x 27¼" (81.9 x 69.2 cm.)
Her Majesty Queen Elizabeth II

PLATE 85 Jan Steen

Catalogue 109 *The Dissolute Household*, c. 1668
Oil on canvas, 31¾ x 35″ (80.5 x 89 cm.)
Wellington Museum, London (Crown Copyright)

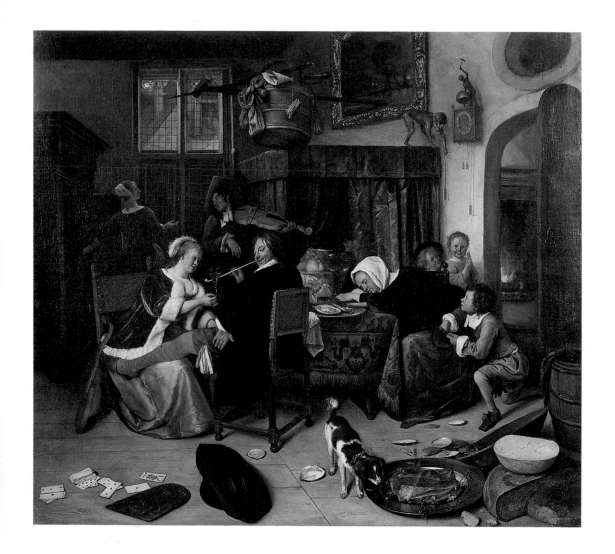

PLATE 86 Jan Steen

Catalogue 110 *Card Players Quarreling*, c. 1664–65
Oil on canvas, 35⅜ x 46⅞" (90 x 119 cm.)
Gemäldegalerie, Staatliche Museen Preussischer Kulturbesitz, Berlin (West), no. 795B

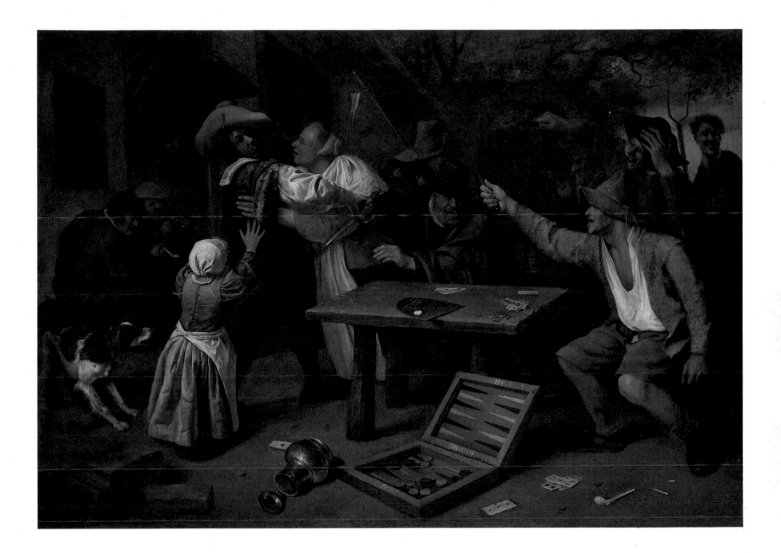

PLATE 87 Jacob van Loo

Catalogue 64 *Musical Party on a Terrace*, c. 1650
Oil on canvas, 28¾ x 25¾" (73 x 65.5 cm.)
Thyssen-Bornemisza Collection, Lugano, cat. no. 168

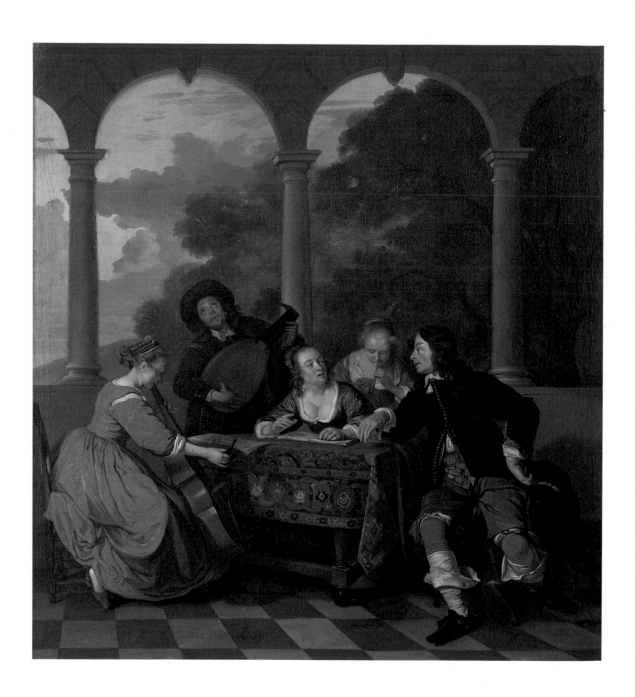

PLATE 88 Gerbrand van den Eeckhout

Catalogue 43 *Party on a Terrace*, 1652
Oil on canvas, 20¼ x 24½" (51.4 x 62.2 cm.)
Worcester Art Museum, Worcester, Massachusetts, no. 1922.208

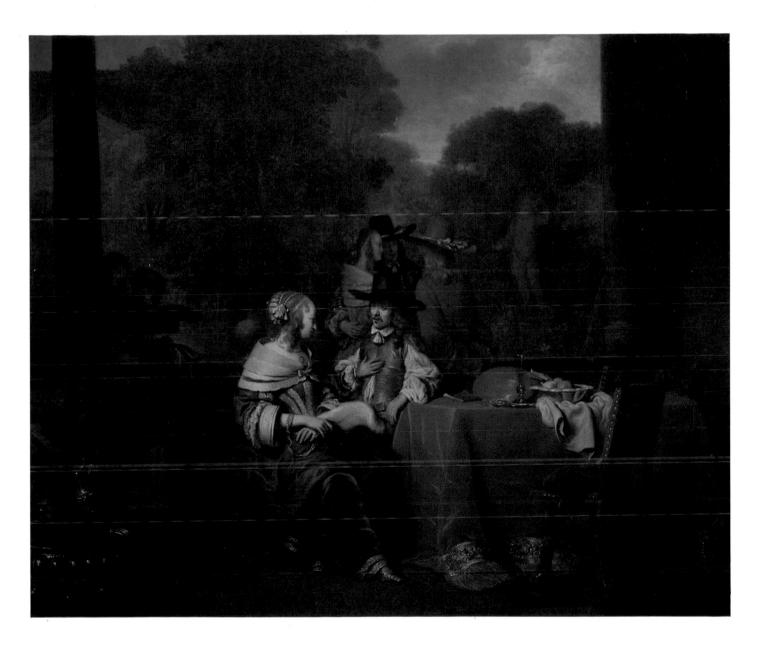

PLATE 89 Jan Victors

Catalogue 120 *The Dentist*, 1654
Oil on canvas, 30¾ x 37¼" (78 x 94.5 cm.)
Amsterdams Historisch Museum, Amsterdam, Van der Hoop Collection

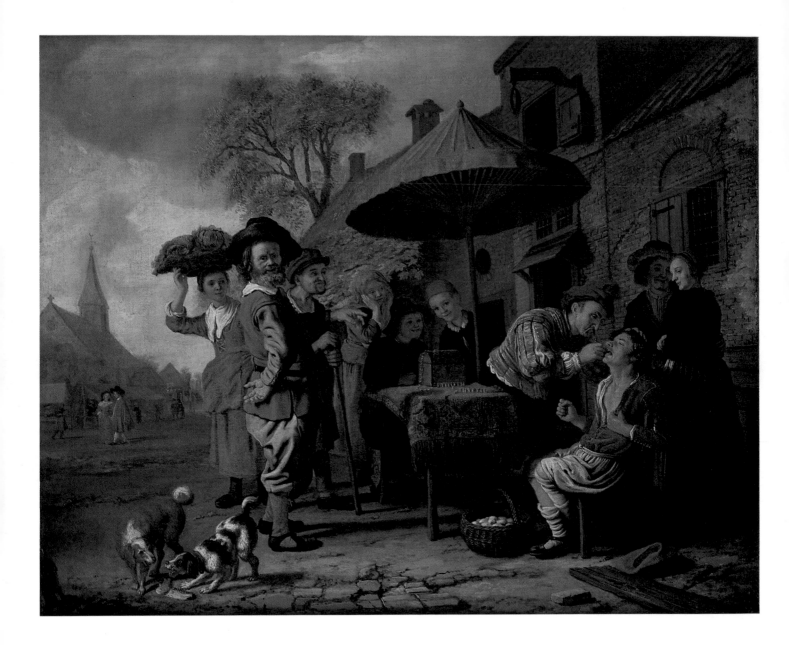

PLATE 90 Cornelis Saftleven

Catalogue 96 *Barn Interior*, c. 1665
Oil on panel, 23½ x 26⅜″ (59.7 x 67 cm.)
Hood Museum of Art, Dartmouth College, Hanover, New Hampshire, no. P983.10

PLATE 91

Cornelis Saftleven & Herman Saftleven

Sleeping Hunter in a Landscape, 164[2]
Oil on panel, 14½ x 20½" (36.8 x 52 cm.)
Collection of Maida and George Abrams, Boston

PLATE 92 Ludolf de Jongh

Catalogue 56

Messenger Reading to a Group in a Tavern, 1657
Oil on canvas, 25⅝ x 20⅞" (65 x 53 cm.)
Mittelrheinisches Landesmuseum, Mainz, inv. no. 800

PLATE 93 Ludolf de Jongh

Catalogue 57 *Hunting Party in the Courtyard of a Country House*, late 1660s
Oil on canvas, 27 x 32" (68.6 x 81.3 cm.)
The Detroit Institute of Arts, Gift of Mr. and Mrs. James S. Whitcomb, no. 58.169

PLATE 94 Hendrick Sorgh

Catalogue 100 *Musical Company,* 1661
Oil on canvas, 26¾ x 32¼" (68 x 82 cm.)
Private Collection

PLATE 95 Hendrick Sorgh

Catalogue 101 *Vegetable Market*, 1662
Oil on panel, 20 x 28″ (51 x 71 cm.)
Rijksmuseum, Amsterdam, no. A717

PLATE 96 Abraham Diepraam

Catalogue 30 *Barroom*, 1665
Oil on canvas, 18⅛ x 20½" (46 x 52 cm.)
Rijksmuseum, Amsterdam, no. A1574

PLATE 97 Nicolaes Maes

Catalogue 65 *Woman Plucking a Duck*, c. 1655–56
Oil on canvas, 22⅞ x 26″ (58 x 66 cm.)
Philadelphia Museum of Art, Gift of Mrs. Gordon A. Hardwick and Mrs. W. Newbold Ely, in
memory of Mr. and Mrs. Roland L. Taylor, 44-9-4

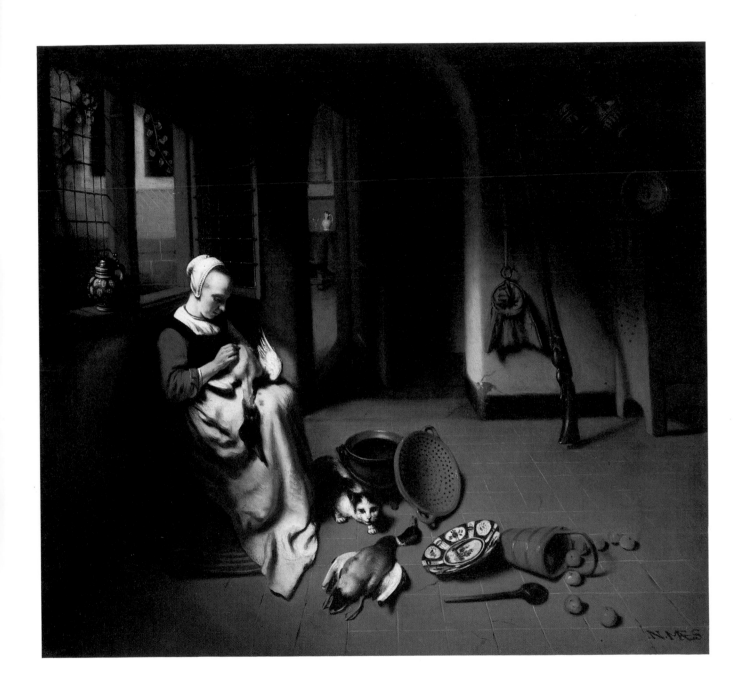

PLATE 98 Nicolaes Maes

Catalogue 66 *The Account Keeper (The Housekeeper).* 1656
Oil on canvas, 26 x 21⅛″ (66 x 53.7 cm.)
The Saint Louis Art Museum, no. 72.1950

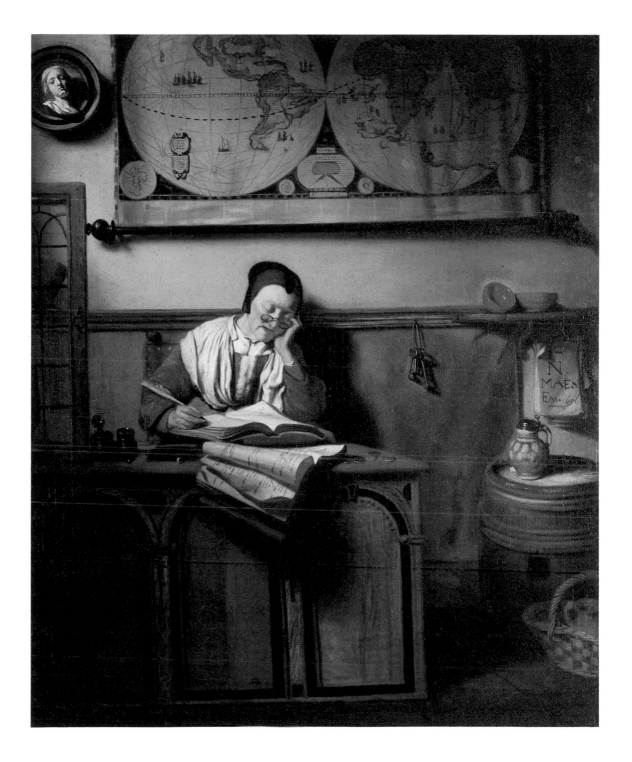

PLATE 99 Nicolaes Maes

Catalogue 67 *The Eavesdropper*, 1657
Oil on canvas, 36⅜ x 48″ (92.5 x 122 cm.)
Dienst Verspreide Rijkskollekties, The Hague, on loan to the Dordrechts Museum, Dordrecht

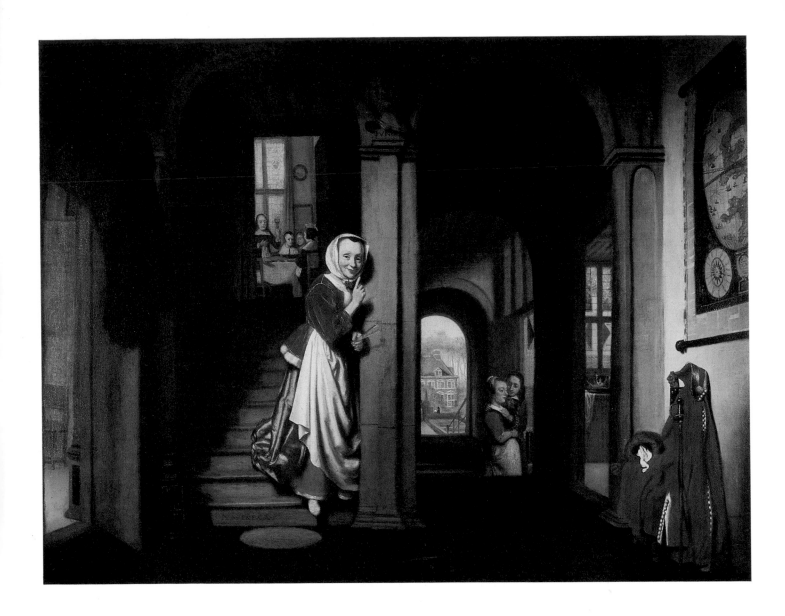

PLATE 100

Pieter de Hooch

Catalogue 50

Two Women in a Courtyard, c. 1657
Oil on canvas, 27¼ x 13⅜″ (69.2 x 34 cm.)
Her Majesty Queen Elizabeth II

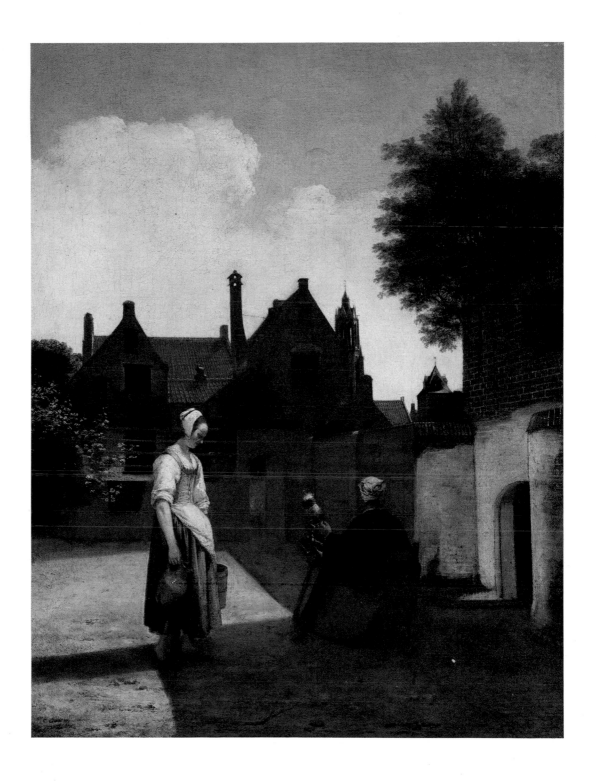

PLATE 101 Pieter de Hooch

Catalogue 51 *Woman Drinking with Two Men and a Maidservant*, c. 1658
Oil on canvas, 29 x 25½" (73.7 x 64.8 cm.)
The Trustees of the National Gallery, London, no. 834

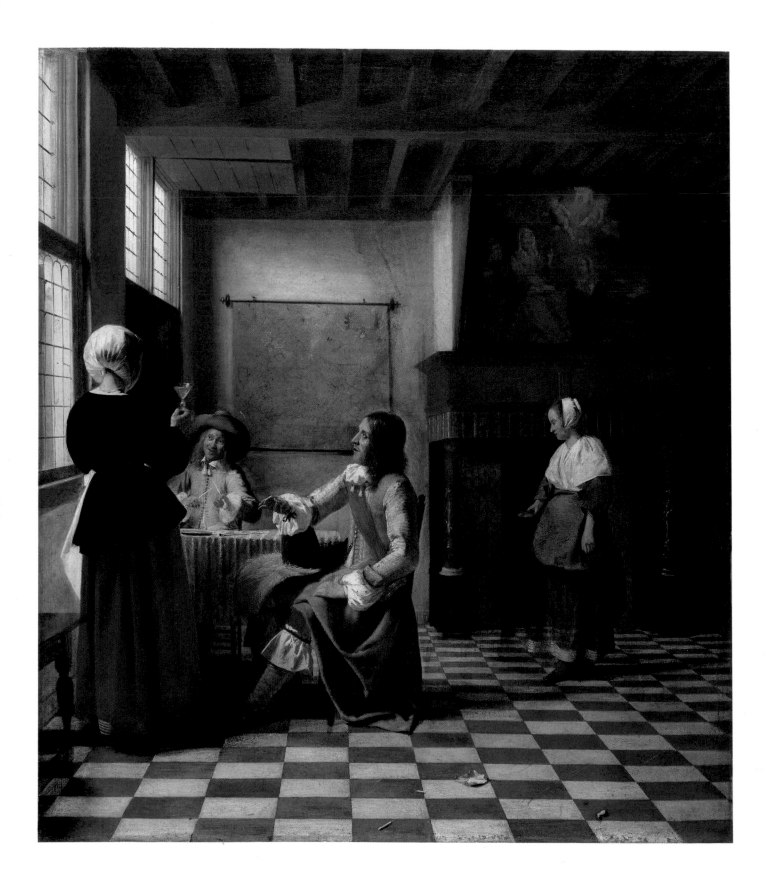

PLATE 102 Pieter de Hooch

Catalogue 52 *Woman Drinking with Soldiers*, 1658
Oil on canvas, 27 x 23⅝" (68.6 x 60 cm.)
Musée du Louvre, Paris, Gift of Mme Gregor Piatigorsky, inv. no. RF 1974-29

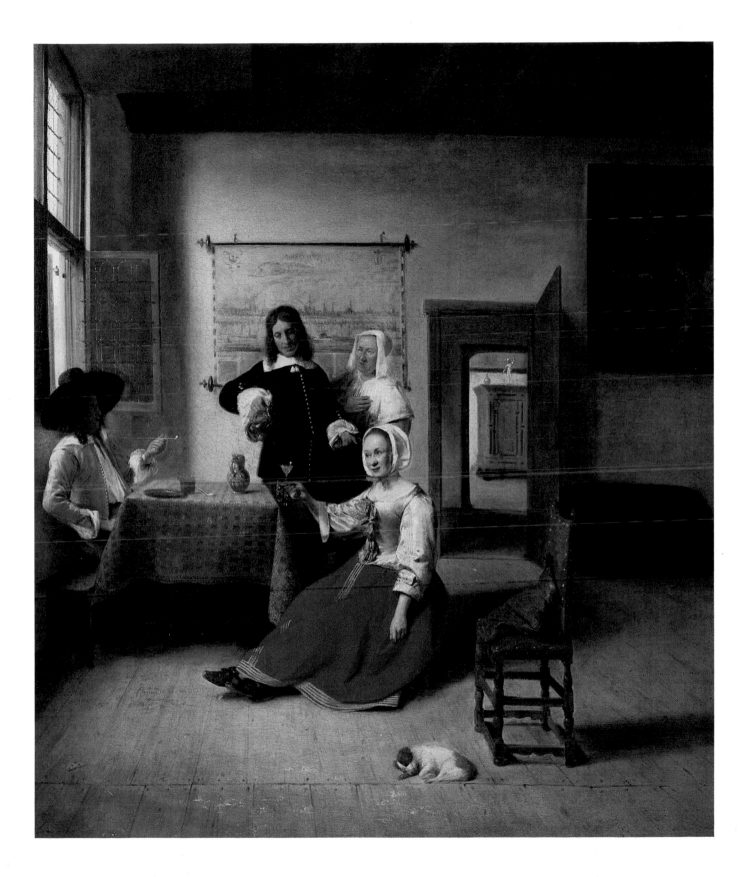

PLATE 103 Pieter de Hooch

Catalogue 53 *Courtyard with an Arbor and Drinkers*, 1658
Oil on canvas, 26⅛ x 22¼″ (66.5 x 56.5 cm.)
Private Collection, Great Britain

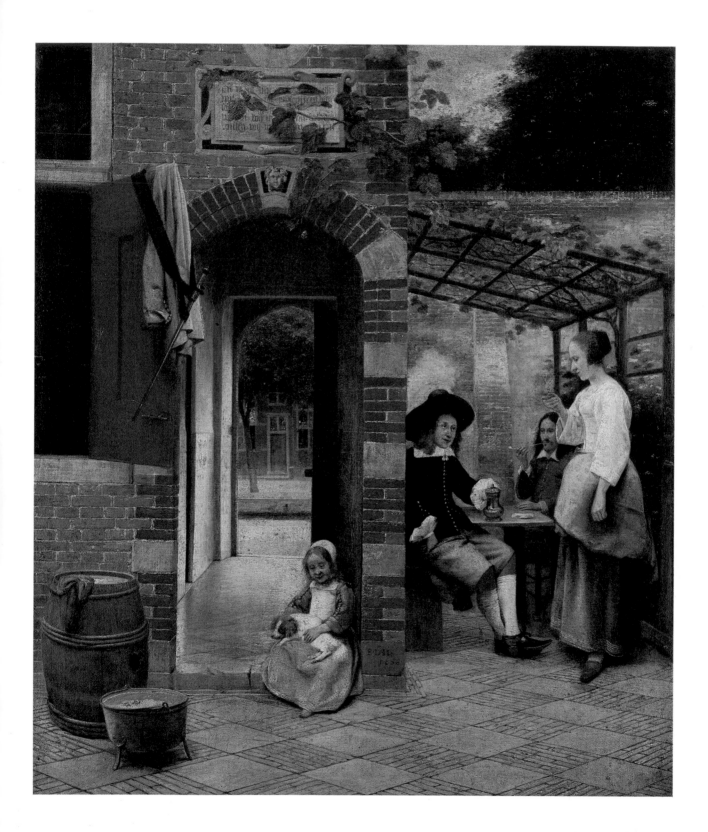

PLATE 104 Pieter de Hooch

Catalogue 54 *Woman Nursing an Infant, with a Child Feeding a Dog*, c. 1658–60
Oil on canvas, 26⅝ x 21⅞″ (67.6 x 55.6 cm.)
The Fine Arts Museums of San Francisco, Gift of the Samuel H. Kress Foundation, no. 61.44.37

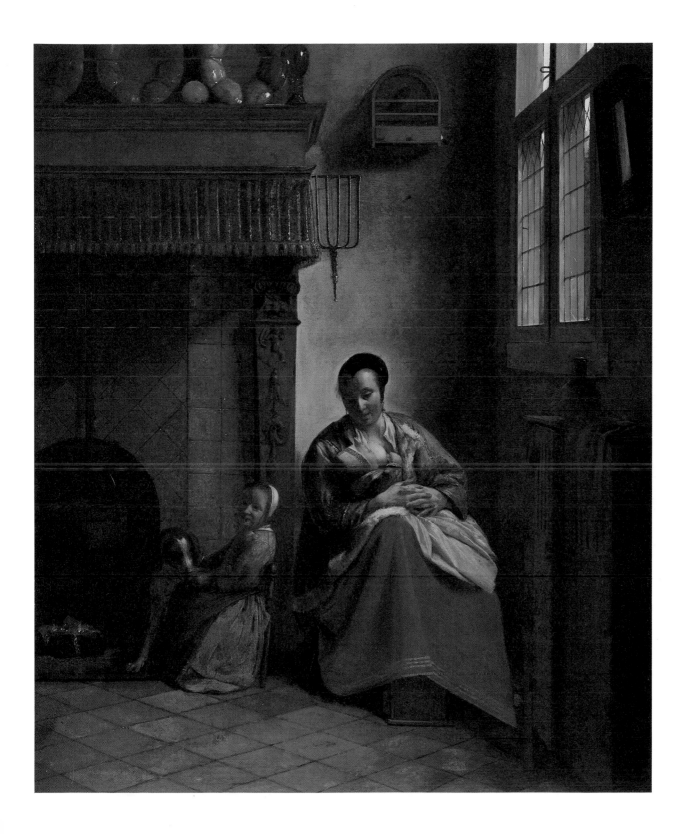

PLATE 105 Pieter de Hooch

Catalogue 55 *Mother Lacing Her Bodice beside a Cradle,* c. 1661–63
Oil on canvas, 36¼ x 39⅜″ (92 x 100 cm.)
Gemäldegalerie, Staatliche Museen Preussischer Kulturbesitz, Berlin (West), no. 820B

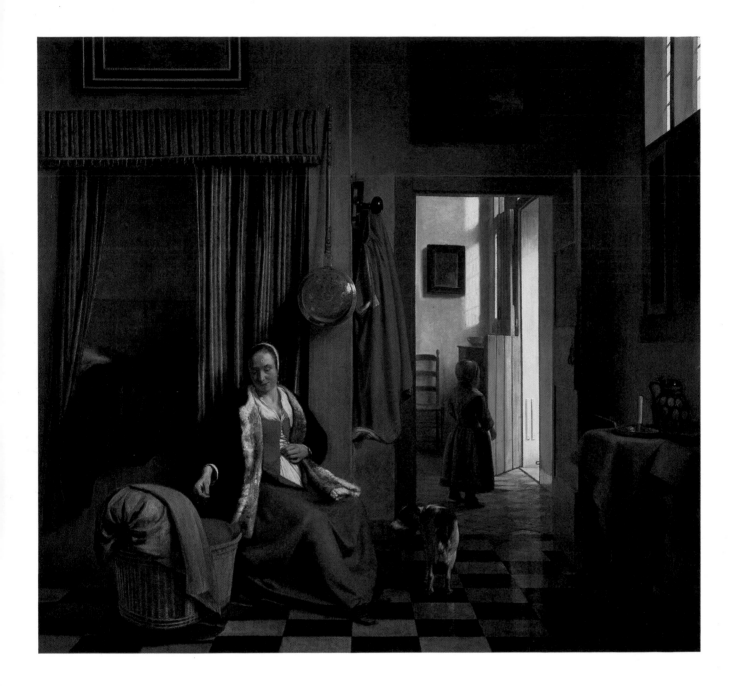

PLATE 106 Johannes Vermeer

Catalogue 116 *Girl with Wineglass*, c. 1658–60
Oil on canvas, 25⅝ x 30¼″ (65 x 77 cm.)
Gemäldegalerie, Staatliche Museen Preussischer Kulturbesitz, Berlin (West), no. 912C

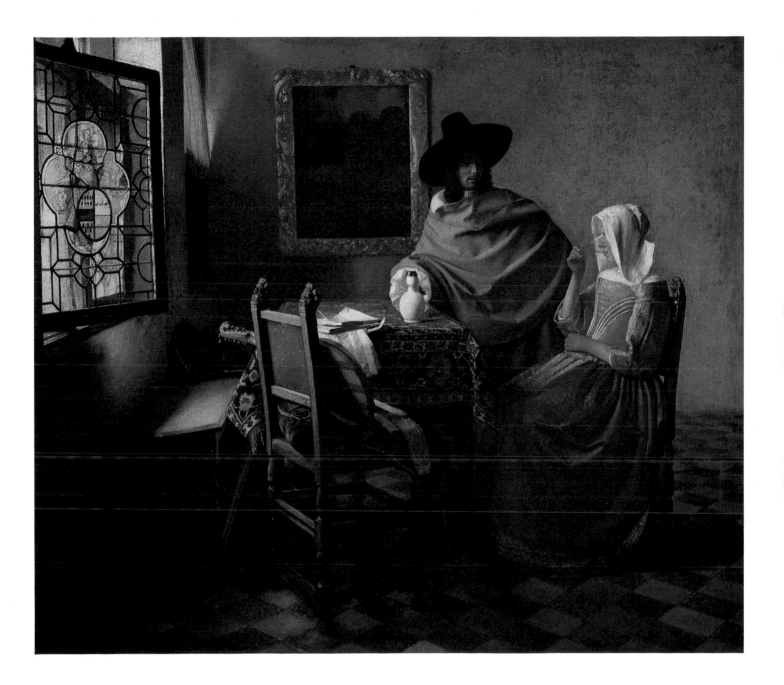

PLATE 107 Johannes Vermeer

Catalogue 117 *Woman Tuning a Lute,* mid-1660s
Oil on canvas, 20¼ x 18″ (51.4 x 45.7 cm.)
The Metropolitan Museum of Art, New York, Bequest of Collis P. Huntington, 1900, 25.110.24

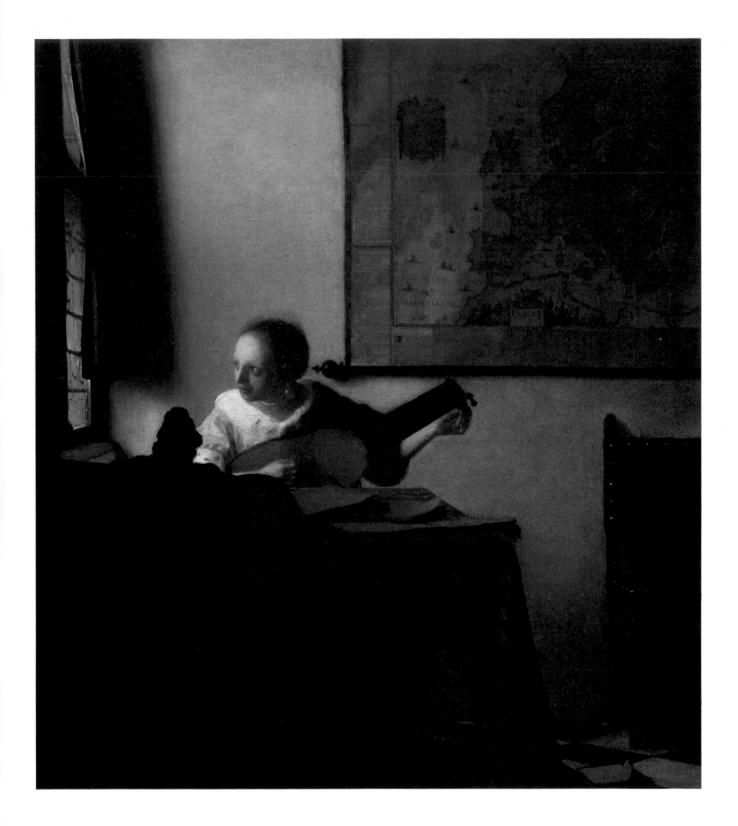

PLATE 108 Johannes Vermeer

Catalogue 118 *Woman Holding a Balance,* c. 1662–64
 Oil on canvas, 16¾ x 15″ (42.5 x 38 cm.)
 National Gallery of Art, Washington, D.C., Widener Collection, inv. no. 693

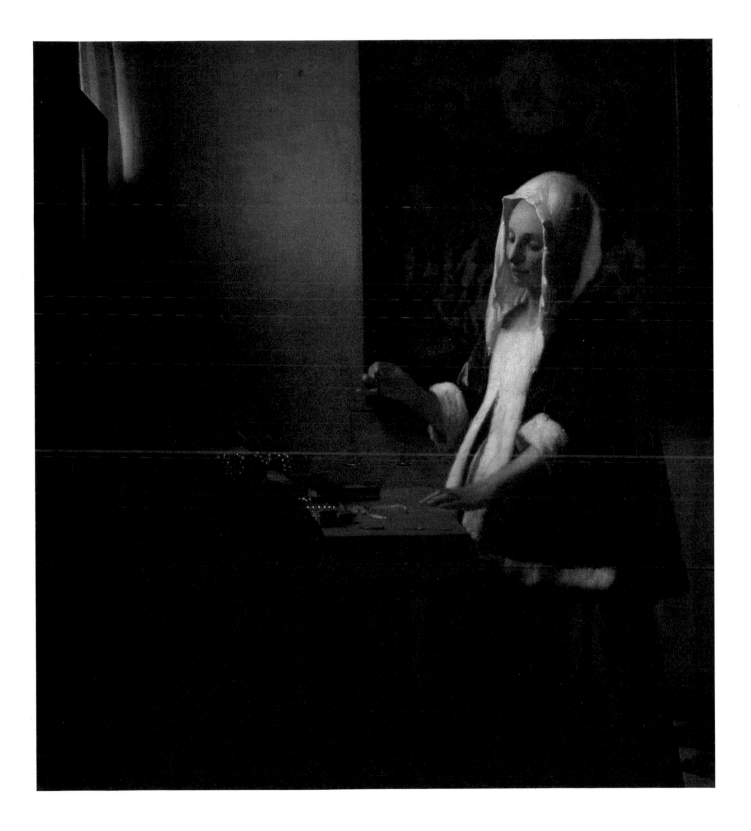

PLATE 109 Johannes Vermeer

Catalogue 119 *Lady at the Virginals with a Gentleman*, c. 1662–65
Oil on canvas, 28⅞ x 25⅜" (73.3 x 64.5 cm.)
Her Majesty Queen Elizabeth II

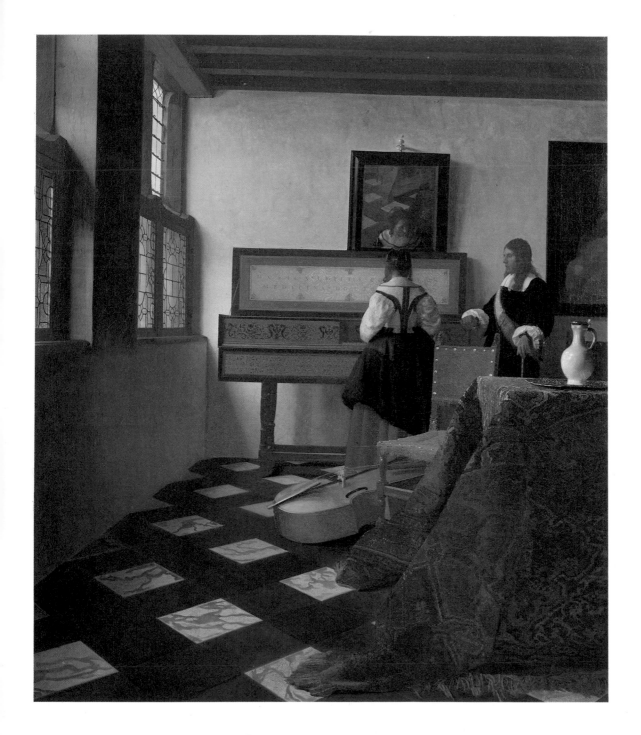

PLATE 110 Emanuel de Witte

Catalogue 127 *Interior with a Woman at a Clavichord*, c. 1665
Oil on canvas, 30½ x 41⅛" (77.5 x 104.5 cm.)
Dienst Verspreide Rijkskollekties, The Hague, on loan to the Museum Boymans–van Beuningen,
Rotterdam, no. 2313

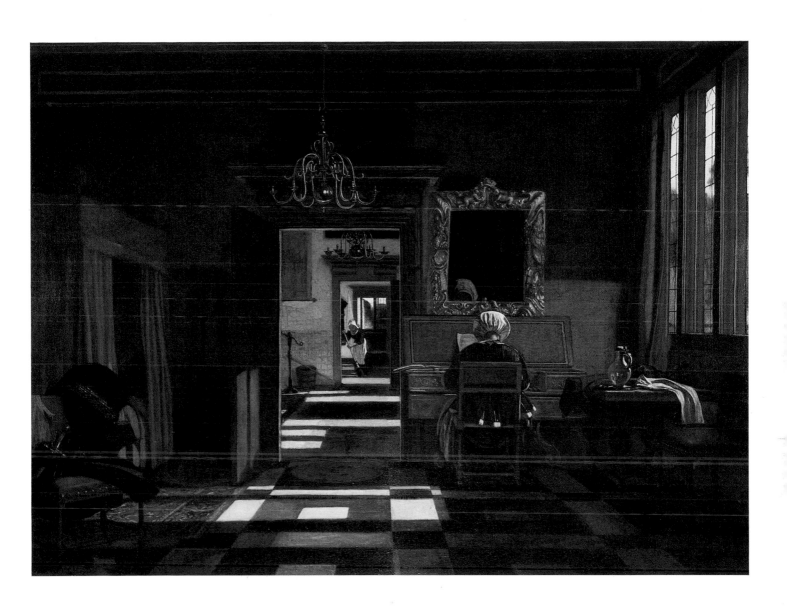

PLATE III Jacobus Vrel

Catalogue 123 *Woman at a Window,* 1654
Oil on panel, 26 x 18¾" (66 x 47.5 cm.)
Kunsthistorisches Museum, Gemäldegalerie, Vienna, inv. no. 6081

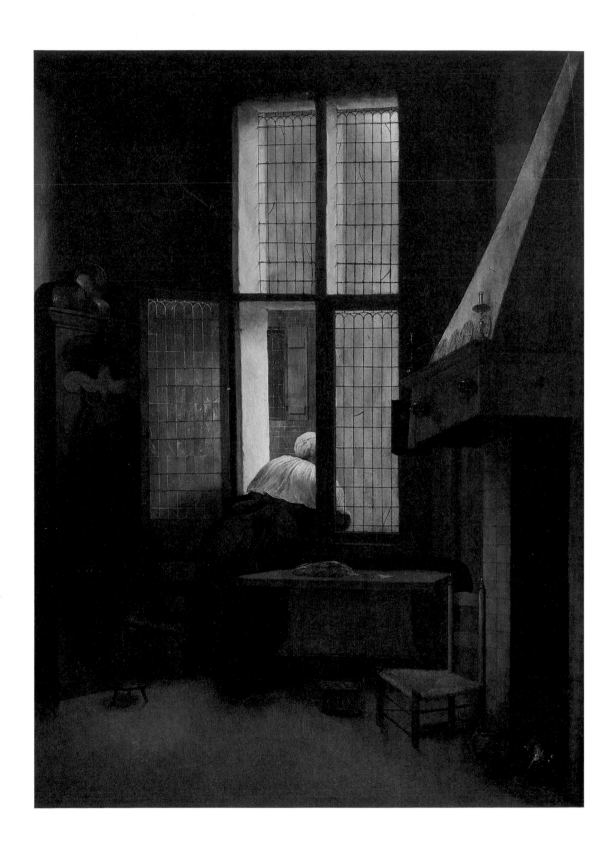

PLATE 112 Esaias Boursse

Catalogue 16 *Interior with a Woman at a Spinning Wheel, 1661*
Oil on canvas, 23⅝ x 19¼" (60 x 49 cm.)
Rijksmuseum, Amsterdam, no. A767

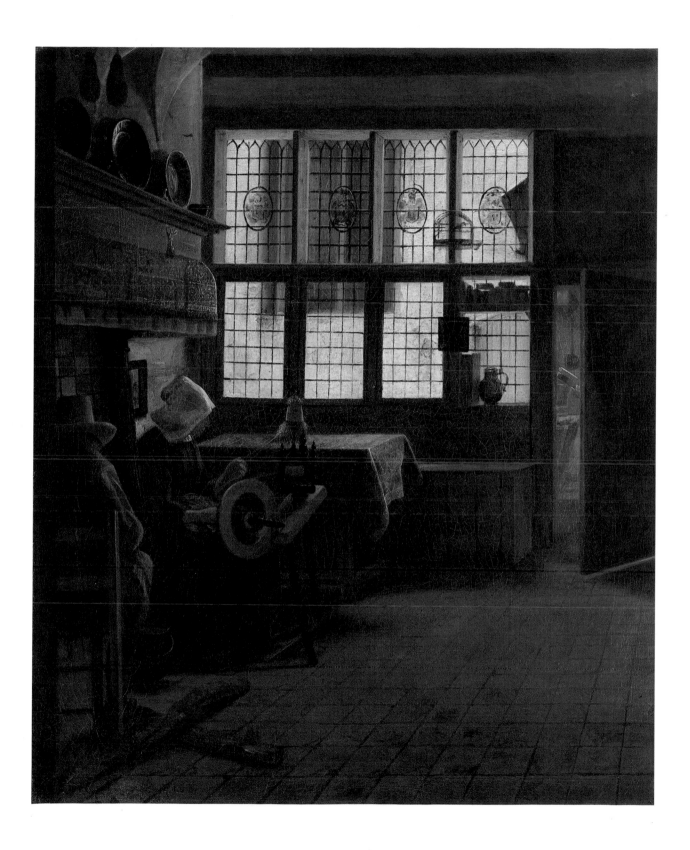

PLATE 113 Pieter Janssens Elinga

Catalogue 44 *Woman Reading,* late 1660s or 1670s
Oil on canvas, 29½ x 24⅜" (75 x 62 cm.)
Bayerische Staatsgemäldesammlungen, Alte Pinakothek, Munich, no. 284

PLATE 113 Pieter Janssens Elinga

Catalogue 44 *Woman Reading,* late 1660s or 1670s
Oil on canvas, 29½ x 24⅜" (75 x 62 cm.)
Bayerische Staatsgemäldesammlungen, Alte Pinakothek, Munich, no. 284

PLATE 114 Jacob Ochtervelt

Catalogue 86 *Violinist and Two Serving Women*, c. 1663–65
Oil on canvas, 20¾ x 16½" (52.7 x 42 cm.)
City of Manchester Art Galleries, 1926.11

PLATE 115 Jacob Ochtervelt

Catalogue 87 *Street Musicians in the Doorway of a House,* 1665
Oil on canvas, 27 x 22" (68.6 x 55.9 cm.)
The Saint Louis Art Museum, Gift of Mrs. Eugene A. Perry in memory of her mother, Mrs. Claude
Kilpatrick, no. 162.1928

PLATE 116 Jacob Ochtervelt

Catalogue 88 *The Music Lesson,* 1671
Oil on canvas, 31⅛ x 25⅜″ (79 x 64.5 cm.)
The Art Institute of Chicago, Mr. and Mrs. Martin A. Ryerson Collection, no. 1933.1088

PLATE 117 Cornelis de Man

Catalogue 68 *The Chess Players*, c. 1670
 Oil on canvas, 38⅜ x 33½" (97.5 x 85 cm.)
 Szépművészeti Múzeum, Budapest, no. 320

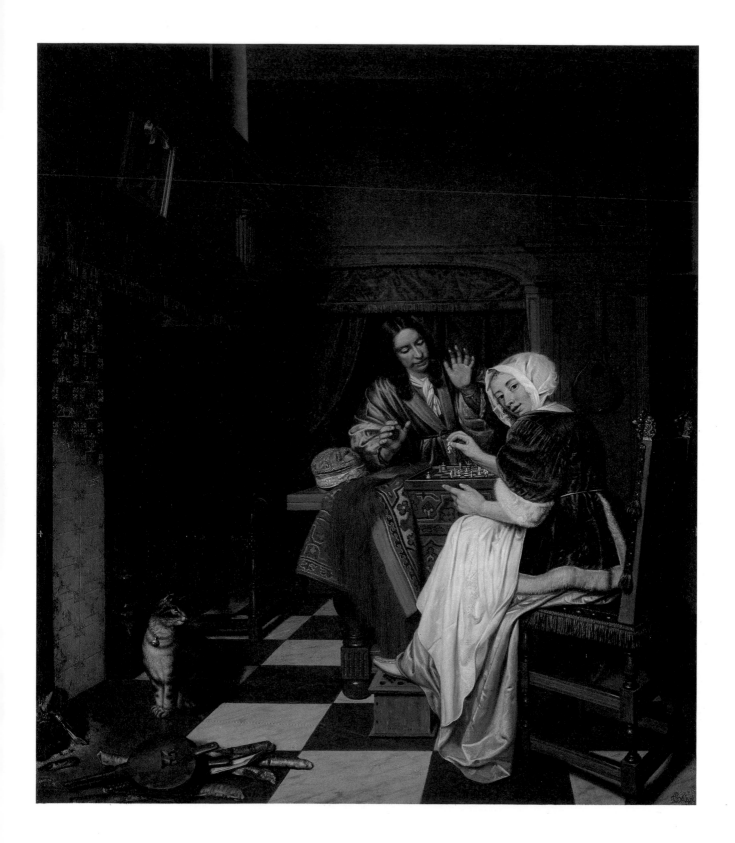

PLATE 118 Cornelis de Man

Catalogue 69 *The Gold Weigher*, c. 1670–75
Oil on canvas, 32⅛ x 26⅝″ (81.5 x 67.5 cm.)
Private Collection, Montreal

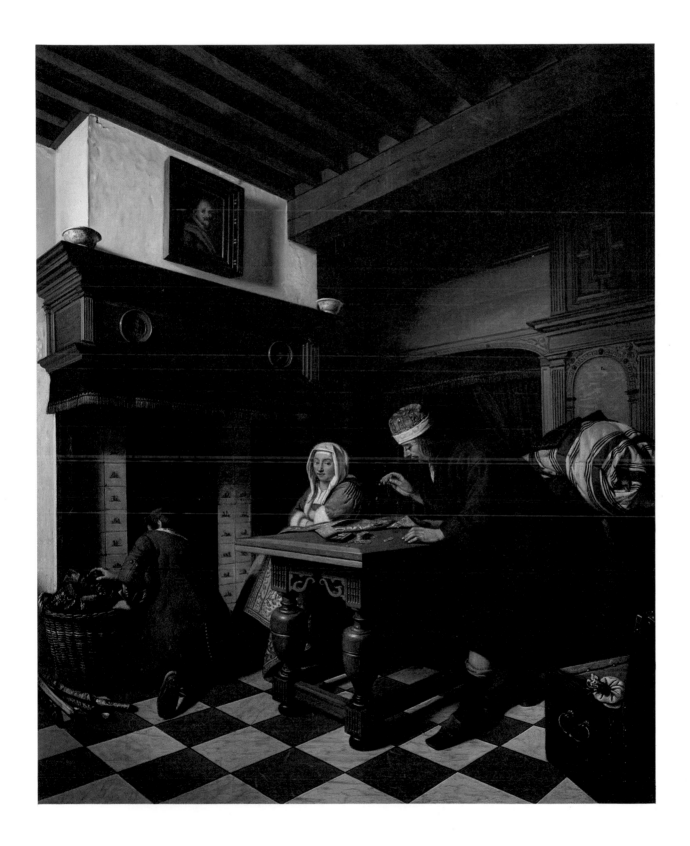

PLATE 118 Cornelis de Man

PLATE 119 Job Berckheyde

Catalogue 6 *The Baker*, c. 1681
Oil on canvas, 25 x 20⅞" (63.5 x 53 cm.)
Worcester Art Museum, Worcester, Massachusetts, Gift of Mr. and Mrs. Milton P. Higgins,
no. 1975. 105

PLATE 119 Job Berckheyde

PLATE 120 Godfried Schalcken

Catalogue 98 *Visit to the Doctor,* 1669
Oil on panel, 13⅜ x 11⅜″ (34 x 29 cm.)
Private Collection, Germany

PLATE 121 Godfried Schalcken

Catalogue 99 *Game of Lady Come into the Garden,* late 1660s
Oil on panel, 25 x 19½″ (63.5 x 49.5 cm.)
Her Majesty Queen Elizabeth II

PLATE 122 Jan Verkolje

Catalogue 115 *Elegant Couple in an Interior,* probably 1674
Oil on canvas, 38 x 22½″ (96.5 x 57.1 cm.)
Private Collection, Great Britain

PLATE 123 Eglon van der Neer

Catalogue 82 *Elegant Couple in an Interior,* c. 1680
Oil on canvas, 33 x 27½" (84 x 70 cm.)
Private Collection, on loan to the National Museum of Wales, Cardiff

PLATE 124 Michiel van Musscher

Catalogue 80 *Doctor Taking a Young Woman's Pulse*, c. 1670–80
Oil on panel, 19⅝ x 15¾″ (50 x 40 cm.)
Private Collection, U.S.A.

PLATE 125 Adriaen van der Werff

Catalogue 125 *Boy with a Mousetrap*, 1676
Oil on panel, 15 x 12⅝″ (38.1 x 32 cm.)
Richard Green Galleries, London

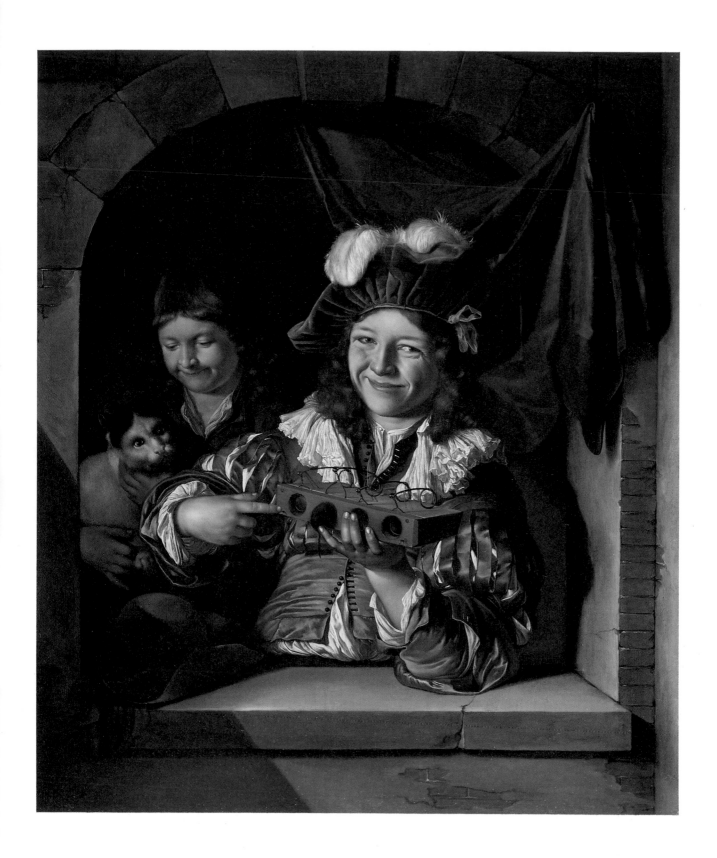

PLATE 126 Adriaen van der Werff

Catalogue 126 *The Chess Players,* c. 1679
Oil on canvas, 26 x 24¼" (66 x 61.6 cm.)
Herzog Anton Ulrich-Museum, Braunschweig, no. 330

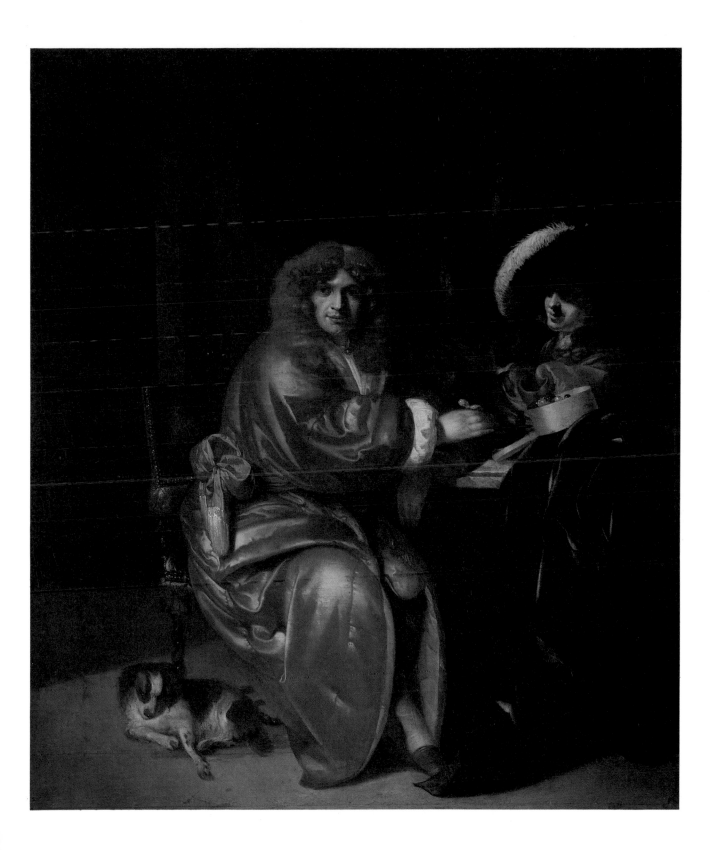

PLATE 127 Matthijs Naiveu

Catalogue 81 *The Cloth Shop*, 1709
Oil on canvas, 20⅞ x 24⅜″ (53 x 62 cm.)
Stedelijk Museum "De Lakenhal," Leiden, no. 567

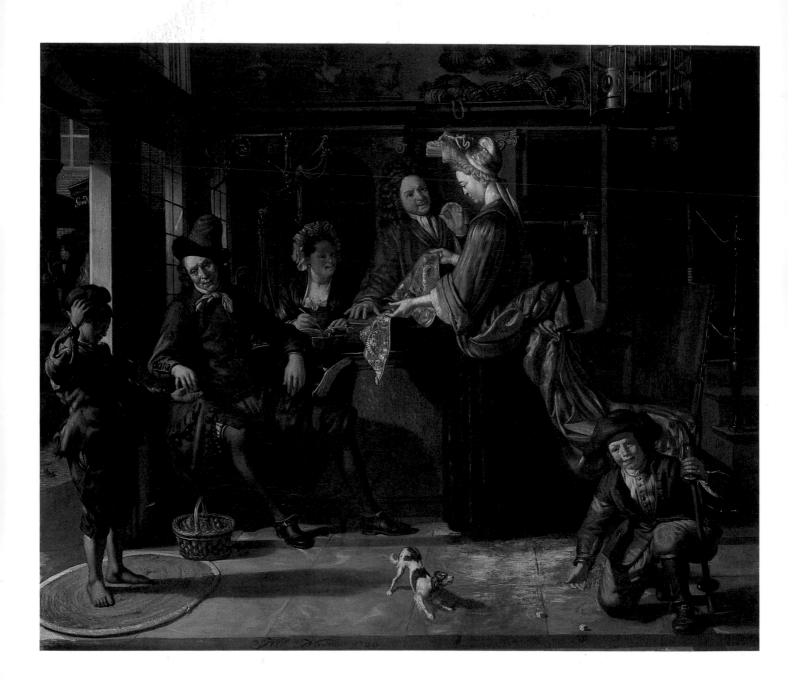

Catalogue

Utrecht? c. 1595–1624 *Utrecht*

The Procuress, 1622
Signed and dated on the lute: T Baburen fe 1622
(TB in ligature)
Oil on canvas, 39¾ x 42¼″ (101 x 107.3 cm.)
Museum of Fine Arts, Boston, Purchased, Maria
T. B. Hopkins Fund, 50.2721

Literature: De Bie 1661, p. 155; Sandrart 1675, p. 186; van Hoogstraten 1678, p. 257; Houbraken 1718–21, vol. 1, p. 221; Kramm 1857–64, vol. 1, p. 37; Nagler 1858–79, vol. 5, pp. 561, 667; Meyer 1872–85, vol. 2, p. 503; Wurzbach 1906–11, vol. 1, p. 38; E. W. Moes in Thieme, Becker 1907–50, vol. 2 (1908), p. 302; Longhi 1926; Fokker 1927; Swillens 1931a; von Schneider 1933, pp. 39–44; Bodmer 1936; Hollstein 1949–, vol. 1, pp. 50–51; Gowing 1951; Bloch 1952; Nicolson 1952; Utrecht/Antwerp 1952, no. 9; Plietzsch 1960, p. 130; Nicolson 1962; Slatkes 1962; Slatkes 1965; Rosenberg et al. 1966, pp. 27–28; Slatkes 1966; Slatkes 1973; Nicolson 1979, pp. 17–19.

Dirck van Baburen was born in the province, if not actually within the city, of Utrecht. His date of birth is unrecorded, but has been calculated by Slatkes (1965 and 1966) to be about 1595 on the evidence of a passage in Giulio Mancini's Considerazioni sulla Pittura *(c. 1620). Nicolson (1962) disagreed with this interpretation, believing that the* giovani di 22 o 23 anni *mentioned by Mancini refers to David de Haen (died 1622), Baburen's collaborator in the decoration of San Pietro in Montorio.*

Baburen is first mentioned in 1611, in the records of the Utrecht Guild of St. Luke, as a pupil of Paulus Moreelse (1571–1638). He subsequently traveled to Italy, perhaps as early as 1612. With David de Haen, he decorated the Pietà Chapel in San Pietro in Montorio in Rome between 1615 and 1620. The altar painting The Entombment, *which is still in place, is closely related to Caravaggio's own treatment of the subject in the Pinacoteca Vaticana. In Rome Baburen enjoyed the patronage of the Marchese Vincenzo Giustiniani and Cardinal Scipione Borghese, who may have secured the San Pietro in Montorio commission for him. The artist is recorded as living in the same house as de Haen in the parish of San Andrea delle Fratte in 1619–20. He returned to Utrecht, probably in 1620, but certainly by 1622. From 1622 until his death two years later, Baburen worked closely with Hendrick ter Brugghen (q.v.); the artists may have even shared a studio. Baburen was buried in the Buurkerk in Utrecht on February 28, 1624.*

Baburen was influenced by the work of Caravaggio (1573–1610) and his followers, especially by that of Bartolommeo Manfredi (c. 1580–c. 1620). An important iconographic innovator, he was the first painter in the North to depict such subjects as Saint Sebastian Attended by Saint Irene *(Kunsthalle, Hamburg) and* Granida and Daifilo *(private collection, New York) from the play by Pieter Cornelisz. Hooft. He also painted half-length single figures of lute players and singers, as well as concerts, card players, and religious and mythological subjects.*

C.B.

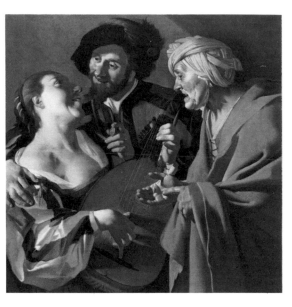

Provenance: Probably Maria Tin (Vermeer's future mother-in-law), November 1631;[1] possibly Sir Hans Sloane; Lt. Col. R.F.A. Sloan-Stanly, Cowes, Isle of Wight; sale, Christie's, London, February 25, 1949, lot 52; dealer Colnaghi, London; purchased by the museum, 1950.

Exhibitions: Utrecht/Antwerp 1952, no. 9; New Haven, Yale University, *Musical Instruments at Yale,* February 19–March 27, 1960, no. 27.

Literature: Gowing 1951, pp. 169–70; Gowing 1952, pp. 35–36; Nicolson 1952, p. 248; Nicolson 1958, p. 63; Judson 1959, p. 75; Stechow 1960, pp. 177–78; Slatkes 1965, cat. A12.[2]

A smiling man, his arm around the shoulder of a lute-playing girl, holds out a coin to her. On the right an elderly, turbaned woman points to the palm of her right hand with the index finger of her left.

Although Baburen provides little evidence other than the bare wall behind the three figures, the scene undoubtedly occurs in a brothel. The old woman is the madam, and she demands payment before the client may enjoy the girl's favors. The traditional representation of brothel scenes in Netherlandish art is closely associated with the New Testament subject of the Prodigal Son in a tavern (Luke 15:13).[3] The earliest example is Lucas van Leyden's woodcut, c. 1520, of a tavern scene: A young woman flirts with a young man while she picks his pocket, and an old woman raises her glass as she observes the couple.[4] The moral is pointed out by a fool who leans through the window; a banderole displays his words: "Wacht, hoet varen sal!" (wait and see how the wind blows). The young man is

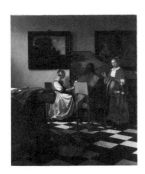

FIG. 1. JOHANNES VER-MEER, *The Concert*, oil on canvas, Isabella Stewart Gardner Museum, Boston.

being robbed and cheated by his apparently friendly companions. Later in the sixteenth century this subject is associated with the artist known as the Braunschweig Monogrammist and with Antwerp painters Jan Massys, Jan Sanders van Hemessen, and Joachim Bueckelaer.

Baburen appears to have been the first painter in the Netherlands to treat this traditional subject in a manner derived from Caravaggio and his Roman followers. The half-length figure format, the filling of the entire picture space with the figures, their "cropping" at the left and right edges, the strong fall of light from the left, and the colorful costumes display Baburen's study of the Caravaggisti. Baburen added his characteristic modeling of forms in simple, flat planes and his original palette. Baburen was followed in his treatment of this subject by Gerrit van Honthorst in a canvas of 1625 (Centraal Museum, Utrecht, cat. 1952, no. 152). Honthorst included three similar half-length figures—the procuress, a young man offering money, and a young woman holding a lute—but he arranged them differently. The man is shown from the back, and the three figures are illuminated by a candle on the table between the man and the girl. Jan van Bijlert, another member of the Utrecht Caravaggisti, painted this subject in the following year and again in the 1620s.[5]

Baburen's *Procuress* (with only slight variations) hangs on the interior back wall in two paintings by Vermeer: *The Concert* (fig. 1) and *Lady Seated at a Virginal* (National Gallery, London, no. 2568).[6] Vermeer included Baburen's composition in the background of these two music-making scenes to stress the association, long established in Northern art and literature, between music and love. Vermeer probably knew Baburen's painting (or a copy of it), which may have been owned by his mother-in-law. Vermeer's 1656 painting *The Procuress* (Gemäldegalerie Alte Meister, Dresden, no. 1335) is strongly influenced by the work of the Utrecht Caravaggisti and may reflect his study of Baburen's painting in particular.

C.B.

1. Maria Tin, Vermeer's future mother-in-law, possessed a painting described as "Een schilderije daer een coppelerste die in de hant wijst" (a painting of a procuress pointing to her hand) in November 1631, according to Blankert (1978b, doc. 7, pp. 145–46).

2. Two versions of Baburen's *Procuress* exist: a seventeenth-century copy, oil on canvas, 39 x 37½" (100 x 96 cm.), Rijksmuseum, Amsterdam, C612; and a copy by Hans van Meegeren, c. 1940, oil on canvas, 38½ x 40½" (98 x 103 cm.), Courtauld Institute of Art, London.

3. This tradition has been traced by Konrad Renger (1970).

4. Unicum, Bibliothèque Nationale, Paris (Hollstein 1949–, s.v. "Lucas van Leyden," no. 33).

5. Herzog Anton-Ulrich Museum, Braunschweig, 1626; a second treatment by Bijlert from the 1620s is in the Musée des Beaux-Arts, Lyons.

6. Blankert 1978b, cat. nos. 17, 31.

Haarlem 1631/32–1664 Haarlem

Merry Company in a Tavern, 1661?
Signed and dated lower right: Bega A° 166[1?]
Oil on canvas, 15¾ x 21¼" (40 x 54 cm.)
Musées Royaux des Beaux-Arts de Belgique,
Brussels, inv. no. 3369

Literature: Houbraken 1718–21, vol. 1, pp. 349–50, and vol. 2, p. 211; Weyerman 1729–69, vol. 4, p. 58; van Gool 1750–51, vol. 1, p. 100; Bartsch 1803–21, vol. 5, pp. 221ff.; Weigel 1843, p. 281; Kramm 1857–64, vol. 1, p. 68; Nagler 1858–79, vol. 1, pp. 158, 1626; Siret 1862; van der Kellen 1866, vol. 1, p. 13; van der Willigen 1870, pp. 30, 75, 76; Meyer 1872–85, vol. 3, p. 293; Dutuit 1881–88, vol. 4, p. 18, and vol. 5, p. 585; Gaedertz 1889; Wurzbach 1906–11, vol. 1, pp. 72–74; E. W. Moes in Thieme, Becker 1907–50, vol. 3 (1910), p. 174; Knoef 1920; Agafonowa 1940; Hollstein 1949–, vol. 1, pp. 203–33; Brière-Misme 1954b; Kuznetsov 1955; van Hees 1956; Boerner, Trautscholdt 1965; Rosenberg et al. 1966, p. 114; Bartsch 1971–, vol. 7, pp. 29–45; Adelaide 1977; Begheyn 1979; Boston/Saint Louis 1980–81, p. 256; Amsterdam/Washington 1981–82, pp. 105–7; Scott forthcoming.

Cornelis Pietersz. Bega was the son of the gold- and silversmith Pieter Jansz. Begijn (or Begga) and Maria Cornelisdr., daughter of the painter Cornelis Cornelisz. van Haarlem (1562–1638). According to a document from April 1650 stating that the artist was eighteen years old, Bega was born in Haarlem in 1631 or 1632. By 1634 the Bega family was living on the Koningstraat in a house owned by Cornelis Cornelisz. van Haarlem. Shortly thereafter they moved to a house on Lange Begijnestraat that was registered in the name of Pieter Jansz. Begijn until 1652. According to an inventory of 1639, Cornelis Cornelisz. left part of his estate, including all his red chalk drawings and half his household effects, gold, silver, and paintings, to his daughter, Maria, and her descendants.

Little is known about Bega's life. In De Groote Schouburgh, a major source on the lives of seventeenth-century Dutch artists, Houbraken claimed that he was the first and best pupil of Adriaen van Ostade (q.v.). Although there is no documentary evidence of a trip to Italy, a drawing tentatively attributed to the artist is inscribed "Bega Romae" (The Dentist, Schlossmuseum, Weimar, inv. no. 4763). In early 1653 Bega traveled in Germany and Switzerland. He was accompanied by three fellow artists, Vincent Laurensz. van der Vinne (1628/29–1702), Theodor Helmbreker (1633–1696), and Willem de Bois (c. 1610–1680). Van der Vinne reported on this trip, described in two illustrated manuscripts. By June 1653 Bega had returned to Haarlem, where he entered the painters' guild on September 1, 1654. In the early 1650s he became acquainted with Leendert van der Cooghen (c. 1610–1681), a fellow Haarlem artist who had just returned from studying with Jacob Jordaens (1593–1678) in Antwerp. Bega died in Haarlem, probably from the plague, on August 27, 1664; he was buried three days later in St. Bavo's.

In the tradition of his teacher, Adriaen van Ostade, most of Bega's paintings, drawings, and etchings depict peasants in village taverns and kitchens. Less frequently he portrayed the life of the burgher and artisan classes.

C.v.B.R.

Provenance: Acquired from Lambreaux, Brussels, by the museum, 1896.

Exhibitions: Brussels, Musées Royaux, *Les Loisirs et les Jeux*, February 22–April 2, 1961; Brussels, Musées Royaux, *Apothéose de la Danse*, September 30–October 29, 1967.

Literature: Brussels, Musées Royaux, cat. 1953, no. 25.

A company of thirteen peasants assemble in a tavern to drink, make music, and dance. To the left of the central, seated figure, who is viewed from the rear, two peasants sing from a sheet of paper and in the middle distance a fiddler plays. A woman dances at the right. From the top of a low stairway on the left, a woman in a black hat hands a ceramic jug down to a serving-woman. In the left corner of the foreground a ceramic pot lies overturned beside a bench that holds a pitcher and a cloak. The right corner is taken up by a low storage closet with a lantern, wooden scales, leather saddlebag, and slouch hat. Several figures in the background are seen from behind. A wicker birdcage with an open door hangs overhead.

Houbraken claimed that Cornelis Bega was Adriaen van Ostade's "first and best" pupil.[1] Like Ostade, Bega painted peasants in taverns, merry company situations, and domestic scenes. Although he became a member of the painters' guild in Haarlem in 1654, the earliest certain date to appear on his paintings is 1658.[2] His style prior to that year is, therefore, a matter of conjecture, but the signed *Dance in a Village Inn* (fig. 1) is probably representative. It takes up the same theme as this picture, but it employs a looser technique and blonder tonality, and devotes more attention to the dark, cavernous space of the tavern. This style and the diagonal composition clearly descend from Adriaen van Ostade's works such as *Villagers Merrymaking at an Inn,* of 1652 (pl. 28).[3]

The last digit of the date on *Merry Company in a Tavern* is unclear but appears to be "1"—a reading supported by stylistic connections with dated paintings. By 1661 Bega was concentrating on tavern scenes that portrayed fewer, larger, and more exactly observed figures that had gained in volume and mass.[4] The horizontal format of this painting is somewhat uncharacteristic; most of Bega's mature works employ upright designs.[5]

The Alchemist, 1663
Signed and dated on blue paper: A⁰ 1663 C
bega
Oil on panel, 14 x 12½″ (35.5 x 31.7 cm.)
H. Shickman Gallery, New York

Provenance: Possibly sale, Duc de Vallière, Paris, February
21, 1781, and sale, Lenoir, Paris, February 26, 1795 (as "Le
chimiste dans son laboratoire");[1] J.C.W. Sawbridge-Erle-
Drax, Olantigh, Wye, Kent; sale, J.C.W. Sawbridge-Erle-
Drax, Christie's, London, May 10, 1935, no. 70; Sir William
Jackson Pope, University of Cambridge; Fischer Scientific
Company, Pittsburgh.

Literature: Alfred Bader, "Cornelis Bega's Alchemist: A Prob-
lem in Art History," *Aldrichimica acta,* vol. 4, no. 2 (1971),
pp. 17–19, fig. 1.

The corner of a room lit by an open window is
filled with a great array of ceramic pots and
glass vessels, many of which are broken or
chipped. Old books and papers lie about and
herbs and flowers hang from the rafters to dry.
In this disorder sits a disheveled, bearded man,
wearing a beret and vest, his stockings fallen
down, weighing out pieces of a bright red sub-
stance on a balance. At the extreme right is a
crude drawing of an oven surmounted by a dis-
tilling vessel; a device of similar design but
disassembled into two parts rests at the man's
feet. Beneath the window are a mortar and pes-
tle, other vessels, and white wrapping paper
containing shards of a brown substance. In the
foreground are more shards of a white substance
in blue wrapping paper. The rich disorder of
primitive scientific equipment and what appear
to be mineral specimens identify the figure as an
alchemist. Forming a brilliant color accent at the
center, the red substance held by the disheveled
researcher could be one of a number of different
minerals favored by alchemists, including cin-
nabar (which turns silver when heated), minium
(a red lead with strong properties), and realgar.
The last mentioned reminds us of alchemy's dan-
gers; it gives off poisonous arsenical and
sulfurous fumes when heated.

In its orthodox form alchemy was a material-
ist philosophy whose medieval practitioners
believed in the universality of nature and the
possibility of transmuting one element into an-
other. The search for the philosopher's stone,
believed to have the power of transmuting the
baser metals into gold, inspired alchemists to
many practical discoveries and prompted the de-
velopment of the first chemical laboratories. In
the seventeenth century, the so-called Age of Ob-
servation, the distinction between science and
showmanship, indeed even magic, was scarcely
clear. Dutch inventor Cornelis Drebbel, for ex-
ample, won the praise of Constantijn Huygens

FIG. 1. CORNELIS BEGA,
Dance in a Village Inn, oil
on panel, Gemäldegalerie
Alte Meister, Dresden, no.
1476.

The *Merry Company in a Tavern* is one
of Bega's most ambitious compositions and
attracted many early admirers; Richard Braken-
burg, for example, quoted the dancing woman
and borrowed elements of the design in a work
dated 1702.[6] The painting's theme of dancing is
reminiscent not only of Ostade's works, but also
of earlier genre paintings (see, for example, pls.
2 and 14). The singing men resemble those in
Bega's *Two Men Singing,* of the following year
(cat. no. 4, fig. 1). The short white ruffs worn by
two figures in the foreground are unusually for-
mal garb for peasants and recall the costume of
the merry rhetoricians' declamator in Steen's
Rhetoricians at a Window (pl. 82).

P.C.S.

1. Houbraken 1718–21, vol. 1, p. 349.

2. See the *Peasant Inn,* dated 1658, Mauritshuis, The Hague,
no. 400. All other dated works are from the last four years of
the artist's life.

3. Other multifigured tavern scenes by Bega that attest to the
early influence of Ostade are in the Narodni Gallery, Prague,
inv. no. DO86; and sale, F. Muller and Co., Amsterdam, July
11–13, 1950, no. 1, ill.

4. Compare, for example, *Peasants Drinking in an Interior,*
signed and dated 1661, where similar figures and still-life
motifs appear (sale, Christie's, London, December 10, 1982,
no. 13).

5. Compare, for example, two other tavern scenes with
violinists: Rijksmuseum, Amsterdam, no. A24; and sale, F.
Muller and Co., Amsterdam, March 21–24, 1950, no. 79, ill.

6. Sale, Theodore Stroefer Collection, Julius Böhler, Munich,
October 28, 1937, no. 16, pl. 8.

Shown in Philadelphia only

and the patronage of James I for his technological and engineering feats, including not only a new process for dyeing wool but also a perpetual motion machine, a diving bell, and a rainmaking machine. Drebbel also dabbled in alchemy, to which he probably introduced his brother-in-law, the artist Hendrik Goltzius, an acquaintance that cost the latter more than a considerable financial investment.[2] A number of artists took an interest in alchemy, often incorporating alchemic symbols into their art.[3]

The common alchemist's obsession to change baser metals into gold and to discover the elixir of youth had by the middle of the sixteenth century given the practice a bad name; in both art

and literature alchemy became the paradigm of human folly. An early representation of the subject, Hieronymous Cock's print after Pieter Bruegel the Elder, depicts an alchemist ruining his family in the vain pursuit of gold (fig. 1). At the right of the print a scholar gestures to the alchemist while pointing to a volume with a chapter heading entitled *Alghe Mist* (All Rubbish), a pun taken up later by Jacob Cats and others.[4]

Among the many Dutch and Flemish artists who painted comical alchemist themes was Bega's presumed teacher Adriaen van Ostade.[5] Ostade's *Alchemist* (National Gallery, London, no. 846) is inscribed "oleum et operam perdis" (you lose your time and effort) and bears the same date, 1661, as an earlier *Alchemist* by Bega (fig. 2). That earlier *Alchemist* by Bega anticipates this picture in both theme and setting. Bega painted other pseudoscientific and medical types, including quack doctors and astrologers,[6] such as *The Astrologer* (fig. 3), in which the profession of the seated figure has been assumed to be astrology because of the celestial globe behind him. However, the book that lies open before him illustrates a human hand, suggesting an additional interest in palmistry.[7] *The Astrologer* employs an artfully cluttered design not unlike that of this *Alchemist*, and it shares a charlatan subject; moreover, it is dated the same year and is identical in size and support, possibly indicating that the two works were conceived as pendants.

Another version of this painting, but on canvas, is in the Bader Collection, Milwaukee.[8]

P.C.S.

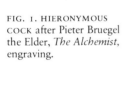

FIG. 1. HIERONYMOUS COCK after Pieter Bruegel the Elder, *The Alchemist*, engraving.

FIG. 2. CORNELIS BEGA, *The Alchemist*, 1661, oil on canvas, formerly Gemäldegalerie, Kassel, cat. 1929, no. 279.

FIG. 3. CORNELIS BEGA, *The Astrologer*, 1663, oil on panel, National Gallery, London, no. 1481.

The Duet, 1663
Signed and dated at the left on the bench: c Bega
A⁰ 1663
Oil on canvas, 17¾ x 16⅛" (45 x 41 cm.)
Nationalmuseum, Stockholm, no. NM310

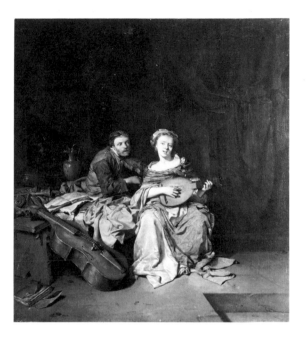

Provenance: De Fonspertuis Collection, Paris; acquired for
Queen Louisa Ulrika, 1748; King Gustav III, inv. 1792, no.
105; Royal Museum Collection, 1816; Nationalmuseum,
1866.

Exhibition: Stockholm, Nationalmuseum, *Holländska Mäs-
tare i Svensk Ago,* March–April 30, 1967, no. 8.

Literature: Wurzbach 1906–11, vol. 1, p. 73; E. W. Moes in
Thieme, Becker 1907–50, vol. 3 (1909), p. 174; Stockholm,
Nationalmuseum, cat. 1958, p. 11, no. 31.

A woman and a bearded man sit together, per-
forming a duet. The woman, who is richly
swathed in brilliant blue and gold drapery, plays
a lute; the man, more simply attired in a shirt,
leather jerkin, and headband, accompanies her
on a violin. Beside the couple there is a still life
of music books, a tall pitcher, and musical in-
struments—a viola da gamba resting on a bench,
a shawm, and an overturned lute. In the lower
right is a step in the stone floor, and in the
background is a heavy swag drawn to reveal
architecture in the shadows.

Although Bega's debt to his teacher, Adriaen
van Ostade, is evident in his scenes of peasants
in taverns and depictions of low-life professions,
such as *Merry Company in a Tavern* and *The
Alchemist* (pls. 33, 34), the artist went further
than any of the master's other followers in de-
veloping his own style.[1] An accomplished
draftsman, Bega left numerous careful figure and
drapery studies in a style inspired by Italian

1. See Hoet 1752, vol. 1, pp. 377, 407, and vol. 2, p. 244.

2. Documents of 1605 indicate that Goltzius was swindled
by a certain Leonard Engelbrecht who claimed to be able to
make gold; see E.W.J. Reznicek, *Hendrik Goltzius.
Zeichnungen* (Utrecht, 1961), vol. 1, pp. 118–19. Personally
critical of alchemy, Constantijn Huygens noted Goltzius's fig-
urative loss of an eye to the practice, referring to the artist's
neglect of his own profession *(De jeugd van Constantijn
Huygens door hemself beschreven,* trans. and ed. A. H. Kan
[Rotterdam, 1971], p. 72).

3. See J. Combe, "Sources alchimiques dans l'art de Jérome
Bosch," *Amour de l'art,* vol. 9 (1946); J. Read, *The Alche-
mist in Life, Literature and Art* (London, 1947); F. C.
Legrand, "Alchimistes et Sabbats de sorcières vus par les
peintres du XVIIe siècle," *Cahiers de Bordeaux-journées in-
ternationales d'études d'art,* 1957; J. van Lennep,
"L'Alchimie et Pierre Bruegel l'ancien," *Bulletin, Musées
Royaux des Beaux-Arts, Brussels,* vol. 14 (1965), pp. 105–
26; Lennep, *Art et Alchimie. Etude de l'iconographie Her-
metique et de son influences* (Paris/Brussels, 1966); Lennep,
"L'Alchimiste: Origine et developpement d'un thème de la
peinture du dix-septième siècle," *Revue belge d'archeologie et
d'histoire de l'art,* vol. 35, no. 3/4 (1966), pp. 149–68; E. E.
Ploos, H. Schipperger, H. Roosen Runge, *Alchimia* (Munich,
1970); M. Winner, *Pieter Bruegel als Zeichner* (Berlin,
1975), cat. no. 67; P. Dreyer, "Bruegels Alchimist von
1558—Versuch einer Deutung ad sensum mysticum," *Jahr-
buch der Berliner Museen,* vol. 19 (1977), pp. 69–113; and
M. Winner, "Zu Bruegels Alchimist," *Pieter Bruegel und
seine Welt* (Berlin, 1979), pp. 193–202.

4. *Proteus ofte Minne-beelden verandert in sinnebeelden*
(Amsterdam, 1627), p. 27. H.A.M. Snelders, "De Bekeerde
Alchimist," *Spiegel Historiael,* vol. 7 (January 1972), pp. 85–
91, also notes the use of this wordplay in Cornelis Udemans's
Het geestelijck gebouw met sinnebeelden (1659) and the
anonymous satire *Al-gemist, of de Verwaande pocher
bekaayt* (1709). Satirical references to alchemists also appear
in Dutch poetry, emblem books, and plays; in 1680, for
example, David Lingelbach (1641–1688), a surgeon and
member of the famous classicist circle "Nil Volentibus Ar-
duum," published his satire *De Bekeerde Alchimist of
Bedroogen Bedrieger* (Amsterdam, 1680).

5. Other Northern artists who depicted alchemists were Jan
van der Straat, David Teniers the Younger (see Braunschweig
1978, cat. no. 35), David Ryckaert III, Jan Steen, Hendrick
Sorgh, Thomas Wyck, Matheus van Helmont, Hendrick
Heerschop, Gerard Dou, Martin de Vos, and Justus van
Bentum.

6. For example, *Quack Doctor,* Collecting Point, Stichting
Nederlands Kunstbezit, inv. 1242.

7. See Brown 1978, no. 14. In discussing the painting he cites
contemporary Dutch literature on palmistry and chiromancy.

8. From the John Sheepshanks Collection; sale, Christie's,
London, 1969; see Alfred Bader, "Cornelis Bega's Alchemist:
A Problem in Art," *Aldrichimica acta,* vol. 4, no. 2 (1971), p.
18, fig. 3.

FIG. I. CORNELIS BEGA, *Two Men Singing*, 1662, oil on panel, National Gallery of Ireland, Dublin, no. 28.

Renaissance and Flemish drawings.[2] In *The Duet* the woman's attire is not an everyday costume worn by Dutch women in 1663 but rather a rich confusion of untailored drapery such as a model might wear while posing in a studio. It serves here to introduce an exotic element into an otherwise traditional musical company subject; moreover, it offers Bega an opportunity to demonstrate his virtuoso technique. The painting style bears some resemblance to the smooth manner developed by Dutch Italianate artists such as Karel Dujardin (pl. 50). There is some evidence, albeit slight, that Bega traveled to Italy as well as to Germany and Switzerland in 1653.

The intense color of the woman's costume reminds us that Bega often drew on blue paper and prepared papers. Although many of the artist's figure studies closely resemble his paintings and etchings, none has been identified as a direct preliminary study. The models in *The Duet* appear in many of Bega's works. At least nine other paintings by the artist are dated 1663.[3] Of the painter's numerous musical company subjects, the *Two Men Singing* (fig. 1) offers a particularly close comparison to this painting.

P.C.S.

1. Ostade's followers include, among others, Cornelis Dusart and Richard Brakenburg.

2. See Amsterdam/Washington 1981–82, pp. 105–7. According to Houbraken, Bega and his fellow-townsman Leendert van der Cooghen, pupil of Jacob Jordaens, often drew from life together. Other Haarlem artists who shared Bega's interest in drawing as well as comparable styles are Cornelis Visscher, Jan de Bray, and Gerrit Berckheyde.

3. See *The Alchemist*, cat. no. 3; *The Astrologer*, cat. no. 3, fig. 3; *Prayer before the Meal*, Rijksmuseum, Amsterdam, no. C95; *Tavern Scene*, Städelsches Kunstinstitut, Frankfurt, no. 209; *Trictrac Players*, French recuperation, no. MNR933 (formerly Hermitage, Leningrad); *Woman with Plant*, lent by George H. Lazarus to Royal Academy, London 1952–53, no. 473; *Man and Woman with Child*, sale, Amsterdam, November 28, 1916, no. 4; *Woman Playing a Lute* and its pendant, *Man Playing a Lute*, Galleria degli Uffizi, Florence, nos. 1187 and 1182.

Shown in Philadelphia and Berlin

Son of the still-life painter Pieter Claesz. (c. 1597–1661), Nicolaes Berchem was born in Haarlem in 1620. He was apprenticed to his father, who in 1634 is mentioned in the records of the Haarlem Guild of St. Luke as "teaching drawing to his son." Houbraken reported that he studied subsequently with Jan van Goyen (1596–1656), Nicolaes Moeyaert (1592/93–1655), Pieter de Grebber (c. 1600–1652/53), Johannes Wils (c. 1600–1666), and his cousin Jan Baptist Weenix (q.v.). The last is unlikely as Weenix was younger than Berchem. Berchem joined the Haarlem guild in June 1642 and by August had three registered pupils.

Although there is no firm evidence that Berchem traveled to Italy, his familiarity with Southern landscape makes such a trip (or trips) likely. He married in 1646, and in 1649 he and his wife, Catrijne Claesdr. de Groot, made a will. It has been suggested that Berchem accompanied Weenix to Rome in 1642, but again without certain evidence, although Weenix lived in Rome from 1642 to 1645. The artist is not mentioned again in the Netherlands until 1656, when he was in Haarlem, where he is also documented in 1657 and 1670. By 1677 he had moved to Amsterdam, where he died in 1683; he was buried in the Westerkerk.

Berchem was a highly productive and well-paid artist. The Italianate landscape scenes of his earliest years reflect the work of Pieter van Laer (q.v.) and Jan Both (c. 1615–1652); he also portrayed imaginary Mediterranean harbor scenes, water and dune landscapes, allegories, religious and mythological subjects, and genre scenes. He painted figures in landscapes by other artists, among them Jacob van Ruisdael (1628/29–1682), Meindert Hobbema (1638–1709), and Jan Hackaert (c. 1629–c. 1685). He etched more than fifty plates, the majority depicting animal subjects. His work was frequently engraved during the seventeenth and eighteenth centuries. Among his many pupils, listed by Houbraken, are Karel Dujardin (q.v.), Abraham Begeyn (c. 1635–1697), Willem Romeyn (c. 1624–c. 1694), Hendrick Mommers (c. 1623–1693), Johannes van der Bent (c. 1650–1690), Dirck Maes (1659–1717), Pieter de Hooch (q.v.), and Jacob Ochtervelt (q.v.).

C.B.

A Moor Presenting a Parrot to a Lady,
mid-1660s
Signed lower right: N Berchem F (NB in ligature)
Oil on canvas, 37 x 35" (94 x 89 cm.)
Wadsworth Atheneum, Hartford, The Ella Gallup Sumner and Mary Catlin Sumner Collection, 1961.29

Literature: De Bie 1661, p. 385; Houbraken 1718–21, vol. 2, pp. 109–14; de Winter 1767; Bartsch 1803–21, vol. 5, p. 245; Smith 1829–42, vol. 5; Kramm 1857–64, vol. 1, p. 76; Nagler 1858–79, vol. 1, p. 1794, and vol. 4, pp. 44, 2328; van der Willigen 1870, pp. 76–77, 252; Dutuit 1881–88, vol. 4, p. 29; Wurzbach 1906–11, vol. 1, pp. 82–85; Hofstede de Groot 1907–28, vol. 9, pp. 51–292; E. W. Moes in Thieme, Becker 1907–50, vol. 4 (1910), pp. 371–72; von Sick 1930; Hoogewerff 1931; Hollstein 1949–, vol. 1, pp. 249–80; Schaar 1954; Schaar 1956; Schaar 1958; Kuznetsov 1960; Maclaren 1960, pp. 20–21; Plietzsch 1960, pp. 147–52; Utrecht 1965, pp. 147–49; Rosenberg et al. 1966, pp. 176–77; Stechow 1966a; Nieuwstraten 1970; Bartsch 1971–, vol. 7, pp. 46–81; Haverkamp Begemann 1972; Schatborn 1974; Blankert 1978a, pp. 147–49; Duparc 1980; Boston/Saint Louis 1980–81, pp. 180–81, 292–93; Amsterdam/Washington 1981–82, pp. 67–68; Schapelhouman 1982; Schloss 1982.

Provenance: Duc de Choiseul-Praslin; sale, Choiseul-Praslin, Paris, February 18, 1793, no. 79, to A. J. Paillet (2,001 francs); Pieter de Smeth van Alphen; sale, Amsterdam, August 1, 1810, no. 11, to de Vries; de Vries, Amsterdam; Six van Hillegom, Amsterdam, 1834 (400 guineas); Muller, Amsterdam, October 16, 1928, no. 2; Hanns Schäffer, Berlin, c. 1930; private collection, Germany; Schaeffer Galleries, New York, 1959; purchased by the Wadsworth Atheneum, 1961.

Exhibitions: Amsterdam 1900, no. 6 (as *Othello and Desdemona*); New York, Schaeffer Galleries, *Twenty-Fifth Anniversary*, 1935–1961, 1961, no. 23; San Francisco 1966, no. 73.

Literature: Smith 1829–42, vol. 5, no. 103; C. Blanc, *Le Tresor de la curiosité*, vol. 2 (Paris, 1857), p. 162; Hofstede de Groot 1907–28, vol. 9, no. 71; von Sick 1930, pls. 25–26; Schaar 1958, p. 51; Stechow 1966a, pp. 159, 217, no. 70; Hartford, Wadsworth Atheneum, cat. 1978, p. 116.

FIG. 1. JOACHIM WTTEWAEL, *The Indian Homage*, ink and wash on paper, Albertina, Vienna, inv. no. 8163.

The setting is a Mediterranean seaport: an imposing classical building, boats, and turbaned traders are seen in the background. In the foreground, an exotically dressed Moor presents a parrot to a young woman. A pikeman stands on the right and watches the Moor. A lute player serenades a girl at the foot of a statue of Venus and Cupid.[1]

In old literature the scene was identified as *Othello and Desdemona* or *Pharaoh sending a Negro for Sarah*. In fact, neither subject is shown here, and Berchem probably did not have a particular literary source in mind. The richly

dressed Moor is paying court to the lady; both the statue of Venus (whose pose echoes that of the lady) and the turtledoves underline the theme of love. The contrast between the lady, who represents the Christian West, and the Moor, who symbolizes the pagan East, is emphasized by the cross she wears prominently around her neck; compare, for example, Joachim Wttewael's drawing known as *The Indian Homage* (fig. 1).

This picture belongs to a group of paintings by Berchem that show an elegantly dressed young woman on the quayside of a busy Mediterranean port. In some of these paintings (for example, one in the Wallace Collection, London, in which the woman's pose is identical), the woman is accompanied by a man who may be the captain of the ship that rides at anchor behind her. In others, as here, she is attended by her maid.[2]

The success of this subject in the Netherlands probably represents a craving for Southern exoticism (a kind of early Orientalism). Such landscapes were painted by both Berchem and his cousin Jan Baptist Weenix. The latter, who signed himself Giovanni Battista Weenix after returning from Rome, most likely pioneered this subject in such paintings as that dated to the day, September 16, 1649, in the Wallace Collection. That work shows a Mediterranean coast with classical ruins and a sarcophagus; a well-dressed, amorous huntsman and his companions occupy the foreground. Berchem apparently adopted Weenix's general setting and evolved even more fantastic and decorative variations. Although none of Berchem's Southern seaport scenes is dated, this painting is probably from the mid-1660s.[3]

C.B.

1. See E. McGrath, "A Netherlandish History by Joachim Wtewael," *Journal of the Warburg and Courtauld Institutes,* vol. 38 (1975), pl. 31a.

2. A version of this painting was engraved by Philippe le Bas (died 1783).

3. This entry is based on that in the excellent Wadsworth Atheneum catalogue (1978, p. 116), which, however, incorrectly states that the painting is dated.

Haarlem 1630–1693 Haarlem

The Baker, c. 1681
Signed lower center: H Berckheyde (HB in ligature); and monogrammed on the bowl: HB
Oil on canvas, 25 x 20⅞" (63.5 x 53 cm.)
Worcester Art Museum, Worcester, Massachusetts, Gift of Mr. and Mrs. Milton P. Higgins, no. 1975.105

Literature: Houbraken 1718–21, vol. 3, pp. 189–97; van der Willigen 1870, pp. 78–79; Meyer 1872–85, vol. 3, p. 586; Wurzbach 1906–11, vol. 1, pp. 85–86; E. W. Moes in Thieme, Becker 1907–50, vol. 4 (1910), pp. 376–77; Hollstein 1949–, vol. 2, p. 1; Bengtsson 1952, p. 54; Stechow 1957; Stechow 1966a; Welu 1977b; Jantzen 1979, pp. 87–88; Liedtke 1982a, pp. 73–74.

The son of a Haarlem butcher, Adriaan Joppe Berckheyde, and Cornelia Gerrits, Job Berckheyde was baptized in Haarlem on January 27, 1630. In November 1644, following early training as a bookbinder, he became a pupil of Jacob Willemsz. de Wet (c. 1610–c. 1675), a Haarlem landscape and genre painter from the circle of Rembrandt (1606–1669). Berckheyde entered the Guild of St. Luke in Haarlem on March 10, 1654. He and his younger brother Gerrit (1638–1698), a cityscape painter, traveled to Germany some time before 1660, when Gerrit entered the painters' guild in Haarlem. The two brothers worked in Cologne, Mannheim, Bonn, and Heidelberg. After returning to Haarlem, Job and Gerrit lived with their unmarried sister, Aeckje. Job died in Haarlem and was interred in Janskerk on November 23, 1693.

Job Berckheyde was primarily an architectural painter. He portrayed the streets, squares, and buildings of his native Haarlem and the cities that he visited in Germany and the Netherlands. His biblical and genre subjects are rare; the latter usually depict professions and peasant scenes.

C.V.B.R.

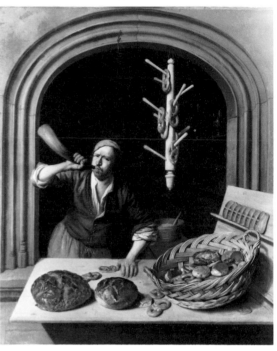

Provenance: Rector Krak Collection, Copenhagen; sale, Else Krak, Winkel and Magnussens, Copenhagen, January 30, 1931, no. 46; private collection, Denmark; Schaeffer Galleries, New York, 1960; Mr. and Mrs. Milton P. Higgins, Worcester, 1961; gift to the museum, 1975.

Exhibition: New Brunswick 1983, p. 61, no. 11, ill.

Literature: P. Gammelbo, *Dutch Still-life Painting from the 16th to the 18th Centuries in Danish Collections* (Copenhagen, 1960), p. 138, fig. 207 (as attributed to Berckheyde); Bernt 1970, vol. 1, no. 92, ill.; Welu 1977b.

Like his younger brother Gerrit, Job Berckheyde is best known for his cityscapes depicting the urban environments of the Netherlands and Germany. Occasionally, as in *The Baker,* he portrayed more specific aspects of city life.[1] The average Dutch town was filled with shops and stalls. A moderately successful merchant often owned the building in which his shop was housed and resided with his family in the rooms above. Jacobus Vrel's *Street Scene* (fig. 1) shows a typical baker's home and place of business.[2]

FIG. 1. JACOBUS VREL, *Street Scene*, oil on panel, Wadsworth Atheneum, Hartford, 1937.489.

FIG. 2. FRANS VAN MIERIS, *The Baker*, 1744, oil on panel, present whereabouts unknown.

FIG. 3. JOB BERCKHEYDE, *The Musician at a Window*, oil on canvas, Staatliches Museum, Schwerin, inv. no. G90.

Opening shop was as simple as opening the shutters on the ground floor. In the sixteenth century some Dutch towns began to restrict the location of bakeries. Wooden structures containing hot ovens were considered fire threats to adjacent buildings,[3] so that bakers were obliged to set up their operations in stone houses. The stone archway in Berckheyde's painting is appropriate to the architecture of a bakery.

In the traditional representation of individual bakers in Dutch genre painting—at least seven examples survive[4]—the man invariably is shown displaying his wares; usually he is sounding his horn to announce the morning's freshly baked bread. The lighthearted nature of the daily ritual apparent in these pictures is echoed in documents of the period. One baker's horn, for example, was inscribed "lecker en warm" (delicious and warm); another bakery was emblazoned with the phrase "Abel slayed his brother dead, here are sold cakes and white bread."[5] This spirited approach toward the baker and his product seems to have lost its naïve charm in the eighteenth century, if we are to draw a comparison with Frans van Mieris's depiction of a leering baker (fig. 2).[6]

In another painting of approximately the same size and composition in the Deutsches Brotmuseum in Ulm, Job Berckheyde provided a similar representation of a baker blowing his horn and displaying his wares.[7] In this work, signed and dated 1681, the baker's offerings include a large *duivelkater*, the giant diamond-shaped bread traditionally prepared during the Christmas season. The close stylistic connection suggests that *The Baker* was executed about the same time. Indeed, were it not for the repetitive subject, one would be tempted to regard the two paintings as pendants; however, a far more likely candidate as a companion to our painting is Berckheyde's *Musician at a Window* (fig. 3),[8] a work that owes its inspiration to Honthorst's *Merry Fiddler* (pl. 7). The dimensions of *The Musician at a Window* (63.8 x 54 cm.) and *The Baker* vary less than one centimeter, and both pictures show figures in the same archway, with objects on the sill projecting illusionistically into the viewer's world.

O.N.

1. See Welu 1977b; Stechow 1957; E. W. Moes in Thieme, Becker 1907–50, vol. 3 (1909), pp. 376–77.

2. Hartford, Wadsworth Atheneum, cat. 1978, p. 200, no. 167. The sign under the porch roof indicates that the house is for rent ("dit huys is te huur").

3. See Schotel 1905, p. 207.

4. See Welu 1977b.

5. "Abel sloegh zijn broeder doot, hier verkoopt men koekjens en wittebroot" (Schotel 1905, pp. 208–9).

6. Compare also van Mieris's 1721 painting of a bakery (Kassel, Staatliche Kunstsammlungen, cat. 1913, p. 41, no. 311). In the drawing by van Mieris in the Fodor Collection (Amsterdam Historical Museum, Amsterdam, inv. no. A10219), the lewd message is more direct than in figure 2. In the drawing, a leering man offers a sausage to a woman carrying a jug and baked buns on a platter.

7. Rotterdam 1983, p. 39, no. 47, ill.

8. James Welu of the Worcester Art Museum kindly brought this painting to my attention.

Gorinchem 1564–1651 Utrecht

Shepherd and Shepherdess, 1627
Signed and dated lower left: A bloemaert fe.
1627
Oil on canvas, 23½ x 29¼" (59.7 x 74.3 cm.)
Niedersächsisches Landesmuseum, Hannover,
PAM 917

Literature: Van Mander 1603–4, pp. 297–98; de Bie 1661, pp. 43–46, 485; Sandrart 1675–79, vol. 2, p. 291; Baldinucci 1686, pp. 44, 61; de Piles 1699, pp. 397–98; Houbraken 1718–21, vol. 1, pp. 43–44; Bloemaert 1740; Blanc 1854–90, vol. 1, p. 373; Kramm 1857–64, vol. 1, p. 101; Obreen 1877–90, vol. 2, p. 274, and vol. 5, pp. 333–35; Muller 1880, p. 146; Hymans 1884, vol. 2, pp. 370f.; Wurzbach 1906–11, vol. 1, pp. 109–11; Sandrart, Peltzer 1925, pp. 153, 157, 164, 172–75, 184, 248; Müller 1927; Delbanco 1928; von Schneider 1933, pp. 52–56; E. W. Moes in Thieme, Becker 1907–50, vol. 4 (1935), pp. 125–26; van Mander, van de Wall 1936, pp. 413–17; Bredius 1937; Hollstein 1949–, vol. 2, pp. 60–69; Philipsen 1957–59; Rosenberg et al. 1966, pp. 16–17, 143; Stechow 1966a; Röthlisberger 1967; Kettering 1977; Braunschweig 1978, pp. 48–51; Nicolson 1979, pp. 23–24; Boston/Saint Louis 1980–81, pp. 33–35; Amsterdam/Washington 1981–82, pp. 38–39; Kettering 1983.

According to Houbraken, Abraham Bloemaert was born in Gorinchem in 1564. His father, Cornelis, was apparently a sculptor, painter, architect, and engineer, who had fled his native Dordrecht for political reasons. As a child, Bloemaert moved with his family from Gorinchem to 's Hertogenbosch and then to Utrecht. His artistic training began with his father, and he also studied briefly with the Utrecht artist Gerrit Splinter (active c. 1569–86) before becoming apprenticed to Joos de Beer (died 1599), who had been a pupil of Frans Floris (c. 1520–1570). Joachim Wttewael (1566–1638) was a fellow-student under de Beer. Bloemaert was in Paris between 1580 and 1583, where he studied with a number of painters, including Hieronymus Francken (1540–1610) of Antwerp. He is documented in Utrecht in 1583 but left in October 1591 to join his father, who had been appointed municipal architect in Amsterdam. Bloemaert returned to Utrecht by November 1593. In 1611 he was one of the founding members of the Utrecht Guild of St. Luke and in 1618, its dean. Bloemaert was married twice, first to Judith Schonenberg on May 2, 1592, in Amsterdam and then, in 1601, to Geertruida de Roy, with whom he had six children. He died in Utrecht on January 27, 1651, and was buried in the church of St. Catherine.

Bloemaert painted relatively few genre scenes; his principal subjects were religious, mythological, and allegorical. He also painted a number of portraits. A renowned artist, Bloemaert was visited in Utrecht by Peter Paul Rubens (1577–1640) and by Queen Elizabeth of Bohemia. He was very active as a teacher and trained successive generations of Utrecht painters, including Cornelis van Poelenburgh (c. 1586–1667), Hendrick ter Brugghen (q.v.), Gerrit van Honthorst (q.v.), Wybrand de Geest (1592–c. 1661), Jacob Gerritsz. Cuyp (1594–1651), Jan van Bijlert (1597–1671), Nicolaes Knüpfer (c. 1603–1655), Willem van Honthorst (1604–1666), Andries and Jan Both (1612/13–1641 and c. 1615–1652, respectively), and Jan Baptist Weenix (q.v.). Bloemaert's Fondamenten der Teecken-Konst (Foundations of the art of drawing), engraved by his son Frederick, was used in the training of Dutch artists until the nineteenth century.

C.B/C.V.B.R.

Provenance: Sale, Christie's, London, 1929; purchased from dealer Benedict, Berlin, 1929.

Exhibition: Braunschweig 1978, cat. no. 3.

Literature: Hannover, Niedersächsische Landesgalerie, cat. 1954, no. 20, p. 38; Hannover, Niedersächsische Landesgalerie, cat. 1969, p. 42; Kettering 1977, p. 29; Braunschweig 1978, cat. no. 3, pp. 48–51; Kettering 1983, p. 87.

A shepherd and a shepherdess are seen in a sunny landscape. The shepherd lies on the ground; in his right hand is a flute, which he slips underneath the skirt of the seated shepherdess.

The bucolic setting and the two figures are characteristic of the Dutch pastoral tradition, which was in the first place a literary phenomenon.[1]

Widespread enthusiasm for pastoral plays, poems, songs, paintings, and prints was initiated in 1605 by *Granida,* a successful play by Pieter Cornelisz. Hooft. Scenes from Hooft's play were depicted by artists (for example, Hendrick ter Brugghen) and the pastoral guise was adopted in portraiture. In Utrecht during the 1620s, ter Brugghen, Paulus Moreelse, Honthorst, Bloemaert, and others treated the shepherdess as an erotic figure or even as a courtesan brazenly flaunting her charms in a low-cut bodice. The erotic possibilities of her encounters with shepherds became a familiar subject. In Bloemaert's painting, the significance of the shepherd's vulgar gesture with his flute is unequivocal.[2]

There is an engraving by Cornelis Bloemaert of a closely related composition, after his father Abraham's design, which is the eighth plate in the *Otia delectant* series (fig. 1). The name of the collection comes from the opening words of the poem by H. de Rooij on the title page; the series, although undated, was probably completed before Cornelis Bloemaert left Utrecht in 1630. The composition in the engraving is reversed; thus the shepherdess sits on the left. She is spinning with the distaff tucked under her right arm and the spindle in her right hand. She is interrupted in this industrious and traditionally virtuous task by the impertinent shepherd, who thrusts his flute underneath her skirt. He is watched by an old woman, perhaps a madam figure, who encourages his crude advances. The shepherdess speaks the following, in Latin: "I

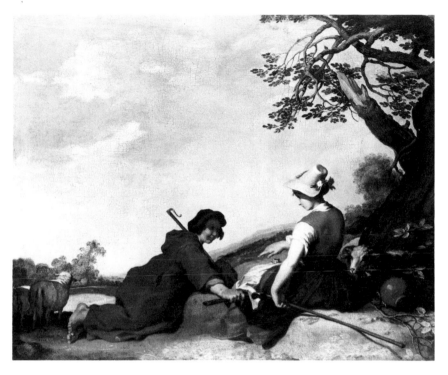

include a vernacular play, *Tryntje Cornelis,* which includes repeated coarse references to physical love. Huygens's play was banned in Holland for many years, but was revived recently for the first performance since the seventeenth century.

Bloemaert's painting is the first dated pastoral scene by a Utrecht artist in which full-length figures are shown in a rural setting (although Pieter Lastman had shown an amorous shepherd and shepherdess in a painting of 1624, in the Pomorskie Museum, Gdansk). In his *Leerdicht* of 1604, Karel van Mander urged artists to treat figures in landscape;[5] however, Bloemaert's painting is more immediately a response to the growing popularity of vernacular pastoral literature in the Dutch republic. Subsequently, the subject of pastoral love was painted again by Bloemaert and by artists from Utrecht and elsewhere.[6]

<div style="text-align: right">C.B.</div>

1. See Kettering 1983.

2. See Braunschweig 1978, cat. no. 3. The authors, despite the obvious meaning of the shepherd's gesture, provide an elaborate iconographic exegesis of the flute motif as a phallic symbol. They also suggest that the jug symbolizes the female genitalia.

3. "Fila guidem duco quae dant mihi vile lucellum laudibus ast horum Tullius impar erit."

4. See Kettering 1977.

5. See van Mander, Miedema 1973, vol. 1, no. 41, p. 217.

6. Kettering (1983) provides numerous references.

FIG. 1. CORNELIS BLOEMAERT, engraving from *Otia delectant.*

am carding wool, which brings the little money, [but] Cicero himself would be unequal to the praise of my work."[3] The shepherdess stands for the virtuous, hardworking woman who is impervious to temptation.

Rembrandt etched a characteristically original—and explicit—treatment of a similar pastoral encounter in his 1642 *Fluteplayer,* in which a shepherdess, who threads a floral wreath, is serenaded by a leering flutist.[4] A modern audience may be puzzled by the crudity, which borders on the worst barroom humor, of Bloemaert's painting and, for that matter, Rembrandt's etching. Bloemaert's indulgence in such humor, when contrasted with his paintings of sophisticated and high-minded religious subjects, mythology, classical history, and learned allegory, is especially surprising. This combination of the vulgar and the sophisticated, the crude and the learned, is distinctive of Dutch art and literature in the early seventeenth century. A comparable example is provided by the distinguished author Constantijn Huygens, secretary to successive Princes of Orange, who was a learned humanist with an international circle of literary acquaintances. His numerous works, many of which are in Latin and French,

Zwolle 1617–1681 Deventer

The Family of the Stone Grinder, c. 1653–55
Monogrammed lower right: GTB
Oil on canvas, 28⅜ x 23¼″ (72 x 59 cm.)
Gemäldegalerie, Staatliche Museen Preussischer
Kulturbesitz, Berlin (West), no. 793

Literature: Houbraken 1718–21, vol. 3, pp. 32, 34–40; Weyerman 1729–69, vol. 2, p. 376; Smith 1829–42, vol. 4, pp. 111–42, and vol. 9, p. 529; Nagler 1835–52, vol. 18, p. 239; Immerzeel 1842–43, vol. 3, p. 132; Kramm 1857–64, vol. 6, p. 1612; Nagler 1858–79, vol. 1, p. 1773, and vol. 2, p. 733; van der Willigen 1870, p. 352; Lemcke 1875; Bode 1881; Bode 1883, pp. 176–90; Bredius 1883; van Doorninck 1883; Bredius 1885b; Moes 1886; Michel 1887; Rosenberg 1897; Bredius 1899b; Houck 1899; Bots 1900; Bode 1906, p. 68; Wurzbach 1906–11, vol. 2, pp. 698–702; de Chennevières 1908; Hofstede de Groot 1908–27, vol. 5, pp. 1–145; A. Bredius in Thieme, Becker 1907–50, vol. 4 (1910), pp. 336–38; Osborn 1910–11; Hellens 1911; Bredius 1915–22; Bode 1917, pp. 98–111; Rothes 1921; Hellens 1926; Hannema 1943; Plietzsch 1944; Scholte 1948; Welcker 1948; Gudlaugsson 1949a; Gudlaugsson 1949b; Gudlaugsson 1955; Moes-Veth 1955; Moes-Veth 1958; Gudlaugsson 1959–60; Maclaren 1960, pp. 32–33; Gudlaugsson 1960–61; Pieper 1961; Amsterdam 1966; Rosenberg et al. 1966, pp. 127–30; Verbeek 1966; Salinger 1967a; The Hague/Münster 1974; Amsterdam 1976, pp. 32–43; Montias 1977; Amsterdam/Washington 1981–82, p. 86; Dudok van Heel 1983; Kettering 1983b.

Born in Zwolle in late 1617, into a well-to-do family, Gerard ter Borch first studied under his father, Gerard ter Borch the Elder (1584–1662), who was in Italy in his youth. Ter Borch's mother, Anna Bufkens, died in 1621. The inscription on one of his drawings in the Rijksprentenkabinet suggests that he was in Amsterdam in 1632. In 1633 he returned to Zwolle, but left again in the summer of 1634 for Haarlem to study with Pieter Molijn (1595–1661). He entered the Haarlem guild in 1635. In July he traveled to London to work with his uncle, the copper-engraver Robert van Voerst. According to Houbraken, after returning to Zwolle in 1636, the artist traveled in Germany, Italy, France, Spain, and the Netherlands. It is possible that he made several short trips to Rome and Naples in 1637, 1640, or 1641; to Madrid in 1636–37 or 1639; and to Antwerp and France in 1640. By 1646 he was in Münster in Westphalia, where he painted miniatures and a group portrait of the delegates to the peace negotiations between Spain and the Netherlands. Houbraken's report that he accompanied the Conde de Peñaranda to Spain in 1648 , where he painted portraits of Philip IV and his court, is probably unreliable; the court did not return to Madrid until September 1650, and records show that ter Borch was in Amsterdam in November 1648, The Hague in 1649, and Kampen in December 1650. On April 22, 1653, he signed a document with the young Johannes Vermeer (q.v.) in Delft. On February 14, 1654, he married Geertruyt Matthijs and settled permanently in Deventer. He became a citizen of the city on February 13, 1655, and was named a gemeensman (common councilor) in 1666. Following the death of his wife, ter Borch visited Amsterdam in 1674, and The Hague and Haarlem in 1675. He died in Deventer on December 8, 1681.

Ter Borch's early genre paintings are similar to the guardroom scenes of Willem Duyster (q.v.) and Pieter Codde (q.v.). By c. 1645 he introduced a new type of small, full-length portrait and around 1650 contributed to the development of a new simplified genre scene with only a few figures, in an upright format. These works are characterized by great technical and psychological refinement. Caspar Netscher (q.v.) was the master's most notable pupil.

C.V.B.R.

Provenance: Duc de Choiseul, Paris; sale, Choiseul, Paris, April 6, 1772, no. 30 (4,809 francs); sale, Prince de Conti, Paris, April 8, 1777, no. 780 (2,400 francs); sale, Chabot, Paris, December 17, 1785 (2,400 francs); sale, Robit, Paris, May 11, 1801, no. 153 (1,800 francs); Duchesse de Berry, Paris; sale, de Berry, London, April 4, 1837, no. 3; acquired by the Königliche Museen, Berlin, 1837.

Exhibitions: Paris 1951, no. 118; The Hague/Münster 1974, pp. 114–16, no. 28, ill.

Literature: Smith 1829–42, vol. 4, no. 18, and suppl., no. 8 (as identical with Smith 1829–42, vol. 4 [as Metsu], no. 76); Wurzbach 1906–11, vol. 2, p. 700; Hofstede de Groot 1907–28, vol. 5, no. 19; Plietzsch 1944, no. 36; J. Verbeek, "Johannes van Cuylenburch en zijn vader Gerrit Lambertsz.," *Oud Holland*, vol. 70 (1955), p. 67; Gudlaugsson 1959–60, vol. 1, pp. 91–92, vol. 2, pp. 110–112, cat. 100, ill. p. 259; Berlin (West), Gemäldegalerie, cat. 1975, pp. 423–24, no. 793, ill.

In a disorderly courtyard, a man lying on a plank sharpens a scythe on a large grindstone as another man watches. A woman, who sits near the doorway in a crumbling masonry wall, cleans her child's hair. A tall, gabled building, its slate roof surmounted by a stork's nest, rises above the grindstone's wooden enclosure. The foreground is littered with blades, a hammer, a broken chair, and shards of crockery.

This painting is an exception in the artist's oeuvre because of its courtyard environment, which dominates the figures, and the depiction of a low-life profession instead of soldiers or high life. The light tonality and colorful palette

are also unusual. In addition to guardroom scenes and portraits, ter Borch executed a few paintings of stable scenes in his early years, but no other courtyards.[1] The date ascribed to the painting is based on a stylistic connection with the *Unwelcome News*, dated 1653 (Mauritshuis, The Hague, inv. no. 176).[2] *The Family of the Stone Grinder* could have been executed several years later, but need not be placed after Pieter de Hooch's courtyards of about 1658, which the work anticipates in theme and daylight tonality.[3] Close examination, however, of ter Borch's space—very likely a yard in Zwolle—reveals little of de Hooch's interest in coherent perspective. The conception of the work and its low-life subject relate more to works by the Ostades, specifically Isaack's paintings from the late 1640s, such as *Peasants before a Farmhouse* (cat. no. 94, fig. 1),[4] and Adriaen's etchings, which include *A Scissors Sharpener*.[5] Knife sharpeners and stone grinders were also depicted by Jan Baptist Weenix and Michael Sweerts.[6] The motif of the mother cradling the child's head in her lap was treated centrally and in a more socially elevated context in ter Borch's *Mother Combing the Hair of Her Child,* from the same period (Mauritshuis, The Hague, inv. no. 744); this *moederzorg* (maternal care) theme had precedents in earlier paintings by, among others, Dirck Hals and Quirijn van Brekelenkam (pl. 60).

Grindstones and scissors and knife sharpeners appeared in emblematic literature of the period. Jacob Cats and Adriaen van de Venne saw amorous, biblical, and moral meanings in the device; they alluded to the paradoxical aspect of the grindstone, which though dull itself will whet the edge of a blade.[7] The motif of the mother combing or delousing her child's hair may also allude to a need to purge and order the mind, the soul, and the body; however, one should bear in mind Gudlaugsson's observation that common motifs such as the stone sharpener need not be emblematic in ter Borch's work.[8]

A close variant of the work by the painter from Zwolle, Johannes van Cuylenburch, is in the John and Mable Ringling Museum, Sarasota;[9] a pastiche survives and is probably a work by Jan Grasdorp.[10]

P.C.S.

1. See, for example, *The Peasant Cart,* formerly C. D. van Hengel, Arnhem (Gudlaugsson 1959–60, vol. 2, no. 36); *The Cow Stall,* J. P. Getty Museum, Malibu (Gudlaugsson 1959–60, vol. 2, no. 74); and *The Horse Stall,* private collection, U.S.A. (Gudlaugsson 1959–60, vol. 2, no. 109).

2. See Gudlaugsson 1959–60, vol. 2, no. 99. The same model was used for the standing man in both paintings.

3. Compare especially de Hooch's *Two Women with a Child in a Courtyard,* c. 1657, Toledo Museum of Art (Sutton 1980, no. 20, pl. 4). Like Jan Steen's so-called *Burgher of Delft and His Daughter,* of 1655, private collection (Braun 1980, no. 78)—also an exceptional work within that master's oeuvre—the Berlin painting is unique among ter Borch's paintings in its precedents for outdoor Delft painting.

4. Gudlaugsson 1959–60, vol. 2, p. 111; compare also Isaack van Ostade, *Man and a Woman before a Barn,* Musées Royaux des Beaux-Arts de Belgique, Brussels, no. 342.

5. See Godefroy 1930, no. 36.

6. See, respectively, *Couple with a Scissors Grinder,* Munich, Alte Pinakothek, cat. 1908, no. 633 (not in later catalogues); and *Street Scene with a Stone Grinder and an Artist Drawing Bernini's "Neptune and Triton"* Museum Boymans–van Beuningen, Rotterdam, inv. no. 2358.

7. Jacob Cats (1614, no. XXV) wrote: "Al is de steen wat plomp en onbequaem tot snyden, Soo wil hy evenwel aan 't mes geen plompheyt leyden" (Although the stone is dull and difficult to cut, it will serve to sharpen a knife); quoted in Gudlaugsson 1959–60, vol. 2, p. 111. As Langemeyer and Hoetinck further observed (see The Hague/Münster 1974, p. 114), Cats's *Proteus* ([Amsterdam, 1658], p. 52; see also Henkel, Schöne 1967, no. 1411) relates the sharpening stone to the hypocritical nature of love: *dat nec habet;* to paradoxical religious notions: *docet ipse docendus,* an allusion to Paul's second letter to the Romans (Romans 2:21); and to moralistic meanings: *peccans peccata corrigit* (sinning begets sin), the last mentioned under the word *scrabo* (from the Latin *scrabes* or *scrabies*), which can refer to roughness, shabbiness, scabies, or mange. The authors of the exhibition catalogue suggested that this might refer respectively to the stone, the impoverished setting, and the motif of the woman and child on the right (see The Hague/Münster 1974). For Adriaen van de Venne's knife-sharpener's song, see "Sinnighe zeeusche slyper," in *Tafereel van sinne-mal* (Middelburg, 1623), pp. 75–84.

8. See Gudlaugsson 1959–60, vol. 2, p. 111.

9. See J. Verbeek, "Johannes van Cuylenburch en zijn vader Gerrit Lambertsz.," *Oud Holland,* vol. 70 (1955), p. 67; Gudlaugsson 1959–60, vol. 2, cat. 100a, pl. 11, fig. 1.

10. Gudlaugsson 1959–60, vol. 2, cat. 100b, pl. 11, fig. 2.

Parental Admonition, c. 1654–55
Oil on canvas, 27½ x 23⅝″ (70 x 60 cm.)
Gemäldegalerie, Staatliche Museen Preussischer
Kulturbesitz, Berlin (West), no. 791

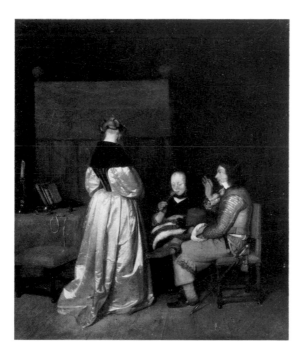

Provenance: Johann Anton Peters (court painter to Prince
Karl Alexander of Lothringen, stadholder of the Nether-
lands), Paris; Peters Collection, sold at auction in two
installments in 1779 and 1787; private collection, Paris;[1]
acquired for the Königliche Gemäldegalerie, Berlin (cat.
1830, no. 278) by G. F. Waagen prior to 1815.

Exhibition: Washington/New York/Chicago 1948–49, no.
123.

Literature: Hofstede de Groot 1908–27, vol. 5, p. 70, no.
187; W. Drost, *Barockmalerei in den germanischen Ländern*
(Handbuch der Kunstwissenschaft) (Potsdam, 1926), p. 187;
Plietzsch 1944, pp. 21, 28f., 45f., no. 60; H. Wölfflin,
Kunstgeschichtliche Grundbegriffe, 10th ed. (Basel, 1948),
pp. 13–16; E. Plietzsch, *Randbemerkungen zur Ausstellung
holländischer Gemälde in Museum Dahlem (Berliner Mu-
seen)*, n.s., vol. 1 (1951), p. 40; Gudlaugsson 1959–60, vol.
1, pp. 97f., pl. 110, and vol. 2, p. 117, no. 110; Rosenberg
et al. 1966, p. 128, pl. 104; The Hague/Münster 1974, p.
126, under no. 32; Berlin (West), Gemäldegalerie cat. 1975,
p. 420, no. 781; Berlin (West), Gemäldegalerie cat. 1978, p.
430, no. 791.

J. G. Wille reproduced ter Borch's painting in an
engraving entitled *Paternal Admonition*. It was
under this name (adopted also by Goethe[2]) that
the picture became widely known. Writers gen-
erally regarded it as a family scene; however,
aspects of the picture contradict such an inter-
pretation: The youthful appearances of the
persons assembled seem not to be separated by a
generation; the swaggering demeanor and mili-
tary garb of the man are at odds with the role of
a solicitous father; moreover, there appears to be
a gold piece held in the soldier's upraised right
hand.[3] If, indeed, it is a coin it would suggest his
real concern, which would have nothing to do
with paternal pedagogy.

The theme of the picture is certainly not
fatherly advice but may be love for hire. The
setting is a room furnished suggestively with a
four-poster bed with closed curtains and a
nearby dressing table. The fee proposed by the
cavalier would be offered in the spirit of the
adage: "Money bends love to its will."[4] He of-
fers it to the one whom Goethe had described as
"the noble creature in the full-flowing, soft-
pleated, white silk gown." It follows that the
woman beside the cavalier would be the dis-
reputable procuress; the charming way in which
she delicately sips her glass of wine scarcely dis-
pels the suggestion.

Love for hire was a theme to which ter Borch
returned on more than one occasion, for exam-
ple in *Soldier Offering a Young Woman Coins*
(pl. 74). Shortly before 1650 in *The Gallant
Officer* (cat. no. 15, fig. 1) and again about
1662–63 in *Young Couple Drinking Wine*
(Gemäldegalerie, Staatliche Museen Preussischer
Kulturbesitz, Berlin [West], no. 791H), ter
Borch presented the amorous incident reduced
to the principals, shown as three-quarter-length
figures depicted against a neutral background.
Masters of the Utrecht School had painted such
subjects for some time, but always in composi-
tions of large format with dramatic Caravag-
gesque contrasts of light and shadow, as in
The Procuress by Dirck van Baburen (pl. 10).

FIG. 1. GERARD TER BORCH, *Parental Admonition,* oil on canvas, Rijksmuseum, Amsterdam, no. A404.

Ter Borch, by comparison, is much more restrained. His painting is marked by decorum and tranquil expression, characteristics that he constantly refined. This trend is reflected in all the preceding examples, and in *Parental Admonition,* which is one of the earliest examples of his mature style.[5] Here the daily life of the peasant is exchanged for the more sophisticated ambiance of the refined burgher. The narrative and the conception of the work suggest distinguished and fashionable society. Indeed, yet another theory has recently suggested that the work depicts a marriage proposal,[6] a subject that well accords with this atmosphere, but is not any more certain to be the subject.

The painting is probably from the period just prior to 1655, the year inscribed on a copy of the work by Caspar Netscher (Gotha, Museum, cat. 1890, no. 298). Thus, as early as 1655, ter Borch had developed an elegant refinement of theme and execution, which was to become a characteristic feature of the classic period of Dutch genre painting.[7] The existence of at least twenty-four copies, imitations, or partial copies of discrete portions, catalogued by Gudlaugsson, testify to the popularity and value of this painting as a model for others.

In this respect the painting excels the somewhat earlier version now in the Rijksmuseum, Amsterdam (fig. 1), in which the scene is conceived in a horizontal format.[8] In the broader expanse on the right, ter Borch introduced the motif of a dog with its head lowered, a mongrel of ignoble pedigree. The four-legged creature may hint at the baser desires that seize its master. That it lends a churlish touch to the overall impression of noble airs and intentions may explain ter Borch's deliberate omission of the dog from the Berlin version. In the transition to a vertical format, the animal is simply omitted. At the same time, the more narrowly conceived angle of vision gives the group of figures greater compactness and enhances the compositional value of the woman seen from the rear.[9]

The orientation of the young woman and the way she inclines her head slightly to one side leaves the viewer in a quandary as to her answer to the question put to her. Ter Borch's use of this motif is typical: the outcome of his narrative always remains tantalizingly obscure. In his *Soldier Offering a Young Woman Coins* (pl. 74), for example, the beautiful woman's downcast eyes veil the mystery of how she will react to the soldier's financial proposition.

<div align="center">J.K.</div>

1. Contrary to older museum catalogues and to Gudlaugsson, the picture was not included in the Giustiniani Collection, which was acquired for the Berlin gallery in 1815 in Paris. Compare L. Salerno, "The Picture Gallery of Vincenzo Giustiniani," *The Burlington Magazine,* vol. 102, no. 682 (January 1960), p. 21.

2. Goethe reported in his *Wahlverwandtschaften* (pt. 2, chap. 5) a sociable evening at which ter Borch's painting was recreated as a *tableau vivant.* Wille's print served as a model.

3. The detail has been rubbed; at an earlier time it may have been painted over as an undesirable motif. Wille's print omits the coin altogether. W. Drost (1926) was probably the first to perceive a mercenary context in the picture.

4. The aphorism is to be found in van Veen (1608), where the accompanying illustration depicts a cupid proffering gifts. For another example of emblematic poetry that aptly characterizes love for hire, see Jacob Cats, *Maechden plicht* (Middelburg, 1628), xxx: "Der pennings reden klinckt best" (money talks). See also Gudlaugsson 1959–60, vol. 1, p. 81, and vol. 2, p. 95, under no. 75.

5. See Gudlaugsson 1959–60, vol. 1, pp. 72–102.

6. See C. Boschma, "Willem Bartel van der Kooi en het tekenonderwijs in Friesland" (Ph.D. diss., Groningen 1976), no. 1.

7. On the influence of ter Borch's work on de Hooch, Vermeer, and van Mieris the Elder, see Sutton 1980, p. 31; Blankert 1975, pp. 24–26; and Naumann 1981a, vol. 1, p. 57.

8. Gudlaugsson 1959–60, vol. 2, p. 116, no. 110.

9. Gudlaugsson, whose opinion follows that of Hofstede de Groot, gives the Amsterdam version priority over the Berlin version in point of time, considering the latter "less animated" in expression and execution. The differences between the two paintings, however, are scarcely noticeable. The term "less animated," may reflect the traditional prejudice against copies and reproductions in general, which are seen as more routine and lacking in sensitivity and originality. In any case, the deterioration of the Amsterdam version makes comparison virtually impossible; however, the Berlin version surely represents a revision or a logical evolution toward more concentrated design.

*Officer Writing a Letter, with a Trumpeter
(The Dispatch),* c. 1658–59
Signed lower right on table crosspiece: GTBorch
(GTB in ligature)
Oil on canvas, 22⅜ x 17¼" (56.8 x 43.8 cm.)
Philadelphia Museum of Art, William L. Elkins
Collection, E24-3-21

Provenance: Possibly sale, Petronella de la Court, widow of
Adam Oortmans, Amsterdam, October 19, 1707, no. 31;
Jan and Pieter Bisschop, Rotterdam, by 1752 (after Jan's
death the collection sold as a whole to Adriaen and Jan
Hope, Amsterdam); Henry Philip Hope, 1833; Henry
Thomas Hope, 1854; Lord Francis Pelham Clinton Hope,
London, cat. 1898, no. 70; entire Hope Collection sold to
dealer P. and D. Colnaghi and A. Wertheimer, London,
1898; W. L. Elkins, Philadelphia, cat. 1900, no. 129; ac-
quired by the museum, 1924.

Exhibitions: Victoria and Albert Museum, London, 1891–98
(on loan from Lord Francis Pelham Clinton Hope); The
Hague/Münster 1974, cat. no. 41, ill.

Literature: Hoet 1752, vol. 2, no. 528; Smith 1829–42, vol.
4, p. 121, no. 11; Waagen 1854, vol. 2, pp. 115–16, no. 2;
*The Hope Collection of Pictures of the Dutch and Flemish
Schools* (London, 1898), no. 70, ill.; Hofstede de Groot
1908–27, vol. 5, p. 16, no. 31; Plietzsch 1944, p. 41 (under
cat. no. 22); Gudlaugsson 1959–60, vol. 1, pp. 114–17, pl.
143, and vol. 2, pp. 154–55, no. 143; Maclaren 1960, pp.
45, 46 n. 17; A. S. Marks, "David Wilkie's 'Letter of Intro-
duction,' " *The Burlington Magazine,* vol. 110, no. 780
(March 1968), p. 127, pl. 15, p. 130; Robinson 1974, p. 40.

An officer seated at a table is absorbed in the
composition of a letter while a messenger with a
long trumpet slung over his shoulder waits at the
left. A white dog stands expectantly in the fore-
ground. Images involving letters—writing,
dictation, reading, and reception—were among
ter Borch's favorite themes. Although letter
themes had appeared earlier in Dutch art (for
example, Dirck Hals's *Seated Woman with a
Letter,* pl. 12), ter Borch was the great popu-
larizer of these subjects. He frequently depicted
elegant young women as the principal figures in
these scenes (for example, his paintings in the
Mauritshuis, The Hague, and the Wallace Col-
lection and Buckingham Palace, London). In the
late 1650s, however, he began to use letter
themes in paintings of military life, which
brought an element of reflection and stillness to
the traditionally rowdy guardroom scene. An ex-
ample of ter Borch's more animated subjects,
The Guardroom (John G. Johnson Collection,
Philadelphia, cat. no. 504), bears the date 1658.
The model for the seated figure in *Officer Writ-
ing a Letter* was probably the painter Caspar
Netscher, who studied with ter Borch until 1658
or 1659; furthermore, stylistic connections with
The Guardroom seem to confirm a date of c.
1658–59 for this painting.[1]

The prominent ace of hearts, which lies beside
shards of a clay pipe on the wooden floor, sug-
gests that the officer pens a love letter.[2] Card
games in Dutch genre were often occasions for
amorous dalliance between the sexes, and the
ace of hearts functioned as a romantic symbol.
Dutch emblem books and letter-writing man-
uals—many of them inspired by the French—
attest to the extraordinary popularity of letter
writing in this period.[3] The earnestness of the
officer who writes the letter implies that he ad-
dresses the recipient "from the heart."[4] In *The
Message,* a painting in Lyons, ter Borch depicted
a young woman reading a letter as a rustic
messenger waits (fig. 1). The Lyons and the
Philadelphia works are not pendants (their mea-
surements differ), as are Gabriel Metsu's *Man
Writing a Letter* and *Woman Reading a Letter*
(Sir Alfred Beit, Bt., Blessington, Ireland), how-
ever, the two paintings by ter Borch complement
one another in theme and design.

P.C.S.

Woman Drinking Wine with a Sleeping
Soldier, early 1660s
Oil on canvas, transferred from panel,
15⅜ x 13⅝″ (39 x 34.5 cm.)
Private Collection

FIG. 1. GERARD TER BORCH,
The Message, oil on canvas,
Musée des Beaux-Arts,
Lyons, inv. no. A109.

1. The same model appears in the painting *Officer Dictating a Letter,* National Gallery, London, no. 5847, and other paintings by ter Borch from this period such as *The Visit,* National Gallery of Art, Washington, D.C., no. 58. The identification with Netscher is based on the model's resemblance to Netscher's lost *Self-Portrait,* known through Wallerant Vaillant's mezzotint (Gudlaugsson 1959–60, vol. 1, pl. 15, fig. 3). A copy of the Philadelphia work in the Musée Granet, Aix-en-Provence (inv. 860.1.195) has been tentatively attributed to Netscher by Gudlaugsson (1959–60, vol. 2, no. 143c, pl. 16), who cites a painting mentioned in the estate left by Netscher's widow on September 11, 1694 (as no. 69: "een Officier, schrijvende een brieff om een trompetter aff te vaerdigen"), which could be identical either with the original or Netscher's copy.

2. In the related painting in London (see note 1), a *repentir* indicates that ter Borch painted out an ace of hearts, perhaps regarding it as an overly conspicuous sign.

3. See Schotel 1903, pp. 234–35; 1905, pp. 248–65; Gudlaugsson 1959–60, vol. 1, pp. 107, 115–17, 126–27; de Jongh 1971, pp. 178–79, no. 133; and Amsterdam 1976, cat. nos. 2, 71. Shortly before the present work was painted, Jan Puget de la Serre's *Le Secrétaire à la mode* appeared in Dutch under the title *Fatsoenlicke Zend-brief-schryver* (1651); see also Krul 1644. Van Veen (1608) includes an emblem depicting cupid with letter inscribed "Sic imagines amantibus, etiam absentium jucunde sunt . . . quanto iucundiores sunt litterae quae vera amantis vestigia, veras notas afferunt."

4. Love letters were taken seriously; indeed, they were admissible evidence in breach-of-promise suits brought before the church councils (see Schotel, note 3). Collections of exemplary love letters, with names like *Post Office of Cupid and Mercury,* were consulted by lovers in search of the bon mot. Bredero's plays and other Dutch dramas are filled with episodes involving billet-doux; in van Santen's *Snappende Sytgen* (1624), May describes a love letter in which "He called me his joy, his consolation, his beloved love, his lodestar, his goddess, and a thousand similar things" ("Hij noemt mij zijn vreucht, zijn troost, zijn lieve lieff, zijn leydstar, zijn godin, en duysent diergelycke dingen" [author's translation]). Eelhart, in Bredero's *Schijn-heyligh* (Hypocrite) (1624), orders a mixture of civet and amber to perfume his missive. Some lovers even signed their names in blood.

Provenance: De Damery, Paris; sale, Duc de Choiseul, Paris, April 6–10, 1772, no. 27 (with the pendant, no. 28, for 3,101 francs, incorrectly described as on canvas, 36 x 30 cm.); sale, Prince de Conti, Paris, March 21, 1777, no. 296, to Destouches (with the pendant for 3,000 francs); sale, Destouches, Paris, March 21, 1794, no. 41 (with the pendant); Prince Alexander Besborodko, Saint Petersburg (Leningrad), according to inscription on back of stretcher (but not in the Koucheleff-Besborodko sale, as Hofstede de Groot recorded, which refers to the pendant); Leningrad, Academy, cat. 1886, no. 73 (as in the collection of Koucheleff-Besborodko), by 1855 (according to notice on back of canvas); Leningrad, Hermitage, by 1919; purchased from the Hermitage by dealer E. Plietzsch for dealers van Diemen & Co., Berlin-Amsterdam, 1930; Mr. and Mrs. D. Birnbaum (later Bingham), London, New York, and Scarsdale, New York (lent to the Museum Boymans, Rotterdam [cat. 1937, no. 441a] and to the Museum of Fine Arts, Boston, 1939–42); S. van den Bergh, 1954 to c. 1975.

Exhibitions: Rotterdam, Museum Boymans–van Beuningen, *Meesterwerken uit vier eeuwen, 1400–1800,* 1938, no. 150, fig. 129; Montreal, Art Association of Montreal, *Loan Exhibition of Great Paintings. Five Centuries of Dutch Art,* 1944, no. 89; Rotterdam, Museum Boymans–van Beuningen, *Kunstschatten uit Nederlandse verzamelingen,* 1955, no. 124, fig. 138 (with incorrect provenance); Rome, Palais des Expositions, 1956–57, no. 295; Laren, Singer Museum, *Kunstschatten. Twee Nederlandse collecties schilderijen,* 1959, no. 80, fig. 43; Leiden, Stedelijk Museum "De Lakenhal," *17de eeuwse meesters uit Nederlands particulier bezit,* 1965, no. 44; The Hague/Münster 1974, pp. 154–55, no. 43, ill.

Literature: Smith 1829–42, vol. 4, pp. 121–22, no. 13 (incorrectly as in the Valdou Collection, Paris), and vol. 9 suppl., p. 531, no. 7 ("Duplicates of these pictures, of unquestionable originality . . . are in the collection of Count Koucheliff Besborodkin, St. Petersburg"); Hofstede de Groot 1907–28, vol. 5, p. 34, no. 81 (as a replica of his no. 79); Plietzsch 1944, p. 48, no. 61, ill.; Gudlaugsson 1959–60, vol. 1, pp. 118–19, 303, fig. 146, and vol. 2, pp. 158–59, no. 146.

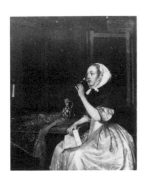

FIG. 1. GERARD TER BORCH, *Drinking Girl with a Letter*, oil on canvas, transferred from panel, Ateneumin Taidemuseo, Helsinki.

FIG. 2. GERARD TER BORCH, *Inn Scene*, oil on panel, Musée Fabre, Montpellier, no. 311.

For almost two centuries this painting was regarded, probably correctly, as the pendant of the *Drinking Girl with a Letter*, now in Helsinki (fig. 1).[1] The pictures were last recorded together in the Besborodko Collection in Saint Petersburg (Leningrad), when they were both transferred from panel to canvas supports. In the 1869 sale of this collection, only the *Drinking Girl with a Letter* was placed at auction; from then the paths of the two paintings diverged. The pendant, which passed to a Russian private collection, was sold later to the museum in Helsinki. The present picture, which was in Russian public collections until its sale by the Hermitage in 1930, has been owned privately since that time. The two pictures were reunited briefly during the ter Borch exhibition of 1974 (The Hague/Münster 1974, no. 43).

To address the question of subject and meaning these two paintings should be considered together. Companion pieces are usually either congruent or opposed in their iconographic programs; in either case, they complement each other.[2] In this instance, the two paintings can be interpreted similarly. The image of a woman drinking undiluted wine, either alone or with a male companion, could have been regarded as shameless, if not sinful, by seventeenth-century Dutchmen.[3] The soldier who has fallen asleep at the table has probably succumbed to the sedative powers of drink or strong tobacco. The theme of the drinking woman and the dazed soldier had been developed by ter Borch almost a decade earlier, when he painted the *Inn Scene*, now in Montpellier (fig. 2).[4] The barmaid in the scene is about to fill her wineglass, while an officer, collapsed on the table, sleeps off his intoxication. The maidservant holds the tankard so that its opening faces the viewer, a motif that in some contexts could symbolize the uterus.[5] Similarly, the porcelain pitcher in the girl's lap in *Woman Drinking Wine* could be interpreted as a sexual reference, especially given the proximity of the phallic clay pipe. Although these motifs were traditional symbols, ter Borch used them only as subtle, indeed subliminal, references to the underlying sexual content. As in most of his genre paintings, symbolism in these companion

pieces is a secondary means of enhancing the narrative.

Ter Borch's half-sister Gesina was the model for the girl in *Woman Drinking Wine* and *Drinking Girl with a Letter*. Gesina, after an unhappy affair with a certain Hendrik Joris, wrote in her poetry album entitled *De papiere lauwekrans* (the paper laurel wreath) that unrequited love can be soothed by the powers of wine: "Cruel Venus, cause of all sorrow/ I expel and ban you from my heart/ because thou bears nothing other than grieving pain/ which is a due to love. I drive you out of my mind./ And ease it with the wine/ The noble sweet wine soothes the human heart/ when drunk moderately and enjoyed with good taste."[6] Gesina wrote the last two lines beside a drawing she made after her brother's painting, which represents a couple cavorting and drinking.[7]

O.N.

1. Gudlaugsson 1959–60, vol. 1, fig. 190.

2. See the discussion in Cornelia Moiso-Diekamp's study on pendants in seventeenth-century Dutch painting: "Das Pendant in der holländischen Malerei des 17. Jahrhunderts" (Ph.D. diss., Cologne, 1977).

3. On the symbolic associations of mixing water with wine, illustrating the virtue of Temperance, see de Jongh (1967, pp. 59–60). For the Dutch reaction to excessive drinking, see Amsterdam (1976, pp. 248–49). Sir William Temple, in defense of the Dutchman's reputation for excessive drinking, explained that the thick foggy air of Holland may prompt its citizens to indulge. Temple observed that very few officers or ministers of state became inebriated, and then only on the occasion of feasts. He added that, to their credit, the merchants and traders, "with whom it [drinking] is customary, never do it in a Morning" (*Observations upon the United Provinces of the Netherlands*, 7th ed. [London, 1705], pp. 174–76).

4. Gudlaugsson (1959–60, vol. 1, fig. 79) dates our picture in the late 1650s, while he places the pendant in Helsinki (fig. 1) to the mid-1660s. This author finds no persuasive argument for dating the two works so far apart. Both were probably executed in the same year, possibly in the early 1660s.

5. See de Jongh 1968–69, p. 45.

6. "Wreede Venus oorzaek aller smert/ k' verjaegh en ban U geheel uyt mijn hert/ want ghij niet anders baert dan droeve pijn./ wech geyle min. K' verdrijf U uyt mijn sin./ En hou het met de wijn/ Der edele soete wyn verquickt des menschen hert/ wanneer hy maetichlyck met smaeck genuttight werd;" quoted in The Hague/Münster 1974, pp. 154, 172 (based on Gudlaugsson 1959–60).

7. Gudlaugsson 1959–60, vol. 1, fig. 68.

Curiosity, c. 1660
Oil on canvas, 30 x 24½″ (76.2 x 62.2 cm.)
The Metropolitan Museum of Art, New York,
The Jules S. Bache Collection, 1949, 49.7.38

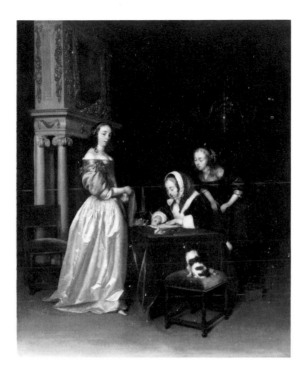

Provenance: Sale, Gaillard de Gagny, Paris, March 29, 1762, no. 15, to Randon de Boisset (3,600 francs); sale, Randon de Boisset, Paris, February 27–March 25, 1777, no. 52, to Lebrun (1,000 francs); sale, Robit, Paris, May 11, 1801, no. 151, to Bonnemaison (9,000 francs); Duc de Berry, Paris; sale, Duchesse de Berry, Paris, April 4–6, 1837, no. 2, to Anatoli Nikolaevich Demidov (15,200 francs); sale, Demidov, Prince of San Donato, Paris, April 18, 1868, no. 19, ill. (71,000 francs); Princesse de Sagan, Paris, by 1883; Baron Achille Seillière; Baronesse Mathilde von Rothschild, Frankfurt, by 1912; Baron Goldschmidt von Rothschild, Frankfurt; dealer Sir Joseph Duveen, New York; J. S. Bache, New York, by 1929 (cat. 1944, no. 38); acquired by the museum, 1949.

Exhibitions: Paris, Galerie Georges Petit, *Cent Chefs d'oeuvre,* 1883, no. 26; London 1929, no. 231; New York, World's Fair, *European Paintings and Sculpture 1300–1800: Masterpieces of Art,* May–October 1939, no. 367; New York, Duveen Galleries, *Paintings of the Great Dutch Masters of the 17th Century,* October 8–November 7, 1942, no. 63; New York, Metropolitan Museum of Art, *The Bache Collection,* June 15–September 15, 1943, no. 39; Kansas City 1958; Boston, Museum of Fine Arts, *Masterpieces of Painting in the Metropolitan Museum of Art,* 1970, p. 46, ill.; New York, Metropolitan Museum of Art, *Masterpieces of Fifty Centuries,* 1970, no. 281, ill.; The Hague/Münster 1974, no. 44, ill.

Literature: W. Buchanan, *Memoirs of Painting* (London, 1824), vol. 2, p. 67, no. 45; Smith 1829–42, vol. 4, p. 118, no. 6, and suppl., no. 3; C. Blanc, *Le Trésor de la Curiosité* (Paris, 1858), vol. 1, pp. 110, 351, 354, and vol. 2, pp. 195, 421; Blanc 1863, p. 16; E. Golichon, "La Galerie de San Donato," *Gazette des Beaux-Arts,* ser. 1, vol. 24 (1868), p. 406; Hofstede de Groot 1907–28, vol. 5, no. 169; W. Gibson, "The Dutch Exhibition at Burlington House," *Apollo,* vol. 8 (December 1928), p. 322, ill.; A. Alexandre, "L'Art hollandais à la Royal Academy," *La Renaissance,* vol. 12 (1929), pp. 119, 122, ill.; Wilenski 1929, p. 238, ill.; Martin 1935–36, vol. 2 (1936), p. 240; Duveen Bros., *Duveen Pic-*

tures in Private Collections of America (New York, 1941), no. 207, ill.; Plietzsch 1944, pp. 21, 47, no. 56, ill.; Gudlaugsson 1959–60, vol. 1, p. 124, ill., p. 314, and vol. 2, pp. 168–69; Egbert Haverkamp Begemann 1965, pp. 38, 40, 62, ill.; Kirschenbaum 1977, p. 40; New York, Metropolitan Museum of Art, cat. 1982, vol. 1, p. 15, and vol. 3, p. 427, ill.

A woman in an ermine-trimmed jacket and a black and white headdress sits at a table writing a letter. Before her are a candle, an inkstand, a watch, and a second letter with a broken seal. A blonde woman leans over the letter writer's shoulder, and a woman wearing a white satin dress with a pink bodice stands at the left. A small spaniel sits on a velvet-upholstered stool in the foreground. At the back left a chair has been placed before an ornate fireplace. A chandelier hangs in the upper right, and a foot stove rests on the floor.

The most accurate dating for this work is probably that proposed on the basis of the costume as "around 1660 or shortly after."[1] The celebration of courtly culture à la mode in this painting and in *Lady at Her Toilet* (pl. 72) is a trend that came to fruition in ter Borch's art only after c. 1660. Here the furnishings and haute couture represent the pinnacle of taste and refinement, and the narrative offers an appropriately sophisticated episode from "polite" society. The eighteenth century's anecdotalizing title *Curiosity,* a sobriquet still in use today, attests to that era's delight in the charming blonde whose irrepressible interest in the letter writer's response to the unsealed missive prompts her to lean precariously over the chairback.[2] Even the spaniel seems absorbed by the writer's concentration.

Dutch artists expressed their admiration for this deft narrative almost immediately. For example, Metsu's *Letter-Writer Surprised* (Wallace Collection, London, no. P240) depicts a soldier's stealthy if rather clumsy efforts to spy on a lady friend's letter, while the same artist's *Woman Composing Music* (fig. 1) takes over *Curiosity's* air of high-born elegance as well as its design and individual motifs. As splendid as Metsu's work is, it fails to match ter Borch's achievement. The mystery evoked by the letter writer is lacking in Metsu's painting, where a woman composing music elicits only sidelong interest from her male companion. Moreover, the stuffs

Lady at Her Toilet, c. 1660
Monogrammed on the fireplace: GTB
Oil on canvas, 30 x 23½″ (76.2 x 59.7 cm.)
The Detroit Institute of Arts, Founders Society
Purchase, Eleanor Clay Ford Fund, General
Membership Fund, Endowment Income Fund,
and Special Activities Fund, no. 65.10

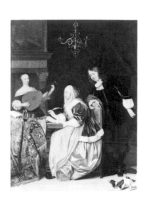

FIG. 1. GABRIEL METSU,
Woman Composing Music,
oil on canvas, Mauritshuis,
The Hague, no. 94.

and surfaces harden slightly under Metsu's brush; the silks still dazzle, but the record of the grain in the wood floor is not without a certain fastidiousness. Later on, in the eighteenth and nineteenth centuries, the curious onlooker or eavesdropper was, of course, devalued to one of the genre painter's stock characters, scarcely more than a cliché expressive of rapt attention in narratives often possessing little inherent interest of their own. Ter Borch's storytelling, by contrast, is always wittily piquant, never precious.

Ter Borch's image of high society may be a compelling one, but it is a fiction. The figures, costumes, and furnishings in this scene are all encountered elsewhere in his art: the girl standing at the left has been identified as the artist's sister Jenneken, whose portrait survives in the Museum of Fine Arts in Boston (inv. no. 47.372); the curious onlooker wears the same dotted black tulle wrap as the mother in the *Woman Peeling Apples* (pl. 73); the dog and the inkstand reappear in the *Lady at Her Toilet* and many other works; the candlestick figures in the *Parental Admonition* (pl. 68); and the room, with minor alterations, resembles those in the paintings in the Buhrle Collection, Zurich,[3] as well as the room in the *Lady at Her Toilet.* Clearly the artist worked not from everyday experience but from a standard set of studio props and a limited group of models. We know from a letter of 1635 that ter Borch owned a relatively large mannequin or lay figure, which undoubtedly spared Jenneken the tedium of posing endlessly as he recorded every shimmering fold of her gown.[4]

P.C.S.

1. Gudlaugsson 1959–60, vol. 1, pp. 124, 314, and vol. 2, pp. 168–69.

2. Dutch sayings warn against undue curiosity: "De nieuwsgierigheid bedriegt de wijsheid" (Curiosity belies wisdom); "Nieuwsgierigheid wacht kwaad bescheid" (Curiosity awaits bad reply, or decision); see Harrebomée 1856–70, vol. 2, p. 127.

3. See Gudlaugsson 1959–60, vol. 2, p. 168, where he also suggests that the candle, watch, and foot stove (compare cat. no. 77, fig. 3) might be symbolic. In The Hague/Münster 1974, the authors suggest that the candle and watch might be warnings against the transitoriness of life and that the candle might allude to the consuming nature of love.

4. See Gudlaugsson 1959–60, vol. 2, pp. 15–16.

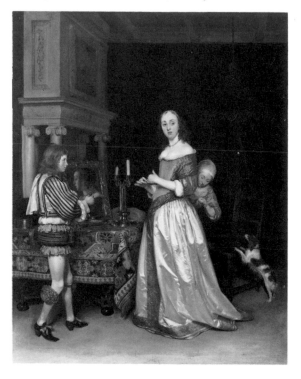

Provenance: Louvre, Paris, c. 1810; Château Saint-Cloud; Willems Collection, Frankfurt, 1833; Lionel de Rothschild, London, acquired 1836, descended in family; The Hon. Mrs. Clive Behrens, London; Major P.E.C. Harris, London.

Exhibitions: London, British Institution, 1844, no. 103; London, Royal Academy, 1878, no. 157, and 1885, no. 121; London 1929, no. 223; Birmingham 1950, no. 63; London 1952–53, no. 395; San Francisco 1966, no. 85, ill.; The Hague/Münster 1974, no. 45, ill.

Literature: Smith 1829–42, vol. 4, no. 61; Waagen 1854–57, vol. 2, p. 129; Hofstede de Groot 1907–28, vol. 5, no. 47; Plietzsch 1944, p. 21, cat. no. 82, pl. 82; Gudlaugsson 1959–60, vol. 1, pp. 123–24, 134, fig. 165, vol. 2, cat. no. 165; Haverkamp Begemann 1965, pp. 38–41, ill., 62–63; The Detroit Institute of Arts, *Selected Works from the Detroit Institute of Arts* (Detroit, 1979), p. 70, no. 47, ill.

This painting, with three others executed in or shortly after 1660 (see cat. no. 12; *The Letter,* Her Majesty Queen Elizabeth II, cat. no. 29; and *A Couple Dancing,* Polesden Lacey, Surrey, cat. no. 50), marks the culmination of a decade-long trend in ter Borch's art toward ever greater elegance.[1] The woman, attired in costly blue and white satin, is surrounded by rich furnishings and appointments. In the background of the amply proportioned room stands a huge marble mantle and canopied bed. An expensive turkish carpet covers the table, on which are a mirror in a silver frame, a silver candlestick, box, and basin. A silver-capped vessel, perhaps containing scented water, is held by a page in remarkably

FIG. I. GERARD TER BORCH, preparatory drawing for *Lady at Her Toilet*, c. 1660, pen and ink on paper, Rijksmuseum, Amsterdam.

FIG. 2. EGLON VAN DER NEER, *Woman Reading a Letter*, oil on canvas, formerly Richard Green Galleries, London.

flamboyant livery with striped jacket and beribboned tights. At the lady's back a maidservant assists with her dress, and a small dog is about to leap onto a chair.

Ter Borch's earlier paintings depicted women at their toilet, admiring themselves in the mirror and washing their hands.[2] A preparatory drawing for the *Lady at Her Toilet* (fig. 1), indicates that in the initial conception the woman turned her back to the viewer as the page, holding a ewer and basin, waited to one side. In the final painted version, ter Borch turned the woman to a three-quarter view that accentuated her pensive expression and somewhat absent-minded gesture in removing, or merely fingering, her ring. This central motif, in ter Borch's characteristic fashion, is richly ambiguous. The washing of the hands was a traditional symbol of absolution with biblical precedence in Pilate's act;[3] similarly, the ring is an age-old attribute of bonding and marriage. Is the woman's preparation for washing, therefore, significant of her innocence or her need for ablution? And what of her abstracted expression and gesture: Is she merely daydreaming as she takes off her jewelry or does she toy with larger issues of romance or marriage?

While the artist left such questions unanswered, he deliberately enhanced the sensuousness of the scene; for example, as Gudlaugsson pointed out, here and elsewhere in these elegant boudoir scenes ter Borch omitted the collar that always covered women's shoulders. He also took liberties with the perspective of the woman's lovely profile in the mirror. Mirrors had many associations for seventeenth-century viewers: the sense of sight, the notion of vanity and falseness of appearance, the ideals of self-knowledge and prudence, the temptations of sensuality and eroticism, and, finally, the transience of all earthly things.[4] The fleeting nature of life has been associated with the extinguished candle, which, however, serves primarily to indicate the morning or daytime hour.[5] Finally, the lapdog has been related, by Gudlaugsson, to a saying popularized by Jacob Cats: "As the girl, so her dog."[6] The same dog appears in the foreground of *Curiosity* (pl. 71), which Gudlaugsson

believed was executed as a pendant. The companionship of Dutch paintings has been too little studied, but it seems clear that the meanings of pendants usually were linked. Thus the wealth of allusion in the *Lady at Her Toilet* is further enriched by its potential connection with the scene of an elegant young woman penning a letter in the company of friends in *Curiosity*. Ter Borch's complex allusions were no less sophisticated than his subjects, but the outstanding characteristic of his paintings is their depiction of an ideal of beauty and lifestyle. This ideal became the paradigm of elegance for whole generations of later high-life genre painters who repeated his themes and designs; Eglon van der Neer's *Woman Reading a Letter* (fig. 2), for example, is clearly based on this painting.[7]

<div align="center">P.C.S.</div>

1. See *Woman at Her Toilet*, Metropolitan Museum of Art, New York (Gudlaugsson 1959–60, vol. 2, no. 8, as about or shortly after 1650).

2. Compare the painting in New York (see note 1); *Girl at a Mirror*, formerly J. de Bruyn Collection (Gudlaugsson 1959–60, vol. 2, no. 83, as after 1650); and *Woman Washing Her Hands*, Gemäldegalerie Alte Meister, Dresden (Gudlaugsson 1959–60, vol. 2, no. 113, as about or shortly after 1655).

3. The relationship was cited in The Hague/Münster (1974, p. 128); see also Ripa 1644, p. 367 (under Innocenza) and the comments of Snoep-Reitsma 1973a, pp. 285ff.

4. On the mirror, see G. F. Hartlaub, "Das Symbol des Spiegels in der bildenden Kunst," *Das Werk des Künstlers*, vol. 2 (1941/42); G. F. Hartlaub, *Zauber des Spiegels* (Munich, 1951); Schwarz 1952; G. Michaud, "Le Thème du miroir dans la symbolisme français," *Cahiers de l'association internationale des études françaises*, 1959, pp. 199–216; O. Casel, *Von Spiegel als Symbol* (Maria Laach, 1961); de Jongh 1971, p. 180 n. 138; de Jongh et al. in Amsterdam 1976, under cat. nos. 9 and 47.

5. See Haverkamp Begemann 1965, p. 62; The Hague/Münster 1974, p. 158.

6. Cats 1658, pt. 3, no. 12; see Gudlaugsson 1959–60, vol. 1, p. 123, and vol. 2, p. 169.

7. Compare also Gabriel Metsu's *Woman at Her Toilet, with a Serving Boy*, Aurora Trust, New York (Robinson 1974, fig. 154); and Caspar Netscher's *Lady at Her Toilet*, sale, Cook, Sotheby's, London, June 25, 1958, no. 104 (*Apollo*, vol. 68 [November 1958], p. xvi, ill.).

Woman Peeling Apples, c. 1660
Oil on canvas, attached to panel, 14⅛ x 12"
(36 x 30.5 cm.)
Kunsthistorisches Museum, Gemäldegalerie,
Vienna, inv. no. GG 588

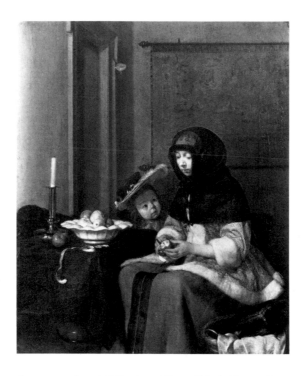

Provenance: Royal Collections, Vienna (Mechel inv. 1783, no. 63);[1] taken by Napoleon's troops to Paris, 1809; returned to Vienna, 1815; Kunsthistorisches Museum, Vienna, cat. 1923, fig. 127.

Exhibitions: New York/Chicago/San Francisco 1950, p. 108, no. 96, ill.; Zurich 1953, no. 153; Rome 1954, no. 14; The Hague/Münster 1974, no. 46, ill.

Literature: Smith 1829–42, vol. 4, no. 69; von Frimmel 1899, p. 561, no. 1366; Hofstede de Groot 1908–27, vol. 5, no. 74; A. B. de Vries, *Jan Vermeer van Delft* (Amsterdam, 1939), p. 55; Gerson 1942, p. 287; Plietzsch 1944, p. 20, no. 38, pl. 1; Gudlaugsson 1949a, pp. 252ff., fig. 20; Gudlaugsson 1959–60, vol. 1, pp. 130–31, 317, fig. 167, and vol. 2, pp. 170–73, no. 167; O. Naumann, in *Small Paintings of the Masters: Masterpieces Reproduced in Actual Size*, ed. L. Shore (New York, 1980), vol. 2, no. 141, ill.; Slatkes 1981, pp. 114–15, ill.

The early provenance proposed for *Woman Peeling Apples*, which posited that it had arrived in Vienna in 1651, resulted in confusion among early critics regarding the work's date of execution. This early reference was dismissed, correctly, as hypothetical by Frimmel,[2] and the work was more plausibly dated to around 1660.[3] Supporting this dating is a copy said to bear a monogram and date of 1661, and a sketch representing the head of a woman (fig. 1), which may well be a preliminary study for this painting.[4]

Although ter Borch is commonly regarded as an innovator in Dutch genre painting, the *Woman Peeling Apples* shows how much he was influenced by developments that preceded him in the 1650s. For example, Nicolaes Maes's *Young*

Girl Peeling Apples takes precedence of subject.[5] Moreover, ter Borch's work has clear stylistic associations with that of Vermeer. Most writers believe, however, that it was not until the mid-1660s that Vermeer began to concentrate on compositions of this type, with figures arranged close to the picture plane, for example, in his *Lady Writing a Letter*.[6] Thus, there seems reason to believe that ter Borch preceded Vermeer in this regard as in so many of his themes. One hastens to add, however, that ter Borch was not the sole inventor of this genre type; Frans van Mieris's *Doctor's Visit*, of 1657 (Kunsthistorisches Museum, Vienna, inv. no. 590), includes a similarly dressed woman in a comparable position in the design.[7]

Ter Borch's domestic scene has a preceptive element that is more clearly represented in two works by Pieter de Hooch. The latter's *Woman Peeling Apples* of 1663 (Wallace Collection, London, no. P23) depicts a mother handing her child the peeled skin of an apple, and *Two Women Teaching a Child to Walk* (fig. 2) shows the housewife offering the whole apple (as a reward?) to her child while a maidservant teaches her to walk.[8] In seventeenth-century Dutch painting the act of training children to walk was frequently employed as an everyday demonstration of the philosophical ideals of practice and exercise,[9] and this notion undoubtedly underscores the mother's pedagogic role in de Hooch's works.

An emblem from Roemer Visscher's popular *Sinnepoppen* showing an overfull bowl of fruit also touches on parental responsibility and may aid our interpretation of ter Borch's painting. The author captions the image *Vroech rijp, vroech rot* (early to ripen, early to rot) and goes on to compare the early ripening and subsequent spoiling of fruit to children who have been forced into premature adulthood. Parents are cautioned that a child who behaves like a wise man will eventually become an adult who acts foolishly, like a child.[10] The moral may be relevant to ter Borch's picture, where the little girl in her fancy hat is charmingly overdressed.

On another level, the painting contains references to vanity and the transitoriness of life, such as the candle and map, traditional symbols for the passage of time and human worldliness.[11]

O.N.

Soldier Offering a Young Woman Coins,
c. 1662–63
Monogrammed on the cartouche on the
fireplace: GTB
Oil on canvas, 26¾ x 21¾″ (68 x 55.2 cm.)
Musée du Louvre, Paris, inv. no. 1899

FIG. 1. Probably by GERARD
TER BORCH, *Head of a
Woman*, chalk with white
heightening on paper,
Rijksmuseum, Amsterdam.

FIG. 2. PIETER DE HOOCH,
*Two Women Teaching a
Child to Walk*, oil on can-
vas, Museum der bildenden
Künste, Leipzig, inv. no.
1558.

1. Although the early provenance for the painting proposed that it came to Vienna in 1651 from the collection of Leopold Wilhelm in Brussels, it does not appear in the 1659 inventory of his possessions.

2. See von Frimmel 1899, p. 561, no. 1366.

3. See G. Glück, *Gemäldegalerie des Kunsthistorisches Museum, Wien* (Vienna, 1923), no. 127, ill.; and A. B. de Vries, *Jan Vermeer van Delft* (Amsterdam, 1939), p. 55.

4. See Gudlaugsson 1959–60, vol. 2, p. 171, no. 167b (note that no. 167e, recorded as signed and dated 1651, may be identical with no. 167b). For the sketch, see Gudlaugsson 1959–60, vol. 1, pp. 130–31, ill. (as formerly attributed to Mozes ter Borch but "with greater probability" by Gerard); and Kettering 1983b, p. 449, pl. 2, fig. 15.

5. Metropolitan Museum of Art, New York, cat. 1980, no. 14.40.612. The painting is undated, but it must be placed close in time to the *Woman Making Lace* of 1655 (Sutton 1980, fig. 18).

6. National Gallery of Art, Washington, D.C.; Blankert 1978b, pl. 20 (as c. 1666). Most critics before and after Blankert have cited the mid-1660s.

7. See Naumann 1981a, vol. 2, p. 120.

8. Sutton 1980, cat. 61, pl. 65, cat. 87, pl. 90.

9. See Emmens 1963a, and *Rembrandt en de Regels van de Kunst* (Amsterdam, 1979), p. 210; see also Durantini 1983, pp. 245–49.

10. Visscher 1614, p. 27; see also Henkel, Schöne 1967, col. 178.

11. On the map, see Ochtervelt's *Music Lesson* (cat. no. 88). Welu identified this map, which is inscribed NOVA ET ACVRATA TOTIVS EVROPAE, and which also appears in three other works by ter Borch, as belonging to a set of four maps designed by William Jansz. Blaeu and published by Claesz Jansz. Visscher in 1608 (1977a, p. 30, no. 40). Another map in the series is portrayed in Brekelenkam's *Man Spinning and Woman Scraping Carrots* (cat. no. 19).

Shown in Philadelphia only

Provenance: Sale, H. van der Vugt, Amsterdam, April 27, 1745, no. 15, to Schouman (440 guilders); sale, J. van der Linden van Slingeland, Dordrecht, August 22, 1785, no. 431, to Fouquet (2,635 guilders); acquired by Louis XVI of France, through Lebrun, 1785 (45,770 francs).

Exhibition: Amsterdam 1976, no. 1, ill.

Literature: Hoet 1752, vol. 2, pp. 157, 492; Smith 1829–42, vol. 4, no. 28; Wurzbach 1906–11, vol. 2, p. 701; Hellens 1911, p. 125, ill.; Hofstede de Groot 1908–27, vol. 5, no. 161; Hannema 1943, pp. 102, 169, ill.; Plietzsch 1944, no. 90; Gudlaugsson 1959–60, vol. 1, pp. 133–34, pl. 189, and vol. 2, no. 189; Hofrichter 1975, p. 24, fig. 6; Paris, Louvre, cat. 1979, p. 29, ill.

A stout soldier in a cuirass and wide boots sits beside a young blonde woman in a fur-trimmed jacket and satin dress. The soldier, his right hand extended, offers her coins taken from a purse in his left hand. She looks down at the coins and pauses before filling her wineglass from a silver pitcher. At the left is a velvet-covered table with a dish of fruit and a silver platter. Behind the table is a white marble fireplace and in the background, a bed covered with a curtain suspended by a cord from the ceiling.

The subject of this painting, despite the woman's elegant attire and the room's rich furnishings, undoubtedly is mercenary love. The Falstaffian soldier—an unlikely inspiration for the picture's traditional and ironical title *The Gallant Officer*—attempts to buy the lady's favors. Individual motifs that appear in other ter

FIG. 1. GERARD TER BORCH, *The Gallant Officer*, c. 1650, oil on panel, Pushkin Museum, Moscow.

FIG. 2. G. VAN BREEN AFTER ESAIAS VAN DE VELDE, *Man Offering a Woman Treasures with Cupid Breaking His Bow*, engraving.

FIG. 3. JUDITH LEYSTER, *The Proposition*, 1631, oil on panel, Mauritshuis, The Hague, no. 564.

Borch paintings include the fireplace and the bed (pl. 72), the woman's jacket (pl. 71), and the table (pl. 69). Ter Borch used the subject shortly before 1650 in a painting now in the Pushkin Museum, Moscow (fig. 1).[1] In the earlier painting the soldier's proffer also seems to catch the girl off guard as she is about to fill a glass. Earlier depictions of venal love by other Dutch artists (for example, pl. 10) often included an old procuress and scarcely disguised the younger woman's lusty complicity in the transaction. The inscription on G. van Breen's print after Esaias van de Velde of a *Man Offering a Woman Treasures with Cupid Breaking His Bow* (fig. 2) also affirms the woman's readiness to enter into a transaction.[2] A very different point of view is provided by Judith Leyster's *Proposition* of 1631 (fig. 3). Leyster's young woman is neither an enticer nor a willing participant; she continues sewing (a time-honored domestic, virtuous activity) and resolutely ignores the man's offer.[3] Although ter Borch's earlier version in Moscow tips the balance slightly in the soldier's favor, his mature treatment of *Soldier Offering a Young Woman Coins*, c. 1662–63, is far more subtle.[4] Here, as before, the outcome of the soldier's crude proposal is unresolved. The lovely girl, poised on the edge of her chair, is caught in a moment of indecision, but her ambivalence hardly suggests the wily coquetry of the seasoned prostitute. The hint of ingenuousness, detectable despite the young woman's dressy refinements, enriches the narrative.

The subject of the Moscow and Paris paintings has been related to ideas expressed in seventeenth-century emblems and sayings. In Otto van Veen's *Amorum Emblemata* (Antwerp, 1609), an illustration of Amor offering gifts is titled *Auro conciliator Amor*. Jacob Cats, in *Maechden-plicht* (Middelburg, 1628), quoted the sayings "Der pennings reden klinckt best" (The sound of the penny speaks clearest; or simply, Money talks) and "Ein maeght die schenckt Haer eertgen crenckt" (The maid offends who makes a gift of her honor).[5] The stout officer and the plate of half-eaten fruit at the left suggest the expression "Als de mensch is vol en zat, wordt hij van den lust gevat" (When a man is full and sated, he will be filled with lust).[6] Oth-

ers have noted that the basket of fruit on the table may allude to love.[7] In seventeenth-century visual arts and literature, fruit was associated with a full range of amorous emotions, from base lust to celestial love. In *Spiegel van den ouden en nieuwen tijdt*, Jacob Cats wrote "Zoo de zucht, zoo de vrucht" (As with the desire, so with the fruit).[8]

P.C.S.

1. Gudlaugsson 1959–60, vol. 2, no. 75.

2. The inscription reads: "Niet de man maer het gelt want hij is vol gebreecken/Ick bemin maar het gewin ick sal hem haest verstreecken/Dus Cupido versint wilt uwen booch niet breecken" (Not the man but the money, because he is completely decrepit. I, however, love profit [and] will quickly procure it. Thus Cupido you need not contrive to break your bow) (author's translation).

3. For discussion, see Hofrichter 1975, pp. 22–26; and Los Angeles, Los Angeles County Museum of Art, *Women Artists: 1550–1950* (December 21, 1976–March 13, 1977), by A. S. Harris and L. Nochlin, p. 74, no. 23, ill. Feminist art historians are undoubtedly correct in attributing this shift of viewpoint to the fact that the painter was a woman. However, their discussion omits Leyster's so-called "Temptation" in which sex roles are reversed, in a traditional theme of unequal lovers: A young man playing a lute studiously ignores money and treasures offered by an old woman (Galleria Nazionale, Rome; Plietzsch 1960, fig. 17).

4. Gudlaugsson 1959–60, vol. 1, pp. 133–34, and vol. 2, p. 185.

5. Gudlaugsson 1959–60, vol. 2, p. 95. Many other old sayings might also have come to mind: "Wat kan man met een gouden sleutel niet open krijgen" (What can't one open with a golden key), "Niets is so goed, zilver noch goud, als te leven buiten schuld" (Nothing is so good, silver or gold, as to live without guilt), and so forth; see Harrebomée 1856–70, vol. 1, p. 254.

6. Harrebomée 1856–70, vol. 2, p. 42.

7. Amsterdam 1976, p. 34; see the quotations from Pieter Lenaerts van der Goes's *Den Druyven—Tros der Amoreusheyt* (1602), and Jacob Westerbaen's poem *Avond-school voor vryers en vrysters*.

8. The Hague 1632, p. 425.

Amsterdam 1631–1672 en route to the Indies

Interior with a Woman at a Spinning Wheel,
1661
Signature at lower left much abraded;
dated: 1661
Oil on canvas, 23⅝ x 19¼" (60 x 49 cm.)
Rijksmuseum, Amsterdam, no. A767

Literature: Kramm 1857–64, vol. 1, p. 141; Thoré-Bürger 1860a, p. 255; Bode, Bredius 1905; Wurzbach 1906–11, vol. 1, p. 160; Valentiner 1913; Bredius 1915–22, vol. 1, pp. 120–26; Valentiner 1928b; Waller 1932; W. Martin in Thieme, Becker 1907–50, vol. 4 (1935), pp. 467–68; Plietzsch 1949; Brière-Misme 1954a; Keyszelitz 1957; Plietzsch 1960, pp. 77–78; Amsterdam 1976, pp. 44–49.

Born in Amsterdam on March 3, 1631, Esaias Boursse was the son of Walloon parents, Jacques Boursse and Annes de Forest. According to an inventory from November 24, 1671, his brother Jan, who lived near Rembrandt (1606–1669) in Amsterdam, collected the master's paintings, drawings, and etchings. Little is known about Esaias's life. He entered the Amsterdam Guild of St. Luke around 1651. Shortly thereafter he appears to have traveled to Italy. He returned to Amsterdam about 1653. Boursse drew up a will in 1661 before embarking as a midshipman in the service of the East India Company. During this voyage he made drawings of the inhabitants of Ceylon, as well as a view of the Cape of Good Hope. He returned to Amsterdam in 1663. In October 1671 Boursse embarked on a second trip for the East India Company; he died aboard ship on November 16, 1672.

A genre painter in the style of Pieter de Hooch (q.v.), Boursse usually depicted women quietly performing household tasks in middle-class interiors. A few works show figures in small courtyards and alleyways.

C.v.B.R.

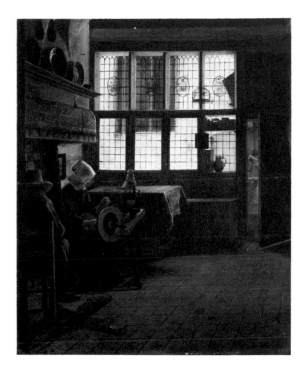

Provenance: Possibly sale, D. Ietswaart, Amsterdam, April 22, 1749, no. 165 (as "Interior with a Woman Spinning," by E. Boursse); sale, W. Gruyter, Amsterdam, October 24–25, 1882, no. 40 (as Pieter de Hooch, with a false signature).

Exhibition: Amsterdam 1976, no. 5, ill.

Literature: Bode 1887, p. 36; Hofstede de Groot 1892, p. 180, no. 10 (as P. de Hooch); Bode, Bredius, 1905, p. 214; Wurzbach 1906–11, vol. 1, p. 160; Hofstede de Groot 1907–28, vol. 1, p. 569 n. 5 (as "now rightly Boursse"); Valentiner 1928b, p. 177, ill.; Valentiner 1929a, p. 198; W. Martin in Thieme, Becker 1907–50, vol. 4 (1935), p. 467; Martin 1935–36, vol. 2, pp. 209–10, fig. 109; Brière-Misme 1954a, pp. 162–63, fig. 12; Plietzsch 1960, p. 78, fig. 127; Bernt 1970, vol. 1, no. 168; Amsterdam, Rijksmuseum, cat. 1976, no. A767; Sutton 1980, p. 53, fig. 57.

A woman at a spinning wheel and a man with his back to the viewer are seated by a hearth. On the mantle are plates and dishes. The shadowed interior is lit by mullioned windows in the back wall. Unidentified escutcheons decorate the windows, a ceramic jug rests on the sill, and a birdcage hangs from the casement. Before the window are a bench and a covered table; at the right an open door leads to another room.

During much of the nineteenth century Esaias Boursse's production was eclipsed by the work of his better-known contemporary Pieter de Hooch. This painting even bore the false signature of the latter artist when it was sold in 1882. The painting's orderly domestic space and dramatic backlighting recall de Hooch's interiors of

FIG. 1. PIETER DE HOOCH, *Woman Preparing Vegetables with a Child*, c. 1657, oil on panel, Musée du Louvre, Paris, inv. no. 1372.

FIG. 2. ESAIAS BOURSSE, *Woman Cooking beside an Unmade Bed*, 1656, oil on canvas, Wallace Collection, London, no. P166.

the later 1650s, for example, *Woman Preparing Vegetables with a Child*, of c. 1657 (fig. 1).[1] While this specific system of illumination had appeared earlier, for example, in paintings by Jacobus Vrel (pl. 111), de Hooch was the first to fully explore the expressive possibilities of natural lighting in domestic interiors. Completed in 1661, the year de Hooch moved to Amsterdam and the year that the seafaring Boursse departed that city for a two-year trip in the service of the East India Company, this painting is closely related to the undated *Interior with Woman Sewing* in the Staatliche Museen Preussischer Kulturbesitz, Berlin (West) (no. 2036).[2] Both works attest to the artist's membership in the so-called de Hooch School, as do Boursse's several courtyard scenes.[3]

Yet Boursse scarcely can be considered a slavish imitator of the Delft artist. Paintings such as *Woman Cooking beside an Unmade Bed*, of 1656 (fig. 2), and *Woman Scraping Radishes*, of 1658 (sale, R. H. Ward, Amsterdam, May 19, 1934, no. 104)[4]—the artist's only other known dated works—prove that he was an innovator in the domestic genre field.[5] Frequently cited as evidence of his formation in Amsterdam under the influence of Rembrandt, the *Woman Cooking beside an Unmade Bed* bears more resemblance to paintings by Quirijn van Brekelenkam, but is already a mature work with a style of its own. Though less concerned with the effects of space and light, it shares with the later *Woman Scraping Radishes* and *Woman Sewing* a highly self-contained figure, a hushed atmosphere, and a concern for still-life detail. Boursse's domestic interiors are not so tidy as de Hooch's and his women more solemn, one might even say resigned in their chores. Some have detected in this work allusions to the celestial rewards of such earthly chores.[6]

P.C.S.

1. See Sutton 1980, no. 18.

2. Compare also the motif of the woman at work with her counterparts in *The Apple Peeler*, Musée des Beaux-Arts, Strassburg, no. 145, and *The Lace Maker*, Hermitage, Leningrad, cat. 1901, no. 862 (as "Dutch School," but attributed by Cornelis Hofstede de Groot in his unpublished notes to Boursse [see Brière-Misme 1954a, p. 160 n. 64, fig. 9]).

3. See, for example, *Courtyard with Bubble Blower*, formerly Gemäldegalerie, Staatliche Museen Preussischer Kulturbesitz, Berlin (West), no. 912A (lost 1945), and *Courtyard with Washerwoman*, Museum Boymans–van Beuningen, Rotterdam, cat. 1962, no. 5.

4. Brière-Misme 1954a, fig. 16.

5. Other undated domestic scenes by Boursse include: *Woman Sewing*, Bonn, Museum, cat. 1927, no. 23; *Woman Feeding an Infant by a Fireplace*, sale, Goldschmidt, Lucerne, September 1–8, 1936, no. 2303; *Woman Peeling Potatoes*, sale, Amsterdam, July 13, 1927 (Brière-Misme 1954a, fig. 17); *Woman Making Lace by Candlelight*, Lugt Collection, Institut Néerlandais, Paris; and *Woman Nursing*, Appleby Bros., London, 1963.

6. When exhibited in 1976 the *Interior with a Woman at a Spinning Wheel* was related to Johan de Brune's emblem praising efforts directed not toward earthly gain but the prospect of heaven's rest (see cat. 19, fig. 1).

Zwammerdam? c. 1620–1668 Leiden

Woman Combing a Child's Hair, 1648
Signed and dated on the fireplace:
Q. v. Brekelenkam 1648
Oil on panel, 22½ x 21" (57 x 53.5 cm.)
Stedelijk Museum "De Lakenhal," Leiden,
no. 47

Literature: Van Eynden, van der Willigen 1816–40, vol. 1, pp. 142–44; Nagler 1858–79, vol. 1, p. 2325, and vol. 4, pp. 3457, 3466; van der Kellen 1875; Obreen 1877–90, vol. 5, pp. 206–7; Havard 1878a; Havard 1879–81, vol. 4, pp. 90–146; Wurzbach 1906–11, vol. 1, pp. 180–81; E. W. Moes in Thieme, Becker 1907–50, vol. 4 (1910), pp. 574–75; Bode 1916–17; Bodkin 1924; van Kuik Mensing 1927–28; Wiersum 1938; Hollstein 1949–, vol. 3, p. 216; Maclaren 1960, p. 60; Plietzsch 1960, pp. 42–44; Rosenberg et al. 1966, p. 132; Stechow 1973; Amsterdam 1976, pp. 50–53.

The date of *Quirijn Gerritsz. van Brekelenkam's* birth is usually given as c. 1620, based on a record from March 8, 1648, when he and a number of other artists banded together to form the Leiden Guild of St. Luke. This is the earliest documentary reference to the artist. Like his sister Aeltje, the wife of the painter Johannes Oudenrogge (1622–1653), Brekelenkam may have been born in Zwammerdam, near Leiden. In April 1648 he married Maria Jansdr. Carle (or Scharle) in the Catholic church in Leiden. According to church records, six children were born to the couple between September 5, 1649, and April 30, 1655, the year Maria died. Brekelenkam remarried on October 23, 1656. His second wife, Elisabeth van Beaumont, the widow of Willem Symonsz., bore him three more children. The artist died in 1668, the year the last of his children was born.

 Brekelenkam's genre paintings usually depict workshop scenes and domestic or peasant interiors.

<div align="right">C.V.B.R.</div>

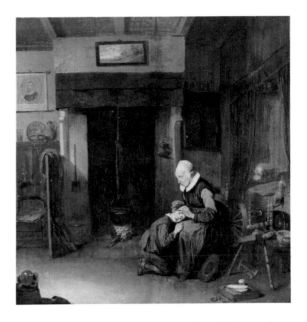

Provenance: Purchased by the museum from dealer F. Kleinberger, Paris, 1907.

Literature: Monatshefte für Kunstwissenschaft, vol. 1 (1908), p. 293, ill.; Leiden, Stedelijk Museum "De Lakenhal," cat. 1925, pp. 11–12, no. 47; *The Burlington Magazine*, vol. 89 (1947), p. 159 n. 4; Leiden, Stedelijk Museum "De Lakenhal," cat. 1949, p. 25, no. 47, pl. 15; Stechow 1973, p. 75 n. 2, and p. 80; Naumann 1981a, vol. 1, p. 54 n. 27.

This painting from 1648 has been cited as Brekelenkam's earliest dated work;[1] however, since the artist married and helped to establish the Leiden Guild of St. Luke in the same year, he must have been more than a mere apprentice, and it is therefore likely that there are paintings that predate this work. The dates on two works have been deciphered as 1647 and other earlier dates have been recorded.[2] Microscopic investigation of one painting, *Woman Making Lace*, thought to be dated 1646, revealed the actual inscription to be 1666 or 1668.[3] Of two paintings supposedly dated 1642, one has been shown to be the work of another artist;[4] the other needs further substantiation.[5] More solid ground supports the remarkably precocious *Pharmacy* (fig. 1), recorded on two separate occasions (1880 and 1953) as signed and dated 1638.[6] If this date is correct, art historians will need to rethink the artist's early development. It is reasonable, indeed, to assume that Brekelenkam would have begun dating works in the late 1630s when he was in his late teens and had completed his apprenticeship.

FIG. 1. QUIRIJN VAN BRE-
KELENKAM, *Pharmacy*,
1638, oil on panel, present
whereabouts unknown.

FIG. 2. Emblem from
ROEMER VISSCHER,
Sinnepoppen (Amsterdam.
1614).

Brekelenkam's humble interior is pleasantly arranged. The woman keeps a tidy home while attending to the chores of cooking, spinning, and caring for the child. This simple, unprepossessing woman who ministers so intently to her child is the pinnacle of domestic virtue. She sets aside the daily duties of the household to delouse the boy's hair before sending him off to school; note that the boy's schoolbox and lunch lie on the floor.[7] The subject of a woman cleaning a child's hair had been treated earlier by Dirck Hals and was taken up several years later by Gerard ter Borch in his masterful painting of c. 1650–53 in the Mauritshuis, The Hague (no. 744; see also pl. 67).

In the emblematic literature of the day, the comb served as a reminder of the dual nature of earthly goods, which could be employed for either virtue or vice. Roemer Visscher accompanied an illustration of a comb (fig. 2) with the Latin phrase *Purgat et ornat* (to cleanse and to adorn),[8] and in his immensely popular *Spiegel van den ouden en nieuwen tijdt*, Jacob Cats drew a parallel between combing one's hair and setting one's head and heart in order: "Comb, comb again and again, and not only the hair, but also what lies hidden inside, to the heartfelt bone."[9] Brekelenkam's picture can thus be regarded as pedagogical; by good example the woman teaches her child the virtues of cleanliness. By cleaning his scalp she is not only caring for his outward appearance; she is also exerting an influence on his impressionable mind. The print over the chair on the left is a portrait of the Leiden theologian Lodovicus de Dieu (1590–1642).[10] Thus it may refer to the need to put the spirit as well as the mind and body in order.

O.N.

1. See Stechow 1973, p. 75 n. 2.

2. *Card Players and a Couple*, dated 164[4 or 7?], Dienst Verspreide Rijkskollekties, no. NK2924; *Woman Making Lace, with a Standing Man*, dated 1647, sale, Paris, May 22, 1933, no. 7, ill.

3. Naumann 1981a, vol. 1, p. 54, fig. 48. The catalogue of the H. J. Wetzel sale, Sotheby Parke Bernet, New York, October 9, 1980, lists the painting (no. 5) as dated 1646. When the work was examined by the present author in 1980 and again in 1981, the third digit appeared to be "4" (Naumann 1981a, vol. 1, p. 54 n. 27). The present owner had the work examined in the conservation laboratory of the Kimbell Art Museum, Fort Worth, Texas, where the date was read as 1663 or 1668 (letter of March 15, 1983).

4. The *Kitchen Scene* (National Gallery of Ireland, Dublin, no. 247), singled out by E. W. Moes (in Thieme, Becker 1907–50, vol. 4 [1910], p. 575) as his earliest dated work, has been reattributed to the Monogrammist IS (see Stechow 1973, p. 75 n. 1, and Dublin, National Gallery of Ireland, cat. 1981, p. 111, no. 247, ill.).

5. The *Blacksmith's Forge*, sale, Hôtel Drouot, Paris, May 14, 1908, no. 12, ill.

6. Sale, San Donato, Florence, March 15, 1880, no. 1112, ill.; sale, Christie's, London, July 10, 1953, no. 53, ill.

7. For similar schoolboxes, see Jan Steen's *Schoolroom* (National Gallery, Scotland; Braun 1980, no. 335, ill., p. 69). The theme "preparation for school" has much in common with another standard genre subject, "prayer before meals" (see O. Naumann, "The Lesson [Reattributed]," in *The William A. Clark Collection: The Corcoran Gallery of Art* [Washington, D.C., 1978], pp. 69–71).

8. Visscher 1614, pt. 1, no. 9; see The Hague/Münster 1974, p. 104.

9. "Kem, kem u menigmael, en niet het hair alleen, Maer ook dat binnen schuylt, tot aen het innigh been" (Cats 1658, p. 173; see also Amsterdam 1976, p. 197) (author's translation).

10. M. L. Wurfbain to Peter C. Sutton (letter dated November 30, 1983).

Interior of a Tailor's Shop, 1653
Signed and dated lower right: Q VB. 1653
(VB in ligature)
Oil on panel, 23⅝ x 33½" (60 x 85 cm.)
Worcester Art Museum, Worcester,
Massachusetts, no. 1910.7

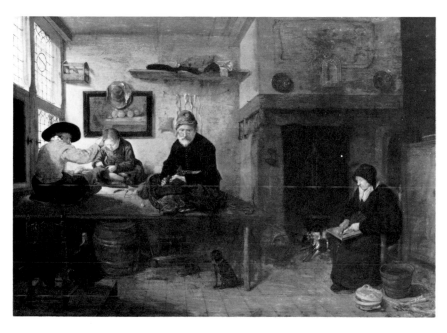

FIG. 1. QUIRIJN VAN BRE-
KELENKAM, *Interior with a
Woman and Girls Making
Lace,* 1654, oil on panel,
Richard Green Galleries,
London.

Provenance: Purchased by the museum from the Ehrich Galleries, New York, 1910.

Exhibitions: Amherst, Amherst College, and South Hadley, Mount Holyoke College, January 31–March 2, 1941; Hartford 1950–51, pp. 5, 23, no. 59, pl. 11; New York 1954–55, no. 16, ill.; New London, Lyman Allyn Museum, *The Golden Age of Dutch Painting,* May 6–June 10, 1962, no. 6.

Literature: Worcester, Worcester Art Museum, cat. 1922, pp. 64–65, 167, ill.; Maclaren 1960, p. 61; Worcester, Worcester Art Museum, cat. 1974, vol. 1, pp. 88–89, and vol. 2, p. 554, ill.

Although the tailor's shop appears frequently in Dutch genre, Brekelenkam is the only artist who seems to have made a specialty of the subject. No less than thirteen variations on this theme have been recorded, with the principal examples in Amsterdam, London, Philadelphia, and Bonn.[1] In nearly all of these pictures a tailor works with two apprentices, who could possibly be his sons. Whether a blood relationship exists between the master and his apprentices, the man is clearly instructing the boys in his trade. In many of the variants, the virtue of this paternal instruction and diligent labor is underscored by other elements in the composition. Here an elderly woman is at work preparing the family's simple meal. The variant in London (National Gallery, no. 2549) shows a younger tailor, whose wife sits nearby nursing an infant. Clearly the artist wished to draw our attention to the humble tasks of the working family. The *Interior with a Woman and Girls Making Lace* from 1654 (fig. 1),[2] a related painting by Brekelenkam

that has recently come to light, depicts a simple domestic interior that has been converted into a workshop for the instruction of lacemaking. The *naaikussen* (literally, sewing cushions)[3] stored on the shelf behind the group suggest that this is more than a simple family activity. Apparently the standing girl has just left her seat to learn an aspect of the lacemaking process. The cloak draped over a nearby table and the purse[4] hung over the empty chair seem to indicate that she is an outsider who has come for instruction.

Whatever the relationship between the woman and girls in this picture, it is clear that Brekelenkam intended the painting to be understood in much the same way as the *Interior of a Tailor's Shop.* In both works the young are instructed by their elders, and the tradition of a craft is passed down from one generation to another. Both in-house professions—lacemaking and sewing—were the natural outgrowth of textile manufacturing, the principal industry in Brekelenkam's hometown of Leiden. Combined with the more rural, so-called cottage industries of spinning and weaving, these family-operated activities formed the backbone of the multifarious *lakenindustrie* (cloth industry) of Leiden.

O.N.

1. For a complete list, see Slive in Worcester, Worcester Art Museum, cat. 1974, p. 89 n. 2. The painting that Slive lists as with J. Goutstikker, Amsterdam, 1916, seems to be identical with the painting in Bonn, Rheinisches Landesmuseum, cat. 1914, pp. 19–20. As pointed out in Philadelphia, Johnson, cat. 1972 (p. 13, no. 534), the pictures in Bonn and Philadelphia are more closely related than the other variations.

2. London art market, 1983. The proximity in size and the similarity of format of this painting and the *Interior of a Tailor's Shop* prompted the present author to consider the two as pendants ("The Old Master Sales in New York," *Tableau,* vol. 4, no. 5 [1982], p. 461); yet the similarities may be only coincidental.

3. The *naaikussen* were cloth-covered wooden cabinets containing various sewing materials (see Schipper-van Lottum 1975, p. 151).

4. The same purse appears in at least three other works; see Gerard ter Borch's portrait of the young Helena van der Schalcke (Rijksmuseum, Amsterdam, no. A1786), Govert Flinck's *Girl by a Highchair* (Mauritshuis, The Hague, no. 676); see O. Naumann, in *Small Paintings of the Masters: Masterpieces Reproduced in Actual Size,* ed. L. Shore [New York, 1980], vol. 2, no. 139), and a portrait by Isaac Luttichuys (Metropolitan Museum of Art, New York, cat. 1980, no. 32.100.10).

Man Spinning and Woman Scraping Carrots,
c. 1653–54
Monogrammed on base of swift: Q v B
(vB in ligature)
Oil on panel, 23¼ x 30½" (59 x 77.5 cm.)
John G. Johnson Collection at the Philadelphia
Museum of Art, no. 535

Provenance: Acquired by John G. Johnson, Philadelphia,
before 1913.

Literature: Philadelphia, Johnson, cat. 1913, p. 112;
Philadelphia, Johnson, cat. 1972, p. 13; Welu 1977a,
p. 21, fig. 38.

An old man wearing a fur cap sits spinning in a
room with a spiral staircase on the right and a
door on the left. With his left hand he pulls the
wool from the swift onto a spool; his right hand
taps the wheel. To the left kneels a woman in
black, scraping carrots on an overturned bucket.
At the far left is a pump with a cabbage resting
on it; on the floor below is a colander and more
carrots. A leather bag hangs from the staircase
and a wall cupboard stores foodstuffs, dishes
and, on top, a lantern. Above the doorway is a
crude map of South America inscribed AMRICA
DIO.

Brekelenkam evidently dated paintings of do-
mestic scenes and merry companies as early as
1647.[1] Around 1652 he began painting the
scenes of artisans, craftsmen, and various profes-
sionals for which he is best remembered.[2] The
present painting is related to this series. Spinning
was associated with domestic virtue in seven-
teenth-century Holland (see cat. no. 50). In an
emblem published by Johan de Brune in 1624,
an elderly couple sits by a fire as the woman
spins and the man carves (fig. 1). The writer
praises their concerted efforts because they are

directed not toward earthly gain but toward the
prospect of "heaven's rest and pleasure."[3] The
fact that the man does the spinning in Bre-
kelenkam's painting reminds the modern viewer
that in the textile industry in Holland spinning
was a widely dispersed vocation, constituting
primary livelihoods for some and important sup-
plements to the incomes of others. An extensive
labor force was concentrated in the textile cen-
ters of Leiden and Haarlem, both in the cities
and the hinterland, where spinners provided un-
finished yarn for the looms, dye works, and
bleacheries of the cities.[4] Owing to the abun-
dance of immigrant labor, particularly from the
Southern Netherlands, the pay for spinning and
related work was appallingly low, the hours in-
terminable (sixteen hours per day in the *laken-
industrie* [cloth industry] in Leiden in the sum-
mer months). In 1667 a publicist for the English
textile industry complained of the advantages
enjoyed by his Dutch competitors, noting that
"day wages in combing, carding, spinning and
weaving are about half as much as must be paid
here."[5] Thus Brekelenkam's old man scarcely
can have realized much profit from his labors
and was well advised to trust only to heaven's
rest.

In the 1650s and early 1660s Brekelenkam
repeatedly depicted men and women spinning.[6]
The work closest in conception to the present
one is *The Spinner* of 1653, where the same
models as well as the same interior seem to ap-
pear (fig. 2).[7] Both the spinning theme and the
interior with the spiral staircase may be inspired
by works executed in the 1630s by another
Leidener, Gerard Dou (see, for example, pl. 53).

Welu has identified the map on the back wall
as the lower-right section of Willem Jansz.
Blaeu's four-sheet map of America published by
Claesz Jansz. Visscher in 1608.[8] The Dutch had
a major presence in South America, primarily in
Brazil and the Caribbean, through the agency of
the Dutch West Indies Company.

P.C.S.

Oudenaerde 1606–1638 Antwerp

FIG. 1. Emblem from JOHAN DE BRUNE, *Emblemata* of *Zinne-werck* (Amsterdam, 1624).

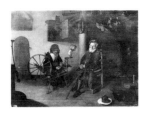

FIG. 2. QUIRIJN VAN BRE-KELENKAM, *The Spinner*, 1653, oil on panel, The Metropolitan Museum of Art, New York, no. 71.110.

1. *Card Players and a Couple* dated 164[4 or 7?], Dienst Verspreide Rijkskollekties, no. NK2924; *Woman Making Lace, with a Standing Man*, dated 1647, sale, Paris, May 22, 1933, no. 7, ill.

2. See *Cobbler with Woman Scraping Carrots*, dated 1652, sale, S. B. Goldschmidt, Vienna, March 11, 1907, no. 10.

3. De Brune 1624, p. 318.

4. See J. de Vries 1974, pp. 184, 240; J. de Vries 1976, p. 101; and van Deursen 1978a, pp. 15–18.

5. Quoted in J. de Vries 1974, p. 184.

6. A copy of the man spinning in the Johnson painting but with the woman drawing beer from a keg instead of scraping vegetables was with the dealer M. Schultess, Basel, in 1938.

7. See also *Man Spinning with a Woman Reading*, formerly B. de Geus van den Heuvel Collection (not in sale April 26–27, 1976); *Woman Spinning with a Cobbler*, signed and dated 1656(?), Lieut. Col. David Davies, Plasdinam Llandinam, Wales; *Woman at a Spinning Wheel with a Man Smoking*, signed and dated 1657 (see London, Eugene Slatter Gallery, 1951 *Exhibition of Dutch and Flemish Masters*, April 30–July 7, 1951, no. 4, ill.); *Male Spinner with a Fisherman*, signed and dated 1663, Rijksmuseum, Amsterdam, no. A60; and *Woman Scraping Carrots beside a Spinning Wheel*, signed and dated 1654, sale, F. Muller & Co., Amsterdam, April 26, 1910, no. 22, ill.

8. Welu 1977a, p. 21, fig. 38. On maps in Dutch domestic interiors, see cat. no. 88.

Shown in Philadelphia only

According to one of the artist's earliest biographers, Isaac Bullaert, Adriaen Brouwer was born in Oudenaerde in Flanders near the Dutch border and died in Antwerp at the age of thirty-two. The record of his burial from February 1, 1638, suggests that he was born in 1606. He may have first studied with his father, who made tapestry cartoons in Oudenaerde. The precise date of Brouwer's arrival in Holland has not been determined, but he probably emigrated around 1621. It is possible that his trip north included a brief stop in Antwerp. Houbraken thought the artist was born in Haarlem and was a pupil of Frans Hals (q.v.), whose studio he would have entered as late as 1623 or early 1624. Given the unreliable nature of Houbraken's other statements about Brouwer's life, the tutelage with Frans Hals must be regarded with some skepticism. The first certain record of the artist places him in Amsterdam in March 1625, at the inn kept by the painter Barent van Someren (c. 1572–1632). On July 23, 1626, he was again in the city, witnessing a sale of pictures.

In 1626 Brouwer evidently returned to Haarlem and was admitted to the rhetoricians' chamber, or amateur literary society, known as De Wijngaertranken, whose motto was "In Liefd Boven Al" (Love above all). On March 10, 1627, Pieter Nootmans, the poet and director of the society, dedicated a tragedy to Brouwer, hailing him as "the world-famous Haarlem painter." Other contemporaries, including Mathijs van den Bergh (1617–1687), a pupil of Rubens (1577–1640), called Brouwer a "Haarlemensis" (native of Haarlem).

During the winter of 1631–32 Brouwer was in Antwerp, where he was admitted to the Guild of St. Luke and accepted Jean Baptiste d'Andois (Jan Dandoy) as a pupil. On March 4, 1632, he stood witness in Antwerp to authenticate a number of paintings attributed to him. Van Dyck (1599–1641) included him in his series of portraits of famous artists, scholars, and statesmen, and inventories reveal that both Rembrandt (1606–1669) and Rubens owned several of his works. Despite the admiration of his colleagues, Brouwer had financial problems, and Cornelis de Bie, a contemporary Flemish writer, claimed that he often paid his bills with quick sketches of life in the taverns he frequented. In the summer of 1632 his debts necessitated an inventory of his effects.

The Pancake Baker, mid–1620s
Oil on panel, 13¼ x 11⅛" (33.7 x 28.3 cm.)
John G. Johnson Collection at the Philadelphia
Museum of Art, no. 681

Literature: Schrevelius
1648, pp. 455–66; de Bie
1661, p. 91; Félibien 1666–
88, vol. 4, p. 92; Sandrart
1675–79, pp. 174, 179;
van Hoogstraten 1678, pp.
15, 67, 87; Félibien 1679,
p. 50; Bullaert 1682, vol. 2,
p. 488; Houbraken 1718–
21, vol. 1, pp. 318–33;
Levensbeschryving 1774–
83, vol. 1, pp. 194–200;
Raepsaet 1852; Blanc
1854–90, vol. 1, p. 525;
Nagler 1858–79, vol. 1, pp.
146, 191; Siret 1859; van
der Willigen 1870, p. 346;
Schmidt 1873; Mantz
1879–80; van den Branden
1881a; van den Branden
1881b; van den Branden
1882–83; Bode 1883, pp.
208–13; Bode 1884a; Bode
1884b; Unger 1884;
Ephrussi 1884–85; de Per-
mentier 1885; Schlie 1887;
de Mont-Louis 1895;
Wurzbach 1906–11, vol. 1,
pp. 193–201; Schmidt-De-
gener 1908a; Schmidt-
Degener 1908b; Hofstede
de Groot 1908–27, vol. 3,
pp. 557–667; F. Schmidt-
Degener in Thieme, Becker
1907–50, vol. 5 (1911), pp.
74–75; Friedländer 1918;
Bode 1922a; Bode 1924;
Schneider 1926–27;
Schneider 1927; Drost
1928; Reynolds 1931; de
Graaf 1937; Böhmer 1940;
van Puyvelde 1940; van
Gelder 1940–41; Ver-
meylen 1941; Hollstein
1949–, vol. 3, pp. 246–49;
Valentiner 1949; Höhne
1960; Salinger 1960; Traut-
scholdt 1961; Knuttel
1962; Rosenberg et al.
1966, pp. 110–12; Stechow
1966a; Ruurs 1974;
Amsterdam 1976, pp. 54–
57; New York/Maastricht
1982; Klinge forthcoming.

*According to documentation from February
23, 1633, Brouwer was arrested and confined in
the fortress at Antwerp. Early biographers at-
tributed the arrest to his dissolute life. A record
from September 23 shows that Brouwer was still
imprisoned. The date of his release is unknown,
but on April 26, 1634, he was living on the
Everdijstraat in Antwerp, in the house of the
copper-engraver Paul du Pont (Paulus Pontius).
In the same year he joined Violiere, the Antwerp
rhetoricians' society. On March 1, 1636, he is
recorded in the company of the painters Jan
Lievens (1607–1674) and Jan de Heem (1606–
1683/84). The cause of his early death remains
unknown. He was buried in the church of the
Carmelite monastery at Antwerp.*

C.v.B.R.

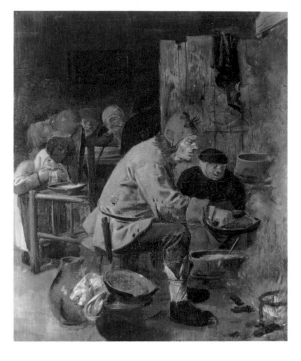

Provenance: Possibly owned by Rembrandt, 1656; John G.
Johnson, Philadelphia, by 1910 (inscribed on rear of panel:
"1898 Harris Sons., London, from Coll. M. Favet 1896").

Exhibition: New Brunswick 1983, no. 18, pl. 5.

Literature: Hofstede de Groot 1908–27, vol. 3, no. 49;
W. R. Valentiner, in Philadelphia, Johnson, cat. 1913, no.
681, ill.; Bode 1921, p. 383; Bode 1924, pp. 53–54; Hepp-
ner 1941, p. 45; Winkler 1960, pp. 216, 220, ill.; Knuttel
1962, pp. 73–76, fig. 39; Rosenberg et al. 1966, pp. 110–
12, pl. 79A; Philadelphia, Johnson, cat. 1972, p. 13, no. 681,
ill.; M. Klinge, in New York/Maastricht 1982, p. 12.

A rough peasant in a patched red coat and cap
sits before a fire cooking pancakes. Seated at his
left in front of a wooden partition, a squat girl
or woman with broad features watches the
cooking. At the rear left, a little girl swills por-
ridge from a bowl on a chair. In the background
other peasants around a table eat and drink. Ce-
ramic pots, bowls, and a cloth form a still life in
the immediate foreground.

Adriaen Brouwer's creation of a powerfully
coarse, unapologetically realistic image of the
peasant was a great innovation in Dutch genre
painting. Although none of Brouwer's works are
dated, *The Pancake Baker* has been considered
an early work from around 1625 or 1626, the
artist's first years in Haarlem and Amsterdam.
The painting's coarse peasant subject, close view
of full-length figures, and raw style and color
scheme—a shrill palette of pink, red, green, and
yellow—are all features shared with works that
have come to be regarded as Brouwer's earliest.[1]

FIG. 1. REMBRANDT, *Pancake Woman and Boy*, 1635, etching.

Details of the execution—the thin application of paint in shadowed areas, the greater build-up in passages of local color, and the flecked highlights and hatching—are characteristic of the young Brouwer, whose free, one might even say brutal, touch so well complements his low-life subjects.[2] Also appropriate to the artist's early style are the squat, gnomelike figures reminiscent of the Bruegelian peasant painting tradition. These features and the especially coarse but expressive technique might suggest that the work was executed even before 1625, but any attribution to the years between 1621 and 1625, the period when Brouwer left his native Oudenaerde and was first documented in the Netherlands, can be only speculative.

Brouwer's admirers included both Rembrandt and the great Flemish artist Peter Paul Rubens. Rubens owned no less than seventeen of the artist's works, and Rembrandt in 1656 possessed six, including "een stuckie van Ad. Brouwer, sijnde een koekebakker" (a work by Ad. Brouwer, showing a pastry-cook). As Valentiner proposed in 1913, this reference could be to *The Pancake Baker*, which, in turn, may have inspired the great master's etching of a *Pancake Woman and Boy* of 1635 (fig. 1).[3]

Pancakes were cheap and were consumed in large quantities by the Dutch lower classes, who purchased them in taverns or from street vendors.[4] The pancake baker seems to have been a comical figure in contemporary Dutch theater, and popular sayings allude to the peasant classes' relish for the dish; for example, "Rijke lieden ziekte en schamele lieden pannekoeken ruikt men verre" (When rich people are sick or poor folk cook pancakes, they can be smelled from afar.)[5]

P.C.S.

1. These include the *Inn with Drunken Peasants* (Rijksmuseum, Amsterdam, no. A64), *Fighting Peasants* (Mauritshuis, The Hague, inv. no. 919; on loan from the Rijksmuseum), *Peasant Feast* (Ruzicka Stiftung, Kunsthaus, Zurich, inv. no. R4), *Slaughter Feast* (Staatliches Museum, Schwerin), and the *Tavern Interior* (Museum Boymans–van Beuningen, Rotterdam, no. 1102). The composition of the last mentioned, a crowded assembly of peasants around a hearth on the right, is similar to that of *The Pancake Baker*.

2. Recently the attribution of this painting to Brouwer has been questioned (recorded in the Johnson Collection Archives, Philadelphia, no. 681), but the concerns raised have not yet been published.

3. See W. L. Strauss and M. van der Meulen, with S.A.C. Dudok van Heel and P.J.M. de Baar, *The Rembrandt Documents* (New York, 1976), p. 349. Rembrandt's etching may also have been inspired by Brouwer's lost *Pancake Woman* known through T. Matham's engraving; see Winkler 1960, p. 216, ill.; and Heppner 1941. Brouwer's treatment of the theme may also have inspired Jan van de Velde II's nocturnal engraving of *The Pancake Woman* (Boston/Saint Louis 1980–81, cat. no. 61, ill.) (as c. 1626).

4. See Rembrandt's drawing of a boy digging into his pocket to pay a pancake woman (Rijksprentenkabinet, Rijksmuseum, Amsterdam, no. A2424).

5. Knuttel (1962, p. 73 n. 2) quotes Mr. Kackadoris from *Een Tafelspel van Meester Kackadoris ende een Doof-Wijf met Ayeren* (Amsterdam, 1596): "Fetch eggs, and bring on board a pancake woman who can make a batter and slap the pancakes on the griddle by the dozen." See Harrebomée 1856–70, vol. 1, p. 427. Pieter Bruegel's *Land of Cocaigne* of 1567 (Alte Pinakothek, Munich, no. 8940) also illustrates the popular saying "In Luilekkerland zijn de huizen met pannekoeken gedekt" (In the land of plenty the roofs are covered with pancakes).

The Smokers (The Peasants of Moerdijk),
c. 1627–30
Oil on panel, 12¼ x 9½″ (31 x 24 cm.)
Private Collection

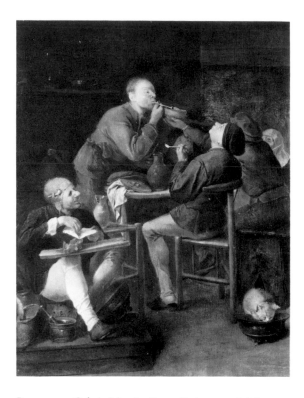

Provenance: Galerie Maurice Kann, Paris, c. 1908; Max Freiherr von Goldschmidt-Rothschild, Frankfurt, until 1939; exhibited in Städelsches Kunstinstitut, Frankfurt, 1939–49; Rosenberg and Stiebel, New York, 1949; Frits Markus, Scarsdale, New York, 1949–71; Hans Cramer, The Hague, 1972–73.

Exhibitions: Frankfurt, Städelsches Kunstinstitut, *Meisterwerke Alter Meister aus Privatbesitz,* 1925, no. 30, pl. 81; New York/Maastricht 1982, no. 3.

Literature: Wurzbach 1906–11, vol. 1, p. 196; Schmidt-Degener, 1908a, p. 5, ill., and pp. 8–10; Schmidt-Degener 1908b, pt. 13, pp. 5–11, pl. 4A; Hofstede de Groot 1908–27, vol. 3, p. 635, no. 127; Schmidt-Degener in Thieme, Becker 1907–50, vol. 5 (1911), p. 74; Bode 1924, p. 48, pl. 17; Knuttel 1962, pp. 89–92, pl. 4.

The fanciful title *The Peasants of Moerdijk* is derived from an eighteenth-century French engraving after Brouwer's painting (fig. 1). Moerdijk, a village in Holland, is just over the border from Brabant. However, we have no reason to believe that the protagonists were inhabitants or that the print records the painting's original title. The engraving, which reproduces the picture in reverse, reveals that in the eighteenth century Brouwer's panel was extended at both sides, and the composition was altered. A cupboard displaying ceramics was added on the left; the fireplace and foreground were enlarged on the right. Furthermore, a standing female figure covered the seated woman at the right edge, and a mortar and pestle and a bowl leaning

against the platform were introduced at the lower left. These eighteenth-century "improvements," except for the mortar and pestle in the left foreground, have been removed, and the vertical format has been restored. The original appearance is documented by an old copy.[1]

The Smokers dates from about 1627–30, the transition between early works such as *The Pancake Baker* (pl. 22) and products of his fully mature style (pls. 23, 24). Instead of the hatching and detached brushwork of the earlier panel, Brouwer resorted to a denser, more saturated application of paint. The restricted palette and rose-gray tonality of *The Pancake Baker* gave way to pronounced local hues of green, red, and gray against the reddish-brown ground. An impressively structured and concentrated pyramidal design replaced the diffuse figural arrangement of the earlier painting. Brouwer resided in Haarlem during the late twenties; the style and imagery of the works he created in those years contributed decisively to the subsequent course of low-life painting in the Netherlands (see, for example, pl. 27).

The custom of smoking tobacco, still a novelty in Brouwer's time, elicited diverse responses from seventeenth-century Dutchmen. Some ascribed medicinal properties to the weed and composed songs and poems praising its powers, but most condemned it as a harmful intoxicant and equated smoking with excessive drinking. Images of smokers in the visual arts evoked various associations, such as the sense of smell in a composition representing the Five Senses. Dissipating smoke juxtaposed with a human figure served as a memento mori. Pictures of low-life types in tobacco dens, like the closely related tavern scenes with drinkers, satirized the immoderate pursuit of sensual gratification.[2]

Certainly, Brouwer's painting is satirical. The stupid, inebriated expression of the fatuous peasant who tilts back his head and exhales skyward, the boorish impulsiveness of the character who lights his pipe from a brazier, and the ugly grin with which the man at lower left regards his companions underscore the grotesque aspects of

Fight over Cards, c. 1631–35
Oil on panel, 13 x 19¼" (33 x 49 cm.)
Bayerische Staatsgemäldesammlungen, Alte
Pinakothek, Munich, no. 562

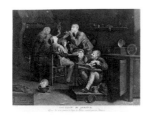

FIG. 1. PIERRE MALEUVRE
after Adriaen Brouwer, *The
Peasants of Moerdijk,*
engraving.

FIG. 2. ADRIAEN BROUWER,
*Sketches of a Seated
Smoker,* pen and brown ink
over graphite on paper,
Kupferstichkabinett,
Gemäldegalerie, Staatliche
Museen Preussischer Kultur-
besitz, Berlin (West), inv.
no. 1374.

the addiction to Nicot's herb. As in the artist's
drinking scenes, uncouth peasants exemplify the
comic and undignified consequences of intem-
perance. Through his peerless ability to invent
bold gestures and to depict expressive faces,
Brouwer brilliantly captures abandonment to
pleasure. His spirited sketches reveal how he
perfected this talent by drawing from life. One
of his rare sheets of studies displays two sketches
of a seated smoker (fig. 2), which with few al-
terations, Brouwer transformed into the exhaling
peasant in *The Smokers.*[3]

<div align="center">W.R.</div>

1. See New York/Maastricht 1982, p. 36.

2. For a discussion of smoking in seventeenth-century Dutch
art see Amsterdam 1976, cat. no. 7.

3. Bode 1924, p. 63, fig. 38; Knuttel 1962, p. 168, fig. 115.
To this author's knowledge the connection between the
drawing (fig. 2) and the painting has not been suggested in
the literature.

Provenance: Sold by Brouwer to Heer Sohier de Vermandois
(for 100 ducats);[1] Elector Johann Wilhelm von der Pfalz,
Düsseldorf; Carl Philipp von der Pfalz, Mannheim; Carl The-
odor von der Pfalz, Mannheim, until 1799; Hofgartengalerie,
Munich, 1799–1836; Alte Pinakothek, Munich, 1836.

Literature: Houbraken 1718–21, vol. 1, pp. 323–24; van
Gool 1750–51, vol. 2, p. 564; Schmidt-Degener 1908a, p.
44, ill. opp. p. 50; Hofstede de Groot 1908–27, vol. 3, p.
660, no. 172; Hanfstaengel 1922, pl. 183; Bode 1924, pp.
80, 84–86, fig. 55; Munich, Alte Pinakothek, cat. 1938, p.
33, no. 562, and cat. 1958, p. 17, no. 562; Knuttel 1962,
pp. 109–10, pl. 8, fig. 66; Rosenberg et al. 1966, p. 111, pl.
80A.

In his biography of Brouwer, Houbraken de-
scribed this picture, which he praised as one of
the master's outstanding creations. His concise
judgment remains valid: "Everything was so nat-
urally expressed in the facial features, according
to the kind of passion represented, and so as-
tonishingly firmly drawn and freely painted that
it serves as an epitome of his art."[2] With the
exception of Jan Steen, no low-life painter could
match Brouwer's capacity to express violent pas-
sion in the faces of his protagonists.

Despite Houbraken's assertion that Brouwer
painted *Fight over Cards* while a young, un-
known artist in Amsterdam, later historians have
ascribed the picture to his Antwerp period; thus
it probably dates from about 1631–35.[3] The
dynamic figural design and the boxlike room,
which shows advanced treatment of interior
space, are characteristic of this phase of his ca-
reer. For comparison with earlier works, see *The
Pancake Baker* (pl. 22) and *The Smokers* (pl.
23). During his transitional Antwerp period,
Brouwer's application of paint was not as broad
and thin as in his later works from 1635–37 (see
pl. 25).

Gangs of brawling peasants constituted one
element in the panoramic kermis scenes of the
sixteenth and early seventeenth centuries, such
as those by Pieter Bruegel, Pieter van der Borcht,
and David Vinckboons (pl. 2).[4] Brouwer and
other low-life painters of his time isolated the
brawlers, drinkers, and dancers from these
crowded outdoor celebrations and turned them
into independent subjects, often situated in-
doors. In an earlier Brouwer painting of a
dispute over cards, the open-air setting recalls
the lively tavern yards that were a prominent

Singing Drinkers, c. 1635–36
Oil on panel, 8⅛ x 6⅛″ (20.7 x 15.5 cm.)
Private Collection

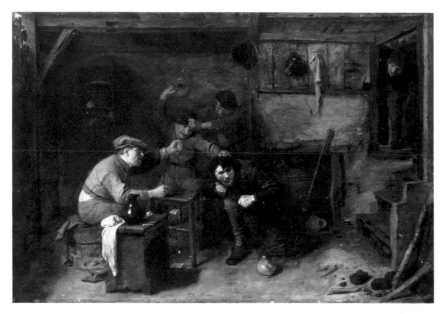

Provenance: Leo Nardus, Suresnes, near Paris, until 1919; J. Goudstikker, Amsterdam, 1919; Hugo Stokvis, Brussels, until 1959; Alice Stokvis, Geneva, until 1969; Edward and John Stokvis, Geneva and New York, until 1970; Hans Cramer, The Hague, 1970–71.

Exhibitions: The Hague, Pulchri Studio, *Collection Goudstikker d'Amsterdam*, 1919, no. 15, ill.; Rotterdam, Museum Boymans–van Beuningen, *Meesterwerken uit vier eeuwen*, 1938, no. 167, fig. 172; New York/Maastricht 1982, no. 8.

Literature: Wurzbach 1906–11, vol. 1, p. 198; Schmidt-Degener 1908a, pp. 21–22, ill. opp. p. 20; Schmidt-Degener 1908b, p. 19, fig. 16A; Hofstede de Groot 1908–27, vol. 3, p. 637, no. 134; F. Schmidt-Degener in Thieme, Becker 1907–50, vol. 5 (1911), p. 74; Bode 1924, pp. 70–71, fig. 46; S. Speth-Holterhoff, *Les peintres flamands de cabinets d'amateurs au XVIIe siècle* (Paris/Brussels, 1957), p. 116, pl. 5; Knuttel 1962, p. 145 (as an imitator of Brouwer).

The minor Flemish master Corneille de Bailleur reproduced this composition in miniature in his painting of a gallery interior dated 1637.[1] This panel has won the endorsement of most Brouwer specialists and is probably the original copied in de Bailleur's gallery picture.[2] The date, as judged from the style of *Singing Drinkers* (pl. 25) is about 1635 or 1636.[3] The free and vigorous application of translucent paint and the three-quarter-length figures in a vaguely described setting typify Brouwer's late genre paintings. Energetic brushwork gives his later panels a breadth and pictorial dash that invite comparison with the paintings of Frans Hals, who might have been his teacher or mentor during Brouwer's residence in Haarlem. In *Singing Drinkers*, animation and spontaneity intensify the physical and emotional vitality of the celebrants, thus contributing to the frenzied tempo of the orgiastic subject.

Between 1625 and 1635, Brouwer and Adriaen van Ostade (pl. 27) developed the type of tavern or domestic interior occupied by merrymaking peasants that remained the fundamental low-life theme for the balance of the century. Before Brouwer, such scenes were rare in Netherlandish art. He innovated the relocation of revelers from the kermis, where they had appeared in numerous sixteenth- and early seventeenth-century paintings and prints, to the earthy makeshift interior that suited the revelers' pleasures and personalities.[4]

In low-life works from the second quarter of the century, merrymakers generally retained the negative associations attached to them in the

detail in the kermisses.[5] The pigs and the conspicuous jugs, familiar symbols of gluttony, confirm that drunkenness fueled the violence.[6] Significantly, a fight over cards had figured in at least one cycle of didactic prints devoted to the evils of inebriation.[7] In the Munich panel, the scattered beer jugs attest that here, too, abundant drink helped spark the fracas. As in his paintings of merry drinkers and smokers, Brouwer uses the antics of coarse peasants to ridicule and condemn the effects of intemperance.

<div align="center">W.R.</div>

1. Houbraken 1718–21, vol. 1, p. 323.

2. "Alles was zoo natuurlyk naar den aart der hartstochten, in de wezenstrekken verbeelt, en zoo verwonderlyk vast geteekent, en los geschildert dat het wel tot een proefstuk van zyn konst kon verstrekken" (Houbraken 1718–21, vol. 1, p. 323) (author's translation).

3. Schmidt-Degener (1908a, p. 44) placed the work in Brouwer's Antwerp period, and later authors have accepted this dating.

4. Pieter van der Borcht's kermis engraving is reproduced and discussed by K.P.F. Moxey, "Sebald Beham's Church Anniversary Holidays: Festive Peasants as Instruments of Repressive Humor," *Simiolus*, vol. 12, nos. 2–3 (1981–82), pp. 121–22, fig. 12.

5. *Fighting Peasants*, Mauritshuis, The Hague, inv. no. A65.

6. See Renger 1970, pp. 72–73, figs. 44, 45.

7. See Renger 1970, pp. 82–83, fig. 56.

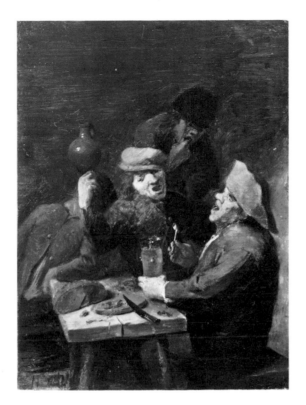

1. See S. Speth-Holterhoff, *Les peintres flamands de cabinets d'amateurs au XVIIe siècle* (Paris/Brussels, 1957), p. 116, pl. 5; New York/Maastricht 1982, no. 8.

2. Knuttel (1962, p. 145), unlike most Brouwer specialists, does not accept this panel as an original.

3. See New York/Maastricht 1982, no. 8.

4. See Schnackenburg 1981, vol. 1, pp. 26–30.

5. "Trahit sua quemque voluptas" (see New York/Maastricht 1982, p. 15, figs. 6, 7).

6. Knuttel 1962, fig. 53, pl. 10. See also the drawings by Willem Buytewech (Rotterdam/Paris 1974–75, no. 39), and David Vinckboons (Wegner, Pée 1980).

7. See Renger 1970, pp. 72–73.

8. On the tradition of the consequences of inebriation, see Renger 1970, pp. 71–95, 106–19, cat. no. 27.

kermis scenes. Fired by drink, Brouwer's peasants behave instinctively: they fight (pl. 24), smoke (pl. 23), dance, sing, and crudely assault women. "Everyone is carried away by his sensual desire" warns the title beneath a nearly contemporary etching after a similarly beery, rustic concert by Brouwer.[5] A celebrant in *Singing Drinkers* betrays his loss of control by regurgitating amidst the revelry. In several drinking scenes of the period, including two by Brouwer, pigs greedily lap up a staggering or prostrate drunkard's vomit.[6] The swine embody the deadly sin of gluttony and serve as a reminder that men who reject moderation sink to the level of beasts.[7] In *Singing Drinkers*, Brouwer did not use a scavenging pig to underscore the admonitory message, which is sufficiently conveyed by the four male figures. Their undisciplined conduct and the retribution experienced by the nauseated man would have aroused the contempt and disgust of the seventeenth-century viewer accustomed to censuring such behavior in kermis scenes and in didactic images representing gluttony or the consequences of inebriation.[8]

W.R.

near Deventer 1588–1629 Utrecht

The Bagpipe Player, 1624
Signed upper right: HTBrugghen fecit 1624
(HTB in ligature)
Oil on canvas, 39¾ x 32⅝″ (101 x 83 cm.)
Wallraf-Richartz-Museum, Cologne, no. 2613

Literature: De Bie 1661, p. 132; Sandrart 1675; de Bie 1708, p. 271; Houbraken 1718–21, vol. 1, pp. 133–35, 156, and vol. 3, p. 46; Weyerman 1729–69, pp. 337–39; Descamps 1753–64, vol. 1, pp. 371–72; Nagler 1835–52, vol. 18, pp. 239, 246; Immerzeel 1842–43, vol. 3, p. 132; Dodt 1846; Molhuyzen 1848; Kramm 1857–64, vol. 6, pp. 1613–14, and suppl., p. 157; Nagler 1858–79, vol. 3, pp. 738, 1586; Obreen 1877–90, vol. 6, p. 37; Muller 1880, pp. 105, 171; Hofstede de Groot 1893a, pp. 273–74, 437–39; Houck 1899; E. W. Moes in Thieme, Becker 1907–50, vol. 5 (1911), p. 113; Collins Baker 1927; Longhi 1927; von Schneider 1927; Buchelius 1928, p. 84; Baumgart 1929; Fokker 1929; von Schneider 1933, pp. 32–39; Isarlo 1941, pp. 234–36; Longhi 1943; Swillens 1945–46; Milan 1951; Pauwels 1951; Block 1952; Gerson 1952b; Longhi 1952; Nicolson 1952; Utrecht/Antwerp 1952; Houtzager 1955; Judson 1956; Nicolson 1956; Nicolson 1957; Nicolson 1958; Maclaren 1960, pp. 63–64; Nicolson 1960; Plietzsch 1960, pp. 143–47; Dayton/Baltimore 1965–66; Rosenberg et al. 1966, pp. 23–25; Salinger 1967b; van Thiel 1971; Nicolson 1973; Nicolson 1979, pp. 97–101.

The youngest son of a wealthy and distinguished Catholic family, Hendrick ter Brugghen was born in 1588 near Deventer in the province of Overijssel. Around 1591, the year Prince Maurits defeated the Catholic faction in Deventer, the family moved to Utrecht. Ter Brugghen's parents, Jan ter Brugghen, a tax collector, and Sophia van Ruempst, had six other sons, five of whom held military posts in the Netherlands and Germany. Ter Brugghen was apprenticed to the leading Utrecht history painter, Abraham Bloemaert (q.v.), until 1603 or 1604 when, at the age of fifteen, he traveled to Italy. He was in Italy for about ten years, principally in Rome, where he met Peter Paul Rubens (1577–1640). Ter Brugghen was in Milan in the summer of 1614, and that autumn returned to the Netherlands, crossing the Alps through the Saint Gotthard Pass.

Back in Utrecht, ter Brugghen married Jacoba Verbeek in 1616; the couple had eight children between 1617 and 1630. The artist entered the Guild of St. Luke in either 1616 or 1617. He died on November 1, 1629, and was buried in the Buurkerk on November 9. The painter Adriaen van der Werff (q.v.) eulogized the artist in a letter from Rotterdam dated April 15, 1707, to ter Brugghen's son Richard, an Utrecht lawyer. In 1707 Richard presented ter Brugghen's paintings of the four evangelists to the government council of Deventer as a permanent memorial to his father.

Ter Brugghen was the first Dutch Caravaggesque painter to visit Italy and to return to the Netherlands. None of the works he executed in Italy are known. His style is an individual interpretation of that of Caravaggio (1573–1610) and, perhaps even more important, Caravaggio's Roman followers.

In addition to genre scenes of musicians and drinkers, ter Brugghen painted a number of biblical, mythological, and literary themes. His earliest dated works are Saint Peter Praying, of 1616 (Centraal Museum, Utrecht, cat. 1971, no. 18) and The Adoration of the Magi, of 1619 (Rijksmuseum, Amsterdam, inv. no. A4118).

<div align="right">C.B./C.V.B.R.</div>

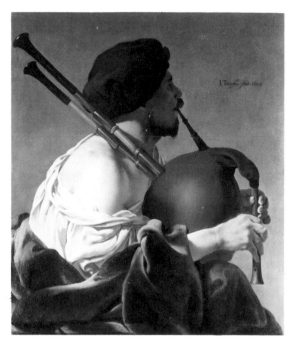

Provenance: Probably Glenz, Berlin 1915;[1] sale, H. W. Lange, Berlin, November 18–19, 1938, no. 151, to the museum.

Literature: J. W. Moltke, "Ein unbekanntes Bild von Hendrick Terbrugghen," *Wallraf-Richartz-Museum Jahrbuch,* no. 11 (1939), pp. 283–85; Nicolson 1958, cat. A17; Cologne, Wallraf-Richartz-Museum, cat. 1967, p. 26.

A bagpipe player, wearing a beret and with his right shoulder bared, is shown half-length. The musician's head, turned to the right, and left hand are in shadow; in contrast, light accentuates his bared shoulder, voluminous shirt, and right hand.

Nicolson noted that there are pentimenti around the outline of the figure and the bagpipe, suggesting that ter Brugghen first intended to make the figure larger. However, pentimenti are common in ter Brugghen's work and may be the consequence of his normal working practice: a deliberate strengthening of the outline of his figures to give the effect of a hard edge. Pentimenti also can be found in all three of his paintings in the National Gallery, London.

In 1621 ter Brugghen first treated the subject of half-length musicians in his pair of flute-playing boys (Gemäldegalerie Alte Meister, Kassel, nos. GK179 and GK180). Half-length single figures of musicians and drinkers are an innovation of the Utrecht Caravaggisti. Although they have been thought to show *rederijkers* (rhetoricians) or to represent one of the senses, this interpretation is unlikely.

C.B.

1. Three versions of *The Bagpipe Player* have been documented. One was revealed on the x-ray photograph of ter Brugghen's *Violinist* (private collection) of 1626 in a Swedish collection (published by G. Glück, "Objective Grundlagen zur Beurteilung alter Gemälde," *Der Kunstwanderer*, vol. 3 [1929–30], pls. 2–3; Nicolson 1958, A76). A second version, which was in the collection of Ragnar Ashberg, Stockholm, 1954, is discussed by Nicolson (1958, A17), who believed it to be a copy. The third version, said by von Schneider (1933, p. 140) to be with Glenz in Berlin in 1915, may be identical with the Cologne painting.

Shown in Philadelphia and Berlin

Willem Buytewech, called "Geestige Willem" (Inventive, or Witty, Willem) in a document from 1656, was the son of Pieter Jacobsz. and Jutzen (Judith) Willemsdr. He was born in Rotterdam, probably in late 1591 or early 1592. His parents were married on February 3, 1591. Willem's father, a shoemaker and candlemaker, was twenty-seven at the time and was living in Rotterdam on the Achterweg beside the Botersloot. The Achterweg established a boundary of the city; the territory beyond, known as the "Buitenachterweg," may have been the source for the family name. At the time of Willem's birth, his parents and his elder half-brother Christoffel were living on the Hoogstraat in the house of Jutzen's first husband, Jacob Stoffelsz. Willem probably continued to live in this house until his departure for Haarlem.

Although the exact date of Buytewech's arrival in Haarlem is unknown, documentary evidence shows that he entered the city's Guild of St. Luke in 1612, the same year as did Hercules Seghers (born 1589/90) and Esaias van de Velde (q.v.). On November 10, 1613, he married Aaltje Jacobsdr. van Amerongen from Haarlem. The couple resided near the Jacobijnenbrug. Their son Pieter was baptized on March 10, 1615. The couple's daughter Pieternelletge was also born in Haarlem, where Buytewech may have had contact with a number of other artists besides Seghers and Esaias van de Velde; Hendrik Goltzius (1558–1617), Cornelis Cornelisz. van Haarlem (1562–1638), Jacob Matham (1571–1631), Jan van de Velde (1593–1641), Pieter Molijn (1595–1661), Dirck Hals (q.v.), and Frans Hals (q.v.) were all living in the city at this time. Buytewech did, in fact, copy Frans Hals's work.

Although Buytewech returned to Rotterdam by August 1617, the time of his son's death, he retained his connections with artists and publishers in Haarlem. On June 21, 1618, he bought a house in the Oppert on the west side of Rotterdam, and had three more children: Lysbeth, Jacob?, and Willem (1625–1670), the only one of the children to become an artist.

Merry Company in the Open Air, c. 1616–17
Oil on canvas, 28 x 37″ (71 x 94 cm.)
Gemäldegalerie, Staatliche Museen Preussischer
Kulturbesitz, Berlin (West), on permanent loan

Literature: Houbraken 1718–21, vol. 2, p. 90; van Eynden, van der Willigen 1816–40, vol. 1, p. 67; Weigel 1837–66, vol. 2, p. 12025; Kramm 1857–64, vol. 1, p. 187, and suppl., p. 30; Nagler 1858–79, vol. 5, p. 1548; van der Kellen 1866, pp. 109, 230; van der Willigen 1870, p. 99; Haverkorn van Rijsewijk 1891; Goldschmidt 1901; Goldschmidt 1902; Haverkorn van Rijsewijk 1905; Wurzbach 1906–11, vol. 1, pp. 227–78; L. Burchard in Thieme, Becker 1907–50, vol. 5 (1911), pp. 310–11; Martin 1916; Schmidt-Degener 1920; Zoege von Manteuffel 1920–21; Bredius 1922; Wiersum 1922; Wiersum 1923; Martin 1925a; Poensgen 1926a; Poensgen 1926b; van Regteren Altena 1926; Six 1926; Knuttel 1928; Knuttel 1929; Martin 1930; van Gelder 1931; van de Waal 1940; Uyttenhoek 1946; van Gelder 1946a; Hollstein 1949–, vol. 4, pp. 53–57; Bengtsson 1952; Gudlaugsson 1956; Haverkamp Begemann 1959; Kunstreich 1959; Plietzsch 1960, pp. 24–25; Haverkamp Begemann 1962; Haverkamp Begemann 1966; Rosenberg et al. 1966, pp. 105–6; New York/Boston/Chicago 1972–73, pp. 26–28; de Vries 1974; Rotterdam/Paris 1974–75; Amsterdam 1976, pp. 64–67; Boston/Saint Louis 1980–81, pp. 64–65, 81–82, 89–91, 96–98; Amsterdam/Washington 1981–82, pp. 40–41.

Buytewech drew up his will on September 16, 1624; he died the following week, on September 23, and was buried in Rotterdam's Grote Kerk.

Buytewech was active primarily as a draftsman and an etcher. His subjects included genre, landscape, biblical scenes, and allegorical themes. He also made drawings to be used as designs for prints by other artists, including Jan van de Velde, and he designed the title page for Bredero's play Lucelle. *His dated works fall between 1606 and 1621. Only about ten paintings, all genre scenes, are known. Although Buytewech had no documented pupils, Houbraken believed that Hendrick Sorgh (q.v.) studied with him.*

C.v.B.R.

Provenance: Camillo Castiglione, Vienna; sale, Amsterdam, September 17 20, 1925, no. 54; sale, Berlin, November 28–29, 1930, no. 42; Galerie Internationale, The Hague, 1936; private collection, Berlin, on loan to the museum from 1958.

Literature: Poensgen 1926a, pp. 93–96, pl. 9; Knuttel 1929, p. 197 n. 2 (as Esaias van de Velde); Würtenberger 1937, p. 43 (as Esaias van de Velde); Kunstreich 1959, pp. 22, 31, no. 16; Haverkamp Begemann 1959, pp. 23–25, 63, no. 2; Plietzsch 1960, p. 25, no. 1; R. Klessmann, *Holländische Malerei des 17. Jahrhunderts*, Bilderhefte der Staatlichen Museen Preussischer Kulturbesitz (Berlin, 1969), pp. 13–14, pl. 3; Rotterdam/Paris 1974–75, p. 3, under cat. no. 1; Berlin (West), Gemäldegalerie, cat. 1975, pp. 75–76; Berlin (West), Gemäldegalerie, cat. 1978.

Young couples in lavish attire have gathered at a richly laid table on a garden terrace. The scene is framed by huge columns, and the figure groups are balanced bilaterally with the main characters—the seated couple at the left and the people standing at the right—arranged across from one another. The center of the scene provides an unobstructed view; in the foreground, a dog stands beside a wine cooler. Farther back is the well-laid table, on which a bird-shaped peacock pie has been served. The background, though empty of activity, offers prospects for social interaction; the shady arbor on the left seems to invite dalliance. Select architectural motifs transform nature into a special realm, sheltered from everyday reality.[1]

The banquet appears to have ended;[2] the figures simply stand or sit, betraying no relationship to their companions beyond physical proximity. Social interaction is reduced to contiguity; each is alone, a symbol of his or her vanity and smugness. The discrete quality of the figures gives their behavior emblematic significance. Similarly, other aspects of the painting, like the motifs of a still-life arrangement, suggest meaning beyond the surface impression.

Various details in the setting and costumes refer to earthly possessions, particularly the wasteful splendor of the sumptuous buffet on the right. The extravagant tableware is rivaled by the precious metals of the wine tankards and a voluminous cooler decorated with animal heads. Such tankards were common in sixteenth-century inn scenes, where they symbolized Gula (gluttony and alcoholism), vices to which the well-appointed table here also tempt.[3] Music, the most transitory art, should complement these

(Mauritshuis, The Hague, no. 199), an elegant party sits before a background closed by a palace view, and clear water flows from a lavishly decorated fountain. Fountains and palaces belong to the iconography of the medieval garden of love, a theme that was continuously reformulated up to the time of Rubens (compare, for example, Esaias van de Velde, pls. 3 and 4). Buytewech's parklike background, which seems to suggest a garden of love, would not have been influenced by Esaias van de Velde, however, whose pictorial narratives with small figures were then in the style of his Flemish teacher Vinckboons. The artist who elevated Vinckboons's prototype to a large format may, in fact, have been Frans Hals. Buytewech's broad, sweeping brushstrokes, with their elements of Flemish mannerism, are reminiscent of Hals. Other familiar motifs are the wine cooler in the foreground, the seated couple on the left, and perhaps the cavalier's turn toward the viewer at the right. On the whole, however, Buytewech's composition is unique, converting the oblique order of his prototype to a strictly orthogonal arrangement.

Produced by a young man in his mid-twenties, this painting is Buytewech's observation of his own generation, the first to enjoy a carefree life in the Dutch Republic after the wars of independence against Spain. The pleasure his figures take in boastful panache and modish extravagance seems to capture the social reality of the time. Much of Buytewech's oeuvre documents and caricatures the style and behavior of his time.[7] In this context, the moral message of *Merry Company in the Open Air* is to be understood as a topical comment. The implicit criticism, mocking but distanced, is not directed at the event itself;[8] instead it is directed at the possibility of excess, the degeneration to which such activities under the influence of Bacchus and Venus may lead.

J.K.

temptations of the palate; however, the melodies have died. The instruments, which at first seem to lie randomly on the ground, are, in fact, carefully arranged as in a *vanitas* still life.[4] As images of transience, the musical instruments represent vain, fleeting pleasures; these young people, in sharp contrast to the Christian virtue of moderation, honor Bacchus and, from the look of the girl's generous décolleté, Venus. The monkey near the couple on the left symbolizes the instinctual side of human nature—seduction and unchastity. Fulfilling its role, the monkey reaches for the woman's dress, not far from where her companion's left foot has already made contact.[5] The vices of pride and lust, the real causes of evil, are represented by the peacock, which is central to the composition. Peacock pies can also be found decorating the richly laid tables at the inns where the Prodigal Son sits amidst prostitutes and drinkers, a profaned religious subject readily adopted by early Dutch genre painters, for example, in an engraving by Cornelis Jansz. Visscher, c. 1608/9, after a drawing by David Vinckboons.[6]

Buytewech was greatly inspired by Haarlem artists such as Esaias van de Velde, whose genre paintings were devoted to the *buitenpartij* (outdoor party). In *The Repast in the Park* of 1614

Merry Company, c. 1620–22
Oil on canvas, 28½ x 25¾″ (72.4 x 65.4 cm.)
Szépművészeti Múzeum, Budapest, no. 3831

1. Note, for example, the church on the right. The significance of the motif is secondary to the picturesque appearance of the building, its vine-covered tower integrated within the natural setting. The gabled front of the church, the rose window, and the tower are reminiscent of the *Monastery Church* in Buytewech's drawing in Berlin (Kupferstichkabinett, inv. no. 12529); see Haverkamp Begemann 1959, pp. 136–37, no. 105, pl. 75.

2. See Poensgen 1926a, p. 93; and Würtenberger 1937, p. 43.

3. See Renger 1970, pp. 71–88, pls. 43–44.

4. Compare Frans Hals, *Singing Boy with a Flute*, pl. 17 and note 5.

5. See R. W. Janson, *Apes and Ape Lore in the Middle Ages and the Renaissance* (London, 1952), *passim;* see also Amsterdam 1976, nos. 27 and 55, with a reference to Karel van Mander's identification of the monkey as a symbol of unchastity and shamelessness (van Mander 1603–4).

6. On Vinckboons's drawing (British Museum, London) and Visscher's engraving, see Goossens (1954a, pp. 90–94, pls. 46–47). See also Bergström 1966, especially pp. 157–59, 164.

7. In January 1617, for example, Buytewech recorded a group of curious onlookers encircling a whale stranded near Katwijk; among them are foppish types of the sort depicted in the Berlin painting. The sketch (Kupferstichkabinett, Berlin, inv. no. 768) served as a model for Buytewech's etching, also of 1617; see Haverkamp Begemann 1959, p. 105, no. 35 (sketch), and p. 178, no. VG 34 (etching).

8. In 1592, for example, Karel van Mander was sympathetic toward the *buitenpartijen* held by his fellow citizens in the woods outside Haarlem; see Amsterdam 1976, pp. 273–75, no. 72. K. van Mander's judgment is recorded in a poem of praise in honor of Haarlem, published by J. D. Rutgers van der Loeff, *Drie Lofdichten op Haarlem* (Haarlem, 1911), p. 22.

Provenance: Depret, Nice (as Dirck Hals); Gustav Hoschek von Mühlheim, Prague, cat. 1907, no. 51 (as D. Hals); acquired from dealer Goudstikker, Amsterdam, 1908.

Exhibitions: London 1929, no. 82; Rotterdam/Paris 1974–75, pp. 12–17, cat. no. 3, pl. 5.

Literature: W. Martin, *Galerie Gustave Ritter Hoschek von Mühlheim in Prag* (Prague, 1907), no. 51, ill. (as D. Hals); Z. von Takács, in *Monatshefte für Kunstwissenschaft*, vol. 1 (1908), p. 1026 (as D. Hals); Martin 1916a, pp. 198–99; Schmidt-Degener 1920; Steinboemer 1924, p. 106; Poensgen 1926b, pp. 87, 98–99 (as Buytewech, beginning of the 1620s); Knuttel 1929, pp. 196–98, pl. 8 (as c. 1622); Martin 1935–36, vol. 1, pp. 101, 103, 358, 450, fig. 59 (as c. 1617); Würtenberger 1937, pp. 55, 56, pl. 17; Bengtsson 1952, p. 28 (as c. 1616); Wilenski 1955, pl. 74 (as "The Prodigal Son"); Plietzsch 1956, pp. 184, 188; Haverkamp Begemann 1959, pp. 26–28, cat. no. 8, fig. 116 (as c. 1620–22); Judson 1959, p. 59 (as shortly before 1620); Kunstreich 1959, pp. 17, 22, 29, 68, 102, fig. 6; Bauch 1960, pp. 32, 33; E. F. van der Grinten 1962, pp. 164–65; A. Pigler, in Budapest, Szépművészeti, cat. 1968, vol. 1, pp. 110–11, no. 3831 (as c. 1620), vol. 2, pl. 247; Welu 1977a, pp. 8–11 (as c. 1617–20), fig. 5.

Three elegantly dressed men and a woman assemble around an octagonal table. The man at the right stands and leans over the table; his counterpart on the left sits and gestures with his pipe. On the table are a lighted candle, smoking materials, a brazier, food, and a glass. On the back wall is a large map inscribed HOLANDIA. Hanging on the wall to the left are wind instruments, to the right a lute and a rapier. On the ground lie two swords, a glove, an overturned glass, and a pewter pitcher. A monkey is chained to the chair back on the right.

FIG. I. WILLEM BUYTEWECH, *Merry Company*, oil on canvas, Museum Boymans–van Beuningen, Rotterdam, inv. no. 1103.

This painting is one of four pioneering interior genre paintings by Buytewech that depict companies of men and women drinking, smoking, and making music (see the other works in Rotterdam [fig. 1], The Hague, and Berlin[1]). The figures in these works are dressed in the height of fashion and behave with slightly exaggerated elegance. As Haverkamp Begemann has observed, Buytewech seems in these works to have been gently mocking his country's new *jeunesse dorée* and their sensual pastimes.[2] The monkey on the chair was a rare and costly pet known for its imitative skills; note that the animal's pose mirrors that of the man leaning over the table. It also was symbolic of sin and sensuality as well as the sense of Taste.[3] Allusions to the other four senses were perceived by Kunstreich; Sight—the lighted candle; Smell—the smoking man; Hearing—the musical instruments; and Touch—the man pressing the girl's arm.[4] The map of the provinces of Holland on the back wall, as Welu has observed, closely resembles a map engraved in 1589 by Jan Pietersz. Saenredam (1565–1607).[5] Its appearance in the midst of this scene of terrestrial pleasures and specifically in proximity to the hostess in the background was considered symbolic by both Kunstreich and de Jongh.[6] Although she no longer wears a globe on her head as did her allegorical prototype, the girl, in their view, is a descendant of Vrouw Wereld, the personification of Lady World, the embodiment of all earthly desire (see cat. no. 78). The drink, the tobacco, as well as the musical instruments could in each case be considered temptations of this world. Potentially erotic symbols also abound—the flutes, lute, sheathed dagger, and the gesture that the man at the left makes with his pipe had sexual associations.[7]

In all its richness of possible symbolic allusion, the painting nonetheless gives a highly naturalistic impression. In a large measure, this was Buytewech's contribution to the history of Dutch genre painting; he informed the allegorical tradition inherited from the sixteenth century with a new truth to life. The Prodigal Son themes and the allegories of Intemperance that were the ancestors of his merry companies were secularized and recast in everyday garb and quotidian situations. The scenes are brought close to the viewer, both literally in the sense of nearness to the picture plane, and figuratively, in the sense of familiar episodes from real experience. Yet for all their easy naturalism, Buytewech's paintings are highly composed. The geometric order and symmetry of this scene—more rigorous than that of the Rotterdam painting to which it often is compared—are evident in many details: the candle's placement at the very center of the picture, the flanking swords, chairs, and instruments, and the choice of an octagonal table. Buytewech, we might recall, was from Rotterdam just like the later painter of highly ordered interiors, Pieter de Hooch.

The costumes of the figures here, as Knuttel first observed, suggest a date of c. 1620 or somewhat later.[8] Van der Grinten thought the figures' angular gestures reflected Buytewech's use of manikins, a studio practice common then as now.[9] However, there are no certain criteria for identifying works executed with the aid of these devices; fashions of deportment or simply Buytewech's deliberately rather arch figure-drawing style could just as readily account for these qualities.

P.C.S.

1. Respectively *Merry Company*, Museum Boymans–van Beuningen, Rotterdam, inv. 1103; *Inn Scene*, Bredius Museum, The Hague, inv. no. 150–1946; *Merry Company*, Gemäldegalerie, Staatliche Museen (Bodemuseum), Berlin, inv. 1983.

2. See Haverkamp Begemann 1959, pp. 26–28; Rotterdam/Paris 1974–75, pp. 12–13.

3. See H. W. Janson, *Apes and Ape Lore in the Middle Ages and the Renaissance* (London, 1952), pp. 241, 261–66; Haverkamp Begemann 1959, p. 71.

4. Kunstreich 1959, p. 68.

5. Saenredam's original was smaller but had virtually the same decorative elements and similar coloring (Welu 1977a, p. 9, fig. 7).

6. Kunstreich 1959, p. 68; de Jongh 1973, p. 203 n. 39.

7. The phallic pitcher on the floor was also called a "pipe"; to "pipe" was slang for copulation. See de Jongh 1971, pp. 175, 178; Rotterdam/Paris 1974–75, p. 10. The man making the rude gesture evidently was popular among later artists; he is quoted in works by both Dirck Hals and Hendrick Pot, in the collections of Armand Hammer and Dr. Henry Clay Frick II, respectively (see Pittsburgh 1954, cat. nos. 18 [as Buytewech], 20). Obscene gestures with pipes are common in later Dutch genre; see, for example, Jan Steen's *Tavern Scene with Pregnant Hostess*, National Gallery, London, no. 5637.

8. Knuttel 1929, pp. 196–98.

9. Van der Grinten 1962, pp. 164–65; see also Rotterdam/Paris 1974–75, p. 10.

Amsterdam 1599–1678 Amsterdam

Young Man with a Pipe, c. 1628–30
Monogrammed at lower right on desk: CP
Oil on panel, 18⅛ x 13⅜" (46 x 34 cm.)
Musée des Beaux-Arts, Lille, inv. no. 240

Literature: Van Eynden, van der Willigen 1816–40, vol. 1, p. 133; Thijm 1874; Obreen 1877–90, vol. 7, p. 300; Havard 1879–81; vol. 3, p. 139; Bode 1883, pp. 141–53; Dozy 1884; Bredius 1888; Wurzbach 1906–11, vol. 1, pp. 309–10; E. W. Moes in Thieme, Becker 1907–50, vol. 7 (1912), p. 156; Benoit 1914; Brandt 1947; Béguin 1952; Maclaren 1960, p. 79; Plietzsch 1960, pp. 29–30; Rosenberg et al. 1966, p. 109; Playter 1972; van Eeghen 1974; Torresan 1975; Nelson forthcoming.

Pieter Codde was the fourth of nine children born to Maria Jansdr. and Jacob Pietersz. Codde, who held the minor government post of paalknecht (clerk for merchants and shippers) in Amsterdam. The artist was baptized on December 11, 1599. Owing to the loss of Amsterdam guild records, Codde's training and early artistic activities are unknown; however, he was recorded as a practicing painter at the time of his marriage in 1623. On October 27, Codde, who was living with his father in the Paalhuis on the Nieuwebrug, married eighteen-year-old Marritge Aerents, the daughter of Arent Elbertsz. Schilt, a substitute sheriff in Amsterdam. By 1630, following the deaths of his father and father-in-law, Codde was wealthy enough to buy his own house on St. Anthoniesbreestraat.

During the late 1620s and early 1630s Codde seems to have been active in literary as well as artistic circles in Amsterdam. In 1627 playwright Elias Herckmans dedicated his tragedy Tyrus to Codde, and in 1633 the artist's own poem of pastoral love was published in the Hollande Nachtegaelken.

Codde's only child, Clara, died in August 1635, and the following year he and his wife separated. A complete inventory of his possessions was drawn up on February 5, 1636.

Known primarily for his genre scenes, Codde also produced a number of history paintings and portraits. In 1637 he completed a work begun in 1633 by Frans Hals (q.v.), a full-length group portrait of Amsterdam civic guards, The Corporalship of Captain Reynier Reael and Lieutenant Cornelis Michielsz. Blaeuw, *also known as* The Meager Company *(Rijksmuseum, Amsterdam, inv. no. C374). Codde rarely dated his works after 1645; however, he continued to paint and remained active in artistic circles in Amsterdam throughout the 1650s. One document tells of his role in the delivery of a painting by Jan Miense Molenaer (q.v.) to Herman Koertens; he served a similar function in 1672, when he and nine other artists were called upon by Gerrit Uylenburgh to certify a number of Italian paintings. On October 8, 1669, Codde drew up his will. He died in October 1678 in the house at 385 Keyzersgracht, which he had bought on January 7, 1657. He was buried on October 12, 1678, in the Oude Kerk, next to his sister Elisabeth.*

C.V.B.R.

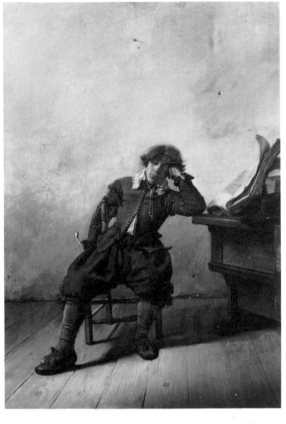

Provenance: A collection in Utrecht; bequeathed to the museum by Antoine Brasseur, 1885.

Exhibitions: Valenciennes, Musée des Beaux-Arts, *Geborgene Kunstwerke aus dem besetzten Nordfrankreich*, 1918, no. 62, ill.; Berlin, Schloss Charlottenburg, *Meisterwerke aus dem Museum in Lille*, 1964, no. 8, ill.; Paris 1965, no. 17, pl. 11; Paris 1970–71, no. 40, ill.; Amsterdam 1971, no. 16.

Literature: Wurzbach 1906–11, vol. 1, p. 310; Benoit 1909, vol. 2, no. 84, pl. 60; Martin 1925b, p. 48, fig. 2; Plietzsch 1956, p. 196, fig. 153; Bauch 1960, pp. 245–46, fig. 217; Plietzsch 1960, p. 30, fig. 20; Rosenberg et al. 1966, p. 109, fig. 79A; Régnier 1968, p. 277; A. P. de Mirimonde, "Musique et symbolisme chez Jan-Davidszoon de Heem, Cornelis Janszoon et Jan II Janszoon de Heem," *Jaarboek van het Koninklijk Museum voor Schone Kunsten*, 1970, p. 266, no. 37, fig. 19; Playter 1972, pp. 89, 92–93; Brown 1976, p. 50; Wright 1978, p. 76, ill.; Oursel 1981, no. 37, ill., p. 69.

A young man sits silhouetted against a white plaster wall, his head resting on his hand, his elbow propped on the corner of a desk. A pipe protrudes from his pocket. The desk holds large books and the young man's hat.

This painting has carried several titles, including "The Reader's Repose," "The First Pipe," "The Student," and most recently "Melancholy."[1] The boy's pose is that of personifica-

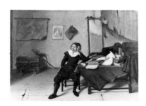

FIG. 1. JAN DAVIDSZ. DE HEEM, *Man Seated at a Table*, 1628, oil on panel, Ashmolean Museum, Oxford.

FIG. 2. Emblem from JACOB CATS, *Emblemata ofte Minnelycke, Zedelijk ende Stichtelijke Sinnebeelden* (Middelburg, 1618), p. 12.

FIG. 3. "H.R." *A Student in His Room*, engraving.

tions of Melancholia, the most famous of which is undoubtedly Dürer's engraving.[2] The painting's close resemblance to Jan Davidsz. de Heem's *Man Seated at a Table* of 1628 (fig. 1) was not noticed until 1925.[3] In the de Heem painting, the scholar's contemplative life is juxtaposed with the active life, exemplified by Christian of Braunschweig, the Protestant general whose portrait engraved by W. J. Delff (after Michiel van Mierevelt's painting at Hampton Court) hangs on the back wall.

Critics differ in their interpretation of the young man's expression. Citing an emblem from Jacob Cats showing a smoker leaning in a pose similar to that of Codde's figure and receiving a handful of pipes from a winged Amor (fig. 2), Bauch suggested that both paintings depict the theme of contentment with little: a table, a chair, and a gratifying smoke are sufficient to the abstemious life of thought.[4] Playter, however, saw the young man as "dejected [or] love sick," and Wright found him "not particularly happy."[5] In cataloging the de Heem, Brown concluded that the student and his counterpart in Codde's painting suffer from boredom and disillusion with the *vita contemplativa*. The disenchantment of Codde's young scholar, however, is scarcely as clear as that of de Heem's; his attitude and expression evoke a whole range of moods and emotions: "revery, sleep, melancholy, [the] contemplative life, creative thinking, inspiration, mourning."[6] A similarly ambivalent, slightly paradoxical view of the scholar's life is the subject of the poem appended to an engraving by "H.R." of a student in his study leaning on a desk cluttered with books, smoking materials, and drinking glasses (fig. 3): "I am a hermit and always in a bustle:/ I sit mostly still yet travel over sea and earth:/ the Dead speak to me, the lifeless provide/ Knowledge for my work, which is my constant goal./ What king is so rich! The world is my fool./ Wisdom is my good, my deficiencies are my virtues./ My chests are not full of money, my poverty is deceptive./ My life is full of pleasure, the vineyard of God is my lord."[7] In far more lyrical and memorable terms, the *Young Man with a Pipe* seems to express similar ideas.

Although Codde had begun painting single-figure compositions by 1625,[8] this picture is surely from a later period and probably postdates de Heem's work of 1628. The simplification of genre's larger merry company groups to compositions with only one or two figures can be related to the advent of the so-called tonal phase of Dutch painting in the late 1620s, which brought with it a more monochrome palette and more subtle uses of value. The silver-gray and ocher hues of this picture reflect the new style. An interesting feature that anticipates Vermeer's style and is repeated elsewhere in Codde's work is the careful attention to the bare plaster wall and the detail of trompe l'oeil nails.

P.C.S.

1. Oursel 1981, no. 37.

2. On Melancholia, see Steen's *Doctor's Visit* (cat. no. 105). Rosenberg and Slive call this painting "a kind of secularization of Dürer's *Melancholia*" (Rosenberg et al. 1966, p. 109).

3. Martin 1925b, p. 48. See J. G. van Gelder, *Catalogue of the Collection of Dutch and Flemish Still Life Pictures Bequeathed by Daisy Linda Ward* (Oxford, 1950), no. 34.

4. Bauch 1960, p. 246.

5. Playter 1972, pp. 89, 92–93; Wright 1978, p. 76.

6. Amsterdam 1971, no. 16.

7. "Een Studentin syn Kamer: Ik ben een Heremyt en altyd in't gewoel:/ Ik sit meest stil, en ga door Zee en aarde lopen:/ Die doot syn spr[e]ke my die levenloos verkoopen/ Voor arbeyd wetenschap waar op ik stadig doel./ Wat Koning is soo rijk! de werelt is mijn sot./ De wijsheyd is mijn goed, mijn seden sijn gebreken./ Mijn kisten nietvol gelt, myn armoe vol van streken./ Mijn leven vol geneugt: mijn heer de wijngaard God" (translation by Haverkamp Begemann).

8. See Codde's *Seated Woman with a Mirror*, National Gallery, London, no. 2584.

Dancing Party, 163[o or 6]
Monogrammed lower right on the book: P.C (in ligature); and dated 163[o or 6]
Oil on panel, 19⅝ x 34¼" (50 x 87 cm.)
(3 cm. added at the top)
Private Collection, Wassenaar

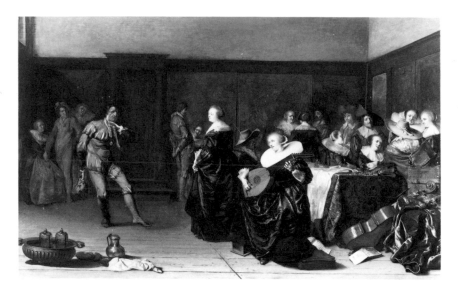

Provenance: Robert, Second Earl of Sunderland; Earl of Spencer, Althorp; dealer Hoogsteder, The Hague.

Exhibitions: Manchester 1857, no. 969 (as Cornelis van Poelenburgh);[1] London, Royal Academy, 1952–53, no. 424.

A party of nineteen merrymakers entertain themselves with music, dance, and wine. Among their number are three men in masks or costumes, one of whom performs a stalking pas de deux at the left with a young woman in a long black dress. To the right a woman in a similar dress but with a wide millstone ruff sits playing a theorbo. Behind her is a table covered with carpet and encircled by a crowd of conversing men and women. A bass viol and a velvet cloak rest on a chair at the right; music books and the case for the theorbo lie on the floor beside her. At the left is a wine cooler, pitcher, plates, and cloth; at the back a closed door.

Dancing was condemned by orthodox Calvinist preachers in Holland as a "vain, rash, unchaste" activity.[2] In 1641, Wassenburgh even claimed that doctors believed dancing was unhealthy, especially after meals when one had to avoid "all violent movements and great shakings of the body."[3] However, the church and the

medical establishment were at odds with popular culture, which embraced the pastime wholeheartedly. Dancing schools and public dance halls sprang up not only in Dutch cities but also in villages. The Spaniard Vásquez claimed that Dutch women were dance crazy.[4] Laws prohibiting dancing at weddings remained in effect in Dordrecht as late as 1681 but dancing was by this time a common pastime of all social classes.[5] Instruction in music and dance was a standard feature of an upper-class education, as Constantijn Huygens's memoirs attest.[6] Vinckboons depicted the dances both of the rich and the poor (see pls. 1, 2), Ostade painted bumptious dance fests at peasant weddings and kermisses, and, following the sixteenth-century Flemish tradition of depicting balls, Codde and his contemporaries Dirck Hals, Duyster, and Palamedesz. depicted the more restrained dances of the well-to-do.

Codde's earliest dancing painting is *The Dance Lesson* in the Louvre (no. MNR452) dated 1627; another *Dancing Party* dated 1633 is in the Akademie, Vienna (inv. no. 1096). These earlier works share with the present painting its diagonal design and focus on a single dancing couple—a long-standing formula for depicting dancing scenes. Closest in design and conception is the Mauritshuis's painting dated 1636 (fig. 1). There we again encounter maskers, the most prominent of whom dances with an elegant lady companion whose back is turned to the viewer.

The maskers in these two related paintings wear costumes reminiscent of the theatrical figures of the commedia dell'arte or the celebrants of carnival. Unlike in Italy, there were no public masquerades in seventeenth-century Holland but on holidays such as Shrove Tuesday, when the common folk celebrated with waffles and beer, the upper classes often held masked dances or put on plays.[7] Prints by Jacques de Gheyn and others represented masked entertainers and a Northern painting tradition depicted elegant merry companies with masked dancers and musicians, for example, Joos van Winghe's *Nocturnal Party* of 1588, where masked musicians gambol as a couple dances before a statue

FIG. 1. PIETER CODDE, *Festivity with Masked Dancers*, 1636, oil on panel, Mauritshuis, The Hague, no. 391.

FIG. 2. JOOS VAN WINGHE, *Nocturnal Party*, 1588, oil on panel, Musées Royaux des Beaux-Arts, Brussels, inv. no. 6736.

FIG. 3. Emblem from OTTO VAN VEEN, *Horatii Flacci Emblemata* (Antwerp, 1612).

of Venus, goddess of love (fig. 2). As Renger has observed, the maskers in these scenes often function as a moral admonition against unchaste or venal love.[8] Among its other meanings, the mask was the symbol of *venus meretrix* and mercenary love. In an emblem under the caption "Voluptatum Usurae, Morbi et Miserliae" (fig. 3) in Otto van Veen's *Horatii Flacci Emblemata*, the masked dances symbolize hidden lust and carnal desire. Quite plausibly, Renger suggested

that something of these meanings still applies to the Mauritshuis *Festivity with Masked Dancers* (fig. 1), which, having been executed nearly fifty years after the van Winghe, sought a more naturalistic appearance, exchanging the allegorical statue of Venus for a piece of everyday furniture, namely a bed.[9] One hastens to note, however, that before the third quarter of the seventeenth century, Dutch domestic architecture rarely included separate chambers for sleeping, thus beds normally appeared in the public rooms. Moreover, in the *Dancing Party* no bed appears, only a door. No more clear than the bed's meaning is whether the maskers' traditional associations with disguised lust and venal love were intended here as an admonition. Elsewhere in Codde's art, such as the *Preparations for a Carnival* (Staatliche Museen Preussischer Kulturbesitz, Berlin [West], no. 800A), the maskers seem little more than actors in a dressing room.

The last digit of the date on this work is undecipherable but may be either "0" or "6." The latter would accord well with the date on the painting in the Mauritshuis (fig. 1).

<div align="right">P.C.S.</div>

1. The attribution undoubtedly resulted from a misunderstanding of the monogram "P C" as "C P."

2. See Schotel 1903, p. 278; van Deursen, 1978b, pp. 17–19.

3. Cited by van Deursen 1978b, p. 17; see Wassenburgh, *Dans-feest der dochteren te Silo: wt den woorde Gods, de oudt-vaders, ende heydensche autheuren met sijn behoorlijcke sauce op-gedischt* (Dordrecht, 1641), p. 128.

4. Cited by van Deursen (1978b, p. 17); see J. Brouwer, *Kronieken van Spaansche soldaten uit het begin van den tachtigjarigen oorlog* (Zutphen, 1933), p. 109.

5. See Schotel 1903, p. 279.

6. *De jeugd Constantijn Huygens door hemzelf beschreven* (Rotterdam, 1971), pp. 20–23.

7. See Schotel 1903, pp. 366–67.

8. See Renger 1972, p. 190.

9. See note 8.

Merry Company, 1631
Monogrammed and dated lower left:
PC anno 1631
Oil on panel, 20½ x 33½" (52 x 85 cm.)
Private Collection, Montreal

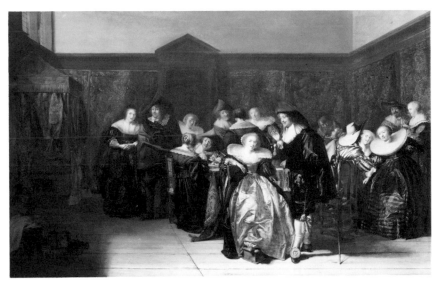

Provenance: The Earl and Countess of Swinton; sale, Christie's, London, November 28, 1975, no. 52; dealer Bruno Meissner, Zurich.

Seventeen figures—ten women and seven men —entertain themselves in a large hall. In the center foreground is a blonde woman seated comfortably with her arm over the chair back and her foot propped on a foot stove. Dressed in pink and black satin with a wide lace collar and headdress, she looks out directly at the viewer. At her side stands a man in a broad black hat with upturned brim and elaborate bows at his knees and ankles. He has removed one glove to gesture expressively with his bare hand. Visible between the couple, on the table behind them, is the head of a turkey decorating a turkey pie. Around the table and to each side men and women converse. Woodwork, including tall wainscoting and a door with framing columns and pediment, as well as green and gold tapestries decorate the walls of the room. Windows above the wainscoting on the left wall illuminate

FIG. 1. PIETER CODDE, *The Assembly,* 1632, oil on panel, The Art Institute of Chicago, no. 33.1069.

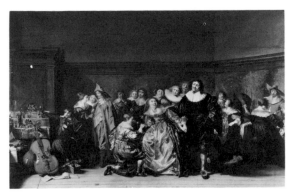

the scene. In the shadows beneath the window are a covered bed, chair, low table, and a wine cooler with bottles of wine.

One of a series of large merry company scenes that Codde evidently began around 1630, this work, dated 1631, most closely resembles *The Assembly,* dated the following year (fig. 1). In that work a similar large gathering of figures with a central couple are also arranged laterally across a horizontal interior with wainscoting.[1] Similar paneled architecture appeared earlier in Willem Buytewech's drawing of an *Interior with a Dancing Couple* (Institut Néerlandais, Paris, inv. no. 4103) and Willem Duyster's *Merry Company* in the Wellington Museum (Apsley House, London, no. WM1524–1948). Other works in this series include the *Merry Company* also dated 1631 in the City Art Gallery, Bristol (inv. no. K1644), and the *Dancing Party* of 1630 or 1636 (pl. 14). Anticipating this series by several years are the large banquet scenes that Dirck Hals executed in collaboration with Dirck van Delen (pl. 11, dated 1628). In Codde's genre scenes, however, the massive Renaissance-style architecture is replaced by more modestly proportioned surroundings, even though the effect of a rich and spacious hall is still conveyed. Codde also placed more emphasis on the figures, which now dominate the space. Recollections of early banquet scenes nonetheless linger in traditional motifs such as the wine cooler and the bird pie; the latter is no longer the traditional peacock of the Prodigal Son scenes and genre subjects (as depicted by Dirck Hals and others) but a turkey. Like tobacco and corn, the turkey had just been introduced to Europe from North America; the Spanish first imported the bird after about 1530.

The convivial company depicted here all gesture easily and expressively. We note, however, that the central man's action in removing one glove was a rhetorical gesture, frequently encountered in Dutch portraiture, expressive of candor, sincerity, and tempered informality.[2] In Codde's *Soldiers in a Guardroom* of 1628, in Dresden, an officer to one side of the room holds a cane in his bare hand while dangling from the other gloved hand the glove that he has removed

FIG. 2. PIETER CODDE,
Soldiers in a Guardroom,
1628, oil on panel,
Gemäldegalerie Alte Meister, Dresden, no. 1387.

(fig. 2). Opposite him soldiers smoke and cavort with a serving woman who sits on the lap of the gayest of their number. The officer's gesture, seemingly on the verge of dropping the glove, has been interpreted as an expression of his willingness to "dispense with propriety" and join the company across the room.[3] In the present work, by contrast, the glove is held firmly and the company unlikely to get out of hand.

Pentimenti in the work—for example, note the brim of the seated man's hat to the left of the central couple and the sword hanging from the chair to the right—document the artist's subtle adjustments of his design.

<div align="center">P.C.S.</div>

1. In all likelihood the subject of the Chicago painting (fig. 1) is a wedding party. Schotel (1903, p. 271) describes similar gatherings, during which all of the silver and gold vessels (often presents from earlier celebrations) owned by the family were brought out for display and used in a succession of elaborate toasts to the newlyweds. Often they began with the smallest cup and ended with the tallest flute. The man kneeling before the couple in the center of the scene drinks from a covered cup, called an *overdekte bokal,* of a type encountered at such occasions. (On the pride taken in such metalware, see Ingvar Bergström, "Portraits of Gilt Cups by Pieter Claesz.," *Tableau,* vol. 5, no. 6 [Summer 1983], pp. 440–45). Whether the subject of our painting, however, is also a wedding celebration is unclear.

2. See Smith 1982, pp. 72–81: "Rhetoric and Etiquette: The Iconography of the Glove."

3. Smith 1982, p. 80.

Shown in Philadelphia only

In De Groote Schouburgh, Houbraken gave an account of an Abraham Diepraam who studied with H. P. Stoop, a glass-painter, in Utrecht, with Hendrick Sorgh (q.v.) in Rotterdam and, after a trip to France, with Adriaen Brouwer (q.v.), possibly in Antwerp. The artist entered the Dordrecht Guild of St. Luke in 1648. Houbraken, who claimed to have met Diepraam in Dordrecht in 1674, goes on to say that the artist died in the Rotterdam poorhouse even though his paintings brought good prices.

Existing documents fail to support Houbraken's statements. The only Diepraam in archival records is an Arent Diepraem, the son of Hendrik Diepraem, a tailor. He was baptized in Rotterdam on January 23, 1622. Although he did study painting, his name cannot be found in the records of the Rotterdam painters' guild. He died in Rotterdam in 1670 and was buried on July 16.

Most modern historians identify the documented Arent Diepraem with the Abraham Diepraam mentioned by Houbraken; however, few believe that he could have had Brouwer as his third master since Brouwer died in 1638. The artist's extant genre works, dating from 1649 until 166(8?), are painted in the tradition of Adriaen Brouwer, Cornelis Saftleven (q.v.), and Hendrick Sorgh; all are low-life scenes of peasants smoking, carousing, or quarreling. A number of works are signed "A. Diepraem." One, formerly in the collection of Adolph Schloss in Paris, is inscribed "Abr. Diepraem."

<div align="right">C.V.B.R.</div>

Barroom, 1665
Signed and dated upper right: A Diepraem 1665
Oil on canvas, 18⅛ x 20½" (46 x 52 cm.)
Rijksmuseum, Amsterdam, no. A1574

Literature: Houbraken
1718–21, vol. 3, pp. 244–
49; Weyerman 1729–69,
vol. 3, p. 96; Nagler 1858–
79, vol. 1, p. 406;
Haverkorn van Rijsewijk
1892b, pp. 250–54;
Hofstede de Groot 1893a,
p. 64; Wurzbach 1906–11,
vol. 1, p. 406; Karl Lilien-
feld in Thieme, Becker
1907–50, vol. 9 (1913), p.
246; Heppner 1946; Holl-
stein 1949–, vol. 5, p. 244;
Maclaren 1960, p. 101.

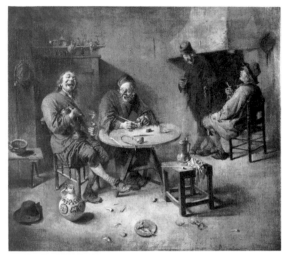

Provenance: S. F. Smith, London; purchased by the museum,
1892.

Literature: Amsterdam, Rijksmuseum, cat. 1976; Wright
1978, p. 82.

FIG. 1. ABRAHAM DIE-
PRAAM, *Peasants in the
Tavern,* 1663, sale, H.
Renner et al., Berlin,
Wertheim, April 30, 1930,
lot 30.

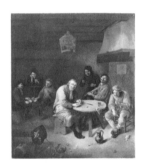

FIG. 2. ABRAHAM DIE-
PRAAM, *Hearing* (from
The Five Senses), oil on
panel, sale, Christie's, New
York, November 4, 1983,
lot 54.

Houbraken must have had works like the *Bar-
room* in mind when he wrote: "I have seen
things by [Diepraam] . . . that were so beau-
tifully painted and so witty in invention they
might have been done by Brouwer."[1] Hou-
braken's biography and the scant documen-
tary information about Diepraam indicate that
he resided in Rotterdam, and his paintings recall
peasant interiors by the Rotterdam masters Cor-
nelis Saftleven and Hendrick Sorgh. The latter,
according to Houbraken, was one of Diepraam's
teachers. It is doubtful that the artist also studied
with Adriaen Brouwer, as Houbraken believed,
but like his fellow Rotterdam low-life painters,
Diepraam admired Brouwer and his Flemish
compatriot David Teniers. In this painting his
debt to them can be discerned in his choice of
delicate blue, purple, and salmon hues against an
olive-brown ground and in the vigorously ani-
mated attitudes and facial expressions of the
protagonists.

Diepraam's earliest recorded painting dates
from 1648; the rest of his oeuvre, as far as we
know, belongs to the 1650s and 1660s.[2] A bibli-
cal scene figured in an eighteenth-century
auction and a picture of a barber-surgeon oper-
ating on a peasant has come down to us,[3] but
most of Diepraam's compositions feature lively
peasant types enjoying their leisure in shabby

and primitively furnished taverns. Some are re-
stricted to a single large figure with only the
barest hint of the setting, and others include sev-
eral characters who occupy a fully described
interior.

Diepraam made use of a limited repertory of
compositions and figure types in his tavern
scenes.[4] An upright panel dated 1663 (fig. 1)
includes some of the same furnishings and de-
tails as the *Barroom.* The card players and the
figures around the table appear to embody the
Five Senses, a conceit common in earlier seven-
teenth-century genre painting but somewhat old-
fashioned by the 1660s. Diepraam depicted the
Five Senses again in a suite of small roundels
that surfaced at a recent sale.[5] There the hurdy-
gurdy grinder who stands for Hearing (fig. 2)
has the same features and expression as the rev-
eler on the left in this composition.

If the merrymakers here do not embody the
Five Senses, they certainly exhibit the attachment
to sensual indulgence that was frequently
ridiculed in earlier tavern scenes. However,
Diepraam eschewed the overtly didactic or satir-
ical approach to the subject embraced by
Brouwer, Steen, and the young Adriaen van Os-
tade. Like Ostade in his later years, Diepraam
seems to assume a more detached attitude to-
ward the peasants' passionate pursuit of
pleasure.

W.R.

1. "Ik heb dingen van hem gezien . . . die zoo fraai
geschildert, en zoo geestig van gedagten waren, als ofze van
Brouwer geschildert waren," Houbraken 1718–21, vol. 3, p.
193 (author's translation).

2. See *Two Peasants,* dated 1648, sale, Marquis of Exeter,
Christie's, London, February 25, 1949, no. 127; K. Lilienfeld
(in Thieme, Becker 1907–50, vol. 9 [1913], p. 246), lists
dated works of 1649, 1651, and 1665.

3. A biblical picture appeared in the Rotterdam auction of Q.
van Biesum, October 18, 1719 (see Lilienfeld in note 2); the
painting of the barber-surgeon at work is in the Mecklen-
burgisches Landesmuseum, Mecklenburg, inv. no. 181.

4. Close in design are two horizontal compositions: the
Drummer with Drinkers (the date 1677 is probably a mis-
reading of 1667), sale, Princesse "X," Galerie Charpentier,
Paris, December 2, 1952, no. 68, ill.; and the *Peasants in a
Tavern,* Staatliche Kunsthalle, Karlsruhe, no. 1804. A tavern
scene that reverses the composition was sold at Christie's,
London, May 14, 1965, no. 83, ill.

5. Sale, Christie's, New York, November 4, 1983, lot 54.

Leiden 1613–1675 Leiden

Man Writing in an Artist's Studio, c. 1628–31
Signed on the book on the table behind the man:
GD . . . (GD in ligature)
Oil on panel, 12⅜ x 9⅞″ (31.5 x 25 cm.)
Private Collection, Montreal

Literature: Orlers 1641, pp. 377, 380; Angel 1642, pp. 23, 56, 57; de Bie 1661, pp. 106, 277; Félibien 1666–88, vol. 4, p. 158; de Monconys 1665–66, pp. 131, 132, 150, 153, 157; Sandrart 1675, pp. 11, 195, 320, 351; van Hoogstraten 1678, pp. 163, 257, 262, 268; Félibien 1679, p. 52; Baldinucci 1686, p. 80; de Piles 1699, pp. 428–30; Houbraken 1718–21, vol. 2, pp. 1–3; Weyerman 1729–69, vol. 2, p. 113, and vol. 4, p. 3; Levensbeschryving 1774–83, vol. 2, pp. 285–90; Smith 1829–42, vol. 1, pp. 1–47; Kolloff 1850; Kramm 1857–64, vol. 2, p. 359, and suppl., p. 46; Nagler 1858–79, vol. 1, p. 2424; Obreen 1877–90, vol. 5, pp. 26–30; Martin 1901; Martin 1902; Wurzbach 1906–11, vol. 1, pp. 416–21; Hofstede de Groot 1908–27, vol. 1, pp. 337–470; Martin 1911; Martin 1913; W. Martin in Thieme, Becker 1907–50, vol. 9 (1913), pp. 503–5; Hollstein 1949–, vol. 5, pp. 267–72; Maclaren 1960, p. 103; Plietzsch 1960, pp. 35–42; Emmens 1963a; Emmens 1963b; Rosenberg et al. 1966, pp. 86–88; Emmens 1971; Snoep-Reitsma 1973a; Amsterdam 1976, pp. 82, 93; Braunschweig 1978, pp. 64–65; Wheelock 1978; Gaskell 1982.

The son of glass-engraver Douwe Jansz. and Marytje Jansdr. van Rosenburg, Gerard Dou was born in Leiden on April 7, 1613. According to Orlers's *Beshrijvinge der Stadt Leyden*, the artist trained first with his father as a glass-engraver, then with the copper-engraver Bartholomeus Dolendo and the glass-painter Pieter Couwenhorn. He was a member of the glazier's guild from 1625 to 1627. In February 1628 Dou entered Rembrandt's studio; he probably remained with the master until Rembrandt (1606–1669) moved to Amsterdam in 1631 or 1632. In 1648 Dou became a founding member of the Leiden Guild of St. Luke.

The artist's patrons included Charles II of England, who received several of Dou's paintings from the States General on the occasion of the Restoration, as well as Queen Christina of Sweden and Archduke Leopold Wilhelm of Austria. Despite his international reputation, Dou rarely left his native city; he even refused Charles's invitation to visit London. Dou was also well respected in Holland, where his paintings fetched high prices. In 1665 Johan de Bye, a local collector, staged an exclusive exhibition in Leiden, which included twenty-seven of the artist's works. A bachelor all his life, Dou died in Leiden and was buried in the Pieterskerk on February 9, 1675.

Producing small, meticulously crafted portraits and still lifes as well as historical and genre pieces, Gerard Dou founded the school of *fijnschilders* (fine painters) in Leiden. His pupils included his nephew Dominicus van Tol (c. 1635–1676), Frans van Mieris (q.v.), Abraham de Pape (c. 1621–1666), Godfried Schalcken (q.v.), Matthijs Naiveu (q.v.), and Carel de Moor (1656–1738). Gabriel Metsu (q.v.) and Pieter van Slingelandt (1640–1691) were also influenced by his work.

C.v.B.R.

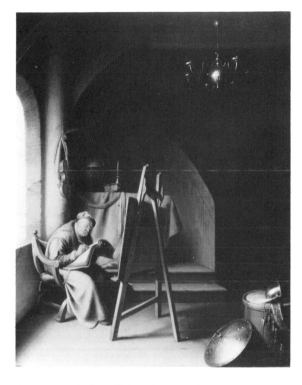

Provenance: William III, London;[1] sale, Bicker van Zwieten, The Hague, April 12, 1741, no. 65, to van Heteren (400 guilders); Adriaen Leonard van Heteren, The Hague, 1752;[2] acquired by the Rijksmuseum, Amsterdam, 1809; sale, Rijksmuseum, Amsterdam, August 4, 1828, to Brondgeest (510 guilders); dealer Emmerson, London, 1829;[3] sale, Charles Brind, London, May 10, 1849, to Lord Northbrook (96.12 pounds sterling); Lord Northbrook Collection, London, cat. 1889, no. 53; dealer Thomas Agnew, London, 1976.

Exhibitions: London, British Institution, 1848; London, Burlington Fine Arts Club, 1900, no. 27.

Literature: Hoet 1752, vol. 2, p. 454; Smith 1829–42, vol. 1, nos. 13 and 103; Waagen 1854, vol. 2, p. 183; Martin 1901, p. 190, no. 56; Hofstede de Groot 1907–28, vol. 1, no. 54; Martin 1913, p. 63, ill.; Bauch 1960, p. 218; *The Burlington Magazine*, vol. 118 (June 1976), p. 443, fig. 111; Sumowski 1983, pp. 530, 564, fig. 267.

Gerard Dou frequently repeated motifs in his early paintings. Although differences in scale immediately separate the *Man Writing in an Artist's Studio* and the *Woman Eating Porridge* (pl. 53), closer scrutiny shows that a similar casement window appears on the left in both compositions. The same window reappears in the *Interior with a Student at Work* (fig. 1) and again in the *Young Violinist* (fig. 2). Comparison of the four works reveals a similar masonry stair railing in the same position in three of the pictures; in the *Man Writing in an Artist's Studio*

FIG. I. GERARD DOU, *Interior with a Student at Work*, oil on panel, present whereabouts unknown.

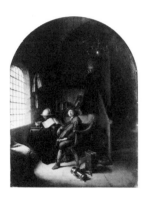

FIG. 2. GERARD DOU, *Young Violinist*, 1637, oil on panel, National Gallery of Scotland, Edinburgh (on loan from the Duke of Sutherland).

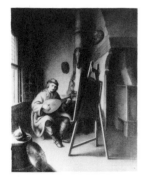

FIG. 3. Attributed to GERARD DOU, *Young Man Playing the Lute in an Artist's Studio*, oil on panel, present whereabouts unknown.

this is replaced by a wooden railing. Certain objects from these pictures—namely, the globe, books, and candlestick—reappear in other works by Dou,[4] and the drum and shield on the floor in the immediate foreground of this painting are repeated in the *Soldier with Armor* in Budapest.[5] These borrowings are highly inventive rearrangements of standard studio props. In each case Dou constructed a genre scene with its own individual style and significance. The central motif of *Young Man Playing the Lute in an Artist's Studio* (fig. 3) is a painter's easel almost identical to the one in the *Man Writing in an Artist's Studio,* but the result is a picture with a totally different effect. The change in the proportion of the figure to the interior space imparts a greater immediacy to the scene with the lute player, and the subject himself seems somewhat less pensive.

The artist often used the traditional device of opposing two different objects or events in order to establish a polarity with an implicit moral message. The viewer is thus offered a contrast— between the active and contemplative life, for instance, or between the world of the flesh and that of the spirit. The latter is likely the case with Dou's lovely *Girl Pouring Liquid from a Window* (van der Vorm Collection, Museum Boymans–van Beuningen, Rotterdam, no. 21) where the act of emptying a chamber pot is contrasted with instruction in prayer.[6] Similarly, in the presence of the young student diligently engaged in his work, the globe and the lute can be regarded as symbols of frivolity and worldly pleasure. In the same way, the drum, shield, and helmet in the foreground of the *Man Writing in an Artist's Studio* and in the related *Young Man Playing the Lute in an Artist's Studio* (fig. 3) oppose the artistic creativity of the central scene. The young man playing the lute might demonstrate the relationship between harmony in music and just proportion in art, a theoretical dictum often cited in the literature and represented in the visual arts.[7] The soldierly attributes, symbols of adventure and the active life, stand in contrast to the cerebral life of the painter, whose mind is the primary source for his product. Like the student in his study, the painter is intimately involved with matters of the intellect reaching far beyond the physical realm.[8] Whether he is underscoring a text, taking notes,

or sketching in a blank notebook (no print is now visible on the page), the man is converting his thought directly into visual symbols, also part of the intellectual process necessary to painting.[9]

O.N.

1. See Smith 1829–42, vol. 1, no. 13.

2. See Hoet 1752, vol. 2, p. 454.

3. See Smith 1829–42, vol. 1, no. 103.

4. The globe and the lute in figure 1 occupy the same positions in a still life in a private collection in Montreal (Sumowski 1983, p. 564, fig. 267). According to Hofstede de Groot (1907–28, vol. 1, p. 360), several of the props in the *Man Writing in an Artist's Studio* are repeated in Dou's *Old Man Writing*, which is known only from a print (Martin 1913, p. 62, ill.); however, this is true only of the globe and books.

5. Sumowski 1983, p. 565, fig. 268.

6. See L. Shore, ed., *Small Paintings of the Masters: Masterpieces Reproduced in Actual Size* (New York, 1980), vol. 2, no. 136.

7. See Amsterdam 1976, pp. 73–75; and Hans Joachim Raupp, "Musik im Atelier," *Oud Holland*, vol. 92, no. 2 (1978), pp. 106–29.

8. Compare the poem by Ludovicus Hondius below an Amsterdam print of 1654 (cited in J. Bruyn's review of *Ferdinand Bol* by A. Blankert, in *Oud Holland*, vol. 97, no. 3 [1983], p. 216 n. 6).

9. The black markings customarily used to indicate a text or inscription may have been removed during cleaning. (Thinly painted blacks are notoriously fugitive under the restorer's swab.) Indeed, the signature on the book behind the seated man has been partially obliterated. In Dou's *Self-Portrait* of 1647 (Gemäldegalerie Alte Meister, Dresden, no. 1704), the artist is shown with his pen resting on the surface of a printed page. According to E. Gaskell, the pen in this painting is "an attribute of personified concepts connected with intellect and study" ("Gerrit Dou, His Patrons and the Art of Painting," *Oxford Art Journal*, vol. 5, no. 1 [1982], p. 16). If the page in the *Man Writing in an Artist's Studio* is truly blank, Dou may have been drawing a reference to the concept of the *tabula rasa* (blank slate) to indicate that the painter possesses the innate ability to create an image from nothing (see Naumann 1981a, vol. 1, pp. 130–32; and E. van de Wetering, "Leidse schilders achter de ezels," in Leiden, Lakenhal, *Geschildert tot Leyden anno 1626* [Leiden, 1976–77], pp. 21–31).

Shown in Philadelphia only

Woman Eating Porridge, c. 1632–37
Signed to right of broom whisk: GDov (GD
in ligature)
Oil on panel, 20¼ x 16⅛" (51.5 x 41 cm.)
Private Collection

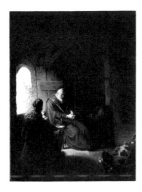

FIG. 1. GERARD DOU, *Tobit and Anna,* oil on panel, National Gallery, London, no. 4189.

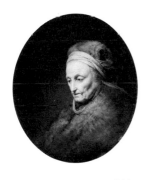

FIG. 2. GERARD DOU, *Old Woman Dressed in a Fur Coat and Hat,* oil on panel, Gemäldegalerie, Staatliche Museen Preussischer Kulturbesitz, Berlin (West), no. 847.

Provenance: Sale, Crawford of Rotterdam, Christie's, London, April 26, 1806, no. 10, to Payne Knight (as Dominicus van Toll);[1] Thomas Andrew Payne Knight, Downton Castle, Ludlow, Shropshire; by descent to Denis Lennox; sale, Christie's, London, May 4, 1979, no. 107, ill.

Exhibitions: Birmingham, Birmingham Museum and Art Gallery, *Art Treasures of the Midlands,* 1934, no. 135; London, Leger Galleries, *Fine Paintings by Old Masters,* 1948, no. 2, p. 2, ill.; Shrewsbury, Shrewsbury Art Gallery, *Pictures from Shropshire Houses,* 1951, no. 10; London 1980, no. 4, ill.; Amsterdam/Groningen 1983, no. 15, ill.

Literature: Martin 1913, p. 102, ill., and p. 184; Graves 1918–21, vol. 3, p. 292; Ivan Gaskell, "Gerrit Dou and *trompe l'oeil,*" *The Burlington Magazine,* vol. 123, no. 936 (March 1981), p. 164; Otto Naumann, "Gerard Dou and Van Tol," *The Burlington Magazine,* vol. 123, no. 943 (October 1981), pp. 617–18, fig. 42; Sumowski 1983, p. 529, under no. 264.

A recent cleaning of this painting has revealed that the woman's cloak and skirt and the tablecloth were actually painted in brilliant shades of purple and blue. This unexpected use of color reminds us that before studying with Rembrandt, Dou was enrolled in the glazier's guild of Leiden. The brilliant colors in this picture help to distinguish Dou's work from that of his master. A number of paintings, including the *Woman Eating Porridge,* have been dated from c. 1628 to 1631, the period of his apprenticeship with Rembrandt. Nevertheless, since Dou did not date any of his works until 1637, the year that appears on the *Young Violinist* (cat. no. 31, fig. 2),[2] we cannot be certain how many of these paintings actually belong to this period. The *Tobit and Anna* (fig. 1), only recently attributed to Dou,[3] possesses the profound humanity and brooding atmosphere more frequently associated with Rembrandt. It was probably executed by Dou in Rembrandt's studio before the summer of 1631.[4] The *Woman Eating Porridge* presents a striking contrast and, along with the *Man Writing in an Artist's Studio* (pl. 52) and at least two other paintings,[5] seems to fit stylistically and temporally between the *Tobit and Anna* and the *Young Violinist,* which shows characteristics of Dou's mature style. Thus the traditional dating of the exhibited painting should probably be altered from c. 1628–31 to c. 1632–37.

The old woman portrayed in this work was probably modeled directly after Rembrandt's mother, who continued to reside in Leiden after her son's departure for Amsterdam. She is certainly the model traditionally identified as Rembrandt's mother in the master's *Old Woman as the Prophetess Hannah* (Rijksmuseum, Amsterdam, no. A3066) and his

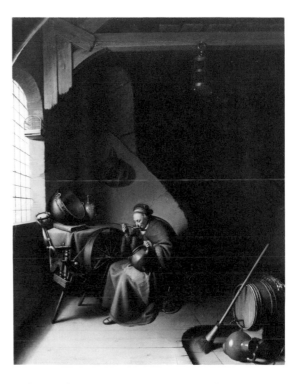

etching of the *Old Woman in Fanciful Dress,* both from 1631.[6] These works must have served as Dou's principal source for his comparable *Old Woman Dressed in a Fur Coat and Hat* (fig. 2).[7] The same model is again recognizable as the woman in Dou's *Old Woman Peeling Apples.*[8] Dou's dependence on Rembrandt in these instances is one further reason to regard the *Woman Eating Porridge* as an example of the artist's first efforts after his apprenticeship.

O.N.

1. See Graves 1918–21, vol. 3, p. 292.

2. See Martin 1913, p. 85, ill. The large picture of *An Artist in His Studio* (London 1980, under no. 2, ill.), said to be signed and dated 1635 by Dou, is actually by Adriaen van Gaesbeeck, to whom it was first attributed.

3. J. Bruyn et al., *A Corpus of Rembrandt Paintings: 1625–1631* (The Hague, 1982), vol. 1, pp. 461–66, no. C3.

4. Rembrandt was probably in Amsterdam by June 20, 1631 (see Walter L. Strauss, ed., *The Rembrandt Documents* [New York, 1979], pp. 79–80).

5. *The Dentist,* Musée du Louvre, Paris, and *Old Woman Peeling Apples,* Gemäldegalerie, Staatliche Museen Preussischer Kulturbesitz, Berlin (West), no. 2031. See Sumowski 1983, nos. 265 and 267, respectively.

6. Gerson 1968, pp. 18, 192–93 (both works ill.).

7. Gemäldegalerie, Staatliche Museen Preussischer Kulturbesitz, Berlin (West), no. 847. For other paintings of Rembrandt's mother by Dou, see Martin 1913, pp. 38–43.

8. Gemäldegalerie, Staatliche Museen Preussischer Kulturbesitz, Berlin (West), no. 2031; Sumowski 1983, no. 265, ill.

Girl Chopping Onions, 1646
Signed and dated upper left: GDOV 1646
(GD in ligature)
Oil on panel, 7¼ x 5⅞″ (18.4 x 14.9 cm.)
Her Majesty Queen Elizabeth II

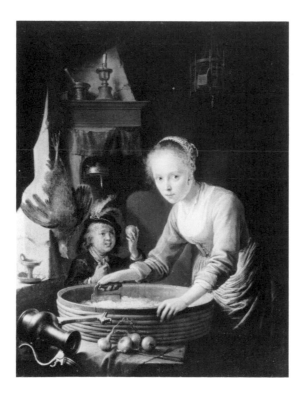

Provenance: Possibly sale, Comtesse de Verrue, Paris, April 29, 1737, no. 64 (as "une servante dans la cuisine"); sale, Gaignat, Paris, February 14, 1769, no. 29;[1] sale, Prince de Conti, Paris, April 8, 1777, no. 323, to Mercier; sale, Choiseul-Praslin, Paris, February 18, 1793, no. 93, to A. J. Paillet; sale, John Trumbull, Christie's, London, February 18, 1797, no. 66, to Bryan; sale, Coxe, Burrell, and Foster, London, May 19, 1798, no. 33; sale, J. Gildemeester, Amsterdam, June 11, 1800, no. 35; to Telting for Sir Thomas Baring (1841 inv., no. 136, as owned by Sir Francis Baring); acquired by George IV (with Baring Collection, no. 10), 1814.

Exhibitions: London, British Institution, 1826, no. 96, and 1827, no. 167; London 1946–47, no. 343.

Literature: Descamps 1753–64, vol. 2, p. 225; W. Buchanan, *Memoirs of Painting* (London, 1824), vol. 1, p. 265; Smith 1829–42, vol. 1, no. 33; Waagen 1837–38, vol. 2, p. 352; Jameson 1844, no. 30; Waagen 1854–57, vol. 2, p. 6; Martin 1901, p. 221, no. 251 (as pendant to the *Maidservant Scouring a Brass Pot*, also in Buckingham Palace [cat. 1982, no. 45]); Martin 1902, p. 110, no. 36; Hofstede de Groot 1907–28, vol. 1, no. 121; Martin 1913, p. 122, ill.; C. J. Bruyn Kops, "De Amsterdamse Verzamelaar Jan Gildemeester Jansz.," *Bulletin van het Rijksmuseum*, vol. 13 (1965), pp. 110–11; Rosenberg et al. 1966, pp. 87–88; White 1982, p. 37, no. 42, pl. 41.

Several Dou paintings depict housewives who, while preparing food, are interrupted by children. The underlying theme is innocence contrasted with experience; the child is ignorant of the amorous or sexual meanings that adults might associate with specific household items or chores.[2] A Dou kitchen scene from the same period (fig. 1) is closely related to this painting; the motifs in both contain elements from Dou's iconographic repertoire. The hanging dead bird symbolizes the sexual act; *vogelen* (to bird) also meant "to copulate."[3] The empty birdcage is associated with the loss of virtue;[4] the overturned tankard in this picture and the enormous vessel in the Montpellier painting symbolize the uterus.[5] The candle and the mortar and pestle in the present work can be regarded as phallic imagery;[6] even the vegetables being prepared in both scenes can be interpreted sexually. In a late sixteenth-century herbal, for instance, the carrot was seen as beneficial for conception: "the gardine carrot is good for them that are slow to the work of increasing the world with childer."[7] The same was true of the onion, which was considerd an aphrodisiac in the seventeenth century.[8] The little boy who holds up an onion to the busy girl seems innocent of the symbolic implication of his gesture; similarly, the happy child who proudly presents the mousetrap in the Montpellier painting is ignorant of its association (see also cat. no. 125). Dou's innocent children are a sharp contrast to Steen's knowing young men in *Gallant Offering* (Musées Royaux des Beaux-Arts, Brussels, no. 444) and *Doctor's Visit* (pl. 81) who ridicule the situation before them by

The Young Mother, c. 1660
Oil on panel, 19⅜ x 14⅜″ (49.1 x 36.5 cm.)
Gemäldegalerie, Staatliche Museen Preussischer
Kulturbesitz, Berlin (West), no. KFMV 269

FIG. I. GERARD DOU,
*Kitchen Scene (The
Mousetrap)*, 1645–50, oil
on panel, Musée Fabre,
Montpellier.

dangling two onions in one hand and a herring
in the other.[9] In *Sinne- en Minnebeelden*, Jacob
Cats provided an amorous association similar to
the imprisoned bird in a cage; he likened the
caged rodent, which pays its life for hunger, to a
lover who gives up his freedom for a kiss.[10] In a
general sense, the mousetrap and the birdcage,
whether occupied or vacant, could stand for ei-
ther the preservation or the loss of virginity.[11]

Some of the meaning of *Girl Chopping
Onions* survived in eighteenth-century France.
On his print after Dou's painting, Pierre Louis
Surugue (1716–1772) inscribed the following
caption, presumably spoken by the child: "I am
perfectly willing to believe that you are/ Knowl-
edgeable in the delectable art of preparing stews/
But I feel even more appetite for you/ Than for
the stew that you are preparing."[12]

O.N.

1 Engraved in reverse for Basan in the *Cabinet de Choiseul*
(Paris, 1771), no. 47, but not in the sales of the Choiseul
Collection: Paris, April 6, 1772, and December 10, 1787.

2. In addition to the picture in Montpellier, other Dou paint-
ings that use this concept are in Copenhagen, Breslau,
Karlsruhe, London, and Leningrad (Martin 1913, pp. 123,
125–26, 128–29, 131, ill., respectively). The iconographic
analysis offered here is influenced by the observations of
Snoep-Reitsma (1973b, p. 185), who, unfortunately, mis-
identified the object in the boy's hand as an egg.

3. See de Jongh 1968–69, pp. 23–52.

4. See de Jongh 1968–69, pp. 47–52; and Amsterdam 1976,
nos. 50, 74. The birdcage could be indicative of a bordello,
as was often the case in sixteenth-century paintings.

5. De Jongh 1968–69, p. 45; compare also cat. no. 11.

6. See de Jongh (1968–69, pp. 43–45) and White (1982,
p. 37).

7. From *The first and seconde partes of the Herbal of
William Turner Doctor in Phisick . . .* (Cologne, 1568), vol.
2, pp. 80ff., as cited in Grosjean (1974, p. 129).

8. De Jongh 1968–69, p. 45; Grosjean 1974, p. 129; Snoep-
Reitsma 1973b, p. 185; see also van Monroy 1964, p. 61.

9. See Philadelphia 1983, p. 23.

10. Cats 1700, p. 24.

11. De Jongh 1967, pp. 37–39; de Jongh 1968–69,
pp. 47–52.

12. "Je veux bien Croire que vous estes/ Scavant en L'art
friand d'apprêter les Ragouts/ Mais je me sens encor plus
d'appetit pour vous/ Que pour le Ragoût que vous faites";
see Snoep-Reitsma (1973b, p. 256 n. 48), who also illustrates
the print (p. 184, fig. 28).

Shown in London only

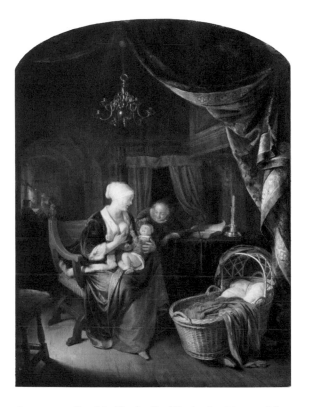

Provenance: Possibly Charles II of England, 1660; possibly
sale, Jan van Beuningen, Amsterdam, May 13, 1716, no. 58;
sale, Duc de Choiseul, Paris, 1787; Duc de Praslin, Paris,
1793; sale, de la Hante, London, 1814; the Earl of
Grosvenor (later the Earl of Westminster); the Duke of West-
minster, Grosvenor House, London, cat. 1888, no. 34;
dealer, Thomas Agnew & Sons, London; acquired for the
museum, 1974.

Exhibitions: London, Burlington Fine Arts Club, 1871, no.
37; London, Royal Academy, 1871, no. 244; London, Royal
Academy, 1895, no. 86; London, Guildhall, 1903, no. 173;
Leiden, Lakenhal, 1906, no. 12; Dublin, Municipal Gal-
lery, 1957, no. 89.

Literature: J. Young, *A Catalogue of Pictures at Grosvenor
House* (London, 1821), no. 23; Smith, 1829–42, vol. 1, p.
23, no. 70; Waagen 1854–57, vol. 2, p. 168; Martin 1901,
pp. 67, 232, no. 306; Hofstede de Groot 1907–28, vol. 1, p.
377, no. 112; Martin, 1913, p. 91; Berlin (West),
Gemäldegalerie, cat. 1975, p. 133, no. KFMV 269; Berlin
(West), Gemäldegalerie, cat. 1978, p. 139, no. KFMV 269;
Sumowski 1983, vol. 1, pp. 500, 533, no. 286, and p. 583,
ill.; Durantini 1983, pp. 7–13, fig. 3.

A young mother sits holding her child in her arm
to nurse it. The moment is enchantingly inter-
rupted by the little girl behind who distracts the
child's attention from its mother's breast with
the merry sound of a toy bell. The scene takes
place in a well-furnished bourgeois interior. A
passageway on the left reveals another room
where a doctor consults with a female patient.
His profession is identified by the urine bottle he
examines in the light from the window.

This picture is an outstanding example of Dou's fully developed style and probably dates from around 1660. The glossy surface shows no visible traces of brushwork, and each element of the painting emerges with its own distinct form and substance: not sharply defined, but subsumed in gradations of atmospheric chiaroscuro. The brass of the chandelier, which literally crowns the event, reflects the light with a warmer glow than the cool silver of the candlestick on the table. The soft velvet of the mother's jacket differs markedly from the rough weave of the tapestry curtain swept up in the Baroque manner. Joachim von Sandrart once reported that the master worked "mit Hülf der Augengläser" (with the aid of a loupe);[1] perhaps the use of a magnifying glass would explain the nearly unsurpassed detail in the rendering of the wood grain on the floorboards and the weave of the wicker cradle.

Dou developed his style from the subtle technique and chiaroscuro of the early works of Rembrandt, who was his teacher. But what for Rembrandt was only a transitional phase leading to the grand style of his broad and painterly mature manner, Dou developed singlemindedly to its utmost perfection. Dou's art had wide-ranging impact. He is considered the founder and foremost representative of the Leiden School of *fijnschilderij* (fine painting).

Dou's meticulous technique was admired by his contemporaries. In his *Beschrijvinge der Stadt Leyden*, the mayor of Leiden wrote that many were amazed at the care of the artist's execution.[2] In 1660 several of Dou's paintings were included with the valuable gifts sent officially by the State to Charles II of England. Among these were the *Young Mother* of 1658 (Mauritshuis, The Hague, no. 32) and presumably the Berlin panel as well.[3] The general esteem in which Dou was held far surpassed that of Rembrandt. This remained true in the subse-

quent classicizing period as well. Not until the second half of the nineteenth century, when Realism and Impressionism promoted a spontaneous and painterly style, was there a reaction against the "smooth manner" of Dou's paintings. In 1901 his once-famous *Woman with Dropsy* of 1663 was removed from the Salon Carré, the gallery of honor in the Louvre, Paris. This was a clear sign that Dou had been demoted from the ranks of the first-class masters.[4] Nevertheless, the artist retains his position as a major representative of Dutch genre painting.

The Berlin picture offers more than just a virtuoso command of detail. Sensitive nuances of chiaroscuro mediate the transitions and imbue colors and tonal values with an exquisite effect. The panel, its coloration based on cool harmonic reds, exudes an aura of preciousness. In the years from 1655 to 1665, Dou's refined technique had reached its fullest development and, consonant with prevailing taste, certainly equaled that of Gerard ter Borch or Johannes Vermeer. Still the artist never achieved their pictorial concentration and power of expression. Dou remained above all a painter of surfaces—in a positive sense. In the Berlin picture the rich interplay of form, color, light, and atmosphere is proffered with the loving devotion of a still-life painter, celebrated according to the principles of "fine painting." Thus the normal intimacy of mother and child is raised to a special realm revealed to the viewer's eye by the swept-up curtain—a device common in Dou's work.

The painter's preference for surface values led him consistently to themes of a circumstantial sort. As a rule, he concentrated on a few actors, most often on an individual figure engaged in simple household tasks amid still-life props. Only occasionally did Dou attempt scenes with several figures, and he avoided subjects that required psychological or dramatic interpretation. Yet his scenes of daily life nearly always reveal an ambitious allegorical program.

The Berlin painting is closely related to the central panel of a famous triptych by Dou lost in a shipwreck in 1771 but retained in an eighteenth-century copy by Willem Joseph Laquy.[5]

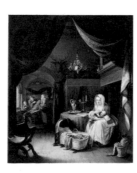

FIG. 1. WILLEM JOSEPH LAQUY after Gerard Dou, triptych, oil on canvas, Rijksmuseum, Amsterdam, no. A2320.

Astronomer by Candlelight, late 1650s
Signed lower left on book: GDov (GD in ligature)
Oil on panel, 12⅝ x 8⅜″ (32 x 21.3 cm.)
Private Collection

This three-part genre painting is governed by a complex iconographic program that refers to Aristotle's *Ethics*, according to which three things are essential to perfect a virtuous upbringing: nature, education, and practice.[6] Aristotle's "practical" philosophy, generally known since the Renaissance, was not forgotten in seventeenth-century Holland.[7] In the central image of the triptych (fig. 1) Nature is shown, according to the Aristotelian conception, in her two contradictory aspects. the active, which creates and sustains life, and the passive, which ends or destroys life. The mother, in the process of nursing her child, embodies the active principle, while the doctor and patient in the background depict the passive element. The left wing of the triptych, a school scene, illustrates proper education. The right wing, showing a man in his study cutting a quill, portrays the completion of training through repeated practice.[8] The interpretation of the central panel can readily be transferred to the Berlin painting, even though Dou has weighted the elements differently. In our version the scene of the doctor's study, indistinct in the dim light, is less prominent. More decisive compositional prominence is granted to Mother Nature, who follows the children's play with solicitous attention.

<div align="center">J.K.</div>

1. Sandrart, Peltzer 1925, p. 195.

2. Orlers 1641, p. 378.

3. Houbraken (1718–21, vol. 2, p. 5), who reports the gift, describes one of the works: "een vrouwtje met haar kintje op den schoot en een meisje dat met hetzelve speelt" (a woman with her child on her lap and a girl playing with the child). Among the extant works, the *Woman Nursing Her Child* of 1660 (Her Majesty Queen Elizabeth II) is the only other serious contender (see Martin 1913, p. 92). In the London painting, however, the girl is not playing; rather she is observing the child, whose undivided attention is given to the mother's breast. Martin left the question open as to which of the two works reached London in 1660 (1901, p. 67). Still, if Houbraken's description is precise, only the Berlin painting can be meant.

4. See Martin 1913, pp. xix, 71; on Dou's reputation compared with Rembrandt's in the seventeenth and eighteenth centuries, see Emmens 1963a, pp. 125–28.

5. See Martin 1901, pp. 155–56; and Martin 1913, pp. 98, 183 n. 93.

6. See Emmens 1963a, pp. 128–36; also see Amsterdam 1976, pp. 90–93, no. 17.

7. See Emmens 1963a, p. 130.

8. The scenes on the exterior wings were not copied by Laquy. According to Houbraken (1718–21, vol. 2, p. 5) they depicted "beeltenissen van de vrye konsten" (personifications of the liberal arts); see Emmens 1963a, p. 129.

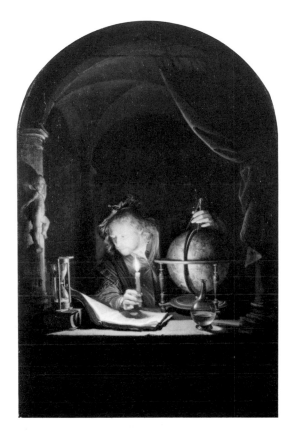

Provenance: Possibly sale, Adriaen van Hoek, Amsterdam, April 7, 1706, no. 2 (as "Astronomicus met een kars in de hand ziende in een Boek" [an astronomer with a candle in his hand looking into a book]); sale, Wilhelm Six, Amsterdam, May 12, 1734, no. 18;[1] probably Wilhelm VII von Hessen-Cassel Collection; sale, Lapeyrière, Paris, April 14, 1817; sale, Joseph Barchard, London, May 6, 1826, to John Smith; dealer John Smith, London; William Beckford, London; Hume, London, by exchange; R. H. Fitzgibbon, London, by 1839; sale, Earl of Clare, London, June 17, 1864; sale, William Delafield, London, April 30, 1870; sale, Albert Levy, London, April 6, 1876, no. 329; Barkley Field Collection, London, by 1888; Lord Astor of Hever, after 1907; sale, Sotheby's, London, July 6, 1983, no. 80, ill.

Exhibitions: London, British Institution, 1839, no. 30; London, Royal Academy, 1873, no. 76; London, Royal Academy, 1888, no. 84.

Literature: Hoet 1752, vol. 1, p. 87, no. 2, and p. 411, no. 18; Smith 1829–42, vol. 1, no. 96, and suppl., no. 15; Martin 1901, p. 190, no. 52, and p. 234, no. 314; Hofstede de Groot 1907–28, vol. 1, nos. 63c, 210.

Although Dou's small panels depicting evening or night scenes with one or two figures in an arched window influenced many Dutch artists in the late seventeenth and eighteenth centuries, they are relatively rare.[2] Since Dou's first authentic *nachtstuk* (night piece), *Boy with a Mousetrap,* was said to bear the date of 1650, the artist apparently did not begin his production of night

FIG. 1. GERARD DOU, *Woman with a Lantern at a Window*, 1658, oil on panel, last recorded in Mandel Collection, New York.

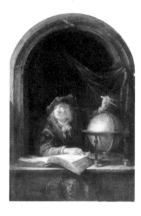

FIG. 2. GERARD DOU, *Young Astronomer*, 1657, oil on panel, Herzog Anton Ulrich-Museum, Braunschweig, no. 304.

FIG. 3. *The Astrologist*, from Johannes and Caspaares Luiken, 100 *Verbeeldingen van Ambachten* (Amsterdam, 1694), p. 88.

scenes until the midpoint of his career.[3] The first painting by Dou to combine a candlelight scene with figures in a window—generally referred to as a *nisstuk* (niche piece) or *vensternis* (window niche)[4]—is the *Girl Holding Grapes and a Candle*, formerly in Dresden and reportedly dated 1656 (with the last digit said to be uncertain). Since this painting has been missing since World War II, it is now impossible to verify the date.[5] The first solidly documented picture by Dou of this type is the *Woman with a Lantern at a Window* of 1658 (fig. 1). Similarities in execution, format, and scale suggest that the *Astronomer by Candlelight* was painted in the same period. Dou's painting of a *Young Astronomer* (fig. 2), which is dated 1657, further supports dating this work in the late 1650s.

The *Young Astronomer* may also offer a clue to our interpretation of the *Astronomer by Candlelight*. The young man impresses us by his seriousness and diligence. His upward gaze might be interpreted as a pious look heavenward. On the other hand, it might be simply a calculated observation of the constellations. These opposing interpretations could have occurred to a contemporary observer of Dou's painting. Throughout Europe and especially in seventeenth-century Holland, the science of astronomy, dignified by the work of Galileo and Kepler, was regarded with a new respect. Yet, both astronomy and astrology were still considered suspect by church officials and much of the population.[6] In the *Astronomer by Candlelight* the candle and hourglass may indicate an element of criticism; both were traditional symbols for the passage of time. The fact that other works by Dou portray scientists as old, bearded men strengthens the allusion to transitoriness and vanity.[7]

As is usual with Dou, the precise interpretation of this painting is left to the viewer. The artist has not informed us whether the man consults a celestial or a terrestrial globe; the detail in this area has intentionally been left vague. It cannot, therefore, be determined whether an astronomer or an astrologist is represented.[8] Although, like Dou, many genre painters deliberately left an element of ambiguity in their pictures, the emblem books of the day were more explicit. The image of an astrologist in a popular book of trades (fig. 3) is explained with the unequivocal caption: "To be seated so lowly

in the dust,/ And to measure the course of the sky high above,/ Seems very insignificant: But it is far more useful,/ To investigate the course of life,/ And what is going to happen at its end,/ So that one avoids Eternal Disaster."[9]

O.N.

1. See Smith 1829–42, vol. 1, no. 96.

2. According to Plietzsch, who based his research on the illustrations in Martin (1913), thirty-seven of Dou's paintings show evening light (1960, p. 40). However, probably only about half of these are rightfully attributed to Dou.

3. Plietzsch says that the first candlelight scenes by Dou appear after 1653 (1960, p. 39), but apparently overlooked the *Boy with a Mousetrap* (Martin 1913, p. 151, ill., as formerly in the W. Dahl Collection, Düsseldorf).

4. See Plietzsch 1960, pp. 38–39; and Naumann 1981a, vol. 1, p. 38 n. 16, and p. 58 n. 46. Dou's earliest-dated window-niche scene is the *Grocery Shop* of 1647 (Musée du Louvre, Paris, inv. no. 1215).

5. See Martin 1913, p. 159, ill. In the 1880 catalogue to the Gemäldegalerie Alte Meister, Dresden (p. 266, no. 1231), the date was published as 1658, but the 1905 catalogue (p. 548, no. 1706) gives the date as 165(6?). See also Hans Ebert, *Kriegsverluste der Dresdener Gemäldegalerie* (Dresden, 1963), p. 94, ill.

6. See Amsterdam 1976, pp. 83–84.

7. See the paintings in Martin (1913, pp. 69 and 148, ill.). Both works include a large open book, a globe, a compass, and an hourglass. The latter painting contains a half-filled vial, which is identical to the one on the windowsill in the *Astronomer by Candlelight*.

8. The distinction could alter the interpretation. In Adriaen Spinniker's *Leerzame Zinnebeelden* (Haarlem, 1714), the image of an astronomer symbolizes the belief that man must travel on two courses, the earthly path described by the evangelists and the heavenly path as seen in the example of Christ (see Braunschweig 1978, p. 65).

9. "De Astrologist. Daar 't meest aan is geleegen, Staat meest te overweegen/ Soo laag in 't stof te zyn geseeten,/ En 's hoogen heemels loop te meeten,/ Schyntveel: Maar 'tis van veel meer nut,/ Den loop des leevens naa te speuren,/ En wat' er Eind' ling staat te beuren,/ Op dat men 't Eeuwich Onheil schut" (author's translation).

Utrecht c. 1600–1667 Utrecht

Soldiers Arming Themselves, mid-1630s
Signed lower right on the leather strap:
JA DVCK (JA in ligature)
Oil on panel, 16⅞ x 22⅜″ (43 x 57 cm.)
H. Shickman Gallery, New York

Literature: Van Eynden, van der Willigen 1816–40, vol. 1, p. 83; Weigel 1843, pp. 24, 25; Kramm 1857–64, vol. 2, pp. 377–78, and vol. 3, p. 959, and suppl., p. 47; Nagler 1858–79, vol. 1, p. 451, and vol. 3, p. 2184; van der Willigen 1870, p. 12; Obreen 1877–90, vol. 5, pp. 155, 290; Schmidt 1879; Muller 1880, pp. 115, 120, 134, 152; Dutuit 1881–88, vol. 5, p. 47; Bode 1883, pp. 134–41; Schlie 1890; Wurzbach 1906–11, vol. 1, pp. 433–34; K. Lilienfeld in Thieme, Becker 1907–50, vol. 10 (1914), p. 40; Hollstein 1949–, vol. 6, pp. 9–11; Béguin 1952; Plietzsch 1960, pp. 32–33; Rosenberg et al. 1966, p. 109; Amsterdam 1976, pp. 94–99; Boston/Saint Louis 1980–81, pp. 133–34.

Little is known about the genre painter and etcher Jacob Duck, who was born in Utrecht around 1600. He is assumed to have been a pupil of the Utrecht artist Joost Cornelisz. Droochsloot (1586–1666), who depicted low-life and street scenes. Listed in the records of the Utrecht Guild of St. Luke of 1621, as a con-terfeyt jongen (apprentice portraitist), Duck was enrolled as a master by 1630–32, and perhaps as early as 1626. In 1629 the artist gave a paint-ing of a musical company to St. Hiob's inn in Utrecht. Since his works were among those raffled off in a lottery sponsored by the Haarlem guild in 1636, Duck had probably become a resident of Haarlem by this time. It is likely that he is the painter "Duck" who entered the Haarlem guild in 1636. On March 28, 1643, and again in 1646 he acted as a witness in Utrecht. From 1656 to 1660 he was in The Hague. He is last documented in guild records of 1660 in The Hague, where he signed as being sixty years of age.

In Utrecht, Jacob Duck continued the tradi-tion of portraying guardroom and merry company scenes popularized by Amsterdam and Delft painters, such as Willem Duyster (q.v.), Pieter Codde (q.v.), and Anthonie Palamedesz. (q.v.). Duck also painted tavern scenes and do-mestic activities. He was active from the late 1620s at least through the 1650s.

C.V.B.R.

Provenance: Dealer H. Shickman, New York, c. 1974; pri-vate collection; dealer H. Shickman, New York, 1982.

Literature: Playter 1972, p. 124.

Soldiers in a simple barnlike interior prepare to march with their fellow troops, visible in the distance through an open doorway. A man on the left attaches a rapier; his rich attire—satin sleeves, fine lace collar and cuffs, feathered hat, bows at the knees and ankles—identifies him as an officer. Standing beside him, a musketeer pulls over his head a bandolier of charges, the leather-covered wooden casings suspended by thongs from a belt. At the extreme left another bandolier hangs beside a musket, which rests on a staff with a U-shaped iron mount. A rack on the right wall supports additional muskets; in front of them, a pikeman wearing a cuirass bends down to assist a colleague with his armor. The latter kneels to tickle the nose of a slumber-ing foot soldier in tattered trousers. A second sleeper, barely visible, rests on the barrel at the right. Still-life elements—a pile of armor, straw mats, a drum, ceramic vessels, and clay pipes— are strewn about. A *repentir* appears in the open doorway; perhaps this figure with a drum once beat reveille.

Part of the attraction of *cortegardjes* (guard-room scenes) was, of course, the opportunity to paint military costumes and weaponry. Duck's depiction of the equipment worn and carried by the musketeer and the pikeman corresponds closely, allowing for some modernizing, with the depictions and accounts of such arms in Jacques de Gheyn's *Wapenhandelinghe van Roers Mus-quetten ende Spiessen* (figs. 1 and 2).[1] Scenes of soldiers mustering out, or preparing to march, were popular among the guardroom painters. The appeal of subjects showing troops called to action was related to the long periods in which Dutch soldiers sat idle.

One probable source for Duck's painting is Pieter Codde's *Guardroom* (fig. 3), where sol-diers muster in a similar barnlike space with a central doorway that offers a view of other sol-diers with bristling pikes.[2] Codde's elegantly attired officer holds a commander's baton and gestures toward the door. The date on the signed painting appears as 163[?];[3] one authority, on the basis of style, has dated it c. 1630.[4] Dates are known for two works by Duck: *Interior of a Stable,* 1628, and *Merry Company,* 1635.[5] Fig-ure types and treatment of space in the latter are

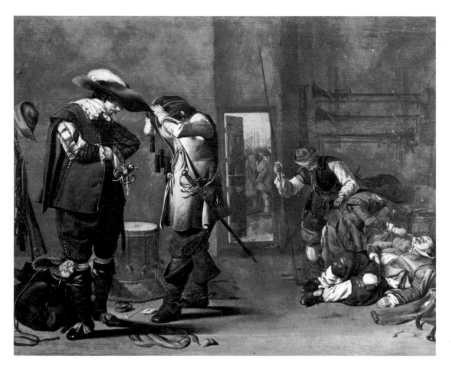

FIGS. 1, 2. Plates from
JACQUES DE GHEYN,
*Wapenhandelinghe van
Roers Musquetten ende
Spiessen* (The Hague,
1607).

closer to *Soldiers Arming Themselves*. More-
over, the costumes and the silver tonality of this
painting support a date in the mid-1630s, which
suggests that it was executed soon after Codde's
Guardroom.

Duck's early development was influenced by
Codde, whose earliest dated genre painting, the
Dancing Lesson of 1627 (Musée du Louvre,
Paris, no. MNR 452), appears in the background
of Duck's early *Merry Company* in the Musée
d'Art et d'Histoire, Nîmes. Duck may have vis-
ited or worked in Codde's studio in Amsterdam
in the 1620s.[6] In *Soldiers Arming Themselves*,
the smooth technique and the figures' quiet ab-
sorption in their tasks—concentration assured
by the artist's pentimento—also recall Willem
Duyster's art. Self-contained images, however,
were scarcely the rule with Duck, whose figures
often look out at the viewer and even invite
complicity, as in his *Raiding Party* (fig. 4).[7] That
painting also depicts sleeping soldiers, a recur-
ring element that may have been influenced by
Utrecht artists such as ter Brugghen (for exam-
ple, *Sleeping Mars*, Centraal Museum, Utrecht,
cat. 1952, no. 52). Slumbering figures, usually in
foreshortened reclining positions, were among
Duck's favorite motifs.[8] His paintings frequently

include a figure who tickles the sleeper's nose, a
detail taken up by many later genre painters,
notably ter Borch.[9]

P.C.S.

1. See the reprint of *Jacques de Gheyn: The Exercise of
Armes* (New York, 1971), with commentary by J. B. Kist.

2. Compare also Pieter Codde's *Guardroom*, sale, C. L. Car-
don, Brussels, June 27–30, 1921, no. 49, ill.

3. See Paola della Pergola, *Galleria Borghese. I Dipinti*, vol.
2 (Rome, 1959), no. 227, ill.

4. Playter 1972, p. 110.

5. Sale, Sotheby's, London, July 11, 1979, no. 47; and Do-
minion Gallery, Montreal, 1983, respectively. Information
from Otto Naumann, who is preparing an article on the
painter.

6. See Playter 1972, p. 123.

7. Also in the National Museum, Prague, is a copy of the
exhibited painting (oil on panel, 18½ x 28″ [47 x 71 cm.],
inv. DO-5225, cat. 1961, no. 44), as "Dutch c. 1640"; from
sale, Sotheby's, London, July 4, 1956, no. 106.

8. Sleeping soldiers also appear in Codde's work; see *Die
Wachtstube*, Staatliche Kunsthalle, Karlsruhe, no. 243. Genre
scenes featuring sleeping soldiers offer potential associations
with the sleeping Mars theme. An etching of a sleeping sol-
dier by Jacques de Gheyn III, for example, is inscribed "Mars
rests after crowning himself with glory; may he rest more
gloriously from now onwards for the good of the people"
(quoted by Nicolson 1958, p. 103; Hollstein 1949–, vol. 8,
s.v. "de Gheyn III," no. 22). It seems unlikely, however, that
Duck's painting of soldiers was intended as a pacifist or,
alternatively, a bellicose statement, the meanings, respec-
tively, that Nicolson (1958, pp. 102–3) and Kahr (1972, nn.
22, 23) have speculated might apply to ter Brugghen's *Sleep-
ing Mars*. See Utrecht, Centraal Museum, *Een schilderij
centraal. De Slapende Mars van Hendrick ter Brugghen*, Jan-
uary 26–March 16, 1980, by E. de Jongh.

9. See ter Borch's *Sleeping Soldier*, Taft Museum, Cincinnati,
cat. 1938, no. 128. As Gudlaugsson noted (1959–60, vol. 2,
p. 134), this popular motif also has Caravaggesque prece-
dents; see Nicolaes Reignier's *Master Tickling a Sleeping
Card Player*, c. 1625, M. H. Baderou Collection, Paris (Heim
Gallery, Paris, 1955, no. 14, ill.). See also Ochtervelt's *Sleep-
ing Soldier*, Manchester City Art Gallery, no. 1979.483
(Kuretsky 1979, no. 15, fig. 26); Martin 1913, no. 177 (as
G. Dou); and Valentiner 1929a, no. 239 (incorrectly as H.
van der Burch).

FIG. 3. PIETER CODDE,
Guardroom, 163[?], oil on
panel, Borghese Gallery,
Rome, no. 227.

FIG. 4. JACOB DUCK, *Raid-
ing Party*, oil on panel,
National Museum, Prague,
no. D-10622.

Card Players and Merrymakers, c. 1640
Oil on panel, 18⅜ x 29″ (46.7 x 73.7 cm.)
Worcester Art Museum, Worcester,
Massachusetts, Charlotte E.W. Buffington Fund,
no. 1974.337

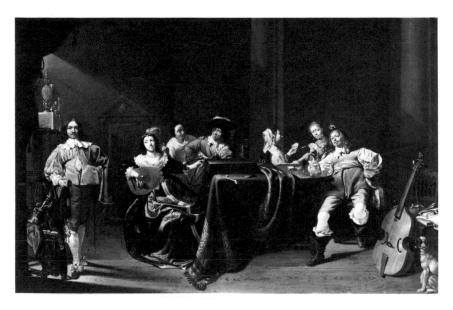

Provenance: Count Brühl, Dresden; acquired by Catherine the Great of Russia, 1769; Hermitage, Leningrad, until sold c. 1930; Curt Bohnewand, Rottach-Egern; dealer P. de Boer, Amsterdam, cat. 1947, no. 43, ill.; purchased by the museum, 1974.

Literature: Hermitage, Leningrad, cats. 1863, 1869–70, 1885, 1895, 1901, ill., 1916 (no. 936); Bode 1883, p. 139; C. Bohnewand and F. Winkler, *Aus der Sammlung Curt Bohnewand* (Munich, 1942), p. 12, fig. 27; Plietzsch 1956, p. 189, fig. 142; Plietzsch 1960, p. 32, fig. 27; Welu 1975b.

In a spacious hall of classical proportions, two men and four women assemble around a table; a third man stands at the left facing the viewer and holding a coin, while a dog sits at the extreme right. At the right end of the table a man and a woman play cards; the stakes—coins and pearls—are spread on the table before them. Between the players a second young woman, no doubt the girl's accomplice, exposes the contents of the man's hand with the aid of a small mirror. A procuress holding a coin at the other end of the table offers the favors of a woman strumming a lute to a man. Still-life elements—a draped carpet, a trictrac game, counters and a die, and a clay pipe—clutter the table and are strewn about the room. At the right a bass viol and violin rest on a chair with books, and at the left elegant glassware stands atop a sideboard.

When first catalogued at the Hermitage, the painting was entitled "A Gambling House" and ascribed to Jan le Ducq (1629/30–1676), a Dutch animal painter who has often been confused with Duck. Although unsigned, the painting is surely by the Utrecht painter Jacob Duck. The figure types are his (compare pls. 38 and 40); indeed the poses of both the man and

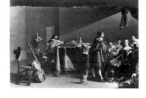

FIG. 1. JACOB DUCK, *Musical Company*, oil on panel, Kunstmuseum, Düsseldorf, inv. no. 287.

the woman at either end of the table recur in his art.[1] Also characteristic of Duck's work are the slightly skewed perspective (the floor appears higher on the right than on the left), the still-life detail, the horizontal composition employing figures assembled around a table at the right, and the shadowed column serving as a repoussoir at the left.[2] A variant, in reverse, of the composition appears in the *Musical Company* in the Kunstmuseum, Düsseldorf (fig. 1), formerly in Schloss Brackenburg.

Card playing was extremely popular in seventeenth-century Holland.[3] Not only were card players found in taverns and in the street but also among upper-class circles and at court. Bredero's farces and rhetoricians' plays refer to a great variety of card games (*roemstekken, flikken, scheepje zeilen, lanterluwen, lansknechten, bellebruiden, frans-* and *boerenjassen,* and so forth), the rules for which, in most cases, unfortunately have been forgotten. Despite or perhaps because of its popularity, the pastime was criticized by moralists as an idle and sinful pursuit. Calvinist preachers such as Petrus de Witte of Leiden and Henricus de Frein of Middelburg fulminated against its potential for seduction and ruin; the latter warned that "(*juffers*) young girls, gotten up like worldly dolls, with adorned heads, bare necks, backs and bosoms," were seduced during card play by young men who would "use the opportunity to wander in the paths of their hearts and [to catch] the glance of their eyes, to kindle foul lusts, never thinking nor believing that they will come before the [Last] Judgment." Condemning also the huge material losses that resulted from gambling at cards, de Frein maintained that the infernal diversion was invented by "the devil and Heathens."[4] Card playing between the sexes had already been depicted in some of the earliest genre paintings by Lucas van Leyden; card cheats, like those depicted here by Duck, also had been long-favored subjects of Northern genre painters, especially the Utrecht followers of Caravaggio, whose *Cardsharpers* ("I Bari") was formerly in the Palazzo Sciarra, Rome. Likewise, the procuress theme was first popularized in the Netherlands by the Utrecht Caravaggisti (see pl. 10). The costumes of the women in Duck's painting, especially that of the lutist with the headdress of pearls and

Sleeping Woman, 1650s
Signed lower center on the foot warmer: *DVCK*
Oil on panel, 9½ x 7¾" (24.1 x 19.7 cm.)
Collection of Peter Eliot

FIG. 2. Emblem from
JOHAN DE BRUNE, *Emblem-ata of zinne-werck*
(Amsterdam, 1624).

feathers, surely are intended to be seductive.[5]

Duck's painting has been related to an emblem from Johan de Brune's *Emblemata of zinne-werck* (fig. 2); the depiction of a couple playing cards by candlelight is titled *U zelven hoort, gheen ander woord* (Listen to yourself, no one else).[6] The verse explains that the man, who has longer-term goals, deliberately allows the woman to win. The emblem thus states a common moral of the day: Trust only yourself and be not deceived by others or your own pride.[7] The depiction of worldly vices—prostitution, gambling, drinking, smoking, and so forth—has been related to the well-known tradition of depicting, in the guise of a contemporary event, the parable of the Prodigal Son (Luke 15:11–32).[8] The ostentatiously clad figure holding a coin at the left may represent the Prodigal Son about to squander his property in loose living, but his detachment from the debauchery is unusual. However, figures that serve as the conduit of artists' messages often are placed at a slight remove from the scene (see cat. no. 79). There can be little doubt, moreover, that vestiges of this moralistic tradition survive in the work. The coin, therefore, underscores the painting's theme of the warning against venal temptations.

Another version or copy of this painting was recuperated in France after World War II.[9]

P.C.S.

1. Compare, respectively, *Stable with Figures*, Speed Museum, Louisville, no. 65.18, and *Le Concert en famille*, Musée des Beaux-Arts, Caen, Collection Mancel, no. 20.

2. Compare *Woman at Her Toilet*, sale, P. van Wyngaerdt et al., Amsterdam, November 7, 1893, no. 62, ill.

3. See Schotel 1905, chap. 6, "Kaartspel," pp. 91–106.

4. From *Het spelen met de kaart den Christenen ongeoorloofd* (1719), which found a large enough readership to be reprinted three times; quoted by Schotel 1905, pp. 91, 104–5 (author's translation).

5. On the negative associations of pearls (the "satanic pearl" and the pearls worn by the Whore of Babylon), see de Jongh 1975–76, pp. 83–85. An attribute of the personification of Unchastity in Cornelis Anthonisz.'s woodcut of 1546 was a feather; see Amsterdam 1976, p. 60, fig. 8a, and de Jongh's discussion of the feather as a symbol of eroticism, transience, and impurity (1971, p. 171 n. 109; Amsterdam 1976, p. 59).

6. Welu 1975b, p. 13.

7. See also de Jongh et al. in Amsterdam 1976, under cat. no. 35, for a discussion of de Brune's emblem and card playing.

8. Welu 1975b, p. 13, where he cites the precedent of Willem Dircksz. Hooft's play *Hedendaeghsche verlooren soon*, of 1630; see also Renger 1970.

9. Recuperation inv. 1954, no. MNR678; 18 x 28¾" (46 x 72 cm.).

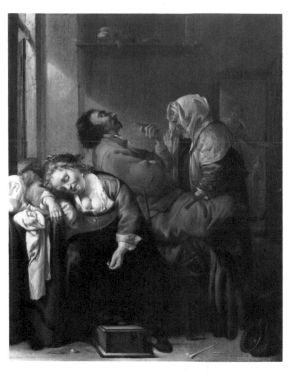

Provenance: Dealer Charles Brunner, Paris, 1920s; Mrs. von Buch, Buenos Aires; dealer Hoogsteder-Naumann, Ltd., New York, 1982.

Three figures are represented in an interior; a fourth, possibly a maidservant, enters through a door on the far side of the room. A young woman sleeps in a chair; her head is supported by her right arm, which rests on pillows placed on a table.[1] Behind her and slightly to the right, a man leans back in his chair; he sleeps despite his precarious position. Another woman tries to tickle him awake with a piece of straw, an action that carries sexual implications.[2]

The painting's erotic message must have offended some; until recently, the sleeping woman's décolletage was covered by an undergarment added by another hand, and the ambivalent position of the other woman's left arm was obscured by a layer of dark overpaint (fig. 1).[3]

The discovery of a possible pendant to the exhibited work (fig. 2) unfortunately fails to fully explain the painting's meaning.[4] The same man is represented, but he is awake and wields a tall glass of wine as a seductive barmaid slides her hand under his shirt. Her assertive sexuality, apparently stimulated by smoking and drinking, is the obvious subject. This interpretation, especially if the two were companion pieces, might clarify the theme of the exhibited painting, which could be female lust and male impotence.

FIG. 1. Overpainted state of *Sleeping Woman,* before cleaning.

FIG. 2. JACOB DUCK, *Scene from a Bawdy House,* oil on panel, present whereabouts unknown.

FIG. 3. JACOB DUCK, *Interior with a Sleeping Woman and Cavalier,* 1650s, oil on panel, Earl of Lichfield, Shugborough.

The brown tonality in this painting is delicately balanced with grays and greens, while the brilliant red of the sleeping woman's bodice enlivens the color scheme. This palette has been cited as characteristic of Duck's earlier pictures (see pls. 38 and 39).[5] However, the use of strong local color, the choice of an upright format, and the depiction of an interior limited to only a few figures are characteristics of his later works. From 1656 to 1660 Duck was active in The Hague,[6] but he probably kept abreast of painting elsewhere in Holland. The multifigured genre scenes of Codde, Kick, and Duyster gradually gave way to more elegant interiors populated by a few figures in paintings by Maes, van den Eeckhout, van Loo, and ter Borch. Duck's career, which spans this period of development, underwent a similar transformation.

In Duck's *Interior with a Sleeping Woman and Cavalier* (fig. 3), which is useful in establishing a date for our work, the man gestures lewdly with his left hand.[7] This painting, along with at least six others by the artist, displays features that are associated with later works.[8] Furthermore, the costumes worn by the protagonists are probably from the 1650s.[9] The subject, which seems to represent a bordello with a sleeping courtesan, is related to our painting.[10]

O.N.

1. Large pentimenti on the left edge of the composition indicate that the pillows were originally placed higher, where they blocked the view of the windowsill.

2. Nanette Salomon, who is preparing a dissertation on "Sleep in Dutch Art," will discuss the elusiveness of the precise meaning of this action. In a painting by Jan Verkolje, a young officer uses a feather to tickle the nose of an old hag (see Hoogsteder-Naumann Ltd., *A Selection of Dutch and Flemish Seventeenth-Century Paintings* [New York, 1981], p. 103).

3. The photograph was in the Frick Art Reference Library, New York, where the owner is indicated as Charles Brunner, a dealer in Paris.

4. Formerly in the collection of Thomas Bodkin, and lent by him to the exhibition in Birmingham 1950, p. 7, no. 14. The picture also measures 9¾ x 7¾" (24.4 x 19.7 cm.), which is very close to the dimensions of the picture exhibited here.

5. See K. Lilienfeld in Thieme, Becker 1907–50, vol. 10 (1914), p. 40.

6. Duck was active at least until 1664, the date of one of his etchings (Bode 1883, p. 135).

7. The meaning is elucidated by a similar painting in the Akademie, Vienna (inv. no. 713), where a man delivers the same gesture, but in an opening formed by the hand of a sleeping woman. The offending subject was eradicated in a copy (sale, Wasserman, Paris, November 26, 1967, no. 12, ill.), in which the man holds a long-stemmed flower. Another gesture, the thumb protruding between fingers, is found in Schalcken's *Doctor's Visit* in the Mauritshuis (see cat. no. 98, fig. 3); E. de Jongh and others (Amsterdam 1976, p. 227) have identified this obviously obscene gesture.

8. See *Woman Playing the Mandolin,* Indianapolis Museum of Art (cat. 1980, pp. 112–13 [as c. 1660–63]); *Sleeping Cavalier,* Dijon Museum, and *Sleeping Servant,* Munich (Naumann 1981a, vol. 1, figs. 112, 114, ill.); *Lady at Her Toilet* (sale, Spencer-Churchill, Christie's, London, October 29, 1965, no. 26); *Seated Woman Tempted by a Procuress* (Galerie International, The Hague); *Interior with a Lady* (sale, Sotheby's, London, February 24, 1971), ill. in *The Burlington Magazine,* vol. 113 (February 1971), p. viii.

9. The man's boot trappings are from around 1650 (compare those illustrated in Kinderen-Besier 1950, p. 138, fig. 115, inserts B [1651] and C [1648]). On the other hand, the woman's elaborate lace jacket, depicted in other paintings by Duck, seems unique to this artist. The man's collar does not appear before 1654 (see Kinderen-Besier 1950, p. 137, fig. 114, insert E [1650] and F [1654]).

10. Duck's depiction of the male intrusion into the female world may be related to Metsu (see Robinson 1974, p. 57, fig. 133).

Amsterdam? c. 1623–1678 Venice

Tale of the Soldier, 1650s
Oil on canvas, 35 x 31½" (89 x 80 cm.)
Yale University Art Gallery, New Haven,
Leonard C. Hanna, Jr., BA 1913, Fund, 1966.84

Literature: De Bie 1661, p. 377; Sandrart 1675, p. 366; Houbraken 1718–21, vol. 2, pp. 108, 273, 352, and vol. 3, pp. 56–61, 201, 218, 327; Weyerman 1729–69, vol. 2, p. 378; Bartsch 1803–21, vol. 1, p. 159; Smith 1829–42, vol. 5, no. 17, and vol. 9, pp. 638, 819; Immerzeel 1842–43, vol. 2, p. 81; Weigel 1843, p. 22; de Belloy 1844; Kramm 1857–64, vol. 3, p. 805; Nagler 1858–79, vol. 1, p. 2459, and vol. 3, p. 2230; Obreen 1877–90, vol. 1, p. 166, and vol. 4, pp. 60, 127, and vol. 5, pp. 16, 144; Dutuit 1881–88, vol. 4, p. 106, and vol. 5, p. 586; Bredius 1906; Wurzbach 1906–11, vol. 1, pp. 435–37; Hofstede de Groot 1907–28, vol. 9, pp. 295–411; E. Plietzsch in Thieme, Becker 1907–50, vol. 10 (1914), pp. 102–4; Marquery 1925; Knoef 1927; Hoogewerff 1940; Hollstein 1949–, vol. 6, pp. 27–44; Brochhagen 1957; Brochhagen 1958; Maclaren 1960, pp. 201–2; Plietzsch 1960, pp. 155–59; Brochhagen 1965; Utrecht 1965; Rosenberg et al. 1966, pp. 178–79; Stechow 1966; Steland 1967; Bartsch 1971, vol. 1, pp. 171–211; Blankert 1978a, pp. 195–97; Boston/Saint Louis 1980–81, pp. 208–9, 212–15, 218; Amsterdam/Washington 1981–82, pp. 70–71; White forthcoming.

Although the precise date and place of Karel Dujardin's birth are unknown, a document from 1672 records him as "omtrent 50 jaren" (around fifty years old). He was probably the son of the painter Guilliam (born 1597), a member of the du Gardyn family of Amsterdam's regent class. Guilliam's only signed painting, the Finding of Moses (Rijksmuseum, Amsterdam, no. A1572), is a pre-Rembrandtist composition with echoes of Pieter Lastman (1583–1633) and Jacob Pynas (1583/84–1631). Little is known of Dujardin's training; however, it was usual for the son of an artist to learn at least the rudiments of painting in his father's studio. In De Groote Schouburgh, Houbraken reported that Dujardin was a pupil of the Italianate landscape painter Nicolaes Berchem (q.v.) in Haarlem.

In the late 1640s Dujardin traveled to Rome, where he was to remain for several years. During this time he apparently joined De Schildersbent, the Netherlandish artists' society, where he was given the name "Bokkebaart" (goatsbeard). According to Houbraken, he married Susanna van Royen in Lyons on his return journey. He was back in Amsterdam by 1650, preparing to leave for Paris. He is again recorded in Amsterdam in September 1652, when he drew up a will, and city records show that he was still in residence in 1655. In the following year and in 1657 and 1658, he is listed as a member of Pictura, the newly founded painters' confraternity in The Hague. By May 1659, he had settled once again in Amsterdam. He is last mentioned there in November 1674. A landscape painting in Antwerp signed and dated "K. Dujardin Fec. Roma 1675" indicates that he was back in Italy the following year. The artist made this trip, which included a visit to North Africa, in the company of a friend, Jan Reynst. Reynst returned home after the trip, but Dujardin remained in Italy. He died in Venice on November 20, 1678.

Dujardin is best known today for Italianate landscapes, but his oeuvre is in fact remarkably varied. In addition to landscapes, the artist executed animal and genre scenes, bambocciate, history paintings (some on a monumental scale), and portraits (including a group portrait from 1669). He also made about fifty etchings.

C.B.

Provenance: Sale, J. van der March, Amsterdam, August 25, 1773, no. 497 (as "manner of Du Jardin"), to Yver (50 guilders); sale, Amsterdam, August 6, 1810, no. 51, to van Yperen (385 guilders); sale, W. Wreesman Borghartz, Amsterdam, April 11, 1816, no. 92, to Roos (280 guilders); sale, Amsterdam, August 17, 1818, no. 26, to Hulswit (176 guilders); sale, Amsterdam, November 26, 1827, no. 28, to Broudgeest (200 guilders); sale, L. Nardus et al., Amsterdam, November 27, 1917, no. 59 (1,600 guilders); dealer W. E. Duits, Amsterdam; sale, Erdman and Hethey, Amsterdam, October 15, 1918, no. 5, to Goudstikker; dealer J. Goudstikker, Amsterdam.

Literature: Hofstede de Groot 1907–28, vol. 9, no. 355; Brochhagen 1958, p. 102; *Selected Paintings and Sculptures from the Yale University Art Gallery* (New Haven, 1972), no. 22.

Two soldiers, seated amidst antique buildings, drink wine and eat bread. On the right a soldier with breastplate, helmet, red cloak, and sword looks out at the spectator and points his index finger at his eye. The soldier's companion with open shirt, bulky stockings, and bandanna uses his hands to illustrate his words. A blond-haired boy sitting beside him watches intently, and a maidservant carrying a tray of meat has stopped to listen.

The sarcophagus is a motif that appears in a number of *bambocciate* as well as in harbor and market scenes by Lingelbach and Jan Baptist Weenix. The prototype was probably the famous Roman porphyry sarcophagus, then in the Pantheon, which in the eighteenth century housed the remains of Pope Clement XII in Saint John Lateran. In this painting the motif suggests the ever-present danger of death in the soldier's calling. Below the sarcophagus is a bas-relief of

Young Woman Milking a Red Cow, 1650s
Signed and dated lower right: K. DU. IARDIN.
Fec. 165 . . . (N reversed)
Oil on canvas, 26 x 23¼″ (66 x 59 cm.)
Nationalmuseum, Stockholm, NM485

Venus and Cupid, which introduces the theme of love; the circular bas-relief on the left may depict Hercules. The three themes that are represented—bravery in the face of death, conquests of love, and heroic strength—are perhaps the subject of the soldier's boastful narrative. His partner, by raising his finger to his eye, implies that much is exaggerated and indeed invented; presumably, he has witnessed his friend in the battlefield and knows the less glamorous truth. The same gesture is made by a man looking out at the spectator in Jan Steen's *Tavern Scene with a Pregnant Hostess* (John G. Johnson Collection at the Philadelphia Museum of Art, no. 520);[1] in that context, it seems to express his ironic amusement at the hostess's condition (or perhaps his confession of responsibility). Neither the gesture of the boasting soldier nor that of his companion can be paralleled with those illustrated and explained in John Bulwer's lexicon *Chirologia* (London, 1642).

Brochhagen has dated the painting to the early 1660s, and some have doubted the picture; however, it is probably a second version of a lost original.[2]

C.B.

1. Peter Sutton first made this comparison (in Philadelphia 1983, p. 34).

2. Brochhagen (1958) discusses four versions of this composition: two paintings, a drawing, and a print. The present painting is listed as no. 17 in Smith (1829–42, vol. 5) and no. 362 in Hofstede de Groot (1907–28, vol. 9). An oil on canvas, 70 x 74 cm., formerly Kaufman's in Berlin, was said to be signed and was last recorded in a 1917 Berlin sale. A drawing in black chalk on blue paper is in Bernard Houthakker's Collection, Amsterdam. A print by Jan van Somer (Hollstein 1949–, vol. 6, no. 38) is inscribed "Kar. d. jardin pinx." According to Hofstede de Groot (1907–28, vol. 9, no. 362), the drawing and the print have the same horizontal format, whereas the Yale painting has a vertical format. Brochhagen, who had seen neither painting, records Houthakker's opinion that the Yale picture is a copy, which was sold in Amsterdam in 1773 as "manner of Du jardin" for 50 guilders. The Kaufman version (present whereabouts unknown) was sold at an Amsterdam auction in 1762 for 325 guilders and was subsequently in the Choiseul Collection. The lost painting is illustrated as no. 54 in the *Recueil d'Estampes Gravées d'après les tableaux du cabinet de Monsieur le Duc de Choiseul* (Paris, 1771), and its size is given as "28 pouces sur 26."

Provenance: Swedish Royal Collection (Queen Louise Ulrike), Drotningholm Palace, 1760 inv., no. 270; King Gustav III, 1792 inv., no. 3; Royal Collection, 1795 inv. (compiled by C. F. Fredenheim), no. 204, and 1816 inv. (compiled by O. Sundel), no. 705; in the Nationalmuseum since 1795.

Exhibition: Utrecht 1965, no. 123.

Literature: Hofstede de Groot 1908–27, vol. 9, no. 93; Stockholm, Nationalmuseum, cat. 1928, p. 88; Stockholm, Nationalmuseum, cat. 1958, pp. 64–65; Brochhagen 1958, p. 86; Blankert 1978a, pp. 29, 203 4.[1]

A young woman, seen from the back, kneels to milk a red cow. A goatherd standing on the left rests his arm on a shepherd's staff as he gazes to his right.

According to Sander, as quoted in the 1928 Stockholm Nationalmuseum catalogue, the last digit of the date, which was then illegible, had formerly been read as "7." In his dissertation on Dujardin, Brochhagen (1958) accepted 1657 as the correct date; subsequently, he suggested that the painting was executed in 1667, a decision

Haarlem 1660–1704 Haarlem

based on its relation to other compositions dominated by large figures.[2] In fact, the third digit is "5," and the painting should be placed at the end of the decade. The painting, as the preceding controversy implies, began a new phase in Dujardin's development: the move from Italianate landscapes in the style of Berchem to more monumental figure and animal groups in landscapes.[3] During this period Dujardin was influenced by the innovations of Paulus Potter.

The milkmaid's feet, with their dirty soles prominently displayed, recall a similar motif in Caravaggio's *Madonna of the Pilgrims* (S. Agostino, Rome). According to Baglione, writing in 1642, the inclusion of "a man with muddy feet" provoked "a great clamour" when the work was put in place, probably in 1604 or 1605.

<div align="center">C.B.</div>

1. Several versions of the original painting are known to exist. Brochhagen notes that the painting of the same composition in the Czernin Gallery, Vienna, is a copy; Hofstede de Groot (1908–27, vol. 9, nos. 155a and 167) lists two other copies; and Blankert (1978a) notes a copy sold in Vienna in 1964 (Dorotheum, 22.9.1964, lot 27).

2. Compare Dujardin's *Sick Goat* (Alte Pinakothek, Munich, no. 291), which Brochhagen dated c. 1664–65; according to Blankert (1978a), it was painted earlier.

3. This phase was characterized as Dujardin's "classicist" period by Brochhagen (1958).

Shown in Philadelphia and Berlin

The son of Jan Tucert (Dusart) of Utrecht and Katharina Brouwers, Cornelis Dusart was born in Haarlem on April 24, 1660. He was apprenticed to Adriaen van Ostade (q.v.) and, according to van Gool, was the most promising of the master's pupils. On January 10, 1679, the artist entered the Guild of St. Luke in Haarlem. Three years later, on March 29, 1682, he is recorded as an unmarried member of the Reformed Church in Haarlem. In 1692 he was appointed a hoofdman (leader) of the painters' guild. Little more is known of Dusart's life. He died on October 1, 1704, and was buried in Haarlem three days later. On July 31, 1708, his art collection was auctioned off in The Hague. It included a number of paintings by Adriaen van Ostade, and possibly some by Isaack van Ostade (q.q.v.), that were completed by Dusart. Apparently the artist had inherited the unfinished works at the time of his master's death in 1685.

Although Dusart is known primarily as a painter of peasant scenes, he was also a draftsman and etcher. His works frequently display an element of caricature.

<div align="right">C.v.B.R.</div>

Pipe Smoker, 1684
Signed and dated lower left: Cor. Dusart 1684
Oil on canvas, 18¾ x 15¾" (47.6 x 40 cm.)
Private Collection, U.S.A.

Literature: Van Gool 1750–51, vol. 2, p. 457; Bartsch 1803–21, vol. 5, p. 463; Nagler 1835–52, vol. 15, p. 20; Weigel 1843, p. 333; Kramm 1857–64, vol. 2, p. 383, and vol. 4, p. 1444; Nagler 1858–79, vol. 1, pp. 2437, 2472; Siret 1861; van der Willigen 1870, pp. 123–25; Dutuit 1881–88, vol. 4, p. 129; Wurzbach 1906–11, vol. 1, pp. 441–44; K. Lilienfeld in Thieme, Becker 1907–50, vol. 10 (1914), pp. 224–25; van Regteren Altena 1946; Hollstein 1949–, vol. 6, pp. 45–85; Boerner, Trautscholdt 1965; Rosenberg et al. 1966, p. 114; Trautscholdt 1966; Bartsch 1971–, vol. 7, pp. 288–325; Boston/Saint Louis 1980–81, pp. 287–89.

Provenance: Güttmann, Vienna; Sir Frederick Montefiore, London; Charles Crouch, London; Louise Carnford, London; Gebr. Douwes, Amsterdam.

FIG. 1. ADRIAEN VAN OSTADE, *Inn with Trictrac and Card Players,* 1675, watercolor, Teylers Museum, Haarlem, no. 80.

In 1750–51 Johan van Gool, an early biographer who continued Houbraken's work, wrote that Dusart "followed close on the heels of his master in everything involving the representation of peasant life."[1] Indeed, Dusart's paintings and drawings from 1679, the year he entered the Haarlem guild, to 1682 so closely resemble those of his teacher, Adriaen van Ostade, that connoisseurs still have difficulty distinguishing the works. After 1682 Dusart began to develop a more distinct personal style and sought inspiration in the paintings of Jan Steen as well as in those of Ostade. The *Pipe Smoker* of 1684 epitomizes this phase of Dusart's career. The subject of the picture, the arrangement of the group around the fire, and the handling of space recall Ostade's scenes of peasants smoking, drinking, and talking around a hearth (fig. 1).[2] Ostade's interiors, however, are broader, deeper, and richer in their portrayal of light and atmosphere. Peasants reclining in their chairs to savor a mouthful of tobacco smoke appear in Ostade's works, but it was Steen who posed his low-life characters in the extravagant attitude struck by Dusart's smoker. Though Steen provided the inspiration for the pose, Dusart probably developed the jaunty, expressive atti-

tude in one of the chalk figure studies from the model that constitute the most attractive component of his work.[3] Characteristic of Dusart's manner are the slightly caricatured expression of the smoker, the strong divisions of light and shade, and the hard coloring and execution.

During the half-century between Brouwer's *Smokers* (pl. 23) and Dusart's *Pipe Smoker,* smoking became a nearly universal custom in the Netherlands,[4] and its treatment by genre painters underwent a fundamental change. Although Dusart gives his smoker a grotesque expression, he does not satirize the tobacco habit as unequivocally as Brouwer. Indeed few images of smokers produced after 1650 exhibit the censorious and didactic fervor portrayed during the first half of the century.

W.R.

1. Van Gool 1750–51, vol. 2, p. 457 (author's translation).

2. See also, for example, Adriaen van Ostade's painting of 1674 at Ascott House, Buckinghamshire, and the watercolor (fig. 1); Schnackenburg 1981, vol. 1, p. 264, fig. 38, and no. 256.

3. See Amsterdam/Washington 1981–82, pp. 110–11, for examples of Dusart's figure studies. Two drawings of a *Smoker* by Dusart in similar but not identical attitudes are in the Museum in Aschaffenburg (see *Münchener Jahrbuch,* vol. 9 [1932], p. 82, fig. 28) and sale, Prestel, Frankfurt, November 10–16, 1920, no. 1867, ill.

4. See Brongers 1964.

Amsterdam 1598/99–1635 Amsterdam

Soldiers beside a Fireplace, c. 1628–32
Oil on panel, 16¾ x 18¼" (42.6 x 46.4 cm.)
John G. Johnson Collection at the Philadelphia
Museum of Art, no. 445

Literature: Angel 1642, p. 55; Houbraken 1718–21, vol. 2, p. 145; Kramm 1857–64, vol. 2, pp. 336, 387; Bode 1883, pp. 161–62; Bredius 1888; Wurzbach 1906–11, vol. 1, pp. 446–47; K. Lilienfeld in Thieme, Becker 1907–50, vol. 10 (1914), p. 257; Bode 1915–16; Wijnman 1935; Hollstein 1949–, vol. 6, p. 86; Maclaren 1960, p. 116; Plietzsch 1960, pp. 30–32; Rosenberg et al. 1966, pp. 108–9; Playter 1972; Amsterdam 1976, pp. 104–11.

Willem Cornelisz. Duyster was born in Amsterdam and baptized in the Oude Kerk on August 30, 1599. His father was Cornelis Dircksz., who was recorded as a textile-cutter in May 1591, when he married Mari Hendricks. By the time of his second marriage in November 1597, to Hendrickje Jeronimus (Duyster's mother), Cornelis had become a carpenter; in 1608 he was a minor official in the city government of Amsterdam. The couple's family included their own four children—Willem, Barbar, Roelof, and Styntge—as well as the two children from Cornelis's first marriage, Dirck and Elisabeth. In 1620 the family moved into a house Cornelis had bought on the north side of the Koningsstraat, an old street in the inner city. The name of the house "De Duystere Werelt" (the dark world), provided Duyster and his half-brother, Dirck, with their adopted surname. The name appears for the first time in a 1625 document concerning a quarrel between Duyster and Pieter Codde (q.v.), a fellow Amsterdam artist; the disagreement took place at Meerhuysen, a country house rented by Barent van Someren (c. 1572–1632), the painter, dealer, and innkeeper who was a patron of Adriaen Brouwer (q.v.).

Duyster's mother died around 1629, his father in 1631. On September 5 of that year, the artist married Margrieta Kick in a double wedding ceremony that also united Margrieta's brother, the Amsterdam genre painter Simon Kick (q.v.), and Duyster's youngest sister, Styntge. After their wedding both couples moved into "De Duystere Werelt." In 1633 a daughter, Anneken, was born to Willem and Margrieta; she was baptized on October 9. Less than a year and a half later, the artist died of the plague that swept the Netherlands. He was buried on January 31, 1635, in the Zuiderkerk.

Because of the loss of Amsterdam guild records, little is known about Willem Duyster's early training as an artist. It has been suggested that he studied under Pieter Codde, but this is unlikely since the artists were contemporaries. It is more probable that Barent van Someren or the portraitist and collector Cornelis van de Voort (c. 1576–1624) taught both Duyster and Codde. Duyster painted portraits as well as genre scenes, and Philips Angel's Lof der Schilderconst *(1642) praised his skill at painting silks.*

C.V.B.R.

Provenance: Probably sale, London, 1904;[1] sale, Christie's, London, 1907(?);[2] acquired by John G. Johnson, by 1913.

Literature: W. R. Valentiner, in Philadelphia, Johnson, cat. 1913, no. 445, ill.; Philadelphia, Johnson, cat. 1941, p. 26; Plietzsch 1960, p. 31; Rosenberg et al., 1966, p. 109, pl. 17b; Playter 1972; Philadelphia, Johnson, cat. 1972, p. 34, no. 445; A. Blankert, in The Hague, Bredius, cat. 1978, p. 41.

Although Duyster also depicted scenes of soldiers looting, taking hostages, and fighting among themselves over booty, the majority of his paintings depict the quieter side of military life.[3] He repeatedly represented soldiers at their ease, drinking and smoking, gaming or playing music, dancing or wooing.[4] With the *Soldiers by Candle and Firelight* (fig. 1), the Johnson Collection painting is one of the most successful of the artist's few nocturnal scenes.[5] The silhouetted figure seated before the fire at the left serves as a traditional repoussoir.[6] Initiated by this motif, the spatial recession is complemented by a second light source, the candle separating the card players to the right, at the back of the room. Just visible along the right side of the panel is the darkened edge of an open door, another device enhancing the illusion of depth. Flickering over the figures' faces, hands, and broad-brimmed hats, the light from the fire of burning peat animates the scene and, seemingly, the conversation. The quiet yet dramatic conception of the figures attests to the fact that Duyster, more than his colleagues Dirck Hals, Codde, Duck, or Kick, anticipates the psychological subtlety of ter Borch.

A replica of the Johnson painting is in the Hermitage, Leningrad (no. 3636).[7] The primacy of the Johnson version is proved by its high quality and many pentimenti, which include the figure of a third soldier who once sat at the table but who was painted out by the artist and now is visible only with infrared reflectography. Another painting that was in the Werner Dahl sale, Amsterdam, 1905, and now is in a private collection has also been considered an autograph replica but is surely a copy.[8] The Dahl copy was dated 1632 when it was exhibited in 1904 in Düsseldorf;[9] moreover, Blankert has observed that a painting by the little-known Hague painter Daniel Cletscher of *Resting Soldiers* (fig. 2) is clearly based on the left side of this composition.[10] Cletscher's death in November 1632 offers a *terminus ad quem* for the origin of Duyster's design.

FIG. 1. WILLEM DUYSTER, *Soldiers by Candle and Firelight*, oil on panel, Staatliches Museum, Schwerin, inv. no. 29.

FIG. 2. DANIEL CLETSCHER, *Resting Soldiers*, oil on panel, Bredius Museum, The Hague, inv. no. 152–1946.

Features of the composition also resemble designs employed by Dirck Hals in the late 1620s; compare, for example, the *Soldiers at Backgammon* dated 1628 (fig. 3), where the guardroom, albeit in daylight, also includes a fireplace on the left opposite an open doorway at the right.[11] Duyster scarcely required the precedent of the less innovative Dirck Hals, and similar designs had already been employed by Willem Buytewech; however, a date of c. 1628–32 for the Johnson picture seems most acceptable. None of Duyster's works bears a date; precise dating for this picture is not possible.

Given the high percentage of mercenaries in the Dutch army, the soldiers depicted here may well be foreigners. Despite distinctive features of their dress, such as the central soldier's splendid fur hat, their nationality is unknown. It may be noted, however, that when a British garrison was sent to Den Briel in 1586, the magistrate raised the soldier's lodging allowance because "being of the English nation [they] were needful of fire and light."[12] The relish the men show for their pipes also attests to the failure of Prince Maurits's campaign to prohibit smoking among his troops.

P.C.S.

1. According to the catalogue of the Werner Dahl sale, Frederick Muller & Co., Amsterdam, October 17, 1905, p. 18, no. 43, a replica ("repetition exacte") appeared in an unspecified sale in London in 1904. It could not have been the version now in the Hermitage, Leningrad, as that painting had already entered the Imperial Collection at that time.

2. According to W. R. Valentiner in Philadelphia, Johnson, cat. 1913, p. 79, no. 445.

3. Looting scenes by Duyster are in the Wernher Collection, Luton Hoo, and the William Benton Museum of Art, Storrs, Connecticut, no. 67.2; scenes of hostages in the Louvre, Paris, inv. no. 1229; scenes of fighting soldiers in the National Gallery, London, no. 1386.

4. See, as examples, Schloss Grünewald, Berlin; National Gallery, London, no. 1387; Rijksmuseum, Amsterdam, nos. A1427, C514; Wellington Museum, Apsley House, London, cat. 1982, no. 41; Royal Museum, Copenhagen, no. 194; Musée de la Chartreuse, Douai, inv. no. 1665.

5. See also *The Masquerade*, Staatliche Museen Preussischer Kulturbesitz, Berlin (West).

6. In 1603, Karel van Mander (see van Mander, Miedema 1973, part 7, stanza 34) wrote in discussing nocturnal lighting effects: "A good effect is achieved by putting in the foreground a dark figure which is in a shadow from top to toe, and by having the light but touch the outline of skin, hair or drapery" (translated by Stechow 1966b, p. 61).

7. Oil on panel, 43.5 x 45.5 cm., cat. 1958, vol. 2, p. 191, ill.; see also Plietzsch 1960.

8. See note 1, above; oil on panel, 41 x 46 cm. (examined by the author in February 1983).

9. Düsseldorf, Kunstpalast, *Internationale Kunstausstellung*, 1904, p. 129, no. 299.

10. A. Blankert, in The Hague, Bredius, cat. 1978, p. 41.

11. Compare Dirck Hals's *Smoking by a Fireplace*, sale Goudstikker, Berlin, December 3, 1940, no. 75; compare also *Guardroom*, Palais des Beaux-Arts, Lille, no. 86.

12. Quoted in van Deursen 1978b, p. 85 (author's translation).

FIG. 3. DIRCK HALS, *Soldiers at Backgammon*, 1628, oil on panel, with dealer P. de Boer, Amsterdam, 1958.

Amsterdam 1621–1674 Amsterdam

Party on a Terrace, 1652
Signed and dated lower left: G. Eeckhout.
F Ano 1652
Oil on canvas, 20¼ x 24½" (51.4 x 62.2 cm.)
Worcester Art Museum, Worcester,
Massachusetts, no. 1922.208

Literature: Houbraken 1718 21, vol. 1, p. 174, and vol. 2, pp. 100–101; Immerzeel 1842–43, vol. 1, p. 215; Blanc 1854–90, vol. 2, p. 192; Kramm 1857–64, vol. 2, pp. 414–15, and suppl., p. 49; Nagler 1858–79, vol. 2, p. 14, and vol. 4, p. 60; van den Eeckhout 1883–84; de Vries 1885–86, p. 141; Hofstede de Groot 1893a, pp. 475, 501; Rovinski 1890, vol. 2, pp. 67–68; Wurzbach 1906–11, vol. 1, pp. 481–83, and vol. 3, pp. 80, 509; R. Bangel in Thieme, Becker 1907–50, vol. 10 (1914), pp. 355–57; Staring 1948a; van der Gelder 1949; Hollstein 1949–, vol. 6, pp. 131–36; Maclaren 1960, p. 117; Plietzsch 1960, pp. 180–81; Sumowski 1962; Rosenberg et al. 1966, pp. 94–95; Roy 1972; Amsterdam/Washington 1981–82, pp. 82–83; Kettering 1983a.

Born in Amsterdam on August 19, 1621, Gerbrand van den Eeckhout was the son of Jan Pietersz., a goldsmith, and Grietie Claes Lydeckers. According to Houbraken, he studied with Rembrandt (1606–1669) and became a close friend of the master. Although the dates of his apprenticeship are not confirmed, most historians believe that he studied with Rembrandt during the second half of the 1630s. The time of van den Eeckhout's enrollment in the Amsterdam painters' guild is unknown. In 1657, through the intervention of his brother Jan, who was head of the wine-rackers' guild, van den Eeckhout received one of his most important commissions, the group portrait Four Officers of the Amsterdam Coopers' and Wine-Rackers' Guild *(National Gallery, London, no. 1459) to be painted for the guild's hall.*

The artist was also an amateur poet. Examples of his writing date from 1654, when he sent a short poem to the Amsterdam poet Jacob Heyblock, and 1657, when he composed a hymn of praise to his friend the Amsterdam landscape painter Willem Schellinks (1627–1678). He is documented as a tax appraiser of art works in 1659, 1669, and 1672. A lifelong resident of Amsterdam, van den Eeckhout died unmarried on September 22, 1674, according to Houbraken; he was buried seven days later in the Oudezijds Kapel.

Although he was an accomplished genre artist, van den Eeckhout is known primarily as a portrait and history painter. Active also as a draftsman and an etcher, he designed pattern books for gold- and silversmiths, including Jan Lutma and Paulus van Vianen.

C.V.B.R.

Provenance: Royal Dutch Collection; Captain Dingwall; P. & D. Colnaghi, London; sold by R. Langton Douglas to the museum, 1922.

Exhibitions: New York, Kleinberger Galleries, and Detroit, Detroit Institute of Arts, *Dutch Masters*, 1931–32; Worcester, Worcester Art Museum, *Rembrandt and His Circle*, February 4–March 1, 1936, p. 35, no. 24, ill.; Kansas City 1967–68, no. 4, ill.; Chicago/Minneapolis/Detroit 1969–70, no. 50, ill.

Literature: E.I.S., "The Garden Party, Gerbrand van den Eeckhout," *Worcester Art Museum Bulletin*, vol. 14, no. 3 (October 1923), pp. 70–72, ill.; *Worcester Art Museum Annual Report* (1926), p. 26, no. 3; W. R. Valentiner, "Dutch Painting in Fine Exhibit at Kleinberger's," *Art News*, vol. 30, no. 5 (October 31, 1931), pp. 6–7; G. Isarlov, "Rembrandt et son Entourage," *La Renaissance*, July–September 1936, p. 34; Worcester, Worcester Art Museum, cat. 1974, vol. 1, pp. 94–95, and vol. 2, p. 555, ill.; Sutton 1980, p. 66 n. 37.

A party of eight figures assembles on a stone terrace with a balustrade. Beyond the portico is a parklike landscape with a statue of a putto on the right and a classical-styled building on the left. In the center of the group a man sits beside a woman at the end of a table, which is covered in red velvet. A lute, songbook, candlestick, cloth, and bowl of fruit rest on the table. In the middle ground a couple leans over the balustrade, and two men and a woman converse. In the left foreground a serving boy pours wine beside a brass cooler.

Although Rembrandt's pupil Gerbrand van den Eeckhout is perhaps best remembered as a history painter and portraitist, he also played a significant though limited role in Amsterdam around mid-century as a genre painter. Together with the works of Jacob van Loo and Gerard ter Borch, van den Eeckhout's upright compositions of relatively large-scale, full-length figures in guardrooms, stables, or more often merry companies (fig. 1) provide precedents for the designs favored by genre painters in the third quarter of the century.[1] No less important was van den Eeckhout's contribution to the tradition of depicting merry companies on terraces. These works descend ultimately from sixteenth-century love gardens and scenes of the Prodigal Son or Man before the Flood or awaiting the Last Judgment as depicted by Dirck Barendsz. and others.[2] More immediate precedents, however, are found in the paintings of Willem Buytewech

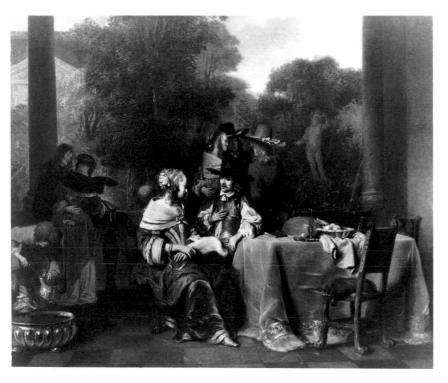

1. See also the musical company of 1653 in the Gemeentemuseum, The Hague, and that of 1655 in the Statens Museum for Kunst, Copenhagen (no. 199). Van den Eeckhout's elegant genre scenes continue until at least 1660; see the *Musical Company* dated 1660, sale, Lempertz, Cologne, November 22, 1973, no. 50, ill.

2. In the Worcester Art Museum's *Annual Report* of 1926, the painting was even titled "Garden of Love"; the painting was subtitled "Allegory" when exhibited in Chicago in 1969 (no. 50).

3. Compare also the undated *Company on a Terrace* (with dealer D. H. Cevat, Amsterdam, 1939), in Gudlaugsson 1959–60, vol. 2, pl. 15, fig. 4.

4. See Gudlaugsson 1959–60, vol. 2, p. 157; Sutton 1980, p. 33.

5. See Sutton 1980, cat. nos. 76 and 91.

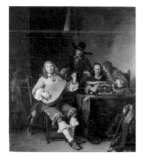

FIG. 1. GERBRAND VAN DEN EECKHOUT, *Musical Company,* oil on canvas, Dienst Verspreide Rijkskollekties, The Hague.

(see pl. 5) and Esaias van de Velde; for example, *Party on a Garden Terrace* (pl. 3) and *Party in a Garden* (pl. 4). Van den Eeckhout's treatment of the theme not only updates the fashions and the tastes in architecture, but also introduces a more naturalistic conception of elegance. The figures are viewed more closely and exhibit a greater repose. These terrace paintings may also reflect Flemish influences; van Dyck and Gonzales Coques depicted groups, in most cases family gatherings, on terraces and beneath stone porticoes.

Perhaps the work that most closely resembles this painting is the artist's *Musical Party on a Terrace* (fig. 2).[3] The importance of van den Eeckhout's works of this type for de Hooch and the Delft School has now been recognized.[4] Testifying to the close resemblance of van den Eeckhout's terrace scenes of the early 1650s to de Hooch's of the late 1660s is the fact that the *Musical Party on a Terrace* was once wrongly attributed to the Delft painter.[5]

<div style="text-align:right">P.C.S.</div>

FIG. 2. GERBRAND VAN DEN EECKHOUT, *Musical Party on a Terrace,* oil on canvas, Metropolitan Museum of Art, New York, no. 26.260.8.

Brugge 1623–before 1682 Amsterdam?

Woman Reading, late 1660s or 1670s
Oil on canvas, 29½ x 24⅜″ (75 x 62 cm.)
Bayerische Staatsgemäldesammlungen, Alte
Pinakothek, Munich, no. 284

Literature: Houbraken
1718–21, vol. 1, p. 286;
Kramm 1857–64, vol. 3, p.
793; Hofstede de Groot
1890; Hofstede de Groot
1891; Wurzbach 1906–11,
vol. 1, pp. 751–52; Bredius
1909c; Bredius 1915–22,
vol. 5, pp. 1767–72; Bre-
dius 1920; C. Hofstede de
Groot in Thieme, Becker
1907–50, vol. 18 (1925),
pp. 418–19; Brière-Misme
1947–48; Gudlaugsson
1952; Plietzsch 1960, pp.
68–70.

Pieter Janssens Elinga was the son of Gisbrecht Janssens, a painter, and Catherine van Assene. He was born in Brugge in Flanders and baptized there on August 18, 1623. Although Janssens Elinga probably received his early artistic training from his father, who died when his son was fourteen, his name does not appear in the register of the Brugge painters' guild. On August 22, 1653, an inventory of his possessions was made in Rotterdam, following the death of his first wife, Beatrix van der Mijlen. This inventory, taken by the Chamber of Orphans to protect the interests of the couple's child, indicates that the artist had financial difficulties.

According to Amsterdam archives a musician from Brugge named Pieter Janssens Elinga became a citizen of the city on March 16, 1657. Janssens apparently also worked as an artist in Amsterdam, for a 1661 inventory of the goods owned by Anthonie Pannekoeck lists a vanitas painting by him. By September 1662, the artist-actor Janssens Elinga and his second wife, Jurina Bos, were living on the Breestraat, the street where Rembrandt (1606–1669) lived between 1639 and 1658. The couple had four children: Johannes, François, Johanna, and Magtilda. The artist appears to have died some time before September 24, 1682, when Jurina is documented as a widow.

A follower of Pieter de Hooch, Janssens Elinga is known both for his genre works and his still lifes. His genre interiors depict quiet rooms with one or more female figures involved in domestic occupations.

C.v.B.R.

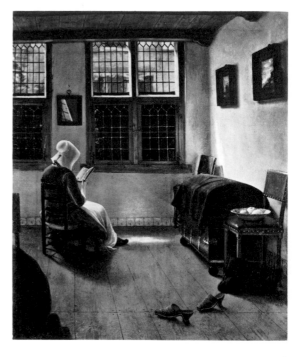

Provenance: Acquired from the dealer de Vigneux, Mannheim, 1791.

Exhibitions: Rotterdam 1935, no. 60, fig. 105; Amsterdam 1948, no. 74.

Literature: Smith 1829–42, vol. 4, p. 231, no. 40 (as Pieter de Hooch); Havard 1879–81, vol. 3, p. 113 (as Pieter de Hooch); Munich, Alte Pinakothek, cat. 1881–84, p. 4, no. 7 (as Pieter de Hooch); C. Hofstede de Groot, "Joannes Janssens," *Zeitschrift für bildende Kunst*, n.s., vol. 1 (1890), p. 134, ill.; Hofstede de Groot 1891, p. 285, no. 8; Hofstede de Groot 1892, p. 185, no. 64; Hofstede de Groot 1907–28, vol. 1, p. 570 n. 14; Bredius 1909c, p. 235; Rothes 1921, p. 47, fig. 78 (as Pieter de Hooch); C. Hofstede de Groot in Thieme, Becker 1907–50, vol. 18 (1925), p. 418; H. Wöfflin, "Über das Rechts und Links im Bilde," *Münchener Jahrbuch der bildenden Kunst*, n.s., vol. 5 (1928), p. 219, figs. 9, 10; Valentiner 1929a, pp. 30, 192, ill., and p. 289 n. 192; Brière-Misme 1947–48, pp. 347–57, fig. 2; L. C. Collins, "A Postscript: An Early Painting by Pieter Janssens Elinga," *Gazette des Beaux-Arts*, vol. 35 (1949), p. 287; Plietzsch 1960, p. 69; Stechow 1960, p. 177; Munich, Alte Pinakothek, cat. 1967, pp. 38–39, no. 284, fig. 79; Sutton 1980, p. 52, fig. 56; Munich, Alte Pinakothek, cat. 1983, pp. 262–63, no. 284, pl. 11.

In a room a woman in a red jacket and white cap sits reading. On the right, against the near wall, a pair of chairs flank a large chest covered with a cloth. A bowl of fruit is on the nearest chair, and a cushion and a pair of shoes lie on the floor before it. Two small landscape paintings in black frames hang on the right wall, and a mirror hangs between the mullioned windows at the back. The darkened form of a cloth, possibly bedding, tossed over a chair in the left foreground serves as a repoussoir. The book

FIG. 1. PIETER JANSSENS
ELINGA, *The Sweeper*, oil on
canvas, Hermitage,
Leningrad.

FIG. 2. PIETER JANSSENS
ELINGA, *A Dutch Interior
with a Girl Playing the
Guitar*, oil on canvas, Phoe-
nix Art Museum, Arizona,
no. 64 235.

(possibly a breviary or a small *volksboek*) that
the woman holds is open to a page headed
"Malo . . ." or "Male . . ." with a facing
illustration.[1]

Like most of the genre paintings by Janssens
Elinga, *Woman Reading* passed in the eighteenth
and nineteenth centuries as the work of Pieter de
Hooch. Indeed, it was considered such a charac-
teristic painting by the master that its right side
served as the model for a view painted by a
deceitful nineteenth-century restorer into the
back of an autograph work by de Hooch, now
in the Musée des Beaux-Arts, Strassburg.[2] In
1890 Hofstede de Groot attributed the picture
to Joannes Janssens;[3] in 1891 he correctly reas-
signed it to Pieter Janssens Elinga on the basis of
its resemblance to *Interior without Figures*
signed "Janssens E." then in the Brockhaus Col-
lection, Leipzig (in 1948 in a private collection,
Lugano), one of only two paintings, aside from
still lifes, signed by this painter.[4] The Brockhaus
painting and a composition entitled *The Sweeper*
(three versions: Hermitage, Leningrad [fig. 1];
the Petit Palais, Paris, inv. no. 486; and formerly
the Riksoff Collection, Paris[5]) employ some of
the same motifs, including the chest with flank-
ing chairs and, Janssens Elinga's trademark, the
reflection cast on the far wall by the chair in the
corner.[6] Like Janssens Elinga's rather exagger-
ated perspectives, this reflection is probably a
caricature of de Hooch's subtler secondary re-
flections; compare, for example, the reflection
on the wall behind the soldier on the left of de
Hooch's *Woman Drinking with Soldiers* (pl.
102). Both the painter's spaces and lighting de-
signs at times seem to betray dependence upon
artists' handbooks.[7]

Hofstede de Groot and Brière-Misme both as-
sumed that the *Woman Reading* and *The
Sweeper* were pendants;[8] Brière-Misme wrote
that the pair was like a "diptych [of] the active
life and the contemplative one, both devoted to
the cult of the home."[9] When this painting was
exhibited in 1967 in Munich the authors of the
catalogue rejected the notion that the pair had
been composed as pendants, which indeed
seems doubtful. A variant of the composition,
in which the reading woman is exchanged for a
woman playing a guitar, is in the Phoenix Art
Museum, Arizona (fig. 2).[10] Although probably
a musician himself, Elinga seems to have painted
only one other musical subject.[11] Another vari-

ant of the composition of the *Woman Reading*
depicted the same room but turned the reader to
face the viewer. This lost painting is known
through a watercolor copy, which is signed and
dated 1798, by R. M. Pruyssenaar.[12]

None of Janssens Elinga's paintings are dated;
however, the genre scenes clearly are indebted to
de Hooch's paintings from the late 1650s and
1660s. Brière-Misme dated *Woman Reading*
around 1675, but the 1967 Munich catalogue
correctly suggests it may have been executed as
early as the late 1660s.

P.C.S.

1. Peter Eikemeier has closely examined this passage and
theorizes that the woman may be reading a copy of *Ridder
Malegijs*, one of the most widely circulated *volksboeken* in
the seventeenth century (letter to Peter Sutton, August 12,
1983).

2. Sutton 1980, cat. 67, fig. 70.

3. C. Hofstede de Groot, "Joannes Janssens," *Zeitschrift für
bildende Kunst*, n.s., vol. 1 (1890), p. 134.

4. Hofstede de Groot 1891, p. 285, no. 8. The Brockhaus
painting is reproduced by Brière-Misme 1947–48, p. 164,
fig. 3; it, too, passed in the eighteenth century as a Pieter de
Hooch; see sale, Amsterdam, April 17–18, 1783, no. 123
(25 guilders). The other interior scene signed "Janssens. E." is
the *Woman with a Strand of Pearls*, Bredius Museum, The
Hague, cat. 54. For the signed still lifes, see N.R.A. Vroom,
*A Modest Message as Intimated by the Painters of the
'Monochrome Banketje'* (Schiedam, 1980), cat. nos. 399–
403.

5. See Brière-Misme 1947–48, p. 349, no. 1, fig. 1.

6. This reflection and variations of the same motifs also reap-
pear in the *Woman Reading with Maidservant Sweeping*,
Staedel Institut, Frankfurt, no. 1129; *The Letter*, sale, A.
Schloss, Paris, May 25, 1949, no. 26 (Brière-Misme 1947–
48, p. 169, fig. 7); *The Smoker*, sale, F. Muller & Co.,
Amsterdam, May 14, 1912, no. 131 (Brière-Misme 1947–
48, p. 170, fig. 8); and *The Smoker*, Museum, Lierre, cat.
1946, no. 73 (Brière-Misme 1947–48, p. 92).

7. Compare the lighting systems of the Brockhaus and Frank-
furt paintings (see notes 4 and 6, above) with recipes
prescribed by Salomon de Cas, *La Perspective avec la raison
des ombres et miroirs* (London, 1612), vol. 2, chap. 8; re-
produced in P. Descargues, *Perspective* (New York, 1977),
pp. 84–85, pl. 59.

8. See Hofstede de Groot 1891, p. 285; and Brière-Misme
1947–48, pp. 347–54.

9. Brière-Misme 1947–48, p. 354.

10. London, Agnew's, *The Seventeenth Century: Pictures by
European Masters*, 1960, no. 6. Several copies of the *Woman
Reading* are also listed in the Munich, Alte Pinakothek, cat.
1967, p. 38.

11. See *Two Musicians*, Hallwyl Collection, Stockholm;
Brière-Misme 1947–48, p. 353, fig. 3.

12. 33.5 x 29 cm., with dealer Boerner, Leipzig, cat. no. 207
(1943), no. 511 (Rijksbureau voor Kunsthistorische Docu-
mentatie, The Hague, no. 21118).

Not exhibited

Dirck Hals

Haarlem 1591–1656 Haarlem

Dirck van Delen

Heusden 1605–1671 Arnemuiden

Literature: Ampzing 1628, p. 371; Schrevelius 1648, p. 383; Kramm 1857–64, vol. 2, p. 632; Nagler 1858–79, vol. 2, p. 1124; Thoré-Bürger 1868b; van der Willigen 1870, p. 149; Bode 1883, pp. 121–26, 613; Wurzbach 1906–11, vol. 1, pp. 635–36; Coninckx 1914; Bode 1915–16; C. Hofstede de Groot in Thieme, Becker 1907–50, vol. 15 (1922), pp. 530–31; Bredius 1923–24b; Hollstein 1949–, vol. 8, p. 214; Maclaren 1960, p. 144; Plietzsch 1960, pp. 26–27; Rosenberg et al. 1966, pp. 106–7; Schatborn 1973; Braunschweig 1978, pp. 84–87; Amsterdam/Washington 1981–82, pp. 74–75.

Literature: De Bie 1661, p. 281; de Monconys 1665–66, p. 113; Houbraken 1718–21, vol. 1, p. 94, vol. 2, p. 231, and vol. 3, p. 309; Kramm 1857–64, suppl., p. 40; Nagler 1858–79, vol. 2, pp. 775, 1029; Schmidt 1874; Obreen 1877–90, vol. 6, pp. 177, 188, 191, 196, 201; Bode 1883, pp. 214–18; Wurzbach 1906–11, vol. 1, pp. 390–92; H. Jantzen in Thieme, Becker 1907–50, vol. 9 (1913), pp. 11–12; Liedtke 1970; Blade 1976; Jantzen 1979, pp. 65–72, 221–23.

The younger brother of Frans Hals (q.v.), Dirck Hals was born in Haarlem and baptized on March 19, 1591. His parents, Franchoys Hals and Adriaentgen van Geertenrijck, had emigrated from Antwerp some time between 1585 and the year of Dirck's birth. Houbraken reports that Dirck studied with his brother Frans. From 1618 to 1626 he was a member of De Wijngaertranken, the rhetoricians' chamber to which Frans also belonged. Between 1621 and 1635 Dirck and his wife, Agnietje Jans, had seven children, including the artist Antonius Hals (born 1621). Dirck is recorded in Leiden in 1641–42 and again in 1648–49, and he may also have spent the intervening years there. He died in Haarlem and was buried on May 17, 1656.

Dirck Hals was a painter and draftsman of genre scenes with small-scale figures, particularly merry companies. In his *Beschrijvinge ende lof der Stad Haerlem,* published in 1628, Samuel Ampzing praised the artist for his "neat little figures." Most of Dirck's paintings are signed and dated between 1619 and 1654.

<div align="right">C.V.B.R.</div>

According to de Bie, Dirck van Delen was born in Heusden, northeast of 's Hertogenbosch, around 1605. He may have received his early artistic training from Hendrick Aertsz. (or Arts) (active early 1600s), a painter of fantastic architectural scenes. He married Maria van der Gracht in Arnemuiden, near Middelburg, around 1625, and the couple settled there by 1626, the year their child was baptized. On May 31, 1628, van Delen became a citizen of Arnemuiden and, later, a burgomaster. He joined the Middelburg painters' guild in 1639 and remained a member until 1665. His collaboration with Dirck Hals indicates that he also had some contact with Haarlem artists.

Maria van Delen died on August 30, 1650, and the artist subsequently married Catharina de Hane, who died on December 24, 1652. On December 8, 1658, the artist married again, this time the widow of Adriaen Fransevan Dorsten of Arnemuiden, Johanna van Baelen, who died on December 16, 1668. Van Delen visited Antwerp in 1666 to collaborate with Theodore Boeyermans (1620–1678) on a large allegory commissioned by the Antwerp painters' guild. He appears to have returned to Antwerp some time between September 18, 1668, and September 18, 1669. According to a late inscription on a painted epitaph to van Delen's three wives (now in the town hall at Arnemuiden), the sixty-six-year-old artist died in Arnemuiden on May 16, 1671.

Working throughout his career in the tradition of Jan Vredeman de Vries (1527–c. 1606), Hendrick van Steenwijk the Elder (c. 1550–1603), and van Steenwijk the Younger (c. 1580–c. 1649), van Delen painted imaginary architecture, mainly interiors and courtyards of churches and palaces in the Northern Renaissance style. The staffage was frequently provided by other artists, including Dirck Hals, Pieter Codde, Anthonie Palamedesz. (q.q.v.), and Jan Olis (c. 1610–1676).

<div align="right">C.V.B.R.</div>

Banquet Scene in a Renaissance Hall, 1628
Signed and dated on wine cooler: D Hals An
1628 (not signed by van Delen)
Oil on panel, 30½ x 53¼″ (77.5 x 135 cm.)
Gemäldegalerie der Akademie der bildenden
Künste, Vienna, inv. no. 684

FIG. 1. Plate from JAN
VREDEMAN DE VRIES,
*Scenographiae sive per-
spectiva* (Antwerp, 1560),
no. 10.

Provenance: Count Anton Lamberg-Sprinzenstein, Vienna,
by 1818; passed with the count's collection to the Akademie,
1822.

Literature: Count Anton Lamberg-Sprinzenstein, listed in
handwritten inventory (Vienna, n.d.) (as Spanish School),
and transfer inventory (Vienna, 1822) (as unknown); Bode
1883, p. 123 (as Dirck Hals); Wurzbach 1906–11, vol. 1, p.
635; Martin 1916a, p. 203; C. Hofstede de Groot in
Thieme, Becker 1907–50, vol. 15 (1922), p. 530; R. Eigen-
berger, *Die Gemäldegalerie der Akademie der bildenden
Künste in Wien* (Vienna/Leipzig, 1927), p. 184, pl. 119;
Martin 1935–36, vol. 1, p. 363, fig. 209; Plietzsch 1956, pp.
191–92, fig. 144; Haverkamp Begemann 1959, p. 50 n. 264;
Plietzsch 1960, p. 20, fig. 8; Vienna, Akademie, cat. 1972,
no. 52; Rotterdam/Paris 1974–75, pl. 12 n. 9; Berlin,
Staatliche Museen (Bodemuseum), cat. 1976, vol. 1, p. 24;
Blade 1976, pp. 129–32, 138, cat. 16, fig. 127.

Twenty-seven elegantly attired people are as-
sembled in a spacious Renaissance-style interior.
An open portico on the left offers a view of a
courtyard; a central doorway in the back wall,
which is flanked by niches and Corinthian pilas-
ters, reveals part of a hearth. At the right, beside
an open door, two serving boys carry in a basket
of glasses and a meat pie decorated with a boar's
hoof. In the foreground is a wine cooler with
jugs of wine; beside it are pewter pitchers and
serving ware, a peacock pie, and a greyhound.
At the left, resting against a table, on which lie a

FIG. 2. DIRCK VAN DELEN,
*Elegant Company in a Ren-
aissance Interior,* 1628, oil
on panel, on loan to Frans
Halsmuseum, Haarlem, cat.
no. 674.

violin and what appear to be music books, are a
violoncello and a rapier; between them, a lute
lies on the marble floor. On a table at the right
are several pieces of elaborate glassware.

Although attributed by Count Lamberg-
Sprinzenstein to the Spanish School and later to
an unknown artist, the picture is clearly signed
by Dirck Hals and dated 1628. In his pioneering
work for the study of Hals's work and genre
painting generally, Bode correctly characterized
the painting as one of Dirck Hals's largest and
best works.[1] T. von Frimmel proposed that the
painting was a collaborative effort between
Hals, who painted the figures, and the Mid-
delburg artist Dirck van Delen, who painted the
architecture.[2] Van Delen and The Hague painter
Bartholomeus van Bassen were late Dutch fol-
lowers of the sixteenth-century Flemish
architectural painter Jan Vredeman de Vries.[3]
Their imaginary church interiors, palaces, and
courtyards descend from Vredeman de Vries's
perspective models. The same is true of their sec-
ular interiors, which usually depict a deep,
boxlike space showing all walls as well as the
floor and ceiling of the room. The pronounced
orthogonals and a central vanishing point of
these works betray their ancestry in perspective
recipes (fig. 1).[4] Van Delen painted this type of
interior until around 1635, when he began ex-
ecuting more intimately scaled secular spaces,
depicting only the corner of the room, albeit still
with *retardataire* Renaissance appointments.
Such works constitute transitional steps toward
later Delft School genre spaces.[5]

The claim that van Delen painted any of Dirck
Hals's spaces has been disputed;[6] however, the
closely related *Elegant Company in a Renais-
sance Interior* (fig. 2), also dated 1628, is signed
by van Delen.[7] Individual figure motifs in this
work reappear in drawings and paintings by
Dirck Hals.[8] Two other secular interiors, in the
Dublin museum and Sir Cecil Newman's Collec-
tion, are signed and dated 1629 by van Delen,
but they include figures that have been correctly
attributed to Dirck Hals.[9] The old assumption
that van Delen studied with Frans Hals in

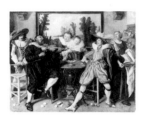

FIG. 3. WILLEM BUYTEWECH, *Merry Company*, c. 1622, oil on canvas, Staatliche Museen (Bodemuseum), Berlin, inv. no. 1983.

Haarlem has been recognized as a misreading of Cornelis de Bie's early account of his life; however, van Delen must have had some contact with Dirck in the late 1620s.[10] Other artists who collaborated with van Delen are Jan Olis, Anthonie Palamedesz., and the Flemish artist Theodore Boeyermans.[11]

Though not an uninventive artist, Dirck Hals frequently quoted or paraphrased compositions and figure motifs from the genre paintings of his older brother Frans and Willem Buytewech. For example, the animated man (with raised hand) in the center of this painting is borrowed from Buytewech's *Merry Company* (fig. 3).[12] The stout, bearded man slightly to the left of the animated man also is found in this and other works by Buytewech.[13]

Vestiges of the tradition of depicting the Prodigal Son appear in details of the scene, such as that of the peacock pie, which symbolized *superbia*, pride, and voluptuousness.[14] A peacock pie figures in the illustration—a merry company with the Prodigal Son at the center raising his glass—on the title page of W. D. Hooft's play *Heden-daeghsche verlooren soon* (The modern-day Prodigal Son), which was published in Amsterdam in 1630.[15] Though clearly descended from these images, the present work and Dirck Hals's other related merry companies seem more a celebration of conviviality and an imaginary ideal of leisure than a secular interpretation of the Prodigal Son.[16]

P.C.S.

1. Bode 1883, p. 123.

2. Von Frimmel 1899, vol. 1, pt. 4, p. 169. On van Delen, see Jantzen 1910, pp. 65–71, and Blade 1976.

3. On Vredeman de Vries, see Jantzen 1910; Schneede 1965; Schneede, "Interieurs von Hans und Paul Vredeman," *Nederlands Kunsthistorisch Jaarboek*, vol. 18 (1967), pp. 125–68; H. Mielke, "Hans Vredeman de Vries" (Diss., Freie Universität, Berlin, 1967).

4. See also as an example of van Bassen's use of these designs, *Company in an Interior*, Rijksmuseum, Amsterdam, no. A864.

5. See, for example, *Musical Company in a Renaissance Hall*, dated 1636, Museum Boymans–van Beuningen, Rotterdam, inv. no. 1158.

6. C. Hofstede de Groot in Thieme, Becker 1907–50, vol. 15 (1922), p. 530.

7. See Plietzsch 1956, p. 192. The writer also mentioned a third example of the two artists' collaboration, formerly in the collection of August Janssen, Amsterdam.

8. See Blade 1976, p. 131. For example, the male figure seated at the extreme right appears in a preliminary drawing in the Rijksprentenkabinet, Amsterdam, for Dirck Hals's painting of 1627 in the Gemäldegalerie, Staatliche Museen Preussischer Kulturbesitz, Berlin (West), no. 816B.

9. Respectively, Dublin, National Gallery of Ireland, no. 119, and Blade 1976, cat. no. 27, fig. 19. Blade (1976, pp. 130, 134, and cat. 29) believes a third *Interior with a Musical Company* (sale, Amsterdam, April 30, 1907, no. 72) is also a collaborative effort of c. 1629/30 by the two artists.

10. De Bie 1661, p. 281; see also Houbraken 1718–21, vol. 1, p. 74. Blade (1976, p. 1129) concludes that they collaborated primarily in c. 1627–29.

11. Blade 1976, p. 95. Blade (pp. 100–152) also believes that Frans Francken the Younger, David Teniers the Younger, and possibly Gonzales Coques and Pieter Codde collaborated with van Delen.

12. Martin 1916a, p. 203; see also Haverkamp Begemann 1959, p. 50 n. 264, and I. Geismeier in Berlin, Staatliche Museen (Bodemuseum), cat. 1976, vol. 1, p. 23. Figure motifs from the Berlin painting also appear in Dirck Hals's merry companies of 1623 (Kunsthalle, Hamburg, no. 675 [not in cat. of 1966]; and with H. Shickman Gallery, New York, 1967, cat. no. 6), c. 1625 (see D. Bax, *Catalogue of the Michaelis Collection* [Capetown, 1967], no. 27), 1626 (National Gallery, London, no. 1074) and, again, of 1628 (present whereabouts unknown; photograph in Rijksbureau voor Kunsthistorische Documentatie, The Hague).

13. Compare the violinist in Buytewech's painting in Berlin (fig. 3), the man on the far side of the table in the Museum Boymans–van Beuningen's painting (no. 1103), and the harpist in the drawing at the Institut Néerlandais, Paris (inv. no. 4103).

14. See Bergström 1966, especially pp. 157–59 n. 41, and p. 164. See also under cat. no. 25.

15. Bergström 1966, fig. 11.

16. Maclaren (1960, p. 145), for example, has written of the National Gallery's *Merry Company* of 1626 (no. 1074): "This type of subject developed out of the Prodigal Son feasting, but the present picture probably has no ulterior significance."

Shown in Philadelphia and Berlin

Seated Woman with a Letter, 1633
Signed and dated on the foot warmer: DHals
(DH in ligature) 1633
Oil on panel, 13½ x 11⅛" (34.3 x 28.3 cm.)
John G. Johnson Collection at the Philadelphia
Museum of Art, no. 434

Provenance: Acquired by John G. Johnson before 1913.

Literature: Philadelphia, Johnson, cat. 1913, vol. 2, p. 66; Philadelphia, Johnson, cat. 1941, p. 28; de Jongh 1967, p. 52, fig. 38; Philadelphia, Johnson, cat. 1972, p. 44, ill.; Amsterdam 1976, p. 121, fig. 25a.

Seated comfortably with her right foot on a foot warmer and her left arm draped over the chair back, a stout woman looks out and smiles at the viewer. In her left hand she holds a creased letter. On the back wall is a seascape (described by Valentiner as "in the manner of Simon de Vlieger"[1]) with a boat on a placid stretch of water. At the upper left is a window; at the right a second chair and a door.

The date on the Johnson Collection painting was correctly deciphered as 1633 in the Johnson Collection catalogues of both 1913 and 1941 but was said to be illegible in the 1972 catalogue. When the painting was cleaned in 1983, the date once again became clear. Single-figure, upright compositions of this type were painted by Dirck Hals by 1630.[2] The following year, in a painting now in Mainz (fig. 1), he first addressed the theme of a woman with a letter in an interior with a seascape, a subject that would be taken up by later artists (for example, Gabriel Metsu, in *Woman Reading a Letter,* Sir Alfred Beit, Bt., Blessington, Ireland, and Vermeer, in *Woman Receiving a Letter,* Rijksmuseum, Amsterdam, no. A1595). While depicting the same theme as the Philadelphia picture, the Mainz painting employs a horizontal format,

FIG. 1. DIRCK HALS, *Woman Tearing Up a Letter,* 1631, oil on panel, Mittelrheinisches Landesmuseum, Mainz, inv. no. 168.

FIG. 2. DIRCK HALS, *The Dreamer,* probably 1631, oil on panel, formerly Khanenko Collection, Kiev.

which reveals more of the room. That interior is sparsely furnished with a trunk, chair, and the single painting—a stormy marine with ships buffeted by high seas. The standing woman sways slightly and tears up the letter. Her distracted look contrasts markedly with the air of contentment and unbuttoned satisfaction of the seated woman in the Johnson Collection painting. The temptation to see the latter as the recipient of reassuring news and the former as the addressee of some unsettling missive—word of a lover lost at sea or the end of an affair—may be more than novelistic speculation. In seventeenth-century Dutch poetry by Jacob van Someren and others, women often write or receive passionate letters from lovers at sea.[3] Furthermore, in discussing Dirck Hals's two works, de Jongh has pointed to the verses by Jan Harmensz. Krul: "Love may rightly be compared with the sea/ from the viewpoint of her changes/ which one hour cause hope/ the next fear: So too goes it with a lover/ who like the skipper/ who journeys to sea/ one day encounters good weather/ the next storms and roaring wind. . . ."[4] It is not always clear, however, in Dirck Hals's work whether a letter brings good or bad news. In the *Woman Reading a Letter by Candlelight* (Bergamo, Accademia Carrara Bergamo, cat. 1950, no. 478) the contents are unknown, as they are in the so-called *Dreamer* (fig. 2), where a seated woman with a letter has kicked off one shoe and stares off inscrutably into space.[5]

<div align="right">P.C.S.</div>

1. See Philadelphia, Johnson, cat. 1913, vol. 2, p. 66, no. 434.

2. See *The Flute Player,* signed and dated 1630, Frans Halsmuseum, Haarlem, no. 122; compare also the undated *Solo,* Akademie der bildenden Künste, Vienna, inv. no. 734, cat. 1972, no. 172. A later development is the *Woman at Her Toilet,* signed and dated 1638, exhibited London 1958, no. 3 (a replica or copy in the Fisher Gallery, University of Southern California, Los Angeles).

3. See Schotel 1903, pp. 188–89.

4. De Jongh 1967, p. 52; Krul 1640, pp. 2–3: "Wel te recht mach Liefde by de Zee vergeleecken werden/ aenghesien haer veranderinge/ die d'eene uyr hoop/ d'ander uyr vreese doet veroorsaecken: even gaet het met een Minnaer/ als het een Schippen doet/ de welcke sich op Zee beghevende/ d'eene dagh goedt we'er/ d'ander dagh storm en bulderende wint gewaer wort . . ." (author's translation).

5. Otto Naumann (see Amsterdam 1976, p. 121 n. 2) first noted the latter work's close resemblance in content, style, and format (oil on panel, 47 x 57 cm.) to the Mainz painting (oil on panel, 45.5 x 56 cm.). Whether the pair are pendants is uncertain. Equally unclear is the object (a seascape or, more likely, a map) on the back wall in the Khanenko picture (fig. 2).

Frans Hals

Antwerp c. 1582/83–1666 Haarlem

Literature: Van Mander 1618, fol. 130; Ampzing 1628, p. 371; Schrevelius 1648, p. 289; de Bie 1661, p. 281; de Monconys 1665–66, p. 159; Houbraken 1718–21, vol. 1, pp. 90–95; Weyerman 1729–69, vol. 1; Descamps 1753–64, vol. 1, pp. 360 ff.; Levensbeschryving 1774–83, vol. 2, pp. 339–45; Loosjes 1789; van Eynden, van der Willigen 1816–40, vol. 1, pp. 374 ff.; Immerzeel 1842–43, vol. 2, pp. 10–11; Kramm 1857–64, vol. 2, p. 632; Thoré-Bürger 1868a; van der Willigen 1870, pp. 139–49, 348–49; Bode 1871; Unger 1873; Neefs 1876, vol. 1, p. 336; Bode 1877; van der Kellen 1878; Bode 1883, pp. 35–94; Friedländer 1902; Wurzbach 1906–11, vol. 1, pp. 636–41; Veldheer et al, 1908; Hofstede de Groot 1908–27, vol. 3, pp. 1–139; Moes 1909; Bredius 1913; Bode, Binder 1914; Bredius 1914; Coninckx 1914; Bode 1914–15; Piérard 1916; Bredius 1917; Rothes 1919; Bredius 1921; Hofstede de Groot in Thieme, Becker 1907–50, vol. 15 (1922), pp. 531–34; Bode 1922b; Valentiner 1923a; Bredius 1923–24a; Schmidt-Degener 1924; Hofstede de Groot 1928; Valentiner 1928c; Dülberg 1930; Detroit 1935; Valentiner 1935; Martin 1935–36, vol. 1; Valentiner 1936; Gratama 1937; Haarlem 1937; Volskaya 1937; Plietzsch 1940; Trivas 1941; Bauch 1942; Gratama 1943; Luns 1948; Baard 1949; Hollstein 1949–, vol. 8, pp. 215–18;

Frans Hals, the son of Franchoys Hals, a cloth-worker from Mechelen, was probably born in Antwerp around 1582/83. Some time after August 1585, when Antwerp fell to the Duke of Parma, Hals's family emigrated to the Northern Netherlands. They had settled in Haarlem by March 1591, when Frans's younger brother Dirck (q.v.) was baptized. Apart from a trip to Antwerp in 1616, Hals may have spent the remainder of his life in Haarlem. His first wife, Annetje Harmansdr., died in June 1615, leaving the artist with two small children. Lysbeth Reyniers, whom Hals married in February 1617, bore him at least eight more children, including the artists Frans the Younger (1618–1669), Reynier (1627-1671), and Nicolaes (1628–1686).

A note in the posthumous second edition of Het Schilder-Boeck *(1618) tells us that Hals studied with Karel van Mander (1548–1606). This apprenticeship must have taken place before 1603, the year van Mander left Haarlem. Hals entered the Guild of St. Luke in 1610, and his earliest dated work, the* Portrait of Jacobus Zaffius, Archdeacon of St. Bavo's *(Frans Halsmuseum, Haarlem, no. 486), was painted the following year. Throughout his career, the artist was repeatedly commissioned to execute group portraits for militia companies and regents. His first such work, the* Banquet of the Officers of the Haarlem Militia Company of St. George *(Frans Halsmuseum, Haarlem, no. 123), was completed in 1616. Additional commissions for group portraits of the St. George and St. Hadrian companies followed in 1627, 1633, and 1639. The artist produced similar works for the regents of the St. Elizabeth Hospital and the city's almshouse (1641 and 1664, respectively). As a portraitist, Hals appears to have enjoyed his greatest popularity in the 1630s. In Beschrijvinge ende lof der Stad Haerlem Samuel Ampzing praised his ability to capture people from life. The artist's activity as a genre painter was relatively brief; although genre subjects appeared very early in his career, none figure in his oeuvre after c. 1640.*

Stories of Hals's profligacy are apparently much embroidered. Documented evidence suggests that he was actually a well-respected artist who enjoyed the patronage of many distinguished members of Dutch society. Nevertheless, in the later years of his life he was destitute and was forced to accept relief from the burgomasters of Haarlem. He died in Haarlem on August 29, 1666, and was buried in St. Bavo's on September 1.

Houbraken mentions that Hals had several apprentices, among them Adriaen Brouwer, Adriaen van Ostade (q.q.v.), Philips Wouwerman (1619–1668), and the artist's brother Dirck. Judith Leyster and Jan Miense Molenaer (q.q.v.) may have also studied with Hals.

C.V.B.R.

Singing Boy with a Flute, c. 1627
Signed lower right: FH (in ligature)
Oil on canvas, 24⅜ x 21½" (62 x 54.6 cm.)[1]
Gemäldegalerie, Staatliche Museen Preussischer
Kulturbesitz, Berlin (West), no. 801A

Rathke 1954; Höhne 1957;
van Roey 1957; van Hees
1959; Juynboll 1959; van
Valkenburg 1959–1962;
Maclaren 1960, pp. 145–
46; de Jongh, Vinken 1961;
Slive 1961; van Thiel 1961;
Baard 1962a; Baard 1962b;
Haarlem 1962; Fromentin
1963, pp. 224–34; de
Jongh, Vinken 1963; Slive
1963a; Slive 1963b; Slive
1964; Kauffman 1965;
Gerson 1966a; Rosenberg
et al. 1966, pp. 30–47; Lin-
nik 1967; Descargues 1968;
Slive 1970–74; Grimm
1971; Grimm 1972; van
Roey 1972; Vienna 1972;
Jowell 1974; Koslow 1975;
van Thiel 1980.

Provenance: Sale, B. Ocke, Leiden, April 21, 1817, no. 45;
sale, Amsterdam, December 16, 1856, no. 19; B. Suermondt
Collection, Aachen; acquired together with the Suermondt
Collection for the Königliches Museum, Berlin, 1874.

Exhibitions: Washington/New York/Chicago 1948–49, cat.
no. 57; Amsterdam 1950, cat. no. 51.

Literature: J. Meyer and W. von Bode, *Verzeichnis der aus-
gestellten Gemälde . . . aus den im Jahre 1874 erworbenen
Sammlungen des Herrn Barthold Suermondt* (Berlin, 1875),
p. 28, no. 19; Bode 1883, pp. 51, 86, no. 90; Hofstede de
Groot 1907–28, vol. 3, pp. 21f., no. 81; Moes 1909, pp.
33–35, 109, no. 218; Valentiner 1923a, pp. 55, 310 n. 53;
Trivas 1941, p. 32, cat. no. 25; Slive 1970–74, vol. 1, p. 88,
and vol. 2, pls. 45–46, and vol. 3, pp. 16ff., cat. no. 25;
Grimm 1972, pp. 22, 27, 70, 200, cat. no. 30; Berlin (West),
Gemäldegalerie, cat. 1975, p. 195, no. 801A; Berlin (West),
Gemäldegalerie, cat. 1978, p. 201, no. 801A.

FIG. 1. FRANS HALS, *Drink-
ing Boy*, c. 1626–28, oil on
panel, Staatliches Museum,
Schwerin.

FIG. 2. FRANS HALS, *Boy
Holding a Flute*, c. 1626–
28, oil on panel, Staatliches
Museum, Schwerin.

Beneath the glowing whitish blue of the feather
on his beret a boy turns his face to the side and
slightly inclines his head as if listening to the
sound of his own song. For the moment his flute
rests unused in his right hand while his raised
left hand keeps time.

Young musicians were one of Frans Hals's
favorite subjects in the 1620s, most often
depictions of similar moments of sensual enjoy-
ment in which his young models respond to the
fleeting pleasure of music or taste. Indeed, Hals's
young musicians are all too ready to lay aside
their instruments in favor of a glass.[2] In the
paired portraits *Drinking Boy* and *Boy Holding
a Flute* in the Staatliches Museum in Schwerin
(figs. 1, 2) both activities are enjoyed con-
currently. The allegorical reference is not
difficult to infer from this juxtaposition: drinker
and flute player are to be understood as embodi-

ments of Taste and Hearing. Such works are
drawn from the theme of the Five Senses, a
grouping that also includes the Berlin painting as
a personification of the sense of hearing.[3]

The human senses have long been a subject
with moral appeal. The instinctual part of the
senses inhibits their essential role as mediators in
the search for God and for higher knowledge.[4]
In Hals's youthful figures we can observe the
effect of near total abandon to the senses. Nega-
tive examples are given as a reminder not to
succumb to the sensual pleasure of earthly temp-
tations. In the case of the young drinker whose
taste for wine ill befits his age, this warning is
evoked in a rather drastic way. In the Book of
Ecclesiastes (2: 8–11) the preacher says: ". . . I
made me singing men and singing women, and
the delights of the sons of men, cups and vessels
to serve to pour out wine. . . . And when I
turned myself to all the works which my hands
had wrought . . . I saw in all things vanity and
vexation of mind, and that nothing was lasting
under the sun."[5] The value of short-lived earthly
delights is questioned; in the context of the bibli-
cal passage the emptiness and transitoriness of
the world and of worldly matters are con-
demned altogether. *Omnia Vanitas*—all is
vanity. Music, the most transitory of the arts, is
often associated with this adage.[6] It is self-evi-
dent that behind such reflections on the world of
human senses there is a vision of the inevitability
of death and the Last Judgment. Hals's young
figures seem far away from death, but they
therefore allude to it all the more decisively.
Other works by Hals from about the same time
depict the common Baroque notion that the end
is already inherent in the beginning, for instance
the *Young Man Holding a Skull* and the *Laugh-
ing Child with a Soap Bubble*.[7] The Berlin
picture also conveys the gloomy admonition of
memento mori, cautioning against wasting the
radiance of youth in vain distractions while
overlooking the essential things in life. The
bright tones of song and flute turn all too
quickly into the rasping of death. The rhymed
couplet on Bloemaert's engraving of a flute
player after Baburen (fig. 3) suggests this kind of
interpretation: "The flute plays sweetly, its
sound is noble,/ but listen to the sound from an
old woman's throat."[8]

FIG. 3. CORNELIS
BLOEMAERT after Dirck van
Baburen, *Flute Player*, en-
graving.

The absorbing gaiety of Hals's small musician is enlivened by the spirited brushstrokes and brilliant light that capture the facial expression and gestures of this engaging figure. The virtuoso illusionism of his painting technique draws an ambiguous relationship between the model's pleasure in hearing and the viewer's in seeing. Here there is perhaps also an overtone of hedonism—enjoy life while you still can. However, Hals was not concerned to present a figure with whom the viewer could identify. The effervescent naturalness of the boy is not altogether genuine: his involvement with his song is an act. The extravagant feathered beret and the cloak draped over his shoulder and chest have been borrowed from a theatrical wardrobe as attributes for this special role. This is another argument for excluding the picture from Hals's corpus of portraits.[9] Furthermore, as the engraving after Baburen shows, both the theme and pictorial type were predetermined. In fact, the Utrecht Caravaggisti portrayed musicians in theatrical costume even before Hals, always in similar format as well, focusing on a single actor presented to the viewer as a life-sized half-length figure. Von Schneider and Judson have postulated the influence of Honthorst, whose *Singing Old Man with a Flute* (Staatliches Museum, Schwerin, no. 517) is similar in musical situation and expressiveness (see also his *Merry Fiddler*, pl. 7).[10] Slatkes, on the other hand, believes Baburen's *Singing Man* of 1622 (Das Gleimhaus, Halberstadt) to be the direct prototype.[11] The list of possible influences has been further expanded, most recently by Slive, who has pointed to ter Brugghen's *Boy Singing* of 1627 (Boston, Museum of Fine Arts, inv. no. 58.975).[12] Certainly Hals was familiar with a broad range of works from the Utrecht School, and comes closest stylistically to ter Brugghen (see the *Flute Player*, Gemäldegalerie Alte Meister, Kassel, no. GK179) in the tonal gradations of his colors, which retain their luminosity and remain free of Caravaggesque chiaroscuro effects.

J.K.

1. This is the original size; a later addition at the bottom of about 5.5 cm., depicting an open music book, is covered by the frame.

2. For example the so-called *Nail Test, Merry Luteplayer, Laughing Boy with a Wine Jug;* Slive 1970–74, vol. 2, cat. nos. 24, 26, 60, and vol. 3, pls. 47, 48, 90.

3. The Schwerin pictures may be the only remaining paintings from a lost cycle originally depicting all Five Senses; Slive 1970–74, vol. 1, p. 79, and vol. 3, p. 35, cat. no. 58, including a 1654 inventory reference to a Five Senses by Hals. A complete, extant cycle by Dirck Hals from 1636 (Mauritshuis, The Hague, nos. 771–775) consists of similar roundels in relatively small format. The question remains whether the Berlin picture could have been part of a cycle as well. It could definitely have been conceived as an independent image, yet the formal composition does not exclude the possibility of a left-hand companion piece. On representations of the Five Senses in Netherlandish painting see the basic study by Kauffmann 1943, pp. 133–57; also see Slive 1970–74, vol. 1, pp. 77–80.

4. Even in antiquity the unbridled senses were represented as objectionable, for instance in the story of Hercules at the crossroads of virtue and vice; see L. Vigne, *The Five Senses* (Lund, 1975), p. 21. There is a concise summary of the evaluation of the senses from the Middle Ages to the modern era in the exhibition catalogue Amsterdam 1976, under no. 23. The engraved cycle of c. 1595–96 by Saenredam after Hendrik Goltzius is typical of the Netherlandish conception; the titles under each image warn of abandoning oneself to the senses. See Hollstein 1949–, vol. 23, pp. 76ff., nos. 101–5; the cycle is illustrated in Slive 1970–74, vol. 1, p. 78, pl. 55.

5. The Douay Bible. Later translations render "vexation of mind" as "a striving after wind" (Revised Standard Version).

6. On the significance of music as a symbol of vanity see Fischer 1975, pp. 43–72. Musical instruments are among the most common motifs in *vanitas* still lifes; see examples in the exhibition catalogue Leiden 1970.

7. Slive 1970–74, vol. 1, cat. nos. 28, 61, and vol. 2, pls. 51, 97–99.

8. Hollstein 1949–, vol. 2, p. 79, no. 284; Slatkes 1969, pp. 81ff. and 135, cat. no. B1; as an engraving by Cornelis Bloemaert of 1625 after a lost original by Dirck van Baburen from c. 1623.

9. According to Valentiner (1923a, p. 310 n. 53) Hals supposedly portrayed his own offspring in his portraits of children. This hypothesis, which cannot be proved through documented portraits, is based on Houbraken's report (1718–21, vol. 1, p. 95) that all the painter's children were enthusiastic singers and instrumentalists.

10. Von Schneider 1933, pp. 61ff., pls. 7a–b; Judson 1959, p. 66 n. 4.

11. Slatkes 1969, pp. 91ff.

12. In referring to the Boston painting of 1627 (see Nicolson 1958, pl. 30a), Slive (1970–74, vol. 3, p. 17, cat. no. 25) contradicts his own suggestion of an early date of 1623/25 for the Berlin portrait. Here he holds to a date of 1627, most recently argued in detail by Grimm 1972, pp. 70–78.

Gerrit van Honthorst

Utrecht 1590–1656 Utrecht

Literature: De Bie 1661, p. 164; Félibien 1666–88, vol. 3, p. 304; Sandrart 1675, pp. 8, 11, 22, 24, 102, 157, 172–74, 179, 184, 266, 303, 311; van Hoogstraten 1678, pp. 234, 257; Félibien 1679, p. 43; Baldinucci 1681–1728, vol. 3, p. 691; de Piles 1699, pp. 402–3; Houbraken 1718–21, vol. 1, pp. 66, 149, and vol. 2, p. 267; Weyerman 1729–69, vol. 1, p. 379; Walpole 1788; van Eynden, van der Willigen 1816–40, vol. 1, p. 154, and vol. 4, p. 115; Kramm 1857–64, vol. 3, p. 723, and suppl., p. 82; Nagler 1858–79, vol. 2, p. 3056; Obreen 1877–90, vol. 3, p. 260, and vol. 5, p. 98; Muller 1880, p. 157; de Kruijff 1891; Wurzbach 1906–11, vol. 1, pp. 709–12; Nissen 1914; Hoogewerff 1917b; Holmes 1923; Hoogewerff 1924; G. J. Hoogewerff in Thieme, Becker 1907–50, vol. 17 (1924), pp. 447–50; von Schneider 1933, pp. 21–31, 134–36; van Gelder 1946b; Hollstein 1949–, vol. 9, pp. 110–14; Nicolson 1952; Utrecht/Antwerp 1952; Millar 1954; Borsook 1954; Judson 1955; Judson 1959; Plietzsch 1960, pp. 127–30; Braun 1960; Maclaren 1960, pp. 178–80; Salinger 1963a; Braun 1966; Rosenberg et al. 1966, pp. 25–27; Reznicek 1972; Braunschweig 1978, pp. 90–91; Nicolson 1979, pp. 57–61; Brenninkmeyer-de Rooij 1982; Kettering 1983a.

Gerrit van Honthorst (or Gherardo della Notte as he was known in Italy) was born in Utrecht in 1590 into a wealthy Catholic family. Both his grandfather and his father were artists: the former, Gerrit Huyghen, was dean of the Utrecht guild in 1579 and the latter, Herman Gerritsz., was a painter of tapestry cartoons. In Utrecht, Honthorst studied with the town's leading history painter, Abraham Bloemaert (q.v.). He went to Rome, perhaps as early as 1610, where he developed a style based on that of Caravaggio (1573–1610) and his Roman followers, in particular, Bartolommeo Manfredi (c. 1580–c. 1620). Honthorst enjoyed a considerable reputation in Rome. He lived for some time in the palace of the Marchese Vincenzo Giustiniani, his principal patron, whose large art collection included works by Caravaggio, Manfredi, Titian, Correggio, Raphael, Reni, and the Carracci. He also enjoyed the patronage of Cardinal Scipione Borghese and the Grand Duke of Tuscany. He painted a number of commissions for churches, among them three canvases for the Passion Chapel of Santa Maria in Aquiro and one for Santa Maria della Scala. Honthorst was back in Utrecht late in 1620, when he married Sophia Rycquert Coopmans; he joined the guild in 1622 and served as dean during the later half of the decade.

By 1625 Honthorst had established his reputation in the Netherlands and is said to have had twenty-four pupils. He concentrated increasingly on portraits, genre scenes, and allegorical and mythological themes, rather than on the religious subjects he had painted for his Roman patrons. In 1627 Rubens (1577–1640) visited him in Utrecht. In the following year, at the invitation of Charles I, Honthorst went to England, where he painted the large allegorical canvas Mercury Presenting the Liberal Arts to Apollo and Diana *(now at Hampton Court Palace) as well as portraits of the king and queen and members of their court. In 1635 he dispatched to Denmark the first of a long series of classical and historical paintings commissioned by King Christian IV. In 1637 the artist entered the guild in The Hague; he remained in the city until 1652 as court painter to the stadholder, for whose palaces at Rijswijk and Honselaersdijk he produced portraits and allegorical paintings. In 1649–50 he contributed to the decoration of the Huis ten Bosch, the summer palace near The Hague. During his years in The Hague, the*

Queen of Bohemia and her daughters were among his pupils. In 1652 Honthorst returned to Utrecht; he died four years later.

Honthorst was one of the few Dutch painters of his day to enjoy an international reputation. He played an important role in bringing knowledge of the work of Caravaggio and his followers to the Netherlands. He introduced to the North the Italian manner of illusionistic decoration, and the large scale decorative works he painted toward the end of his career show the influence of Rubens and the Carracci. His portraits are a development of the court style of Michiel van Mierevelt (1567–1641). Among his many pupils were Jan van Bronchorst (c. 1603–1661) and Joachim van Sandrart (1606–1688), whose Teutsche Academie of 1675 gives the fullest account of Honthorst's career.

C.B.

The Merry Fiddler, 1623
Signed and dated in the center of the ledge:
G Honthorst. fe. 1623 (GH in ligature)
Oil on canvas, 42½ x 35″ (108 x 89 cm.)
Rijksmuseum, Amsterdam, no. A180

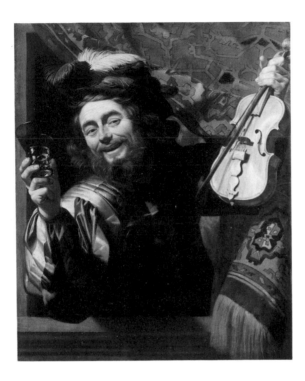

Provenance: Johann Georg Eimbke, Berlin, 1761; sale, J. Viet, Amsterdam, October 12, 1774, no. 106; sale, M. E. Sluipwijk-Gravin van Moes, Amsterdam, April 20, 1803; sale, Huis met de Hoofden, July 16, 1819, no. 74, to de Vries; purchased from C. Josi, Amsterdam, 1824.

Exhibition: Utrecht/Antwerp 1952, no. 47.

Literature: Hoogewerff 1924, p. 12; von Schneider 1933, pp. 28, 134; Gudlaugsson 1938, p. 68; Nicolson 1952, p. 251; Judson 1959, cat. 168; Braun 1966, cat. 49; Rosenberg et al. 1966, p. 28; A. Moir, *The Italian Followers of Caravaggio* (Cambridge, Mass., 1967), vol. 1, p. 120; Amsterdam, Rijksmuseum, cat. 1976, p. 285; Nicolson 1979, p. 60.

A smiling man with a violin in his left hand and a wineglass in his right leans out a window that is draped with a turkish carpet. He is shown half-length and wears a brightly colored doublet and a hat decorated with ostrich feathers.

The single half-length genre figure is an innovation of the Utrecht Caravaggisti. The earliest surviving examples are Abraham Bloemaert's *Flute Player* of 1621 (Utrecht, Centraal Museum, cat. 1951, no. 17) and Dirck van Baburen's *Lute Player* of 1622 (also in the Centraal Museum). Honthorst's earliest-known example is the present painting of 1623. Although Caravaggio painted a single lute player (Hermitage, Leningrad, no. 217), Honthorst's Italian source seems to have been Bartolommeo Manfredi—either one of his single figures (see the *Man Holding a Wineglass,* Galleria Estense, Modena), or his multifigured gambling and party scenes.

In *The Merry Fiddler*, Honthorst apparently wanted to convey a delight in wine and music. According to Judson, the violinist, who is said to be "in a late Burgundian theatrical costume," is "probably a *rederijker* [rhetorician] buffoon transposed to represent the sense of Taste."[1] The costume is actually closer to Italian models, particularly the striped doublets worn by Caravaggio's and Manfredi's *bravi.* Nor is it clear why Honthorst's figure should be thought of as a *rederijker.* When *rederijkers* are represented in Dutch art, as in Jan Steen's *Rhetoricians at a Window* (pl. 82), where they declaim their verses, they indeed lean out over a ledge. However, they are identified specifically by their dress (including laurel wreaths), by their actions, and even by accompanying inscriptions.[2] Furthermore, Honthorst's violinist cannot be identified satisfactorily with the sense of Taste. In series of the Five Senses, such as that engraved by Jan Saenredam after Goltzius, Taste is represented by an amorous couple drinking wine, and Hearing, by a couple playing the virginals and the lute.[3] A figure with wineglass *and* violin cannot be identified as one or the other of the senses. It is misleading to attempt to interpret the Italian-derived secular iconography of single figures like Honthorst's in terms of traditional Netherlandish themes. *The Merry Fiddler* should rather be thought of in the context of Italian Caravaggesque subject matter.

<div align="right">C.B.</div>

1. Judson 1959, cat. 168.

2. For other *rederijker* paintings by Jan Steen, see cat. no. 106.

3. Hollstein 1949–, vol. 8, nos. 380–84.

The Concert, c. 1625
Oil on canvas, 66⅛ x 79½" (168 x 202 cm.)
Galleria Borghese, Rome, no. 31

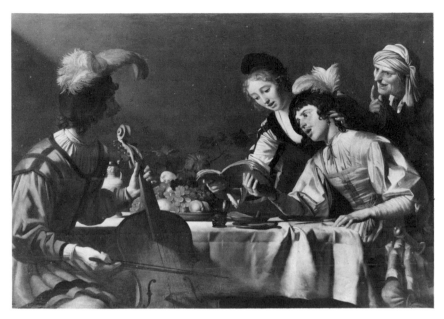

Provenance: Probably sale, H. Arentz., Amsterdam, April 11, 1770, lot 40, as formerly in the collection of van Borsselen (Honthorst's younger daughter), to van der Dussen;[1] sale, van der Dussen, Amsterdam, October 31, 1774, lot 24 (as 52 x 79" [140.4 x 213.3 cm.]); sale, J. H. Viet, The Hague, September 25, 1780, lot 79, to Bersjon; anonymous sale, Amsterdam, April 17, 1783 (as 52 x 80" [140.4 x 216 cm.]), to Coclair; possibly among acquisitions made by Marcantonio Borghese, 1783.[2]

Exhibitions: Milan 1951; Utrecht/Antwerp 1952, no. 41.[3]

Literature: Hoogewerff 1924, p. 11; von Schneider 1933, pp. 24, 135; B.J.A. Renckens and G. van der Kuyl, *Kunsthistorische Mededelingen*, no. 2 (1947), p. 6; Gerson 1952b, p. 289; Nicolson 1952, p. 251; Judson 1959, cat. no. 190;[4] P. della Pergola, *Galleria Borghese: I Dipinti*, no. 2 (1959), cat. no. 238; Nicolson 1979, p. 59.

FIG. 1. CARAVAGGIO, detail of *The Supper at Emmaus*, National Gallery, London.

Four figures are assembled at a table laid with fruit and wine. An amorous young couple sing together from the songbook that they hold; the young woman, who is standing and leaning forward, rests her left hand on the young man's neck. They sing to the accompaniment of the cellist on the left. He looks up, distracted by the old woman on the right who has just entered the room. Raising her index finger to her lips in the traditional gesture of silence, she asks him to disregard her presence and not bring it to the attention of the young man. With her deeply lined face and elaborate turban, she typifies the traditional procuress type. The painting depicts a traditional Caravaggesque subject: a young man, identifiable as the Prodigal Son, in a brothel.

Nicolson noted the remarkable detail of the still life, which can be compared to Caravaggio's still life in the London *Supper at Emmaus* (fig. 1). Renckens observed the similarity of the cellist

to that in a painting attributed to the Gorinchem artist Gysbrecht van der Kuyl (Chrysler Museum, Norfolk, Virginia). The cellist in van der Kuyl's *Concert* is taken from Honthorst's *Concert*.

There has been considerable debate as to when Honthorst executed this painting. In his review of the 1952 exhibition, Gerson dated it c. 1625, around the same time as the Utrecht *Procuress* (Centraal Museum, no. 152), which is dated 1625. Nicolson, who also reviewed the exhibition, preferred c. 1622, soon after Honthorst's return from Italy. He stressed similarities to contemporary Flemish painting and to the still-life paintings of Caravaggio. In the Borghese catalogue, della Pergola argued that Honthorst painted *The Concert* while in Italy, c. 1615–20. Judson followed Gerson in comparing its "lack of warmth and the hard, brittle and refined quality of the figures" with paintings of 1625 and after, particularly the Utrecht *Procuress* and *Diana at the Hunt* of 1627 (formerly Schloss Grünewald); he believed it should be dated c. 1626–27.

Judson correctly notes a significant change in technique from that of the Uffizi *Merry Company* (no. 730), probably commissioned for the Grand Duke of Tuscany, to the Utrecht *Procuress* of more than five years later. A secular composition, the Uffizi picture is of a type similar to *The Concert*, painted during Honthorst's Italian years (probably c. 1620). The increased dryness of handling, the greater linearity in figure outlines, the new harshness in modeling shadows, and the marked lightening of the palette are all aspects of Honthorst's gradual move from thorough-going Caravaggism to a style that owes much to the Haarlem classicists. The Borghese painting is far closer to the Utrecht *Procuress* and so should be dated c. 1625.

C.B.

1. As on canvas, 52 x 79" (140.4 x 213.3 cm.), "Hy zit te Musiceeren aan een Tafel, die gedeckt, en met eenige vruchten en drank voorzien is, vezeld van twee vrouwspersonen, voor de Tafel zit een Muzikant, speelende op de Bas."

2. As "Bacchanale di Gherardo de Loiresse, longo pmi 6¹/₁₂ alto pmi 6¹/₁₂." First inventory documentation is in *Fidecommesso Artistico della Famiglia Borghese* (1833, p. 19), as Flemish School, Galleria Borghese Archivio.

3. In the Utrecht/Antwerp catalogue, the painting is incorrectly said to be signed.

4. Judson states that an autographed replica was owned by the Earls of Carlisle at Castle Howard. It was sold to Cevat in the G.H.A. Howard sale in London (Christie's, February 18, 1944). A version was exhibited at the Koetser Gallery, New York, February 25 to March 25, 1946, no. 15; it is most recently recorded in a collection in South America.

Rotterdam 1629–1684 Amsterdam

Two Women in a Courtyard, c. 1657
Signed lower left: P·D·HOOCH
Oil on canvas, 27¼ x 13⅜" (69.2 x 34 cm.)
Her Majesty Queen Elizabeth II

Literature: Houbraken 1718–21, vol. 2, pp. 27, 34; Descamps 1753–64; Smith 1829–42, vol. 4, pp. 217–42, and suppl., pp. 563–74; Immerzeel 1842–43, vol. 2, pp. 51–52; van der Kellen 1876a; Havard 1877; Obreen 1877–90, vol. 1, pp. 45, 59, and vol. 4, p. 101; Lemcke 1878; Havard 1879–81, vol. 3, pp. 61–138; Haverkorn van Rijsewijk 1880; Bredius 1881a; Bredius 1881b; Bredius 1889; Haverkorn van Rijsewijk 1892a; Hofstede de Groot 1892; Wurzbach 1906–11, vol. 1, pp. 716–18; Hofstede de Groot 1908–27, vol. 1, pp. 471–570; Bode 1911; de Rudder 1913; Steenhoff 1920; Rothes 1921, pp. 38–56; Tietze-Conrat 1922; Plasschaert 1924; K. Lilienfeld in Thieme, Becker 1907–50, vol. 17 (1924), pp. 452–54; Collins Baker 1925; Valentiner 1926–27; Brière-Misme 1927; Valentiner 1929a; van Thienen 1945; Oosterloo 1948; Hollstein 1949–, vol. 9, p. 117; Maclaren 1960, pp. 183–85; Salinger 1963b; Gerson 1966b; Rosenberg et al. 1966, pp. 124–27; Stechow 1966; Amsterdam 1976, pp. 130–33; Fleischer 1978; Sutton 1980.

The son of a master bricklayer and a midwife, Pieter Hendricksz. de Hooch (also spelled de Hoogh) was baptized in Rotterdam on December 20, 1629. He was apprenticed to the Italianate landscapist Nicolaes Berchem (q.v.) at the same time as Jacob Ochtervelt (q.v.). In 1652 de Hooch was in Delft, where he and the artist Hendrick van der Burch (born 1627) witnessed the signing of a will. A record from the following year lists him as a painter and dienaar (servant) to the merchant Justus de la Grange; an inventory of the latter's collection from 1655 shows that he owned eleven of de Hooch's paintings. Although the artist attended a baptism in Leiden in 1653, he was living in Rotterdam in 1654 when he married Jannetje van der Burch of Delft, probably the sister of Hendrick van der Burch. Seven children were born to the couple. De Hooch joined the Guild of St. Luke in Delft in 1655 and paid dues in 1656 and 1657. By April 1661 (and perhaps as much as eleven months earlier), he had settled in Amsterdam. Except for a visit to Delft in 1663, de Hooch seems to have remained in Amsterdam for the rest of his life. He died in the Dolhuis (insane asylum) and was buried in St. Anthonis Kerkhof on March 24, 1684. The date and circumstances of his entry into the insane asylum are unknown.

De Hooch is best remembered for his Delft-period paintings, which depict middle-class figures in orderly interiors and sunlit courtyards. Less well known are his early guardroom scenes and later paintings produced in Amsterdam of elegant home and high life. Although de Hooch had no recorded pupils, he probably influenced a number of artists, including Pieter Janssens Elinga, Jacobus Vrel, Esaias Boursse, and the great Johannes Vermeer (q.q.v.).

P.C.S.

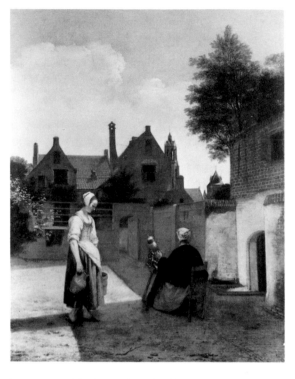

Provenance: Sale, Amsterdam, October 18, 1819, no. 27, to Hulswit (506 guilders); sale, R. Bernal, London, May 8, 1824, no. 33, to Peacock (150 pounds sterling); sale, T. Emmerson, London, May 2, 1829, no. 152, to Phillips for George IV (426 pounds sterling).

Exhibitions: London, British Institution, 1829, no. 108; London, Royal Academy, 1886, no. 98; London 1946–47, no. 347; The Hague 1948, no. 2, p. 13, ill.; London 1952–53, no. 408; London, Queen's Gallery, cat. 1971, no. 14, pl. 13.

Literature: Smith 1829–42, vol. 4, no. 27; Waagen 1837–38, vol. 2, p. 167; Jameson 1844, p. 27; Waagen 1854–57, vol. 2, p. 11; Kramm 1857–64, vol. 3, p. 733; Blanc 1863, p. 8; Havard 1879–81, vol. 3, p. 110, no. 1; Hofstede de Groot 1892, no. 40; Bode 1906, p. 58; Wurzbach 1906–11, vol. 1, p. 717; Hofstede de Groot 1907–28, vol. 1, no. 292; de Rudder 1913, pp. 61, 99, ill. p. 56; Rothes 1921, p. 47, fig. 85; Collins Baker 1925, pp. 6, 7 (as c. 1664–65); Brière-Misme 1927, pp. 58, 65, 66 (as c. 1658); Valentiner 1929a, no. 45 (as c. 1656); Cust 1930, no. 19, ill.; Sutton 1980, pp. 24, 25, 49, no. 36, pls. 39, 37; White 1982, p. 61, cat. no. 84.

An old woman, her back to the viewer, sits at her spinning wheel in a shaded area of a courtyard. A younger woman, squinting against the sun, approaches from the left carrying a pitcher and a pail. On the right is a sunken doorway; in the distance are an open gate, gabled houses, the spire of the Nieuwe Kerk, and the tower of the Town Hall in Delft.

Perhaps de Hooch's greatest single innovation was his revelation of the special beauty of Dutch courtyards. These subjects enabled him to explore his two loves: orderly enclosed space and

Woman Drinking with Two Men and a Maid-servant, c. 1658
Signed lower left on the table: PDH
Oil on canvas, 29 x 25½" (73.7 x 64.8 cm.)
The Trustees of the National Gallery, London,
no. 834

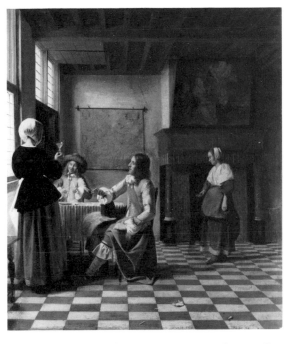

the effects of daylight. Here a brilliant afternoon sun floods the courtyard with geometric patterns. As many have remarked, his angular, stiffly moving figures complement his rectilinear designs. Although the present painting is undated, its light tonality and color scheme are characteristic of the artist's works of c. 1658 (for example, pl. 103). The date 1657 on one of five known copies of the painting could document a lost date on the original.[1] A similar design and theme appear in *Woman Carrying a Bucket in a Courtyard* (fig. 1), which may postdate this painting by several years;[2] other comparable courtyard scenes are in a private collection and the National Gallery, London.[3] These works recall the bleaching yards and courtyards in old Delft but usually introduce actual architecture into fanciful designs. The same gabled house in the right rear of the present painting, for example, reappears in different positions in at least two other courtyard scenes.[4]

Spinning, like sewing (see cat. no. 15, fig. 3), had long been associated with domestic virtue.[5] From its biblical source as one of the activities of the good wife (Proverbs 31:19), spinning became the attribute of a woman's virtue in history themes (such as the Wise and Foolish Virgins, Lucretia and Her Women Spinning), genre, and portraiture.[6] Roemer Visscher published an emblem of a distaff as a symbol of moderation in his *Sinnepoppen* (Amsterdam, 1614), and a late seventeenth-century emblem (fig. 2) of a spinner carried the motto *Huislykheid is 't vrouwen kroon cieraad* (domesticity is a woman's crowning ornament).

<div align="right">P.C.S.</div>

1. Sutton 1980, p. 86, no. 36c.

2. Sutton 1980, cat. no. 37, pl. 40.

3. Sutton 1980, no. 21, pl. v, and no. 44, pl. x.

4. Sutton 1980, cat. nos. 20 and 21.

5. See Gudlaugsson 1959–60, vol. 2, p. 107; de Jongh 1967, p. 65; Amsterdam 1976, no. 3; and Schipper-van Lottum 1975, p. 163.

6. See J. Bruyn Hzn., "Vroege portretten van Maerten van Heemskerck," *Bulletin van het Rijksmuseum,* vol. 3, no. 2 (1955), pp. 27–35.

Shown in London only

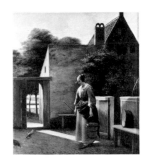

FIG. 1. PIETER DE HOOCH, *Woman Carrying a Bucket in a Courtyard,* oil on canvas, private collection, Great Britain.

FIG. 2. Emblem of a Spinner from *Verzameling van uytgeleesene Sinne-beelden* (Leiden, 1696), p. 4.

Provenance: Possibly sale, D. Ietswaart, Amsterdam, April 22, 1749, no. 197 (70 guilders); sale, van Leyden, Paris, September 10, 1804, no. 43, to Paillet (5,500 francs); bought with other paintings owned by the Comte de Pourtalès, Paris, 1826, by Emmerson and Smith, who sold it to Sir Robert Peel, Bt.; purchased by the National Gallery with the Peel Collection, 1871.

Exhibition: London 1976, no. 60, ill. p. 54.

Literature: Possibly Hoet 1752, vol. 2, p. 251; Smith 1829–42, vol. 4, no. 49; Waagen 1837–38, vol. 1, p. 287; Jameson 1844, p. 354, no. 14; Kugler 1847, vol. 2, p. 512; Waagen 1854, vol. 1, p. 403; Blanc 1854–90, vol. 2, p. 220; Blanc 1863, pp. 6, 8; Havard 1879–81, vol. 3, pp. 62, 87, 126, no. 2; Gower 1880, p. 111; Wedmore 1880, p. 53; Havard 1881, p. 183, fig. 53; Hofstede de Groot 1892, no. 37; Wurzbach 1906–11, vol. 1, p. 717; Hofstede de Groot 1907–28, vol. 1, no. 183; Jantzen 1912, pp. 24, 25; de Rudder 1913, pp. 28, 50, 98, ill.; Collins Baker 1925, pp. 5, 6, pl. 4; Valentiner 1926–27, p. 61; Brière-Misme 1927, p. 58; Valentiner 1929a, pp. xiii, xvii, no. 52, ill.; van Thienen 1945, pp. 32, 35, 44, 46–47, ill. p. 24; Plietzsch 1956, p. 182; Maclaren 1960, pp. 186–88, no. 834; Blankert 1975, pp. 32, 33, 45, 48, fig. 23; Welu 1975a, p. 535 n. 35; Foucart 1976, pp. 31–32, fig. 2; Sutton 1980, pp. 22, 43, cat. no. 29, pl. 27.

In an interior with checkered floor, tiled fireplace, and wooden ceiling beams, three merrymakers assemble around a table beside a brightly illuminated window. A woman, her back to the viewer, raises a wineglass to two male companions; one man, evidently an officer, sits with his plumed hat in his lap while the second holds a pair of clay pipes. Behind and to the right, a maidservant brings a brazier of coals. A map of the seventeen provinces of the Netherlands, tentatively identified as an early map published by Huyck Allart (active c. 1650–75),

FIG. I. PIETER DE HOOCH, *The Card Players*, 1658, oil on canvas, Her Majesty Queen Elizabeth II.

hangs on the back wall.[1] Above the mantle is a painting of the Education of the Virgin.[2] On the upper halves of the windows, shutters hinged at the top have been drawn back to admit the light. Shards of a pipe and a scrap of paper litter the foreground.

This highly ordered interior attests to de Hooch's famous command of perspective and his expressive use of light and atmosphere. With great logic, de Hooch has executed orthogonals or lines of sight that converge in a vanishing point. The illusion of space, enhanced by subtle adjustments of hue and value, is far more compellingly naturalistic than in, for example, van Delen's earlier formularized banquet halls (see pl. 11) or even those interiors by Koedijck and Maes that immediately precede de Hooch's painting (see pl. 63 and cat. no. 67, fig. 1). Here the figures seem enveloped by air, the room filled with silvery light. The painting was probably executed in Delft around 1658, the date that appears on *The Card Players* (fig. 1), *Soldier Paying a Hostess* (Marquess of Bute, Scotland), and *Woman Drinking with Soldiers* (pl. 102)— three interiors with merry companies, which all share aspects of the London painting's style and design.[3]

De Hooch used a logical but surprisingly flexible working method to achieve order and balance in these works. Infrared photographs of the London painting reveal traces of underdrawing, indicating that the perspective scheme and the architecture were drawn first, while the figures, as clearly seen in thin passages, were painted only after the spatial environment was completed. Numerous pentimenti, which include a bearded man who, with time, has emerged as a ghost just to the left of the maidservant, attest to the artist's changes of mind and personal editing.

As first noted by the author of the van Leyden sale catalogue of 1804, the man with the pipes on the far side of the table may be pretending to play the violin; in the nineteenth century the painting was titled "La Chanson Joyeuse" because the girl with her back to the viewer was thought to be singing.[4] With the traditional device of the painting within the painting, de Hooch seems to have commented on this merrymaking. Although such details are not always meaningful in de Hooch's work, here and in the Louvre's painting (pl. 102), the religious painting in the background probably stands in sacred opposition to the worldly diversions in the foreground.[5] The moral lessons embodied and epitomized by the theme of the Education of the Virgin are ignored by the idle merrymakers.

A work of long-standing popularity, the National Gallery's painting even inspired a fake (Museum Boymans–van Beuningen, Rotterdam) by the renowned modern forger of Vermeer, Han van Meegeren.[6]

P.C.S.

1. See Welu 1975, p. 535a n. 35.

2. Attributed to Ferdinand Bol in the 1804 van Leyden sale catalogue (no. 43), this painting within the painting has a possible source in an unidentified altarpiece in the Esterházy Chapel at Ering, South Bavaria; see Sutton 1980, p. 82, fig. 38.

3. See Sutton 1980, nos. 26–28, pls. 23–26; also dated 1658 are the *Woman and Two Children* (private collection; see Sutton 1980, no. 30, pl. 28) and two courtyard scenes on loan to the National Gallery of Scotland, Edinburgh (pl. 103) and the National Gallery, London (no. 835), respectively, in Sutton (1980, nos. 33, 34, pls. viii, ix).

4. Havard 1881, p. 183.

5. See Sutton 1980, pp. 43–45.

6. Sutton 1980, fig. 65.

Woman Drinking with Soldiers, 1658
Signed and dated lower left on the bench:
P.D.H. 1658 (PDH in ligature)
Oil on canvas, 27 x 23⅝" (68.6 x 60 cm.)
Musée du Louvre, Paris, inv. no. RF 1974-29

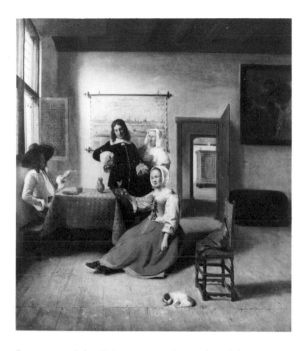

Provenance: Sale, G. Braamcamp, Amsterdam, July 31, 1771, no. 87, to Jan Hope (420 guilders); Hope Collection, by descent to Lord F. Pelham Clinton-Hope; entire collection purchased by Colnaghi's and Wertheimer, 1898; Baron Alphonse de Rothschild, Paris, by 1907; Baron Edouard de Rothschild, Paris, by 1921; H. Goering, Berlin, c. 1944; restituted to the Rothschilds, 1947; Mme Gregor Piatigorsky (daughter of Baroness Edouard de Rothschild), who gave it to the Louvre, 1974.

Exhibitions: London, British Institution, 1818, no. 101, and 1864, no. 85; London, Royal Academy, 1881, no. 126; Paris, Orangerie, *Les Chefs-d'oeuvre des collections françaises retrouvés en allemagne par la commission de récupération artistique et les services alliés,* 1946, no. 85.

Literature: Smith 1829–42, vol. 4, no. 2; Waagen 1837–38, vol. 2, p. 145; Waagen 1854, vol. 2, p. 119; Kramm 1857–64, vol. 3, p. 733; Havard 1879–81, vol. 3, p. 128; London, Victoria and Albert Museum, *Catalogue of Pictures of Dutch and Flemish Schools Lent to the South Kensington Museum by Lord Francis Pelham Clinton-Hope* (London, 1891), no. 34; Hofstede de Groot 1892, no. 46; Wurzbach 1906–11, vol. 1, p. 717; Hofstede de Groot 1907–28, vol. 1, no. 195; Jantzen 1912, p. 24; de Rudder 1913, p. 98; Brière-Misme 1921, p. 343; Brière-Misme 1927, pp. 58, 60–61, ill.; Valentiner 1929a, no. 33, ill.; Collins Baker 1930, p. 198; Würtenberger 1937, p. 82; Bille 1961, vol. 1, fig. 87, and vol. 2, no. 87, pp. 21–21a, 99; Jacques Foucart, "Un troisième Pieter de Hooch au Louvre," *La Revue du Louvre,* vol. 26 (1972), pp. 31–34, ill.; Paris, Louvre, cat. 1979, p. 72, ill.; Sutton 1980, pp. 20, 23, 43, no. 26, pl. 23.

In the corner of a carefully ordered interior, two men and two women assemble around a table. At the center of the scene sits a young woman in a brilliant red dress and silver jacket. She holds up a wineglass, which a man in black obligingly fills. At the right an old woman presses close and seems to speak to the man. Seated on a bench across the table, a second man in a yellow jacket and black hat smokes a long clay pipe. The open window behind him and the raised overhead shutter admit gentle daylight, which fills the room. In the foreground a small dog sleeps near a chair. A red and blue pillow on the chair exhibits special attention to still-life detail. Two pictures hang on the back wall; an engraved view of Amsterdam and, above a chest on the floor at the right, a partially visible painting of Christ and the Adulteress. A doorway at the back right offers a glimpse across two rooms to a large oak cupboard inlaid with ebony. Just visible on top of the cupboard are a ceramic vase and a small statue of Mercury.

Although often overlooked in the past, the date 1658 clearly appears on *Woman Drinking with Soldiers.*[1] The undated London painting of the same period (pl. 101) exhibits a similar design. In addition to spatial clarity and careful organization, the two works share merry company themes—soldiers relaxing with women—and, very possibly, similar meanings. The supposition that more than a glass of wine will be shared in the Louvre's painting stems partly from the importuning old woman, reminiscent of the procuress types in earlier works by, among others, Baburen (pl. 10), Honthorst (pl. 8), and Duck (pl. 39). Even more indicative is the painting within the painting of Christ and the Adulteress (John 8:1–11), depicted on the right rear wall (fig. 1). Here, as in the London picture, the religious painting stands in opposition to the profane merrymaking. Although its sexual allusions complement the theme, its biblical moral—"He that is without sin among you, let him first cast a stone at her" (John 8:7)—offers admonitory contrast. Whether the sleeping dog—a time-honored symbol of vigilant fidelity[2]—and the statue of Mercury complement the picture's meaning is unclear. Mercury, according to van Mander, was not only the initiator of the arts and the protector of commerce and *rhetorica,* but also had his darker side as god of thieves and rogues.[3] The same painting

Courtyard with an Arbor and Drinkers, 1658
Signed and dated in center: P•D•H 1658
Oil on canvas, 26⅛ x 22¼″ (66.5 x 56.5 cm.)
Private Collection, Great Britain

FIG. 1. Christ and the Adulteress, detail of de Hooch's *Woman Drinking with Soldiers.*

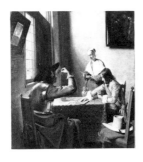

FIG. 2. PIETER DE HOOCH, *The Card Players,* oil on panel, private collection, Switzerland.

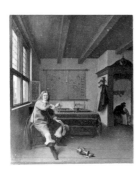

FIG. 3. ISAACK KOEDIJCK, *The Empty Glass,* 1648, oil on panel, private collection.

within this painting reappears in the upper right corner of de Hooch's *Card Players* (fig. 2), where its allusions to adultery and promiscuity may be related to the ace held by the soldier in the foreground: a potential symbol of fidelity to one love (see cat. nos. 10, 108).[4]

The exceptional naturalism of de Hooch's interiors of 1658 is clear if they are compared to their immediate antecedents, such as Maes's *Woman Plucking a Duck* (pl. 97) or Koedijck's *Empty Glass* of 1648 (fig. 3). De Hooch is more rational than Maes; confident of the logic and consistency of his spaces, he fills them with light. For all their calculation, however, his interiors are never airless boxes. The open doors and windows not only offer physical and psychological release, but also seem to admit the moist Dutch air, which fills the space and envelops his figures, creating a far more compellingly naturalistic effect. Koedijck's *Empty Glass,* which in many respects anticipates the design of this picture, shares little of its sensitivity to light, atmosphere, and color. It was de Hooch who fully appreciated that the illusion of pictorial space is more than a matter of orthogonal geometry.

P.C.S.

1. Brière-Misme (1927, pp. 58, 60) noted the date, but Valentiner (1929a, no. 33) missed it.

2. See Andrea Alciati, *Emblematum libellus* (Paris, 1542), p. 138.

3. See van Mander 1604, "Wtlegginge op den Metamorphosis," fol. 9–9v.

4. Sutton 1980, cat. no. 25, pl. 22.

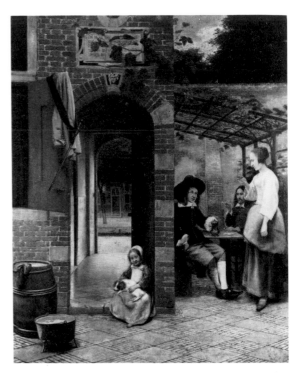

Provenance: Empress Josephine, Château Malmaison, Rueil, cat. 1811, no. 67, inv. 1814, no. 1012 (valued at 300 francs); Walscott [Wolschott?] Collection, Antwerp; bought by Edward Solly, Berlin, a few years before 1833; sale, E. Solly, London, May 31, 1837, no. 90, to G. Byng (535 pounds sterling); George Byng, London, until after 1842; Viscount Enfield, by 1856; by descent to the Earl of Stafford, Wrotham Park, Enfield.

Exhibitions: London, British Institution, 1839, no. 8; London, British Institution, 1842, no. 187; London, British Institution, 1856, no. 56; London, Royal Academy, 1881, no. 101; London, Royal Academy, 1893, no. 64; London 1929, no. 311; London 1938, no. 240; London 1952–53, no. 376.

Literature: Rueil, Château Malmaison, cat. 1811, no. 67; Smith 1829–42, vol. 4, no. 47, and suppl., no. 15; Waagen 1854–57, p. 323; Kramm 1855–64, vol. 3, p. 733; M. de Lescure, *Le Château de la Malmaison* (Paris, 1867), p. 274; Havard 1879–81, vol. 3, p. 95, no. 3; Hofstede de Groot 1892, no. 53; Wurzbach 1906–11, vol. 1, p. 717; Hofstede de Groot 1907–28, vol. 1, no. 299; de Rudder 1913, pp. 17, 21, 35, 101; Collins Baker 1925, pp. 4–5, pl. 2; Valentiner 1926–27, pp. 57, 58; Brière-Misme 1927, p. 62, p. 59, ill.; Valentiner 1929a, pp. xvi, xvii, no. 54; van Thienen 1945, p. 28, ill., and pp. 34, 35; Gerson 1952a, p. 38, fig. 106; Maclaren 1960, pp. 188–89; S. Grandjean, *Inventaire après décès de l'Impératrice Joséphine à Malmaison (1814)* (Paris 1964), p. 145, no. 1012; Blankert 1975, pp. 55–57, fig. 29; Sutton 1980, pp. 24, 26, cat. no. 33, pls. viii, 32 (detail).

FIG. 1. Plaque from No. 157 Oude Delft.

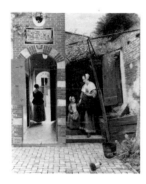

FIG. 2. PIETER DE HOOCH, *Courtyard in Delft*, 1658, oil on canvas, National Gallery, London, no. 835.

A breezeway in a brick courtyard offers a view through the house to a street, a canal, and another home. Beneath a trellised arbor on the right, two men drink and smoke at a table. The woman who stands beside them holds a wineglass. A man's coat and a bandolier with sword hang from the shutter of the window on the left. In the doorway sits a little girl with a dog on her lap. A barrel and a footed metal caldron are in the left foreground. Over the archway and below a small oval window is a tablet with an inscription partially obscured by vines; this plaque originally hung over the entrance of the Hieronymusdael Cloister in Delft and still survives in the garden behind No. 157 Oude Delft (fig. 1).[1] The inscription reads: "This is in St. Jerome's vale, if you wish to repair to patience and meekness. For we must first descend if we wish to be raised. 1614."[2]

Around 1658, de Hooch painted other merry companies in courtyards, for example, *Soldiers and a Woman Drinking* (National Gallery of Art, Washington, D.C., no. 56).[3] The courtyards, like de Hooch's interiors, have highly ordered geometric designs and often include a *doorkijkje*—a perspectival vista or view of neighboring spaces—that relieves the sense of closure. Bright daylight, pure saturated colors, and a silvery tonality characterize this series of masterpieces painted in Delft. De Hooch captured, as no other painter, the orderly appearance of the city with its gridlike plan, narrow canals, and many small, enclosed courtyards *(hofjes)*. It is remarkable, however, that these scenes are largely fictional. The wall at the right in this painting resembles sections of the old Town Wall; the glimpse through the breezeway suggests a site on the Oude Delft or the Binnenwatersloot, where the artist's wife lived and where many small courtyards still exist. A variant of this design (fig. 2) attests to the imaginary nature of the scene. Although the artist used the same design and repeated motifs like the archway and stone tablet, he changed virtually all the other details—the brickwork, the arbor, the wall at the right, and the view through the archway. The arbor with a merry company was also exchanged for a domestic scene of a mother and her daughter. In our painting, which was probably the first of the two versions, the tablet, although not identical to its source, is closer in the division of lines than its London counterpart.[4] This fact, along with the

more relaxed grouping of figures in the London version, points to our painting's primacy.

Whether the tablet's call for patience and humility (like the background religious paintings in plates 101 and 102) stands in moral opposition to the merrymakers' fun is unclear, especially given its reappearance in the London painting's scene of exemplary behavior. If a lesson was de Hooch's first concern, one would expect a more legible inscription. Whatever de Hooch's intent, the epigraph's tenor evokes the simplicity and tranquility of his courtyards.

At least seven copies of the painting exist and the little girl with a dog was formerly painted into Samuel van Hoogstraten's figureless *Interior with Slippers* (Musée du Louvre, Paris, no. RF3722).

P.C.S.

1. Hofstede de Groot 1907–28, vol. 1, no. 291.

2. "Dit is in sint hieronimus daelle/ wildt v tot pacientie en lijdt-/ saemheijt begeeven/ wandt wij muetten eerst daelle/ willen wij worden verheeven./ 1614." Translation from Maclaren 1960, p. 188.

3. Sutton 1980, cat. no. 35A, pls. 34, 36, 38.

4. Maclaren 1960, p. 189.

Shown in Philadelphia only

Woman Nursing an Infant, with a Child Feeding a Dog, c. 1658–60
Remnants of a signature on the foot warmer
Oil on canvas, 26⅝ x 21⅞" (67.6 x 55.6 cm.)
The Fine Arts Museums of San Francisco, Gift of the Samuel H. Kress Foundation, no. 61.44.37

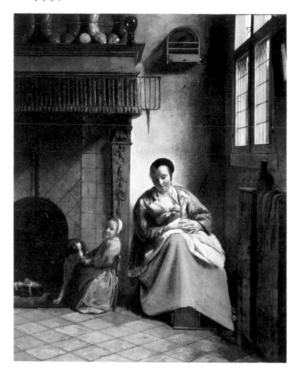

Provenance: Probably van Loon Collection, Amsterdam, by 1825;[1] van Loon Collection acquired *en bloc* by the Rothschilds, Paris, before 1880; Ronald Brakespeare, Henley; Knoedler & Co., New York, 1916; private collection, New York, by 1926; sale, K. D. Butterworth, New York, October 20, 1954, no. 29; dealer Frederick Mont, New York; Samuel H. Kress Collection, 1955 (no. κ2120).

Exhibitions: New York 1925, no. 6; Washington 1961–62, no. 45; Kansas City 1967–68, no. 6.

Literature: Smith 1829–42, vol. 4, no. 43; Havard 1879–81, p. 91, no. 2; Hofstede de Groot 1892, no. 73; Hofstede de Groot 1907–28, vol. 1, no. 11; Valentiner 1926–27, p. 61, fig. 6; Brière-Misme 1927, p. 76, ill. p. 70; Valentiner 1926–27, p. 76, no. 15; Valentiner 1929a, p. xviii, no. 71 (as c. 1663); van Thienen 1945, pp. 41, 46, ill. p. 40; San Francisco, de Young Museum, cat. 1966, p. 133, ill. (as c. 1663); Eisler 1977, p. 153, no. κ2120, fig. 139 (as late 1660s or early 1670s); Sutton 1980, pp. 21, 30, 83–84, cat. 32, pl. vii, pls. 30, 31 (as c. 1658–60); Durantini 1983, pp. 27–28, 38, fig. 11.

Pieter de Hooch's two greatest accomplishments were interrelated, namely the revelation of the beauty of space and light in Dutch homes, and the celebration of domesticity, specifically in the person of the mistress of the household—the *huisvrouw* and mother. Women and children, almost to the exclusion of husbands and fathers, repeatedly appear in simple situations in the home. De Hooch's preoccupation with women in domestic themes is related to the sanctity and centrality of the home in Dutch society. The *Woman Nursing an Infant* and the *Mother Lacing Her Bodice* (pl. 105) are two of his loveliest paintings of this theme. In this painting, a mother sits in the corner of a room with her feet propped on a small foot warmer as she nurses her infant. At her side, her young daughter feeds the family pet. In imitating her mother's gentle nurturance, the little girl underscores the premium the Dutch placed on pedagogy in the home.[2] Unlike Steen, whose depictions of the saying "As the old ones sing, so the young ones twitter" illustrate the harmful effects of parents who ignore the fact that their children ape their dissolute ways, de Hooch shows the benefits of these imitative instincts. Though a common household article and, hence, not necessarily symbolic, the birdcage at the upper right may reiterate the allusions to domestic virtue; emblems depicting a bird in a cage in contemporary literature were appended with verses referring to the "sweet slavery of [marital] love."[3] Love, of course, is also associated with the cupid that decorates the pilaster on the fireplace.

Woman Nursing an Infant evidently descends from a series of paintings of women at work by Nicolaes Maes, c. 1655 (see pl. 97).[4] Maes, who anticipated de Hooch's interest in space and domestic themes, spotlighted the figure and cast his background mostly in shadow, thus disguising his imperfect understanding of perspective, whereas de Hooch flooded his scene with daylight. The geometry of de Hooch's interior—the foreshortening of the mullioned window, the squares of the tiled floor and fireplace, the right angle of the corner—never falters. The whitewashed walls of de Hooch's spaces, those perimeters of private life, form a comforting framework for daily chores. His palette, set here by the triad of the primary hues (blue, red, and yellow) in the nursing mother's costume, complements the simple structural clarity of his designs.[5]

Mother Lacing Her Bodice beside a Cradle,
c. 1661–63
Oil on canvas, 36¼ x 39⅜″ (92 x 100 cm.)
Gemäldegalerie, Staatliche Museen Preussischer
Kulturbesitz, Berlin (West), no. 820B

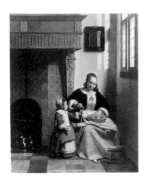

FIG. 1. PIETER DE HOOCH,
*Woman Peeling Apples with
a Child*, oil on canvas,
Wallace Collection, London,
no. P23.

The classical order of de Hooch's Delft period
compositions, so suited to the worldless serenity
of his subjects, must have appealed to his fellow
townsman Vermeer, who developed the theme of
one or two figures in the lighted corner of a
room to unequaled perfection. De Hooch, evi-
dently recognizing the extraordinary success of
his own paintings of the late 1650s, often re-
turned to their designs. *Woman Peeling Apples
with a Child* (fig. 1), for example, employs vir-
tually the same composition even in such details
as the decorations on the fireplace. Yet its
greater formality, cooler light, more intense
color scheme, and possibly even the smaller
motifs on the tiles, point to later origins, proba-
bly in de Hooch's first years in Amsterdam, or
about 1663.[6]

<div align="center">P.C.S.</div>

1. According to Havard (1879–81, p. 91, no. 2) identical
with Smith 1829–42, vol. 4, no. 43.

2. Durantini's assumption (1983, p. 27) that the mother's
nurturance is contrasted with the girl's "improper" act of
feeding and thus "demeans the image of the nursing woman
by equating a dog with an infant" probably misinterprets the
image. Her suggestion, moreover, that the dog eating out of
the child's lap has "sexual overtones" is ludicrous in the
larger context of de Hooch's art.

3. Jacob Cats, *Silenus Alcibiadis, sive Proteus* (Amsterdam,
1622), p. 74, with motto: "Amissa Libertate Laetior"; for
discussion, see de Jongh 1967, pp. 34–38; de Jongh 1968–
69, pp. 50–51; de Jongh et al. in Amsterdam 1976, under
cat. 58.

4. See *Woman Making Lace*, dated 1655, private collection
(Sutton 1980, fig. 18) and *Woman Scraping Parsnips*, Na-
tional Gallery, London, no. 159.

5. To demonstrate the history of color in Dutch painting,
Jantzen (1912) used de Hooch's oeuvre as his primary exam-
ple, concluding that his development culminated in the
period 1654–63 (roughly corresponding to his Delft period),
which was characterized by a highly rational use of color.

6. Sutton 1980, p. 30, cat. 61, pl. 65.

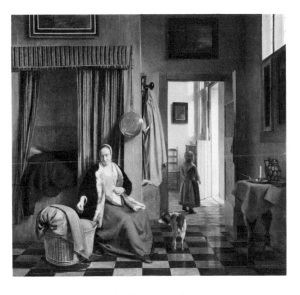

Provenance: Sale, Marin, Paris, March 22, 1790, no. 102, to
Saubert (1,500 francs); Mme Hoffman, Haarlem, by 1827;
bought by dealer Nieuwenhuys from executors of the Hoff-
man Estate, 1846; sale, Schneider, Berlin, April 6–7, 1876,
no. 13, to the museum.

Exhibitions: Washington/New York/Chicago 1948–49, no.
99 (Washington), no. 63 (New York); Amsterdam 1950, no.
57, fig. 97; Paris 1951, no. 91, pl. 118.

Literature: Smith 1829–42, vol. 4, nos. 9, 52, and suppl.
(1842), no. 26; L. Wronski, *Revue des Arts*, vol. 5 (1876), p.
16 (as N. Maes); L. Gonse, *Revue des Arts*, vol. 5 (1876), p.
72; Hofstede de Groot 1892, no. 16; Bode 1906, p. 59;
Wurzbach 1906–11, vol. 1, p. 716; Hofstede de Groot
1907–28, vol. 1, no. 3; Jantzen 1912, pp. 13–18; de Rudder
1913, pp. 16, 27, 39, 43, 101, ill.; K. Lilienfeld in Thieme,
Becker 1907–50, vol. 17 (1924), p. 453; Collins Baker
1925, pp. 6, 7 (as c. 1665); Valentiner 1926–27, p. 61 (as
before 1663); Brière-Misme 1927, pp. 58, 62; Valentiner
1929a, p. xvii, no. 56 (as c. 1659–60); van Thienen 1945,
pp. 35–36, ill.; Brière-Misme 1954a, pp. 78–79, fig. 6;
Rosenberg et al. 1966, p. 125, pl. 100B; Robinson 1974, pp.
62, 83 n. 93; Berlin (West), Gemäldegalerie, cat. 1975, p.
206, no. 820B (as c. 1659–60); Sutton 1980, pp. 30, 54, 91,
cat. no. 51, pls. 54, 55 (as c. 1661–63).

Seated beside a wicker cradle in front of an en-
closed bed covered with a striped curtain, a
woman smiles as she laces her bodice. A door-
way at the right leads to a lighted foyer, or
voorhuis, where a young child stands silhouetted
near an open half-door. The lower portion of
the window on the right is shuttered; the open
upper half admits gentle daylight, which falls di-
agonally across the scene. A gleaming brass bed
warmer hangs beside the alcove of the bed; to
the side is a red cloak or skirt on a coat rack.
Before the window is a small table with a
candlestick and ceramic jug. A small dog stands
on the tiled floor at the woman's feet.

FIG. 1. PIETER DE HOOCH,
The Bedroom, oil on can-
vas, National Gallery of
Art, Washington, D.C.,
no. 629.

FIG. 2. MARTEN VAN CLEVE,
The Formal Visit, oil on
panel, John G. Johnson Col-
lection at the Philadelphia
Museum of Art, no. 424.

FIG. 3. PIETER DE HOOCH,
*Mother Nursing and a
Maidservant with a Child*,
oil on canvas, Kunst-
historisches Museum,
Vienna, inv. no. 5976.

This unsigned painting once was incorrectly attributed to the Dordrecht master Nicolaes Maes, whose earlier works influenced de Hooch's domestic themes. Entirely characteristic of de Hooch, the picture is an outstanding example of his work from the early 1660s.[1] In 1907 Hofstede de Groot called it the best painting by the artist in Germany, a claim that still holds true. With the mother placed beside the covered bed and the child silhouetted before the sunny doorway, the design recalls compositions that de Hooch first developed in Delft (see fig. 1).[2] De Hooch's virtuoso treatment of light (note especially the reflections on the tiled floor) also began in the Delft period. However, the more monumental scale of the Berlin painting and its stronger chiaroscuro point to origins in the early Amsterdam years. In execution and coloring it is closest to *Portrait of a Family at Music* of 1663 (Cleveland Museum of Art, Cleveland, no. 51.355);[3] both works exhibit a newly refined touch and special attention to details and textures of still-life elements.

The mother in the Berlin painting smiles at the cradle; presumably, she has just finished nursing her infant. Breast feeding among the upper classes did not become widespread until the seventeenth century, although recommended by many earlier writers. The fact that Moryson, early in the seventeenth century, found it noteworthy that "most commonly [Dutch] mothers nurse their children themselves" attests to the recent spread of the practice.[4] Painted about fifty years earlier, Marten van Cleve's *Formal Visit* (fig. 2) probably depicts a wealthy couple visiting their child in the household of a wet nurse. Amidst objects and animals in the disorderly peasant kitchen, the mother kneels beside the nurse, who sits on the floor and holds the child on a straw mat used for nursing *(bakermat)*. The husband, standing on the right, dispenses money. Like many authors of the period, the physician Johan van Beverwijck strongly recommended that mothers suckle their own children.[5] A mother who nursed her own child passed on not only nourishment, but also her morals and intellectual capacities; some believed the milk was actually whitened blood. One of Jacob Cats's favorite aphorisms emphasized the mother's duty to nurse: "She who bears her children is mother in part,/ But she who nurses her children is a complete mother."[6] In addition, he issued a lengthy warning against the dangers of entrusting one's child to a wet nurse, who, on the one hand, might be a drunk or a degenerate who would neglect the infant or pass on her lowly and immoral character. He further warned that she might become more loved and respected than the mother herself. In accordance with prevailing seventeenth-century notions of maternal obligations and domestic virtue, even the richest of de Hooch's women nurse their own children (see fig. 3).

P.C.S.

1. L. Wronski in *Revue des Arts*, vol. 5 (1876), p. 16.

2. Sutton 1980, cat. 40A.

3. See Sutton 1980, cat. 53.

4. Moryson 1971, pt. 3, bk. 4, p. 289.

5. See *Schat der gesontheyt* (Utrecht, 1651), pp. 605–15. For other Dutch and European authors who advocated maternal nursing, see Durantini 1983, pp. 18–20.

6. "Een die haer kinders baert, is moeder voor een deel,/ Maer die haer kinders sooght, is moeder in 't geheel." Jacob Cats, *Houwelick, dat is de gantsche gelegenheyt des echtenstaets* (Middelburg, 1625), in *Alle de Werken* (Amsterdam, 1712), p. 275 (author's translation).

Rotterdam? 1616–1679 *Hillegersberg*

Messenger Reading to a Group in a Tavern,
1657
Signed and dated on the fireplace:
L. DJongh 1657 (D J in ligature)
Oil on canvas, 25⅝ x 20⅞″ (65 x 53 cm.)
Mittelrheinisches Landesmuseum, Mainz,
inv. no. 800

Literature: Van Spaan
1698, p. 421; Houbraken
1718–21, vol. 2, pp. 33–
34; Kramm 1857–64, vol.
3, p. 816; Bode 1883, pp.
168–70; Haverkorn van
Rijsewijk 1896; Wurzbach
1906–11, vol. 1, p. 762; C.
Hofstede de Groot in
Thieme, Becker 1907–50,
vol. 19 (1926), pp. 132–34;
Bredius 1928a; Hollstein
1949–, vol. 9, p. 222; Hel-
bers 1955; Plietzsch 1960,
pp. 55–58; Schatborn
1975; Fleischer 1978;
Amsterdam/Washington
1981–82, p. 77; Fleischer
forthcoming.

*Ludolf de Jongh was the son of the tanner and
shoemaker Leendert Leendertsz. According to
Houbraken, he was born in the village of Over-
schie in 1616, but municipal records suggest that
his birthplace was actually nearby Rotterdam.
Houbraken further claimed that de Jongh stud-
ied with Cornelis Saftleven (q.v.) in Rotterdam,
Anthonie Palamedesz. (q.v.) in Delft, and Jan
van Bijlert (1597–1671) in Utrecht before trav-
eling to France with Frans Bacon in 1635. He
remained in France for seven years, returning to
Rotterdam around 1642. On February 6, 1646,
the artist married Adriana Montagne, the daugh-
ter of Pieter Montagne. In 1652, through the
offices of his father-in-law, de Jongh became a
major in the Rotterdam militia company; he
subsequently executed a large group portrait of
his fellow members. The artist also served as
governor of the city's Oudemannenhuis (old
men's home). On October 26, 1665, he was
appointed protector of Hillegersberg, a village
north of Rotterdam. According to town records,
he died there, childless, between May 27 and
September 8, 1679.*

*De Jongh's oeuvre is composed of portraits,
historical subjects, genre works, and city- and
landscape scenes. In his* Beschrijvinge der Stad
Rotterdam *(1698), van Spaan claims that de
Jongh also painted room decorations; however,
none have survived. He collaborated occasion-
ally with his brother-in-law, Dirck Wijntrack
(c. 1625–1678), and the landscapist Joris van
der Haagen (c. 1615–1669).*

C.V.B.R.

Provenance: Jhr. H. A. Steengracht van Duivenvoorde, The
Hague; sale, Steengracht, Georges Petit, Paris, June 9, 1913,
no. 35, ill; purchased by the museum.

Exhibitions: Mainz, Haus am Dom, *Niederländische
Gemälde aus Mainzer Galeriebesitz,* May 13–October 2,
1955, no. 33, fig. 30; Speyer, Historisch Museum der Pfalz,
Ein Grosses Jahrhundert der Malerei, April 13–June 10,
1957, no. 51, fig. 31.

Literature: Bode 1883, p. 169; Haverkorn van Rijsewijk
1896, p. 45; C. Hofstede de Groot in Thieme, Becker 1907–
50, vol. 19 (1926), p. 132; Plietzsch 1960, p. 57, fig. 77;
Bernt 1970, vol. 2, fig. 594; Fleischer 1978, p. 59, fig. 17;
Sutton 1980, pp. 12–13, fig. 3; Mainz, Mittelrheinisches
Landesmuseum, cat. 1980, p. 113, ill.

In a tavern interior a messenger sits on a low,
three-legged stool reading from a piece of paper.
He wears a tall, short-brimmed hat and has a
long trumpet slung over his shoulder. An old
man sits across from the messenger, listening at-
tentively. In his right hand he holds a pipe, in his
left a bottle. Another man sits behind the trum-
peter, and a girl leans on the back of the old
man's chair. The scene is lighted from a window
at the left. At the back right is a hearth; in the
center foreground a brazier rests atop a foot
stove.

In addition to portraits, history paintings,
hunting and riding scenes, elegant genre subjects,
land- and cityscapes, and courtyard paintings,[1]
Ludolf de Jongh executed a number of stable
scenes and soldier paintings. The *Messenger
Reading to a Group in a Tavern* bears the ear-
liest date in this series, the only other dated

example being the *Tavern Scene* of 1658 (fig. 1). Several related paintings appear to be earlier works.[2] The fact that such scenes resemble the early guardroom portrayals of de Jongh's Rotterdam colleague Pieter de Hooch and the persuasive argument that at least two paintings formerly attributed to de Hooch are actually the work of de Jongh[3] make it quite possible that the young de Hooch was influenced by the older artist in the early 1650s. De Jongh's later elegant genre, courtyard, and garden subjects suggest, however, that the direction of influence may have reversed around 1658, when de Hooch began painting his own highly ordered courtyard scenes, such as *Courtyard with an Arbor and Drinkers* (pl. 103). At the very least, the artists' working relationship became a more reciprocal one.

The messenger in this painting may be reading the sheet aloud because the company in attendance cannot read. Ludovico Guicciardini surely exaggerated when he claimed in 1565 that almost everyone in the countryside of Holland could read and write.[4] Although accurate literacy statistics are unavailable, records of betrothals in Amsterdam from around this time indicate that one out of three men and two out of three women could not sign their own names.[5] The sheet from which the messenger reads may be a letter, but it could also be a broadsheet or pamphlet. Before newsletters *(corantos)* or newspapers were widely circulated, pamphlets were printed on all varieties of topical subjects.[6] More than twenty thousand Dutch pamphlets have survived from the period between 1560 and 1795.[7]

P.C.S.

1. As examples, see respectively, *Portrait of a Mother and Daughter*, signed and dated 1653, Gemäldegalerie Alte Meister, Dresden; *Granida and Daifilo*, Kulturgeschichtliches Museum, Osnabrück; *Riders before an Inn*, Musée d'Art et d'Histoire, Geneva; *Woman Receiving a Letter in a Foyer*, National Trust, Ascott House; *View of the Kneuterdijk in The Hague*, Kunsthistorisches Museum, Vienna; and *Hunting Party in the Courtyard of a Country House* (pl. 93).

2. See the *Public House*, which was sold as early as 1775 as the work of de Jongh, and the so-called *Reprimand*, which bears the artist's signature (Fleischer 1978, figs. 18 and 19, respectively).

3. Fleischer 1978, pp. 57–64; see *Reveille*, North Carolina Museum of Art, Raleigh, inv. no. 52.9.45 (Sutton 1980, no. D21—the painting was sold as early as 1780 as the work of de Jongh) and *Paying the Hostess*, private collection, New York (Sutton 1980, no. D20).

4. Ludovico Guicciardini, *Commentari delle cose più memorabili segrite in Europa* (Venice, 1565); quoted by Murris 1925, p. 113.

5. Van Deursen 1978b, p. 68. Working-class women entered the labor force earlier than their male counterparts and were thus more poorly educated.

6. Amsterdam's earliest newspaper appeared around 1620; the *Rotterdamsche Courant* did not begin until 1717. See Schotel 1905, pp. 66–80.

7. Parker 1977, p. 269; see also W.P.C. Knuttel, *Catalogus van de pamfletten verzameling berustende in de Koninklijke Bibliotheek*, 8 vols. (The Hague, 1889–1916); and van Deursen 1978b, pp. 90–97.

FIG. 1. LUDOLF DE JONGH, *Tavern Scene*, 1658, oil on canvas, Groninger Museum, Groningen.

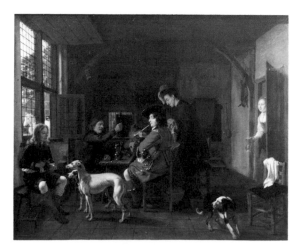

Hunting Party in the Courtyard of a Country House, late 1660s
Oil on canvas, 27 x 32" (68.6 x 81.3 cm.)
The Detroit Institute of Arts, Gift of Mr. and Mrs. James S. Whitcomb, no. 58.169

Provenance: London art market, 1956; Mortimer Brandt, New York, 1958.

Exhibition: Saint Petersburg/Atlanta 1975, no. 17, ill.

Literature: Plietzsch 1960, p. 57, pl. 78; Detroit, Detroit Institute of Arts, cat. 1965, p. 60.

An elegant couple on horseback assemble with their dogs, bearers, and servants in the brick forecourt of a classical-styled country home. A shaft of morning light falls on a pikeman about to lead the party through the heavy stone entranceway at the left. Bounded on both sides and at the back, the boxlike courtyard is constructed with special attention to perspective.

De Jongh's interest in courtyard space was undoubtedly inspired by his fellow Rotterdamer Pieter de Hooch, who had begun painting the orderly but more intimately scaled middle-class courtyards of Delft by 1658, the date of his *Courtyard with an Arbor and Drinkers* (pl. 103). De Jongh's courtyards give a greater impression of closure, in part because he often includes the second lateral wall, as in his rather rigidly constructed *Courtyard Scene* (Metropolitan Museum of Art, New York, acc. no. 20.155.5). His courtyards thus differ from de Hooch's in some of the same ways in which the interiors of Janssens Elinga are distinguishable from the master's.

The *Hunting Party* is one of the most successful of de Jongh's courtyards and garden scenes. It foregoes the exaggerated perspectival vistas he often introduced, as in *A Formal Garden* (Her Majesty Queen Elizabeth II) and *Scene in a Garden* (fig. 1),[1] but still offers a particularly sensitive treatment of light and atmosphere. Owing to the scarcity of dated works by de Jongh, situating this picture in his oeuvre is problematic. The work probably precedes the *Scene in a Garden* of 1676, which repeats its lighting system, and surely postdates the *Messenger Reading to a Group in a Tavern* of 1657 (pl. 92) and the *Tavern Scene* of 1658 (see cat. no. 56, fig. 1). No dated genre paintings by the artist are known between 1658 and 1676. The *Hunting Party* is perhaps closest in conception to the undated *Elegant Company in a Courtyard with a Coach* (fig. 2), which in the past has been wrongly attributed to de Hooch.[2] Judging from the costumes, both works appear to date from the late sixties.

Many wealthy Dutch families built country homes in emulation of the landed aristocracy, particularly after mid-century. The favored sites lay along the Amstel and Vecht rivers. Architectural painters like Jan van der Heyden did a brisk business in depicting country houses, both real and fictional, and genre painters, like de Hooch and de Jongh, painted their inhabitants' leisured diversions.[3] The actual house in the *Hunting Party,* with its lovely order of double Corinthian pilasters and its brick tower with marble quoins, has not been identified. In all likelihood it is imaginary; Dutch castles *(sloten)* and country homes were rarely so grand. More-

FIG. 1. LUDOLF DE JONGH, *Scene in a Garden*, 1676, oil on canvas, private collection.

FIG. 2. LUDOLF DE JONGH, *Elegant Company in a Courtyard with a Coach*, oil on canvas, P. de Boer, Amsterdam, 1963.

over, pentimenti in the work, which indicate a rethinking of details of the facade, suggest that the painting is not a record of an existing building.[4] The activities depicted here, however, are appropriate to the elegant setting. Hunting was closely associated with the court and nobility in Holland. The pursuit of most game was limited to the aristocracy and other officers of state. Highly restrictive gaming laws, handed down and overseen by the court, defined the hunting season and specified the type and quantity of game allowed, and even the breed and number of dogs permitted on the hunt.[5] Hunting with a greyhound (see the dog at the pikeman's side), for example, was permitted only once a week.

<div align="right">P.C.S.</div>

1. See Capetown, South African National Gallery, *Natale Labia Collection on Loan to the South African National Gallery Capetown* (Capetown, n.d.), ill.; also London, Wildenstein Galleries, *Twenty Masterpieces from the Natale Labia Collection* (London, April 26–May 26, 1978), no. 11, ill.

2. See Paris 1967, no. 51, pl. 15 (as "Pieter de Hoogh"). Plietzsch was the first to correctly attribute the work to de Jongh (1960, p. 57); see Sutton 1980, cat. D32.

3. For van der Heyden's works, see H. Wagner, *Jan van der Heyden* (Amsterdam/Haarlem, 1971), pp. 44–46. See, for example, Pieter de Hooch's *Skittles Players in the Garden of a Country Home*, c. 1663–66 (James A. de Rothschild Collection, Waddesdon Manor; Sutton 1980, cat. 60A).

4. See Saint Petersburg/Atlanta 1975, p. 32.

5. The ordinances governing hunting were recorded in two sources: Paullus Merula's *Placaten ende ordonnancien op 'tstuck vande Wildernissen* (The Hague, 1605) and "Het Jachts-Bedrijff," an anonymous manuscript from 1636 in the Royal Library, The Hague (published in *Nedelandsche Jager*, [1898–1900], nos. 169–238); see S. A. Sullivan, "The Dutch Game Piece" (Ph.D. diss., Case Western Reserve University, 1978) and "Rembrandt's *Self Portrait with a Dead Bittern*," *The Art Bulletin*, vol. 62, no. 2 (June 1980), pp. 236–43.

Little is known of Simon Kick's life. Born in Delft in 1603, he was the son of an Amsterdam japanner. He moved to Amsterdam before 1624, becoming a permanent resident, and is again documented in the city in 1631, 1633, 1643, 1646, 1647, 1651, and 1652. He belonged to a circle of artists including Jacob Duck, Pieter Codde, and Willem Duyster (q.q.v.) who painted soldiers in guardrooms, officers smoking and banqueting, and interior scenes with merry companies. On September 5, 1631, Kick married Styntge Duyster in a double wedding ceremony that also united Styntge's brother, the painter Willem Duyster, and Margrieta Kick, Simon's sister.

Kick died in Amsterdam and was buried on September 26, 1652. According to Houbraken, he taught his son, the still-life painter Cornelis Kick (1635–1681); no other pupils are known.

<div align="right">C.V.B.R.</div>

Company of Soldiers, mid to late 1640s
Oil on panel, 48 x 48″ (122 x 122 cm.)
Private Collection

Literature: Bode 1883, pp. 153–56; Bode, Bredius 1889; Wurzbach 1906–11, vol. 1, pp. 276–77; Bode 1915–16; Bredius 1915–22, vol. 3, pp. 793–94, and vol. 7, p. 31; C. Hofstede de Groot in Thieme, Becker 1907–50, vol. 20 (1927), pp. 254–55; Haex 1981–82.

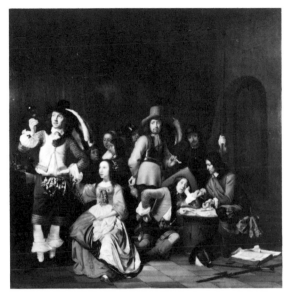

Provenance: Possibly sale, Johannes van Bergen van der Grip, Soeterwoude, June 26, 1784 (as "A Corps de Garde with soldiers and Weapons"); Marquis de Foz, late 1800s; sale, Christie's, London, June 11, 1892, no. 79, ill. (as Godfried Schalcken); dealer Kleinberger, Paris; sold to dealer Forbes & Patterson, London; sold to J. R. Robinson, London, c. 1894–95;[1] sale, J. R. Robinson, Christie's, London, June 6, 1923, no. 71, to Jennings (900 guineas); evidently reacquired by Robinson's daughter, Princess Labia, by 1958–59; sale, Mrs. P. A. Chamier et al., Christie's, London, April 10, 1981, no. 22, ill.; with dealer P. de Boer, Amsterdam.

Exhibitions: London, Royal Academy, *The Robinson Collection,* 1958, no. 13; Capetown, National Gallery of South Africa, *The Sir Joseph Robinson Collection,* 1959.

Literature: C. Hofstede de Groot in Thieme, Becker 1907–50, vol. 20 (1927), p. 254; *The Robinson Collection: Paintings from the Collection of the Late Sir J. B. Robinson* (London, 1958), p. 39; Haex 1981–82, pp. 294–98, ill.

FIG. 1. SIMON KICK, *Standard Bearer with Other Soldiers,* 1648, oil on canvas, formerly Baszanger Collection, Geneva.

FIG. 2. SIMON KICK, *Officers and Soldiers,* oil on panel, Kunstmuseum, Basel, inv. no. 387.

A group of eleven figures—officers, soldiers, two women, and boys attired in brightly colored costumes—assemble in a tall, shadowed space. Two sappers, seated and kneeling at the right, converse over a map that they have spread out on a drum. At the left an elegantly attired officer with a young lady seated at his left raises his roemer, perhaps in a festive toast. Tall stone archways in the background reveal additional architecture.

The painting's subject has been identified, perhaps correctly, as a scene of soldiers relaxing before attempting to besiege a city.[2] The presence of women in the group in no way obviates a military subject. Armies in the seventeenth century always traveled with an entourage; indeed the camp followers—women, children, tradesmen, *soetelaars* (sutlers), tramps, and vagabonds—sometimes outnumbered the regular troops.[3]

Prior to 1895 the painting carried the false signature of Godfried Schalcken, who enjoyed considerable renown in the eighteenth and nineteenth centuries; however, it is surely the work of the lesser-known Kick, whose earliest dated works are a Rembrandtesque *Man in a Turban Reading a Book* from 1637 (Art Institute, Dayton) and a *Study of an Old Man* from 1639 (Rijksmuseum, Amsterdam, no. A2841). Although Kick's only other dated works are from 1648, in all likelihood he had begun painting guardroom scenes well before that date. Two of these dated works are related in style and subject to this painting: *Soldiers Resting* (Kaiser Friedrich Museum, Berlin, no. 858A; destroyed 1945) and the *Standard Bearer with Other Soldiers* (fig. 1).[4]

The latter work and the *Company of Soldiers* also share a similar design—a somewhat crowded composition with an officer toasting prominently while the other figures strike poses of studied informality—as well as some of the same models.[5] Also characteristic of Kick are the relatively large-scale diagonal composition and individual figure motifs, such as the toasting gesture and the lounging officer. The latter motif reappears in *Officers and Soldiers* (fig. 2), a painting that is also comparable for its grand architectural setting—the vaulted interior of a great hall or church—and its unusual square format. Apparently Kick shared Willem Duyster's taste for soldier themes and a refined technique and perhaps also something of his brother-in-law's original approach to painting formats; Kick, however, never experimented like Duyster with circular or oval panels. The artist differs from Duyster in his stronger tonal contrasts and bolder colors, qualities undoubtedly related to the fact that his career lasted longer; while Duyster, who died in 1635, worked at the height of the tonal phase of Dutch painting, Kick lived until 1652.

The costumes and accessories in the *Company of Soldiers* assist in the dating. The toasting officer's shirt jacket of a French cut trimmed with buttons worn over a loose blouse and his three-quarter-length trousers with embroidered edges are representative of a style that became popular after 1640; his full white stockings were in fashion in 1641–42. The halberd in the right foreground is a weapon carried by lieutenants or captains in the early 1640s. The *wandeldegen* (literally a "walking sword," a ceremonial weapon), also in the right foreground, was not in use after 1645.[6] Thus it is likely that the painting dates from the mid to late 1640s.

Given this date, the inspiration for Kick's painting could have come from Rembrandt's *Night Watch* of 1642 (Rijksmuseum, Amsterdam, no. C5). Elements of the design and scattered details—the highlighted officers in the foreground, the densely grouped soldiers behind them (especially the two helmeted soldiers to either side of the central figure), the tall pikes and the drum at the right, and the darkened archway from which the figures, in effect, fan out toward the viewer—all recall Rembrandt's masterpiece. The resemblance to the most famous of all militia company portraits raises the question of whether Kick's figures might include portraits.

<div align="center">P.C.S.</div>

1. According to the unpublished fiches of C. Hofstede de Groot, preserved at the Rijksbureau voor Kunsthistorische Documentatie, The Hague.

2. Haex 1981–82, p. 295.

3. See Playter 1972, p. 104; and J. Boxel, *Vertoogh van de Krijghs—Oefeninge* (The Hague, 1673), bk. 3, p. 19.

4. With dealer Koti, Paris, 1951. Haex 1981–82, p. 294, ill. A third painting by Kick dated 1648 is the *Toilette Scene,* Museum der Bildenden Künste, Leipzig, no. 1036.

5. A copy of the figure in a cuirass and the two helmeted figures flanking him was wrongly attributed to Pieter de Hooch (sale, Heuschen, Wuppertal, October 6, 1954; ill. in *Weltkunst* [September 1, 1954]).

6. In identifying the costumes and accessories, Haex (1981–82, p. 296) acknowledges the assistance of R.B.F. van der Sloot and J. G. Kerkhoven of the Koninklijk Nederlands Legermuseum "General Hoefer," Leiden.

Isaack Koedijck was the son of Jan Koedijck and Magdalena Ysacksdr. Documents from 1641 and 1664 that give his age suggest that the artist was born in Amsterdam in 1617 or 1618. On May 10, 1641, Koedijck and Sophia de Solemne, the widow of Gideons Bouwens, recorded their banns in Amsterdam; they were married eight days later in Leiden. The couple lived alternately in Leiden and in Amsterdam, and there is evidence that they had financial problems in both cities. On July 29, 1642, the artist owed rent on a house in Leiden, and on November 16, 1644, an inventory of his household goods was made in Amsterdam in his absence. On December 29, 1644, he evidently reached an agreement with his creditors. He was in Leiden on January 18, 1645, but by March 8 he had returned to Amsterdam, where he witnessed the wedding of the artist Karel Slabbaert (c. 1619–1654) and Cornelia Bouwens, his wife's former sister-in-law.

Koedijck is next documented on August 4, 1651, with his wife in Batavia. He was awaiting passage with the Dutch East India Company to Agra, where he was to serve as court painter to the Great Mogul Dschahangir. By the end of the year, he had arrived in Surat, the headquarters of the Dutch East India Company, and was forced to give up the remainder of his trip. On September 17, 1652, he was employed by the company as a merchant and was stationed at Ahmadabad, north of Surat. After acting in this capacity (both in Ahmadabad and Surat) for more than four years, Koedijck was discharged. In 1659 after several months as a secretary with the Batavian government, he was again employed by the East India Company, this time as commander of the fleet returning to Holland. By August 9 Koedijck was back in the Netherlands.

Throughout the next decade, the artist is documented in both Haarlem and Amsterdam. His wife died in early 1667, leaving three daughters (one from her first marriage). Koedijck died, probably in Amsterdam, shortly before March 17, 1668, when his will was read.

<div align="right">C.V.B.R.</div>

The Foot Operation, late 1640s or c. 1650
Signed in full on the crosspiece of the table
Oil on panel, 35⅝ x 28½" (90.5 x 72.5 cm.)
The Trustees of the Late Julius Lowenstein

Literature: Van Gool 1750–51, vol. 1, p. 36; van Eynden, van der Willigen 1816–40, vol. 1, p. 324, and vol. 4, p. 135; Thoré-Bürger 1858, p. 101; Thoré-Bürger 1860a, p. 63; Hofstede de Groot 1903; Wurzbach 1906–11, vol. 1, p. 312; Bredius 1909a; Martin 1909b; Hofstede de Groot 1927; C. Hofstede de Groot in Thieme, Becker 1907–50, vol. 21 (1927), pp. 111–13; Plietzsch 1960, p. 79.

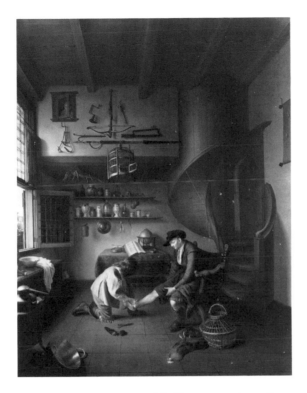

Provenance: Willem Lormier, The Hague, 1752 (according to Thoré-Bürger 1860a); Julius Böhler, Munich; Adolphe Schloss, Paris, 1906; sale, A. Schloss, Galerie Charpentier, Paris, December 5, 1951, no. 32, pl. 22 (as "Le Chirurgien"); dealer A. Brod, London, by 1952, who sold it to the present owner.

Exhibitions: Leiden 1906, no. 23A; London 1952–53, no. 421.

Literature: Thoré-Bürger 1860a, p. 64; A. Bredius, *L'Exposition du Tricentenaire de Rembrandt* (Leiden, 1906), pl. 21; Martin 1909b, p. 2; Hofstede de Groot 1927; C. Hofstede de Groot in Thieme, Becker 1907–50, vol. 21 (1927), p. 112; J. de Loos-Haaxman, *De Landverzameling, Schilderijen in Batavia* (Leiden, 1941), pl. 26; Bazin 1950, no. 120, ill.; Robinson 1974, pp. 92, 98–99, 222, fig. 226.

A barber-surgeon kneeling at the left bandages the foot of a birdseller seated in an armchair. To the right in the steep, boxlike interior is a spiral staircase with doorway and, in the left wall, mullioned windows. At the back of the room is a table covered with carpet, with a terrestrial globe and a large book open to a page inscribed "Maurits van Nassau." Above it are shelves covered with ceramic vessels, glass jars, a metal bowl, a corncob, medical instruments, a rattan basket used to hold urinalysis vials, and a skull and the skeleton of a small animal. Hanging above are a birdcage and a stuffed crocodile as well as various tools (a drill and a saw) and weapons (a crossbow and a harpoon). Before the window are a mirror, vessel, and bowl with a cloth on a table; on the floor are an alembic and metal basin. On the right wall is cloth hanging with small objects attached, very likely the bags of medicine that commonly were displayed by medical types at their outdoor stands. The bird-seller's wicker cage and a bound rooster lie on the floor across from the surgeon's dressing kit. A woman peeks through a tiny window at the top of the back wall and figures crossing a bridge appear through the window at the left. A stork's nest is just visible in the distance.

The barber-surgeon was distinguished from the university-trained doctor in the seventeenth century. Surgeon's guilds with rules governing membership and public practice had been established in the Netherlands as early as the fourteenth century.[1] Not all guilds, however, distinguished between master surgeons and master barbers. Consequently one might as readily go to a surgeon to have one's beard trimmed as to have a boil lanced or to undergo such common medical practices as bloodletting. Johan van Beverwijck, though scarcely so distinguished as the great Netherlandish anatomist Versalius, was one of the country's leading doctors who praised the surgeon in his "Lof der Chirugie": "Surgery or the art of healing, [is] a primary aspect of medicine [and] has, among all the arts practiced with the hand, been highly respected and prized, indeed the Roman lawgivers conferred the name of doctor on surgeons."[2] Both in the theater and the visual arts, however, the barber-surgeon no less than the doctor was usually a figure of ridicule (see pl. 81). The barber-surgeon's reputation was tarnished by the many quacksalvers who peddled their services at the market or during kermis. These charlatans included *keisnijders* (literally "stone cutters," who convinced unlettered peasants that they could cut out the "stone" of their ignorance with a head operation), *piskijkers* (shady diagnosticians who claimed to be able to read ailments in the patient's urine), *kopsters* (who applied painfully hot metal cups to the patient's skin, supposedly to draw the illness to the surface), and those brutally amateurish dentists, the *kiezentrekkers* (see pl. 89).[3] Most of these quacks were depicted by sixteenth-century artists, beginning with Hieronymus Bosch (Prado, Madrid) and Lucas van Leyden, who made prints of surgeons and dentists. The immediate forerunners of

FIG. I. CORNELIS DUSART,
The Kopster, 1695, etching.

FIG. 2. ISAACK KOEDIJCK,
The Reveler, 1650, oil on
panel, The Hermitage,
Leningrad, inv. no. 1862.

FIG. 3. Engraving from JAN
VREDEMAN DE VRIES, *Per-
spectiva* (Antwerp, 1604),
pl. 36.

Koedijck's picture are paintings by Brouwer
and Dou and his circle.[4]

At least in the sixteenth and the early decades
of the seventeenth century, paintings of barber-
surgeons and other medical types operating usu-
ally fall under the purview of low life because
the patient invariably was a grimacing peasant.
Often the latter was accompanied by his con-
cerned spouse or other gawking companions.
Koedijck's patient, despite his jaunty felt hat, is
also a common peasant type, the *vogelaar* or
birdseller—a figure potentially with both comic
and lewdly amorous associations.[5] Yet, unlike
foot operations depicted by other artists, such as
Jan Steen and Cornelis Dusart (fig. 1), Koedijck
barely stressed the comical possibilities of the
subject aside from the hint of a smile on the face
of the girl in the window.[6] Rather, as in Willem
Buytewech's drawings (Teylers Museum,
Haarlem, inv. nos. 0 22 and 23), the barber-
surgeon appears as a respectable burgher, his of-
fice outfitted with all the scholarly and
gentlemanly trappings of the day. The surgeon's
guildhall in Amsterdam was furnished not only
with Rembrandt's famous *Anatomy Lessons of
Dr. Tulp* (Mauritshuis, The Hague, no. 146)
and *Dr. Deyman* (Rijksmuseum, Amsterdam,
no. C85) but also with displays of medical in-
struments and "curiosities." The stuffed
crocodile was a standard feature of surgeons'
offices and apothecaries' shops, perhaps because
of associations with the salamander—the crea-
ture credited in alchemical theory with the *elixir
vitae* because it was believed to live in fire.[7] A
weapon made obsolete by the musket, the
crossbow was still the symbol of specific militia
companies, those exemplary middle-class social
organizations. The harpoon is more difficult to
explain but whale jawbones often appeared
among apothecaries' and surgeons' supplies.

Both the figures' costumes and the stylistic re-
lationship to the artist's *Empty Glass,* dated
1648 (three extant versions;[8] see cat. no. 52, fig.
3), and *The Reveler,* dated 1650 (fig. 2) suggest
that this undated painting was executed in the
late 1640s or c. 1650. Not as sophisticated as
the later masters of perspective, de Hooch and

Vermeer, Koedijck nonetheless was interested in
the expressive possibilities of interior space.[9] His
works often include views to secondary spaces
and that favored motif of all students of perspec-
tive, the spiral staircase (see fig. 3). Gerard Dou's
paintings of the 1630s once again influenced his
spaces but the greater order of Koedijck's works
anticipates Delft School interiors.

<div align="center">P.C.S.</div>

1. On the barber-surgeon's guilds and profession, see Schotel
1905, pp. 173–90.

2. Quoted by Schotel 1905, p. 174 (author's translation).

3. For a discussion of the Dutch genre tradition of depicting
keisnijders, piskijkers, dentists, medicinesellers as well as doc-
tors, see de Vries 1977, pp. 91–98, who also cites literature
on medical themes in art. Diane Karp, curator of the Ars
Medica Collection at the Philadelphia Museum of Art, also
shared her insights.

4. See, for examples, Knuttle 1962, fig. 56 and pl. 7, and
Martin 1913, nos. 79 and 80. Neither of the latter *keisnijder*
scenes now seems likely to be by Dou himself but their exis-
tence suggests the possibility of prototypes painted by the
masters in the 1630s.

5. See cat. no. 71 and de Jongh 1968–69, pp. 22–74.
Vogelen (to bird) was a seventeenth-century euphemism for
copulation and the *vogelaar* often played the role of the pro-
curer or lover. Note also the open birdcage overhead; see cat.
no. 54.

6. See Steen's *Foot Operation,* formerly Piek Collection, The
Hague (Braun 1980, no. 140), and Hofstede de Groot 1907–
28, vol. 4, nos. 188, 189, 200, etc.; see also as examples, the
*Foot Operation*s by Pieter Quast, Rijksmuseum, Amsterdam
(no. A1756), and sometimes attributed to Johannes Natus in
Philadelphia, Johnson, cat. 1972, no. 511.

7. For alchemical literature, see cat. no. 3.

8. See Hofstede de Groot 1927, p. 190.

9. The artist's achievements in this regard are, in part, over-
looked because of the loss at sea of two of his major works
purchased from the famous Braamcamp Collection (see Bille
1961, nos. 44 and 45) by Catherine II of Russia.

Pieter van Laer

Haarlem 1599–after 1642 Haarlem?

Literature: Schrevelius 1647, pp. 290, 384; de Bie 1661, p. 169; Félibien 1666–88, vol. 4, p. 148; de Monconys 1665–66, pp. 104, 131–32, 173; Sandrart 1675, pp. 8, 11–12, 30, 177, 182–86, 195, 198, 201, 220, 259, 326, 330, 333, 353, and vol. 2, p. 311; van Hoogstraten 1678, pp. 95, 311; Malvasia 1678, vol. 2, p. 267; Félibien 1679, p. 51; de Piles 1699, pp. 415–16; Houbraken 1718–21, vol. 1, p. 359; Passeri 1772, p. 53; Bartsch 1803–21, vol. 1, p. 3; Nagler 1835–52, vol. 7, p. 220; Immerzeel 1842–43, vol. 2, p. 145; Weigel 1843, p. 1; Blanc 1854–90, vol. 2, p. 480; Kramm 1857–64, vol. 3, p. 926; Nagler 1858–79, vol. 2, p. 1216, and vol. 4, p. 2893; Bertolotti 1880, pp. 119–24, 128–38; Dutuit 1881–88, vol. 5, p. 37; Moes 1894; Wurzbach 1906–11, vol. 2, pp. 2–5; Hoogewerff 1913–17; Hoogewerff 1915; Burchard 1917, p. 87; Hoogewerff 1923; Hoogewerff 1926; G. J, Hoogewerff in Thieme, Becker 1907–50, vol. 22 (1928), pp. 196–97; Hoogewerff 1932–33; Hoogewerff 1936; Schillings 1937; Hoogewerff 1938; Welcker 1942; Hoogewerff 1942–43; Welcker 1947; Hollstein 1949–, vol. 10, pp. 4–10; Briganti 1950; Rome 1950; Hoogewerff 1952; Leiden 1954; Briganti 1956; Kurtz 1958; Rotterdam/Rome 1958–59; Plietzsch 1960, pp. 137–38; Utrecht 1965; Caraceni 1966; Rosenberg et al. 1966, pp. 172–74; Stechow 1966a; Blankert 1968; Janeck 1968; Snoep 1968–69; Bartsch 1971–, vol. 1, pp. 1–16; Michalkowa 1971; Janeck 1976; Salerno 1977–78, vol. 1, pp. 306–25; Blankert 1978a, pp. 24–25, 92–98; Kren 1980; Boston/ Saint Louis 1980–81, pp. 122–24; Amsterdam/Washington 1981–82, pp. 62–63; Levine forthcoming.

Pieter Boddingh van Laer was born in Haarlem in 1599 and was baptized in the Reformed Church. Although nothing is known of his training, van Laer's early work reveals the influence of Esaias van de Velde (q.v.). His elder brother Roelant (1610/11–c. 1640) was also a painter, and the two traveled to Italy together, arriving in Rome in 1625 or 1626. They may have traveled through France. Soon after his arrival in Rome, Pieter joined De Schildersbent, the Roman fraternal organization founded by Dutch artists, and was given the Bent name "Bamboccio" (rag doll or puppet). The nickname probably referred to the awkwardness caused by a physical deformity; apparently he was hunchbacked.

In Rome, van Laer and his friend Giovanni del Campo (c. 1600–1650) lived together in the artistic community in the parish of Santa Maria del Popolo, on the Via Margutta and the Via del Babuino, where van Laer met Claude Lorrain (1600–1682), Nicolas Poussin (1594–1665), Andries Both (1612/13–1641), and Joachim van Sandrart (1606–1688). In his Teutsche Academie, Sandrart reports that he, van Laer, Lorrain, and Poussin rode together to Tivoli to draw landscapes from nature. Van Laer enjoyed considerable success in Rome. His principal patrons included Cardinal Francesco Maria Brancaccio and the Viceroy of Naples, Ferdinando Ajan de Ribera, to whom the artist dedicated a series of landscape etchings in 1636.

Van Laer is last recorded in Rome in 1638. He returned to the Netherlands via Vienna, where he attempted, unsuccessfully, to sell a painting to Emperor Ferdinand III. He was in Haarlem in 1639, living with his brother Nicolaes, a schoolmaster. In the same year he visited Sandrart in Amsterdam, and the two artists went to Leiden to see Gerard Dou (q.v.). Van Laer is mentioned for the last time in his sister's will, drawn up in 1642 when he left Haarlem. Schrevelius, the artist's biographer, says that he set out for Rome and subsequently disappeared; he compares his sudden disappearance to that of the philosopher Empedocles, who fell into the crater of Mount Etna.

Van Laer is best known for his bambocciate, small-scale street scenes showing beggars, peddlers, and musicians. These works are painted on dark grounds and bring the techniques of Caravaggio and his Roman followers to small, multifigured genre compositions. Passeri, an early Italian biographer, described his Italian street scenes as a "window onto life." Van Laer is also mentioned in early biographies and inventories as an animal and landscape painter; his pioneering importance for these subjects has only recently been recognized. The artist provides a key link between the Italianate landscape painters of the 1620s, particularly Cornelis van Poelenburgh (c. 1586–1667) and Bartolomeus Breenburgh (c. 1599–1655/59), and the generation who began work in the mid-1640s, including Jan Asselijn (died 1652), Nicolaes Berchem, Karel Dujardin, and Jan Baptist Weenix (q.q.v.). He also influenced Philips Wouwerman (1619–1668), Paulus Potter (1625–1654), and Adriaen van de Velde (1636–1672). Van Laer also executed a number of history paintings and portraits. Adding to the remarkable range of his work is the recent discovery of a songbook to which he contributed emblematic and satiric drawings and verses.

C.B.

Landscape with Mora Players (The Small Limekiln), c. 1636–37
Oil on panel, 13⅛ x 18½" (33.3 x 47 cm.)
Szépművészeti Múzeum, Budapest, no. 296

Provenance: Definitely recorded for the first time in Esterházy Collection, Budapest, 1812, cat. 61 (as P. van Laer).[1]

Exhibitions: Utrecht 1965, no. 37; Dresden, Albertinium, *Europäische Landschaftsmalerei, 1550–1650,* 1972, no. 53.

Literature: Houbraken 1718–21, vol. 1, p. 363; Hoogewerff 1932–33, pp. 115, 251; Briganti 1950, pp. 190, 197; Waddingham 1964, pp. 21–22; M. Chiarini, "Due mostre e un libro," *Paragone,* vol. 16, no. 187 (September 1965), p. 76; Stechow 1966a, p. 215 n. 34; Janeck 1968, cat. no. AIV2, pp. 865–68; A. Pigler in Budapest, Szépművészeti Múzeum, cat. 1968, vol. 1, pp. 367–68; Steland-Stief 1971, p. 52; Salerno 1977–78, vol. 1, pp. 310, 323, ill.

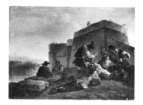

FIG. 1. PIETER VAN LAER, *Landscape with Mora Players,* oil on panel, Alte Pinakothek, Munich, inv. no. 7265.

The group of ragged beggars on the right are playing the ancient game of *mora.* As the game involves only the hands, in which certain gestures, the open palm, the fingers extended, for example, beat others, it could be played by the poorest people. On the left are two men playing a card game. On the extreme right is an elderly man, probably a shepherd. He is not included in the Munich version (fig. 1) or the print after van Laer by Cornelis Visscher, *The Small Limekiln,*[2] and may have been added as an afterthought. The sleeve of his right arm carefully goes around that of the nearest beggar. In the background is a limekiln with men at work.

The inscription "P. di Laer pinxit Rome" on Cornelis Visscher's print *The Small Limekiln* identifies this composition (without the figure on the extreme right) as the work of Pieter van Laer during his years in Rome. The group of beggars is used again by van Laer, also against the background of a limekiln, in another composition preserved only in a print by Cornelis Visscher, *The Great Limekiln* (fig. 2). However, the very bold, even rough and sketchy, treatment of the group of beggars in the Budapest painting caused Waddingham (1964, pp. 21–22) to suggest that these figures were by Andries Both and that the landscape was the work of his brother, Jan, both of whom were in Rome in the second half of the 1630s. Andries is known to have been a friend of van Laer in Rome. Waddingham made some telling comparisons with drawings by Andries Both. Stechow, Steland-Stief, Janeck, and Chiarini tentatively endorsed Waddingham's attribution, which was, however, rejected by Blankert, who believed that the painting demonstrated the influence of Andries Both's figure style on van Laer (Utrecht 1965, no. 37). This is inherently unlikely, as there is much evidence to suggest that van Laer, the elder by about twelve years, was the more innovative artist. The attribution to the Boths was also rejected by the author of the 1972 Dresden catalogue (Ildiko Ember) on the grounds that the composition, landscape, and figure group were all characteristic of van Laer's later years in Rome, c. 1636.

Although the traditional attribution has been retained here, the present writer believes that it is quite possible that the slightly smaller Munich painting (fig. 1)[3] is in fact van Laer's original from which Visscher's print was made, and that the Budapest painting is a close variant by Andries and Jan Both. What is not in doubt is that the composition is by van Laer and well illustrates the type of subject-matter and open format he evolved during his Roman years. Nor is the dating in doubt; it must be from c. 1636–37, shortly before van Laer's departure from Rome. The complexity of attribution also serves to emphasize the closeness of the artistic contacts between the Bamboccianti in these years.

C.B.

FIG. 2. CORNELIS VISSCHER after Pieter van Laer, *The Great Limekiln*, engraving.

1. Sandrart described a painting in his own collection that may be this one: "Von Peter van Laer al' Bambots: eine Tafel, darinn etlishe Italiänische Spitzbuben zu Rom das Spiel-Alamore spielen bey einem Kalchofen, des Autoris beste Arbeit" (1675–79, p. 330). A painting described as "Nog een van dezelve [Pieter van Laer, alias Bamboots] zynde a lamourspeelders" was lot 18 in the sale, Johann van Tongeren, The Hague, March 24, 1692 (500 guilders) (Hoet 1752, vol. 1, p. 12). "Een Kapitael stuk, zynde à la Mour-Speelders, van Bamboots" was lot 12 in the sale, Jan Agges, August 16, 1702 (310 guilders) (Hoet 1752, vol. 1, p. 65). There were two paintings by van Laer of this subject in the sale, Quirijn van Biesum, Rotterdam, October 18, 1719: lot 105 was "A l'amour-Speelders door P. van Laer, alias Bamboots, van zijn besten trant"; the size is given as "h. 2v. 2 en een half d., br. 2v. 6 d." [68 x 77 cm.], and this painting cannot therefore be either the Budapest (pl. 43) or the Munich (fig. 1) painting; lot 110 was "Een Kalkoven, Waerin A' l'amour Speelders, van denzelven" [van Laer], no size is given (see Hoet 1752, vol. 1, p. 232).

2. In reverse, omitting the figure on the extreme right, 10⅞ x 14⅞" (27.7 x 37.7 cm.), Hollstein 1949–, vol. 10, s.v. "Visscher," no. 20.

3. 11⅞ x 16⅛" (30.3 x 41 cm.). From the collection of Margrave of Ansbach.

Judith Leyster was born in Haarlem and baptized on July 28, 1609. She was the daughter of Jan Willemsz., a brewer of Flemish origin who took his surname from his Haarlem brewery—the "Ley-ster" (lodestar). Nothing is known of her early training, but Leyster must have been an established artist by 1627, for she is cited in Samuel Ampzing's Beschrijvinge ende lof der Stad Haerlem, *published in 1628 but written prior to February 1, 1627. Around 1628 her family moved to Vreeland near Utrecht, where she could have received additional training. By September 1629 her parents had moved to Zaandam near Amsterdam, but Judith herself probably returned to Haarlem, where she may have become a pupil of Frans Hals (q.v.). In November 1631 she is documented as a witness at the baptism of one of Hals's children, and she produced paintings in the manner of the master. By 1633 Leyster had entered the Haarlem Guild of St. Luke; she was the first woman known to be admitted. In 1635 she is recorded as having three students: W. W. (Willem Wouters), Davit de Bury, and Hendrick Jacobs. In October 1635 she went before the Guild of St. Luke to demand payment from the mother of her student Willem Wouters, who had left her studio to study with Frans Hals.*

In May 1636 Leyster and fellow-artist Jan Miense Molenaer (q.v.) published their wedding banns; they married the following month in Heemstede near Haarlem. The couple moved to Amsterdam, where they lived until 1648. In October of that year Leyster and Molenaer bought a house in Heemstede. They lived in Heemstede or in Haarlem, often visiting Amsterdam, where they owned another house, until Leyster's death in 1660. She was buried in Heemstede on February 10.

Although Leyster was primarily a painter of genre scenes, many of which portray children, she also executed a few portraits and still lifes of flowers and fruit. Dated works from 1629 to 1652 by her are known.

C.V.B.R.

Merry Trio, c. 1629–31
Oil on canvas, 34⅝ x 28¾" (88 x 73 cm.)
Collection of Mr. and Mrs. P. L. Galjart,
The Netherlands

Literature: Ampzing 1628, p. 370; Schrevelius 1648, p. 290; Kramm 1857–64, vol. 4, p. 979; van der Willigen 1870, pp. 14, 27, 140, 201–2; Obreen 1877–90, vol. 7, p. 292; Hofstede de Groot 1893b; Hooft 1897; Wurzbach 1906–11, vol. 2, p. 41; Bredius 1915–22, vol. 1, pp. 1–26; Bredius 1917; Kalff 1918; Kalff 1920; von Schneider 1922; Harms 1927; Hofstede de Groot 1929; Neurdenburg 1929; G. Poensgen in Thieme, Becker 1907–50, vol. 23 (1929), pp. 176–77; Wijnman 1932; von Schneider 1933, pp. 63–66; Schillings 1937b; Hollstein 1949–, vol. 11, p. 1; Dubiez 1956; Maclaren 1960, p. 218; Plietzsch 1960, pp. 29, 167–68; Rosenberg et al. 1966, pp. 107–8; Hofrichter 1975; Hofrichter 1976; Hofrichter 1979; Hofrichter 1983.

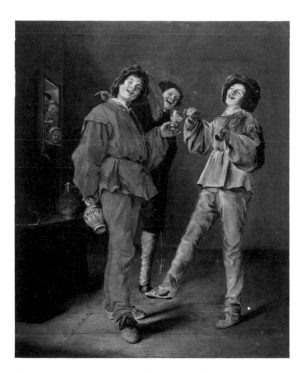

Provenance: Sir George Donaldson, London, by 1903; F. Muller & Co., Amsterdam, 1908; dealer Agnews, London, 1910; M. van den Honert, Blaricum, The Netherlands (on loan to the Mauritshuis, The Hague, until 1940, thereafter to the International Red Cross, The Hague); by descent to present owners.

Exhibitions: London, Guildhall, Corporation of London Art Gallery, *Dutch Art: Twenty-One Examples of the Most Notable Dutch Artists,* 1903, no. 185 (as Frans Hals and Judith Leyster); Amsterdam, F. Muller & Co., *Album . . . tentoonstelling van oude meesters bij Frederik Muller & Co.,* 1918, no. 7; Zurich 1953, no. 78; Rome 1954, no. 80, ill.

Literature: "The Dutch Exhibition at the Guildhall. I. The Old Masters," *The Burlington Magazine,* vol. 2, no. 4 (1903), p. 55; Harms 1927, pp. 145–47, 237, no. 15; Gratama 1943, p. 71; Slive 1970–74, vol. 3, p. 116, no. L2–2; Hofrichter 1976, pp. 139–40; Hofrichter 1983, pp. 106–7, fig. 2.

Three youths standing in an interior laugh, drink, and make music. At the right one plays a fiddle; in front of the laughing fellow in the middle, a drinker toasts with a glass in one hand while holding a ceramic jug behind his back with the other. A second jug rests on the bench at the left. Behind it a man, woman, and child look in through the open door and laugh.

Like other works by Judith Leyster, this painting was once thought to be, at least in part, the work of Frans Hals, who was probably her

teacher. It was catalogued as a collaborative effort when exhibited at the London Guildhall in 1903; however, the reviewer in 1903 for *The Burlington Magazine* properly doubted that Hals had anything to do with the painting's execution, noting that its technique and color scheme are clearly different from those of the famous Haarlem artist. Leyster evidently thought highly of this picture since she excerpted the figure of the fiddler and painted it on the easel in the background of her *Self-Portrait* of c. 1633 (fig. 1) over the figure of a young girl, which is still visible in infrared photographs. The substitution may have been made, as Hofrichter suggests, to demonstrate "her expertise as a genre painter . . . as well as a portrait painter . . . thus demonstrating the versatility of her skills."[1] The confident self-image she projects in the *Self-Portrait*—a persona supported by the account of her successfully bringing suit in the Haarlem guild for the return of a student pirated by Frans Hals—is consistent with such a show of talent.

A date of c. 1629–31 is suggested by Hofrichter for the *Merry Trio* on the basis of the work's resemblance in technique to the *Serenade*, dated 1629 (Rijksmuseum, Amsterdam, no. A2326), and to another monogrammed but undated night scene in the John G. Johnson Collection at the Philadelphia Museum of Art, the *Gay Cavaliers* (fig. 2).[2] The latter painting is nearly identical in size to this work, similar in design and in spirited theme, and also shares the same earliest provenance (Sir George Donaldson, London, by 1903). The two may have been designed as pendants, as the authors of the catalogue of the 1918 exhibition at Frederik Muller & Co. in Amsterdam assumed and Hofrichter supports. In its original state the Johnson Collection painting probably resembled the present work even more closely. A copy of this picture indicates that it once included a prominent *vanitas* symbol: a lifesize skeleton holding a skull, an hourglass, and a candle stood between the two young drinkers (fig. 3). This memento mori perhaps was thought excessively ghoulish by a later owner who had it painted out; the skeleton's leg and foot were incorporated into the table with candle. If the Johnson painting was, as seems quite possible, companioned with the present work, its moral warning would presumably apply to the young merrymakers here as well. Although these figures were

FIG. 1. JUDITH LEYSTER, *Self-Portrait*, c. 1633, oil on canvas, National Gallery of Art, Washington, D.C., no. 1050.

FIG. 2. JUDITH LEYSTER, *Gay Cavaliers*, oil on canvas, John G. Johnson Collection at the Philadelphia Museum of Art, no. 440.

FIG. 3. After JUDITH LEYSTER, *Gay Cavaliers with Skeleton*, oil on canvas, dealer P. de Boer, Amsterdam, 1976 (from J. van Duijvendijk, Scheveningen).

believed by Harms to be girls in boys' clothing,[3] more likely they are boys in festival or theatrical attire. Hofrichter[4] likens their colorful loose-fitting outfits to that of Capitano from the commedia dell'arte as engraved by Jacques Callot. Conceivably they also could be carnival celebrants like the maskers depicted by Pieter Codde (see pl. 14) and others. The popularity of Leyster's picture is proved by the existence of three early copies[5] and the free quotation of the figure on the left in a copy of a lost *Merry Trio* by Frans Hals.[6]

P.C.S.

1. Hofrichter 1983, p. 107.

2. Based on information in Frima Fox Hofrichter's forthcoming monograph on Leyster. Since her ideas about these pictures began developing in earlier publications, we are especially grateful to her for sharing the full text of her entries.

3. Harms 1927, p. 237.

4. Hofrichter MSS. See note 2, above.

5. Duke of Richmond, Goodward Estate (National Trust), Chichester; private collection, London, 1928/29, with a cityscape in the background; and sale, Brussels, Palais des Beaux-Arts, December 14, 1954, no. 36.

6. Sale, Paris, November 14, 1967, no. 26.

Jan Lingelbach was born in Frankfurt in 1622, but by 1634 his family had settled in Amsterdam, where his father, David, ran the Nieuwe Doolhof, a successful pleasure garden. The identity of Lingelbach's teacher remains unknown. Houbraken says that the artist left Amsterdam in 1642 to travel to France and that two years later he went on to Rome, where he worked until 1650. This account is supported by the few surviving documents: Lingelbach is recorded in 1647 and 1648 as living in Rome on the Strada Paolina delli Greci and in the following year on the nearby Horto di Napoli. In Rome, Lingelbach came under the powerful influence of the style of Pieter van Laer (q.v.), who had given his nickname, Il Bamboccio, to a new type of small-scale genre painting representing Italian street life—the bambocciate. Although van Laer had returned to Haarlem by 1639, a number of artists, among them Jan Miel (q.v.) and Michelangelo Cerquozzi (1602–1660), continued to work in his manner. So closely did Lingelbach follow the style of Il Bamboccio that there has been much confusion about the attribution of individual paintings; the oeuvres of the Bamboccianti have only recently begun to be disentangled.

According to Houbraken, Lingelbach left Rome on May 8, 1650, to return to Amsterdam; however, no documents record his presence there until 1653, when he married and was granted citizenship. He was buried in the city's Old Lutheran Church.

After returning to Holland, Lingelbach became increasingly influenced by the work of the successful and prolific Philips Wouwerman (1619–1668), in particular by his landscapes that depict figures at work or riding. Lingelbach also painted Italianate landscapes and seaports in the manner of Jan Baptist Weenix (q.v.) and his son, Jan (1642–1719). He collaborated with a number of artists, painting figures in landscapes by, among others, Jan Hackaert (c. 1629–c. 1685), Philips Koninck (1619–1688), Frederick de Moucheron (1633–1686), and Jan Wijnants (c. 1635–1684).

C.B.

The Cake Seller, late 1640s
Oil on canvas, 13 x 16½" (33 x 42 cm.)
Galleria Nazionale d'Arte Antica, Palazzo
Corsini, Rome, no. 1009

Literature: Houbraken 1718–21, vol. 2, pp. 145–47; Weyerman 1729–69, vol. 2, p. 219; Nagler 1835–52, vol. 7, pp. 541f.; Immerzeel 1842–43, vol. 2, p. 179; Kramm 1857–64, vol. 4, p. 988; Nagler 1858–79, vol. 1, pp. 1924, 1948, and vol. 4, p. 947; Havard 1879–81, vol. 1, pp. 113ff., and vol. 2, p. 182; de Vries 1885–86, vol. 3, p. 159; Wurzbach 1906–11, vol. 2, pp. 54–55; Thieme, Becker 1907–50, vol. 23 (1929), p. 252; Hoogewerff 1942–43; Hollstein 1949–, vol. 11, p. 82; Hoogewerff 1952; Busiri Vici 1959; Maclaren 1960, p. 225; Stechow 1966; Burger-Wegener 1976; Welu 1977c; Blankert 1978a, pp. 214–17; Kren 1982; Schloss 1982.

Provenance: Galleria Torlonia; purchased by Duca Giovanni Torlonia, early 1800s; presented to the Italian State, 1892.

Exhibitions: Rome, Galleria Borghese, *Mostra di Capolavori della Pittura Olandese,* 1928, no. 63; Rome 1950, no. 1; Milan 1951, no. 123; Rome 1954, no. 77; Rome, Palazzo Barberini, *Caravaggio e i Caravaggeschi,* 1955, no. 19; Rotterdam 1958, no. 77, pl. 67.

Literature: G. J. Hoogewerff, "Quadri olandesi e fiamminghe nella Galleria Nazionale d'arte antica in Roma," *L'arte* (1911), p. 31; Briganti 1950, p. 190; Rosenberg et al. 1966, p. 173; Janeck 1968, cat. no. C111; Salerno 1977–78, vol. 1, pp. 306, 311, ill.; Blankert 1978a, pp. 23–24; Kren 1982, pp. 45ff.

Two groups of Italian men are shown against a background of a town wall. In the foreground on the left, a *ciambellaro,* the seller of *ciambelle* (bread rings), has set up his portable stall, a large wicker basket on three legs, outside the town gates. In addition to the *ciambelle,* the basket holds a multicolored wheel that is being spun by the elderly man on the right. This is presumably a game of chance, similar to roulette. In the background on the right a group of seated men play cards; a fully loaded donkey stands beside them.

Until recently this painting was generally accepted as the work of Pieter van Laer, painted during his Roman period (c. 1626–c. 1638). Janeck was the first to doubt this attribution, and Kren described the work as "the greatest achievement of Lingelbach's Roman period."[1] In arguing his attribution to Lingelbach, Kren com-

pared the painting to the *Riders at an Inn* (Musée du Louvre, Paris, inv. 1438), which is securely attributed to van Laer. He correctly noted that the Louvre painting, which is evenly lit, lacks the dramatic contrasts in the fall of light that is such a striking feature of *The Cake Seller.* Here the lighting has the effect of monumentalizing the figures in a manner closer to that of Michael Sweerts, whose stay in Rome overlapped that of Lingelbach. Kren also pointed out that the simplicity of the architectural and landscape forms in the background is not characteristic of van Laer, who, as can be clearly seen in the Louvre *Riders at an Inn,* is far more inventive in his posing of figures, often showing them twisting in motion, than the distinctly stolid figures of *The Cake Seller.* Kren's comparisons to signed paintings by Lingelbach, notably the *Dentist on Horseback* of 1651 (Rijksmuseum, Amsterdam, no. A226) are entirely persuasive. The coarse canvas of *The Cake Seller* and its thin priming with a red ground do, as Kren observed, support the stylistic arguments for a Roman origin.

The painting should be dated to the second half of the 1640s, which, although van Laer had left Rome some years earlier, was a period of remarkable vitality for the Bamboccianti, among whom Lingelbach can now be seen to be a major figure. It was around this time that Jan Miel painted his *Carnival in the Piazza Colonna, Rome* (pl. 46) and Michael Sweerts his series of the Seven Acts of Mercy, works that with Lingelbach's *Cake Seller* rank among the very greatest achievements of the Bamboccianti.

C.B.

1. See Kren 1982, p. 45. The other scholars cited under Literature attribute the work to van Laer.

Village Festival, early 1650s
Signed lower right: J. LiNGELbACH
Oil on canvas, 34½ x 47½" (87.6 x 120.7 cm.)
Castle Museum, Nottingham, inv. no. 04–92

Provenance: Sale, Bicker and Wijckersloot, Amsterdam, July 19, 1809, lot 30 (376 guilders); sale, W. Wreeman Bogartz, April 11, 1816, lot 113 (270 guilders); presented to the museum by Richard Godson Millns, 1904.

Exhibitions: Bournemouth, Russell Cotes Museum and Art Gallery, *The Art of Dancing,* 1958; Kingston-upon-Hull, Ferens Art Gallery, *Dutch Painting of the Seventeenth Century,* 1961, no. 64; London, Royal Academy, *Primitives to Picasso,* 1962, no. 116; Newcastle, Laing Art Gallery, *Dutch Landscape Painting,* 1983, no. 64.

Literature: Thieme, Becker 1907–50, vol. 23 (1929), p. 252; Nottingham, Nottingham Castle Museum, cat. 1928, no. 67; Burger-Wegener 1976, cat. no. 113.

In the center of a village a maypole has been erected on which a woman's straw hat and shawl flutter in the wind. Villagers are dancing around the maypole to the music of a bagpipe player, a man who plays the flute and drum and, on the right, a woman with a tambourine. On the left beneath an awning other villagers drink, sleep, flirt, and watch.

Although painted after Lingelbach's return to the Netherlands, the scene is clearly meant to represent—in an idyllic manner—an Italian village festival. The misty landscape recession on the right is strongly reminiscent of similar Italianate effects employed by Jan Both and Nicolaes Berchem. Comparison with *The Cake Seller* (pl. 44) reveals how much more ambitious this composition is and to what a marked extent Lingelbach has softened the contrasts of light and shadow; a blue-gray tonality pervades the whole painting. These features betray the powerful influence of Philips Wouwerman. As is to be expected of an artist who was primarily a figure painter, the villagers are all strongly characterized. The painting should be dated to the early 1650s, not long after Lingelbach's return to Amsterdam.

C.B.

Sluis 1614–1670 Paris

Musical Party on a Terrace, c. 1650
Signed on table stretcher: J. V. LOO
Oil on canvas, 28¾ x 25¾" (73 x 65.5 cm.)
Thyssen-Bornemisza Collection, Lugano, cat.
no. 168

Literature: Félibien 1666–88, vol. 5, p. 84; Félibien 1679, p. 63; Houbraken 1718–21, vol. 3, p. 172; van Eynden, van der Willigen 1816–42, vol. 1, p. 134; Michiels 1865–76, vol. 10, p. 22; Wurzbach 1906–11, vol. 2, pp. 64–65; Bredius 1916a; von Schneider 1925–26; Thieme, Becker 1907–50, vol. 23 (1929), pp. 363–64; Hollstein 1949–, vol. 11, p. 105; Plietzsch 1960, pp. 76–77; van Loo 1966; Amsterdam/Washington 1981–82, pp. 94–95.

Jacob van Loo was born in Sluis in 1614. He was the son of the painter Johannes van Loo (born c. 1585) and probably received his first artistic training from his father. He may have been active in Amsterdam by August 1635, when he was involved in a delivery of paintings to the Amsterdam dealer Maerten Cretzer. In 1642 he married Anna Lengele, sister of the artist Maerten Lengele (died 1668). Of the couple's seven children, the two youngest sons, Abraham (also known as Abraham Lodewijk or Louis; 1652–1712) and Johannes (born 1654), became painters.

On January 24, 1652, van Loo became a citizen of Amsterdam, where his career was flourishing. In 1649 Constantijn Huygens, secretary to the stadholder, Frederik Hendrik, considered him worthy of recommendation for the decorations of the Huis ten Bosch, the new palace near The Hague. Although the artist was not selected for this project, he did receive several important commissions during the 1650s, among them an allegorical painting for the Oudezijds Huiszittenhuis, an Amsterdam workhouse, and portraits of the directors of the Aalmoezeniers Armen Werkhuis (almoners' workhouse for the poor) in Haarlem. In 1654 a poem by Jan Vos praised van Loo, with Rembrandt (1606–1669) and his pupils Ferdinand Bol (1616–1680) and Govert Flinck (1615–1660), the portraitist Bartholomeus van der Helst (1613–1670), and the still-life painter Willem Kalf (1619–1693).

In the autumn of 1660 van Loo became involved in a fight that ended in a fatality and was forced to flee Amsterdam. He eventually reached Paris, and in 1663 he joined the Académie Royale de Peinture. The artist died in Paris on November 26, 1670.

Van Loo is noted as a portraitist as well as a painter of mythological, allegorical, and genre scenes. According to Houbraken, Eglon van der Neer (q.v.) was apprenticed to van Loo in Amsterdam.

C.v.B.R.

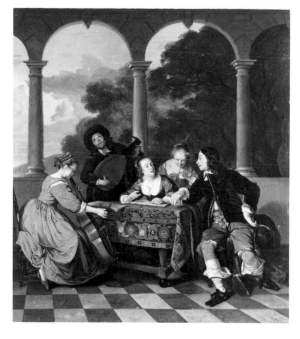

Provenance: Conrad Bugge Collection, Copenhagen, before 1837; sale, S. Bugge, Copenhagen, August 21, 1837, no. 43; Thyssen-Bornemisza Collection.

Exhibition: Munich 1930, no. 195.

Literature: Lugano, Thyssen-Bornemisza Collection, cat. 1937, vol. 1, p. 90, no. 243, 1958, no. 243, and 1969, vol. 1, pp. 194–95, no. 168.

Jacob van Loo and his Amsterdam colleague Gerbrand van den Eeckhout were the progenitors of a new elegant conversation piece around 1650.[1] Although the upper-class gatherings depicted by Willem Buytewech and Esaias van de Velde (pls. 3–6), among others, predate van Loo's and van den Eeckhout's paintings by more than a quarter-century, these early genre pieces are essentially different from the representation developed by van den Eeckhout and van Loo around the midpoint of the seventeenth century. In both their interior and exterior scenes, these two artists concentrated on smaller gatherings of figures, enveloping them in atmosphere. The contrast between light and dark is more pronounced and creates a completely different effect than that of the early, more additive pictures. The distinctions are clear if we compare this painting with van de Velde's *Party on a Garden Terrace* (pl. 3).

Van den Eeckhout's concurrent development of elegant outdoor scenes is illustrated by his *Party on a Terrace* of 1652 (pl. 88), where only a few finely dressed figures converse or gaze into the garden. Like van Loo, van den Eeckhout in-

FIG. 1. JACOB VAN LOO, *Concert with Four Figures*, 1649, oil on canvas, present whereabouts unknown.

FIG. 2. JACOB VAN LOO, *Interior with an Amorous Couple*, 1650, oil on canvas, art market, Holland, 1982.

troduced musical instruments to underscore the harmony of the group. The servant boy on the left preparing the wine is a vestigial motif carried over from the early merry companies of Vinckboons, Codde, and Palamedesz. (pls. 1, 15, and 16). Van Loo's picture makes innovative advances with its balanced composition and more stately, vertical format. Furthermore, the arches and columns impart an orderly arrangement to the scene, prefiguring the classical compositions of de Hooch and Vermeer.

Although the *Musical Party on a Terrace*, like its replica in the Hermitage,[2] is undated, we can arrive at an approximate dating by comparing it with two closely allied and well-documented works by the same artist. Primary among these is the *Concert with Four Figures* (fig. 1), which bears the date of 1649.[3] Two of the protagonists in the *Concert* bear a striking resemblance to the seated man and singing woman in this painting. The two models appear again in a previously unpublished genre scene from 1650 (fig. 2). We can thus assume that van Loo's *Musical Party on a Terrace* was executed around 1650 and probably before 1652, the date on van den Eeckhout's painting in Worcester.[4]

In the development of the elegant conversation piece, van Loo seems to have preceded even the precocious and influential ter Borch. Only one of ter Borch's paintings of this type has been dated before the mid-1650s—namely, the lovely *Woman at Her Toilet* (Metropolitan Museum of Art, New York, acc. no. 17.190.10).[5] As an upper-class genre scene with full-length figures, this little picture was unique in ter Borch's oeuvre until he painted the well-known *Parental Admonition* of c. 1654–55 (pl. 68).

O.N.

1. Blankert stresses the importance of these two artists in this context (1978b, p. 24); see also Plietzsch 1960, p. 77.

2. Leningrad, Hermitage, cat. 1901, pp. 205–6, no. 1252; Kuznetsov, Linnik 1982, no. 112, ill. More architecture is visible at the top of this painting; the exhibited picture, shorter by 2 cm., was probably cut down.

3. See Blankert 1978b, p. 25, fig. 20. The picture was advertised in *The Burlington Magazine*, vol. 97, no. 633 (December 1955), pl. 16, with the dealer Duits in London. It has since passed through the hands of Victor Spark in New York, who sold it to a private collector in Germany.

4. In the 1969 catalogue to the Thyssen-Bornemisza Collection (see Literature), Ebbinge-Wubben dates the picture by van Loo to the 1650s. This early dating establishes the artist as a possible source for Ochtervelt's outdoor musical companies (see Kuretsky 1979, p. 13, cat. nos. 5, 6, 10, figs. 11, 14, 22).

5. Gudlaugsson 1959–60, vol. 1, fig. 80.

Dordrecht archives indicate that Maes was born in January 1634. His father, Gerrit, was a Dordrecht merchant who married on December 15, 1619. According to Houbraken, Maes learned drawing from "een gemeen Meester" (an ordinary master) and painting from Rembrandt (1609–1669), with whom he studied in Amsterdam in the late 1640s or early 1650s. By the end of 1653, Maes had returned to his native Dordrecht; he evidently remained in the city for some twenty years. On January 31, 1654, he married Adriana Brouwers, the widow of the preacher Dr. Arnoldus de Gelder. The couple had three children, one of whom died young. On March 29, 1658, Maes purchased a house on the Steechoversloot and on July 31, 1665, he bought a garden. According to Houbraken, Maes traveled to Antwerp to study the works of Rubens (1577–1640), van Dyck (1599–1641), and other Flemings and to visit a number of artists, including Jacob Jordaens (1593–1678). The trip probably took place in the early or mid-1660s. By 1673 Maes had moved to Amsterdam, where he died in December 1693.

Maes's earliest dated work, The Dismissal of Hagar, *of 1653 (Metropolitan Museum of Art, New York, no. 1971.73), has a religious theme, and several other Rembrandtesque works attributed to his early career depict biblical subjects. By 1654 Maes was painting domestic genre scenes; these continue until 1659. He began painting portraits by 1655, and after 1660 he confined himself to portraiture, exchanging his Rembrandtesque manner for an elegant style that shows the influence of Flemish art, especially that of van Dyck. Houbraken praised Maes's portraits and claimed that they were much sought after.*

C.v.B.R.

Woman Plucking a Duck, c. 1655–56
Signed lower right: .N. MAES (AE in ligature)
Oil on canvas, 22⅞ x 26″ (58 x 66 cm.)
Philadelphia Museum of Art, Gift of Mrs. Gordon A. Hardwick and Mrs. W. Newbold Ely, in memory of Mr. and Mrs. Roland L. Taylor, 44-9-4

Literature: Houbraken 1718–21, vol. 1, pp. 131, 317, vol. 2, pp. 273–77, and vol. 3, pp. 252, 337; Smith 1829–42, vol. 4, pp. 243–49, and vol. 9, p. 575; Nagler 1835–52, vol. 8, p. 150; Kramm 1857–64, vol. 4, p. 1032; Veth 1890; Wurzbach 1906–11, vol. 2, pp. 89–91; Hofstede de Groot 1908–27, vol. 6, pp. 473–605; Bode 1917, p. 65; Valentiner 1923b; Bredius 1923–24c; Valentiner 1924a; H. Wichman in Thieme, Becker 1907–50, vol. 23 (1929), pp. 546–47; Dordrecht 1934; Martin 1935–36; Münz 1937; Hollstein 1949–, vol. 11, p. 156; Plietzsch 1959; Maclaren 1960, p. 227; Plietzsch 1960, pp. 184–85; Held 1964; Rosenberg et al. 1966, pp. 96–97; Walsh 1972; Amsterdam 1976, pp. 142–49; Amsterdam/ Washington 1981–82, p. 84; Robinson forthcoming.

Provenance: Sale, Comte de Tureene, Paris, May 17, 1852, lot 44, to Nieuwenhuys; sale, Adrian Hope, Christie's, London, June 30, 1894, lot 39, to Sedelmeyer; Jules Porgès, Paris; F. Kleinberger, Paris; A. de Ridder, Cronberg, by 1910; sale, A. de Ridder, Paris, June 2, 1924, lot 38; D. A. Hoogendijk, Amsterdam, 1928; Duveen, New York.

Exhibition: Chicago/Minneapolis/Detroit 1969–70, no. 88.

Literature: Sedelmeyer 1898, no. 81; Bode 1913, no. 33; Hofstede de Groot 1908–27, vol. 6, no. 28; Valentiner 1924a, pl. 43; de Jonge 1947, p. 70, and fig. 42.

The *Woman Plucking a Duck* belongs to a group of more than fifteen paintings by Maes that feature a housewife or maidservant seated in an interior and engaged in an everyday activity, such as sewing, spinning, lacemaking, caring for children, reading, or preparing food. The artist's dated interiors range from 1655 through 1658; the undated ones should undoubtedly be assigned to the same period. The evocative representation of space in these works, the warm harmonies of blacks, whites, and subdued reds, the poetic chiaroscuro, and the sympathetic portrayals of women absorbed in their work rank these interiors among the artist's most appealing pictures. The domestic intimacy of these scenes, as well as their broad touch, color, and moving use of light and shade, bears witness to Maes's admiration for paintings by Rembrandt, with whom he studied.

Maes must have executed *Woman Plucking a Duck* in 1655 or 1656. The painting's restricted palette and soft, pervasive shadows recall the dark tonalities of pictures he produced in 1655,[1] while the views into adjacent indoor and outdoor areas reveal the artist's interest in depicting complicated perspectives, developed in his later *Eavesdropper* (pl. 99). The skewed perspective of the sloping floor and of the doorframe that

leads to the rear chamber attests to the difficulty he experienced in rendering what, for a Dutch painter of the mid-1650s, was a daringly intricate succession of spaces. Maes showed a precocious interest in the representation of large-scaled, firmly structured, and atmospherically unified suites of rooms that was perfected by Pieter de Hooch in 1658.[2] *Woman Plucking a Duck* is Maes's first attempt to depict an interior in which we catch a sidelong glimpse of a back chamber; he tackled the problem again in *The Eavesdropper,* a more mature work and the culmination of his experiments with such complicated indoor perspectives.

Maes's contemporaries would have recognized the veiled erotic message of this painting. The wine pitcher and glass in the far room evoke a second human presence, and the game bag and fowling piece suggest that it is a male. The ducks the hunter has shot introduce an explicit allusion to physical love. In seventeenth-century Dutch the verb *vogelen* (literally, "to bird") meant both to hunt birds and, in vulgar usage, to copulate. A number of contemporary paintings and prints show a man sometimes toting a gun or sporting hunting garb who presents or sells a bird to a lady.[3] The profane double entendre of this exchange can be more or less obvious. The duck tenderly plucked by the kitchenmaid in this painting alludes to the hunter's gift of love. It is characteristic of Maes that he eschewed the flagrantly bawdy approach preferred by some of his colleagues.[4] Here the artist merely hinted at the man's presence and judiciously incorporated the birds, hunting paraphernalia, and the prowling cat, another metaphor for erotic desire, into a mundane scene in a tranquil bourgeois home.[5]

The exquisitely painted majolica plate on the floor is of Dutch manufacture, but its decoration reflects the influence of Chinese porcelains that began to reach the Netherlands around 1600.[6]

W.R.

1. Compare *Woman Scraping Parsnips* (National Gallery, London, no. 159) and *The Idle Servant* (cat. no. 67, fig. 1). Both works are dated 1655.

2. See Sutton 1980, pp. 20–21; Brown 1978, p. 33.

3. See de Jongh 1968–69.

4. See de Jongh 1968–69 for other examples. In a painting by Maes's follower Reinier Covyn, which shares many details with this work, the hunter raises a glass and embraces the maidservant as she plucks a duck (sale, Christie's, New York, January 9, 1981, lot 161).

5. See Amsterdam 1976, nos. 33 and 34 for the symbolism of the cat.

6. See de Jonge 1947, p. 70, and figs. 41, 42.

The Account Keeper (The Housekeeper), 1656
Signed and dated on the right: N. MAES. F. An.
1656
Oil on canvas, 26 x 21⅛″ (66 x 53.7 cm.)
The Saint Louis Art Museum, no. 72.1950

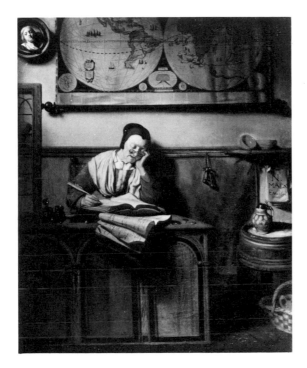

Provenance: Count Leopold Sternberg, Czechoslovakia;
Mortimer Brandt Gallery, New York.

Literature: Rathbone 1951, pp. 42–45, condensed reprint in
The Art Quarterly, vol. 15 (1952), pp. 184–89; de Jongh
1973, pp. 202–3; Burke 1980, p. 24.

Maes's genre paintings frequently communicate
an explicit moral message, and *The Account
Keeper* is no exception. Surrounded by coins and
ledgers, the woman in the painting has been de-
scribed as a personification of avarice on the
basis of comparisons with sixteenth- and seven-
teenth-century images of miserly gold weighers
and money-changers. According to this inter-
pretation, the world map on the wall alludes to
the sinful and worldly nature of her pursuit of
financial gain, and the bust of Juno at the upper
left refers to the goddess's role as patroness of
commerce.[1]

One significant detail casts doubt on this
reading of the picture. While most misers in six-
teenth- and seventeenth-century art alertly count
their money or gloat over their possessions, this
bookkeeper has fallen sleep. The bookkeeper
supports her head in an attitude that denotes
indolence and negligence in numerous works of
the period. Maes himself painted other pictures
that feature a man or a woman who has dozed
off as a result of drunkenness or lethargy;[2] in
one painting, a housewife ridicules her napping
kitchenmaid for the viewer's amusement and ed-
ification.[3] These works belong to a venerable

tradition of visual representations of the deadly
sin of sloth. It is the woman's laziness and dere-
liction of her account keeping, not her greed,
that Maes presents for our moral judgment. The
bust of Juno, included to evince commerce, re-
minds us of the financial duties she fails to
execute.

Compared to the artist's *Woman Plucking a
Duck* (pl. 97), *The Account Keeper* exhibits the
onset of a stylistic change that is more pro-
nounced in Maes's work of the later 1650s. His
palette becomes slightly cooler; instead of dark
tonalities and soft, pervasive shadows, brighter
daylight penetrates nearly every corner of the
interior. Details and outlines of forms stand out
more distinctly. The design embodies formal in-
novations introduced to Dutch genre painting by
ter Borch around 1650 and subsequently em-
braced by other leading specialists such as
Metsu, de Hooch, van Mieris, and Vermeer. The
upright format, the restriction of the composi-
tion to a single figure and a few furnishings, and
the stabilizing horizontal and vertical accents
epitomize the clear, simple structure and impres-
sive scale that distinguish the best genre pictures
produced during the third quarter of the century.
In *The Account Keeper,* clarity and balance of
arrangement impose a sense of serenity that ac-
cords well with the lethargic attitude of the
protagonist.

A mediocre copy of *The Account Keeper* by
an unidentified hand passed as an original by
Maes before the Saint Louis work came to
light.[4]

W.R.

1. See de Jongh 1973, pp. 202–3.

2. Valentiner 1924a, pls. 33, 35, 37; Amsterdam 1976, cat.
nos. 32 and 33. See also a painting from a private collection
of a girl picking the pocket of a drunken man who sleeps, in
Hofstede de Groot 1908–27, vol. 6, no. 102.

3. *The Idle Servant* (cat. no. 67, fig. 1); see Amsterdam 1976,
cat. no. 33, for an interpretation of the work.

4. The Hague, Dienst Verspreide Rijkskollekties, inv. no.
NK1624; Valentiner 1924a, pl. 14; Hofstede de Groot 1908–
27, vol. 6, no. 54. When Valentiner saw the Saint Louis
version, he recognized it as the original and the work he had
published in 1924 as a copy; Rathbone 1951, p. 45.

The Eavesdropper, 1657
Signed and dated on the step: N. MAES. F A⁰
1657
Oil on canvas, 36⅜ x 48″ (92.5 x 122 cm.)
Dienst Verspreide Rijkskollekties, The Hague,
on loan to the Dordrechts Museum, Dordrecht

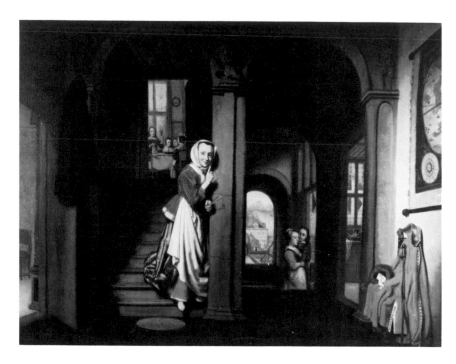

Provenance: Hoofman, Haarlem, 1837; sold privately at
Amsterdam to the Six family, 1838; sale, Six, F. Muller &
Co., Amsterdam, October 16, 1928, lot 22; Kunstzaal
Kleykamp, The Hague; Knoedler, London.

Exhibitions: Amsterdam 1900, no. 64; Dordrecht 1934;
Amsterdam 1976, no. 34.

Literature: Smith 1829–42, suppl. no. 3; Hofstede de Groot
1907–28, vol. 6, no. 121; Valentiner 1924a, pl. 42; Brière-
Misme 1950, no. 6, p. 234, fig. 7, and pp. 236–37; E. de
Jongh, "De Luistervink, Nicolaes Maes, 1634–1693," *Open-
baar Kunstbezit,* no. 14 (February 1970); Slatkes 1981,
p. 122.

The most engaging of Maes's genre paintings are
the so-called eavesdroppers or listeners. In each
of the six similar compositions that are extant, a
prominent figure pauses on a staircase to eaves-
drop on an encounter that takes place in a
basement or back room. In all, the listener casts
a vivid look at the viewer and raises an index
finger to the lips. The four dated works were
executed between 1655 and 1657, and the two
undated ones surely belong to the same years.[1]
The painting of 1657 is the latest and most am-
bitious of the group.

Maes's talent for portraying lively facial ex-
pressions and for inventing poses and gestures
that convey delicate shades of psychological
meaning is nowhere more evident than in these
pictures. Several spirited pen sketches of listeners
have survived;[2] although none relates directly to
the compelling figure in this work, they all illus-
trate the persistent study of glances and body
language that preceded the eavesdropper
paintings.

FIG. 1. NICOLAES MAES, *The
Idle Servant,* 1655, oil on
panel, National Gallery,
London, no. 207.

The picture's imposing symmetrical design,
elaborately contrived recession, and assorted
glimpses into adjacent rooms mark the climax of
Maes's interest in rendering interior space.
Paired archways divided by a pilaster introduce
the monumental stairwells that penetrate far into
the picture and frame the views up to the salon
and down to the garden. The unlikely structure
was inspired less by actual domestic architecture
than by Maes's concern with the formal problem
of creating an illusion of space and by the pecu-
liar narrative requirements of the subject.

The intrigue depicted here and its moral im-
plications are clear, although certain details re-
main enigmatic. The woman, on her way
downstairs from the salon, discovers her scullery
maid in amorous conversation with a well-
dressed young man. A cat snatches the meat left
unattended in the kitchen, an act that not only
exposes the maid's negligence but also may have
been interpreted by Maes's contemporaries as a
metaphor for seduction.[3] Comparison with
other versions of the theme by Maes and by
Isaack Koedijck confirms that the liaison is
illicit.[4]

The eavesdropper's gesture is a demand for
silence; coupled with her vivid glance, it captures
the viewer's attention, which is directed toward
the lovers. More important, the raised index fin-
ger serves an admonitory purpose. Her signal
invokes the moral dimension of the affair and
suggests censure of the couple's misbehavior.[5] In
Maes's *Idle Servant* (fig. 1), the housewife who
presents her dozing kitchenmaid to the audience
performs the same didactic function.[6] Her smile
and the eavesdropper's wry grin ridicule the
moral shortcomings of their servants.

These housewives play a role acted by professional jesters in fifteenth-, sixteenth-, and early seventeenth-century scenes of debauchery. Unnoticed by the dissolute protagonists, the fool addresses the spectator with a significant look or signal designed to expose and mock their reprobate conduct.[7] In a drawing of about 1620, a fool amidst a merry company admonishes the viewer with the identical gesture of Maes's eavesdropper.[8] Maes and other genre painters of his time, such as Jan Steen, replaced the professional jesters with figures in everyday costume.[9]

Some aspects of the composition require further elucidation: Did Maes include the bust of Juno, goddess of marriage, as an ironic touch or as a suggested antidote to the couple's dalliance?;[10] and what essential part does the feasting company upstairs play?

W.R.

1. Hofstede de Groot 1907–28, vol. 6, nos. 121 (as dated 1657), 122, 123 (as dated 1655), 124 (as dated 1656), 125, and 127 (as dated 1655). Nos. 121–25 are illustrated in Valentiner (1924a, pls. 38–42).

2. Examples are illustrated in Valentiner (1924a, figs. 6, 44–48).

3. Amsterdam 1976, cat. nos. 33, 34.

4. Koedijck painted a kitchenmaid fondled by a young man who reaches under her skirt. The lost painting is recorded in a watercolor copy by Laquy (Bille 1961, p. 11, no. 44). In Maes's painting in Apsley House, London (Hofstede de Groot 1907–28, vol. 6, no. 125), we also spy on an unchaste liaison: A man reaches through a window to caress a maidservant's breast.

5. On the admonitory character of the gesture, see the interpretation of Adriaen van der Werff's *Allegory on the Education of Youth* in Becker 1976, no. 2, pp. 88–90.

6. See Amsterdam 1976, cat. no. 33.

7. See E. Tietze-Conrat, *Dwarfs and Jesters in Art* (London, 1957), pp. 52–54; and K. Moxey, "Master E. S. and the Folly of Love," *Simiolus*, vol. 11, nos. 3/4 (1980), p. 146, and figs. 11, 12.

8. Johann Liss, *Merry Company with an Elegant Couple*, probably 1620; Augsburg, Rathaus, and Cleveland, Cleveland Museum of Art, *Johann Liss*, 1975, no. B45.

9. For examples of such figures in Steen's work, see de Vries 1976, pls. 18, 29, 32, 45, 47, 49, and Philadelphia 1983, nos. 5, 6, 8.

10. E. de Jongh (in Amsterdam 1976, no. 34) suggests that the head of Juno, who was also goddess of the home, is a reminder that the maid should remain at her domestic work rather than abscond with her suitor.

The painter and engraver Cornelis de Man was born in Delft on July 1, 1621. Shortly after entering the city's Guild of St. Luke on December 29, 1642, he traveled through Paris and Lyons to Italy, where he visited Florence, Rome, and Venice. He remained in Italy until about 1654, when he is again recorded in Delft. He apparently collaborated with another Delft artist, Leonaert Bramer (1596–1674), on the decoration of the St. Luke Guild House in 1661 and on that of the Prinsenhof in 1667. From 1657 until 1696, de Man served as a hoofdman (leader) of the painters' guild in Delft. In 1700 he was residing in The Hague. According to Houbraken, he died a bachelor in 1706; on September 1 of that year his possessions were sold at public auction.

Primarily a portraitist between 1655 and 1661, de Man began painting genre subjects and church interiors by c. 1660. His early genre scenes resemble those of Jan Miense Molenaer (q.v.) while his later ones are in the Delft School tradition. De Man's genre style shows the influence of Gerard Dou, Pieter de Hooch, Johannes Vermeer, and Jan Steen (q.q.v.) while his architectural paintings reflect the impact of Emanuel de Witte (q.v.) and Gerard Houckgeest (c. 1600–1661).

C.v.B.R.

The Chess Players, c. 1670
Signed lower right: CDMan (CDM in ligature)
Oil on canvas, 38⅜ x 33½" (97.5 x 85 cm.)
Szépművészeti Múzeum, Budapest, no. 320

Literature: Bleijswyck 1667, p. 859; Houbraken 1718–21, vol. 1, p. 236, and vol. 2, pp. 99–100; Weyerman 1729–69, vol. 2, p. 182; Immerzeel 1842–43, vol. 2, p. 197; Kramm 1857–64, vol. 4, pp. 1031, 1049; van der Kellen 1866, pp. 47–50, 227; Obreen 1877–90, vol. 1, p. 6; Bredius 1880b; Wurzbach 1906–11, vol. 2, pp. 94–95; Thieme, Becker 1907–50, vol. 23 (1929), p. 602; Wichman 1918; Brière-Misme 1935a, pp. 1–26, 281–82, 97–120; Hollstein 1949–, vol. 11, p. 162; Amsterdam 1976, pp. 160–61; Jantzen 1979, p. 227; Liedtke 1982a, pp. 118–24; Liedtke 1982b.

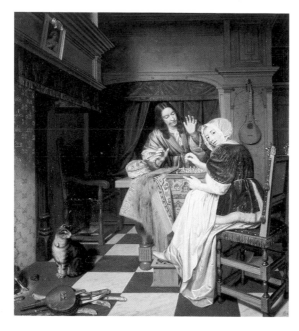

Provenance: Esterházy Collection, inv. 1820, no. 982; Budapest, Szépművészeti Múzeum, cat. 1906, no. 464.

Exhibition: Amsterdam 1976, no. 36, ill.

Literature: Parthey 1863–64, vol. 2, p. 72, no. 1; Otto Mündler, 1869 inventory of the Esterházy Gallery, in *Az Országos Magyar Szépművészeti Múzeum állagai* (Budapest, 1909), vol. 9, p. 50; Bredius 1880b, p. 375; C. Hofstede de Groot, "Kritische opmerkingen omtrent eenige schilderijen in 's Rijksmuseum," *Oud Holland*, vol. 6 (1889), p. 167; T. von Frimmel, *Kleine Galeriestudien* (Bamberg, 1892), vol. 1, p. 156; Hofstede de Groot 1903; Wurzbach 1906–11, vol. 2, p. 95; J. C. van Dyke, *Critical Notes on the Imperial Gallery and Budapest Museum* (New York, 1914), p. 140; Brière-Misme 1935a, p. 5; Mojzer 1967, no. 33, ill.; Bernt 1970, no. 723, ill.; Liedtke 1982a, p. 119.

Like *The Gold Weigher* by Cornelis de Man (pl. 118), *The Chess Players* offers an intimate glimpse of an upper-class home. The man's elegant satin jacket and the woman's ermine-lined velvet housecoat attest to their prosperity. The richly appointed interiors in both paintings are similar in many details; the artist surely meant to convey the *deftig* (elegant) atmosphere of a patrician home. Even the cat basking in the warmth of the hearth seems to express contentment with domestic pleasures. Within this comfortable and alluring interior a confrontation takes place: the couple engage in a game of chess. The woman is about to make a move that seems to alarm her partner. By looking back and indicating her move with her left hand, she seems to address the viewer in a conspiratorial spirit. The observer is encouraged to speculate: Will it be checkmate or merely an unexpected move?

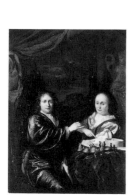

FIG. 1. ADRIAEN VAN DER WERFF, *Couple Playing Chess*, oil on panel, Gemäldegalerie Alte Meister, Dresden.

In traditional iconography in European art, chess playing was associated in various ways with *vanitas* ideas, as is likely to be the case in Adriaen van der Werff's painting (pl. 126). Alternatively, and much more commonly, the contest was likened to the game of love. In the Middle Ages and through the sixteenth century this was its primary association, but by the late seventeenth century, when the game had spread in popularity from the aristocracy to a broader audience among the upper classes, its symbolism had become subordinated to other associations, mostly social in nature. Nonetheless, a metaphoric link with lovemaking persisted, as in van der Werff's *Couple Playing Chess* (fig. 1), where a couple clad like those in van der Werff's *Chess Players* are occupied with the game; behind them stands the allegorical figure of Victory. The man is about to move one of his pieces while the woman points to her queen, as if to suggest that the man's victory is trivial when compared to the triumph in love attained by the queen, surrogate of the clever woman.[1] De Man's scene can be similarly interpreted.

A number of the painting's details lend themselves to symbolic interpretation. The foot warmer was a common feature of Dutch genre paintings (see pls. 12, 19, and 104), a fact that reflects its widespread use in the household.[2] Here the prominent foot stove may be an allusion to the submissive relationship between man and woman in the game of love. The cat warming itself by the heat of the fire might also be a symbol of female dominance,[3] but such pets were so common that their appearance may preclude specific interpretation. Other details of the picture range in their significance from the obvious, such as the bed, to the ambiguous, namely

The Gold Weigher, c. 1670–75
Oil on canvas, 32⅛ x 26⅝" (81.5 x 67.5 cm.)
Private Collection, Montreal

the bellows, or *blaasbalg,* on the floor. Bellows were commonly employed to stoke the fire on a hearth and were thus sometimes regarded as a metaphor for the kindling of passion.[4] However, the bellows was also the attribute of the fool, as in the sixteenth-century Dutch motto "De gek is bij de blaasbalg gekomen" (The fool has come to the bellows; that is to say: The fool has met his equal)[5]—words that could readily be spoken by the coquettish girl in de Man's picture. In this context yet a third association might apply. Roemer Visscher captioned his illustration of bellows fanning a flame with the words *Ventilante doctrina* (to fan knowledge), thereby drawing a parallel between stirring flames and awakening the spark of knowledge by proper instruction.[6] Thus one might speculate that the woman comments with her knowing glance and gesture on the success of her partner's instruction, which now enables her to beat him at his own game.

<div align="center">O.N.</div>

1. The interpretation offered here was suggested by E. de Jongh et al. in Amsterdam 1976, pp. 155–57.

2. The English traveler Fynes Moryson observed of Dutch women in 1617: "Some of the chiefe women not able to abide the extreme cold, and loth to put fire under them for heat (as the common use is) because it causeth wrinkles and spots on their bodies, doe use to weare breeches of linnen or silke" (quoted in H. K. Morse, *Elizabethan Pageantry* [London, 1934], p. 15).

3. The game of love may be compared to the game of cat and mouse. In this context the bell worn by the cat may indicate restraints put on the woman, as the sound of the bell prevents the cat from catching birds and mice. The Dutch motto "Eene goede muiskat moet men geene bellen annbinden" (One should not attach bells to a good mouser) may thus apply. Harrebomée lists the following expressions that might also pertain: "Eene kat, die asch likt, zult guj geen meel geven" and "Eene kat kijkt wel op een' koning" (1856–70, vol. 1, p. 59).

4. See Amsterdam 1976, pp. 127–29, 157 n. 8.

5. Bax 1979, p. 223. See also Harrebomée 1856–70, vol. 1, p. 59. Bax also documents the cat as a traditional symbol of folly in the Netherlands (p. 228).

6. Visscher 1614 (1949 reprint, p. 2); see Naumann 1981a, p. 98, and n. 52.

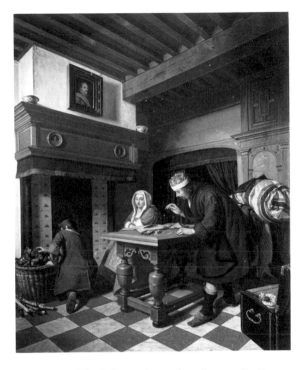

Provenance: Sale, Juriaans, Amsterdam, August 28, 1817, no. 31 (as Nicolaes Koedijk), to de Vries (940 guilders); Six Collection, Amsterdam, cat. 1900, no. 51 (as Koedijck); sale, Six, Amsterdam, October 16, 1928, no. 25, ill.; Dr. C.J.K. van Aalst, Hoevelaken, Holland; lent by him to Centraal Museum, Utrecht, cat. 1933, no. 319, fig. 68, and cat. 1952, no. 1135; dealer Cramer, The Hague, cat. 1975–76, no. 94, ill.; dealer Speelman, London.

Exhibitions: Rotterdam 1935, no. 67, ill. 108; Arnhem, Gemeente Museum, *Tentoonstelling van 17de eeuwse meesters uit Gelders bezit,* June–August 1953, no. 39; Delft, Prinsenhof, *Meesterwerken vit Delft,* 1962, no. 23; The Hague, Gemeentemuseum, *Stedenspiegel,* October 28–December 7, 1964, no. 398; Delft, Prinsenhof, *26th Art Fair,* Autumn 1975.

Literature: Thoré-Bürger 1860, p. 65 (as Koedijk); C. Hofstede de Groot, "Kritische opmerkingen omtrent eenige schilderijen in 's Rijksmuseum," *Oud Holland,* vol. 6 (1889), p. 167, no. 687; C. Hofstede de Groot, "Die Auction Thoré-Bürger," *Repertorium für Kunstwissenschaft,* vol. 16 (1893), p. 118, under no. 26; Hofstede de Groot 1903, p. 39; Wurzbach 1906–11, vol. 1, p. 312, and vol. 2, p. 95; Bredius et al. 1897–1904, vol. 3, p. 210, ill.; Sluyterman 1917, pp. 82, 86, fig. 83; Brière-Misme 1935a, pp. 104–5, fig. 17; Martin 1935–36, p. 208; J. W. von Moltke, *Dutch and Flemish Old Masters in the Collection of Dr. C.J.K. van Aalst* (printed privately, 1939), p. 194, pl. 46; Plietzsch 1960, p. 73, fig. 116; Liedtke 1982a, p. 119, fig. 97; Liedtke 1982b, p. 63, fig. 3.

A man dressed in a voluminous housecoat and cap leans over a table as he weighs gold coins. He has pushed back the table cover to make room for his weights and money. A chest or strongbox in the lower right contains a white cloth bag, in all likelihood a moneybag. A woman in a white headdress and fur-trimmed jacket sits on the far side of the heavy oak table.

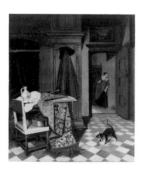

FIG. 1. CORNELIS DE MAN, *The Sweeper*, 1666, oil on canvas, with Edmond Meert, Saint-Nicolas, Belgium, 1935.

A boy kneels before her, building a fire from peat stored in a wicker basket. The decorated fireplace has a carved wood mantle, flanking columns, ceramic tiles, and roundels with bust-length figures, apparently Christ and the Virgin Mary. Ceramic bowls rest on the corners of the mantle. Above it hangs a portrait of a bearded man in armor wearing an orange sash, undoubtedly Prince Maurits of Orange.[1] In the background there is an enclosed bed and a carefully observed still life of bedding piled on a chair. The wall has elaborate fluted wood paneling and wainscoting. The prominent wood ceiling beams and the checkered marble floor contribute to the illusion of spatial recession.

Like much of the artist's oeuvre, this work was assigned to Isaack Koedijck in the nineteenth century. Hofstede de Groot was the first to correctly attribute *The Gold Weigher* together with a core group of similar works, all of which resemble the signed *Chess Players* (pl. 117).[2] Though chronology of de Man's work must necessarily be tentative, his early genre paintings like *Merriment in a Peasant Inn* (Mauritshuis, The Hague, no. 91), which, based on the costumes, dates from the mid to late 1650s, recall the Haarlem and Rotterdam stable and peasant painting traditions, particularly the work of Jan Miense Molenaer.[3] The concern for orderly interior space in *The Gold Weigher*, however, clearly shows de Man's indebtedness to his juniors of the Delft School, de Hooch (see pl. 101) and Vermeer. To judge from the costumes, especially that of the man (the model in variations of the same attire is almost a trademark of de Man's art), the painting can scarcely date much before c. 1670. Moreover, similar woodwork appears in de Man's only dated genre scene, *The Sweeper* of 1666 (fig. 1), where the space is not yet so well resolved. Indeed, *The Gold Weigher* shows considerable sophistication in the use of dual point perspective, a refinement that de Hooch, for all his mastery of space, never attempted. De Man would have been familiar with dual point perspective through his work as a painter of church interiors; this use of perspective enjoyed popularity among the Delft architectural painters Gerard Houckgeest, Emanuel de Witte, and Hendrick van Vliet, and claimed early roots in Jan Vredeman de Vries's perspective designs.[4] De Man would also have had the precedent of Jan Steen's genre paintings,

such as *Twelfth Night Feast* (Her Majesty Queen Elizabeth II, cat. 1982, no. 190). Although similar rooms and architectural motifs recur in other genre works by de Man, including *The Chess Players*, *Geographers* (Kunsthalle, Hamburg, inv. no. 239), and *Morning in Delft* (fig. 2),[5] it is unlikely that these works accurately record a specific room. Large pentimenti in the main ceiling beam and mantle of the fireplace in *The Gold Weigher* show that de Man, like de Hooch and Maes, took artistic liberties with his spaces.

Like his spaces, de Man's subjects—men of learning seated at a table, figures receiving letters, musical parties, and domestic scenes—recall the thematic repertoire of Vermeer. The gold-weigher theme invites comparison with Vermeer's *Woman Holding a Balance* (pl. 108); the standing figure's pose, lightly holding the scales in the right hand while touching the table with the left, may even recall, albeit vaguely, that of Vermeer's woman.[6] But de Man's *Gold Weigher* and his other version of this theme, *The Old Gold Weigher* (fig. 3), have much older precedents in the tradition, begun in the early sixteenth century, of depicting professional men—merchants, bankers, tax collectors, goldsmiths and, of course, usurers—weighing gold.[7] As in the literature of the period, the act of weighing gold in these images was often associated with avarice and greed.[8] It was also traditionally related to the Last Judgment (Leviticus 19:35; see cat. no. 118); Jan Steen, for example, depicted a terrified old gold weigher confronted by an image of death in the form of a skeleton looking in at the window (Statens Museum for Kunst, Copenhagen, no. 680). It is possible then that de Man's gold weighers, especially the wizened old man seated in the elegant interior in *The Old Gold Weigher*, personify or at least are associated with avarice. The man's gesture in *The Gold Weigher* and the presence of the strongbox, the traditional attribute of misers, point to such an interpretation; still the man in our painting would have to be an unusually young miser. As in the *Morning in Delft*, where the man in the housecoat sits with a sheet of paper as his wife instructs the maidservant, nothing in this painting suggests that de

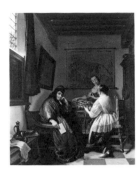

FIG. 2. CORNELIS DE MAN, *Morning in Delft*, oil on canvas, private collection, U.S.A.

FIG. 3. CORNELIS DE MAN, *The Old Gold Weigher*, with Gaston Neumans, Paris, c. 1931.

Man is critical of *burgerlijk* comforts. Indeed the gold weigher here seems little more than an industrious businessman. Note that he starts work early; the bedding and the boy stoking the fire point to the morning hour. Gold weighing could, after all, be a respectable activity, as it surely was in Rembrandt's etched *Portrait of the Receiver General, Jan Uytenbogaert* (previously known as "The Gold Weigher") of 1639. The scales could also be indicative of evenhanded, fair, and just behavior, as in images of Justitia.[9] In Johann Mannich's *Sacra Emblemata,* published in Nuremberg in 1625, an emblem of scales suspended beneath the eye of God and above a table holding weights and measures (fig. 4) is the symbol of the honorable and fair businessman.[10] The man in *The Gold Weigher* works under the scrutiny of both church and state; see the roundels of Jesus and the Virgin and the portrait of Prince Maurits.

P.C.S.

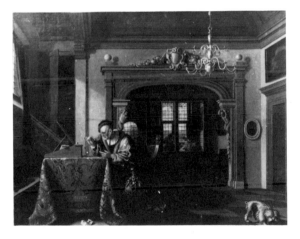

FIG. 4. Emblem from JOHANN MANNICH, *Sacra Emblemata* (Nuremberg, 1625), p. 81.

1. See Brière-Misme 1935a, p. 104.

2. See Hofstede de Groot 1903, p. 39.

3. See Brière-Misme 1935a, pp. 24–25. For a discussion of the meaning of *Merriment in a Peasant Inn,* see Amsterdam 1976, no. 37.

4. See Liedtke 1982a, especially fig. 37; and Jan Vredeman de Vries, *Perspective* (The Hague, 1604–5), pt. 1, pl. 24.

5. For other examples, see *Music Party with Harpist* (sale, London, August 1, 1928, no. 30 [wrongly as Pieter de Hooch]; Brière-Misme 1935a, fig. 15) and *The Letter* (Musée des Beaux-Arts, Marseilles; Brière-Misme 1935a, fig. 21).

6. Another artist whose themes and figure types often closely resemble those of de Man is the Rembrandt pupil A. Dullaert.

7. Sixteenth-century artists who depicted this theme include, among others, Quentin Massys and Marinus van Reymerswaele.

8. See de Jongh's discussion of the title page of Krul 1644 and the references to miserly gold weighers in Poirters, *Het Masker vande wereldt afgetrocken* (Antwerp, 1646), and Johannes de Castro, *De on-ghemaskerde liefde des hemels* (Antwerp, 1686), in Amsterdam 1976, under cat. no. 31, Salomon Koninck's *Gold Weigher* in the Museum Boymans–van Beuningen, Rotterdam (no. 1420).

9. See Ripa 1644, p. 432 and pl. 127; Harrebomée (1856–70, vol. 2, p. 253) cites the expression "De wijze weegt woorden met het goudgewigt" (The wise weigh their words with a gold weight).

10. See Henkel, Schöne 1967, col. 1436.

Shown in Philadelphia only

Leiden 1629–1667 Amsterdam

Interior of a Smithy, mid to late 1650s
Signed lower right: GMetsu (GM in ligature)
Oil on canvas, 25¾ x 28⅞″ (65.4 x 73.3 cm.)
The Trustees of the National Gallery, London,
no. 2591

Literature: De Monconys 1665–66, p. 173; Houbraken 1718–21, vol. 3, pp. 32, 40–42, 51, 211; Smith 1829–42, vol. 4, pp. 70–110, and vol. 9, p. 517; Immerzeel 1842–43, vol. 2, p. 217; Kramm 1857–64, vol. 4, pp. 1103ff., and suppl., p. 108; Obreen 1877–90, vol. 5, pp. 4, 206; Havard 1879–81, vol. 2, p. 186; de Vries 1883; Bode 1906, vol. 2, pp. 60–67; Wurzbach 1906–11, vol. 2, pp. 149–52; Bredius 1907; Hofstede de Groot 1908–27, vol. 1, pp. 253–335; Kronig 1909; Kronig 1915; Jessen 1917–18; H. Gerson in Thieme, Becker 1907–50, vol. 24 (1930), pp. 439–41; Plietzsch 1936; Hollstein 1949–, vol. 14, pp. 15–17; Renckens, Duyvetter 1959; Maclaren 1960, p. 241; Wipper 1960; van Regteren Altena 1963; Leiden 1966; Rosenberg et al. 1966, pp. 130–32; Gudlaugsson 1968; Schneede 1968; Robinson 1974; Amsterdam 1976, pp. 164–71; Braunschweig 1978, pp. 96–97; Wurfbain 1979; Amsterdam/Washington 1981–82, p. 85.

Leiden and Amsterdam records from the 1650s suggest that Gabriel Metsu, the son of the Flemish painter Jacques Metsue and his third wife, Jacquemijntje Garniers, was born in Leiden in January 1629 shortly before his father's death. Houbraken assumed that the artist was apprenticed to Gerard Dou (q.v.). In March 1648 he was one of the founding members of the Leiden Guild of St. Luke. He apparently left the city in 1650 or 1651, only to return the following year. Leiden records show that he and his half-brothers and sisters registered claims to their mother's estate in 1654. By July 1657, Metsu had moved to Amsterdam and was living on the Prinsengracht. On April 12, 1658, he married Isabella de Wolff from Enkhuizen, daughter of the painter Maria de Wolff-de Grebber (born c. 1600) and a relative of the Haarlem classicist painter Pieter de Grebber (c. 1600–1652/53). On January 9, 1659, Metsu became a citizen of Amsterdam, and on July 22, 1664, he and Isabella drew up their will. The artist died in Amsterdam in 1667, at the age of thirty-nine. He was buried in the Nieuwe Kerk on October 24.

Although Metsu favored genre scenes, he also executed a number of portraits, still lifes, and game bird pieces. A few of his history paintings predate 1655. Metsu's only known pupil is the genre and portrait painter Michiel van Musscher (q.v.).

C.v.B.R.

Provenance: Sale, Abraham Delfos et al., The Hague, June 10, 1807, lot 71; sale, Baroness van Leiden, Warmond Castle, near Leiden, July 31, 1816, lot 25, to Coclers (100 guilders); sale, Christie's, London, June 26, 1824, lot 38 (bought in, 245 guineas); Reverend W. Jones Thomas, Llanthomas Hayon, Breconshire; sale, London, July 10, 1886, lot 164, to Salting (399 pounds sterling); George Salting bequest, 1910.

Exhibition: Leiden 1966, no. 38, ill.

Literature: Smith 1829–42, vol. 3, no. 75; Kronig 1909, p. 104; Hofstede de Groot 1908–27, vol. 1, no. 200; J.B.F. van Gils, "De Stockholmer Smidse van Gabriel Metsu," *Oud Holland,* vol. 60 (1943), p. 69; Maclaren 1960, pp. 245–46, no. 2591; Gudlaugsson 1968a, pp. 23, 41 (as c. 1657); Schneede 1968, p. 47 n. 10; Robinson 1974, pp. 50, 54, 82, 174, fig. 124.

In the darkened interior of a smithy, an aged blacksmith shapes a red-hot horseshoe on an anvil as an impatient patron waits to one side. The horse, its unshod hoof raised, stands in the open door. Behind the blacksmith, a young apprentice spins a grinding wheel and tends the fire. Metalworking tools hang from racks and wooden ceiling beams and are strewn about the floor. Above the doorway are mullioned windows with painted glass, the most visible depicting an escutcheon with a central scene.

When the picture was sold in 1824 its subject was incorrectly identified as "The discovery of Charles II in his flight by the blacksmith." The London painting is one of several by Metsu that depict blacksmiths. Although none in the series is dated, the earliest is probably *Venus and Amor at Vulcan's Forge.*[1] Metsu's *Woman Weeping in a Blacksmith's Shop* (fig. 1) depicts a crying woman bound to a chair by an iron band as a menacing smith seems to force her to sign a document.[2] Reminiscent of *The Usurer* of 1654 in the Museum of Fine Arts, Boston (no. 89.501), this curious painting has been interpreted as an illustration of the saying "to write a debt in a chimney,"[3] but may illustrate an episode from a poem by Adriaen van de Venne.[4] *The Armorer* in the Rijksmuseum (fig. 2) also depicts a smithy but evidently without literary reference or allusions to popular sayings.[5] The London painting, although its meaning remains unclear, has been rightly seen as the most fully developed of the series and has been dated convincingly to the mid to late 1650s.[6] A copy of the painting is in the Dienst Verspreide Rijkskollekties (no. NK2870).

A social contrast is drawn between the common tradesman and the courtly rider. The painting's subject, moreover, can be related to the tradition of depicting professions and occupations; among others, Quirijn van Brekelenkam, Pieter Quast, Cornelis Beelt, Paulus Potter, and Philips Wouwerman depicted smithies and ferriers.[7] The scene's anecdotal quality—the momentary exchange between the two main figures—and the thoroughgoing inventory of the tools of the artisan's trade anticipate in an unwanted fashion nineteenth-century pre-Raphaelite painting. Yet this surface realism, as always, must not obscure the consideration of other meanings; to what extent might the tradesman, like Metsu's earlier blacksmiths, be associated with Vulcan (identified with the Greek artisan-god Hephaestus, or sometimes called Mulciber)?[8] The most ill-favored of the gods, born ugly and lame, Vulcan was cast out of heaven by his mother Juno. As the god of fire Vulcan was associated with love and passion, but also with conflagration and destruction. Nothing in this scene, however, clarifies speculation of a larger narrative context for the smithy and his condescending customer.

P.C.S.

1. Sale, Schönlank, Cologne, April 28, 1896, no. 117, ill., present whereabouts unknown; Hofstede de Groot 1908–27, vol. 1, no. 18; Robinson 1974, fig. 13. Maclaren (1960, p. 245) believed it might only be a copy of an early Metsu. One possible source of inspiration for Metsu's treatment of this rather rare theme may have been Pieter de Grebber's lost painting of *Venus Having Cupid's Weapons Forged by Vulcan,* executed before 1638 for the royal palace at Honselaarsdijk. Haarlem classicist de Grebber and Metsu were related by marriage.

2. Hofstede de Groot 1908–27, vol. 1, no. 17; Robinson 1974, fig. 12.

3. J.B.F. van Gils, "De Stockholmer Smidse van Gabriel Metsu," *Oud Holland,* vol. 60 (1943), pp. 68–70.

4. See A. van de Venne, *Sinne-vonck op den hollandschen . .* (The Hague, 1634). The scene would depict the moment when the Sicilian smithy Doddus captures the "Begeer-wijf" in his magic stool, a theme reminiscent of the classical tale of Vulcan capturing Juno.

5. See Hofstede de Groot 1908–27, vol. 1, no. 219; and Robinson 1974, fig. 14.

6. The date, according to Maclaren (1960, p. 245), is "later . . . than 1654 . . . but can hardly be after 1658"; Gudlaugsson (1968a, p. 41) believes it to be c. 1657. Robinson (1974, p. 50) says it was painted "before 1658" and is from the "late 1650s" because of "hints of the Delft School" (p. 54).

7. Brekelenkam's *Smithy* is known only through a copy, formerly Schidlowsky Collection, Leningrad (sale, Paris, May 14, 1908, no. 121). Gudlaugsson (1968a, p. 41) has rightly called the model for the smithy in the London painting "Brekelenkam-like."

8. On Vulcan, see K. van Mander, *Wtlegghingh op den Metamorphosis* (Haarlem, 1604), fols. 14–16; and M. Delcourt, *Hephaistos ou la légende du magicien* (Paris, 1957).

FIG. 1. GABRIEL METSU, *Woman Weeping in a Blacksmith's Shop,* oil on canvas, Nationalmuseum, Stockholm, no. NM512.

FIG. 2. GABRIEL METSU, *The Armorer,* oil on canvas, Rijksmuseum, Amsterdam, no. A2156.

The Hunter's Gift, c. 1658–60
Signed at the left: G. Metzu
Oil on canvas, 20 x 18⅞″ (51 x 48 cm.)
The City of Amsterdam, on loan to the
Rijksmuseum, Amsterdam, no. C177

Provenance: Sale, J. Goll van Franckenstein, Amsterdam,
July 1, 1833, no. 48, to G. de Vries for A. van der Hoop
(12,400 guilders); van der Hoop Collection, Amsterdam;
bequeathed to the city of Amsterdam, 1885.

Exhibition: Leiden 1966, no. 27, ill.

Literature: Smith 1829–42, vol. 4, no. 92, and suppl., no.
25; C. J. Nieuwenhuys, *A Review of the Lives and Works of
Some of the Most Eminent Painters* (London, 1834), pp.
293–94; Immerzeel 1842–43, vol. 2, p. 218; Thoré-Bürger
1860a, pp. 100–102; Hofstede de Groot 1907–28, vol. 1
(1907), no. 180; Martin 1935–36, vol. 2, p. 224; Gudlaugs-
son 1968a, p. 27 (as c. 1658); de Jongh 1968–69, pp. 35–
36, fig. 9; Robinson 1974, pp. 26–30, 38, 56, 60, 91, fig. 24
(as late 1650s); Amsterdam, Rijksmuseum, cat. 1976, p.
379, no. C177, ill.; Wheelock 1976, p. 458.

A man and a woman are seated next to one
another in an interior illuminated by a window
above a table on the left. To the right is a spiral
staircase. A hunter's gun and a dead duck lie in
the lower right corner. The man offers the
woman a dead partridge as a large hunting dog
rests its muzzle against his knee. Holding a sew-
ing cushion in her lap, the woman has removed
her shoes. A tiny lapdog stands near a small
book on the carpet-covered table. Behind the
woman and on top of a *kast* (wardrobe), a white
plaster Cupid stands in front of a painting on
the wall.

Gabriel Metsu often juxtaposed male and
female social roles, for example, the man as
moneylender and the woman as harried client in
The Usurer (1654, Museum of Fine Arts,
Boston, no. 89.501), or in the Rijksmuseum
painting, the man as hunter and the woman as
housewife. Here even the different breeds of
dogs underscore the contrast. In the densely pop-

ulated Netherlands, hunting was a pastime
reserved for the upper classes and closely regu-
lated by the court, hence an appropriate activity
for figures in high-life genre scenes.[1] Metsu never
depicted actual hunting, only its quiet after-
math;[2] usually, the hunter has returned with the
quarry and offers it to his lady. The Rijks-
museum's painting is the best of Metsu's three
variations on the theme of the Hunter's Gift,[3] a
subject treated earlier by Pieter Codde (fig. 1).
One of several nineteenth-century authors who
praised the Rijksmuseum painting, Thoré-Bürger
observed that in Metsu's elegant companies
"love is always a member of the party. . . . Here,
we have Cupid himself."[4] Other amorous de-
tails, less recognizable to modern viewers but
probably obvious to Metsu's contemporaries,
are the dead birds. Numerous seventeenth-cen-
tury texts indicate that in Dutch and German
vogel (bird) was often synonymous with the
phallus; *vogelen* (to bird) was a euphemism for
sexual intercourse; and *vogelaar* (bird catcher)
could refer to a procurer or a lover.[5] In prints
the sexual connotations of birds were expressed
in many forms, from Hendrik Goltzius's person-
ification of Libido as a manneristic seminude
woman holding up a bird, to Gillis van Breen's
naturalistic depiction of a bird seller (fig. 2) who,
according to the appended verses, refuses to sell
a lady client his bird because it is reserved for a
hostess that he "birds" regularly. A meaning
comparable to that of the latter print was proba-
bly intended in Metsu's *Bird Seller with Lady
Customer* (Staatliche Kunstsammlungen, Dres-
den, no. 1733).[6] In the Rijksmuseum painting,
the hunter's offering is probably a sexual propo-
sition. As in Judith Leyster's *Proposition* of
1631 (cat. no. 15, fig. 3), the woman is ap-
proached as she sews—a time-honored domestic
subject. Here, however, she acknowledges the
man and seems caught in a moment of indeci-
sion. Though the woman has made herself
comfortable by kicking off her slippers, she
keeps a firm hold on her sewing cushion while
reaching across the table with her right hand for

FIG. 1. PIETER CODDE, *Return of the Hunters*, 1635, oil on panel, on loan to the Rijksmuseum, Amsterdam, no. C1578.

FIG. 2. GILLIS VAN BREEN after C. Clock, *Bird Seller*, engraving.

a little book, identified by some as a Bible or prayer book;[7] her very pose expresses her moral dilemma.

Although the erotic associations of birds were not restricted to types of fowl, the fact that the hunter offers the woman a partridge is probably significant. According to Ripa, there was no better way to illustrate "immoderate lust and untamed lewdness" than with the partridge, which was believed to break its own eggs in order to be able to mate more often.[8] In a letter of 1635, Caspar Barlaeus, who had recently lost his wife, thanked the poet P. C. Hooft for a brace of partridges, but expressed surprise at his choice of gift: "Sending partridges to me a widower, is in any regard strange. You send me the lewdest of birds, the very symbol and hieroglyph of Venus, which can only evoke memories of the caresses I miss as a widower."[9]

The Hunter's Gift surely dates from Metsu's early years in Amsterdam: after 1657 but probably not as late as 1661. The painting is close in style to *Music Party*, 1659 (pl. 66). Metsu's scenes of hunters evidently left a strong impression on later artists such as Arie de Vois, Pieter van Slingelandt, Jan Verkolje, and Adriaen van der Werff.[10]

P.C.S.

1. For more information on hunting, see cat. no. 57.

2. For example, *Hunter in a Landscape*, Kunsthalle, Hamburg, no. 378; *Hunter Bathing in a Landscape*, Geneva; *The Sleeping Hunter*, Wallace Collection, London, no. P251; and *Hunter in a Niche*, 1661, Mauritshuis, The Hague, no. 93, are illustrated, respectively, in Robinson (1974, figs. 35, 33, 36, and 29).

3. See also the versions in the Uffizi, Florence, no. P1063 (Robinson 1974, fig. 132) and formerly owned by Alphonse de Rothschild, Paris (Hofstede de Groot 1907–28, no. 182; Robinson 1974, p. 134).

4. Thoré-Bürger 1860a, p. 101.

5. De Jongh 1968–69.

6. See de Jongh 1968–69, pp. 24–25, figs. 1 and 2.

7. Wheelock 1976, p. 458. For a discussion of the shoe as a female and erotic symbol in Dutch literature, see de Jongh (1968–69, pp. 36–37).

8. Cited by de Jongh (1968–69, p. 29); see Ripa (1644, pp. 143–44).

9. De Jongh 1968–69, p. 29; Caspar Barlaeus, *Epistolarum Liber* (Amsterdam, 1667), p. 627–29.

10. See Robinson 1974, pp. 27, 30, 91.

Music Party, 1659
Signed and dated lower left on the piece of
paper: G METSU 1659 (GM in ligature)
Oil on canvas, 24½ x 21⅜″ (61.6 x 54.3 cm.)
The Metropolitan Museum of Art, New York,
Gift of Henry G. Marquand, 1890, 91.26.11

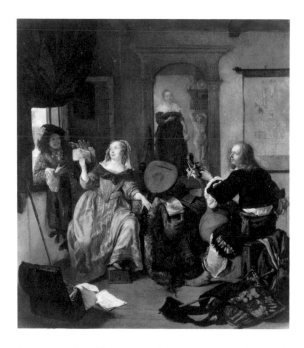

Provenance: Possibly Marquis de Voyer, 1756;[1] sale, E. Val-
kenier-Hooft, Amsterdam, August 31, 1796, no. 25, to
Fouquet (1,005 guilders); sale, Pierre Fouquet, Amsterdam,
April 13–14, 1801, no. 42, to Roos (670 guilders); sale,
Robit, Paris, May 21, 1801, no. 69, to La Roche (4,500
francs); Michael Bryan, London; Bryan's Gallery, London,
November 6, 1801, no. 78; sale, Bryan, Paris, December 6,
1801, no. 82; sale, J. Smith, 1825, to Zachary (420 pounds
sterling); sale, Zachary, London, 1828, to Philips (525
pounds sterling); Frederick Perkins, Chipstead, Surrey, by
1832; sale, Perkins, Georges Petit, Paris, June 3, 1889, no. 9,
ill. with engraving by J. Sevrette (sale never held); sale, Perk-
ins, Christie's, London, June 14, 1890; dealer Colnaghi,
London; Henry G. Marquand, New York.

Exhibitions: London, British Gallery, 1832, no. 103; New
York, Metropolitan Museum of Art, *The Hudson-Fulton
Celebration,* comp. W. R. Valentiner, vol. 1 (1909), pp. 25,
64, no. 63, pl. opp. p. 64; New York, Metropolitan Museum
of Art, *Art Treasures of the Metropolitan,* 1952–53, no.
118; Leiden 1966, no. 42; Kansas City 1967–68, p. 14, no.
12, p. 31, ill.; Boston, Museum of Fine Arts, *Masterpiece
Show,* August–October 1970.

Literature: Descamps 1753–64, vol. 2, p. 243 (see note 1);
W. Buchanen, *Memoirs of Painting* (London, 1824), vol. 2,
p. 53, no. 69; Smith 1829–42, vol. 4, no. 53; W. Bode, "Alte
Kunstwerke in den Sammlungen der Vereinigten Staaten,"
Zeitschrift für bildende Kunst, n.s., vol. 6 (1895), p. 18;
Hofstede de Groot 1907–28, vol. 1, no. 164; J. Breck,
"L'Art Hollandais à l'exposition Hudson-Fulton à New
York," *L'Art Flamand et Hollandais,* vol. 13 (1910), p. 57;
K. Cox, "Dutch Pictures in the Hudson-Fulton Exhibition,
III," *The Burlington Magazine,* vol. 16, no. 83 (February
1910), p. 305; Plietzsch 1936, pp. 5, 9; Gowing 1952, p.
155 n. 142; de Mirimonde 1966, pp. 281, 283, fig. 32;
Gudlaugsson 1968a, pp. 13, 14, 24, 25, 41, fig. 5; Schneede
1968, p. 47; Robinson 1974, pp. 37, 49, 54, 59, 60, 64,
138, fig. 68; Wheelock 1976, p. 458; Welu 1977a, p. 64 n.
24; C. Baetjer in New York, Metropolitan Museum of Art,
cat. 1980, vol. 1, p. 125, vol. 3, p. 443, ill.; Naumann
1981a, vol. 1, p. 51 n. 15, fig. 44.

Two men and a woman are about to play music
in an interior. The woman, dressed in satin and
a silk shawl, holds a lute with one hand and
passes a songbook with the other to an elegantly
attired man who leans on the window sill. To
the right and seated on the other side of a table
covered with an oriental carpet is a gentleman
who wears wide-mouthed boots and a black
costume decorated with ribbons; he tunes a
violoncello. Through a doorway framed with
pilasters, a serving-woman carries a tray and a
ceramic jug. In the left foreground is an open
chest with other music books; to the right a
sword and bandolier lie on an embroidered
cushion. A map hangs to the right of the open
doorway, which reveals part of a fireplace with
caryatids.

There appears to be little support for the eight-
eenth-century assumption that the three figures
portray Metsu, his wife, and Jan Steen.[2] Like
many other works by the artist, the painting
seems to depict an anonymous musical gather-
ing; see, for example, the other musical com-
panies in the National Gallery, London (no.
838), Waddesdon Manor, Aylesbury (no. 65),
Mauritshuis, The Hague (no. 94), the Wernher
Collection, Luton Hoo, the Hermitage,
Leningrad, and Buckingham Palace (no. 101).[3]
Plietzsch felt that the painting had an "un-
mistakable" connection with the artist's early
work, namely the paintings executed in Leiden
before his move to Amsterdam in or before
1657.[4] The conception of the figures, though
somewhat less animated, resembles that of
paintings like *The Usurer* of 1654 (Museum of
Fine Arts, Boston, no. 89.501) and the undated
but certainly early *Brothel Scene* in the Her-
mitage (fig. 1).[5] Like the revelers in the latter
work, the woman who leans back with her foot
propped on the foot warmer is especially remi-
niscent of the figure types of Nicolaes Knüpfer,
the Utrecht artist who made a strong impres-
sion on the young Metsu. The interior could
also indicate early influences; the room, like
those of Dou and his Leiden followers, includes
a curtain over the window, ceiling beams, and a
staircase and doorway at the back, the last cre-
ating an abrupt spatial transition imperfectly
disguised by the lady's lute.[6] At the same time,
Metsu's fluid touch has little to do with Dou's
fastidious love of detail.

FIG. 1. GABRIEL METSU, *Brothel Scene,* oil on canvas, Hermitage, Leningrad, no. 922.

Gudlaugsson found these qualities difficult to reconcile with the painting's date and figure grouping, which, he rightly observed, recalls works from the late 1640s and early 1650s by Amsterdam painters Jacob van Loo and Gerbrand van den Eeckhout (see cat. no. 64, fig. 1 and cat. no. 43, fig. 1).[7] He conjectured that the picture was begun by 1657 but was dated two years later; this, he argued, would explain the figures' costumes—and the fact that the signature and date appear to be painted in two different colors. While Gudlaugsson's chronology is the most plausible yet advanced for Metsu's development, his reasoning here seems too elaborately contrived.[8] Though costumes of this period can provide a fairly exact *terminus a quo,* they are less precise as a *terminus ad quem,* especially when involving a distinction of only two years. Furthermore, close examination of the signature and date reveals scarcely any distinction in color or style; most important, there is no reason to doubt that the picture was executed in 1659. Although the painting shares points of continuity with Metsu's early work, it exhibits a more refined technique than that of the Boston *Usurer* of 1654. Certainly not a tentative work, the picture is a mature and masterfully assured statement by the artist.

The enchained caryatid that supports the fireplace may be an allegorical element alluding to the danger of excessive affection for music and love.[9] The partially visible map at the right was identified as that of Holland and West Friesland, by Balthasar Florisz. van Berckenrode, first published by Willem Jansz. Blaeu in 1620, and revised and reissued by Claes Jansz. Visscher in 1651 and 1656.[10] While Metsu's *Music Party* shows one of the new editions, Vermeer's *Soldier and Laughing Girl* (cat. no. 88, fig. 2) includes the unrevised and geographically outdated edition.

The splendid harmony of color in the *Music Party* supports Descamps's praise of Metsu's palette. The eighteenth-century French writer recommended Metsu above all other Dutch painters as a model for the genre painters of his age.[11]

P.C.S.

1. According to Smith (1829–42, vol. 4, no. 53), however, the painting mentioned by Descamps (1753–64, vol. 2, p. 243) as in the Marquis de Voyer Collection is described only as "un Concert."

2. According to the Robit sale catalogue of 1801, the traditional identification came from "une belle collection de la Hollande," doubtless the Valkenier Collection; see also Smith 1829–42, vol. 4, no. 53. Compare Metsu's poorly preserved *Self-Portrait* and *Portrait of the Artist's Wife* in the J. B. Speed Museum, Louisville, Kentucky (Hofstede de Groot 1907–28, vol. 1, nos. 223, 232; Robinson 1974, figs. 43, 44). The standing figure at the window, who is assumed to be Steen, bears little resemblance to that artist, whose features are well known (see pls. 79, 81, 82, and 85) and Steen's *Self-Portrait,* Rijksmuseum, Amsterdam, no. A383.

3. Respectively, Hofstede de Groot (1907–28, vol. 1), nos. 154, 148, 162, 159, 151, 156; Robinson 1974, figs. 73, 157, 158, 159, 205, and 69.

4. Plietzsch 1936, p. 9.

5. Hofstede de Groot 1907–28, vol. 1, no. 187; see also *The Concert,* Dr. C. Benedict, Paris, 1934; Robinson 1974, pp. 74–75, fig. 181, as an early work or copy thereof.

6. *The Young Lady at Her Toilet,* Norton Simon Foundation, Pasadena, California (Hofstede de Groot 1907–28, vol. 1, no. 88; Robinson 1974, fig. 122), employs a similar Dou-like space, but the theme and figures are more reminiscent of Jacob Duck.

7. See Gudlaugsson 1968a, p. 9.

8. See Naumann 1981a, vol. 1, p. 51 n. 15.

9. Mirimonde 1966, p. 281. The caryatid supporting a fireplace also appears in Metsu's *Woman Seated at a Table and a Man Tuning a Violin,* National Gallery, London, no. 838, and *Woman with Glass and Tankard,* Musée du Louvre, Paris, inv. 1464.

10. Welu 1977a, p. 64 n. 24.

11. Descamps 1753–64, vol. 2 (1754), p. 243.

Jan Miel

Beveren 1599–1664 Turin

Jan Miel was born in Beveren, six miles west of Antwerp, in 1599. Although Baldinucci claims that he studied with Gerard Seghers (1591–1651) in Antwerp, the artist's name does not appear in the liggeren (registers) for the Antwerp guild. Miel is first documented in Rome in 1636, when he and other foreign artists met with officials of the Roman Accademia di San Luca; however, he must have arrived in the city by 1633, the date of two paintings of Roman street scenes that closely reflect the work of Pieter van Laer (q.v.), who had been living in Rome since 1625/26. In 1640 Miel's name appears for the first time in Roman parish records. For the next twenty years he lived on the Via della Vita and the Via delle Mercede. Miel joined De Schildersbent soon after his arrival in Rome and was given the Bent name "Bieco" (a threatening look). In 1647 he became a member of the confraternity of San Giuliano dei Fiamminghi; in 1648 he was inducted into the Accademia di San Luca; and in 1650 he entered the congregation of the Virtuosi at the Pantheon.

Although Miel had made his reputation as a painter of bambocciate in the manner of van Laer and had a number of important patrons including Agostino Fransone and the Marchese Tommaso Raggi, he was in the studio of Andrea Sacchi (1599–1661) in 1641 and subsequently began to specialize in the painting of large-scale history pictures. His main sources of inspiration as a history painter were Sacchi and Nicolas Poussin (1594–1665), although in 1654 he spent eight months in Bologna and Parma studying the work of Correggio and the Carracci. Miel also worked in fresco, in the Roman churches of San Martino ai Monti, Santa Maria dell' Anima, and San Lorenzo in Lucina.

In 1659 the artist arrived in Turin to work for Duke Carlo Emmanuele II; among his ducal commissions were the decoration of the Sala di Diana in the royal hunting lodge at Venaria and soffitti in the Palazzo Reale. In 1663 his patron awarded him a knighthood of the order of Saint Maurice and Saint Lazarus. The artist died in Turin in the following year and was buried in the Cathedral of San Giovanni. Miel is remarkable among Netherlandish artists who traveled to Italy not only because he remained there and enjoyed a successful career, but also in making the transition from painter of bambocciate to painter of large-scale history paintings on canvas and in fresco.

Literature: De Bie 1661, p. 368; Baldinucci 1681–1728, vol. 6; Houbraken 1718–21, vol. 2, p. 144; Passeri 1772; Bartsch 1803–21, vol. 1, p. 337; Nagler 1835–52, vol. 9, p. 258; Immerzeel 1842–43, vol. 2, p. 225; Weigel 1843, p. 431; Blanc 1854–90, vol. 3, p. 27; Kramm 1857–64, vol. 4, p. 1118; Nagler 1858–79, vol. 3, p. 2791; Obreen 1877–90, vol. 3, p. 214, and vol. 7, p. 190; Bertolotti 1880; Dutuit 1881–88, vol. 5, p. 185; Wurzbach 1906–11, vol. 2, pp. 160–61; Thieme, Becker 1907–50, vol. 24 (1930), pp. 537–38; Hess 1932; Hollstein 1949–, vol. 14, pp. 31–37; Busiri Vici 1958; Busiri Vici 1958–59; Busschaert 1964; Bodart 1970; Bartsch 1971–, vol. 1, pp. 318–26; Kren 1979.

C.B.

Carnival in the Piazza Colonna, Rome, c. 1645
Oil on canvas, 35 x 69¼" (89 x 176 cm.)
Wadsworth Atheneum, Hartford, The Ella Gallup Sumner and Mary Catlin Sumner Collection, 1938.603

Provenance: Marchese Tommaso Raggi, Rome; Raggi family, Rome, 1710;[1] Count Sellon d'Allaman, Geneva, 1795;[2] d'Allaman's Collection was dispersed gradually during the first half of the nineteenth century; Karl Loevenich Gallery, New York, 1932 (as Pieter van Laer); purchased by the Wadsworth Atheneum, 1938.

Exhibitions: New York, Kleinberger Galleries, *Italian Baroque Painting and Drawing*, October 1932, p. 6 (lent by Loevenich); Los Angeles, Los Angeles County Museum, *Dutch, Flemish, and German Old Masters*, 1936, no. 10 (lent by Loevenich); Baltimore, Johns Hopkins University, *Venice Carnival and Divertissements through Three Centuries*, 1941, no. 1; Oberlin, Allen Memorial Art Museum, *Italian Seicento Painting*, 1952, no. 9; Pittsburgh 1954, no. 21; Rotterdam/Rome 1958–59, no. 92.

Literature: Baldinucci 1681–1728, vol. 6, p. 367; Bodart 1970, vol. 1, p. 391 n. 4; Hartford, Wadsworth Atheneum, cat. 1978, no. 92; Kren 1979, cat. no. A15.[3]

The Piazza Colonna is shown crowded with masked and extravagantly dressed carnival revelers. On a wagon to the left of the column, among the actors of the commedia dell'arte, are the characters of Harlequin and Scaramouche (in black), the Doctor (with a book), and Pulcinella. Among the throng are peddlers, beggars, musicians, and a fortune-teller. At lower right, two beggars play *mora* (see cat. no. 60). The Palazzo Bufalo-Ferrajoli and the church of Santa Maria della Pietà (later San Bartolommeo dei Bergamaschi), both standing today, are in the background. The church of San Paolo in Colonna, on the right, and the houses to its left, were demolished in 1659. An effigy hanging from the gallows at left symbolizes the end of winter, a ritual of the last day of the carnival.

The large size of the painting, which is almost six feet wide, is unusual for a *bambocciata*. Because the painting was one of a series commissioned for the Roman Palazzo of Marchese Tommaso Raggi under the Cam-

pidoglio, the painting was probably intended as a *sopraporta* or another form of palace decoration. The series comprised five paintings and appears to have had a unified iconographic program of scenes depicting everyday life in Rome and scenes set among the ruins. This is the only known *bambocciata* decorative scheme of this type. Michelangelo Cerquozzi, a native Roman painter of *bambocciate*, probably contributed to the series; influenced by van Laer and Miel, he joined the Accademia di San Luca in 1650. Motifs from the painting were used by another Netherlandish painter of *bambocciate*, Jan Lingelbach.[4] The large size and the oblong format enabled Miel to fill the canvas with a rich variety of incidents, thereby creating the effect of six more conventional *bambocciate* squeezed into a single painting. Both the topographical accuracy of the setting and the format anticipate the *vedute* of Vanvitelli and others who were active later in the century.

C.B.

1. According to Baldinucci, this painting was one of a series of five Roman scenes painted by Miel and others for Marchese Raggi (1595/6–1679), a Genoese nobleman (1681–1728, vol. 6, p. 367). The Raggi family still owned the paintings in 1710, when they were exhibited in the cloister of San Salvatore in Lauro, Rome.

2. See *Catalogue raisonné des 215 tableaux les plus capitaux de M. le Comte de Sellon d'Allaman* (Geneva, 1795), no. 113.

3. This entry is based on that in the catalogue section of Kren's dissertation and on the entry, also by Kren, in Hartford, Wadsworth Atheneum, cat. 1978, no. 92.

4. Burger-Wegener 1976, pp. 58, 178–79.

Leiden 1635–1681 Leiden

The Peasant Inn, 1655–57
Signed lower right: F van Mieris
Oil on panel, 14⅞ x 11⅞" (37.9 x 30.1 cm.)
Stedelijk Museum "De Lakenhal," Leiden,
no. 527

Literature: De Bie 1661, pp. 404–5; de Piles 1699, pp. 430–31; Houbraken 1718–21, vol. 3, pp. 1–12, 343, 389; van Gool 1750–51, vol. 1, p. 39; Levensbeschryving 1774–83, vol. 8, pp. 321–32; van Eynden, van der Willigen 1816–40, vol. 1, p. 418, and vol. 4, p. 183; Smith 1829–42, vol. 1, pp. 61–87, and vol. 9, p. 34; Nagler 1835–52, vol. 9, p. 264; Immerzeel 1842–43, vol. 3, p. 226; Schinkel 1850; Blanc 1853–54, pp. 81–90; Kramm 1857–64, vol. 4, p. 1124; Nagler 1858–79, vol. 2, pp. 2288, 2294, 2295; Lemcke 1878; Sacher-Masoch 1891; Wurzbach 1906–11, vol. 2, pp. 164–67; Hofstede de Groot 1907–28, vol. 10; Bredius 1909b; Brunt 1911; W. Stechow in Thieme, Becker 1907–50, vol. 24 (1930), pp. 540–41; Juynboll 1935; Hollstein 1949–, vol. 14, pp. 44–46; Maclaren 1960, pp. 248–49; Plietzsch 1960, pp. 49–55; Rosenberg et al. 1966, p. 132; Gudlaugsson 1967; Amsterdam 1976, pp. 172–75; Naumann 1978; Braunschweig 1978, pp. 98–101; Naumann 1981a; Naumann 1981b.

Frans van Mieris was born in Leiden on April 16, 1635, to Jansz. Bastiaensz., a goldsmith, and Christine Willemsdr. van Garbartijn. Although originally apprenticed as a goldsmith to his cousin Willem Fransz., by 1650 van Mieris had become a pupil of the famous glass-painter and drawing master Abraham van Toorenvliet (c. 1640–1692) in Leiden. After a brief period with van Toorenvliet, the artist began an apprenticeship with Gerard Dou (q.v.), who referred to van Mieris as "the prince of his pupils." He studied next with Abraham van den Tempel (1622/23–1672), a Leiden history and portrait painter, and finally returned to Dou's studio for the remainder of his training. In 1657 he married Cunera van der Cock, who bore him five children. On May 14, 1658, van Mieris entered the Leiden Guild of St. Luke; he served as a hoofdman (leader) in 1663 and 1664 and a deken (dean) in 1665.

Van Mieris seems to have spent his entire life in Leiden, moving frequently within the city limits. An extremely popular painter, he was highly paid by a number of Leiden's wealthiest and most prominent citizens. He also received a number of important commissions from Grand Duke Cosimo III de Medici and Archduke Leopold Wilhelm, who unsuccessfully offered him the position of court painter in Vienna. Despite his more than respectable income, notarial and court records from the 1660s and 1670s indicate that van Mieris was constantly in debt. The records also substantiate Houbraken's claim that the artist was a habitual drunkard. He appears, however, to have been well respected; upon his death on March 12, 1681, he was buried alongside prominent Leiden citizens at the Pieterskerk.

A leading member of the Leiden School of fijnschilders (fine painters), van Mieris painted small interior genre scenes, portraits, and a few historical subjects. In style and theme he is closely related to his teacher Gerard Dou. His attention to meticulous detail was imitated by his pupils and sons, Willem (1662–1747) and Jan (1660–1690), and his grandson Frans van Mieris the Younger (1689–1763). Another pupil was the Leiden genre and portrait painter Carel de Moor (1656–1738).

C.V.B.R.

Provenance: Kurfürstliche Galerie, Schleissheim, Munich (inv. 1748, p. 4r, inv. 1775, no. 777); Residenz, Munich, 1799, no. 726; Bavarian Royal Collections, passed to the Pinakothek, Munich; Alte Pinakothek, Munich; acquired for the "Lakenhal" by the Jan Steen Commission, 1928.

Exhibitions: Oslow, Nasjonalgalleriet, *Fra Rembrandt til Vermeer,* 1959, no. 41, ill.; San Francisco 1966, no. 84, ill.

Literature: Smith 1829–42, vol. 1, no. 84; Wurzbach 1906–11, vol. 2, p. 166; Hofstede de Groot 1907–28, vol. 10, no. 106; Munich, Alte Pinakothek, cat. 1925, no. 582; Leiden, Lakenhal, cat. 1949, pl. 181, no. 527, pl. 21; Plietzsch 1960, pp. 50–51; Bernt 1970, vol. 2, no. 766, ill.; Naumann 1981a, vol. 1, p. 47, and vol. 2, p. 18, no. 15, pl. 15.

Van Mieris's *Peasant Inn* shows a rustic interior cluttered with various items of food and drink. The large keg of beer with its drip pot in the immediate foreground and the mussel shells draining in a ceramic sieve in the lower right help to identify it as a tavern or an eatery. The woman is either the proprietor or a serving maid, and the men are her clients. The woman appears to be engaged in conversation with the man on the far side of the table, apparently concerning the dried fish to which she points. The man is occupied in cutting tobacco, while his partner downs a large wooden tankard of beer.

The painting belongs to the earliest period of van Mieris's career as a painter, that is, before he dated his first independent work, *The Doctor's Visit* of 1657 now in Vienna.[1] During this time the artist was strongly influenced by his

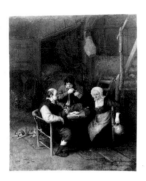

FIG. I. ADRIAEN VAN OSTADE, *Peasant Inn*, oil on panel, Kunsthistorisches Museum, Vienna, no. 9038.

FIG. 2. JACOB OCHTERVELT, *Tavern Scene*, 1651, oil on canvas, private collection, the Netherlands.

master, Gerard Dou. Around the middle of the decade, van Mieris painted at least five other Dou-like pictures sharing the same compositional structure;[2] the paintings are arranged in an upright format, and a repoussoir on the left serves to situate the figures—limited from one to three—in a convincing space. Although the formula is elementary, it may have been derived from Dou, who employed it in two paintings from around 1650, which show a similar keg of beer and drip pot on the left.[3] That Dou was familiar with the motif as early as the 1630s is evident from his early painting of a *Woman Eating Porridge* (pl. 53).

Precise dating of *The Peasant Inn* is essential for establishing its proper relationship to two works painted by Adriaen van Ostade and Jacob Ochtervelt during the same period. Ostade's *Peasant Inn* (fig. I)[4] bears only a generic relationship to van Mieris's picture, yet the choice of a humble interior showing three full-length figures—one man drinking, another smoking, and a serving-woman—may be more than coinciden-

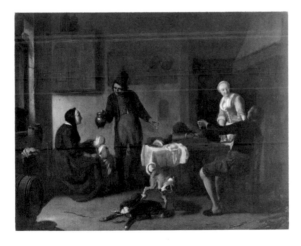

tal. The hanging wicker bottle that appears in both paintings is another shared motif, but it probably does not connote any interdependence; judging from comparable examples in other Dutch paintings, this was a common object that merely indicated a tavern. Whatever the relationship between these two works, the invention of the peasant interior must be credited to Ostade, who specialized in this genre long before van Mieris began painting.

Jacob Ochtervelt's recently discovered *Tavern Scene* (fig. 2), reportedly signed and dated 1651,[5] is much more closely related to *The Peasant Inn*. This work adds a new dimension to the

previously recognized relationship between the two artists. Many works show that van Mieris provided inspiration for Ochtervelt,[6] but until now no instance of the latter's influence on the former has come to light. This picture, probably painted when the fifteen-year-old Ochtervelt studied the art of painting under Nicolaes Berchem, forces one to rethink the artist's early career;[7] furthermore, it demonstrates that the relationship between Ochtervelt and van Mieris was not merely one of dependence. The two artists must have carried on a viable and productive artistic dialogue. In both works we recognize a similar keg of beer and a fireplace to the side of a figure group. In both works a standing maid-servant wears a red bodice over tan and white undergarments, while the seated man wears a dark jacket or vest with brown breeches. By expanding his composition on the left, Ochtervelt combines a Steen-like family gathering with an Ostade-like peasant interior, a pastiche not uncharacteristic for the artist in his early years.

The Peasant Inn is one of the earliest indications that van Mieris would become more than a mere follower of Dou. The masterful handling of light reveals a dimension of van Mieris's art that would distinguish him from his teacher. Although both artists are unmatched practitioners of the ultrafine technique of *Feinmalerei* or *fijnschilderij* (literally, "fine painting"),[8] it was van Mieris who made the more substantial contribution in the overall refinement of Dutch painting after the early 1660s.

O.N.

1. See Plietzsch 1960, pp. 50–51; and Naumann 1981a, vol. 1, pls. 10–15.

2. Naumann 1981a, vol. 2, pls. 10–15.

3. Martin 1913, pp. 94, 96 (left), ill.

4. Vienna, Kunsthistorisches Museum, cat. 1972, p. 71, inv. no. 9038 (as probably datable to the 1650s); see Naumann 1981a, vol. 1, p. 47 n. 59.

5. Sale, Parke-Bernet, New York, March 6, 1975, no. 63, ill. (as signed in monogram by Gabriel Metsu and dated 1653); now in a private collection in the Netherlands. A cleaning of the painting after its purchase by a Belgian dealer revealed the signature and date: J. ochtervelt f. 1651. On the basis of a photograph, Susan Donahue-Kuretsky, author of the monograph on Ochtervelt (Kuretsky 1979), tentatively accepts the picture as Ochtervelt's earliest dated work (letter of February 3, 1983).

6. See Kuretsky 1979, pp. 15–18, 20, 44, 48; and Naumann 1981a, vol. 1, pp. 59–63, 75, 130.

7. See Kuretsky 1979, p. 13.

8. For a brief discussion of these terms, see Naumann 1981a, vol. 1.

Teasing the Pet, 1660
Remnant of signature and date upper right
Oil on panel, 10⅞ x 7⅞″ (27.5 x 20 cm.)
The Royal Cabinet of Paintings, Mauritshuis,
The Hague, no. 108

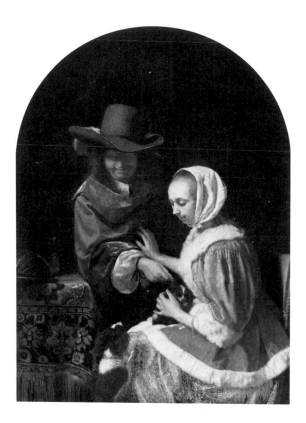

Provenance: Coenraad Baron Droste, 1717; sale, The Hague,
July 21, 1734, no. 86; sale, Bicker van Zwieten, The Hague,
April 12, 1741, no. 53 (bought in); bought by de Roore for
van Slingelandt, before 1752; sale, Govert van Slingelandt,
The Hague, May 18, 1786, no. 14; Prince William V of
Orange, The Hague; removed by Napoleon to Paris (Paris,
cat. 1815, p. 52, no. 434); subsequently returned to Holland.

Exhibition: The Hague, Mauritshuis, *150 jaar,* 1966–67,
no. 27.

Literature: Coenraad Baron Droste, *De Harderkouten en an-
dere Dichten* (Rotterdam, 1717), p. 58, no. 8; Descamps
1753–64, vol. 1, p. 21; Joshua Reynolds, "A Journey to
Flanders and Holland in the Year 1781," in *The Literary
Works of Sir Joshua Reynolds,* ed. H. W. Beechy (London,
1890), vol. 2, p. 191; Smith 1829–42, vol. 1, no. 4, and
suppl., no. 4; Wurzbach 1906–11, vol. 2, p. 165; Hofstede
de Groot 1907–28, vol. 10, no. 208; Robinson 1974, pp.
91–93; Beatrijs Brenninkmeyer-de Rooij, "De Schilde-
rijengalerij van Prins Willem V op het Buitenhof te Den
Haag," *Antiek,* vol. 11, no. 2 (1976), p. 167, no. 88, ill.;
Naumann 1981a, vol. 1, pp. 60–61, 63, 68, 110, 128, fig.
67, and vol. 2, cat. no. 35, pl. 35.

The present painting raises an issue in the defini-
tion of genre painting. Although *Teasing the Pet*
is clearly a scene of everyday life, the anonymity
that usually characterizes genre painting is lack-
ing. In 1717 Coenraad Baron Droste, the earliest
recorded owner of the work, identified the fig-
ures of the man and woman as van Mieris and
his wife: "Who else could better furnish his pic-
tures with turkish carpet, variegated and velvet
clothes, than the elder Mieris, who here repre-

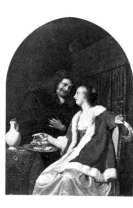

FIG. 1. FRANS VAN MIERIS,
The Oyster Meal, 1661, oil
on panel, Mauritshuis, The
Hague, no. 819.

sents himself, playing with a puppy on his wife's
lap?"[1] All later references to the work, indeed all
available evidence, support Droste's statement.[2]
Thus the picture belongs to two categories of
painting, portraiture as well as genre.

Despite our knowledge of the identity of the
couple in this picture, the work is still difficult to
interpret. Attempts to find a hidden or second-
ary meaning in the painting have proven fruit-
less.[3] The man's gesture in pulling the lapdog's
ear obviously may be regarded as a playful ad-
vance on the woman, who responds by coyly
pushing away the importuning man. Although
this interpretation seems likely, we must resist
the temptation to read a story into the work. In
the mid-eighteenth century, one observer went
so far as to identify the second dog as the
puppy's mother, who attempts to prevent the
attack on her offspring.[4]

Van Mieris's *Oyster Meal* (fig. 1) may be the
pendant to this picture, a connection that could
help to clarify the meaning of both works.[5]
Teasing the Pet might be regarded as an offer of
seduction refused, while its potential companion,
The Oyster Meal, would represent the proposal
accepted.

<div align="center">O.N.</div>

1. *De Harderkouten en andere Dichten* (Rotterdam, 1717),
p. 58, no. 8: "Wie heeft met Turks tapyt, bont en fluweele
kleeren,/ Syn schilderyen ooit so weten te stofferen,/ Als
d'oude Mieris kost, die hier sich selfs verbeelt,/ En op syn
Vrouwe schoot met een jong hontje speelt" (see Naumann
1981a, vol. 2, p. 41).

2. See Naumann 1981a, vol. 1, pp. 125–34, and note 4,
below.

3. Naumann 1981a, vol. 1, p. 110.

4. Hoet 1752, vol. 2, p. 404 (collection van Slingelandt):
"Een stukje van de oude Frans Mieris, verbeeldende den
Schilder zelfs en zyn Vrouw, die een hondje op de schoot
heeft, het welk hy by het oor trekt, dat de moer van het
hondje soekt te weeren."

5. The linkage of the pictures as pendants (Naumann 1981a,
vol. 1, pp. 60–61, 110) is strongly opposed by Cornelia
Moiso-Diekamp (see her forthcoming study of pendants in
Dutch seventeenth-century paintings, p. 9, no. D6). In a letter
of April 18, 1983, Moiso-Diekamp argues that since the
original arched tops of the paintings differ in shape, the two
works could not be pendants. However, when the two panels
were unframed in 1977, the contours of both works matched
perfectly.

Young Woman Standing before a Mirror, 1670?
Oil on panel, 16⅞ x 12⅜″ (43 x 31.5 cm.)
Bayerische Staatsgemäldesammlungen, Alte
Pinakothek, Munich, no. 219

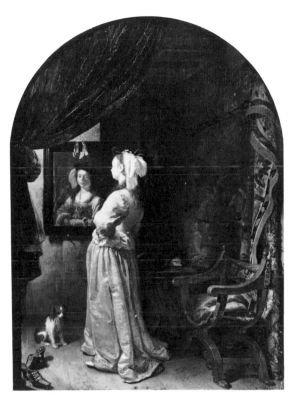

Provenance: Schleissheim, inv. no. 1748 (p. 4r), and cat.
1765, no. 191 (as signed and dated 1670); moved to the
Hofgartengalerie, Munich, 1781; Residenz, Munich, 1799,
no. 725; passed to the Alte Pinakothek.

Exhibitions: Amsterdam 1948 and Paris 1949, no. 110.

Literature: Smith 1829–42, vol. 1, no. 91; Munich, Alte
Pinakothek, cat. 1904, no. 423 (as unsigned); Wurzbach
1906–11, vol. 2, p. 166; Hofstede de Groot 1907–28, vol.
10, no. 80; Plietzsch 1960, p. 52, fig. 67 (as datable to the
early 1660s); Gudlaugsson 1967, pp. 421–22, ill.; Brown
1976, p. 12, pl. 48 (as c. 1662–63); Naumann 1981a, vol. 1,
pp. 78, 82; vol. 2, pp. 91–92, no. 76, pl. 76.

In the late eighteenth century, this painting was
recorded as signed and dated 1670, but it bears
no such inscription today. Plietzsch dated the
painting to the early 1660s because of its rela-
tionship to the artist's *Woman Teasing a Puppy*
(Hermitage, Leningrad, no. 915), a picture that
can be convincingly dated around 1660.[1] The
style of *Young Woman Standing before a Mir-
ror,* however, differs from that of the Leningrad
painting, which typifies van Mieris's early works
in its depiction of an interior with relatively
complex and clearly delineated background ele-
ments. The Munich painting displays a darker,
less elaborate space, a type of chiaroscuro that
appeared in his works around 1670, beginning
with the *Sleeping Courtesan* (Uffizi, Florence,
no. P1820), which was probably executed in
1669.[2] The closest and most revealing compara-

tive painting is the artist's *Woman and a
Procuress,* 1671 (Gemäldegalerie Alte Meister,
Dresden, no. 1742), which exhibits numerous
parallels in execution and displays the same dog
in the lower left corner.[3]

Even in this advanced stage of his career, the
Leiden artist continued to draw inspiration from
Gerard ter Borch, whose works greatly influ-
enced van Mieris during his early maturity as a
painter. The theme of a woman before a mirror
had appeared at least since the time of Hierony-
mus Bosch, when the subject stood for the sin of
superbia (pride). In Holland the theme was de-
veloped and popularized by ter Borch shortly
after 1650, when he painted *Young Woman at
Her Toilet* (fig. 1).[4] During the same period, ter
Borch painted *Woman at a Mirror* (Rijks-
museum, Amsterdam, no. A4039),[5] where the
reflection of the woman's face is the focal point
of the picture. Although van Mieris possibly
knew both works, the painting that was inspired
by this knowledge is much more than a pastiche.
Reflecting current painting trends, van Mieris
displayed impressive craftsmanship and vir-
tuosity.[6] In the Munich painting, the woman's
shimmering satin dress, beige jacket, and yellow
feather stand together like a column in the richly
colored interior of browns, blues, and reds. The
discarded shoes in the lower left corner add a
touch of green to the composition, providing
variation within the color scheme; icon-
ographically, they introduce a secondary
meaning. In other works, a woman removing
her shoes or stockings has erotic implications.[7]
Other objects that may have iconographic sig-
nificance include her cap, a symbol of pride and
unchastity;[8] the mirror, a time-honored sign of
vanity or human frailty, could also connote
lasciviousness or voluptuousness.[9] The dog, tra-
ditionally representing fidelity, may be merely an
obedient plaything, a substitute for a lover who
is controlled by a vain woman's charms.[10]

<div align="right">O.N.</div>

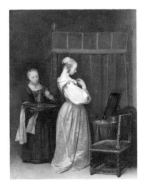

FIG. 1. GERARD TER BORCH,
*Young Woman at Her
Toilet,* oil on panel, Metro-
politan Museum of Art,
New York, 17.190.10.

1. Naumann 1981a, vol. 1, pp. 56–57, and vol. 2, pp. 35–36, no. 32, pl. 32.

2. Naumann 1981a, vol. 2, pp. 89–91, no. 75, pl. 75.

3. Naumann 1981a, vol. 2, pp. 99–100, no. 87, pl. 87. Painted in 1671, van Mieris's *Wife of Jerobaum with the Prophet Ahiajah* also contains a *savonarola*, or sixteenth-century folding chair (Naumann 1981a, vol. 2, pl. 85). See also ter Borch's *Woman Washing Her Hands*, c. 1655, where a dog is depicted similarly (Gudlaugsson 1959–60, vol. 1, fig. 113).

4. Gudlaugsson 1959–60, vol. 1, fig. 80 (as c. 1650).

5. Gudlaugsson 1959–60, vol. 1, fig. 83 (as shortly after 1650).

6. Compare the contemporary paintings of de Hooch, c. 1675 (Sutton 1980, p. 109, no. 115, fig. 118) and Ochtervelt, c. 1669 (Kuretsky 1979, p. 78, no. 59, fig. 57).

7. See B.J.P. Broos, "De caers uut, de schaemschoe uut. Een vergeten erotisch symbool," *Vrij Nederland*, April 24, 1971, p. 25; and Amsterdam 1976, pp. 245, 259–61.

8. De Jongh 1971, pp. 171, 192; and Amsterdam 1976, pp. 59–60. In 1604 van Mander suggested that attaching three feathers to the purse held by the allegory of Livelihood symbolized pride (Stechow 1966a, p. 72).

9. Compare Amsterdam 1976, pp. 168, 192; and Brown 1978, p. 25.

10. Although Dutch artists needed no reminding, van Mander, in his 1604 handbook on allegorical personification (*Uytbeeldinghe der Figueren*), spelled out the significance of the dog: "By the dog one indicates fidelity; for the dog is most faithful and never forgets a kindness shown him" (translated in Stechow 1966a, p. 71). On the multifarious interpretations applied to dogs and their mistresses, see Naumann 1981a, vol. 1, pp. 105–6. Dogs were among the pets traditionally kept by courtesans; in this sense they could indicate lust or animal passion (see Donald Posner, *Watteau. A Lady at Her Toilet* [New York, 1973], p. 79). According to Konrad Renger (1970, p. 130), dogs (and cats) could serve as references to prostitution in sixteenth-century prints. De Jongh (1968–69, p. 41) demonstrated that the dog could stand for unchastity. See also cat. no. 108.

A notarized document dated November 21, 1637, giving the painter's age as about twenty-seven, indicates that Jan Miense Molenaer was born in Haarlem around 1610. Although he has frequently been referred to as a pupil of Frans Hals (q.v.), nothing certain is known of his artistic training. In June 1636, when he married the painter Judith Leyster (q.v.) in Heemstede, Molenaer was recorded as a resident of Haarlem. The couple moved to Amsterdam soon after their wedding, possibly because Molenaer's property had been confiscated by the court to pay his debts.

Molenaer and Leyster are mentioned periodically in Amsterdam records until 1648. A document from March 1, 1644, reveals that the artist Jan Lievens (1607–1674) lived in their house briefly. In October 1648 the couple returned to Heemstede, where Molenaer bought a house and property. Although both he and Judith Leyster continued to live in the Haarlem-Heemstede area, records indicate that Molenaer bought another house in Amsterdam on the Voetboogstraat on January 9, 1655, and lived there from May to October. In the same year he obtained a third house, on the Lombardsteech in Haarlem. Molenaer drew up his will on September 8, 1668, a few days before his death. He was buried in Haarlem on September 19; his possessions were inventoried on October 10, 1668.

Molenaer is known primarily as a painter of genre scenes depicting high and low life. He also produced a number of allegorical works, a few portraits, and some scenes from theatrical performances. His religious works often incorporate the peasant types found in his genre scenes.

C.v.B.R.

The Duet, c. 1629–31
Signed lower right on foot warmer: I. Molenaer
Oil on canvas, 26⅛ x 20½" (66.4 x 52.1 cm.)
Seattle Art Museum, Gift of the Samuel H. Kress
Foundation, inv. no. 61.162

Literature: Schrevelius 1648, p. 384; Houbraken 1718–21, vol. 2, p. 90; Bartsch 1803–21, vol. 4, p. 1; van Eynden, van der Willigen 1816–40, vol. 1, p. 103; Nagler 1835–52, vol. 9, p. 365; Weigel 1843, p. 146; Blanc 1854–90, vol. 3, p. 36; Kramm 1857–64, vol. 4, p. 1139; Nagler 1858–79, vol. 3, pp. 2789, 2829; van der Willigen 1870, pp. 31, 225; Obreen 1877–90, vol. 5, p. 15, and vol. 7, pp. 289–304; Bode 1883, pp. 199–205; Bode, Bredius 1890, pp. 65–78; Durand-Gréville 1895; Wurzbach 1906–11, vol. 2, pp. 176–78; Bredius 1908; Bredius 1915–22, vol. 1, pp. 1–26, and vol. 7, pp. 154–61; Kalff 1920; A. von Schneider in Thieme, Becker 1907–50, vol. 35 (1931), pp. 30–32; Hollstein 1949–, vol. 14, pp. 64–68; Dubiez 1956; Maclaren 1960, pp. 256–57; Plietzsch 1960, pp. 27–29; Rosenberg et al. 1966, pp. 107–8; van Thiel 1967–68; Bartsch 1971–, vol. 5, p. 9; Amsterdam 1976, pp. 176–85; Daniëls 1976; Braunschweig 1978, pp. 106–15; Boston/Saint Louis 1980–81, p. 119; Amsterdam/Washington 1981–82, pp. 262–63.

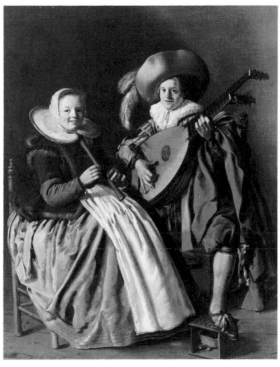

Provenance: Leroy M. Backus, Seattle; dealer D. Katz, Dieren, Holland, by 1938; Schaeffer Galleries, New York, by 1948; Kress Collection, Seattle, 1954.

Exhibitions: Providence, Rhode Island School of Design, *Dutch Painting in the Seventeenth Century,* December 1938–January 1939, no. 31; New York, *Schaeffer Galleries Bulletin,* no. 7 (November 1948); Indianapolis, Indiana, John Herron Art Museum, *The Young Rembrandt and His Times,* February 14–March 23, 1958, and San Diego, Fine Arts Gallery, April 11–May 18, 1958, no. 52; Allentown 1965, p. 44, no. 50, ill.; Milwaukee, Milwaukee Art Center, *The Inner Circle,* September 15–October 23, 1966, no. 68.

Literature: Seattle, Seattle Art Museum, cat. 1954, p. 66; Eisler 1977, pp. 135–36, no. K1998, fig. 122; DIAL 43C74.32.1.

Dressed in a plumed hat, striped doublet, ruff, and cape, the young man on the right plays a theorbo. His accompanist on the recorder is a smiling young woman attired in a wide skirt, fur-trimmed jacket with oversleeves, white cap, and broad, lace-edged collar. Scholars have taken this painting to be a self-portrait of Molenaer with Judith Leyster; the two artists were married in 1636.[1] Although Leyster herself painted a similar musical couple (fig. 1), this identification of the sitters, if indeed they are portraits, seems uncertain.[2] On the other hand, the picture has correctly been considered to be an early work (see fig. 2).[3] Similar technique, figure types, and bright, clear colors are encountered in Molenaer's earliest dated works of 1629; for example, the *Family in an Interior*

(Mittelrheinisches Landesmuseum, Mainz, no. 831).[4] Moreover, the man in *The Duet* wears virtually the same costume as the painter in the *Artist's Studio* of 1631 (Staatliche Museen [Bodemuseum], Berlin). Molenaer's genre paintings from the later 1630s and 1640s, such as the *Boys with Dwarfs* (pl. 21), usually deal with less elegant subjects and are more animated in design and somewhat looser in execution. During his last two decades of activity, the artist painted peasant scenes that are crowded and sometimes carelessly executed.[5]

Here the couple's musical harmony could, of course, be a metaphor for their amorous involvement. One writer sees the foot warmer—a common piece of furniture used to stave off chill[6]—as "an emblematic allusion to passion."[7] However, the couple here scarcely appear to be burning with desire. Other associations of the foot warmer might be more appropriate. In his commentary on an emblem of a foot warmer published in 1614 (fig. 3) with the motto *Mignon des Dames* (ladies' favorite), Roemer Visscher explained that men who attempt to win women's favors with gallantries could take a lesson from the humble foot stove, which owes its popularity with the ladies to its simple utility.

P.C.S.

FIG. 1. JUDITH LEYSTER, *Merry Company,* 1630, oil on panel, Musée du Louvre, Paris, inv. RF2131.

Woman at Her Toilet (Lady World), 1633
Signed and dated lower left on virginal:
Molenaer 1633
Oil on canvas, 40⅛ x 50″ (102 x 127 cm.)
The Toledo Museum of Art, Gift of Edward
Drummond Libbey, no. 75.21

FIG. 2. JAN MIENSE
MOLENAER, *A Young Man
Playing a Theorbo and a
Young Woman Playing a
Cittern*, oil on canvas, National Gallery, London, no.
1293.

FIG. 3. Emblem from
ROEMER VISSCHER, *Sinnepoppen* (Amsterdam,
1614), p. 178.

1. The identification was W. R. Valentiner's (see Seattle, Seattle Art Museum, cat. 1954, p. 66); it was accepted by Colin Eisler (1977, p. 135).

2. Compare Leyster's *Self-Portrait* (cat. no. 61, fig. 1).

3. See Seattle, Seattle Art Museum, cat. 1954, p. 66 (as "rather early"); Eisler 1977, p. 135 (as c. 1630). Another musical couple by Molenaer (see fig. 2) has also been dated to the early 1630s; see Maclaren 1960, p. 257. Compare also Molenaer's *Couple Playing Music*, Staatliches Museum, Schwerin, cat. 1886, no. 450 (wrongly as "Franz Hals"). Such paintings of elegant musical couples descend from earlier musical companies by Willem Buytewech, Dirck Hals, and Pieter Codde. A copy of *The Duet* (oil on panel, 17½ x 13¾″ [44.5 x 35 cm.]) was sold as a Dirck Hals in the H. Weustenberg sale, Berlin, October 27, 1908, no. 55, ill.

4. See also *Two Boys and a Girl Making Music* (National Gallery, London, no. 5416) and *At Breakfast* (Kunsthaus Heylshof, Worms, cat. 1927, pl. 18).

5. See, for example, *Peasants Carousing*, dated 1662 (Museum of Fine Arts, Boston, no. 07.500).

6. Fynes Moryson observed in 1617: "The weomen, as well at home, as in the Churches, to drive away cold, put under them little pannes of fier, covered with boxes of wood, boored full of holes in the top" (Moryson 1971, pt. 3, bk. 2, pp. 94–95).

7. Eisler 1977, pp. 135–36.

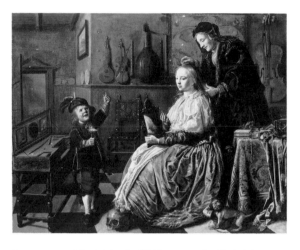

Provenance: Sale, Major R. W. Doyne et al., Christie's, London, February 26, 1926, no. 91, to Sabin (435 pounds sterling); dealer E. & A. Silberman, New York, 1942–46; Julius Held, Old Bennington, Vermont, 1946–68; J. M. Cath, New York; dealer S. Nijstad, The Hague; gift of Edward Drummond Libbey to the museum.

Exhibitions: Grand Rapids, Michigan, Grand Rapids Art Gallery, *Masterpieces of Dutch Art*, May 7–30, 1940, no. 53; San Francisco, California Palace of the Legion of Honor, *Vanity Fair. An Exhibition of Styles of Women's Headdress and Adornment through the Ages*, June–July 1942, no. 42; Baltimore, Baltimore Museum of Art, *Musical Instruments and Their Portrayal in Art*, April 26–June 2, 1946, no. 32; Providence, Rhode Island School of Design, March 7–April 29, 1951, no. 22; Pittsburgh 1954, no. 37; Leiden 1970, no. 18, ill.; Amsterdam 1976, cat. no. 43, ill.

Literature: E. Winternitz, "Music for the Eye," *Art News*, vol. 45 (June 1946), p. 27, ill. 56; E. de Jongh, "Homo Bulla en Vrouw Wereld: allegorische figuren in geëigende en camouflerende dracht," *Vrij Nederland*, August 1, 1970, p. 7; de Jongh 1971, pp. 181–83, fig. 19; de Jongh 1973, pp. 202–3, fig. 7; Toledo, Museum of Art, cat. 1976, p. 113, ill.

A young woman, seated in an interior and holding a ring and a mirror, is having her hair combed by an old woman. To the right is a table covered with jewels, trinkets, and an oriental rug. On the floor a chained monkey sticks its paw into one of the young woman's shoes; a skull serves as the woman's footrest. To the left a small boy blows soap bubbles. The room is filled with various musical instruments: at the left, a virginal, and hanging on the back wall, a cittern, violin, shawm, lute, recorder, transverse flute, and violoncello. At the back on the far left is an open door; above the young woman's head hangs a map of the world.

While owned by the dealer Silberman in the 1940s the painting was known as "The Preparation for the Wedding." Its appearance of an everyday scene was at that time, and as late as 1954, enhanced by the fact that the skull in the foreground was overpainted with a footstool.[1]

FIG. 1. HENDRIK GOLTZIUS, *The Allegory of Transitoriness*, engraving.

FIG. 2. After PIETER BALTENS, *Dens dans des Werelts*, engraving.

FIG. 3. JACOB OCHTERVELT, *Lady with Servant and Dog*, c. 1671–73, oil on canvas, Museum of Art, Carnegie Institute, Pittsburgh.

With the removal of this apocryphal addition the skull reemerged. However, even before the death's-head was rediscovered, the painting was exhibited in Pittsburgh in 1954 with the title "Vanity"; in Leiden in 1970 it was called "Allegory of Human Vanity."[2] Not only the skull but also the boy blowing bubbles (the notion of *homo bulla* ["Man is like a bubble"]; see fig. 1) and many other details of the scene—the mirror alluding to both the vanity of personal conceit and the falseness of appearances, the jewelry calling to mind wealth's temptations, and perhaps the musical instruments pointing to the enticements of life—can be related to the pervasive and singularly elastic notion of the vanity of worldly concerns.[3]

De Jongh was the first to recognize that the key to the painting's symbolic program and the woman's identity lies not in the many *vanitas* symbols but in more inconspicuous detail, namely the contiguousness of the circle of the map on the wall and the crown of the young woman's head. This conjunction identifies her as *Vrouw Wereld* (Frau Welt or Lady World), the beautiful and seductive personification of all vice and lust.[4] The allegorical figure of Lady World was earlier depicted with a globe or an imperial orb on her head and often held a mirror or a bubble as a secondary attribute.[5] In a print after Pieter Baltens depicting the popular theme "De dans om de wereld" (Dance around the world), Lady World, outfitted with her traditional symbols and stepping on a pile of straw labeled *vanitas,* stands at the center of a wild dance of motley characters personifying various vices (fig. 2). In Molenaer's painting other details allude to Lady World's seductive and sinful ways. The

chained monkey, here making a potentially obscene gesture, was a traditional inhabitant of medieval love gardens and alluded to those who are voluntary prisoners of sin.[6] For van Mander the ape was the symbol of immorality and shamelessness.[7] Seventeenth-century emblematic literature (by Roemer Visscher, Jacob Cats, and others) interpreted combing as an allusion to cleansing of the soul.[8] Despite its outward naturalism, therefore, this painting may be a call for the need to cleanse the world of sin.

As de Jongh observed, Molenaer's painting is an innovative interpretation of an older allegorical tradition; by exchanging Vrouw Wereld's globe or orb for a map he gave the symbolism a new and more natural appearance. The allegorical figure is accommodated to the realm of burgher's comforts and her wiles and implicit warnings made all the more immediate. A later interpretation of the personification, as de Jongh points out, is Jacob Ochtervelt's *Lady with Servant and Dog,* where the woman's head once again just touches a map on the back wall (fig. 3). Lady World, her terrestrial appetites even more guilefully disguised, thus remains a party to the elegant diversions of later Dutch genre.

<div align="right">P.C.S.</div>

1. A photograph taken at the time of the 1926 sale already shows the overpaint; see also the reproduction in Pittsburgh 1954, no. 37.

2. In the exhibition *Ijdelheid der Ijdelheden: Hollandse Vanitasvoorstellingen vit de zeventiende eeuw* [Vanity of vanities: seventeenth-century Dutch depictions of *vanitas*], no. 18.

3. On the idea of *homo bulla*, see in addition to the Leiden catalogue, H. W. Janson, "The Putto with the Death's Head," *The Art Bulletin*, vol. 19 (1937), pp. 423–30; W. Stechow, "Homo Bulla," *The Art Bulletin*, vol. 20 (1938), pp. 227–28; Knipping 1939–42, vol. 1, pp. 117–20; de Jongh 1967, p. 86; de Jongh 1971, pp. 167–69; and de Jongh in Amsterdam 1976, nos. 4, 20.

4. See de Jongh 1973, p. 203.

5. On medieval depictions of Lady World, see Stammler 1959. De Jongh's article (1973) traces the continuation of this tradition in seventeenth-century Dutch art and literature; see also E. de Jongh, "Homo Bulla en Vrouw Wereld: allegorische figuren in geëigende en camouflerende dracht," *Vrij Nederland*, August 1, 1970, p. 7; de Jongh 1971, p. 180; Amsterdam 1976, no. 73.

6. On apes and their negative associations, see H. W. Janson, *Apes and Ape Lore in the Middle Ages and the Renaissance* (London, 1952), pp. 29–71, 145–62.

7. References in van Mander 1604, fol. 128v., cited by de Jongh in Amsterdam 1976, under nos. 27, 55.

8. See Snoep-Reitsma 1973a, p. 288; see also Amsterdam 1976, no. 49.

Boys with Dwarfs, 1646
Signed and dated on the right: Jan miense
molenaer 1646
Oil on canvas, 42½ x 50¾″ (108 x 129 cm.)
Stedelijk van Abbemuseum, Eindhoven

Provenance: Sale, Christie's, London, June 25, 1925, no. 18, to Asscher & Welker; Howard Young Galleries, New York; Lawrence Fischer, Detroit; dealer Asscher & Welcker, London, 1928; dealer D. Katz, Dieren, Holland, 1936; gift of D. Katz to the museum, February 1937.

Exhibitions: Amsterdam, Rijksmuseum, *Oude Kunst,* 1936, no. 110; Eindhoven, van Abbemuseum, December 22, 1936–January 1, 1937, no. 45.

An animated crowd gathers at the corner of a building. In the lower right a dwarf is about to throw a rock at a group of boys who laugh and taunt him as they scatter. A woman dwarf stands beside the stone thrower, holding his coat. Behind the tiny couple there are four fig-ures of normal stature: a fashionably dressed young man and woman, a small boy, and an old, bearded man; a black dog looks out from the foreground. A tavern signboard attached to the building depicts a scene of an old peasant in a winter landscape with a marketing basket and a walking stick on the ground before him. He tucks his right hand in his coat while blowing on his left. Below the image is the inscription "Inde/verkluemden/Boer" (the benumbed peasant).

Outdoor genre scenes with triangular com-positions consisting of a building on the right and a crowd of figures assembled before it had already appeared in Molenaer's early work; for

example, *The Dentist,* signed and dated 1630 (Herzog Anton Ulrich–Museum, Braunschweig, inv. 668).[1] The arrangement of the figures in *Boys with Dwarfs,* with the boys tumbling over one another to escape their diminutive adversary, may ultimately descend, like other Molenaer compositions, from Pieter Bruegel's designs, in this case from his *Parable of the Blind* (fig. 1).[2] Molenaer's painting seeks a com-parable effect of headlong action through a sequence of figures descending to the lower left. Antic figure types, often including brawling, uproarious, or mischievous children, appear regularly in Molenaer's works from the 1630s and 1640s; see especially the so-called *Drunken Peddler,* which depicts street urchins and other figures bating a peasant.[3]

Molenaer's works also frequently depict dwarfs. In his *Artist's Studio* (Staatliche Museen [Bodemuseum], Berlin), the dwarf seen here dances playfully with a dog between posing sessions for a genre scene. In *Peter's Denial of Christ* of 1636 (Szépművészeti Múzeum, Budapest, no. 57.26), a dwarf exotically clad in a turban warms his boots at a hearth. In a painting in Bonn (fig. 2), a dwarf plays music for a couple who dance in the presence of rollicking children and an elegantly attired man and woman.[4]

Dwarfs were sought after by royalty and the wealthy as servants and entertainers throughout history. At the courts in seven-teenth-century Europe, they were often privileged retainers, who amused their patrons simply by their stature or through services and performances.[5] In Holland, where life at court was far less lavish than in Spain, France, or England, dwarfs frequently assumed their tradi-tional roles as street entertainers, exposing themselves to ridicule. Although the story in this painting is unclear, the boys appear to have provoked a dwarf who retaliates effectively if unlawfully; while there seems to have been no statute against bating dwarfs, laws prohibited throwing stones. In the bailiwick of Woerden, the fine was twenty guilders; at the public lot-tery held for the Dolhuis (asylum) in Amsterdam in 1592, not only was the throwing of stones and mud forbidden but also snow-balls, even though the drawing was held in August.[6]

FIG. 1. PIETER BRUEGEL, *Parable of the Blind*, 1568, tempera on canvas, Galleria Nazionale de Capodimonte, Naples.

FIG. 2. JAN MIENSE MOLENAER, *Dancing Couple in a Village Street*, oil on canvas, Rheinisches Landesmuseum, Bonn, inv. GK 160.

FIG. 3. Emblem from GABRIEL ROLLENHAGEN, ed., *Nucleus Emblematum Se- Letissimorum, Quae Itali Vulgo Impresas* (Arnhem, 1611), no. 22.

Given Molenaer's interest in allegory and symbolic allusions (see cat. no. 78), the *Boys with Dwarfs* may encode a lesson, a forgotten saying, or homily. In the context of the boys' wicked fun, the gesture made by the peasant on the signboard is indicative not only of cold (*verkluemden* means "benumbed by chill or dampness") but also of idleness.[7] An emblem of a dwarf standing on stilts before a mirror (fig. 3), published by Gabriel Rollenhagen in 1611, was a symbol of the unalterableness of Nature.[8] Perhaps Molenaer was making a statement about idle cruelty's permanence as a feature of human nature. However, we must bear in mind the callousness of the age; for all their charitable institutions, the Dutch probably were as quick to regard deformity with contempt or amusement as other seventeenth-century Europeans. The cripples on Amsterdam's streets were hustled into hospitals and almshouses as much out of repulsion as compassion.

Although Molenaer, like Steen, surely intended such scenes to be humorous, he probably also wished to convey a message. The conduit of this message may be the group on the right—the young couple, the old man, and the boy. In several moralizing paintings by Molenaer and other earlier Dutch genre painters, a young couple standing to one side of the scene seems to embody the audience or recipients of the artist's message;[9] see, as examples of this conceit, the *Musical Party* of 1635 (Virginia Museum of Fine Arts, Richmond, acc. no. 49-11-19) and the *Ball Players* of 1631 (G.L.M. Daniëls Collection, Vlaardingen), in which the couple represents the lovers or newlyweds to whom the moralizing is directed.[10] In *Boys with Dwarfs,* the varied group of observers on the right, if not the embodiment of the ages of man, would seem at the very least to indicate that Molenaer wished to address a broad sampling of humankind.[11]

P.C.S.

1. See Braunschweig 1978, no. 21, ill. See also the composition of *The Quack Surgeon,* oil on canvas, 27⅛ x 40½" (69 x 103 cm.), falsely signed and dated "R. Brakenburgh 1678" but possibly a copy of a lost Molenaer (Münster, Landesmuseum der Provinz Westfalen für Kunst und Kulturgeschichte, *Meisterwerke holländischer und flämischer Malerei aus Westfälischem Privatbesitz* [August 6–October 22, 1939], no. 45).

2. In the inventory of Molenaer's possessions assembled on October 10, 1668, there appeared "Een grote pannebruloft nae Bruegel," possibly a copy of Bruegel's *Peasant Wedding Feast* (Kunsthistorisches Museum, Vienna, no. 1027); see Bredius 1915–22, vol. 1, p. 7, no. 131. Molenaer's interest in sixteenth-century work is also proven by his ownership of two unidentified paintings by Lucas van Leyden (nos. 97 and 174 in Molenaer's 1668 inventory).

3. Sale, Freeman's, Philadelphia, October 29–30, 1954, no. 107, ill. Also see *Boys Fighting* (Hermitage, Leningrad, no. 5607), *Merrymakers before a Tavern* (Dienst Verspreide Rijkskollekties, The Hague, no. NK3048), *Peasant Children Merrymaking* (sale, Christie's, London, July 8, 1983, no. 32), and *Twelfth Night* (Princes of Liechtenstein Collection, Vaduz, cat. 1980, no. 85).

4. Bonn, Rheinisches Landesmuseum, *Gemälde bis 1900* (Bonn, 1982), pp. 354–55, ill.; see also the *Dwarf with a Vanitas Still Life,* sale, Earl of Landesborough, Christie's, London, October 26, 1945, no. 67 (as "T. Wijck" but possibly by Molenaer).

5. In Adriaen van de Venne's *Fishing for Souls* (Rijksmuseum, Amsterdam, no. A447)—an allegorical representation of the rival Protestant and Catholic religions during the Twelve-Year Truce—a courtly dwarf with an entourage of laughing boys appears prominently on the Spanish "shore."

6. See van Deursen 1978b, vol. 2, pp. 50, 54.

7. On the gesture, see Koslow 1975, pp. 418–32.

8. In the Latin verses attached, the dwarf asks: "How is it that I am only one cubit high?/ Alas, [because] no art corrects Nature's traits" (author's translation).

9. De Jongh (1971, p. 148) discusses these attending couples in works by Isaack Elyas (*Festive Company,* Rijksmuseum, Amsterdam, no. A1754) and Molenaer; Thomas Kren relates them to contemporary forms of theater, such as the *tafelspel* (see Kren 1980, pp. 75–78).

10. For interpretations of these works, see van Thiel 1967–68, pp. 91–99; Amsterdam 1976, no. 44; and Daniëls 1976. Note also the attending couple in figure 2.

11. An example of Molenaer's clear depiction of the ages of man and their appropriate activities is his *Portrait of the van Loon Ruyhaven Family* (van Loon Collection, Amsterdam).

Rotterdam 1645–1705 Amsterdam

Doctor Taking a Young Woman's Pulse,
c. 1670–80
Remnants of signature on the cartouche on the fireplace: M.../P[inxit]
Oil on panel, 19⅝ x 15¾" (50 x 40 cm.)
Private Collection, U.S.A.

Literature: Houbraken 1718–21, vol. 1, p. 270, and vol. 3, pp. 210–12; Hoet 1752, vol. 1, pp. 89ff.; Nagler 1835–52, vol. 10, p. 78; de Laborde 1839, p. 171; Immerzeel 1842–43, vol. 2, p. 249; Blanc 1854–90, vol. 3, p. 79; Kramm 1857–64, vol. 4, p. 1178; Wurzbach 1906–11, vol. 2, p. 207; Hofstede de Groot 1907–28, vol. 3, p. 455; Bredius 1915–22, vol. 3, pp. 387–99; Wiersum 1927a; Thieme, Becker 1907–28, vol. 25 (1931), pp. 293–94; Hollstein 1949–, vol. 14, pp. 120–21; Plietzsch 1960, pp. 73–74; van Thiel 1969; van Thiel 1974.

The painter and engraver Michiel van Musscher was born in Rotterdam on January 27, 1645. According to Houbraken, he studied drawing with the history painter Martin Saagmolen (c. 1620–1669) for two months in 1660, and in the following year became a pupil of the Leiden history and portrait painter Abraham van den Tempel (1622/23–1672), who at that time was living in Amsterdam. In 1665, again according to Houbraken, van Musscher received seven lessons from another Amsterdam artist, Gabriel Metsu (q.v.) and in 1667, he spent three months in the studio of the Haarlem artist Adriaen van Ostade (q.v.). By 1668 he had returned to Rotterdam. Little else is known about the artist's life until 1678, when he married Eva Visscher on July 30. Ten years later he became a citizen of Amsterdam. A second marriage, to Elsie Klanes, took place on June 17, 1693. After her death in 1699 the artist's goods were inventoried. Van Musscher drew up a will on June 13, 1705; he died in Amsterdam seven days later. A second inventory of his goods was made on July 20, 1705, and his artistic effects were auctioned on April 12, 1706.

In addition to genre scenes painted in the manner of Gabriel Metsu and Frans van Mieris (q.q.v.), van Musscher produced portraits of prosperous burghers in richly furnished interiors. His known pupils include the history painter Ottomar Elliger the Younger (1666–1732) and the portrait and still-life painter Dirck van Valkenburg (1675–1721).

C.v.B.R.

Provenance: Possibly inventory of M. van Musscher's estate, 1705, no. 33 (as "Een sieckvroutje" [A sick woman]); possibly sale, M. van Musscher, April 12, 1706 (see Hoet); dealer D. Katz, Dieren, 1938; private collection, Holland; private collection, U.S.A.

Literature: Possibly Hoet 1752, vol. 1, p. 89; Naumann 1981a, vol. 2, p. 146, no. C26.

A doctor in an elaborate ruff and vented jacket has removed one glove to feel the pulse of a seated young woman. Wearing green silk, red velvet, and a white headdress, the young woman rests one foot on a foot warmer while inclining her head slightly toward the physician. A smiling old woman in black leans over a table that is partially covered with a turkish carpet. She holds the straw basket used to store the urinalysis vial, which is on the table beside a silver bowl and spoon. On the floor in the foreground is a string, the woman's shoe, and a chamber pot. At the back right is a covered bed; above the mantle on the left is a painting of Venus and Cupid.

The subject of this painting, a doctor's visit, is familiar from earlier paintings by Jan Steen (see cat. no. 105). The girl's slightly dejected look, the doctor's archaic dress and serious manner, and details like the urinalysis vial, string, chamber pot, and painting within the painting indicate a traditional diagnosis of lovesickness or pregnancy. Van Musscher's primary source is probably Steen's pioneering version of this theme in Munich (Bayerische Staatsgemäldesammlungen, Alte Pinakothek, no. 158),[1] where

FIG. I. GABRIEL METSU, *Doctor's Visit,* oil on canvas, Hermitage, Leningrad, no. 919.

FIG. 2. MICHIEL VAN MUSSCHER, *Woman and Maidservant,* present whereabouts unknown.

the figures are disposed very similarly but with more comical animation. Another probable source was painted by van Musscher's teacher Gabriel Metsu,[2] whose *Doctor's Visit* (fig. 1) exhibits similar figure types, setting, and still-life details.[3] The resemblance is so close that the signature of Metsu, a more highly valued artist, was falsified on van Musscher's painting. Recent removal of the forged name revealed that the original signature was deliberately abraded before it was overpainted; nonetheless, traces of the autograph remain. A painting of this subject was among those by van Musscher in his estate and sale of 1706. Furthermore, the technique and figure types resemble those in works like *Woman and Maidservant* (fig. 2), dated 16[?]9.[4] The third digit of the date, which has been read as "6," is recorded as being unclear;[5] the woman's costume could indicate a later date, presumably 1679. Likewise, the date of *Doctor Taking a Young Woman's Pulse* may be as late as c. 1680.

<div align="center">P.C.S.</div>

1. Braun 1980, no. 154.

2. Houbraken (1718–21, vol. 3, p. 165) asserts that van Musscher studied with Metsu in 1665.

3. Hofstede de Groot 1907, no. 114; Robinson 1974, fig. 138.

4. Sale, Weber of Hamburg, Lepke, Berlin, February 20–22, 1912, no. 330. The old, unpublished attribution to Frans van Mieris was rejected by Naumann (1981a, vol. 2, no. C26), who suggested de Man, van Musscher, or Verkolje as alternatives.

5. Wurzbach 1906–11, vol. 1, p. 207; see also K. Woermann, *Wissenschaftlich Verzeichnis der Älteren Gemälde der Galerie Weber in Hamburg* (Dresden, 1907), no. 330.

The genre and still-life painter Matthijs Naiveu was born in Leiden and baptized on April 16, 1647. According to Houbraken, he studied there with Abraham Toorenvliet (c. 1640–1692) and then with Gerard Dou (q.v.). In 1671 he entered the city's Guild of St. Luke and in 1677 became a hoofdman (leader); in the same year he moved to Amsterdam. Naiveu became a citizen of the city on March 9, 1696, and died there around 1721.

<div align="center">C.V.B.R.</div>

Literature: Houbraken 1718–21, vol. 3, pp. 228–29; Weyermann 1729–69, vol. 3, p. 62; Hoet 1752, vol. 1, pp. 26, 440, 558; Nagler 1835–52, vol. 10, p. 214; Immerzeel 1842–43, vol. 2, p. 263; Kramm 1857–64, vol. 4, p. 1195; Thoré-Bürger 1858, p. 174; Thoré-Bürger 1860a, p. 190; Wurzbach 1906–11, vol. 2, p. 214; Hofstede de Groot 1907–28, vol. 1, pp. 466–67; Thieme, Becker 1907–50, vol. 25 (1931), p. 335.

The Cloth Shop, 1709
Signed and dated lower center:
Mˢ Naiveu. 1709
Oil on canvas, 20⅞ x 24⅜″ (53 x 62 cm.)
Stedelijk Museum "De Lakenhal," Leiden,
no. 567

Provenance: Purchased from W. A. Luz, Berlin-Zehlendorf, 1933; Leiden, Lakenhal, cat. 1949, no. 567.

Naiveu's painting depicts the interior of a cloth shop with a merchant and his wife behind the counter negotiating a sale. Their elegantly dressed female client is apparently at the point of reaching a decision concerning the purchase of the rich, gold-brocaded cloth she has in her hands. The merchant seems to be delivering his concluding remarks. His wife waits in anticipation, her pen hovering over the account book. The man seated on the left, undoubtedly the patient husband of the woman engaged in shopping, gives alms to the beggar boy at the door.[1]

The boy looking out at the viewer from the foreground provides the key to the scene. He has just thrown a pair of dice, an act that commonly indicates the element of chance.[2] Here the boy's action underscores the moment of decision. The scales on the counter, used in the pricing of merchandise, also relate to the transaction in hand, which, figuratively speaking, hangs in the balance.[3]

In the 1949 Leiden catalogue this picture is titled "The Gold-Brocade Shop." Undoubtedly the establishment represented by Naiveu did offer gold-brocaded cloth, but judging from the variety of fabric in the cabinet behind the coun-

ter and in the upper room on the right, the shop sold many other types of cloth, both plain and fancy. The signboard partially visible through the entranceway reads "Goud . . ." (gold . . .), which could indicate either the shop's name, "Goude Leeuw" (The Golden Lion), or its specialty, gold brocade.

Naiveu's choice of subject matter was not without precedent; Frans van Mieris painted a similar setting in 1660 (fig. 1). Naiveu may have known of the work of his Leiden colleague; however, it is unlikely that he saw van Mieris's painting, for it left the Netherlands shortly after its execution, almost a half-century before Naiveu's portrayal.[4]

<div align="right">O.N.</div>

1. In *De Groote Schouburgh* (1718–21, vol. 3, p. 229), Houbraken wrote that Naiveu's greatest masterpiece was a representation of the Seven Works of Mercy. This painting (or series) was known to Houbraken only by reputation and has not been connected with any existing work by the artist (see Hofstede de Groot 1893a, pp. 149–50).

2. In Jan Steen's *Easy Come, Easy Go* (pl. 79), the figure of Fortuna standing on a die has been interpreted, like the game of trictrac, as an allegorical reference to the vicissitudes of fortune (see Keyszelitz 1959, pp. 44–45).

3. Scales were frequently used in emblematic literature to indicate fortune. Gabriel Rollenhagen (*Nucleus Emblematum Se-Letissimorum, Quae Itali Vulgo Impresas* [Arnhem, 1611], no. 83) juxtaposed an image of scales held by a hand in the clouds with the phrase "According to eternal decree, fortune remains invariable; nevertheless, it is no more powerful than fervent prayer" (author's translation; see Henkel, Schöne 1967, col. 1434). In his immensely popular *Sinnepoppen*, published in Amsterdam in 1614, Roemer Visscher captioned an image of empty scales with the motto "Stom en rechtveerdich" (Mute and just).

4. See Naumann 1981a, vol. 2, pp. 33–35, no. 31.

Eglon van der Neer

Amsterdam c. 1634–1703 Düsseldorf

FIG. I. FRANS VAN MIERIS, *The Cloth Shop*, 1660, oil on panel, Kunsthistorisches Museum, Vienna, inv. no. 586.

Houbraken's statement that Eglon van der Neer died in 1703 at the age of seventy puts the date of the artist's birth in Amsterdam around 1634. He apparently studied with his father, the moonlight and winter landscapist Aert van der Neer (1603/4–1677), and with Jacob van Loo (q.v.). After his training, the twenty-year-old Eglon went to France, where he became painter to Count van Dona, the Dutch governor of the principality of Orange. By early 1659 he had returned to Holland, and on February 20 he married Maria Wagensvelt, daughter of the notary-secretary of the Rechtbank (judicial court) of Schieland in Rotterdam. At the time of his marriage, van der Neer was living in Amsterdam, and it was there that his first child was baptized on February 15, 1660; Houbraken stated that the couple had fifteen additional children. According to municipal documents, van der Neer was back in Rotterdam by June 20, 1664; he is recorded in that city until 1679. During this period he occasionally spent time in Amsterdam and The Hague; in 1670 he was admitted to Pictura, The Hague's confraternity of painters, and on December 31, 1678, he witnessed the marriage in Amsterdam of the still-life painter Willem van Aelst (1627–1683). Following the death of his wife in 1677, he traveled to Flanders and lived in Brussels on the Cellebroerstraat from 1679 to 1689. In 1681 he married the miniaturist Marie du Chatel, daughter of the artist François du Chatel (1625–1694). According to Houbraken, the couple had nine children; Marie died in Brussels.

On July 18, 1687, van der Neer was appointed court painter to Charles II of Spain; it appears, however, that he did not go to Spain, for on August 5, 1689, he is recorded in Amsterdam. The following year van der Neer accepted the position of court painter to the Elector Palatine, Johann Wilhelm, in Düsseldorf. In this post, which he held until his death, he succeeded Johann Spilberg, who had died on August 10, 1690. In December 1697 Eglon married for a third time; his new wife was the artist Adriana Spilberg (born 1652), daughter of his predecessor and widow of the painter Willem Breekvelt (1658–1687). Six years after his marriage van der Neer died in Düsseldorf on May 3, 1703.

In addition to his elegant genre interiors, van der Neer produced history paintings, portraits, and landscapes. Dated paintings range from 1662 to 1702. Houbraken mentions only one pupil, Adriaen van der Werff of Rotterdam (q.v.).

C.V.B.R.

Elegant Couple in an Interior, c. 1680
Signed upper right: Eglon H. van der Neer
Oil on canvas, 33 x 27½" (84 x 70 cm.)
Private Collection, on loan to the National
Museum of Wales, Cardiff

Literature: Van Spaan 1698, p. 421; Houbraken 1718–21, vol. 1, p. 270, and vol. 3, pp. 46, 172–75, 353, 389; Weyerman 1729–69, vol. 2, p. 8; Smith 1829–42, vol. 4, p. 169, and vol. 9, p. 548; Nagler 1835–52, vol. 10, p. 169; Immerzeel 1842–43, vol. 2, p. 258; Kramm 1857–64, vol. 4, p. 1192; Obreen 1877–90, vol. 4, pp. 104, 153; Wurzbach 1906–11, vol. 2, pp. 223–25; Thieme, Becker 1907–50, vol. 25 (1931), p. 375; Hofstede de Groot 1908–27, vol. 5, pp. 475–525; Hollstein 1949–, vol. 14, p. 142; Maclaren 1960, pp. 265–66; Plietzsch 1960, pp. 186–87; Rosenberg et al. 1966, p. 211; Stechow 1966a; Braunschweig 1978, pp. 116–19.

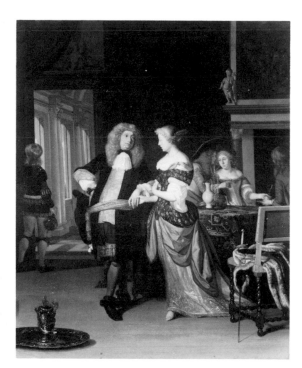

Provenance: Sale, G. Braamcamp, Amsterdam, July 31, 1771, no. 147, to Henry Jan Hope (560 guilders); Henry Philip Hope Collection, 1833; by descent to Lord Francis Pelham Clinton-Hope, Deepdene, who sold his collection to dealers Wertheimer and Colnaghi, London, 1898; sale, Adolf Goerz, Christie's, London, March 8, 1902, no. 71 (sale cancelled); sale, Sir Joseph B. Robinson, Christie's, London, July 6, 1923, no. 76 (bought in) (as dated 1676); by descent to Ida Princess Labia and Count N.A.D. Labia.

Exhibitions: Manchester 1857, no. 951; London, South Kensington Museum 1891, no. 37; London, Royal Academy, *The Robinson Collection,* 1958, no. 56 (as dated 1678); Cape Town 1959, no. 50, pl. 37; Zurich, Kunsthaus, 1962, no. 32; New York, Wildenstein, *Twenty Masterpieces from the Natale Labia Collection,* 1978, p. 25, no. 12, ill. (since the cleaning, no date is visible).

Literature: Smith 1829–42, vol. 4, p. 172, no. 6 (Hope Collection); Hofstede de Groot 1908–27, vol. 5, p. 499, no. 97; Waagen 1837–38, vol. 2, p. 332; Waagen 1854–57, vol. 2, p. 117; Thoré-Bürger 1860b, p. 277; Plietzsch 1960, p. 187, pl. 343 (as painted in 1687);[1] Bille 1961, vol. 1, p. 106, ill., and vol. 2, pp. 35–35a, 108.

Although no date is presently visible, this painting was recorded as bearing the date of either 1676 or 1678, the latter being more likely because of style and the figures' costumes.[2] In 1678 van der Neer painted *Woman Tuning the Lute,*[3] a similarly executed work that is dominated by a single figure seated close to the picture plane. The background has a comparable masonry gallery, also bathed in sunlight; the artist seems to have used the same models for the seated musician and the standing woman that figure prominently in our picture. The same facial type is retained for the elegant lady in van der Neer's *Interior with a Woman and Her Servants* of 1682 (fig. 1).[4] The ewer and basin placed on the table by the maidservant are identical to the vessel and plate in the foreground of our painting.[5] This elaborate piece of craftsmanship may be the key to one possible interpretation of the scene.

In van der Neer's *Interior with a Woman Washing Her Hands* (fig. 2), a richly clad young lady is assisted by a servant boy wearing a French page's uniform; similar dress is worn by both the page (in fig. 1) and the boy seen from the rear (pl. 123).[6] In iconographic analyses of the picture in The Hague, the ewer and the basin have been identified as traditional symbols of purity.[7] The woman in this picture may be cleansing herself by literally washing her hands of the libidinous activity in the background, which probably represents a bordello. A young man—the eager client—bursts into the room, but the maid restrains him from joining the prostitute who beckons from the bedcovers as she sheds her slippers.

A similar but less-pronounced contrast might be perceived in our painting, in which the elegantly attired couple stroll away from the two who continue to cavort and indulge themselves. One servant presents a glass of wine while the other leaves to replenish the supply. The conspicuous ewer and basin in the foreground may allude to the virtue necessary to avoid contamination of the flesh. Juxtaposition for moralizing was an artistic technique with precedents in Northern European mannerist painting as well as in the works of Gerard Dou (see cat. no. 34)[8] and other Dutch genre painters.

Various details in the background unfortunately fail to clarify the subject. The painting above the mantle, which is now difficult to decipher, appears to depict a battle scene (a possible reference to passion) with one man brandishing a flag.[9] The statue on the mantle may represent Amor or Cupid, but this, too, is unclear. The animal carved in relief over the doorway, however, is certainly a griffin, the fabulous creature often associated with lust.[10] Though varied in meaning and, thus, hardly a *clavis interpretandi,* in at least one emblem the motif has been associated with Salvation guided by Virtue, a notion not unsuited to the painting's associations.[11]

O.N.

FIG. 1. EGLON VAN DER NEER, *Interior with a Woman and Her Servants*, 1682, oil on canvas, present whereabouts unknown.

FIG. 2. EGLON VAN DER NEER, *Interior with a Woman Washing Her Hands*, 1675, oil on panel, Mauritshuis, The Hague, no. 862.

1. Plietzsch's contention that the picture was painted in 1687, which was probably a misprint for 1678, is untenable.

2. Compare the dress illustrated in Kinderen-Besier 1950, pp. 214 (1672), 229 (1683).

3. Munich, Alte Pinakothek, cat. 1983, p. 366, no. 204, ill.

4. Last recorded with the Green Galleries, London, 1982 (Naumann 1981a, vol. 1, fig. 92).

5. A similar ewer and basin appear in Eglon van der Neer's *Guiscardo and Guismonda* of 1674 (Alan Jacob's Gallery, London, cat. 1973, p. 31, ill.), which was copied with variations (notably the omission of this element) by his pupil Adriaen van der Werff (Cambridge, Fitzwilliam Museum, cat. 1960, p. 141, no. 373, pl. 72).

6. The same type of garb is worn by the young men attending Chancellor Séguier in le Brun's impressive portrait in the Louvre (cat. 1974, vol. 1, p. 281, no. 441, p. 207, ill.).

7. Amsterdam 1976, p. 195. See also Snoep-Reitsma 1973a, pp. 287–88.

8. Compare Emmens 1973, pp. 93–101; and Grosjean 1974, pp. 131–36.

9. For other battle paintings in genre scenes, see de Jongh 1971, pp. 146–48; Amsterdam 1976, no. 6.

10. Compare Bax 1979, p. 339.

11. Gabriel Rollenhagen, *Nucleus Emblematum* (Arnhem, 1611), no. 5; see Henkel, Schöne 1967, cols. 626–27. The emblem reads, in translation: "Guided by Virtue, accompanied by Fortune. May Fortune be the companion and Virtue the guide. Our effort would not be in vain, if it is carried out in the name of the Lord."

Caspar Netscher was the son of Johannes Netscher, a sculptor from Stuttgart; his mother was the daughter of Burgomaster Vetter of Heidelberg. The year and place of Netscher's birth remain points of conjecture: Houbraken stated that he was born in 1639 in Prague, but later in his account he gave Heidelberg as the birthplace; Roger de Piles maintained that Netscher was born in Prague in 1635 or 1636. As a child, Netscher was taken to Arnhem, where he was placed in the care of the physician Arnold Tulliken. The artist first studied with Herman Coster, a still-life, genre, and portrait painter active in Arnhem from 1642 to 1659. Around 1654, Netscher was a pupil of Gerard ter Borch (q.v.) in Deventer, where he later worked for a number of art dealers. In 1658 or 1659 Netscher sailed for Rome, but he disembarked at Bordeaux, where he married Maria Godyn on November 25, 1659. According to van Gool, Caspar's oldest son, the painter Theodorus, was born in Bordeaux in 1661. Netscher returned to the Netherlands by October 1662, when he joined the painters' guild in The Hague. In 1668 he became a citizen of The Hague, where he spent the remainder of his life. Houbraken stated that he died of gout on January 15, 1684, leaving a fortune of eighty thousand guilders. He was survived by nine of his twelve children and his wife, who married Nicolas Jollatt in 1687 and died on September 11, 1694.

Chaff Cutter with a Woman Spinning and a Young Boy, c. 1662–64
Signed and dated on base of chaff cutter:
C. Nets . . . 1649
Oil on canvas, 26 x 31" (66 x 79 cm.)
John G. Johnson Collection at the Philadelphia Museum of Art, no. 544

Until the late 1660s, Netscher painted historical and genre scenes as well as portraits. During the 1670s and 1680s, he confined himself to portraiture, becoming so renowned that Charles II invited him to England. Artists influenced by Netscher include his sons, Theodorus (1661–1732), Constantijn (1668–1723), and Antonie (died 1713), as well as many of the painters of small portraits in the last quarter of the seventeenth century.

C.v.B.R.

Literature: De Piles 1699, pp. 441–45; Houbraken 1718–21, vol. 1, p. 6, and vol. 2, p. 131, and vol. 3, pp. 37, 92–96, 291, 327, 337; van Gool 1750–51, vol. 1, p. 76; Walpole 1788, p. 247; Smith 1829–42, vol. 4, pp. 143–68, and vol. 9, pp. 538, 818; Nagler 1835–52, vol. 10, p. 194; Immerzeel 1842–43, vol. 2, p. 260; Blanc 1854–90, vol. 3, p. 96; Kramm 1857–64, vol. 4, p. 1193; Nagler 1858–79, vol. 2, p. 459; Lemcke 1875a; Obreen 1877–90, vol. 4, p. 150, and vol. 5, p. 131; Bredius 1887; van Sypesteyn 1888–89; Netscher 1889; Wurzbach 1906–11, vol. 2, pp. 226–29; Hofstede de Groot, 1908–27, vol. 5, pp. 146–308; Portheine 1914; Huffschmid 1924; R. Fritz, in Thieme, Becker 1907–50, vol. 25 (1931), p. 398; Hollstein 1949–, vol. 14, pp. 143–46; Gudlaugsson 1950; Plietzsch 1959; Plietzsch 1960, pp. 59–63; Maclaren 1960, pp. 266–67; Blankert 1966; Rosenberg et al. 1966, p. 130; Amsterdam 1976, pp. 196–99.

Provenance: Sale, Amsterdam, August 23, 1808, no. 119, to van Yperen (as G Netscher) (1,055 guilders); possibly Castle, Sagan, 1864;[1] sale, d'Hautpoul, Hôtel Drouot, Paris, June 29, 1905, no. 19, ill. (as Gabriel Metzu, 1649); Sedelmeyer Gallery, Paris, 1906, cat. no. 21.

Literature: Bode, Bredius 1905 (as Esaias Boursse); F. J. Mather, Jr., "Recent Additions to the Collection of Mr. John G. Johnson, Philadelphia," *The Burlington Magazine*, vol. 9, no. 41 (August 1906), p. 358, ill. (as signed and dated G. Metsu, 1648); Grant 1908, p. 144 (as Metsu); Wurzbach 1906–11, vol. 2, pp. 149, 151 (as Metsu); Hofstede de Groot 1908–27, vol. 5, no. 83 (as Netscher); W. R. Valentiner, in Philadelphia, Johnson, cat. 1913, no. 544, ill. (as signed and dated C. Netsch . . . 1649); Valentiner 1928b, p. 177 n. 2 (as Netscher); Philadelphia, Johnson, cat. 1941, p. 39 (attributed to Gerard ter Borch); Plietzsch 1960, p. 61 (as Netscher); Philadelphia, Johnson, cat. 1972, pp. 64–65, no. 544 (as Netscher, dated 164[?]).

Although this painting was recognized as the work of Netscher at least as early as 1808, it was sold as a Metsu in 1905, by which time the signature had been altered to resemble that of the latter artist. Disregarding the signature, Bode and Bredius attributed the work to Esaias Boursse. In reassigning the painting to Netscher, Hofstede de Groot correctly observed that the Metsu signature was a forgery. Except for W. Martin, whose (verbal) assignment of the painting to ter Borch prompted the tentative attribution in the 1941 Johnson catalogue, scholars have since accepted the work as part of Netscher's oeuvre.

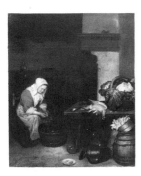

FIG. 1. CASPAR NETSCHER, *The Kitchen,* oil on canvas, Staatliche Museen, Berlin, no. 848.

FIG. 2. CASPAR NETSCHER, *Knife Sharpener,* 1662, oil on canvas, Galleria Sabauda, Turin, no. 315.

FIG. 3. Attributed to CASPAR NETSCHER, *Chaff Cutter,* oil on panel, Rijksmuseum, Amsterdam, no. A319.

The misattributions of this painting probably reflect the fact that Netscher's first independent paintings of peasants and lower-class figures in stables and simple domestic interiors are relatively scarce; as a genre painter the artist is known more for his copies of ter Borch and for his later more elegant domestic and merry company scenes (see pl. 76). Indeed, the author of the 1808 sale catalogue noted that this painting was a "rare subject by this esteemed master." Related domestic scenes include the pendants *The Spinner* and *The Sewer* (formerly in Dresden, nos. 1352, 1533), *The Kitchen* (fig. 1), and *The Apple Peeler* (with the dealer Duits, 1950–51).[2] The model depicted as the elderly spinner in the present painting reappears in the Dresden and Berlin works, as well as in the more elegant *La belle Limonadière* (E. Bührle Collection, Zurich).[3] While none of these works is dated, the *Knife Sharpener* (fig. 2) has been said to be inscribed 1662.[4] The pose of the central figure, turning in his long coat to look at the viewer as he bends to his task, resembles that of the chaff cutter in the Johnson painting. The latter's activity and pose should also be compared with those of the central figure in *Chaff Cutter* (fig. 3), which, though unsigned and undated, is tentatively attributed to Netscher.

The date on the Philadelphia *Chaff Cutter* has been deciphered most frequently as 1649. Given the dubious nature of the signature and the certain fact of Netscher's birth in 1639, such a dating must surely be discounted. Valentiner speculated that the third digit "was probably originally a six,"[5] but a date of 1669 is probably too late (compare the more refined technique and greater elegance of *The Spinner* dated 1665 in the National Gallery, London, no. 845). The Philadelphia *Chaff Cutter* appears more accomplished than the *Knife Sharpener,* judging only from photographs, and thus may date from c. 1662 to 1664, the year of Netscher's undisputed masterpiece, *The Lace Maker* (cat. no. 84, fig. 1).

Though no longer an outright copy of his teacher's work, nor even so directly dependent upon the latter's subject matter as the *Knife Sharpener,* which invites comparison with ter Borch's *Stone Grinder* (pl. 67), the present painting does recall ter Borch's stable scenes of the early 1650s.[6] In arrangement and conception, however, the three quiet, laboring figures are closer to Brekelenkam's artisan families at work. The stable space is not unlike the settings of peasant scenes by the Ostades and other Haarlem peasant painters, but its richly observed still life placed to one side (compare especially the still life in *The Kitchen*) reminds one more of the barn interiors executed by the Rotterdam peasant painters Herman and Cornelis Saftleven, Hendrick Sorgh, and Frans Rijkhals.

Cutting chaff (finely cut hay or straw, used for fodder) or trimming thatch—the exact nature of the man's work is unclear, but he certainly is not cutting grain as has often been supposed—were activities, like spinning, that had been depicted in earlier Labors of the Months series as work suited to the fall and winter months. The cabbage and greens at the right also suggest a fall scene. Although the act of separating wheat from chaff was a traditional attribute of Prudence, it seems unlikely that Netscher intended his scene to be interpreted allegorically.

P.C.S.

1. Parthey 1863–64, vol. 2, p. 189; Hofstede de Groot 1907–28, vol. 5, no. 86A: "A Chaff-Cutter and a Maid-Servant. Canvas."

2. See Birmingham 1950, no. 44.

3. Hofstede de Groot 1907–28, vol. 5, no. 87; see London 1952–53, no. 436; and Zurich, Kunsthaus, *Sammlung Emil G. Bührle,* June 7–September 30, 1958, no. 12.

4. Hofstede de Groot 1907–28, vol. 5, no. 81.

5. Philadelphia, Johnson, cat. 1913.

6. Compare Gudlaugsson 1959–60, nos. 74 and 109.

Musical Company, 1665
Signed and dated lower left on the theorbo case:
CNetscher f. 1665 (CN in ligature)
Oil on canvas, 19⅞ x 18″ (50.4 x 45.7 cm.)
Bayerische Staatsgemäldesammlungen, Alte
Pinakothek, Munich, no. 618

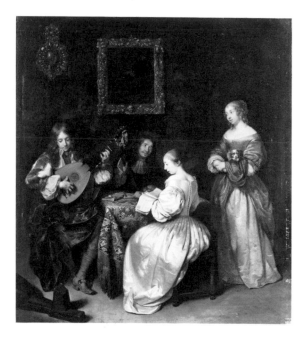

Provenance: From the Mannheim Galerie, 1799.

Literature: Smith 1829–42, vol. 4, no. 59; W. Lübke, "Die
Holbeinbilder in Karlsruhe," *Repertorium für Kunst-
wissenschaft,* vol. 10 (1887), p. 375; Hofstede de Groot
1908–27, vol. 5, no. 116; Martin 1921a, p. 82, fig. 44; R.
Fritz in Thieme, Becker 1907–50, vol. 25 (1931), p. 358;
Maclaren 1960, p. 273; Plietzsch 1960, p. 61; Munich, Alte
Pinakothek, cat. 1967, p. 51, no. 618, fig. 86; Munich, Alte
Pinakothek, cat. 1983, p. 367, no. 618, ill.

Two men and two women form a music party
around a table covered with an oriental carpet.
On the left a refined-looking young man with
long hair, slashed jacket, full blouse, and velvet
cape plays a theorbo. Its case rests at his feet. On
the near side of the table, a woman dressed in a
white satin gown sings from a songbook. A man
seated across from her with songbooks spread
before him beats time. On the right a second
woman in a silk gown holds a lapdog. A dark
landscape in a gilt frame decorated with putti
and a silver sconce decorate the back wall.

Although at least six replicas or copies exist,[1]
this painting is clearly the finest example of its
popular design. The elegance of its subject and
the figures' gallicized manners and attire reflect
not only Netscher's response to the supremely
refined works of his teacher, Gerard ter Borch,
but probably also his sojourn in France and
later observation of courtly society as a portrait-
ist in The Hague, where he was living when he
painted this work. Despite the fact that
Netscher's masterpiece, the splendidly under-
stated *Lace Maker* (fig. 1), was executed only

FIG. 1. CASPAR NETSCHER,
The Lace Maker, 1664, oil
on canvas, Wallace Collec-
tion, London, no. P237.

one year earlier, by this time the artist's pictures
were increasingly devoted to more aristocratic
diversions; for example, the *Musical Company*
(fig. 2) employs a design similar to that of the
Munich painting and is also dated 1665.[2] Even
domestic subjects were treated with a new ele-
gance; see *Woman at a Spinning Wheel,* dated
1665 (National Gallery, London, no. 845). With
the more aristocratic figure types and themes
came a darkening of Netscher's palette and a
muted, softer technique. Only later, however,
did his figures thicken and his touch loosen to a
blowsy, at times careless, stroke.

Several other musical company scenes by
Netscher, all with arched tops, invite compari-
son with the Munich painting, not only for their
themes but also for shared models and aspects of
style. The *Singing Woman and Lute Player in a
Window* (Gemäldegalerie Alte Meister, Dresden,
inv. no. 1347) is again dated 1665 but employs
a "niche" composition and a more minute tech-
nique in imitation of Dou.[3] The so-called *Singing
Lesson* and the *Bass Viol Lesson* (Musée du
Louvre, Paris, inv. nos. 1604 and 1605) exhibit
a style closer to that of the Munich picture, and
the latter repeats the motif of the landscape in
the gilt frame. Finally, perhaps the most attrac-
tive composition in the series is the *Lady at a
Clavier with a Man Singing* (fig. 3), where the
interior is enriched by a classical colonnade and
statuary.

In the Munich painting the lingering sidelong
glance shared by the standing woman and the
man on the far side of the table suggests, at the
very least, that they devote less than their full
attention to their music. The author of the 1983
catalogue of Munich's paintings assumes their
exchange is amorous in nature and goes on to
speculate that it contrasts with a "higher form of
Love" embodied by the other couple. He would
even see the "disharmony" of the juxtaposed
couples reiterated in the contrasting shapes of
the sconce and landscape.[4]

P.C.S.

Presentation of a Medallion Portrait,
c. 1665–68
Signed and dated at the right: C. Netscher 16 . . .
Oil on canvas, 24⅜ x 26⅝″ (62 x 67.5 cm.)
Szépművészeti Múzeum, Budapest, no. 250

FIG. 2. CASPAR NETSCHER,
Musical Company, 1665,
oil on panel, Mauritshuis,
The Hague, no. 125.

FIG. 3. CASPAR NETSCHER,
*Lady at a Clavier with a
Man Singing,* oil on canvas
on panel, Gemäldegalerie
Alte Meister, Dresden.

1. These include the following: (1) oil on canvas, 19⅞ x 18″ (50.5 x 45.7 cm.), Karlsruhe, Staatliche Kunsthalle, cat. 1966, no. 265; (2) oil on canvas, 21⅞ x 17¾″ (55.5 x 45 cm.), London, National Gallery, no. 1879; (3) oil on canvas, 19¼ x 15⅜″ (49 x 39 cm.), Rouen, Musée des Beaux Arts, cat. 1890, no. 455; (4) oil on canvas, 20 x 17⅛″ (51 x 43.5 cm.), sale, Klopfer, Helbing, Munich, November 24, 1908, no. 187, ill.; (5) oil on panel, 22⅝ x 18½″ (57.5 x 47 cm.), sale, Gräfin I. Roland Coudenhove-Kalergi et al., Fischer, Lucerne, November 17, 1951, no. 2659, ill.; (6) oil on panel, 23¼ x 17¾″ (59 x 45 cm.), sale, Galliera, Paris, December 12, 1960, no. 58, ill.

2. The stone relief in the background depicting the Abduction of Helen may well have a bearing on the painting's meaning. The composition of a group seated with a woman in a rich satin costume standing to one side no doubt descends from ter Borch; compare the *Gallant Conversation,* of c. 1655, Staatliches Museum, Schwerin (Gudlaugsson 1959–60, no. 112).

3. Dresden, Gemäldegalerie Alte Meister, cat. 1982, p. 240, as *Self-Portrait and the Artist's Wife.*

4. Munich, Alte Pinakothek, cat. 1983, p. 367, no. 618.

Provenance: From the Esterházy Collection, cat. 1812, vol. 10, no. 31 (as Gabriel Metsu).

Literature: Smith 1829–42, vol. 4, no. 138 (as G. ter Borch); O. Mündler, *Schätzungsliste von Otto Mündler über die Bestände der Esterházy-galerie* (1869) (Budapest, 1909), vol. 10, p. 169 (as G. Metsu); Bredius 1880b, p. 375 (as G. Metsu); K. Pulsky, *Gemäldegalerie* (Budapest, 1883), vol. 2, p. 14 (as C. Netscher); T. von Frimmel, *Kleine Galeriestudien* (Bamberg, 1892), vol. 1, p. 175 (as C. Netscher); Hofstede de Groot 1907–28, vol. 1, no. 188c (as G. Metsu), and vol. 5, no. 101 (as C. Netscher); G. de Térey in Budapest, Szépművészeti, cat. 1924, n.p. (as Netscher but as a possible copy of ter Borch); Plietzsch 1944, p. 35 (as Netscher); Gudlaugsson 1959–60, vol. 2, pp. 278, 289; A. Pigler in Budapest, Szépművészeti, cat. 1968, vol. 1, p. 481, no. 250, vol. 2, pl. 305; M. Mojzer in Budapest, Szépművészeti, cat. 1974.

An elegantly attired young man holding up a medallion with miniature portrait in his right hand kneels before a young woman seated casually with her arm over the chair back. Holding his plumed hat on his knee, the young man wears a jacket with slashed sleeves and back, full blouse, and a bandolier and sword. The woman wears a light-colored silk gown with bodice, stomacher, and darker mantle. Behind and between the two, a serving boy pours a glass of wine. At the left a maidservant holds a silver ewer and salver above a table covered with an oriental carpet, on which are a mirror and a silver bowl with spoon. In the background on the left is a covered bed; on the right is a closed door.

FIG. 1. GERARD TER BORCH, *The Courtship*, chalk on paper, Rijksmuseum, Amsterdam, no. A812.

When this painting was in the Esterházy Collection it was ascribed to Gabriel Metsu, whose falsified signature appeared with an inaccurate date: "G. Metsu 1646." Although Smith called the painting "a capital work" by Gerard ter Borch,[1] Pulsky restored proper attribution to Netscher in an 1883 collection catalogue. In 1924, G. de Térey thought it could be a copy of a ter Borch painting, but Plietzsch later rejected the copy theory. The painting was attributed to Netscher by Pigler and Gudlaugsson, the latter noting that the woman wears the same costume as her counterpart in a painting by Netscher in the Kunsthalle, Basel, which was formerly misattributed to ter Borch.

The youthful Netscher painted copies of works by his teacher Gerard ter Borch (for example, cat. nos. 9 and 10). Although the Budapest painting is not a copy, it resembles ter Borch's work in several respects. The theme of a young man making a presentation to a richly attired woman in an elegant setting is, of course, reminiscent of *Parental Admonition* (pl. 68), where even the man's hand gesture is similar. However, the design with the kneeling and seated figures in profile, as well as the whole conception of this subject, seems to be based on ter Borch's drawing known as *The Courtship* (fig. 1), from the famous ter Borch family collection preserved in the Rijksmuseum.[2] The drawing depicts a young man kneeling with his hat on his knee in front of a seated young woman holding a feather fan. His amorous intentions are indicated by the love-garden landscape, the leaping stag in the background, and Cupid, who aims at the suitor. In Netscher's work the subject is moved indoors to a more quotidian setting. The woman's nonchalance in receiving the young man would suggest that he is only the courier of his master's portrait and affections. The presentation of a portrait of the beloved had a long pictorial history that included, among other precedents, Rubens's famous depiction of Henry IV receiving Marie de Medici's portrait, in the Medici Cycle at the Louvre. Here the presentation of the medallion may be the *trouwpenning* offered by a suitor as a token of betrothal.[3] Another possible allusion to marriage is the silver dish and spoon on the table. In Friesland and elsewhere, this *brandewijnskom* was filled with a mixture of brandy, raisins, and sugar that

was offered ceremonially to visitors of the betrothed, who were required to take three spoonsful (often from the bride-to-be's baby spoon) before departing.[4] The glass of wine no doubt is refreshment for the bearer of the medallion, but the serving boy's action is also reminiscent of the gesture of personifications of Temperance, perhaps an allusion to the need for temperance in the consideration of such important matters as marriage.[5]

The date on the present work was partially abraded when the overpainted signature of Metsu was removed. On stylistic grounds the painting may be linked to Netscher's works from the mid-1660s or somewhat later, such as *Musical Company* of 1665 (pl. 76).

P.C.S.

1. Smith 1829–42, vol. 4, no. 138.

2. On the collection, see Bredius 1883, pp. 370ff., pp. 406ff.; and Kettering 1983b, pp. 443–51. As Gudlaugsson noted (1959–60, vol. 1, p. 94, ill.), the inscription "Gerhard T B" on *The Courtship* is in his sister Gesina's hand, but the attribution to ter Borch is certain.

3. See Schotel 1903, p. 235.

4. C. Boschma identified a similar bowl in ter Borch's *Parental Admonition*, which he believes also depicts an offer of marriage ("Willem Bartel van der Kooi en het tekenonderwijs in Friesland" [Diss., Groningen, 1976]).

5. Both the page and the woman with the salver and ewer probably reflect the influence of ter Borch; compare Gudlaugsson 1959–60, nos. 80–112.

Violinist and Two Serving Women, c. 1663–65
Oil on canvas, 20¾ x 16½" (52.7 x 42 cm.)
City of Manchester Art Galleries, 1926.11

Literature: Houbraken 1718–21, vol. 2, p. 35; van Gool 1750–51, vol. 2; p. 488; Nagler 1835–52, vol. 10, p. 301, and vol. 19, p. 188; Immerzeel 1842–43, vol. 3, p. 149; Kramm 1857–64, vol. 6, p. 1653; Thoré-Bürger 1858, p. 251; Nagler 1858–79, vol. 3, p. 888; Thoré-Bürger 1860a, p. 249; Obreen 1877–90, vol. 1, p. 155, and vol. 5, pp. 316–22; Wurzbach 1906–11, vol. 2, p. 249; Valentiner 1924b; H. Gerson, in Thieme, Becker 1907–50, vol. 25 (1931), pp. 556–57; Plietzsch 1937; Hollstein 1949–, vol. 14, p. 187; Maclaren 1960, p. 277; Plietzsch 1960, pp. 64–68; Rosenberg et al. 1966, p. 211; Kuretsky 1973; Kuretsky 1975; Amsterdam 1976, pp. 202–5; Kuretsky 1979.

Jacob Ochtervelt was baptized in February 1634 in the Reformed Church of Rotterdam. His parents were Lucas Hendricksz., a bridgeman of the Roode Brugge in Rotterdam, and Trindtge Jans. Houbraken states that Ochtervelt and Pieter de Hooch (q.v.) were fellow pupils under Nicolaes Berchem (q.v.) in Haarlem. Although the date of this apprenticeship is not known, Ochtervelt was back in Rotterdam in 1655, living on the Wagenstraat. On November 28, 1655, he and Dirkje Meesters posted their wedding banns; they were married in the Reformed Church on December 14. The couple apparently had no children of their own, but Ochtervelt was guardian to his brother Jan's children, and after 1665 he helped to provide for Andries Meesters, an orphaned child of his wife's family. On May 1, 1667, Ochtervelt and his wife moved into a rented house on the north side of the Hoogstraat.

Although Ochtervelt's name is listed in fourteen Rotterdam documents between 1661 and 1672, usually as a witness for his brother-in-law, the notary Dirck Meesters, there is no record of his entrance into the Rotterdam painters' guild. The earliest guild document to mention his name is the register of October 18, 1667, that lists the nominees for hoofdman *(leader) for the period from 1667 to 1669. Ochtervelt lost this election to Cornelis Saftleven (q.v.). The artist is last documented in Rotterdam on July 10, 1672, when he and Dirkje were witnesses at a baptism.*

According to a taxation register from 1674, Ochtervelt and his wife had moved to Amsterdam by this time and had bought property. In the same year the artist painted a group portrait for the regents of the Amsterdam leper house. By 1679 the couple had rented a house at 608 Keyzersgracht; when the house was sold by foreclosure in January 1681, they moved to the Schapenmarkt, near the Royal Mint. Ochtervelt died the following year; he was buried in the Nieuwezijds Kapel on May 1. Dirkje later moved back to Rotterdam; she died on February 11, 1710.

Most of Ochtervelt's genre scenes depict the domestic interiors of wealthy burghers. The artist also painted merry companies, family portraits and, early in his career, several history pieces and hunting scenes.

C.V.B.R.

Provenance: Sale, de la Court-Backer, Luchtmans, Leiden, September 8, 1766, no. 61; Lord Francis Pelham Clinton Hope; sale, Hope, Christie's, London, July 20, 1917, no. 40; purchased by the gallery from dealer Agnew & Sons, February 1926.

Exhibitions: London, British Institution, 1855, no. 3; London 1952–53, no. 441; Sheffield 1956, no. 36.

Literature: Terwesten 1770, p. 550, no. 61; Kramm 1857–64, p. 1653; Graves 1918–21, vol. 3, p. 1361; Valentiner 1924b, p. 270, fig. 7; Plietzsch 1937, p. 364; Plietzsch 1960, p. 67; Kuretsky 1979, pp. 6, 15, 16, 57, 60, 61, 62, 63, cat. no. 20, fig. 27 (as c. 1663–65); Manchester, City Art Gallery, cat. 1980, p. 75, ill.; Naumann 1981a, vol. 1, p. 56 n. 35, fig. 52.

Two lively serving girls—one holding a pewter tankard, the other a roemer—draw near to enjoy the music of a dashing violinist wearing a jerkin with slashed sleeves. The source for this work has been identified as a painting of 1658 by Frans van Mieris (fig. 1).[1] The two figures who form the right side of Ochtervelt's trio, the chair at the left, and the cittern and map on the wall paraphrase elements of van Mieris's composition. Yet, while Ochtervelt's painting clearly attests to his admiration for the Leiden painter's design and refined technique, his approach to the narrative is deliberately less explicit. Although the middle serving girl retains her counterpart's décolletage, gone are the frank sexual allusions—the man drawing the girl toward him by her apron, the couple necking in the open doorway, the bedding overhead, and,

Street Musicians in the Doorway of a House,
1665
Signed and dated on floor tile: JOchtervelt 1665
Oil on canvas, 27 x 22" (68.6 x 55.9 cm.)
The Saint Louis Art Museum, Gift of Mrs.
Eugene A. Perry in memory of her mother,
Mrs. Claude Kilpatrick, no. 162.1928

of course, the copulating dogs. Just as Ochtervelt preferred a softer half-light to van Mieris's descriptive daylight, so too he replaced sexual candor with the more circumspect aura of playful romance. The simple addition of the second serving girl insured that the couple is no longer alone. The girl's slightly attenuated form and eccentric profile reveal Ochtervelt's greater taste for artifice. Her high forehead and the long curve of her neck are virtual trademarks of the artist's women.

P.C.S.

1. Naumann 1981a, vol. 2, cat. 23, pl. 23, 23 a–d, and vol. 2, frontispiece.

FIG. 1. FRANS VAN MIERIS, *Inn Scene,* 1658, oil on panel, Mauritshuis, The Hague, no. 860.

Provenance: Sale, Lambert-du Porail, Lebrun, Paris, March 27, 1787, no. 126, to Drouillet; sale, Coclers, Lebrun, Paris, February 9, 1789, no. 74, to Dufour; sale, Lebrun, Paris, April 11–30, 1791, no. 145; J. B. Puthon, Vienna, 1840; Josef Winter, Vienna; Baroness Stummer von Tavarnok, Vienna, 1895; gift to the museum.

Exhibitions: Vienna 1873, no. 16; New York 1954–55, no. 56; Saint Petersburg/Atlanta 1975, no. 33, ill.

Literature: Blanc 1854–90, vol. 2, pp. 116, 135; *Katalog einer Sammlung von Olgemälden alter Meister aus der Italienischen, Niederländischen, Spanischen, und Altdeutschen Schule des Herrn Josef Winter* (Vienna, 1875), p. 28, no. 128; T. von Frimmel, *Verzeichnis der Gemälde im Besitz der Frau Baronin Auguste Stummer von Tavarnok (Galerie Winter)* (Vienna, 1895), p. 56, no. 133; T. von Frimmel, "Zur Geschichte der Puthon'schen Gemäldesammlungen," *Blätter für Gemäldekunde,* vol. 7, no. 2 (July–August 1911), pp. 24–25; T. von Frimmel, "Der wiedergefundene Ochtervelt im Wiener Nationalmuseum," *Studien und Skizzen zur Gemäldekunde,* vol. 5 (1920–21), p. 173; H. Gerson in Thieme, Becker 1907–50, vol. 25 (1931), p. 556; Plietzsch 1937, p. 370; Plietzsch 1960, p. 65; S. Donahue (Kuretsky), "Two Paintings by Ochtervelt in the Wadsworth Atheneum," *Bulletin of the Wadsworth Atheneum,* 6th ser., vol. 5, no. 2 (1968), pp. 46, 52 n. 1; Kuretsky 1979, pp. 35, 59, 63, 79, cat. no. 24, fig. 122; Burke 1980, p. 16.

Jacob Ochtervelt's entrance-hall scenes are unquestionably his most innovative contribution to the history of Dutch genre. These works (Kuretsky identifies nine in the series) all depict the *voorhuis* (foyer) of an elegant private home with an open doorway, at which musicians or food vendors appear.[1] The Saint Louis painting, the finest of the series, is characteristic of Ochtervelt's treatment of the entrance-hall

FIG. 1. DAVID VINCKBOONS, *Blind Hurdy-Gurdy Player*, 1605, oil on panel, present whereabouts unknown.

FIG. 2. PIETER DE HOOCH, *Boy Handing a Basket to a Woman in a Doorway*, oil on canvas, Wallace Collection, London, no. P27.

theme; the threshold is used to contrast not only interior and exterior space but also public and private life and different social classes. Looking into the elegant marble-floored hallway, a smiling hurdy-gurdy player and a violinist make music as a maid leads an excited child to the doorway. Seated at the left, attired in rich blue and salmon pink satin, the mistress of the household holds coins to reward the street performers, among the most impoverished members of seventeenth-century Dutch society. Scarcely a critical commentary, Ochtervelt's juxtaposition of the privileged family and the simple but equally idealized musicians offered his wealthy patrons a reassuring image of the social order. Like his contemporary and close acquaintance Pieter de Hooch, Ochtervelt used the view of the street and city beyond to underscore the seclusion and privacy of the home.

Ochtervelt did not invent the elements of his entrance-hall scenes; Vinckboons (see fig. 1), Brekelenkam, and Maes had earlier painted scenes of vendors and entertainers on the doorsteps or just inside the doorways of houses. Moreover, Ochtervelt's central motif—the figures standing in a backlighted doorway—is anticipated in works like de Hooch's *Boy Handing a Basket to a Woman in a Doorway* (fig. 2), which clearly predates the Saint Louis picture of 1665 and probably precedes the rest of the series.[2] It was Ochtervelt, however, who realized the full potential and popularized the theme; his influence, detectable in eighteenth-century works by Abraham van Strij, lasted well into the nineteenth century. The splendid technique of the Saint Louis painting, in which the stuffs and surfaces of the costumes and architecture are painted in exquisite detail, probably reflects the artist's admiration for the Leiden *fijnschilders* (fine painters), notably Frans van Mieris, whose work was the greatest influence on Ochtervelt's art of the 1660s.[3]

P.C.S.

1. See *Street Musicians*, Gemäldegalerie, Staatliche Museen Preussischer Kulturbesitz, Berlin (West), no. 1972; *Fish Seller*, Mauritshuis, The Hague, no. 195; *Poultry Seller*, present whereabouts unknown; *Cherry Seller*, Museum Mayer van den Bergh, Antwerp, no. 895; *Grape Seller* and *Fish Seller*, Hermitage, Leningrad, nos. 951 and 952; *Street Musicians*, Rijksmuseum, Amsterdam, no. A2114; *Fish Seller*, Pushkin Museum, Moscow, no. 635 (respectively, Kuretsky 1979, nos. 16, 41, 50, 51, 54, 55, 62, and 103).

2. Kuretsky (1979, p. 59) believes *Street Musicians* (Gemäldegalerie, Staatliche Museen Preussischer Kulturbesitz, Berlin [West]) is the earliest of the series, dating the work c. 1660–63, or from virtually the same period as the Wallace Collection's de Hooch (fig. 2).

3. See cat. no. 86 and Kuretsky 1979, pp. 15–16.

The Music Lesson, 1671
Signed and dated on the lower right corner of
the map border: J. Ochtervelt 1671
Oil on canvas, 31⅛ x 25⅜″ (79 x 64.5 cm.)
The Art Institute of Chicago, Mr. and Mrs.
Martin A. Ryerson Collection, no. 1933.1088

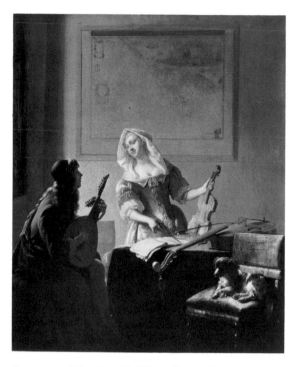

Provenance: Prince Demidoff, Pratolino, Italy; Martin A.
Reyerson, Chicago.

Exhibitions: Toledo, Toledo Museum of Art, *Inaugural Ex-
hibition,* January–February 1912, no. 197; Detroit 1929, no.
46; Chicago, The Art Institute of Chicago, *A Century of
Progress,* June 1–November 1, 1933, no. 70; New York, M.
Knoedler & Co., *Holland Indoors and Outdoors,* January
1938, no. 22; New York, Duveen Galleries, *Great Dutch
Masters,* October 8–November 7, 1942, no. 37; Boston,
Museum of Fine Arts, *The Age of Rembrandt,* 1966, no. 86.

Literature: W. Bode, "Alte Kunstwerke in den Sammlungen
in der Vereinigten Staaten," *Zeitschrift für bildenden Künste,*
n.s., vol. 6 (1895), p. 76; Valentiner 1924b, pp. 269–70,
274, 277, fig. 5; F.E.W. Freund, "Die Ausstellung altholländ-
ischer Malerei in Detroit," *Der Cicerone,* vol. 21, pt. 2
(1929), p. 705, ill.; W. Heil, "Holländische Ausstellung im
Detroiter Museum," *Pantheon,* vol. 5 (January 1930), p. 36,
ill.; H. Gerson in Thieme, Becker 1907–50, vol. 25 (1931),
p. 556; Plietzsch 1937, pp. 364, 371, ill.; Chicago, Art In-
stitute, cat. 1961, p. 345, ill.; S. Donahue (Kuretsky), "Two
Paintings by Ochtervelt in the Wadsworth Atheneum," *Bul-
letin of the Wadsworth Atheneum,* 6th ser., vol. 5, no. 2
(1968), p. 51, fig. 5; Welu 1975a, p. 539 n. 49; Kuretsky
1979, pp. 23, 28, 33 n. 41, pp. 52, 69, 73, 76, 77, 80, 85,
92, cat. 63, fig. 75.

In describing Ochtervelt's later development,
Susan Donahue Kuretsky has written: "The easy
camaraderie expressed in Ochtervelt's genre
scenes of the 1660s evolves, in the following
decade, into an atmosphere of more restrained
politesse."[1] *The Music Lesson* of 1671 attests to
this new elegance and social refinement. A lady
in a beribboned gown, pearls, and a white head-
dress leans gracefully toward the silhouetted
figure of a man playing a theorbo as she daintily
points the bow of her violin to a passage in a

music book. A violoncello lies on the table in
foreshortened perspective, and a small dog rests
on a chair covered in intense lime green at the
lower right. On the back wall is a large map of
the seventeen provinces.

If van Mieris was the greatest single influence
on Ochtervelt in the previous decade (see cat.
no. 86), his importance in the 1670s was
eclipsed by that of ter Borch, whose impact is
clear, for example, in Ochtervelt's *Trictrac
Players* (fig. 1), also dated 1671.[2] There, military
gallants and ladies of studied refinement amuse
themselves with game and song in a dark,
vaguely defined interior reminiscent of ter
Borch's. Though not as essentially as the painter
from Deventer, Vermeer also influenced Ochter-
velt during the 1670s; his *Soldier and Laughing
Girl* (fig. 2) has rightly been identified as the
primary source for the Chicago painting.[3] Al-
though Ochtervelt omitted both the pronounced
foreshortening and the light source at the win-
dow on the left, he paraphrased Vermeer's
lighting system—contrasting the darkened sil-
houette of the man and the brightly lit figure of
the smiling woman opposite him—as well as in-
dividual motifs, such as the map. The Delft
painter had an impact on his contemporaries
that belies his limited oeuvre. When Ochtervelt
interpreted a source he characteristically gave
the figures more elegance and grace; he trans-
formed Vermeer's simple, convivial chat into a
balletic exchange.

Although the violin is usually played by men
in Dutch genre scenes, female violinists are en-
countered elsewhere in Ochtervelt's work.[4] Also
depicted elsewhere is the map of "Germania In-
ferior" by Claes Jansz. Visscher (1581–1652)
(see fig. 3); the only known copy is in the Biblio-
thèque Nationale, Paris.[5] Because it predates the
standard modern practice of orienting north at
the upper edge, west is at the top of this map,
which reappears in three other paintings by
Ochtervelt, as well as Vermeer's *Art of Painting*
(Kunsthistorisches Museum, Vienna, no. 395),
and Nicolaes Maes's *Eavesdropper* paintings in
the collection of Queen Elizabeth II (cat. 1982,
no. 100, pl. 88) and the Wellington Museum,
Apsley House (cat. 1982, no. 102).[6]

The seventeenth century was the golden age of
Dutch cartography. Amsterdam, the commercial
hub of the foremost seafaring nation, was re-
nowned worldwide as the leading publishing

FIG. 1. JACOB OCHTERVELT, *The Trictrac Players,* 1671, oil on canvas, Museum der bildenden Künste, Leipzig, no. 1560.

FIG. 2. JOHANNES VERMEER, *Soldier and Laughing Girl,* oil on canvas, The Frick Collection, New York, no. A936.

FIG. 3. CLAES JANSZ. VISSCHER, map of "Germania Inferior," Bibliothèque Nationale, Paris, no. GE. DD. 5732.

center of maps and sea charts by well-known cartographers such as Jodicus Hondius (1563–1612), Willem Jansz. Blaeu (1571–1638), the Visscher family, and others. Their achievements were appreciated not only by scientists and sailors but also by artists. Ochtervelt's contemporary Samuel van Hoogstraten wrote: "How valuable is a good map wherein one views the world as from another world, thanks to the art of drawing."[7] When maps appear in genre scenes like the Chicago painting one should ask whether they should be considered as a possible allusion to worldliness, as in the case of mappemundi.[8] At the same time, maps like Visscher's were viewed as beautiful objects in their own right. Clearly the Dutch used them as decorative furnishings because old, geographically outdated maps were frequently reissued.[9]

<div align="center">P.C.S.</div>

1. Kuretsky 1979, p. 24.

2. Kuretsky 1979, cat. 64, fig. 77.

3. Kuretsky 1979, p. 23.

4. See the paintings in a private collection, Germany, and in the Statens Museum for Kunst, Copenhagen (respectively, Kuretsky 1979, cats. 43 and 46, figs. 49 and 52).

5. Welu 1975a, p. 539.

6. See note 5. Ochtervelt's *Music Lesson,* Reiss Museum im Zeughaus, Mannheim; *Grape Seller,* 1669, Hermitage, Leningrad, no. 951; and *Lady with Servant and a Dog,* New York Historical Society, no. B-143; respectively, Kuretsky 1979, cat. nos. 40, 54, 75, figs. 46, 130, 87.

7. Van Hoogstraten 1678, p. 7 (author's translation).

8. A number of studies have investigated the symbolism of cartographic material in Dutch paintings: A. Meintschel, "Die Wandkarte und der Globus als Bildmotive im niederländischen Barock" (Diss., Halle, 1952); Kunstreich 1959, p. 70; Haverkamp Begemann 1959, p. 214 n. 140; de Jongh 1967, p. 67; de Jongh 1971, p. 183; de Jongh 1973, pp. 198–206; de Jongh et al. in Amsterdam 1976, cat. nos. 34 and 43; and Welu 1975a, pp. 540–46.

9. Welu 1975a, p. 534.

Adriaen van Ostade was baptized in Haarlem on December 10, 1610. He was the third of eight children born to the weaver Jan Hendricx van Eyndhoven and Janneke Hendriksdr. Although there is no documented evidence of his training, Houbraken states that he studied with Frans Hals (q.v.) around 1627. If this is correct, he and Adriaen Brouwer (q.v.) may have been fellow-pupils. The first record of Ostade as an artist is his notarized statement from June 8, 1632, in which he testified to Gerrit van Allen, an Utrecht goldsmith, that he had completed and signed a painting for the ebony-worker Corstiaen Pietersz. This commission indicates that he had already established a reputation outside his native Haarlem.

Ostade must have entered the Haarlem Guild of St. Luke by 1634; one of his works appeared in an April lottery of guild members' works organized by Dirck Hals (q.v.). In 1636 he was a member of the militia company Oude Schuts. Two years later, on July 26, he married Machteltje Pietersdr. of Haarlem. The artist is next mentioned in Haarlem records from March 30, 1640, when he was sued by Salomon van Ruysdael (1600/3–1670) for default in payment of fourteen guilders for tuition and board. On March 8, 1642, Ostade and his wife drew up a will; seven and a half months later she died, childless, and was buried in St. Bavo's on September 27. Ostade remarried on May 26, 1657. His second wife, Anna Ingels, was from a wealthy, devoutly Catholic family; the artist may have converted about the time of his marriage. Although he had bought a house on the Cromme Elleboochsteech in September 1650, Ostade and Anna moved to the Koningstraat after their marriage. By August 1663 they were living in a house on the Veerstraat. The couple had only one child, Johanna Maria, whose birthdate remains unknown, but the artist became guardian of his sister Maeyeken's five children in 1655 and his brother Jan's children in 1668. Ostade was elected a hoofdman (leader) of the painters' guild in 1647 and 1661, and was appointed deken (dean) in 1662. Four years later, shortly after filing her will, Anna died; she was buried in St. Bavo's on November 24. Municipal documents from 1669 and 1673 indicate that the artist inherited a substantial amount from both Anna and her father; by 1670 he was living

Drinking Figures and Crying Children, 1634
Signed and dated lower right: A Ostade 1634
Oil on panel, 12¼ x 16⅞″ (31.1 x 42.8 cm.)
Sarah Campbell Blaffer Foundation, Houston

Literature: De Bie 1661, p. 258; Houbraken 1718–21, vol. 1, pp. 320, 347–49; Weyerman 1729–69, vol. 2, p. 91; Bartsch 1803–21, vol. 1, pp. 347–88; Smith 1829–42, vol. 1, pp. 107–78, and vol. 9, pp. 79–136; Nagler 1835–52, vol. 10, p. 393; Immerzeel 1842–43, vol. 2, p. 286; Boerner 1856; Kramm 1857–64, vol. 4, p. 1233, and suppl., p. 115; Nagler 1858–79, vol. 1, pp. 1093, 1095; Fancheux 1862; Gaedertz 1869; van der Willigen 1870, pp. 21–23, 29, 233–41; Houssaye 1876; Jacque 1876; Obreen 1877–90, vol. 1, p. 154; Bode 1879; Havard 1879–81, vol. 4, p. 83; Vosmaer 1880; Duplessis 1881; Vosmaer 1882b; Bode 1883, pp. 205–8; Gaedertz 1887; Wessely 1888; van de Wiele 1893a; van de Wiele 1893b; Springer 1898; Rosenberg 1900; Springer 1901; Wurzbach 1906–11, vol. 2, pp. 273–87; Rüttgers 1907; Hofstede de Groot 1908–27, vol. 3, pp. 140–436; Amsterdam 1910; Rovinski, Tschétchouline 1912; van Hüffel 1915; Bode 1916a; Kalff 1916–17; Bremmer 1917; Davidsohn 1922; Bock 1923; Mallett 1924; Trautscholdt 1929; Godefroy 1930; R. Fritz in Thieme, Becker 1907–50, vol. 26 (1932), pp. 74–75; Bredius 1939; New York 1939; van Gelder 1941; Kok 1948; Hollstein 1949–, vol. 15, pp. 1–70; Klessman 1960; Trautscholdt 1959; Leningrad 1960; Maclaren 1960, pp. 282–83; Rouir 1962; Boerner, Trautscholdt 1965; Salinger 1965; Rosenberg et al. 1966, pp. 112–13; Stechow 1966a; Schnackenburg 1970; Bartsch 1971–, vol. 1, pp. 327–63; Boston/Saint Louis 1980–81, pp. 157–59, 162, 168–69, 269; Miedema 1981; Paris 1981; Schnackenburg 1981; Amsterdam/Washington 1981–82, pp. 80–81.

on the Ridderstraat in a wealthy area of Haarlem. On April 21, 1685, Ostade witnessed the marriage settlement of his daughter and the surgeon Dirck van der Stoel of Haarlem. The artist died only six days later and was buried on May 2 in St. Bavo's. His daughter's notice in the Haarlem *Courant* of June 19 indicates that Ostade's works and materials were to be at auction on July 3 and 4. A second auction was held on April 27, 1686.

Although he produced a few history paintings and portraits, Adriaen van Ostade was primarily a painter and etcher of peasant genre scenes. His oeuvre consists of several hundred paintings, about fifty etchings, and numerous drawings and watercolors. Among his pupils were his brother Isaack, Cornelis Dusart, Cornelis Bega, Michiel van Musscher, and Jan Steen (q.q.v.).

C.v.B.R.

Provenance: P. de Boer Gallery, Amsterdam, 1979.

Exhibition: New Brunswick 1983, cat. no. 88.

Literature: Wright 1981, pp. 136–37.

From a contemporary document and three dated pictures recorded in sale catalogues, we know that Adriaen van Ostade's career was launched by 1632.[1] A small group of undated peasant scenes characterized by their bare, shallow interiors and flat, dumpy figures may be assigned on stylistic grounds to the period before 1633.[2]

Drinking Figures and Crying Children is a fine example of the artist's early style and of the type of low-life scene he produced during the initial phase of his activity. Painted in 1634, about the time Ostade joined the Haarlem Guild of St. Luke, it shows the twenty-three- or twenty-four-year-old master in full command of design and technique. *Peasants Playing Cards* of 1633, Ostade's earliest datable painting, features a similar rustic interior and an equally impressive deployment of light and shadow.[3] However, it lacks this painting's mastery of space, which constitutes a significant advance in the artist's development.

Although there is no proof for Houbraken's report that Ostade and Adriaen Brouwer worked together in the studio of Frans Hals, Ostade undoubtedly knew Brouwer and his work. The Flemish master resided in Haarlem until about 1631, and Ostade must have completed his training around that time. Moreover, his early paintings clearly show his liking for Brouwer's style and subject matter. The pinks and blues in *Drinking Figures and Crying Children*, for example, are related to the cool, delicate colors frequently used by the older artist. Here, as in Brouwer's works, they make an arresting impression against the earthy, brown background without disturbing the tonal harmony of the whole.

Despite Brouwer's influence, Ostade's artistic personality asserted itself from the outset. His touch is more refined and precise than Brouwer's dashing, open brushwork. Under Rembrandt's influence, he cultivated a forceful chiaroscuro with sensitively graduated shadows; Brouwer showed less interest in eloquent divisions of light and dark.[4] Moreover, the figures in Ostade's early interiors are generally smaller and less individualized than Brouwer's, and their faces are frequently turned away from the viewer or half-

1. Hofstede de Groot 1907–28, vol. 3, nos. 274zus., 529, and 770 are dated 1632. Hofstede de Groot personally examined no. 274zus.; today all three pictures are untraceable.

2. Schnackenburg 1970, no. 3, pp. 158–69.

3. Schnackenburg 1970, fig. 1.

4. On Ostade and Rembrandt, see Schnackenburg 1970, p. 158, with additional literature.

5. Compare, for example, Knuttel 1962, pls. 1–3.

concealed beneath ungainly hats. In sum, while Brouwer conveyed the meaning of a work primarily through the facial features and the gestures of the protagonists, the young Ostade relied on the body language of his vigorously designed but rather impersonal figures and on the expressive capacities of light, space, and atmosphere.

Ostade's early peasant scenes frequently depict the denizens of rustic taverns and cottages in unbridled physical and emotional situations. In this picture the boy attacking his sister with a wooden spoon and the man raising his glass in uproarious enjoyment of the fracas are captured at the height of their emotions. Even the pictorial structure, incorporating the spectacularly slouched attitudes of the figures and the energetic diagonal accents of the beams and walls, underscores the vitality of the moment. The immediate precedents for such a boisterous treatment certainly lie in the unruly tavern scenes of Adriaen Brouwer.[5]

For a discussion of the possible moral, didactic implications of paintings that depict drinkers, smokers, and barroom brawlers, see Brouwer's *Smokers* (cat. no. 21).

W.R.

Villagers Merrymaking at an Inn, 1652
Signed and dated lower center: A v Ostade 1652
Oil on panel, 16¾ x 21⅞″ (42.5 x 55.5 cm.)
The Toledo Museum of Art, Gift of Edward
Drummond Libbey, no. 69.339

Provenance: T. Emmerson, London, 1829; Tardieu, Paris;
sale, Simonet, Paris, March 31–April 3, 1841, lot 67; Thé-
odore Patureau, Paris; sale, Leroy, Laneuville, Paris, April
20–21, 1857, lot 21; sale, Marquis de Saint-Cloud,
Laneuville, Paris, April 10–11, 1864, lot 67; sale, Alphonse
Oudry, Febvre, Paris, April 19–20, 1869, lot 49; Octave
Gallice, Epernay; Charles Sedelmeyer Gallery, Paris, 1900;
Henry Heugel and descendants, Paris, until 1968; Heim Gal-
lery, Paris.

Literature: Smith 1829–42, suppl., no. 52; *Sedelmeyer Gal-
lery: Illustrated Catalogue of the Sixth Series of* 100
Paintings by Old Masters (Paris, 1900), no. 26; Hofstede de
Groot 1908–27, vol. 3, no. 546; Bode 1916a, p. 4; Traut-
scholdt 1929, no. 103, p. 79; Godefroy 1930, no. 49;
Toledo, Museum of Art, cat. 1976, p. 119, pl. 110;
Schnackenburg 1981, vol. 1, p. 95, nos. 72, 73, 74.

In his enthusiastic appraisal of Adriaen van Os-
tade's paintings, Houbraken singled out "the
domestic interiors with all their ramshackle fur-
nishings and inns and taverns complete with
their trappings, which he was capable of repre-
senting as cleverly and realistically as anyone
ever did," as well as "the figures in their cos-
tumes doing all sorts of activities, so naturally
peasantlike and witty that it is astonishing how
he was able to contrive it."[1]

Houbraken's encomium conveys an idea of
what a near contemporary admired in a painting
like *Villagers Merrymaking at an Inn,* which
ranks as a masterpiece of Ostade's middle period
and provides an instructive example of the
change in style he introduced between about
1645 and the early fifties. Comparison of this
painting with his tavern and domestic interiors
from the 1630s shows that the tall, deep, and
carefully structured space plays a more promi-
nent and articulate role in this composition, as
do the picturesque clutter and rustic appoint-
ments that Houbraken so judiciously com-
mended. The loose, eccentric pictorial organiza-
tion of *Drinking Figures and Crying Children*
(pl. 27) has given way to a disciplined semi-
circular arrangement of the figures and to a
comprehensive unity imposed by the dominant
diagonal of the right wall. The artist's palette
has become varied, and the pale pinks and gray-
blues of the earlier work have yielded to deeper
red and blue accents in the costumes. Ostade's
figures are now convincingly posed and solidly
modeled. The animated faces and natural ges-
tures eloquently express the individuality of each
of the merrymakers, whose vividly delineated
personalities distinguish them from the anony-
mous low-life types in the earlier work. The
concentration and finesse of the nimble male
dancer and the radiant good nature and ingen-
uous delight of the young mother are
particularly memorable characterizations.

These stylistic innovations were accompanied
by a change in Ostade's approach to his subject
matter. From the mid-forties on, he eschewed
the violence and coarse debauchery he had
portrayed with such gusto at the outset of his
career. His merrymakers now disport themselves
with joviality and rustic dignity; they appear bet-
ter dressed and more content, and they occupy
more comfortable quarters than the close,
stablelike interiors of the early paintings. The
unwelcome attentions of the amorous peasant
on the left seem almost courtly compared to the
crude assaults committed by his brethren in the
artist's works of the thirties. Barely reminiscent
of the orgiastic kermis revelries from which they
ultimately derive, the decorous rustic dances
and tavern scenes of Ostade's maturity no
longer satirize or condemn the conduct of the
protagonists.

Interior of a Peasant's Cottage, 1668
Signed and dated on the right over the fireplace:
AV. Ostade 1668 (AV in ligature)
Oil on panel, 18⅜ x 16⅜″ (46.7 x 41.6 cm.)
Her Majesty Queen Elizabeth II

FIG. 1. ADRIAEN VAN
OSTADE, *Dancing Man,*
black chalk or charcoal on
blue paper, Kunsthalle,
Hamburg, inv. no. 22293
(recto).

FIG. 2. ADRIAEN VAN
OSTADE, *Two Couples,*
black chalk or charcoal on
blue paper, Kunsthalle,
Hamburg, inv. no. 22293
(verso).

FIG. 3. ADRIAEN VAN
OSTADE, *The Dance at the
Inn,* pen and brown ink
over graphite, brown and
gray wash on paper, Musée
Condé, Chantilly, inv. no.
349bis.

Three vigorous studies for figures in this paint-
ing have come down to us. All are drawn in
black chalk or charcoal on blue paper.[2] Two of
them appear on a single sheet: on the recto is a
study for the dancing man (fig. 1), and on the
verso is a sketch for the lusty peasant and the
reluctant woman he embraces (fig. 2). Ostade
used the couple on the right of the verso in a
different painting of roughly the same date.[3] The
third chalk drawing prepares the figure of the
drinker seated with his left leg up on a bench.[4]
One additional sheet related to our picture is a
large pen and wash drawing of the whole com-
position (fig. 3). It corresponds so precisely to
the painting that it is probably a replica of the
finished work by the artist himself rather than a
preparatory study. Ostade incised its outlines to
transfer the design to a copper plate and pro-
duced an etching that reverses the image but
is nearly identical to the drawing in size and
detail.[5]

　　　　　　　　　　　　　W.R.

1. Houbraken 1718–21, vol. 1, pp. 347–48
(author's translation).

2. Schnackenburg notes that the drawings are often so
rubbed it is difficult to tell whether the artist used chalk or
charcoal (1981, vol. 1, p. 44).

3. See Schnackenburg 1981, p. 95, cat. no. 73.

4. See Schnackenburg 1981, p. 96, cat. no. 74.

5. The undated etching is reproduced as no. 49 in Godefroy
1930.

Shown in Philadelphia only

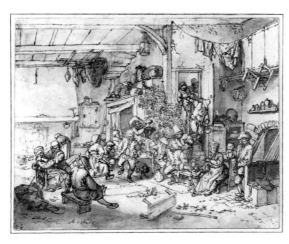

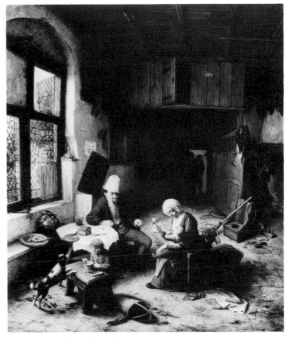

Provenance: Sale, P. de Smeth van Alphen, Amsterdam, Au-
gust 17, 1810, lot 69, to Lafontaine; sale, Christie's, London,
June 12, 1811, lot 59;[1] Royal Collection, Great Britain.

Exhibitions: London, British Institution, 1826, no. 30;
London, British Institution, 1827, no. 57; London 1946–47,
no. 325; Hull, Ferens Art Gallery, *Dutch Painting of the
Seventeenth Century,* 1961, no. 78.

Literature: Smith 1829–42, vol. 1, no. 146; Waagen 1837–
38, vol. 2, p. 362; Jameson 1844, p. 33, no. 77; Waagen
1854–57, vol. 2, p. 13; Rosenberg 1900, p. 76, fig. 65;
Hofstede de Groot 1908–27, vol. 3, nos. 460, 774a; White
1982, p. 87, no. 132.

Deeply touching representations of parental de-
votion were not confined to the middle-class
domestic scenes executed by Pieter de Hooch,
Nicolaes Maes, and other painters of bourgeois
life. Adriaen van Ostade's etching *The Family* of
1647 (fig. 1), which shows a peasant woman
fondly nursing her baby in a tumbledown inte-
rior, anticipates by several years the glimpses of
radiant mothers in well-appointed sitting rooms
depicted by Maes and de Hooch during the
fifties (see pl. 104). Moreover, Ostade's print im-
plies that mistresses of rustic households could
embody the same ideals of maternal love and
dedication prescribed for bourgeois wives in the
writings of Jacob Cats and presented so poet-
ically in pictures by the great masters of the
middle-class interior.

　　The *Interior of a Peasant's Cottage,* dated
twenty-one years after the innovative etching, is
Ostade's most moving portrayal of familial af-
fection. The benevolent solicitude of the woman

FIG. 1. ADRIAEN VAN
OSTADE, *The Family,* 1647,
etching.

FIG. 2. ADRIAEN VAN
OSTADE, *Asking for the
Doll,* 1679, etching.

absorbed in amusing her child with a doll and the unfeigned delight of the doting father are genuine and utterly devoid of sentimentality (see fig. 2). In her handbook of 1844, Mrs. Jameson singled out the sincerity of the feelings expressed in the painting, praising "the homely truth of the sentiment."[2] That Ostade's contemporaries also responded to his tender evocations of domestic felicity may be deduced from the verse beneath an etching after another of his paintings of a peasant family at home. It reads, in part: "Yet we love our little child from the heart, and that is no trifle./ Thus we regard our miserable hovel as a splendid mansion."[3] The lines suggest that a peasant couple's parental love and pride could run so deep as to compensate for the afflictions of poverty.

Although there appear to be no direct precedents in contemporary Dutch genre painting for Ostade's peasant family scenes, the print of 1647 bears a telling resemblance to Rembrandt's painting *The Holy Family* of 1640.[4] On other occasions Ostade translated Rembrandt's sacred images into mundane subjects,[5] and his low-life domestic compositions may have originated in the same way. He may also have known a work by Pieter Bruegel the Elder, now lost but recorded in several copies and variants by Bruegel's sons Jan and Pieter the Younger and by his follower Marten van Cleve (see cat. no. 55, fig. 2). These paintings represent the busy interior of a peasant's house during a visit by the landlord and his wife, and invariably feature a woman in a *bakermat,* the crib-shaped straw seat used by nursing mothers. The precise meaning of the pictures has not been determined, and we do not know whether the peasant woman is the wet nurse for the rich couple's child or whether the wealthy pair are the foster parents of the farm children.[6] In any event, because they show a picturesque rustic interior dominated by an affectionate mother caring for a child, the Bruegelian compositions of the sixteenth and early seventeenth centuries are at least indirect antecedents of Ostade's low-life family scenes.

The domestic and tavern interiors Ostade painted from the 1660s until his death are set in comfortable rooms of stately dimensions that surpass his earlier efforts at projecting a profound and expansive space. In this work he exploits the diminishing width of the floor as well as the receding lines of the wall, the partition at the right, and the ceiling beams to contrive a compelling illusion of depth. Sensitively observed daylight pours into the cottage, illuminating the vivid expressions of the parents and casting strong shadows that throw the figures and objects in the foreground into high relief.

W.R.

1. According to Smith, the painting was bought privately before the sale by Lord Yarmouth for George IV (1829–42, vol. 1, no. 146).

2. Jameson 1844, p. 33.

3. The painting is lost, but the composition is known through a preparatory drawing and the print after the picture by Jan de Visscher; see Schnackenburg 1981, vol. 1, pp. 91–92, cat. no. 55, and p. 58 (author's translation).

4. A. Bredius and H. Gerson, *Rembrandt: The Complete Edition of the Paintings,* 4th ed. (London, 1971), no. 563. There is additional evidence to suggest that Ostade knew Rembrandt's picture; see H. Gerson, "Rembrandt en de schilderkunst in Haarlem," in *Miscellenea I. Q. van Regteren Altena* (Amsterdam, 1969), p. 140.

5. Gerson (see note 4), pp. 140–41.

6. The latter interpretation is implied by K. Ertz in his discussion of the paintings in Brussels, Palais des Beaux-Arts, *Bruegel—une dynastie de peintres* (Brussels, 1980), cat. nos. 117, 118. An inventory of the collection of Pierre Wynants of Antwerp made in 1669 referred to Marten van Cleve's painting or a similar work as "De Voesterheer, van Merten van Cleff" (Philadelphia, Johnson, cat. 1972, p. 25).

Shown in London only

The Fishwife, 1672
Signed and dated on base of column:
A v Ostade 1672
Oil on canvas, 14⅜ x 15½" (36.5 x 39.4 cm.)
Rijksmuseum, Amsterdam, no. A3246

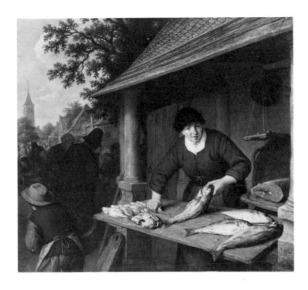

Provenance: G. Braamcamp, by 1752; sale, G. Braamcamp, Amsterdam, July 31, 1771, lot 155, to P. Oets; sale, P. de Smeth van Alphen, Amsterdam, August 1, 1810, lot 70, to Roos; Six Collection, Amsterdam, by 1829; sale, J. Six, F. Muller & Co., Amsterdam, October 16, 1928, lot 34; Lady Deterding, London; presented to the museum by Sir H. Deterding, 1936.

Exhibitions: Amsterdam 1900, no. 104; London 1929, no. 174.

Literature: Smith 1829–42, vol. 1, p. 119, no. 42, and suppl., p. 117, no. 126; Hofstede de Groot 1907–28, vol. 3, no. 130; Bode 1916a, p. 8, no. 1; C. Veth, "Sir Henry Deterding's Schenking aan Nederlandsche Musea," *Maandblad voor Beeldende Kunsten,* vol. 13, no. 6 (1936), pp. 172–73; Bille 1961, vol. 1, p. 86, and vol. 2, pp. 37, 109, no. 155; Amsterdam 1976, p. 430, no. A3246; Schnackenburg 1981, p. 61.

Over the course of his long career, Adriaen van Ostade painted and etched several scenes of people earning their living. Like the artist himself, the subjects of these works gradually moved up the economic ladder. The itinerant musicians and peddlers he depicted in the 1630s and 1640s gave way in later years to respectable tradespeople and comfortable lawyers. The few works that portray the modest shops and market stalls of bakers, cobblers, painters, and fishmongers date from the sixties and seventies. Thanks to his powers of observation and design, Ostade provides us with more than simple records of the habits and work places of seventeenth-century Dutch tradesmen; rather he endows his subjects with a dignity and entrepreneurial energy that transcend mere reportage and lend the pictures universal human appeal.

In *The Fishwife* he created an image of unforgettable immediacy. By bringing the column,

FIG. 1. Attributed to CORNELIS DUSART, *The Fishmonger,* oil on panel, Szépművészeti Múzeum, Budapest, inv. no. 306.

the roof, and the corner of the makeshift table to the very edge of the canvas, Ostade has cleverly linked the viewer with the space of the painting. His brilliant illusionism, combined with the fishmonger's vivid glance and spontaneous gestures, compels the viewer into the role of an approaching customer. We seem to follow on the heels of the young assistant who hurries off to the left. The woman offers a fish for our consideration and, her knife held at the ready, awaits our order to fillet the delectable creature. With her strong and engaging personality, the fishwife is as radically different from the anonymous peasants in Ostade's early works as the bright local hues are from the tonal painting the artist cultivated in the 1630s and 1640s (see pl. 27). The pink of the salmon and the clear blue of the sky are particularly fresh accents.

The architecture of the fishwife's booth was inspired by that of the actual fishmongers' stalls in the artist's hometown. A painting by Job Berckheyde shows the Haarlem fishmarket as it appeared in Ostade's time.[1] The low, projecting roofs and the stumpy Doric columns that support them are virtually identical to those in the picture shown here.

The Fishwife provided the point of departure for a drawing and a related painting from 1683 by Ostade's pupil Cornelis Dusart.[2] In these works, the fishwife's booth is viewed from a distance, in the center of a marketplace that contains other fishmongers' stalls. Another version (fig. 1) of Ostade's painting differs considerably in details from the Rijksmuseum work; the pedestrian execution of the picture and the dull characterization of the fishwife cast doubt on its attribution to Ostade. Whether it should be ascribed entirely or in part to Cornelis Dusart, as has been suggested, or to a third, as yet unidentified, artist remains unresolved.[3]

The Cottage Dooryard, 1673
Signed and dated lower left: A. Ostade 1673
Oil on canvas, 17⅜ x 15½″ (44 x 39.5 cm.)
National Gallery of Art, Washington, D.C.,
Widener Collection, 1942, inv. no. 644

Fishmarkets and fishmongers have figured in
Netherlandish paintings since the 1560s.[4] In
seventeenth-century Holland such scenes were
depicted by Hendrick Sorgh, Emanuel de Witte,
and Jan Steen, as well as by Ostade and others.[5]
An early example is the impressive canvas of
1627 by the Dordrecht master Jacob Gerritsz.
Cuyp.[6] Scholars have interpreted sixteenth-
century paintings of fishmarkets as allegories of
Winter and as veiled representations of the
Christian dichotomy between the material and
the spiritual life.[7] There is no evidence, however,
that the present work, or any of Ostade's other
paintings of fishmongers,[8] embodies either of
these ideas.

<div align="center">W.R.</div>

1. Berckheyde's painting was with P. de Boer, Amsterdam,
1942; DIAL, 41C68.

2. The drawing is discussed and illustrated in Schnackenburg
1981, vol. 1, p. 61, and fig. 72. The painting is reproduced in
Amsterdam 1976, p. 206, no. A98.

3. In Budapest, Szépművészeti Múzeum, cat. 1968, p. 514,
no. 306, and Mojzer 1967, no. 22, it is attributed to
Adriaen van Ostade. According to the Szépművészeti cata-
logue, the suggestion that the painting was partly by Dusart
was made as early as 1869. In an article in *Kunstchronik*
(n.s., vol. 28 [1917], p. 501), G. von Térey proposed that
Ostade began the work and Dusart completed it.

4. Paintings of fishmarkets dated in the 1560s and 1570s by
Joachim Bueckelaer are listed by Moxey 1977, pp. 95–96.

5. See DIAL, 41C68, for examples.

6. *Aelbert Cuyp en zijn Familie: Schilders te Dordrecht* (Dor-
drecht, 1977–78), no. 3.

7. See DIAL, 41C68, for a painting of a fish and meat mar-
ket by Frederik van Valckenborch that represents Winter in
a cycle of the Seasons. Emmens (1973, p. 96) interpreted a
fishmarket by Bueckelaer as a Christian allegory.

8. For other paintings of fishsellers by Ostade, see Hofstede
de Groot 1907–28, vol. 3, nos. 115–19 and 502.

Provenance: Sale, Swalmius, Rotterdam, May 15, 1747, no.
2; sale, Jacques de Roore, Rotterdam, September 4, 1747,
no. 84, to Jan Bisschop; Bisschop Collection sold *en bloc* to
A. Hope, 1771; H. P. Hope, 1815; T. Hope; Lord Francis
Pelham Clinton Hope, Deepdene; P.A.B. Widener, Phila-
delphia; J. E. Widener, Elkins Park.

Exhibitions: London, British Institution, 1815, no. 142;
Manchester, *Art Treasures . . . ,* 1857, no. 735; London,
Royal Academy, 1881, no. 106; New York, Metropolitan
Museum of Art, *Hudson-Fulton Celebration,* 1909, no. 69.

Literature: Hoet 1752, vol. 2, p. 196, no. 2, and p. 206, no.
84; Smith 1829–42, vol. 1, p. 158, no. 188; Waagen 1854,
vol. 2, p. 119, no. 3; Thoré-Bürger 1857, p. 312; Hofstede
de Groot 1907–28, vol. 3, no. 503; C. Hofstede de Groot
and W. R. Valentiner, *Pictures in the Collection of P.A.B.
Widener: Early German, Dutch and Flemish Schools* (Phila-
delphia, 1913), no. 28; E. Waldman, "Die Sammlung
Widener," *Pantheon,* vol. 21 (November 1938), p. 336;
Washington, D.C., National Gallery of Art, cat. 1965, p.
98, no. 644; Walker 1975, p. 287, pl. 381; J. W. Niemeijer,
"De Kunstverzameling van John Hope," *Nederlands
Kunsthistorisch Jaarboek,* vol. 32 (1981), p. 192, fig. 16, p.
193, no. 180; H. Nichols B. Clark, "A Taste for the
Netherlands: The Impact of Seventeenth Century Dutch
and Flemish Genre Painting on American Art 1800–1860,"
American Art Journal, vol. 14, no. 2 (Spring 1982), pp. 25–
26, fig. 2; H. Nichols B. Clark, "A Fresh Look at the Art of
Francis W. Edmonds: Dutch Sources and American Mean-
ings," *American Art Journal,* vol. 14, no. 3 (Summer 1982),
p. 78.

Comparison of *The Cottage Dooryard* of 1673
with *Merry Company at an Inn* of c. 1648 (fig.
1) illustrates the stylistic distance Adriaen van
Ostade traveled during the third quarter of the
century. The restricted palette and dark, earthy
tonalities of the earlier period have given way

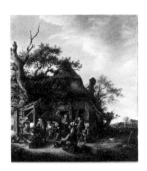

FIG. 1. ADRIAEN VAN OSTADE, *Merry Company at an Inn*, c. 1648, oil on canvas, Staatliche Kunstsammlungen, Kassel, no. GK275.

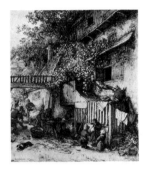

FIG. 2. ADRIAEN VAN OSTADE, *Pig Slaughtering in a Peasant Village*, 1673, pen and watercolor on paper, British Museum, London, inv. no. E1895.

to a cool, sparkling daylight, transparent atmosphere, and strong local colors. The innovations in Ostade's style after 1650 were accompanied by a no less pronounced change in the activities and social conditions of the peasants he portrayed. With time, his low-life types became more subdued and better dressed and their surroundings more comfortable. The drinking bouts and brawls he depicted in the thirties and forties (see pl. 27) yielded to quiet scenes around the domestic hearth or the alehouse fire, and even his peasant dances became more restrained. Ostade's new treatment of his subject matter is an index of the relative prosperity of the Dutch peasant as well as a reflection of his own artistic development.

Dooryard scenes originated in the works of Dutch low-life artists. David Vinckboons, Rembrandt, the Ostade brothers, and even Gerard ter Borch produced paintings and etchings of everyday events outside peasant cottages before Pieter de Hooch and others selected the pristine stoops and courtyards of bourgeois homes as settings for more genteel encounters.[1] This painting bears a fascinating resemblance to one of ter Borch's rare low-life pictures, the poetic *Family of the Stone Grinder* (pl. 67), which dates from about two decades earlier.[2] The dirt enclosures and rustic houses in the Ostade and ter Borch works seem remote from the immaculate brick courtyards portrayed by de Hooch (pl. 103).

Despite the social distance between their subjects, Ostade and the high-life masters shared a profound regard for the family. Indeed, Ostade was a pioneer in the development of the intimate, emotionally moving domestic narratives more readily associated with de Hooch, Nicolaes Maes, and other specialists in middle-class themes.[3] The mother in *The Cottage Dooryard*, like the busy bourgeois housewives in the interiors of Maes or de Hooch, embodies the dignity and virtue of household work. Absorbed in cleaning mussels for the family dinner, she is the nucleus around whom the others are arrayed and the object of the affectionate glances of the father and the youngest child. The vine clinging to the cottage, frequently an image of fertility and conjugal felicity,[4] may have been included here to invoke these qualities.

Two of Ostade's watercolors, both signed and dated 1673, relate to *The Cottage Dooryard*.

Woman Shucking Mussels (Amsterdam, Historisch Museum [Fodor Collection], inv. no. 10235) repeats the Washington composition with barely discernible changes in details. In the other, *Pig Slaughtering in a Peasant Village* (fig. 2), some elements of the setting are identical, but others differ considerably, and the work has an entirely different cast of figures.[5]

Masterpieces like *The Cottage Dooryard* and *The Fishwife* (pl. 30) refute Hofstede de Groot's assertion that Ostade's art declined around 1670.[6] The assured, precise touch in the details and the exceptional rendering of light, atmosphere, and the textures of the weathered cottage show that his skills of execution remained unimpaired. The same holds true for Ostade's unfailing coloristic taste and for the consistent skill and invention displayed in the characterization of his lively figures. Thoré-Bürger summarized the visual qualities of *The Cottage Dooryard* with the concise eloquence that informs all his writings: "It is at once vigorous and clear, very broad in execution and very spiritual in the details."[7]

W.R.

1. See Sutton 1980, pp. 24–27.

2. Gudlaugsson 1959–60, vol. 1, pl. 100.

3. Ostade's etchings *The Family* (cat. no. 91, fig. 1) of 1647 and *The Father of the Family* (Bartsch 1803–21, no. 33) of 1648 are quite early examples of tender domestic scenes.

4. The image was inspired by Psalm 128: "Thy wife shall be as a fruitful vine by the side of thine house: thy children like olive plants round thy table." Obvious allusions to Psalm 128 are incorporated in prints by Claes Jansz. Visscher and Jacques de Gheyn the Younger (see Rotterdam, Museum Boymans–van Beuningen, *Dames gaan voor* [1975–76], no. 98) and in an anonymous Dutch family portrait of 1602 (see Thornton 1978, p. 239, fig. 228). In all these works vines grow conspicuously by the house. Other family portraits in interiors include vines that can be glimpsed through a window: see Nicolaes Maes's *Family of Zwijndrecht* of 1656 (Norton Simon Museum, Pasadena) and Jan Steen's *Family Group* (Martin 1954, pl. 84).

5. Schnackenburg 1981, vol. 1, p. 127, cat. nos. 237, 238, and vol. 2, pl. 111, figs. 237, 238.

6. Hofstede de Groot 1907–28, vol. 3, pp. 149–50.

7. Thoré-Bürger 1857, p. 312 (author's translation).

Isaack van Ostade

Haarlem 1621–1649 Haarlem

Literature: Houbraken
1718–21, vol. 1, p. 347;
Weyerman 1729–69, vol. 2,
p. 91; Smith 1829–42, vol.
1, pp. 179–98, and vol. 9,
pp. 121, 815; Immerzeel
1842–43, vol. 2, p. 288;
Kramm 1857–64, vol. 4;
van der Willigen 1870, pp.
29, 233–40; van de Wiele
1893b; Rosenberg 1900;
Wurzbach 1906–11, vol. 2,
pp. 287–89; Hofstede de
Groot 1908–27, vol. 3, pp.
437–556; Bode 1916a;
Kalff 1916–17; R. Fritz in
Thieme, Becker 1907–50,
vol. 26 (1932), p. 75;
Scheyer 1939; Klessman
1960; Maclaren 1960, p.
288; Rosenberg et al. 1966,
pp. 113–14; Stechow
1966a; Paris 1981;
Schnackenburg 1981.

*The youngest child of Jan Hendricx van
Eyndhoven and Janneke Hendriksdr., Isaack
van Ostade was born in Haarlem and baptized
on June 2, 1621. Houbraken stated that he was
a pupil of his brother, Adriaen van Ostade
(q.v.). In 1643 he entered the Haarlem painters'
guild. His name appeared in guild records again
that year when the council arbitrated his three-
year dispute with the Rotterdam dealer Leendert
Heendricx concerning payment and delivery of
paintings. Ostade continued to live in Haarlem
until his death in 1649. He was buried on Octo-
ber 16 in St. Bavo's.*

*Isaack's artistic career lasted only a decade;
his first dated painting is from 1639. Isaack spe-
cialized in genre scenes depicting peasant life.
His earliest works are closely related in style to
those of his brother Adriaen. Isaack's drawings
are sketched with a pen and lightly washed.*

C.v.B.R.

Rest by a Cottage, 1648
Signed and dated lower center: Isack van
O[stade] 1648 (16 in ligature)
Oil on panel, 14¾ x 18⅞″ (37.5 x 48 cm.)
Frans Halsmuseum, Haarlem, no. 537a

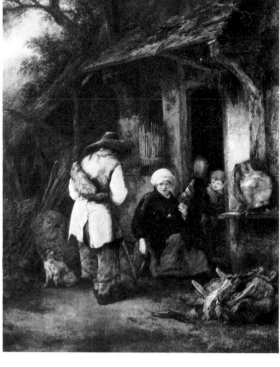

Provenance: Purchased by the museum, 1963.

Literature: Baard 1967, p. 32, fig. 13; Haarlem, Frans
Halsmuseum, cat. 1969, p. 54, no. 738.

Although his career lasted only a decade, Isaack
van Ostade ranks among the outstanding inno-
vators of Dutch low-life and landscape painting.
His earliest peasant scenes closely resemble those
of his brother and teacher Adriaen, but Isaack's
versatile and independent personality swiftly
asserted itself. His meteoric development is no
less impressive than his prodigious output.

Isaack made his most significant contribution
in outdoor scenes that combine landscape and
peasant genre elements. His mature paintings of
travelers resting, taking refreshment, and feeding
their horses outside a rustic hostelry and the
winterscapes featuring the lively traffic on or be-
side a frozen river are more plentiful and more
original than his early low-life interiors. As a
painter of the outdoors, Isaack surpassed and
probably influenced his brother. In the winter
scenes he drew upon his acute powers of ob-
servation and his technical ability to render
magnificent monochrome skies and a damp,
chilly atmosphere suffused with pale, golden
sunlight. Apart from his predilection for land-
scape, Isaack's work is distinguishable from his
brother's by the brighter, richer palette, the bril-

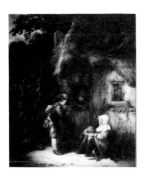

FIG. 1. ISAACK VAN OSTADE, *Peasants before a Farmhouse*, 1649, oil on panel, Thyssen-Bornemisza Collection, Lugano, no. 241.

FIG. 2. ADRIAEN VAN OSTADE, *Woman Winding upon a Reel*, after 1670, etching.

liant and varied touch, and the idyllic mood exemplified by *Rest by a Cottage*.

This picture was formerly called "A Rest before an Inn,"[1] but the structure shown is clearly a peasant cottage. A traveler with a backpack and a walking staff has paused to converse with a woman who sits in the yard and works her spindle. Her two children in the doorway react to the visitor with an endearing combination of shyness, curiosity, and anticipation. Their responses and the dog's fearful look affirm that the man is a stranger.

Low-life scenes set in the dooryard of a house appeared early in the century in works by David Vinckboons and in Rembrandt's etchings of the 1630s.[2] From the late thirties onward Adriaen and Isaack van Ostade depicted itinerant musicians, tradespeople, and travelers engaging the residents of peasant cottages and artisans' houses.[3] While the musicians and tradesmen belonged to the venerable iconographic tradition of street vendors,[4] the Ostades were apparently the first to adopt leisurely conversation between locals and a passing traveler as the subject for a picture. The theme, which did not become popular among Dutch genre painters, remains unstudied, but it seems doubtful that these encounters have any veiled moral or allegorical significance.

The year after he painted *Rest by a Cottage*, Isaack produced an equally fine variant (fig. 1). Here the father leans over the door to listen to the visitor while his wife sits to the side and attends to their child. Long after Isaack's death, Adriaen van Ostade made an etching and four drawings that show a traveler in discussion with a woman, who sits before her house and winds yarn (fig. 2).[5]

W.R.

1. Baard 1967.

2. Goossens 1954a, figs. 40, 41, 55, 56, 58, 69. See Rembrandt's etchings (Bartsch 1803–21, nos. 119, 121, and 128 [dated 1641]).

3. Hofstede de Groot 1908–27, vol. 3, Adriaen van Ostade, nos. 422 (dated 1640), 423, 429–31, 435, 437 (dated 1641), 446 (dated 1637), 450, and Isaack van Ostade, nos. 106, 107, 209, 211b, 211e, 211f, 211h, 213b, 213d, 216e, 218. See also Adriaen van Ostade's etchings (Bartsch 1803–21, nos. 29, 36, 38, 44, and 45).

4. On the tradition of street vendors and street cries in prints, see W. Steinitz, *"Les Cris de Paris" und die Kaufrufdarstellung in der Druckgraphik bis 1800* (Salzburg, 1971); and San Francisco, California Palace of the Legion of Honor, *Street Cries and Itinerant Tradesmen in European Prints*, 1970.

5. Schnackenburg dates the print (Bartsch 1803–21, no. 25) after 1670 (1981, vol. 1, p. 46). Two of the drawings (Schnackenburg 1981, nos. 211, 212) are studies in reverse for the etching. Of the two watercolor versions (Schnackenburg 1981, nos. 213, 214), one is dated 1684.

Delft 1601–1673 Amsterdam

Elegant Company Gaming and Drinking,
c. 1632–34
Oil on panel, 20¼ x 31½" (51.4 x 80 cm.)
Richard Green Galleries, London

Literature: Van Bleijswyck 1667, p. 847; Houbraken 1718–21, vol. 1, p. 304, and vol. 2, p. 33; Nagler 1835–52, vol. 10, p. 471; Nagler 1858–79, vol. 4, pp. 2753, 2760; Jorissen 1877; Havard 1878b; Havard 1879–81, vol. 2, pp. 1, 177; Bredius 1880; Bode 1883, pp. 126–33; de Roever 1883; Wurzbach 1906–11, vol. 2, pp. 297–99; Burg 1911; Bredius 1916b; Thieme, Becker 1907–50, vol. 26 (1932), p. 155; Plietzsch 1960, p. 34; Rosenberg et al. 1966, p. 109.

Anthonie Palamedesz. was born in Delft in 1601. Shortly after his birth his father, a lapidary, is recorded in the service of James I of England, and it is believed that his younger brother, the painter Palamedes Palamedesz. (1607–1638), was born in London. Anthonie was apprenticed to the portrait and court painter Michiel van Mierevelt (1567–1641) in Delft. On December 6, 1621, he was admitted to the city's Guild of St. Luke and in 1635, 1658, 1663, and 1672, he served as a hoofdman (leader). On March 30, 1630, the artist married Anna Joosten van Hoorendijck, who bore him three children: Palamedes (1633–1705), a painter, Joost, and Maritge. Anna died on October 17, 1651, and Palamedesz. remarried around 1660. He and his second wife, Aagje Woedewart, had one son, Arthur. At the time of his death on November 27, 1673, Palamedesz. was probably living in Amsterdam with his oldest son. He was buried there on December 1, 1673.

Palamedesz.'s genre pieces depicting elegant interiors with merry companies making music or playing cards and scenes of soldiers dining or gambling are linked in spirit to the works of the Haarlem and Amsterdam painters Dirck Hals (q.v.), Pieter Codde (q.v.), and Willem Duyster (q.v.). Palamedesz. also produced portraits, landscapes, and still lifes and provided staffage in works by Anthonie de Lorme (c. 1610–1673) and Dirck van Delen (q.v.). His pupils included his brother Palamedes, his son Palamedes, and Ludolf de Jongh (q.v.), the Rotterdam painter of genre scenes, landscapes, and portraits.

C.v.B.R.

A group of thirteen figures assemble in an interior around a table to drink, play trictrac and cards, and to flirt and embrace. At the left, behind the shadowed silhouette of a chest, a serving boy pours a glass of wine beside a table. Paintings and a map decorate the walls.

Although Palamedesz. enrolled in the Delft guild in 1621, he did not date a painting until 1632, the year that appears on the merry company in the Mauritshuis (fig. 1) and three other similar musical and elegant company scenes.[1] That Palamedesz. may have begun his activity as a genre painter several years earlier is suggested by the fact that all of these works represent accomplished efforts by a mature master.[2] Indeed, the artist's paintings from 1632 to 1634 are his best; a close variant of the Mauritshuis composition, now in the Rijksmuseum, Amsterdam (no. A1353), bears the date 1633, and a *Company of Drinkers with a Bass Viol Player* is dated 1634 (fig. 2). The *Elegant Company Gaming and Drinking* shares with these works the elegantly attired figures silhouetted against a light-colored wall, the animated but assured touch, and the rather vaguely defined space. It also takes over the design, encountered in the Mauritshuis and the Rijksmuseum paintings as well as in the undated musical company in Cologne (Wallraf-Richartz-Museum, no. 1058), which juxtaposes the figures around the table and the serving boy opposite. The darkened repoussoir at the left was a common device used to enhance the sense of space. Several of the models and figure motifs in the present work also reappear elsewhere in Palamedesz.'s early works.[3]

Although direct quotations are rare, Palamedesz.'s early interior genre scenes are similar

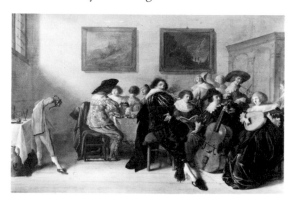

FIG. 1. ANTHONIE PALAMEDESZ., *Merry Company*, 1632, oil on panel, Mauritshuis, The Hague, no. 615.

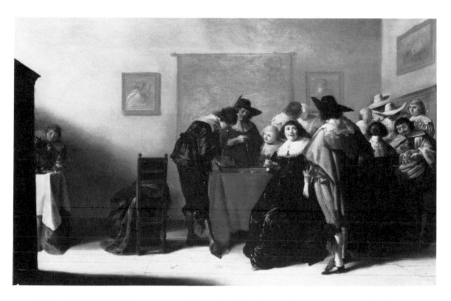

FIG. 2. ANTHONIE PALAMEDESZ., *Company of Drinkers with a Bass Viol Player*, 1634, oil on panel, private collection.

FIG. 3. H. ALDEGREVER, *Socordia*, 1549, etching.

to and probably dependent upon works by Willem Buytewech, Dirck Hals, Pieter Codde, and Willem Duyster. His rarer outdoor scenes descend once again from those of Buytewech, Esaias van de Velde, and Dirck Hals.[4] In the 1640s and 1650s, he painted soldier scenes in guardrooms and stables, which recall the designs of Duyster and Duck but adopt a looser, less-refined technique.[5] A long-lived painter, Palamedesz. continued to produce elegant genre scenes until his death at age seventy-two.[6]

Companies of men and women playing games were frequently likened to the game of love and its vicissitudes. Moreover, trictrac, card playing, and similar amusements had long been condemned by moralists as idle and foolish activities. In a print series of vices from 1549, for example, H. Aldegrever depicted *Socordia* (fig. 3), the personification of all idleness, worthlessness, and folly, as a woman standing in a ball court holding a trictrac board and playing cards. A similar image was used in a woodcut three years earlier by Cornelis Anthonisz. to depict Idleness.[7] Inevitably, the games were also associated with heavy drinking, fighting (see pl. 86), and unchastity. Thus, they often featured in series of vices and the effects of intemperance, like those engraved by Jacob Matham.[8]

The potential symbolism of other features of the scene should also be considered. The map on the back wall has not been identified, but it appears to be a world map; hence it could allude to the worldliness of the company's concerns.

The seascape with buffeted ship at the right appears so often in Palamedesz.'s work that it must have been a studio prop, but the pair of half-length images of saints to either side of the map could offer moral counterpoint to the merry-making. Similarly, the serving boy pouring wine, like his counterpart in works by Vinckboons and Steen (pls. 1 and 79), could call to mind earlier representations of Temperantia (Temperance or Moderation), such as those by Lucas van Leyden and Hendrik Goltzius. In the larger context of Palamedesz.'s art, however, didactic or moralizing elements seem rarely to be central to his meaning.

P.C.S.

1. *Merry Company*, Atheneum, Helsinki (from the Sinbrychoff Collection, cat. 1936, no. 19); *Musical Company*, W. Duschnitz, Vienna; and *Outdoor Garden Party with Musicians*, sale, Christie's, London, March 20, 1936, no. 17.

2. Note, however, that the genre painter Jacob van Velsen (died 1656), who was Palamedesz.'s contemporary in Delft, seems to have only begun painting about this time. His earliest dated work is a merry company of 1631 (see Playter 1972, fig. 83), and all his other works are from the early 1630s.

3. For example, the central smoker and girl with a lute in the Mauritshuis painting reappear in a picture in Brussels, Musées Royaux des Beaux-Arts de Belgique, cat. 1949, no. 345.

4. See the *Merry Company* mentioned in note 1 and *Garden Party*, formerly in the Staatliche Museen, Berlin, cat. 1931, no. 758A (destroyed World War II).

5. See, as examples, *Guardroom*, dated 1647, Rijksmuseum, Amsterdam, no. A3024, and *Guardroom with Trumpeter*, dated 1654, Muzeum Narodowe, Warsaw, inv. no. 131115.

6. See *Elegant Company in Interior with Gilt Leather*, dated 1673, Chrysler Museum at Norfolk, Norfolk.

7. See Renger 1970, p. 81, fig. 52; and Amsterdam 1976, p. 109, fig. 22a.

8. See Renger 1970, pp. 71–95, especially fig. 55; and Amsterdam 1976, p. 110, fig. 22c.

Gorinchem c. 1607–1681 Rotterdam

Barn Interior, c. 1665
Monogrammed lower left: CS
Oil on panel, 23½ x 26⅜″ (59.7 x 67 cm.)
Hood Museum of Art, Dartmouth College,
Hanover, New Hampshire, no. P983.10

Literature: De Bie 1661, p. 412; van Hoogstraten 1678, p. 184; van Spaan 1698, pp. 421ff.; Houbraken 1718–21, vol. 1, p. 342, and vol. 2, p. 33; Weyerman 1729–69, vol. 2, p. 86; Nagler 1835–52, vol. 14, p. 192; Immerzeel 1842–43, vol. 3, p. 51; Blanc 1854–90, vol. 3, p. 406; Kramm 1857–64, vol. 5, p. 1435; Thoré-Bürger 1858, p. 170; Nagler 1858–79, vol. 2, pp. 353–54, 385; Thoré-Bürger 1860a, pp. 268, 355; Parthey 1863–64, vol. 2, pp. 474ff.; van der Kellen 1866, pp. 204, 232; Hofstede de Groot 1897; Haverkorn van Rijsewijk 1899; Wurzbach 1906–11, vol. 2, pp. 548–49; Wiersum 1931; Blok 1933; W. Stechow in Thieme, Becker 1907–50, vol. 29 (1935), pp. 309–10; van Klaveren 1936; van Campen 1937; Heppner 1946; Hollstein 1949–, vol. 23, pp. 111–18; de Mirimonde 1961b; Renckens 1962; Rosenberg et al. 1966, p. 112; Schulz 1978; Amsterdam/Washington 1981–82, p. 78.

Cornelis Saftleven was the son of Herman Saftleven, an artist who was probably a native of Amsterdam. In 1602 Herman is recorded in Rotterdam; shortly thereafter he married Lijntge Cornelisdr. Moelants, the widow of Abraham van Bazeroode, in Gorinchem or Rotterdam. According to a Rotterdam document from September 29, 1655, their oldest son, Cornelis, was born in Gorinchem, probably in 1607. After Cornelis's birth, his parents returned to Rotterdam, where their second son, the artist Herman the Younger (q.v.), was born. A third son, Abraham, also an artist, was born around 1611. In 1613 the elder Herman bought a house in Rotterdam on the Delftschevaart near the Raambrug; in 1619 he bought a second house on the Leeuwenlaan. Cornelis's mother died in February 1625, and the artist's father married Lucretia de Beauvois in March 1626; he died the following year, leaving his three underage sons in the guardianship of Hendrick Adriansz. and Jan Matheusz. van der Poel of Rotterdam.

Cornelis remained in Rotterdam until around 1632, when he traveled to Antwerp. By 1634 he was in Utrecht, where his brother Herman had been living, probably since 1632. In 1634–35 the two brothers were commissioned to paint a portrait of the Godard van Reede family. Cornelis is next documented in 1637, when he was living on the Lombardstraat in Rotterdam. On November 18, 1648, he married Catharina van der Heyden, the widow of Joris Lambertsz. Catharina died in 1654, and Cornelis married Elisabeth van den Avondt, a Catholic, on September 25, 1655. The couple's one child, Maria Jacoba, was baptized on May 1, 1660, and died on April 2, 1662. On October 18, 1667, Cornelis was appointed deken (dean) of the Rotterdam Guild of St. Luke. He died in Rotterdam on June 1, 1681, in the house "op het Franschewater," in which he had lived since 1648. He was buried on June 5, 1681, in the Franschekerk in Rotterdam.

Cornelis Saftleven was a draftsman and an etcher as well as a painter. His subjects include landscapes, barn interiors with still-life elements, and religious scenes and peasant genre often of a satirical nature. Although Saftleven had no documented students, Houbraken stated that Ludolf de Jongh (q.v.) studied with him.

C.v.B.R.

Provenance: Sale, van der Marck, Amsterdam, August 25, 1773, no. 290, to Hendrik van Maarseveen; sale, Christie's, London, February 18, 1916, no. 93; Lord Rothermere; dealer Hoogsteder, The Hague and New York, by 1975.

Literature: Schulz 1978, pp. 37, 38, 249, no. 718, fig. 52.

An embracing couple seated on a spiral staircase in a barn look out directly at the viewer and smile. At the lower right a small boy plays with puppies before a crude doghouse. The bitch barks at a cat on the stair. A dinner pot and a loaf of bread rest on the steps. In the background on the right a woman talks to a peasant as she milks a cow. Sheep and a donkey stand in the shadows.

Together with other Rotterdam and Middelburg painters, including above all his brother Herman,[1] but also possibly Pieter de Bloot and Frans Rijkhals, Cornelis Saftleven played a role in the early 1630s in introducing the stable interior to peasant genre.[2] Hendrick Sorgh also took up these subjects shortly thereafter. The barns and byres depicted by these artists usually have dirt floors, dark cavernous ceilings, wooden partitions, and beam supports. They frequently shelter farm animals; however, they might also serve as domiciles or social-gathering places for peasants. They often include large still lifes of everyday objects—brass and ceramic jugs and vessels, utensils, wicker baskets, and tools. In the typical stable type developed by the Rotterdam-area painters, a still life and/or animals appear in the foreground beside a wall parallel to the picture plane; the figures are placed before or opposite a view of the darkened recesses of the stable, where subsidiary figures usually can be seen in the distance. These works had an almost immediate impact in the South on the well-known Antwerp painter David Teniers the Younger, whose *Supper in a Barn* (fig. 1) is dated 1634, and they may also have left their mark in the North on the Ostades in Haarlem.[3] Teniers, in turn, was to have a lasting influence on Cornelis Saftleven.

The *Barn Interior* is a mature statement by Saftleven; it reflects the greater spaciousness that characterized his stable interiors after c. 1640. Although dated barn scenes from the 1660s are

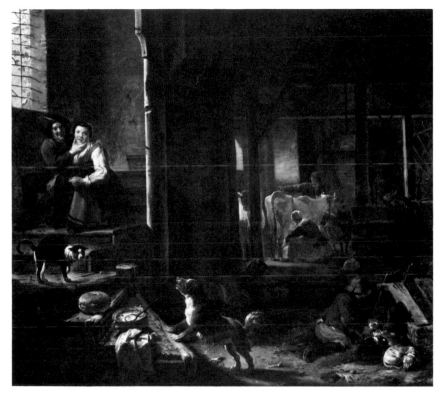

scarce, the figure and animal types of these works are close to those in this painting.[4] The motif of a woman milking a cow in a drawing dated 1665 in the British Museum closely resembles the figures shown here in the distance.[5] The peasant couple in the intimate embrace on the stairway remind us of depictions of amorous grappling by Teniers and Brouwer, as in the latter's *Tavern Scene* (fig. 2).[6] A couple playfully wrestling in a stable appear in a drawing by

Saftleven dated 1651 (fig. 3),[7] a work that also anticipates aspects of our painting's design and motifs like the child on the right in the slouch hat. However, the *Barn Interior*'s greater architectural order reflects developments in genre painting in south Holland, primarily in Dordrecht and Delft, in the 1650s. In Nicolaes Maes's Eavesdropper series (see pl. 99), for example, the master or mistress of the household invariably stands on a spiral staircase or the landing of a flight of stairs as he or she discovers the maidservant and her lover in an embrace. The anecdotal quality of the *Barn Interior*, in part a product of the figures' eye contact with the viewer, is also reminiscent of Maes. Now, however, there is no master to scold the couple. Nor does the household pet make off with food, but the dispute between the dog and the cat over the dinner pot may still recall expressions condemning neglect, such as "Honden en katten wenschen om roekelooze dienstboden" (Dogs and cats like nothing better than reckless servants).[8] The qualities of these two animals—the sensuousness of the cat[9] and the faithful loyalty of the dog, here seen protecting her litter[10]— were juxtaposed by Dutch writers as opposing qualities of human nature; Adriaen van de Venne, for example, wrote of "Goed honds, kwaad kats."[11] In their sexual roughhousing, however, Saftleven's mugging peasants scarcely seem troubled by any moral dilemma.

P.C.S.

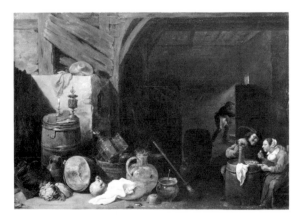

FIG. 1. DAVID TENIERS THE YOUNGER, *Supper in a Barn*, 1634, oil on panel, Staatliche Kunsthalle, Karlsruhe, inv. no. 193.

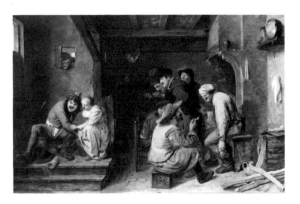

FIG. 2. ADRIAEN BROUWER, *Tavern Scene*, oil on panel, on loan to the National Gallery, London.

FIG. 3. CORNELIS SAFTLEVEN, *Stable Interior with Eight Figures*, 1651, brown and gray ink, pen, and wash on paper, Rijksprentenkabinet, Rijksmuseum, Amsterdam, A2464.

Herman Saftleven

Rotterdam 1609–1685 Utrecht

1. See, for example, Herman Saftleven's *Boys Playing Marbles*, signed and dated 1634, Musées Royaux des Beaux-Arts de Belgique, Brussels, inv. no. 407.

2. See Klinge 1977, pp. 68–91; Schulz 1978, pp. 17–19 (see cat. nos. 651–54, 661–63); and Schulz 1982. Heppner first discussed these painters as a group (1946). See also A. Bredius, "De Schilder François Rijkhals," *Oud Holland*, vol. 35 (1917), pp. 1–11; and L. Grisebach, *Willem Kalf* (Berlin, 1974), pp. 73–76.

3. On the Saftlevens' influence on Teniers, see M. Klinge in New York/Maastricht 1982, p. 20. On the Ostades' early stable interiors, see Klessman 1960; and Schnackenburg 1970.

4. Compare Schulz 1978, no. 551 (dated 1663) and no. 627 (dated 1666).

5. Schulz 1978, drawing cat. no. 427; see Hind 1931, vol. 4, p. 49, no. 13, ill.

6. Also see Brouwer's *Fight over Cards* (pl. 24).

7. Schulz 1978, drawing cat. no. 221, fig. 75.

8. Harrebomée 1856–70, vol. 1, p. 321. For variations of this expression ("Die te laat komt, vindt den hond in den pot" [The latecomer will find the dog in the pot] or "Een open pot of open kuil, Daarin steekt ligt de hond zijn muil" [An open pot or open hole, therein a dog will soon stick his muzzle]), see Harrebomée 1856–70, vol. 3, p. 227.

9. See de Jongh 1968–69, pp. 47–48; de Jongh 1971, p. 183; and de Jongh et al. in Amsterdam 1976, pp. 135, 146. Speaking of the need for parents to guard their daughters' chastity, the Fleming Adriaen Poirters wrote: "More than once the slinking kitty has stolen the meat from the kettle."

10. An age-old emblem of fidelity, the dog also symbolized marriage; see Andrea Alciati, *Emblematum libellus* (Paris, 1542), p. 138.

11. *Tafereel van de belacchende werelt* (The Hague, 1635), p. 202. Popular sayings (for example, "Zij leven [kijven, vechten] als katten en honden") also stress these conflicts and contrasts; see Harrebomée 1856–70, vol. 1 (1856), p. 322.

Herman Saftleven, born in Rotterdam in 1609, was the son of the painter Herman Saftleven the Elder and Lijntge Cornelisdr. Moelants. His brothers, Cornelis (q.v.) and Abraham (1611/13–c. 1646), were also artists. The elder Herman may have been an art dealer as well as a painter, for an inventory of his possessions taken after his death lists a number of paintings by other artists, including Cornelis Cornelisz. van Haarlem (1562–1638), Esaias van de Velde (q.v.), Roelant Saverij (1576–1639), Hercules Seghers (born 1589/90), and Dirck Hals (q.v.). After Herman the Elder's death in 1627, his three sons were placed in the care of two Rotterdam citizens, Hendrick Adriansz. and Jan Matheusz. van der Poel. Herman and Cornelis were registered as pupils in the Guild of St. Luke when Abraham enrolled on June 12, 1627. Herman, who had gained some recognition as an etcher, moved into a house on the Korte Jansstraat in Utrecht around 1632. On May 15, 1633, he married Anna van Vliet, daughter of Dirck van Vliet and Levina van Westhuyse. The couple lived in a house near St. Pieterskerk. They had two sons, Dirck and Herman, and two daughters, Levina and the flower painter Sara Saftleven. On December 21, 1639, Saftleven bought a house behind St. Pieterskerk, which was his Utrecht residence until his death. Shortly afterwards he purchased a section of small houses at the entrance to the Maliebaan. Between 1655 and 1667 he held various offices in the Utrecht painters' guild. He traveled along the Moselle and in the Rhineland, and in 1667 he may have lived for a time in Elberfeld. In 1684 Saftleven sold the houses on the Maliebaan. He died in Utrecht on January 5 of the following year and was buried in the Buurkerk. His wife Anna died on October 10.

Herman Saftleven was primarily a landscapist. Some early works from 1634–37 depict peasant interiors in the style of his brother, Cornelis, but even during this early period the artist was beginning to confine himself to landscape painting. His landscapes from the 1630s show the influence of Jan van Goyen (1596–1656) and Pieter Molijn (1596–1661); in the 1650s he painted in the manner of Cornelis van Poelenburgh (c. 1586–1667) and Jan Both (c. 1615–1652), Italianate painters of Utrecht; in the 1660s and

Literature: De Bie 1661, p. 275; de Monconys 1665–66, p. 132; Houbraken 1718–21, vol. 1, pp. 340–42, and vol. 3, pp. 138, 198, 199, 293, 339, 360; Weyerman 1729–69, vol. 2, pp. 83–86; Bartsch 1803–21, vol. 1, pp. 237ff.; Nagler 1835–52, vol. 14, p. 183; Immerzeel 1842–43, vol. 3, p. 52; Weigel 1843, p. 31; Wap 1852; Wap 1853; Kramm 1857–64, vol. 5, p. 1435; Thoré-Bürger 1858, pp. 149, 151; Nagler 1858–79, vol. 3, p. 1219; Thoré-Bürger 1860a, pp. 142, 209, 355; Obreen 1877–90, vol. 2, pp. 71–93, 266, and vol. 5, pp. 48, 115–28; Muller 1880, pp. 129, 131, 168; Dutuit 1881–88, vol. 4, pp. 4, 285; Blanc 1888, vol. 3; Wurzbach 1906–11, vol. 2, pp. 549–51; Erasmus 1909; Sterck 1924–25; Sandrart, Peltzer 1925, pp. 190, 216; Molkenboer 1926–27; Swillens 1931b; W. Stechow in Thieme, Becker 1907–50, vol. 29 (1935), pp. 310–11; van Campen 1937; Heppner 1946; Hollstein 1949–, vol. 23, pp. 119–48; Maclaren 1960, pp. 382–83; Nieuwstraten 1965; Stechow 1966a; Bolten 1970; Bartsch 1971–, vol. 1, pp. 240–66; Klinge 1977; Schulz 1977; Schulz 1978; Boston/Saint Louis 1980–81, pp. 167–68, 171–72, 196–97; Schulz 1982.

Sleeping Hunter in a Landscape, 164[2]
Signed and dated lower right: Saft Levens 164-
Oil on panel, 14½ x 20½″ (36.8 x 52 cm.)
Collection of Maida and George Abrams,
Boston

*afterwards his works were inspired by the
Flemish followers of Jan Bruegel the Elder
(1568–1625) and by his own travels in the
Rhineland. Saftleven also etched; his dated
prints range from 1640 to 1669. In the 1660s
the poet Joost van den Vondel composed a
number of poems in praise of the artist's work.
Saftleven's patrons included Lady Alathea
Talbot, widow of Thomas Howard, Earl of
Arundel. According to Houbraken, the land-
scape painters Johannes Vorstermans (1643–c.
1699) and Jan van Bunnik (1654–1727) were
among his students. Another pupil was Willem
van Bemmel (1630–1708).*

 C.V.B.R.

Provenance: Sale, Brussels, December 13, 1774, no. 37; sale,
The Hague, September 27, 1791, no. 30, to Coclers; sale,
Christie's, London, April 25, 1952, no. 83 (as A. Lievens);
Walter Chrysler, Provincetown, Massachusetts.

Exhibition: Saint Petersburg/Atlanta 1975, no. 10, pl. 10.

Literature: Schulz 1978, p. 28, no. 646, pl. 29.

A hunter lies sleeping on the side of a hill, be-
neath a tree. A greyhound rests beside him, and
another dog is visible at the crest of the hill. The
hunter leans against his musket, which has a
gutted hare slung over its barrel. A dead duck
lies beside the hunter's hat. A broad panorama
stretches to the right.

 The attribution of this painting to Jan Andries
Lievens, son of the painter Jan Lievens, in the
sale of 1952 was undoubtedly based on a mis-
reading of the signature. The fact that the
painting bears the plural signature "Saft Levens"
confirms that the work is a rare instance of col-
laboration between the two brothers Cornelis
and Herman Saftleven. Portraits of the two
artists are thought, probably correctly, to be
preserved in Cornelis's *Duet* (fig. 1). An excep-
tionally versatile artist, Cornelis experimented
with a wide range of subjects besides genre
works, including animal scenes, landscapes, alle-
gories, political satires, illustrations of proverbs,
scenes of monsters and hell, biblical subjects,
and portraits. Herman, on the other hand, spe-
cialized primarily in landscapes.[1] The over-
arching oak on the left in this painting, the
darkened hillock, and the lovely vista on the
right are undoubtedly his work. The two broth-
ers evidently had collaborated earlier; although
Cornelis alone signed the work, Schulz believes
both their hands are detectable in the *Van Reede
Family Portrait* of 1634–35 (Stichting Slot
Zuilen, Maarsen).[2]

 The landscape design of this work, with its
silhouetted hillside and distant panorama, re-
sembles compositions favored by Cornelis van
Poelenburgh, the leader of the first generation of
Dutch Italianate painters in Utrecht. In Poelen-
burgh's *Landscape with Flight into Egypt,* of
1625 (fig. 2), as in the Saftlevens' work, the
success of the design depends upon the bold
silhouette of the hill. Pentimenti in both works—
Cornelis Saftleven lowered the position of the
second dog and Poelenburgh redrew the back of
one of his cows—attest to the careful adjust-
ments that achieve these effects.

1. On Herman Saftleven, see Nieuwstraten 1965, pp. 81–117; and Schulz 1982.

2. Schulz 1978, p. 27, no. 643, fig. 13.

3. Schulz 1978, no. 56, fig. 64. The three other paintings by Cornelis dated 1642 are the pendants *Annunciation to the Shepherds* and *Adoration of the Shepherds*, Bayerische Staatsgemäldesammlungen, Munich, nos. 1703 and 1707, and *Merry Company with Peasants and a Monk*, Rijksmuseum, Amsterdam, no. A715.

The *Sleeping Hunter in a Landscape* can be dated 1642 on the basis of the date on Cornelis's preparatory drawing for the hunter (fig. 3).[3] Several changes appear in the final painting: the figure's head is thrown farther back and the gesture of the hunter's left hand is accommodated to the gun that he holds. Particularly effective is the contrast of the hunter's profound sleep and the alert watch of the sinewy greyhound, which seems to harken to the sound of the hunt in the lower right background. The painting, a highly naturalistic mixture of genre and landscape, offers an interesting contrast to Bloemaert's more bucolic, idealized treatment of life in the out-of-doors (pl. 42).

P.C.S.

FIG. 3. CORNELIS SAFTLEVEN, *Sleeping Hunter*, 1642, black chalk and wash on paper, Collection of Maida and George Abrams, Boston.

FIG. 1. CORNELIS SAFTLEVEN, *The Duet*, oil on panel, Akademie der bildenden Künste, Vienna, no. 692.

FIG. 2. CORNELIS VAN POELENBURGH, *Landscape with Flight into Egypt*, 1625, oil on canvas, Centraal Museum, Utrecht, inv. no. 8391.

Made 1634–1706 The Hague

Visit to the Doctor, 1669
Signed and dated lower left: 1669 G. Schalcken
Oil on panel, 13⅜ x 11⅜" (34 x 29 cm.)
Private Collection, Germany

Literature: Van Balen 1677, p. 688; Houbraken 1718–21, vol. 3, pp. 175–77, 343, 354, 384; Weyerman 1729–69, vol. 3, p. 11; Walpole 1788, p. 296; Smith 1829–42, vol. 4, pp. 265–90, and vol. 9, p. 588; Nagler 1835–52, vol. 15, p. 130; Immerzeel 1842–43, vol. 3, p. 58; Blanc 1854–90, vol. 3, p. 438; Kramm 1857–64, vol. 5, p. 1454; Nagler 1858–79, vol. 3, p. 355; Obreen 1877–90, vol. 5, pp. 170–71, and vol. 6, pp. 1–2; Veth 1892, pp. 1–11; Wurzbach 1906–11, vol. 2, pp. 567–69; Hofstede de Groot 1908–27, vol. 5, pp. 309–419; E. Trautscholdt in Thieme, Becker 1907–50, vol. 29 (1935), pp. 569–71; Hollstein 1949–, vol. 24, pp. 151–56; Plietzsch 1959; Maclaren 1960, pp. 388–89; Plietzsch 1960, pp. 188–89; Rosenberg et al. 1966, pp. 211–12; Braunschweig 1978, pp. 140–47; Hecht 1980.

Godfried Schalcken was born in 1634 in Made, near Dordrecht, in North Brabant. He was the son of Cornelis Schalckius, parish minister of Made, and Alletta Lydius, daughter of the clergyman Balthasar Lydius, both from Dordrecht. The artist had three brothers, Balthasar, Johannes, and Cornelis, and two sisters, Alletta and Maria. In 1654 the family moved to Dordrecht, where Schalckius had been appointed rector of the Latin School on September 30. Houbraken reported that Schalcken studied with Samuel van Hoogstraten (1627–1678) in Dordrecht between 1656 and 1662 and then with Gerard Dou (q.v.) in Leiden—both pupils of Rembrandt (1606–1669). By 1665 Schalcken had returned to Dordrecht, for he is registered as an ensign in the militia company. On October 31, 1679, the artist married Françoise van Dimen of Breda. Of their seven children, only one daughter, Françoise, baptized in Dordrecht on June 28, 1690, survived to adulthood.

In 1686 the family moved to the Wijnstraat in Dordrecht, where they lived in the "twelfth house past the Nieuwbrug." Five years later Schalcken was living in The Hague; on February 28, 1691, he paid a membership fee of eighteen guilders to Pictura, the painters' confraternity. By November 12 of that year, however, he was again a resident of Dordrecht. In May 1692 Schalcken traveled to London, where he remained until 1697. During these years he painted several portraits of William III. By June 1698 Schalcken had returned to The Hague, and on August 31, 1699, he became a citizen. He is documented as a resident of the city in 1700 and 1702, but in 1703 he was in Düsseldorf painting for the Elector Palatine, Johann Wilhelm. Schalcken is again mentioned in The Hague records of 1704 and 1705, when he filed his will. He died in the city in November 1706, and was survived by his wife and daughter.

Schalcken painted primarily portraits and genre scenes, a great number of which are nocturnal and illuminated by artificial light. Less often he depicted genre-like biblical or mythological subjects. His works also include drawings and etchings. The Leiden portrait and genre painter Carel de Moor (1656–1738) and the candlelight painter Arnold Boonen (1669–1729) are among Schalcken's pupils, as are his sister Maria and his nephew Jacobus (1683–1733).

C.V.B.R.

Literature: The Burlington Magazine, vol. 106 (April 1964), p. vi, ill.; Thornton 1978, p. 136, fig. 109.

This painting, which first reappeared in 1964, is Schalcken's earliest surviving work.[1] As such, it serves to place other undated works into the artist's early period of activity. Two candidates for this dating are the *Head of a Bearded Man* (sale, Christie's, London, July 19, 1973, no. 207) and the *Portrait of an Elderly Artist* (fig. 1). Both employ the model portrayed as the doctor in the exhibited picture.[2]

Although Schalcken studied the art of painting with both Samuel van Hoogstraten and Gerard Dou, this picture indicates that Dou was likely the prevailing influence in Schalcken's early, independent style of painting. In fact, the principal inspiration for this work seems to have been Dou's painting of 1653 (fig. 2), one of the earliest representations of the doctor's visit in seventeenth-century Dutch art.[3] Elements common to both pictures—the arched format, mullioned window, drawn back curtain, weeping female figure, turkish carpet, not to mention the doctor in a beret examining a urine vial in the light—suggest some connection between the pictures. Still, the differences are significant; one could argue that the common features stem from a shared source or from the traditional Northern European portrayal of the doctor's foibles.[4] As in most depictions of the doctor's visit in Dutch

FIG. 1. GODFRIED
SCHALCKEN, *Portrait of an
Elderly Artist*, oil on panel,
Städelsches Kunstinstitut
und Städtische Galerie,
Frankfurt, inv. no. 166.

FIG. 2. GERARD DOU, *The
Doctor's Visit*, 1653, oil on
panel, Kunsthistorisches
Museum, Vienna, inv. no.
592.

FIG. 3. GODFRIED
SCHALCKEN, *The Doctor's
Visit*, oil on panel,
Mauritshuis, The Hague, on
loan from the Dienst Ver-
spreide Rijkskollekties, inv.
no. B1115.

art of this period, the physician in both paintings
is dressed in fanciful garb—dress that would
immediately reveal him as a charlatan to a con-
temporary beholder (see cat. no. 105). Never-
theless, the naïve women in both scenes are
moved to tears by the quack's diagnosis of the
urine sample. In Dou's picture, the older woman
may have been informed of her impending
death; in Schalcken's conception, the young girl
has apparently just learned that she has lovesick-
ness or is pregnant. The color of the liquid in the
vial is bright red. Among the symptoms of love-
sickness mentioned by van Beverwijck were a
quick pulse, poor appetite, rapid mood changes,
a pale complexion, sunken eyes, and red and
fiery urine.[5]

Although urinalysis was a respected diagnostic
tool in the seventeenth century, quacks claimed
they could identify all sorts of maladies by sim-
ply looking at a patient's urine.[6] A lost picture
by Jan Steen supposedly shows a doctor care-
fully examining a flask of urine while his young
patient faints into the arms of her mother. The
painting was inscribed: "Unless I am mistaken,
this girl is with child."[7] In a later portrayal of
the doctor's visit (fig. 3), Schalcken makes the
function of the urine analysis explicit: a tiny em-
bryo appears in the flask, leaving no doubt as to
the precise meaning of the picture.[8]

O.N.

1. Before the discovery of the exhibited painting, a "half-
length figure of a young lady holding a light," supposedly
signed and dated 1671, was thought to be Schalcken's ear-
liest work. The description, derived from Parthey's account
of the von Tettau Collection in Erfurt (1863–64, vol. 2), is
recorded in Hofstede de Groot (1907–28, vol. 5, no. 225d).
Unfortunately, this painting has not been identified with any
existing work.

2. Both works are on panel, the former measuring 7½ x 6"
(19 x 15.2 cm.) and the latter 9⅜ x 7½" (24 x 19 cm.).
Although the sitter was tentatively identified as Schalcken in
the Frankfurt catalogue (1924, p. 184, no. 166), this was
dismissed by Hofstede de Groot (1907–28, vol. 5, no. 334).

3. See Naumann 1981a, vol. 1, p. 50 n. 10 and p. 99.

4. In his 1884 catalogue to the Vienna museum (p. 101, no.
782), Engerth stated that Dou's painting had been owned by
Archduke Leopold Wilhelm in Brussels before his departure
for Vienna in 1656. However, the painting does not appear
in the comprehensive inventory made of the Archduke's col-
lection in 1659–60. If Engerth is correct (he often cites
erroneous provenance), it is unlikely that Schalcken could
have known Dou's painting, for it would have left the coun-
try before he reached the age of thirteen.

5. See J. van Beverwijck, *Schat der Ongesontheyt* (Dordrecht,
1647), pp. 453–68.

6. See Bedaux 1975, p. 17; and Naumann 1981a, vol. 1, p.
99.

7. "Als ik my niet verzind/ Is deze Meid met kind." See
Hofstede de Groot 1907–28, vol. 4, no. 146; and cat. no.
105.

8. See Amsterdam 1976, pp. 226–27.

Game of Lady Come into the Garden,
late 1660s
Traces of a signature, formerly read as:
G. Schalcken me fecit
Oil on panel, 25 x 19½" (63.5 x 49.5 cm.)
Her Majesty Queen Elizabeth II

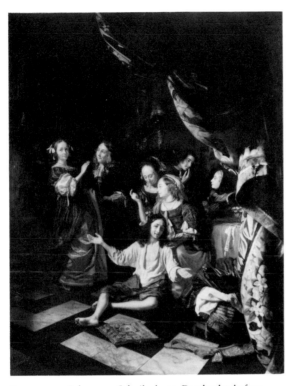

Provenance: Johan van Schuilenburg, Dordrecht, before 1718;[1] sale, The Hague, September 30, 1735, no. 57; possibly Collection of Louis XVI at the time of the French Revolution; sale, Amsterdam, June 26, 1799, no. 15, to J. Schmidt; sale, Walsh Porter, Christie's, London, March 23, 1803, no. 47, to H. Phillips for George IV.

Exhibitions: London, British Institution, 1826, no. 40; London, British Institution, 1827, no. 134; Manchester 1857, no. 1052; London 1946–47, no. 339; Amsterdam 1976, no. 57.

Literature: Houbraken 1718–21, vol. 3, pp. 175–76; W. H. Pyne, *The History of the Royal Residences* (London, 1819), vol. 3, p. 83; Smith 1829–42, vol. 4, no. 2; Waagen 1837–38, vol. 2, p. 355; Jameson 1844, no. 103; Waagen 1854–57, vol. 2, pp. 8–9; Hofstede de Groot 1907–28, vol. 5, no. 166.

FIG. 1. Emblem from JOHAN DE BRUNE, *Emblemata of zinne-werck* (Amsterdam, 1624), no. 30.

Although Houbraken described this painting in detail, its subject remains uncertain. According to the biographer, the game being played is *Vrouwtje kom ten Hoof,* or, literally, Lady Come into the Garden (or Courtyard). Mentioning only that the game was a popular activity with the young people in Dordrecht, Houbraken failed to explain its rules or significance.[2] As he observed, the character seated in the center is dressed only in his shirttails and trousers; his elegant outer clothing has been piled up on the floor beside him. The man shrugs his shoulders, as if to say that he is helpless to prevent the two women from undressing him. One woman beckons to the girl standing on the left who playfully refuses the offer to join in.

The issue of who wore the pants in the family, that is, who had the upper hand in a relationship, was a traditional iconographic theme in Dutch art and literature. It enjoyed special popularity in the sixteenth and seventeenth centuries and may shed some light on the game. A prime example of this time-honored subject is a popular print published in Antwerp in the mid-sixteenth century that illustrates the Battle for the Trousers. The engraving, which is known as *Overhand* (upper hand), shows a submissive husband surrendering his pants to his domineering wife; the inscription reads: "Where the woman has the upper hand, and wears the trousers,/ There it is that Jan de Man lives according to the dictates of his wife."[3]

Closer to Schalcken's painting in time and outward appearance is the illustration in Johan de Brune's *Emblemata of zinne-werck* of 1624 (fig. 1), where a young man cavorts with two maidens, losing articles of his clothing in the process. The print is captioned "Iongh Hovelingh, oud schovelingh" (young dandy, old discard), implying that the cavalier will soon be cast off by the women. De Brune explains to his reader that a woman out for pleasure can only lead to man's anguish: "It is the greatest vice that a man might have/ To be in the service of a woman who enjoys entertainment with us. . . . / Who finds thousands of vices, in which she is seldom mistaken,/ Because she is a woman and she is full of cunning./ Whoever might be the God of this type of woman,/ He has given us a sea of misery."[4]

If *Vrouwtje kom ten Hoof* was truly a licentious game and not simply a playfully erotic variation on the modern game Post Office,[5] it seems strange that the artist included himself and his sister Maria as the two most prominent figures. Perhaps Schalcken intended for those who recognized them an ironical comment, as Rembrandt surely did when he portrayed himself and his wife as the Prodigal Son and a prostitute.[6] Be this as it may, Houbraken's assertion that Schalcken represented himself as the seated man is certainly correct; proof lies in a comparison with the artist's self-portrait in Cambridge.[7] Both paintings show the artist at around twenty-five years of age; thus they must have been executed in the later 1660s. This dating puts them among the artist's earliest surviving efforts in paint.

O.N.

Rotterdam 1609/11–1670 Rotterdam

1. See Houbraken 1718–21, vol. 3, pp. 175–76.

2. In his biography of Schalcken, Houbraken wrote: ". . . in 't kabinet van den Heere Joh: van Schuilenburg hangt verbeeldende dat zeker Spel dat de Jonge luiden te Dordrecht in dien tyd gewoon waren te spelen, wanneer zy met malkander om vrolyk te wezen in gezelschap kwamen, genoemt, Vrouwtje, kom ten Hoof. Waar in hy zig zelf verbeeld heeft, zittende ontkleed tot zyn hemd en onderbroek aan den schoot van een Juffrouw. De andere beeltjes zyn meê pourtretten, en waren in dien tyd van elk bekent. Over het tapytkleed zietmaen dat hy een maand geschildert heeft, naderhand zetten hy zig tot het schilderen van pourtretten waar van 'er nog een goed getal te Dordrecht onder de geachtste geslachten te zien zyn" (. . . in the cabinet of Mr. Joh. van Schuilenburg hangs the representation of a certain game that the youngsters of Dordrecht would commonly play at that time, whenever they gathered with each other to have fun together, called, Lady Come into the Garden. He [Schalcken] portrayed himself dressed in his shirtsleeves and underwear and seated against the lap of a girl. The other faces are also portraits, and were recognized by all at the time. Concerning the tapestry [in the painting], it is said that he worked on it for one month, after which he set himself to paint portraits, wherein there is still to be seen a good number of Dordrecht's most esteemed families) (author's translation).

3. "Waer de Vrouw d'overhandt heeft, en draecht de brouck/ Daer ist dat Jan de Man leeft naer aduys van den douck." Translation and transcription from W. S. Gibson, "Some Flemish Popular Prints from Hieronymus Cock and His Contemporaries," *The Art Bulletin*, vol. 60 (1978), p. 677 n. 23, and p. 678, fig. 5. See also Gibson's "Bruegel, Dulle Griet, and Sexist Politics in the Sixteenth Century," in *Pieter Bruegel und seine Welt* (Berlin, 1979), pp. 10–11.

4. De Brune 1624, pp. 213–21; cited in Amsterdam 1976, p. 95: "'t Is wel het grootste quaed, dat een mensch hebben magh/ Een vrouw ten dienst te staen, die met ons houd te lach./ . . . / Die duyzend quaeden vint, daer in zy zelden mist,/ Om dat zy is een vrouw, en dat zy is vol list./ Wie dat die God magh zijn van deze vrouwen-benden,/ Hy heeft ons toeghebracht een zee van veel ellenden" (author's translation).

5. According to Bob Haboldt, the phrase *Vrouwtje kom ten Hoof* may well have conveyed a lascivious meaning in the seventeenth century (conversation, November 7, 1983). The modern Dutch idiom *Iemand het hof maken* connotes amorous pursuit or aggressive courtship, and an old Dutch proverb uses the word *hof* as a metaphor for whore (compare Harrebomée 1856–70, vol. 1, p. 313).

6. See Bergström 1966. For the identity of Maria Schalcken, see White 1982, p. 118.

7. Cambridge, Fitzwilliam Museum, *Catalogue of Paintings* (Cambridge, 1960), vol. 1, p. 116, no. 368, pl. 63. For the dating of this picture, see Götz Eckardt, *Selbstbildnisse niederländischer Maler des 17. Jahrhundert* (Berlin, 1971), p. 206. The identity of the sitter in the portrait in Cambridge was questioned by Hofstede de Groot (1907–28, vol. 5, p. 391, no. 280), but the subject bears sufficient resemblance to Schalcken in the engraved portrait in Houbraken (1718–21, vol. 3, opposite p. 176) to warrant a positive identification.

Shown in London only

Hendrick Martensz. Sorgh, who also signed his works "Sorch" and "de Sorch," was born in Rotterdam, probably between 1609 and 1611; a self-portrait was mentioned by Houbraken, dated 1645 and inscribed "Aet. 34" (age 34), but a document of 1646 states Hendrick's age as "about" 37. The artist was the son of Maerten Claesz. Rochusse or Rokes (a surname that, contrary to many accounts, Sorgh never seems to have adopted), who acquired the sobriquet Zorg ("careful" in Dutch) because of the extraordinary care with which he handled cargo as an ordinaris marktschuijtvoerder (common market bargeman) on the Rotterdam–Dordrecht line. Hendrick's mother was Maerten's second wife, Lysbeth Hendricks from Antwerp. Houbraken claimed that Sorgh studied with the Antwerp painter David Teniers (1610–1690) and Willem Buytewech (q.v.). Since Buytewech died in 1624, the latter apprenticeship would have taken place when Sorgh was only in his early teens. In 1630 Sorgh drew up a will in Rotterdam, and in 1633 he married Ariaentge Pieters, daughter of a Delftshaven merchant, who bore him at least five children. The artist seems to have remained a resident of Rotterdam. In 1637 he bought a house on the Steiger called "Het Vrouwehoofd" from a marktskipper (market barge skipper) from Utrecht for a substantial sum. The new house was only five doors from the docking place of the Dordrecht barge. A document from 1638 describes Sorgh himself as a marktskipper "between this city [Rotterdam] and Dordrecht." This seems to have been a more official position than that held by his father. Sorgh's appointment to the honorary municipal post of broodweger (bread weigher) in 1657 and brandmeester (fire chief) in 1659, together with his appearance in 1646 at a rabbit hunt in Vlaardingen with the schepen (sheriff) of Rotterdam, prove that he enjoyed a somewhat elevated social standing. In 1654 the artist was commissioned by the city of Rotterdam to restore a portrait of Erasmus, and in 1659 he was named a hoofdman (leader) of the Guild of St. Luke. The year before he died, he bought a flower garden on the Schiekade. He was buried at the Grote Kerk before June 28, 1670.

Sorgh specialized in depicting peasant interiors and, after c. 1653, market scenes. He also painted a few portraits and a number of marine and history paintings. Together with other Rotterdam painters, notably Herman and Cornelis

Literature: Houbraken 1718–21, vol. 2, pp. 89–90, and vol. 3, p. 244; Weyerman 1729–69, vol. 2, p. 173; Nagler 1835–52, vol. 22, p. 319; Immerzeel 1842–43, vol. 3, p. 261; Kramm 1857–64, vol. 6, p. 1902; Nagler 1858–79, vol. 4, p. 2031; Thoré-Bürger 1860a, pp. 105, 271; van der Kellen 1876b; Obreen 1877–90, vol. 1, p. 153; Sorgh 1890; Haverkorn van Rijsewijk 1892b, pp. 238–50; Wurzbach 1906–11, vol. 2, pp. 641–42; W. R. Juynboll in Thieme, Becker 1907–50, vol. 31 (1937), p. 294; Heppner 1946; Maclaren 1960, p. 394; Plietzsch 1960, pp. 80–81; Amsterdam 1976, pp. 228–31; Schneeman 1982.

Musical Company, 1661
Signed and dated at right on the stool: HM.
Sorgh 1661 (HM in ligature)
Oil on canvas, 26¾ x 32¼" (68 x 82 cm.)
Private Collection

Saftleven (q.q.v.), Sorgh helped to develop a peasant painting tradition related to but distinct from the styles followed by Teniers in Antwerp and by Adriaen Brouwer (q.v.) and Adriaen and Isaack van Ostade (q.q.v.) in Haarlem. Several artists also imitated his style. In addition to those mentioned above, painters whose works have been mistaken for Sorgh's include Adriaen Lucasz. Fonteyn (died 1661), Gerrit Lundens (1622–c. 1677), and Hendrik Potuyl (active c. 1639). Pieter Nijs (born 1624), Peter Crijnse Volmarijn (c. 1629–1679), and Cornelis Dorsman (active c. 1660) were students of Sorgh.

P.C.S.

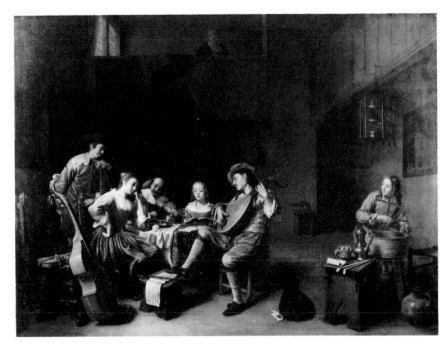

Provenance: Possibly sale, J. van der Linden van Slingeland, Dordrecht, August 22, 1785, no. 393, to Laytsche (135 guilders); sale, van Steenberghen, De Goesin-Verhaeghe, Ghent, October 28, 1802, no. 12; Graf von Nemes, Budapest; dealer D. Katz, Dieren, Holland, 1935; dealer S. Nijstad, The Hague, c. 1949.

Exhibition: Rotterdam 1935, no. 64.

A company of five people—three men and two women—are assembled around a table. One of the men plays a theorbo, another a violin. One of the women sings while beating time to the music. Another man and a woman listen attentively. At the left are a chair, a chamber pot, and, resting on a bench, a viola da gamba and a violin; in the center right a theorbo case lies on the floor; a cittern hangs on the back wall. A young serving boy washes wineglasses at the right beside a bench with clay pipes, paper containing tobacco, a brazier, and a pewter pitcher, which are arranged as a still life. On the table covered with a carpet are music books, fruit, and pretzels. A birdcage hangs above the boy's head, and two large ceramic wine vessels rest on the floor beside the washtub. In the rear of the room, behind a covered bed, a third woman appears on a wooden balcony. A cat sleeps on a bench at the right, and another balcony projects along the right wall. On the right wall is a painting whose subject is indistinct but may represent three standing religious figures.

The majority of Sorgh's paintings are kitchen or market scenes, such as the *Vegetable Market* (pl. 95), or peasant subjects set in taverns or

FIG. 1. HENDRICK SORGH,
*Musical Company (The
Lute Player)*, 1661, oil on
panel, Rijksmuseum,
Amsterdam, no. A495.

barns. Even his religious and mythological sub-
jects such as the Adoration of the Shepherds,
Christ in the House of Mary and Martha, the
Supper at Emmaus, and the Satyr and the Peas-
ant incorporate these interests. Although Sorgh's
low-life music subjects are dated as early as
1647,[1] it was only around 1660 that he began
painting musicians of a more elevated society
playing costlier instruments (note the viola da
gamba's carved head[2]). Presumably to enhance
this aura of elegance or to evoke exotic the-
atricality, the costumes of the figures in this
painting are imaginary pastiches of old-fash-
ioned (sixteenth- and early-seventeenth-century)
dress. The same is true of the romantic outfit
worn by the theorbo player in Sorgh's *Musical
Company* (fig. 1) also dated 1661.[3] There, even
the architecture—an open veranda with a gate
and curtain—is fanciful. Although balconies
could serve as sleeping lofts, as in Frans van
Mieris's *Inn Scene* (Mauritshuis, The Hague, no.
860), rarely were they as extensive as those de-
picted here; thus, perhaps the setting, like the
costumes, is the artist's invention.

A Rotterdamer, Sorgh may have gained his
interest in more complex spaces from paintings
produced in nearby Delft in the late 1650s by
Pieter de Hooch and Vermeer, but his figural
arrangement—players at table set to one side
with the serving boy opposite—was a time-hon-
ored genre design; compare, for example,
Anthonie Palamedesz.'s *Elegant Company Gam-
ing and Drinking* of 1632–34 (pl. 16). In
Sorgh's painting music is once again mixed with
potential allusions to love and passion—the bird
in the birdcage and even the pose of the girl
whose head rests in her hand.[4] Pretzels evidently
were sometimes rewards for musical perfor-
mances.[5]

P.C.S.

1. See, for example, *Peasant Interior with a Violinist* (Na-
tionalmuseum, Stockholm, no. NM340), signed and dated
1647.

2. For a discussion of this type of decoration, see M. Prick
van Wely, "Mensenhoofden en dierekoppen als versiering
aan oude snaarinstrumenten," *Antiek*, vol. 10, no. 4
(November 1975), pp. 412–16.

3. See Amsterdam 1976, no. 60.

4. See Jan Steen's *Doctor's Visit* (cat. no. 105) for a discus-
sion of this pose.

5. A print by Cornelis Bloemaert of two boys holding a
pretzel as they sing is inscribed: "Wij singen vast wat nieuwe,
en hebben doch een buijt/ Een kraekling is ons winst, maer t
liedtken moet eerst wt."

Vegetable Market, 1662
Signed: HM Sorgh (HM in ligature) and dated
at the left on the wall: 1662
Oil on panel, 20 x 28″ (51 x 71 cm.)
Rijksmuseum, Amsterdam, no. A717

Provenance: Sale, H. Muilman, Amsterdam, April 12, 1813, no. 192; bequeathed to the museum by Jhr. J.S.A. van de Poll, Amsterdam, 1880.

Exhibitions: Paris 1967, cat. no. 179, ill.; Amsterdam, Amsterdam Historical Museum, *Opkomst en bloei van het Noordnederlandse stadsgezicht in de 17de eeuw,* 1977, no. 124, ill.

Literature: V. de Stuers, *Nederlandsche Kunstbode* (1880), vol. 2, p. 245; Wurzbach 1906–11, vol. 2, p. 641; Plietzsch 1960, p. 80; P. W. Klein, "Gouden eeuw en pruikentijd—een beeld van contrasten?" *Spiegel Historiael,* vol. 1 (1967), p. 549, ill.; Amsterdam, Rijksmuseum, cat. 1976, no. A717, ill.; H.J.P.J. Vandommele, "De Appel en de Nederlanden," *Spiegel Historiael,* vol. 3 (1978), p. 27, fig. 8; Schneeman 1982, p. 142, no. 54, fig. 40.

FIG. 1. JOACHIM WTTEWAEL, *Vegetable Market,* 1618, oil on panel, Centraal Museum, Utrecht, inv. no. 2262.

A woman in a straw hat sitting before a brick building looks out at the viewer. She holds a muskmelon, and the baskets surrounding her are piled high with fruit and vegetables. A man in a slouch hat sits to her left; he gestures as he converses with a standing woman holding a basket of artichokes. Behind, to the right, a woman purchases herring. In the distance men unload other vegetables from boats docked along the quay. Gabled roofs of houses form the backdrop. At the right is an overturned wheelbarrow.

The son of an *ordinaris marktschuijtvoerder* (common market bargeman) and a *marktskipper* (market barge skipper) himself, Hendrick Sorgh made a specialty of market scenes. Most of these works are horizontal in format and depict a vegetable, fruit, fish, or poultry stand. The saleswoman sits to one side with a view opposite of the sails of market barges or of a cobblestone street with booths and stands operated by other

saleswomen. Save for the *Fishmarket* of 1667 (Gemäldegalerie Alte Meister, Dresden, no. 1806), which has an upright format,[1] the *Vegetable Market* is the last dated example in the series.[2]

In the sixteenth century, market scenes had been a specialty of the Flemish artists Pieter Aertsen and Joachim Bueckelaer, for example, Bueckelaer's *Market Wives with Poultry and Vegetables,* of 1561 (Kunsthistorisches Museum, Vienna, inv. no. 3559), and *Fishmarket,* of 1574 (Koninklijk Museum voor Schone Kunsten, Antwerp, no. 814). In most cases these works carried allegorical and specifically religio-moralistic messages, such as a warning against man's carnality and worldly appetites.[3] In other sixteenth-century paintings, market scenes of poultry, fish, vegetables, fruit, and other products symbolized the months of the year as in the *Vegetable Market* (Kunsthistorisches Museum, Vienna, inv. no. 7626) attributed to Lucas van Valkenborch.[4] In early Dutch representations of markets, like Joachim Wttewael's somewhat *retardataire Vegetable Market* (fig. 1), the scene can also embody a maxim or aphorism; here the gesture of the child holding up an apple probably alludes to the Dutch saying "One rotten apple in the basket ruins the fruit."[5] Jacob Cats's *Spiegel van den ouden en nieuwen tijdt* includes an emblem of a woman holding up a melon with the motto in French "Amis sont comme le melon,/ De dix souvent pas un est bon" (Friends are like melons,/ Often only one is good).[6]

Although both Jan van de Velde and Willem Buytewech, Sorgh's presumed teacher, drew market scenes,[7] the first significant revival of interest in these subjects occurred after c. 1650 and incorporated the new interest in cityscape painting. Sorgh was one of the pioneers of this trend;[8] his market scenes won the admiration of imitators almost immediately. Adriaen Lucasz. Fonteyn's *Mussel Market near Roobrug, Rotterdam,* for example, is dated 1657 (Rijksmuseum, Amsterdam, no. A1941).

The bounty displayed by Sorgh's greengrocer attests to the richness of the produce offered at the weekly markets in Dutch cities. Most of the vegetables depicted—radishes, turnips, squash, cabbages, and carrots—had long been indigenous to Holland; the artichoke, however, had only recently been introduced by way of Italy from the Levant. P. Hondius, author of *Dapes exemptae of de Mouse-schans, d.i. de soeticheydt des buytenlevens*, proudly claimed to have been the first to grow it.[9]

P.C.S.

1. A second scene of a fishmarket with an upright format and half-length figures is in the City Art Galleries, Manchester (no. 303a).

2. The earliest in the series appears to be the *Vegetable Market*, dated 1653, which is a pendant to the *Fishmarket*, dated the following year (Staatliche Kunstsammlungen, Kassel, nos. GK285 and GK286). The *View of the Grote Markt with Vegetable Stall* (Museum Boymans–van Beuningen, Rotterdam, inv. no. 1818) and the *Couple at a Vegetable Market* (sale, Christie's, London, November 29, 1974, no. 74) are dated 1654 and 1660, respectively. An undated scene of a fishmarket (Rijksmuseum, Amsterdam, no. C227) and another of a poultry market (Offentliche Kunstsammlungen, Kunstmuseum, Basel, inv. no. 1168), like the Kassel paintings, are probably pendants. The pair sold together in the Hendrick Sorgh (the artist's grandson) sale, Amsterdam, March 28, 1720, nos. 19 and 18, respectively; sale, George Bruyn, March 16, 1724, nos. 15 and 14, respectively; and sale, Wannaar et al., Amsterdam, May 17, 1757, nos. 112 and 113. Two other undated scenes of vegetable stands complete the series; one was formerly in the H. Wetzlar Collection in Paris (cat. 1952, no. 84), and the other was sold at Christie's in London on April 6, 1977 (no. 66). The former appears to be the closest in the series to the *Vegetable Market* in style and conception.

3. See Emmens 1973, pp. 93–101; and Grosjean 1974, pp. 121–43.

4. On van Valkenborch's market scenes, see T. von Frimmel, "Eine Reihe von Jahreszeiten-Bildern des Lucas van Valckenborch," *Blätter für Gemäldekunde*, vol. 1 (1905), pp. 111–18; and A. Wied, "Lucas van Valckenborch," *Jahrbuch der kunsthistorischen Sammlungen in Wien*, n.s., vol. 67, no. 31 (1971), pp. 175–81.

5. "Eén rotte appel in de mand maakt al het gave fruit te schand"; see DIAL 41C65 and Amsterdam 1976, no. 77.

6. In *Alle de Werken* (Amsterdam, 1657), p. 14.

7. See Jan van de Velde's *Vegetable Market* (F. Lugt Collection, Institut Néerlandais, Paris) and Willem Buytewech's *Mussel Merchant* (Pierpont Morgan Library, New York, inv. no. 1959.5).

8. Other early painters of these subjects include Sybrant van Beest, Jan Victors, Gerard Dou, Adriaen van Ostade (see pl. 30), Jan Steen, and Quirijn van Brekelenkam.

9. See Schotel 1905, p. 203, and the author's discussion of Dutch vegetable and fruit markets, pp. 202–6.

Leiden 1625/26–1679 Leiden

Prayer before the Meal, 1660
Signed and dated on the placard on the back
wall: JAN STEEN 1660
Oil on panel, 20¾ x 17½" (52.7 x 44.5 cm.)
The Walter Morrison Collection, Sudeley Castle,
Gloucestershire

Literature: Houbraken
1718–21, vol. 1, p. 374,
vol. 2, p. 245, and vol. 3,
pp. 7, 12–30; Weyerman
1729–69, vol. 2, p. 348;
Descamps 1753–64, vol. 3,
pp. 26–31; Reynolds 1774,
vol. 1, p. 401; Reynolds
1781, vol. 2, pp. 194–207;
Reynolds 1786, vol. 2, p.
69; Smith 1829–42, vol. 4,
pp. xv–xx, 1–69, and vol.
9, p. 473; Nagler 1835–52,
vol. 17, p. 234; Zwigtman
1840; Immerzeel 1842–43,
vol. 3, p. 110; Blanc 1854–
90, vol. 3, p. 583; Kramm
1857–64, vol. 5, p. 1562;
Thoré-Bürger 1858, pp.
104–18; Westrheene 1858;
Nagler 1858–79, vol. 4, p.
383; Thoré-Bürger 1860a,
pp. 107–20; Westrheene
1864; van der Willigen
1870, p. 38, 267–70; Bode
1873; Obreen 1877–90,
vol. 5, p. 207; Bode 1883,
pp. 193–96; Rosenberg
1897; Bredius 1899a;
Somov 1899; Bode 1906;
Marius 1906; Wurzbach
1906–11, vol. 2, pp. 655–
58; Hofstede de Groot
1908–27, vol. 4, pp. 1–
252; Bode 1909, pp. 94–
109; Holmes 1909; London
1909; Martin 1910; Martin
1921b; Martin 1924;
Leiden 1926; Bredius 1927;
Schmidt-Degener 1927;
Schmidt-Degener, van
Gelder 1927; Hofstede de
Groot 1927–28; Martin
1927–28; Stechow 1928–
29; Henkel 1931–32; Kelk
1932; van Gils 1935; Mar-
tin 1935; van Gils 1937; E.
Trautscholdt in Thieme,
Becker 1907–50, vol. 31
(1937), pp. 509–15; de
Jonge 1939; Heppner
1939–40; Simon 1940; van
Gils 1942; van Regteren Al-
tena 1943; Gudlaugsson
1945; Martin 1947; Gerson
1948; Bijleveld 1950; de
Groot 1952; Martin 1954;
The Hague 1958–59; Mac-
laren 1960, pp. 395–96;
Rosenberg et al. 1966, pp.
133–38; Held 1967; von
Criegern 1971; de Vries
1973; de Vries 1974–75;
Gudlaugsson 1975; Amster-
dam 1976, pp. 232–49; de
Vries 1976a; de Vries
1976b; Kirschenbaum
1977; de Vries 1977; Braun
1980; Amsterdam/Wash-
ington 1981–82, p. 79;
Philadelphia 1983.

Although the exact date of Steen's birth has not
been determined, records show that he enrolled
in the university in Leiden in 1646 at the age of
twenty. Thus he must have been born in 1625 or
1626. Houbraken claimed that he was a pupil of
Jan van Goyen (1596–1656), and Weyerman
stated that he studied successively with Nicolaes
Knüpfer (c. 1603–1655) in Utrecht, Adriaen van
Ostade (q.v.) in Haarlem, and van Goyen in The
Hague. In March 1648, Steen became one of the
first members of the newly formed St. Luke's
Guild in Leiden. In September of the following
year, he married van Goyen's daughter in The
Hague and apparently remained in the city until
the summer of 1654. Although Steen's father, a
grain-handler and brewer, leased a brewery for
his son in Delft between 1654 and 1657, no
evidence suggests that the artist spent much time
in the city. Between September and April 1654
he appears in Leiden records, and from 1656 to
1660 he lived in a small house in Warmond,
several miles from Leiden. Steen settled in
Haarlem by 1661, when he entered the city's
guild. In 1670 he moved to Leiden, where he
had inherited his father's house. On at least two
occasions he paid or covered outstanding debts
by bartering paintings, receiving less than ten
guilders (a relatively small amount) per painting.
In 1672 he was granted permission to open an
inn. A widower from May 1669, Steen married
Marije Herculens van Egmont in 1673. In 1671,
1672, and 1673, he served as a hoofdman
(leader) and in 1674 as a deken (dean) of the
Leiden guild. The artist died early in 1679;
Marije survived him by eight years.

Nothing in the certain facts of Steen's life jus-
tifies his reputation as a drunken profligate. A
highly productive painter of exceptional narra-
tive and comic genius, he is best remembered for
his many humorous genre scenes. His history
paintings are, however, equally significant. Sur-
prisingly, only one sheet of drawings is known
(Rijksprentenkabinet, Rijksmuseum, Amster-
dam). Although Steen had no recorded pupils,
he was widely imitated; among those who cop-
ied his style, the Haarlem artist Richard
Brakenburgh (1650–1702) is the best known.

P.C.S.

Provenance: Sale, J. Enschede, Haarlem, May 30, 1786, no.
128, to Ocke; sale, E. M. Engelberts, Amsterdam, August 25,
1817, no. 91, to de Vries; Baron Collot d'Escury, Leeu-
warden, October 17, 1831; with dealer Chaplin, London,
1831; Edmund Phipps, London, by 1854; Charles Morrison,
London, by 1907.

Exhibitions: London, British Gallery, 1819; London, Royal
Academy, 1879, no. 54, 1889, no. 69, and 1907, no. 73.

Literature: Smith 1829–42, vol. 4, no. 185; Waagen 1854,
vol. 2, p. 262, suppl. p. 108; Westrheene 1856, no. 380;
Hofstede de Groot 1908–27, vol. 1, no. 375 and 397b;
Bredius 1927, p. 61, ill.; Martin 1935–36, vol. 2, p. 264; de
Groot 1952, pp. 61–62; de Vries 1976a, pp. 10–11, 57, fig.
25; de Vries 1977, pp. 46, 48, 49–50, 52, 129 n. 79, no. 90;
Braun 1980, no. 115, ill.; Philadelphia 1983, p. 29, fig. 27.

A family gathers around a table in the corner
of the room to partake of a meal. The mother,
dressed in a gray jacket and white cap and col-
lar, sits on a bench below the open window, her
young child in her lap. The father, who sits
across from them, has removed his hat and
prays earnestly. Bread and cheese are on the
table, a platter of ham is on a barrel in the fore-
ground, and a ceramic jug is on the bench. A
belkroon (a little chandelier with a bell in the
center), which hangs overhead, is decorated with
a leafy branch and inscribed "u wille moet
geschieden" (Thy will be done). The verse on the
placard nailed to the back wall is a stanza from
Proverbs 30:7–9: "Three things I desire only
and no more/ Above all to love God the Father/
Not to covet an abundance of riches/ But to de-
sire what the wisest prayed for/ [Only] an honest
life in this vale—/ On these three all is based."[1]

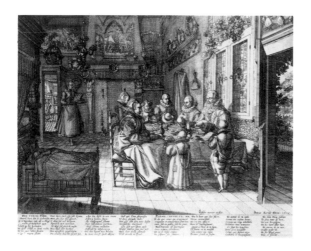

FIG. I. CLAES JANSZ.
VISSCHER, *Prayer before the
Meal*, 1609, engraving.

FIG. 2. ADRIAEN VAN
OSTADE, *Prayer before the
Meal*, 1653, etching.

A small shelf at the upper right supports a candle, a taper, books, a skull with a straw wreath, and a sheet of paper inscribed "Gedenckt te sterven" (Think on death).

Steen, although usually remembered as a painter of comic subjects, also depicted serious history and genre themes. One of his favorite subjects was *Gebed voor de Maaltijd* (Prayer before the meal). This "domestic virtue" genre theme undoubtedly owed its popularity to the view that the home and family were the sacred core of Dutch society and culture.[2] Printmakers frequently appended biblical inscriptions; C. J. Visscher appended verses from Psalm 128 referring to familial virtue to his 1609 print of the subject (fig. 1). Steen, following this practice, included an inscription paraphrasing the ideas from Proverbs of a balanced, God-fearing, and devout life. Steen's version of the prayer theme owned by the Duke of Rutland, Belvoir Castle, Grantham, includes a similar inscription.[3] In the Sudeley and Rutland paintings and the version in the John G. Johnson Collection at the Philadelphia Museum of Art, passages from the Lord's Prayer are shown on the *belkroon*.[4] Only the present work, however, adds the *vanitas* inscription "Think on death," a warning made all the more central to the painting's meaning by the inclusion of the adjacent key, no doubt the *clavis interpretandi* (the same motif is in pl. 80).

Although a number of artists had used the prayer theme earlier, Steen probably was inspired by his teacher, Adriaen van Ostade, whose etching of the *Prayer before the Meal* (fig. 2) depicts a humble peasant family at grace. Steen's three-quarter-length, corner-view composition, with the foreshortened window on the

left and the light-colored rear wall, recalls the Delft interiors of Pieter de Hooch and Vermeer. However, Steen's interest in still-life detail (note especially the ham and heavy burlap cloth on the barrel) reminds us that he was living in Warmond, near Leiden, when he executed this work in 1660. In the same year, Steen completed the elegant *Portrait of Bernardina Margriet van Raesfelt*, also known as the *Poultry Yard* (Mauritshuis, The Hague, no. 166), which also seems to reflect his admiration for the minute, refined touch of the Leiden *fijnschilders*.[5]

A copy of the present work of the same dimensions but on canvas transferred from panel was in the Alfred Wallach sale (Paris, April 3, 1962, no. 17, ill.).[6]

P.C.S.

1. "Drie dingen wensch ick en niet meer/ voor al te minnen Godt den heer/ geen overvloet van Ryckdoms schat/ maer wens om tgeen de wyste badt/ Een eerlyck leven op dit dal/ in dese drie bestaet het al" (author's translation).

2. Some of the artists who addressed this theme in both prints and paintings were Hendrik Goltzius, Claes Jansz. Visscher, Jacques de Gheyn, Gerard Dou, Frans van Mieris the Elder, Jan Miense Molenaer, Quirijn van Brekelenkam, Adriaen van Ostade, Nicolaes Maes, Pieter de Hooch, Abraham van Dyck, and Carel van der Pluym. On the tradition of domestic virtue themes in Dutch genre, see Sutton 1980, pp. 45–49; on the theme of the Prayer before the Meal, see O. Naumann, "The Lesson (Reattributed)," in Washington, D.C., Corcoran Gallery of Art, *The William A. Clark Collection* (April 26–July 16, 1978), pp. 66–71; Philadelphia 1983, pp. 29–31; and Durantini 1983, pp. 52–58.

3. Hofstede de Groot 1908–27, vol. 1, no. 374; Braun 1980, no. 174; de Vries 1976a, pl. 46. Inscribed on the small scroll above the mantle: "Salemons/ gebet/ overvloedige/ Rijkdom noch/ Armoede groot/ En wilt my heere/ op deser Aert/ niet gheven." J.B.F. van Gils ("Het Gebed voor dem Maaltijd van Jan Steen," *Oud Holland*, vol. 57 [1940], p. 192) found the full text of this prayer in Johan Rammazeyn, *Die Historie van den ouden Tobias* (Gouda, 1647).

4. The Duke of Rutland's painting is inscribed "Ons dagelyckx Broot" (Our daily bread); the John G. Johnson Collection painting (no. 514; see Philadelphia 1983, pp. 29–31, pl. 7), indistinctly "Pa[ter] Nos[trum]. . . ." Other identified and unidentified versions of the Prayer before the Meal by or attributed to Steen are listed in Philadelphia 1983, p. 31 n. 10.

5. Also dated 1660 are the *Oyster Meal* (cat. no. 103, fig. 1) (Hofstede de Groot 1908–27, vol. 1, nos. 566 and 856; Braun 1980, no. 114) and *Laban Searching for His Idols*, Stedelijk Museum "De Lakenhal," Leiden (Hofstede de Groot 1908–27, vol. 1, nos. 4 and 652a; de Vries 1976a, fig. 26; Braun 1980, no. 347). The date on the latter is no longer legible, but as early as 1852 was deciphered as 1660.

6. 20¾ x 17¼" (53 x 44 cm.). Its provenance was confused with that of the Morrison Collection's original.

Shown in London only

Easy Come, Easy Go, 1661
Inscribed, signed, and dated on mantlepiece:
Soo gewonne Soo verteert 16 JSteen
(JS in ligature) 61
Oil on canvas, 31 x 41" (79 x 104 cm.)
Museum Boymans–van Beuningen, Rotterdam,
no. 2527

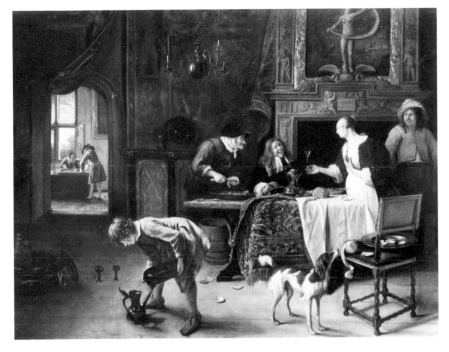

Provenance: Jan Bisschop, Rotterdam; acquired by A. Hope, 1771; T. H. Hope; Lord Francis Pelham Clinton Hope, Deepdene; acquired by the dealers Colnaghi and Wertheimer, 1898; L. Neumann, London; sale, L. Neumann, London, July 4, 1919, no. 17, to dealer Colnaghi, who sold it to D. G. van Beuningen, Vierhouten, Holland; acquired with the D. G. van Beuningen Collection, 1958.

Exhibitions: London, British Institution, 1815; Manchester 1857, no. 936; London, Royal Academy, 1881, no. 104; London, South Kensington Museum, 1891, no. 11; London 1909, no. 24; Paris 1921, no. 102; Leiden 1926, no. 26; London, Royal Academy, 1929, no. 186, ill.; Rotterdam 1935, no. 78, fig. 104; Rotterdam, Museum Boymans, *Meesterwerken uit vier eeuwen* 1400–1800, June 25–October 15, 1938, cat. no. 137, fig. 106; Rotterdam, Museum Boymans, *Honderd jaar Museum Boymans Rotterdam, Meesterwerken uit de verzameling D. G. van Beuningen,* June 8–October 8, 1949, no. 68; Paris, Petit Palais, *Chefs d'oeuvre de la collection D. G. van Beuningen,* 1952, no. 121, fig. 40; Rotterdam, Museum Boymans, *Kunstschatten uit Nederlandse verzamelingen,* July 19–September 25, 1955, no. 120, fig. 127.

Literature: Reynolds 1774, p. 201; Smith 1829–42, vol. 4, no. 148; Westrheene 1856, no. 87; Waagen 1854, vol. 2, p. 118; Hofstede de Groot 1907–28, vol. 1, no. 854; *Beeldende Kunst,* vol. 14 (1926/27), no. 5, p. 5A; Martin 1926, p. 14, ill. pl. 5; Bredius 1927, p. 51, pl. 38; Schmidt-Degener, van Gelder 1927, pp. 41–42, ill.; T. H. Lunsingh Scheurleer, "De Schoorsteenontwerpen van I. Barbet en hun invloed in Nederland," *Oud Holland,* vol. 52 (1935), p. 264, fig. 3 (detail); Martin 1935–36, vol. 2, p. 264, fig. 142; de Jonge 1939, p. 27, ill; de Groot 1952, pp. 113, 121, 139, 141, 155, 159, fig. 15; Martin 1954, pp. 38–39, 79, ill.; Keyszelitz 1959, fig. 1; Rotterdam, Museum Boymans, cat. 1962, no. 2527, ill.; de Vries 1976a, pp. 18–19, pl. 27; Amsterdam 1976, p. 110, fig. 22c; de Vries 1977, pp. 52–53, cat. no. 94; Sutton 1980, p. 30; Braun 1980, no. 143, pl. 38.

FIG. 1. JAN STEEN, *The Oyster Meal,* 1660, oil on canvas, formerly Collection of Earl of Lonsdale, Askham Hall, Penrith.

In an elegantly furnished room, a laughing man with Steen's features sits at a marble-topped table covered with an oriental carpet and a white cloth. On the table are a silver saltcellar, a loaf of bread, platters, and oyster shells. An old woman shucks oysters for the man as a young woman in a fur-lined jacket offers a glass of wine. Another server stands to the right of a richly carved mantlepiece. In the foreground, a boy fills a pitcher with wine from a large cooler at the left. On the right a dog sniffs a partly peeled lemon, which rests on a chair with a platter of oyster shells. Other shells and glasses lie on the floor. At the left rear, a tapestry is drawn back, and an open door reveals two men playing trictrac.

A good example of the richer interiors that Steen began to depict when he moved from Warmond to Haarlem, this painting of 1661 is a variant of a slightly larger painting of the previous year (fig. 1).[1] The various changes in the later painting—the elimination of the armchair at the left, the increased activity of the serving boy, the introduction of an attendant on the right, the more careful observation of the carpet, and the alteration of the view through the doorway—attest to the artist's successful efforts at self-improvement. Steen often repeated themes (for example, *The Doctor's Visit* and *Beware of Luxury*) as well as compositions (such as the *Rhetoricians*), but rarely executed such close variants. Possibly the positive reception or quick sale of the first version dictated the second. The new monumentality of these two works reappears in the so-called "Toast to the Fatherland," Steen's other dated work of 1661.[2] Gabriel Metsu and Pieter de Hooch also adopted a grander and more elegant interior type around 1660, reflecting the increasing refinement of domestic taste in Dutch society generally.

The ex-Lonsdale painting has traditionally been titled *The Oyster Meal,* and oysters figure prominently in both versions. Oysters were considered a delicacy in seventeenth-century Holland; popular belief held that they stimulated the libido. The comments of Jacob Cats and Johan van Beverwijck, perhaps the most widely read medical authority of his day, affirm these aphrodisiacal effects. Beverwijck wrote that oysters "arouse appetites and the desire to eat and to make love, which pleases both lusty and delicate bodies."[3] The old woman, whose features

FIG. 2. Fireplace design by
ABRAHAM BOSSE after I.
Barbet, 1633, engraving.

recall the Dutch saying "Spitze neus en spitze kin, daar zit de duivel in" (Pointed nose and pointed chin, the devil dwells therein), is reminiscent of procuress types (compare pl. 10) while the sultry young woman with the wineglass offers the man what can only be described as a come-hither look. The model for the mustachioed attendant in the Rotterdam painting was assumed by Sir Joshua Reynolds, perhaps correctly, to be Frans van Mieris.[4]

The richly adorned fireplace in both versions is taken from an engraving by Abraham Bosse, after a design that was created by I. Barbet in Paris in 1633 and published in a model book of fireplaces printed in Amsterdam in 1641 (fig. 2).[5] The plaque in the center of the painting is inscribed "Soo gewonne Soo verteert" (Easy come, easy go), the central theme of the painting. The nude figure with a billowing sail of drapery represents Fortuna, or Dame Fortune, whose whimsical changes will soon curtail the extravagant and carefree behavior of the man who sits at the table. De Jongh has compared this detail to Roemer Visscher's emblem titled *Virtus Liberalior,* which depicts Fortuna.[6] In the Rotterdam painting, a gaming die replaces the sphere and death's-head on which Fortuna stands in the ex-Lonsdale version. Fortuna has long been associated with games of chance, such as dice, cards, and backgammon.[7] This probably explains Steen's decision to change the view of a couple descending a staircase for the scene of two trictrac players. To each side of Fortuna and on the mantle are symbols of adversity (a bundle of thorned branches, a weeping putto with a crutch, leg irons, crossed crutches, a beggar's bowl, and a leper's rattle) and prosperity (a cornucopia, a smiling putto with laurel wreath and scepter, a regent's crown, moneybags, and crossed scepters). Even the background seascape juxtaposes good and ill fortune, depicting one vessel safely under sail at the right and another shipwrecked on rocks at the left. Steen's rich symbolism both serves the notion of the vicissitudes of fortune and warns against wastefulness.

<div align="center">P.C.S.</div>

1. 41½ x 53¼" (105.6 x 135.4 cm.); Smith 1829–42, vol. 4, nos. 3, 207, and suppl., no. 5; Westrheene 1856, no. 127; Hofstede de Groot 1907–28, vol. 1, nos. 566a, 856; de Vries 1977, no. 93; Braun 1980, no. 114.

2. Private collection; Smith 1829–42, vol. 4, no. 138 and suppl., no. 29; Westrheene 1856, no. 152; Hofstede de Groot 1907–28, vol. 1, nos. 517 and 559; de Vries 1977, no. 95; Braun 1980, no. 144.

3. ". . . appetijt verwecken, en lust omte eten, en byte slapen, 't welck alle beyde de lustighe en delicate luyden wel aenstaet" (quoted by de Jongh 1971, p. 169 n. 98); Jacob Cats, *Houwelick, Dat is, Het gantsche Beleyt des Echten-Staets* (Amsterdam, 1661), p. 162; Johan van Beverwijck, *Schat der Gesontheydt* (Utrecht, 1651), p. 141; Ripa 1644, p. 467. Ripa related the oyster to the senses of taste and touch, thus prompting Keyszelitz (1959, p. 45) to make the improbable suggestion that the various Senses were depicted in the Rotterdam painting: the dog sniffing the lemon symbolized Smell and the boy pouring the wine, Sight.

4. Among the paintings in the Hope Collection mentioned in *A Journey to Flanders and Holland* (1781): "An Oyster Feast by J. Steen, in which is introduced an excellent figure of old Mieris, standing with his hands behind him" (see Naumann 1981a, p. 129).

5. *Livre d'architecture d'autels et de cheminées de Barbet, architecte.* See T. H. Lunsingh Scheurleer, "De Schoorsteen-ontwerpen van I. Barbet en hun invloed in Nederland," *Oud Holland,* vol. 52 (1935), pp. 261–65.

6. Visscher 1614, p. 177; see de Jongh in Amsterdam 1976, p. 102; "Men [covet] the high arching generosity of good Fortune: but to what avail? Riches, honor and status, these are gone in an hour or less. But Virtue is much more generous; because she provides gifts that never fade, such as: Wisdom, moderation, patience, a contented mind and a happy disposition" (author's translation). On Steen's depiction of Fortuna, see Keyszelitz 1959, pp. 40–42; on the iconography of Fortune generally, see also T. de Bry, *Emblemata nobilitatis* (Frankfurt, 1593), p. 5; A. Doren, "Fortuna im Mittelalter und in der Renaissance," *Vorträge der Bibliothek Warburg,* vol. 1 (1922–23), pp. 77–144; W. Patch, *The Goddess Fortuna in Medieval Literature* (1927); I. Wyss, *Virtù und Fortuna bei Boiardo und Ariost* (Leipzig and Berlin, 1931); R. Wittkower, "Chance, Time and Virtue," *Journal of the Warburg and Courtauld Institutes,* vol. 1 (1937–38), pp. 313–21; and J. A. Mazzeo, *Renaissance and Seventeenth Century Studies* (New York, 1964), pp. 91–96.

7. See Keyszelitz 1959, pp. 42–44; and Amsterdam 1976, pp. 110–11.

Beware of Luxury, 1663
Signed and dated lower left on barrel: JS16[63?]
Inscribed lower right on the slate: In weelde Siet
Toe; and below: 000001 Soma op.
Oil on canvas, 41⅜ x 57″ (105 x 145 cm.)
Kunsthistorisches Museum, Gemäldegalerie,
Vienna, inv. no. 791

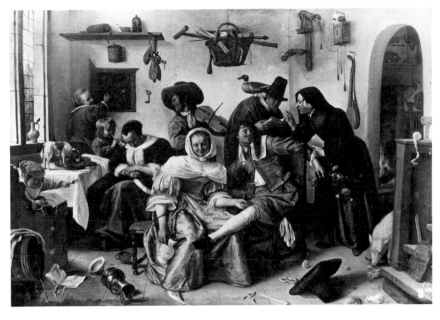

Provenance: Sale, Bertels, Brussels, 1779, no. 40 (610
guilders); Duke of Lorraine (died July 4, 1780), Brussels, inv.
1783, no. 27; entered Imperial Collection, Vienna, 1783.

Exhibitions: Rijksmuseum, Amsterdam, *Kunstschatten uit
Weenen*, 1947, no. 153; Zurich, *Holländer des 17. Jahrhunderts*, 1953, no. 150; Vienna, Kunsthistorisches Museum,
Österreich Amerika–Ausstellung, 1953; The Hague 1958–
59, no. 28, ill.

Literature: Smith 1829–42, vol. 4, no. 35; Westrheene 1856,
nos. 162 and 347; Waagen 1862, pt. 2, p. 132; Hofstede de
Groot 1908–27, vol. 1, no. 102; Martin 1935–36, vol. 2, p.
264; de Jonge 1939, pp. 38–40; de Groot 1952, pp. 62–66,
90–93, 110, 155, 159; Martin 1954, p. 48; Vienna,
Kunsthistorisches Museum, cat. 1972, p. 88, pl. 67; de Vries
1976a, pp. 9, 18, pl. 34; de Vries 1977, pp. 53, 55, 57, 58,
no. 98; Braun 1980, p. 45, no. 179, ill.; Durantini 1983, p.
61, fig. 35.

The slate in the lower right is inscribed with the
proverb "In weelde Siet Toe" (Beware of luxury); below is a reckoning and the words "Soma
op." The laconic saying "sums up" the picture,
which like the Wellington Museum's painting
(pl. 85), depicts the Dissolute Household theme.

The composition is crowded with various
instances of intemperance, which, in the
Bruegelian tradition, allude to common proverbs
or aphorisms.[1] An amorous couple, sitting in the
center, drink wine and embrace intimately.[2] The
man's pose—his leg over the woman's—is a traditional symbol of sexual intercourse and may
allude to the saying: "Het zijn sterke benen, die
de weelde kunnen dragen" (Strong legs are
needed to carry luxury).[3] An old woman at the
right, possibly a *hopje* or *begijntje* (nun), remonstrates by shaking her finger at the couple,

FIG. 1. JAN STEEN, *As the
Old Ones Sing, So the
Young Ones Pipe*, oil on
canvas, Mauritshuis, The
Hague, no. 742.

while a somberly dressed man, identified by
some as a Quaker (note the duck, literally a
"quacker," on his shoulder) expostulates from a
book.[4] At the lower left, the contents of an overturned pewter pitcher and a keg of wine spill
onto the floor. The sleeping woman is probably
the neglectful mistress of the house; "Die slapen
gaat, niet weet hoe hij ontwaken zal" (He who
goes to sleep doesn't know how he will wake
up). Before her a small dog has jumped onto the
table to gobble a meat pie and a young child
drags on a clay pipe.[5] The latter may be a play
on the word *pijp* (pipe), as in the saying that
Steen illustrated frequently: "As the old ones
sing, so the young ones pipe" (see fig. 1).
Toward the rear in *Beware of Luxury*, a boy
violinist plays a tune as a young girl steals a coin
from a wall cupboard filled with valuables—
"De gelegenheid maakt de dief" (Opportunity
makes a thief). Coins and other valuables are
spread before the baby in the high chair; the
infant holds a silver spoon and a chain with a
medallion, possibly a christening medal. The
child's bowl has fallen and broken on the floor
beside an important-looking document with a
seal. Through the door on the right one glimpses
the kitchen, where an unattended roast has
fallen into the fire. In the lower right, a pig with
the spout from the open keg in its mouth (no
doubt referring to the saying "Hier trekt de zeug
den tap uit"[6]) sniffs at roses, which have fallen
from a branch held by the lover; here the
proverb surely is "Strooit geen rozen voor de
varkens," literally "Don't spread roses before
pigs," or in English, "pearls before swine." The
hat on the floor in front of the doorway could
allude to the untranslatable saying, "Hij gooit
zijn hoed maar voor de deur," another expression of carelessness and intemperance. The cards
nearby, the wine pitcher, and the ostentatiously
clad girl (possibly the family's eldest daughter
or, if one assumes that the man is the father, a
prostitute[7]) recall the expression "Kaart, keurs
en kan, bederven menig man" (Cards, women
[literally "bodices"], and drink have ruined
many a man). Beside the cittern hanging on the
wall at the right, a monkey—traditional symbol
of foolishness, shamelessness, and sensuality[8]—
has climbed up to stop the clock; here several
sayings may apply: "In dwaasheid wordt de tijd
vergeten" (In foolishness time is forgotten), "Het

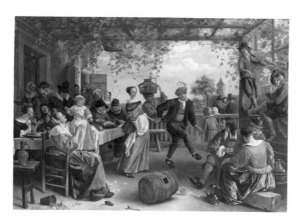

FIG. 2. JAN STEEN, *The Dancing Couple*, 1663, oil on canvas, Widener Collection, National Gallery of Art, Washington, D.C., no. 677.

leven is geen apenspel" (Life is no ape's game), and "Als apen hooge klimmen willen,/ Dan siet men straex haar kale billen" (When apes would climb high, one presently sees their bare bottoms).[9]

Although the saying on the slate best sums up the scene, the key on the wall beside the strong-box is probably the *clavis interpretandi* because it hangs directly below empty moneybags. Yet another common expression, "Jonge luiaard, oude bedelaars" (Young idlers, old beggars), explains the contents of the basket hung from the ceiling. For the scene's dissolute youth these are the attributes of old age's dissipation and ruin— a bottle, cards, *zwavelstokjes* (the predecessors of matches) to sell or to light pipes, the twin symbols of violence and punishment (the sword and the switch), a so-called *Lazarusklep* or noisemaker (hanging inconspicuously but ominously on the left) carried by beggars with contagious diseases, and a beggar's crutch.[10] "Waar weelde en hoogmoed vooruit gaan, omt schande en schade achteraan" (Where luxury and pride prevail, shame and destruction follow).

The date on the picture is indistinct, but as early as 1862 it was deciphered as 1663,[11] the same year as *A Woman at Her Toilet* (Her Majesty Queen Elizabeth II) and *The Dancing Couple* in the National Gallery, Washington, D.C. (fig. 2). The latter work is particularly close in style and execution. The Vienna painting's interior and light-colored walls, much brighter in overall tonality than the Apsley House version (pl. 85), reflect Steen's contacts with Delft in the mid-1650s. However, the large scale, the animation of the figures, and the colorful palette indicate Haarlem influences—Frans Hals and perhaps Jan Miense Molenaer.

P.C.S.

1. De Groot 1952, pp. 63–66, 90–93.

2. De Groot 1952, p. 64, cites Cats: "Sie sit en lolt, of sit en vrijt; verlet syn werk, vergeet syn sijt" (roughly, Those who sit and loll about or sit and make love neglect their work, and waste their time).

3. On this gesture, see L. Steinberg, "Michelangelo's Florentine *Pietà: The Missing Leg*," *The Art Bulletin*, vol. 50, no. 4 (December 1970), pp. 343–53.

4. See de Jonge 1939, p. 40; de Groot 1952, pp. 90–91. The word duck (*eend*) appeared in sixteenth- and seventeenth-century expressions playing on the word *einde*, as in "end of one's understanding" and "wit's end"; thus it was a symbol of foolishness and stupidity. In the present context, de Groot (1952, p. 91 n. 19) also thought it might allude to the saying "Het zijn mooie woorden: maar de eenden leggen de eieren" (literally, They are pretty words, but the ducks lay the eggs), again a play on the word "end," meaning the end results are what count.

5. See de Groot 1952, pp. 91–92. In addition to its traditional identification with fidelity, the dog also had negative associations as an attribute of envy and impurity. Dogs eating from the neglected pot appear frequently in genre scenes by Steen and his contemporaries, often alluding to the idea expressed by Cats in the saying "Een open pot, een open beurs,/ Een open deur, een open keurs,/ Een open mont, een open kist,/ Daer wordt gemeenlick yet gemist" (An open pot, an open purse,/ An open door, an open bodice,/ An open mouth, an open case,/ There commonly something is lost).

6. See Harrebomée 1856–70, vol. 2, p. 499. This untranslatable expression and the next are illustrated in Frans Hogenberg's *The Blue Cloak*, a print of 1558 illustrating forty different Flemish proverbs; illustrated in W. Gibson, *Bruegel* (New York and Toronto, 1977), fig. 43.

7. De Groot 1952, p. 65: "Die den eenen voet in't hoerhuys set,/ Set den anderen in't gasthuys" (He who sets one foot in the whorehouse, sets the other in the hospital).

8. See H. W. Janson, *Apes and Ape Lore in the Middle Ages and the Renaissance* (London, 1952); and de Jongh et al. in Amsterdam 1976, under cat. nos. 27, 43, and 55.

9. Jacob Cats, *Spiegel van den ouden en nieuwen tijdt*, in *Alle de wercken* (Amsterdam, 1665), p. 556.

10. De Groot 1952, p. 65: "Hij loopt op een draf naar de bedelstaf" (He runs at a trot after a beggar's crutch).

11. Waagen 1862, pt. 2, p. 132.

Shown in Berlin only

The Doctor's Visit, 1663–65
Signed lower right: JSteen (JS in ligature)
Oil on panel, 18⅛ x 14½″ (46 x 36.8 cm.)
John G. Johnson Collection at the Philadelphia
Museum of Art, no. 510

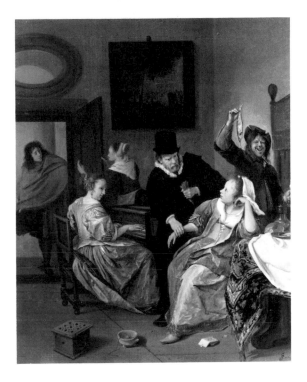

Provenance: Sale, Jean Hendrik van Heemskerk; The Hague, March 29–30, 1770, no. 109, to C. van Heemskerk (314 guilders); sale, Cornelis van Heemskerk, The Hague, November 16, 1783, no. 2, to Wubbels for Baron Nagel (500 guilders); sale, Baron von Nagel, Christie's, London, March 21, 1795; sale, Crawford, Christie's, London, April 26, 1806, no. 13, to Lord Kinnaird (63 pounds sterling); sale, Albert Levy, Christie's, London, April 6, 1876, no. 370 (204 pounds sterling); Jean Louis Miéville, London, by 1878; sale, J. L. Miéville, Christie's, London, April 29, 1899, no. 83, to dealer Agnew & Sons (789 pounds sterling); purchased by John G. Johnson from Agnew's, London, May 1899.

Exhibitions: London, Royal Academy, 1878, no. 133 (lent by J. L. Miéville); New York World's Fair, *Masterpieces of Art,* 1938, no. 358; Philadelphia 1983, no. 5, ill.

Literature: Smith 1829–42, vol. 4, no. 76; Westrheene 1856, no. 362; Hofstede de Groot 1908–27, vol. 1, pp. 164, 172, ill.; Philadelphia, Johnson, cat. 1913, vol. 2, p. 101, ill.; E. Trautscholdt in Thieme, Becker 1907–50, vol. 31 (1937), p. 511; Philadelphia, Johnson, cat. 1941, p. 28; Philadelphia, Johnson, cat. 1972, p. 81, ill; de Groot 1952, p. 116; Bedaux 1975, pp. 31–35, fig. 18; de Vries 1976a, p. 16, pl. 44; de Vries 1977, pp. 58–59, 67, 99–100, 131 n. 110, p. 148 n. 138, no. 123; Braun 1980, no. 315, ill.

Although the painting was correctly identified when sold in 1770, 1783, and 1876, and when exhibited in 1878, it carried the anecdotal title "The Unexpected Return" in the Crawford sale of 1806 and was interpreted as "the jealousy and indifference of the husband and wife." The subject, as late as the Miéville sale of 1899, was thought to represent a husband discovering his wife's infidelity. Hofstede de Groot was the first author to restore the correct title.

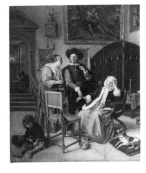

FIG. 1. JAN STEEN, *The Doctor's Visit,* oil on panel, Wellington Museum (Apsley House), London, no. 89.

The doctor's visit, one of Steen's favorite and most influential themes, was the subject of at least eighteen of his paintings. The patient is always a young woman who evidently suffers from lovesickness, erotic melancholy, or pregnancy. Several of these scenes are actually inscribed with variations on the expression "Daer baet geen medesijn, want het is minne-pijn" (No doctor needed there, since it is the pain of love).[1] A lost painting was more explicit: "Als ik my niet verzind/ Is deze Meid met kind" (Unless I am mistaken, this girl is with child).[2] Various accessories in Steen's doctor scenes allude to love and pregnancy. In some paintings, beds, billets-doux, a sculpture of Cupid, and a painting within the painting refer to romantic or erotic love.[3] On the back wall of *The Doctor's Visit* in the Wellington Museum (fig. 1), for example, is a painting of Venus and Adonis.[4] While the painting within the painting from the Johnson Collection is only a landscape, other details of the scene support the assumption that the girl is suffering from *la maladie d'amour*.

The piece of ribbon, which smolders in the brazier, was a quack technique for determining pregnancy;[5] this method also appears in other versions of the doctor theme. Another presumed symptom of lovesickness was the quickening of the patient's pulse in the presence of his or her lover. In all likelihood, the painting illustrates this phenomenon because the doctor taking the girl's pulse is obviously startled;[6] her sudden reaction is to the young man who beckons from the doorway at the left.

Lovesickness, known to seventeenth-century Dutchmen as *soetepijn, minne-pijn,* or *minne-koorts,* was related in the pathology of the period to the Four Humors and, in turn, to the Four Temperaments. Repressed or unsatisfied love was believed to cause melancholy.[7] Figures symbolizing Melancholia traditionally pose with their head leaning on their hand, the attitude of the patient in the Philadelphia painting (and in fig. 1). The music played by the woman at the clavichord could be a remedy for melancholy.[8] Wine, considered a cure for lovesickness since Ovid's time, was another remedy.[9] In a version that is a partial copy of the Philadelphia painting, the doctor and his patient are included; however, an old woman bringing a large roemer of wine replaces the other figures.[10]

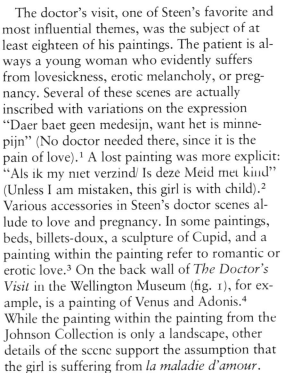

Steen's contemporaries would have recognized that the physician in this and other doctor scenes wears old-fashioned dress. His costume, unlike those of the other figures, is a hodge-podge of sixteenth- and early seventeenth-century fashion. As several writers have observed, the doctor's attire and ludicrously pompous manner typify doctor types found on the stage, above all the commedia dell'arte.[11] The link between Dutch and Italian doctor types was cemented by the French theater, where Molière developed the doctor figure most fully.[12] On the Dutch stage the satirical doctor made his entrance early in plays by Samuel Coster (a doctor himself), P. C. Hooft, and others. None of Steen's doctor scenes is based on a scene from an actual play; instead, it was the general comic types that attracted him.[13] The medical buffoon, with his antiquated attire, is a curiously detached figure out of the past—a pedantic man whose foolish pride in his own learning incapacitates him for life. On the stage, as in Steen's paintings, love ultimately befuddles the doctor.

The laughing young man with Jan Steen's features at the right also has theatrical associations. His mugging for the viewer and elements of his costume, such as the slashed beret, recall the fool of rhetoricians' societies (see pl. 82).[14] He holds a herring, the attribute of Shrovetide merriment and revelers, hence a symbol of folly, unchastity, and licentiousness. The herring, along with the two onions in his other hand, is an obvious phallic symbol.[15] Furthermore, the herring may allude to telling people the plain, unsalted truth, in this case the revelation of the girl's pregnancy. The Dutch expression "Iemand een bokking geven" (to give someone a red herring) meant to rebuke someone, to confront a person with his or her shortcomings for the purpose of self-improvement—the traditional role of the fool.[16]

A mature work from the early to mid-1660s, this finely executed picture attests to Steen's debt to the Leiden *fijnschilders,* but the strength of characterization is uniquely his own.[17]

P.C.S.

1. See Alte Pinakothek, Munich, inv. no. 158 (Hofstede de Groot 1908–27, vol. 1, no. 138; Braun 1980, p. 154); Stichting Willem van der Vorm, Boymans Museum, Rotterdam (Hofstede de Groot 1908–27, vol. 1, no. 136; Braun 241); Staatliches Museum, Schwerin, inv. no. 2478 (Hofstede de Groot 1908–27, vol. 1, no. 141; Braun 1980, no. 155); Taft Museum, Cincinnati, acc. no. 1931.396.57. On the saying's sources, see Bedaux 1975, p. 28 n. 20.

2. Sale, Kien van Citters, Amsterdam, August 21, 1798, no. 73; see Hofstede de Groot 1907–28, vol. 1, no. 146.

3. A statue of Cupid appears, for example, in the doctor scenes in Munich (see note 1), the Metropolitan Museum of Art, New York (acc. no. 46.13.2) and one of the Mauritshuis's two versions of the theme (The Hague, no. 167) (see note 4).

4. 18¾ x 16⅛" (47.5 x 41 cm.). The Taft Museum's painting has a painting of a pair of unidentified lovers. The Mauritshuis's other *Doctor's Visit* (no. 168) includes a painting of the *Abduction of Hippodamia by the Centaur with a Horse Trainer,* which Bedaux (1975, pp. 40–42) interprets as a commentary on unbridled passion and its control; see also Amsterdam 1976, no. 63. In *The Lovesick Maiden* in the Metropolitan Museum of Art, New York (no. 46.13.2), two copulating dogs appear in the background, a motif once overpainted by a censorious restorer.

5. See van Gils 1920, pp. 200–201; van Gils 1921, pp. 2561–63. The *schorteband* (ribbon) was taken from the lady's garment and the diagnosis was made from the smell that resulted when it was burned; in support of this interpretation, van Gils (1920, p. 201) cites Jacob Campo Weyerman, *Oog in 't zeil* (1780), p. 199.

6. See Bedaux 1975, pp. 31–35. In a short commentary on the phenomenon, called "Polstastinge der Liefde" (Taking the pulse of love), Jacob Cats (*Alle de wercken, Proefsteen van den Trou-Ringh* [Amsterdam, 1665], vol. 3, pp. 46–63) noted that the belief has classical sources in the story of Antiochus and Stratonice, a theme depicted by Steen (formerly in the Wetzlar Collection, Amsterdam [Hofstede de Groot 1908–27, vol. 1, no. 54 and 84b; Braun 1980, no. 302]). For van Beverwijck's comments on lovesickness, see cat. no. 98.

7. See Bedaux (1975, pp. 27–29), who cites the following source material: J. Ferand, *De la maladie d'amour ou melancholie erotique* (Paris, 1623); van Beverwijck 1651, pp. 121–34; Ripa 1644, pp. 494–97; and R. Burton, *The Anatomy of Melancholy* (London, 1972). For discussion, see also L. Babb, *The Elizabethan Malady: A Study of Melancholia in English Literature from 1580–1642* (Ann Arbor, 1951); R. Klibansky and E. Panofsky, *Saturn and Melancholy* (London, 1964); and J. Starobinski, *Histoire du traitement de la mélancholie des origines à 1900* (Basel, 1960).

8. See Bedaux 1975, p. 31, no. 25. Bedaux notes, however, that the therapeutic effects of music were under dispute; van Beverwijck, for example, is contradictory on music's healing properties. See also Fischer 1975, pp. 31–36, "The Good and the Evil Music." A common inscription on seventeenth-century clavichords and one that appears on the instrument in Steen's *Family Portrait* in the Nelson Gallery of Art, Atkins Museum of Fine Arts, Kansas City (inv. no. 67–8), was "Musica Pellit Curas" (Music drives away care).

9. See Bedaux 1975, p. 35 n. 29.

10. Oil on panel, 12½ x 9⅞" (32 x 25 cm.), sale, Charles Loeser et al. (R. Dooyes Collection), Sotheby's, London, December 9, 1959, no. 44, ill.; compare Hofstede de Groot 1908–27, vol. 1, no. 143, and Braun 1980, no. B26.

Rhetoricians at a Window, 1662–66
Inscribed on shield beneath the window: IVGHT NEMT IN; and on the paper held by the man on the left: LOF LIET
Oil on canvas, 29⅛ x 23¼″ (74 x 59 cm.)
John G. Johnson Collection at the Philadelphia Museum of Art, no. 512

11. Meige 1899, pp. 57–68, 227–60, 340–52, 420–32; Meige 1900, pp. 187–90, 217–61; van Gils 1917, pp. 107–10; van Gils 1935, pp. 130 ff.; van Gils 1937, pp. 92 ff.; van Gils 1942, pp. 57 ff.; Gudlaugsson, pp. 8–23. See also de Groot 1952, pp. 51–56, 121 ff.; de Vries 1977, pp. 98–101. On the commedia dell'arte, see Smith 1964.

12. See van Gils 1917, p. 41; Gudlaugsson 1975, p. 18; de Groot 1952, pp. 53 ff. The doctor's role was codified by such Molière plays as *L'Amour médecin*, *Le Malade imaginaire*, and *Le Médicin malgré lui*.

13. Gudlaugsson 1975, p. 66.

14. A similar character appeared in a doctor painting by Steen, which was lost; see Hofstede de Groot 1908–27, vol. 1, no. 147, and Westrheene 1856, no. 258.

15. The same objects are borne by the ludicrous suitor in the painting in the Musée Royaux des Beaux Arts, Brussels, cat. no. 444; Hofstede de Groot 1908–27, vol. 1, no. 385; Braun 1980, no. 224.

16. On the herring, see Bax 1979, pp. 218–19. As the symbol of folly, the fish was the namesake of the comic character Peeckelhaering whose portrait by Frans Hals of 1628–30 (now in the Hessisches Landesmuseum, Kassel, cat. 1958, no. 216) appears at the right in fig. 1. See also van Thiel 1961, pp. 153–70.

17. Braun's (1980) dating of 1668–70 is probably too late; de Vries (1977) suggests, more credibly, 1663–65.

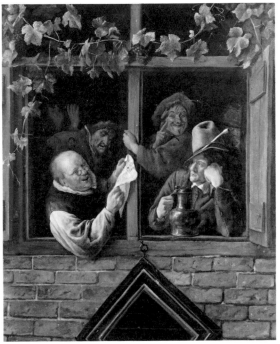

Provenance: Probably sale, Christie's, London, 1827 (110 pounds sterling);[1] sale, Mrs. Skeffington Smyth of Godalming, London, March 3, 1906, no. 82, to Coureau (892 pounds sterling); with dealer Kleinberger, Paris, 1906; owned by John G. Johnson in 1907, probably acquired from Kleinberger.

Exhibitions: Leiden 1906; Baltimore, Walters Art Gallery, 1951; Philadelphia 1983, no. 6, pl. 6 (as c. 1661–66).

Literature: Probably Smith 1829–42, vol. 4, no. 156; probably Westrheene 1856, no. 299; Hofstede de Groot 1908–27, vol. 1, no. 694; Grant 1908, p. 144; Philadelphia, Johnson, cat. 1913, p. 102, no. 512, ill.; Antal 1925, p. 113; Bredius 1927, p. 75, pl. 92; E. Trautscholdt in Thieme, Becker 1907–50, vol. 31 (1937), p. 513; Heppner 1939–40, p. 29; Philadelphia, Johnson, cat. 1941, p. 38; Martin 1954, p. 83, fig. 78; Philadelphia, Johnson, cat. 1972, pp. 81–82, no. 512, ill.; Braun 1980, no. 217 (as 1664–66).

Six men are seen in a mullioned window festooned with vines. On the left a spectacled man, who wears the sleeveless doublet with full blouse and short ruff of the declamator (orator) of the rhetoricians' chambers *(rederijkerskamers)*, reads from a sheet headed LOF LIET (Song of praise). The sober-faced man who wears a fur cap and looks over his shoulder may be the *factor*, or poet. On the right a skeptical-looking young man in a tall gray hat with a clay pipe stuck in the band leans on the sill; his left hand supports his head, and his right hand holds a large metal tankard. He is perhaps the *momus*, or critic, and the foolishly grinning fellow in a red beret and cock's feather behind him is certainly the *sot*, or jester. The latter has Jan Steen's own features. Two additional figures appear in

FIG. 1. JAN STEEN, *Rhetoricians at a Window*, oil on panel, Worcester Art Museum, Worcester, Massachusetts, no. 1954.22.

the shadowy background. The one on the left empties a glass of wine, in a gesture recalling the derogatory rhyme *rederijker–kannekijker* (rhetorician–can-looker or drunkard). On the right a man in a tall hat strikes a sour expression. A blazon, or diamond-shaped shield, which bears a wineglass and two crossed clay pipes, hangs on the brick wall beneath the shuttered window. The inscription, nearly obscured by abrasion, reads: IVGHT NEMT IN (Youth is attractive).

The painting, which is neither signed nor dated, has always been accepted as a work by Steen. The subject was first correctly identified by Hofstede de Groot.[2] Rhetoricians' chambers were first established in the sixteenth century; these amateur literary societies offered dramatic readings, performances, and literary competitions to the public.[3] For the most part, their members were from trade guilds: the *rederijkers* were local carpenters, joiners, tailors, and other craftsmen. Jan Steen is not known to have been a rhetorician; however, a surprising number of active or associate members of the Haarlem guild, whose motto was "Liefde boven al" (Love above all), were artists: Frans Hals (1616–25), Dirck Hals (1618–24), Esaias van de Velde (1617–18), Adriaen Brouwer (as "Arien Brower," in 1626), and Job Berckheyde (1665–72).[4] Artists may have made a literary contribution and certainly served to paint scenery, properties, and the blazon decorated with the guild's emblem and motto. A painting in the Worcester Art Museum (fig. 1) is closely related in subject and design to the Philadelphia painting. In the former, the blazon includes an emblem of a flowering plant in a pot and the motto "In liefde bloeinde" (Flourishing in love), which was the coat of arms of the Amsterdam guild known as De Egelantier.[5] The blazon in the painting from the Johnson Collection was first identified by Heppner as that of "De groene laurierspruit" (The green laurel shoot), the rhetoricians' group in The Hague.[6]

The emblem's crossed pipes and wineglass, as well as the members' drinking, remind us that the function of *rederijker* groups was as much social as literary. Furthermore, the motto "Iught nemt in" may be a pun on the verb *innemen*, meaning not only to be attractive but also to take in, in the sense of swallowing food or drink

(especially alcohol) in abundance. The heavily fruited vine above the window probably alludes to the members' love of the grape. A far more boisterous gathering of rhetoricians is depicted in Steen's painting in Brussels (fig. 2); the members' drinking is emphasized not only by their rowdy merrymaking and the cup and pitcher hung at the window, but also by the quatrain attached to a wreath of flowers overhead: "They rhyme only about dry subjects/ These poets of Bacchus/ They have already drunk a barrel of bost [cheap beer]/ Now they also would eat."[7] A similar broadly satirical view of rhetoricians emerged in later seventeenth-century Dutch comedies and farces, where members are portrayed as coarse and uncivilized, often from villages and the lower classes.[8] There probably was an element of truth in this view. *Rederijkerskamers*, particularly in the Southern Netherlands, contributed significantly to the growth of Dutch literature in the sixteenth and early seventeenth centuries; members who were first-rank poets included Hendrick Laurensz. Spieghel (1549–1614), Roemer Visscher (1547–1620), Jacob Duym (early seventeenth century), and in the following generation, Cornelis Pietersz. Hooft (1546–1626), Gerbrand Adriaensz. Bredero (1585–1618), Samuel Coster (1579–1665), and Joost van den Vondel (1587–1679). However, no truly distinguished later seventeenth-century authors were rhetoricians, and no important literature was produced for the *rederijkerskamers*. The tradition survived into the eighteenth century, but for the most part in the hinterland.

The four main characters in this work represent the Four Temperaments according to one theory.[9] A copy of the work was titled *The Five Senses*.[10] However, the figures, as in the related pictures in Worcester, Brussels, and Munich,[11] are probably officeholders in the *rederijkerskamers*. Although the autobiographical nature of Steen's art has often been overemphasized, that he took the important role of the sot not only in

FIG. 2. JAN STEEN, *The Rhetoricians,* oil on canvas, Musées Royaux des Beaux-Arts de Belgique, Brussels, cat. no. 445.

his *rederijkers* painting but also in other genre scenes (for example, *The Doctor's Visit,* pl. 81) was certainly no accident. Steen's uncle performed as the sot Piero for the Leiden group known as De Witte Accolijnen;[12] however, Steen's attraction to the jester's role probably stemmed from his love of exposing and humorously castigating human failing.

Steen's window compositions with half-timbered walls may represent the upper part of small buildings constructed expressly for rhetoricians; these structures, often near town gates, were erected on high pilings (the area beneath, presumably serving as a stage).[13] A fuller view of these buildings is seen in other paintings by Steen.[14] It is also possible that the window is simply part of a tavern, which is clearly the case in the Brussels painting.

P.C.S.

1. See Smith 1829–42, vol. 1, no. 156, and Westrheene 1856, no. 299.

2. Hofstede de Groot 1908–27, vol. 1, no. 694.

3. The pioneering study of the rhetoricians is Schotel 1862–64. See also P. van Duyse, *De rederijkerskamers in Nederland,* 2 vols. (Ghent, 1900–1902); J. A. Worp, *Geschiedenis van den Amsterdamschen Schouwburg* (Amsterdam, 1920); Ellerbroeck-Fortuin 1937; J. J. Mak, *De Rederijkers* (Amsterdam, 1944); G. J. Steenbergen, *Het landjuweel van de rederijkers* (Leuven, 1950); W.M.H. Hummelen, *De sinnekens in het rederijkersdrama* (Groningen, 1958); H. Pleij, "De sociale funktie van humor en trivialiteit op het rederijkersspelen," *Spektator,* vol. 5 (1975–76), pp. 108–27. On Jan Steen and the rhetoricians, see van Gils 1937, pp. 92–93; Heppner 1939–40, pp. 22–48; and Gudlaugsson 1945.

4. Heppner 1939–40, p. 23. In 1588 the printer Harmen Jansz. Muller observed that among the members of the Amsterdam rhetoricians guild De Egelantier there were "veel schilders ende veel cloecke ende constige Gheesten so wel in Rhetorica als in schilderijen" (many painters and many worthy and witty souls as able in matters of rhetoric as in painting), quoted by Ellerbroeck-Fortuin 1937, p. 31.

5. See Heppner 1939–40, pp. 28–29; Hofstede de Groot 1908–27, vol. 1, no. 234; Braun 1980, no. 103; Worcester, Worcester Art Museum, cat. 1974, vol. 1, pp. 139–42, vol. 2, p. 564. Compare also the *Rhetoricians at a Window,* Bayerische Staatsgemäldesammlungen, Munich, inv. no. 5277.

6. Heppner 1939–40, p. 29.

7. Musées Royaux des Beaux Arts, no. 445 (Hofstede de Groot 1908–27, vol. 1, no. 233; Heppner 1939–40, pp. 25–27; Braun 1980, no. 227). In another painting of a *Merry Company in a Tavern Courtyard with Rederijkers* (sale, Camberlyn d'Amougies et al. [Mandl], F. Muller & Co., Amsterdam, July 13, 1926, no. 656; Hofstede de Groot 1908–27, vol. 4, no. 536; de Vries 1977, no. 71; Braun 1980, no. 275; Philadelphia 1983, p. 27, fig. 25), we read the inscription "When one has right merrily drunk and eaten heartily, one scarcely will forget friendly pipes"—probably a play on the word "pypen," meaning to smoke a pipe or to sing (author's translation).

8. See, for example, the anonymous theater piece titled *Klucht van Jean de la Roy, of D'ingebeelde Rijke* (Amsterdam, 1665), discussed in Philadelphia 1983, p. 28 n. 12.

9. Antal 1925, p. 118.

10. Oil on canvas, 24 x 22⅞" (61 x 58 cm.), sale, Comte Cavens, Le Foy, Brussels, May 23–24, 1922, no. 141, ill. (see Hofstede de Groot 1908–27, vol. 1, no. 524); probably identical with the painting in the K. Bosman Collection, Berg en Dal, 1967 (Rijksbureau voor Kunsthistorische Documentatie, The Hague, neg. no. 28353). Other copies are listed in Philadelphia 1983, p. 28 n. 14.

11. Figs. 1 and 2; and oil on canvas, 27⅜ x 24⁷/₁₆" (69 x 63 cm.), Bayerische Staatsgemäldesammlungen, Munich, inv. no. 5277.

12. See Bredius 1927, pp. 78, 82. Pieter Cornelisz. van der Morsch was depicted in this role by Frans Hals (Carnegie Institute, Pittsburgh).

13. Heppner 1939–40, p. 32.

14. See, for example, the painting from the Mandl sale mentioned in note 7, and the *Fair at Oegstgeest,* Institute of Arts, Detroit, acc. no. 39.673 (Hofstede de Groot 1908–27, vol. 1, no. 644; Braun 1980, no. 74).

The Schoolmaster, c. 1663–65
Oil on canvas, 42⅞ x 31⅞" (109 x 81 cm.)
National Gallery of Ireland, Dublin

Provenance: Probably sale, I. Hoogenbergh, Amsterdam, April 10, 1743, no. 42, and sale, W. Lormier, The Hague, July 4, 1763, no. 245;[1] sale, H. Philips, London, 1815; sale, G. T. Cholmondeley, London, 1831, purchased by Squibb; purchased by the National Gallery of Ireland from Colnaghi's, London, 1879.

Exhibitions: London, British Institution, 1818; London, Royal Academy, 1883, no. 249; London, Royal Academy, 1929, no. 241; London, Royal Academy, 1952–53, no. 573; The Hague 1958–59, no. 31, ill.

Literature: Hoet 1752, vol. 2, p. 438; Smith 1829–42, vol. 4, no. 21; Westrheene 1856, no. 240; Hofstede de Groot 1908–27, vol. 1, no. 285; Bredius 1927, p. 23; Martin 1954, p. 61; de Vries 1977, pp. 57, 58, cat. no. 116; Braun 1980, no. 198, ill.; Dublin, National Gallery, cat. 1981, no. 226, ill.; Durantini 1983, pp. 120, 158–60, fig. 58.

The aged schoolmaster sits in a heavy armchair, his right profile in full view. A weeping boy reluctantly holds out his hand to receive a stroke from the master's ferule; the student's crumpled lesson lies in the foreground. A girl standing beside the teacher's table laughs at the boy's punishment, but a small boy beside her watches with concern. Two children holding their lessons approach the teacher's desk; others work on slates and paper in the background. Shears, a ceramic vessel, and an hourglass hang from the left rear wall, which has a bookshelf and a niche containing bottles.

By the pitiable standards of the day, literacy was relatively high in the Netherlands, but the quality of elementary education varied greatly depending on the schoolmaster, whose position was neither well paid nor prestigious.[2] Valcooch, who taught at Barsigherhorn and wrote a handbook in 1591 for village schoolmasters, complained bitterly about the low wages and the lack of thought given to the selection of teachers.[3] Insufficient pay forced many schoolmasters to take supplemental jobs. In some cases, teaching jobs were awarded as social service positions, mere sinecures for those unable to do other work.[4] In 1620 the communities of Schore and Vlake complained of a teacher who, despite a decade at his post, was virtually illiterate, knew nothing about mathematics, and apparently had no inclination to teach.[5] Some improvements were made by mid-century; an edict of 1655 required all teaching candidates to be able to read, write, perform four basic calculations, and know the tunes of hymns.[6] The Reformed Church had decreed that the schoolmaster's duty was primarily religious and not scholastic; teachers took an oath of allegiance to the church (to eliminate Catholics or forbidden books) and were required to teach the catechism.[7] Despite these requirements, complaints of teachers corrupting the young were perennial. Schoolmasters were accused of everything from failing to offer religious instruction to fighting, visiting brothels, and opening a tavern for their pupils;[8] drinking, however, was the most frequent complaint. In fairness, the life of a pedagogue in the seventeenth-century Netherlands was often ungratifying because of low pay, sporadic student attendance (particularly in rural areas), narrow curriculum, long hours (in the summer, 6:00 A.M. to 7:00 P.M.), short vacations, and unbearably noisy classrooms resulting from oral recitation.[9]

The physical punishment depicted in Steen's painting in Dublin is neither excessive nor brutal by seventeenth-century standards. Use of the rod or ferule to discipline students—like the humiliating "donkey board" sometimes strung around the offending child's neck—was an accepted educational practice.[10] Valcooch, who recommended their use, advised only that a teacher not strike in anger.[11] Dordrecht laws even protected schoolmasters from enraged parents seeking a teacher's dismissal because of physical abuse.[12] On the other hand, visiting Frenchmen

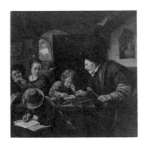

FIG. 1. JAN STEEN, *The Strict Schoolmaster*, oil on panel, sale, Christie's, London, July 8, 1927.

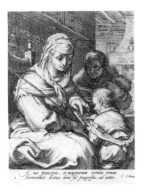

FIG. 2. CORNELIS DREBBEL after Hendrik Goltzius, *Schoolmistress*, engraving.

FIG. 3. JAN STEEN, *The Unruly School*, oil on canvas, Collection of the Duke of Sutherland, on loan to the National Gallery of Scotland, Edinburgh.

like Parival, who taught in Leiden, felt that Dutch children were undisciplined and needed to be beaten more often.[13] The gentler Dutch attitude toward corporal punishment in school is reflected by a regulation of 1682; teachers were instructed to exchange the rod and ferule for other methods, such as keeping children after hours or shaming them in front of their peers.[14]

Whether the bottles in the niche above the schoolmaster's chair indicate that he was a drinker is unclear. The bookshelf has been related to an emblem by Roemer Visscher in which books are "Food for the Wild Spirit," a means of taming the unruly, the unmannered, the unlearned.[15] The shears below might even recall the expression that Dutchmen used in defense of spoiling their children: "Cut off the nose and spoil the face."[16] The schoolmaster, like Steen's comic doctor types (see cat. no. 105), wears an unhistorical, semitheatrical costume in this and two similar versions that show the same old man (see fig. 1).[17] His sleeveless frock, yellow jacket with striped sleeves, short ruff, and black cap are neither mid-seventeenth century dress nor antiquated sixteenth-century costume. This ursine character who swats little boys is a much-diminished descendant of the dignified medieval depictions of Grammar, which provide the ultimate prototypes of Steen's schoolmaster scenes.[18] Cornelis Drebbel's early seventeenth-century print after Goltzius of Grammar (fig. 2) is an intermediary image that depicts a simple schoolmistress instead of a medieval scholar, but the devotion to learning is no less compelling. In the Dublin painting, on the other hand, one need not share in the little girl's *Schadenfreude* to be amused by Steen's parody of the once-high calling of education. A broader stage is set for the

satire of *The Unruly School* (fig. 3), a subject treated earlier by Brouwer and his circle.[19] The chaotic scene illustrates a school run without discipline; manic urchins climb on the tables, fight, or doze directly in front of the neglectful, self-occupied schoolmaster. In *The Unruly School,* a child at the right offers spectacles to an owl perched beside a lighted lantern, which no doubt alludes to one of Steen's favorite sayings: "What need of spectacles or candle if the owl cannot and will not see."[20] The blindness here is not so much that of the students as that of the teacher. While the squinty-eyed Dublin schoolmaster has seen the need for discipline, he is probably no less myopic in his approach to education.

The large-scale figures and the technique of the Dublin painting may be compared to paintings dated 1663 (see pl. 80 and cat. no. 104, fig. 2). The composition also resembles that of the famous *Saint Nicholas Feast* (Rijksmuseum, Amsterdam, no. A385), usually dated c. 1663–65. In addition, several copies and imitations have been listed by Braun.[21]

P.C.S.

1. The dimensions in the sales were 41¼ x 32½" (104.9 x 81.6 cm.) and 45⅞ x 32⅝" (116.4 x 83 cm.), respectively.

2. On Dutch schools, see G. Schotel, *Het Illustre School te Dordrecht* (Utrecht, 1857); Schotel 1903, pp. 79–112; Wouters, Visser 1926; Hoogland n.d.; Zumthor 1962; van Deursen 1978b, pp. 57–83. On the tradition of depicting education and schools in the Netherlands, see Durantini 1983, pp. 93–176. French observers differed in their appraisal of Dutch schools (see Murris 1925, p. 113). For example, F. M. Janiçon, who lived in Holland from 1685 onward, commended their quality (see *Etat present de la République de Province-Unies* [The Hague, 1730], vol. 1, p. 12), while C.-P. Coste d'Arnobat (*Voyage au pays de Bambouc, suivi d'observation intéressantes sur les indiennes sur la Hollande et sur l'Angleterre* [Brussels and Paris, 1789], pp. 304–5) was utterly contemptuous of their instructors' qualifications to teach.

3. See Valcooch 1926, pp. 16–17. Although *predekants* (preachers) had a minimum wage, schoolteachers did not; see van Deursen 1978b, p. 62.

4. Van Deursen 1978b, p. 66; Valcooch (1926, p. 63) complained that all that was required to open a school was the payment of thirteen guilders to the community.

5. See Wouters, Visser 1926, p. 98.

6. See Zumthor 1962, p. 103.

7. Hoogland n.d., p. 7. In Haarlem the preachers and elders of the Reformed Church visited the schools monthly for inspection (van Deursen 1978b, p. 60).

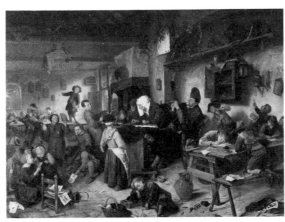

Inn with Violinist and Card Players, c. 1665–68
Signed lower left: J. Steen (JS in ligature)
Oil on canvas, 32¼ x 27¼" (81.9 x 69.2 cm.)
Her Majesty Queen Elizabeth II

8. See Valcooch 1926, pp. 55–56; Wouters, Visser 1926, pp. 97–101; and Durantini 1983, p. 167.

9. Valcooch 1926, pp. 9–10; Schotel 1903, pp. 80–86; Zumthor 1962, pp. 104–6; van Deursen 1978b, pp. 62–67; and Durantini 1983, p. 168.

10. The word *ferule* is derived from *ferula* or fennel. Roman schoolmasters used stalks of fennel to beat their pupils. In the seventeenth century, the ferule was made of wood and shaped like a spoon with a flat bowl; see Schotel 1903, p. 86; Durantini 1983, pp. 127, 332, nn. 121 and 122.

11. Valcooch 1926, p. 14.

12. See Durantini 1983, p. 126.

13. Parival 1651, p. 20. Antoine de la Barre de Beaumarchais (*La Hollandois, ou lettres sur la Hollande ancienne et moderne* [Frankfurt, 1737]), who visited Holland in 1735, states that the first lesson a Dutch father gives the teacher is "Do not hit my son."

14. Wouters, Visser 1926, p. 102.

15. See Durantini 1983, p. 120; Visscher 1614, no. 30.

16. Parival 1651, p. 27.

17. Compare the schoolmaster paintings owned by the Marquis of Northampton, Ashby Castle (Hofstede de Groot 1908–27, vol. 1, no. 139; Braun 1980, no. 248) and fig. 1 (Hofstede de Groot 1908–27, vol. 1, no. 299; Braun 1980, no. 183). The same model also appears in the *Alchemist* (Wallace Collection, London) and the *Satyr and the Peasant* (Bredius Museum, The Hague).

18. On the concept of *grammatica* and the tradition of representing Grammar, see Miedema 1975, pp. 2–13; and Durantini 1983, 94–130.

19. On the unruly school tradition, see Durantini 1983, pp. 130–36. Fascinating features of the Sutherland painting are Steen's quotations from Raphael's *School of Athens;* see G. Smith, "Jan Steen and Raphael," *The Burlington Magazine,* vol. 123, no. 936 (March 1981), pp. 159–60.

20. "Wat baet er kaers en bril als den uyl niet sien en will."

21. Under Braun 1980, no. 198.

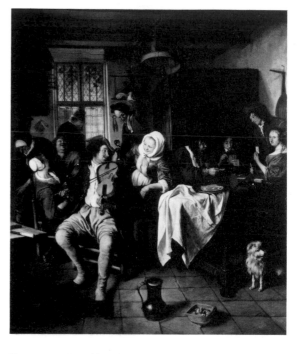

Provenance: Possibly sale, J. P. Wierman of Leiden, Amsterdam, August 18, 1762, no. 42; sale, Mme Veuve Cliquet-Andrioli, Amsterdam, July 18, 1803, no. 45, to Pruyssennar; sale, Paris, 1809;[1] sale, Michael Bryan, London, May 25, 1810, no. 107; purchased from Joseph Waring by George IV, April 1, 1818 (170 pounds sterling).

Exhibitions: London, British Institution, 1826; London, British Institution, 1827; London, Royal Academy, 1946–47, no. 311.

Literature: Smith 1829–42, vol. 4, no. 88; Waagen 1837–38, vol. 2, pp. 356–57; Jameson 1844, no. 108; Waagen 1854–57, vol. 2, p. 10; Westrheene 1856, no. 55; Bredius 1899a, p. 50; Hofstede de Groot 1908–27, vol. 1, no. 532; Martin 1954, p. 54, pl. 55; de Vries 1976a, p. 79, pl. 47 (as c. 1665–68); de Vries 1977, p. 65, no. 149; Braun 1980, no. 278, ill. (as 1666–70); White 1982, no. 191, pl. 169.

A young fiddler sits at the center of a group of eleven figures assembled in a tavern. His music draws a smile from a serving girl leaning on a table beside him. At the right two men play cards with an elegantly attired young woman while another man watches. Looking out at the viewer, the woman holds up a card and smiles. Other playful figures have gathered at the left beside a hearth and at the back. A tankard and brazier rest in the foreground and a small dog looks off to the right. There is a covered bed at the right, and overhead a *belkroon* (see cat. no. 102) is decorated with branches.

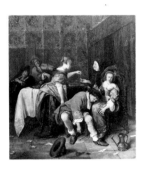

FIG. I. JAN STEEN, *Bad Company*, oil on panel, Musée du Louvre, Paris, inv. no. RF301.

Like his presumed teacher, Adriaen van Ostade, Steen painted tavern scenes throughout his career. In many of them a prominent violinist entertains the patrons, who sometimes dance.[2] Although some critics believe that Steen himself is the violinist in this painting,[3] the older, heavy-set man by the hearth more closely resembles the artist. In a painting in the Mauritshuis in The Hague, Steen depicted himself as a foppish old violinist cheated by a young strumpet and her crone partner.[4] More often in his art, however, the fiddler plays on cheerfully as others are victimized or dissipate themselves (see pls. 80 and 85).

In *Bad Company* (fig. 1), a violinist plays as two splendidly overdressed whores fleece a customer who has passed out. Christopher White has suggested, quite plausibly, that the woman in this picture who holds up a red ace and looks out so pointedly at the viewer might also be a prostitute: "She holds up the ace of diamonds and demonstrates her power over her elderly male opponents. The dog in the right foreground may provide a reference to her profession."[5] Dogs were often the symbols of prostitutes;[6] Gillis van Breen's print after Karel van Mander (fig. 2) depicts an inn with a man being cuddled by two prostitutes as he feeds two dogs. A smaller dog sits in the prostitute's lap. The leafy decoration on the *belkroon* sometimes signified a special celebration, such as Prince's Day (November 15)[7]—note the print of a rider on a charging horse on the back wall—but also seems to have been an everyday ornament of taverns, as in *Interior of an Inn with an Old Man* (Rijksmuseum, Amsterdam, no. A3347). De Vries's dating of the painting as c. 1665–68 is preferable to Braun's 1666–70.

P.C.S.

1. See Smith 1829–42, vol. 4, no. 88.

2. See, for example, Braun 1980, nos. 27, 180, 349.

3. See Smith 1829–42, vol. 4, no. 88; and Waagen 1854–57, vol. 2, p. 10.

4. Braun 1980, no. 340, p. 70, ill.

5. White 1982, p. 125.

6. See Renger 1970, p. 130; also see pl. 59.

7. See, for example, Braun 1980, no. 276 (Rijksmuseum, Amsterdam, no. A384).

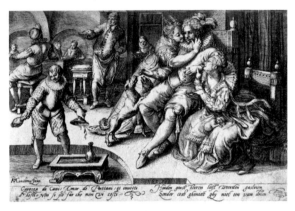

FIG. 2. GILLIS VAN BREEN after Karel van Mander, engraving.

The Dissolute Household, c. 1668
Signed lower left on the slate: JSteen (JS in ligature); and inscribed: BEDURFVE HUISHOW
Oil on canvas, 31¾ x 35″ (80.5 x 89 cm.)
Wellington Museum, London, no.
WM1541-1948 (Crown Copyright)

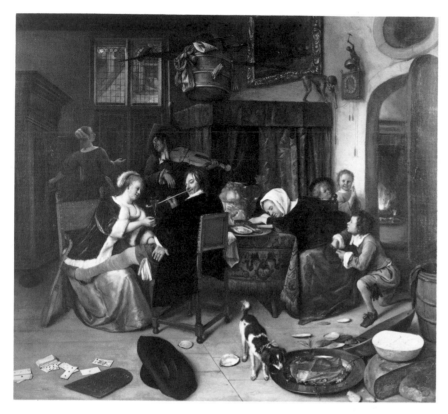

Provenance: Sale, P. de Smeth van Alphen, Amsterdam, August 1, 1810, no. 96, to Rijers; sale, W. Rijers, Amsterdam, September 21, 1814, no. 143, to Eversdijk; purchased for the Duke of Wellington by Féréol Bonnemaison, Paris, 1818.

Exhibitions: London, British Institution, 1821, no. 44; London 1831, no. 150; London 1845, no. 48 (as "Jan Steen's Family"); London, Royal Academy, 1886, no. 90; London 1909, no. 11; London 1929, no. 177; London, Arts Council, 1949, no. 10; The Hague 1958–59, no. 34, ill. (as 1663–65); Bordeaux, *La Femme et l'artiste,* 1964, no. 63; Hull, Ferens Art Gallery, *Scholars of Nature,* 1981, no. 33.

Literature: Smith 1829–42, vol. 4, no. 78; Waagen 1854, vol. 2, p. 273; J. D. Passavant, *Tour of a German Artist in England* (London, 1836), p. 172; Westrheene 1856, no. 74; London, Apsley House, cat. 1901, no. 73; Hofstede de Groot 1908–27, vol. 1, no. 109; Bredius 1927, p. 41, pl. 17; de Groot 1952, p. 111; Martin 1954, p. 51, pl. 49; de Vries 1977, pp. 65, 133 n. 126, no. 147 (as 1665–70); Schama 1979, pp. 103–7; Braun 1980, no. 197, ill. (as c. 1663–65).

The title of this painting, as in the artist's closely related *Beware of Luxury* (cat. no. 104), is inscribed on a reckoning slate in the lower left. *The Dissolute Household* abounds with details that illustrate the effects of intemperance. A smoker with Jan Steen's features, who sits at a table in the center, leers over his shoulder at the viewer. His stockinged leg is thrown across the lap of a young woman, whose extravagant attire, décolletage, beauty spots, and pearled headdress with feather probably identify her as a prostitute.[1] Additional erotic allusions include

the (remarkably large!) oysters, which were legendary aphrodisiacs (see cat. no. 103); the notoriously lascivious monkey; the luscious still life of fruit;[2] the meat (flesh) with a sprig of myrtle (symbol of Venus);[3] and the ace of hearts playing card.[4] In addition to the expression "Cards, women, and drink have ruined many a man" (see cat. no. 104), the cards on the floor in front of the prostitute could recall the saying "De hoeren hebben de kaart" (Whores hold the cards).[5] At the opposite end of the table, a woman in white headdress, probably the neglectful mistress of the household, slumbers heavily with head in hands. Her sleep has been brought on by the enormous roemer of wine on the table before her and, possibly, by the gluttonous array of foods—bread, meat, cheese—on the floor beside her. In her drunkenness, the housewife not only neglects the food (to the delight of a small spaniel) and the blazing fire in the next room, but also her husband's infidelity and the thievery of her children, who stealthily empty her purse, and her maidservant, who steals her jewelry. The maid, the object of the starry-eyed young violinist's passion, loots the family *kast* in the rear left. Three details, seen in the Vienna painting (pl. 80), underscore the painting's various themes of excess: the hat on the floor alludes to a maxim expressive of recklessness; the monkey stopping the clock recalls the moral that, in foolishness, time is forgotten; and the attributes of beggary, sickness, and ruin—the profligate's wages of sin—hang overhead.

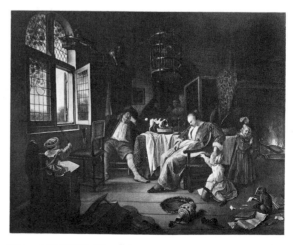

FIG. 1. JAN STEEN, *Dissolute Household,* oil on canvas, present whereabouts unknown.

1. The stocking, or *kous,* often had obscene connotations, as in *piskous* or *flapkous*—slang expressions for whores; see de Jongh 1971, p. 174, and Amsterdam 1976, under cat. nos. 64 and 68. On the varied and potentially contradictory associations of pearls, see de Jongh 1975–76. On the feather as a symbol of transience, pride, eroticism, and impurity, see de Jongh 1971, p. 171 n. 109, and Amsterdam 1976, under cat. no. 8.

2. On fruit as a symbol of lust and an attribute of the Foolish Virgins, see Amsterdam 1976, p. 34. See also cat. no. 15.

3. See Schama 1979, p. 107.

4. See cat. nos. 10 and 108. Whether the knave of clubs lying beside the ace is significant is unclear.

5. De Groot 1952, p. 111; Harrebomée 1856–70, vol. 1, p. 371.

6. Hofstede de Groot 1908–27, vol. 1, no. 110; Braun 1980, no. 190.

7. *Musical Company,* signed and dated, The Art Institute of Chicago (Hofstede de Groot 1908–27, vol. 1, no. 442; Braun 1980, no. 265).

8. Hofstede de Groot 1908–27, vol. 1, no. 494; Braun 1980, no. 296.

9. De Vries 1977, p. 133 n. 126.

FIG. 2. JAN STEEN, *The Twelfth Night Feast,* 1668, oil on canvas, Staatliche Kunstsammlungen, Kassel, no. GK296.

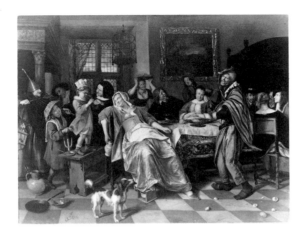

In another version by Steen, which was formerly in the Schloss collection, Paris (fig. 1),[6] again the parents have collapsed in a drunken stupor as the children and family pets run amok. In that work, however, a large Bible rests among the musical instruments and the litter created by the monkey in the foreground; on a sheet of paper at the right, a partially visible inscription concludes "Syt des slapend sot, vergeeten syt ge van Godt" (To be a sleeping sot is to be forgotten by God). Though Steen surely expected us to laugh at his scenes of intemperance, their moral admonition is nonetheless clear.

The Wellington Museum's painting is the most advanced and probably the latest of Steen's versions of this theme. It certainly postdates the much brighter and more broadly executed picture in Vienna of 1663 (pl. 80) and probably the painting formerly in the Schloss collection (fig. 1), which has the exaggerated perspective of Steen's painting of 1666 in Chicago.[7] By comparison these two earlier compositions appear more additive in conception. In the Wellington Museum's picture, the darker overall tonality, which contributes to the unification of the design, and the finer technique resemble *The Twelfth Night Feast,* dated 1668 (fig. 2), pointing to origins in the same period.[8] De Vries correctly proposed this later dating and called attention to a very late work by Pieter Codde, which takes over the Dissolute Household theme.[9]

P.C.S.

Card Players Quarreling, c. 1664–65
Signed lower left on the fragment of
architectural molding: IS
Oil on canvas, 35⅜ x 46⅞″ (90 x 119 cm.)
Gemäldegalerie, Staatliche Museen Preussischer
Kulturbesitz, Berlin (West), no. 795B

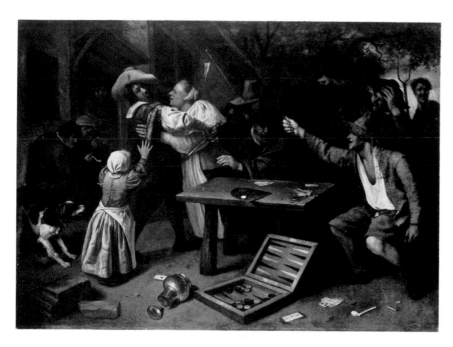

Provenance: Murch, brought to England from Oldenburg,
1827; Philips auction, London, 1828; Gunthorpe auction,
London, 1842; I. L. Nieuwenhuys, Brussels, 1855; Barthold
Suermondt, Aachen; acquired with Suermondt Collection for
the Berlin museum, 1874.

Exhibition: Leiden 1926, no. 3.

Literature: Smith 1829–42, vol. 4, p. 52, no. 154; West-
rheene 1856, p. 161, no. 378; J. Meyer and W. von Bode,
*Verzeichnis der ausgestellten Gemälde . . . aus den im Jahre
1874 erworbenen Sammlungen des Herrn Barthold Suer-
mondt* (Berlin, 1875), p. 70, no. 78; Rosenberg 1897, p. 98,
fig. 28; Hofstede de Groot 1907–28, vol. 1, pp. 193–94,
no. 767; Wurzbach 1906–11, vol. 2, p. 657; Bredius 1927,
p. 44; Gudlaugsson 1945, p. 43, fig. 29; Berlin (West),
Gemäldegalerie, cat. 1975, p. 410, no. 795B; Berlin (West),
Gemäldegalerie, cat. 1978, p. 419, no. 795B; Braun 1980, p.
138, no. 346, ill.

Gamblers gathered at a rough-hewn wooden
table in front of a country tavern have fallen into
violent dispute. Peasants on the right have pulled
out pitchforks and knives, while on the left a
man wearing a leather jacket and colored
leggings draws his sword. Members of the
"weaker" sex, a small girl and a woman, stop
him from pulling the dangerous weapon out of
its sheath. The elderly man behind the table re-
acts more calmly, maintaining perspective amid
the melee and attempting to pacify both sides.
The slate, as well as the cards and backgammon
board on the ground, indicates that the quarrel
centers on the loss of the game, probably in the
belief that cheating has occurred. The soldier ap-
pears the dupe because the modest winnings lie
on the peasant's side of the table. The large
pewter tankard in the foreground reveals that
alcohol has intensified the incident. A figure

bearing a pilgrim's banner hurries away from
this inhospitable place; the peasants on the left,
one of whom watches from the doorway, follow
the disagreement with amusement and the
slightly bleary look of regular tavern goers.

Here Steen has once more proved himself an
imaginative narrator, a distinction matched by
his compositional skill, especially in the arrange-
ment of scenes with many figures. The several
directions of movement generated by the event
are well contained within a closed composi-
tion—seemingly hopeless confusion carefully
structured. The figures are arrayed relief-like
across the breadth of the canvas, not in a simple
row but in spatially staggered alternations of
tight and loose groupings, loud and restrained
action, pronounced and subdued color; thus the
action—its dramatic climax, the impetuous con-
frontation of cavalier and peasant—is decisively
accented without disturbing the rhythm of the
whole. Steen was content to identify the locale
through summary details. The facade of the tav-
ern and the gate in the middle ground, which,
along with the trees behind it, close the space,
are rendered with broad brushwork. The care-
fully modeled figures, on the other hand, are
painted with a more refined technique. Despite
the drastic subject, Steen did not ignore surface
details. The cavalier's flashing sword and the
pewter tankard in the foreground display bril-
liant passages of *fijnschilderij* technique, as does
the slate with piece of bright white chalk, which
emphasizes the center of the picture.

Varied in subject matter and style, and some-
times uneven in quality, Steen's sizeable oeuvre
is difficult to order chronologically. The few
dated works are insufficient to reconstruct a
clearly defined sequence, but because Steen was
receptive to local school traditions, his frequent
changes of residence offer stylistic clues.[1] From
1656–61 he worked in Warmond, near Leiden;
his meticulous treatment of objects on the
ground and on the table, as well as the delinea-
tion and textural detailing of the costume on
the left may reflect the influence of the Leiden
School of *fijnschilderij.* In outfitting the little
girl in a yellow satin dress with a white apron,
he may have been thinking of the *Portrait of
Bernardina Margriet van Raesfelt* (the so-called
Poultry Yard) of 1660, a major work in the
Leiden style (Mauritshuis, The Hague, no.
166).[2] Yet the traces of the Leiden style are ves-
tigial, indicating a *terminus ad quem* long past.

FIG. 1. HIERONYMUS
BOSCH, detail of *Ira*
(Anger), from tabletop of
the *Seven Deadly Sins*,
Prado, Madrid, no. 2822.

FIG. 2. JACOB MATHAM,
Card Players Quarreling,
from a series of four engrav-
ings on *The Effects of
Intemperance*.

More closely related are the populous figure
compositions in large format that Steen pro-
duced shortly after his move to Haarlem; in
Beware of Luxury (cat. no. 104), an interior
scene of 1663 and one of the high points in his
oeuvre, Steen shows himself above all a figure
painter. In the thematically related *Card Players
Quarreling* of 1664 (Alte Pinakothek, Munich,
no. 276), he became, rather suddenly, an interior
painter.[3] The ample space that surrounds the ar-
guing peasants reveals Steen's effort to impart
freedom of movement to concentrated groups of
figures previously confined to flat, foreground
stages. In works from the following period, the
expanded setting is retained and occupied en-
tirely by the actors;[4] in addition, the color values
are muted and the brushwork is softer. Although
the Berlin picture precedes this stylistic phase,
initial steps are detectable; Steen's sorting of fig-
ures into groups separated by vertical and
horizontal space and his use of color as a distinc-
tion between primary and secondary actors
increase the spaciousness of the scene.[5]

Though the artist's style may appear volatile
and sometimes contradictory, the subject of his
pictures is consistent and straightforward: the
denunciation of human misconduct. The adver-
saries, weapons in hand, have lost their self-
control; they are allegories of *Ira* (Anger), one
of the seven deadly sins (see fig. 1). The forces
driving them to these vices—alcohol and gam-
bling—are set directly before our eyes through
the pewter tankard and the backgammon game.
Jacob Matham had already illustrated this sub-
ject in one of four engravings on *The Effects of
Intemperance*. Matham's *Card Players Quarrel-
ing* is symbolic of *Ira*, the final stage of human
degradation related to violence (fig. 2).[6] This
still-mannerist work is the source of Steen's pic-
torial scheme of men threatening each other
across the table and women attempting to pacify
them. Whereas Matham has used the accouter-
ments of a sinful life as dramatic elements (the
wine jug and game board tumbling from the
table), Steen has set off the objects, thus enhanc-
ing their symbolic value. Whether Steen's
arrangement was chosen for emblematic clarity
of some far-reaching implication is unclear.[7]

Steen's dim view of human weakness is al-
together free of bloodless moralizing. The
peasant on the right gazes laughingly at the
viewer. The figures move in a theatrically exag-
gerated way, provoking a humorous response.
The armed cavalier was thought to represent a
soldier, but his costume and emphatic pose show
that he is indeed an actor.[8] He represents Cap-
itano, the flashy loudmouth of the commedia
dell'arte, a harmless character who can be
effortlessly kept in his place by a woman and a
little girl. Steen often incorporated stage figures
and theatrical situations in his pictorial narra-
tives; here it was comedy, light entertainment
with a moral lesson, that most appealed to his
own temperament.

J.K.

1. A chronology based on his places of residence has already
been attempted by Holmes (1909, pp. 243–44); see also de
Vries 1977, p. 26.

2. De Vries 1976b, pls. 54–55; de Vries 1977, pp. 47–48,
160, no. 79.

3. De Vries 1977, pp. 54, 59, 63, no. 101.

4. Compare Steen's *Unruly School* (cat. no. 107, fig. 3); de
Vries 1976b, pl. 60, as c. 1674–78, and de Vries 1977, pp.
59, 164, no. 127, but correctly dated c. 1667. Compare also
Steen's *Wedding Banquet*, 1667 (Apsley House, London); de
Vries 1977, pp. 16, 165, no. 134.

5. A date of c. 1664–65, as suggested by Lyckle de Vries in a
conversation of November 1983, is not inappropriate. Braun
dates the work c. 1671, based partly on comparison with
Steen's 1671 *Card Players Quarreling* (Gemeente Museum,
Arnhem, no. NK2167). Stylistically, however, these two
works are not closely related. Comparable figure groups do
not necessarily indicate the same date of execution; Steen
repeated successful pictorial solutions, independently of his
prevailing style.

6. Hollstein 1949–, pp. 312–15; see also Renger 1970, pp.
81–83, figs. 53–56.

7. In addition to their narrower significance as symbols of
gambling fever, backgammon and playing cards stood for
leecheyt (ledigheid: idleness). "Leecheyt is moeder van alle
quaethede" (Idleness is the parent of all vice) was the current
proverb. Perhaps Steen also wanted to point to this causal
relationship with a compositional accent on the game board.
See Renger 1970, pp. 81–88; see also the thorough discus-
sion of Willem Duyster's *Backgammon Players* in Amster-
dam 1976, pp. 109–11, no. 22. On the significance of back-
gammon in Steen's *Easy Come, Easy Go*, 1661, see cat. no.
103.

8. Bredius 1927, p. 44; and Gudlaugsson 1945, p. 34.

Michael Sweerts

Brussels 1618–1664 Goa

Literature: Bartsch 1803–21, vol. 4, p. 413; Nagler 1835–52, vol. 18, p. 57; Immerzeel 1842–43, vol. 3, p. 125; Weigel 1843, p. 224; Blanc 1854–90, vol. 3, p. 623; Kramm 1857–64, vol. 5, pp. 1594, 1596; Nagler 1858–79, vol. 4, p. 2133; Wurzbach 1906–11, vol. 2, pp. 684–85; Martin 1907; Hoogewerff 1911; Hofstede de Groot 1915–16, pp. 123–25; Hoogewerff 1916; Valentiner 1930–31; Baudiment 1934; Longhi 1934; Hoogewerff 1936; Verwoerd 1937; Hoogewerff 1938; E. Trautscholdt in Thieme, Becker 1907–50, vol. 32 (1938), pp. 348–50; Bloch 1950; Stechow 1951; Kultzen 1954; Roh 1955–56; Longhi 1958; Rotterdam/Rome 1958–59; van Regteren Altena 1959; Plietzsch 1960, pp. 206–11; Bloch 1965; Rosenberg et al. 1966, p. 174; Bloch 1968; Bodart 1970; Bartsch 1971–, vol. 5, pp. 376–84; Boschloo 1972; Bloch 1973; Waddingham 1976–77; Kultzen 1980; Kultzen 1982; Kultzen 1983.

The son of a linen merchant, Michael Sweerts was baptized in the Catholic Church of St. Nicholas in Brussels on September 29, 1618. Nothing is known of his training as an artist. He was in Rome by Easter 1646, when he is recorded in the parochial registers of S. Maria del Popolo; he was living on the Via Margutta. He is mentioned in the minutes of the Accademia di San Luca from October 7 as an aggregato (an unofficial assistant). It is not known exactly when he left Rome (there are two paintings signed and dated Rome 1652), but he may have remained in the city until 1654. He was back in Brussels in 1656 when he received permission from the magistrates to open an "academy for drawing from life." He joined the Brussels guild in 1659, and in the following year he is mentioned for the first time in the records of a Catholic missionary group, the Société des Missions Etrangères. A Lazarist priest associated with this group recorded in his diary that he and a French Franciscan lay brother named de Chameson met Sweerts in Amsterdam in 1661. He wrote that the artist, whom he considered "one of the greatest, if not the greatest, painter in the world," "ate no meat, fasted almost every day, slept on a hard floor, gave money to the poor, and took communion three or four times a week." The diarist called Sweerts "a remarkable person," in whom he believed he could discern fanatical religious traits. In November 1661, when Francis Pallu, the bishop of Heliopolis and superior of the Société, left Paris for Marseilles en route to the Far East, Sweerts was a lay brother in the party. They traveled via Aleppo in Syria to Tabriz in Persia, where they arrived in June 1662. There Pallu asked Sweerts, who had offended a number of his companions, to leave the mission. Pallu wrote of the incident: "I do not think the mission was the right place for him, nor he the right man for the mission." Sweerts remained in the East, but little is known of his subsequent movements except that he visited a Portuguese Jesuit mission on the west coast of India and died in Goa in 1664.

Sweerts was a highly original artist. In Rome he studied the work of Caravaggio (1573–1610) and his Roman followers as well as that of Pieter van Laer (q.v.), who had applied Caravaggesque effects to depictions of street life. His oeuvre includes scenes of Italian street life and men gaming, single figures of peasants, a number of portraits, and a series of the Seven Acts of Charity (four from this series are in the Rijksmuseum, Amsterdam). Sweerts also took a particular interest in scenes of young artists working both in and out of the studio, drawing from the antique and from life. His own paintings reveal his fascination with antique sculpture.

C.B.

The Academy, c. 1656–58
Oil on canvas, 30⅛ x 43¼″ (76.5 x 110 cm.)
Frans Halsmuseum, Haarlem, no. 270

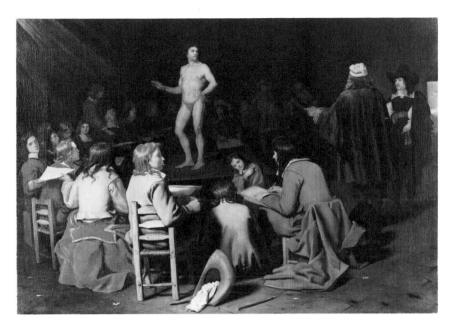

Provenance: Jhr. L. J. Quarles van Ufford Collection; sale, Jhr. L. J. Quarles, 1874; presented to the museum, 1876.

Exhibition: Rotterdam/Rome 1958–59, no. 38.

Literature: Martin 1907, p. 148; Kultzen 1954, no. 55; Bloch 1968, pp. 20 ff.; Waddingham 1976–77, pp. 59–60; Kultzen 1982, pp. 124–25.[1]

Within the academy, a large bare room, the students are drawing from a male model who stands on a low platform. The teacher, seen from the rear on the right, is apparently explaining the proceedings to a visitor.

Sweerts painted a number of pictures showing young artists drawing from plaster casts and drawing from life outside the studio, but this is his only painting of an academy. The work bears a special significance in the context of Sweerts's own life, as we know that he was given permission to open an "academie van die teeckeninghen naer het leven" (academy for drawing from life) in Brussels on April 3, 1656. While learning to draw from the antique and from models in his master's studio was a part of every young Dutch and Flemish apprentice artist's training, academies of this type were rare in the Netherlands. Among the few precedents were those set up by Cornelis Cornelisz. van Haarlem, Hendrik Goltzius, and Karel van Mander in Haarlem around 1590, and by Gerrit van Uylenborch in Amsterdam in the 1620s. Sweerts, who had lived in Rome for several years, presumably had Italian prototypes in mind, such as the academy set up by Baccio Bandinelli in 1531 in the Belvedere at Rome. Around the same time that

he applied to open his academy, Sweerts made a series of etchings to be used in teaching young students to draw. Sadly we know nothing more of Sweerts's academy.

It was first suggested by Stechow (1951), and supported by Kultzen (1954), that Sweerts was in Amsterdam by 1658. In the Rotterdam/Rome exhibition (1958–59), Kultzen argued that this painting was executed during his stay in that city. There is, in fact, no firm evidence that the painter was in Amsterdam before 1661, and it seems more logical to associate the painting with the Brussels academy and to date it accordingly as c. 1656–58.

C.B.

1. Kultzen notes two copies: 55a was on the New York art market in 1954, and 55b was on the art market in The Hague before 1936.

Amsterdam c. 1590–1630 The Hague

Party on a Garden Terrace, before 1620
Signed lower right: E.V.VE[LDE] 16 . . [1]
Oil on canvas, presumably transferred from
wood, 17 x 30¼″ (43 x 77 cm.)
Gemäldegalerie, Staatliche Museen Preussischer
Kulturbesitz, Berlin (West), no. 1838

Literature: Houbraken 1718–21, vol. 1, pp. 171, 173, 275, 303; Nagler 1835–52, vol. 20, p. 37; Immerzeel 1842–43, vol. 3, p. 159; Blanc 1854–90, vol. 4, p. 99; Kramm 1857–64, vol. 6, pp. 1687ff.; Nagler 1858–79, vol. 2, p. 1806; van der Willigen 1870, p. 305; Obreen 1877–90, vol. 3, pp. 260, 298, and vol. 4, p. 4; Michel 1892; Wurzbach 1906–11, vol. 2, pp. 751–52; Thieme, Becker 1907–50, vol. 34 (1940), pp. 199–200; Bradley 1917; Block 1917–18; Plietzsch 1918–19; Poensgen 1924; Sandrart, Peltzer 1925, pp. 182, 311; Zoege van Manteuffel 1927; Siwajew 1940; Stechow 1947; Bengtsson 1952; Gerson 1955; Rotterdam 1959; Maclaren 1960, pp. 418–19; Plietzsch 1960, pp. 94–97; Rosenberg et al. 1966, pp. 104–5, 145–46; Stechow 1966a; Boston/Saint Louis 1980–81, pp. 50–54, 66–70, 99–100; Amsterdam 1981; Amsterdam/Washington 1981–82, p. 43; Keyes forthcoming.

Esaias van de Velde was the son of the Antwerp painter Anthonie van de Velde (born c. 1557), who had emigrated to Amsterdam. According to city documents, Esaias must have been born in Amsterdam around 1590. He may have received his early artistic training from David Vinckboons (q.v.) or from Gillis van Coninxloo (1544–1607), the gifted Flemish landscape painter who had emigrated to Amsterdam. By 1610 van de Velde was living in Haarlem, where he married Catelijn Maertens of Ghent on April 10 of the following year. The couple had at least two children, including the artists Esaias the Younger (born 1615) and Anthonie the Younger (1617–1672). Van de Velde was admitted to the Haarlem Guild of St. Luke in 1612, the same year as were Willem Buytewech (q.v.) and the landscape painter and etcher Hercules Seghers (born c. 1589/90). He was a member of the rhetoricians' chamber De Wijngaertranken from 1617 to 1618. In 1618 he moved to The Hague, where he entered the painters' guild in October. Van de Velde died in The Hague and was buried on November 18, 1630.

An etcher and draftsman as well as a painter, Esaias van de Velde is known primarily for his genre scenes and landscapes. He also contributed figures to the church interiors of Bartholomeus van Bassen (died 1652). His pupils included the landscapists Jan van Goyen (1596–1656), Pieter de Neyn (1597–1639), and Jan Asselijn (1610–1652).

C.v.B.R.

Provenance: Acquired for the museum in the Berlin art market, 1918.

Literature: Plietzsch 1918–19, pp. 138–43, fig. 71 (as c. 1610); R. Grosse, *Die holländische Landschaftskunst, 1600–1650* (Berlin, 1925), pp. 45, 115 n. 51 (as shortly before or c. 1620); Zoege von Manteuffel 1927, p. 15, fig. 7 (as c. 1620); *Beschreibendes Verzeichnis der Gemälde im Kaiser-Friedrich-Museum . . .*, 9th ed. (Berlin, 1931), p. 502, no. 1838 (as c. 1610); Würtenberger 1937, pp. 45–47; Thieme, Becker 1907–50, vol. 34 (1940), p. 119; H. Gerson, *Van Geertgen tot Frans Hals* (Amsterdam, 1950), p. 48, fig. 118 (as an early work); Plietzsch 1960, p. 96 (as c. 1620/24); Bernt 1970, vol. 3, no. 882, ill.; Berlin (West), Gemäldegalerie, cat. 1975, pp. 450–51, no. 1838 (c. 1615); Berlin (West), Gemäldegalerie, cat. 1978, p. 459, no. 1838.

An elegantly attired party has gathered around a richly laid table on a garden terrace. The figure grouping in the left foreground is bordered by the dense foliage of trees and by huge columns draped with a curtain. On the right, in contrast, is an open view past the terrace balustrade to the garden where a couple strolls, and the slender column of a fountain rises against a slightly clouded sky. The action of the figure scene seems to have no point; the meal has ended or been interrupted, a situation familiar to the servant waiting inconspicuously on the left. Yet there is an element of tension in this image of social companionship. Whereas the amorous relationship of the couple behind the table has been fulfilled, their hands having found each other, the foppishly dressed cavalier to the left has not yet achieved this goal. In a suggestive, casual pose he woos his table companion who turns toward him with coquettish attention, causing him to forget the wineglass in his hand. The splendidly dressed officer on the right sits by himself, content to enjoy his clay pipe. In his colorful, meticulously rendered costume, he provides an appropriate counterbalance to his opposite across the table. The free symmetry of the figure group is echoed in the clarity of the overall composition. The shadowy green of the foliage, which reaches over and unites the figures, is set against the whitish blue of the sky in simple alternation between right and left as well as near and far.

Esaias van de Velde was primarily a landscape painter and one of his generation's most advanced representatives in this field. He painted several banquets in the open air (*buitenpartijen*). His *Repast in the Park*, of 1614 (Mauritshuis, The Hague, no. 199)[2] is still dependent on prototypes by the Flemish-born artist David Vinckboons in its miniaturist conception;

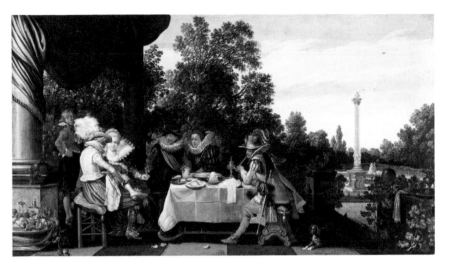

however, his *Banquet in the Open Air* of 1615 (Rijksmuseum, Amsterdam, no. A1765) shows a more original approach to the subject.[3] The figures are treated less emphatically, assembled in a less additive fashion, and integrated easily into the depth of the natural setting.[4] The mannerist treatment of the trees assigns the Berlin painting to a later stylistic phase of development. Chronological clues also can be derived from the form of the signature on the painter's dated and undated works. The reduction to "E.V.VELDE" found on the Berlin canvas does not appear before 1616.[5] Buytewech's famous etching of *Lucelle and Ascagnes* of 1616, from which Esaias borrowed the gestures of the couple on the left, offers a *terminus a quo*.[6] The columns and the draped curtain suggest he may also have known Buytewech's *Merry Company in the Open Air* of c. 1616–17 (pl. 5). A date shortly before 1620 seems justified. The strongly animated figure grouping of his *Banquet in a Palace Park* of 1624 (Kunsthistorisches Museum, Vienna, inv. no. 6754),[7] richly nuanced in light and shadow, has not yet been attained in the Berlin painting. There is, however, an anticipation of this later work. A palatial structure like that in the Vienna painting was also planned for the Berlin composition. Among the discoveries revealed by infrared analysis were the outlines of architectural elements to the right above the fountain columns, a plan that, for unknown reasons, did not survive beyond the stage of underpainting.[8]

Van de Velde's preference for architectural settings again points to David Vinckboons, whose own *Banquet in the Open Air* of about 1610 (Rijksmuseum, Amsterdam, no. A2109)[9] depicts

a carefully tended park in the background with a fountain and palace grounds. Both motifs are common in the medieval garden of love, a subject that was repeated by various artists, including Rubens.[10] Van de Velde was aware of this fertile tradition; unlike that of Vinckboons, his garden of love, no longer separate from the figures, is the locus of action. Van de Velde's garden thus serves an expressive role, both complementing and transcending the amorous figural scene. The garden of love is understood as an ideal and desirable realm somewhere far removed from everyday reality.

Other formulaic conventions were adopted, thus Netherlandish painting is replete with banquet scenes of different meanings: the feast of Levi, the rich man and poor Lazarus, the earthly life of Mary Magdalen, people feasting before the Flood or the Last Judgment, feasts of the Olympian gods, the marriage of Peleus, and so forth.[11] Especially popular were scenes from the parable of the Prodigal Son who squandered his inheritance among whores. Vinckboons's *Banquet in the Open Air* is clearly tied to this theme, since it derives from one of his own drawings from 1608 (British Museum, London) an imaginative depiction of the Prodigal Son's dissipation in food, music, dance, and lovemaking.[12] Cornelis Jansz. Visscher circulated the design in a reproductive engraving that was then employed by no less than Frans Hals in the *Banquet in the Open Air* of 1610 (formerly Staatliche Museen, Berlin, destroyed in 1945).[13] Vinckboons portrayed the biblical hero making amatory advances rather than attending to his guests at a crowded dinner party; he and his female companion, who turns to him with her wineglass in hand, are absorbed by their amorous intentions and have conveniently drawn their chairs away from the table. The couple is similarly emphasized in Frans Hals's work, in Buytewech's *Merry Company in the Open Air* (pl. 5), and in van de Velde's painting.[14] Retitling these works because of their association with the parable would not be justified. Yet an iconographic proximity to portrayals of the Prodigal Son is undeniable, and to this extent a moral lesson can be drawn from the sense of the biblical parable: do not squander your patrimony in loose society; rather, devote yourself to the virtuous life. This admonition is underscored by the pitcher and basin on the balustrade to the right, traditional symbols of purity and chastity.[15]

The unusual architecture of the fountain may also have a symbolic meaning. The stationary, stable elements of base and column support the mobile, unstable form of a sphere. In 1624 Otto van Veen introduced his *Emblemata sive symbola* with a depiction of a sphere, specifically the world globe, resting on a mighty cube. The motto for this emblem reads "Mobile fit fixum" (The moveable is fixed); the cube, identified with the word *quies* (quiet), symbolizes that which does not move. The opposition between rest and movement found in this configuration easily relates to human characteristics. In the emblem's explanatory text the cube denotes the good ruler who puts an end to excess and confusion (the sphere).[16] The cube then must be understood as a pictorialization of the secure foundation of human virtue *(sedes virtutis)*. Van de Velde heightened this meaning by placing a column, traditional attribute of steadfastness *(fortitudo)*, atop the fountain base. In the face of so much moral power as embodied in the architectural supports, Fortuna, the unacknowledged goddess of spheres, can have no effect. Given the fountain's location and the activity of the party, this may be a final admonition to avoid the distraction of fleeting pleasures.

J.K.

1. All attempts to decipher the last two numerals of the date failed during the 1982 restoration of the painting.

2. The Hague, Mauritshuis, cat. 1935, pp. 366–67, no. 199; see the discussion of the painting by Bauch 1960, pp. 30–31.

3. Amsterdam, Rijksmuseum, cat. 1976, p. 558, A1765; Würtenberger 1937, p. 44.

4. See Haverkamp Begemann 1959, p. 24.

5. Stechow 1947, pp. 83–84.

6. See Haverkamp Begemann 1959, pp. 177–78, VG 33.

7. Vienna, Kunsthistorisches Museum, cat. 1972, p. 94, inv. no. 6754.

8. The infrared examination was performed by Gerard Schulz, Berlin, 1983.

9. Amsterdam, Rijksmuseum, cat. 1976, p. 580, no. A2109; on the painting's iconography, see Amsterdam 1976, pp. 273–75, no. 72.

10. Raimond van Marle, *Iconographie de l'art profane au moyen-âge et à la renaissance*, vol. 2 (The Hague, 1932), pp. 422–32; de Jongh 1967, pp. 27–28; Amsterdam 1976, p. 126, no. 27.

11. Würtenberger 1937, pp. 12–23.

12. Goossens 1954a, pp. 91–92.

13. Reproduced as fig. 29 (see Introduction "Masters of Dutch Genre Painting").

14. That Esaias van de Velde knew the engraving after Vinckboons is shown by the prominence of the napkin hanging over the table's edge.

15. Snoep-Reitsma 1973a, pp. 286–90.

16. Otto Vaenius (Otto van Veen), *Emblemata sive symbola* . . . (Brussels, 1624), p. 1, no. 1; on this subject see also W. S. Hetkscher, "Goethe im Banne der Sinnbilder," *Jahrbuch der Hamburger Kunstsammlungen*, no. 7 (1926), pp. 35–51; and E. Panofsky, *Studies in Iconology* (New York, 1967), p. 255.

Party in a Garden, 1619
Signed and dated lower right: E.V. Velde 1619
Oil on panel, 13⅜ x 20¼" (34 x 51.5 cm.)
Frans Halsmuseum, Haarlem, no. 76-415

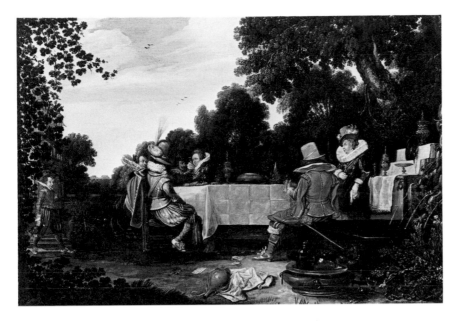

Provenance: Probably sale, de Saint-Seve, Paris, Hôtel Drouot, April 15–17, 1875, lot 285; sale, Guillemot et al., F. Muller & Co., Amsterdam, June 19, 1920, lot 31, to Mak van Bever; sale, F. Muller & Co., Amsterdam, December 12–15, 1922, lot 192, to Mak van Bever; private collection, the Netherlands; sale, Mak van Waay, Amsterdam, May 1, 1974, lot 269, to Richard Green; Richard Green Gallery, London, 1974; Gallery Rob Noortman, Hulsberg, Holland; J. M. Driessen Veghel, Holland; Gallery Rob Noortman, Hulsberg, Holland.

Literature: Gallery Rob Noortman, Hulsberg, 1975, cat. no. 1; Keyes forthcoming, cat. no. 62, and pl. 137.[1]

FIG. 1. ESAIAS VAN DE VELDE, *Garden Party,* c. 1615, etching.

Although he is best known as the most innovative Dutch landscapist of his generation, Esaias van de Velde produced a few paintings and an etching, *Garden Party* of c. 1615 (fig. 1), that represent outdoor banquets attended by elegantly dressed young men and women. The artist's *Party on a Garden Terrace* (pl. 3) is another, earlier version of the theme.

This type of al fresco merry company scene was developed between about 1608 and 1620 by David Vinckboons, Willem Buytewech (see pl. 5), Dirck Hals, and Esaias van de Velde. Vinckboons's *Outdoor Merry Company* of 1610 (pl. 1) builds upon his own very similar design for a drawing dated two years earlier (cat. no. 121, fig. 2). Significantly, the drawing depicts the Prodigal Son and belongs to a series devoted to the parable. Sixteenth-century representations of this subject and of Mankind Awaiting the Last Judgment furnished the compositional and iconographic models for the secular banquets painted by Vinckboons, Esaias van de Velde, and others.[2] Van de Velde's acquaintance with

Vinckboons's innovations is documented. A drawing by him of a merry company similar to Vinckboons's *Outdoor Merry Company* bears a contemporary inscription stating that it reproduces a now-lost work by Vinckboons.[3] Moreover, van de Velde's earliest banquet picture, the panel dated 1614 in the Mauritshuis (no. 199), clearly depends on Vinckboons's example.[4]

While van de Velde's outdoor banquets of 1614 and 1615[5] retain some of the exuberant gaiety of Vinckboons's compositions, a restrained mood prevails in the *Party in a Garden* and in the extraordinary etching *Garden Party* (fig. 1). C. S. Ackley has written of the print that it is pervaded by "a wistfulness, as if youth had just discovered the brevity and transience of the pleasures of this world."[6] If not as pensive as the etching, our picture is tinged with a poetic melancholy not found to the same degree in the artist's other banquet paintings. The serene, idealized setting that recalls the love gardens of late medieval art, the refined gestures and expressions of the lovers, the almost-audible music of the lute accompanied by the soft splash of the fountain, and the beguiling anonymity of the gallants who turn away from us lend the work an exquisite air of intimacy and genteel romance.

Van de Velde took pains to describe the material luxury enjoyed by the lovers: their rich costumes represent the *dernier cri* in contemporary fashion, a smartly clad young waiter attends to their needs as they wait to dine on peacock pie and other delicacies, precious objects of metalwork are displayed on the table and sideboard, and the folds of the tablecloth are still crisp.

As noted above, van de Velde's erotic idyll descends from sixteenth-century images of the Prodigal Son and Mankind Awaiting the Last Judgment. For the artist's contemporaries, this visual tradition remained a vital one. Moreover in the young Dutch Republic, idleness, gourmandise, and sumptuousness smacked of aristocratic culture and were roundly denounced by moralists.[7] Thus viewers would have immediately grasped the didactic import of the painting: love, youth, beauty, wealth, and luxury are as transient as the lute's sweet strains; better be content with little and think on one's salvation because

FIG. 2. JAN VAN DE VELDE, *Death Surprising a Young Couple*, c. 1620, etching.

death is at hand. A contemporary etching (fig. 2) by the artist's cousin Jan van de Velde makes explicit the message implied in the painting. It shows a young couple, surrounded by attributes of wealth, whose elegant repast is interrupted by the Grim Reaper. The inscription beneath the image states: "We often sit in luxury, while Death is closer than we know." Thanks to its poetic feeling and alluring display of worldly luxury, *Party in a Garden* conveys the *vanitas* admonition even more poignantly.

W.R.

1. Information on provenance and literature kindly supplied by Dr. G. S. Keyes.

2. Wegner, Pée 1980, p. 82, cat. no. 39b; J. R. Judson, *Dirck Barendsz.* (Amsterdam, 1970), pp. 95–97; Amsterdam 1976, cat. no. 72.

3. J. G. van Gelder, *Jan van de Velde 1593–1641: Tekenaarschilder* (The Hague, 1933), p. 36, and fig. 11. Van Gelder notes that the inscription is in the hand of Claes Jansz. Visscher.

4. Goossens 1954a, pp. 96–97.

5. The painting of 1615 is in the Rijksmuseum, Amsterdam (no. A1765).

6. Boston/Saint Louis 1980–81, cat. no. 59, p. 100.

7. See Amsterdam 1976, cat. no. 72.

The painter and poet Adriaen van de Venne was born in Delft in 1589 following his parents' move from Lier in Brabant (Flanders). He studied first with the goldsmith Simon Valck in Leiden and then became a pupil of the grisaille painter Hieronymus van Diest (active c. 1600) in The Hague. After a possible trip to Antwerp around 1607, van de Venne moved to Middelburg, where his father, Pieter, had been living since 1605. The artist was active in Middelburg from about 1608 or 1614 to 1625; during this period he painted historical and mythological themes and landscapes in the style of Pieter Bruegel (c. 1525–1569). He also made illustrations for the works of the Zeeland poet-moralists Jacob Cats and Johan de Brune. These were published by his elder brother Jan, who had established a printing shop and art dealership in Middelburg in 1608. In 1614 van de Venne married Elisabeth de Pours in Middelburg, and the couple had at least two children, including the painters Huybregt (c. 1634/35–c. 1675) and Pieter (died 1657). Following his brother's death in 1625, van de Venne moved to The Hague. Registered as a member of the Guild of St. Luke in 1625, he was appointed deken (dean) in 1637. In 1656 he is listed as one of the founders of the painting confraternity Pictura. He died in The Hague on November 12, 1662.

In addition to historical, mythological, and landscape paintings and illustrations for poetry and Dutch proverbs, van de Venne also depicted genre scenes (both in grisaille and color) and portraits. The artist received a number of commissions from the Princes of Orange and the King of Denmark.

C.v.B.R.

Poor Luxury, 1635
Signed and dated lower center: 1635 Ad V.
Venne; and inscribed: Arme Weelde
Oil on panel, 13 x 23⅝″ (33 x 60 cm.)
Museum Boymans–van Beuningen, Rotterdam,
no. 1896

Literature: De Bie 1661, pp.
234–36; van Bleijswyck
1667, p. 857; Houbraken
1718–21, vol. 1, pp. 136–
37; Immerzeel 1842–43,
vol. 3, p. 165; Kramm
1857–64, vol. 6, p. 1696,
and suppl., p. 150; Obreen
1877–90, vol. 3, p. 258,
vol. 4, pp. 59, 128, vol. 5,
p. 68, and vol. 7, p. 37;
Franken 1878; Ising 1889;
van Loo 1899; Wurzbach
1906–11, vol. 2, pp. 758–
60; Bredius 1915–22, vol.
2, pp. 374–93, and vol. 7,
pp. 240–44; Knuttel 1917;
Henkel 1934; Mulder
1937; Thieme, Becker
1907–50, vol. 34 (1940), p.
213; Bol 1958; Plietzsch
1960, pp. 91–94; Laansma
1965; Rosenberg et al.
1966, p. 104; Stechow
1966a; Amsterdam 1976,
pp. 250–61; Braunschweig
1978, pp. 160–63; Boston/
Saint Louis 1980–81, pp.
105–106; Bol 1982–83.

Provenance: Given to the museum by August Coster,
Brussels, 1886.

Literature: Franken 1878, no. 37; Martin 1935–36, vol. 1,
p. 372, fig. 220; Bol 1958, p. 131 n. 10, p. 135, fig. 18, and
p. 142; Rotterdam, Boymans cat. 1962, p. 146, no. 1896;
Bol 1982–83, pp. 56–57, fig. 76, and p. 60.

The low-life pictures executed in grisaille or
brunaille by the prolific and multitalented
Adriaen van de Venne constitute a separate
chapter in the history of Dutch genre painting.
No other artist worked consistently in mono-
chrome, and none shared van de Venne's
peculiar literary approach to the subject matter.

Although van de Venne's earliest known
grisaille dates from the late teens, when he still
resided in Middelburg, he began to produce the
works regularly only after he settled in The
Hague in 1625.[1] Dozens of these works have
come down to us, including replicas and variants
of several compositions. Not all depict low-life
themes; they also treat religious subjects, guard-
rooms, portraits, and allegories played out by
members of the upper classes. Bold and concen-
trated in design, vigorously executed in tones of
gray or brown heightened with spirited touches
of white, and composed of furiously expressive
figures, these humorous, satirical, and occasion-
ally touching paintings abound with visual wit
and literary allusion.[2]

The protagonists of most of van de Venne's
low-life scenes inhabit a different social world
from that portrayed by Adriaen Brouwer,
Adriaen van Ostade, and Cornelis Bega. While
the latter depicted the working poor, van de
Venne's grisailles often feature the vagrants, beg-
gars, cripples, street performers, prostitutes, and
thieves who lived outside of society. The author-
ities regarded these unfortunates as a menacing

rabble, harried them from place to place, and frequently excluded them from the benefits of municipal charity. Only a handful of artists—van de Venne, Rembrandt, David Vinckboons, Pieter de Bloot, Joost Droochsloot, and Jan van Vliet—depicted the underclass, and most of them did so rarely.

Van de Venne's indigents are portrayed in a variety of situations from the extravagantly comic to the somberly tragic. Most often they dance or brawl, wallowing in idleness, greed, lust, and other vices commonly ascribed to the poor, but they also suffer and die in pitiful misery.[3] The artist nearly always added a banderole inscribed with a word, phrase, or saying that functions as the title of his picture. The inscriptions, which testify to the intellectual pleasure that van de Venne and his contemporaries derived from irony, puns, and double entendres, not only help us to interpret the subject, but also often enrich its meaning with their pithy commentary. Combined with the didactic imagery, the titles endow van de Venne's grisailles with a literary and specifically emblematic character that recalls his splendid illustrations to the poems of Jacob Cats.

Here the oxymoron *Arme Weelde* (poor luxury) satirizes the contrived festiveness of the miserable dancers. While a dance is one luxury the poor can afford, this one makes for a poor luxury indeed. The woman in the left foreground chuckles with mockery and introduces the viewer to the procession of pitiful wretches as they hobble and bounce to the vulgar sound of the hurdy-gurdy, ground out by a musician of doubtful artistry who wears an inverted basket for a hat. Van de Venne undoubtedly intended the outstretched arms that punctuate the composition as a pun on the title: *arm* in Dutch means both "arm" and "poor." It is difficult to detect any sympathy for the plight of the disenfranchised in this work, and the same holds true for most, although not all, of the artist's low-life paintings. Here, the poor serve as the butt of ridicule and contempt, embodiments of the sin of idleness and of the folly of self-delusion.

Van de Venne had used the title *Arme Weelde* for an earlier grisaille, dated 1631, which depicts a crippled woman and a man on crutches embracing as they dance.[4] Two other grisailles feature a group of outcasts gamboling to the music of a hurdy-gurdy. One bears the title

Boere-Vreught (peasant joy);[5] the second, which represents a ring dance and is dated in the same year as the Rotterdam panel, is inscribed *All-om-arm* (poor all around).[6] A composition of *Fighting Peasants* by van de Venne is dated the same year as *Poor Luxury* and employs a similar design.[7]

W.R.

1. L. J. Bol maintains that his earliest known grisaille, *De neuzenslijper* in Göteborg, is dated 1612 (1982–83, vol. 6, no. 2, p. 53). However, the most recent catalogue of the Göteborg museum notes that although the date is unclear, it seems to read "1618" (Göteborgs Konstmuseum, *Malerisamlingen* [1979], p. 99, cat. no. 86).

2. Two articles by L. J. Bol are the only studies that deal in depth with these grisailles; see Bol 1958 and Bol 1982–83, vol. 6, no. 2.

3. For examples, see Bol 1958 and Bol 1982–83, vol. 6, no. 2. For those that show some compassion for indigents who die in misery, see Braunschweig 1978, cat. no. 38.

4. Bol 1982–83, vol. 6, no. 2, p. 56.

5. Bol 1958, p. 131 n. 10.

6. Bol 1982–83, vol. 6, no. 2, p. 60, fig. 78.

7. Sale, Christie's, London, March 12, 1976, no. 68.

Jan Verkolje

Amsterdam 1650–1693 Delft

Elegant Couple in an Interior, probably 1674
Signed and dated lower left: 1671 or 1674
Oil on canvas, 38 x 22½" (96.5 x 57.1 cm.)
Private Collection, Great Britain

Literature: Houbraken 1718–21, vol. 1, p. 236, vol. 2, p. 196, and vol. 3, pp. 282–86; Weyermann 1729–69, vol. 3, p. 125; Nagler 1835–52, vol. 20, p. 109; de Laborde 1839, p. 142; Immerzeel 1842–43, vol. 3, p. 177; Blanc 1854–90, vol. 4, p. 107; Kramm 1857–64, vol. 6, p. 1723; Nagler 1858–79, vol. 4, p. 596; Wessely 1868; Burman Becker 1869; Burman Becker 1874; Obreen 1877–90, vol. 3, pp. 197–206, and vol. 6, p. 14; Wurzbach 1906–11, vol. 2, pp. 771–72; Thieme, Becker 1907–50, vol. 34 (1940), p. 257; Plietzsch 1960, pp. 187–88; Rosenberg et al. 1966, p. 211; Amsterdam 1976, pp. 266–67; Boston/Saint Louis 1980–81, pp. 283–84.

The son of Benjamin Verkolje, a locksmith, Jan Verkolje was born in Amsterdam on February 9, 1650. According to Houbraken, he studied with Jan Andries Lievens (1644–1680) for six months, completing unfinished mythological and genre paintings begun by the artist Gerrit Pietersz. van Zijl (1619–1665). In October 1672 Verkolje married Judith Voorheul of Delft; the couple had three daughters and two sons. After settling in Delft, the artist entered the Guild of St. Luke on June 19, 1673; he served as its deken (dean) between 1678 and 1688. Verkolje died at the age of forty-three; he was buried in Delft on May 8, 1693.

Verkolje painted mythological themes and portraits as well as genre scenes of elegant figures in rich interiors. His engravings in mezzotint made between 1680 and 1684 after works by Peter Lely (1618–1680), Godfried Kneller (1646–1723), and Willem Wissing (c. 1656–1687) suggest that he may have visited London some time during this period. Among his pupils, Houbraken mentioned Albertus van der Burgh (born 1672), Joan van der Spriet (active c. 1700), Thomas van der Wilt (1659–1733), Willem Verschuuring (1657–1715), and his two sons, Nicolaas (1673 1746) and Johannes (died 1760).

C.V.B.R.

Provenance: Danby Family Collection; George Affleck, by inheritance; sale, Swinton Estate, 1882, to Samuel Cunliffe-Lister, later 1st Lord Masham; his family, by descent; sale, Christie's, London, November 28, 1975, no. 66, ill.

Exhibition: London, Royal Academy, 1952–53, no. 451.

Literature: Thornton 1978, p. 139, fig. 112.

The date on this picture has been deciphered as either 1671 or 1674; the last digit remains unclear. From the few dated works that survive, however, it is more likely that the picture was painted in 1674. It was in that year that Verkolje painted his masterpiece *The Messenger* (fig. 1), which bears some resemblance to our painting: the couples are comparably dressed and the dogs assume similar poses.[1] In their upright formats and clarity of representation, these two pictures differ from the artist's *Musical Company* (fig. 2) of the previous year. The heavier atmosphere and darker tonality that characterize the *Musical Company* and others from the same period were abandoned after the artist moved to Delft.[2]

Verkolje's *Messenger* is dependent on works produced almost two decades earlier by Gerard ter Borch and Pieter de Hooch.[3] Another work indebted to de Hooch's subject matter is Verkolje's *Woman Nursing an Infant,* of 1675, in the Louvre.[4] Parallels can also be drawn between our picture and contemporary works by de Hooch, specifically the *Musical Party with Four Figures* in Honolulu, which is also dated

FIG. 1. JAN VERKOLJE, *The Messenger*, 1674, oil on canvas, Mauritshuis, The Hague, no. 685.

FIG. 2. JAN VERKOLJE, *Musical Company*, 1673, oil on canvas, Rijksmuseum, Amsterdam, no. A721.

1674.[5] In many of these musical companies, men and women appear as couples either singing or playing a duet on stringed instruments. Such instruments were expensive luxury items and a sign of status.[6]

The fact that representations of musical gatherings of this type record an upper-class social practice does not eliminate the possibility that the paintings have metaphorical meaning. The musical harmony that we can imagine hearing from these images might be a reference to the personal compatibility of the scene, whether it be a family gathering, a concert among friends, or the intimate meeting of a young couple. According to Ripa's *Iconologia* (1644), Harmony itself was depicted by a woman holding a viola da gamba.[7] In this painting the man points to the viola da gamba while the woman holds a lute, a potential symbol of voluptuousness and luxury.[8] The essence of the painting is the relationship between two exceedingly handsome people of aristocratic demeanor who tenderly hold hands as they gaze amorously into each other's eyes. In some senses, the scene could be regarded as a further development of a subject treated more subtly in Vermeer's *Woman Tuning a Lute* (pl. 107). While the girl in Vermeer's painting readies herself for a performance with an unseen accompanist, the young lovers in Verkolje's painting have already found each other.

Paintings within paintings, as we have seen, can serve as a device by which the artist comments on his subject. In *The Messenger* (fig. 1), for example, the painting in the background depicts the story of Adonis, who was lured away from his beloved Venus to the hunt, where he was killed by a wild boar sent by the jealous god Mars. Just as *The Messenger* is a contemporary seventeenth-century version of the tale of Venus and Adonis, the amorous associations of the *Elegant Couple in an Interior* are reiterated by the painting over the mantlepiece, which, though only partly visible, depicts an embracing couple in classical drapery.

A copy of this painting was in the collection of Lord Dunsany as Cornelis de Man.[9]

O.N.

1. For *The Messenger*, see The Hague, Mauritshuis, cat. 1977, p. 245, no. 685, ill.

2. See, for example, the *Merry Company in an Interior*, on the New York art market (Hoogsteder-Naumann, Ltd., *A Selection of Dutch and Flemish Seventeenth-Century Paintings* [New York, 1983], pp. 101–5).

3. See Naumann 1981a, vol. 1, pp. 102–3 n. 3.

4. The painting in the Louvre (cat. 1979, p. 145, inv. 1928, ill.) is related to several of de Hooch's works; see especially Sutton 1980, cat. 113, pl. 116, cat. 112A, pl. 115, and cat. 98, pl. 100. Also see de Hooch's *Woman Nursing an Infant* (pl. 104).

5. Sutton 1980, cat. 108, pl. 110. Few formal parallels exist, but note the similar stance of the prominent female figure.

6. Constantijn Huygens, the cultivated secretary to the stadholder, recalled that he learned to play the viola, the lute, and the spinet at a very early age (cited in Playter 1972, p. 59). H. J. Raupp has pointed out that the ability to play musical instruments was a symbol of status in seventeenth-century Holland ("Musik im Atelier," *Oud Holland*, vol. 92, no. 2 [1978], p. 107).

7. Ripa 1644, p. 341, in the reprinted edition, Soest, 1971. Compare Amsterdam 1976, p. 74.

8. De Jongh 1971, p. 178.

9. *Oud Holland*, vol. 52 (1955), p. 101, fig. 16.

Johannes Vermeer

Delft 1632–1675 Delft

Literature: De Monconys 1665–66, p. 149; Bleijswyck 1667, pp. 859ff.; Houbraken 1718–21, vol. 1, p. 236; van Eynden, van der Willigen 1816–40, vol. 1, p. 164; Nagler 1835–52, vol. 20, p. 117; Immerzeel 1842–43, vol. 3, p. 180; Waagen 1854–57, vol. 4, p. 482; Kramm 1857–64, vol. 6, pp. 1725, 1727; Thoré-Bürger 1866; Obreen 1877–90, vol. 4, pp. 289–304; Bredius 1885a; Havard 1888; Wurzbach 1906–11, vol. 2, pp. 774–77; Hofstede de Groot 1907; Hofstede de Groot 1908–27, vol. 1, pp. 579–607; Bredius 1910; Plietzsch 1911; Voss 1912; Hale 1913; Bredius 1916c; Bouricius 1925; Henkel 1931–32; Valentiner 1932; Lazarev 1933; von Schneider 1933, pp. 79–81; Heppner 1935; Rotterdam 1935; Hale 1937; Heppner 1938; Boogaard-Bosch 1939; van Thienen n.d.; E. Trautscholdt in Thieme, Becker 1907–50, vol. 36 (1940), pp. 265–75; Neurdenburg 1942; Blum 1945; van Peer 1946; van Gelder 1948; de Vries 1948; van Thienen 1949; Swillens 1950; Neurdenburg 1951; van Peer 1951; Gowing 1952; Malraux 1952; Bloch 1954; van Peer 1957; van Gelder 1958; Goldscheider 1958; van Peer 1959; Maclaren 1960, pp. 435–36; Goldscheider 1964; Seymour 1964; The Hague/ Paris 1966; Rosenberg et al. 1966, pp. 114–23; Schwarz 1966; Gerson 1967; Koningsberger 1967; Gudlaugsson 1968b; Kühn 1968; van Peer 1968; Slive 1968; Fink 1971; Kahr 1972; Grimme 1974; Blankert 1975; Welu 1975a; Amsterdam 1976, pp. 268–71; Gerson 1977; Montias 1977a; van Straaten 1977a; Welu 1977a; Wheelock 1977, pp. 261–321; Blankert 1978b; Braunschweig 1978, pp. 164–69; Montias 1980; Seth 1980; Wheelock 1981.

Born in Delft, where he was baptized on October 31, 1632, Johannes Vermeer was the second child and only son of Reynier Jansz. and Digna Balthasars of Antwerp. In 1638 the family lived in a small house on the narrow Voldersgracht. In 1641 Reynier, a Protestant silk-weaver, innkeeper, and art dealer purchased a large house with an inn, the "Mechelen," which lay on the north side of the Marktveld on the southwestern corner of the Oudemanhuissteech. Leonaert Bramer (1596–1674) and Carel Fabritius (1622–1654), both respected Delft artists, have been suggested as possible candidates for Vermeer's teacher. Although Vermeer apparently inherited Reynier's property and business in October 1652, no evidence suggests that he succeeded his father as innkeeper; however, the artist apparently was a practicing art dealer.

On April 5, 1653, Vermeer married Catharina Bolnes of Delft. Catharina's mother, Maria Thins, a wealthy Catholic divorcée, had originally objected to the marriage, and the artist Leonaert Bramer, a Catholic, had interceded on Vermeer's behalf. Although the couple may have had as many as fourteen children, only eight of the children's names are known. In time good relations were evidently established between Vermeer and his mother-in-law; the artist's family eventually moved from the "Mechelen" into her house on the Oude Langendijk, and Vermeer is believed to have converted to Catholicism.

Recently discovered archival material reveals that Vermeer met Gerard ter Borch (q.v.) in Delft in 1653, when both artists witnessed the signing of an affidavit. On December 29 of that year, Vermeer was admitted as a master to the painters' guild, and in 1662, 1663, 1670, and 1671, he served as a hoofdman (leader). Contemporaries apparently thought highly of his talent. Balthasar de Monconys, a French nobleman who visited Vermeer in Delft in 1663, reported that his paintings were expensive, and four years later a poem by Arnold Bon in Dirck van Bleijswyck's Beschryvinge der Stadt Delft of 1667 refers to the artist as a worthy successor to the "Phoenix" Carel Fabritius, who had died in 1654. Vermeer's expertise as a connoisseur of paintings was also acknowledged. On May 23,

1672, he was called to The Hague to judge the authenticity of paintings attributed to Holbein, Raphael, Giorgione, and Titian.

Despite inheritances from his mother and sister in 1670 and 1671, Vermeer was troubled by financial difficulties that continued until his death. Buried in the Oude Kerk in Delft on December 15, 1675, the artist was survived by eleven children, eight of whom were underage, and his wife, Catharina. An inventory of Vermeer's estate was filed on February 29, 1676, and in April, Catharina petitioned for bankruptcy. On September 30 Antonie van Leeuwenhoek, the famed microscopist and apparently a friend of the artist, was named trustee for Vermeer's estate.

Vermeer's artistic production was small; only thirty-four paintings have survived. In addition to genre scenes, he also executed religious subjects, allegories, and cityscapes. No students are known.

C.v.B.R.

Girl with Wineglass, c. 1658–61
Oil on canvas, 25⅝ x 30¼" (65 x 77 cm.)
Gemäldegalerie, Staatliche Museen Preussischer
Kulturbesitz, Berlin (West), no. 912C

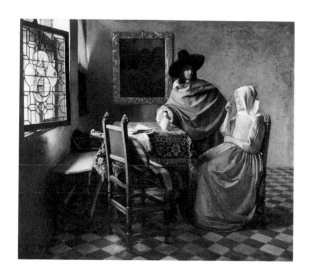

Provenance: Sale, Jan van Loon, Delft, July 18, 1736, no. 16
(52 guilders); John Hope, Amsterdam, 1785; Hope's heirs,
England, 1794; Sir Henry Thomas Hope Collection, Deep-
dene, Surrey, 1862; Lord Henry Francis Pelham Clinton
Hope, cat. 1891, no. 54; sale, London, 1898, no. LIV, ill.;
sale, London, entire collection to P. & D. Colnaghi and A.
Wertheimer, London; acquired by W. von Bode for the
museum, 1901.

Exhibitions: Washington/New York/Chicago 1948–49, cat.
no. 139; Amsterdam 1950, cat. no. 111; Paris 1951, no.
121.

Literature: Hoet 1752, vol. 2, p. 390; Thoré-Bürger 1866, p.
552, no. 20; Hofstede de Groot 1907–28, vol. 1, p. 603, no.
37; Plietzsch 1911, pp. 64, 114, no. 37, pl. xxiii; M. Eisler,
"Der Raum bei Jan Vermeer," *Jahrbuch der kunst-
historischen Sammlungen des allerhöchsten Kaiserhauses,*
vol. 33 (1916), pp. 270–71; von Weiher 1937, pp. 111–12;
Plietzsch 1939, pp. 23, 25–26, 61, no. 29, pl. 17; E. Traut-
scholdt in Thieme, Becker 1907–50, vol. 34 (1940), p. 268;
Neurdenburg 1942, pp. 65–69; de Vries 1945, pp. 51, 110,
no. 12, pl. 40; Swillens 1950, pp. 55–56, no. 15, pl. 15; E.
Plietzsch, "Randbemerkungen zur Ausstellung holländischer
Gemälde im Museum Dahlem," *Berliner Museen,* n.s., vol. I
(1951), pp. 39–40, ill. no. 6; Gowing 1952, p. 112, no. ix,
pls. 18–20; Goldscheider 1958, pp. 135–36, no. 11, pls. 30–
33; Bloch 1963; Grimme 1974, pp. 48–50, ill.; Berlin
(West), Gemäldegalerie, cat. 1975, p. 454, no. 912C; Berlin
(West), Gemäldegalerie, cat. 1978, p. 462, no. 912C; Whee-
lock 1977, pp. 280–81, ill. nos. 85–86; Blankert 1978b, pp.
35, 40, 158, no. 8, pls. 8a–b; R. Klessmann in Braunschweig
1978, pp. 165–68, under no. 39; Wheelock 1981, p. 90,
pl. 14.

In cool daylight filtered through a stained-glass
window, an elegant cavalier stands next to a
young woman seated at a table.[1] She drinks
wine, tilting the glass to her face as if to avoid
his attentive gaze; holding a jug, he is ready to
offer her more wine. An amorous relationship,
perhaps of a dubious sort, is suggested with
great delicacy;[2] nothing in the scene is coarse or
explicitly erotic. A clue to the picture's message
may be the lute, a prop favored by Vermeer (see
Woman Tuning a Lute, pl. 107). This instru-
ment, generally seen as a symbol of harmony,

also carried the negative association of frivolity.[3]

The calmness of the couple is matched by the
clear construction of the interior. The corner of
a room is shown in an exact perspectival projec-
tion of simple orthogonal relationships; the
window sill and the table follow this alignment,
as does—in complex perspective—the diamond-
shaped pattern of the floor tiles. Even the com-
bination of profile and frontal views of the
couple maintains the orthogonal principle of
arrangement. The cavalier's gaze and the place-
ment of the chair with the lute diverge,
emphasizing the thematic significance of these
two elements; the same is true for the partly
opened window with the coat of arms.[4] Vermeer
depicted this window again in *Woman and Two
Men* (fig. 1); in both cases the female figure
holds knotted bands or straps in her left hand. A
similar motif appears in an emblem published by
Gabriel Rollenhagen in 1617 (fig. 2); the
straps form a bridle that, along with the square in the
figure's other hand, is an attribute of Temperan-
tia (moderation).[5] "Serva modum" (preserve
moderation) is the emblem's motto. The Tem-
perantia of the leaded-glass window makes the
same appeal, less appropriately in the Berlin
painting than in the more provocative Braun-
schweig canvas.

While Vermeer emphasized light in his earlier
paintings, here, a new accent is placed on color.
The red, blue, and yellow stained glass refracts
the daylight into colors at its source, the win-
dow. The interior is given its own hue; where-
ever color is lacking, bluish tonal nuances
emerge through the curtain on the rear window
and in the stone gray of the walls. The glowing
colors of the figures and furnishings are balanced
spatially; the expansive color of the picture re-
sults from a significantly broadened space.

Vermeer had previously conceived his middle-
class interiors as close-ups of human figures con-
fined by their immediate surroundings, as in the
Woman Reading a Letter (Gemäldegalerie Alte
Meister, Dresden, no. 1336), the *Soldier and
Laughing Girl* (cat. no. 88, fig. 2), and the
Milkmaid (Rijksmuseum, Amsterdam, no.
A2344). The Berlin painting, the first in which
he abandoned this close view, allows the viewer
to step back, and the new distance broadens the
angle of vision. The interior is no longer subor-
dinate to the figures; now part of the interior,
they are set amidst the larger context of their

FIG. 1. JOHANNES VER-
MEER, *Woman and Two
Men*, oil on canvas, Herzog
Anton Ulrich-Museum,
Braunschweig, no. 316.

FIG. 2. Emblem from
GABRIEL ROLLENHAGEN, ed.
Selectorum Emblematum
(Arnhem, 1617).

surroundings. In addition, color, light, and at-
mosphere exhibit new freedom of movement.

These innovations characterize Vermeer's first
mature style, of c. 1658–61. The precise model-
ing of forms and the somewhat pasty application
of color—especially in brightly lit areas—relate
the Berlin picture to his earlier works. The
monumental forms of the Amsterdam *Milkmaid*
have retreated, yet the subtle brushwork of the
Braunschweig *Woman and Two Men* is still to
be achieved. The Braunschweig "pendant," in
many ways related to the Berlin painting, reflects
Vermeer's stylistic development toward 1662,
particularly the influence of Frans van Mieris the
Elder.[6] The Berlin picture was most likely ex-
ecuted around 1660–61;[7] however, a slightly
earlier date is tenable, though the painting can-
not be placed earlier than the first masterpieces
of Pieter de Hooch, Vermeer's Delft colleague.
De Hooch's *Woman Drinking with Soldiers* (pl.
102) and *Woman Drinking with Two Men and
a Maidservant* (pl. 101), both of c. 1658, antici-
pate Vermeer not only in subject matter but also
in the spacious arrangement of interiors suffused
with bright daylight.[8] Works from de Hooch's
mature period are conceived and arranged pri-
marily according to the architecture of the
interior space, a practice that was one of the
master's most important contributions to the
history of painting. De Hooch was one of the
first Dutch genre painters to have created a "nat-
ural environment" for his figures. That he was
surpassed by Vermeer, a talent of the highest
rank, in no way diminishes his contribution.

The Berlin picture's impressive, calculated
composition attests to Vermeer's transformation
of de Hooch's interior type. Furthermore, the
illusionistic technique is fully present in the dif-
ferentiation of surface values without being
exhausted for these purely objective ends. The
diffused light enhances the qualities of objects.
The girl's silk dress shines like the pure cool
shades of fresh roses. Indeed, there is little to
indicate that this figure's chastity may be com-
promised by the wine. A purely aesthetical
response, however, is incomplete without con-
sideration of content. The restless quality of light
and the somber landscape painting beside the
cavalier provide counterpoints to the studied
order of the interior, perhaps as evocations of
the spiritual state of the room's inhabitants.

J.K.

1. When this painting was purchased, the window area
showed extensive overpainting, which was subsequently re-
moved without damage to the original paint surface; the rear
window had been painted out, and a curtain had been added
to the front window, which offered a view into a wooded
landscape. See Plietzsch 1951, p. 41, pl. 6.

2. Paul warned against succumbing to the pleasure of wine
(Ephesians 5:18). The Dutch considered alcohol consump-
tion, especially by women, a serious offense against common
decency. See Amsterdam 1976, pp. 248–49, no. 6; and
Braunschweig 1978, p. 97, no. 17.

3. On music and love in Vermeer's paintings, see A. P. de
Mirimonde, "Les sujets musicaux chez Vermeer van Delft,"
Gazette des Beaux-Arts, vol. 57, no. 4 (1973), p. 49. On the
lute as an erotic motif, see Amsterdam 1976, pp. 59–61,
no. 8.

4. Neurdenburg 1942 (pp. 65–69) identifies the arms as
those of Janetje J. Vogel (died 1624), first wife of Moses J.
Nederveen. The couple lived in Delft, probably in the house
later inhabited by Vermeer. The coat of arms—perhaps in the
form of a stained-glass window—may have been in his home.

5. The interpretation as a personification of Temperantia
goes back to J. Müller, Kiel. See the extensive discussion of
the Braunschweig Vermeer in the catalogue by R. Klessmann
(Braunschweig 1978, pp. 165–68); see also Klessmann's *Die
holländischen Gemälde* (Braunschweig, 1983), pp. 208–9,
no. 316.

6. Naumann (1981a, vol. 1, p. 61) identifies this influence in
the Berlin painting, specifically in details of costume (the hat
and the cavalier's cloak) and in the motif of the wine jug
(presumably Delft faience) that are reminiscent of van
Mieris's works of 1660 (see cat. no. 75) and of 1661 in the
Mauritshuis, The Hague. But these are external connections.
In fact there is no apparent stylistic evidence of contact with
the Leiden master until the Braunschweig Vermeer, where
parallels can be seen in both the painting technique and in the
undisguised flirtatiousness of the scene.

7. Blankert 1978b, pp. 40, 158, no. 8 (with references to
earlier dating suggestions); Wheelock (1981, pl. 90) dates the
painting c. 1658–60.

8. Plietzsch (1911, pp. 25–28) was the first to acknowledge
de Hooch's influence on Vermeer's early interiors; see Sutton
1980, pp. 23, 61 n. 24 (with a concise discussion of the
contradictory scholarly opinions); see also Blankert 1978b,
pp. 29–30 and Wheelock 1981, pp. 21–22, 90.

Woman Tuning a Lute, mid-1660s
Oil on canvas, 20¼ x 18″ (51.4 x 45.7 cm.)
The Metropolitan Museum of Art, New York,
Bequest of Collis P. Huntington, 1900,
25.110.24

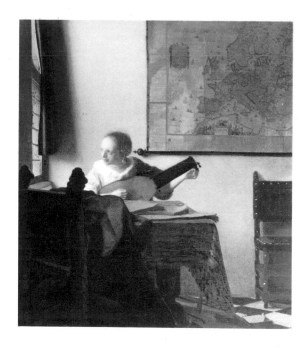

Provenance: Sale, P. van der Schley and Daniel de Pré, Roos, Amsterdam, December 22, 1817, no. 62, to Coclers (65 guilders); purchased in England by Collis B. Huntington, New York, bequeathed by him to the museum, 1897; transferred to the museum by his son, 1925.

Exhibitions: New York, Metropolitan Museum of Art, *The Hudson-Fulton Celebration,* 1909, no. 135, ill.; New York, Metropolitan Museum of Art, *Fiftieth Anniversary Exhibition,* 1920; Philadelphia, Philadelphia Museum of Art, *Diamond Jubilee Exhibition: Masterpieces of Painting,* 1950–51, no. 42 (as 1663–64); New York, Metropolitan Museum of Art, *The Painter's Light,* 1971, p. 8, no. 13 (as c. 1664).

Literature: J. Breck, "L'Art Hollandais à l'exposition Hudson-Fulton à New York," *L'Art Flamande et Hollandais,* vol. 13 (1910), p. 57; K. Cox, "Dutch Pictures in the Hudson-Fulton Exhibition," *The Burlington Magazine,* vol. 16, no. 82 (January 1910), p. 245; Plietzsch 1911, pp. 61, 118 n. 30 (as latter half of 1660s) ([Munich, 1939], p. 60, no. 19); Hofstede de Groot 1913, suppl. 1, no. 45, pl. 45; Hale 1913, pp. 258–60; Johansen 1920, pp. 197–98 (as c. 1665–67); "Pictures Lent for the Fiftieth Anniversary Exhibition," *Metropolitan Museum of Art Bulletin,* vol. 15, no. 8 (August 1920), p. 184; "The Collis P. Huntington Collection Comes to the Museum," *Metropolitan Museum of Art Bulletin,* vol. 20, no. 6 (June 1925), pp. 142, 144 ill. (see also H. B. Wehle, p. 180); Vanzype 1925, p. 87, pl. 39; Chantavoine 1926, pp. 36ff., 47 (as 1660s); E. Trautscholdt in Thieme, Becker 1907–50, vol. 24 (1926), p. 268; Valentiner 1932, p. 324 (as after 1660); Blum 1945, p. 33; E. E. Gardner, "Thoré's Sphinx," *Metropolitan Museum of Art Bulletin,* n.s., vol. 7, no. 3 (November 1948), p. 77, ill., and p. 78; de Vries 1948, pp. 40, 89, no. 20, pl. 20 (as c. 1663–64); Swillens 1950, pp. 31, 52, nos. 6, 67, 72, 79ff., 87, pl. 6; Gowing 1952, pp. 132ff., no. 16 ([New York, 1970], pp. 132–34, pl. 40); Malraux 1952, p. 68, no. 15, p. 18, opp. p. 71, ill.; Bloch 1954, p. 34, pl. 52 (as c. 1665); Goldscheider 1958, p. 137, no. 18, pls. 46, 47 (as c. 1664); de Mirimonde 1961a, pp. 37ff., fig. 2, p. 31; Jacob, Bianconi 1967, p. 93, no. 27, fig. 27, pls. 45, 47 (as 1663–64); Gerson 1967, col. 743; E. Fahy and F. Watson, *The Wrightsman Collection,* vol. 5 (1973), p. 316; Walsh, von Sonnenburg 1973, no. 4,

pl. 46; Grimme 1974, cat. no. 26, fig. 17 (as c. 1666 or later); Blankert 1975, p. 166, no. B1, and p. 200, ill.; Welu 1975a, p. 42; Wright 1976, p. 48, no. 22, ill.; Gerson 1977, p. 289; Blankert 1978b, p. 77 n. 61, pp. 78 n. 100, 169, 171, no. B1; C. Brown (review of Blankert 1978b), *Apollo,* vol. 112 (1980), p. 66; Slatkes 1981, pp. 60–61 (as c. 1662–65); Wheelock 1981, pp. 112–13, pl. 25.

A young woman sits alone in a room, tuning a lute while gazing out the window at the left. With her left hand she adjusts the peg on the lute, and with the other she plucks a chord. Various books, apparently containing musical scores, lie strewn about on the table before her. An additional *liedboek* (songbook) is visible on the tiled floor beside a bass viol that protrudes from beneath the table. On the near side of the table there is a chair with carved lion's-head finials. A large piece of drapery, possibly an article of clothing such as a cloak, lies on the table. A map of Europe hanging on the back wall and another chair, matching the one in the foreground, complete the scene.

Despite the simplicity of this domestic interior, or perhaps because of it, observers have sought to interpret it as part of a larger narrative. The study by de Mirimonde (1961a), though erroneous in some respects,[1] formed the basis for speculative interpretation. The author reasoned that the lady awaits the arrival of a male visitor who will accompany her on the bass viol. Given the traditional associations between music and love in the literature and art of the day,[2] the musical accompanist could be the lady's lover. The woman's expression might, therefore, be one of anticipation, but also could simply be self-absorbed concentration—her full attention devoted to the sound of a note. This alternate interpretation need not obviate a possible reference to the woman's expected partner. Those acquainted with musical instruments know that when one stringed instrument is tuned, another in the immediate vicinity will resonate. The Dutch moralist Jacob Cats was well aware of this phenomenon when he interpreted a scene of a man with a lute (fig. 1) as suggestive of the emotional empathy of lovers.[3] As the strings of musical instruments resonate, so the "heart-strings" of two lovers sound as one.

The map, based on a known chart of Europe,[4] also could hint at a man absented from the music chamber. The words EUROPE and MARE ATLANTICUS might suggest that he is a traveler on a journey. The map's traditional associations

FIG. 1. Emblem from JACOB CATS, *Proteus Ofte Minne-beelden Verandert in Sinne-beelden* (Amsterdam, 1658).

with worldliness (see cat. no. 78), may also serve to contrast the intimate domicile with the outside world.

Perhaps because of problems relating to its condition, the *Woman Tuning a Lute* has proved difficult to place in Vermeer's accepted oeuvre. The hardness of the picture in its overpainted state before the extensive restoration of 1944 could reasonably have prompted a dating late in the artist's career. However, a comparison between this image and a photograph taken after cleaning but before inpainting reveals a striking transformation. Although some glazes have been lost,[5] the delicacy of touch, the softness of contour, and the overall hazy atmosphere are all qualities that link the picture with the *Lady Writing* in Washington, D.C. (National Gallery of Art, no. 1664). Consequently, the painting should be considered an authentic—albeit somewhat damaged—Vermeer, and, like the *Lady Writing*, should be dated to the mid-1660s.

O.N.

1. Although de Mirimonde's interpretations (1961a) might be revealing for certain individual pictures, the author's approach—to view Vermeer's musical scenes as episodes before, during, and after the concert—is wholly unhistorical. The author himself would admit that when the paintings are arranged in order of execution (to the extent that this is possible), they fail to illustrate a continuous narrative.

2. See Walsh, von Sonnenburg 1973, p. 196; and Amsterdam 1976, pp. 105–107.

3. Slatkes (1981) was the first to associate this emblem with the painting. Our illustration, from Cats's *Proteus Ofte Minne-beelden* (p. 86), is taken from the 1658 edition of the author's collected works (*Alle de Wercken* [Amsterdam]). Additional verses go on to explain musical resonance and its application to the hearts of lovers: "Eens was ick op een tijt by Rosemont gekomen,/ Ick hadde met beleyt twee luyten mee genomen;/ Op d'eene lag een stroo (siet! wat een vreemde streek)/ Dat sprong in haesten op, met dat de toon geleeck/ Ghy roert my, Rosemont, ghy roert my sonder raecken,/ En, schoon ick elders ben, noch kondy my genaecken:/ Siet! daer twee herten zijn op eenen toon gepast,/ Daer voelt men menigmael oock dat men niet en tast." (Once upon a time when I visited Rosamund,/ I had brought two lutes, on purpose;/ On one of them a straw was lying, and look how curious:/ It rapidly jumped up as soon as the tone corresponded./ You touch me, Rosamund, you stir me without touching me,/ You reach me in spite of my being elsewhere:/ Look! Where two hearts are tuned to one tone,/ One can often feel without touching) (author's translation).

4. According to Welu (1975a), the map was designed by Jodocus Hondius in 1613; however, only one example of the original plan is extant. The map was reissued by Jan Blaeu in 1659 with minor changes; three examples of this later edition survive.

5. H. von Sonnenburg's report in the museum files (February 1964) concludes that there is as much as eighty-percent paint loss in some areas. It is estimated that approximately one-third of the surface is covered with old repaint. The damaged areas are confined largely to the lower left, throughout the dark foreground section and extending upward along the left edge. Although the shadow in the upper left is damaged, the curtain itself is in good condition, as is the window, the map, the face of the girl, the tabletop, and the lower portion of the wall near the window sill.

Woman Holding a Balance, c. 1662–64
Oil on canvas, 16¾ x 15″ (42.5 x 38 cm.)
National Gallery of Art, Washington, D.C.,
Widener Collection, inv. no. 693

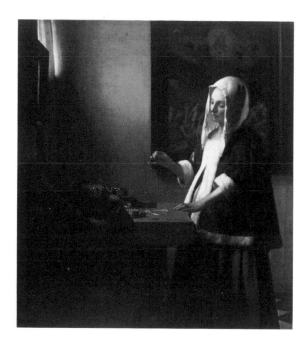

Provenance: Sale, Dissius, Amsterdam, May 16, 1696, no. 1;
Isaac Rooleeuw, Amsterdam; sale, Amsterdam, April 20,
1701, no. 6; Paolo van Uchelen, Amsterdam, 1703; sale,
Amsterdam, March 18, 1767, no. 6, to Kok (170 guilders);
sale, Nicolaas Nieuhoff, Ph. van der Schley, Amsterdam,
April 14, 1777, no. 116, to van den Bogaard (235 guilders);
sale [Roi di Bavière], Munich, December 5, 1826, no. 101
(as "Gabriel Metzu, et selon d'autres van der Meer . . ."");
sale, Duc de C[araman], Lacoste, Paris, May 10, 1830, no.
68; sale, Casimir Péreir, Christie's, London, May 5, 1848,
no. 7, to Péreir's son (141 pounds sterling and 15 shillings);
sale, Comtesse de Ségur-Péreir; dealer F. Lippmann, London;
P. & D. Colnaghi's, London; P.A.B. Widener, Lynnewood
Hall, Elkins Park, Pa., by 1913 (cat. 1913, vol. 1, no. 47 ill.);
Joseph Widener, Lynnewood Hall, cat. 1931, p. 50; National Gallery, Widener Collection, 1942.

Literature: Hoet 1752, vol. 1, p. 62; Thoré-Bürger 1866, no.
26/27; C. Hofstede de Groot, "A Newly Discovered Picture
by Vermeer of Delft," *The Burlington Magazine*, vol. 18, no.
93 (December 1910), pp. 133–34; Bode 1911; Plietzsch
1911, p. 49, no. 35; Hofstede de Groot 1908–27, vol. 1, no.
10; T. von Frimmel, "A Woman Weighing Pearls" by Vermeer
of Delft," *The Burlington Magazine*, vol. 22, no. 115 (October 1912), pp. 48–49, ill.; de Vries 1945, no. 23, fig. 49 (as
c. 1662–63); Rudolph 1938, pp. 408–9; Swillens 1950, p.
105; Gowing 1952, pp. 135–36, pls. 44–46; Bloch 1963 (as
1660–65); Goldscheider 1967, no. 21 (as 1665); Jacob,
Bianconi 1967, cat. 24 (as c. 1662–63); R. Carstensen and
M. Putscher, "Ein Bild von Vermeer in medizinhistorischen
Sicht," *Deutsches Aerzteblatt-Aertzliche Mitteilungen*, vol.
68, no. 52 (1971), pp. 1–6; Walsh, von Sonnenburg 1973, p.
79, ill.; Blankert 1978b, pp. 22, 41–44, 49, 54, 67, no. 15
(as 1662–65); Grimme 1974, p. 54, cat. no. 17, pls. 11, 12
(as c. 1665); S.A.C. Dudok van Heel, in *Jaarboek van het
Genootschap Amstelodamum*, vol. 37 (1975), p. 162; Alpers
1976, p. 25; A. K. Wheelock, Jr. (review of Blankert 1975),
The Art Bulletin, vol. 59 (1977), pp. 439–41; Seth 1980, pp.
32–34, 39, fig. 8; Sutton 1980, p. 45 n. 37, ill.; Slatkes
1981, pp. 55–56, ill. (as c. 1662–63); Wheelock 1981, pp.
106–9 (as c. 1662–64); Salomon 1983, ill.

In the corner of a room, a woman in white headdress and fur-trimmed jacket stands at a table.
She holds a balance in her right hand; her left is
poised on the table's edge. The carpet covering
the heavy piece of furniture has been pushed
back to make room for an open box filled with
pearls and gold jewelry, as well as other smaller
boxes, ribbons, another strand of pearls, and
coins. A mirror hangs on the wall at left, where
light falls from a window. The light divides the
scene diagonally into two virtually equal triangles of light and shadow. The lighted triangle
is intersected by the darkened rectangle of a
painting, which equals exactly one-fourth of the
picture space. At the center of the painting's superbly rational and understated geometry is the
balance.

With only three dated paintings, Vermeer's
oeuvre presents renowned uncertainties of chronology.[1] Nonetheless, writers have reached a
consensus in dating the Washington painting to
the early 1660s or, more precisely, c. 1662–
64/5. There are two closely related paintings that
also restrict their subject to the solitary figure of
a woman standing in profile before a table:
Woman Reading a Letter (fig. 1) and *Woman
with a Pearl Necklace* (Gemäldegalerie,
Staatliche Museen Preussischer Kulturbesitz,
Berlin [West], no. 912B). These, along with
Woman Holding a Balance, represent the pinnacle of Vermeer's achievement of classical
simplicity and repose. Despite the everyday
theme, the image has timeless grandeur, balance,
and serenity. Aspects of the design, to be sure,
are not without precedent; Blankert compared
the woman's still three-quarter-length figure
to that of the clavichord player in Frans van
Mieris's *Duet* of 1658 (fig. 2).[2] Yet, in characteristic fashion Vermeer improves an already
successful idea by a studious reduction and consolidation of forms and an expressive new use of
light.

When the painting was sold in 1696 it was
described as "a young woman weighing gold, in
a little case box . . . painted in an uncommonly
artful and powerful manner."[3] Gold weighers, as
several writers have pointed out, were popular
subjects among Northern painters from the sixteenth century onward.[4] In addition to those
who assumed that the woman weighs gold, there
were others who believed she weighs pearls. One
of these authors was Herbert Rudolph, who in a

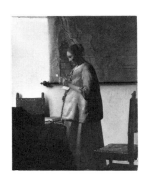

FIG. I. JOHANNES VER-MEER, *Woman Reading a Letter*, oil on canvas, Rijksmuseum, Amsterdam, no. C251.

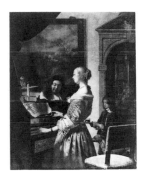

FIG. 2. FRANS VAN MIERIS, *The Duet*, 1658, oil on panel, Staatliches Museum, Schwerin, no. G82.

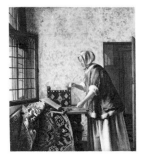

FIG. 3. PIETER DE HOOCH, *Woman Weighing Coins*, oil on canvas, Gemälde-galerie, Staatliche Museen Preussischer Kulturbesitz, Berlin (West), no. 1041B.

pioneering article argued that the *clavis interpretandi* of Vermeer's work was the painting within the painting, a depiction of the Last Judgment.[5] He concluded that the act of weighing pearls was contrasted with the final weighing of souls and saw the woman as a personification of worldliness and vanity. Her role, he reasoned, is supported by other details of the scene, such as the mirror and the costly objects and furnishings. Those who believed the woman weighs gold reached much the same conclusion.[6] Moreover, several observers have seen the woman as occupying the place of Saint Michael, prefiguring in a mundane fashion the archangel's famous role.[7] Recently, however, the notion that the painting is a *vanitas* image has increasingly been rejected, and its potential allusions to the virtues of honesty, justice, temperance, and moderation have been stressed.[8]

Wheelock was the first to point out that microscopic examination of the balance reveals that the scales, in fact, contain neither gold nor pearls, but are empty.[9] The woman is not weighing anything; she is simply adjusting the scales. Another detail that has often been overlooked is the woman's pregnancy. Although the voluminous housecoats worn by women in this period sometimes leave the matter in question, here her state seems undeniable.[10] Ironically, Vermeer had fourteen children but never painted children in his genre scenes; certainly, he had ample opportunity to observe and contemplate pregnancy. Carstensen and Putscher theorized that the painting alluded to the traditional belief that the sex of an unborn child could be divined by weighing pearls.[11] Citing Wheelock's discovery, Salomon rejected the divination theory, reasoning instead that the scales were empty because the fate of the soul of the unborn child had yet to be determined.[12] A controversy over the issue of predestination and free will was raging at this time among various Protestant sects in the Netherlands. Vermeer evidently converted to Catholicism when he married; Salomon asserts that *Woman Holding a Balance* is the artist's statement of his belief in the unborn child's purity, its "unblemished soul." The scales—the central motif of the painting—are empty because the soul's fate at the Last Judgment cannot yet be determined.

The iconographies of both the mirror and the pearl were richly varied, indeed potentially contradictory.[13] One meaning of the pearl (*margarita* in Latin) was its function as the attribute of Saint Margaret, the intercessor at childbirth who also assures a successful term of pregnancy.[14] The mirror symbolizes not only vanity, but also self-knowledge; the blank mirror, Salomon suggests, could allude to the unborn child's unknown future. Salomon's argument relating the painting to the concept of free will is more persuasive than her effort to link the image with astrological symbolism (the scale as the sign of Libra) or her implication that the *kastje* in which the painting appeared in 1696 in the Dissius sale may have been designed to ensure private viewing for Catholic patrons.[15] Certainly the "little box" was not a perspective device or peepshow as some have supposed;[16] rather, like the curtains that frequently hung over paintings, it probably was designed to protect the painting. Three unidentified paintings by Vermeer were listed in the Dissius inventory of June 20, 1682, as in *kastjes,* and Dou's paintings were frequently placed in cases or boxes.[17] Moreover, there is little reason to think this "Catholic" painting would have been too controversial to be displayed openly if its subject was misconstrued as early as 1696.

The impact of *Woman Holding a Balance* was felt almost immediately among Vermeer's contemporaries. Pieter de Hooch's *Woman Weighing Coins* (fig. 3) and Pieter Janssens Elinga's *Woman with a Strand of Pearls* (Bredius Museum, The Hague, no. 54) are based on the picture. The former places greater emphasis on the space, opening a doorway at the right, while omitting Vermeer's *clavis interpretandi,* changes that are highly characteristic of de Hooch. Great as de Hooch's Berlin painting is, it diminishes the concentration and power of Vermeer's prototype.

P.C.S.

Lady at the Virginals with a Gentleman,
c. 1662–65
Signed lower right: IVMeer (IVM in ligature)
Oil on canvas, 28⅞ x 25⅜″ (73.3 x 64.5 cm.)
Her Majesty Queen Elizabeth II

1. *The Procuress,* dated 1656, is in the Gemäldegalerie Alte Meister, Dresden; *The Astronomer,* dated 1668, was recently acquired by the Musée du Louvre, Paris; and *The Geographer,* dated 1669, is in the Städelsches Kunstinstitut, Frankfurt, inv. no. 1149.

2. Blankert 1978b, p. 44.

3. The description "Een Juffrouw die goud weegt, in een kasje . . . extraordinaer konstig en kragtig geschildert" appears in *Catalogue van schilderijen, Vekogt den 16. May 1696, in Amsterdam,* no. 1; see Blankert 1978b, p. 145.

4. See Gowing 1952 n. 101; and Blankert 1978b, p. 45. Gold weighers also were depicted by the Master of Female Half-Lengths, Jan van Hemessen, and, in the seventeenth century, Willem de Poorter, Gabriel Metsu, Gerard Dou, and Vermeer's hypothetical teacher Leonaert Bramer, as well as by Cornelis de Man (see cat. no. 69).

5. Rudolph 1938. De Vries (1945, p. 56, no. 23) and Swillens (1950, p. 105) also entitled it the "Pearl Weigher."

6. See Gowing 1952, pp. 135–36; and Blankert 1978b, p. 45.

7. See Gowing 1952, p. 135; Wheelock 1981, p. 106; and Slatkes 1981, p. 56.

8. For Swillens (1950, p. 105), the Last Judgment scene pointed to "consideration . . . honesty and religious sense"; Alpers (1976, p. 25) stressed the allusion to ideals of justice (Justitia); Wheelock (1977, p. 460; and 1981, p. 106) saw in the painting "a statement about the importance of temperance and moderation in the conduct of one's life," a view also promoted by Seth (1980, pp. 32–34, 39), who interpreted the balance as "a symbol of consideration, temperance and related virtues."

9. Wheelock 1977, p. 106.

10. The woman in the Rijksmuseum's painting (fig. 1) appears to be pregnant; compare also the woman at the right in *The Concert* (cat. no. 1, fig. 1).

11. R. Carstensen and M. Putscher, "Ein Bild von Vermeer in medizinhistorischen Sicht," *Deutsches Aerzteblatt-Aertzliche Mitteilungen,* vol. 68, no. 52 (1971), pp. 1–6; Walsh (Walsh, von Sonnenburg 1973, p. 79) accepted this theory. On the woman's pregnancy, see Seth (1980, pp. 34, 39) and Slatkes (1981, p. 56).

12. Salomon 1983, pp. 217–19.

13. On pearls, see de Jongh 1975–76; on the mirror, see ter Borch's *Lady at Her Toilet* (cat. no. 13) and van Mieris's *Young Woman Standing before a Mirror* (cat. no. 76).

14. See de Jongh 1975–76, p. 85.

15. Salomon 1983, pp. 219–21.

16. See van Gelder 1948; Boström 1949; and van Regteren Altena 1949.

17. See Blankert 1978b, p. 153, doc. no. 59.

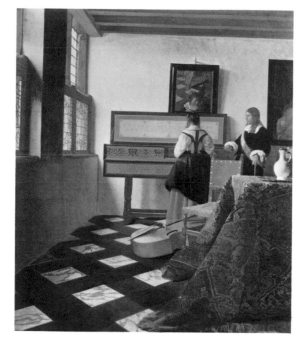

Provenance: Sale, Amsterdam, May 16, 1696, no. 6; Giovanni Antonio Pellegrini, probably acquired in The Hague, 1718; sale, Pellegrini, to Consul Smith; George III, acquired with Smith Collection (in the "Flemish and Dutch List"), no. 91 (as by Frans van Mieris).

Exhibitions: London, Royal Academy, 1946–47, no. 305; The Hague 1948, no. 10.

Literature: Jameson 1842, p. 249, no. 84 (as E. van der Neer); Waagen 1854–57, vol. 2, p. 433 (as E. van der Neer); Thoré-Bürger 1866, no. 10; Hofstede de Groot 1908–27, vol. 1, no. 28; Plietzsch 1939, no. 21; de Vries 1948, p. 86, ill.; Gowing 1952, pp. 37–40, 52–55, 119–27; Bloch 1954, p. 32; de Mirimonde 1961a, p. 47; F. Vivian, "Joseph Smith and Giovanni Antonio Pellegrini," *The Burlington Magazine,* vol. 104, no. 713 (August 1962), pp. 330–33; Rosenberg et al. 1966, pp. 119, 122–23, 271 n. 5; Fink 1971, pp. 500, 502–4; Grimme 1974, no. 13, ill.; Blankert 1978b, pp. 44–45, 162, no. 16, ill.; Wheelock 1981, no. 19, ill.; Slatkes 1981, pp. 63–64; White 1982, pp. 143–45, no. 230, ill.

A woman, her back to the viewer, stands at a virginals at the far end of a room, where a man watches her. In the foreground, a white earthenware jug has been set on a table covered with a turkish carpet. A bass viol lies on the tiled floor beside a chair. On the back wall are a mirror and a painting. The lid of the virginals bears the inscription "MUSICA LETITIAE CO[ME?]S/ MEDICINA DOLOR[IS?]" (music—companion of pleasure, balm of sorrow).

Although the painting now clearly shows Vermeer's signature, it was wrongly assigned to Frans van Mieris in the eighteenth century and to Eglon van der Neer well into the nineteenth—two artists who then enjoyed greater renown.

Within Vermeer's oeuvre, this painting is closest in theme, design, and style to *The Concert* (cat. no. 1, fig. 1), which also juxtaposes a musical company at the far end of a room with a table and still-life elements in the foreground. The interiors of the two paintings are Vermeer's deepest, and the works share a strong interest in perspective and the illusion of space. Nearly identical in size, the two canvases have sometimes been regarded as pendants.[1] Gowing, noting the complementary themes, concluded that they were a "celebration of the pleasures and sorrows of love," an idea summed up in the epigraph of the virginals' legend.[2] On the back wall of *The Concert* hangs Baburen's *Procuress* (cat. no. 1), with its clear allusion to love's sensual delights.[3] In the picture from the Royal Collection, an unidentified painting of Roman Charity is partially visible in the right background.[4] (Vermeer's mother-in-law is known to have owned a picture of this subject.) The story told by Valerius Maximus related how the aged Cimon, who was being starved while imprisoned awaiting execution, was secretly breast-fed by his daughter Pero.[5] In addition to a lesson about familial duty, the theme carries strong erotic associations, which Gowing thought could here allude to amorous captivity.[6] Thus the man listening to the woman's music would be the prisoner of love, the antithesis of the allusions in *The Concert* to love's pleasures. A. P. de Mirimonde's contention that Vermeer emphasized the man's age in this painting to show his predicament in the end of an affair is unconvincing.[7] Slatkes noted the relationship between the pictures but discussed their meanings separately, observing that the subject of Roman Charity was used by the classical author to show the superiority of painting over the other arts as a moral force.[8] Vermeer's inclusion of the painting within the painting, with its subject's reference to filial piety, thus would allude to the positive moral role played by the arts.

An interesting detail in the painting is the mirror, which demonstrates Vermeer's sophisticated understanding of mirror images;[9] the girl's reflection is both slightly out of focus and diminished in scale—actual visual effects that other artists, for example van Mieris (pl. 59), failed to depict accurately. The mirror also reflects the base of the artist's easel, but unlike Vermeer's *Allegory of the Art of Painting* (Kunsthistorisches Museum, Vienna, inv. no. 9128), the artist himself is not depicted. The box just visible beside the easel is probably a paintbox and not a *camera obscura*, as some writers have contended;[10] however, this does not rule out the possibility that Vermeer consulted such a device in executing this work. Both the room's pronounced perspective and the "halated" highlights (note especially the slightly diffused spots of light and color in the carpet and still life in the foreground) are features associated with the use of this instrument.[11]

Dating the work, as with almost all paintings by Vermeer, is largely a matter of conjecture. Like *The Concert* it seems to be a further development of the interiors in Berlin (cat. no. 116) and Braunschweig (cat. no. 116, fig. 1) but not as late as *The Astronomer* of 1668 and *The Geographer* of 1669. Vermeer's painting, like de Hooch's works from the early 1660s (see, for example, *The Linen Chest* of 1663, Rijksmuseum, Amsterdam, no. C1191) displays the tighter manner and smaller figure type that constitute part of the Delft painters' response to ter Borch and the Leiden *fijnschilders*. Consequently, a date in the mid-1660s or c. 1662–65 seems most reasonable.

P.C.S.

Amsterdam 1619/20–c. 1676 Dutch East Indies?

1. See White 1983, p. 145. Vermeer painted other pendants but only in single figure compositions; see *The Astronomer* of 1668 (newly acquired by the Musée du Louvre, Paris) and *The Geographer* of 1669 (Städelsches Kunstinstitut, Frankfurt, inv. no. 1149), and the pendants at the National Gallery, London, nos. 1383 and 2568.

2. Gowing 1952, p. 125.

3. Vermeer very possibly owned this painting, which could have influenced his own early *Procuress* of 1656 in Dresden (Gemäldegalerie Alte Meister, no. 1335).

4. This too may have been the work of a Caravaggesque artist. The theme was popular among the Utrecht painters, who seem to have been influenced by an early composition by Rubens (Hermitage, Leningrad): Baburen's version is in the York City Art Gallery, ter Brugghen's is lost (Nicolson 1958, no. c83), and Honthorst's is known through a copy (Bayerische Staatsgemäldesammlungen, Munich, inv. no. 6670). Paulus Moreelse, Abraham Bloemaert, and Christian van Couwenberg also treated the theme. Gowing (1952, p. 123) compared the painting in Vermeer's picture to one attributed to a follower of Mattheus Stomer in the Prado, Madrid.

5. *Factorum et Dictorum Memorabilium*, bk. 9, ch. 4.

6. Gowing 1952.

7. De Mirimonde 1961, p. 47. The author's habit of reading sequential narratives into the works of Vermeer and other seventeenth-century Dutch genre painters is essentially unhistorical.

8. Slatkes 1981, p. 64.

9. See Fink 1971, p. 500.

10. See, for example, Slatkes 1981, p. 64.

11. On Vermeer's possible use of these devices, see A. Hyatt Mayor, "The Photographic Eye," *The Metropolitan Museum of Art Bulletin*, vol. 5 (1946), pp. 15–26; Seymour 1964; Schwarz 1966; Fink 1971; Wheelock 1977; and Wheelock 1981, pp. 33–39.

Shown in London only

Jan Victors, the older stepbrother of the painter Jacobus Victors (1640–1705), was baptized "Hans" on June 13, 1619, in the Oude Kerk in Amsterdam. Although his artistic training is undocumented, early works indicate that he may have studied with Rembrandt (1606–1669) in the mid to late 1630s, when Jacob Backer (1608–1651), Ferdinand Bol (1616–1680), and Govert Flinck (1615–1660) were apprenticed to the master. In 1642 he married Jannetje Bellers; the couple had nine children before Jannetje's death in 1661. Victors lived in Amsterdam until January 1676. Later that year he sailed to the Dutch East Indies as a siecketrooster *(literally, comforter of the sick) in the service of the East India Company. He died either there or en route.*

Victors's early works include religious subjects and portraits executed in the style of Rembrandt and the history painter Pieter Lastman (1583–1633). After c. 1650 he produced outdoor genre scenes showing village peddlers, quacks, craftsmen, butchers, and vendors. These paintings sometimes resemble, and may have inspired, contemporary works by Nicolaes Maes (q.v.). Victors's scenes of indoor peasant life are less frequent.

C.v.B.R.

Literature: Van Eynden, van der Willigen 1816–40, vol. 1, p. 106; Nagler 1835–52, vol. 20, pp. 222, 224; Immerzeel 1842–43, vol. 3, p. 191; Kramm 1857–64, vol. 6, p. 1752; Leuppe 1879–80; de Vries 1886; Wurzbach 1906–11, vol. 2, pp. 788–89; Bredius 1915–22, vol. 2, pp. 596–600, and vol. 7, pp. 255–56; Thieme, Becker 1907–50, vol. 34 (1940), p. 330; Maclaren 1960, p. 441; Zafran 1977; Miller 1982.

The Dentist, 1654
Signed and dated on the side of the table:
Jan Victoors fe i654
Oil on canvas, 30¾ x 37¼″ (78 x 94.5 cm.)
Amsterdams Historisch Museum, Amsterdam,
Van der Hoop Collection

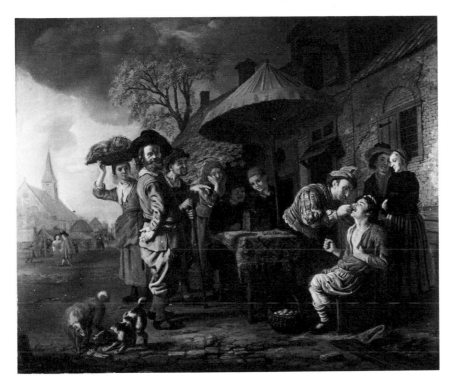

FIG. 1. JAN VICTORS,
Butcher's Shop, 1651, oil
on canvas, York City Art
Gallery, York, no. 79.

FIG. 2. GERARD DOU, *The
Quack,* 1652, oil on panel,
Museum Boymans–van
Beuningen, Rotterdam, no.
st 4.

Provenance: Sale, John Smith, London, to A. van der Hoop,
Amsterdam, 1833; van der Hoop bequest to the city of
Amsterdam, 1854; on loan to Rijksmuseum, Amsterdam,
1885–1973; on permanent loan to the Amsterdams Historisch Museum.

Literature: Thoré-Bürger 1860, pp. 29–30; Bredius et al.
1897–1904, vol. 3, p. 67, ill.; Amsterdam, Rijksmuseum,
cat. 1912, p. 285, no. 2555; Amsterdam, Historisch
Museum, cat. 1975, p. 346, no. 475; Martin 1935/36, vol.
2, p. 128.

Like his colleague Nicolaes Maes, Jan Victors
probably studied the art of painting under
Rembrandt and began to paint genre scenes after
leaving his apprenticeship.[1] Victors excelled at
rendering complex and little-known biblical
themes with a level of quality that is not always
equaled in his less-familiar genre paintings.[2] The
outdoor scenes, often devoted to street life and
featuring itinerant tradesmen, are frequently
peopled by squat figures who gather around a
central person or event. At their best, these
works prove that Victors can rival Maes or
Brekelenkam. Outstanding among Victors's
genre paintings is the *Butcher's Shop* of 1651
(fig. 1), in the York City Art Gallery, a picture
that succeeds largely because the artist reduced
the company to only six people arranged before
an architectural background.

The figures in *The Dentist* are organized in a
frieze-like formation parallel to the picture
plane, while the buildings recede obliquely be-
hind them. In the background, surrounded by
local market stalls, is a village church, one of the
artist's favorite devices.[3] The villagers have inter-
rupted their daily routine to witness the
spectacle of a tooth pulling. Though not as satir-
ical as some depictions of ignorant peasants
being deceived by a clever quack, the artist none-
theless pokes fun at this pseudoprofession. The
umbrella was undoubtedly set up to attract at-
tention, and the itinerant dentist wears an exotic
shirt with slashed sleeves, but the theatrics often
associated with the tooth-puller theme have been
played down.[4]

The scene in this painting is more realistic
than traditional depictions of charlatans and
quacksalvers in Netherlandish art.[5] Perhaps best
remembered through Dou's famous *Quack* of
1652 in Rotterdam (fig. 2), these unschooled
itinerants—the scourge of guild-regulated physi-
cians, barber surgeons, and apothecaries—were
almost always the subject of ridicule in literature
and art.[6] The mockery of the dentist's lack of
professional skills was a central feature of most
representations of the tooth-puller theme in
Dutch and Flemish art, from Bruegel to Mole-
naer. Only a few artists (notably Brekelenkam)
depicted the profession with sympathy. This was
one of Victors's favorite subjects; he depicted
tooth pullers on two other occasions.[7]

This picture probably has meaning beyond
mere depiction. The peasant types on the left
stare with awe and wonder at the painful opera-
tion, while the couple on the right look with
skepticism. By depicting two dogs snarling over
a jawbone in the lower left, the artist has in-
serted an ironic note, perhaps suggesting that the
process of deterioration, made poignant in the
decay and loss of teeth, is only one step in man's
inevitable journey to the grave. Whatever the
precise meaning of the painting, one can be cer-
tain that dentists did a brisk business in the
Netherlands in the seventeenth century. The big
trading companies' ventures in South America
and the Caribbean had greatly increased the
amount of sugar in the average Dutchman's diet.

O.N.

1. In recent literature, Victors is assumed to have studied with Rembrandt, but this tutelage is undocumented and was not even suggested until the nineteenth century (see Ben Broos, "Fame Shared is Fame Doubled," in Amsterdam/ Groningen 1983, p. 47).

2. The biblical pictures have received some study (Zafran 1977), but the portraits and genre paintings—a considerable portion of the artist's oeuvre—have been neglected. Debra Miller is now writing a monograph on Victors for the University of Delaware.

3. Victors also used the church in the *Greengrocer*, 1654, in the Rijksmuseum, Amsterdam (cat. 1976, p. 579, no. C2345, ill.) and the *Village Scene with a Cobbler*, c. 1654, in the National Gallery, London (cat. 1973, p. 790, no. 1312, ill.).

4. Johan Ferdinand Beck, a wandering dentist in eighteenth-century Germany, actually gave theatrical performances on tour. He eventually became a theater director and was given the title "Komödien-Principal" (Proskauer, Witt 1962, pl. 79).

5. See cat. nos. 59 and 105; see also Schotel 1905, pp. 165–90; Bedaux 1975; and Naumann 1981a, vol. 1, pp. 97–103.

6. On Dou's painting, see Emmens 1971, pp. 4a–b, and Amsterdam 1976, pp. 87–89. On surgeons and quacks, see M. A. van Andel, *Chirurgijns, vrije meesters, beunhazen en kwakzalvers. De chirurgijnsgilden en de praktijk der heelkunde (1400–1800)* (The Hague, 1981).

7. One depiction is illustrated in Proskauer, Witt 1962, pl. 89; the other is in the museum in Serpukhov, Russia (cat. by A. Redkin I. Topuriya, 1977, no. 74, ill. [as transferred from Moscow in 1962]). On representations of this theme, see Braunschweig 1978, pp. 106–9. Theodor Rombout's lively *Tooth Puller* in the Prado (cat. 1975, vol. 1, pp. 221–22, no. 1635, vol. 2, p. 160, ill.) was engraved with derisive verses shortly after its execution by Andries Pauwels (1600–1639); see J. J. Pindborg and L. Marritz, *The Dentist in Art* (Chicago, 1960), pp. 34–35, for a reproduction of the engraving and a translation of the caption.

David Vinckboons was born on August 13, 1576, in the Flemish town of Mechelen, where his family was first documented as residents in 1489. His father, Philip (1545–1601), entered the city's painting guild in 1573, about thirteen years after his marriage to Cornelia Carré, the widow of the painter Philip Loemans of Leipzig. The couple had five children. In 1579 they moved to Antwerp, where Philip entered the guild and David became his pupil. According to Karel van Mander, David's earliest training was in watercolors, the medium in which his father specialized. He later studied oil painting with an unknown master. In 1586, when Antwerp came under Spanish control, the Vinckboons family, members of the Protestant sect, was one of the 136 families permitted to emigrate. In 1591, after a brief stay in Middelburg, the family settled in Amsterdam.

On October 8, 1602, David Vinckboons was in Leeuwarden, where he married Agnieta van Loon, the daughter of Jan van Loon, a Leeuwarden notary and attorney, and Mayeke Hasselberch. Agnieta was the sister of the painter Willem van Loon (born c. 1591). Shortly after their wedding the couple resided in Amsterdam, where all of their ten children were born. Van Mander's Het Schilder-boeck of 1604 lists the artist as a current resident of Amsterdam. On March 1, 1607, he attended the Amsterdam auction of the goods of the landscapist Gillis van Coninxloo (1544–1607). Vinckboons bought a house in Amsterdam on St. Anthoniesbreestraat, on the north corner of the Salamandersteech, on January 28, 1611. He took in at least one boarder, his pupil Willem Helming of Zeeland.

Outdoor Merry Company, 1610
Monogrammed and dated at the left on the tree trunk: DvB 1610
Oil and tempera on panel, 16⅛ x 26⅞"
(41 x 68.3 cm.)
Gemäldegalerie der Akademie der bildenden Künste, Vienna, inv. no. 592

Provenance: Duke Anton Lamberg-Sprinzenstein.

Literature: Eigenberger 1927, pp. 436–37, pl. 71; Goossens 1977, p. 99, fig. 52; Legrand 1963, pp. 119–24; Vienna, Akademie, cat. 1972, p. 38, no. 47; Goodman 1982, p. 251, fig. 5.

Literature: Houbraken 1718–21, vol. 3, p. 69; Nagler 1835–52, vol. 20, p. 350; Immerzeel 1842–43, vol. 3, p. 194; Blanc 1854–90, vol. 4, p. 127; Kramm 1857–64, vol. 1, p. 122, and vol. 6, pp. 1756f.; Michiels 1870; Obreen 1877–90, vol. 6, p. 52; van Mander, Hymans 1884, vol. 2, p. 334; Wurzbach 1906–11, vol. 2, pp. 790–92; Coninckx 1907; Coninckx 1908; Springer 1910; Verburgt 1916; Sandrart, Peltzer 1925, p. 155; van Balen 1939; Sthyr 1939; Vermeulen 1939; de Luynsche 1940; Z. van Manteuffel in Thieme, Becker 1907–50, vol. 34 (1940), pp. 387–88; Held 1951; van Eeghen 1952; Goossens 1954a; Goossens 1954b; Czober 1963; Goossens 1966; Rosenberg et al. 1966, pp. 103–4; Stechow 1966a; Wegner, Pée 1980; Boston/Saint Louis 1980–81, pp. 39–41.

The exact date of Vinckboons's death remains a point of conjecture. According to some early twentieth-century historians, the artist died in 1629, but Bredius's Künstler-Inventare *mentions that Vinckboons attended an auction on December 5, 1629. Furthermore, the artist's latest painting,* Fishing Couple *(Gemäldegalerie, Staatliche Museen Preussischer Kulturbesitz, Berlin [West], no. 1851), is dated 1630. The Amsterdam municipal register of 1631, which records a payment on the Vinckboons's house, does not mention whether the artist was deceased; however, the city orphanage record for January 12, 1633, refers to Agnieta as a widow with eight underage children. The absence of Vinckboons's name from Amsterdam burial registers has prompted speculation that the artist may have died outside the city. His gravesite remains unknown.*

Vinckboons's genre subjects are often depicted within landscape settings that reflect his contact with Gillis van Coninxloo. Vinckboons also painted historical and biblical themes and night scenes. Proclaimed "one of the greatest painters in Amsterdam" in 1618 by the German art lover Gottfridt Müller, Vinckboons attracted a number of students; among them were Gillis d'Hondecoeter (c. 1580–1638) and probably Esaias van de Velde (q.v.).

C.v.B.R.

Fifteen elegantly attired figures have assembled in a forest clearing beneath a grove of trees. Some of them play music while others form couples to dance, converse, or embrace. The silhouetted trees in the middle distance screen the view of a river landscape with a castle and other buildings. Here and there are tiny figures fishing or relaxing with music in a shaded bower.

In addition to landscapes, history subjects, and peasant paintings, David Vinckboons depicted fashionably attired figures making music, feasting, and courting in the open air.[1] Standing at the threshold of the seventeenth century, these works initiate the Dutch high-life genre tradition and trace their roots to the medieval garden of love and such moralizing traditions as the depiction of the Prodigal Son.[2] Vinckboons's immediate predecessors and contemporaries in the depiction of such themes were the Flemish artists Sebastian Vranx (1573–1647), Louis de Caulery (active 1594–1620), and Crispin de Passe (c. 1565–1637). A plate from Crispin de Passe's *Hortus Voluptatum* of 1599 (fig. 1) attests to the survival of the love-garden tradition and illustrates its conventions—the garden or parklike landscapes with fountains and arbors and the lovers promenading, playing music, drinking wine or simply sitting and embracing. The verses in the print celebrate the leisured existence of "sportive and joyful youth in springtime when the earth spreads her flowers."[3] The arcadian setting in the painting by Vinckboons also offers a poetic view of nature, complete with slender trees and embroidered foliage reminiscent of the mannerist landscapes of Gillis van Coninxloo. As Goodman has recently shown, these genteel fêtes also can be related to early seventeenth-century tracts on etiquette and manners and courtesy books, one of which was entitled *Le Jardin d'amour*.[4] Setting an ideal standard of upper-class decorum, French courtesy books were popular among the Dutch haute bourgeoisie. Polite conversation, according to *Le Manuel d'amour* of 1614, was the essence of social life; good company discoursed on love, the agent of harmony and happiness. René Bary's *La Maison des jeux* recommended that fashionable parties

meet out of doors in gardens in order to stimu-late the senses.[5] The artist and poet Karel van Mander likewise versified in 1592 on the joys of picnics and outings for eating, drinking, playing, reading, and singing in the woods around his beloved Haarlem.[6] Innumerable Dutch seven-teenth-century love songs and poems describe courtships, trysts, and lovers' dalliance in woods, gardens, and leafy glades.[7]

FIG. 1. Engraving from CRISPIN DE PASSE, *Hortus Voluptatum* (1599).

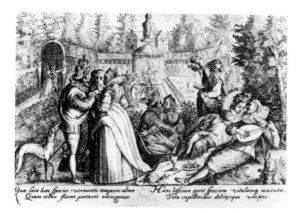

FIG. 2. DAVID VINCKBOONS, *Prodigal Son*, 1608, pen and brown ink with brown and gray-blue wash on pa-per, British Museum, London, no. 13231.

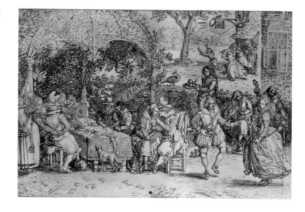

Vinckboons's outdoor parties also can be re-lated to the tradition of depicting the parable of the Prodigal Son (Luke 15:11–24), specifically the scene in which he squanders his inheritance in riotous living. Vinckboons himself depicted the parable in 1608 in a series of drawings pre-served in the British Museum, London. In one sheet from the series (fig. 2), an elegant com-pany, much like the refined party in the Vienna painting, entertain themselves with food, drink, music, and dance in a vine-covered arbor; in the background, the Prodigal Son is driven from an inn by women wielding brooms. In discussing the "atmosphere of the Prodigal Son" in the art-ist's related *Fête Champêtre* in Amsterdam, de Jongh noted that elegant companies in gardens appeared in the background of depictions of Su-perbia, the personification of the sin of pride.[8] Thus, in addition to the charming gaiety of the frolicking couples and the lyrical treatment of the landscape, this picture may have had moral overtones for early seventeenth-century viewers.

P.C.S.

1. See also *The Fête Champêtre*, undated, Rijksmuseum, Amsterdam, no. A2109; *Merry Company in a Park*, mono-grammed and dated 1619, formerly with dealer L. N. Malmedé, Cologne (Goossens 1977, p. 87, fig. 9); and *Out-door Banquet Scene* (after Vinckboons), undated, Statens Museum for Kunst, Copenhagen, no. sp 175. Devoting the greatest attention to the landscape, the Akademie's painting is probably the earliest of this group.

2. See Würtenberger 1937, p. 39; Goossens 1954a; Goossens 1966; Legrand 1963, pp. 119–24; de Jongh et al. in Amster-dam 1976, no. 72; Oliver T. Banks, *Watteau and the North* (New York and London, 1977), pp. 167–73; and Goodman 1982, pp. 250–51.

3. Quoted and translated by Goodman 1982, p. 250.

4. *Le jardin d'amour, où il est enseigné la méthode et adresse pour bien entretenir une maitresse* (Toulouse, n.d.); see Goodman 1982, pp. 248–52.

5. See Goodman 1982 n. 30; René Bary, *La Maison des jeux* (Paris, 1642), vol. 1, pp. 180, 186, 188–89, 250.

6. See J. D. Rutgers van der Loeff, *Drie lofdichten op Haarlem* (Haarlem, 1911), p. 22.

7. Even the titles of songbooks (for example, Starter's "Frie-sian Garden of Delights" or the anonymous "Cupid's Pleasure Garden") often reflected these ideals.

8. See note 1. De Jongh, in Amsterdam 1976, p. 274, fig. 72b (illustrating Théodore de Bry's engraving of Superbia).

Shown in Philadelphia and Berlin

Peasant Kermis, 1629
Signed and dated at the right: Dvinck-Boons
Ano 1629; inscribed at left on sign: Sotcap.
Oil on panel, 16 x 26⅝" (40.5 x 67.5 cm.)
The Royal Cabinet of Paintings, Mauritshuis,
The Hague, no. 542

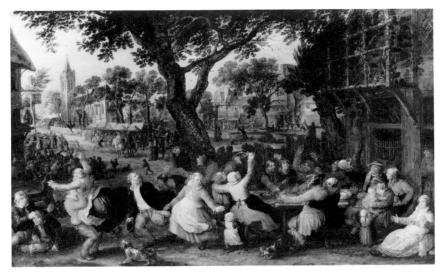

Provenance: Sale, Bos de Harlingen, Amsterdam, February 21, 1888, lot 171, to the Mauritshuis.

Literature: The Hague, Mauritshuis, cat. 1914, pp. 414–15, no. 542; The Hague, Mauritshuis, cat. 1935, pp. 379–80, no. 542; Goossens 1954a, pp. 126–33, figs. 69, 70; Bernt 1970, vol. 3, no. 1310; The Hague, Mauritshuis, cat. 1977, p. 251, no. 542; Schnackenburg 1981, p. 26.

A native of Mechelen and schooled in the Flemish tradition, Vinckboons drew inspiration from the art of Pieter Bruegel the Elder, whose legacy constituted the very fountainhead of low-life genre in the Netherlands. Vinckboons's compositions provided in turn the point of

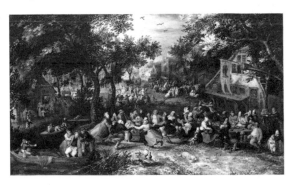

FIG. 1. DAVID VINCKBOONS, *Kermis,* oil on panel, Staatliche Kunstsammlungen, Dresden, inv. no. 937.

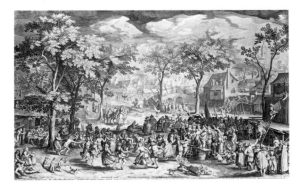

FIG. 2. WILLEM SWANEN-BURGH after David Vinckboons, *Kermis,* engraving.

departure for images of peasants and beggars by Rembrandt, Adriaen van Ostade, and others.

This panel, which dates from the last year of the artist's life, is the latest of approximately a dozen paintings and drawings of kermisses and peasant dances. It occupies an isolated place in Vinckboons's oeuvre, as his other works on these themes belong to the period between 1601 and about 1611.[1] All his kermis paintings follow the same basic schema: an inn figures prominently in a foreground corner, clusters of revelers gather along the tree-lined street of a village, and a church rises in the background (fig. 1).[2] The bird's-eye panorama of the earlier pictures encompasses a vast sweep of the village and innumerable tiny figures, while in the present work Vinckboons lowers the viewpoint and focuses on the celebrants in the foreground, representing their robust, brightly clothed, and vigorously modeled forms on a relatively large scale. The compositional and iconographic roots of his paintings and drawings lie in the kermis prints designed by Pieter Bruegel the Elder around 1560.[3] Although the prints were his primary inspiration, Vinckboons also studied works by older Bruegel followers such as Jacob Savery.[4]

A family of pigs in the right distance may allude to gluttony, the deadly sin committed so conspicuously by the figures in the foreground.[5] Behind them peasants clash in a violent fracas. The gaming, drinking, and moral laxity of Dutch kermisses often led to brawls—indeed so regularly that in some villages an organized street fight was an integral part of the festivities.[6] To the left of the tree trunk are the stalls of the hawkers who plied every fair. In front of the booths, riders muster to compete at *ganstrekken* (Tug the Goose), a cruel but popular amusement that involved a live goose tied upside down to a line. The horsemen approached at a fast clip and tried to pull the goose free by its greased neck.[7]

An engraving after an early Vinckboons kermis (fig. 2) includes an inscription that helps to interpret the Mauritshuis painting, which resembles the print in content but differs greatly in detail. "See these peasant folk, see these minions of Bacchus./ One eats, drinks and fills to the brim, the other/ vomits on the ground./ One sings and dances lustily, the other yells and/ wants to fight,/ And all the while health and money are ebbing/ away."[8]

The verses leave no doubt about the print's didactic message. That the Mauritshuis picture also embodies an admonishment against debauchery and profligacy is suggested by the unrestrained celebrants who eat, drink, vomit, kiss, brawl, and dissipate their health and livelihood, as well as by the inn sign that hangs above the revelers at left. It displays a jester's head and the word *sotcap* (fool's cap), a reminder that indulgence in vice not only violates the Christian moral code but also as an abuse of reason and dignity constitutes a supreme example of human folly.

Four copies after the Mauritshuis painting have been identified.[9]

<div align="center">W.R.</div>

1. A discussion of Vinckboons's paintings and drawings of kermisses and peasant dances is found in Goossens (1954a, 65–83, 126–132, figs. 30–41, 69, 70); and Goossens (1966, pp. 66–74, figs. 3, 4). A recent study of the drawings is found in Wegner, Pée (1980, nos. 16, 18, 19, 27, 33–35).

2. The Dresden painting (fig. 1) is undated, but a copy at Kromeriz Castle, inv. no. 365 (oil on panel, 16⅛ x 27½" [41 x 70 cm.]), is signed and dated 1601.

3. R. van Bastelaer, *Les Estampes de Pieter Bruegel l'Ancien* (Brussels, 1908), nos. 207, 208. A thorough discussion of Bruegel's drawing for van Bastelaer no. 208 appears in Berlin, Staatliche Museen, Kupferstichkabinett, *Pieter Bruegel der Altere als Zeichner: Herkunft und Nachfolge*, 1975, no. 68. Wegner, Pée (1980, p. 40) recount Bruegel's influence on Vinckboons's kermis scenes.

4. *Large Kermis* (Wegner, Pée 1980, no. 16) betrays the influence of J. Savery's painting, sold at Sotheby's, New York, January 21, 1982, lot 71.

5. See *Pieter Bruegel der Altere als Zeichner* (Berlin, 1975), under no. 68.

6. See Zumthor 1962, pp. 191–92.

7. See Zumthor 1962, p. 168.

8. Goossens 1954a, p. 67, fig. 31. For the inscription, see Miedema 1977, p. 212.

9. Panel, 18⅞ x 29⅞" (48 x 76 cm.), with G. Douwes, Amsterdam, 1940; panel, 20 x 28" (51 x 71 cm.), Pushkin Museum, Moscow, inv. no. 3104; panel, 20⅞ x 38⅝" (53 x 98 cm.), sale, Dittmar, van der Vliet et al., Lepke, Berlin, May 4, 1897, lot 59, ill.; panel, dated 1611, formerly National Gallery, Oslo (sale, Christie's, London, November 17, 1982, lot 7).

Jacobus Vrel is known only by the signatures on some of his paintings. Scholars believe that he was active between 1654 and 1662, and he is generally associated with the circle of Pieter de Hooch (q.v.) and the School of Delft. The artist could, however, have been a native of Friesland, the lower Rhineland, or Flanders; two of his paintings of street scenes depict friars dressed in the habits of the Capuchin monks of the Dutch-Flemish border region. Vrel painted simple domestic interiors, courtyards, and street scenes. Two paintings of Gothic church interiors are also known. In the past his works were misattributed to Johannes Vermeer, Isaack Koedijck, Pieter de Hooch, and Pieter Janssens Elinga (q.q.v.).

<div align="center">C.v.B.R.</div>

Woman at a Window, 1654
Signed and dated lower left on cupboard:
J. frel 1654.
Oil on panel, 26 x 18¾″ (66 x 47.5 cm.)
Kunsthistorisches Museum, Gemäldegalerie,
Vienna, inv. no. 6081

Literature: Wurzbach
1906–11, vol. 2, pp. 825–
26; Jantzen 1910, p. 174;
Hofstede de Groot 1915
16; Bredius 1915–22, vol.
7, p. 202; Valentiner 1927–
28; Valentiner 1929b;
Brière-Misme 1935b;
Thieme, Becker 1907–50,
vol. 34 (1940), p. 570;
Plietzsch 1949; Valentiner
1959; Plietzsch 1960, pp.
81–83; Régnier 1968;
Snoep 1973.

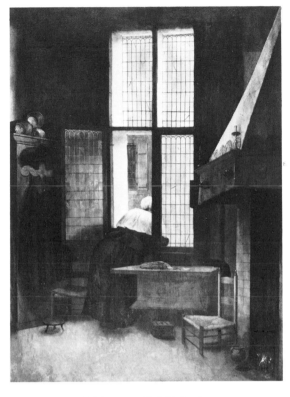

Provenance: Archduke Leopold Wilhelm, inv. 1659, no.
739B; Schloss Pressburger, 1781; reacquired from Frau
Gabriel Imhof von Geisslinghof, Vienna, 1908.

Literature: Berger 1883, p. cl; Wurzbach 1906–11, vol. 2, p.
825; Hofstede de Groot 1915–16, p. 210; Valentiner 1928a,
p. 78; Valentiner 1929a, p. xxxiv; Valentiner 1929b, p. 91;
Brière-Misme 1935b, pp. 100, 102, 157–58, 165, fig. 7;
Thieme, Becker 1907–50, vol. 34 (1940), p. 570; Plietzsch
1960, pp. 81, 83; Vienna, Kunsthistorisches Museum, cat.
1972, p. 104, pl. 74; Sutton 1980, pp. 22, 63 n. 43, fig. 19.

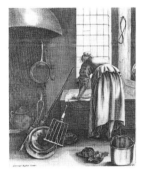

FIG. 1. GEERTRUYT ROGH-
MAN, *Woman before a Win-
dow Cleaning Kitchen
Utensils,* etching.

FIG. 2. JACOBUS VREL,
The Convalescent, oil on
panel, present whereabouts
unknown.

In a domestic interior with a tiled fireplace on the
right and a cupboard on the left, a woman with
her back to the viewer leans out a tall, narrow
window. The room is furnished with two sim-
ple wooden chairs, a footstool, foot warmer,
and a table. A man's hat and cloak hang at the
left and the woman's sewing lies on the table.
Metalware cooking pots are piled on top of the
cupboard, plates and candlesticks decorate the
mantlepiece, and cups hang from nails around
the mantle.

Nothing certain is known about Vrel's life or
the location of his activity.[1] The artist's charm-
ingly naïve manner and limited oeuvre have
prompted speculation that he may have been
only an amateur "Sunday" painter.[2] Of his
approximately thirty existing paintings, the
Vienna interior is the only signed and dated
work. Typical of his art are the domestic
theme, sparse back-lighted interior, attenuated

space, and curiously stunted furniture. Similar
shadowed domestic interiors lighted by tall
windows in the back wall and displaying many
of the same furnishings appear in Vrel's paint-
ings in the museums in Brussels and Lille.[3] The
maternal themes of these two works recur in
Detroit's *Woman Combing a Child's Hair* and
Woman Waving to a Child through a Window
(private collection, The Hague, 1960).[4] Other
works like the present one depict the single fig-
ure of a woman, usually viewed from behind or
in lost profile, attending to a fire, reading,
sleeping, performing chores such as laundering
or simply standing *contre-jour* before the win-
dow. A possible source for the Vienna paint-
ing's design is Geertruyt Roghman's *Woman
before a Window Cleaning Kitchen Utensils* (fig.
1), one of a series of etchings dealing with do-
mestic chores, which probably dates from the
1640s.

Vrel is often discussed as a member of the "de
Hooch School"; however, the date, 1654, on the
Vienna painting is four years earlier than de
Hooch's earliest dated Delft interiors (see cat.
nos. 51 and 52). There is no reason to doubt
the Vienna painting's date since it had already
appeared together with a pendant, the so-called
Convalescent (fig. 2; formerly Dr. Liebermann,
Berlin, present whereabouts unknown), in the
inventory of Archduke Leopold Wilhelm's
collection in 1659.[5] In all probability the paint-
ings were purchased for the latter's gallery in
Brussels (whose curator was the Flemish
painter David Teniers the Younger) during
Leopold Wilhelm's term as governor of the
Spanish Lowlands (1646–56). The enigmatic
Vrel thus seems to have anticipated Delft art-
ists' interests in domestic themes and effects of
light; however, he never attained de Hooch's
mastery of perspective or shared his interest in
views to adjoining spaces. Although Vrel often
included glimpses through a door or a window
to the narrow, diminutive streets seen in his
cityscapes, he never included views to other
rooms. For Vrel—the ultimate "intimiste," as
Brière-Misme chose to call Delft School art-
ists—it was enough to focus on the single all-
purpose room that formed the center of the
kleine burger's (little citizen's) home life. His
rather naïve drawing style and technique, a
straightforward manner without glazes or other
refinements, complement his unpretentious do-
mestic narratives.

P.C.S.

1. C. Hofstede de Groot (1903) thought Vrel worked in Gelderland. Valentiner (1929a, pp. xxxii–xxxv) proposed Friesland on the Lower Rhine area. W. Martin (1935–36, vol. 2, p. 510 n. 289) preferred the eastern Netherlandish provinces or Westphalia because of the architecture in his paintings. Noting the Capuchin monks in Vrel's street scene in Hartford (Wadsworth Atheneum, no. 167), Régnier (1968, p. 282) suggested a small town near the German or Flemish border where such monks were more likely to be seen. Finally, Lyckle de Vries (1977) has proposed Dordrecht. The early appearance of his paintings in Archduke Leopold Wilhelm's collection might point to his activity in or around Brussels, but no evidence of the artist has been discovered in the Belgian archives.

2. See Plietzsch 1960, p. 81

3. Respectively, the *Woman and Child by a Table*, Musées Royaux des Beaux-Arts, Brussels, inv. no. 2826, and *The Recitation*, Musée des Beaux-Arts, Lille. A remarkable feature of the former is the appearance of a piece of West African sculpture by the hearth.

4. Respectively, Detroit Institute of the Arts, no. 28.42, and Plietzsch 1960, fig. 137.

5. The two paintings by "Jacob Frell" described as "Zwey Stückel einer Grossen von Ohlfarb auf Holtz, warin in einem ein hollandisches Camin darbey ein kranckhe Fraw sitczt,/ unndt in dem andern ein Fraw zum Fenster hinauszschawet" (see Berger 1883, p. cl, no. 739). The traditional assumption that the sleeping woman seated before a fire with a cat is sick is supported by Vrel's painting the *Sick Bed*, Musée Royal des Beaux-Arts, Antwerp, no. 790. Brière-Misme (1935b, p. 165) noted that the difference in the pendants' dimensions results from the fact that *The Convalescent* (22⅞ x 18½" [58 x 47 cm.]) has been cut down.

Shown in London only

Born in Amsterdam in 1621, Weenix was one of four children of the architect Jan Weenix and Grietgen Heremans. He was apprenticed in Amsterdam to Jan Micker (c. 1598–1664), the brother-in-law of his sister Lijsbeth. He studied next with Abraham Bloemaert (q.v.) in Utrecht and finally, for about two years, with Nicolaes Moeyaert (1592/93–1655) in Amsterdam. At eighteen, Weenix married Justina, daughter of the landscape painter Gillis d'Hondecoeter (c. 1580–1638). The couple had two sons: Jan (1642–1719), a still-life, landscape, and portrait painter, and Gillis.

In late 1642 or early 1643, shortly after drawing up a will in Amsterdam, Weenix traveled to Italy. In Rome he joined the Netherlandish artists' society De Schildersbent, where he became known as "Ratel" (rattle) because of his speech defect. According to Houbraken, Weenix remained in Italy for four years, spending most of this time in Rome in the service of Cardinal Giovanni Battista Pamphili, who became Pope Innocent X in 1644. The artist probably adopted his middle name from this powerful patron. Weenix was back in Amsterdam by June 1647, when Bartholomeus van der Helst (1613–1670) painted his portrait. By 1649 he had settled in Utrecht, where he was elected an officer of the painters' guild. Documents from 1653 show that he was closely involved, as both painter and dealer, with the collector Baron van Wyttenhorst. In 1657 Weenix moved to the Huis ter Mey, near Utrecht. According to Houbraken, he died there in 1660 or 1661, at the age of thirty-nine.

Weenix's dated works range from 1641 to 1658; however, few pieces from his Italian period have survived. The fanciful Italianate landscapes and seaports and the still lifes executed after his return from Rome are signed "Gio[vanni] Batt[ist]a Weenix." His oeuvre also includes portraits as well as drawings and etchings of landscapes, figures, and animals; his genre works are rare. Among his pupils were his son Jan, his nephew Melchior d'Hondecoeter (1636–1695), and Nicolaes Berchem (q.v.), who may have been a cousin.

C.v.B.R.

Mother and Child with Cat, 1647
Signed and dated at the right on the crib:
Gio[vanni] Batt[ist]a Weenix aNO
(NO in ligature) 1647
Oil on canvas, 18½ x 17″ (47 x 43 cm.)
Private Collection, New York

Literature: De Bie 1661, p. 277; Houbraken 1718–21, vol. 2, pp. 77–83, 111, 113, 131, and vol. 3, pp. 70, 72; van Gool 1750–51, vol. 1, p. 78; Levensbeschryving 1774–83, vol. 9, pp. 122–30; Nagler 1835–52, vol. 21, p. 199; Immerzeel 1842–43, vol. 3, p. 223; Weigel 1843, p. 65; Blanc 1854–90, vol. 4, p. 197; Kramm 1857–64, vol. 6, p. 1835ff.; Nagler 1858–79, vol. 4, p. 641; Obreen 1877–90, vol. 2, p. 72; Muller 1880, pp. 3, 129; Dutuit 1881–88, vol. 6, p. 622; Bode 1883, p. 174; Wurzbach 1906–11, vol. 2, pp. 846–47; Bredius 1928b; Thieme, Becker 1907–50, vol. 35 (1942), pp. 246–47; Stechow 1948; Maclaren 1960, pp. 448–49; Plietzsch 1960, pp. 138–40; Utrecht 1965; Rosenberg et al. 1966, pp. 177–78; Stechow 1966a; Ginnings 1970; Bartsch 1971–, vol. 1, pp. 364–66; Blankert 1978a, pp. 27, 174–84; Duparc 1980, pp. 37–43; Boston/Saint Louis 1980–81, pp. 178–79; Amsterdam/Washington 1981–82, p. 69; Schloss 1982; Kettering 1983; Schloss 1983.

Provenance: Probably Adriaen de Waert, Amsterdam, whose collection was appraised in 1695;[1] Galerie van Diemen, Berlin, by 1929; Dr. R. Schloessmann, Berlin, 1933; private collection, Germany, 1960; sale, Sotheby's, London, March 9, 1983, no. 75, ill.

Exhibition: Berlin, Galerie Dr. Schäffer, *Die Meister des holländischen Interieurs,* April–May 1929, no. 105a.

Literature: Bredius 1915–22, vol. 4, p. 1238; Stechow 1948, p. 186; Plietzsch 1960, p. 139, pl. 238; Blankert 1978a, p. 176; Ginnings 1970; Sutton 1980, p. 45, fig. 45.

Seated in profile with her right foot on a foot warmer, a woman looks out at the viewer while holding her infant in her lap. The child holds a wooden flute. On the right a cat plays with a ball. Behind appear a canopied bed and cradle. At the back left is an open door and on the wall, the sketchy indication of a map.

This painting is one of the rare interior genre scenes by an artist who specialized chiefly in imaginary Italianate landscapes, harbor views, and dead-game still lifes. The signature on the work, "Gio[vanni] Batt[ist]a Weenix," employs the Italian spelling that the artist invariably used following his return from a sojourn in Italy. In the words of the will that he drafted before departing, he made the trip to "experiment with his art."[2] Although dated works had appeared as early as 1641, no works are dated or can be attributed with certainty to the years 1643–47, which Weenix spent in Italy.[3] The *Mother and Child* bears the year of his return to Amsterdam. Also dated 1647 is the *Landscape with Ford and*

FIG. 1. JAN BAPTIST WEENIX, *Italian Peasants and Ruins,* oil on canvas, The Detroit Institute of Arts, no. 41.57.

Rider (Hermitage, Leningrad, no. 3140), proof that Weenix had by that time begun painting Italianate landscapes with ruins. His works of this type often include a mother and child prominently in the foreground; see, for example, *Italian Peasants and Ruins* (fig. 1), which is close to the present work in its colorful palette, liquid touch, and motifs like the child holding the flute; compare also the later and more tightly executed *Italian Landscape with Inn and Ruins,* dated 1658 (Mauritshuis, The Hague, no. 901).[4] Interior scenes with maternal and domestic themes had earlier been treated by Dutch genre artists, such as Buytewech, Dirck Hals, Leyster, Molenaer, Dou, and Rembrandt. However, Weenix's graceful and fluent manner—his son, Jan Weenix, boasted to Houbraken of his father's facility[5]—attests to his Italian experience; the freedom of his technique is evident in the many pentimenti (for example, the changes in the cat's legs).[6] It may be recalled that an early pioneer of domestic genre subjects in drawing, Dirck de Vries, was also strongly influenced by his Italian experience.[7]

P.C.S.

1. "Een vroutje met een kint op de schoot van J. B. Weenix . . . f90-" (see Bredius 1915–22, vol. 4, p. 1238, no. 30).

2. Published by Bredius 1928b, p. 177.

3. See the drawing of *Landscape with a Hermit,* dated 1641, in the Albertina, Vienna, and the painting of *Tobias Asleep,* formerly dated 1642, in the Museum Boymans–van Beuningen, Rotterdam, no. 1204. Blankert (1978a, pp. 175–76) discusses the works that have been assigned uncertainly to Weenix's Italian years.

4. Contrary to Stechow's assumption (1948, p. 186), Houbraken (1718–21, vol. 2, p. 82) was probably referring to this greater slickness and refinement of Weenix's later manner rather than to his domestic genre subjects when the writer likened his art to that of Dou and van Mieris.

5. Jan Weenix claimed that his father could paint three life-size half-length portraits in a single day and that he had also seen him paint a picture as large as seven feet long in the same period of time (Houbraken 1718–21, vol. 2, p. 82).

6. On the symbolic associations of cats (sensuality, voluptuousness, and so forth), see cat. nos. 65 and 96; de Jongh 1968–69, pp. 47–48; de Jongh 1971, p. 183; and Amsterdam 1976, nos. 34 and 135. Compare also J. B. Weenix's *Thievish Cat,* Bryan Collection, New York Historical Society, New York, cat. 1915, no. B-189.

7. A friend of Hendrik Goltzius and potentially an important influence on Jacques de Gheyn II, de Vries in the late sixteenth century produced remarkably simple drawings of women and children that seem to stem from his experience of Titian's circle in Venice; see E.K.J. Reznicek, *Die Zeichnungen von Hendrik Goltzius* (Utrecht, 1961), vol. 1, pp. 172–73 n. 78.

Adriaen van der Werff

Kralingen 1659–1722 Rotterdam

Literature: Houbraken 1718–21, vol. 1, pp. 135, 270, vol. 2, p. 27, and vol. 3, pp. 175, 267, 353, 387–408; Poot 1722; van Gool 1750–51, vol. 2, pp. 376–410; Smith 1829–42, vol. 4, pp. 181–215, and vol. 9, p. 550; Nagler 1835–52, vol. 21, p. 290; Goethals 1838; Immerzeel 1842–43, vol. 3, p. 227; Blanc 1854–90, vol. 4, p. 204; Kramm 1857–64, vol. 6, p. 1842; de Roever 1887; Wurzbach 1906–11, vol. 2, pp. 850–52; Hofstede de Groot 1907–28, vol. 10; de Jongh 1924; Wiersum 1927b; Thieme, Becker 1907–50, vol. 35 (1942), pp. 393–95; van Valkenhoff 1947; Plietzsch 1951; Plietzsch 1959; Maclaren 1960, p. 450; Buck 1965; Knüttel 1966; Pelinck 1966; Rosenberg et al. 1966; Knüttel 1968; Munich 1972; Rotterdam 1973; Becker 1976; Braunschweig 1978, pp. 178–81.

Adriaen van der Werff, the son of a miller, was born in Kralingen, near Rotterdam, on January 21, 1659. Houbraken wrote that the young artist studied with Eglon van der Neer (q.v.) in Rotterdam for about four years after a period of instruction with the Rotterdam genre and portrait painter Cornelis Picolet (1626–1679). His contract with van der Neer stipulated that van der Werff would assist the master who would, in turn, teach him the technique of fijnschilderij *(fine painting) traditionally associated with Leiden painters. Upon completion of his training, the seventeen-year-old van der Werff established himself as an independent master specializing in small-scale portraiture. On August 19, 1687, the artist married Margarethe Rees, who bore him five children. The couple settled permanently in Rotterdam, where in 1690–91 van der Werff was elected one of the principal members of the painters' guild.*

The artist studied the drawing and painting collection owned by his patron, the Rotterdam art connoisseur Nicolaes Flinck, as well as the famous antique collection belonging to the Six family in Amsterdam and the Lairesse paintings owned by the de Flines. In 1696 he met the Elector Palatine, Johann Wilhelm, who appointed him court painter in 1697 at the salary of four thousand guilders a year. Required to devote six months of each year to painting for the Elector, van der Werff turned to producing religious and mythological subjects and genre scenes that would suit his patron's taste. During the next several years, specifically in 1697, 1698, 1703, and 1712, the artist traveled between Rotterdam and Düsseldorf to deliver commissioned works and to paint portraits of the Elector's family. In 1703 the Elector created him a knight (thereafter van der Werff signed his works "Chevalier") and increased his annual service commitment from six months to nine months. Following Johann Wilhelm's death in 1716, van der Werff enjoyed the patronage of the French Regent, King August II of Poland, and other noted collectors in Russia and Europe. The artist died in Rotterdam on November 12, 1722; he was survived by his wife and his daughter Maria.

In addition to his numerous painting assignments, van der Werff was commissioned to design the facades of a number of merchant houses and a stock exchange (Bourse) in Rotterdam. The fame and wealth earned by van der Werff as a mature painter who was greatly influenced by the popular contemporary French classical taste prompted Houbraken to refer to him as the greatest Dutch artist. His principal student and assistant in both painting and bookkeeping was his brother, Pieter van der Werff (c. 1665–c. 1731), who imitated him closely and made copies of his works.

C.v.B.R.

Boy with a Mousetrap, 1676
Signed and dated above the niche:
A v d Werff f. 1676
Oil on panel, 15 x 12⅝″ (38.1 x 32 cm.)
Richard Green Galleries, London

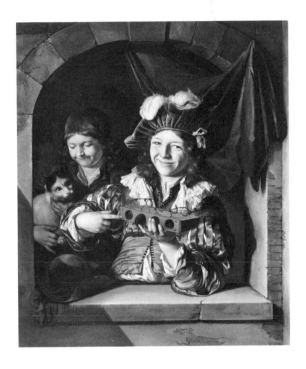

Provenance: Miss E. N. Bostock, London, 1912; Commander J. Bostock, D.S.C., by descent.

Exhibition: London, Richard Green Galleries, *Exhibition of Old Master Paintings,* November 16–December 23, 1983, no. 11, ill.

Two boys appear in a stone window with arched top. The closest to the viewer wears a jacket with slashed sleeves, loosened white collar, and red velvet beret decorated with a white feather. Grinning at the viewer, he holds up a mousetrap and points to a dead mouse in one of the holes. Behind him a second boy holds a cat. On the sill rests the latter's hat; above, a green curtain is drawn back.

The earliest known dated work by Adriaen van der Werff, this painting was executed when the artist was only seventeen. It clearly attests to the tutelage of his second teacher in Rotterdam, Eglon van der Neer, whose *Children with a Birdcage and a Cat* in Karlsruhe (fig. 1) is exceptionally close in both conception and style, as well as complementary in theme. The appearance of the present, only recently published, work serves to clarify van der Werff's early years. The four-year period during which Houbraken claimed that he studied with Eglon van der Neer probably occurred between 1675 and 1679, when van der Neer departed Rotterdam and married.[1] The extremely slick, enamel-like execution of the present painting proves that van der Werff first imitated his teacher's style

before developing a slightly softer, but equally refined manner of his own.[2] In his mature works painted after c. 1678–80, van der Werff abandoned genre for history subjects painted in a high classical manner.

The model for the boy with the mousetrap may, in fact, be van der Werff himself; compare the *Portrait of a Young Artist,* formerly dated 1678, in the Rijksmuseum, Amsterdam (no. A1715), which is often said to be a self-portrait. In the latter work the sitter holds in his hand a small painting of an embracing couple, possibly based on a Frans van Mieris, as he smiles at the viewer.[3] The subject of the Richard Green Galleries' painting is probably amorous as well. As E. de Jongh observed in his discussion of van der Werff's other undated version of the *Boy with a Mousetrap* in the National Gallery, London (no. 3049), for classical authors the trapped mouse was a metaphor for punished immoderation, an idea that was given a more specifically amorous meaning in Dutch literature: as the mouse sacrifices its life for treats, the man pays for stolen kisses with his heart.[4] In an emblem of 1621 (fig. 2), Heinsius compares the person who cannot live with or without love to a mouse sitting between a trap and a cat. The subject of a figure with a mousetrap and a cat was first popularized among the Leiden *fijnschilders* by Dou, who depicted a pretty girl at a window with these and other love symbols.[5] Van der Werff's painting in London originally had a pendant, now lost, which we know from engravings closely imitated the Karlsruhe painting by Eglon van der Neer (fig. 1).[6] The subject of the boys with the cat and the birdcage can refer to the idea of love's pleasurable captivity (the cage as an emblem of the "sweet slavery of love"),[7] while the bird that escapes its cage is traditionally associated with lost virtue. The pain of that loss is expressed all too clearly by van der Werff's hollering boy in *Boy with a Cat and Dead Bird,* dated 1678 (fig. 3), where once again the subject may be the dangers of love.

P.C.S.

FIG. 1. EGLON VAN DER NEER, *Children with a Birdcage and a Cat,* oil on panel, Staatliche Kunsthalle, Karlsruhe, cat. no. 280.

FIG. 2. Emblem from DANIEL HEINSIUS, "Emblemata amatoria," *Nederduysche poemata* (Leiden, 1621), p. 44.

The Chess Players, c. 1679
Oil on canvas, 26 x 24½" (66 x 61.6 cm.)
Herzog Anton Ulrich-Museum, Braunschweig,
no. 330

FIG. 3. ADRIAEN VAN DER
WERFF, *Boy with a Cat and
Dead Bird*, 1678, oil on
panel, Wachtmeister Collec-
tion, Wanas.

1. Communication from Otto Naumann, who is preparing a
short monograph on van der Neer.

2. Compare also van der Werff's *Hunter's Return*, dated
1678, private collection, New York; Robinson 1974, fig. 28.

3. See Naumann 1981a, vol. 1, p. 62.

4. See de Jongh in Amsterdam 1976, cat. no. 75, with refer-
ence to Cats's emblem (*Alle de Werken* [Amsterdam and
Utrecht, 1700], vol. 1, p. 24) entitled "Fit spolians spolium"
(The thief becomes the loot).

5. See *Girl with a Mousetrap and Cat* (Martin 1913, p. 113,
ill.); for discussion see de Jongh 1968–69, pp. 43–46.

6. See Maclaren 1960, pp. 451–52; compare Amsterdam
1976, fig. 75a.

7. See cat. no. 54.

Provenance: Reportedly purchased by the painter Pascha
Johann Friedrich Weitsch, Brugge, 1770, for Prince Heinrich
of Prussia, but sold to Duke Carl I of Braunschweig for the
gallery at Salzdahlum (400 talers);[1] sale, Willem van Wouw,
The Hague, May 29, 1764, no. 29 (as "Twee Heeren t'
zamen Schaaken speelende zeer uitvoerig, door denzelven
[Adr. van der Werff], in zyn Jonge tydt") (31 guilders); taken
by Napoleon to Paris, 1807–15; returned to the museum in
Braunschweig.

Exhibition: Braunschweig 1978, no. 42, ill.

Literature: Parthey 1863–64, vol. 2, p. 776, no. 127; H.
Riegel, *Beiträge zur niederländischen Kunstgeschichte* (Berlin,
1882), vol. 2, pp. 342ff.; F. Schlie, "Kleine Studien über
einige niederländische und deutsche Meister in der
Grossherzoglichen Gemäldegalerie zu Schwerin," *Zeitschrift
für bildende Kunst*, vol. 17 (1882), p. 180; Hofstede de
Groot 1907–28, vol. 10, no. 155; Gudlaugsson 1950;
*Kunsthistorische Mededelingen van het Rijksbureau voor
Kunsthistorische Documentatie*, vol. 5, no. 6 (1950), p. 243,
fig. 2; Plietzsch 1951, p. 138; H. van Hall, *Portretten van
nederlandse beeldende kunstenaars* (Amsterdam, 1963), p.
367, no. 3; Rotterdam 1973, p. 24; A. Müller Hofstede, *Der
Landschaftsmaler Pascha Johann Friedrich Weitsch 1723–
1803* (Braunschweig, 1973), p. 39, fig. 6; C. Brown, "The
Language of Paintings," *Apollo*, vol. 109, no. 1
(January 1979), p. 58, fig. 6.

Although the game of chess had its roots in an-
tiquity and was played in Europe at least from
medieval times, it is a relatively rare subject in
seventeenth-century Dutch genre painting.[2]
From its initial representation in Western art, the
game was associated with two distinct allegori-
cal ideas. It was frequently used to symbolize the
game of love, as in Cornelis de Man's painting
(pl. 117). At other times a parallel was drawn
between the game of chess and the life of man;

FIG. 1. JAN DE BRAY, *Chess Player*, etching.

FIG. 2. ADRIAEN VAN DER WERFF, *Two Chess Players*, 1679, oil on panel, Staatliches Museum, Schwerin, no. 365.

FIG. 3. ADRIAEN VAN DER WERFF, *Painter in His Studio*, oil on panel, Hermitage, Leningrad.

therefore, the chess game belongs to the *vanitas* or memento mori tradition. Adriaen van der Werff's *Chess Players* is an excellent example of this second tradition.[3] Essential to the latter association is a reference to the game's end, indicated here by the man returning the playing pieces to the wooden box. In a sixteenth-century emblem book illustrating a similar scene with a man putting away the pieces, the various elements of the chessboard are likened to the different classes of mankind, from king to pawn.[4] During the game, as in the course of life, some men are more powerful than others, but at the end of the contest—at the moment of death—all are equal in God's eyes. The man on the far side of the table in van der Werff's painting raises his hands in a gesture of despair, presumably because he has lost but also perhaps as a reference to the inevitability of death. The focus of his gaze suggests that he addresses his victorious opponent, as if to admit that he is unbeatable. The praise bestowed upon an opponent is a substitute for the laurel wreath of honor traditionally awarded the victor in battle. Jan de Bray's etching (fig. 1), showing a man similarly dressed in his *robe-de-chambre*, is captioned: "Seat yourself at the table chessboard,/ The contest confers a wreath of honor."[5]

In discussing the allegorical implications of the game, we bear in mind that chess has been traditionally regarded as a battle of intellect in which there is no element of chance. Chess began as a game of kings, but by the late seventeenth century it had become a popular parlor game for learned and wealthy gentlemen who enjoyed a mental challenge.[6] In a variant of this painting in Schwerin (fig. 2), van der Werff added a cello and books on the floor, as well as a lute on the table and bookshelves against the back wall.[7] The interior has been transformed into a music room and study—a setting appropriate to the intellectual game of chess.

The version in Schwerin (fig. 2) is dated 1679, and van der Werff probably executed the Braunschweig painting in the same year. In its conception and handling *The Chess Players* is very close to the *Painter in His Studio* in Leningrad (fig. 3), a painting that, though undated, is certainly from this period: it portrays the artist himself at about the same age as he appears in his self-portrait of 1679 in Schwerin.[8] Like *The Chess Players*, the *Painter in His Studio* contains symbolic references to transitoriness and honor. The death's-head crowned with laurel on the table is present to remind the painter that any honors bestowed upon him in life are meaningless after death.

<div align="center">O.N.</div>

1. A. Müller Hofstede, *Der Landschaftsmaler Pascha Johann Friedrich Weitsch 1723–1803* (Braunschweig, 1973), p. 39.

2. For a brief discussion of the origins of chess, see Schotel 1905, pp. 107–9.

3. The interpretation offered here is largely based on Braunschweig 1978, pp. 179–81, and to a lesser extent on Schotel 1905, pp. 107–17.

4. Guillaume de la Perrière, *Théâtre des bons engins* (Paris, 1539), emblem no. 27 (cited in full and ill. in Braunschweig 1978, pp. 179, 180, fig. 74, and p. 181 n. 6).

5. Clifford S. Ackley in Boston/Saint Louis 1980–81, p. 255, no. 175, ill. The Dutch verses read: "Aen d'Edle Schaeck dis set u neer,/ Het Stayd spel geeft een Krans van Eer."

6. As Schotel (1905, p. 114) relates, chess was played by Prince Maurits, Frederik Hendrik, and William III. Schotel also points out that chess was never a game for the common Dutch tavern, but by the late seventeenth century was played in exclusive coffeehouses and was gaining a wider audience.

7. Schwerin, Staatliches Museum, cat. 1962, no. 365; see Hofstede de Groot 1907–28, vol. 10, p. 276, no. 157.

8. Schwerin, Staatliches Museum, cat. 1962, no. 367. Compare G. Eckardt, *Selbstbildnisse niederländischer Maler des 17. Jahrhunderts* (Berlin, 1971), p. 213. One should also compare van der Werff's self-portrait in the Rijksmuseum (no. A1715), which once bore the date of 1678. The prominent figure in the Braunschweig painting had been identified as the painter himself (see Hofstede de Groot 1907–28, vol. 10, no. 155), but this is untenable in light of the self-portraits cited above.

Shown in Philadelphia and Berlin

Emanuel de Witte

Alkmaar c. 1617–1692 Amsterdam

Literature: Houbraken 1718–21, vol. 1, pp. 223, 282–87, and vol. 2, p. 292; Nagler 1835–52, vol. 22, p. 1; Immerzeel 1842–43, vol. 3, p. 244; Nagler 1858–79, vol. 2, p. 1559; Obreen 1877–90, vol. 1, pp. 6, 37, 44, and vol. 2, p. 28; Wurzbach 1906–11, vol. 2, p. 894; Bredius 1915–22, vol. 5, pp. 1829–47, and vol. 7, pp. 294–95; Bode 1916b; Brière-Misme 1923; Holmes 1923; Hannema 1932; Rotterdam 1935; Hennus 1936; Richardson 1938; Volskaya 1939; E. Trautscholdt in Thieme, Becker 1907–50, vol. 36 (1947), pp. 121–27; Belonje 1949; Maclaren 1960, pp. 455–56; Manke 1963; Rosenberg et al. 1966, pp. 192–93; Stechow 1966a; Salinger 1967c; Manke 1972; Wheelock 1975–76; Amsterdam 1976, pp. 288–89; Wheelock 1977, pp. 221–60; Jantzen 1979, pp. 113–26; Liedtke 1982a, pp. 76–96, 115–17.

Emanuel de Witte was the son of Pieter de Wit, a schoolmaster, and Jacomijntje Marijnus. Although Houbraken reported that he was born in 1607, documents place his birth at around 1617. The record of his betrothal in the Amsterdam marriage register of 1655 lists Alkmaar as the artist's birthplace.

De Witte entered the Alkmaar Guild of St. Luke in 1636, following an apprenticeship, mentioned by Houbraken, with the still-life painter Evert van Aelst (1602–1657) in Delft. On July 7, 1639, and June 26, 1640, he was in Rotterdam, but he must have returned to Delft by 1641, for his daughter Jaquemyntgen was baptized there in October. On June 23, 1642, he entered the city's Guild of St. Luke, and on October 4, 1642, the date of his marriage to Jaquemyntgen's mother, Geertgen Arents, he was living on the Choerstraat in Delft. The couple's second daughter, Lysbeth, was born in 1646. De Witte's name appears periodically in city documents between 1644 and 1650. He is first mentioned in Amsterdam on January 24, 1652. After traveling to Haarlem in April 1654 to serve as an appraiser of paintings with Allart and Caesar van Everdingen (1621–1675 and 1617/21–1678, respectively) and Pieter Soutman (c. 1580–1657), de Witte returned to Amsterdam, where as a widower he wed the twenty-eight-year-old Lysbeth Lodewyck van der Plass on September 3, 1655. During the next seventeen years, the artist is mentioned frequently in Amsterdam records.

Despite a commission from the King of Denmark in 1658, de Witte was often in debt. In his later life he was forced to indenture himself to an Amsterdam notary. Houbraken wrote that the artist took his own life in 1692. After eleven weeks his body was found in an Amsterdam canal that had frozen over.

The history paintings and portraits from de Witte's early career show the influence of a number of artists, including Gerard Dou (q.v.) and representatives of the Utrecht School. After 1650 de Witte specialized in architectural paintings (primarily church interiors); along with Gerard Houckgeest (c. 1600–1661) and Hendrick van Vliet (1611/12–1675), he is considered one of the principal exponents of the Delft architectural style. He also painted genre scenes set within domestic interiors, fanciful harbor views, mythological subjects and, after 1660, open-air market scenes. The artist's only known pupil was Hendrick van Streeck (1659–c. 1719), an Amsterdam painter of still lifes and church interiors.

C.v.B.R.

Interior with a Woman at a Clavichord, c. 1665
Signed (falsely) lower right: P. de Hooch
Oil on canvas, 30½ x 41⅛" (77.5 x 104.5 cm.)
Dienst Verspreide Rijkskollekties, The Hague,
on loan to the Museum Boymans–van
Beuningen, Rotterdam, no. 2313

Provenance: Probably King Jan Sobieski, Castle Wilanow,
inv. 1696, no. 136; dealer Sulley, London, 1908; Say Collec-
tion, Paris; Princess Broglie, née Say, Paris (as P. de Hooch);
dealer F. Kleinberger, Paris, c. 1914; A. van der Ven Collec-
tion, Deventer; dealer N. Beetz, Amsterdam, 1935; dealer D.
Katz, Dieren, Holland; Lanz Collection, Amsterdam, 1941.

Exhibitions: Rotterdam 1925;[1] London, Royal Academy,
1929, no. 307; Rotterdam 1935, no. 128, fig. 96; The
Hague 1936, no. 598; Zurich 1953, no. 180, ill.; Rome
1954–55, no. 182, ill.; Glasgow 1956; Ottawa 1960;
Amsterdam 1976, no. 76, ill.

Literature: Bode 1917, p. 273; Brière-Misme 1923, pp. 153–
55, ill.; Hennus 1936, p. 11, ill.; K. G. Simon, *Zeitschrift für
Kunstgeschichte*, vol. 7 (1938), p. 95 n. 4; E. Trautscholdt
in Thieme, Becker 1907–50, vol. 36 (1947), p. 123 (as c.
1665–70); Manke 1963, p. 34, no. 241, fig. 45 (as c. 1660);
de Jongh 1968, pp. 9–9b, ill. (as c. 1660); Kahr 1978, pp.
185–86, 267, 284, fig. 144; Sutton 1980, p. 31 nn. 21, 22
(as mid-1660s), and p. 53, fig. 29; Slatkes 1981, pp. 152–55,
ill.

In 1721 Houbraken, one of Emanuel de Witte's
earliest biographers, wrote that "in the painting
of churches, no one was his equal with regard to
orderly architecture, innovative use of light, and
well-formed figures."[2] Though an exceptional
genre painting by this specialist in church inte-
riors, the *Woman at a Clavichord* testifies to his
skill in perspective and in creating the illusion of
space. The lines of sight (orthogonals) estab-
lished by the architecture and tiled floor of a
richly furnished room meet in a distant vanish-
ing point glimpsed through an open doorway
and across three adjacent rooms. Light falling
from windows on the right alternates with deep
shadow, slowing the movement into space and

FIG. I. EMANUEL DE WITTE,
Interior of a Church, oil on
canvas, Museum Boymans–
van Beuningen, Rotterdam,
no. 1993.

disguising the carefully constructed geometry.
De Witte's masterful use of light and atmosphere
thus overcomes the conspicuous contrivance of
earlier perspectival interiors, such as Dirck Hals
and Dirck van Delen's *Banquet Scene in a
Renaissance Hall* (pl. 11).

The past attribution of this work to Pieter de
Hooch was undoubtedly due to the masterful
treatment of space.[3] De Hooch, who certainly
knew de Witte's work in Amsterdam in the early
1660s, had probably encountered it even earlier
in Delft.[4] The artist could have learned much
from de Witte's approach to light and shade;
indeed his later, more tenebrous paintings often
exhibit similar bold contrasts. However, the sys-
tem in the present work of distributing light in
bands—a technique often encountered in de
Witte's church interiors (see fig. 1)—was foreign
to de Hooch. On the other hand, de Hooch was
the unrivaled master of naturalistic, perspec-
tivally ordered interiors (see pls. 101 and 102),
and the uniqueness of this work within de
Witte's oeuvre suggests that its inspiration came
from his younger colleague.[5] The combination
of deep space and motifs like the woman playing
the clavichord, her back to the viewer, may also
reflect Vermeer's influence (see pl. 109).

De Witte was probably living in Amsterdam
when he painted this picture; yet none of the
city's homes, even the grandest houses along the
Herengracht, could boast the breadth and ex-
pansive layout of this house. The glimpse of
trees through windows on two sides might sug-
gest a country home, but the scale again seems
exceedingly grand by Dutch standards. In all
likelihood, the structure is imaginary.

At first glance the splendidly still figures in this
scene seem secondary to the space, little more
than architectural members, mere indicators of
human presence. Only gradually do we discover
that the music played by the woman at the
clavichord is heard not only by the maid sweep-
ing in the far room but also by the owner of the
clothes and sword slung over the chair in the left
foreground: a man just visible in the canopied
bed in the shadows. Critics have speculated that
he could be sick.[6] The belief in music's curative
powers was long-standing (see cat. no. 105) with
a biblical precedent in the account of David
playing for the angry Saul (1 Samuel 16:14–23).
Actual inscriptions on clavichords from the

period, often visible in Dutch genre scenes, allude to this belief with sayings such as "Musica Pellit Curas" (Music dispels care) or "Musica Laetitia Comes Medicina Dolorum" (Music, companion of joy, balm of sorrow).[7] As we have seen, music was often a prelude to love; a potentially amorous allusion has been perceived in the cartouche above the door, which includes three gold rings and three bent palm branches, possibly a symbol of engagement.[8]

P.C.S.

1. See Manke 1963, p. 129: the painting was exhibited in Rotterdam 1925; The Hague 1936; Glasgow 1956; and Ottawa 1960.

2. Houbraken 1718–21, vol. 1, p. 223 (author's translation).

3. Also long misattributed to de Hooch was another version of this composition, which is in the Museum of Fine Arts, Montreal, cat. 1960, no. 41, ill.; it was probably painted in 1667 for the dealer L. M. Doucy (see Manke 1963, p. 3 n. 6). See also Hofstede de Groot 1907–28, vol. 1, no. 169 (as Pieter de Hooch); and Manke 1963, no. 241a. According to the entry for this painting in the catalogue of the Verstolk Gallery compiled by the dealer A. Brondgeest in 1846 (see J. Weale and J. P. Richter, *A Descriptive Catalogue of the Collection of Pictures Belonging to the Earl of Northbrook* [London, 1889], p. 200, no. 14), the work was also wrongly assigned several times to Nicolaes Maes.

4. In 1670 de Hooch testified in a suit brought against de Witte concerning a picture (National Gallery, London, no. 3682), which he had seen before September 1663; see Maclaren 1960, pp. 458–59; Manke 1963, pp. 4–5, 69; and Sutton 1980, p. 10 n. 16.

5. See Manke 1963, pp. 34–35; and Sutton 1980, p. 31. Compare de Hooch's *Interior with a Woman Reading and a Child with a Hoop* from the Arenberg Collection (Sutton 1980, cat. 50, fig. 53).

6. E. de Jongh et al. in Amsterdam 1976, p. 289.

7. See, for example, the clavichord in Steen's *Family Portrait*, William Rockhill Nelson Gallery of Art, Atkins Museum of Fine Art, Kansas City, Missouri, inv. no. 67-8 and Vermeer's *Lady at the Virginals* (pl. 109). Slatkes (1981, p. 155) sees the theme of both the latter work and de Witte's painting as dealing with "the role of music in overcoming melancholy"; see cat. no. 105.

8. See de Jongh 1968, p. 9b.

Bibliography

Adelaide 1977
Adelaide, Art Gallery of South Australia. *Cornelis Bega Etchings*. September 23–October 23, 1977. Catalogue by Barry Pearce.

Adriani 1942
G. Adriani. "Niederländische Genremalerei." *Kunst dem Volk*, vol. 13, no. 1 (1942), pp. 1–11.

Agafonowa 1940
X. Agafonowa. "The Drawings of Cornelis Bega in the Hermitage" (in Russian). *Soobshcheniia [Reports of the Hermitage Museum]*, vol. 1 (1940), pp. 55–64.

Allentown 1965
Allentown, Allentown Art Museum. *Seventeenth Century Painters of Haarlem*. April 2–June 13, 1965. Catalogue by Richard Hirsch.

Alpers 1975–76
Svetlana Alpers. "Realism as a Comic Mode: Low-Life Painting Seen through Bredero's Eyes." *Simiolus*, vol. 8, no. 3 (1975–76), pp. 115–44.

Alpers 1976
_____ . "Describe or Narrate? A Problem in Realistic Representation." *New Literary History*, vol. 8, no. 1 (Autumn 1976), pp. 15–41.

Alpers 1978–79
_____ . "Taking Pictures Seriously: A Reply to Hessel Miedema." *Simiolus*, vol. 10, no. 1 (1978–79), pp. 46–50.

Alpers 1983
_____ . *The Art of Describing: Dutch Art in the Seventeenth Century*. Chicago, 1983.

Amman, Sachs 1568
Jost Amman and Hans Sachs. *Ständebuch*. 1568. Reprint. Translated by Stanley Appelbaum, under the title *The Book of Trades*. New York, 1973. Introduction by Benjamin A. Rifkin.

Ampzing 1621
Samuel Ampzing. *Het Lof der Stadt Haerlem in Hollant*. Haarlem, 1621.

Ampzing 1628
_____ . *Beschrijvinge ende Lof der Stad Haerlem*. Haarlem, 1628.

Amsterdam 1900
Amsterdam, Stedelijk Museum. *Catalogus der verzameling schilderijen en familie-portretten van de Heeren Jhr. P. H. Six van Vromade, Jhr. Dr. J. Six, en Jhr. W. Six*. 1900.

Amsterdam 1910
Amsterdam, Rijksmuseum, Rijksprentenkabinet. *Adriaen van Ostade, etsen*. 1910.

Amsterdam 1934
Amsterdam, Maatschappij "Arti et Amicitiae." *Nederlandsche Italianiserende schilders uit de 16e en 17e eeuw*. 1934.

Amsterdam 1948
Amsterdam, Rijksmuseum. *Meesterwerken uit de Oude Pinacotheek te München*. July 18–October 24, 1948.

Amsterdam 1950
Amsterdam, Rijksmuseum. *120 Beroemde schilderijen uit het Kaiser-Friedrich-Museum te Berlijn*. June 17–September 17, 1950.

Amsterdam 1966
Amsterdam, Rijksmuseum, Rijksprentenkabinet. *Tekeningen van de familie Ter Borch*. June–September, 1966. Introductory notes by J. W. N[iemeijer].

Amsterdam 1971
Amsterdam, Rijksmuseum. *Hollandse schilderijen uit Franse Musea*. March 6–May 25, 1971.

Amsterdam 1976
Amsterdam, Rijksmuseum. *Tot Lering en Vermaak*. September 16–December 5, 1976. Catalogue by E. de Jongh et al.

Amsterdam 1981
Amsterdam, Gebr. Douwes. *Esaias van de Velde, schilder: 1590/91–1630, Jan van Goyen, tekenaaer: 1596–1656*. 1981. Catalogue by Evert J. M. Douwes.

Amsterdam/Groningen 1983
Amsterdam, Kunsthandel K. and V. Waterman Gallery. *The Impact of Genius: Rembrandt, His Pupils and Followers in the Seventeenth Century*. April 22–May 17, 1983. Also shown at Groningen, Groninger Museum voor Stad en Lande, May 20–June 20, 1983.

Amsterdam, Rijksmuseum, cat. 1976
Amsterdam, Rijksmuseum. *All the Paintings of the Rijksmuseum in Amsterdam*. 1976. Catalogue by Pieter van Thiel et al.

Amsterdam/Washington 1981–82
Amsterdam, Rijksmuseum, Rijksprentenkabinet. *Dutch Figure Drawings from the Seventeenth Century*. December 19, 1981–February 21, 1982. Also shown at Washington, D.C., National Gallery of Art, April 11–June 13, 1982. Catalogue by Peter Schatborn.

Andresen 1870–73
Andreas Andresen. *Handbuch für Kupferstich-Sammler*. 2 vols. Leipzig, 1870–73.

Angel 1642
Philips Angel. *Lof der Schilderconst*. Leiden, 1642. Reprint. Utrecht, 1969.

Ann Arbor 1964
Ann Arbor, The University of Michigan, Museum of Art. *Italy through Dutch Eyes: Dutch Seventeenth Century Landscape Artists in Italy*. April 22–May 24, 1964. Introduction by W. Stechow.

Antal 1925
Friedrich Antal. "Concerning Some Jan Steen Pictures in America." *Art in America*, vol. 13, no. 3 (April 1925), pp. 107–16.

Baard 1949
H. P. Baard. *The Civic Guard Portrait Groups*. Translated by C. H. Peacock. Amsterdam and New York, 1949.

Baard 1962a
_____ . *Frans Hals en het schutterstuk*. Amsterdam, 1962.

Baard 1962b
_____ . "Frans Hals, spiegel van zijn tijdgenoten." *Fibula*, vol. 3 (1962), pp. 33–39.

Baard 1967
_____ . *Dutch Painting*. Translated by J. J. Kliphuis. Munich, 1967.

von Baldass 1918
Ludwig von Baldass. "Die Anfänge des niederländischen Sittenbildes." In *Ausgewählte Kunstwerke der Sammlung Lanckoroński Wien*. Vienna, 1918.

Baldinucci 1681–1728
F. Baldinucci. *Delle Notizie dei Professori del Disegno da Cimabue in Qua*. 6 vols. Florence, 1681–1728.

Baldinucci 1686
———. *Cominciamento e Progresso dell'Arte dell'intagliare in rame*. Florence, 1686.

van Balen 1939
C. L. van Balen. "Het probleem Vinckboons-Vingboons opgelost." *Oud Holland*, vol. 56 (1939), pp. 97–112, 273.

van Balen 1677
Matthys van Balen. *Beschryvinge der Stad Dordrecht*. Dordrecht, 1677.

Balkema 1844
C. H. Balkema. *Biographie des peintres Flamands et Hollandais qui ont existé depuis Jean et Hubert van Eyck jusqu'a nos jours*. Ghent, 1844.

Barbour 1950
Violet Barbour. *Capitalism in Amsterdam in the Seventeenth Century*. Baltimore, 1950.

Bartsch 1803–21
Adam von Bartsch. *Le Peintre Graveur*. 21 vols. Vienna, 1803–21.

Bartsch 1971–.
———. *Le Peintre Graveur Illustré: Illustrations to Adam Bartsch's "Le Peintre Graveur."* Vols. 12–21. Edited by Caroline Karpinski. New York, 1971–.

Bauch 1942
Kurt Bauch. *Frans Hals*. Cologne, 1942.

Bauch 1960
———. *Der frühe Rembrandt und seine Zeit*. Berlin, 1960.

Baudiment 1934
L. Baudiment. *F. Pallu, principal fondateur de la Société des missions etrangères (1626–84)*. Paris, 1934.

Baumgart 1929
Fritz Baumgart. "Beiträge zu Hendrick Terbrugghen." *Oud Holland*, vol. 46 (1929), pp. 222–33.

Bax 1951
D. Bax. *Skilders wat Vertel*. Capetown, 1951.

Bax 1979
———. *Hieronymus Bosch: His Picture-Writing Deciphered*. Translated by M. A. Bax-Botha. Rotterdam, 1979.

Bazin 1950
Germain Bazin. *Les Grands Maîtres Hollandais*. Merveilles de l'Art. Paris, 1950.

Bazin 1952
———. "La notion d'intérieur dans l'art néerlandais." *Gazette des Beaux-Arts*, 6th ser., vol. 39 (1952), pp. 5–26, 62–67.

Becker 1976
Jochen Becker. "'Dieses emblematische Stück stellet die Erziehung der Jugend vor': Zu Adriaen van der Werff: München, Alte Pinakothek, Inv. Nr. 250." *Oud Holland*, vol. 90 (1976), pp. 77–107.

Bedaux 1975
J. B. Bedaux. "Minnekoorts-, zwangerschaps- en doodsverschijnselen op zeventiende-eeuwse schilderijen." *Antiek*, vol. 10, no. 1 (June–July 1975), pp. 17–42.

Beeren 1962
Willem A. Beeren. *Frans Hals*. Utrecht, [1962].

Begheyn 1979
P. J. Begheyn. "Biografische gegevens betreffende de Haarlemse schilder Cornelis Bega (ca. 1632–1664) en zijn verwanten." *Oud Holland*, vol. 93 (1979), pp. 270–78.

Béguin 1952
Sylvie Béguin. "Pieter Codde et Jacob Duck." *Oud Holland*, vol. 67 (1952), pp. 112–16.

de Belloy 1844
Auguste de Belloy. *Karel Dujardin: Comédie en un acte et en vers*. Paris, 1844.

Belonje 1949
J. Belonje. "Nogmaals Emanuel de Witte." *Oud Holland*, vol. 64 (1949), pp. 109–10.

Bengtsson 1952
Ake Bengtsson. *Studies on the Rise of Realistic Landscape Painting in Holland, 1610–1625*. Stockholm, 1952. (Special issue of *Figura*, vol. 3.)

Bengtsson, Omberg 1951
Ake Bengtsson and Hildegard Omberg. "Structural Changes in Dutch Seventeenth Century Landscape, Still-life, Genre, and Architectural Painting." *Figura*, vol. 1 (1951), pp. 13–56.

Benoit 1909
F. Benoit. *La Peinture au Musée de Lille*. 3 vols. Paris, 1909.

Benoit 1914
———. "Un petit maître hollandais, Pieter Jacobsz. Codde." *Revue de l'art ancien et moderne*, vol. 35 (1914), pp. 15–32.

Berger 1883
Adolf Berger. "Inventar der Kunstsammlung des Erzherzogs Leopold Wilhelm von Österreich." *Jahrbuch der Kunsthistorischen Sammlungen des Allerhöchsten Kaiserhauses*, vol. 1 (1883), pp. 79–85.

Bergström 1966
Ingvar Bergström. "Rembrandt's Double-Portrait of Himself and Saskia at the Dresden Gallery: A Tradition Transformed." *Nederlands kunsthistorisch jaarboek*, vol. 17 (1966), pp. 143–69.

Berkes, Borghero 1974
Sàndor Berkes and Gertrude Borghero. *Praktischer Führer durch die Sammlung Thyssen-Bornemisza*. Castagnola, 1974.

Berlin, Bode, cat. 1976
Berlin, Staatliche Museen, Gemäldegalerie. *Holländische und flämische Gemälde des 17. Jahrhunderts in Bode-Museen*. Berlin, 1976. Catalogue by Irene Geismeier.

Berlin (West), Gemäldegalerie, cat. 1975
Berlin (West), Staatliche Museen Preussischer Kulturbesitz, Gemäldegalerie. *Katalog der ausgestellten Gemälde des 13. bis 18. Jahrhunderts*. Berlin, 1975. Catalogue by Henning Bock and Jan Kelch.

Berlin (West), Gemäldegalerie, cat. 1978
Berlin (West), Staatliche Museen Preussischer Kulturbesitz, Gemäldegalerie. *Catalogue of Paintings, 13th–18th Century*. Translated by Linda B. Parshall. 2nd ed. Berlin, 1978.

Bernt 1957–58
Walther Bernt. *Die niederländischen Zeichner des 17. Jahrhunderts*. 2 vols. Munich, 1957–58.

Bernt 1970
———. *The Netherlandish Painters of the Seventeenth Century*. Translated by P. S. Falla. 3 vols. London, 1970.

Bertolotti 1880
Antonino Bertolotti. *Artisti belgi ed olandesi a Roma nei secoli XVI e XVII*. Florence, 1880.

van Beverwijck 1651
Johan van Beverwijck. *Alle de Wercken, soo in de medicijne als chirurgye*. Utrecht, 1651.

Bialostocki 1966
Jan Bialostocki. *Stil und Ikonographie*. Dresden, 1966.

Bicker Caarten 1949
A. Bicker Caarten. "Het vroegere gebruik van de bakkershoren in Leiden en Rijnland." *Leidsch jaarboekje*, vol. 41 (1949), pp. 85–91.

de Bie 1661
Cornelis de Bie. *Het Gulden Cabinet van de edele vry Schilderconst*. Antwerp, 1661. Reprint. Soest, 1971.

de Bie 1708
———. *Den Spiegel van de Verdrayde Werelt*. Antwerp, 1708.

Bientjes 1967
J. Bientjes. *Holland und die Holländer im Urteil deutscher Reisender (1400–1800)*. Groningen, 1967.

Bijleveld 1950
W.J.J.C. Bijleveld. *Om den hoenderhoef door Jan Steen*. Leiden, 1950.

Bille 1961
Clara Bille. *De tempel der kunst of het kabinet van den Heer Braamcamp*. 2 vols. Amsterdam, 1961.

Birmingham 1950
Birmingham, Birmingham Museum and Art Gallery. *Some Dutch Cabinet Pictures of the 17th Century*. August 26–October 8, 1950.

Blade 1976
Timothy Trent Blade. "The Paintings of Dirck van Delen." Diss., University of Minnesota, 1976.

Blanc 1853–54
Charles Blanc. "François Miéris (le vieux) né en 1635–mort en 1681." *La Renaissance*, vol. 15 (1853–54), pp. 81–90.

Blanc 1854–90
_____ . *Manuel de l'amateur d'estampes*. 4 vols. Paris, 1854–90.

Blanc 1857
_____ . *Les Trésors de l'art à Manchester*. Paris, 1857.

Blanc 1863
_____ . *Histoire des peintres de toutes les écoles*. Vols. 10–11, *Ecole Hollandaise*. Paris, 1863.

Blankert 1966
Albert Blankert. "Invul-portretten door Caspar en Constantyn Netscher." *Oud Holland*, vol. 81 (1966), pp. 263–69.

Blankert 1968
_____ . "Over Pieter van Laer als dier- en landschapschilder." *Oud Holland*, vol. 83 (1968), pp. 117–34.

Blankert 1975
_____ . *Johannes Vermeer van Delft, 1632–1675*. Utrecht, 1975. Contributions by Rob Ruurs and Willem L. van de Watering.

Blankert 1978a
_____ . *Nederlandse 17ᵉ eeuwse Italianiserende landschapschilders*. Soest, 1978 [reprint of Utrecht 1965].

Blankert 1978b
_____ . *Vermeer of Delft: Complete Edition of the Paintings*. Translated by Gary Schwartz, Mrs. Hinke Boot-Tuinman, and Mrs. N. van de Watering-Köhler. Revised. Oxford, 1978. Contributions by Rob Ruurs and Willem L. van de Watering [see Blankert 1975].

van Bleijswyck 1667
Dirck van Bleijswyck. *Beschryvinge der Stadt Delft*. 2 vols. Delft, 1667.

Bloch 1950
Vitale Bloch. "Nederland en Italië." *Maandblad voor beeldende kunsten*, vol. 26 (1950), pp. 214–19, 260.

Bloch 1952
_____ . "I Carravageschi a Utrecht e Anversa." *Paragone*, vol. 33 (September 1952), pp. 14–20.

Bloch 1954
_____ . *Tutta la pittura di Vermeer di Delft*. n.p., 1954.

Bloch 1963
_____ . *All the Paintings of Jan Vermeer*. Translated by Michael Kitson. London, 1963 [see Bloch 1954].

Bloch 1965
_____ . "Michael Sweerts und Italien." *Jahrbuch der staatlichen Kunstsammlungen in Baden-Württemberg*, vol. 2 (1965), pp. 155–74.

Bloch 1968
_____ . *Michael Sweerts*. The Hague, 1968.

Bloch 1973
_____ . "Postskriptum zu Sweerts." In *Album Amicorum J. G. van Gelder*, edited by J. Bruyn et al., pp. 40–41. The Hague, 1973.

Block 1917–18
I. Block. "Teekeningen van Esaias van de Velde, Jan van Goyen en Pieter de Molijn." *Oude Kunst*, vol. 3 (1917–18), pp. 17–19.

Bloemaert 1740
Oorspronkelyk en vermaard konstryk tekenboek van Abraham Bloemaert, geestryk getekent, en meesterlyk geggraveert bij . . . Frederik Bloemaart. Amsterdam, 1740.

Blok 1933
J. M. Blok. "Cornelis Saftleven." In *Nieuw Nederlandsch Biografisch Woordenboek*, vol. 9 (1933), pp. 923–25.

Blum 1945
André Blum. *Vermeer et Thoré-Bürger*. Geneva, 1945.

Bock 1923
Elfried Bock. *Adriaen van Ostade: Die Radierungen des Meisters in originalgetreuen Nachbildungen*. Berlin, 1923.

Bodart 1970
Didier Bodart. *Les Peintres des Pays-Bas méridionaux et de la principauté de Liège à Rome au XVIIème siècle*. Etudes d'histoire de l'art. 2 vols. Brussels and Rome, 1970.

Bode 1871
Wilhelm von Bode. "Frans Hals und seine Schule." Diss., Leipzig, 1871. (Reprinted in *Jahrbuch für Kunstwissenschaft*, vol. 4 [1871], pp. 1–66.)

Bode 1873
_____ . "Zur Biographie und Charakteristik Jan Steens." *Zeitschrift für bildende Kunst*, vol. 8 (1873), pp. 353–57.

Bode 1877
_____ . "Frans Hals." In *Kunst und Künstler Deutschlands und der Niederlande . . .* , edited by R. Dohme, vol. 1, no. 22, pp. 79–112. Leipzig, 1877.

Bode 1879
_____ . "Adriaan van Ostade als Zeichner und Maler." *Die graphischen Künste*, vol. 1 (1879), pp. 37–48.

Bode 1881
_____ . "Der künstlerische Entwicklungsgang des Geraard Terborch." *Jahrbuch der königlich preussischen Kunstsammlungen*, vol. 2 (1881), pp. 144–57.

Bode 1883
_____ . *Studien zur Geschichte der holländischen Malerei*. Braunschweig, 1883.

Bode 1884a
_____ . *Adriaen Brouwer: Ein Bild seines Lebens und seines Schaffens*. Vienna, 1884.

Bode 1884b
_____ . "Adriaen Brouwer." *Die graphischen Künste*, vol. 6 (1884), pp. 21–72.

Bode 1887
_____ . "Die Ausstellung alter Gemälde . . . in Düsseldorf und Brussels 1886." *Repertorium für Kunstwissenschaft*, vol. 10 (1887), p. 36.

Bode 1906
_____ . *Rembrandt und seine Zeitgenossen*. Leipzig, 1906.

Bode 1909
_____ . *Great Masters of Dutch and Flemish Painting*. Translated by Margaret L. Clarke. London and New York, 1909. Reprint. 1967.

Bode 1911
_____ . "Jan Vermeer und Pieter de Hooch als Konkurrenten." *Jahrbuch der königlich preussischen Kunstsammlungen*, vol. 32 (1911), pp. 1–2.

Bode 1913
_____ . *The Collection of Pictures of the Late Herr A. de Ridder*. Translated by Harry Virgin. Berlin, 1913.

Bode 1914–15
_____ . "Frans Hals." *Velhagen und Klasings Monatshefte*, vol. 29 (1914–15), pp. 289–304.

Bode 1915–16
_____ . "Gemäldegalerie. Neue Erwerbungen [D. Hals: Vroolijk gezelscap; W. C. Duyster: Vastenavondzotten; Symon Kick: Overval op de heide]." *Amtliche Berichte aus den königlichen Kunstsammlungen*, vol. 37 (1915–16), pp. 17–24.

Bode 1916a
_____ . "Die beiden Ostade." *Zeitschrift für bildende Kunst*, vol. 27 (1916), pp. 1–10.

Bode 1916b
_____ . "Emanuel de Witte." *Zeitschrift für bildende Kunst*, vol. 27 (1916), pp. 157–62.

Bode 1916–17
_____ . "Quiringh G. Brekelenkam, ein Maler des holländischen Kleinbürgertums." *Velhagen und Klasings Monatshefte*, vol. 31 (1916–17), pp. 42–53.

Bode 1917
_____ . *Die Meister der holländischen und vlämischen Malerschulen* [Leipzig, 1917]. 8th ed. Leipzig, 1956. Notes by Eduard Plietzsch.

Bode 1921–23
_____ . *Die Meister der holländischen und vlämischen Malerschulen*. 3rd ed. Leipzig, 1921–23.

Bode 1922a
———. "Adriaen Brouwer, Erweiterung seines Maler-werks." *Jahrbuch der königlich preussischen Kunstsammlungen*, vol. 43 (1922), pp. 35–46.

Bode 1922b
———. "Frans Hals als Landschafter." *Kunst und Künstler*, vol. 20 (1922), pp. 223–28.

Bode 1924
———. *Adriaen Brouwer: Sein Leben und seine Werke.* Berlin, 1924.

Bode, Binder 1914
Wilhelm von Bode and M. J. Binder. *Frans Hals: Sein Leben und seine Werke.* 2 vols. Berlin, 1914. (English translation by M. W. Brockwell. London, 1914.)

Bode, Bredius 1889
Wilhelm von Bode and Abraham Bredius. "Der amster-damer Genremaler Symon Kick." *Jahrbuch der königlich preussischen Kunstsammlungen*, vol. 10 (1889), pp. 102–9.

Bode, Bredius 1890
Wilhelm von Bode and Abraham Bredius. "Der haarlemer Maler Johannes Molenaer in Amsterdam." *Jahrbuch der königlich preussischen Kunstsammlungen*, vol. 11 (1890), pp. 65–78.

Bode, Bredius 1905
Wilhelm von Bode and Abraham Bredius. "Esaias Boursse, ein Schüler Rembrandts." *Jahrbuch der königlich preussischen Kunstsammlungen*, vol. 26 (1905), pp. 205–14.

Bode, Valentiner 1907
Wilhelm von Bode and W. R. Valentiner. *Hand-zeichnungen altholländischer Genremaler.* Berlin, 1907.

Bodkin 1924
Thomas Bodkin. "Quiringh Brekelenkam's Master." *The Burlington Magazine*, vol. 44, no. 250 (January 1924), pp. 26–31.

Bodmer 1936
Heinrich Bodmer. "Aus dem römischen Caravaggio-Kreise (Theodor von Baburen und Giovanni Serodine)." *Resumés Congrès Berne*, vol. 1 (1936), pp. 98–99.

Boekenoogen, van Heurck 1930
G. J. Boekenoogen and E. van Heurck. *L'Imagerie populaire des Pays-Bas.* Paris, 1930.

Boerner 1856
C. G. Boerner. "Adriaen van Ostade." *Archiv für die zeichnenden Künste*, vol. 2 (1856), pp. 104–28.

Boerner, Trautscholdt 1965
C. G. Boerner and Eduard Trautscholdt. *A. Ostade, C. Bega, Corn. Dusart.* Düsseldorf, 1965.

Böhm 1928
Franz J. Böhm. "Begriff und Wesen des Genre." *Zeitschrift für Asthetik und allgemeine Kunst-wissenschaft*, vol. 22 (1928), pp. 166–91.

Böhmer 1940
G. Böhmer. *Der Landschafter Adriaen Brouwer.* Munich, 1940.

Bol 1958
Laurens J. Bol. "Een Middelburgse Brueghel-groep. VII. Adriaen Pietersz. van de Venne, schilder en teyckenaer: A. Middelburgse periode ca. 1614–1625; B. Haagse periode 1625–1662." Parts 1, 2. *Oud Holland*, vol. 73 (1958), pp. 59–79, 128–47.

Bol 1982–83
———. "Adriaen Pietersz. van de Venne, schilder en teyckenaer." Parts 1–7. *Tableau*, vol. 5, no. 2 (November–December 1982), pp. 168–75; no. 3 (December 1982–January 1983), pp. 254–61; no. 4 (February 1983), pp. 276–83; vol. 5, no. 5 (April 1983), pp. 342–47; vol. 5, no. 6 (Summer 1983), pp. 416–21; vol. 6, no. 1 (September–October 1983), pp. 54–63; vol. 6, no. 2 (November–December 1983), pp. 53–63.

Bolten 1970
Jaap Bolten. "Een landschapstekening van Herman Saftleven." In *Opstellen voor H. van de Waal*, pp. 9–17. Leiden, 1970.

Boogaard-Bosch 1939
A. C. Boogaard-Bosch. "Een onbekende acte betreffende den vader van Jan Vermeer." *Nieuwe Rotterdamsche Courant.* January 25, 1939.

Boon 1942
K. G. Boon. *De schilders voor Rembrandt.* Antwerp, 1942.

Borenius 1945
Tancred Borenius. *Dutch Indoor Subjects.* London, 1945.

Bories 1913–14
Johan Bories. "Hollandsch binnenhuis in beeld/The Dutch Interior Reproductions." *Holland*, vol. 1 (1913–14), pp. 16–32.

Borsook 1954
Eve Borsook. "Documents Concerning the Artistic Asso-ciates of Santa Maria della Scala in Rome." *The Burlington Magazine*, vol. 96, no. 617 (August 1954), pp. 270–73.

Boschloo 1972
A.W.A. Boschloo. "Over BambOCR en kikvorsen." *Nederlands kunsthistorisch jaarboek*, vol. 23 (1972), pp. 191–202.

Boston/Saint Louis 1980–81
Boston, Museum of Fine Arts. *Printmaking in the Age of Rembrandt.* October 28, 1980–January 4, 1981. Also shown at Saint Louis, The Saint Louis Art Museum, February 19–April 12, 1981. Catalogue by Clifford S. Ackley; essay by William W. Robinson.

Bots 1900
P. M. Bots. "De kunstschilder Terborch." *De Katholieke gids*, vol. 12 (1900), pp. 409–24.

Bouricius 1925
L.G.N. Bouricius. "Vermeeriana." *Oud Holland*, vol. 42 (1925), pp. 271–73.

Boxer 1977
C. R. Boxer. *The Dutch Seaborne Empire, 1600–1800.* 3rd ed. London, 1977.

Bradley 1917
William Appenwall Bradley. "The Van de Veldes." *Print Collectors' Quarterly*, vol. 7, no. 1 (February 1917), pp. 55–89.

van den Branden 1881a
F. Joseph van den Branden. *Adriaan Brouwer en Joos van Craesbeeck.* Haarlem, 1881.

van den Branden 1881b
———. "Adriaan Brouwer." *Nederlandsche kunstbode*, vol. 3 (1881), pp. 156–57.

van den Branden 1882–83
———. "Adriaan Brouwer." Parts 1, 2. *Nederlandsch Dicht- en Kunsthalle*, vol. 4 (1882), pp. 532–40; vol. 5 (1883), pp. 11–20.

Brandt 1947
P. Brandt, Jr. "Notities over het Leven en Werk van den Amsterdamschen schilder Pieter Codde." *Historia*, vol. 12, no. 2 (February 1947), pp. 27–37.

Braudel 1981
Fernand Braudel. *The Structures of Everyday Life.* Civilization and Capitalism, 15th–18th Century, vol. 1. Translated and revised by Siân Reynolds. New York, 1981.

Braudel 1982
———. *The Wheels of Commerce.* Civilization and Capitalism, 15th–18th Century, vol. 2. Translated and revised by Siân Reynolds. New York, 1982.

Braun 1960
Herman Braun. *Gerard und Willem van Honthorst.* Göttingen, 1960.

Braun 1966
———. "Gerard und Willem van Honthorst." Diss., Göttingen, 1966.

Braun 1980
Karel Braun. *Alle tot nu toe bekende schilderijen van Jan Steen.* Meesters der Schilderkunst. Rotterdam, 1980.

Braunschweig 1978
Braunschweig, Herzog Anton Ulrich-Museum. *Die Sprache der Bilder: Realität und Bedeutung in der niederländischen Malerei des 17. Jahrhunderts.* Septem-ber 6–November 5, 1978. Introduction by E. de Jongh; essays by Lothar Dittrich and Konrad Renger.

Bredius 1880a
Abraham Bredius. "Iets over de Palamedessen [Stevensz. of Stevaerts]." *Nederlandsche kunstbode*, vol. 2 (1880), pp. 310–11.

Bredius 1880b
_____ . "Cornelis de Man." *Nederlandsche kunstbode*, vol. 2 (1880), p. 375.

Bredius 1881a
_____ ."Iets over de Hooch." *Nederlandsche kunstbode*, vol. 3 (1881), p. 126.

Bredius 1881b
_____ . "Nog eens de Hooch." *Nederlandsche kunstbode*, vol. 3 (1881), p. 172.

Bredius 1883
_____ . "Die Ter Borch Sammlung." *Zeitschrift für bildende Kunst*, vol. 18 (1883), pp. 370–73, 406–10.

Bredius 1885a
_____ . "Iets over Johannes Vermeer." *Oud Holland*, vol. 3 (1885), pp. 217–22.

Bredius 1885b
_____ . "Etwas über die Terborchs und den Maler Bernard van Vollenhoven." *Der Kunstfreund*, vol. 1 (1885), pp. 229–32.

Bredius 1887
_____ . "Een en ander over Caspar Netscher." *Oud Holland*, vol. 5 (1887), pp. 263–71.

Bredius 1888
_____ ."Iets over Pieter Codde en Willem Duyster." *Oud Holland*, vol. 6 (1888), pp. 187–94.

Bredius 1889
_____ . "Bijdragen tot de biographie van Pieter de Hoogh." *Oud Holland*, vol. 7 (1889), pp. 161–68.

Bredius 1891
_____ . "De kunsthandel te Amsterdam in de XVIIde eeuw." *Amsterdamsch jaarboekje*, 1891, pp. 54–71.

Bredius 1899a
_____ . *Jan Steen, met honderd platen*. Amsterdam, [1899].

Bredius 1899b
_____ . "Gerard ter Borch 1648 te Amsterdam." *Oud Holland*, vol. 17 (1899), pp. 189–90.

Bredius 1906
_____ . "De nalatenschap van Carel Du Jardin." *Oud Holland*, vol. 24 (1906), pp. 223–32.

Bredius 1907
_____ . "Iets over de jeugd van Gabriël Metsu." *Oud Holland*, vol. 25 (1907), pp. 197–203.

Bredius 1908
_____ . "Jan Miense Molenaer: Nieuwe gegevens omtrent zijn leven en zijn werk." *Oud Holland*, vol. 26 (1908), pp. 41–42.

Bredius 1909a
_____ . "Nieuwe bijzonderheden over Isaack Jansz. Koedyck." *Oud Holland*, vol. 27 (1909), pp. 5–12.

Bredius 1909b
_____ . "De oom van van Mieris als restaurateur van oude schilderijen." *Oud Holland*, vol. 27 (1909), p. 64.

Bredius 1909c
_____ . "De schilder Pieter Janssens Elinga." *Oud Holland*, vol. 27 (1909), pp. 235–37.

Bredius 1910
_____ . "Nieuwe bijdragen over Johannnes [*sic*] Vermeer." *Oud Holland*, vol. 28 (1910), pp. 61–64.

Bredius 1913
_____ . "De geschiedenis van een schutterstuk." *Oud Holland*, vol. 31 (1913), pp. 81–84.

Bredius 1914
_____ . "De ouders van Frans Hals." *Oud Holland*, vol. 32 (1914), p. 216.

Bredius 1915–22
_____ . *Künstler-Inventare: Urkunden zur Geschichte der holländischen Kunst des XVIten, XVIIten, und XVIIIten Jahrhunderts*. 8 vols. The Hague, 1915–22.

Bredius 1916a
_____ . "Waarom Jacob van Loo in 1660 Amsterdam verliet." *Oud Holland*, vol. 34 (1916), pp. 47–52.

Bredius 1916b
_____ . "Wat Anthony Palamedes aan een portret verdiende." *Oud Holland*, vol. 34 (1916), pp. 131–32.

Bredius 1916c
_____ . "Schilderijen uit de nalatenschap van den Delft'schen Vermeer." *Oud Holland*, vol. 34 (1916), pp. 160–61.

Bredius 1917
_____ . "Een conflict tusschen Frans Hals en Judith Leyster." *Oud Holland*, vol. 35 (1917), pp. 71–73.

Bredius 1920
_____ . "Schilders-musicanten [Pieter Janssens Elinga, Michiel Nouts]." *Oud Holland*, vol. 38 (1920), pp. 180–83, 232.

Bredius 1921
_____ . "Heeft Frans Hals zijn vrouw geslagen?" *Oud Holland*, vol. 39 (1921), p. 64.

Bredius 1922
_____ . "Een teekening van Willem Buytewech." *Oud Holland*, vol. 40 (1922), p. 174.

Bredius 1923–24a
_____ . "Archiefsprokkels betreffende Frans Hals." *Oud Holland*, vol. 41 (1923–24), pp. 19–30.

Bredius 1923–24b
_____ . "Archiefsprokkels betreffende Dirck Hals." *Oud Holland*, vol. 41 (1923–24), pp. 60–61.

Bredius 1923–24c
_____ . "Bijdragen tot een biografie van Nicolaes Maes." *Oud Holland*, vol. 41 (1923–24), pp. 207–14.

Bredius 1927
_____ . *Jan Steen*. Amsterdam, 1927.

Bredius 1928a
_____ . "Pieter de Hooch und Ludolph de Jongh." *Kunstchronik und Kunstliteratur*, vol. 62, no. 6 (September 1928), pp. 65–67.

Bredius 1928b
_____ . "Een testament van Jan Baptist Weenicx." *Oud Holland*, vol. 45 (1928), pp. 177–78.

Bredius 1937
_____ . "Gegevens omtrent Abraham Bloemaert." *Oud Holland*, vol. 54 (1937), pp. 177–78.

Bredius 1939
_____ . "Een en ander over Adriaen van Ostade." *Oud Holland*, vol. 56 (1939), pp. 241–46.

Bredius et al. 1897–1904
Abraham Bredius et al. *Amsterdam in de zeventiende eeuw*. Edited by P. J. Blok. 3 vols. The Hague, 1897–1904.

Bremmer 1917
H. P. Bremmer. *Het compleete etswerk van Adriaen van Ostade*. Utrecht, 1917.

Brenninkmeyer-de Rooij 1982
B. Brenninkmeyer-de Rooij. "Notities betreffende de decoratie van de Oranjezaal in Huis ten Bosch." *Oud Holland*, vol. 96 (April 1982), pp. 133–90.

Brieger 1922
Lothar Brieger. *Das Genrebild: Die Entwicklung der bürgerlichen Malerei*. Munich, 1922.

Brière-Misme 1921
Clotilde Brière-Misme. "Un Pieter de Hooch inconnu au Musée de Lisbonne." *Gazette des Beaux-Arts*, 5th ser., vol. 4 (1921), pp. 340–44.

Brière-Misme 1923
_____ . "Un petit maître hollandais: Emmanuel de Witte." *Gazette des Beaux-Arts*, 5th ser., vol. 7 (1923), pp. 137–56.

Brière-Misme 1927
_____ . "Tableaux inédits ou peu connus de Pieter de Hooch." Parts 1–3. *Gazette des Beaux-Arts*, 5th ser., vol. 15 (1927), pp. 361–80; vol. 16 (1927), pp. 51–79, 258–86.

Brière-Misme 1935a
_____ . "Un Emule de Vermeer et de Pieter de Hooch, Cornélis de Man." Parts 1–3. *Oud Holland*, vol. 52 (1935), pp. 1–26, 97–120, 281–82.

Brière-Misme 1935b
_____ . "Un 'Intimiste' hollandais, Jacob Vrel." Parts 1, 2. *Revue de l'art ancien et moderne*, vol. 68 (June–December 1935), pp. 97–114, 157–72.

Brière-Misme 1947–48
_____ . "A Dutch Intimist, Pieter Janssens Elinga." Parts 1–4. *Gazette des Beaux-Arts*, 6th ser., vol. 31 (1947), pp. 89–102, 151–64; vol. 32 (1947), pp. 159–76; vol. 33 (1948), pp. 347–66.

Brière-Misme 1950
———. "Un Petit Maître hollandais, Cornelis Bisschop (1630–1674)." Parts 1–5. *Oud Holland*, vol. 65 (1950), pp. 24–40, 104–16, 139–51, 178–92, 227–40.

Brière-Misme 1954a
———. "Un 'Intimiste' hollandais, Esaias Boursse, 1631–1672." Parts 1–4. *Oud Holland*, vol. 69 (1954), pp. 18–30, 72–91, 150–66, 213–21.

Brière-Misme 1954b
———. "L'Enigme du Maître C. B." *La Revue des Arts*, vol. 4, no. 3 (September 1954), pp. 143–52.

Briganti 1950
Giuliano Briganti. "Pieter van Laer e Michelangelo Cerquozzi." *Proporzioni*, vol. 3 (1950), pp. 185–98.

Briganti 1956
———. "Bamboccianti." In *Encyclopedia of World Art*, vol. 2, cols. 207–11.

Brion 1964
Marcel Brion. *L'Age d'or de la peinture hollandaise.* Brussels, 1964.

Brochhagen 1957
E. Brochhagen. "Karel Dujardins späte Landschaften." *Bulletin de Musées Royaux des Beaux-Arts*, vol. 6 (1957), pp. 236–54.

Brochhagen 1958
———. "Karel Dujardin: Ein Beitrag zum Italianismus in Holland im 17. Jahrhundert." Diss., Cologne, 1958.

Brochhagen 1965
———. "Die Landschaftsmalerei der niederländischen Italianisten: Zu einer Ausstellung des Centraal Museums Utrecht." *Kunstchronik*, vol. 18, no. 7 (July 1965), pp. 177–85.

Brongers 1964
Georg A. Brongers. *Nicotiana Tabacum: The History of Tobacco and Tobacco Smoking in the Netherlands.* Groningen, 1964.

Brown 1976
Christopher Brown. *Dutch Genre Painting.* Oxford and New York, 1976.

Brown 1978
———. *The National Gallery Lends Dutch Genre Painting.* London, 1978.

Brugmans 1931
H. Brugmans. *Het huiselijk en maatschapelijk leven onzer voorouders.* 2 vols. Amsterdam, 1931.

de Bruijn 1973
H. C. de Bruijn, Jr. "De Bentveughels: onze Italianiserende schilders uit de 17e eeuw." *Op den Uitkijk*, no. 10 (July 1973), pp. 489–93.

de Brune 1624
Johan de Brune. *Emblemata of zinne-werck.* Amsterdam, 1624. Reprint. Soest, 1970.

Brunt 1911
Aty Brunt. "F. van Mieris en zijn werken in onze Hollandsche verzamelingen." *Morks Magazijn*, vol. 13 (1911), pp. 481–90.

Bruyn et al. 1978
J. Bruyn et al. "Historisch perspektief van het Hollandse zeventiende eeuwse 'genre' geïllustreed aan enkele themas." Grote Werkgroep Nieuwere Tijd, Kunsthistorisch Instituut, Universiteit van Amsterdam, 1978. Mimeograph.

Buchelius 1928
[Arend van Buchell]. *Arnoldus Buchelius, "Res Pictoriae," 1583–1639.* Edited by G. J. Hoogewerff and J. Q. van Regteren Altena. The Hague, 1928.

Buck 1965
Richard D. Buck. "Adriaen van der Werff and Prussian Blue." *Allen Memorial Art Museum Bulletin*, vol. 22, no. 2 (1965), pp. 74–76.

Budapest, Szépművészeti, cat. 1924
Budapest, Szépművészeti Múzeum. *Catalogue of Paintings by Old Masters.* 1924. Catalogue by Gabriel de Térey.

Budapest, Szépművészeti, cat. 1968
Budapest, Szépművészeti Múzeum. *Katalog der Galerie Alter Meister.* 2 vols. 1968. Catalogue by A. Pigler.

Budapest, Szépművészeti, cat. 1974
Budapest, Szépművészeti Múzeum. *Dutch Genre Paintings.* 1974. Catalogue by Miklós Mojzer.

Budde 1929
Illa Budde. *Die Idylle im holländischen Barock.* Cologne, 1929.

Bullaert 1682
Isaac Bullaert. *Academie des Sciences et des Arts.* Paris, 1682.

Burchard 1917
Ludwig Burchard. *Die holländischen Radierer von Rembrandt.* Berlin, 1917.

Burckhardt 1919
Jakob Burckhardt. "Über die niederländische Genremalerei." In *Vorträge 1844–1887.* Basel, 1919.

Burda 1969
Christa Burda. "Das Trompe-l'oeil in der holländischen Malerei des 17. Jahrhunderts." Diss., Munich, 1969.

Burg 1911
Herman Burg. "Über einige Porträts des Antonius Palmedesz." *Monatshefte für Kunstwissenschaft*, vol. 4 (1911), pp. 293–95.

Burger-Wegener 1976
C. Burger-Wegener. "Johannes Lingelbach, 1622–1674." Diss., Berlin, 1976.

Burke 1980
James D. Burke. "Dutch Paintings." *Bulletin, Saint Louis Art Museum*, n.s., vol. 15, no. 4 (Winter 1980), pp. 5–24.

Burke 1973
Peter Burke. "Patrician Culture: Venice and Amsterdam in the Seventeenth Century." *Transactions of the Royal Historical Society*, 5th ser., vol. 23 (1973), pp. 135ff.

Burke 1974
———. *Venice and Amsterdam: A Study of Seventeenth Century Elites.* London, 1974.

Burke 1978a
———. *Popular Culture in Early Modern Europe.* New York, 1978.

Burke 1978b
———. "Dutch Popular Culture in the Seventeenth Century." *Mededelingen-Universiteit Erasmus-Rotterdam*, no. 3 (1978).

Burman Becker 1869
J. G. Burman Becker. *Notices sur la famille Verkolje.* Copenhagen, 1869.

Burman Becker 1874
———. "De Verkoljen." *De Dietsche warande*, vol. 10 (1874), pp. 491–505.

Busiri Vici 1958
Andrea Busiri Vici. "Carnevalate popolari romane di Jan Miel." *Studi Romani*, vol. 6 (1958), pp. 39–50.

Busiri Vici 1958–59
———. "Opere di Jan Miel alla Carte Sabauda." *Bollettino Piemontese della Società di Archeologia, e Belle Arte*, vols. 12, 13 (1958–59), pp. 94–118.

Busiri Vici 1959
———. "Fantasie romane di Johannes Lingelbach." *Studi Romani*, vol. 7 (January–February 1959), pp. 42–53.

Busschaert 1964
A. Busschaert. "Jan Meel alias Miel (1599–1664) schilder geboortig van Beveren." *Het Land van Beveren*, vol. 7 (1964), pp. 34–36.

van Campen 1937
J.W.C. van Campen. "Vondels relaties met Utrechtsche kunstenaars." *Jaarboekje van Oud-Utrecht*, 1937, pp. 29–55.

Cape Town 1959
 Cape Town, National Gallery of South Africa. *Catalogue of the Exhibition of the Sir Joseph Robinson Collection, Lent by Princess Labia.* 1959.
Caraceni 1966
 A. Caraceni. *Appunti su Pieter van Laer.* Quaderni d'Arte Secentesca. Rome, 1966.
Cats 1614
 Jacob Cats. *Sinne- en Minnebeelden.* Middelburg, 1614.
Cats 1658
 ———. *Spiegel van den ouden en nieuwen tijdt.* Amsterdam, 1658.
Cats 1665
 ———. *Alle de wercken, Proefsteen van den Trou-Ringh.* Amsterdam, 1665.
Cats 1700
 ———. *Alle de wercken, soo oude als nieuwe.* 2 vols. Amsterdam, 1700.
Chantavoine 1926
 J. Chantavoine. *Ver Meer de Delft.* Paris, 1926.
de Chennevières 1908
 Henry de Chennevières. "Ter Borch." *L'Art et les artistes,* vol. 8 (1908), pp. 99–106.
Chicago, The Art Institute, cat. 1961
 Chicago, The Art Institute of Chicago. *Paintings in The Art Institute of Chicago: A Catalogue of the Picture Collection.* 1961.
Chicago/Minneapolis/Detroit 1969–70
 Chicago, The Art Institute of Chicago. *Rembrandt after Three Hundred Years.* Also shown at Minneapolis, Minneapolis Institute of Arts, and Detroit, Detroit Institute of Arts. Entries by J. R. Judson, E. Haverkamp Begemann, and A. M. Logan.
Collins Baker 1925
 C. H. Collins Baker. *Pieter de Hooch.* Masters of Painting, vol. 1. London, 1925.
Collins Baker 1927
 ———. "Hendrik Terbrugghen and Plein Air." *The Burlington Magazine,* vol. 50, no. 289 (April 1927), pp. 196–202.
Collins Baker 1930
 ———. "De Hooch or Not De Hooch." *The Burlington Magazine,* vol. 57, no. 331 (October 1930), pp. 198–99 [review of Valentiner 1929a].
Cologne, Wallraf-Richartz, cat. 1967
 Cologne, Wallraf-Richartz-Museum. *Katalog der niederländischen Gemälde von 1550 bis 1800.* 1967. Catalogue by Horst Vey and Annamaria Kesting.
Coninckx 1907
 H. Coninckx. "David Vinckboons, peintre, et son oeuvre et la famille de ce nom." *Annales de l'Académie royale d'archéologie de Belgique,* vol. 59 (1907), pp. 405–52.
Coninckx 1908
 ———. *David Vinckboons, peintre, et son oeuvre et la famille de ce nom.* Antwerp, 1908.
Coninckx 1914
 ———. "Les Hals à Malines." *Annales de l'Académie royale d'archéologie de Belgique,* vol. 66 (1914), pp. 145–84.
de Coo 1947
 J. de Coo. *De boer in de kunst van de 9e tot de 19e eeuw.* Antwerp, 1947.
Coremans 1949
 P. B. Coremans. *Van Meegeren's Faked Vermeers and De Hoochs.* Translated by A. Hardy and C. M. Hunt. Amsterdam, 1949.
von Criegern 1971
 Axel von Criegern. "Abfahrt von einem Wirtshaus: Ikonographische Studie zu einem Thema von Jan Steen." *Oud Holland,* vol. 86 (1971), pp. 9–31.
Cust 1931
 Lionel Cust. *The King's Pictures from Buckingham Palace, Windsor Castle, and Hampton Court.* 3 vols. London, 1931.

Czobor 1963
 Agnes Czobor. "Zu Vinckboons' Darstellungen von Soldatenszenen." *Oud Holland,* vol. 78 (1963), pp. 151–53.
Daly 1979
 Peter M. Daly. *Emblem Theory: Recent German Contributions to the Characterization of the Emblem Genre.* Wolfenbütteler Forschungen, vol. 9. Nendeln, 1979.
Daniëls 1976
 G.L.M. Daniëls. "Doe heb ick uyt verkooren. . . ." *Antiek,* vol. 11, no. 4 (November 1976), pp. 329–41.
Dapper 1663
 O[lfert] D[apper]. *Historische beschreyving der Stadt Amsterdam.* Amsterdam, 1663.
Davidsohn 1922
 Paul Davidsohn. *Adriaen van Ostade, 1610–1685: Verzeichnis seiner Originalradierungen.* Leipzig, 1922.
Dayot 1911
 A. Dayot. *Grands et petits maîtres hollandais.* Paris, 1911.
Dayton/Baltimore 1965–66
 Dayton, Dayton Art Institute. *Hendrick Terbrugghen in America.* October 15–November 28, 1965. Also shown at Baltimore, Baltimore Museum of Art, December 19, 1965–January 30, 1966. Catalogue by Leonard J. Slatkes.
Delbanco 1928
 Gustav Delbanco. *Der Maler Abraham Bloemaert.* Strassburg, 1928.
Demetz 1963
 Peter Demetz. "Defenses of Dutch [genre] Painting and the Theory of Realism." *Comparative Literature,* vol. 15, no. 2 (Spring 1963), pp. 97–115.
Denis, Knuttel, Meischke 1961
 Valentin Denis, Gerard Knuttel, and Rudolf Meischke. "Flemish and Dutch Art." In *Encyclopedia of World Art,* vol. 5, cols. 401–51.
Dersjant 1946
 G. M. Dersjant. "Kaarslichtschilders uit de XVIIe eeuw." *Die Constghesellen Maandblad voor beeldende kunst,* vol. 1 (1946), pp. 43–45, 111–14.
Descamps 1753–64
 Jean Baptiste Descamps. *La Vie des peintres flamands, allemands et hollandais.* 4 vols. Paris, 1753–64.
Descargues 1968
 Pierre Descargues. *Hals.* Geneva, 1968 (English edition translated by J. Emmons. Cleveland, 1968).
Detroit 1929
 Detroit, The Detroit Institute of Arts. *Dutch Genre and Landscape Painting.* October 16–November 10, 1929.
Detroit 1935
 Detroit, The Detroit Institute of Arts. *An Exhibition of Fifty Paintings by Frans Hals.* January 10–February 28, 1935. Introduction and catalogue by W. R. Valentiner.
Detroit, Institute, cat. 1965
 Detroit, The Detroit Institute of Arts. *A Check List of the Paintings Acquired before June, 1965.*
van Deursen 1978a
 A. Th. van Deursen. *Het dagelijks brood.* Het kopergeld van de Gouden Eeuw, vol. 1. Amsterdam, 1978.
van Deursen 1978b
 ———. *Volkskultuur.* Het kopergeld van de Gouden Eeuw, vol. 2. Amsterdam, 1978.
van Deursen 1980a
 ———. *Volk en overheid.* Het kopergeld van de Gouden Eeuw, vol. 3. Assen, 1980.
van Deursen 1980b
 ———. *Hel en hemel.* Het kopergeld van de Gouden Eeuw, vol. 4. Assen, 1980.
DIAL
 Rijksbureau voor Kunsthistorische Documentatie. *Decimal Index of the Art of the Low Countries.* The Hague, 1958–.
van Dillen 1970
 J. G. van Dillen. *Van rijkdom en regenten: Handboek tot de economische en sociale geschiedenis van Nederland tijdens de republiek.* The Hague, 1970.

van Dillen 1974
 ———. *Bronnen tot de geschiedenis van het Bedrijfs-leven en het geldwezen van Amsterdam.* 3 vols. The Hague, 1974.
Dodt 1846
 J. J. Dodt van Flensburg. "Heyndrick ter Brugghen." *Berigten van het Historisch Genootschap te Utrecht,* vol. 1 (1846), pp. 129–36.
Dohmann 1958
 A. Dohmann. "Les Evènements contemporains dans la peinture hollandaise du XVII^e siècle." *Revue d'histoire moderne et contemporaine,* vol. 5 (1958), pp. 265–82.
van Doorninck 1883
 J. J. van Doorninck. "Het schildersgeschlacht Ter Borch." *Verslagen en mededeelingen der Vereeniging tot beoefening van Overijsselsch Regt en Geschiedenis,* vol. 13 (1883), pp. 1–22.
Dordrecht 1934
 Dordrecht, Dordrechts Museum. *Nicolaes Maes.* 1934.
Dozy 1884
 C. M. Dozy. "Pieter Codde, de schilder en de dichter." *Oud Holland,* vol. 2 (1884), pp. 34–67.
Dresden, Gemäldegalerie, cat. 1982
 Dresden, Staatliche Kunstsammlungen, Gemäldegalerie Alte Meister. *Gemäldegalerie Alte Meister Dresden: Katalog der ausgestellten Werke.* 2nd ed. 1982.
Drost 1928
 W. Drost. *Motivübernahme bei Jakob Jordaens und Adriaen Brouwer.* Königsberg, 1928.
Dubiez 1956
 F. J. Dubiez. "Het schildersechtpaar Judith Leyster en Jan Miense Molenaer in Amsterdam." *Ons Amsterdam,* vol. 8 (1956), pp. 142–44.
Dublin, National Gallery, cat. 1981
 Dublin, National Gallery of Ireland. *Illustrated Summary Catalogue of Paintings.* 1981.
Dubrzycka 1958
 Anna Dubrzycka. *Hals* (in Polish). Warsaw, 1958.
Dudok van Heel 1983
 S.A.C. Dudok van Heel. "In presentie van de Heer Gerard ter Borch." In *Essays in Northern European Art Presented to Egbert Haverkamp Begemann on His Sixtieth Birthday,* edited by Anne-Marie Logan, pp. 66–71. Doornspijk, 1983.
Dülberg 1930
 F. Dülberg. *Frans Hals: Ein Leben und ein Werk.* Stuttgart, 1930.
Duparc 1980
 F[rits] J. Duparc, Jr. "Een teruggevonden schilderij van N. Berchem en J. B. Weenix." *Oud Holland,* vol. 94 (1980), pp. 37–43.
Duplessis 1881
 G. Duplessis. *Eaux-fortes de Van Ostade.* Paris, 1881.
Durand-Gréville 1895
 E. Durand-Gréville. "La signature de Jan Molenaer." *La Chronique des arts et de la curiosité,* 1895, pp. 253–54.
Durantini 1983
 Mary Frances Durantini, *The Child in Seventeenth-Century Dutch Painting.* Studies in the Fine Arts. Iconography: no. 7. Ann Arbor, 1983.
Dutuit 1881–88
 Eugène Dutuit. *Manuel de l'amateur d'estampes.* 6 vols. Paris, 1881–88.

van den Eeckhout 1883–84
 "Eenige bijzonderheden betrekkelijk de familie van den beroemden Nederlandsch schilder Gerbrand van den Eeckhout." *Algemeen Nederlands familieblad,* vol. 1 (1883–84), nos. 104–5.
van Eeghen 1952
 I. H. van Eeghen. "De familie Vinckboons-Vingboons." *Oud Holland,* vol. 67 (1952), pp. 217–32.
van Eeghen 1974
 ———. "Pieter Codde en Frans Hals." *Amstelodamum,* vol. 61 (1974), pp. 137–41.
Eigenberger 1927
 Robert Eigenberger. *Die Gemäldegalerie der Akademie der bildenden Künste in Wien.* 2 vols. Vienna, 1927.
Eisler 1977
 Colin Eisler. *Paintings from the Samuel H. Kress Collection.* Oxford, 1977.

Eisler 1923
 Max Eisler. *Alt-Delft Kultur und Kunst.* Amsterdam and Vienna, 1923.
Ellerbroeck-Fortuin 1937
 Else Ellerbroeck-Fortuin. *Amsterdamse rederijkersspelen in de zeventiende eeuw.* Groningen and Batavia, 1937.
Emmens 1963a
 J. A. Emmens. "Natuur, onderwijzing en oefening: Bij een drieluik van Gerrit Dou." In *Album Discipulorum, aangeboden aan Professor Dr. J. G. van Gelder,* pp. 125–63. Utrecht, 1963.
Emmens 1963b
 ———. "Kunstenaar en publiek in een schilderij van Gerrit Dou in het Museum Boymans–van Beuningen." *Vereniging van Nederlandse Kunsthistorici te Rotterdam.* December 21, 1963.
Emmens 1971
 ———. "Gerard Dou, 'De Kwakzalver.'" *Openbaar Kunstbezit,* vol. 15 (1971), pp. 4a–b.
Emmens 1973
 ———. "'Eins aber ist nötig': Zu Inhalt und Bedeutung von Markt- und Küchen-stücken des 16. Jahrhunderts." In *Album Amicorum J. G. van Gelder,* edited by J. Bruyn et al., pp. 93–101. The Hague, 1973.
Ephrussi 1884–85
 C. Ephrussi. "A propos d'Adriaen Brouwer." Parts 1, 2. *Gazette des Beaux-Arts,* 2nd ser., vol. 30 (1884), pp. 306–13; vol. 31 (1885), pp. 164–76.
Erasmus 1909
 K. Erasmus. "Die Hermann Saftleven-Ausstellung im Rijksprentenkabinet." *Der Cicerone,* vol. 1, no. 19 (1909), pp. 611–12.
van Eynden, van der Willigen 1816–40
 R. van Eynden and A. van der Willigen. *Geschiedenis der vaderlandsche schilderkunst sedert de helft der XVIII eeuw.* 4 vols. Haarlem, 1816–40.

Fancheux 1862
 L. E. Fancheux. *Catalogue raisonné de toutes les estampes qui forment l'oeuvre gravé d'Adriaen van Ostade.* Paris, 1862.
Félibien 1666–88
 André Félibien. *Entretiens sur les vies et sur les ouvrages des plus excellens peintres anciens et modernes.* 5 vols. Paris, 1666–88.
Félibien 1679
 ———. *Noms des peintres les plus célèbres et les plus connus, anciens et modernes.* Paris, 1679. Reprint. Geneva, 1972.
Fink 1971
 Daniel A. Fink. "Vermeer's Use of the Camera Obscura: A Comparative Study." *The Art Bulletin,* vol. 53, no. 4 (December 1971), pp. 493–505.
Finlay 1953
 Ian F. Finlay. "Musical Instruments in 17th-Century Dutch Painting." *The Galpin Society Journal,* vol. 6 (1953), pp. 52–69.
Fischer 1975
 Pieter Fischer. *Music in Paintings of the Low Countries in the 16th and 17th Centuries.* Amsterdam, 1975.
Fishman 1979
 Jane Susannah Fishman. "'Boerenverdriet': Violence between Peasants and Soldiers in the Art of the 16th- and 17th-Century Netherlands." Diss., University of California, Berkeley, 1979.
Fleischer 1978
 R[oland] E. Fleischer. "Ludolf de Jongh and the Early Work of Pieter de Hooch." *Oud Holland,* vol. 92 (1978), pp. 49–67.
Fleischer forthcoming
 ———. *Ludolf de Jongh.* Great Minor Masters. Netherlandish Painters from the Past. Doornspijk, forthcoming.

Floerke 1905
H. Floerke. *Studien zur niederländischen Kunst- und Kulturgeschichte: Die Formen des Kunsthandels, das Atelier und die Sammler in den Niederlanden vom 15–18 Jahrhundert.* Munich, 1905.

Fokker 1927
T. H. Fokker. "Twee Nederlandsche navolgers van Caravaggio te Rome." *Oud Holland,* vol. 44 (1927), pp. 131–37.

Fokker 1929
_____. "Nederlandsche schilders in Zuid-Italië." *Oud Holland,* vol. 46 (1929), pp. 1–24.

Foucart 1976
Jacques Foucart. "Un troisième Pieter de Hooch au Louvre." *La Revue du Louvre,* vol. 26, no. 1 (1976), pp. 30–34.

Franken 1878
Daniel Franken. *Adriaen van de Venne.* Amsterdam, 1878.

Frederiks 1888
P. J. Frederiks. "Philip Angel's 'Lof der Schilderkonst.'" *Oud Holland,* vol. 6 (1888), pp. 113–22.

Friedländer 1902
Max J. Friedländer. "Frans Hals." *Das Museum von Wilhelm Spemann,* vol. 7 (1902), pp. 41–44.

Friedländer 1918
_____. "Adriaen Brouwer." *Der Belfried,* vol. 2 (1918), pp. 324–27.

Friedländer 1923
_____. *Die Niederlandischen Maler des 17. Jahrhunderts.* Propyläen Kunstgeschichte, vol. 12. Berlin, 1923.

Friedländer 1947
_____. "Vom Wesen der Genremalerei und dem Entstehen der Bildgattung." In M. J. Friedländer, *Essays über die Landschaftsmalerei und andere Bildgattungen,* pp. 191–210. The Hague, 1947.

von Frimmel 1899
T. von Frimmel. *Geschichte der Wiener Gemäldesammlungen.* Leipzig, 1899.

Fromentin 1963
Eugène Fromentin. *The Old Masters of Belgium and Holland.* Introduction by Meyer Schapiro. New York, 1963.

Gaedertz 1869
Theodor Gaedertz. *Adrian van Ostade: Sein Leben und seine Kunst.* Lübeck, 1869.

Gaedertz 1887
_____. "Der Geburtsort des Adrian van Ostade." In T. Gaedertz, *Kunststreifzüge: Gesammelte Aufsätze aus dem Gebiete der bildenden Kunst und Kunstgeschichte,* pp. 174–82. Lübeck, 1889.

Gaedertz 1889
_____. "Cornelis Bega." In T. Gaedertz, *Kunststreifzüge: Gesammelte Aufsätze aus dem Gebiete der bildenden Kunst und Kunstgeschichte,* pp. 183 88. Lübeck, 1889.

Gaskell 1982
Ivan Gaskell. "Gerrit Dou, His Patrons and the Art of Painting." *Oxford Art Journal,* vol. 5, no. 1 (1982), pp. 15–23.

Gaskell 1983
_____. "Art for the Oligarchs." *Art History,* vol. 6, no. 2 (June 1983), pp. 236–41.

Geisenheimer 1911
Hans Geisenheimer. "Beiträge zur Geschichte des niederländischen Kunsthandels in der zweiten Hälfte des XVII. Jahrhunderts." *Jahrbuch der königlich preussischen Kunstsammlungen,* vol. 32 (1911), pp. 34–61.

van Gelder 1948
H. E. van Gelder. "Perspectieven bij Vermeer." *Kunsthistorische mededelingen van het Rijksbureau voor Kunsthistorische Documentatie,* vol. 3, no. 3 (1948), pp. 34–36.

van Gelder 1931
J. G. van Gelder. "De etsen van Willem Buytewech." *Oud Holland,* vol. 48 (1931), pp. 49–72.

van Gelder 1940–41
_____. "Adriaen Brouwer." *Maandblad voor beeldende kunst,* vol. 27 (1940–41), pp. 65–72.

van Gelder 1941
_____. *Adriaen van Ostade: 50 etsen.* Haarlem, 1941.

van Gelder 1946a
_____. "Willem Buytewegh: Twee jeugdteekeningen." *Kunsthistorische mededelingen van het Rijksbureau voor Kunsthistorische Documentatie,* vol. 1, no. 2 (1946), p. 26.

van Gelder 1946b
_____. "Honthorstiana." *Kunsthistorische mededelingen van het Rijksbureau voor Kunsthistorische Documentatie,* vol. 1, nos. 4–5 (1946), pp. 56–58.

van Gelder 1949
_____. "Gerbrand van den Eeckhout als portrettist." *Kunsthistorische mededelingen van het Rijksbureau voor Kunsthistorische Documentatie,* vol. 4, nos. 1–2 (1949), pp. 15–17.

van Gelder 1958
_____. *De schilderkunst van Jan Vermeer.* Commentary by J. A. Emmens. Utrecht, 1958.

van Gelder 1961
_____. "Two Aspects of the Dutch Baroque: Reason and Emotion." In *Essays in Honor of Erwin Panofsky.* 2 vols. Edited by Millard Meiss. Vol. 1, pp. 445–53. New York, 1961.

Genaille 1952
Robert Genaille. "La Peinture de genre aux anciens Pays-Bas au XVIᵉ siècle." *Gazette des Beaux-Arts,* 6th ser., vol. 39 (1952), pp. 243–52.

Gerson 1942
Horst Gerson. *Ausbreitung und Nachwirkung der holländischen Malerei des 17. Jahrhunderts.* Haarlem, 1942.

Gerson 1948
_____. "Landschappen van Jan Steen." *Kunsthistorische mededelingen van het Rijksbureau voor Kunsthistorische Documentatie,* vol. 3, no. 4 (1948), pp. 50–56.

Gerson 1952a
_____. *Het tijdperk van Rembrandt en Vermeer.* De Nederlandse schilderkunst, vol. 2. Amsterdam, 1952.

Gerson 1952b
_____. "Die Ausstellung Caravaggio und die Niederlande." *Kunstchronik,* vol. 5, no. 11 (1952), pp. 287–93.

Gerson 1955
_____. "Enkele vroege werken van Esaias van de Velde." *Oud Holland,* vol. 70 (1955), pp. 131–34.

Gerson 1966a
_____. "Frans Hals." In *Kindlers Malerei Lexikon,* vol. 3, pp. 30–43.

Gerson 1966b
_____. "Pieter de Hooch." In *Kindlers Malerei Lexikon,* vol. 3, pp. 308–12.

Gerson 1967
_____. "Jan (Johannes) Vermeer." In *Encyclopedia of World Art,* vol. 14, cols. 739–45.

Gerson 1968
_____. *Rembrandt Paintings.* New York and Amsterdam, 1968.

Gerson 1969
_____. "Rembrandt en de schilderkunst in Haarlem." In *Miscellenea I. Q. van Regteren Altena,* pp. 138–42, 333–35. Amsterdam, 1969.

Gerson 1977
_____. "Recent Literature on Vermeer." *The Burlington Magazine,* vol. 119, no. 889 (April 1977), pp. 288–90.

Geyl 1961–64
Pieter Geyl. *The Netherlands in the Seventeenth Century.* 2 vols. London, 1961–64.

van Gils 1917
J.B.F. van Gils. *De dokter in de oude Nederlandsche tooneelliteratuur.* Haarlem, 1917.

van Gils 1920
_____. "Een detail op de doktersschilderijen van Jan Steen." *Oud Holland,* vol. 38 (1920), pp. 200–201.

van Gils 1921
_____. "Een detail op de doktersschilderijen van Jan Steen." *Nederlandsch tijdschrift voor geneeskunde,* vol. 65 (1921), pp. 2561–63.

van Gils 1935
———. "Jan Steen en de rederijkers." *Oud Holland*, vol. 52 (1935), pp. 130–33.

van Gils 1937
———. "Jan Steen in den schouwburg." *Op de hoogte*, vol. 34 (March 1937), pp. 92–93.

van Gils 1942
———. "Jan Steen in den schouwburg." *Oud Holland*, vol. 59 (1942), pp. 57–63.

Ginnings 1970
Rebecca Jean Ginnings. "Art of Jan Baptist Weenix and Jan Weenix." Diss., University of Delaware, 1970.

Godefroy 1930
Louis Godefroy. *L'Oeuvre gravé de Adriaen van Ostade*. Paris, 1930.

Godfrey 1949
F. M. Godfrey. "Painters of the Domestic Scene in XVIIth Century Holland." *Apollo*, vol. 50 (December 1949), pp. 160–63.

Goethals 1838
F. V. Goethals. "Adrian van der Werf." In F. V. Goethals, *Lectures relatives à l'histoire des sciences, des arts, des lettres*, pp. 245–61. Brussels, 1838.

Goldscheider 1958
Ludwig Goldscheider. *Johannes Vermeer: Complete Paintings*. London, 1958.

Goldscheider 1964
———. "Vermeers Lehrer." *Pantheon*, vol. 22, no. 1 (January–February 1964), pp. 35–38.

Goldscheider 1967
———. *Johannes Vermeer: Complete Paintings*. 2nd ed. London, 1967 [see Goldscheider 1958].

Goldschmidt 1897
A. Goldschmidt. "Anfänge des Genre-bildes." *Das Museum von Wilhelm Spemann*, vol. 2 (1897), pp. 33–36.

Goldschmidt 1901
———. "Zeichnungen und Radierungen des Willem Buytewech." *Sitzungsberichte der Kunstgeschichtliche Gesellschaft*, 1901, pp. 14–16.

Goldschmidt 1902
———. "Willem Buytewech." *Jahrbuch der königlich preussischen Kunstsammlungen*, vol. 23 (1902), pp. 100–17.

Goodman 1982
Elise Goodman. "Reubens' 'Conversatie à la Mode': Garden of Leisure, Fashion, and Gallantry." *The Art Bulletin*, vol. 64, no. 2 (June 1982), pp. 247–59.

van Gool 1750–51
Johan van Gool. *De tieuwe schouburg der Nederlansche kunstschilders en schilderessen*. 2 vols. The Hague, 1750–51. Reprint. Soest, 1971.

Goossens 1954a
Korneel Goossens. *David Vinckboons*. Antwerp and The Hague, 1954. Reprint. Soest, 1977.

Goossens 1954b
———. "David Vinckboons." *Bulletin des Musées royaux des Beaux-Arts*, vol. 3 (March 1954), pp. 33–43.

Goossens 1966
———. "Nog meer over David Vinckboons." *Jaarboek van het Koninklijk Museum voor Schone kunsten te Antwerpen*, 1966, pp. 59–106.

Goossens 1977
———. *David Vinckboons*. Soest, 1977 [reprint of Goossens 1954a].

Gotha, Museum, cat. 1890
Gotha, Herzogliches Museum. *Katalog der herzoglichen Gemäldegalerie*. 1890. Catalogue by Carl Aldenhoven.

Gower 1880
Ronald Gower. *The Figure Painters of Holland*. London, 1880.

Gowing 1951
Lawrence Gowing. "Light on Baburen and Vermeer." *The Burlington Magazine*, vol. 93, no. 578 (May 1951), pp. 169–70.

Gowing 1952
———. *Vermeer*. London, 1952.

de Graaf 1937
D. A. de Graaf. "Drie eeuwen na den dood van Adriaen Brouwer." *Historia*, vol. 3 (1937), pp. 266–68.

de Graaf 1938
———. "Een XVIIᵉ eeuwsche decadent: Adriaen Brouwer, ± 1605–1638." *Elsevier's geïllustreed maandschrift*, vol. 95 (1938), pp. 104–10.

Grant 1908
J. Kirby Grant. "Mr. John G. Johnson's Collection of Pictures in Philadelphia." Part 4. *The Connoisseur*, vol. 22, no. 87 (1908), pp. 141–52.

Gratama 1937
G. D. Gratama. "De reprimande aan Frans Hals." *Historia*, vol. 3 (1937), pp. 241–42.

Gratama 1943
———. *Frans Hals*. The Hague, 1943. 2nd ed. 1946.

Graves 1918–21
Algernon Graves. *Art Sales from Early in the Eighteenth Century to Early in the Twentieth Century*. 3 vols. London, 1918–21. Reprint. Trowbridge, 1973.

Grimm 1971
Claus Grimm. "Frans Hals und seine 'Schule.'" *Münchner Jahrbuch der bildenden Kunst*, vol. 22 (1971), pp. 146–78.

Grimm 1972
———. *Frans Hals*. Berlin, 1972.

Grimme 1974
Ernst G. Grimme. *Jan Vermeer van Delft*. Cologne, 1974.

van der Grinten 1962
E. F. van der Grinten. "Le Cachalot et le mannequin: Deux facettes de la réalité dans l'art hollandais du seizième et du dix-septième siècles." *Nederlands kunsthistorisch jaarboek*, vol. 13 (1962), pp. 149–79.

de Groot 1952
Cornelis Wilhelmus de Groot. *Jan Steen: Beeld en woord*. Utrecht, 1952.

Grosjean 1974
Ardis Grosjean. "Toward an Interpretation of Pieter Aertsen's Profane Iconography." *Konsthistorisk tidskrift*, vol. 43, nos. 3–4 (December 1974), pp. 121–43.

Gudlaugsson 1938
S. J. Gudlaugsson. *Ikonographische Studien über die holländische Malerei und das Theater des 17. Jahrhunderts*. Würzburg, 1938.

Gudlaugsson 1945
———. *Komedianten bij Jan Steen en zijn tijdgenoten*. The Hague, 1945.

Gudlaugsson 1948
———. "Adriaen Pauw's intocht te Munster, een gemeenschappelijk werk van Gerard ter Borch en Gerard van der Horst." *Oud Holland*, vol. 63 (1948), pp. 39–46.

Gudlaugsson 1949a
———. "De datering van de schilderijen van Gerard ter Borch." *Nederlands kunsthistorisch jaarboek*, vol. 2 (1949), pp. 235–67.

Gudlaugsson 1949b
———. "Gerard ter Borch in Spain." In *Résumés des rapports et communications du 16ᵉ congres international d'histoire de l'art*. Lisbon, 1949.

Gudlaugsson 1950
———. "Ten onrechte aan Caspar Netscher toegeschreven schilderijen van Adriaen van der Werff, Reynier de la Haye, Thomas van der Wilt, en Johan van Haensbergen." *Oud Holland*, vol. 65 (1950), pp. 241–47.

Gudlaugsson 1952
———. "Een teruggevonden werk van Pieter Janssens Elinga." *Oud Holland*, vol. 67 (1952), pp. 178–79.

Gudlaugsson 1955
———. "Was is er van Ter Borchs schilderijen in het IJsselgebied overgebleven?" *Overijssel jaarboek voor cultuur en historie*, vol. 9 (1955), pp. 46–62.

Gudlaugsson 1956
———. "Een uitzonderlijk werk van Willem Pietersz. Buytewech." *Oud Holland*, vol. 71 (1956), pp. 226–29.

Gudlaugsson 1959–60
———. *Geraert ter Borch*. 2 vols. The Hague, 1959–60.

Gudlaugsson 1960–61
_____ . "Ter Borch und das holländische Gesellgkeitsbild seiner Zeit." *Sitzungsberichte der Kunstgeschichtlichen Gesellschaft zu Berlin*, n.s., vol. 9 (October 1960–May 1961), pp. 13–14.

Gudlaugsson 1967
_____ . "Frans van Mieris d. Ä." In *Kindlers Malerei Lexikon*, vol. 4, pp. 420–22.

Gudlaugsson 1968a
_____ . "Kanttekeningen bij de ontwikkeling van Metsu." *Oud Holland*, vol. 83 (1968), pp. 13–44.

Gudlaugsson 1968b
_____ . "Jan (Johannes) Vermeer." In *Kindlers Malerei Lexikon*, vol. 5, pp. 656–64.

Gudlaugsson 1975
_____ . *The Comedians in the Work of Jan Steen and His Contemporaries*. Translated by James Brockway and Patricia Wadle. Soest, 1975 [translation of Gudlaugsson 1945].

Haarlem 1937
Haarlem, Frans Halsmuseum. *Frans Hals: Tentoonstelling ter gelegenheid van het 75-jarig bestaan van het Gemeente-lijk Museum te Haarlem op 30 Juni 1937*. Introduction by G. D. Gratama; catalogue by G. D. Gratama and J. L. A. A. M. van Rijkevorsel.

Haarlem 1946
Haarlem, Frans Halsmuseum. *Haarlemsche meesters uit de eeuw van Frans Hals*. July 6–September 16, 1946. Introduction by H. P. Baard.

Haarlem 1962
Haarlem, Frans Halsmuseum. *Frans Hals: Exhibition on the Occasion of the Centenary of the Municipal Museum at Haarlem, 1862–1962*. June 16–September 30, 1962. Introduction by H. P. Baard; catalogue by S. Slive.

Haarlem, Frans Halsmuseum, cat. 1955
Haarlem, Frans Halsmuseum. *Frans Halsmuseum: Municipal Art Gallery at Haarlem*. 1955.

Haarlem, Frans Halsmuseum, cat. 1969
Haarlem, Frans Halsmuseum. *Frans Halsmuseum, Haarlem*. 1969.

Haex 1981–82
Odette Haex. "Een soldatenstuk van de 17de-eeuwse Amsterdamse genreschilder Simon Kick/A Soldier's Piece by the 17th Century Genre Painter Simon Kick." *Tableau*, vol. 4, no. 3 (December 1981–January 1982), pp. 294–98.

The Hague 1948
The Hague, Mauritshuis. *Masterpieces of the Dutch School from the Collection of H. M. the King of England*. August 6–September 26, 1948.

The Hague 1958–59
The Hague, Mauritshuis. *Jan Steen*. December 20, 1958–February 15, 1959. Catalogue by P.N.H. Domela Nieuwenhuis.

The Hague, Mauritshuis, cat. 1914
The Hague, Mauritshuis. *Musée Royal de la Haye (Mauritshuis): Catalogue raisonné des tableaux et des sculptures*. 2nd ed. 1914.

The Hague, Mauritshuis, cat. 1935
The Hague, Mauritshuis. *Musée Royal de la Haye (Mauritshuis): Catalogue raisonné des tableaux et des sculptures*. 3rd ed. 1935.

The Hague, Mauritshuis, cat. 1977
The Hague, Mauritshuis. *The Royal Cabinet of Paintings: Illustrated General Catalogue*. 1977.

The Hague, Bredius, cat. 1978
The Hague, Museum Bredius. *Catalogus van de schilderijen en tekeningen*. 1978. Catalogue by Albert Blankert.

The Hague/Münster 1974
The Hague, Mauritshuis. *Gerard Ter Borch, Zwolle 1617–Deventer 1681*. March 9–April 28, 1974. Also shown at Münster, Landesmuseum, 1974. Catalogue by S. J. Gudlaugsson, J. P. Guépin, and Lyckle de Vries.

The Hague/Paris 1966
The Hague, Mauritshuis. *In het licht van Vermeer: Vijf eeuwen schilderkunst*. June 25–September 5, 1966. Also shown at Paris, Orangerie des Tuileries, September 25–November 25, 1966. Introduction by R. Huyghe and A. B. de Vries.

Haks 1982
D. Haks. *Huwelijk en gezin in Holland in de 17de en 18de eeuw*. Assen, 1982.

Hale 1913
Philip L. Hale. *Jan Vermeer of Delft*. Boston, 1913.

Hale 1937
_____ . *Vermeer*. London, 1937.

Haley 1972
K.H.D. Haley. *The Dutch in the Seventeenth Century*. London, 1972.

Hana 1930
Herman Hana. "Het binnenhuis." In H. Hana, *Het schouwtooneel der schilderkunst*, pp. 109–26. Nijkerk, 1930.

Hanfstaengl 1922
E. Hanfstaengl. *Meisterwerke der Alteren Pinakothek in München*. 3rd ed. Munich, 1922.

Hannema 1932
D. Hannema. "Over 'beelden, historien en portretten' van Emanuel de Witte." *Outheidkundig jaarboek*, 4th ser., vol. 1 (1932), pp. 116–20.

Hannema 1943
F. Hannema. *Gerard Terborch*. Amsterdam, [1943].

Hannover, Niedersächsischen Landesgalerie, cat. 1954
Hannover, Niedersächsischen Landesgalerie. *Katalog der Gemälde alter Meister in der niedersächsischen Landesgalerie, Hannover*. 1954. Catalogue by G. von der Osten.

Hannover, Niedersächsische Landesgalerie, cat. 1969
Hannover, Niedersächsische Landesgalerie. *Niedersächsische Landesgalerie, Hannover*. Cologne, 1969. Catalogue by Harald Seiler.

Harms 1927
Juliane Harms. "Judith Leyster: Ihr Leben und ihr Werk." Parts 1–5. *Oud Holland*, vol. 44 (1927), pp. 88–96, 112–26, 145–54, 221–44, 275–79.

Harrebomée 1856–70
P. J. Harrebomée. *Spreekwoordenboek der Nederlandsche taal of verzameling van Nederlandsche spreekwoorden en spreekwoordelijke uitdrukkingen*. 3 vols. Utrecht, 1856–70.

Hartford 1950–51
Hartford, Wadsworth Atheneum. *Life in Seventeenth Century Holland*. November 21, 1950–January 14, 1951. Introduction by C. C. Cunningham.

Hartford, Wadsworth Atheneum, cat. 1978
Hartford, Wadsworth Atheneum. *Wadsworth Atheneum Paintings. Catalogue I. The Netherlands and the German-Speaking Countries, Fifteenth–Nineteenth Centuries*. Edited by Egbert Haverkamp Begemann. 1978.

Havard 1877
Henry Havard. "L'Etat civil des maîtres hollandais: Pieter de Hooch." *Gazette des Beaux-Arts*, 2nd ser., vol. 15 (1877), pp. 519–24.

Havard 1878a
_____ . "L'Etat civil de Quiring Brekelenkamp." *La Chronique des arts et de la curiosité*, 1878, pp. 69–70, 75.

Havard 1878b
_____ . "L'Etat civil des maîtres hollandais: Les Palamèdes." *Gazette des Beaux-Arts*, 2nd ser., vol. 17 (1878), pp. 360–72.

Havard 1879–81
_____ . *L'Art et les artistes hollandais*. 4 vols. Paris, 1879–81.

Havard 1881
_____ . *Histoire de la peinture hollandais*. Paris, [1881].

Havard 1885
_____ . *The Dutch School of Painting*. Translated by G. Powell. London, 1885.

Havard 1888
_____ . *Van der Meer de Delft*. Les Artistes célèbres. Paris, 1888.

Havelaar 1919
J. Havelaar. *Oud-Hollandsche figuurschilders.* 2nd ed. Haarlem, 1919.

Haverkamp Begemann 1959
Egbert Haverkamp Begemann. *Willem Buytewech.* Amsterdam, 1959.

Haverkamp Begemann 1962
——. "The Etchings of Willem Buytewech." In *Prints: Thirteen Illustrated Essays on the Art of the Print*, edited by Carl Zigrosser, pp. 55–81. New York, 1962.

Haverkamp Begemann 1965
——. "Terborch's 'Lady at Her Toilet.'" *The Art News*, vol. 64 (December 1965), pp. 38–41, 62–63.

Haverkamp Begemann 1966
——. "A Standing Cavalier by Willem Buytewech." *Master Drawings*, vol. 4 (1966), pp. 155–57.

Haverkamp Begemann 1972
——. "Nicolaes Berchem in honore Horst Gerson propter artem navigandi." *Nederlands kunsthistorisch jaarboek*, vol. 23 (1972), pp. 273–74.

Haverkorn van Rijsewijk 1880
P. Haverkorn van Rijsewijk. "Pieter de Hooch." *Nederlandsche kunstbode*, vol. 2 (1880), pp. 163–65.

Haverkorn van Rijsewijk 1891
——. "Willem Pietersz. Buytewech." *Oud Holland*, vol. 9 (1891), pp. 56–61.

Haverkorn van Rijsewijk 1892a
——. "Pieter de Hooch of de Hoogh." *Oud Holland*, vol. 10 (1892), pp. 172–77.

Haverkorn van Rijsewijk 1892b
——. "Rotterdamsche Schilders." *Oud Holland*, vol. 10 (1892), pp. 238–56.

Haverkorn van Rijsewijk 1896
——. "Ludolf (Leuff) de Jongh." *Oud Holland*, vol. 14 (1896), pp. 36–46.

Haverkorn van Rijsewijk 1899
——. "De geboorteplaats van Cornelis Saftleven." *Oud Holland*, vol. 17 (1899), pp. 239–40.

Haverkorn van Rijsewijk 1905
——. "Willem Pietersz. Buijtewech." *Oud Holland*, vol. 23 (1905), pp. 163–64.

Hecht 1980
Peter Hecht. "Candlelight and Dirty Fingers, or Royal Virtue in Disguise: Some Thoughts on Weyerman and Godfried Schalcken." *Simiolus*, vol. 11, no. 1 (1980), pp. 23–38.

Heckscher, Wirth 1967
W. S. Heckscher and K. A. Wirth. "Emblem, Emblembuch." In *Reallexikon zur deutschen Kunstgeschichte*, vol. 5, cols. 85–229. Stuttgart, 1967.

van Hees 1956
C. A. van Hees. "Nadere gegevens omtrent de Haarlemse vrienden Leendert van der Cooghen en Cornelis Bega." *Oud Holland*, vol. 71 (1956), pp. 243–44.

van Hees 1959
——. "Archivalia betreffende Frans Hals en de zijnen." *Oud Holland*, vol. 74 (1959), pp. 36–42.

Helbers 1955
G. C. Helbers. "Archiefsprokkelingen." *Oud Holland*, vol. 70 (1955), p. 118.

Held 1951
Julius S. Held. "Notes on David Vinckeboons." *Oud Holland*, vol. 66 (1951), pp. 241–44.

Held 1964
——. "Nicolaes Maes." In *Encyclopedia of World Art*, vol. 9, cols. 369–70.

Held 1967
——. "Jan Steen." In *Encyclopedia of World Art*, vol. 13, cols. 374–75.

Hellens 1911
Franz Hellens. *Gérard Terborch.* Brussels, 1911.

Hellens 1926
——. "Un Peintre de la société hollandaise, Gérard Terburg." *L'Art vivant*, vol. 2 (1926), pp. 331–34.

Henkel 1931–32
M. D. Henkel. "Jan Steen und der Delfter Vermeer." *Der Kunstwanderer*, 1931–32, pp. 265–66.

Henkel 1934
——. "Van-de-Venne-Ausstellung, Amsterdam." *Pantheon*, vol. 13 (1934), p. 154.

Henkel, Schöne 1967
Arthur Henkel and Albrecht Schöne. *Emblemata: Handbuch zur Sinnbildkunst des XVI. und XVII. Jahrhunderts.* Stuttgart, 1967. 2nd ed. Stuttgart, 1978.

Hennus 1936
M. F. Hennus. "Emanuel de Witte, 1617–92." *Maandblad voor beeldende kunsten*, vol. 13 (1936), pp. 3–12.

Heppner 1935
A. Heppner. "Vermeer: Seine künstlerische Herkunft und Ausstrahlung." *Pantheon*, vol. 16 (August 1935), pp. 255–65.

Heppner 1938
——. "Thoré-Bürger en Holland: De ontdekker van Vermeer en zijn liefde voor Neerland's kunst." Parts 1–3. *Oud Holland*, vol. 55 (1938), pp. 17–34, 67–82, 129–44.

Heppner 1939–40
——. "The Popular Theatre of the Rederijkers in the Work of Jan Steen and His Contemporaries." *Journal of the Warburg and Courtauld Institutes*, vol. 3 (1939–40), pp. 22–48.

Heppner 1941
——. "Brouwer's Influence upon Rembrandt." *The Art Quarterly*, vol. 4, no. 1 (1941), pp. 40–55.

Heppner 1946
——. "Rotterdam as the Center of a 'Dutch Teniers Group.'" *Art in America*, vol. 34, no. 1 (January 1946), pp. 15–30.

Hess 1932
Jacob Hess. "Arbeiten des Malers Jan Miel in Turin." *Mededeelingen van het Nederlandsch Historisch Instituut te Rome*, n.s., vol. 2 (1932), pp. 141–52 (reprinted in *Kunstgeschichtliche Studien zu Renaissance und Barock*, vol. 1 [1967], pp. 81–87).

Hind 1931
Arthur M. Hind. *Catalogue of Drawings by Dutch and Flemish Artists.* 5 vols. London, 1931.

Hoet 1752
Gerard Hoet. *Catalogus of Naamlyst van schilderyen.* 3 vols. in 2. The Hague, 1752 [supplemented in Terwesten 1770]. Reprint. Soest, 1976.

Hofrichter 1975
Frima Fox Hofrichter. "Judith Leyster's Proposition: Between Virtue and Vice." *The Feminist Art Journal*, vol. 4, no. 3 (Fall 1975), pp. 22–26.

Hofrichter 1976
——. "Judith Leyster." In *Women Artists: 1550–1950*, edited by A. S. Harris and L. Nochlin, pp. 137–40. New York, 1976.

Hofrichter 1979
——. "Judith Leyster, 1609–1660." Diss., Rutgers University, 1979.

Hofrichter 1983
——. "Judith Leyster's 'Self Portrait'; 'Ut Pictura Poesis.'" In *Essays in Northern European Art Presented to Egbert Haverkamp Begemann on His Sixtieth Birthday*, edited by Anne-Marie Logan, pp. 106–9. Doornspijk, 1983.

Hofstede de Groot 1890
Cornelis Hofstede de Groot. "Johannes Janssens." *Zeitschrift für bildende Kunst*, n.s., vol. 1 (1890), pp. 132–35.

Hofstede de Groot 1891
——. "De schilder Janssens [Elinga], een navolger van Pieter de Hooch." *Oud Holland*, vol. 9 (1891), pp. 266–96.

Hofstede de Groot 1892
——. "Proeve eener kritische beschrijving van het werk van Pieter de Hooch." *Oud Holland*, vol. 10 (1892), pp. 178–91.

Hofstede de Groot 1893a
——. *Arnold Houbraken und seine "Groote Schouburgh," kritisch beleuchtet.* Quellenstudien zur holländischen Kunstgeschichte, vol. 1. The Hague, 1893.

Hofstede de Groot 1893b
_____ . "Judith Leyster." *Jahrbuch der königlich preussischen Kunstsammlungen*, vol. 14 (1893), pp. 190–98, 232.

Hofstede de Groot 1897
_____ . "Een spotteekening van Cornelis Saftleven op de Dordtsche Synode." *Oud Holland*, vol. 15 (1897), pp. 121–23.

Hofstede de Groot 1903
_____ . "Die Koedijck-Rätsel und ihre Lösung." *Jahrbuch der königlich preussischen Kunstsammlungen*, vol. 24 (1903), pp. 39–46.

Hofstede de Groot 1907
_____ . *Jan Vermeer van Delft en Carel Fabritius*. The Hague, 1907.

Hofstede de Groot 1907–28
_____ . *Beschreibendes und kritisches Verzeichnis der Werke der hervorragendsten holländischen Maler des XVII. Jahrhunderts*. 10 vols. Esslingen and Paris, 1907–28.

Hofstede de Groot 1908–27
_____ . *A Catalogue Raisonné of the Works of the Most Eminent Dutch Painters of the Seventeenth Century*. Translated by Edward G. Hawke. 8 vols. London, 1908–27.

Hofstede de Groot 1913
_____ . *Jan Vermeer van Delft en Carel Fabritius*. The Hague, 1913.

Hofstede de Groot 1916
_____ . "Jacobus Vrel." *Oude kunst*, vol. 1 (1916), pp. 209–11.

Hofstede de Groot 1927
_____ . "Isaack Koedijk." In *Festschrift für Max J. Friedländer. Zum 60. Geburtstag*, pp. 181–90. Leipzig, 1927.

Hofstede de Groot 1927–28
_____ . "Jan Steen and His Master Nicholaes Knupfers." *Art in America*, vol. 16 (1927–28), pp. 249–53.

Hofstede de Groot 1928
_____ . "Frans Hals as a Genre Painter." *The Art News*, vol. 26, no. 28 (April 14, 1928), pp. 45–46.

Hofstede de Groot 1929
_____ . "Schilderijen door Judith Leyster." *Oud Holland*, vol. 46 (1929), pp. 25–26.

Höhne 1957
Erich Höhne. *Frans Hals*. Leipzig, 1957.

Höhne 1960
_____ . *Adriaen Brouwer*. Leipzig, 1960.

Hollstein 1949–
F.W.H. Hollstein. *Dutch and Flemish Etchings, Engravings, and Woodcuts*. Vols. 1–. Amsterdam, 1949–.

Holmes 1909
C. J. H[olmes]. "Notes on the Chronology of Jan Steen." *The Burlington Magazine*, vol. 15, no. 76 (July 1909), pp. 243–44.

Holmes 1923
Charles Holmes. "Honthorst, Fabritius, and de Witte." *The Burlington Magazine*, vol. 42, no. 239 (February 1923), pp. 82–88.

Hooft 1897
C. G. 't Hooft. "Judith Leyster." *Eigen Haard*, 1897, p. 216.

Hoogewerff 1911
G. J. Hoogewerff. "Nadere gegevens over Michiel Sweerts." *Oud Holland*, vol. 29 (1911), pp. 134–38.

Hoogewerff 1913–17
_____ . *Bescheiden in Italië omtrent Nederlandsche kunstenaars en geleerden*. Vols. 1, 2. The Hague, 1913–17.

Hoogewerff 1915
_____ . "De Stichting der Nederlandsche Schildersbent te Rome." In *Feest-Bundel, Dr. Abraham Bredius*, pp. 109ff. Amsterdam, 1915.

Hoogewerff 1916
_____ . "Michiel Sweerts te Rome." *Oud Holland*, vol. 34 (1916), pp. 109–10.

Hoogewerff 1917a
_____ . *Bescheiden in Italië omtrent Nederlandsche kunstenaars en geleerden*. Vol. 3. The Hague, 1917.

Hoogewerff 1917b
_____ . "De werken van Gerard Honthorst te Rome, Naschrift: Honthorst in Italië." Parts 1–3. *Onze kunst*, vol. 31 (1917), pp. 37–50, 81–92, 141–44.

Hoogewerff 1923
_____ . "Bentvogels te Rome en hun feesten." *Mededeelingen van het Nederlandsch Historisch Instituut te Rome*, vol. 3 (1923), pp. 223–48.

Hoogewerff 1924
_____ . *Gherardo delle Notti*. Rome, 1924.

Hoogewerff 1926
_____ . "De Nederlandsche kunstenaars te Rome in de 17e eeuw en hun conflict met de Academie van St. Lucas." *Mededeelingen der Koninklijke Akademie van Wetenschappen, Afdeeling Letterkunde*, vol. 62, no. 4 (1926), pp. 117ff.

Hoogewerff 1929
_____ . "Nederlandsche schilders en Italiaansche scholing in de 17de eeuw." *Mededeelingen van het Nederlandsch Historisch Instituut te Rome*, vol. 9 (1929), pp. 147–74.

Hoogewerff 1931
_____ . "Wanneer en hoe vaak was Berchem in Italië?" *Oud Holland*, vol. 48 (1931), pp. 84–87.

Hoogewerff 1932–33
_____ . "Pieter van Laer en zijn vrienden." Parts 1–4. *Oud Holland*, vol. 49 (1932), pp. 1–17, 205–20; vol. 50 (1933), pp. 103–17, 250–62.

Hoogewerff 1936
_____ . "Pieter van Laer en zijn vrienden." *Mededeelingen van het Nederlandsch Historisch Instituut te Rome*, 2nd ser., vol. 6 (1936), pp. 119–28.

Hoogewerff 1938
_____ . "Nederlandsche kunstenaars te Rome, 1600–1725." *Mededeelingen van het Nederlandsch Historisch Instituut te Rome*, 2nd ser., vol. 8 (1938), pp. 49–125.

Hoogewerff 1940
_____ . "Karel Dujardin's schilderijen met gewijde voorstellingen." *Mededeelingen van het Nederlandsch Historisch Instituut te Rome*, 2nd ser., vol. 10 (1940), pp. 107–22.

Hoogewerff 1942–43
_____ . "Nederlandsche kunstenaars te Rome (1600–1725)." *Studien van het Nederlandsch Historisch Instituut te Rome*, 3rd ser., vol. 3 (1942–43), pp. 1–366.

Hoogewerff 1952
_____ . *De Bentvueghels*. The Hague, 1952.

Hoogland n.d.
P. Hoogland. *Onderwijs in Amsterdam in vroeger tijd*. Amsterdam, n.d.

van Hoogstraten 1678
Samuel van Hoogstraeten [Hoogstraten]. *Inleyding tot de hooge schoole der schilderkonst: Anders de Zichtbaere Werelt*. Rotterdam, 1678. Reprint. Soest, 1969; Ann Arbor, 1980.

Houbraken 1718–21
Arnold Houbraken. *De Groote Schouburgh der Nederlantsche Konstschilders en Schilderessen*. 3 vols. Amsterdam, 1718–21. Reprint. Maastricht, 1943–53; Amsterdam, 1976.

Houck 1899
M. E. Houck. "Mededeelingen betreffende Gerhard Terborch . . . en Hendrick ter Brugghen." *Verslagen en mededeelingen der Vereeniging tot beoefening van Over-ijsselsch Regt en Geschedenis*, vol. 20 (1899), pp. 103ff.

Houssaye 1848
Arsène Houssaye. *Histoire de la peinture flamande et hollandaise*. Vol. 2. Paris, 1848.

Houssaye 1876
_____ . *Van Ostade: Sa Vie et son oeuvre*. Les Peintres du Cabaret. Paris, 1876.

Houtzager 1955
Elisabeth Houtzager. "Opmerkingen over het werk van Hendrick Terbrugghen." *Nederlands kunsthistorisch jaarboek*, vol. 6 (1955), pp. 143–50.

Howell 1907
James Howell. *Epistolae Ho-Elianae, or the Familiar Letters of James Howell.* 2 vols. Boston, 1907.

van Huffel 1915
N. G. Huffel. "Het etswerk van Adriaan van Ostade." *Elsevier's geïllustreed maandschrift,* vol. 49 (1915), pp. 21–32.

Huffschmid 1924
Max Huffschmid. "Stammt der holländische Maler Kaspar Netscher aus Heidelberg?" *Neue Archiv für die Geschichte der Stadt Heidelberg,* vol. 11 (1924), pp. 166–79.

Huizinga 1968
J. H. Huizinga. *Dutch Civilisation in the Seventeenth Century.* Translated by Arnold J. Pomerans. London, 1968.

Hymans 1884
Karel van Mander. *Le Livre des peintres: Vie des peintres flamands, hollandais, et allemands.* 1604. Translated, with notes and commentary by Henri Hymans. 2 vols. Paris, 1884.

IJzendijke 1955
IJzendijke, Raadhuis. *Hollands leven in de Gouden Eeuw.* June 30–September 20, 1955.

Immerzeel 1842–43
C. Immerzeel. *De levens en werken der Hollandsche en Vlaamsche kunstschilders, beeldouwers, graveurs en bouwmeesters van het begin der vijftiende eeuw tot heden.* 3 vols. Amsterdam, 1842–43.

Indianapolis, Museum of Art, cat. 1980
Indianapolis, Indianapolis Museum of Art. *100 Masterpieces of Painting.* 1980. Catalogue by Anthony F. Janson and A. Ian Fraser.

Isarlo 1941
George Isarlo. *Caravage et le caravagisme européen.* Aix-en-Provence, 1941.

Ising 1889
Arnold Ising. "Een schilder-dichter uit de zeventiende eeuw [Adriaen van de Venne]." *De Gids,* 1889, pp. 126–56.

Jacob, Bianconi 1967
John Jacob and Piero Bianconi. *The Complete Paintings of Vermeer.* New York, 1967.

Jacque 1876
Charles Jacque. *Van Ostade: Sa Vie et son oeuvre.* Paris, 1876.

Jameson 1842
Mrs. [Anna B.] Jameson. *A Handbook to the Public Galleries of Art in and near London.* 2 vols. London, 1842.

Jameson 1844
———. *Companion to the Most Celebrated Private Galleries of Art in London.* London, 1844.

Janeck 1968
Axel Janeck. "Untersuchung über den holländischen Maler Pieter van Laer, genannt Bamboccio." Diss., Würzburg, 1968.

Janeck 1976
———. "Naturalismus and Realismus: Untersuchungen zur Darstellung der Natur bei Pieter van Laer und Claude Lorrain." *Storia dell'arte,* no. 28 (September–December 1976), pp. 285–304.

Jansen 1983
G. H. Jansen. "Kermis in de Noordelijke Nederlanden." *Spiegel historiael,* vol. 18, no. 11 (November 1983), pp. 578–85.

Jantzen 1910
Hans Jantzen. *Das niederländische Architekturbild.* Leipzig, 1910.

Jantzen 1912
———. *Farbenwahl und Farbengebung in der holländischen Malerei des XVII. Jahrhunderts.* Parchim, [1912].

Jantzen 1979
———. *Das niederländische Architekturbild.* 2nd ed. Braunschweig, 1979.

Jessen 1917–18
Jarno Jessen [Anna Michaelson]. "Gabriel Metsu, ein Maler des holländischen Bürgertums." *Velhagen und Klasings Monatshefte,* vol. 32 (1917–18), pp. 160–70.

Johansen 1920
P. Johansen. "Jan Vermeer de Delft, à propos de l'ordre chronologique de ses tableaux." *Oud Holland,* vol. 38 (1920), pp. 185–99.

de Jonge 1939
C. H. de Jonge. *Jan Steen.* Palet Serie, no. 8. Amsterdam, 1939.

de Jonge 1947
———. *Oud Nederlandsche majolica en Delftsche aardewerk: Een ontwikkelings geschiedenis van omstreeks 1550–1800.* Amsterdam, 1947 [English edition translated by Marie-Christine Hellin. New York, 1969].

de Jongh 1967
E. de Jongh. *Zinne- en minnebeelden in de schilderkunst van de zeventiende eeuw.* Amsterdam, 1967.

de Jongh 1968
———. "'Interieur' Emanuel de Witte (1617–1692)." *Openbaar Kunstbezit,* vol. 12 (1968), pp. 9–9b.

de Jongh 1968–69
———. "Erotica in vogelperspectief: De dubbelzinnigheid van een reeks 17de eeuwse genrevoorstellingen." *Simiolus,* vol. 3, no. 1 (1968–69), pp. 22–74.

de Jongh 1971
———. "Realisme et schijnrealisme in de Hollandse schilderkunst van de zeventiende eeuw." In Brussels, Musées Royaux d'Art et d'Histoire, *Rembrandt en zijn tijd,* 1971, pp. 143–94.

de Jongh 1973
———. "Vermommingen van Vrouw Wereld in de 17de eeuw." In *Album Amicorum J. G. van Gelder,* edited by J. Bruyn et al., pp. 198–206. The Hague, 1973.

de Jongh 1975–76
———. "Pearls of Virtue and Pearls of Vice." *Simiolus,* vol. 8, no. 2 (1975–76), pp. 69–97.

de Jongh 1982
———. "The Interpretation of Still Life Paintings: Possibilities and Limits." In Auckland, Auckland City Art Gallery, *Still Life in the Age of Rembrandt,* 1982, pp. 27–37.

de Jongh, Vinken 1961
E. de Jongh and P. J. Vinken. "Frans Hals als voortzetter van een emblematische traditie." *Oud Holland,* vol. 76 (1961), pp. 117–52.

de Jongh, Vinken 1963
E. de Jongh and P. J. Vinken. "De boosaardigheid van Hals' regenten en regentessen." *Oud Holland,* vol. 78 (1963), pp. 1–26.

de Jongh 1924
E.D.J. de Jongh, Jr. "Adriaan van der Werff, een Rotterdamsch kunstenaar." *Vragen van den dag,* vol. 39 (1924), pp. 358–65.

Jorissen 1877
T. Jorissen. *Palamedes en Gijsbrandt van Amstel.* Amsterdam, 1877.

Jowell 1974
Frances Suzman Jowell. "Thoré-Bürger and the Revival of Frans Hals." *The Art Bulletin,* vol. 56, no. 1 (March 1974), pp. 101–17.

Judson 1955
J. Richard Judson. "Two Documents Concerning Honthorst's Return to the Netherlands." *Oud Holland,* vol. 70 (1955), p. 66.

Judson 1956
———. "Terbrugghen as a Draughtsman." *The Burlington Magazine,* vol. 98, no. 644 (November 1956), p. 411.

Judson 1959
———. *Gerrit van Honthorst: A Discussion of His Position in Dutch Art.* The Hague, 1959.

Juynboll 1935
W. R. Juynboll. "Frans van Mieris." *Nieuwe Rotterdamsche Courant.* April 14, 1935.

Juynboll 1959
———. "Frans Hals." In W. R. Juynboll, *Winkler Prins van de Kunst,* vol. 2, pp. 153ff. Amsterdam and Brussels, 1959.

Kahr 1972
Madlyn Millner Kahr. "Vermeer's Girl Asleep: A Moral Emblem." *Metropolitan Museum Journal*, vol. 6 (1972), pp. 115–32.

Kahr 1978
_____ . *Dutch Painting in the Seventeenth Century.* New York, 1978.

Kalff 1916–17
S. Kalff. "Adriaen en Isaak van Ostade." *Oude Kunst*, vol. 2 (1916–17), pp. 217–22.

Kalff 1918
_____ . "Eene Haarlemsche schilderes." *De nieuwe gids*, vol. 33 (1918), pp. 399–409.

Kalff 1920
_____ . "Een kunstenaarsecht paar [Jan Miense Molenaer en Judith Leyster]." *Morks Magazijn*, vol. 43 (1920), pp. 57–66.

Kansas City 1967–68
Kansas City, The Nelson Gallery of Art and Atkins Museum. *Paintings of 17th Century Dutch Interiors.* December 1, 1967–January 7, 1968. Catalogue by Ralph Coe.

Kassel, Gemäldegalerie, cat. 1958
Kassel, Staatliche Kunstsammlungen, Gemäldegalerie. *Katalog der Staatlichen Gemäldegalerie zu Kassel. 1958.*

Kassel, Gemäldegalerie, cat. 1969
Kassel, Staatliche Kunstsammlungen, Gemäldegalerie. *Die Gemäldegalerie der Staatlichen Kunstsammlungen.* 1969. Catalogue by E. Herzog and G. Gronau.

Kauffmann 1943
Hans Kauffmann. "Die Fünfsinne in der niederländischen Malerei des 17. Jahrhunderts." In *Kunstgeschichtliche Studien: Festschrift für Dagobert Frey zum 23. April 1943*, edited by Hans Tintelnot, pp. 133–57. Breslau, 1943.

Kauffmann 1965
_____ . "Die Schützenbilder des Frans Hals." In *Walter Friedländer zum 90. Geburtstag*, edited by Georg Kaufmann and Willibald Sauerländer, pp. 101ff. Berlin, 1965.

Kelk 1932
Cornelius J. Kelk. *Jan Steen.* Amsterdam, 1932.

van der Kellen 1875
D. van der Kellen, Jr. "De kleermakerswinkel van Quirijn Brekelenkamp." *Eigen Haard*, 1875, p. 172.

van der Kellen 1876a
_____ . "Pieter de Hooge." *Eigen Haard*, 1876, pp. 151–52.

van der Kellen 1876b
_____ . "De vischmarkt van Hendrik Martensz. Sorgh." *Eigen Haard*, 1876, pp. 326–27.

van der Kellen 1878
_____ . "Frans Hals." *Eigen Haard*, 1878, pp. 141–44.

van der Kellen 1866
J. Philip van der Kellen. *Le Peintre-graveur hollandais et flamand.* Utrecht, 1866.

Kettering 1977
Alison McNeil Kettering. "Rembrandt's 'Flute Player': A Unique Treatment of Pastoral." *Simiolus*, vol. 9, no. 1 (1977), pp. 19–44.

Kettering 1983a
_____ . *The Dutch Arcadia: Pastoral Art and Its Audience in the Golden Age.* Montclair, N.J., 1983.

Kettering 1983b
_____ . "Ter Borch's Studio Estate." *Apollo*, vol. 117, no. 256 (June 1983), pp. 443–51.

Keulers 1944
P. H. Keulers. "Das Lachen bei Frans Hals." *Maandblad der Nederlandsch-Duitsche kultuurgemeenschap*, vol. 4 (July 1944), pp. 6–11.

Keyes forthcoming
George S. Keyes. *Esaias van de Velde (1587–1630).* Doornspijk, forthcoming.

Keyszelitz 1956
Robert Keyszelitz. "Der 'Clavis interpretandi' in der holländischen Malerei des 17. Jahrhunderts." Diss., Munich, 1956.

Keyszelitz 1957
_____ . "'Die beiden Seifenbläser' des Esaias Boursse im aachener Suermondtmuseum: Eine Allegorie der Vanitas." *Aachener Kunstblätter*, vol. 22 (1957), pp. 19–26.

Keyszelitz 1959
_____ . "Zur Deutung von Jan Steens 'Soo gewonnen, soo verteert.'" *Zeitschrift für Kunstgeschichte*, vol. 22, no. 1 (1959), pp. 40–45.

Keyszelitz 1964
_____ . "Genre und Stilleben als Sinnbild in der holländischen Malerei des 17. Jahrhunderts." *Alte und moderne Kunst*, vol. 9, no. 74 (1964), pp. 16–19.

Kinderen-Besier 1950
J. H. der Kinderen-Besier. *Spelevaart der mode: De kledij onzer voorouders in de zeventiende eeuw.* Amsterdam, 1950.

Kirschenbaum 1977
Baruch D. Kirschenbaum. *The Religious and Historical Paintings of Jan Steen.* New York, 1977.

van Klaveren 1936
G. van Klaveren. "Saftleven en Utrecht." *Maandblad van Oud-Utrecht*, vol. 11 (1936), pp. 76–77.

Klessman 1960
Rüdiger Klessman. "Die Anfänge des Bauerninterieurs bei den Brüdern Ostade." *Jahrbuch der berliner Museen*, vol. 2 (1960), pp. 92–115.

Klinge 1977
Margret Klinge-Gross. "Herman Saftleven als Zeichner und Maler bäuerlicher Interieurs." *Wallraf-Richartz-Jahrbuch*, vol. 38 (1977), pp. 68–91.

Klinge forthcoming
_____ . *Adriaen Brouwer.* Forthcoming.

Knipping 1939–42
J. B. Knipping. *De iconografie van de Contra-Reformatie in de Nederlanden.* 2 vols. Hilversum, 1939–42 [English edition, Nieuwkoop and Leiden, 1974].

Knoef 1920
J. Knoef. "Het etswerk van Cornelis Bega (1620–1664)." *Elsevier's geïllustreed maandschrift*, vol. 60 (1920), pp. 289–95.

Knoef 1927
_____ . "Het etswerk van K. Dujardin." *Elsevier's geïllustreed maandschrift*, vol. 73 (1927), pp. 171–78.

Knüttel 1966
Brigitte Knüttel. "Spielende Kinder bei einer Herkulesgruppe: Zu einer Tugend-Allegorie von Adriaen van der Werff." *Oud Holland*, vol. 81 (1966), pp. 245–58.

Knüttel 1968
_____ . "Adriaen van der Werff." In *Kindlers Malerei Lexikon*, vol. 5, pp. 751 53.

Knüttel 1917
Gerard Knüttel. "Das Gemälde des Seelenfischfangs von Adriaen Pietersz. van de Venne." Diss., The Hague, 1917.

Knüttel 1928
_____ . "Willem Buytewegh." *Mededeelingen van den Dienst voor Kunsten en Wetenschappen der Gemeente 's Gravenhage*, vol. 2, no. 4 (April 1928), pp. 116–24.

Knüttel 1929
_____ . "Willem Buytewegh, van Manierisme tot Naturalisme." *Mededeelingen van den Dienst voor Kunsten en Wetenschappen der Gemeente 's Gravenhage*, vol. 2, nos. 5–6 (December 1929), pp. 181–98.

Knüttel 1962
_____ . *Adriaen Brouwer: The Master and His Work.* Translated by J. G. Talma-Schilthuis and Robert Wheaton. The Hague, 1962.

Kok 1948
J. Kok. *Adriaen van Ostade als etser.* Bussum, 1948.

Kolloff 1850
E. Kolloff. "Das Geburtsjahr Gerhard Dous." *Deutsche Kunstblatt*, vol. 1 (1850), pp. 138–39.

Koningsberger 1967
Hans Koningsberger. *The World of Vermeer, 1632–1675.* New York, 1967.

Koslow 1967
Susan Koslow. "De wonderlijke Perspectyfkas: An Aspect of Seventeenth Century Dutch Painting." *Oud Holland*, vol. 82 (1967), pp. 35–56.

Koslow 1975
 ——— . "Frans Hals's 'Fisherboys': Exemplars of Idleness." *The Art Bulletin*, vol. 57, no. 3 (September 1975), pp. 418–32.

Kramm 1857–64
 Christiaan Kramm. *De Levens en Werken der Hollandsche en Vlaamsche Kunstschilders, Beeldhouwers, Graveurs en Bouwmeesters, van den vroegsten tot op onzen tijd.* 7 vols. Amsterdam, 1857–64.

Kren 1979
 Thomas J. Kren. "Jan Miel (1599–1644): A Flemish Painter in Rome." 3 vols. in 2. Diss., Yale University, 1979.

Kren 1980
 ——— . "Chi non vuol Baccho: Roeland van Laer's Burlesque Painting about Dutch Artists in Rome." *Simiolus*, vol. 11, no. 2 (1980), pp. 63–80.

Kren 1982
 ——— . "Jan Lingelbach in Rome." *The J. Paul Getty Museum Journal*, vol. 10 (1982), pp. 45–62.

Kronig 1909
 J. O. Kronig. "Gabriel Metsu." Parts 1, 2. *Revue de l'art ancien et moderne*, vol. 25 (1909), pp. 93–104, 213–24.

Kronig 1915
 ——— . "Wie was de leermeester van Gabriël Metsu?" In *Feest-bundel, Dr. Abraham Bredius*, edited by H. E. van Gelder, pp. 135–38. Amsterdam, 1915.

de Kruijff 1891
 C. A. de Kruijff. "Contract namens konig Christiaan IV [door Simon van de Pas] met Gerrerdt van Honthorst." *Utrecht Jaarboek*, vol. 51 (1891), pp. 251–52.

Krul 1640
 Jan Hermansz. Krul. *Minnenbeelden: Toe-gepast de lievende jonckheyt.* Amsterdam, 1640.

Krul 1644
 ——— . *De Pampiere Wereld.* Amsterdam, 1644.

Kugler 1847
 D. Franz Kugler. *Handbuch der Geschichte der Malerei seit Constantin dem Grossen.* 2nd ed. 2 vols. Berlin, 1847.

Kugler, Waagen 1860
 ——— . *Handbook of Painting: The German, Flemish and Dutch Schools.* Enlarged and edited by G. F. Waagen. 2 vols. London, 1860.

Kühn 1968
 Hermann Kühn. "A Study of the Pigments and the Grounds Used by Jan Vermeer." *National Gallery of Art Report and Studies in the History of Art*, vol. 2 (1968), pp. 155–202.

van Kuik Mensing 1927–28
 A. v[an] K[uik] M[ensing]. "Quirijn Brekelenkam." *Ons eigen Tijdschrift*, vol. 6 (1927–28), pp. 364–66.

Kultzen 1954
 Rolf Kultzen. "Michael Sweerts, 1624–1664." Diss., Hamburg, 1954.

Kultzen 1980
 ——— . "Frühe Arbeiten von Michael Sweerts." *Pantheon*, vol. 38, no. 1 (1980), pp. 64–68.

Kultzen 1982
 ——— . "Michael Sweerts als Lernender und Lehrer." *Münchner Jahrbuch der bildenden Kunst*, 3rd ser., vol. 33 (1982), pp. 109–30.

Kultzen 1983
 ——— . "Französische Anklänge im Werk von Michael Sweerts." In *Essays in Northern European Art Presented to Egbert Haverkamp Begemann on His Sixtieth Birthday*, edited by Anne-Marie Logan, pp. 127–33. Doornspijk, 1983.

Kunstreich 1957
 Jan Siefke Kunstreich. "Studien zu Willem Buytewech, 1591–1624." Diss., Kiel, 1957.

Kunstreich 1959
 ——— . *Der 'Geistreiche Willem': Studien zu Willem Buytewech, 1591–1624.* Kiel, 1959.

Kuretsky 1973
 Susan Donahue Kuretsky. "The Ochtervelt Documents." *Oud Holland*, vol. 87 (1973), pp. 124–41.

Kuretsky 1975
 ——— . "The Ochtervelt Documents (aanvulling)." *Oud Holland*, vol. 89 (1975), pp. 65–66.

Kuretsky 1979
 ——— . *The Paintings of Jacob Ochtervelt (1634–1682).* Montclair, N.J., 1979.

Kurtz 1958
 G. H. Kurtz. "Nog eens: Bodding (Van Laer)." *Oud Holland*, vol. 73 (1958), pp. 231–32.

Kuznetsov 1955
 J. Kuznetsov. "Vnov opredelennaja kartina Kornelisa Vega." *Soobschenia Gosudarstvennogo*, no. 8 (1955), pp. 21–22.

Kuznetsov 1960
 ——— . "Claes Berchem and His Works in the Hermitage" (in Russian). In *Iz istorii russkogo i zapadnoevropeiskogo iskusstva* (*Sbornik posvyashchen 40–letiyu nauchnoi deyatel' nosti V. N. Lazarev*), edited by O. I. Podobedova and V. N. Grashchenkov, pp. 325–55. Moscow, 1960.

Kuznetsov, Linnik 1982
 J. Kuznetsov and I. Linnik. *Dutch Paintings in Soviet Museums.* New York, 1982.

Laansma 1965
 S. Laansma. "Adriaan van de Venne en het 'Tabacksuygen.'" *Amstelodamum*, vol. 52 (1965), pp. 40–47.

de Laborde 1839
 Léon de Laborde. *Histoire de la gravure en manière noire.* Paris, 1839.

de Lairesse 1740
 Gerard de Lairesse. *Het Groot Schilderboek.* Haarlem, 1740. Reprint. Soest, 1969.

Landwehr 1970
 John Landwehr. *Emblem Books in the Low Countries, 1554–1949: A Bibliography.* Utrecht, 1970.

Landwehr 1981
 ——— . *De Nederlander uit en thuis: Spiegel van het dagelijkse leven uit bijzondere zeventiende-eeuse boeken.* Alphen aan den Rijn, 1981.

Larsen 1967
 Erik Larsen. "The Duality of Flemish and Dutch Art in the Seventeenth Century." In *Stil und Überlieferung in der Kunst des Abendlandes* (Akten des 21. Internationalen Kongresses für Kunstgeschichte in Bonn, 1964), vol. 2, pp. 59–65. Berlin, 1967.

Larsen, Davidson 1979
 Erik Larsen and Jane P. Davidson. *Calvinistic Economy and 17th Century Dutch Art.* Lawrence, Ks., 1979.

Lawrence/New Haven/Austin
 Lawrence, The Spencer Museum of Art, University of Kansas. *Dutch Prints of Daily Life: Mirrors of Life or Masks of Moral?* October 8–December 31, 1983. Also shown at New Haven, Yale University Art Gallery, January 15–February 26, 1984 and Austin, Huntington Gallery, University of Texas at Austin, March 18–April 29, 1984. Catalogue by Linda A. Stone-Ferrier.

Lazarev 1933
 V. N. Lazarev. *Vermeer* (in Russian). Moscow, 1933.

Lebel 1953
 Robert Lebel. "Introduction à l'intimisme hollandais." *Connaissance des arts*, no. 17 (July 15, 1953), pp. 24–29.

Legrand 1963
 F. C. Legrand. *Les Peintres flamands de genre au XVIIe siècle.* Brussels, 1963.

Leiden 1906
 Leiden, Stedelijk Museum "De Lakenhal." *Catalogus der tentoonstelling van schilderijen en teekeningen van Rembrandt en schilderijen van andere Leidsche meesters der zeventiende eeuw.* July 15–September 15, 1906.

Leiden 1926
 Leiden, Stedelijk Museum "De Lakenhal." *Katalogus tentoonstelling Jan Steen.* 1926.

Leiden 1966
 Leiden, Stedelijk Museum "De Lakenhal." *Gabriel Metsu.* June 22–September 5, 1966. Catalogue by J. N. van Wessem and Lucia Thyssen.

Leiden 1970
Leiden, Stedelijk Museum "De Lakenhal." *IJdelheid der ijdelheiden.* June 26–August 23, 1970. Essay by Ingvar Bergström.

Leiden 1954
Leiden, University of Leiden Print Room. *Nederlanders te Rome.* 1954.

Leiden, cat. 1949
Leiden, Stedelijk Museum "De Lakenhal." *Beschrijvende catalogus van de schilderijn en tekeningen.* 1949.

Lemcke 1875
Carl Lemcke. "Gerhard Terborch, Gabriel Metzu, Kaspar Netscher." In *Kunst und Künstler des Mittelalters und der Neuzeit,* edited by Robert Dohme, no. 24. Leipzig, 1875.

Lemcke 1878
_____ . "Pieter de Hooch, Jan van der Meer, Adrian van der Werff." In *Kunst und Künstler des Mittelalters und der Neuzeit,* edited by Robert Dohme, nos. 29–31. Leipzig, 1878.

Leningrad 1960
Leningrad, The Hermitage. *Adriaen van Ostade* (in Russian). 1960. Catalogue by J. Kuznetsov.

Leningrad, Hermitage, cat. 1901
Leningrad, The Hermitage. *Catalogue de la Galerie des Tableaux.* Vol. 2, *Ecoles Néerlandaises et Ecole Allemande.* Saint Petersburg [Leningrad], 1901. Catalogue by A. Somov.

Leuppe 1879–80
P. A. Leuppe. "Johannes Fictor (Victorsz.), constschilder te Amsterdam." *Archief voor Nederlandsche kunstgeschiedenis,* vol. 2 (1879–80), pp. 282–83.

Levensbeschryving 1774–83
Levensbeschryving van eenige . . . meest Nederlandse mannen en vrouwen. 10 vols. Amsterdam, 1774–83.

Levine forthcoming
David Levine. *Pieter van Laer.* Great Minor Masters. Netherlandish Painters from the Past. Doornspijk, forthcoming.

Leymarie 1947
Jean Leymarie. "Intérieurs de Hollande." *Elites françaises,* vol. 3 (April–May 1947), pp. 13–17.

Leymarie 1961
_____ . *The Spirit of the Letter in Painting.* Translated by James Emmons. Lausanne, 1961.

L'Honoré 1779
Samuel-Francois L'Honoré. *La Hollande au dix-huitième siècle.* The Hague, 1779.

Liedtke 1970
Walter A. Liedtke. "From Vredeman de Vries to Dirck van Delen: Sources of Imaginary Architectural Painting." *Rhode Island School of Design Bulletin,* vol. 57, no. 2 (Winter 1970), pp. 15–25.

Liedtke 1982a
_____ . *Architectural Painting in Delft: Gerard Houckgeest, Hendrick van Vliet, Emanuel de Witte.* Doornspijk, 1982.

Liedtke 1982b
_____ . "Cornelis de Man as a Painter of Church Interiors." *Tableau,* vol. 5, no. 1 (1982), pp. 62–66.

Lindström 1951
Arne Lindström. *Sisäkuva Alankomaiden taiteessa.* Helsinki, 1951.

Linnik 1967
I. Linnik. *Frans Hals, 1581/85–1666* (in Russian). Leningrad, 1967.

Linnik, Vsevolozhskaya 1975
I. Linnik and S. Vsevolozhskaya. *Caravaggio and His Followers.* Translated by V. Vorontsov and J. Nemeckij. Leningrad, 1975.

London 1909
London, Dowdeswell and Dowdeswell. *Jan Steen.* 1909.

London 1929
London, Royal Academy of Arts. *Commemorative Catalogue of the Exhibition of Dutch Art . . . of the Royal Academy.* January–March 1929.

London 1938
London, Royal Academy of Arts. *Catalogue of the Exhibition of 17th Century Art in Europe.* January 3–March 12, 1938.

London 1946–47
London, Royal Academy of Arts. *The King's Pictures . . . at the Royal Academy of Arts.* 1946–47.

London 1952–53
London, Royal Academy of Arts. *Dutch Pictures, 1450–1750.* 1952–53.

London 1958
London, Arts Council of Great Britain. *Dutch Genre Painting.* 1958.

London 1976
London, The National Gallery. *Art in Seventeenth Century Holland.* September 30–December 12, 1976. Catalogue by Christopher Brown et al.

London 1980
London, David Carritt, Ltd. (Artemis Group). *Ten Paintings by Gerard Dou.* 1980.

London, Apsley House, cat. 1901
London, Wellington Museum, Apsley House. *A Descriptive and Historical Catalogue of the Pictures and Sculpture at Apsley House.* 1901. Catalogue by Evelyn Wellington.

London, The Queen's Gallery, cat. 1971
London, The Queen's Gallery, Buckingham Palace. *Dutch Pictures from the Royal Collection.* 1971. Introduction by Oliver Millar.

London, South Kensington Museum, 1891
London, South Kensington Museum (Victoria and Albert). *Pictures of the Dutch and Flemish Schools, Lent by Lord Francis Pelham Clinton-Hope.* 1891.

Longhi 1926
Roberto Longhi. "Dirk van Baburen." *Vita artistica,* vol. 1 (1926), p. 69.

Longhi 1927
_____ . "Ter Bruggen e la parte nostra." *Vita artistica,* vol. 2 (1927), pp. 105–16.

Longhi 1934
_____ . "Zu Michiel Sweerts." *Oud Holland,* vol. 51 (1934), pp. 271–77.

Longhi 1943
_____ . "Ultimi Studi sul Caravaggio e la sua Cerchia." *Proporzioni,* vol. 1 (1943), pp. 5–63.

Longhi 1952
_____ . "Caravaggio en de Nederlanden, catalogus, Utrecht-Antwerpen, 1952." *Paragone,* vol. 33 (September 1952), pp. 52–58.

Longhi 1958
_____ . "Qualche appunto su Michele Sweerts." *Paragone,* vol. 9, no. 107 (1958), pp. 73–74.

van Loo 1966
"Jacob van Loo." *Amstelodamum,* vol. 53 (1966), p. 167.

van Loo 1899
A. W. Sanders van Loo. "Iets over A. P. van de Venne." *De Vlaamsche School,* vol. 3 (1899), pp. 347–53.

Loosjes 1789
A. Loosjes. *Frans Hals, Lierzang.* Haarlem, 1789.

Luns 1946
T. Luns. *Frans Hals.* Palet Serie, no. 27. Amsterdam, 1946.

de Luynsche 1940
T. H. de Luynsche. "David Vinckboons en het Kasteel van Verneuil." *Oud Holland,* vol. 57 (1940), pp. 206–11.

Maclaren 1960
Neil Maclaren. *The National Gallery Catalogues: The Dutch School.* London, 1960.

Magerøy 1951
Ellen Marie Magerøy. *Hollandsk interiørmalerei i det 17. århundre.* Oslo, 1951.

Mainz, Mittelrheinisches Landesmuseum, cat. 1980
Mainz, Mittelrheinisches Landesmuseum. *Fuhrer durch Mittelrheinisches Landesmuseum Mainz.* 1980.

Mallett 1924
John Mallett. "The Etchings of Adriaen van Ostade (1610–1685)." *The Connoisseur,* vol. 68, no. 270 (February 1924), pp. 95–98.

Malraux 1952
André Malraux, ed. *Vermeer de Delft*. Paris, 1952.

Malvasia 1678
C. C. Malvasia. *Felsina pittrice*. Bologna, 1678.

Manchester 1857
Catalogue of the Art Treasures of the United Kingdom, Collected at Manchester in 1857. Edited by J. B. Waring. London, 1857.

Manchester, City Art Gallery, cat. 1980
Manchester, Manchester City Art Gallery. *Concise Catalogue of Foreign Paintings*. 1980.

van Mander 1603–4
Karel van Mander. *Het Schilder-boeck*. Haarlem, 1603–4. Reprint. Utrecht, 1969.

van Mander 1618
———. *Het Schilder-boeck . . . hier bijgevoeght het leven der Autheurs*. Amsterdam, 1618.

van Mander, Miedema 1973
Karel van Mander. *Den grondt der edel vry schilder-const*. Edited with commentary by Hessel Miedema. 2 vols. Utrecht, 1973.

van Mander, van de Wall 1936
Karel van Mander. *Dutch and Flemish Painters*. Translation and introduction by Constant van de Wall. New York, 1936.

Manke 1963
Ilse Manke. *Emanuel de Witte, 1617–1692*. Amsterdam, 1963.

Manke 1972
———. "Nachträge zum Werkkatalog von Emanuel de Witte." *Pantheon*, vol. 30, no. 5 (September–October 1972), pp. 389–91.

Mantz 1879–80
Paul Mantz. "Adrien Brauwer." Parts 1, 2. *Gazette des Beaux-Arts*, 2nd ser., vol. 20 (1879), pp. 465–76; vol. 21 (1880), pp. 29–49.

Marius 1906
G. H. Marius. *Jan Steen*. Amsterdam, 1906.

Marquery 1925
Henry Marquery. "Les Animaux dans l'oeuvre de Karel Du Jardin." *L'Amateur d'estampes*, vol. 4 (1925), pp. 80–86.

Martin 1901
W. Martin. "Het leven en de werken van Gerrit Dou beschouwd in verband met het schildersleven van zijn tijd." Diss., Leiden, 1901.

Martin 1902
———. *Gerard Dou*. London, 1902 [abridged translation of Martin 1901, by Clara Bell].

Martin 1905
———. "The Life of a Dutch Artist in the Seventeenth Century." Parts 1–3. *The Burlington Magazine*, vol. 7 (May, September 1905), pp. 125–28, 416–27; vol. 8 (October 1905), pp. 13–24. Translated by Augusta von Schneider.

Martin 1906
———. "How a Dutch Picture Was Painted." *The Burlington Magazine*, vol. 10, no. 45 (December 1906), pp. 144–54. Translated by Campbell Dodgson.

Martin 1907
———. "Michiel Sweerts als Schilder: Proeve van een biografie en een catalogus van zijn schilderijen." *Oud Holland*, vol. 25 (1907), pp. 133–56.

Martin 1908
———. "Über den Geschmack des holländischen Publikums im 17. Jahrhundert mit Bezug auf die damalige Malerei." *Monatshefte für Kunstwissenschaft*, vol. 1, no. 9 (September 1908), pp. 727–53.

Martin 1909
———. "Isaack Jansz. Koedyck, schilder van levensgroote figuren." *Oud Holland*, vol. 27 (1909), pp. 1–4.

Martin 1910
———. "Studien zu Jan Steen." *Monatshefte für Kunstwissenschaft*, vol. 3 (1910), pp. 179–89.

Martin 1911
———. *Gérard Dou, sa vie et son oeuvre: Etude sur la peinture hollandaise et les marchands au dix–septième siècle*. Paris, 1911.

Martin 1913
———. *Gerard Dou*. Klassiker der Kunst. Stuttgart, 1913.

Martin 1916
———. "Hoe schilderde Willem Buytewech?" *Oud Holland*, vol. 34 (1916), pp. 197–203.

Martin 1921a
———. *Alt-Holländische Bilder*. Berlin, 1921.

Martin 1921b
———. "Jan Steen." In *Nieuw Nederlandsch biografisch woordenboek*, edited by P. C. Molhuysen, P. J. Blok and L. Knappert, part 5, pp. 802–5. Leiden, 1921.

Martin 1924
———. *Jan Steen*. Amsterdam, 1924.

Martin 1925a
———. "Buytewech, Rembrandt en Frans Hals." *Oud Holland*, vol. 42 (1925), pp. 48–51.

Martin 1925b
———. "Figuurstukken van Jan Davidszoon de Heem." *Oud Holland*, vol. 42 (1925), pp. 42–45.

Martin 1926
———. *Jan Steen, over zijn leven en kunst: Naar aanleiding van de Jan Steen tentoonstelling te Leiden*. Leiden, 1926.

Martin 1927–28
———. "Neues über Jan Steen." *Zeitschrift für bildende Kunst*, vol. 61 (1927–28), pp. 325–41.

Martin 1930
———. "Nog een schilderij van Buytewech." *Oud Holland*, vol. 47 (1930), pp. 190–92.

Martin 1935
———. "Jan Steen as a Landscape Painter." *The Burlington Magazine*, vol. 67, no. 392 (November 1935), pp. 211–12.

Martin 1935–36
———. *De Hollandsche schilderkunst in de zeventiende eeuw*. Vol. 1, *Frans Hals en zijn tijd*. Vol. 2, *Rembrandt en zijn tijd*. Amsterdam, 1935–36.

Martin 1947
———. "Vraagstukken betreffende Jan Steen." *Oud Holland*, vol. 62 (1947), pp. 92–102.

Martin 1951
———. *Dutch Painting of the Great Period, 1650–1697*. Translated by D. Horning. London, 1951.

Martin 1954
———. *Jan Steen*. Bibliotheek der nederlandsche kunst. Amsterdam, 1954.

Meige 1899
Henry Meige. "Les Peintres de la médecine, le mal d'amour." Parts 1–4. *Nouvelle iconographie de la Salpêtrière*, vol. 12 (1899), pp. 57–68, 227–60, 340–52, 420–32.

Meige 1900
———. "Les Médecins de Jan Steen." Parts 1, 2. *Janus*, vol. 5 (1900), pp. 187–90, 217–26.

Meischke, Zantkuijl 1969
I. R. Meischke and H. J. Zantkuijl. *Het Nederlandse woonhuis van 1300–1800*. Haarlem, 1969.

Meyer 1872–85
Julius Meyer, ed. *Allgemeines Künstler-Lexikon*. 3 vols. Leipzig, 1872–85.

Michalkowa 1971
Janina Michalkowa. "Quelques remarques sur Pieter van Laer." *Oud Holland*, vol. 86 (1971), pp. 188–95.

Michel 1887
Emile Michel. *Gérard Terbourg (Ter Borch) et sa famille*. Paris and London, 1887.

Michel 1892
———. *Les Van de Velde*. Les Artistes célèbres. Paris, 1892.

Michiels 1865–76
Alfred Michiels. *Histoire de la peinture flamande depuis ses débuts jusqu'en 1864*. 2nd ed. 10 vols. Paris, 1865–76.

Michiels 1870
———. "David Vinckboons." *Kunstkronijk*, 3rd ser., vol. 11 (1870), pp. 13–15.

Miedema 1972
Hessel Miedema. *Karel van Mander: Het bio-bibliografisch materiaal*. Amsterdam, 1972.

Miedema 1975
———. "Over het realisme in de Nederlandse schilderkunst van de zeventiende eeuw." *Oud Holland*, vol. 89 (1975), pp. 2–16.

Miedema 1977
———. "Realism and Comic Mode: The Peasant." *Simiolus*, vol. 9, no. 4 (1977), pp. 205–19.

Miedema 1980
———. *De archiefbescheiden van het St. Lukasgilde te Haarlem*. Alphen aan den Rijn, 1980.

Miedema 1981
———. "Verder onderzoek naar zeventiende-eeuwse schilderijformaten in Noord-Nederland." *Oud Holland*, vol. 95 (1981), pp. 31–49.

Milan 1951
Milan, Palazzo Reale. *Mostra del Caravaggio e dei Caravaggeschi*. 2nd ed. 1951. Introduction by Roberto Longhi.

Millar 1954
Oliver Millar. "Charles I, Honthorst, and Van Dyck." *The Burlington Magazine*, vol. 96, no. 610 (January 1954), pp. 36–42.

Miller 1982
Debra Miller. "Jan Victors: An Old Testament Subject in the Indianapolis Museum of Art." *Perceptions*, vol. 2 (December 1982), pp. 23–29.

Milwaukee 1974
Milwaukee, The University of Wisconsin Art History Galleries. *Low-Life in the Lowlands: 17th Century Dutch and Flemish Genre Painting*. February 29–March 22, 1974. Catalogue by Mark Chepp, Verna Curtis, and Marilyn Giaimo.

de Mirimonde 1961a
A. P. de Mirimonde. "Les Sujets musicaux chez Vermeer de Delft." *Gazette des Beaux-Arts*, 6th ser., vol. 57 (1961), pp. 29–52.

de Mirimonde 1961b
———. "Cornelis Saftleven dans les musées de province français." *La Revue du Louvre*, vol. 11 (1961), pp. 197–206.

de Mirimonde 1962
———. "La Musique dans les oeuvres hollandaises du Louvre." Parts 1, 2. *La Revue du Louvre*, vol. 12 (1962), pp. 123–38, 175–84.

de Mirimonde 1964
———. "Les Concerts des muses chez les maîtres du Nord." *Gazette des Beaux-Arts*, 6th ser., vol. 63 (1964), pp. 129–58.

de Mirimonde 1966
———. "La Musique dans les allégories de l'amour." Parts 1, 2. *Gazette des Beaux-Arts*, 6th ser., vol. 68 (1966), pp. 265–90; vol. 69 (1967), pp. 319–46.

Moes 1886
E. W. Moes. "Gerard ter Borch en zijne familie." *Oud Holland*, vol. 4 (1886), pp. 145–65.

Moes 1894
———. "Een te weinig opgemerkte bron voor het leven van Pieter van Laer." *Oud Holland*, vol. 12 (1894), pp. 95–106.

Moes 1909
———. *Frans Hals: Sa Vie et son oeuvre*. Translated by J. de Bosschere. Brussels, 1909.

Moes-Veth 1955
A. J. Moes-Veth. "Mozes ter Borch als sujet van zijn broer Gerard." *Bulletin van het Rijksmuseum*, vol. 3, no. 2 (1955), pp. 36–46.

Moes-Veth 1958
———. "Mozes of Gerard Terborch?" *Bulletin van het Rijksmuseum*, vol. 6, no. 1 (1958), pp. 17–21.

Mojzer 1967
Miklós Mojzer. *Dutch Genre Painting*. New York, 1967.

Molhuyzen 1848
P. C. Molhuyzen. "Over den Schilder H. ter Brugghen en diens geslacht." *Kroniek van het Historisch Genootschap te Utrecht*, vol. 4 (1848), pp. 132–33.

Molkenboer 1926–27
B. H. Molkenboer. "Utrecht, Vondel, Zachtleven en Booth." *Verslagen vereeniging het Vondelmuseum*, vol. 13 (1926–27), pp. 16–27.

de Monconys 1665–66
Balthasar de Monconys. *Journal des voyages de Monsieur de Monconys*. Vol. 2, *Voyage de Pays-Bas zomer 1663*. Lyons, 1665–66.

von Monroy 1964
E. F. von Monroy. *Embleme und Emblembücher in den Niederlanden, 1560–1630*. Utrecht, 1964.

Montias 1977a
J. M. Montias. "The Guild of St. Luke in 17th-Century Delft and the Economic Status of Artists and Artisans." *Simiolus*, vol. 9, no. 2 (1977), pp. 93–105.

Montias 1977b
———. "New Documents on Vermeer and His Family." *Oud Holland*, vol. 91 (1977), pp. 267–87.

Montias 1980
———. "Vermeer and His Milieu: Conclusion of an Archival Study." *Oud Holland*, vol. 94 (1980), pp. 44–62.

Montias 1982
———. *Artists and Artisans in Delft in the Seventeenth Century: A Socio-Economic Study of the Seventeenth Century*. Princeton, 1982.

de Mont-Louis 1895
René de Mont-Louis. *Adrien Brower, le petit peintre flamand*. Limoges, 1895.

Montreal/Toronto 1969
Montreal, The Montreal Museum of Fine Arts. *Rembrandt and His Pupils*. January 9–February 23, 1969. Also shown at Toronto, Art Gallery of Ontario, March 14–April 27, 1969. Catalogue by J. Bruyn and David G. Carter.

Moryson 1971
Fynes Moryson. *An Itinerary*. London, 1617. Reprint. Amsterdam and New York, 1971.

Moxey 1977
Keith P. F. Moxey. *Pieter Aertsen, Joachim Beuckelaer, and the Rise of Secular Painting in the Context of the Reformation*. New York, 1977.

Mulder 1937
Adriana W. J. Mulder. "De huwelijksloterij, grisaille door Adriaan van de Venne." *Vereeniging Oranje-Nassau Museum*, 1937, pp. 24–25.

Müller 1927
Cornelius Müller. "Abraham Bloemaert als Landschaftsmaler." *Oud Holland*, vol. 44 (1927), pp. 193–208.

Muller 1880
Samuel Muller. *De Utrechtsche archieven*. Vol. 1, *Schildersvereenigingen te Utrecht*. Utrecht, 1880.

Muls 1946
J. Muls. *De boer in de kunst*. Louvain, 1946.

Munich 1972
Munich, Alte Pinakothek. *Adriaen van der Werff (1659–1722)*. March 15–October 1, 1972. Introduction and catalogue by Peter Eikemeier.

Munich 1930
Munich, Neue Pinakothek. *Sammlung Schloss Rohoncz*. 1930.

Munich, Alte Pinakothek, cat. 1938
Munich, Alte Pinakothek. *Catalogue of the Alte Pinakothek*. 19th ed. 1938.

Munich, Alte Pinakothek, cat. 1958
Munich, Alte Pinakothek. *Kurzes Verzeichnis der Bilder*. 2nd ed. 1958.

Munich, Alte Pinakothek, cat. 1967
Munich, Alte Pinakothek. *Holländische Malerei des 17. Jahrhunderts*. 1967.

Münz 1937
Ludwig Münz. "Nicholaes Maes, Aert de Gelder, Barent Fabritius, und Rembrandt." Parts 1, 2. *Die graphischen Künste*, n.s., vol. 2, no. 3 (1937), pp. 95–108; no. 4, pp. 151–59.

Murris 1925
Roelof Murris. *La Hollande et les hollandais au XVIIe et au XVIIIe siècles, vus par les français*. Paris, 1925.

Nagler 1835–52
G. K. Nagler. *Neues allgemeines Künstler-Lexikon.* 22 vols. Munich, 1835–52.

Nagler 1858–79
G. K. Nagler, A. Andressen, and C. Clauss. *Die Monogrammisten und diejenigen bekannten und unbekannten Künstler.* 6 vols. Munich, 1858–79.

Nash 1972
J. M. Nash. *The Age of Rembrandt and Vermeer: Dutch Painting in the Seventeenth Century.* London, 1972.

Naumann 1978
Otto Naumann. "Frans van Mieris as a Draughtsman." *Master Drawings,* vol. 16, no. 1 (Spring 1978), pp. 3–34.

Naumann 1981a
————. *Frans van Mieris, the Elder (1635–1681).* 2 vols. Doornspijk, 1981.

Naumann 1981b
————. "Van Mieris, riant betaald schilder/Van Mieris as a 'Money Maker.'" *Tableau,* vol. 3, no. 5 (April–May 1981), pp. 649–56.

Neeffs 1876
Emmanuel Neeffs. *Histoire de la peinture et de la sculpture à Malines.* 2 vols. Gent, 1876.

Nelson forthcoming
Kristi Nelson. *Pieter Codde.* Great Minor Masters. Netherlandish Painters from the Past. Doornspijk, forthcoming.

Netscher 1889
Pieter M. Netscher. *Geslachtsregister der familie Netscher, met levensschetsen van de schilders Caspar, Theodorus, en Constantyn en genealogische tabellen.* The Hague, 1889.

Neurdenburg 1929
Elisabeth Neurdenburg. "Judith Leyster." *Oud Holland,* vol. 46 (1929), pp. 27–30.

Neurdenburg 1942
————. "Johannes Vermeer: Eenige opmerkingen naar aanleiding van de nieuwste studies over den Delftschen schilder." *Oud Holland,* vol. 59 (1942), pp. 65–73.

Neurdenburg 1951
————. "Nog eenige opmerkingen over Johannes Vermeer van Delft." *Oud Holland,* vol. 66 (1951), pp. 34–44.

New Brunswick 1983
New Brunswick, New Jersey, The Jane Voorhees Zimmerli Art Museum, Rutgers, The State University of New Jersey. *Haarlem: The Seventeenth Century.* February 20–April 17, 1983. Catalogue by Frima Fox Hofrichter; introduction by Egbert Haverkamp Begemann; essay by J. J. Temminck.

New York 1925
New York, M. Knoedler and Co. *Loan Exhibition of Dutch Masters of the Seventeenth Century.* November 16–28, 1925.

New York 1939
New York, M. A. McDonald Gallery. *Prints by Adriaen van Ostade.* October–November, 1939. Catalogue by Robert McDonald.

New York 1954–55
New York, Metropolitan Museum of Art. *Dutch Painting: The Golden Age.* Also shown at Toledo, Toledo Museum of Art, and Toronto, Art Gallery of Toronto. 1954–55.

New York/Boston/Chicago 1972–73
New York, The Pierpoint Morgan Library. *Dutch Genre Drawings of the Seventeenth Century.* Also shown at Boston, The Museum of Fine Arts, and Chicago, The Art Institute of Chicago. 1972–73. Introduction by K. G. Boon; catalogue by Peter Schatborn.

New York/Chicago/San Francisco 1950
New York, Metropolitan Museum of Art. *The Vienna Treasures.* 1950. Shown at Chicago, The Art Institute of Chicago; San Francisco, M. H. de Young Memorial Museum; Washington, D.C., National Gallery of Art; Saint Louis, City Art Museum; Toledo, Toledo Museum of Art; Toronto, Art Gallery of Toronto; Boston, The Museum of Fine Arts; Philadelphia, Philadelphia

Museum of Art. Also shown at Brussels/Amsterdam, 1947; Paris, 1947–48; Stockholm, 1948; Copenhagen/London, 1949.

New York/Maastricht 1982
New York, Noortman and Brod. *Adriaen Brouwer, David Teniers the Younger.* October 7–30, 1982. Also shown at Maastricht, Noortman and Brod, November 19–December 11, 1982. Catalogue by Margret Klinge.

Nicolson 1952
Benedict Nicolson. "Caravaggio and the Netherlands." *The Burlington Magazine,* vol. 94, no. 594 (September 1952), pp. 247–52.

Nicolson 1956
————. "The Rijksmuseum 'Incredulity' and Terbrugghen's Chronology." *The Burlington Magazine,* vol. 98, no. 637 (April 1956), pp. 103–10.

Nicolson 1957
————. "Terbrugghen Repeating Himself." In *Miscellanea Professor Dr. D. Roggen,* pp. 193–203. Antwerp, 1957.

Nicolson 1958
————. *Hendrick Terbrugghen.* London, 1958.

Nicolson 1960
————. "Second Thoughts about Terbrugghen." *The Burlington Magazine,* vol. 102, no. 692 (November 1960) pp. 465–73.

Nicolson 1962
————. "A Postscript to Baburen." *The Burlington Magazine,* vol. 104, no. 717 (December 1962), pp. 539–43.

Nicolson 1973
————. "Terbrugghen since 1960." In *Album Amicorum J. G. van Gelder,* edited by J. Bruyn et al., pp. 237–41. The Hague, 1973.

Nicolson 1979
————. *The International Caravaggesque Movement: Lists of Pictures by Caravaggio and His Followers throughout Europe from 1590–1650.* Oxford, 1979.

Nieuwstraten 1965
J. Nieuwstraten. "De ontwikkeling van Herman Saftlevens kunst tot 1650." *Nederlands kunsthistorisch jaarboek,* vol. 16 (1965), pp. 81–117.

Nieuwstraten 1970
————. "Nicolaes Berchem (1620–1683): Italiaans landschap." *Openbaar Kunstbezit,* vol. 14 (1970), p. 9.

Nissen 1914
Momme Nissen. "Rembrandt und Honthorst." *Oud Holland,* vol. 32 (1914), pp. 73–80.

Obreen 1877–90
F.D.O. Obreen. *Archief voor Nederlandsche Kunstgeschiedenis.* 7 vols. Rotterdam, 1877–1890. Reprint. Soest, 1976.

Oosterloo 1948
J. H. Oosterloo. *De meesters van Delft: Leven en werken van de Delftse schilders der zeventiende eeuw.* Amsterdam, 1948.

Orlers 1641
J. J. Orlers. *Beschrijvinge der Stadt Leyden.* 2nd ed. Leiden, 1641.

Osborn 1910–11
Max Osborn. "Gerard Terborch." *Velhagen und Klasings Monatshefte,* vol. 25 (1910–11), pp. 193–206.

Osborne 1971
Harold Osborne, ed. "Genre." In *The Oxford Companion to Art,* pp. 465–67.

Oursel 1981
Hervé Oursel. *Grands noms, grandes figures du Musée de Lille: Donation d'Antonie Brasseur.* Lille, 1981.

Overbury 1856
Thomas Overbury. *The Miscellaneous Works in Prose and Verse.* London, 1856.

Paris 1921
Paris, Musée du Jeu de Paume. *Exposition hollandais.* April–May 1921.

Paris 1949
Paris, Musée du Louvre. *Chefs d'oeuvre de la Pinacotheque de Munich.* 1949 [see also Amsterdam 1948].

Paris 1951
Paris, Musée du Petit Palais. *Chefs d'oeuvre des Musées de Berlin.* 1951.

Paris 1965
Paris, Institut Néerlandais. *Le Décor de la vie privée en Hollande au XVIIe siècle.* February 1–March 7, 1965.

Paris 1966
Paris, Musée de l'Orangerie. *Dans la lumière de Vermeer.* 1966.

Paris 1967
Paris, Musée des Arts Décoratifs. *La Vie en Hollande au XVIIe siècle.* January 11–March 20, 1967. Introduction by Paul Zumthor.

Paris 1970–71
Paris, Musée du Petit Palais. *Le Siècle de Rembrandt: Tableaux hollandais des collections publiques françaises.* November 17, 1970–February 15, 1971.

Paris 1981
Paris, Institut Néerlandais. *Le Monde paysan d'Adriaen et Isack van Ostade.* January 8–February 6, 1981. Introduction and catalogue by Bernhard Schnackenburg.

Paris, Louvre, cat. 1979
Paris, Musée du Louvre. *Ecoles flamande et hollandaise.* Vol. 1 of *Catalogue sommaire illustré des peintures du Musée du Louvre.* Paris, 1979. Catalogue by Arnauld Brejon de Lavergnée, Jacques Foucart, and Nicole Reynaud.

Parival 1651
Jean Nicolaes Parival. *Les Délices de la Hollande.* Leiden, 1651.

Parker 1977
Geoffrey Parker. *The Dutch Revolt.* Ithaca, 1977.

Parthey 1863–64
Gustav F. C. Parthey. *Deutscher Bildersaal: Verzeichnis der in Deutschland vorhandenen Oelbilder verstorbener Maler aller Schulen.* 2 vols. Berlin, 1863–64.

Passeri 1772
Giambattista Passeri. *Vite de' Pittori, Scultori, ed Architetti che anno lavorato in Roma.* Rome, 1772.

Pauwels 1951
H. Pauwels. "Nieuwe toeschrijvingen bij het oeuvre van Hendrik Ter Brugghen." *Gentse bijdragen tot de kunstgeschiedenis,* vol. 13 (1951), pp. 153–67.

van Peer 1946
A.J.J.M. van Peer. "Was Jan Vermeer van Delft Katholiek?" *Katholiek cultureel tijdschrift,* vol. 2, no. 12 (1946), pp. 468–70.

van Peer 1951
———. "Rondom Jan Vermeer van Delft: De kinderen van Vermeer." *Katholiek cultureel tijdschrift,* vol. 4, no. 6 (1951), pp. 615–26.

van Peer 1957
———. "Drie collecties schilderijen van Jan Vermeer." *Oud Holland,* vol. 72 (1957), pp. 92–103.

van Peer 1959
———. "Rondom Jan Vermeer van Delft." *Oud Holland,* vol. 74 (1959), pp. 240–45.

van Peer 1968
———. "Jan Vermeer van Delft: Drie archiefvondsten." *Oud Holland,* vol. 83 (1968), pp. 220–23.

Pelinck 1966
E. Pelinck. "De ontwerpen van Adriaen van der Werff voor De Larrey's 'Histoire d'Angleterre, d'Ecosse, et d'Irlande.'" *Oud Holland,* vol. 81 (1966), pp. 52–58.

de Permentier 1885
de Permentier. *Adrien Brauwer.* Brussels, 1885.

Pevsner 1940
N. Pevsner. *Academies of Art Past and Present.* Cambridge, 1940.

Philadelphia 1983
Philadelphia, Philadelphia Museum of Art. *Jan Steen: Comedy and Admonition.* January 15–July 3, 1983 [*Bulletin of the Philadelphia Museum of Art,* vol. 78, nos. 337–38 (Winter 1982/Spring 1983)]. Catalogue by Peter C. Sutton with appendix by Marigene H. Butler.

Philadelphia, cat 1900
William L. Elkins. *Catalogue of Paintings in the Private Collection of W. L. Elkins.* 2 vols. Paris, 1900.

Philadelphia, Johnson, cat. 1913
Philadelphia, John G. Johnson Collection. *Flemish and Dutch Paintings.* Vol. 2 of *Catalogue of a Collection of Paintings and Some Art Objects.* Philadelphia, 1913. Catalogue by W. R. Valentiner.

Philadelphia, Johnson, cat. 1941
Philadelphia, John G. Johnson Collection. *Catalogue of Paintings.* Philadelphia, 1941. Catalogue by Henri Marceau.

Philadelphia, Johnson, cat. 1972
Philadelphia, John G. Johnson Collection. *Catalogue of Flemish and Dutch Paintings.* Philadelphia, 1972. Catalogue by Barbara Sweeney.

Philadelphia, Museum Checklist, 1965
Philadelphia, Philadelphia Museum of Art. *Checklist of Paintings in the Philadelphia Museum of Art.* Philadelphia, 1965.

Philipsen 1957–59
J.P.W. Philipsen. "Abraham Bloemaert en zijn omgeving." *Oud Gorcum Varia,* 1957–59, pp. 31–32.

Pieper 1961
Paul Pieper. *Gerard Ter Borch in Münster.* Münster, 1961.

Piérard 1916
Louis Piérard. "Le 250e anniversaire de Frans Hals." *La Revue de Hollande,* vol. 3 (1916), pp. 328–31.

de Piles 1699
Roger de Piles. *Abrégé de la vie des Peintres.* Paris, 1699. 2nd ed. Paris, 1715. Translated as *The Art of Painting, and the Lives of the Painters.* London, 1706.

Pittsburgh 1954
Pittsburgh, Carnegie Institute. *Pictures of Everyday Life: Genre Painting in Europe, 1500–1900.* October 14–December 12, 1954. Introduction by Gordon Bailey Washburn.

Plasschaert 1924
Albert Plasschaert. *Johannes Vermeer en Pieter de Hooch.* Amsterdam, 1924.

Playter 1972
Caroline Bigler Playter. "Willem Duyster and Pieter Codde: The 'Duystere Werelt' of Dutch Genre Painting, c. 1625–1635." Diss., Harvard University, 1972.

Plietzsch 1911
Eduard Plietzsch. *Vermeer van Delft.* Leipzig, 1911.

Plietzsch 1918–19
———. "Esaias van de Velde's 'Gesellschaft auf der Terrasse.'" *Amtliche Berichte aus den königlichen Kunstsammlungen,* vol. 40 (1918–19), pp. 137–43.

Plietzsch 1936
———. "Gabriel Metsu." *Pantheon,* vol. 17 (January–June 1936), pp. 1–13.

Plietzsch 1937
———. "Jacob Ochtervelt." *Pantheon,* vol. 20 (July–December 1937), pp. 364–72.

Plietzsch 1939
———. *Vermeer van Delft.* Munich, 1939.

Plietzsch 1940
———. *Frans Hals.* Burg bei Magdeburg, [1940].

Plietzsch 1944
———. *Gerard Ter Borch.* Vienna, 1944.

Plietzsch 1949
———. "Jacobus Vrel und Esaias Boursse." *Zeitschrift für Kunst,* vol. 3 (1949), pp. 248–60.

Plietzsch 1951
———. "Adriaen van der Werff." *The Art Quarterly,* vol. 14, no. 2 (Summer 1951), pp. 137–47. Translated by Liselotte Moser.

Plietzsch 1956
———. "Randbemerkungen zur holländischen Interieurmalerei am Beginn des 17. Jarhunderts." *Wallraf-Richartz-Jahrbuch,* vol. 18 (1956), pp. 174–96.

Plietzsch 1959

———— . "Randbemerkungen zur holländischen Malerei vom Ende des 17. Jahrhunderts." In *Festschrift Friedrich Winkler*, edited by Hans Möhle, pp. 313–25. Berlin, 1959.

Plietzsch 1960

———— . *Holländische und flämische Maler des 17. Jahrhunderts*. Leipzig, 1960.

Poensgen 1924

Georg Poensgen. "Der Landschaftstil des Esaias van de Velde." Diss., Freiburg, 1924.

Poensgen 1926a

———— . "Beiträge zur Kunst des Willem Buytewech." *Jahrbuch der königlich preussischen Kunstsammlungen*, vol. 48 (1926), pp. 87–102.

Poensgen 1926b

———— . "Gemälde des Willem Buytewech im Kaiser-Friedrich-Museum." *Amtliche Berichte aus den königlichen Kunstsammlungen*, vol. 47 (1926), pp. 83–85.

Poot 1722

H. K. Poot. "Kunstkroon, voor den edelen heere Adriaen vander Werf, ridder, enz. fenix der schilders." In H. K. Poot, *Gedichten*, pp. 285–89. Delft, 1722.

Porterman 1977

K. Porterman. *Inleiding tot de Nederlandse emblemataliteratuur*. Groningen, 1977.

Portheine 1914

H. Portheine, Jr. *De kunstschilder Caspar Netscher, zijn vrouw en kinderen*. Arnhem, 1914.

Price 1974

J. L. Price. *Culture and Society in the Dutch Republic during the 17th Century*. New York, 1974.

Proskauer, Witt 1962

Curt Proskauer and Frits H. Witt. *Bildgeschichte der Zahnheilkunde*. Cologne, 1962.

van Puyvelde 1940

Leo van Puyvelde. "The Development of Brouwer's Compositions." *The Burlington Magazine*, vol. 77, no. 452 (November 1940), pp. 140–44.

Raepsaet 1852

H. Raepsaet. *Quelques recherches sur Adrien de Brauwere*. Gent, 1852.

Rathbone 1951

Perry T. Rathbone. "'The Housekeeper' by Nicolaes Maes." *Bulletin of the City Art Museum of Saint Louis*, vol. 36, no. 3 (Fall 1951), pp. 42–45.

Rathke 1952

E. Rathke. "Bildnistypen bei Frans Hals." Diss., Cologne, 1952.

Regin 1976

Deric Regin. *Traders, Artists, Burghers: A Cultural History of Amsterdam in the 17th Century*. Assen, 1976.

Régnier 1968

Gérard Régnier. "Jacob Vrel, un Vermeer du pauvre." *Gazette des Beaux-Arts*, 6th ser., vol. 71 (May–June 1968), pp. 269–82.

van Regteren Altena 1926

J. Q. van Regteren Altena. "De nieuwe Buytewech." *Maandblad voor beeldende kunsten*, vol. 2 (1926), pp. 165–68.

van Regteren Altena 1943

———— . "Hoe teekende Jan Steen?" *Oud Holland*, vol. 60 (1943), pp. 97–117.

van Regteren Altena 1946

———— . "De voorvaderen van Cornelis Dusart." *Oud Holland*, vol. 61 (1946), pp. 130–33.

van Regteren Altena 1949

———— . "Hoge kunst of spielerei?" *Kunsthistorische mededelingen van het Rijksbureau voor Kunsthistorische Documentatie*, vol. 4, nos. 1–2 (1949), p. 24.

van Regteran Altena 1959

———— . "Over Michael Sweerts als portrettist." *Oud Holland*, vol. 74 (1959), pp. 222–24.

van Regteren Altena 1963

———— . "Gabriel Metsu as a Draughtsman." *Master Drawings*, vol. 1 (1963), pp. 13–19.

Renckens 1962

B.J.A. Renckens. "Enkele notities bij vroege werken van Cornelis Saftleven." *Bulletin Museum Boymans–van Beuningen*, vol. 13, no. 1 (1962), pp. 59–74.

Renckens, Duyvetter 1959

B.J.A. Renckens and J. Duyvetter. "De vrouw van Gabriel Metsu, Isabella de Wolff, geboortig van Enkhuizen." *Oud Holland*, vol. 74 (1959), pp. 179–82.

Renger 1970

Konrad Renger. *Lockere Gesellschaft: Zur Ikonographie des verlorenen Sohnes und von Wirtshausszenen in der niederländischen Malerei*. Berlin, 1970.

Renger 1972

———— . "Joos van Winghes 'Nachtbancket met een Mascarade' und verwandte Darstellungen." *Jahrbuch der Berliner Museen*, vol. 14 (1972), pp. 161–93.

Reynolds 1931

E. J. Reynolds. *Some Brouwer Problems*. Lausanne, 1931.

Reynolds 1774

Sir Joshua Reynolds. "The Sixth Discourse." In *The Literary Works of Sir Joshua Reynolds*, vol. 1. Edited by Henry William Beechey. London, 1851.

Reynolds 1786

———— . "The Thirteenth Discourse." In *The Literary Works of Sir Joshua Reynolds*, vol. 2. Edited by Henry William Beechey. London, 1851.

Reynolds 1781

———— . "A Journey to Flanders and Holland in the Year MDCCLXXXI." In *The Literary Works of Sir Joshua Reynolds*, vol. 2. Edited by Henry William Beechey. London, 1851.

Reznicek 1963

E.K.J. Reznicek. "Realism as a 'Sideroad' or Byway in Dutch Art." *International Congress of the History of Art: Studies in Western Art*, vol. 2 (1963), pp. 247–53.

Reznicek 1972

———— . "Hont Horstiana." *Nederlands kunsthistorisch jaarboek*, vol. 23 (1972), pp. 167–89.

Richardson 1938

E. P. Richardson. "De Witte and the Imaginative Nature of Dutch Art." *The Art Quarterly*, vol. 1, no. 1 (Winter 1938), pp. 5–17.

Ripa 1644

Cesare Ripa. *Iconologia of Uytbeeldinghe des Verstands*. Translated by D. P. Pers. Amsterdam, 1644. Reprint. Soest, 1971.

Robinson 1974

Franklin W. Robinson. *Gabriel Metsu (1629–1667): A Study of His Place in Dutch Genre Painting of the Golden Age*. New York, 1974.

Robinson forthcoming

William Robinson. "The Early Works of Nicolaes Maes." Diss., Harvard University, forthcoming.

de Roever 1883

N. de Roever. "Iets over de kinderen en de begraafplaats van Anthonie Palamedesz." *Oud Holland*, vol. 1 (1883), pp. 164–65.

de Roever 1887

———— . "Een bezoek aan den Ridder Adriaen van der Werff, kunstschilder, in 1710." *Oud Holland*, vol. 5 (1887), pp. 67–71.

van Roey 1957

J. van Roey. "'Frans Hals van Antwerpen': Nieuwe gegevens over de ouders van Frans Hals." *Antwerpen*, vol. 3 (1957), 117–20.

van Roey 1972

———— . "De familie van Frans Hals: Nieuwe gegevens uit Antwerpen." *Jaarboek van het Koninklijk Museum voor Schone Kunsten te Amsterdam*, 1972, pp. 145–70.

Roh 1921

Franz Roh. *Holländische Malerei*. Jena, 1921.

Roh 1955–56

———— . "Zur Interpretation von Michiel Sweerts." *Die Kunst und das schöne Heim*, vol. 54 (1955–56), pp. 281–84.

Rome 1950

Rome, Palazzo Massimo alle Colonne. *I Bamboccianti*. 1950. Catalogue by G. Briganti.

Rome 1954
Rome, Palazzo delle Esposizioni. *Mostra di pittura olandese del seicento.* January 4–February 14, 1954.

Rome 1954–55
Rome, Palazzo Barberini. *I Fiamminghi e olandesi del 600.* December 1954–January 1955.

Rome, Palais des Expositions, 1956–57
Rome, Palais des Expositions. *Le XVII^e siècle européen.* 1956–57.

Ronday 1956
H. Ronday. *De boer in de Nederlandse schilderkunst, 1550–1900.* The Hague, 1956.

Roorda 1964
D. J. Roorda. "The Ruling Classes in the 17th Century." In *Britain and the Netherlands,* edited by J. S. Bromley and E. H. Kossmann, vol. 2, pp. 109–33. Groningen, 1974.

Rosenberg 1897
Adolf Rosenberg. *Terborch und Jan Steen.* Bielefeld, 1897.

Rosenberg 1900
_____ . *Adriaen und Isack van Ostade.* Bielefeld, 1900.

Rosenberg et al. 1966
Jakob Rosenberg, Seymour Slive, and E. H. ter Kuile. *Dutch Art and Architecture, 1600–1800.* Harmondsworth and Baltimore, 1966.

Rothes 1919
Walter Rothes. *Franz Hals und die holländische Figurenmalerei.* Die Kunst dem Volke, no. 37. Munich, 1919.

Rothes 1921
_____ . *Terborch und das holländische Gesellschaftsbild.* Die Kunst dem Volke, nos. 41–42. Munich, 1921.

Röthlisberger 1967
Marcel Röthlisberger. "Abraham Bloemaert." *Katalog der 14. Ausstellung in Wien der Galerie Friederike Pallamar,* Autumn 1967, pp. 15–26.

Rotterdam 1935
Rotterdam, Museum Boymans. *Vermeer, oorsprong en invloed, Fabritius, de Hooch, de Witte.* July 9–October 9, 1935. Catalogue by D. Hannema.

Rotterdam 1959
Rotterdam, Museum Boymans–van Beuningen. *Esaias van de Velde, Jan van de Velde, grafiek.* April 20–June 21, 1959. Foreword by B.J.D. Ihle.

Rotterdam 1973
Rotterdam, Historisch Museum. *Adriaen van der Werff, Kralingen 1659–1722 Rotterdam.* 1973. Essay by D. P. Snoep.

Rotterdam 1983
Rotterdam, Museum Boymans–van Beuningen. *Brood: De geschiedenis van het brood en het broodgebruik in Nederland.* October 2–November 14, 1983.

Rotterdam, Boymans, cat. 1962
Rotterdam, Museum Boymans–van Beuningen. *Catalogus schilderijen tot 1800.* 1962.

Rotterdam/Paris 1974–75
Rotterdam, Museum Boymans–van Beuningen. *Willem Buytewech, 1591–1624.* November 30, 1974–January 12, 1975. Also shown at Paris, Institut Néerlandais, January 24–March 9, 1975. Introduction by E. Haverkamp Begemann.

Rotterdam/Rome 1958–59
Rotterdam, Museum Boymans–van Beuningen. *Michael Sweerts en tijdgenoten.* October 4–November 23, 1958. Also shown at Rome, Palazzo Veneziano, December 6, 1958–February 1, 1959. Catalogue by R. Kultzen and N. Carpegna.

Rouir 1962
E. Rouir. "A La Découverte d'un graveur, Adrien van Ostade." *Le Livre et l'estampe,* no. 32 (1962), pp. 305–23.

Rovinski 1894
Dmitri Rovinski. *L'Oeuvre gravé des élèves de Rembrandt.* Saint Petersburg, 1894.

Rovinski, Tschétchouline 1912
Dmitri Rovinski and Nicolas Tschétchouline. *L'Oeuvre gravé d'Adrien van Ostade.* Saint Petersburg, 1912.

Rowen 1972
Herbert H. Rowen. *Johan de Witt: Grand Pensionary of Holland, 1625–1672.* Princeton, 1972.

Roy 1972
Rainer Roy. "Studien zu Gerbrand van den Eeckhout." Diss., Vienna, 1972.

de Rudder 1913
Arthur de Rudder. *Pieter de Hooch et son oeuvre.* Brussels and Paris, 1913.

Rudolph 1938
Herbert Rudolph. "'Vanitas': Die Bedeutung mittelalterlicher und humanistischer Bildinhalte in der niederländischen Malerei des 17. Jahrhunderts." In *Festschrift für Wilhelm Pinder,* pp. 405–33. Leipzig, 1938.

Rüttgers 1907
Severin Rüttgers. *Aus den Radierungen des Adriaen van Ostade.* Berlin, 1907.

Ruurs 1974
Rob Ruurs. "Adrianus Brouwer, gryllorum pictor." *Proef,* vol. 3 (May 1974), pp. 87–88.

Sacher-Masoch 1891
Leopold van Sacher-Masoch. *Die Abenteuer des Franz van Mieris, und andere Malergeschichten.* Mannheim, 1891.

Saint Petersburg/Atlanta 1975
Saint Petersburg, Museum of Fine Arts. *Dutch Life in the Golden Century.* January 21–March 2, 1975. Also shown at Atlanta, High Museum of Art, April 4–May 4, 1975. Catalogue by Franklin W. Robinson.

Salerno 1977–78
Luigi Salerno. *Pittori di paesaggio del seicento a Roma* (in Italian and English). Translated by Clovis Whitfield and Catherine Enggass. 3 vols. Rome, 1977–78.

Salinger 1960
Margaretta M. Salinger. "Adriaen Brouwer (Brauwer)." In *Encyclopedia of World Art,* vol. 2, cols. 631–32.

Salinger 1963a
_____ . "Gerritt van Honthorst." In *Encyclopedia of World Art,* vol. 7, cols. 604–5.

Salinger 1963b
_____ . "Pieter (Hendricksz.) de Hooch." In *Encyclopedia of World Art,* vol. 7, cols. 605–6.

Salinger 1965
_____ . "Adriaen van Ostade." In *Encyclopedia of World Art,* vol. 10, cols. 851–52.

Salinger 1967a
_____ . "Geraert Terborch." In *Encyclopedia of World Art,* vol. 13, cols. 1036–37.

Salinger 1967b
_____ . "Hendrick Terbrugghen." In *Encyclopedia of World Art,* vol. 13, cols. 1037–38.

Salinger 1967c
_____ . "Emanuel de Witte." In *Encyclopedia of World Art,* vol. 14, col. 849.

Salomon 1983
Nanette Salomon. "Vermeer and the Balance of Destiny." In *Essays in Northern European Art Presented to Egbert Haverkamp Begemann on His Sixtieth Birthday,* edited by Anne-Marie Logan, pp. 216–21. Doornspijk, 1983.

Sandrart 1675
Joachim von Sandrart. *L'Academia todesca della architectura, scultura e pittura: oder Teutsche Academie der Edlen Bau-, Bild- und Mahlerey-Künste.* 2 vols. in 1. Nuremberg, 1675.

Sandrart, Peltzer 1925
_____ . *Teutsche Academie der Edlen Bau-, Bild- und Mahlerey-Künste.* Edited with commentary by A. R. Peltzer. Munich, 1925.

San Francisco 1966
San Francisco, California Palace of the Legion of Honor. *The Age of Rembrandt.* October 10–November 13, 1966. Also shown at Toledo, Toledo Museum of Art, November 26, 1966–January 8, 1967, and Boston, Museum of Fine Arts, January 21–March 5, 1967.

San Francisco, de Young Museum, cat. 1966
 San Francisco, M. H. de Young Memorial Museum.
 *European Works of Art in the M. H. de Young Memorial
 Museum.* Berkeley, 1966.
Schaar 1954
 E. Schaar. "Berchem und Begeijn." *Oud Holland*, vol. 69
 (1954), pp. 241–45.
Schaar 1956
 ———. "Zeichnungen Berchems zu Landkarten." *Oud
 Holland*, vol. 71 (1956), pp. 239–43.
Schaar 1958
 ———. *Studien zu Nicolaes Berchem.* Diss., Cologne,
 1958.
Schama 1979
 ———. "The Unruly Realm: Appetite and Restraint in
 Seventeenth Century Holland." *Daedalus*, vol. 108, no. 3
 (Summer 1979), pp. 103–23.
Schama 1980
 Simon Schama. "Wives and Wantons: Versions of
 Womanhood in 17th Century Dutch Art." *The Oxford
 Art Journal*, vol. 3, no. 1 (April 1980), pp. 5–13.
Schapelhouman 1982
 Marijn Schapelhouman. "Twee tekeningen van Nicolaes
 Berchem." *Oud Holland*, vol. 96 (1982), pp. 123–26.
Schatborn 1973
 Peter Schatborn. "Olieverfschetsen van Dirck Hals."
 Bulletin van het Rijksmuseum, vol. 21, no. 3 (November
 1973), pp. 107–16.
Schatborn 1974
 ———. "Figuurstudies van Nicolaes Berchem." *Bulletin
 van het Rijksmuseum*, vol. 22, no. 1 (March 1974),
 pp. 3–16.
Schatborn 1975
 ———. "Figuurstudies van Ludolf de Jongh." *Oud
 Holland*, vol. 89 (1975), pp. 79–85.
Scheyer 1939
 Ernst Scheyer. "Portraits of the Brothers van Ostade."
 The Art Quarterly, vol. 2, no. 2 (Spring 1939),
 pp. 134–41.
Schillings 1937a
 André Schillings. "Bambaccio." *Nederland*, vol. 89
 (1937), pp. 1031–38.
Schillings 1937b
 ———. "Judith Leyster." *Nederland*, vol. 89 (1937),
 pp. 849–56.
Schinkel 1850
 A. D. Schinkel. "Brieven van en aan Frans van Mieris:
 Geslachtlijst van Van Mieris." In A. D. Schinkel,
 Geschied- en letterkundige bijdragen, pp. 47–81, 87–92.
 The Hague, 1850.
Schipper-van Lottum 1975
 M.G.A. Schipper-van Lottum. "Een naijmantgen met een
 naijcussen." *Antiek*, vol. 10, no. 2 (August–September
 1975), pp. 137–63.
Schlie 1887
 Friedrich Schlie. "Adriaen Brouwer." *Zeitschrift für
 bildende Kunst*, vol. 22 (1887), pp. 133–43.
Schlie 1890
 ———. "Jacob Duck." *Repertorium für Kunst-
 wissenschaft*, vol. 13 (1890), pp. 55–59.
Schloss 1982
 Christine Skeeles Schloss. *Travel, Trade, and Tempta-
 tion: The Dutch Italianate Harbor Scene, 1640–1680.*
 Ann Arbor, 1982 [revision of Diss., Yale University,
 1978].
Schloss 1983
 ———. "A Note on Jan Baptist Weenix's Patronage in
 Rome." In *Essays in Northern European Art Presented
 to Egbert Haverkamp Begemann on His Sixtieth Birth-
 day*, edited by Anne-Marie Logan, pp. 237–38.
 Doornspijk, 1983.
Schmidt 1873
 Wilhelm Schmidt. *Das Leben des Malers Adriaen
 Brouwer: Kritische Beleuchtung der über ihn verbreiteten
 Sagen.* Leipzig, 1873.
Schmidt 1874
 ———. "Dirk van Deelen und Adriaen Brouwer."
 Zeitschrift für bildende Kunst, vol. 9 (1874), pp. 95–96.
Schmidt 1879
 ———. "Ueber A. und J. Duc." *Repertorium für
 Kunstwissenschaft*, vol. 2 (1879), pp. 424–25.

Schmidt-Degener 1908a
 F. Schmidt-Degener. *Adriaen Brouwer et son évolution
 artistique.* Brussels, 1908.
Schmidt-Degener 1908b
 ———. *Adriaen Brouwer en de ontwikkeling zijner
 kunst.* Amsterdam, 1908.
Schmidt-Degener 1920
 ———. "William Buytewech." *Nieuwe Rotterdamsche
 Courant.* March 4, 1920. Reprinted in F. Schmidt-
 Degener, *Het blijvend beeld der Hollandse kunst.* Vol. 1
 of *Verzamelde studiën en essays van Dr. F. Schmidt-
 Degener.* Edited by A. van Schendel. Amsterdam, 1949.
Schmidt-Degener 1924
 ———. *Frans Hals.* Amsterdam, 1924. Reprinted in F.
 Schmidt-Degener, *Het blijvend beeld der Hollandse
 kunst.* Vol. 1 of *Verzamelde studiën en essays van Dr. F.
 Schmidt-Degener.* Edited by A. van Schendel. Amster-
 dam, 1949.
Schmidt-Degener 1927
 ———. *Veertig meesterwerken van Jan Steen.* Notes on
 the illustrations by H. E. van Gelder. Amsterdam, 1927.
Schmidt-Degener, van Gelder 1927
 F. Schmidt-Degener and H. E. van Gelder. *Jan Steen.*
 Translated by G. J. Renier. London, 1927.
Schnackenburg 1970
 Bernhard Schnackenburg. "Die Anfänge des Bauernin-
 terieurs bei Adriaen van Ostade." *Oud Holland*, vol. 85
 (1970), pp. 158–69.
Schnackenburg 1981
 ———. *Adriaen van Ostade, Isack van Ostade:
 Zeichnungen und Aquarelle.* 2 vols. Hamburg, 1981.
Schneede 1965
 Uwe M. Schneede. "Das repräsentative Gesellschaftsbild
 in der niederländischen Malerei des 17. Jahrhunderts und
 seine Grundlagen bei Hans Vredeman de Vries." Diss.,
 Kiel, 1965.
Schneede 1968
 ———. "Gabriel Metsu und der holländische Real-
 ismus." *Oud Holland*, vol. 83, no. 1 (1968), pp. 45–61.
Schneeman 1982
 Liane T. Schneeman. "Hendrick Martensz. Sorgh: A
 Painter of Rotterdam." Diss., The Pennsylvania State
 University, 1982.
von Schneider 1922
 Arthur von Schneider. "Gerard Honthorst und Judith
 Leyster." *Oud Holland*, vol. 40 (1922), pp. 169–73.
von Schneider 1925–26
 ———. "Jacob van Loo." *Zeitschrift für bildende
 Kunst*, vol. 59 (1925–26), pp. 66–78.
von Schneider 1927
 ———. "Entlehnungen Hendrick Ter-Brugghens aus
 dem Werk Caravaggios." *Oud Holland*, vol. 44 (1927),
 pp. 261–69.
von Schneider 1933
 ———. *Caravaggio und die Niederländer.* [Marburg],
 1933. 2nd ed. with new foreword. Amsterdam, 1967.
Schneider 1926–27
 Hans Schneider. "Bildnisse Adriaen Brouwers und seiner
 Freunde." *Zeitschrift für bildende Kunst*, vol. 60
 (1926–27), pp. 270–72.
Schneider 1927
 ———. "Bildnisse des Adriaen Brouwer." In *Festschrift
 für Max J. Friedländer zum 60. Geburtstage*, pp. 148–55.
 Leipzig, 1927.
Schöffer 1966
 E. Schöffer. "Did Holland's Golden Age Coincide with a
 Period of Crisis?" *Acta Historiae Neerlandica*, vol. 1
 (1966), pp. 82–107.
Scholte 1948
 J. H. Scholte. "Munster in het werk van Gerard Ter
 Borch." *Oud Holland*, vol. 63 (1948), pp. 9–38.
van den Schoor 1975
 H. van den Schoor. "Bentveughel signatures in Santa
 Costanza in Roma." *Mededeelingen van het
 Nederlandsch Historisch Instituut te Rome*, vol. 38,
 no. 3 (1975), pp. 77–86.

Schotel 1862–64
G.D.J. Schotel. *Geschiedenis in der rederijkers in Neder-land.* 2 vols. Amsterdam, 1862–64.

Schotel 1903
_____. *Het Oud-Hollandsch huisgezin der zeventiende eeuw.* Arnhem, 1903.

Schotel 1905
_____. *Het maatschappelijk leven onzer vaderen in de zeventiende eeuw.* Arnhem, 1905.

Schrevelius 1647
T. Schrevelius. *Harlemum, sive urbis Harlementis Incunabula, incrementa, fortuna varia, in pace, in bello.* Haarlem, 1647.

Schrevelius 1648
_____. *Harlemias: Of, de eerste stichting der stad Haarlem.* Haarlem, 1648.

Schulz 1977
Wolfgang Schulz. "Blumenzeichnungen von Herman Saftleven d'I." *Zeitschrift für Kunstgeschichte,* vol. 40, no. 2 (1977), pp. 135–53.

Schulz 1978
_____. *Cornelis Saftleven, 1607–1681: Leben und Werke mit einem kritischen Katalog der Gemälde und Zeichnungen.* Beiträge zur Kunstgeschichte, vol. 14. Berlin and New York, 1978.

Schulz 1982
_____. *Herman Saftleven, 1609–1685: Leben und Werke mit einem Katalog der Gemälde und Zeichnungen.* Berlin and New York, 1982.

Schwarz 1952
Heinrich Schwarz. "The Mirror in Art." *The Art Quarterly,* vol. 15, no. 2 (Summer 1952), pp. 97–118.

Schwarz 1966
_____. "Vermeer and the Camera Obscura." *Pantheon,* vol. 24 (1966), pp. 170–82.

Schwerin, Staatliches Museum, 1962
Schwerin, Staatliches Museum. *Holländische Maler des XVII. Jahrhunderts.* 1962.

Scott forthcoming
Mary Ann Scott. "Cornelis Bega: Painter, Etcher, and Draughtsman." Diss., University of Maryland, forthcoming.

Seattle, Art Museum, cat. 1954
Seattle, Seattle Art Museum. *European Paintings and Sculpture from the Samuel H. Kress Collection.* 1954.

Sedelmeyer 1898
Charles Sedelmeyer. *Illustrated Catalogue of 300 Paintings by Old Masters of the Dutch, Flemish, Italian, French, and English Schools.* Paris, 1898.

Seth 1980
Lennart Seth. "Vermeer och Van Veens 'Amorum Emblemata.'" *Konsthistorisk tidskrift,* vol. 49, no. 1 (June 1980), pp. 17–40.

Seymour 1964
Charles Seymour, Jr. "Dark Chamber and Light-Filled Room: Vermeer and the Camera Obscura." *The Art Bulletin,* vol. 46, no. 3 (September 1964), pp. 323–31.

Shipp 1953
Horace Shipp. *The Dutch Masters.* New York, 1953.

von Sick 1930
I. von Sick. *Nicolaes Berchem, ein Vorläufer des Rokoko.* Berlin, 1930.

Simon 1940
Kurt Erich Simon. "Jan Steen und Utrecht." *Pantheon,* vol. 26 (June–December 1940), pp. 162–65.

Simons 1923
E. I. S[imons]. "The Garden Party: Gerbrand van den Eeckhout." *Bulletin of the Worchester Art Museum,* vol. 14, no. 3 (October 1923), pp. 70–72.

Simpson 1953
Frank Simpson. "Dutch Paintings in England before 1760." *The Burlington Magazine,* vol. 95, no. 599 (February 1953), pp. 39–42.

Šip 1963
Jaromir Šip. "Meditation on Genre in Painting [in the 17th century Netherlands]" (in Russian). *Vytvarné umeni,* no. 3 (1963), pp. 89–106.

Siret 1859
A. Siret. "Revendications nationales: Sur le lieu de naissance d'Adrien Brouwer." *Journal des beaux-arts et de la littérature,* vol. 1 (1859), pp. 3–5.

Siret 1861
_____. "A propos de Corneille Dusart." *Journal des beaux-arts et de la littérature,* vol. 3 (1861), p. 107.

Siret 1862
_____. "Les Bega, Begyn ou Begeyn." *Journal des beaux-arts et de la litterature,* vol. 4 (1862), pp. 126–27.

Siwajew 1940
M. Siwajew. "Esaias van de Velde als Schlachtenmaler." *Travaux de département de l'art européen [du] Musée de l'Ermitage,* vol. 1 (1940), pp. 67–77.

Six 1926
J. Six. "Willem Buytewech's 'Met Rozeknoppen omstaan.'" *Oud Holland,* vol. 43 (1926), pp. 97–101.

Slatkes 1962
Leonard J. Slatkes. "Dirck van Baburen (c. 1595–1624): A Dutch Painter in Utrecht and Rome." Diss., Utrecht, 1962.

Slatkes 1965
_____. *Dirck van Baburen (c. 1595–1624): A Dutch Painter in Utrecht and Rome.* Utrecht, 1965.

Slatkes 1966
_____. "David de Haen and Dirck van Baburen in Rome." *Oud Holland,* vol. 81 (1966), pp. 173–86.

Slatkes 1969
_____. *Dirck van Baburen.* 2nd ed. Utrecht, 1969.

Slatkes 1973
_____. "Additions to Dirck van Baburen." In *Album Amicorum J. G. van Gelder,* edited by J. Bruyn et al., pp. 267–73. The Hague, 1973.

Slatkes 1981
_____. *Vermeer and His Contemporaries.* New York, 1981.

Slive 1956
Seymour Slive. "Notes on the Relationship of Protestantism to Seventeenth Century Dutch Painting." *The Art Quarterly,* vol. 19 (1956), pp. 3–15.

Slive 1961
_____. "Frans Hals Studies." *Oud Holland,* vol. 76 (1961), pp. 173–200.

Slive 1962
_____. "Realism and Symbolism in Seventeenth-Century Dutch Painting." *Daedalus,* vol. 91 (1962), pp. 469–500.

Slive 1963a
_____. "On the Meaning of Frans Hals' 'Malle Babbe.'" *The Burlington Magazine,* vol. 105, no. 727 (October 1963), pp. 432–36.

Slive 1963b
_____. "Frans Hals." In *Encyclopedia of World Art,* vol. 7, cols. 264–69.

Slive 1964
_____. "Frans Hals Reconsidered." *Art News Annual,* 1964, pp. 50–81.

Slive 1968
_____. "'Een dronke slapende meyd aen een Tafel' by Jan Vermeer." In *Festschrift Ulrich Middeldorf,* edited by Antje Kosegarten and Peter Tigler, vol. 1, pp. 452–59. Berlin, 1968.

Slive 1970–74
_____. *Frans Hals.* Kress Foundation Studies in the History of European Art. 3 vols. London and New York, 1970–74.

Sluyterman 1917
Karel Sluyterman. *Huisraad en binnenhuis in Nederland in vroegere eeuwen.* The Hague, 1917. Reprint. 1979.

Smith 1982
David R. Smith. *Masks of Wedlock: Seventeenth-Century Dutch Marriage Portraiture.* Ann Arbor, 1982.

Smith 1829–42
J. A. Smith. *A Catalogue Raisonné of the Works of the Most Eminent Dutch, Flemish, and French Painters.* 9 vols. and suppl. London, 1829–42.

Smith 1964
Winifred Smith. *The Commedia dell'Arte.* New York, 1964.

Snoep 1968–69
D. P. Snoep. "Een 17de eeuws liedboek met tekeningen van Gerard ter Borch de Oude en Pieter en Roeland van Laer." *Simiolus*, vol. 3, no. 2 (1968–69), pp. 77–134.

Snoep 1973
_____ . "Jacob Vrel: De ziekenoppos." *Openbaar Kunstbezit*, vol. 17 (1973), pp. 29–32.

Snoep-Reitsma 1973a
Ella Snoep-Reitsma. "De waterzuchtige vrouw van Gerard Dou en de betekenis van de lampetkan." In *Album Amicorum J. G. van Gelder*, edited by J. Bruyn et al., pp. 285–92. The Hague, 1973.

Snoep-Reitsma 1973b
_____ . "Chardin and the Bourgeois Ideals of His Time." *Nederlands kunsthistorisch jaarboek*, vol. 24 (1973), pp. 147–243.

Snoep-Reitsma 1975
_____ . "Verschuivende betekenissen van zeventiende eeuwse Nederlandse genrevoorstellingen." Diss., Utrecht, 1975.

Somov 1899
A. Somov. "Dutch Genre Painting in the 17th Century: Jan Steen." *Art and Design* (1899).

Sorgh 1890
"Het sterfjaar van Hendrik Maertensz. Sorgh." *Rotterdamsch jaarboekje*, vol. 2 (1890), p. 158.

van Spaan 1698
Gerard van Spaan. *Beschrijvinge der Stad Rotterdam*. Rotterdam, 1968. Reprint. Antwerp, 1943.

Springer 1898
Jaro Springer. *Das radirte Werk des Adriaen van Ostade*. Berlin, 1898.

Springer 1901
_____ . "Die Chronologie der Radierungen Ostades." *Sitzungsberichte der Kunstgeschichtlichen Gesellschaft*, no. 2 (1901), pp. 7–8.

Springer 1910
_____ . "Vinckboons als Zeichner für den Kupferstich." *Amtliche Berichte aus den königlichen Kunstsammlungen*, vol. 31, no. 11 (August 1910), pp. 295–97.

Stammler 1959
Wolfgang Stammler. *Frau Welt: Eine mittelalterliche Allegorie*. Freiburg, [1959].

Staring 1948a
A. Staring. "Portretten door Gerbrand van den Eeckhout." *Oud Holland*, vol. 63 (1948), pp. 180–88.

Staring 1948b
_____ . *Kunsthistorische verkenningen: Een bundel kunsthistorische opstellen. Onbetreden gebieden der Nederlandsche kunstgeschiedenis*. The Hague, 1948.

Staring 1956
_____ . *De Hollanders thuis: Gezelschapstukken uit drie eeuwen*. The Hague, 1956.

Stechow 1928–29
Wolfgang Stechow. "Bemerkungen zu Jan Steens künstlerischer Entwicklung." *Zeitschrift für bildende Kunst*, vol. 62 (1928–29), pp. 173–79.

Stechow 1947
_____ . "Esajas van de Velde and the Beginnings of Dutch Landscape Painting." *Nederlandsch kunsthistorisch jaarboek*, vol. 1 (1947), pp. 83–94.

Stechow 1948
_____ . "Jan Baptist Weenix." *The Art Quarterly*, vol. 11, no. 3 (Summer 1948), pp. 181–99.

Stechow 1951
_____ . "Some Portraits by Michael Sweerts." *The Art Quarterly*, vol. 14, no. 3 (Autumn 1951), pp. 206–15.

Stechow 1957
_____ . "Job Berckheyde's 'Bakery Shop.'" *Allen Memorial Art Museum Bulletin*, vol. 15, no. 1 (Fall 1957), pp. 5–14.

Stechow 1960
_____ . "Landscape Paintings in Dutch Seventeenth Century Interiors." *Nederlands kunsthistorisch jaarboek*, vol. 11 (1960), pp. 165–84.

Stechow 1966a
_____ . *Dutch Landscape Painting of the Seventeenth Century*. Kress Foundation Studies in the History of European Art, vol. 1. London and New York, 1966.

Stechow 1966b
_____ . *Northern Renaissance Art, 1400–1600: Sources and Documents*. Englewood Cliffs, N.J., 1966.

Stechow 1973
_____ . "A Genre Painting by Brekelenkam." *Allen Memorial Art Museum Bulletin*, vol. 30, no. 2 (Winter 1973), pp. 74–84.

Stechow, Comer 1975–76
Wolfgang Stechow and Christopher Comer. "The History of the Term *Genre*." *Allen Memorial Art Museum Bulletin*, vol. 33, no. 2 (1975–76), pp. 89–94.

Steenhoff 1920
W. J. Steenhoff. "Pieter de Hoogh." *Van onzen tijd*, vol. 20 (1920), pp. 164–67, 169–70.

Steinboemer 1924
G. Steinboemer. "Die Entstehung des niederländischen Geselligkeitsbilden." Diss., Berlin, 1924.

Steland 1967
Charlotte Steland. "Jan Asselijn und Karel Dujardin." *Raggi, Zeitschrift für Kunstgeschichte und Archäologie*, vol. 7 (1967), pp. 99–106.

Steland-Stief 1971
A. C. Steland-Stief. *Jan Asselijn*. Amsterdam, 1971.

Sterck 1924-25
J.F.M. Sterck. "Vondel en Herman Saftleven." *Verslag vereeniging het Vondelmuseum*, vol. 12 (1924–25), pp. 27–31 (reprinted in J.F.M. Sterck, *Oud en nieuw over Joost van den Vondel*, pp. 121–24. Amsterdam, 1932).

Stewart 1979
Alison G. Stewart. *Unequal Lovers: A Study of Unequal Couples in Northern Art*. New York, 1979.

Sthyr 1939
Jörgen Sthyr. "David Vinckboons (1576–1629) 'Die Boere Cermis,' Copenhagen, Printroom." *Old Master Drawings*, vol. 14, no. 53 (June 1939), pp. 8–10.

Stockholm, Nationalmuseum, cat. 1928
Stockholm, Nationalmuseum. *Catalogue descriptif des collections des peintures au Musée National: Maîtres étrangers*. Stockholm, 1928.

Stockholm, Nationalmuseum, cat. 1958
Stockholm, Nationalmuseum. *Äldre utländska Målningar och skulpturer*. Stockholm, 1958.

van Straaten 1977a
Evert van Straaten. *Johannes Vermeer, 1632–1675: Een Delfts schilder en de cultuur van zijn tijd*. The Hague, 1977.

van Straaten 1977b
_____ . *Koud tot op het bot: De verbielding van de winter in de zestiende en zeventiende eeuw in de Nederlanden*. The Hague, 1977.

Sumowski 1962
Werner Sumowski. "Gerbrand van den Eeckhout als zeichner." *Oud Holland*, vol. 77 (1962), pp. 11–39.

Sumowski 1983
_____ . *Gemälde der Rembrandt Schüler*. Vol. 1. London and Pfalz, 1983.

Sutton 1980
Peter C. Sutton. *Pieter de Hooch: Complete Edition with a Catalogue Raisonné*. New York, 1980.

Swillens 1931a
P.T.A. Swillens. "De schilder Theodorus (of Dirck?) van Baburen." *Oud Holland*, vol. 48 (1931), pp. 88–96.

Swillens 1931b
_____ . "Het kunstboek van Herman Saftleven." *Vondel-kroniek*, vol. 2 (1931), pp. 18–23.

Swillens 1945–46
_____ . "Rubens bezoek aan Utrecht." *Jaarboekje van Oud-Utrecht*, 1945–46, pp. 105ff.

Swillens 1950
_____ . *Johannes Vermeer: Painter of Delft, 1632–1675*. Translated by C. M. Breuning-Williamson. Utrecht and Brussels, 1950.

van Sypesteyn 1888–89
C. A. van Sypesteyn. "De schildersfamilie Netscher." *Haagsche Stemmen*, 1888–89, pp. 361–70.

Temple 1705
William Temple. *Observations upon the United Provinces of the Netherlands*. 7th ed. London, 1705.

Temple 1972
_____ . *Observations upon the United Provinces of the Netherlands*. Oxford, 1972 [first published 1673].

Terwesten 1770
Pieter Terwesten. *Catalogus of Naamlyst van Schilderyen, met derzelver prysen zedert den 22. Augusti 1752 tot den 21. November 1768*. The Hague, 1770 [suppl. to Hoet 1752]. Reprint. The Hague, 1976.

Thiel 1968
Erika Thiel. *Geschichte des Kostüms*. Berlin, 1968.

van Thiel 1961
P.J.J. van Thiel. "Frans Hals' portret van de Leidse rederijkersnar Pieter Cornelisz. van der Morsch, alias Piero (1543–1628)." *Oud Holland*, vol. 76 (1961), pp. 153–72.

van Thiel 1967–68
_____ . "Marriage Symbolism in a Musical Party by Jan Miense Molenaar." *Simiolus*, vol. 2, no. 2 (1967–68), pp. 91–99.

van Thiel 1969
_____ . "Michiel van Musscher's vroegste werk naar aanleiding van zijn portret van het echtpaar Comans." *Bulletin van het Rijksmuseum*, vol. 17, no. 1 (March 1969), pp. 3–36.

van Thiel 1971
_____ . "De aanbidding der koningen en ander vroeg werk van Hendrick ter Brugghen." *Bulletin van het Rijksmuseum*, vol. 19, no. 3 (December 1971), pp. 91–116.

van Thiel 1974
_____ . "Andermaal Michiel van Musscher: Zijn zelfportretten." *Bulletin van het Rijksmuseum*, vol. 22, no. 4 (December 1974), pp. 131–49.

van Thiel 1980
_____ . "De betekenis van het portret van Verdonck door Frans Hals." *Oud Holland*, vol. 94 (1980), pp. 112–40.

Thieme, Becker 1907–50
Ulrich Thieme and Felix Becker, eds. *Allgemeines Lexikon der bildenden Künstler von der Antike bis zur Gegenwart*. 37 vols. Leipzig, 1907–50.

van Thienen 1930
F.W.S. van Thienen. *Das Kostüm der Blütezeit Hollands, 1600–1660*. Kunstwissenschaftliche Studien, vol. 6. Berlin, 1930.

van Thienen 1932
_____ . "Een en ander over de kleeding der Nederlandsche boeren in de zeventiende eeuw." *Oudheidkundig jaarboek*, 4th ser., vol. 1 (1932), pp. 145–53.

van Thienen 1945
_____ . *Pieter de Hoogh*. Palet Serie. Amsterdam, [c. 1945].

van Thienen 1949
_____ . *Jan Vermeer van Delft*. Amsterdam, 1949.

van Thienen 1951
_____ . *The Great Age of Holland, 1600–60*. Costume of the Western World. Translated by F. G. Renier and A. Cliff. London, 1951.

van Thienen n.d.
_____ . *Vermeer*. Palet Serie. Amsterdam, n.d.

Thijm 1874
J.A. A[lberdingk] Th[ijm]. "De Codden." *De Dietsche warande*, vol. 10 (1874), pp. 287–309.

Thomas 1981
Haye Thomas. *Het dagelijks leven in de 17de eeuw*. Amsterdam and Brussels, 1981.

Thoré-Bürger 1857
T.E.J. Thoré [W. Bürger]. *Trésors d'Art exposés à Manchester en 1857*. Paris, 1857.

Thoré-Bürger 1858
_____ . *Amsterdam et La Haye*. Musées de la Hollande, vol. 1. Paris, 1858.

Thoré-Bürger 1860a
_____ . *Musée van der Hoop à Amsterdam et Musée de Rotterdam*. Musées de la Hollande, vol. 2. Paris, 1860.

Thoré-Bürger 1860b
_____ . *Trésors d'Art en Angleterre*. Brussels, 1860 [new edition of *Trésors d'Art exposés à Manchester en 1857*. Paris, 1857].

Thoré-Bürger 1866
_____ . "Van der Meer de Delft." Parts 1–3. *Gazette des Beaux-Arts*, 1st ser., vol. 21 (1866), pp. 279–330, 458–70, 542–75 [reprinted in Blum 1945].

Thoré-Bürger 1868a
_____ . "Frans Hals." *Gazette des Beaux-Arts*, 1st ser., vol. 24 (1868), pp. 219–32, 431.

Thoré-Bürger 1868b
_____ . "Dirk Hals et les fils de Frans." *Gazette des Beaux-Arts*, 1st ser., vol. 25 (1868), pp. 390–402.

Thornton 1978
Peter Thornton. *Seventeenth-Century Interior Decoration in England, France, and Holland*. New Haven and London, 1978.

Tietze-Conrat 1922
E. Tietze-Conrat. *Die delfter Malerschule: Carel Fabritius, Pieter de Hooch, Jan Vermeer*. Leipzig, 1922.

Timmers 1959
J.J.M. Timmers. *A History of Dutch Life and Art*. Translated by Mary F. Hedlund. London, 1959.

Toledo, Museum of Art, cat. 1976
Toledo, Toledo Museum of Art. *European Paintings*. Catalogue by W. Hutton. Toledo, 1976.

Torresan 1975
Di Paolo Torresan. "Per una rivalutazione di Pieter Codde." *Antichità Viva*, vol. 14, no. 1 (1975), pp. 12–23.

Trautscholdt 1929
E. Trautscholdt. "Notes on Adriaen van Ostade." *The Burlington Magazine*, vol. 54, no. 311 (February 1929), pp. 74–80.

Trautscholdt 1954–55
_____ . "Altholländisches Leben-gezeichnet." *Imprimatur*, vol. 12 (1954–55), pp. 34–39.

Trautscholdt 1959
_____ . "Über Adriaen van Ostade als Zeichner." In *Festschrift Friedrich Winkler*, edited by Hans Möhle, pp. 280–305. Berlin, 1959.

Trautscholdt 1961
_____ . "'De oude Koekebakster': Nachtrag zu Adriaen Brouwer." *Pantheon*, vol. 19, no. 4 (1961), pp. 187–95.

Trautscholdt 1966
_____ . "Beiträge zu Cornelis Dusart." *Nederlands kunsthistorisch jaarboek*, vol. 17 (1966), pp. 171–200.

Trautscholdt 1967
_____ . "Some Remarks on Drawings from the Studio and Circle of the van Ostade Brothers." *Master Drawings*, vol. 5, no. 2 (1967), pp. 159–65.

Trivas 1941
N. S. Trivas. *The Paintings of Frans Hals*. New York and London, 1941.

Trnek 1982
Renate Trnek. *Niederländer und Italien: Italianisante Landschafts- und Genremalerei von Niederländern des 17. Jahrhunderts in der Gemäldegalerie der Akademie der bildenden Künste in Wien*. Vienna, 1982.

Tuinman 1720–26
Carolus Tuinman. *De oorsprong en uitlegging van daghelyks gebwikte Nederduitsche spreekwoorden*. 2 vols. Middelburg, 1720–26.

Unger 1884
J. H .W. Unger. "Adriaan Brouwer te Haarlem." *Oud Holland*, vol. 2 (1884), pp. 161–69.

Unger 1873
W. Unger. *Etsen naar Frans Hals*. Essay by C. Vosmaer. Leiden, 1873.

Utrecht 1965
Utrecht, Centraal Museum. *Nederlandse 17e eeuwse Italianiserende landschapschilders*. 1965. Catalogue by Albert Blankert.

Utrecht/Antwerp 1952
Utrecht, Centraal Museum. *Caravaggio en de Nederlanden*. June 15–August 3, 1952. Also shown at Antwerp, Musée Royal des Beaux-Arts, August 10–September 28, 1952. Introduction by J. G. van Gelder and D. Roggen.

Valcooch 1926
P. A. de Planque. *Valcooch's regel der Duytsche school-meesters*. Groningen, 1926.

Valentiner 1913
W. R. Valentiner. "Esaias Boursse." *Art in America*, vol. 1, no. 1 (January 1913), pp. 30–39.

Valentiner 1923a
———. *Frans Hals*. Klassiker der Kunst in Gesamt-ausgaben, vol. 28. 2nd ed. Stuttgart, 1923.

Valentiner 1923b
———. "Early Drawings by Nicolaes Maes." *The Burlington Magazine*, vol. 43, no. 244 (July 1923), pp. 16–22.

Valentiner 1924a
———. *Nicolaes Maes*. Stuttgart, 1924.

Valentiner 1924b
———. "Jacob Ochtervelt." *Art in America*, vol. 12, no. 6 (October 1924), pp. 269–84.

Valentiner 1926–27
———. "Pieter de Hooch." Parts 1, 2. *Art in America*, vol. 15, no. 1 (December 1926), pp. 45–64; vol. 15, no. 2 (February 1927), pp. 67–77.

Valentiner 1928a
———. "Paintings by Pieter de Hooch and Jacobus Vrel." *Bulletin of the Detroit Institute of Arts*, vol. 9, no. 7 (April 1928), pp. 78–81.

Valentiner 1928b
———. "Dutch Painters of the School of Pieter de Hooch [Part 1: Esaias Boursse]." *Art in America*, vol. 16, no. 4 (June 1928), pp. 168–80.

Valentiner 1928c
———. "Rediscovered Paintings by Frans Hals." *Art in America*, vol. 16, no. 6 (October 1928), pp. 235–49.

Valentiner 1929a
———. *Pieter de Hooch*. Klassiker der Kunst in Gesamtausgaben, vol. 35. Stuttgart, 1929 [English edition translated by Alice M. Sharkey and E. Schwandt. London and New York, 1930].

Valentiner 1929b
———. "Dutch Genre Painters in the Manner of Pieter de Hooch. II. Jacobus Vrel." *Art in America*, vol. 17, no. 2 (February 1929), pp. 86–92 [see Valentiner 1928b for Part 1].

Valentiner 1930–31
———. "A Painter's Atelier by Michiel Sweerts." *Bulletin of the Detroit Institute of Arts*, vol. 12 (1930–31), pp. 4–6.

Valentiner 1932
———. "Zum 300. Geburtstag Jan Vermeers, Oktober 1932: Vermeer und die Meister die holländischen Genremalerei." *Pantheon*, vol. 10 (October 1932), pp. 305–24.

Valentiner 1935
———. "New Additions to the Work of Frans Hals." *Art in America*, vol. 23, no. 3 (June 1935), pp. 85–103.

Valentiner 1936
———. *Frans Hals Paintings in America*. Westport, Ct., 1936.

Valentiner 1949
———. "Teniers and Brouwer." *The Art Quarterly*, vol. 12, no. 1 (Winter 1949), pp. 89–91.

Valentiner 1959
———. "Jacque de Ville or Jacobus Vrel." *Bulletin of the J. Paul Getty Museum of Art*, vol. 1 (1959), pp. 23–26.

van Valkenburg 1959–62
C. C. van Valkenburg. "De Haarlemse schuttersstukken." Parts 1, 2. *Haarlem jaarboek 1958* (1959), pp. 59ff; *Haarlem jaarboek 1961* (1962), pp. 47ff.

van Valkenhoff 1947
Pierre van Valkenhoff. "Adriann van der Werff en Hubert Korneliszoon Poot." *Pen en penseel*, 1947, pp. 196–204.

Vanzype 1925
Gustave Vanzype. *Vermeer de Delft*. 3rd ed. Paris and Brussels, 1925.

van Veen 1607
Otto van Veen. *Horatii Flacci Emblemata*. Antwerp, 1607.

van Veen 1608
———. *Amorum Emblemata*. Antwerp, 1608. Reprint. Hildesheim and New York, 1970.

Veldheer et al. 1908
J. G. Veldheer, C. J. Gonnet and F. Schmidt-Degener. *Frans Hals in Haarlem*. Amsterdam, 1908.

Verbeek 1966
J. Verbeek. "Tekeningen van de familie Ter Borch." *Antiek*, vol. 1, no. 2 (1966), pp. 34–39.

Verburgt 1916
J. W. Verburgt. "De vier jaargetijden van David Vinckboons." *Jaarboekje van het Oudheidkundig Genootschap "Niftarlake,"* 1916, pp. 25–35.

Vermeulen 1939
Frans Vermeulen. "Enkele aanteekeningen betreffende het probleem Vingboons." *Oud Holland*, vol. 56 (1939), pp. 268–73.

Vermeylen 1941
A. Vermeylen. "Adriaan Brouwer." In *100 groote Vlamingen: Vlaanderens roem en grootheid in zijn beroemde mannen*, pp. 235–37. Utrecht, 1941.

Verwoerd 1937
C. Verwoerd. "Michael Sweerts, een Nederlandsch kunstschilder uit de XVIIIe [sic] eeuw, aspirant broeder-missionaris." *Het missiewerk*, vol. 18 (1937), pp. 166–68.

Veth 1915
Cornelis Veth. *Frans Hals en Jan Steen*. Baarn, 1915.

Veth 1947
———. *Gezelligheid en ongezelligheid in de Nederlandsche en Vlaamsche schilderkunst*. Amsterdam, 1947.

Veth 1890
G. H. Veth. "Aanteekeningen omtrent eenige Dordrechtsche schilders: 18. Nicolaes Maes." *Oud Holland*, vol. 8 (1890), pp. 125–42.

Veth 1892
———. "Aanteekeningen omtrent eenige Dordrechtsche schilders: 32. Godefridus Schalcken." *Oud Holland*, vol. 10 (1892), pp. 1–11.

Vienna 1873
Vienna, K. K. Österreichisches Museum. *Gemälde alter Meister aus dem wiener Privatbesitz*. August–September, 1873.

Vienna 1972
Vienna, Galerie Friederike Pallamar. *Die Hals-Familie und ihre Zeit*. November 15–December 31, 1972. Catalogue by Rudolf Pallamar.

Vienna, Akademie, cat. 1972
Vienna, Akademie der bildenden Künste. *Katalog der Gemäldegalerie*. 1972. Catalogue by Margarethe Poch-Kalous.

Vienna, Kunhistorishes, cat. 1972
Vienna, Kunsthistorisches Museum. *Hollandisch Meister des 15., 16., und 17. Jahrhunderts: Katolog der Gemäldegalerie*. 1972.

Villot 1852
F. Villot. *Notice des tableaux exposés dans les galeries du Musée national du Louvre*. Part 2, *Écoles allemande, flamand, et hollandaise*. Paris, 1852.

Visscher 1614
Roemer Visscher. *Sinnepoppen*. Amsterdam, 1614. Reprint with introduction and notes by L. Brummel. The Hague, 1949.

Volskaya 1937
V. Volskaya. *Frans Hals* (in Russian). Moscow, 1937.

Volskaya 1939
_____ . "Genre Paintings by Emanuel de Witte in the Puskin Museum of Fine Arts" (in Russian). In *Papers of the Puskin Museum of Fine Arts.* Moscow, 1939.

Vosmaer 1880
C. Vosmaer. "Adriaan van Ostade." *L'Art*, vol. 22, no. 3 (1880), pp. 241–50, 265–68.

Vosmaer 1882a
_____ . "Frans Hals." In C. Vosmaer, *Over kunst: Schetsen en studiën*, pp. 85–155. Leiden, 1882.

Vosmaer 1882b
_____ . "Adriaan van Ostade." In C. Vosmaer, *Over kunst: Schetsen en studiën*, pp. 156–72. Leiden, 1882.

Voss 1912
Hermann Voss. "Vermeer van Delft und die utrechter Schule." *Monatshefte für Kunstwissenschaft*, vol. 5 (1912), pp. 79–83.

Vrankrijker 1937
A. C. J. de Vrankrijker. *Het maatschappelijk leven in Nederland in de Gouden Eeuw.* Amsterdam, 1937.

de Vries 1945
A. B. de Vries. *Jan Vermeer van Delft.* Basel, 1945.

de Vries 1948
_____ . *Jan Vermeer van Delft.* 2nd ed. London, 1948.

de Vries 1955
_____ . "Negentiende eeuwse kunstcritiek en zeventiende eeuwse schilderkunst." *Nederlands kunsthistorisch jaarboek*, vol. 6 (1955), pp. 157–68.

de Vries 1883
A. D. de Vries. "Het testament en sterfjaar van Gabriel Metsu." *Oud Holland*, vol. 1 (1883), pp. 78–80.

de Vries 1885–86
_____ . "Biografische aanteekeningen betreffende voornamelijk Amsterdamsche schilders, plaatsnijders, enz. en hunne verwanten." Parts 1–5. *Oud Holland*, vol. 3 (1885), pp. 55–80, 135–60, 223–40; vol. 4 (1886), pp. 135–44, 215–24.

de Vries 1973
Lyckle de Vries. "Achttiende- en negentiende-eeuwse auteurs over Jan Steen." *Oud Holland*, vol. 87 (1973), pp. 227–38.

de Vries 1974
_____ . "Willem Buytewech verbannen naar Rotterdam [Museum Boymans–van Beuningen]." *Hollands maandblad*, vol. 15, no. 325 (1974), pp. 15–20.

de Vries 1974–75
_____ . "Jan Steen: Seine Stellung in der Tradition des Genrebildes." *Sitzungsberichte der Kunstgeschichtliche Gesellschaft zu Berlin*, vol. 23 (October 1974–May 1975), pp. 10–12.

de Vries 1976a
_____ . *Jan Steen: De schilderende Uilenspiegel.* Amsterdam, 1976.

de Vries 1976b
_____ . *Jan Steen: De groote meesters.* Weert, 1976.

de Vries 1977
_____ . "Jan Steen, 'de kluchtschilder.'" Diss., Groningen, 1977.

J. de Vries 1974
Jan de Vries. *The Dutch Rural Economy in the Golden Age, 1500–1700.* New Haven and London, 1974.

J. de Vries 1976
_____ . *The Economy of Europe in the Age of Crises, 1600–1750.* Cambridge, 1976.

Waagen 1837–38
G. F. Waagen. *Kunstwerke und Künstler in England.* 2 vols. Berlin, 1837–38.

Waagen 1854
_____ . *Treasures of Art in Great Britain.* 4 vols. London, 1854.

Waagen 1862
_____ . *Handbuch der deutschen und niederländischen Malerschulen.* Stuttgart, 1862.

van de Waal 1940
H. van de Waal. "Buytewech en Frisius." *Oud Holland*, vol. 57 (1940), pp. 123–39.

Waddingham 1964
M. R. Waddingham. "Andries and Jan Both in France and Italy." *Paragone*, vol. 15, no. 171 (May 1964), pp. 13–43.

Waddingham 1976–77
_____ . "Michael Sweerts, 'Boy Copying the Head of a Roman Emperor.'" *The Minneapolis Institute of Arts Bulletin*, vol. 63 (1976–77), pp. 57–65.

Wagner 1967
Anni Wagner. "Im Wohnzimmer eines holländischen Bürgerhauses aus dem 17. Jahrhundert." *Die Kunst und das schöne Heim*, vol. 65, no. 11 (August 1967), pp. 538–39.

Walker 1975
John Walker. *National Gallery of Art, Washington, D.C.* New York, 1975.

Waller 1932
F. G. Waller. "De familie van de schilders (Esaias) Boursse en (Joan) de Nise (Jan Denysz.)." *Maandblad de Nederlandsch leeuw*, vol. 50 (1932), cols. 237–43.

Walpole 1788
Horace Walpole. *Anecdotes of Painting in England.* London, 1788. Reprint. London, 1872.

Walsh 1972
John Walsh, Jr. "The Earliest Dated Painting by Nicolaes Maes." *Metropolitan Museum Journal*, vol. 6 (1972), pp. 105–14.

Walsh, von Sonnenburg 1973
John Walsh, Jr. "Vermeer." Hubert von Sonnenburg. "Technical Comments." *Metropolitan Museum of Art Bulletin*, vol. 31 (Summer 1973), pp. 181–228.

Wap 1852
J.J.F. Wap. "Herman Saftleven en de orkaan van 1674." *Utrechtsche volks-almanak*, 1852, pp. 140–77.

Wap 1853
_____ . "Herman Saftleven en de orkaan van 1674." *Astrea, Maandschrift voor schoone Kunst*, vol. 2 (1853), pp. 42–52, 83–84.

Washburn 1962
Gordon Bailey Washburn. "Genre and Secular Subjects: Definition of the Concept of 'Genre Art'; The West in Medieval and Modern Times." In *Encyclopedia of World Art*, vol. 6, cols. 81–83, 86–99.

Washington 1961–62
Washington, D.C., National Gallery of Art. *Exhibition of Art Treasures for America from the Samuel H. Kress Collection.* December 10, 1961–February 4, 1962.

Washington, National Gallery, cat. 1965
Washington, D.C., National Gallery of Art. *Summary Catalogue of European Paintings and Sculpture.* 2 vols. 1965.

Washington/Detroit/Amsterdam 1980–81
Washington, D.C., National Gallery of Art. *Gods, Saints and Heroes: Dutch Painting in the Age of Rembrandt.* November 2, 1980–January 4, 1981. Also shown at Detroit, The Detroit Institute of Arts, February 16–April 19, 1981; Amsterdam, Rijksmuseum, May 18–July 19, 1981. Catalogue by Albert Blankert et al.

Washington/New York/Chicago 1948–49
Washington, D.C., National Gallery of Art. *Paintings from the Berlin Museum.* March 17–April 18, 1948. Also shown at New York, Metropolitan Museum of Art, May 17–June 13, 1948, and the following institutions: Chicago, The Art Institute; Detroit, The Detroit Institute of Arts; Cleveland, The Cleveland Museum of Art; Minneapolis, The Minneapolis Institute of Arts; San Francisco, The M. H. De Young Memorial Museum; Los Angeles, The Los Angeles County Museum; Saint Louis, The City Art Museum of Saint Louis; Pittsburgh, Carnegie Institute; Toledo, Toledo Museum of Art. 1948–49.

Watelet 1757
C. Watelet. "Genre." In *Encyclopédie, ou Dictionnaire raisonné des sciences, des arts et des métiers*, vol. 7, pp. 589–99. Paris, 1757.

Wedmore 1880
Frederick Wedmore. *The Masters of Genre Painting*. London, 1880.

Wegner, Pée 1980
Wolfgang Wegner and Herbert Pée. "Die Zeichnungen des David Vinckboons." *Münchner Jahrbuch der bildenden Kunst*, vol. 31 (1980), pp. 35–128.

Weigel 1837–66
Rudolph Weigel. *Kunstkatalog*. 35 vols. Leipzig, 1837–66.

Weigel 1843
———. *Suppléments au peintre-graveur de Adam Bartsch*. Vol. 1. Leipzig, 1843.

von Weiher 1937
Lucy von Weiher. *Der Innenraum in der holländischen Malerei des XVII. Jahrhunderts*. Würzburg, 1937 (Diss., Munich, 1934).

Welcker 1942
A. Welcker. "P. Boddink alias Pieter van Laer, Orlando Bodding alias Roeland of Orlando van Laer, Nicolaes Bodding alias N. Boddingh van Laer of Ds. Nicolaes Boddingius." *Oud Holland*, vol. 59 (1942), pp. 80–89.

Welcker 1947
———. "Pieter Boddink alias Pieter van Laer." *Oud Holland*, vol. 62 (1947), pp. 206–8.

Welcker 1948
———. "De stamouders van een schildersgeslacht Harmen ter Borch en Catharina van Colen." *Oud Holland*, vol. 63 (1948), pp. 112–20.

Welu 1975a
James A. Welu. "Vermeer: His Cartographic Sources." *The Art Bulletin*, vol. 57, no. 4 (December 1975), pp. 529–47.

Welu 1975b
———. "'Card Players and Merrymakers': A Moral Lesson." *Worcester Art Museum Bulletin*, n.s., vol. 4, no. 3 (May 1975), pp. 8–16.

Welu 1977a
———. "Vermeer and Cartography." Diss., Boston University, 1977.

Welu 1977b
———. "Job Berckheyde's 'Baker.'" *Worcester Art Museum Bulletin*, n.s., vol. 6, no. 3 (May 1977), pp. 1–9.

Welu 1977c
———. "A Street Scene by Johannes Lingelbach." *Worcester Art Museum Bulletin*, n.s., vol. 6, no. 3 (May 1977), pp. 10–17.

Wessely 1868
J. E. Wessely. "Jan Verkolje: Verzeichniss seiner Schabkunstblätter." *Archiv für die zeichnenden Künste*, vol. 14 (1868), pp. 99–115, 271.

Wessely 1888
———. *Adriaen van Ostade: Verzeichnis seiner Original-Radirungen und der graphischen Nachbildungen nach seinen Werken*. Hamburg, 1888.

Westrheene 1856
Tobias van Westrheene. *Jan Steen: Etude sur l'art en Hollande*. The Hague, 1856.

Westrheene 1858
———. "Jan Steen: Geschiedenis en fantasie." *Kunstkronijk*, vol. 19 (1858), pp. 77–79, 81–86.

Westrheene 1864
———. *Jan Steen: Historisch-romantische schetsen*. Leiden, 1864.

Weyerman, 1729–69
J. C. Weyerman. *De levens beschryvingen der nederlandsche konstschilders en konstschilderessen*. 4 vols. The Hague, 1729–69.

Wheelock 1975–76
Arthur K. Wheelock, Jr. "Gerard Houckgeest and Emanuel de Witte: Architectural Painting in Delft around 1650." *Simiolus*, vol. 8, no. 3 (1975–76), pp. 167–85.

Wheelock 1976
———. Review of *Gabriel Metsu (1629–1667): A Study of His Place in Dutch Genre Painting of the Golden Age*, by Franklin W. Robinson. *The Art Bulletin*, vol. 58, no. 3 (September 1976), pp. 456–59 [see Robinson 1974].

Wheelock 1977
———. *Perspective, Optics, and Delft Artists Around 1650*. New York, 1977 (Diss., Harvard University, 1973).

Wheelock 1978
———. "Reappraisal of Gerard Dou's Reputation." In Corcoran Gallery of Art, *The William A. Clark Collection: An Exhibition Marking the 50th Anniversary of the Installation of the Clark Collection, April 26–July 16, 1978*, pp. 60–67. Washington, D.C., 1978.

Wheelock 1981
———. *Jan Vermeer*. New York, 1981.

Wheelock 1983
———. "Northern Baroque." In *Encyclopedia of World Art*, vol. 16, pp. 195–210.

White 1982
Christopher White. *The Dutch Pictures in the Collection of Her Majesty the Queen*. Cambridge, 1982.

White forthcoming
———. *Karel Dujardin*. Great Minor Masters. Netherlandish Painters from the Past. Doornspijk, forthcoming.

Wichmann 1918
H. Wichmann. "Leonaert Bramer: Sein Leban und seine Kunst." Diss., Berlin, 1918.

van de Wiele 1893a
Marguerite van de Wiele. "La Hollande des van Ostade." *L'Art*, vol. 54 (1893), pp. 192–96.

van de Wiele 1893b
———. *Les frères van Ostade*. Les Artistes célèbres. Paris, 1893.

Wiersum 1922
E. Wiersum. "Willem Pietersz. Buytewech, 1591/2–1624." *Oud Holland*, vol. 40 (1922), pp. 55–56.

Wiersum 1923
———. "Willem Pietersz. Buytewech, 1591–1624." *Rotterdamsch jaarboekje*, 3rd ser., vol. 1 (1923), pp. 52–61.

Wiersum 1927a
———. "De Rotterdamsche familie Van Musscher." *De navorscher*, vol. 76 (1927), pp. 255–56.

Wiersum 1927b
———. "Ridder Adriaen van der Werff." *Rotterdamsch jaarboekje*, 3rd ser., vol. 5 (1927), pp. 1–15.

Wiersum 1931
———. "Cornelis Saftleven, geboren te Gorcum in 1607, overleden te Rotterdam in 1681." *Rotterdamsch jaarboekje*, 3rd ser., vol. 9 (1931), pp. 88–90.

Wiersum 1938
———. "De schoenmakerswerkplaats van Brekelenkam." *Oud Holland*, vol. 55 (1938), pp. 211–13.

Wiesner 1976
Herbert Wiesner. *Master Painters of Holland: Dutch Painting in the Seventeenth Century*. Oxford and New York, 1976.

Wijnman 1932
H. F. Wijnman. "Het geboortejaar van Judith Leyster." *Oud Holland*, vol. 49 (1932), pp. 62–65.

Wijnman 1935
———. "De Amsterdamsche genreschilder Willem Cornelisz. Duyster." *Amstelodamum*, vol. 22 (1935), pp. 33–34.

Wilenski 1929
R. H. Wilenski. *An Introduction to Dutch Art*. London, 1929.

Wilenski 1955
———. *Dutch Painting*. New York, 1955.

van der Willigen 1870
Adriaan van der Willigen. *Les Artistes de Harlem: Notices historiques avec un précis sur la Gilde de St. Luc*. Haarlem, 1870. Reprint. Nieuwkoop, 1970.

Wilson 1977
Charles Wilson. *The Dutch Republic and the Civilization of the Seventeenth Century*. New York and Toronto, 1977.

Wind 1964
Barry Wind. "The Bambocciata: Its Character and Its Sources." Masters thesis, New York University, 1964.

Wind 1973
_____ . "Studies in Genre Painting, 1580–1630." Diss.,
New York University, 1973.

Winkler 1960
Friedrich Winkler. "Ein frühes Werk von Adriaen
Brouwer." *Pantheon*, vol. 18, no. 5 (September–October
1960), pp. 213–21.

de Winter 1767
Hendrick de Winter. *Beredeneerde catalogus van alle de
prenten van Nicolas Berchem*. Amsterdam, 1767.

Winternitz 1979
Emanuel Winternitz. *Musical Instruments and Their
Symbolism in Western Art: Studies in Musical Iconology*.
New Haven, 1979.

Wipper 1960
B. P. Wipper. "The Development of the Work of Gabriel
Metsu" (in Russian). In *Festschrift Lazarev on the
History of Russian and West European Art*,
pp. 314–24. Moscow, 1960.

Worcester, Worcester Art Museum, cat. 1974
Worcester, Worcester Art Museum. *European Paintings
in the Collection of the Worcester Art Museum*. 2 vols.
1974. Essay on 'Dutch School' by Seymour Slive.

Worp 1904
J. A. Worp. *Geschiedenis van het drama en het tooneel
in Nederland*. Groningen, 1904.

Wouters, Visser 1926
D. Wouters and W. J. Visser. *Geschiedenis van de
opvoeding en het onderwijs, vooral in Nederland*.
Groningen, 1926.

Wrangel 1908
N. Wrangel. "Les Peintres de genre et les portraitistes
Néerlandais des XVIIᵉ et XVIIIᵉ siècles." *Starye Gody*,
1908, pp. 675–92.

Wright 1976
Christopher Wright. *Vermeer*. London, 1976.

Wright 1978
_____ . *The Dutch Painters: 100 Seventeenth Century
Masters*. New York, 1978.

Wright 1981
_____ . *A Golden Age of Painting: Dutch, Flemish,
German Paintings, Sixteenth–Seventeenth Centuries,
from the Collection of the Sarah Campbell Blaffer
Foundation*. San Antonio, 1981.

Wurfbain 1979
M. L. Wurfbain. "Vrouwenfiguren in schilderijen uit
Gabriël Metsu's Leidse jaren." *Tableau*, vol. 2, no. 1
(October–November 1979), pp. 14–18.

Würtenberger 1937
F. Würtenberger. *Das holländische Gesellschaftsbild*.
Schramberg im Schwarzwald, 1937.

Wurzbach 1906–11
Alfred Wurzbach. *Niederländisches Künstler-Lexikon*.
3 vols. Vienna and Leipzig, 1906–11. Reprint. Amster-
dam, 1974.

Zafran 1977
Eric Zafran. "Jan Victors and the Bible." *The Israel
Museum News*, no. 12 (1977), pp. 92–120.

von Zesen 1664
Filips von Zesen. *Beschreibung der Stadt Amsterdam*.
Amsterdam, 1664.

Zoege von Manteuffel 1920–21
Kurt Zoege von Manteuffel. "Ein Gemälde Willem
Buytewechs im Kaiser-Fredrich-Museum." *Amtliche
Berichte aus den Königlichen Kunstsammlungen*,
vol. 42 (1920–21), pp. 44–47.

Zoege von Manteuffel 1927
_____ . *Die Künstlerfamilie van de Velde*. Künstler-
monographien, vol. 117. Bielefeld, 1927.

Zumthor 1962
Paul Zumthor. *Daily Life in Rembrandt's Holland*.
Translated by S. W. Taylor. London, 1962.

Zurich 1953
Zurich, Kunsthaus. *Holländer des 17. Jahrhunderts*.
November 4–December 12, 1953.

Zwigtman 1840
C. Zwigtman. *Levens-Bijzonderheden van Jan Steen,
geschetst in twee zangen*. Tholen, 1840.

Acknowledgments

In the five years since the idea was conceived to mount an exhibition tracing the rise and full achievement of Dutch genre painting, many people have given of their time and skills. Otto Naumann and William Robinson advised in the organization and selection of paintings from the outset. For their insights as well as their contributions to this catalogue, I am deeply grateful. Jan Kelch and Christopher Brown kindly agreed to join this team, providing insights about European collections and once again making essential contributions to the catalogue. A friend to all the authors, Professor Egbert Haverkamp Begemann has been an invaluable advisor throughout the research and organization of this project.

The exhibition would not have been possible without the early approval and guidance of Jean Sutherland Boggs, former director of the Philadelphia Museum of Art, and the continuing support of Anne d'Harnoncourt, who shepherded it to completion. Joe Rishel's kindly administrative and scholarly advice was essential. For her tireless and versatile efforts in the organization of the show and the preparation of the catalogue, I am indebted to Cynthia von Bogendorf-Rupprath. Ella Schaap is gratefully acknowledged not only for her collaboration as she prepared a concurrent exhibition devoted to Dutch tiles, but also in translations from Dutch. Other members of the staff of the Philadelphia Museum of Art who contributed substantially toward the realization of this project include: Suzanne Wells, Jane Watkins, Laurence Channing, Marigene Butler, George Marcus, Irene Taurins, Tara Robinson, Carl Strehlke, Martha Small, Sandra Horrocks, Conna Clark, Teresa Reagan, Meri Green, Alice Lefton, Janet Greenwood, Judith Ebbert Boust, and David Watt. Linda Parshall and Edward Cooperrider translated into English texts written in German.

In addition to the lenders to the exhibition, I wish to thank the following people who have assisted in various ways with information, advice, and aid: Clifford S. Ackley, Henry and Ann Adams, Katharine Baetjer, John Baskett, Tuja van den Berg, Pieter Biesboer, Albert Blankert, Piergiuseppe Bozzetti, Beatrijs Brenninkmeijer-de Rooij, Richard R. Brettell, Hugh Brigstocke, James D. Burke, Jean K. Cadogan, Giuseppe Cassini, Görel Cavalli-Björkman, Hans Max Cramer, Frits Duparc, Peter Eikemeier, James Fack, Roland E. Fleisher, Jacques Foucart, Irene Geismeier, Jeroen Giltay, Gregory Hedberg, Terrell Hillebrand, Frima Fox Hofrichter, John Hoogsteder, William Hutton, Christophe P. Janet, Piet de Jonge, Eddy de Jongh, Ian Kennedy, George Keyes, W. Th. Kloek, Michael Komanicki, Ildiko Korosi-Ember, Gerbrand Kotting, Thomas Kren, Susan Donahue Kuretsky, J. I. Kuznetsow, Gerhard Langemeyer, Katharine C. Lee, Laurence Libin, Walter Liedtke, Suzanne Lindsay, Iva Lisikewycz, Anne-Marie Logan, Juan J. Luña, Hugh Macandrew, J. Patrice Marandel, Anneliese Mayer-Meintschell, Oliver Millar, Debra Miller, J. M. Montias, Theo van den Muijsenberg, J. Nieuwstraten, Hervé Oursel, Henry Pauwels, Sir John Pope-Hennessy, Simon de Pury, Konrad Renger, Pierre Rosenberg, John Rowlands, Scott Schaeffer, Simon Schama, Erich Schleier, Mary Ann Scott, Alan Shestack, Seymour Slive, Eric Jan and Nicolette Sluyter, Anthony Speelman, Theodore Stebbins, Hans Strutz, Scott Sullivan, P.J.J. van Thiel, Peter Thornton, Lyckle de Vries, John Walsh, Jr., Willem L. van de Watering, John C. and Charlotte Weber, James A. Welu, Arthur Wheelock, M. L. Wurfbain, and Martin Zimet.

Finally, to the authors' wives and families, heartfelt thanks for your enduring support and to Bug and Page my love.

P.C.S.

Photographs from the Royal Collection are reproduced by gracious permission of Her Majesty Queen Elizabeth II.

Photographs were supplied by the owners and lenders, except where noted below.

Introduction: Masters of Seventeenth-Century Dutch Genre Painting: Courtesy of A.C.L.-Bruxelles, figs. 1, 21; Jörg P. Anders, Berlin, fig. 101; Bullarty Lomeo, New York, fig. 94; courtesy of Courtauld Institute of Art, London, figs. 29, 93, 98; A. Dingjan, The Hague, figs. 52, 55, 75; Frequin, Holland, figs. 51, 76; Anne Gold, Aachen, fig. 26; courtesy of Rheinisches Bildarchiv, Cologne, fig. 48; courtesy of the Rijksbureau voor Kunsthistorische Documentatie, The Hague, fig. 7; Walter Steinkopf, Berlin, fig. 13.

Introduction: Life and Culture in the Golden Age: Jörg P. Anders, Berlin, figs. 11, 24; courtesy of Atlas van Stolk, Rotterdam, fig. 2; E. Irving Blomstrann, New Britain, Conn., fig. 23; A. Dingjan, The Hague, fig. 5; Frequin, Holland, fig. 13.

Plates and catalogue: Courtesy of A.C.L.-Bruxelles, cat. no. 2, cat. no. 28, fig. 2, cat. no. 106, fig. 2; Jörg P. Anders, Berlin, pls. 3, 5, 17, 67, 68, 86, 105, 106, cat. nos. 8, 9, 47, 55, 112, 116, cat. no. 21, fig. 2, cat. no. 118, fig. 3; De Antonis Fotografo, cat. no. 62; Joachim Blauel, pls. 59, 76; F. Bruckmann, Munich, cat. no. 75, fig. 1; Brunel, Lugano, cat. no. 64; courtesy of Courtauld Institute of Art, London, cat. no. 6, fig. 2, cat. no. 31, figs. 1, 3, cat. no. 38, fig. 3, cat. no. 69, figs. 1, 3, cat. no. 72, fig. 1, cat. no. 87, fig. 1, cat. no. 103, fig. 1; Prudence Cummings Assoc., London, cat. no. 23; Deutsche Fotothek, Dresden, cat. no. 29, fig. 2; A. Dingjan, The Hague, pl. 57, cat. nos. 50, 75, 94, cat. no. 12, fig. 1; Foto Stijns, Dordrecht, cat. no. 67; Frequin, Holland, cat. nos. 21, 69, 79, 103, 127, cat. no. 127, fig. 1; courtesy of Gemeentelijke Archiefdienst, Delft, cat. no. 53, fig. 1; Giraudon, Paris, cat. no. 90, fig. 3; Tom Haartsen, Oudekerk a/d Amstel, pl. 32, cat. no. 113, cat. no. 45, fig. 2, Hickey-Robertson, Houston, cat. no. 89; Jürgen Hinrichs, pl. 113; Szelényi Károly, pl. 6; B. P. Keiser, pl. 126; Jannes Linders, pls. 26, 79; Bruno Meissner, Zurich, cat. no. 29; J. Howard Miller, Amarillo, cat. no. 44, fig. 2; Eric E. Mitchell, pls. 37, 62, 75; Claude O'Sughru, Montpellier, cat. no. 33, fig. 1; Photo Meyer, Vienna, pl. 73; Photo Musées Nationaux, pl. 74; courtesy of Rheinisches Bildarchiv, Cologne, cat. no. 24; courtesy of the Rijksbureau voor Kunsthistorische Documentatie, The Hague, cat. no. 100, cat. no. 17, fig. 1, cat. no. 42, fig. 3, cat. no. 52, fig. 3, cat. no. 58, fig. 1, cat. no. 64, fig. 1; Gordon H. Roberton, pls. 84, 100, 109; Tom Scott, Edinburgh, cat. no. 53; Walter Steinkopf, Berlin, cat. no. 25, cat. no. 32, fig. 2; Studio Koppelman, Maarssen, pl. 18, cat. no. 61; Joseph Szaszfai, Branford, Conn., pl. 49, cat. no. 73.

Index of Artists

Biographies of artists precede catalogue entries.

Baburen, Dirck van, cat. no. 1; pl. 10
Bega, Cornelis, cat. nos. 2–4; pls. 33–35
Berchem, Nicolaes, cat. no. 5; pl. 51
Berckheyde, Job, cat. no. 6; pl. 119
Bloemaert, Abraham, cat. no. 7; pl. 42
Borch, Gerard ter, cat. nos. 8–15; pls. 67–74
Boursse, Esaias, cat. no. 16; pl. 112
Brekelenkam, Quirijn van, cat. nos. 17–19; pls. 60–62
Brouwer, Adriaen, cat. nos. 20–23; pls. 22–25
Brugghen, Hendrick ter, cat. no. 24; pl. 9
Buytewech, Willem, cat. nos. 25–26; pls. 5–6
Codde, Pieter, cat. nos. 27–29; pls. 13–15
Delen, Dirck van, cat. no. 45; pl. 11
Diepraam, Abraham, cat. no. 30; pl. 96
Dou, Gerard, cat. nos. 31–35; pls. 52–56
Duck, Jacob, cat. nos. 36–38; pls. 38–40
Dujardin, Karel, cat. nos. 39–40; pls. 49–50
Dusart, Cornelis, cat. no. 41; pl. 36
Duyster, Willem, cat. no. 42; pl. 37
Eeckhout, Gerbrand van den, cat. no. 43; pl. 88
Elinga, Pieter Janssens, cat. no. 44; pl. 113
Hals, Dirck, cat. nos. 45–46; pls. 11–12
Hals, Frans, cat. no. 47; pl. 17
Honthorst, Gerrit van, cat. nos. 48–49; pls. 7–8
Hooch, Pieter de, cat. nos. 50–55; pls. 100–105
Jongh, Ludolf de, cat. nos. 56–57; pls. 92–93
Kick, Simon, cat. no. 58; pl. 41
Koedijck, Isaack, cat. no. 59; pl. 63
Laer, Pieter van, cat. no. 60; pl. 43
Leyster, Judith, cat. no. 61; pl. 18
Lingelbach, Jan, cat. nos. 62–63; pls. 44–45
Loo, Jacob van, cat. no. 64; pl. 87
Maes, Nicolaes, cat. nos. 65–67; pls. 97–99
Man, Cornelis de, cat. nos. 68–69; pls. 117–18
Metsu, Gabriel, cat. nos. 70–72; pls. 64–66
Miel, Jan, cat. no. 73; pl. 46
Mieris, Frans van, cat. nos. 74–76; pls. 57–59
Molenaer, Jan Miense, cat. nos. 77–79; pls. 19–21
Musscher, Michiel van, cat. no. 80; pl. 124
Naiveu, Matthijs, cat. no. 81; pl. 127

Neer, Eglon van der, cat. no. 82; pl. 123
Netscher, Caspar, cat. nos. 83–85; pls. 75–77
Ochtervelt, Jacob, cat. nos. 86–88; pls. 114–16
Ostade, Adriaen van, cat. nos. 89–93; pls. 27–31
Ostade, Isaack van, cat. no. 94; pl. 32
Palamedesz., Anthonie, cat. no. 95; pl. 16
Saftleven, Cornelis, cat. nos. 96–97; pls. 90–91
Saftleven, Herman; cat. no. 97; pl. 91
Schalcken, Godfried, cat. nos. 98–99; pls. 120–21
Sorgh, Hendrick, cat. nos. 100 101; pls. 94 95
Steen, Jan, cat. nos. 102–10; pls. 78–86
Sweerts, Michael, cat. no. 111; pl. 47
Velde, Esaias van de, cat. nos. 112–13; pls. 3–4
Venne, Adriaen van de, cat. no. 114; pl. 26
Verkolje, Jan, cat. no. 115; pl. 122
Vermeer, Johannes, cat. nos. 116–19; pls. 106–9
Victors, Jan, cat. no. 120; pl. 89
Vinckboons, David, cat. nos. 121–22; pls. 1–2
Vrel, Jacobus, cat. no. 123; pl. 111
Weenix, Jan Baptist, cat. no. 124; pl. 48
Werff, Adriaen van der, cat. nos. 125–26; pls. 125–26
Witte, Emanuel de, cat. no. 127; p. 110